The Print Council Index to Oeuvre-Catalogues of Prints by European and American Artists

The Print Council Index to Oeuvre-Catalogues of Prints by European and American Artists

*Under the Sponsorship of
the Print Council of America*

Compiled by

TIMOTHY A. RIGGS

KRAUS INTERNATIONAL PUBLICATIONS

Millwood, New York • London, England • Schaan, Liechtenstein

A Division of Kraus-Thomson Organization Limited

Copyright © 1983 by the Print Council of America

First printing 1983

Printed in the United States of America

Library of Congress Cataloging in Publication Data

Riggs, Timothy A., 1942–
 The Print Council index to oeuvre-catalogues of
prints by European and American artists.

 1. Prints—Catalogs—Indexes. I. Print Council of
America. II. Title.
Z5947.A3R53 1983 [NE90] 769.92′2 82-48986
ISBN 0-527-75346-7

To
The Memory of
Lessing J. Rosenwald
1891-1979
Founder of
The Print Council of America

Contents

Note: Artists known by monograms are listed alphabetically under **Monograms** (beginning on page 515). Indecipherable monograms and figures are listed at the end of the monogram section.

Artists known by nicknames, like the Master of the Playing Cards, are listed alphabetically under **Masters** (beginning on page 480). Artists known by dates, like the Master of 1515, are also listed under **Masters** and precede those artists known by nicknames.

Preface

The Print Council of America commissioned me to assemble this index to oeuvre-catalogues in 1970, with funds provided by the Old Dominion Foundation and the Avalon Foundation. Egbert Haverkamp-Begemann and I worked out the basic format for the book; other members of the Print Council who were particularly generous with advice during its early stages were Edgar Breitenbach, Harold Joachim, Elizabeth Roth, and the late Heinrich Schwartz.

Between 1970 and 1973 I examined oeuvre-catalogues in print rooms and libraries across the United States and Europe, and received generous assistance from the staff members of all the institutions listed on pages xliii–xlv. In particular I want to thank Cliff Ackley, Jean Adhémar, Maurice Bloch, Alan Fern, J. G. van Gelder, Sinclair Hitchings, Fritz Koreny, R. E. Lewis, Katharina Meyer, Lydia de Pauw-de Veen, Konrad Renger, John Rowlands, Eleanor Sayre, Peter Wick, Matthias Winner, and the late Gunter Troche. Dorine Newton completed the indexing of the catalogues by Bartsch and Passavant, especially demanding because of the many changes in attribution which have occurred since those books were compiled. Other indexing of multi-artist catalogues was done by Ellen Berezin, Nancy Bialler, Mark Gerstein, Susan Kane, Gail Margolis, Alan Martin, and Otto Nauman.

The Worcester Art Museum, whose staff I joined in 1973, made space available for me to store and work on the stacks of entry slips that we had accumulated. The long task of turning these into a finished manuscript was greatly facilitated by the editorial advice and assistance of Penny Mattern (who in addition proofread virtually the entire manuscript with me) and Ellen Berezin. Jean Connor, Lois Grinnel, Ellen Laipson, and Carol Zerrow all helped with the monotonous work of standardizing entries and proofing the manuscript, which was typed with meticulous care by Pearl Jolicoeur. As members of a Print Council advisory committee, Sinclair Hitchings and Susan Reed offered much-needed encouragement at a time when the end seemed very far away. I am equally grateful for the friendship and support of my colleagues in Worcester during the period, especially Ellen Berezin, Bonnie Grad and Penny Mattern. Steven Goulden edited the finished manuscript for publication, and Ann Keck-Henderson's thoughtful criticism helped to make the introductory section a readable piece of prose.

Lessing Rosenwald took an interest in this project from its inception, secured the financial backing that made it possible, and made available to me his own magnificent library of print reference books. The manuscript was completed a few months before his death; the book is dedicated to his memory.

A Note
to the User

The *Print Council Index* is for you if you need to know about the prints that a particular artist has made (or that have been made after his designs) and want to find out if there is an oeuvre-catalogue of his prints. A print oeuvre-catalogue is defined here as any listing of the artist's total output in prints, or some clearly defined section of that output: for example, all the prints in one technique, or all the prints made up to a certain date. Catalogues of the output of print publishers and publishing houses have been included as well.

Arrangement

The *Print Council Index* is arranged alphabetically by the name of the artist or publisher whose work is being catalogued. Artists known only by dates (Master of 1515) and by nicknames (Master of the Banderoles, Master of the Playing Cards) are grouped under the heading **Masters Known By Names or Nicknames** (beginning on page 480); dates precede nicknames, which are in alphabetical order. Artists known only by monogram are grouped under **Monograms and Figures** (beginning on page 515), even though they too are commonly referred to as Master (Master ES, Master IB with the bird).[1] Indecipherable monograms and figures (夊 ▦ ꜔ 大) are grouped at the end of the monogram section. Under the name of the artist, the oeuvre-catalogues of his work are arranged in order of publication date.

 If the artist you are looking for is not listed in the *Print Council Index,* check the section *Multi-Artist Catalogues Not Indexed* (page xxxvii). One of the books listed there may contain a partial or complete oeuvre-catalogue of his work.

[1]Monograms are identified by the numbers of C. K. Nagler's *Die Monogrammisten*, abbreviated as [Nagler, *Mon.*]. Nagler's transcription and alphabetization of monograms is followed, except in a few cases where his transcriptions have been shown to be incorrect. (Note that in transcribing a monogram it is often a subjective decision concerning the order in which to put the letters, and if you are looking for a monogram you read as **ES,** you may find it under **SE.**) Within the alphabetical sequence, monograms listed in Nagler precede any which are not listed there, and monograms from Nagler are listed in the order established by him.

Description of Catalogues

The artists Augustin Hirschvogel and Andrea del Sarto will serve as examples to show how oeuvre-catalogues are listed and described.

> **Hirschvogel,** Augustin *(c.1503–1553)*
> [B.] IX, pp. 170–207.
>> Entries: 136+. Pre-metric. Inscriptions. Described. Copies mentioned.

The first line of the entry is the bibliographic description of the catalogue: author, title, place and date of publication. [B.] is an abbreviation for Adam Bartsch's *Le Peintre Graveur,* which contains hundreds of oeuvre-catalogues; the bibliographic description for this and other frequently cited works is given in the *List of Abbreviations for Frequently Cited Books and Periodicals* (beginning on page xxiii). The abbreviation is followed by the volume and page numbers for the Hirschvogel catalogue. Next comes a series of code words and phrases describing the contents of the catalogue and showing what information it provides for each print. (These and all other descriptive terms are defined at length in the *Glossary of Symbols and Code Words,* beginning on page xvii). There are 136 entries in the catalogue, but they refer to more than 136 prints, because a set of prints is given only one entry number. The dimensions of the prints are given in an obsolete (pre-metric) unit of measure. Inscriptions on the prints are transcribed wholly or in part; the subject matter of each print is described; and, when a print has been copied, the copy is mentioned in the catalogue.

> [P.] III, pp. 257–259.
>> Entries: 9 (additional to [B.]). Premetric. Inscriptions. Described. Located.

This catalogue, by Passavant, is a supplement to Bartsch, cataloguing 9 prints not known to the earlier scholar. Besides giving dimensions and inscriptions and describing the subject matter of each print, Passavant gives the location of at least one impression of each.

> [Wess.] I, p. 137.
>> Entries: 1 (additional to [B.] and [P.]). Millimeters. Inscriptions. Described.

Another supplement, listing only prints unknown to Bartsch and Passavant. Dimensions are given in millimeters.

> Nehring, Alfred. *Über Herberstain und Hirsfogel; Beiträge zur Kenntnis ihres Lebens und ihrer Werke.* Berlin: Ferd. Dümmler, 1897.
>> Bibliography of books (published by Herberstain) with illustrations by.

This is not a print oeuvre-catalogue, but a bibliography of the books containing prints by or after Hirschvogel. (This particular bibliography is limited to books issued by the publisher Herberstain.) The *Print Council Index* includes bibliographies of illustrated books, but does not describe them in the same detail as oeuvre-catalogues.

> Schwarz, K. *Augustin Hirschvogel; ein deutscher Meister der Renaissance.* Berlin: Julius Bond, 1917. Reprint. 2 vols. New York: Collectors Editions, 1971.
> Entries: 156. Millimeters. Inscriptions. States. Described. Illustrated (selection in 1917 edition, complete in 1971 reprint). Located. 1971 reprint has additional information.

This entry covers two editions of Schwarz's catalogue. Unless otherwise noted, the descriptive terms refer to both editions. Schwarz catalogues 156 prints, with a separate entry number for each one (unlike Bartsch). Besides the types of information given by the earlier catalogues, Schwarz notes the existence of different states of the same print. The 1917 edition illustrates some but not all of the prints (see "Selection" in the *Glossary*). The 1971 reprint gives an illustration of each print, and also provides some information not included in the 1917 edition.

> **Sarto,** Andrea del *(1486–1530)*
> [B.] XII: *See* **Chiaroscuro Woodcuts**

Because Bartsch's catalogue of woodcuts in the chiaroscuro technique is not subdivided by artist, it is described under the name of the technique, with cross references like this one to the artists whose work is included.

> Shearman, John. *Andrea del Sarto.* Oxford: Clarendon Press, 1965.
> Catalogue of paintings; prints after are mentioned where extant.

Shearman does not formally catalogue the prints after Andrea del Sarto's paintings, but in his catalogue of paintings he mentions the prints that were made after them. Like bibliographies of illustrated books, catalogues of this type are included in the *Print Council Index* but not described in detail.

Catalogues not Completely Described

Normally, if a code word or symbol is missing from the description of a catalogue, it means that the catalogue does not give that information. The following catalogue, for example, is simply a list of titles and dimensions:

> **Schoofs,** Rudolf *(20th cent.)*
> Kunsthalle Bremen. *Rudolf Schoofs;*
> *Gravuren 1959–1965; nach dem Verzeichnis*
> *des Kunstlers gedruckt.* Bremen (West
> Germany), 1965.
>> Entries: 80+. Millimeters.

For some multi-artist catalogues, however, the *Print Council Index* does not give a complete description. These catalogues are marked with an asterisk:

> **Schoor,** Jacobus van *(fl. c.1633)*
> [W.] II, p. 583.
>> Entries: 3.*

The asterisk indicates that you should check the main entry for the catalogue in the *List of Abbreviations for Frequently Cited Books and Periodicals,* where you will find it more fully described.

Hard-to-find Catalogues

For hard-to-find catalogues, manuscript catalogues and catalogues published in limited editions, the *Print Council Index* gives the abbreviation for the name of a library or print room where the catalogue can be found.

> **Kravtsov,** Gershon *(20th cent.)*
> Perkin, W. D. *Gerschon Krawzow, en rus-*
> *sisk exlibriskunstner; opusliste.* n.p., Exlib-
> risten, 1970. 50 copies. (NN)
>> Entries: 140 (bookplates only, to 1968).
>> Millimeters. Described. Illustrated
>> (selection).

"(NN)," at the end of the bibliographic description, is an abbreviation for the New York Public Library. *See List of Abbreviations for Libraries,* beginning on page xliii.

Limits of the Index

According to the title page, the *Print Council Index* covers all oeuvre-catalogues of prints by and after European and American artists. In practice, the statement on the title page needs some qualification.

No catalogues published later than 1972 are included.

Printmakers who confined themselves to maps or calligraphy are not covered.

Artists belonging to the European tradition in former colonial areas like Australia have been included, as well as the artists of Europe and North and South America.

The indexing of multi-artist catalogues is not perfectly consistent. Beraldi's *Les graveurs du xixe siècle* is indexed, although some of Beraldi's entries are not complete oeuvre-catalogues; Nagler's *Die Monogrammisten* is not indexed, although some of Nagler's entries are complete oeuvre-catalogues. The list of *Multi-Artist Catalogues Not*

Indexed (beginning on page xxxvii) is a warning that the *Print Council Index* is not complete in this respect, and can be a guide to further research.

Finally, there are the catalogues that have completely escaped listing. If you are dealing with an artist whose reputation was primarily local, there may well be an oeuvre-catalogue in manuscript, mimeograph, or ephemeral pamphlet, which never entered the major libraries and print rooms that were consulted for this index, but can be found in a local museum, library, or historical society.

Glossary of Symbols and Code Words

The following symbols, terms, and phrases are used in the *Print Council Index* with certain specific meanings. Although these meanings conform for the most part to ordinary English usage, they have been defined here at length to prevent possible misunderstanding.

* Placed at the end of an entry in the *Print Council Index*, an asterisk indicates that the entry as it stands is incomplete, and should be supplemented by checking the main entry for the catalogue in question, in the *List of Abbreviations for Frequently Cited Books and Periodicals*.

\+ Following the number of entries in a catalogue, the plus sign indicates that the actual number of prints catalogued is greater, either because sets of prints have been catalogued as single entries or because supplementary entries have been interpolated by the cataloguer without renumbering.

Additional to, Additional information to

"Additional to" indicates that the catalogue in question is a supplement to an earlier catalogue, listing only prints which the earlier work omitted. "Additional information to" indicates that the catalogue in question provides additional information (correction of errors, additional states, etc.) about prints catalogued in the earlier work.

Bibliography for each entry

In a number of particularly thorough catalogues, the description of each print is accompanied by a bibliography listing the references to that print in earlier literature.

Bibliography of books with illustrations by

Unless otherwise noted, a "bibliography of books with illustrations by" an artist

does not catalogue individual book illustrations, but simply gives a bibliographic description of each book.

Catalogue of paintings; prints after are mentioned where extant

In an oeuvre-catalogue of paintings by an artist, the prints which have been made after a painting are sometimes mentioned as part of the catalogue entry describing that painting. Such a catalogue incidentally becomes a kind of oeuvre-catalogue of the prints made after the work of the artist in question, although the prints themselves are not described or collected together in a list. Catalogues like this are listed with the phrase "Catalogue of paintings; prints after are mentioned where extant," but not described more precisely.

Complete?

"Complete?," in parentheses, following the number of entries in the description of a catalogue, indicates that it is not clear whether the work is a true oeuvre-catalogue or a generous selection of the artist's prints.

Copies mentioned

"Copies mentioned" indicates that the entry for a print includes mention of the copies (repetitions by other artists) of that print, usually with some indication of how they can be distinguished from the original.

Described

For older, unillustrated catalogues, "described" indicates that the subject of the print catalogued is described in such a way as to distinguish it from other prints of the same subject. When the catalogue is illustrated such description is naturally superfluous, and "described" may simply indicate that additional descriptive information is provided for the print such as the type of paper it is printed on or its color if it is illustrated in black and white.

Doubtful

"Doubtful" prints are those about which the cataloguer appears to be in doubt, unwilling either to accept or reject them as the work of the artist in question. Older catalogues often refer to these as "prints attributed to" the artist.

Edition (ed.)

The publication data for new editions of a catalogue are given at the end of the regular bibliographic citation, preceded by the words "2d ed.," "3d ed." and so forth. Occasionally the phrase "many later editions" is used, when the catalogue has passed through too many to describe individually.

When a catalogue has been translated into another language, the translated title and the publication data are preceded by the words "English ed.," "French ed.," and so forth. "English" and "French" here refer to language, not nationality, and could be used for American or Belgian publications. Multiple simultaneous editions in the same language are not necessarily all listed.

Entries

As far as possible, the numbering system used by the catalogue in question has been followed. If the catalogue uses no numbering system, that is noted by the phrase "Entries: unnumbered" and the page numbers of the catalogue are given to provide a rough indication of the catalogue's length.

If the catalogue does not cover all prints by the artist, its limits are indicated in parentheses following the number of entries. "(woodcuts only, to 1928)" for instance, means that the catalogue covers only woodcuts, although the artist is known to have used other print techniques, and that it covers only prints done up to 1928, although the artist may have continued to work after that.

The number of entries in a catalogue is not necessarily the same as the number of prints catalogued. Sometimes *different states of the same print are separately numbered,* so that the number of entries is greater than the number of prints. Alternatively, a set of prints may be given a single entry number, so that the number of entries is less than the total number of prints. These situations are pointed out when they occur.

Extract from

When a catalogue appears first in a periodical and later is published separately both publications are noted (see "Separately published"). Occasionally, however, the separate publication has been found but the original periodical reference could not be traced. In that case the separate publication is cited, followed by the phrase "Extract from" (the periodical in question).

Illustrated

"Illustrated" indicates that the catalogue in question provides a reproduction of every print catalogued.

Inches

"Inches" indicates that the catalogue in question cites dimensions in English measure. Normally, of course, this is in inches and fractions of an inch, but a few old catalogues of early American prints use a curious pseudo-decimal system; in this notation 4.8 inches means 4-8/16 or 4-1/2 inches.

Inscriptions

"Inscriptions" indicates that the catalogue in question transcribes (or more usually, summarizes) the inscriptions on each print catalogued.

Located

"Located" indicates that the catalogue in question mentions the location of one or more impressions of each print catalogued. Occasionally, for extremely rare prints, a catalogue will give the location of every known impression, and this is pointed out when it occurs.

Millimeters

"Millimeters" indicates that the catalogue in question uses the metric system, but not necessarily that millimeters (as opposed to meters or centimeters) are used.

Ms.

A manuscript catalogue is followed by "ms." and the abbreviation for the library where the manuscript can be found. The same system identifies manuscript notes or a manuscript addition to a published catalogue.

Not seen

"Not seen," following the citation of a catalogue, indicates that the catalogue in question has been described from secondary sources.

"Not seen by ———," in the enumeration of entries in a catalogue, indicates that the cataloguer described those prints from secondary sources.

Paper fold measure

"Paper fold measure" indicates that the catalogue in question gives dimensions in the traditional sizes derived from the folding of a full sheet of paper: plano (unfolded), folio (folded in half), quarto (folded in quarters), octavo (folded into eighths) and so forth. This gives only a rough indication of size, but occasionally will be useful in identifying a print.

Pre-metric

"Pre-metric" indicates that the catalogue in question uses one of the old Continental European measuring systems, usually the *pied de Paris*. Dimensions are noted in inches and lines *(pouces et lignes,* or *Zollen und Linien),* often abbreviated thus: 4″ 6‴ (4 inches 6 lines).

Prints by, Prints after

Unless otherwise noted, the works listed in the *Print Council Index* are catalogues of prints by the artist in question. If a catalogue includes prints after the artist's designs, the fact is noted in the enumeration of the entries: "54 prints after" or "54 prints by and after" or "54 prints by, 25 after."

Rejected

"Rejected" prints are those which the author of the catalogue in question does not accept as being by the artist whose work he is cataloguing, but nevertheless lists to show that they have not been accidentally omitted.

Reprint

"Reprint," following the description of the first edition of a catalogue, means an unaltered or facsimile republication, often done nowadays by photographing the original edition.

Selection

"Selection," in parentheses, following one of the terms defined in this glossary, indicates that the catalogue in question provides this information for some of its entries but not all: "Described (selection)," for example, means some prints in the catalogue are described, others not. "Illustrated (selection)" is a special case: it means that more than 10 percent of the prints catalogued are illustrated. When

fewer than 10 percent of the prints are illustrated, the illustrations have not been mentioned at all, unless they are clearly a significant adjunct to the catalogue.

Separately published

When a catalogue appears in a periodical and subsequently as a separate publication, the periodical reference is cited first, followed by the words "Separately published" and the publication data for the separate publication. The title is repeated only when it has been altered.

States

"States" indicates that the catalogue in question takes note of the different states of the prints catalogued. Normally this means that some distinguishing characteristic of each state of a given print is noted. There are a few summary checklists, however, where only the number of states is given, without any attempt to distinguish them.

Unnumbered

"Unnumbered" indicates that the catalogue in question uses no numbering system to identify the prints catalogued. To give a rough idea of the extent of such a catalogue, the pages it covers have been noted: "Entries: unnumbered, pp. 36–175." For a few very short catalogues without numbering, the entries have simply been counted and the number given. In that case the *Print Council Index* does not mention that the catalogue has no numbering system of its own.

List of Abbreviations for Frequently Cited Books and Periodicals

All abbreviations used in the *Print Council Index* for periodicals and multi-artist catalogues are listed here. Unless otherwise noted, the periodical runs listed have been examined in their entirety for oeuvre-catalogues, and all of the multi-artist catalogues for which a full citation is given have been completely indexed. Abbreviations for multi-artist catalogues which have not been completely indexed are also given here, but the user is referred to the list of those catalogues (p. xxxvii) for the full citation.

[A.]
Andresen, Andreas. *Der deutsche Peintre-graveur, oder die deutschen Maler als Kupferstecher nach ihrem Leben und ihren Werken, von dem letzten Drittel des 16. Jahrhunderts bis zum Schluss des 18. Jahrhunderts, und in Anschluss an Bartsch's Peintre-graveur, an Robert-Dumesnil's und Prosper de Baudicour's französischen Peintre-graveur.* 5 vols. Leipzig: Rudolph Weigel, Alexander Danz, 1864–1878. Reprint. New York: Collectors Editions, 1969. Sixth volume of plates selected by Benjamin A. Rifkin. New York: Collectors Editions, 1971 (not seen).

[A. 1800]
Andresen, Andreas. *Die deutschen Maler-Radirer (peintres-graveurs) des neunzehnten Jahrhunderts, nach ihren Leben und Werken.* 5 vols. Leipzig: Alexander Danz, 1878.

[Allen]
Allen, Charles Dexter. *American Bookplates, a guide to their study.* New York: Macmillan and Co., 1894. London: George Bell and Sons, 1895. Reprint. New York: Macmillan and Co., 1905. (Not seen). New York: Benjamin Blom, 1968 (not seen).

 A list of bookplates is given under each artist's name. A second list of all

bookplates, arranged by owner, gives fuller catalogue information. Inscriptions. Described. Illustrated (selection).

[*Amer. Art Review*]
American art review, a journal devoted to the practice, theory, history, and archaeology of art. Vols. 1–2 (1879–1881).

[*Am. Est.*]
L'Amateur d'estampes. Vols. 1–13 (1921–1934).

[*AMG.*]
Arts et metiers graphiques. Vols. 1–11, nos. 1–68 (1927–1939).

[AN.]
Alpago-Novello, Luigi. "Gli incisori bellunesi; saggio storico-bibliografico." *Atti del Reale Istituto Veneto di Scienze, Lettere ed Arti 99, parte seconda, classe di scienze morali e lettere.* 1939–1940, pp. 471–716. Separately published. Venice: Premiate Officine Grafiche Carlo Ferrari, 1940.

[AN. 1968]
Alpago-Novello, Alberto. Catalogues in: Auditorium, Belluno [Bruno Passamani et al, compilers.] *Marco Ricci e gli incisori bellunesi del '700 e '800 esposti all' Auditorium di Belluno.* Belluno, 1968.

[Andresen, *Handbuch*]
See *Multi-Artist Catalogues Not Indexed,* p. xxxvii.

[Ap.]
Apell, Aloys. *Handbuch für Kupferstichsammler, oder Lexikon der vorzüglichsten Kupferstecher des XIX. Jahrhunderts welche in Linienmanier gearbeitet haben, sowie Beschreibung ihrer besten und gesuchtesten Blätter.* Leipzig: Alexander Danz, 1880. Reprint. Walluf bei Weisbaden (West Germany): M. Shandig, 1972 (not seen).
Catalogues are generally incomplete, but the only available reference for most of the artists. Dimensions are given for some prints (paper fold measure), and states are distinguished.

[*Arch. Ex.-lib.*]
Archives de la Société française des collectionneurs d'ex-libris. Vols. 1–43 (1894–1936).

[*AzB.*]
Arntz, Wilhelm F., ed. *Arntz-Bulletin; Dokumentation der Kunst des 20. Jahrhunderts.* Haag/Oberbayern (West Germany): Verlag Gertrud Arntz-Winter, 1968–1972. Vol. 1, nos. 1–8.

[B.]
Bartsch, Adam. *Le Peintre graveur.* 21 vols. Vienna: J. V. Degen, 1803–1821.

Reprint. Leipzig: Joh. Ambr. Barth, 1854–1876. Reprint. Würzburg (Germany), 1920–1922 (not seen). Reprint (21 vols. in 4). Hildesheim (West Germany): Georg Olms, 1970 (not seen).

[Basan]

See *Multi-Artist Catalogues Not Indexed*, p. xxxvii.

[Baud.]

Baudicour, Prosper de. *Le peintre-graveur français continué, ou catalogue raisonné des estampes gravées par les peintres et les dessinateurs de l'école française nés dans le XVIIIe siècle.* 2 vols. Paris: Mme Bouchard Huzard, Rapilly [etc.], 1859–1861. Reprint. Paris: F. de Nobele, 1967.

[*Bb.*]

Borsenblatt für den deutschen Buchhandel. Vols. 1–138 (1834–1972). (EMSB) Only catalogues known from other sources were extracted from this periodical.

[Ber.]

Beraldi, Henri. *Les graveurs du XIXe siècle, guide de l'amateur d'estampes modernes.* 12 vols. Paris: Librairie L. Conquet, 1885–1892.
Beraldi does not provide complete catalogues for all of the artists he lists. I have indexed all artists listed by Beraldi, but provided only a volume and page reference for those not fully catalogued.

[B. *Remb.*]

Bartsch, Adam. *Catalogue raisonné de toutes les estampes qui forment l'oeuvre de Rembrandt et ceux de ses principaux imitateurs.* 2 vols. Vienna: A. Blumauer, 1797.

[B. *Reni*]

Bartsch, Adam. *Catalogue raisonné des estampes gravées à l'eau-forte par Guido Reni et de celles de ses disciples Simon Cantarini, dit le Pesarese, Jean-André et Elisabeth Sirani, et Laurent Loli.* Vienna: A. Blumauer, 1795.

[Brun]

See *Multi-Artist Catalogues Not Indexed*, p. xxxvii.

[*Bull. des B. A.*]

Bulletin des Beaux-Arts. Vols. 1–3 (1883–1886).

[Burch.]

Burchard, Ludwig. *Die holländischen Radierer vor Rembrandt, mit beschreibenden Verzeichnissen und biographischen Übersichten. 2. durch 12 Tafeln und ein alphabetisches Register vermehrte Ausgabe.* Berlin: Paul Cassirer, 1917. (First edition is a dissertation, Universität Halle, 1912. Not seen.).

[*Burl. M.*]

The Burlington Magazine. Vols. 1–112 (1903–1970).

[*Cab. am. ant.*]

Le Cabinet de l'amateur et de l'antiquaire. Vols. 1–4 (1842–1846).

[Carey]

Carey, John Thomas. "The American lithograph from its inception to 1865 with biographical considerations of twenty lithographers and a check list of their works." Dissertation, Ohio State University, 1954. (Microfilm, DLC)

[CdB.]

Corrard de Breban, ———. *Les graveurs troyens; recherches sur leur vie et leurs oeuvres.* Troyes (France): Alexis Sacard; Paris: Rapilly, 1868. (MH)

[*Conn.*]

The Connoisseur. Vols. 1–181 (1901–1972).

[Daulby]

Daulby, Daniel. *A descriptive catalogue of the works of Rembrandt, and of his scholars Bol, Livens, and Van Vliet compiled from the original etchings and from the catalogues of De Burgy, Gersaint, Helle and Glomy, Marcus, and Yver.* Liverpool (England): J. M'Creery, 1796.

[Del.]

Delteil, Loys. *Le peintre-graveur illustré.* 31 vols. Paris: Published by the author, 1906–1926. Reprint. New York: Collectors Editions Ltd., Da Capo Press, 1969. Vol. 30 (Albert Besnard) is by Louis Godefroy.

[Dim.]

Dimier, Louis, ed. *Les peintres français du XVIIIe siècle; histoire des vies et catalogue des oeuvres.* 2 vols. Paris and Brussels: G. van Oest, 1928, 1930.

[Dis. 1927]

Disertori, Benvenuto. "I Rami Raimondeschi alla R. Calcografia (notizia aggiunta al Bartsch)." *Bibliofilia* 29 (1927): 345–356. Separately published. Florence: Leo S. Olschki, 1927.

[Dis. 1929]

Disertori, Benvenuto. "Rami cinquecenteschi alla R. Calcografia (notizia aggiunta al vol. XV del Bartsch)." *Bibliofilia* 31 (1929): 1–14.

[Dlabacž]

See *Multi-Artist Catalogues Not Indexed,* p. xxxvii.

[Dus.]

Dussler, Luitpold. *Die Incunabeln der deutschen Lithographie (1796–1821).* Berlin: Heinrich Tiedemann, 1925.

[Dut.]

Dutuit, Eugène. *Manuel de l'amateur d'estampes.* Vols. I, IV–VI. Paris: A. Lévy,

1884–1885. (Other volumes not published). Reprint. Amsterdam: G. W. Hissink, 1970–1972 (not seen).

Dutuit does not provide complete catalogues for all the artists he lists. Incomplete catalogues in Dutuit are indicated by an asterisk in this bibliography. Complete catalogues in Dutuit are usually based on earlier works ([B.], [P.], [Weigel] and others) but with additional information and entries.

[Evans]

A. E. Evans and Sons. *Additional notes to "Le peintre-graveur" of Bartsch; a descriptive catalogue of nearly four hundred engravings (unknown to Bartsch at the period of publication of his invaluable work) by artists of whose activities he has given a detailed account.* London, A. E. Evans and Sons, 1857. Printed with: *The fine art circular and print collector's manual; catalogue of nearly six thousand etchings and engravings by artists of every school and period . . . with an appendix consisting of a catalogue raisonné of nearly 400 prints unknown to Bartsch.* London: A. E. Evans and Sons, [1857?]. (MH)

[F.]

Fielding, Mantle. *American engravers upon copper and steel, biographical sketches and check lists of engravings, a supplement to David McNeely Stauffer's American engravers.* Philadelphia: Privately printed, 1917. 220 copies. (MH) Reprint. New York: Burt Franklin, 1964, 1971 (not seen).

Entries: 1932 (engravings and etchings only, additional to [St.], arranged by engraver but continuously numbered). Inches. Inscriptions. States. Described (selection). To save space, the *Print Council Index* provides only page references to the engravers in the catalogue.

[*GBA.*]

Gazette des Beaux-arts. 1st ser. vol. 1–6th ser. vol. 80 (1859–1972).

[Ge.]

Geisberg, Max. *Der deutsche Einblatt-Holzschnitt in der ersten Hälfte des 16. Jahrhunderts.* 43 portfolios and index vol. Munich: Hugo Schmidt Verlag, 1923–1931.

The index volume arranges the prints by artist and assigns numbers to them. Because of changed attributions in the course of publication a few artists, such as Hans Dürer, are listed in the index but have no numbered prints assigned to them.

[*GK.*]

Die graphischen Künste. Vols. 1–56 (1879–1933), n.s. 1–7 (1936–1943).

[Gon.]

Goncourt, Edmond and Jules de. *L'Art du dix-huitième siècle.* 12 fasc. Paris: E. Dentu, 1859–1875 (not seen). 2d ed. 2 vols. Paris: Rapilly, 1873–1874. 3d ed. 2 vols. Paris: A. Quantin, 1880–1882. Other later editions.

Page references in the *Print Council Index* are to the third edition "revue et augmentée."

[Heinecken]

See *Multi-Artist Catalogues Not Indexed,* p. xxxvii.

[Heller]

Heller, Joseph. *Zusätze zu Adam Bartsch's Le Peintre Graveur.* Bamberg (Germany): J. G. Sickmüller, 1844.

[Herbet] I-V

Herbet, Felix. "Les Graveurs de l'école de Fontainebleau," *Annales de la Société historique et archéologique du Gâtinais* 14 (1896): 56–102 (I, Catalogue de l'oeuvre de L. D.), 257–291 (II, Catalogue de l'oeuvre de Fantuzi). *Annales* 17 (1899): 1–53 (III, Dominique Florentin et les burinistes). *Annales* 18 (1900): 293–355 (IV, Les eaux-fortes nommées ou marquées). *Annales* 20 (1902): 55–86 (V, Les eaux-fortes anonymes). Separately published. 5 vols. Fontainebleau (France): Maurice Bourges, 1896–1902. 1 vol. Amsterdam: B. M. Israel, 1969.

> The page numbers cited for Herbet in the individual entries of the *Print Council Index* refer to the publication in *Annales de la Société historique et archéologique du Gâtinais.*

[H. *Ger.*]

Hollstein, F. W. H. et al. *German engravings, etchings and woodcuts ca. 1400–1700.* 8 vols. Amsterdam: Menno Hertzberger, 1954–1968. (In progress in 1972: A–Friedrich).

> Catalogues are compiled from various primary and secondary sources, and information provided varies greatly within a single catalogue. The *Print Council Index* indicates only the number of entries and the presence or absence of illustrations, but in addition the catalogues usually give dimensions (millimeters or paper fold measure) and sometimes inscriptions and states.

[Hind]

Hind, Arthur M. *Early Italian engraving; a critical catalogue with complete reproduction of all the prints described.* 7 vols. London: Bernard Quaritch Ltd., 1938–1948.

[Hind, *Engl.*]

Hind, Arthur M.; Corbett, Margery; and Norton, Michael. *Engraving in England in the sixteenth and seventeenth centuries; a descriptive catalogue with introductions.* 3 vols. Cambridge: Cambridge University Press, 1952–1964.

[H. L.]

Hippert, T., and Linnig, J. *Le peintre graveur hollandais et belge du XIXe siècle.* 2 vols., continuously paginated. Brussels: Fr. J. Oliver, 1874, 1879. Originally published in installments in *Le Bibliophile belge* 5–14 (1869–1879).

> Extra-illustrated copy in 4 vols. (EBr) with many impressions of the prints listed in the catalogue.

[H. *Neth.*]

Hollstein, F. W. H. et al. *Dutch and Flemish etchings, engravings and woodcuts, ca. 1450–1700.* Vols. I–XV, XVIII, XIX. Amsterdam: Menno Hertzberger, 1949–1969. (In progress in 1972: A–De Passe, and Rembrandt).

Catalogues are frequently compiled from various secondary sources, and information provided varies greatly within a single catalogue. The *Print Council Index* indicates only the number of entries and the presence or absence of illustrations, but in addition the catalogues usually give dimensions (millimeters or paper fold measure) and sometimes inscriptions and states.

[Huber and Rost]

See *Multi-Artist Catalogues Not Indexed,* p. xxxvii.

[Hüsgen]

Hüsgen, Henrich Sebastian. *Artistisches Magazin, enthaltend das Leben und die Verzeichnisse der Werke hiesiger und anderer Künstler.* Frankfurt am Main: J. Bayrhoffer, 1790.

[I. F. F.]

See *Multi-Artist Catalogues Not Indexed,* p. xxxvii.

[*JKw.*]

[*Zahns*] *Jahrbücher für Kunstwissenschaft.* Vols. 1–5 (1868–1873).

[Joubert]

See *Multi-Artist Catalogues Not Indexed,* p. xxxvii.

[*JprK.*]

Jahrbuch der königlich-preussischen Kunstsammlungen. Vols. 1–61 (1880–1940). After 1918: *Jahrbuch der preussischen Kunstsammlungen.*

[Kh.]

Der Kunsthandel. Vols. 1, 4, 8–18 (1909, 1912, 1916–1926). (ENGM) A complete run of this periodical was not available for consultation. Catalogues in the missing volumes have been recorded from [Singer].

[Kramm]

See *Multi-Artist Catalogues Not Indexed,* p. xxxvii.

[Laborde]

See *Multi-Artist Catalogues Not Indexed,* p. xxxvii.

[L. D.]

Lawrence, H. W., and Dighton, Basil Lewis. *French line engravings of the late eighteenth century.* London: Lawrence and Jellicoe Ltd., 1910. 1050 copies.

Lawrence and Dighton catalogue only a selection of prints for the artists they list, but those prints are very thoroughly catalogued, with states carefully described.

[Lebl.]

See *Multi-Artist Catalogues Not Indexed*, p. xxxvii.

[Le Comte]

See *Multi-Artist Catalogues Not Indexed*, p. xxxvii.

[Lehrs]

Lehrs, Max. *Geschichte und kritischer Katalog des deutschen, niederländischen und französischen Kupferstichs im XV. Jahrhundert.* 9 vols. and 1 plate vol. Vienna: Gesellschaft für vervielfältigende Kunst, 1908–1934. Reprint. New York: Collectors Editions, n.d.

[Lugt, *Ventes*]

Lugt, Frits. *Repertoire des catalogues de ventes publiques intéressant l'art ou la curiosité.* 3 vols. The Hague: Martinus Nijhoff, 1938–1964.
A bibliography of art sale catalogues from 1600 to 1900.

[M.]

Meyer, Julius et al. *Allgemeines Künstler-Lexikon, unter Mitwirkung der namhaftesten Fachgelehrten des In- und Auslandes.* 3 vols. Leipzig: Wilhelm Engelmann, 1872–1885. (Covers A–Bezz.).
Catalogues listing only one print after an artist have been omitted.

[Mariette, *Peintres*]

See *Multi-Artist Catalogues Not Indexed*, p. xxxvii.

[*Mém. Abbréville*]

Mémoires de la Société d'emulation d'Abbéville. 1st ser., vol. 1–4th ser., vol. 10 (1797–1963).
Only catalogues known from other sources were extracted from this periodical.

[*Mém. lorraine*]

Mémoires de la Société d'archéologie lorraine. 1st ser., vol. 1–3d ser., vol. 28 (1850–1900).
Only catalogues known from other sources were extracted from this periodical.

[Merlo]

Merlo, Johann Jakob. *Nachrichten von dem Leben und den Werken Kölnischer Kunstler.* Cologne: J. M. Heberle (H. Lempertz), 1850. Enlarged ed. *Kölnische Künstler in alter und neuer Zeit; Johann Jacob Merlos neu bearb. und erweiterte Nachrichten von dem Leben und den Werken Kölnischer Künstler, hrsg. von Eduard Firminich Richartz*

unter Mitwirkung von Hermann Keussen. Publikationen der Gesellschaft fuer rheinische Geschichtskunde, 9. Düsseldorf: L. Schwann, 1895. Reprint (1895 edition). Nieuwkoop (Netherlands): B. de Graaf, 1966.

References in the *Print Council Index* are to the 1895 edition. Merlo provides catalogues for many of the artists he lists, but it is often uncertain whether they are meant to be complete. The *Print Council Index* provides a page reference for every artist with a list of prints in [Merlo], but gives the number of entries and other descriptive data only when the list seems to aim at completeness.

[*MGvK.*]

Mitteilungen der Gesellschaft für vervielfältigende Kunst. 1879–1887, 1892–1933 (replaced from 1888 to 1891 by *Chronik der vervielfältigende Kunst*).
Issued as a supplement to [*GK.*].

[Nagler]

See *Multi-Artist Catalogues Not Indexed*, p. xxxvii.

[Nagler, *Mon.*]

See *Multi-Artist Catalogues Not Indexed*, p. xxxvii.

[*N. Arch.*]

[*Naumanns*] *Archiv für die zeichnenden Künste mit besonderer Beziehung auf Kupferstecher- und Holzschneidekunst und ihre Geschichte . . . hrsg. von Dr. Robert Naumann.* Vols. 1–16 (1855–1870).

[*N. ExT.*]

Nordisk Exlibris Tidsskrift. Vols. 1–24 (1946–1972).

[*Oud-Holl.*]

Oud-Holland. Vols. 1–86 (1883–1971; no volume published in 1972).

[P.]

Passavant, Johann David. *Le peintre-graveur, contenant l'histoire de la gravure sur bois, sur métal et au burin jusque vers la fin du XVI. siècle, l'histoire du nielle avec complément de la partie descriptive de l'essai sur les nielles du Duchesne ainé, et un catalogue supplementaire aux estampes du XV. et XVI. siècle du peintre-graveur de Adam Bartsch.* 6 vols. Leipzig: Rudolph Weigel, 1860–1864. Reprint (6 vols. in 3). New York: Burt Franklin, n.d. (not seen).

[*Pa. Mag.*]

The Pennsylvania magazine of history and biography. Vols. 1–96 (1877-1972).

[*P. Conn.*]

The print connoisseur. Vols. 1–12 (1920–1932).

[*PCQ.*]

The print collector's quarterly. Vols. 1–30 (1911–1950).

[Pr.]

Zigrosser, Carl, ed. *Prints; thirteen illustrated essays on the art of the print, selected for the Print Council of America.* New York: Holt, Rinehart and Winston, 1962.

[QCS.]

I Quaderni del conosciotore di stampe. Nos. 1–13 (1970–1972). (ERH)

[RD.]

Robert-Dumesnil, A.P.F. *Le peintre-graveur français, ou catalogue raisonné des estampes gravées par les peintres et les dessinateurs de l'école française, ouvrage faisant suite au peintre-graveur de M. Bartsch.* 11 vols. Paris: Gabriel Warée, Mme Huzard, etc., 1835–1871. (Vol. 11 is by Georges Duplessis). Reprint (11 vols. in 6). Paris: F. de Nobele, 1967.

[*Rep. Kw.*]

Repertorium fur Kunstwissenschaft. Vols. 1–52 (1876–1931).

[*Réunion Soc. B. A. dép.*]

Réunion des sociétés des beaux-arts des départements. 1st session–38th session (1877–1914).

[Rov.]

Rovinski, Dmitri. *Polnoe sobranie gravjur" uchenikov" Rembrandta i masterov" rabotavshkh" v" ego manere, 478 fototipij ve" retushch sobal" i privel" v" porjadok"/ L'Oeuvre gravé des élèves de Rembrandt et des maîtres qui ont gravé dans son goût, 478 phototypies sans retouches avec un catalogue raissoné.* St. Petersburg: Tipografija i Imperatorskoj Akademii Nauk"/Imprimerie de l'Académie Impériale des Sciences, 1894.

Rovinski provides complete catalogues of the work of Ferdinand Bol, Jan Lievens, and Jan Jorisz van Vliet. Some of the lists which he gives for other artists seem to be confined to prints in which the influence of Rembrandt is predominant.

[Ru.]

Russell, Charles Edward. *English mezzotint portraits and their states.* 2 vols. London: Halton and Truscott Smith, Ltd., 1926. 625 copies. (MH)

[*RUA.*]

Revue universelle des arts. Vols. 1–23 (1855–1866).

[Sch.]

Schiefler, Gustav. *Verzeichnis des graphischen Werks neuerer hamburgischer Kunstler bis 1904.* Hamburg: 1904 (not seen).

References to the catalogues in this work are taken from [Singer].

[Schreiber, *Handbuch*]

See *Multi-Artist Catalogues Not Indexed,* p. xxxvii.

[Schreiber, *Metallschneidekunst*]

Schreiber, Wilhelm Ludwig. *Die Meister der Metallschneidekunst nebst einem nach Schulen geordneten Katalog ihrer Arbeiten.* Studien zur deutschen Kunstgeschichte, 241. Strasbourg: J. H. Ed. Heitz, 1926.

Schreiber provides only lists of titles in this work, but supplies a catalogue reference for each print to [Schreiber, *Handbuch*] (see *Multi-Artist Catalogues Not Indexed*, p. xxxvii), where the prints are more extensively described.

[*Schw. M.*]

Das schwäbische Museum; Zeitschrift für Kultur, Kunst und Geschichte Schwabens. Vols. 1–9 (1925–1933).

[Siltzer]

Siltzer, Captain Frank. *The story of British sporting prints.* London: Hutchinson and Co., 1925. Reprint. New York: Scribner's, 1930 (not seen).

Siltzer lists only prints of sporting subjects. It is not always clear whether the catalogues are intended to be complete.

[Singer]

Singer, Hans W. *Handbuch für Kupferstichsammler.* Leipzig: K. W. Hiersemann, 1922.

Singer provides a bibliography of oeuvre-catalogues of prints, but supplies only the name of the author and the place and date of publication. A few of the catalogues in his work could not be traced, and are listed in the *Print Council Index* from Singer's incomplete citations.

[Sm.]

Smith, John Chaloner. *British mezzotinto portraits, being a descriptive catalogue of these engravings from the introduction of the art to the early part of the present century.* 5 vols. London: Henry Sotheran and Co. 1883–1884.

Addenda sheets are inserted, unpaginated, at the end of each volume. Annotated copy (CsmH) with additional information.

[St.]

Stauffer, David McNeely. *American engravers upon copper and steel.* 2 vols. New York: Grolier Club, 1907. 353 copies. (MH) Reprint. New York: Burt Franklin, 1964, 1974 (not seen).

Vol. I contains biographies of engravers; vol. II is a catalogue. Entries: 3438 (engravings and etchings only, arranged by engraver but continuously numbered). Inches. Inscriptions. States. Described (selection). To save space, the *Print Council Index* provides only page references to the engravers in the catalogue. An index to the artists after whom the prints were made exists: Gage, Thomas Hovey: *An artist's index to Stauffers "American engravers."* Worcester (Mass.), 1921.

[ThB.]

See *Multi-Artist Catalogues Not Indexed*, p. xxxvii.

[vdK.]

Kellen, J. Philippus van der. *Le peintre-graveur hollandais et flamand, ou catalogue raisonné des estampes gravées par les peintres de l'école hollandaise et flamande; ouvrage faisant suite au peintre-graveur de Bartsch*. Utrecht: Kemink et Fils, 1866–1873. Reprint. New York and Hildesheim (West Germany), 1977 (not seen).

[Vesme]

Vesme, Alexandre de [Baudi di Vesme, Alessandro]. *Le peintre-graveur italien, ouvrage faisant suite au peintre-graveur de Bartsch*. Milan: Ulrico Hoepli, 1906.

[*Vieux P.*]

Bulletin de la société archéologique, historique et artistique "Le Vieux papier" pour l'étude de la vie et des moeurs d'autrefois. Vols. 1–26 (1900–1972).

[W.]

Wurzbach, Alfred von. *Niederländisches Künstler-Lexikon, auf Grund archivalischer Forschungen bearbeitet*. 3 vols. Vienna: Verlag von Halm und Goldmann, 1906–1911. Reprint (3 vols. in 2). Amsterdam: B. M. Israhel, 1968.

To save space, the *Print Council Index* gives only the number of entries in Wurzbach's catalogues. Many of them list only the titles of the prints, but occasionally dimensions are given (paper fold measure) and inscriptions partially transcribed. Copies with notes by J. C. J. Bierens de Haan (ERB), and by H. van Hall (EA); additional entries and information.

[Weigel]

Weigel, Rudolph. *Suppléments au peintre-graveur de Adam Bartsch*. Leipzig: Rudolph Weigel, 1843. Reprint. Würzburg (Germany): Verlagsdruckerei Würzburg, 1922.

[Wess.] I-IV

Wessely, Joseph Eduard. "Supplemente zu den Handbüchern der Kupferstichkunde." [*Rep. Kw.*] 4 (1881): 120–156 (I, deutsche Schule), 227–268 (II, neiderländische Schule); [*Rep. Kw.*] 5 (1881): 42–62 (III, italienische Schule, IV, französische Schule). Separately published. Stuttgart: Verlag von W. Spemann, 1881. (NN)

The page numbers cited for Wessely in the individual entries of the *Print Council Index* refer to the publication in [*Rep. Kw.*]

[WrJ.]

Jahrbuch der kunsthistorischen Sammlungen des allerhöchsten Kaiserhauses. Vols. 1–36, n.s. 1–32 (1883–1972). After 1918: *Jahrbuch der kunsthistorischen Sammlungen in Wien*.

[ZbK.]

Zeitschrift für bildende Kunst. Vols. 1–65 (n.s. 41) (1866–1932).

[Zerner]

Zerner, Henri. *École de Fontainebleau, gravures.* Paris: Arts et Metiers Graphiques, 1969. English ed. *The School of Fontainebleau, etchings and engravings.* London: Thames and Hudson, 1969.

> English edition incorporates revisions. Catalogues are not paginated in French edition.

Multi-Artist Catalogues Not Indexed

As explained in the *Note to the User*, the following works include partial and sometimes complete catalogues of prints by the artists they cover, but for various reasons it was impossible to list them under the name of each artist. They are given here as a guide to further research for the user who has failed to find an adequate catalogue listed for a particular artist in the *Print Council Index* itself.

[Andresen, *Handbuch*]
> Andresen, Andreas. *Handbuch für Kupferstichsammler, oder Lexikon der Kupferstecher, Maler-Radierer und Formschneider aller Länder und Schulen nach Massgabe ihres geschätzesten Blätter und Werke.* 2 vols. Leipzig: T. O. Weigel, 1870–1873.
>> Pre-metric (selection). Paper fold measure (selection). States (selection). Prints by artists of all schools and periods. Selective catalogues.

[Audin and Vial]
> Audin, Marius, and Eugène Vial. *Dictionnaire des artistes et ouvriers d'art de la France; Lyonnais.* Paris: Bibliothèque d'Art et d'Archéologie, 1918–1919.
>> Titles only. Prints by artists working in the Lyonnais in France. Selective catalogues are provided for some but not all artists. Some catalogues are extensive, possibly complete.

[Basan]
> Basan, F. *Dictionnaire des graveurs anciens et modernes depuis l'origine de la gravure avec une notice des principales estampes qu'ils ont gravées suivi des catalogues des oeuvres de Jacques Jordans, et de Corneille Visscher.* 3 vols. Paris: Chez De Lormel [etc.], 1767. 2d ed. Paris: Published by the author, 1789.
>> Titles only. Prints by artists of all schools and periods. Selective catalogues, except for Jordaens and Visscher.

[Brun]
> Brun, Carl, et al. *Schweizerisches Künstler-Lexikon, herausgegeben mit Unterstützung des Bundes und kunstfreundlichen Privater vom Schweizerischen Kunstverein.* 4

vols. Frauenfeld (Switzerland): Verlag von Huber und Co., 1905–1917. Reprint. Nendeln (Liechtenstein): Kraus Reprint, 1967 (not seen).

Millimeters (selection). Prints by Swiss artists only. Selective catalogues are provided for some printmakers but not all. Some catalogues are extensive, possibly complete.

[Dlabacž]

Dlabacž, Gottfried Johann. *Allgemeines historisches Künstler-Lexikon für Böhmen und zum Teil auch für Mähren und Schlesien.* 3 vols. Prague: Gottlieb Haase, 1815. Reprint (3 vols. in 1). Hildesheim (West Germany): Georg Olms Verlag, 1973.

Paper fold measure (selection). Inscription (selection). Described (selection). Prints by artists active in Bohemia, Moravia and Silesia. Extensive catalogues are provided for a few artists. Reprint edition includes: Sternbert-Manderscheid, Franz von, and Bergner, Paul. *Beiträge u. Berichtigungen zu Dlabacž Lexikon Böhmischer Künstler.* Prague: Verlag der K. André'schen Buchhandlung Max Berwald, 1913.

[Heinecken]

Heinecken, Karl Heinrich von. *Dictionnaire des artistes dont nous avons les estampes, avec une notice détaillé de leurs ouvrages gravés.* 4 vols. Leipzig: Jean Gottlob Immanuel Breitkopf, 1778–1790. (Covers A–Diz). Reprint. New York: Johnson Reprint Corporation, 1970 (not seen).

Paper fold measure (selection). Described (selection). Prints by and after artists of all schools and periods, arranged alphabetically (A–Diz only). Most catalogues are highly selective; extensive catalogues of Marcantonio, Agostino Veneziano, and Marco da Ravenna.

[Huber and Rost]

Huber, M., and Rost, C. C. H. *Handbuch für Kunstliebhaber und Sammler über die vornehmsten Kupferstecher und ihre Werke vom Anfange dieser Kunst bis auf gegenwärtige Zeit, chronologisch und in Schulen geordnet, nach der französischen Handschrift des Herrn M. Huber bearbeitet von C. C. H. Rost.* 9 vols. Zurich: Drell, Gessner, Füssli und Compagnie, 1796–1808.

Pre-metric (selection). Prints by artists of all schools and periods. Catalogues are fairly extensive but incomplete.

[I.F.F. 1500]

Bibliothèque Nationale, Paris [André Linzeler and Jean Adhémar, compilers]. *Inventaire du fonds français; graveurs du seizème siècle.* 2 vols. Paris: M. Le Garrec, 1932–1935.

Millimeters. Inscriptions (selection). Described (selection). Located. Prints by French artists of the sixteenth century. Catalogues list all prints in the Bibliothèque Nationale, and for many artists this is equivalent to a complete or nearly complete oeuvre-catalogue.

[I.F.F. 1600]

Bibliothèque Nationale, Paris [Roger-Armand Weigert, compiler]. *Inventaire du fonds français; graveurs du XVIIe siècle.* 5 vols. Paris: Bibliothèque Nationale, 1939–1968. (Covers A–Jousse).

Millimeters. Inscriptions (selection). Described (selection). Located. Prints by French artists of the seventeenth century. See previous entry.

[I.F.F. 1700]

Bibliothèque Nationale, Paris [Marcel Roux et al., compilers]. *Inventaire du fonds français; graveurs du dix-huitième siècle.* 11 vols. Paris: Maurice Le Garrec, 1930–1970. (Covers A–Jahandier).

Millimeters. Inscriptions (selection). Described (selection). Located. Prints by French artists of the eighteenth century. See entry for [I.F.F. 1500].

[I.F.F. 1800]

Bibliothèque Nationale, Paris [Jean Laran et al., compilers]. *Inventaire du fonds français après 1800.* 14 vols. Paris: Maurice Le Garrec, 1930–1967. (Covers A–Lys).

Millimeters. Inscriptions (selection). Described (selection). Located. Prints by French artists of the nineteenth and twentieth centuries. See entry for [I.F.F. 1500].

[Joubert]

Joubert, F. E. *Manuel de l'amateur d'estampes, faisant suite au Manuel du libraire et dans lequel on trouvera, depuis l'origine de la gravure; 1°. les remarques qui determinent le mérite et la priorité des épreuves; 2°. les caractères auxquels on distingue les originaux d'avec les copies; 3°. les prix que les pièces capitales peuvent conserver dans le commerce, en raison de leur rareté et de l'opinion des amateurs; 4°. des tableaux séculaires offrant les artistes contemporains sur des lignes annuelles et à toutes les époques désirables.* 3 vols. Paris: Published by the author, 1821.

Pre-metric (selection). Prints by and after artists of all schools and periods. Highly selective catalogues.

[Kramm]

Kramm, Christaan. *De Levens en werken der hollandsche en vlaamsche Kunstschilders, beeldhouwers, graveurs en bouwmeesters van den vroegsten tot op onzen tijd.* 7 vols. Amsterdam: Gebroeders Diederichs, 1858–1864.

Paper fold measure (selection). Prints by and after Dutch and Flemish artists. Selective catalogues, provided for some but not all the artists listed.

[Laborde]

Laborde, Léon de. *Histoire de la gravure en manière noire.* Histoire de la découverte de l'impression et de son application à la gravure, aux caractères mobiles et à la lithographie, 5. Paris: Jules Didot l'ainé, 1839.

Pre-metric (selection). Paper fold measure (selection). Inscriptions (selection). Described (selection). Prints in mezzotint by artists of all schools, working before 1720. Catalogues are extensive or complete.

[Lebl.]

Le Blanc, Charles. *Manuel de l'amateur d'estampes, contenant le dictionnaire des graveurs de toutes les nations, dans lequel sont décrites les estampes rares, précieuses et intéressantes avec l'indication de leurs différents états et des prix auxquels ces estampes ont été portées dans les ventes publiques.* 4 vols. Paris: Émile Bouillon, 1854–1888. Reprint (4 vols. in 2). Amsterdam: G. W. Hissink, 1970.

Millimeters (selection). Paper fold measure (selection). Inscriptions (selection). States (selection). Described (selection). Prints by artists of all schools and periods. Catalogues vary greatly; some highly selective, others extensive or complete, but mostly based on earlier publications. The *Print Council Index* cites a few catalogues, which are based on unpublished materials.

[Le Comte]

Le Comte, Florent. *Cabinet des singularitez d'architecture, sculpture, peinture et graveure, ou introduction à la connoissance des plus beaux arts, figurés sous les tableaux, les statues et les estampes.* 3 vols. Paris: N. Le Clerc 1699–1700. 2d ed. Brussels: L. Marchant, 1702 (not seen). Reprint (1st ed.). Geneva: Minkoff Reprints, 1972 (not seen).

Described (selection). Prints by and after a limited number of artists, including Callot, van Dyck, Mellan, Nanteuil, Poussin, Raphael and Rubens. Catalogues are extensive or complete.

[Mariette, *Peintres*]

Mariette, Pierre Jean. *Les Grands peintres, I: écoles d'Italie; notices biographiques et catalogues des oeuvres reproduites par la gravure, XVIe-XVIIIe siècle.* Paris: Les Beaux-Arts, Édition d'Études et de Documents, 1969. 500 copies.

Described. Prints after Italian artists. Catalogues are extensive or complete. A selection from the manuscript notes of Pierre Jean Mariette (1694–1774), reproduced in facsimile.

[Nagler]

Nagler, G. K. *Neues allgemeines Künstler-Lexikon, oder Nachrichten von dem Leben und den Werken der Maler, Bildhauer, Baumeister, Kupferstecher, Formschneider, Lithographen, Zeichner, Medailleure, Elfenbeinarbeiter, etc.* 22 vols. Munich: E. A. Fleischmann, 1835–1852. 2d ed. 25 vols. Linz (Austria): E. Mareis, 1904–1914. 3d ed. 25 vols. Leipzig: Schwarzenberg und Schumann, 1924. 4th ed. 25 vols. Vienna: Manz'sche Verlags- und Universitätsbuchhandlung, 1924.

Paper fold measure (selection). Inscriptions (selection). Prints by and after artists of all schools and periods. Catalogues are provided for many artists but not all; they vary greatly, some being highly selective while others are extensive or complete.

[Nagler, *Mon.*]

Nagler, G. K. [continued by A. Andresen and C. Clauss]. *Die Monogrammisten und diejenigen bekannten und unbekannten Künstler aller Schulen welche sich zur Bezeichnung ihrer Werke eines figürlichen Zeichens, der Initialen des Namens, der Abbreviatur desselben etc. bedient haben . . . mit den raisonnirenden Verzeichnissen der*

Werke anonymer Meister, deren Zeichen gegeben sind, und der Hinweisung auf die mit Monogrammen oder Initialen bezeichneten Produkte bekannter Künstler. 5 vols. Munich: G. Franz, 1858–1879. Reprint. Munich: G. Hirth's Verlag, 1919. Reprint. Nieuwkoop (Netherlands): B. de Graaf, 1966 (not seen).

Pre-metric (selection). Paper fold measure (selection). Inscriptions (selection). States (selection). Described (selection). Prints by and after artists of all schools and periods who used monograms to sign their work, whether or not their true names are known. Catalogues are often extensive or complete. Additional information and entries to previously published catalogues is also provided.

The *Print Council Index* identifies monograms by the reference numbers given to them in Nagler's *Die Monogrammisten.* **S** *(fl. c.1520)* [Nagler, *Mon.*] IV, no. 3861, for example, means that this particular monogram **S** is the one reproduced and discussed by Nagler under number 3862 in volume IV. The *Print Council Index* does not list every monogram in Nagler, but only those for which oeuvre-catalogues exist in other publications.

[Schreiber, *Handbuch*]

Schreiber, Wilhelm Ludwig. *Handbuch der Holz- und Metallschnitte des XV Jahrhunderts; stark vermehrte und bis zu den neuesten Funden ergänzte Umarbeitung des Manuel de l'amateur de la gravure sur bois et sur metal au XVe siècle.* 8 vols. Leipzig: Verlag Karl W. Hierseman, 1926–1930.

Millimeters. Inscriptions. Described. Located. 2,998 woodcuts and metalcuts of the fifteenth century, arranged by subject. Dictionary of the monograms which appear on them.

[ThB.]

Thieme, Ulrich, Becker, Felix et al. *Allgemeines Lexikon der bildenden Künstler von der Antike bis zur Gegenwart.* 37 vols. Leipzig: Verlag von Wilhelm Engelmann, 1907–1950. (After vol. 4, Verlag von E. A. Seemann.)

A very small number of catalogues of prints by artists. Some are cited in the *Print Council Index,* but no attempt was made to search through the entire publication for them.

List of Abbreviations for Libraries

The following abbreviations, when they refer to libraries in the United States, are generally taken from the *Union List of Serials in Libraries of the United States and Canada* (3d ed., New York: H. W. Wilson Company, 1965). Similar abbreviations have been used for libraries in Europe; these all begin with the letter *E* to avoid any accidental duplication of an abbreviation used in the *Union List.*

If a print room is cited it is the print room's reference library that was consulted for the *Print Council Index.* When various departments within a museum or library were consulted the entire institution has been cited.

Addresses for museums, art libraries and art dealers mentioned here can be found in the *International Directory of Arts* (Frankfurt am Main: Müller GmbH. and Co., published annually).

CSfAc Achenbach Foundation for Graphic Arts, California Palace of the Legion of Honor (Fine Arts Museums of San Francisco). San Francisco, California.

CLCM Los Angeles County Museum of Art. Los Angeles, California.

CLU University of California at Los Angeles. Los Angeles, California.

CSmH Huntington Library. San Marino, California.

CtW Davison Art Center, Wesleyan University. Middletown, Connecticut.

CtY Yale University. New Haven, Connecticut.

DLC Library of Congress, Washington, D.C.

EA Rijksprentenkabinet. Amsterdam, Netherlands.

EAKhI Kunsthistorisch Instituut. Amsterdam, Netherlands.

EBKb Kunstbibliothek. Berlin, Federal Republic of Germany.

EBKk Kupferstichkabinett. Berlin, Federal Republic of Germany.

EBM British Museum. London, England.

EBr Bibliothèque Royale Albert Ier. Brussels, Belgium.

EBrM Musées Royaux des Beaux-Arts de Belgique. Brussels, Belgium.

ECol P. and D. Colnaghi and Co. (art dealer). London, England.

EFBN Biblioteca Nazionale Centrale. Florence, Italy.

EFKI Kunsthistorisches Institut in Florenz. Florence, Italy.

EFU Gabinetto Disengni e Stampe degli Uffizi. Florence, Italy.

EHG Haags Gemeentemuseum. The Hague, Netherlands.

EHKB Koninklijke Bibliotheek. The Hague, Netherlands.

EHT Teylers Museum. Haarlem, Netherlands.

EL Prentenkabinet en Munt- en Penningskabinet der Rijksuniversiteit. Leiden, Netherlands.

ELVA Victoria and Albert Museum. London, England.

EMSB Bayerische Staatsbibliothek. Munich, Federal Republic of Germany.

EMSGS Staatliche Graphische Sammlung. Munich, Federal Republic of Germany.

EMZK Zentralinstitut für Kunstgeschichte. Munich, Federal Republic of Germany.

ENGM Germanisches Nationalmuseum. Nuremberg, Federal Republic of Germany.

EOBKk Kupferstichkabinett, Staatliche Museen zu Berlin. Berlin, German Democratic Republic.

EOBMB Museumsbibliothek, Staatliche Museen zu Berlin. Berlin, German Democratic Republic.

EPAA Bibliothèque d'Art et d'Archéologie (Foundation Jacques Doucet). Paris, France.

EPBN Bibliothèque Nationale. Paris. France.

EPLecomte Marcel Lecomte (art dealer). Paris, France.

EPPr Paul Prouté S. A. (art dealer). Paris, France.

ERB Museum Boymans-van Beuningen. Rotterdam, Netherlands.

ERH Bibliotheca Hertziana (Max-Planck-Institut). Rome, Italy.

ERIASA Istituto Nazionale d'Archeologia e Storia dell'Arte. Rome, Italy.

ERKD Rijksbureau voor Kunsthistorische Documentatie. The Hague, Netherlands.

EUD Kunsthistorisch Instituut der Rijksuniversiteit. Utrecht, Netherlands.

EUW Library of Dr. J. G. van Gelder, Wilhelminapark. Utrecht, Netherlands.

EWA Graphische Sammlung Albertina. Vienna, Austria.

ICB Art Institute of Chicago. Chicago, Illinois.

MB Boston Public Library. Boston, Massachusetts.

MBMu Museum of Fine Arts. Boston, Massachusetts.

MH Harvard University. Cambridge, Massachusetts.

NJP Princeton University. Princeton, New Jersey.

NN New York Public Library. New York, New York.

NNMM Metropolitan Museum of Art. New York, New York.

NNMo Museum of Modern Art. New York, New York.

PJRo Rosenwald Collection. Formerly in Jenkintown, Pennsylvania, now divided between the Library of Congress and the National Gallery of Art, Washington, D.C.

Vi Virginia State Library. Richmond, Virginia.

The Print Council Index
to Oeuvre-Catalogues
of Prints by
European and
American Artists

A

Aa, Hillebrand van der *(1659/60–1722)*
[M.] I, p. 1.
Entries: 9+ . Paper fold measure
(selection). Inscriptions.

Aarhuus, Anders Ottesen *(fl. c.1650)*
[M.] I, p. 2.
Entries: 3. Paper fold measure.

Abbate, Niccolo dell' *(c.1512–1571)*
[M.] I, pp. 4–9.
Entries: 1 print by, 45+ prints after.
Paper fold measure (selection). In-
scriptions (selection).

Abbati, Pietro Giovanni *(fl. 1700–1733)*
[M.] I, p. 10.
Entries: 2+ prints after. Paper fold
measure.

Abbatini, Guido Ubaldo *(c.1600–1656)*
[M.] I, p. 11.
Entries: 3 prints after. Paper fold
measure.

Abbé, ——— *(18th cent.)*
[M.] I, p. 11.
Entries: 1. Described.

Abbé, Hendrik *(b. 1639)*
[M.] I, pp. 11–12.
Entries: 5+ prints after. Paper fold
measure.

Abbema, Louise *(b. 1858)*
[Ber.] I, p. 9.*

Abbema, Wilhelm von *(1812–1889)*
[M.] I, pp. 12–13.

Entries: 28. Paper fold measure. De-
scribed (selection).

[Ap.] pp. 1–2.
Entries: 21.*

Abbiati, Giuseppe *(fl. c.1700)*
[M.] I, p. 13.
Entries: 6+ . Described (selection).

Abbot, J. *(fl. c.1770)*
[M.] I, p. 14.
Entries: 1. Inscriptions.

Abbott, ——— *(dates uncertain)*
[Siltzer] p. 327.
Entries: unnumbered, p. 327, prints
after. Inches. Inscriptions. Illustrated
(selection).

Abbott, Lemuel Francis *(1760–1803)*
[M.] I, p. 14.
Entries: 26 prints after. Paper fold
measure.

Abel, E. H. *(fl. c.1780)*
[M.] I, p. 20.
Entries: 4 prints after. Paper fold
measure.

Abel, Ernst August *(c.1720–1782)*
[M.] I, p. 20.
Entries: 1 print by, 2 after.

Abel, Gottlieb Friedrich *(b. 1763)*
[M.] I, p. 20.
Entries: 5+ .

Abel, Josef *(1764–1818)*
[A. 1800] III pp. 70–79.

Abel, Josef *(continued)*

Entries: 18. Pre-metric. Inscriptions. States. Described. Also, list of 6 prints after, not fully catalogued.

[M.] I, pp. 20–21.
Entries: 20 prints by, 12 after. Paper fold measure (selection).

Abendroth, Amandus Augustus *(1767–1842)*
[Dus.] p. 7.
Entries: 2 (lithographs only, to 1821). Paper fold measure.

Abent, Leonhard *(fl. c.1576)*
[M.] I, p. 24.
Entries: 1 print after. Inscriptions.

Åberg, Fredrik Ulrik *(c.1760–after 1809)*
[M.] I, p. 24.
Entries: 1 print after.

Aberli, Johann Ludwig *(1723–1786)*
[M.] I, p. 24.
Entries: 20+ prints by, 32+ after. Paper fold measure. Inscriptions (selection).

Lonchamp, F. C. *J.-L. Aberli (1723–1786): son temps, sa vie et son oeuvre, avec un catalogue complet méthodique et raisonné.* Paris and Lausanne (Switzerland): Librairie des Bibliophiles, 1927. 400 copies. (NN)
Entries: 35+ prints by, 54+ after. Millimeters. Inscriptions. States. Illustrated (selection).

Abernethie, —— *(fl. c.1785)*
[St.] p. 3.*

[F.] p. 43.*

Aberry, J. *(fl. c.1753)*
[M.] I, p. 25.
Entries: 1. Paper fold measure. Inscriptions.

Abildgaard, Nicolai Abraham *(1743–1809)*
[M.] I, pp. 26–27.
Entries: 13+ prints after. Paper fold measure (selection).

Abot, Eugène Michel Joseph *(1836–1894)*
[Ber.] I, pp. 9–11.*

Abraham, Tancrede *(1836–1895)*
[M.] I, pp. 32–33.
Entries: 7. Paper fold measure (selection).

[Ber.] I, pp. 11–12.*

Abramson, Abraham *(1754–1811)*
[M.] I, p. 33.
Entries: 4 prints after. Paper fold measure. Inscriptions. Described.

Abry, Louis *(1643–1720)*
[B.] XXI, pp. 232–233.
Entries: 1. Pre-metric. Inscriptions. Described.

[M.] I, p. 34.
Entries: 2. Paper fold measure. Inscriptions.

[W.] I, p. 2.
Entries: 2.*

[H. *Neth.*] I, p. 1.
Entries: 2. Illustrated (selection).*

Absolon, John *(1815–1895)*
[M.] I, p. 35.
Entries: 20+ prints after. Paper fold measure (selection).

Accama, Bernardus *(1697–1756)*
[M.] I, p. 37.
Entries: 7 prints after. Paper fold measure (selection).

Accius, Cesare Antonio *(early 17th cent.)*
[M.] I, pp. 37–38.
Entries: 3. Pre-metric. Inscriptions. Described.

Achard, Jean Alexis *(1807–1884)*
[M.] I, pp. 38–39.
 Entries: 16. Paper fold measure.
 States.

[H. L.] pp. 1–7.
 Entries: 18. Millimeters. Inscriptions.
 States. Described.

Reymond, Marcel. *J. Achard, peintre paysagiste.* Paris: Librairie Fischbacher, 1887. (EPBN)
 Entries: 48. Millimeters. Inscriptions.
 Described.

[Ber.] I, p. 12; II, pp. 131–136.
 Entries: 48. Millimeters. Described.
 Based on Reymond.

Achen, Johann von *(1552–1615)*
[M.] I, pp. 39–43.
 Entries: 162 prints after. Paper fold
 measure. Inscriptions.

[Merlo] pp. 1–24.
 Entries: 162 prints after. Paper fold
 measure. Inscriptions (selection). De-
 scribed (selection).

[H. *Ger.*] I, pp. 1–5.
 Entries: 185 prints after. Illustrated
 (selection).*

Heiden, Rüdiger an der. "Die Porträt-malerei des Hans von Aachen." [*WrJ.*] 66 (1970): 135–226.
 Entries: 33 paintings by, and prints
 after them; 34 prints and other copies
 after lost paintings; portraits only. In-
 scriptions. Described. Illustrated
 (selection). Includes some prints not
 in [Merlo].

Achenbach, Andreas *(1815–1910)*
[M.] I., pp. 43–46.
 Entries: 46 prints by, 8 after. Paper
 fold measure. States.

[ThB.] I, pp. 42–43.
 Entries: unnumbered, p. 43 (addi-
 tional to [M.]).

Städtische Kunstsammlungen zu Düsseldorf. *Die Graphik Andreas Achenbachs, mit einer Auswahl von Aquarellen und Handzeichnungen.* Ausstellungen zur Geschichte der Düsseldorfer Malerei, 3. Düsseldorf (Germany), 1916. (EOBMB)
 Entries: 81+ prints by and after.
 Millimeters. Inscriptions. Described
 (selection).

Achenbach, Oswald *(1827–1905)*
[M.] I, pp. 46–48.
 Entries: 9 prints by, 4 after. Paper fold
 measure.

Achener, Maurice *(b. 1881)*
Sedeyn, Louis. "The etchings of Maurice Achener." [*P. Conn.*] 3 (1923): 322–349.
 Entries: 151. Millimeters. Copy sepa-
 rately bound, with typed addition,
 nos. 152–157. (NN)

Clement-Janin. "Maurice Achener, peintre-graveur alsatien." *Byblis* 2 (1923): 1–11, and 4 unnumbered pages following p. 30.
 Entries: unnumbered, 4 pp. (to 1923).
 Millimeters.

Achilles, A. *(fl. 1829–1841)*
[M.] I, p. 48.
 Entries: 13 prints by, 1 after. Paper fold
 measure.

Acker, J. *(19th cent.)*
[Ber.] I, p. 12.*

Ackerman, Helmut *(20th cent.)*
Netzer, Remigius. "Helmut Acker-manns Radierungen zum Simson." *Illustration 63* 9 (1972): pp. 59–60.
 Bibliography of books with illustra-
 tions by (to 1972).

Ackerman [Rudolph] **and Co.** *(19th cent.)*
Ackerman and Co. *Ackerman's catalogue of books and prints for the year 1830.* London: R. Ackerman, 1830. (NN)
 Entries: pp. 1–25 books, pp. 26–74 prints. Print dimensions in inches. Sale catalogue of books and prints, mostly published by Ackerman.

Ackerman, Peter *(20th cent.)*
Kunstverein für die Rheinlande und Westfalen, Düsseldorf. *Peter Ackerman; Radierungen 1963–1970, Handzeichnungen 1963–1969.* Düsseldorf (West Germany), 1970. (ENGM)
 Entries: 176 (to 1970). Millimeters. Illustrated.

Acqua, Cesare dell' *(1821–1904)*
[M.] I, pp. 54–55.
 Entries: 2 prints after. Paper fold measure. Described.

[H. L.] pp. 172–173.
 Entries: 1. Millimeters. Inscriptions. Described.

Acqua, Cristoforo dall' *(1734–1787)*
[M.] I., pp. 52–53.
 Entries: 80. Paper fold measure. Inscriptions (selection).

Acqua, Giuseppe dall' *(fl. c.1790)*
[M.] I., p. 53.
 Entries: 78. Paper fold measure.

Acquaroni, Antonio *(19th cent.)*
[M.] II. p. 199.
 Entries: 3. Inscriptions.

Acquaroni, Giuseppe *(1780–1847)*
[M.] I, p. 55.
 Entries: 4+. Paper fold measure.

Adam, Albrecht *(1786–1862)*
[M.] I, pp. 65–68.
 Entries: 101+ prints by, 66+ after. Paper fold measure.

[Dus.] pp. 7–8.
 Entries: 7+ (lithographs only, to 1821). Millimeters. Inscriptions (selection).

Adam, Benno *(1812–1892)*
[M.] I, pp. 69–70.
 Entries: 19+ prints by, 9+ after. Paper fold measure.

Adam, Emil *(b. 1843)*
[M.] I, pp. 72–73.
 Entries: 2 prints by and after. Paper fold measure.

Adam, Eugen Carl *(1817–1880)*
[M.] I, pp. 71–72.
 Entries: 12 prints by, 8 after. Paper fold measure.

Adam, Franz *(1815–1886)*
[M.] I, pp. 70–71.
 Entries: 19 prints by, 5 after. Paper fold measure.

Adam, Georg *(1784–1823)*
[M.] I, pp. 63–64.
 Entries: 54+ prints by, 2+ after. Paper fold measure.

Adam, Hans *(fl. 1553–1567)*
[M.] I, pp. 56–57.
 Entries: 7. Paper fold measure. Inscriptions. Described.

Adam, Heinrich *(1787–1862)*
[M.] I, pp. 68–69.
 Entries: 52 prints by, 5 after. Paper fold measure.

[Dus.] p. 8.
 Entries: 4 (lithographs only, to 1821).

Hämmerle, Albert. "Die Lithographie in Augsburg." [*Schw. M.*] (1927), pp. 184–196.
 Entries: 1 (lithograph, before 1821). Millimeters. Inscriptions. Described. Located.

Adam, Henri Georges *(1904–1967)*
Gheerbrant, Bernard. *Henri-Georges Adam; oeuvre gravé, 1939–1957.* Paris: La Hune, 1957. 500 copies. (MH)
Entries: 120 (from 1939 to 1957). Millimeters. Illustrated.

"Henri Georges Adam; Graphik."
[*AzB.*] I, pp. 2–5.
Entries: 121–125 (additional to Gheerbrant). Millimeters. Inscriptions. Described. Illustrated.

Hôtel de la Monnaie, Paris. *A la rencontre d'Adam; l'integralité de ses estampes et de ses médailles parmi d'autres oeuvres.* Paris, 1968. (NNMA)
Entries: 148 (from 1934). Millimeters. Illustrated (selection).

Adam, J. *(dates uncertain)*
[M.] I, p. 73.
Entries: 2. Paper fold measure.

Adam, Jakob *(1748–1811)*
[M.] I, pp. 61–63.
Entries: 113 prints by, 2 after. Paper fold measure.

Adam, Jean *(fl. c.1820)*
[Ber.] I, p. 13.*

Adam, Julius *(1826–1874)*
[M.] I, p. 72.
Entries: 12+. Paper fold measure.

Adam, Lambert Sigisbert *(1700–1759)*
[M.] I, pp. 58–59.
Entries: 2+ prints by, 3+ after. Paper fold measure. Inscriptions.

Adam, Nicolas Sébastien *(1705–1778)*
[M.] I, pp. 59–60.
Entries: 3. Paper fold measure (selection).

Adam, Philipp *(17th cent.)*
[M.] I, p. 57.
Entries: 12. Paper fold measure.

Adam, Pierre Michel *(b. 1799)*
[M.] I, p. 73.
Entries: 15+. Paper fold measure.

[Ap.] p. 2.
Entries: 7.*

[Ber.] I, pp. 13–15.*

Adam, Victor *(1801–1866)*
[M.] I, pp. 73–76.
Entries: 105+ prints by, 19+ after. Paper fold measure.

[Ber.] I, pp. 15–22.*

Adamek, Johann *(b. 1840)*
[M.] I, p. 76.
Entries: 5 prints after. Paper fold measure.

Adams, Edward *(19th cent.)*
[M.] I, p. 78.
Entries: 2+. Paper fold measure.

Adams, Francis Edward *(fl. c.1773)*
[M.] I, p. 78.
Entries: 2. Paper fold measure. Inscriptions.

[Sm.] I, pp. 1–2.
Entries: 4 (portraits only). Inches. Inscriptions. States. Described. See also [Sm.] I, p. 4 (Monogrammist EWA).

[Ru.] p. 1.
Additional information to [Sm.]

Adams, Robert *(1540–1595)*
[M.] I, p. 78.
Entries: 3+ prints by and after. Paper fold measure.

Adcock, G. *(early 19th cent.)*
[M.] I, p. 79.
Entries: 15. Paper fold measure.

Adelhauser, Hans *(fl. c.1567)*
[M.] I, p. 81.
Entries: 1. Paper fold measure. Inscriptions. Described.

Adelhauser, Hans *(continued)*

[H. *Ger.*] I, p. 5.
 Entries: 1 print after.*

Adeline, Louis Jules *(19th cent.)*
[Ber.] I, pp. 22–29.*

Adelmann, Johann Christian Wilhelm
(b. c.1780)
[M.] I, p. 81.
 Entries: 2 prints by, 1 after. Paper
 fold measure. Inscriptions.

Ademollo, Luigi *(1764–1849)*
[M.] I, pp. 81–82.
 Entries: 8. Paper fold measure.

Adler-Mesnard, Eugène Edouard
(d. 1884)
[Ber.] I, pp. 29–30.*

Adriaensz, Gerard *(fl. c.1658)*
[W.] I, p. 3.
 Entries: 1 print after.*

Aelst, Isaeck van *(fl. 1629–1663)*
[H. *Neth.*] I, p. 2.
 Entries: 1. Illustrated.*

Aelst, J. van *(fl. c.1629)*
[M.] I, p. 100.
 Entries: 2. Paper fold measure (selec-
 tion).

Aelst, Nicolaus van *(c.1526-after 1613)*
[M.] I, pp. 99–100.
 Entries: 17+ . Paper fold measure
 (selection). Inscriptions (selection).

Aelst, Wille van *(b. 1625/26)*
[W.] I, p. 5.
 Entries: 1 print after.*

[H. *Neth.*] I, p. 2.
 Entries: 1 print after.*

Aeneae, Petrus *(fl. 1680–1700)*
[M.] I, pp. 101–102.

Entries: 14. Millimeters (selection).
Paper fold measure (selection). In-
scriptions. Described (selection).

[W.] I, p. 5.
 Entries: 15.*

[H. *Neth.*] I, p. 2.
 Entries: 14.*

Aertsen, Pieter *(1508–1557)*
[M.] I, pp. 104–106.
 Entries: 6 prints after. Paper fold mea-
 sure. Described (selection).

[W.] I, p. 7.
 Entries: 6 prints after.*

[H. *Neth.*] I, p. 4.
 Entries: 3 prints by, 6 after.*

Afanassjeff, Afanassi Afanassjewitsch
(1758–c.1800)
[M.] I, p. 110.
 Entries: 3+ .

Afinger, Bernhard *(1813–1882)*
[M.] I, pp. 110–112.
 Entries: 2 prints by and after. Paper
 fold measure.

Afinger, Nikolaus *(1818–1852)*
[M.] I, p. 112.
 Entries: 5. Paper fold measure. States.

Agar, Jacques d' *(1640–1715)*
[M.] I, pp. 114–115.
 Entries: 14 prints after. Paper fold
 measure.

Agar, John Samuel *(fl. 1796–1835)*
[M.] I, pp. 115–116.
 Entries: 50+ . Paper fold measure.
 States.

Agasse, Jacques Laurent *(1767–1849)*
[Siltzer] pp. 36–41.
 Entries: unnumbered, pp. 36–41
 (prints after). Inches (selection). In-
 scriptions. States. Illustrated (selec-
 tion).

Agasse, Jean *(fl. c.1800)*
 [M.] I, pp. 116–117.
 Entries: 2 prints by, 7 after. Paper fold measure.

Agata, Antonio dell' *(18th cent.)*
 [Vesme] p. 509.
 Entries: 2. Millimeters. Inscriptions. Described. Located.

Agénois, le comte A. d' *(fl. c.1730)*
 [M.] I, p. 119.
 Entries: 2. Paper fold measure. Inscriptions. Described.

Aggas, Ralph *(1540/45–c.1617)*
 [M.] I, p. 121.
 Entries: 4 prints after. Pre-metric (selection). Inscriptions.

Aglio, Agostino *(1777–1857)*
 [M.] I, p. 123.
 Entries: 6+ prints by, 2+ after. Paper fold measure.

Agnelli, Federico *(fl. c.1700)*
 [M.] I, pp. 123–124.
 Entries: 16+. Paper fold measure. Inscriptions (selection).

Agresti, Livio *(fl. 1550–1580)*
 [M.] I, pp. 135–136.
 Entries: 11 prints after. Paper fold measure. Inscriptions.

Agricola, Christoph Ludwig *(1667–1719)*
 [M.] I, pp. 137–138.
 Entries: 3 prints by, 2 after, 4 perhaps by. Paper fold measure. Inscriptions. Described (selection).

Agricola, Filippo *(1776–1857)*
 [M.] I, p. 139.
 Entries: 3 prints after. Paper fold measure.

Agricola, Karl Joseph Aloys *(1779–1852)*
 [M.] I, pp. 139–141.

Entries: 48 prints by, 14 after. Paper fold measure. States.

 [A. 1800] IV, pp. 1–29.
 Entries: 59 prints by, 3 rejected prints. Millimeters. Inscriptions. States. Described. Also, list of 12 prints after, not fully catalogued.

 [Ap.] pp. 3–4.
 Entries: 15.*

Schwarz, Heinrich. "Nachträge zu Andresens 'Deutschen Malerradierern'," [*MGvK.*] 1924, pp. 41–51.
 Entries: 2 (additional to [A. 1800]). Millimeters. Inscriptions. Described. Located.

Agricola, Luigi *(c.1750–1821)*
 [M.] I, pp. 138–139.
 Entries: 21+ prints after. Paper fold measure. Inscriptions.

Aguesca, Laurenzo *(fl. c.1645)*
 [M.] I, p. 143.
 Entries: 1. Paper fold measure.

Ahlborn, August Wilhelm Julius *(1796–1857)*
 [M.] I, pp. 148–149.
 Entries: 4 prints by, 2 after. Paper fold measure.

Ahrendts, Leopold *(fl. c.1850)*
 [M.] I, p. 149.
 Entries: 3. Paper fold measure.

Ahumada, ——— *(fl. c.1725)*
 [M.] I, pp. 149–150.
 Entries: 1. Paper fold measure. Inscriptions.

Aichhorn, J.B.S. *(fl. c.1790)*
 [M.] I., p. 150.
 Entries: 1. Paper fold measure.

Aigen, Karl *(1684–1762)*
 [M.] I, p. 150.

Aigen, Karl *(continued)*

> Entries: 2 prints after. Paper fold measure.

Aigner, Jos[eph] Matthäus *(1818–1886)*
> [M.] I, pp. 151–152.
>> Entries: 4 prints after. Paper fold measure.

Aikman, Alexander T. *(fl. c.1841)*
> [M.] I, p. 153.
>> Entries: 2. Paper fold measure. States.

Aikman, William *(1682–1731)*
> [M.] I, p. 153.
>> Entries: 2 prints by, 17 after. Paper fold measure (selection).

Ainmiller, Max Emanuel *(1807–1870)*
> [M.] I, pp. 154–155.
>> Entries: 5+ prints after. Paper fold measure.
>
> [Dus.] p. 8.
>> Entries: 1 (lithographs only, to 1821). Millimeters. Inscriptions. Located.

Aita de la Penuela, Mathilde *(fl. 1859–1869)*
> [M.] I, pp. 155–156.
>> Entries: 11 prints after. Paper fold measure.

Aitken, J. *(fl. c.1795)*
> [Siltzer] p. 344.
>> Entries: unnumbered, p. 344. Inscriptions.

Aitken, Robert *(1734–1802)*
> [St.] pp. 3–5.*
>
> [F.] pp. 43–44.*

Ajtai, Michel D. *(fl. c.1775)*
> [M.] I, p. 156.
>> Entries: 2. Paper fold measure.

Aken, Jan van *(1614–1661)*
> [B.] I, pp. 271–284.

> Entries: 21. Pre-metric. Inscriptions. Described.

> [Heller] p. 1.
>> Additional information to [B.].
>
> [Weigel] pp. 36–37.
>> Additional information to [B.].
>
> [M.] I, pp. 158–159.
>> Entries: 21 prints by, 1 after. Paper fold measure. Inscriptions. States.
>
> [Dut.] IV, pp. 1–5.
>> Entries: 21. Millimeters. Inscriptions. States. Described.
>
> [W.] I, p. 8.
>> Entries: 21 prints by, 1 after.*
>
> [H. *Neth.*] I, pp. 5–9.
>> Entries: 21. Illustrated.*

Akersloot, William Outgertsz
(fl. 1624–1633)
> [M.] I, pp. 161–162.
>> Entries: 17. Paper fold measure. Inscriptions. States. Described.
>
> [W.] I, p. 9.
>> Entries: 17.*
>
> [H. *Neth.*] I, pp. 10–23.
>> Entries: 18. Illustrated.*

Akin, James *(1773–1846)*
> [Allen] p. 117.
>
> [St.] pp. 5–8.*
>
> [F.] pp. 44–46.*
>
> Quimby, Maureen O'Brien. "The political art of James Akin." *Winterthur Portfolio* 7 (1972): 59–112.
>> Entries: 88+ prints and drawings by. Inches. Inscriptions. Described. Illustrated (selection). Located.

Alasonière, Fabien Henri *(fl. c.1900)*
> [Ber.] I, p. 30.*

Alaux, Jean *(1786–1864)*
> [M.] I, pp. 167–168.

Entries: 1 print by, 1 after. Paper fold measure.

Alavoine, Jean Antoine *(1776–1834)*
[M.] I, pp. 168–169.
Entries: 2. Paper fold measure (selection). Inscriptions. States.

[Ber.] I, pp. 30–31.*

Albane, ——— *(fl. c.1790)*
[M.] I, p. 170.
Entries: 2.

Albanesi, Angelo *(fl. c.1780)*
[M.] I, p. 171.
Entries: 2. Paper fold measure.

Albani, Francesco *(1578–1660)*
[B.] XVIII, pp. 342–343.
Entries: 1. Pre-metric. Inscriptions. Described.

[M.] I, pp. 171–181.
Entries: 247 prints after. Paper fold measure. Inscriptions (selection).

Albert Kasimir, Herzog von Sachsen-Teschen *(1738–1822)*
[M.] I, p. 186.
Entries: 3 prints after. Paper fold measure. Inscriptions.

Albert, Prince Consort of England *(1819–1861)*
[M.] I, p. 186.
Entries: 2 prints after. Paper fold measure. Inscriptions.

Scott-Elliot, A. H. "The etchings by Queen Victoria and Prince Albert." *Bulletin of the New York Public Library* 65 (1961): 139–153.
Entries: 25 etchings by, 2 doubtful etchings, 2 lithographs. Millimeters. Inscriptions. Described. Located (selection).

Albert, Alfred *(fl. 1833–1876)*
[Ber.] I, p. 31.*

Albert, Friedrich Wilhelm Ferd[inand] Th[eodor] *(b. 1822)*
[M.] I, pp. 186–187.
Entries: 20+. Paper fold measure.

Alberti, Carl *(19th cent.)*
[M.] I, p. 218.
Entries: 2 prints after. Paper fold measure.

Alberti, Cherubino *(1553–1615)*
[B.] XVII, pp. 45–122.
Entries: 172. Pre-metric. Inscriptions. States. Described. Copies noted. Appendix with doubtful and rejected prints, pp. 112–122.

[M.] I. pp. 204–214.
Entries: 189 prints by, 3 after, 4 doubtful prints. Paper fold measure. Inscriptions. States.

[Wess.] III, pp. 42–43.
Entries: 1 (additional to [B.]). Millimeters. Inscriptions. Described. Located. Additional information to [B.].

Alberti, Ignaz *(fl. 1780–1801)*
[M.] I, p. 217.
Entries: 4. Paper fold measure.

Alberti, Jean Eugène Charles *(b. 1781)*
[M.] I, p. 218.
Entries: 7. Paper fold measure.

Alberti, Pierfrancesco *(1584–1638)*
[B.] XVII, pp. 313–314.
Entries: 1. Pre-metric. Inscriptions. Described.

[M.] I, p. 215.
Entries: 10. Paper fold measure. Inscriptions. Described.

Albertinelli, Mariotto di Bigio di Bindo *(1474–1515)*
[M.] I, pp. 218–224.
Entries: 19 prints after. Paper fold measure.

Albertolli, Ferdinando *(b. 1781)*
[M.] I, p. 228.
 Entries: 7+. Paper fold measure.
 States.

Albertolli, Giocondo *(1742–1839)*
[M.] I, pp. 226–227.
 Entries: 6+ prints after. Paper fold
 measure.

Albertolli, Raffaello *(b. 1770)*
[M.] I, p. 228.
 Entries: 4 prints by, 1 after. Paper fold
 measure.

Alberts, F. *(19th cent.)*
[Merlo] p. 37.
 Entries: 3. Paper fold measure. In-
 scriptions. Described (selection).

Albin, Eleazar *(fl. 1720–1740)*
[M.] I, p. 232.
 Entries: 5+ prints after. Paper fold
 measure.

Albini, Alessandro *(1568–1646)*
[M.] I, pp. 232–233.
 Entries: 3 prints after. Paper fold mea-
 sure.

Albrecht, Balthasar Augustin *(1687–1765)*
[M.] I, pp. 234–235.
 Entries: 6 prints after. Paper fold mea-
 sure.

Albrecht, Bernhard *(d. 1822)*
[M.] I, pp. 235–236.
 Entries: 3. Paper fold measure. In-
 scriptions. States.

Albrecht, J. Wolfgang *(fl. c.1741)*
[M.] I, p. 235.
 Entries: 2 prints after. Paper fold mea-
 sure. Inscriptions.

Albrier, Joseph *(1791–1863)*
[M.] I, p. 236.

Entries: 11 prints after. Paper fold
measure.

Alcayde, José *(fl. 1834–1860)*
[M.] I, p. 237.
 Entries: 3. Paper fold measure. In-
 scriptions.

Aldano Maldo, Amadis de *(18th cent.)*
[M.] I, p. 238.
 Entries: 3. Paper fold measure. In-
 scriptions (selection).

Aldegrever, Heinrich *(1502–1555/61)*
See also **Monogram AD** [Nagler, *Mon.*]
I, no. 1084

[B.] VIII, pp. 362–455.
 Entries: 289. Pre-metric. Inscriptions.
 States. Described. Copies noted. Ap-
 pendix with one doubtful print. Ap-
 pendix with 9 prints falsely attributed
 to Aldegrever.

[P.] IV, pp. 102–107.
 Entries: 7 engravings (additional to
 [B.]), 1 rejected print (additional to
 [B.]), 3 woodcuts (additional to [B.]).
 Pre-metric. Inscriptions. Described.
 Located (selection). Copies noted.
 Additional information to [B.].

[Evans] p. 24.
 Entries: 1 (additional to [B.]). Millime-
 ters. Inscriptions. Described.

[Heller] p. 1–4.
 Additional information to [B.].

[M.] I, pp. 239–254. (English translation,
ms., EBM)
 Entries: 290 engravings by, 20 doubt-
 ful engravings by, 4 woodcuts by, 8
 prints after. Millimeters (selection).
 Paper fold measure (selection). In-
 scriptions. States. Described (selec-
 tion).

[Wess.] I, p. 122.
 Entries: 1 (additional to [B.] and [P.]).
 Millimeters. Inscriptions. Described.

[W.] III, pp. 3–6.
Entries: 12 prints by (portraits and woodcuts only); 3 after.*

Beets, N. "The Virgin seated on a bank: an undescribed woodcut by Heinrich Aldegrever." [Burl. M.] 16 (1909–10): 347–351.
Entries: 5 (woodcuts other than portraits). Millimeters. Inscriptions. Described (selection). Illustrated (selection). Located.

Dodgson, Campbell. "Jacob meditating on Joseph's Dreams: an undescribed woodcut by Heinrich Aldegrever." [Burl. M.] 13 (1908): 219.
Entries: 1 (additional to previous catalogues). Millimeters. Inscriptions. Described. Illustrated. Located.

[Ge.] nos. 1–9.
Entries: 9 (woodcuts only). Described. Illustrated. Located.

Zschelletzschky, Herbert. Das graphische Werk Heinrich Aldegrevers; ein Beitrag zu seinem Stil im Rahmen der deutschen Stilentwicklung. Studien zur deutschen Kunstgeschichte, 292. Strasbourg (France): J. H. Ed. Heitz, 1935. (MH)
Additional information to [M.]; on copies and borrowings from Aldegrever.

[H. Ger.] I, pp. 6–145.
Entries: 320 engravings by, 8 engravings after, 10 woodcuts by. Illustrated (selection).*

Aldenburgh, Daniel (17th cent.)
[M.] I, p. 254.
Entries: 9. Paper fold measure. Inscriptions.

[Merlo] pp. 38–39.
Entries: 10. Paper fold measure. Inscriptions. Described.

Aldenrath, Heinrich Jakob (1775–1844)
[M.] I, pp. 254–255.

Entries: 16 prints by, 1 after. Paper fold measure.

[Dus.] p. 8.
Entries: 2 (lithographs only, to 1821). Millimeters. Inscriptions. Located.

Aldewerelt, Herman van (1629–1669)
[M.] I, p. 255.
Entries: 8 prints after. Paper fold measure. Inscriptions. States. Described.

[W.] I, p. 10.
Entries: 7 prints after.*

[H. Neth.] I, p. 23.
Entries: 7 prints after.*

Aldrovandini, Pompeo (1677–1735/39)
[M.] I, pp. 258–259.
Entries: 3 prints after. Paper fold measure.

Aleander, Johann Abraham (1766–1853)
[M.] I, p. 259.
Entries: 2.

Alechinsky, Pierre (b. 1927)
Galerie van de Loo, Munich. Pierre Alechinsky; 20 Jahre Impressionen; Oeuvrekatalog Druckgraphik. Munich, 1967. (CLU)
Entries: 283 (to 1967). Millimeters. Inscriptions. Described. Illustrated. Last four prints are not illustrated.

[AzB.] I, pp. 22–31.
Additional information to Galerie van de Loo, 1967.

Alefounder, John (18th cent.)
[M.] I, p. 259.
Entries: 2 prints after. Paper fold measure.

Alenis, Tommaso de (fl. 1500–1515)
[M.] I, pp. 266–267.
Entries: 2 prints after (19th cent.).

Alès, Auguste François *(1797–1878)*
[M.] I, p. 271.
Entries: 20+. Paper fold measure. Described (selection).

[Ber.] I, pp. 31–32.*

Alesio, Matteo Perez de *(b. c.1547)*
[M.] I, pp. 271–272.
Entries: 3 prints by, 2 after. Paper fold measure. Inscriptions. Described (selection).

Alessandri, Innocente *(18th cent.)*
[M.] I, pp. 273–274.
Entries: 38+. Paper fold measure. Inscriptions (selection). States.

Alessio, Antonio di *(fl. c.1570)*
[M.] I, p. 280.
Entries: 4. Paper fold measure. Inscriptions. Described.

Alexander, John *(fl. 1715–1752)*
[M.] I, p. 282.
Entries: 8 prints by, 2 after. Paper fold measure. Inscriptions.

Alexander, Prinz von Württemberg
(19th cent.)
[Dus.] p. 9.
Entries: 1. Paper fold measure.

Alexander, William *(1767–1816)*
[M.] I, pp. 282–284.
Entries: 79+ prints by, 10+ prints after. Paper fold measure. Inscriptions (selection).

Alfaro y Gomez, Juan de *(1640–1680)*
[M.] I, p. 295.
Entries: 1.

Alfiano, Don Epifanio d' *(fl. 1591–1607)*
[M.] I, p. 296.
Entries: 3+. Paper fold measure. Inscriptions.

Alfieri, Aurelio *(b. 1800)*
[M.] I, pp. 296–298.
Entries: 50. Paper fold measure.

[Ap.] p. 4.
Entries: 9.*

Algardi, Allessandro *(1602–1654)*
[B.] XIX, pp. 74–77.
Entries: 2 (both doubtful, attributed by [B.] to Simon Guillain). Pre-metric. Inscriptions. Described.

[M.] I, pp. 300–306.
Entries: 6 prints by (doubtful), 24 after. Paper fold measure. Inscriptions.

Algarotti, Francesco *(1712–1764)*
[M.] I, pp. 306–307.
Entries: 23. Paper fold measure (selection). Inscriptions. Described.

Aliamet, François Germain *(1734–1788)*
[M.] I, p. 311.
Entries: 25. Paper fold measure.

Aliamet, Jean Jacques *(1726–1788)*
[M.] I, pp. 309–311
Entries: 107+. Paper fold measure. States.

Deslignières, V. E. *Catalogue raisonné de l'oeuvre gravé de Jacques Aliamet d'Abbeville.* Paris: Rapilly, 1896. 200 copies. (MH)
Entries: 262. Millimeters. Inscriptions. States. Described.

[L. D.] p. 1.
Entries: 1. Millimeters. Inscriptions. States. Described. Incomplete catalogue.*

Aliberti, Giuseppe *(18th cent.)*
[M.] I, p. 312.
Entries: 4.

Aligny, Theodore *(1798–1871)*
[M.] I, p. 314.
Entries: 13. Paper fold measure.

Aliprandi, Giacomo *(fl. c.1800)*
[M.] I, p. 315.
 Entries: 24. Paper fold measure.

Alix, Jean *(b. 1615)*
[RD.] IV, pp. 19–21; XI, pp. 1–2.
 Entries: 8. Pre-metric. Inscriptions.
 States. Described.

[M.] I, pp. 315–316.
 Entries: 8. Paper fold measure. States.
 Described (selection).

Alix, Pierre Michel *(1762–1817)*
[M.] I, pp. 316–320.
 Entries: 105. Paper fold measure. In-
 scriptions (selection). States. De-
 scribed (selection).

[Ber.] I, pp. 32–34.
 Entries: 22 (prints after 1800 only).

Alken, Henry *(fl. 1800–1850)*
[M.] I, pp. 321–322.
 Entries: 20+ prints by, 15+ after.
 Paper fold measure.

"English sporting prints, the colored
engravings of Henry Alken." *Boston
Transcript,* July 20, 1910. (photostat, NN)
 Entries: 107+. Paper fold measure.
 Ms. addition, 8 additional entries.
 (NN)

[Siltzer] pp. 43–74, 344–345.
 Entries: unnumbered, pp. 43–74
 (prints by and after). Inches (selec-
 tion). Inscriptions.

Ms. catalogue. (ICB)
 Entries: unnumbered, 14 pp. Paper
 fold measure. Inscriptions (selection).
 Described (selection).

Alken, Henry II *(1810–1892)*
[Siltzer] pp. 75–76; 345.
 Entries: unnumbered, pp. 75–76
 (prints by and after). Inches (selec-
 tion). Inscriptions.

Alken, J. *(19th cent.)*
[Siltzer] p. 345.
 Entries: unnumbered, p. 345. Inscrip-
 tions.

Alken, Samuel *(fl. 1780–1798)*
[M.] I, p. 321.
 Entries: 24+. Paper fold measure. In-
 scriptions (selection).

[Siltzer] pp. 42–43; 75; 345.
 Entries: unnumbered, p. 75 (prints by
 and after). Inches (selection). Inscrip-
 tions.

Allais, Angelique Briceau *(fl. c.1800)*
[M.] I, p. 324.
 Entries: 13+. Paper fold measure. In-
 scriptions (selection). Described
 (selection).

Allais, Jean Alexandre *(1792–1850)*
[M.] I, pp. 324–326.
 Entries: 64. Paper fold measure.
 States.

[Ap.] pp. 4–5.
 Entries: 6.*

[Ber.] I, pp. 34–36.*

Allais, Louis Jean *(1762–1833)*
[M.] I, pp. 323–324.
 Entries: 33+. Paper fold measure. De-
 scribed (selection).

[Ber.] I, p. 34.*

Allais, Prosper Paul *(b. 1827)*
[M.] I, p. 326.
 Entries: 20. Paper fold measure. De-
 scribed (selection).

[Ap.] p. 5.
 Entries: 3.*

[Ber.] I, pp. 36–40.
 Entries: 51.

Allan, Andreas *(18th cent.)*
[M.] I, pp. 326–327.

Allan, Andreas *(continued)*

Entries: 2 prints after. Paper fold measure.

Allan, David *(1744–1796)*
[M.] I, pp. 327–328.
Entries: 21+ prints by, 12+ after. Millimeters (selection). Paper fold measure (selection). Inscriptions (selection).

Gordon, T. Crouther. *David Allan of Alloa, 1744–1796, the Scottish Hogarth.* Alva (Scotland): Robert Cunningham and Sons, 1951. (EBM)
Entries: unnumbered, pp. 83–91 (list of all works, including prints). Inches. Located.

Allan, Sir William *(1782–1850)*
[M.] I, pp. 328–329.
Entries: 1 print by, 26 after. Paper fold measure.

Allard, Abraham *(fl. c.1700)*
[M.] I, p. 330.
Entries: 42+. Paper fold measure (selection).

[W.] I, p. 11.
Entries: 19.*

Allard, Carel *(b. 1648)*
[M.] I. pp. 330–331.
Entries: 52 prints by and published by. Paper fold measure.

[W.] I, p. 11.
Entries: 18.*

[H. *Neth.*] I, p. 24.
Entries: 53.*

Allard, Hugo [or Huych] *(d. 1684)*
[M.] I, p. 331.
Entries: 8. Paper fold measure. Inscriptions (selection).

[W.] I, p. 11.
Entries: 11.*

[H. *Neth.*] I, p. 25.
Entries: 19.*

Allardice, S. *(fl. 1794–1803)*
[Allen] p. 117.*

Allason, Thomas *(1790–1852)*
[M.] I, p. 331.
Entries: 2+ prints after. Paper fold measure.

Allebé, August *(1838–1927)*
Stuers, Charles Hubert de. *Het lithographisch werk van August Allebé; beschrijvende catalogus met inleiding.* Dissertation, University of Leiden. Utrecht (Netherlands): De Ploeg, 1929. (MH)
Entries: 39. Millimeters. Inscriptions. States. Described. Illustrated (selection). Located (selection).

Knoef, J. "Onbekende grafiek van A. Allebé," [*Oud-Holl.*] 68 (1953): 174–178.
Entries: 11 wood engravings after. Millimeters. Inscriptions. Described.

Allegrain, Etienne *(1644–1736)*
[RD] VIII, pp. 276–279; XI, p. 2.
Entries: 8. Millimeters. Inscriptions. Described.

[M.] I, pp. 332–333.
Entries: 8. Paper fold measure. Inscriptions.

Allegrini, Francesco *(1587–1663)*
[M.] I, pp. 482–483.
Entries: 7 prints after. Paper fold measure.

Allegrini, Francesco *(b. 1729)*
[M.] I, p. 483.
Entries: 4+.

Allegrini, Giuseppe *(18th cent.)*
[M.] I, p. 483.
Entries: 7. Paper fold measure. Inscriptions.

Allemand, Gustave *(1846–1888)*
 [Ber.] I, pp. 44–45.
 Entries: 12. Paper fold measure (selection). Inscriptions (selection).

Allemand, Louis Hector *(1809–1886)*
 [M.] I, pp. 484–486.
 Entries: 53. Paper fold measure. Inscriptions. States. Described.

 [Ber.] I, pp. 40–44.
 Entries: 65. Paper fold measure. Inscriptions (selection).

Allen, Folpert van Ouden *(d. 1715)*
 [M.] I, pp. 486–487.
 Entries: 1 print by, 2 after. Paper fold measure. Inscriptions (selection).

 [W.] I, p. 10.
 Entries: 3+ (prints after).*

Allen, Frans *(fl. c.1650)*
 [M.] I, p. 487.
 Entries: 10+. Paper fold measure.

Allen, James Baylie *(1803–1876)*
 [M.] I, pp. 488–489.
 Entries: 44+. Paper fold measure. States.

 [Ap.] p. 5.
 Entries: 4.*

Allen, James C. *(19th cent.)*
 [M.] I, p. 488.
 Entries: 19+. Paper fold measure.

Allen, Joel *(1755–1825)*
 [St.] pp. 9–10.

 [F.] pp. 46–47.*

Allen, Joseph *(c.1770–1839)*
 [M.] I, p. 487.
 Entries: 14 prints after.

Allen, Luther *(fl. c.1790)*
 [St.] p. 10.*

 [F.] p. 47.*

Allen, Thomas *(fl. 1767–1772)*
 [M.] I, p. 487.
 Entries: 3 prints after. Paper fold measure.

Allen, Thomas *(1803–1833)*
 [M.] I, p. 489.
 Entries: 5+. Paper fold measure.

Allet, Jean Charles *(fl. 1690–1732)*
 [M.] I, pp. 489–490.
 Entries: 31+. Paper fold measure. Inscriptions (selection).

Allgeyer, Julius *(1829–1900)*
 [M.] I, p. 490.
 Entries: 7+. Paper fold measure.

 [Ap.] pp. 5–6.
 Entries: 6.*

Allier, Achille *(1808–1836)*
 [M.] I, p. 491.
 Entries: 2+. Paper fold measure.

 [Ber.] I, p. 45.*

Allingham, Charles *(fl. c.1800)*
 [M.] I, p. 491.
 Entries: 8 prints after. Paper fold measure.

Allix, François *(1752–1794)*
 [M.] I, p. 493.
 Entries: 8+. Paper fold measure.

Allmer, J. C. *(19th cent.)*
 [M.] I, p. 493.
 Entries: 12. Paper fold measure.

Alloja, Giuseppe *(fl. 1756–1759)*
 [M.] I, p. 520.
 Entries: 4+.

Alloja, Raffaello *(fl. c.1790)*
 [M.] I, p. 520.
 Entries: 7. Paper fold measure.

Allom, Thomas *(1804–1872)*
 [M.] I, pp. 493–494.

Allom, Thomas *(continued)*

Entries: 5+ prints by, 43+ after. Paper
fold measure (selection).

Allongé, Auguste *(1833–1898)*
[Ber.] I, p. 45.*

Allori, Alessandro *(1535–1607)*
[M.] I, pp. 503–507.
Entries: 27 prints after. Paper fold
measure. Inscriptions. Described
(selection).

Allori, Christofano *(1577–1621)*
[M.] I, pp. 508–513.
Entries: 37 prints after. Paper fold
measure. Inscriptions (selection).

Allou, Adélaide *(18th cent.)*
[M.] I, p. 513.
Entries: 10. Paper fold measure.

Allou, Gilles *(1670–1751)*
[M.] I, p. 513.
Entries: 7 prints after. Paper fold
measure. Inscriptions.

Allport, J. V. *(18th cent.)*
[M.] I, p. 513.
Entries: 2. Paper fold measure.

Allston, Washington *(1779–1843)*
[M.] I, pp. 513–515.
Entries: 7+ prints after. Paper fold
measure.

Alma-Tadema, Laurence *(1836–1912)*
[W.] II, p. 688.
Entries: 1.*

Almeida, Francisco Thomas d' *(1778–1866)*
[M.] I, p. 516.
Entries: 3.

Soares, Ernesto. *Francisco Bartolozzi e os
seus discipulos em Portugal.* Estudos-
Naciones sob a égide do Instituto de
Coimbra, 3. Gaia (Portugal): Edições
Apolino, 1930. (NN)
Entries: 14+. Millimeters. Inscrip-
tions. Described. Located.

Almeida, Romão Eloi de *(18th cent.)*
Soares, Ernesto. *Francisco Bartolozzi e os
seus discipulos em Portugal.* Estudos-
Naciones sob a égide do Instituto de
Coimbra, 3. Gaia (Portugal): Edições
Apolino, 1930. (NN)
Entries: 11. Millimeters. Inscriptions.
Described. Located.

Almeloveen, Jan van *(fl. c.1680)*
[B.] I, pp. 287–306.
Entries: 37. Pre-metric. Inscriptions.
Described.

[Weigel] pp. 37–39.
Additional information to [B.].

[M.] I, pp. 516–517.
Entries: 38. Millimeters (selection).
Paper fold measure (selection). In-
scriptions. States. Described.

[Dut.] IV, pp. 5–11; V, p. 585.
Entries: 36. Millimeters. Inscriptions.
States. Described.

[W.] I, p. 12
Entries: 38.*

[H. *Neth.*] I, pp. 26–34.
Entries: 38. Illustrated.*

Almfelt, Lorentz Axel *(1781–1844)*
[M.] I, pp. 517–518.
Entries: 8. Inscriptions (selection).
Described (selection).

Aloisi-Galanini, Baldassare *(1577–1638)*
[B.] XVIII, pp. 335–341.
Entries: 52. Pre-metric. Inscriptions.
Described (selection).

[M.] I, pp. 518–519.
Entries: 51. Paper fold measure. In-
scriptions (selection).

Alophe, Marie Alexandre *(1812–1883)*
[Ber.] I, pp. 46–49.*

Alpago-Novello, Alberto *(b. 1889)*
[AN.] pp. 707–708.
Entries: unnumbered, pp. 707–708 (to 1922). Millimeters. Inscriptions. Described.

Alpresa, Frank *(20th cent.)*
Catasús, Joan. *Los Exlibris de Frank Alpresa.* Madrid: Luis Bardon Lopez [1954?].

Not seen. *See* [*N. ExT*] 6 (1954): 63

Alram, Johann *(fl. c.1820)*
[M.] I, p. 527.
Entries: 5. Paper fold measure. States.

Als, Peter *(1726–1776)*
[M.] I, p. 527.
Entries: 3 prints after. Paper fold measure.

Alströmer, Johan *(1742–1786)*
[M.] I, p. 531.
Entries: 2. Paper fold measure. Inscriptions. Described.

Alt, Jakob *(1789–1872)*
[M.] I, p. 532.
Entries: 11+ prints by, 4+ after. Paper fold measure.

Alt, Rudolph von *(1812–1905)*
[M.] I, pp. 532–535.
Entries: 8+ prints by, 18+ after. Paper fold measure.

Weixlgärtner, Arpad. "Rudolf von Alt als Graphiker." [*GK*] 29 (1906): 45–46. Catalog: "Rudolf von Alts graphische Arbeiten." [*MGvK.*] 1906, pp. 27–32, 75 (Supplement).
Entries: 29 lithographs, 21 etchings. unnumbered list of reproductive lithographs by. Millimeters. Inscriptions. States. Described.

Altdorfer, Albrecht *(c.1480–1538)*
[B.] VIII, pp. 41–81.
Entries: 159. Pre-metric. Inscriptions. States. Described. Copies noted.

[Heller] pp. 4–6.
Additional information to [B.].

[P.] III, pp. 301–305.
Entries: 11 engravings (additional to [B.]), 2 woodcuts (additional to [B.]). Additional information to [B.].

[M.] I, pp. 537–553.
Entries: 111 engravings by, 68 woodcuts by, 10 engravings attributed to, 7 prints after. Millimeters (selection). Paper fold measure (selection). Inscriptions (selection). Described (selection).

[Wess.] I, p. 123.
Entries: 4 (additional to [B.] and [P.]). Millimeters. Inscriptions. Described.

Waldmann, Emil. *Albrecht Altdorfer.* London: Medici Society, 1923. (MBMu)
Entries: 115 (etchings and engravings only). Millimeters. Inscriptions. States. Described. Illustrated. Located.

[Ge.] nos. 10–44.
Entries: 35 (woodcuts only). Described. Illustrated. Located.

Winzinger, Franz. *Albrecht Altdorfer, Graphik: Holzschnitte, Kupferstiche, Radierungen.* Munich: R. Piper und Co., 1963. (MBMu)
Entries: 240 (209–240 are workshop prints). Millimeters. Inscriptions. States. Described. Illustrated. Located. Bibliography for each entry. Table of watermarks.

[H. *Ger.*] I, pp. 146–269.
Entries: 132 engravings, 91 woodcuts, 6 prints after. Illustrated (selection).*

Altdorfer, Erhard *(1485–c.1562)*
See also **Monogram EA** 1506 [Nagler, *Mon.*] II, no. 1498

[P.] IV, pp. 45–51.
Entries: 81. Pre-metric. Inscriptions. Described.

[M.] I, pp. 553–554.
Entries: 14+ (woodcuts only). Pre-metric (selection). Paper fold measure (selection). Described (selection).

[Ge.] no. 45.
Entries: 1 (woodcuts only). Described. Illustrated. Located.

Jürgens, Walther. *Erhard Altdorfer; seine Werke und seine Bedeutung für die Bibel-illustration des 16. Jahrhunderts.* Lübeck (Germany): Otto Quitzow, 1931. 150 copies. (MH)
Entries: 17 (prints, drawings, and illustrated books). Illustrated.

Winzinger, Franz. *Albrecht Altdorfer, Graphik: Holzschnitte, Kupferstiche, Radierungen.* Munich: R. Piper und Co., 1963. (MBMu)
Entries: 4. Millimeters. Inscriptions. States. Described. Illustrated. Located. Bibliography for each entry. Table of watermarks.

[H. *Ger.*] I, pp. 270–276.
Entries: 143. Illustrated (selection).*

Altheim, Wilhelm *(1871–1914)*
Klipstein, August. *Das graphische Werk Wilhelm Altheims; beschreibendes Verzeichnis seiner Radierungen und Lithographien.* Bern, 1927. (ICB)
Entries: 35. Millimeters. Inscriptions. States. Described. Illustrated.

Alting, C. *(fl. c.1800)*
[M.] I, p. 557.
Entries: 3 prints after. Paper fold measure.

Altini, Ignazio *(fl. c.1800)*
[M.] I, p. 557.
Entries: 6. Paper fold measure.

[Ap.] p. 6.
Entries: 3.*

Altissimo, Christofano *(d. 1605)*
[M.] I, pp. 557–558.
Entries: 2 prints after. Paper fold measure.

Altmann, Anton *(1808–1871)*
[A. 1800] III, pp. 187–192.
Entries: 5. Pre-metric. Inscriptions. Described.

[M.] I, pp. 558–559.
Entries: 5. Paper fold measure.

Altmann, Karl *(1800–1861)*
[M.] I, p. 558.
Entries: 1 print by, 1 after. Paper fold measure.

Altomonte, Andreas *(1699–1780)*
[M.] I, p. 563.
Entries: 1. Paper fold measure. Inscriptions.

Altomonte, Martin *(1657–1745)*
[M.] I pp. 562–563.
Entries: 1 print by, 3 after. Paper fold measure (selection). Inscriptions (selection). Described (selection).

Alton, Eduard d' *(1772–1840)*
[M.] I, pp. 563–564.
Entries: 42+ . Paper fold measure.

[Dus.] p. 9.
Entries: 3 (lithographs only, to 1821). Described.

Altzenbach, Wilhelm *(17th cent.)*
[M.] I, p. 565.
Entries: 13+ . Paper fold measure.

[Merlo] pp. 42–43.
Entries: 12+. Paper fold measure (selection). Inscriptions.

[H. *Ger.*] II, p. 1.
Entries: 13.*

Alù, Niccolo *(fl. 1687–1707)*
[M.] I, p. 565.
Entries: 3+. Paper fold measure.

Amalteo, Pomponio *(1505–1588)*
[M.] I, pp. 587–592.
Entries: 1 print by, 1 after. Millimeters (selection). Paper fold measure (selection). Inscriptions. Described.

Amand, Jacques François *(1730–1769)*
[Baud.] I, pp. 138–141.
Entries: 3. Millimeters. Inscriptions. States. Described.

[M.] I, p. 593.
Entries: 4 prints by, 3 after. Millimeters (selection). Paper fold measure (selection). Inscriptions (selection). States. Described (selection).

Amasöder, Johann Georg
(1750–before 1808)
[M.] I, p. 594.
Entries: 2. Paper fold measure.

Amati, Pietro *(fl. c.1800)*
[M.] I, p. 594.
Entries: 4+. Paper fold measure.

Amato, Francesco *(17th cent.)*
[B.] XXI, pp. 204–207.
Entries: 5. Pre-metric. Inscriptions. States. Described.

[M.] I, pp. 596–597.
Entries: 6. Millimeters (selection). Pre-metric (selection). Inscriptions. Described.

Amaury-Duval, Eugène Emmanuel
(1806–1885)
[M.] 1, pp. 597–598.
Entries: 2 prints after. Paper fold measure.

[Ber.] I, p. 49.*

Amberg, Wilhelm *(1822–1899)*
[M.] I, pp. 599–600.
Entries: 9 prints after. Paper fold measure.

Amberger, Christoph *(c.1505–1561/2)*
[M.] I, pp. 600–603.
Entries: 8. Paper fold measure.

[Ge.] nos. 46–51.
Entries: 6 (woodcuts only). Described. Illustrated. Located.

[H. *Ger.*] II, pp. 2–5.
Entries: 22 prints by, 7 after. Illustrated (selection).*

Ambrogi, Domenico *(c.1600–after 1678)*
[B.] XIX, pp. 198–201.
Entries: 2. Pre-metric. Inscriptions. Described. Appendix with 1 print not seen by [B.].

[M.] I, pp. 603–604.
Entries: 3 prints by, 4 after. Paper fold measure. Inscriptions (selection). Described (selection).

Ambrose, C. *(fl. 1824–1848)*
[M.] I, p. 609.
Entries: 2 prints after. Paper fold measure.

Ambrosi, Francesco *(18th cent.)*
[M.] I, p. 610.
Entries: 76+. Paper fold measure.

Ambrosi, Francesco *(19th cent.)*
[M.] I, p. 611.
Entries: 3. Paper fold measure. States.

Ambrosi, Francesco *(continued)*

[Ap.] p. 6.
 Entries: 2.*

Amédée, Jules *(fl. c.1856)*
[Ber.] I, p. 49.*

Amerling, Friedrich von *(1803–1887)*
[M.] I, pp. 625–626.
 Entries: 20 prints after. Paper
 fold measure.

Ames, —— *(fl. 1777–1786)*
[M.] I, p. 627.
 Entries: 3. Paper fold measure. In-
 scriptions (selection). Described
 (selection).

Ames, Ezra *(1768–1836)*
Cortelyou, Irwin F. Catalogue. In *Ezra
Ames of Albany,* by Theodore Bolton and
Irwin F. Cortelyou. New York: New
York Historical Society, 1955. (MH)
 Entries: 23 prints after (portraits only).
 Inches. Inscriptions. De-
 scribed.

Ames, Joseph Alexander *(1816–1872)*
[M.] I, p. 627.
 Entries: 5 prints after. Paper fold
 measure.

Ametller, Blas *(1768–1841)*
[M.] I, p. 628.
 Entries: 21+. Paper fold measure.

[Ap.] pp. 6–7.
 Entries: 15.*

Amici, Domenico *(b. 1808)*
[M.] I, p. 629.
 Entries: 2+. Paper fold measure.

Amici, Francesco *(18th cent.)*
[M.] I, p. 629.
 Entries: 12.

Amidano, Luigi *(fl. c.1650)*
[Vesme] p. 25.
 Entries: 1. Millimeters. Inscriptions.
 Described. Located.

Amiel, Louis Felix *(1802–1864)*
[M.] I, p. 630.
 Entries: 2 prints after. Paper fold
 measure.

Amiet, Kuno *(1868–1961)*
von Mandach, C. *Cuno Amiet; vollstän-
diges Verzeichnis der Druckgraphik des
Künstlers.* Thun and Bern (Switzerland):
Verlag der Schweizerischen Gra-
phischen Gesellschaft, 1939. 400 copies.
(NN)
 Entries: 129 (to 1939). Millimeters.
 States. Described. Illustrated. Lo-
 cated.

[*AzB.*] I, pp. 35–63.
 Entries: 59 (additional to von Man-
 dach). Millimeters. Inscriptions.
 States. Described. Illustrated.

Amigoni, Carlotta *(18th cent.)*
[M.] I, p. 636.
 Entries: 1. Paper fold measure. In-
 scriptions.

Amigoni, Jacopo *(1675–1752)*
[B.] XXI, pp. 309–311.
 Entries: 3. Pre-metric. Inscriptions.
 Described. Appendix with 5 doubtful
 prints.

[M.] I, pp. 631–636.
 Entries: 180 prints after. Paper fold
 measure. Described (selection).

Amling, Karl Gustav von *(1651–1702)*
[M.] I, pp. 636–639.
 Entries: 114 prints by, 3 after. Paper
 fold measure. Inscriptions (selection).
 Described (selection).

[H. *Ger.*] II, pp. 6–7.
 Entries: 114 prints by, 3 after.*

Amman, Jost *(1539–1591)*
 [B.] IX, pp. 351–383.
 Entries: 50+ . Pre-metric. Inscriptions.
 States. Described.

 [Heller] pp. 6–16.
 Additional information to [B.].

 Becker, Carl. *Jost Amman; Zeichner und Formschneider, Kupferätzer und Stecher.* Leipzig: Rudolph Weigel, 1854. (MBMu) Reprint. Nieuwkoop (Netherlands): De Graaf, 1951. (MH)
 Entries: 140. Pre-metric. Inscriptions.
 States. Described.

 Wiechmann-Kadow. "Holzschnitte altdeutscher Meister." [*N. Arch.*] 1 (1855): 122–130.
 Additional information to Becker.

 [P.] III, pp. 463–465.
 Entries: 6 (additional to Becker).
 Pre-metric. Inscriptions. Described.
 Located (selection). Additional information to Becker.

 [A.] I, pp. 99–448.
 Entries: 254+ etchings, 15+ doubtful and rejected etchings; etchings and engravings after, unnumbered, pp. 196–98; 257+ woodcuts, 4+ doubtful and rejected woodcuts. Pre-metric. Inscriptions. States. Described. Concordance with Becker.

 [M.] I, pp. 639–651.
 Entries: 234+ etchings by, 254+ woodcuts by, 16+ doubtful prints, 19+ prints after. Paper fold measure. Inscriptions (selection). States.

 Pilz, Kurt. *Die Zeichnungen und das graphische Werk des Jost Amman 1539–1591 Zürich-Nürnberg (die Frühzeit 1539–1565).* Extract from *Anzeiger für schweizerische Altertumskunde,* n.s. 35 (1933). Zurich: Buchdruckerei Berichthaus, 1933. (EBKk)
 Entries: unnumbered, pp. 43–82.
 (chronological survey of works in all media done between 1539 and 1565). Inscriptions (selection). States. Described (selection). Located (selection).

 [H. *Ger.*] II, pp. 8–57.
 Entries: 254 etchings by, 257 woodcuts by, 44 prints after. Illustrated (selection).*

Ammanati, Bartolommeo *(1511–1592)*
 [M.] I, pp. 652–660.
 Entries: 3 prints after. Paper fold measure. Inscriptions (selection).

Ammann, Jeremias *(fl. 1660—1671)*
 [M.] I, p. 651.
 Entries: 4+ . Paper fold measure. Inscriptions.

 [H. *Ger.*] II, p. 8.
 Entries: 4.*

Ammann, Johannes *(1695–1751)*
 [M.] I, pp. 651–652.
 Entries: 9. Paper fold measure (selection). Inscriptions (selection).

Ammon, Hans *(c.1585–1632)*
 [M.] I, p. 660.
 Entries: 3. Paper fold measure. Inscriptions (selection). Described (selection).

 [A.] IV, pp. 284–286.
 Entries: 1. Pre-metric. Inscriptions. States. Described.

 [H. *Ger.*] II, p. 58.
 Entries: 3.*

Ammon, Klemens *(fl. c.1650)*
 [M.] I, p. 661.
 Entries: 11+ . Paper fold measure.

 [H. *Ger.*] II, p. 58.
 Entries: 11+ .*

Amon, Anton *(fl. 1780–1800)*
 [M.] I, p. 661.
 Entries: 8. Paper fold measure.

Amorosi, Antonio *(c.1660–after 1736)*
[M.] I, pp. 661–662.
Entries: 5 prints after. Paper fold measure. Inscriptions (selection). Described (selection).

Amort, Kaspar I *(1612–1675)*
[M.] I, pp. 662–663.
Entries: 6+ prints after. Paper fold measure.

[H. *Ger.*] II, p. 59.
Entries: 6 prints after.*

Amort, Kaspar II *(c.1640–1684)*
[H. *Ger.*] II, p. 59.
Entries: 1+ prints after.*

Amsler, Samuel *(1791–1849)*
[M.] I, pp. 663–669.
Entries: 50+ prints by, 4+ after. Paper fold measure. Inscriptions (selection). States.

[Ap.] pp. 7–11.
Entries: 35.*

Anastasi, Auguste Paul Charles
(1820–1889)
[M.] I, pp. 671–672.
Entries: 32. Paper fold measure. Described.

[Ber.] I, pp. 49–50.*

Ancelin, Mme ———— *(19th cent.)*
[Ber.] I, p. 50.*

Ancellet, ———— *(19th cent.)*
[Ber.] I, p. 50.*

Ancinelli, Flaminio degli
See **Torri,** Flaminio

Anckarsvärd, Mikael Gustaf *(1792–1878)*
[M.] I, p. 673.
Entries: 16. Paper fold measure.

Anderle, Jiří *(20th cent.)*
Baukunst-Galerie, Cologne, *Jiří Anderle;*

vollständiges Werkverzeichnis der Graphik mit allen Zuständen. Cologne: Edition Baukunst, 1972– . (DLC)
Entries: 104 (to 1973). Millimeters. Inscriptions. States. Described. Illustrated.

Anderloni, Faustino *(1766–1847)*
[M.] I, pp. 674–676.
Entries: 23+ . Paper fold measure. States. Described (selection).

[Ap.] pp. 11–12.
Entries: 13.*

Anderloni, Pietro *(1785–1849)*
[M.] I, pp. 676–678.
Entries: 35 prints by, 1 after. Paper fold measure. States. Described (selection).

[Ap.] pp. 13–16.
Entries: 35.*

Anderloni, Emilio. *Opere e vita di Pietro Anderloni.* Milan: G. Modiano e C., 1903. (EFBN)
Entries: unnumbered, p. 126 (complete?). Millimeters. Illustrated (selection).

Anders, Friedrich *(fl. c.1797)*
[M.] I, pp. 678–679.
Entries: 2 prints after. Paper fold measure.

Anderson, Alexander *(1775–1870)*
[M.] I, p. 680.
Entries: 8+ .

Duyckinck, Evert Augustus. *A brief catalogue of books illustrated with engravings by Dr. Alexander Anderson, with a biographical sketch of the artist.* New York: Thompson and Moreau, 1885. 100 copies. (NN)
Bibliography of books with illustrations by.

[Allen] pp. 117–122.*

[St.] pp. 11–14.*

[F.] pp. 47–50.*

Anderson, Ann
See **Maverick** family

Anderson, Hugh *(fl. 1811–1824)*
[St.] p. 15.*

[F.] pp. 50–51.*

Anderson, Johannes *(1793–1851)*
[M.] I, pp. 679–680.
Entries: 3.

Anderson, Karl Kristofer *(d. 1863)*
[M.] I, p. 681.
Entries: 16. Paper fold measure.

Anderson, Oskar Leonhard *(1836–1868)*
[M.] I, p. 681.
Entries: 3+. Paper fold measure.

Anderson, Stanley *(b. 1884)*
Hardie, Martin. "The Etchings and Engravings of Stanley Anderson." [*PCQ.*] 20 (1933): 221–246.
Entries: 144 (to 1932). Inches.

Lowe, Ian. "Catalogue of the Prints of Stanley Anderson." Unpublished ms. (MB)
Entries: 197. Inches. Millimeters. Inscriptions. States.

Anderson, W. *(fl. c.1800)*
[M.] I, p. 680.
Entries: 4 prints after. Paper fold measure.

Andiran, Frédéric François d' *(1802–1876)*
[Ber.] V, pp. 86–87.*

Andorff, Friedrich August *(1819–1875)*
[M.] I, pp. 682–683.
Entries: 16+. Paper fold measure. States, Described (selection).

[Ap.] p. 17.
Entries: 6.*

Andouard, F. *(b. 1734)*
[M.] I, p. 683.
Entries: 3. Paper fold measure.

Andrade, Joseph *(18th cent.)*
[M.] I, p. 683.
Entries: 2. Paper fold measure.

Andras, Catherine *(fl. 1799–1824)*
[M.] I, p. 683.
Entries: 3 prints after. Paper fold measure.

Andrásy, Emanuel, Graf *(19th cent.)*
[M.] I, pp. 683–684.
Entries: 2+ prints after. Paper fold measure.

Andre, ——— *(19th cent.)*
[M.] I, p. 689.
Entries: 26 prints after. Paper fold measure.

André, ——— [publisher] *(19th cent.)*
[Ber.] I, pp. 50–52.*

André, Mme ——— *(fl. c.1800)*
[M.] I, p. 689.
Entries: 1. Paper fold measure.

André, Alexandrine *(fl. 1830–1840)*
[M.] I, p. 689.
Entries: 2. Paper fold measure.

[Ber.] I, p. 52.*

Andre, Dietrich Ernst *(c.1680–after 1730)*
[M.] I, p. 685.
Entries: 1. Paper fold measure. Inscriptions. Described.

André, Jean *(1662–1753)*
[M.] I, pp. 684–685.
Entries: 29 prints after. Paper fold measure. Inscriptions (selection).

Andre, Johann *(1775–1842)*
[Dus.] pp. 9–10.

Andre, Johann *(continued)*

Entries: 9 (lithographs only, to 1821). Inscriptions.

André, Jules *(1807–1869)*
[M.] I, p. 689.
Entries: 2. Millimeters. Inscriptions. States.

[Ber.] I, p. 52.*

André, M. François *(d. 1783)*
[M.] I, pp. 685–689.
Entries: 5 prints by, 21 after. Paper fold measure. Inscriptions (selection). States. Described (selection).

Andrea, Nicolaus *(fl. 1573–1606)*
[B.] IX, pp. 512–515.
Entries: 4. Pre-metric. Inscriptions. Described.

[P.] IV, pp. 190–191.
Entries: 4 (additional to [B.]). Paper fold measure. Pre-metric. Inscriptions. Described. Located (selection).

[M.] I, p. 712.
Entries: 10. Pre-metric (selection). Paper fold measure (selection). Inscriptions (selection). Described (selection).

[A.] IV, pp. 1–10.
Entries: 10+ engravings, 1 woodcut. Pre-metric. Inscriptions. Described.

[H. *Ger.*] II, pp. 59–61.
Entries: 13. Illustrated (selection).*

Andrea, Zoan
See **Zoan Andrea**

Andreae, August Heinrich *(1804–1846)*
[M.] I, pp. 712–713.
Entries: 6. Paper fold measure. Described (selection).

Andreae, Hieronymus *(d. 1556)*
[H. *Ger.*] II, p. 61.
Entries: 2.*

Andreae, Karl [Christian] *(1823–1904)*
[M.] I, pp. 713–714.
Entries: 4+ prints by, 12+ after. Paper fold measure. States.

Andreani, Andrea *(fl. 1584–1610)*
[B.] XII: *See* **Chiaroscuro Woodcuts**

[P.] VI: *See* **Chiaroscuro Woodcuts**

[M.] I, pp. 715–727.
Entries: 38 prints by, 29 published by. Paper fold measure. Inscriptions. States. Described.

[Wess.] III, p. 43.
Entries: 1 (additional to [B.]). States.

Andreasi, Ippolito *(c.1548–1608)*
[M.] II, p. 4.
Entries: 9 prints after. Paper fold measure. Inscriptions (selection). Described (selection).

Andrejeff, Alexei *(18th cent.)*
[M.] II, p. 6.
Entries: 1. Millimeters. Inscriptions.

Andrejeff, Wassili *(17th cent.)*
[M.] II, pp. 5–6.
Entries: 26. Millimeters (selection). Inscriptions. Described (selection).

Andreoni, Francesco *(fl. c.1700)*
[M.] II, p. 11.
Entries: 2 prints after. Paper fold measure. Inscriptions.

Andresohn, Erasmus *(1651–1731)*
[M.] I, p. 679.
Entries: 13. Paper fold measure.

Andrew, Best, and Leloir *(19th cent.)*
[Ber.] I, pp. 51–54.*

Andrews, ——— (18th cent.)
[M.] II, p. 13.
Entries: 9 prints after. Paper fold measure.

Andrews, Henry *(fl. 1797–1828)*
[M.] II, p. 13.
Entries: 4+ prints after. Paper fold measure.

Andrews, James *(fl. 1830–1861)*
[M.] II, p. 14.
Entries: 2+ prints after. Paper fold measure.

Andrews, Joseph *(1806–1873)*
[Ap.] pp. 17–18.
Entries: 16.

Fielding, Mantle. "Joseph Andrews."
[*Pa. Mag.*] 31 (1907): 103–113; 207–231.
Entries: 148. Inches. Inscriptions. States. Described (selection).

Andrian, Werburg *(19th cent.)*
[Dus.] p. 10.
Entries: 1 (lithographs only; before 1821). Millimeters. Inscriptions. Located.

Andriani, ——— (fl. c.1763)
[M.] II, p. 15.
Entries: 1. Paper fold measure. Inscriptions. Described.

Andriessen, Adriaen *(fl. c.1614)*
[W.] I, p. 14.
Entries: 2 prints after.*

Andriessen, Jurriaan *(1742–1819)*
[M.] II, p. 15.
Entries: 2 prints after. Paper fold measure (selection).

[W.] I, p. 14.
Entries: 2 prints after.*

Andrieu, ——— (fl. c.1850)
[Ber.] I, p. 54.*

Andrieu, Bertrand *(1761–1822)*
[M.] II, pp. 16–18.
Entries: 34.

Andriot, François *(b. c.1660)*
[M.] II, pp. 18–19.
Entries: 23. Paper fold measure. Inscriptions (selection). States. Described (selection).

Androuet Ducerceau, Jacques
See **Ducerceau**

Anelay, ——— (18th cent.)
[M.] II, p. 30.
Entries: 4 prints after. Paper fold measure.

Anesi, Paolo *(fl. 1725–1766)*
[M.] II, pp. 30–31.
Entries: 17. Paper fold measure. Inscriptions. States. Described (selection).

Ange, François de l' *(1675–1756)*
[M.] II, pp. 31–32.
Entries: 2+ prints after. Paper fold measure.

Angel, Fray *(fl. c.1737)*
[M.] II, p. 33.
Entries: 1.

Angel, Philips *(fl. 1639–1683)*
[M.] II, pp. 32–33.
Entries: 2. Millimeters (selection). Inscriptions. Described.

[Rov.] p. 65.
Entries: 1. Millimeters. Inscriptions. Described. Illustrated. Located.

[W.] I, p. 15.
Entries: 2.*

[H. *Neth.*] I, p. 35.
Entries: 2. Illustrated (selection).*

Angeletti, Alessandro *(fl. c.1795)*
 [M.] II, p. 34.
 Entries: 4. Paper fold measure.

Angeletti, Pietro *(fl. 1758–1786)*
 [M.] II, p. 34.
 Entries: 3 prints after. Paper fold
 measure. Inscriptions.

Angeli, Alessandro *(fl. 1821–1824)*
 [M.] II, p. 45.
 Entries: 7. Paper fold measure. States.

 [Th.B.] I, p. 494.
 Entries: 8+. Paper fold measure.

Angeli, Filippo d' [called "Filippo Napoli-
tano"] *(fl. 1619–1640)*
 [M.] II, pp. 43–44.
 Entries: 4 prints after. Paper fold
 measure. Inscriptions (selection).

Angeli, G. *(fl. c.1800)*
 [M.] II p. 45.
 Entries: 4. Paper fold measure.

Angeli, Giuseppe *(b. 1709)*
 [M.] II, pp. 44–45.
 Entries: 13 prints after. Paper fold
 measure. Described (selection).

Angelini, Costanzo *(1760–1853)*
 [M.] II, p. 46
 Entries: 3+ prints after. Paper fold
 measure.

Angelini, Luigi *(1884–1969)*
 Servolini, Luigi. *Grafica d'arte di Luigi
 Angelini.* Incisori d'Italia. Milan and
 Bergamo (Italy): Bolis, 1966.
 Not seen.

Angelis, Johannes de *(fl. c.1700)*
 [M.] II, p. 48.
 Entries: 3 prints after. Inscriptions.
 Described (selection).

Angell, Samuel *(fl. 1830–1850)*
 [M.] II, p. 49.
 Entries: 9. Paper fold measure.

Angelo, Pedro *(fl. 1597–1616)*
 [M.] II, p. 50.
 Entries: 7. Paper fold measure (selec-
 tion).

Angelo, Valenti *(b. 1897)*
 Haas, Irvin. "A bibliography of the work
 of Valenti Angelo." *Prints* 7 (1936–1937):
 277–285.
 Bibliography of books with illustra-
 tions by, to 1938.

Angier, Paul *(fl. c.1749)*
 [M.] II, p. 58.
 Entries: 4. Paper fold measure. In-
 scriptions (selection).

Angillis, Pieter *(1685–1734)*
 [M.] II, p. 59.
 Entries: 5 prints after. Paper fold
 measure.

Angles, Matthäus des *(1667–1741)*
 [M.] II, p. 60.
 Entries: 4 prints after. Paper fold
 measure.

 [W.] I, p. 15.
 Entries: 2 prints after.*

Angolo del Moro, Battista *(16th cent.)*
 [B.] XVI, pp. 175–200.
 Entries: 36. Pre-metric. Inscriptions.
 States. Described. Appendix with 1
 doubtful print.

 [P.] VI, pp. 180–181.
 Entries: 7 (additional to [B.]). Pre-
 metric. Inscriptions. Described. Addi-
 tional information to [B.].

 [M.] II, pp. 34–39.
 Entries: 74 prints by, 2 rejected prints,
 3 after. Pre-metric (selection). Paper

fold measure (selection). Inscriptions. States. Described (selection).

[Wess.] III, pp. 43–44.
Entries: 2 (additional to [B.]). Millimeters. Described. Located. Additional information to [B.].

Angolo del Moro, Marco *(fl. 1570–1585)*
[B.] XVI, pp. 201–208.
Entries: 8. Pre-metric. Inscriptions. Described.

[P.] VI, p. 182.
Entries: 1 (additional to [B.]). Inscriptions. Described. Additional information to [B.].

[M.] II, pp. 40–43.
Entries: 27. Paper fold measure. Inscriptions. States. Described (selection).

[Wess.] III, p. 43.
Additional information to [B.].

Anguier, François *(1604–1669)*
[M.] II, pp. 60–62.
Entries: 12 prints after.

Anguier, Michel *(1612–1686)*
[M.] II, pp. 62–63.
Entries: 26 prints after. Paper fold measure (selection).

Anguisciola, Sofonisba *(1527–after 1623)*
[M.] II, pp. 64–67.
Entries: 14 prints after. Paper fold measure. Described (selection).

Angus, William *(1752–1821)*
[M.] II, pp. 68–69.
Entries: 22+. Paper fold measure. Inscriptions (selection). States.

Anichini, Pietro *(17th cent.)*
[M.] II, p. 71.
Entries: 6. Paper fold measure. Inscriptions (selection). Described (selection).

Anker, Albert *(1831–1910)*
[M.] II, pp. 72–74.
Entries: 4 prints by, 9 after. Paper fold measure (selection). Inscriptions (selection). Described (selection).

Anna, Alessandro d' *(18th cent.)*
[M.] II, p. 76.
Entries: 9 prints after. Paper fold measure.

Annedouche, Alfred Joseph *(b. 1833)*
[M.] II, p. 76.
Entries: 15. Paper fold measure. Described (selection).

[Ap.] p. 18.
Entries: 5.*

[Ber.] I, p. 55.
Entries: 21.

Année, Charles Antoine Marie *(1812–1842)*
[M.] II, p. 76.
Entries: 6 prints after. Paper fold measure.

Anner, Emil *(1870–1925)*
Wartmann, W. *Emil Anner; Verzeichnis sämtlicher Radierungen, freie Arbeiten, und Gelegenheitsgraphik.* Zurich: Kunsthaus Zürich, 1926. (ICB)
Entries: 300. Millimeters. Inscriptions. Described. Ms. catalogue, in Zurich, Kunsthaus, is more thorough than the printed version. (Not seen; [*AzB.*] I, p. 67).

Annert, Friedrich Albrecht *(1759–1800)*
[M.] II, p. 78.
Entries: 13+. Paper fold measure.

Annigoni, Pietro *(b. 1910)*
[*AzB.*] 1, pp. 68–74.
Bibliography of books with illustrations by.

Annin, William B. *(fl. 1813–1831)*
[St.] pp. 15–18.*

[F.] p. 52.*

Annin and **Smith** *(19th cent.)*
[Allen] p. 122.*

[St.] pp. 18–21.*

[F.] pp. 52–54.*

Annis, W. T. *(fl. c.1810)*
[M.] II, p. 79.
 Entries: 9. Paper fold measure.

[Sm.] I, pp. 2–4, and "additions and corrections."
 Entries: 6 (portraits only). Inches. Inscriptions. States. Described. Illustrated (selection).

[Ru.] p. 1.
 Entries: 2 (portraits only, additional to [Sm.]). Inches (selection). Inscriptions (selection). Described (selection).

Anone, ——— *(dates uncertain)*
[M.] II, p. 79.
 Entries: 1. Paper fold measure.

Anschütz, Hermann *(1802–1880)*
[M.] II, p. 82.
 Entries: 1 print by, 1 after. Paper fold measure.

Ansdell, Richard *(1815–1885)*
[M.] II, pp. 82–85.
 Entries: 16 prints by, 90 after. Paper fold measure.

Anse, Luggert van *(fl. 1709–1716)*
[M.] II, p. 85.
 Entries: 4. Paper fold measure. Inscriptions (selection).

Anselin, Jean Louis *(1754–1823)*
[M.] II, pp. 85–86.

Entries: 18. Paper fold measure. Inscriptions (selection). States. Described (selection).

[Ap.] pp. 18–19.
 Entries: 15.*

[Ber.] I, pp. 55–56.*

[L. D.] pp. 2–3.
 Entries: 3. Millimeters. Inscriptions. States. Described. Incomplete catalogue.*

Ansell, Charles *(18th cent.)*
[M.] II, p. 86.
 Entries: 17 prints after. Paper fold measure (selection).

[Siltzer] p. 76.
 Entries: unnumbered, p. 76 (prints after). Inscriptions.

Anselmi, Michelangelo [Called "Michelangelo da Siena"] *(1491–1554)*
[M.] II, pp. 86–88.
 Entries: 7 prints after (19th cent.). Paper fold measure. Inscriptions (selection).

Anshelm, Thomas *(c.1465–1524)*
[Ge.] nos. 52–56.
 Entries: 5 (single-sheet woodcuts only). Described. Illustrated. Located.

[H. *Ger.*] II, pp. 62–64.
 Entries: 5. Illustrated.*

Ansiaux, J. J. E. Antoine *(1764–1840)*
[M.] II, pp. 90–91.
 Entries: 5+ prints after. Paper fold measure (selection).

Anspach, J. *(fl. c.1811)*
[M.] II, p. 91.
 Entries: 4 prints by, 2 after. Paper fold measure.

[W.] I, p. 16.
 Entries: 2 prints after.*

Anstatt, W. *(19th cent.)*
[Dus.] p. 10.
 Entries: 1 (lithographs only, to 1821).

Antes, Horst *(b. 1936)*
Kern, Hermann et al. *Antes; Verzeichnis der Bücher von Horst Antes.* Worpswede (West Germany): Worpsweder Kunsthalle, 1968. (NNMo)
 Bibliography of books with illustrations by.

Gercken, Günther. *Werkverzeichnis der Radierungen Horst Antes; 1962–1966.* Munich: Galerie Stangl, 1968. 1000 copies. (DLC)
 Entries: 162 (to 1966). Millimeters. States. Illustrated.

[*AzB.*] I, pp. 75–79.
 Additional information to Kern and Gercken.

Antichi, Prospero [called "Prospero Bresciano] *(d. 1592?)*
[M.] II, pp. 101–102.
 Entries: 5+ prints after. Paper fold measure (selection). Inscriptions. Described (selection).

Antigna, Jean Pierre Alexandre *(1817–1878)*
[M.] II, pp. 103–105.
 Entries: 22 prints after. Paper fold measure. Described.

Antipjeff, Peter *(c.1744–1785)*
[M.] II, p. 111.
 Entries: 9. Paper fold measure.

Antiquus, Johannes *(1702–1750)*
[W.] I, p. 16.
 Entries: 1 print after.*

Antoine, Sébastien *(1687–1760?)*
Beaupré, J.-N. "Notice sur quelques graveurs nancéiens du XVIII^e siècle et sur leurs ouvrages." [*Mém. lorraine*] 2d ser., 9 (1867): 217–220. Separately published, n.p., n.d.

 Entries: 17. Millimeters. Inscriptions. Described (selection).

[M.] II, p. 113.
 Entries: 11. Paper fold measure. Inscriptions.

Antolini, Gianantonio *(1754–1842)*
[M.] II, p. 116.
 Entries: 5+ prints after. Paper fold measure.

Antonelli, Vincenzo *(fl. c.1770)*
[M.] II, p. 118.
 Entries: 4. Paper fold measure. Inscriptions (selection). •

Antonini, Carlo *(fl. c.1800)*
[M.] II, pp. 129–130.
 Entries: 14+ prints by, 1+ after. Paper fold measure. Inscriptions (selection).

Antonio da Trento *(fl. 1527–1531)*
[B.] XII: *See* **Chiaroscuro Woodcuts**

[P.] VI: *See* **Chiaroscuro Woodcuts**

[Evans] pp. 9–10.
 Entries: 2 (additional to [B.]). Millimeters. Inscriptions. Described.

[M.] II, pp. 149–155.
 Entries: 36. Paper fold measure. Inscriptions. States. Described. Copies noted.

Suster, Guido. *Di Antonio da Trento e dei suoi chiaroscuri.* Extract from *Archivio Trentino, XVII,* fasc. 1. Trento (Italy): Giovanni Zippel, 1902. (MH)
 Entries: 36. Millimeters. Described. Illustrated (selection).

Zava Boccazzi, Franco. *Antonio da Trento incisore (prima metà XVI sec.).* Trento (Italy): Collana Artisti Trentini, 1962. (ICB)
 Entries: 8 woodcuts by, 19 woodcuts attributed to, 82 etchings by, 13 etchings attributed to. Illustrated (selec-

Antonio da Trento *(continued)*

tion). Located (selection). Antonio da Trento is here identified with Antonio Fantuzzi.

Antonissen, Henricus Josephus *(1737–1794)*
[M.] II, pp. 159–160.
Entries: 2. Paper fold measure (selection). Inscriptions.

[H. L.] pp. 8–9.
Entries: 2. Millimeters. Inscriptions. States. Described.

[W.] I, p. 25.
Entries: 2.*

Antoniszoon, Cornelis *(fl. 1533–1559)*
[B.] IX, pp. 152–154.
Entries: 5. Pre-metric. Inscriptions. States. Described.

[P.] III, pp. 30–34.
Entries: 10 woodcuts (additional to [B.]), 3 etchings. Pre-metric. Inscriptions. Described. Located.

[M.] II, pp. 97–100.
Entries: 47. Pre-metric (selection). Paper fold measure (selection). Inscriptions. States. Described (selection).

[W.] I, pp. 23–24.
Entries: 32+ .*

Wescher, Paul. "Beiträge zu Cornelius Teunissen von Amsterdam; Zeichnungen und Holzschnitte." [*Oud-Holl.*] 45 (1928): 33–39.
Entries: 3 (woodcuts previously unattributed to Antoniszoon). Millimeters (selection). Inscriptions (selection). Described. Illustrated (selection). Located.

Dubiez, F. J. *Cornelius Anthoniszoon van Amsterdam; zijn leven en werken.* Amsterdam: H. D. Pfann, 1969. (EUW)

Entries: 39+ maps and woodcuts, 3+ engravings and etchings. Millimeters. Inscriptions. Described. Illustrated (selection). Located.

Antony, —— *(16th cent.)*
[M.] II, p. 161.
Entries: 1. Paper fold measure. Inscriptions. States. Described.

Antropoff, Alexei Petrowitsch *(1716–1795)*
[M.] II, pp. 161–162.
Entries: 2 prints after. Millimeters (selection). Inscriptions.

Apel, J. *(18th cent.)*
[M.] II, p. 163.
Entries: 8. Paper fold measure.

Apel, Johann Heinrich *(fl. 1763–1801)*
[M.] II, pp. 163–164.
Entries: 10. Paper fold measure. Described (selection).

Apens, Cornelius
See **Apeus**

Apeus, Cornelius *(fl. 1665–1678)*
[M.] II, pp. 174–175.
Entries: 6. Paper fold measure. Inscriptions. Described.

[W.] I, p. 25.
Entries: 6+ .*

[H. *Neth.*] I, pp. 36–38.
Entries: 6+ . Illustrated (selection).*

Apostool, Cornelius *(1762–1844)*
[M.] II, pp. 182–183.
Entries: 24+ . Paper fold measure.

[W.] I, p. 25.
Entries: 4+ .*

[Siltzer] p. 345.
Entries: unnumbered, p. 345. Inscriptions.

Appel, Karel *(b. 1921)*
Claus, Hugo. *Karel Appel, painter.* Amsterdam: A. J. G. Strengholt, 1962. (EUD)
 Bibliography of books with illustrations by.

Appelius, Johann *(fl. 1774–1790)*
[M.] II, p. 183.
 Entries: 2 prints after. Paper fold measure.

Appelman, Gonsales *(fl. 1671–1689)*
[M.] II, p. 186.
 Entries: 5. Paper fold measure. Inscriptions (selection).

Appelmans, C. G. *(fl. 1617–1633)*
[M.] II, p. 186.
 Entries: 2. Paper fold measure.

Appelmans, G. *(fl. c.1670)*
[M.] II, pp. 186–187.
 Entries: 4+. Paper fold measure.

Appert, A. *(fl. c.1840)*
[M.] II, p. 187.
 Entries: 10. Paper fold measure (selection).

[Ber.] I, p. 56.*

Appian, Adolphe *(1818–1898)*
[M.] II, pp. 187–188.
 Entries: 18 prints by, 3 after. Paper fold measure. Inscriptions. States.

[Ber.] I, pp. 56–57.*

Jennings, Herbert H. "Adolphe Appian." [*PCQ.*] 12 (1925): 94–117.
 Entries: 59. Millimeters. Illustrated (selection).

Curtis, Atherton, and Prouté, Paul. *Adolphe Appian, son oeuvre gravé et lithographié.* Paris: Paul Prouté S. A., 1968. (MBMu)

Entries: 76. Millimeters. Inscriptions. States. Described. Illustrated. Located (selection).

Appiani, Andrea *(1754–1817)*
[M.] II, pp. 190–193.
 Entries: 4 prints by, 28+ after. Paper fold measure.

Appiani, Joseph [Giuseppe] *(d. 1786)*
[M.] II, pp. 189–190.
 Entries: 2+ prints by, 3+ after. Paper fold measure. Inscriptions (selection). Described (selection).

Appiani, Niccolò [Nicola] *(fl. c.1510)*
[M.] II, p. 188.
 Entries: 2 prints after. Paper fold measure.

Appier, Jean *(fl. c.1600)*
Favier, J. *Jean Appier et J. Appier dit Hanzelet, graveurs lorrains du XVII*e *siècle.* Extract from *Mémoires de la Société d'archéologie lorraine et du Musée historique lorraine.* Nancy (France): Sidot Frères, 1890. (ICB)
 Entries: unnumbered, pp. 12–17. Millimeters. Inscriptions. Described (selection). Illustrated (selection).

Appier, Jean [called "Hanzelet"] *(1596–after 1630)*
 [M.] II, pp. 193–195.
 Entries: 6. Millimeters (selection). Paper fold measure (selection). Inscriptions. Described.

Favier, J. *Jean Appier et J. Appier dit Hanzelet, graveurs lorrains du XVII*e *siècle.* Extract from *Mémoires de la Société d'archéologie lorraine et du Museé historique lorraine.* Nancy (France): Sidot Frères, 1890. (ICB)
 Entries: unnumbered, pp. 18–47. Millimeters (selection). Paper fold measure (selection). Inscriptions (selection). Described (selection). Illustrated (selection).

Appold, Johann Leonhard *(1809–1858)*
[M.] II, p. 195.
 Entries: 15. Paper fold measure.
 States.

 [Ap.] pp. 19–20.
 Entries: 14.*

Appoloni, Q. M. *(fl. c.1850)*
[M.] II, pp. 177–178.
 Entries: 4+. Paper fold measure. In-
 scriptions (selection).

 [Ap.] p. 20.
 Entries: 3.*

Aquila, Francesco Faraone *(fl. 1690–1740)*
[M.] II, pp. 204–206.
 Entries: 2+ prints after his own de-
 signs, 84+ after the designs of others.
 Paper fold measure. Inscriptions
 (selection). States.

Aquila, Pietro *(d. 1692)*
[M.] II, pp. 201–204.
 Entries: 11+ prints after his own de-
 signs, 42+ after the designs of others.
 Paper fold measure. Inscriptions
 (selection). States. Described (selec-
 tion).

Aquila, Pompeo dall'
See **Cesura**

Aquilano
See **Cicchino,** Tobia, and **Santis,** Orazio
de

Arago, Jacques Etienne Victor *(1790–1855)*
[Ber.] I, pp. 57–58.*

Arbes, Joseph Friedrich August d'
See **Darbes**

Arbien, Hans [Johann] *(1713–1766)*
[M.] II, p. 214.
 Entries: 2 prints after. Paper fold
 measure.

Archer, John Wykeham *(1806–1864)*
[M.] II, p. 218.
 Entries: 4+. Paper fold measure.

Arconio, Mario *(1569–1635)*
[M.] II, p. 222.
 Entries: 5. Paper fold measure. In-
 scriptions (selection).

Ardemans, Teodoro *(1664–1726)*
[M.] II, pp. 228–229.
 Entries: 2 prints after. Paper fold mea-
 sure. Described.

Ardizone, Simone di
See **Simone di Ardizone**

Ardy, Bartolommeo *(1821–1889)*
[M.] II, p. 232.
 Entries: 1. Paper fold measure.

Arenberg, Augustus Maria Raimund,
Fürst von *(1753–1833)*
[M.] II, p. 234.
 Entries: 2. Paper fold measure.

Arenberg, Pauline von
See **Schwarzenberg**

Arendonck, Jean Jacques Antoine van
(1822–1881)
[M.] II, pp. 234–235.
 Entries: 3 prints after. Paper fold
 measure.

Arends, Jan *(1738–1805)*
[M.] II, p. 235.
 Entries: 1. Paper fold measure. In-
 scriptions.

 [W.] I, p. 28.
 Entries: 1.*

Arenhold, Gerhard Justus *(d. 1775)*
[M.] II, p. 235.
 Entries: 4 prints after. Paper fold mea-
 sure (selection). Inscriptions (selec-
 tion).

Arenius, Olof *(1701–1766)*
[M.] II, pp. 235–236.
 Entries: 8 prints after. Paper fold measure. Inscriptions.

Arentz, Richard *(fl. 1540–1560)*
[M.] II, p. 237.
 Entries: 1. Inscriptions.

Aretin, Adam, Freiherr von *(1769–1822)*
[M.] II, p. 237.
 Entries: 3+. Paper fold measure.

Aretin, Frederike, Baronin von *(fl. c.1820)*
[M.] II, p. 238.
 Entries: 2. Paper fold measure. Inscriptions.

Aretin, Georg, Freiherr von *(1771–1843)*
[M.] II, p. 237.
 Entries: 4. Paper fold measure. Inscriptions.

Aretin, Rosa, Baronin von *(b. 1794)*
[M.] II, p. 238.
 Entries: 5. Paper fold measure. Inscriptions.

Aretusi, Cesare *(d. 1612)*
[M.] II, pp. 239–241.
 Entries: 1. Paper fold measure. Inscriptions. Described.

Arfwedson, Carl *(d. 1861)*
[M.] II, p. 245.
 Entries: 3. Paper fold measure.

Argelati, Antonio Bartolommeo *(fl. c.1700)*
[M.] II, p. 245.
 Entries: 1. Paper fold measure. Inscriptions. Described.

Argent, A. L. d' *(fl. 1789–1812)*
[M.] II, p. 245.
 Entries: 9. Paper fold measure.

Argnani, F. *(fl. c.1841)*
[M.] II, p. 246.
 Entries: 2. Paper fold measure.

Argumosa, ——— *(fl. c.1800)*
[M.] II, p. 247.
 Entries: 1 Paper fold measure. Inscriptions.

Arhardt, Johann Jakob *(fl. 1636–1661)*
[M.] II, pp. 247–248.
 Entries: 4 prints after. Paper fold measure. Inscriptions (selection).

Arlaud, Jacques Antoine *(1668–1743)*
[M.] II, pp. 258–259.
 Entries: 6 prints after. Paper fold measure.

Arldt, C. W. *(19th cent.)*
[M.] II, p. 259.
 Entries: 16+. Paper fold measure.

Armand-Dumaresq, Édouard *(1826–1895)*
[Ber.] I, pp. 58–59.*

Armfield, George *(1840–1862)*
[M.] II, p. 263.
 Entries: 6 prints after. Paper fold measure.

Armi, Andreas von Dall'
See **Dall'Armi**

Armi, Franz Xavier von Dall'
See **Dall'Armi**

Armitage, Edward *(1817–1896)*
[M.] II, pp. 263–264.
 Entries: 10 prints after. Paper fold measure.

Arms, John Taylor *(1887–1953)*
Eaton, Cynthia. "The aquatints of John Taylor Arms." [P. *Conn.*] 1 (1921): 104–121.
 Entries: 19 (aquatints only, to 1920?). Inches. Described. Illustrated (selection).

Eaton, Cynthia. *John Taylor Arms, aquatinter.* Boston (Mass.): Charles E. Goodspeed and Co., 1923.

Arms, John Taylor *(continued)*

Entries: 42. Inches. Illustrated (selection).

Whitmore, Elizabeth M. "John Taylor Arms; notes on the development of an American etcher." [*P. Conn.*] 5 (1925): 266–304. Separately published. New York: Privately printed, 1925.
Entries: 126 (etchings only, to 1925). Inches. Illustrated (selection). Ms. addition (NN); 35 additional entries (to 1949).

Crafton Collection. *John Taylor Arms.* American Etchers, 5. New York: Crafton Collection, 1930.
Entries: 146 (to 1929). Inches. Illustrated (selection).

Arms, Dorothy Noyes; Probstfield, Marie; and Hayes, May Bradshaw. "Descriptive catalogue of the work of John Taylor Arms." Unpublished ms., 1962. (NN)
Entries: 440. Inches. Described (selection). States are referred to, but not listed or described.

Armstrong, Cosmo *(fl. 1800–1836)*
[M.] II, pp. 264–265.
Entries: 13+. Paper fold measure.

Armytage, James Charles *(c.1820–1897)*
[M.] II, pp. 265–266.
Entries: 36. Paper fold measure.

[Ap.] pp. 20–21.
Entries: 10.*

Arnald, George *(1763–1841)*
[M.] II, pp. 266–267.
Entries: 13. Paper fold measure. Inscriptions (selection).

Arnaudies, Francisco *(fl. c.1774)*
[M.] II, p. 268.

Entries: 2+ prints after. Paper fold measure. Inscriptions (selection). Described (selection).

Arndt, Franz Gustav *(1842–1905)*
[M.] II, p. 270.
Entries: 1. Paper fold measure.

Arndt, J. *(dates uncertain)*
[M.] II, p. 270.
Entries: 1. Paper fold measure.

Arndt, Wilhelm *(d. 1813)*
[M.] II, pp. 269–270.
Entries: 61+ prints by, 2+ after. Paper fold measure.

Arnel, Thomas *(20th cent.)*
Pedersen, Thomas. "Thomas Arnel," [*N. ExT.*] 8 (1956): 51–53.
Entries: pp. 52–53 (bookplates only, to 1956?). Described. Illustrated (selection).

Arnemius, Arnoldus *(fl. c.1556)*
[M.] II, pp. 270–271.
Entries: 1. Paper fold measure. Inscriptions. Described.

Arnesen, David *(1818–1895)*
[M.] II, p. 271.
Entries: 2 prints after. Paper fold measure.

Arnim, Bettina von *(1785–1859)*
[M.] II, p. 271.
Entries: 2. Paper fold measure.

Arnim, Ferdinand Heinrich Ludwig von *(1814–1866)*
[M.] II, pp. 271–272.
Entries: 3+ prints after. Paper fold measure.

Arnold, Carl Heinrich *(1793–1874)*
[M.] II, p. 277.
Entries: 3. Paper fold measure.

Arnold, Carl Heinrich *(b. 1829)*
[M.] II, pp. 277–279.
 Entries: 44 prints by and after. Paper
 fold measure. States.

Arnold, Jörg *(fl. 1586–1589)*
Hämmerle, Albert. "Jörg Arnold."
[*Schw. M.*] 1931, pp. 190–193.
 Entries: 12. Millimeters. Inscriptions.
 Described. Illustrated (selection). Lo-
 cated. Copies noted.

Arnold, Johann *(1735–after 1772)*
[M.] II, p. 275.
 Entries: 31. Paper fold measure.

Arnold, Johann Friedrich *(c.1780–1809)*
[M.] II, p. 277.
 Entries: 10. Paper fold measure. In-
 scriptions. States.

Arnold, Jonas *(fl. 1640–1669)*
[M.] II, pp. 273–274.
 Entries: 8+ prints by, 7+ after. Paper
 fold measure. Inscriptions (selection).
 Described (selection).

Arnoldt, Jeres *(fl. c.1600)*
[M.] II, p. 280.
 Entries: 4+. Paper fold measure. In-
 scriptions (selection).

Arnoullet, Jean *(fl. c.1566)*
[M.] II, p. 286.
 Entries: 1. Millimeters. Inscriptions.
 Described.

Arnoult, Nicolas *(fl. 1680–1700)*
[M.] II, pp. 287–295.
 Entries: 257. Inscriptions. States. De-
 scribed.

Arnout, Jean Baptiste *(1788–after 1865)*
[M.] II, p. 295.
 Entries: 12+. Paper fold measure.

[Ber.] I, pp. 59–61.*

Arnout, Louis Jules *(b. 1814)*
[M.] II, pp. 295–296.
 Entries: 13+ prints by, 1+ after. Paper
 fold measure.

[Ber.] I, p. 61.*

Arnoux, Charles Albert d' *(1820–1882)*
[Ber.] II, pp. 45–49.*

Arnswald, Bernhard von *(b. 1807)*
[M.] II, p. 296.
 Entries: 5. Paper fold measure. In-
 scriptions.

Arnulphi [**Arnulphy**], Claude *(1697–1786)*
[M.] II, p. 297.
 Entries: 8 prints after. Paper fold
 measure (selection).

Raimbault, Maurice. "Arnulphy." In
[*Dim.*] I, pp. 301–310.
 Entries: 5 prints after lost works.

Arnutius, ——— *(fl. c.1756)*
[M.] II, p. 297.
 Entries: 1. Paper fold measure.

Arnz, Albert *(b. 1832)*
[M.] II, p. 297.
 Entries: 1. Paper fold measure.

Arp, Hans *(b. 1888)*
Hagenlocher, Marguerite. Catalogue. In
Hans Arp, by Carola Giedion-Welcker.
Stuttgart: Gerd Hatje, 1957.
 Bibliography of books by and books
 with illustrations by.

[*AzB.*] I, pp. 85–280 (to 1972; still in prog-
ress?)
 Entries: 361 (woodcuts and litho-
 graphs). Millimeters. Inscriptions.
 States. Described. Illustrated.

Årre, Olof Jacobsson *(1729–1809)*
[M.] II, pp. 300–301.
 Entries: 11+. Paper fold measure. In-
 scriptions (selection).

Arrigoni, Anton *(1788–1851)*
[Dus.] pp. 10–11.
Entries: 4. Millimeters. Inscriptions.
Located.

Arrivet, J. *(fl. c.1750)*
[M.] II, p. 304.
Entries: 6+ . Paper fold measure.

Artan de Saint Martin, Louis *(1837–1890)*
[H. L.] p. 10.
Entries: 1. Millimeters. Inscriptions.
States. Described.

[M.] II, pp. 305–306.
Entries: 1. Millimeters. Inscriptions.
States. Described.

Artaria, Claudio *(1810–1862)*
[M.] II, pp. 306–307.
Entries: 5. Paper fold measure. States.

[Ap.] p. 21.
Entries: 5.*

Artaria, Karl *(c.1792–1866)*
[M.] II, p. 306.
Entries: 4. Paper fold measure. In-
scriptions.

Artaria, Matthias *(1814–1885)*
[M.] II, pp. 307–308.
Entries: 4 prints after. Paper fold
measure.

Artaria, Rudolf *(1812–1836)*
[M.] II, p. 307.
Entries: 1. Paper fold measure. In-
scriptions.

Artaud, William *(fl. 1780–1822)*
[M.] II, p. 308.
Entries: 13 prints after. Paper fold
measure.

Arteaga, Francisco de *(fl. 1671–1711)*
[M.] II, p. 309.
Entries: 3+ . Paper fold measure.

Arteaga y Alfaro, Matias *(1630–1703)*
[M.] II, pp. 308–309.
Entries: 6+ .

Arter, Paul Julius *(1797–1839)*
[M.] II, p. 310.
Entries: 1 print by, 1 after. Paper fold
measure.

Arthois, Jacques d' *(1613–1686)*
[M.] II, pp. 311–314.
Entries: 22 prints after. Paper fold
measure.

[H. *Neth.*] I, p. 39.
Entries: 22 prints after.*

Artlett, Richard Austin *(1807–1873)*
[M.] II, pp. 314–315.
Entries: 57. Paper fold measure.

Arts, Hendrik *(fl. c.1600)*
[H. *Neth.*] I, p. 39.
Entries: 2 prints after.*

Artvelt, Andries van *(1590–1652)*
[M.] II, pp. 316–317.
Entries: 1 print by, 1 after. Paper fold
measure (selection). Inscriptions
(selection).

Arvidson, Anders Arvid *(d. 1832)*
[M.] II, p. 318.
Entries: 2. Paper fold measure.

Arvidsson, Truls *(c.1660–1711)*
[M.] II, p. 318.
Entries: 8. Paper fold measure (selec-
tion).

Asam, Cosmas Damian *(1686–1739)*
[M.] II, pp. 321–323.
Entries: 2 prints by, 18 after. Paper
fold measure. Inscriptions. States.
Described (selection).

Asam, Egid Quirin *(1692–1750)*
[M.] II, pp. 321–323.

Entries: 3 prints after. Paper fold measure. Inscriptions.

Asam, Hans Georg *(c.1649–1711)*
[M.] II, pp. 320–321.
Entries: 2 prints after. Paper fold measure. Inscriptions. Described (selection).

Asam, Johann *(fl. c.1710)*
[M.] II, p. 320.
Entries: 2 prints after. Paper fold measure. Inscriptions.

Åsberg, Stig *(b. 1909)*
Asklund, Erik. *Stig Åsberg.* Stockholm: Folket i Bilds Konstklubb, 1953.
Entries: unnumbered, 1 p. (to 1953). Millimeters. Illustrated (selection).

Asbroek, Franz
See **Aspruck**

Asch, Pieter Jansz van *(1603–1678)*
[W.] I, p. 30.
Entries: 2 prints after.*

[H. *Neth.*] I, p. 39.
Entries: 1 print after.*

Aschmann, Johann Jakob *(1747–1809)*
[M.] II, p. 325.
Entries: 3+. Paper fold measure.

Ashby, H. *(1744–1818)*
[M.] II, p. 326.
Entries: 6 prints after. Paper fold measure.

Ashby, W. *(fl. 1821–1833)*
[M.] II, p. 326.
Entries: 11. Paper fold measure. States.

Asher, Louis [Julius Ludwig] *(1804–1878)*
[M.] II, pp. 326–327.
Entries: 4 prints after. Paper fold measure.

Ashford, William *(c.1746–1824)*
[M.] II, p. 327.
Entries: 4 prints after. Paper fold measure.

Ashley, Alfred *(fl. c.1850)*
[M.] II, pp. 327–328.
Entries: 4+. Paper fold measure.

Ashton, Matthew *(18th cent.)*
[M.] II, p. 328.
Entries: 2 prints after. Paper fold measure

Asioli, Giuseppe *(1783–1845)*
[M.] II, pp. 328–329.
Entries: 42. Paper fold measure (selection).

[Ap.] pp. 21–22.
Entries: 14.*

Asner, Franz *(b. 1742)*
[M.] II, p. 355.
Entries: 4+. Paper fold measure.

Asner, Leonhard *(18th cent.)*
[M.] II, p. 355.
Entries: 3+. Paper fold measure.

Asp, Hjalmar *(1879–1940)*
Serner, Gertrude. *Hjalmar Asp, 1879–1940.* Malmö (Sweden): Skånes Konstförenings Publikation, 1945.
Entries: unnumbered, pp. 69–72. Millimeters. Illustrated (selection).

Aspari, Domenico *(1745–1831)*
[M.] II, pp. 330–331.
Entries: 28. Paper fold measure.

Asper, Hans *(1499–1571)*
[P.] III, p. 474.
Entries: 1. Pre-metric. Inscriptions. Described.

[M.] II, pp. 331–337.
Catalogue of paintings; prints after are mentioned where extant.

Asper, Hans *(continued)*

[H. *Ger.*] II, p. 65.
Entries: 23 prints after.*

Asperslagh, Louis *(b. 1893)*
Andersson, Egart. "Lou Asperslags ex-libris." [*N. ExT.*] 6 (1954): 21–22.
Entries: 19 (bookplates only, to 1954). Illustrated (selection).

Aspertini, Amico *(c.1475–1552)*
[M.] II, pp. 337–340.
Entries: 2 (appendix with 5 rejected prints). Pre-metric. Inscriptions (selection). Described.

Asprucci, Antonio *(1723–1808)*
[M.] II, p. 342.
Entries: 4 prints after. Paper fold measure. Inscriptions.

Aspruck, Franz *(fl. 1598–1603)*
[M.] II, pp. 342–344.
Entries: 14 prints by, 20 after. Paper fold measure. Inscriptions. Described (selection).

[W.] I, p. 31.
Entries: 14.

Hämmerle, Albert. "Franciscus Aspruck." [*Schw. M.*] 1925, 46–55.
Entries: 20 prints after. Inscriptions (selection).

[H. *Neth.*] I, pp. 40–42.
Entries: 14 prints by, 20 after. Illustrated (selection).*

Assche, Henri van *(1774–1841)*
[M.] II, pp. 344–345.
Entries: 2 prints by, 15 after.

Asselijn, Jan [called "Crabbetje"] *(c.1610–1652)*
[M.] II, pp. 348–350.
Entries: 1 print by, 39 after. Paper fold measure. Inscriptions (selection). Described (selection).

[W.] I, p. 32.
Entries: 1.*

[H. *Neth.*] I, pp. 43–44.
Entries: 1 print by, 39 after. Illustrated (print by).*

Steland-Stief, Anne Charlotte. *Jan Asselijn; nach 1610 bis 1652.* Amsterdam: Van Gendt en Co., 1971.
Catalogue of paintings; prints after are mentioned where extant.

Asselin, Maurice *(1882–1947)*
Jean, René. *M. Asselin.* Paris: G. Crès et Cie, 1928.
Entries: 65 etchings, 12 lithographs (to 1928). Millimeters (etchings only).

Asselineau, Léon August *(1808–1889)*
[M.] II, pp. 346–347.
Entries: 11+ . Paper fold measure.

[Ber.] I, p. 61.*

Assen, A. van *(d. 1817)*
[M.] II, p. 351.
Entries: 9. Paper fold measure. Described.

Assen, Jan van *(c.1635–1695)*
[W.] I, p. 32.
Entries: 1 print after.*

[H. *Neth.*] I, p. 44.
Entries: 2.*

Assié, Adrien
See **Dassier**

Assmann, Christian Gottfried *(fl. c.1800)*
[M.] II, p. 354.
Entries: 2 prints by, 2 after. Paper fold measure.

Assmus, Robert *(b. 1837)*
[M.] II, pp. 354–355.
Entries: 1 print by, 23 after. Paper fold measure.

Astor, Diego de *(fl. 1606–1640)*
 [M.] II, pp. 357–358.
 Entries: 8. Paper fold measure. In-
scriptions.

Astruc de Vissec
See **Vissec,** Astruc de

Atkinson, Frederick *(fl. c.1800)*
 [M.] II, p. 360.
 Entries: 28. Paper fold measure.

Atkinson, John Augustus *(1775–after 1831)*
 [M.] II, pp. 360–361.
 Entries: 8+ prints by, 11+ after. Paper
fold measure. Inscriptions (selection).

 [Siltzer] p. 345.
 Entries: unnumbered, p. 345, prints
by and after. Inscriptions.

Atkinson, Thomas Lewis *(1817–after 1889)*
 [M.] II, pp. 362–363.
 Entries: 70. Paper fold measure.

 [Siltzer] p. 345.
 Entries: unnumbered, p. 345.

Atthalin, Louis *(19th cent.)*
 [Ber.] I, pp. 61–62.*

Attlmayr, Richard Isidor von *(b. 1831)*
 [M.] II, pp. 366–367.
 Entries: 4 prints after.

Atzinger, Joseph *(1814–1885)*
 [M.] II, p. 367.
 Entries: 11+ . Paper fold measure. In-
scriptions.

Aubépine, Marcel Jules Gingembre d'
(b. 1843)
 [Ber.] V, p. 91.*

Auber, L. *(fl. c.1690)*
 [M.] II, p. 368.
 Entries: 3. Paper fold measure. In-
scriptions (selection).

Aubert, A. *(fl. c.1800)*
 [M.] II, p. 371.
 Entries: 7. Paper fold measure. States.
Described (selection).

 [Ap.] p. 22.
 Entries: 7.*

 [Ber.] I, p. 62.*

Aubert, Ernest Jean *(1824–1906)*
 [M.] II, pp. 372–373.
 Entries: 5 engravings by, 17 litho-
graphs by, 6 prints after. Paper fold
measure.

 [Ap.] p. 22.
 Entries: 2.*

 [Ber.] I, pp. 63–64.*

Aubert, Jean *(fl. 1720–1741)*
 [M.] II, p. 369.
 Entries: 10+ . Paper fold measure. In-
scriptions (selection). Described
(selection).

Aubert, Louis *(fl. 1740–1780)*
 [M.] II, pp. 370–371.
 Entries: 9 prints after. Paper fold
measure.

Aubert, Michel *(1700–1757)*
 [M.] II, pp. 369–370.
 Entries: 59+ . Paper fold measure.

Aubert, Pierre Eugène *(1789–1847)*
 [M.] II, p. 372.
 Entries: 15+ . Paper fold measure. In-
scriptions (selection).

 [Ap.] p. 23.
 Entries: 7.*

 [Ber.] I, pp. 62–63.*

Aubertin, François *(1773–1821)*
 [M.] II, pp. 373–374.
 Entries: 45+ . Paper fold measure.

 [Ber.] I, p. 64.*

Aubry, Abraham *(fl. 1650–1682)*
[M.] II, pp. 376–378.
Entries: 25+ prints by, 7+ doubtful prints. Paper fold measure. Inscriptions (selection). Described (selection).

Aubry, Adrian [François Leon Adrien] *(b. 1834)*
[M.] II, pp. 382–383.
Entries: 7 (etchings only). Millimeters. Inscriptions.

Aubry, Charles *(19th cent.)*
[Ber.] I, pp. 64–66.*

Aubry, Étienne *(1745–1781)*
[M.] II, p. 378.
Entries: 19 prints after. Paper fold measure. Inscriptions (selection). Described (selection).

Aubry, J. *(fl. c.1650)*
[M.] II, p. 375.
Entries: 1. Paper fold measure. Inscriptions.

Aubry, Peter *(1610–1686)*
[M.] II, pp. 375–376.
Entries: 37 prints by, 13 doubtful prints. Paper fold measure. Inscriptions (selection). States. Described (selection).

Aubry-Lecomte, Hyacinthe Louis Victor *(1787–1858)*
Galimard, Auguste. *Aubry-Lecomte. Les grands artistes contemporains.* Paris: E. Dentu, 1860.
Entries: unnumbered, pp. 18–24.

[M.] II, pp. 379–382.
Entries: 139. Paper fold measure. Inscriptions (selection). Described (selection).

[Ber.] I, pp. 67–72.
Entries: 28+.

Audenaerd, Robert van *(1663–1743)*
[M.] II, pp. 383–387.
Entries: 82+. Paper fold measure. Inscriptions (selection). Described (selection).

Auder, ⸺ *(18th cent.)*
[M.] II, p. 387.
Entries: 4. Paper fold measure. Inscriptions.

Audibrand, François Adolphe Bruneau *(1810–after 1865)*
[Ber.] I, p. 73.*

Audinet, Philipp *(1766–1837)*
[M.] II, pp. 387–388.
Entries: 51+. Paper fold measure. Inscriptions (selection).

[Sm.] I, p. 4, and "additions and corrections."
Entries: 2 (portraits only). Inches. Inscriptions. Described.

[Ru.] pp. 1–2.
Entries: 2 (portraits only, additional to [Sm.]). Inches (selection). Described. Additional information to [Sm.].

Audouin, Pierre *(1768–1822)*
[M.] II, pp. 388–391.
Entries: 66. Paper fold measure. Inscriptions. States.

[Ap.] pp. 23–27.
Entries: 49.*

[Ber.] I, pp. 73–79.*

Audran, Benoît I *(1661–1721)*
[M.] II, pp. 417–423.
Entries: 227. Paper fold measure. Inscriptions (selection). States. Described (selection).

Audran, Benoît II *(1698–1772)*
[M.] II, pp. 428–431.

Entries: 68. Paper fold measure. Inscriptions (selection). States. Described (selection).

Audran, Charles *(1594–1674)*
[M.] II, pp. 392–403.
Entries: 223. Paper fold measure. Inscriptions (selection). States. Described (selection).

Audran, Claude I *(1597–1675)*
[M.] II, pp. 403–404.
Entries: 18+ . Paper fold measure. Inscriptions (selection). States. Described (selection).

Audran, Gérard *(1640–1703)*
[RD.] IX, pp. 237–322; XI, pp. 2–3.
Entries: 216. Millimeters. Inscriptions. States. Described.

[M.] II, pp. 405–417.
Entries: 136+ . Paper fold measure. Inscriptions (selection). States. Described (selection).

Audran, Germain *(1631–1710)*
[M.] II, p. 404.
Entries: 30. Paper fold measure. Inscriptions (selection). States. Described (selection).

Audran, Jean *(1667–1756)*
[M.] II, pp. 423–428.
Entries: 289. Paper fold measure. Inscriptions (selection). States. Described (selection).

Audran, Louis *(1670–1712)*
[M.] II, p. 428.
Entries: 14. Paper fold measure. Inscriptions (selection).

Audran, Prosper Gabriel *(1744–1819)*
[Baud.] II, pp. 291–297.
Entries: 12. Millimeters. Inscriptions. Described.

[M.] II, p. 431.
Entries: 12. Paper fold measure. Inscriptions (selection).

Audubon, John James *(1780–1851)*
Hanaburgh, E. F. *Audubon's "Birds of America"; a check list of first issues of the plates in the first folio edition, 1828–1838.* Buchanan (N.Y.): Published by the author, 1941. (NN)
Entries: 435 prints after ("Birds of America" only). Inscriptions. States. List of watermarks on papers of first editions.

Auer, Johann Paul *(1638–1687)*
[M.] II, pp. 433–434.
Entries: 10 prints after. Paper fold measure. Inscriptions. Described.

Auer, Kaspar *(1795–1821)*
[M.] II, pp. 435–436.
Entries: 18+ . Paper fold measure. Inscriptions.

[Dus.] p. 11.
Entries: 5+ (lithographs only, to 1821). Millimeters. Located (selection).

Auerbach, Johann Gottfried *(1697–1753)*
[M.] II, p. 436.
Entries: 1 print by, 18 after. Paper fold measure. Inscriptions (selection).

Aufray de Roc' Bhian, Alphonse Édouard Enguerand *(b. 1833)*
[Ber.] I, pp. 79–80.
Entries: 26.

Auger, Adrien Victor *(b. 1787)*
[M.] II, p. 437.
Entries: 3. Paper fold measure.

Auger, Victor *(fl. 1772–1774)*
[M.] II, p. 437.
Entries: 2 prints after.

Augier, L. *(fl. c.1700)*
 [M.] II, p. 438.
 Entries: 2 prints after. Paper fold
 measure.

Augrand, Parfait *(b. 1782)*
 [M.] II, p. 438.
 Entries: 20. Paper fold measure.

Augustin, Jean Baptiste Jacques
(1759–1832)
 [M.] II, p. 440.
 Entries: 11+ prints after. Paper fold
 measure.

Augustini, Jacobus Luberti *(1748–1822)*
 [M.] II, p. 441.
 Entries: 1. Paper fold measure. In-
 scriptions.

 [W.] I, p. 34.
 Entries: 1.*

Augustini, Jan *(1725–1773)*
 [M.] II, pp. 440–441.
 Entries: 4 prints after. Paper fold mea-
 sure. Inscriptions.

Auliczek, Dominik *(1734–1804)*
 [M.] II, pp. 441–442.
 Entries: 1. Paper fold measure. De-
 scribed.

Aulitscheck, N. *(19th cent.)*
 [Dus.] p. 12.
 Entries: 1 (lithographs only, to 1821).
 Millimeters. Inscriptions. Located.

Aumuller, Xavier *(fl. c.1800)*
 [M.] II, p. 442.
 Entries: 3. Paper fold measure.

Aur, Anton *(fl. c.1700)*
 [M.] II, p. 443.
 Entries: 1. Paper fold measure. In-
 scriptions.

Aureli, Nicolò *(fl. 1805–1836)*
 [M.] II, p. 443.
 Entries: 15+. Paper fold measure.

 [Ap.] pp. 27–28.
 Entries: 9.*

Aurnhammer, E. J. *(1772–1817)*
 [Dus.] p. 11.
 Entries: 6 (lithographs only, to 1821).
 Millimeters. Inscriptions. Described.
 Located.

Auroux, Nicolas *(fl. 1649–1670)*
 [M.] II, pp. 445–446.
 Entries: 30. Paper fold measure. In-
 scriptions. Described.

Ausfeld, Johann Carl *(1782–1851)*
 [Dus.] p. 12.
 Entries: 2 (lithographs only, to 1821).
 Inscriptions.

Austen, John *(20th cent.)*
 Richardson, Dorothy M. *John Austen and
 the inseparables.* London: William Jack-
 son, 1930. (NN)
 Bibliography of books with illustra-
 tions by.

Austin, Richard *(fl. 1788–1830)*
 Lewis, Walter. *Richard Austin; engraver to
 the printing trade between the years 1788
 and 1830.* Cambridge: The University
 Press, 1937. 100 copies.
 Bibliography of books with illustra-
 tions by.

Austin, Robert Sargent *(1895–1973)*
 Dodgson, Campbell. *A catalogue of etch-
 ings and engravings by Robert Austin, R.
 E., 1913–1929.* London: Twenty-One
 Gallery, 1930. 160 copies. (MB)
 Entries: 89 (to 1929). Inches. Millime-
 ters. Inscriptions. States. Illustrated.
 Ms. additions (ELCo) by Harold J. L.
 Wright: additional states, and list of
 titles for 39 additional prints.

Austin, William *(1721–1820)*
[M.] II, pp. 447–448.
> Entries: 37+. Paper fold measure. Inscriptions (selection).

Autguers, G. *(fl. 1624–1630)*
[M.] II, p. 449.
> Entries: 5. Paper fold measure. Inscriptions. States.

Autreau, Jacques *(1657–1745)*
[M.] II, pp. 450–451.
> Entries: 9 prints after. Paper fold measure (selection). Inscriptions (selection).

Autreau, Louis *(c.1692–1760)*
[M.] II, p. 451.
> Entries: 4 prints after. Paper fold measure.

Auvray, Alexandre Hippolyte *(1798–1860)*
[M.] II, p. 452.
> Entries: 1. Paper fold measure.

Auvray, Pierre Laurent *(b. 1736)*
[M.] II, p. 452.
> Entries: 17. Paper fold measure.

[L. D.] p. 3.
> Entries: 1. Millimeters. Inscriptions. States. Described. Incomplete catalogue.*

Avanzo, Johann *(1804–1853)*
[M.] II, p. 458.
> Entries: 11. Paper fold measure.

Avati, Mario *(b. 1921)*
Dassonville, Gustave Arthur. *Les livres illustrés par Avati.* n.p., 1964. 107 copies. (DLC)
> Bibliography of books with illustrations by.

Aved, Jacques André Joseph *(1702–1766)*
[M.] II, pp. 458–460.
> Entries: 39 prints after. Paper fold measure. Inscriptions (selection). Described (selection).

Aveele, Johannes van den *(fl. 1678–1727)*
[M.] II, pp. 460–461.
> Entries: 38+. Paper fold measure. Inscriptions (selection).

Aveline, Antoine *(1691–1743)*
[M.] II, pp. 463–464.
> Entries: 32+. Paper fold measure (selection).

Aveline, François Antoine *(1727–1780)*
[M.] II, p. 466.
> Entries: 33. Paper fold measure.

Aveline, Jean *(1739–1781)*
[M.] II, p. 466.
> Entries: 4. Paper fold measure.

Aveline, Pierre I *(1660?–1722?)*
[M.] II, pp. 462–463.
> Entries: 52+. Paper fold measure.

Aveline, Pierre II *(1702–1760)*
[M.] II, pp. 464–466.
> Entries: 159+. Paper fold measure. States.

Avellimo, Giulio *(d. 1700)*
[M.] II, p. 467.
> Entries: 2 prints after.

Avercamp, Barent *(1612–1679)*
Welcker, Clara J. *Hendrick Averkamp, 1585–1634; bijgenaamd "de stomme van Campen," en Barent Averkamp, 1612–1679; schilders tot Campen.* Zwolle (Netherlands): De Erven J. J. Tijl, 1933.
> Entries: 1. Illustrated. Located.

Avercamp, Hendrik *(1585–1634)*
[M.] II, pp. 469–470.
> Entries: 1 print by (doubtful), 17 prints after. Paper fold measure. Inscriptions (selection).

Avercamp, Hendrik *(continued)*

[W.] I, p. 36.
Entries: 2 prints by, 18 after.*

Welcker, Clara J. *Hendrick Averkamp 1585–1634; bijgenaamd "de stomme van Campen," en Barent Averkamp, 1612–1679; schilders tot Campen.* Zwolle (Netherlands): De Erven J. J. Tijl, 1933.
Entries: 17+ prints after. Millimeters (selection). Inscriptions (selection). Described (selection). Illustrated (selection).

[H. *Neth.*] I, p. 45.
Entries: 19 prints after.*

Avery, Milton *(1893–1965)*
Brooklyn Museum [Una E. Johnson and Jo Miller, compilers]. *Milton Avery; prints and drawings 1930–1964.* New York: Shorewood Publishers, 1966.
Entries: 46 prints, excluding monotypes. Inches. Illustrated (selection). Also, incomplete list of 21 monotypes.

Avery, Samuel Putnam *(1822–1904)*
Sieben Morgen, Ruth. "Samuel Putnam Avery (1822–1904), engraver on wood; a bio-bibliographical study." Thesis, Master's of Library Science, Columbia University, 1940. Revised, with additions, 1942. (NN)
Entries: unnumbered, pp. 78–157. Millimeters. Inscriptions. Located.

Avice, Henri d' *(fl. 1642–1654)*
[M.] II, p. 477.
Entries: 3 prints by, 3 after. Paper fold measure.

Avogadro, Pietro *(fl. c.1700)*
[M.] II, pp. 478–479.
Entries: 2 prints after. Paper fold measure.

Avont, Pieter van *(1599/1600–1652)*
[M.] II, pp. 479–484.

Entries: 36 prints by, 61 after. Paper fold measure. Inscriptions (selection). Described (selection).

[W.] I, p. 37; III, p. 14.
Entries: 36 prints by, 1+ after.*

[H. *Neth.*] I, pp. 46–49.
Entries: 36 prints by, 84 after. Illustrated (selection).*

Avril, Jean Jacques I *(1744–1831)*
[M.] II, pp. 484–487.
Entries: 116+. Paper fold measure. Inscriptions (selection). States.

[Ap.] pp. 28–29.
Entries: 30.*

Avril, Jean Jacques II *(1771–1835)*
[M.] II, pp. 487–488.
Entries: 28. Paper fold measure. States.

[Ap.] p. 30.
Entries: 7.*

[Ber.] I, pp. 80–81.*

Avril, Paul *(b. 1843)*
[Ber.] I, pp. 81–84.
Entries: 14+ (to 1884).

Axmann, Josef *(1793–1873)*
[M.] II, pp. 490–491.
Entries: 60+. Paper fold measure.

[Ap.] p. 30.
Entries: 4.*

Ayala, Josefa de [called "Josefa de Obidos"] *(c.1630–1684)*
[M.] II, p. 492.
Entries: 1. Paper fold measure. Inscriptions.

Aylesford, Heneage Finch, Earl of *(1751–1812)*
[M.] II, p. 493.
Entries: 19. Paper fold measure.

Oppé, A. P. "The Fourth Earl of Aylesford." [PCQ.] 11 (1924): 262–292.
Entries: 85. Inches. Inscriptions. States. Illustrated (selection). Located. Ms. catalogue (EBM) has every print described.

Aylmer, F. *(19th cent.)*
[M.] II, p. 493.
Entries: 2 prints after. Paper fold measure.

Aylmer, T. B. *(19th cent.)*
[M.] II, p. 493.
Entries: 2 prints after. Paper fold measure (selection).

Ayrer, Christian Victor *(1650–1719)*
[M.] II, p. 493.
Entries: 5. Paper fold measure. Inscriptions.

Aze, ——— *(fl. 1828–1835)*
[M.] II, p. 494.
Entries: 2. Paper fold measure. Inscriptions.

Aze, Valère Adolphe Louis *(1823–1884)*
[M.] II, p. 494.
Entries: 2 prints after. Paper fold measure.

Azeglio, Massimo Taparelli, Marchese *(1798–1866)*
[M.] II, pp. 494–495.
Entries: 2 prints after. Paper fold measure. Inscriptions.

Azelt, Johann *(b. 1654)*
[M.] II, p. 495.
Entries: 25. Paper fold measure. Inscriptions (selection).

B

B ———, J. W. *(fl. c.1813)*
[St.] p. 49.*

B ———, S. P. *(fl. c.1815)*
[F.] p. 54.*

Baade, Knud Andreassen *(1808–1879)*
[M.] II, p. 499.
Entries: 2 prints after. Paper fold measure.

Baader, Amalie
See **Schattenhofer**

Baader, Johann Michael *(b. 1736)*
[M.] II, p. 499.

Entries: 2+ prints by, 5+ prints after. Paper fold measure.

Babberger, August *(1885–1936)*
Württenberger, Franzsepp. *Das graphische Werk von August Babberger.* Schriften der Staatlichen Kunsthalle Karlsruhe, 5. Karlsruhe (West Germany): Staatliche Kunsthalle, 1954.
Entries: 94 etchings, 29 woodcuts, 37 woodcuts for books. Millimeters. Inscriptions. Described.

Babel, P. E. *(fl. 1725–1765)*
[M.] II, pp. 500–502.

Babel, P. E. *(continued)*

Entries: 13+ prints by, 5+ prints by
after other artists, 8+ prints after.
Paper fold measure.

Babin, ———— *(fl. c.1750)*
[M.] II, p. 502.
Entries: 1+. Paper fold measure.

Babo, Lambert von *(1790–1862)*
[M.] II, p. 502.
Entries: 5+. Paper fold measure.

Baburen, Dirck van *(d. 1624)*
[M.] II, pp. 503–504.
Entries: 1 print by, 6 after. Paper fold
measure. Inscriptions (selection).

[W.] I, p. 38.
Entries: 6 prints after.*

[H. *Neth.*] I, pp. 50–51.
Entries: 1 print by, 6 after. Illustrated
(selection).*

Slatkes, Leonard J. *Dirck van Baburen
(c.1595–1624) a Dutch painter in Utrecht
and Rome.* Utrecht: Haentjens Dekker en
Gumbert, 1965.
Catalogue of paintings, prints after
them are mentioned where extant.

Bacchi, Raffaele *(1716–1767)*
[M.] II, p. 505.
Entries: 3 prints after. Paper fold measure.

Bacci, Torello *(19th cent.)*
[M.] II, p. 506.
Entries: 2 prints after. Paper fold measure.

Bacciarelli, Marcello *(1731–1818)*
[M.] II, p. 506.
Entries: 7 prints after. Paper fold
measure.

Bach, Abraham *(fl. c.1680)*
[M.] II, pp. 507–508.

Entries: 3. Paper fold measure. In-
scriptions (selection). Described
(selection).

[H. *Ger.*] II, p. 65.
Entries: 4+.*

Bach, Aino *(20th cent.)*
Bernstein, B. *Aino Bach.* Tallinn (USSR):
Eesti N.S.V. Kunst, 1961. (NN)
Entries: unnumbered, pp. 54–66
(works in all media).

Bach, Carl Daniel Friedrich *(1756–1826)*
[M.] II, pp. 508–509.
Entries: 2+ prints by, 3+ after. Paper
fold measure (selection).

Bach, Christian Wilhelm *(18th cent.)*
[M.] II, p. 508.
Entries: 1 print by, 1 after.

Bach, Gottlieb Friedrich *(1714–1785)*
[M.] II, p. 508.
Entries: 3 prints after. Paper fold
measure.

Bach, Johann Philipp *(1752–1846)*
[M.] II, p. 508.
Entries: 4 prints after. Paper fold
measure (selection).

Bach, Johann Samuel *(1749–1778)*
[M.] II, p. 508.
Entries: 5 prints after.

Bach, Max *(b. 1841)*
[M.] II, pp. 509–510.
Entries: 6+. Paper fold measure.

Bachaumont, Louis Petit de *(c.1715–1771)*
[M.] II, p. 510.
Entries: 2. Paper fold measure.

Bachel, ———— *(18th cent.)*
[M.] II, p. 510.
Entries: 8. Paper fold measure.

Bacheley, Jacques *(1712–1781)*
[M.] II, pp. 510–511.
 Entries: 19. Paper fold measure. In-
 scriptions (selection). Described
 (selection).

Bacheley, L. G. M. *(fl. c.1800)*
[M.] II, p. 511.
 Entries: 1. Paper fold measure.

Bacher, Otto Henry *(1856–1909)*
 Koehler, Sylvester R. "The works of the
 American etchers XVI: Otto H. Bacher."
 [*Amer. Art Review*] 2, pt. 1 (1881): 51–52.
 Entries: 24 (prints of 1879 only).
 Inches. Inscriptions.

Bachmann, J. *(19th cent.)*
[M.] II, p. 515.
 Entries: 3. Paper fold measure.

Bachmayr, D *(19th cent.)*
[Dus.] pp. 12–13.
 Entries: 4 (lithographs only, to 1821).
 Millimeters (selection). Inscriptions
 (selection). Located (selection).

Back, Jakob Conrad *(fl. c.1760)*
[M.] II, pp. 515–516.
 Entries: 8. Paper fold measure (selec-
 tion). Inscriptions (selection).

Backenberg, Felix *(fl. c.1850)*
[Ap.] p. 31.
 Entries: 1.*

[ThB.] II, p. 320.
 Entries: 4 (additional to [Ap.]).

Backer, Adriaen *(1636–1684)*
[W.] I, p. 39.
 Entries: 2 prints after.*

[H. *Neth.*] I, p. 51.
 Entries: 3 prints after.*

Backer, B. *(fl. c.1750)*
[M.] II, p. 520.
 Entries: 10. Paper fold measure.

Backer, Cornelius *(b. 1771)*
[W.] I, p. 39.
 Entries: 2 prints after.*

Backer, Franz de *(fl. 1693–1749)*
[M.] II, pp. 519–520.
 Entries: 7 prints by, one after. Paper
 fold measure.

[W.] I, p. 39.
 Entries: 6.*

Backer, Jakob de *(c.1560–c.1590)*
[M.] II, pp. 516–517.
 Entries: 2 prints after. Paper fold mea-
 sure (selection). Inscriptions. De-
 scribed.

[W.] I, p. 40.
 Entries: 4 prints after.*

[H. *Neth.*] I, p. 52.
 Entries: 5 prints by, 5 after. Prints by
 are illustrated; prints after are not.

Backer, Jakob Adriaensz *(1608–1651)*
[M.] II, pp. 517–518.
 Entries: 8 prints by, 16 after. Pre-
 metric (selection). Paper fold measure
 (selection). Inscriptions (selection).
 Described (selection).

[W.] I, p. 41.
 Entries: 5 prints by, 14 after.*

Bauch, Kurt. *Jakob Adriansz. Backer, ein
Rembrandtschüler aus Friesland.* Berlin: G.
Grote'sche Verlagsbuchhandlung, 1926.
 Entries: 5 prints by, 1 after. Millime-
 ters. Inscriptions. States. Described.
 Illustrated (selection). Located (selec-
 tion).

[H. *Neth.*] I, p. 53.
 Entries: 15 prints after.*

Backer, John James *(1648–1697)*
[W.] I, p. 41.
 Entries: 1 print after.*

Backer, Nicolas de
 See **Backer,** John James

Backereel, Gillis *(1572–before 1662)*
[W.] I, p. 41.
Entries: 1 print after.*

[H. *Neth.*] I, p. 53.
Entries: 1 print after.*

Bakhuijzen, Alexander H. *(b. c.1830)*
[M.] II, p. 525.
Entries: 1. Inscriptions.

Backhuysen, Ludolf *(1631–1708)*
[B.] IV, pp. 271–283.
Entries: 13. Pre-metric. Inscriptions.
States. Described.

Smith, John. *A Catalogue raisonné of the works of the most eminent Dutch, Flemish, and French painters.* Vol. 6, pp. 401–455.
London: Smith and Son, 1835.
Entries: 13. Described.

Weigel, pp. 197–200.
Entries: 2 (additional to [B.]). Pre-metric. Inscriptions. Described. Appendix with 2 prints cited by Weigel from other sources.

Heller, p. 16.
Additional information to [B.].

[M.] II, pp. 521–524.
Entries: 19 prints by, 28 after. Paper fold measure. Inscriptions (selection). States. Described (selection).

[Dut.] IV, pp. 11–18; V, p. 585.
Entries: 15. Millimeters. Inscriptions. States. Described. Appendix with 4 additional prints, not fully catalogued.

[W.] I, p. 43.
Entries: 20.*

[H. *Neth.*] I, pp. 54–63.
Entries: 20 prints by, 21 after. Illustrated (selection).*

Bacler d'Albe, Louis Albert Guillain, Baron de *(1761–1824)*
[M.] II, p. 525.

Entries: 9+ prints by, 8+ after. Paper fold measure.

[Ber.] I, pp. 84–85.*

Bacon, Frederick *(1803–1887)*
[M.] II, p. 526.
Entries: 27. Paper fold measure. States.

[Ap.] p. 31.
Entries: 12.*

Badalocchio, Sisto *(1581/85–1647)*
[B.] XVIII, pp. 352–360.
Entries: 34. Pre-metric. Inscriptions. Described.

[M.] II, pp. 527–530.
Entries: 31 prints by, 5 doubtful prints, 6 prints after. Millimeters (selection). Paper fold measure (selection). Inscriptions. States. Described (selection).

Badens, Frans *(1571–c.1621)*
[W.] I, p. 44.
Entries: 2 prints after.*

[H. *Neth.*] I, p. 63.
Entries: 2 prints after.*

Baderna, Bartolomeo *(fl. 1655–1685)*
[Vesme] pp. 339–340.
Entries: 5. Millimeters. Inscriptions. Described. Located (selection).

Badessa, —— *(fl. c.1700)*
[M.] II, p. 532.
Entries: 1. Millimeters. Inscriptions. Described.

Badiale, Alessandro *(1623–1668)*
[B.] XIX, pp. 225–229.
Entries: 5. Pre-metric. Inscriptions. Described.

[M.] II, pp. 532–533.
Entries: 7. Paper fold measure. Inscriptions. States. Described.

Badoureau, J. F. *(fl. 1819–1835)*
[M.] II, pp. 533–534.
Entries: 29.

[Ber.] I, pp. 85–86.*

Baeck, Elias *(1679–1747)*
[M.] II, pp. 534–535.
Entries: 53. Paper fold measure.

Baen, Jan de *(1633–1702)*
[M.] II, p. 537.
Entries: 1 print by, 13 after. Paper fold measure. Inscriptions (selection).

[W.] I, p. 45.
Entries: 1 print by, 15 after.*

[H. *Neth.*] I, pp. 64–65.
Entries: 1 print by, 21 after. Illustrated (selection).*

Baerdemaecker, Félix de *(1836–1878)*
[M.] II, p. 538.
Entries: 2. Millimeters. Inscriptions. States.

[H. L.] pp. 61–62.
Entries: 2. Millimeters. Inscriptions. States. Described.

Bärenholdt, H. C. *(b. 1890)*
Bärenholdt, H. C. *H. C. Bärenholdt; Exlibris 1913–1947.* Copenhagen: Privately printed, 1947. 175 copies. (DLC)
Entries: 95 (bookplates only, to 1947). Illustrated (selection).

F [ougt], K [nud]. "Fortegnelse over H. C. Bärenholdts exlibris siden 1941." [*N. ExT.*] 1 (1946–47): 61–63.
Entries: 29 (bookplates only, additional to Bärenholdt). Illustrated (selection).

Rindholt, Svend. "Håndslag og Hilsen til en exlibriskunstner; i anledning af H. C. Bärenholdts 70-ars dag." [*N. ExT.*] 12 (1960): 4–9.
Entries: 59 (bookplates only, additional to Bärenholdt and Fougt).

Baerenstecher, Nicolaus Gottlieb *(1768–1808?)*
[M.] II, pp. 538–539.
Entries: 8. Paper fold measure.

Baerentzen, Emilius Ditlev *(1799–1868)*
[M.] II, p. 539.
Entries: 25. Paper fold measure.

Baertsoen, Albert *(1866–1922)*
Fierens-Gevaert, ———. *Albert Baertsoen.* Brussels: G. van Oest et Cie, 1910. (EBrM)
Entries: 27.

Baes, Martin *(fl. 1614–1631)*
[M.] II, pp. 540–541; III, p. 103.
Entries: 18+ . Paper fold measure. Inscriptions (selection).

[W.] I, p. 45.
Entries: 8.*

[H. *Neth.*] I, pp. 66–69.
Entries: 18+ . Illustrated (selection).*

Baeschlin, Johann Jakob *(1745–1789)*
[M.] II, p. 541.
Entries: 2. Paper fold measure. States.

Bässler, W. *(d. 1853)*
[M.] II, p. 541.
Entries: 4. Paper fold measure.

Bagelaar, Ernst Willem Jan *(1775–1837)*
[H. L.] pp. 11–61.
Entries: 177. Millimeters. Inscriptions. States. Described.

[M.] II, pp. 543–545.
Entries: 176.

Bager, Johann Daniel *(1734–1815)*
[M.] II, p. 545.
Entries: 2 prints by, 1 after. Paper fold measure. Inscriptions (selection).

Baggerts, C. *(18th cent.)*
[M.] II, p. 545.
Entries: 1. Paper fold measure.

Baglioni, Cesare *(c.1550–c.1620)*
[M.] II, p. 546.
 Entries: 1 print by, 3 after. Paper fold
 measure. Inscriptions. States.

Bagnini, Carlo *(fl. c.1650)*
[M.] II, p. 548.
 Entries: 3. Paper fold measure (selec-
 tion).

Bahmann, Ferdinand *(b. 1800)*
[M.] II, p. 548.
 Entries: 10. Paper fold measure.
 States.

[Ap.] pp. 31–32.
 Entries: 3.*

Baillie, Alexander *(fl. 1764–1776)*
[M.] II, p. 549.
 Entries: 3. Paper fold measure. In-
 scriptions (selection).

Baillie, William *(1723–1810)*
[M.] II, pp. 549–556.
 Entries: 101. Paper fold measure.
 Inscriptions. States. Described.

[Sm.] I, pp. 5–6, and "additions and cor-
rections" section.
 Entries: 4 (portraits only). Inches. In-
 scriptions. States. Described.

[Ru.] p. 2.
 Additional information to [Sm.].

Bailliu, Pieter de *(b. 1613)*
[M.] II, pp. 556–562.
 Entries: 103+ . Paper fold measure. In-
 scriptions (selection). States. De-
 scribed (selection).

[W.] I, pp. 46–47.
 Entries: 67+ .*

[H. *Neth.*] I, pp. 70–76.
 Entries: 106+ . Illustrated (selection).*

Bailly, David *(1584–c.1657)*
[M.] II, pp. 563–564.

 Entries: 4+ prints by, 8+ after. Paper
 fold measure (selection). Inscriptions
 (selection).

[W.] I, p. 48.
 Entries: 3 prints by, 8 after.

[H. *Neth.*] I, pp. 77–78.
 Entries: 3+ prints by, 10 after.

Bailly, Jacques I *(c.1634–1679)*
[RD.] II, pp. 89–91; XI, p. 3
 Entries: 12. Pre-metric. Inscriptions.
 Described.

Bailly, James *(19th cent.?)*
[Siltzer] p. 346.
 Entries: unnumbered, p. 346. Inscrip-
 tions.

Baisch, Wilhelm Heinrich Gottlieb
(1805–1864)
 [M.] II, p. 565.
 Entries: 4. Paper fold measure.

Baj, Enrico *(b. 1924)*
 Petit, Jean. *Baj; catalogue 1 de l'oeuvre
 gravé; catalogue 1 of the printed graphic work
 1952–70.* Geneva: Jean Petit, 1970.
 Entries: 293 prints, 21 multiples (to
 1970). Millimeters. Illustrated.

Baker, James H. *(b. 1829)*
[M.] II, pp. 566–567.
 Entries: 36. Paper fold measure.

Baker, John *(fl. 1832–1835)*
[F.] pp. 54–55.*

Baker, W. Carmichael *(19th cent.)*
[Siltzer] p. 328.
 Entries: unnumbered, p. 328 (prints
 after). Inches. Inscriptions. De-
 scribed.

Bakewell, Thomas *(18th cent.)*
[M.] II, p. 567.
 Entries: 2. Paper fold measure.

Bakhuijzen, Hendrik van de Sande *(1795–1860)*
[M.] II, p. 524.
 Entries: 6. Paper fold measure.

Bakhuijzen, Julius Jacobus van de Sande *(b. 1835)*
[M.] II, pp. 524–525.
 Entries: 3.

Bakof, Julius *(1819–1857)*
[M.] II, p. 568.
 Entries: 2. Paper fold measure.

Baksteen, Dirk *(1886–1956)*
Goossens, Korneel. *Dirk Baksteen 1886–1956.* Antwerp (Belgium): Het Grafisch Genootschap [1956?]. 300 copies. (EBr)
 Entries: 228 (to 1956). Millimeters.
 Illustrated (selection).

Bal, Cornelis Joseph *(1820–1867)*
[M.] II, p. 568.
 Entries: 4. Paper fold measure. States.

[Ap.] p. 32.
 Entries: 5.*

Balabin, Patrikei *(b. 1734)*
[M.] II, p. 568.
 Entries: 4. Millimeters (selection).

Balassa, Franz von *(19th cent.)*
[Dus.] p. 13.
 Entries: 1 (lithographs only, to 1821). Millimeters. Inscriptions. Located.

Balcewicz, Franz Wenzel *(fl. c.1750)*
[M.] II, pp. 569–570.
 Entries: 8. Paper fold measure.

Balch, Vistus *(1799–1884)*
[F.] pp. 55–58.* .

Baldi, Antonio *(c.1692–c.1773)*
[M.] II, pp. 573–574.
 Entries: 10. Paper fold measure (selection).

Baldi, Lazzaro *(1624–1703)*
[B.] XXI, pp. 87–88.
 Entries: 1. Pre-metric. Inscriptions. Described.

[M.] II, pp. 572–573.
 Entries: 1 print by, 36 after. Paper fold measure. Inscriptions (selection). Described (selection).

Balding, H. C. *(fl. 1869–1876)*
[M.] II, p. 574.
 Entries: 4. Paper fold measure.

Baldini, Baccio *(fl. 1460–1480)*
[B.] XIII, pp. 161–200, 423–425.
 Entries: 62 prints by, 8 prints not seen by [B.]. Pre-metric. Inscriptions. States. Described. Copies mentioned.

Evans, pp. 7–8, 10–11.
 Entries: 4 (additional to [B.]). Millimeters. Inscriptions. Described.

[P.]V, pp. 27–48.
 Entries: 22+ prints by (additional to [B.]), 8 prints described from other sources (additional to [B.]), 4 niello prints (additional to [B.]). Pre-metric. Inscriptions. States. Described. Located. Additional information to [B.]. [P.] rejects certain prints given to Baldini by [B.], and adds others classed by [B.] as anonymous.

[M.] II, pp. 574–612.
 Entries: 177 fine manner prints, 68 broad manner prints, (actually a list of all early Florentine engravings with discussion of the attribution of various prints). Paper fold measure (selection). Inscriptions. States. Described.

[Hind] I, pp. 9–10 and passim.
 Discussion of the problem of attributing prints to Baldini.

Baldrey, John K. *(fl. 1780–1810)*
[M.] II, p. 615.
 Entries: 18+ . Paper fold measure.

Baldung Grien, Hans *(1484/85–1545)*
[B.] VII, pp. 301–322.
　Entries: 2 engravings, 59 woodcuts.
　Pre-metric. Inscriptions. States. De-
　scribed. Copies mentioned.

[Evans] pp. 11, 28.
　Entries: 2 (additional to [B.]). Millime-
　ters. Inscriptions. Described.

[P.] III, pp. 318–326.
　Entries: 4 engravings and etchings
　(additional to [B.]), 25 woodcuts
　(additional to [B.]), 1 doubtful print.
　Pre-metric. Inscriptions. Described.
　Located (selection). Additional in-
　formation to [B.].

[M.] II, pp. 617–637.
　Entries: 4 engravings, 155 woodcuts, 3
　doubtful engravings, 12 doubtful
　woodcuts, 11 prints after. Millimeters
　(selection). Pre-metric (selection). In-
　scriptions. Described.

Curjel, Hans. *Hans Baldung Grien.*
Munich: O. C. Recht Verlag, 1923.
　Entries: 6 engravings, 85 single wood-
　cuts, 24 books with woodcut illustra-
　tions. Millimeters. Described (selec-
　tion). Located (selection). Refers to
　[M.].

Curjel, Hans. *Holzschnitte des Hans Bal-
dung Grien, mit fünfzig Abbildungen.*
Munich: Allgemeine Verlagsanstalt,
1924.
　Entries: 50 woodcuts illustrated, with
　[B.], [M.] and Curjel nos. Illustrated.
　Complement to 1923 catalogue.

Parker, K. T. "The engravings of Hans
Baldung Grien." [PCQ.] 12 (1925): 419–
434.
　Entries: 6 prints by, 4 doubtful and
　rejected prints (engravings only).
　Millimeters. Inscriptions. States. Il-
　lustrated. Located.

[Ge.] nos. 57–132.

Entries: 76 (single-sheet woodcuts
only). Described. Illustrated. Located.

Koch, Carl. "Katalog der erhaltenen
Gemälde, der Einblattholzschnitte und
illustrierten Bücher von Hans Baldung
Grien." *Kunstchronik* 6 (1953): 297–302.
　Summary chronological list, with ref-
　erences to earlier catalogues and addi-
　tional information.

[H. *Ger.*] II, pp. 66–158.
　Entries: 282 prints by, 7 after. Illus-
　trated (selection).*

Staatliche Kunsthalle, Karlsruhe [Ernst
Brochhagen and Jan Lants, compilers.]
Hans Baldung Grien. Karlsruhe (West
Germany), 1959.
　Entries: 7 engravings, 87 single wood-
　cuts, 52 books with woodcut illustra-
　tions. Millimeters. Inscriptions.
　States. Described (selection). Illus-
　trated. Located.

Möhle, Hans. "Zwei bisher unbekannte
Holzschnitt-illustrationen von Hans
Baldung." Berliner Museen, *Berichte aus
den ehem. preussischen Kunstsammlungen,*
n.s. 11 (1961): 15–17.
　Entries: 2 (additional to earlier cata-
　logues). Described. Illustrated.

Oldenbourg, Consuelo. *Die Buch-
holzschnitte des Hans Baldung Grien, ein
bibliographisches Verzeichnis ihrer Verwen-
dungen.* Studien zur deutschen
Kunstgeschichte, 335. Baden-Baden and
Strasbourg: Verlag Heitz, 1962.
　Entries: 387 (woodcuts for books
　only). Millimeters. Inscriptions.
　States. Illustrated (selection). Editions
　of books are bibliographically de-
　scribed.

Baldus, Hans
　See **Monogram BH** [Nagler, *Mon.*] I, no.
　1882

Balechou, Jean Joseph *(1719–1764)*
[M.] II, pp. 637–641.
Entries: 56. Paper fold measure. Inscriptions (selection). States. Described.

Belleudy, Jules. *J.-J. Balechou, graveur du roi (1716–1764).* Extract from *Mémoires de l'Académie de Vaucluse,* 1st semester, 1908. Avignon, (France): Éditions de l'Académie de Vaucluse, 1908.
Entries: 95. Millimeters (selection). Paper fold measure (selection). Inscriptions (selection). States. Described (selection).

Balen, Hendrik I van *(1575–1632)*
[W.] III, p. 16.
Entries: 12 prints after.*

[H. *Neth.*] I, p. 79.
Entries: 20 prints after.*

Balen, Jan van *(1611–1654)*
[H. *Neth.*] I, p. 79.
Entries: 1 print after.*

Balen, Matthys *(1684–after 1750)*
[M.] II, p. 643.
Entries: 4 prints by, 6 after. Paper fold measure.

[W.] I, p. 49.
Entries: 4.*

Balestra, Antonio *(1666–1740)*
[B.] XXI, pp. 293–296.
Entries: 4. Pre-metric. Inscriptions. Described. Appendix with 4 prints not seen by [B.].

[M.] II, pp. 644–646.
Entries: 10 prints by, 59 after. Paper fold measure (selection). Inscriptions (selection). States. Described (selection).

[Wess.] III, p. 44.
Entries: 1 (additional to [B.]). Millimeters. Inscriptions. Described.

Balestra, Giovanni *(1774–1842)*
[M.] II, pp. 646–647.
Entries: 26+. Paper fold measure. Inscriptions (selection). States. Described (selection).

[Ap.] pp. 32–33.
Entries: 27.*

Balfourier, Adolphe Paul Émile *(b. 1816)*
[M.] II, p. 647.
Entries: 4. Paper fold measure.

Ballard, F. *(fl. c.1625)*
[M.] II, p. 650.
Entries: 3. Paper fold measure. Inscriptions (selection).

Balleis, Macarius *(1761–1790)*
[M.] II, pp. 650–651.
Entries: 11. Paper fold measure.

Ballenberger, Karl *(1801–1860)*
[M.] II, p. 651.
Entries: 1 print by, 2 after. Paper fold measure. Inscriptions (selection).

Ballero, Giovanni *(19th cent.)*
[M.] II, p. 651.
Entries: 5. Paper fold measure.

Ballester, Joaquin *(c.1741–c.1800)*
[M.] II, pp. 643–644.
Entries: 19. Paper fold measure. Described (selection).

Ballin, Auguste *(b. 1842)*
[Ber.] I, p. 86.*

Ballin, Joel [John] *(1822–1885)*
[M.] II, p. 653.
Entries: 25. Paper fold measure.

[Ber.] I, p. 87.*

Ballini, Giulio *(fl. c.1569)*
[M.] II, p. 653.
Entries: one set of 71 prints.

Balmer, Joseph A. *(b. 1828)*
[M.] II, pp. 654–655.
Entries: 2. Paper fold measure.

Baltard, Louis Pierre *(1764–1846)*
[M.] II, pp. 655–656.
Entries: 27+ prints by, 2+ after. Paper
fold measure.

[Ber.] I, pp. 87–89.*

Baltens, Pieter *(c.1525–1598)*
[M.] II, pp. 658–659.
Entries: 4+. Paper fold measure. In-
scriptions (selection). Described
(selection).

[W.] I, p. 50.
Entries: 7+.*

[H. *Neth.*] I, pp. 80–87.
Entries: 27+. Illustrated (selection).*

Balze, ——— *(19th cent.)*
[Ber.] I, p. 89.*

Balzer, Anton *(1771–1807)*
[M.] II, pp. 664–665.
Entries: 29+ prints by, 2+ after. Paper
fold measure.

Narodni Galerie v Praze. *Jan a Antonin
Balzer grafika.* Prague, 1968.
Entries: 140 (complete?). Millimeters.
Inscriptions. Illustrated (selection).

Balzer, Gregor *(c.1754–1824)*
[M.] II, p. 664.
Entries: 7. Paper fold measure.

Balzer, Johann *(1738–1799)*
[M.] II, pp. 661–664.
Entries: 246+ prints by, 1+ after.
Paper fold measure.

Narodni Galerie v Praze. *Jan a Antonin
Balzer grafika.* Prague, 1968.
Entries: 241 (complete?) Millimeters.
Inscriptions. Illustrated (selection).

Balzer, Johann Karl *(1768–1805)*
[M.] II, p. 665.
Entries: 5+. Paper fold measure.

Balzer, Matthias *(18th cent.)*
[M.] II, p. 664.
Entries: 8+. Paper fold measure.

Bamberger, Fritz *(1814–1873)*
[M.] II, pp. 665–666.
Entries: 1 print by, 3 after.

Bance, ——— *(fl. c.1800)*
[Ber.] I, p. 89.*

Banck, Jan van der *(d. 1739)*
See **Vanderbank,** John

Banck, Pieter van der *(1649–1697)*
[M.] II, pp. 667–668.
Entries: 49. Paper fold measure (selec-
tion).

Bandel, Jos [eph] Ernst von *(1800–1876)*
[Dus.] p. 13.
Entries: 1 (lithographs only, to 1821).
Millimeters. Inscriptions. Located.

Bandinelli, Baccio *(1493–1560)*
[M.] II, pp. 671–677.
Entries: 9 prints after sculpture, 63
after drawings. Paper fold measure
(selection). Described (selection).

Bang, Hieronymus *(1553–1629/33)*
[M.] II, pp. 677–678.
Entries: 80. Millimeters (selection).
Paper fold measure (selection). De-
scribed (selection).

[H. *Ger.*] II, p. 159.
Entries: 83+.*

Bang, Theodor [Dietrich] *(c.1580–1625)*
[M.] II, p. 678.
Entries: 21. Paper fold measure. In-
scriptions (selection). Described
(selection).

[H. *Ger.*] II, p. 160.
 Entries: 21. Illustrated (selection).*

Bankel, Johannes *(1837–1906)*
 [Ap.] p. 33.
 Entries: 3.*

Banks, Thomas *(1735–1805)*
 [M.] II, p. 679.
 Entries: 3 prints by, 2 after. Paper fold measure.

Bannerman, Alexander *(c.1730–c.1780)*
 [M.] II, pp. 679–680.
 Entries: 68. Paper fold measure.

Bannerman, J. *(19th cent.)*
 [St.] pp. 21–22.*

 [F.] p. 58.*

Banzo, Antonio *(fl. c.1810)*
 [M.] II, pp. 680–681.
 Entries: 47. Paper fold measure. States.

 [Ap.] pp. 33–34.
 Entries: 10.*

Baour, F. *(18th cent.)*
 [M.] II, p. 681.
 Entries: 3. Paper fold measure (selection).

Baptist, Jacobus *(fl. c.1700)*
 [M.] II, p. 681.
 Entries: 19+. Paper fold measure. Inscriptions (selection).

Baptiste, Martin Sylvestre *(1791–1859)*
 [Ber.] I, pp. 89–90.*

Baquoy, Jean Charles *(1721–1777)*
 [M.] II, p. 682.
 Entries: 37+. Paper fold measure. States.

 [L. D.] p. 3.

Entries: 2. Millimeters. Inscriptions. States. Illustrated. Incomplete catalogue.*

Baquoy, Louise Sebastienne [called "Henriette"] *(b. 1792)*
 [M.] II, p. 683.
 Entries: 3+. Paper fold measure.

Baquoy, Maurice *(c.1680–1747)*
 [M.] II, p. 682.
 Entries: 3+. Paper fold measure. Inscriptions (selection).

Baquoy, Pierre Charles *(1759–1829)*
 [M.] II, pp. 682–683.
 Entries: 24+. Paper fold measure. States.

 [Ap.] pp. 34–35.
 Entries: 9.*

 [Ber.] I, pp. 90–91.*

Bar, Alexandre de *(b. 1821)*
 [M.] II, pp. 684–685.
 Entries: 16. Millimeters (selection). Inscriptions (selection). States. Described (selection).

 [Ber.] I, pp. 92–99.
 Entries: 76 (to 1882). Paper fold measure. Described (selection).

Bär, Ernst *(19th cent.)*
 [Dus.] p. 13.
 Entries: 1 (lithographs only, to 1821). Millimeters. Inscriptions. Located.

Bar, Jacques Charles *(fl. 1776–1800)*
 [M.] II, p. 684.
 Entries: 7+. Millimeters (selection). Paper fold measure (selection).

Bara, —— *(19th cent.)*
 [Ber.] I, p. 99.*

Bara, Jean *(b. c.1812)*
 [M.] II, p. 686.
 Entries: 6. Millimeters.

Bara, Johan *(1603–1668)*
 [M.] II, pp. 685–686.
 Entries: 64. Paper fold measure. States.
 Described (selection).

 [W.] I, p. 52.
 Entries: 64.*

 [H. *Neth.*] I, pp. 88–97.
 Entries: 67. Illustrated (selection).*

Barabé, Pierre André *(fl. c.1730)*
 [M.] II, p. 687.
 Entries: 13. Millimeters (selection).
 Paper fold measure (selection). In-
 scriptions (selection).

Baranets'ka, Stefanijá *(20th cent.)*
 V'iunyk, Andrii O. *Stefanija Gebus-
 Baranets'ka.* Kiev (USSR): Mistetstvo,
 1968. (DLC)
 Entries: unnumbered, pp. 40–50 (to
 1965). Millimeters. Illustrated (selec-
 tion).

Baranezki, Glykeri *(18th cent.)*
 [M.] II, p. 688.
 Entries: 3. Millimeters (selection).

Barathier, ——— *(19th cent.)*
 [Ber.] I, p. 99.*

Baratta, Alessandro *(fl. c.1630)*
 [M.] II, p. 689.
 Entries: 2+. Paper fold measure.
 States.

Baratta, Antonio *(1724–1787)*
 [M.] II, p. 690.
 Entries: 33+. Paper fold measure.

Baratta, Carlo *(17th cent.)*
 [M.] II, p. 689.
 Entries: 1. Millimeters. Inscriptions.
 Described.

Baratta, Laurens *(fl. c.1629)*
 [M.] II, p. 689.
 Entries: 22. Paper fold measure.

 [W.] I, p. 52.
 Entries: 22.*

 [H. *Neth.*] I, p. 98.
 Entries: 22. Illustrated (selection).*

Baratti, Antonio *(1724–1787)*
 [AN.] pp. 573–601.
 Entries: unnumbered, pp. 580–601.
 Millimeters. Inscriptions. Described
 (selection).

 [AN. 1968] pp. 172–173.
 Entries: unnumbered, pp. 172–173
 (additional to [AN.]). Millimeters. In-
 scriptions.

Baratti, Tomaso *(fl. c.1772)*
 [AN.] pp. 651–654.
 Entries: unnumbered, pp. 652–654.
 Millimeters. Inscriptions. Described.

 [AN. 1968] p. 175.
 Entries: unnumbered, p. 175 (addi-
 tional to [AN.]). Millimeters. Inscrip-
 tions.

Baratti, Valentina *(d. 1779)*
 [AN.] p. 602.
 Entries: unnumbered, p. 602. Millime-
 ters.

Barbabin, François *(18th cent.)*
 [RD.] III, pp. 313–314.
 Entries: 4. Pre-metric. Inscriptions.
 Described.

Barbaran, Louis *(fl. c.1673)*
 [M.] II, p. 692.
 Entries: 3. Millimeters. Inscriptions.

Barbari, Jacopo da *(1440/50–1511/15)*
 [B.] VII, pp. 516–527.
 Entries: 24. Pre-metric. Inscriptions.
 Described. Copies mentioned.

 [Heller] pp. 16–17.
 Additional information to [B.].

 [Evans] p. 44.

Entries: 5 (additional to [B.]). Millimeters. Inscriptions. Described.

Galichon, Émile. "Jacopo da Barbarj." [*GBA.*] 1st ser., 11 (1861): 311–319, 445–458.
Entries: 29 engravings, 1 woodcut. Millimeters. Inscriptions. Described. Illustrated (selection).

[P.] III, pp. 134–143.
Entries: 9 (additional to [B.]). Pre-metric. Inscriptions. States. Described. Located. Additional information to [B.]. Watermarks described. Copies mentioned.

[M.] II, pp. 706–716.
Entries: 34 engravings, 3 woodcuts. Millimeters. Inscriptions. States. Described.

Canditto, A. E. de [Adr. Wittert]. *Jacob de Barbari et Albert Dürer.* Brussels: G.-A. van Trigt, 1881.
Entries: 43. Pre-metric. Millimeters. Inscriptions. Described.

François, A. W. *Jacob de Barbari et Albert Dürer; Appendice.* Brussels: G.-A. van Trigt, n.d.
Entries: 5 (additional to Canditto). Pre-metric (selection). Inscriptions (selection). Described (selection). Additional information to Canditto.

[W.] I, p. 57.
Entries: 32.*

Kristeller, Paul. *Das Werk des Jacopo da Barbari.* Berlin: Internationale Chalkographische Gesellschaft, 1896. English edition: *Engravings and woodcuts by Jacopo de' Barbari.* French edition: *L'Oeuvre de Jacopo de' Barbari.*
Entries: 33. Described. Illustrated. Located. Copies mentioned.

Borenius, Tancred. *Four early Italian engravers.* London and Boston (Mass.): Medici Society, 1923.
Entries: 30. Millimeters. Inscriptions. States. Described. Illustrated. Located. Copies mentioned.

Hevesy, André de. *Jacopo de Barbari, le maître au caducée.* Paris and Brussels: G. van Oest, 1925.
Entries: 33. Described (selection). Illustrated (selection). Follows Kristeller's numbering.

[Hind] V, pp. 141–158.
Entries: 29 prints by, 1 doubtful print. Millimeters. Inscriptions. Described. Illustrated. Located. 4 additional prints after or related to Barbari are mentioned, p. 145.

Servolini, Luigi. *Jacopo de' Barbari.* Padua: Le Tre Venezie, 1944.
Entries: 30 (engravings only). Millimeters. Described (selection). Illustrated. Located. Copies mentioned.

Schilling, Heidemarie. "Studien zu Jacopo de Barbari's graphischem Werk." Dissertation, University of Graz, 1969. (EWA)
Entries: 25 (engravings only). Millimeters. Inscriptions. Described. Located. Bibliography for each entry. Discussion of chronology and other problems relating to the engravings.

Barbarini, Franz *(1804–1873)*
[M.] II, pp. 716–717.
Entries: 39 prints by, 2 after. Paper fold measure. Inscriptions. States.

Barbault, Jean *(1705–1766)*
[M.] II, pp. 718–719.
Entries: 7+ prints by, 3+ after. Paper fold measure. Inscriptions (selection). States.

Barbazelli, Teodoro *(fl. c.1750)*
[M.] II, p. 719.
Entries: 1+. Paper fold measure.

Barbazza, Antonio Giuseppe *(b. 1722)*
[M.] II, p. 719.
Entries: 8. Paper fold measure. Inscriptions (selection).

Barbazza, Francesco *(fl. c.1780)*
[M.] II, p. 719.
Entries: 3+. Paper fold measure.

Barbé, Jean Baptiste *(1578–1649)*
[M.] II, pp. 719–724.
Entries: 148. Paper fold measure. Inscriptions (selection). States. Described (selection).

[W.] I, p. 58.
Entries: 22+.*

[H. *Neth.*] I, pp. 99–101.
Entries: 148.*

Barbella, Giovanni Giacomo *(1590–1656)*
[M.] II, p. 724.
Entries: 1. Paper fold measure. Inscriptions. Described.

Barber, J. *(fl. c.1830)*
[M.] II, p. 725.
Entries: 4+. Paper fold measure.

Barber, John Warner *(1798–1885)*
[F.] pp. 58–59.*

Nash, Chauncey C. "John Warner Barber and his books." *The Walpole Society Note Book,* 1934, pp. 30–69.
Bibliography of books with illustrations by.

Barbery, Louis *(fl. 1670–1690)*
[M.] II, p. 725.
Entries: 13. Paper fold measure.

Barbey, Antonio *(fl. c.1700)*
[M.] II, p. 726.
Entries: 3.

Barbié, Jacques *(fl. 1755–1790)*
[M.] II, p. 727.
Entries: 8. Paper fold measure. Inscriptions. States. Described.

Barbiere, Domenico del *(1506–1565/75)*
[B.] XVI, pp. 355–362.

Entries: 9. Pre-metric. Inscriptions. Described. Appendix with 22 rejected prints.

[P.] VI, pp. 198–200.
Entries: 3 (additional to [B.]). Pre-metric. Inscriptions. Described. Additional information to [B.].

[M.] II, pp. 727–728.
Entries: 13. Millimeters. Inscriptions. Described (selection).

[Wess.] III, p. 44.
Additional information to [B.].

[Herbet] III, pp. 1–14; V, p. 82.
Entries: 27. Millimeters. Inscriptions. Described. Located (selection).

[Zerner] no. 8.
Entries: 22. Millimeters. Inscriptions. States. Described. Illustrated.

Barbieri, Lodovico *(fl. 1660–1704)*
[B.] XIX, pp. 418–419.
Entries: 1. Pre-metric. Inscriptions. Described.

Barbieri, Luca *(17th cent.)*
[M.] III, p. 10.
Entries: 1 print by, 1 after. Millimeters (selection). Inscriptions.

Barbiers, Pieter Bartholomeusz *(1772–1837)*
[M.] III, p. 11.
Entries: 1+ print by, 1+ after. Paper fold measure.

Barbiers, Pieter Pietersz *(1749–1842)*
[M.] III, pp. 10–11.
Entries: 3. Paper fold measure.

Barbiers, Pieter II *(1798–1848)*
[H. L.] p. 62.
Entries: 1. Millimeters. Inscriptions. States. Described.

[M.] III, p. 11.
Entries: 1. Millimeters. Inscriptions.

Barboni, Matteo *(fl. c.1800)*
 [M.] III, p. 11.
 Entries: 4. Paper fold measure.

Barcelon, Juan *(18th cent.)*
 [M.] III, p. 12.
 Entries: 27. Paper fold measure.

Barckhan, Johann Hieronymus
(1785–after 1855)
 [Dus.] p. 13.
 Entries: 1 (lithographs only, to 1821).
 Millimeters. Inscriptions. Located.

Bard, James *(1815–1897)* and John
(1815–1856)
 Brown, Alexander Crosby. "Check list
 of works of James and John Bard, to-
 gether with bibliographical notes citing
 reproductions of their work." *Art in
 America* 37 (1949): 67–78.
 Entries: unnumbered, pp. 72–78
 (works in all media, including prints
 after). Located.

Bardin, Ambroise Marguérite *(b. 1768)*
 [M.] III, p. 13.
 Entries: 2. Millimeters.

Bardou, Johann *(18th cent.)*
 [M.] III, p. 14.
 Entries: 2 prints by, 12 after. Paper
 fold measure.

Barducci, V. *(fl. c.1768)*
 [M.] III, p. 14.
 Entries: 1.

Barenger, James *(1780–1831)*
 [Siltzer] pp. 77–79.
 Entries: unnumbered, p. 79, prints af-
 ter. Inches (selection). Inscriptions.

Barenger, J., and J. Sillett *(19th cent.)*
 [Siltzer] p. 79.
 Entries: unnumbered, p. 79, prints af-
 ter. Inches. Inscriptions.

Barentsz, Dirck I *(1534–1592)*
 [M.] III, pp. 15–16.
 Entries: 46 prints after. Paper fold
 measure.

 [W.] I, p. 60.
 Entries: 20+ prints after.*

 [H. *Neth.*] I, p. 102.
 Entries: 46+ prints after.*

 Judson, J. Richard. *Dirck Barendsz; 1534–
 1592.* Amsterdam: Vangendt & Co.,
 1970.
 Entries: 46+ prints after. Millimeters.
 Inscriptions. Described (selection). Il-
 lustrated (selection). Bibliography for
 each entry.

Baretta, Francesco *(fl. c.1800)*
 [M.] III, p. 16.
 Entries: 2. Paper fold measure (selec-
 tion).

Bareuille, ——— *(fl. c.1780)*
 [M.] III, p. 16.
 Entries: 2. Millimeters (selection).

Barfus, Paul *(1823–1895)*
 [Ap.] p. 35.
 Entries: 13.*

 [M.] III, p. 17.
 Entries: 11. Paper fold measure.

Bargas, A. F. *(fl. c.1690)*
 [M.] III, p. 17.
 Entries: 10. Paper fold measure. In-
 scriptions.

 [W.] I, p. 60.
 Entries: 9.*

Bargiacchi, Flaminio *(19th cent.)*
 [M.] III, p. 17.
 Entries: 3. Paper fold measure.

Bargue, Charles *(d. 1883)*
 [M.] III, pp. 17–18.
 Entries: 2+. Paper fold measure.

 [Ber.] I, pp. 99–100.*

Barker, Thomas *(1769–1847)*
[M.] III, p. 22.
 Entries: 2+ prints by, 1+ after. Paper
 fold measure.

Barker, William *(fl. 1795–1803)*
[St.] p. 22.*

[F.] p. 59.*

Barkhaus-Wiesenhütten, Charlotte von
(1736–1804)
[M.] III, p. 23.
 Entries: 19. Paper fold measure (selec-
 tion).

Barlacchi, Tommaso *(16th cent.)*
[M.] III, p. 23.
 Entries: 1. Inscriptions.

Barlach, Ernst *(1870–1938)*
Schult, Friedrich. *Ernst Barlach, das
graphische Werk.* Hamburg: Dr. Ernst
Hauswedell und Co., 1958.
 Entries: 297. Millimeters. Inscribed.
 States. Described. Illustrated. Lo-
 cated (selection). Papers described.

Stubbe, Wolf. "Bemerkungen zu Bar-
lach's Druckgraphik." *Jahrbuch der Ham-
burger Kunstsammlungen* 4 (1959): 87–96.
 Additional information to Schult.

Kunsthalle Bremen [Henning Bock,
Christian von Heusinger and Peter
Blome, compilers]. *Ernst Barlach; das
druckgraphische Werk; Dore und Kurt
Ruetti-Stiftung.* Bremen (West Ger-
many), 1968.
 Additional information to Schult. Bib-
 liography for the publications *Krieges-
 zeit* and *Der Bilderman.*

Barlow, Francis *(1626–1702)*
[M.] III, pp. 23–24.
 Entries: 4+ prints by, 47+ after. Paper
 fold measure.

Barlow, Thomas Oldham *(1824–1889)*
[M.] III, p. 24.
 Entries: 31. Millimeters (selection).

Barnard, William *(1774–1849)*
[M.] III, p. 26.
 Entries: 12. Paper fold measure.

[Sm.] I, pp. 7–12, and "additions and
corrections" section.
 Entries: 21 (portraits only). Inches. In-
 scriptions. States. Described.

[Siltzer] p. 346.
 Entries: unnumbered, p. 346. Inscrip-
 tions.

[Ru.] pp. 2–6.
 Entries: 4 (portraits only, additional to
 [Sm.]). Inches (selection). Inscrip-
 tions (selection). Described. Addi-
 tional information to [Sm.]).

Barnet, Will *(b. 1911)*
Brooklyn Musuem [Una E. Johnson and
Jo Miller, compilers]. *Will Barnet; prints
1932–1964.* New York: Shorewood Pub-
lishers, 1965.
 Entries: 114 (to 1964). Inches. Illus-
 trated (selection).

AAA Gallery, New York [Sylvan Cole,
compiler]. *Will Barnett; etchings, litho-
graphs, woodcuts, serigraphs, 1932–1972;
catalogue raisonné.* New York, 1972.
 Entries: 147 (to 1972). Inches. De-
 scribed. Illustrated.

Barney, Joseph *(18th cent.)*
[M.] III, p. 27.
 Entries: 3. Paper fold measure (selec-
 tion).

Barney, William Whiston *(fl. c.1800)*
[M.] III, p. 27.
 Entries: 7+. Paper fold measure.

[Sm.] I, pp. 12–17, and "additions and
corrections" section.

Entries: 21 (portraits only). Inches. In-scriptions. States. Described.

[Siltzer] p. 346.
Entries: unnumbered, p. 346. Inscriptions.

[Ru.] pp. 6–8.
Entries: 1 (portraits only, additional to [Sm.]). Inches. Inscriptions. States. Described. Additional information to [Sm.].

Barni, Giuseppe *(fl. c.1850)*
[Ap.] p. 35.
Entries: 2.*

[M.] III, p. 27.
Entries: 4. Paper fold measure (selection).

Barns, [John?] *(18th cent.)*
[M.] III, p. 27.
Entries: 17.

Barocci, Federico *(1526–1612)*
[B.] XII: *See* **Chiaroscuro Woodcuts**

[B.] XVII, p. 1–4.
Entries: 4. Pre-metric. Inscriptions. Described.

[Wess.] III, p. 44.
Additional information to [B.].

[M.] III, pp. 27–30.
Entries: 4 prints by, 45 after. Millime-ters (selection). Paper fold measure (selection). Inscriptions. States.

Olsen, Harald. *Federico Barocci.*
Copenhagen: Munksgaard, 1962.
Catalogue of Barocci's total oeuvre, including 4 etchings; prints after his paintings are mentioned but not de-scribed; prints are not set apart from paintings or separately numbered. Described. Illustrated.

Barocci, Luigi *(19th cent.)*
[Ap.] p. 36.
Entries: 4.*

Baron, Bernard *(1700–1762)*
[M.] III, pp. 30–31.
Entries: 72. Paper fold measure. In-scriptions (selection).

Baron, Claude *(b. 1738)*
[M.] III, p. 31.
Entries: 86. Paper fold measure (selec-tion).

Baron, Henri Charles Antoine *(1816–1885)*
[Ber.] I, pp. 100–101.*

Baron, Jean *(b. 1616 or 1631)*
[M.] III, p. 30.
Entries: 98. Millimeters (selection). Paper fold measure (selection).

Baron, Jean [Balthazar Jean] *(1788–1869)*
[M.] III, pp. 31–32.
Entries: 24. Paper fold measure.

Chatelain, A. H. Ms. catalogue, Library of the Palais des Arts, Lyons. (not seen)
Entries: 127 (to 1850).

Baroni, Carlo *(fl. 1761–1775)*
[M.] III, p. 34.
Entries: 5. Paper fold measure (selec-tion).

Barra, Jan [Joannes] *(d. 1634)*
[Hind, *Engl.*] III, pp. 95–101.
Entries: 13+ (prints done in England only). Inches. Inscriptions. States. Described. Illustrated (selection). Lo-cated.

Barralet, John James *(1747–1815)*
[St.] pp. 22–23.*

[F.] p. 60.*

Barras, Sébastien *(1653–1703)*
[RD.] IV, pp. 231–245; XI, pp. 3–5.
Entries: 40. Pre-metric. Inscriptions. States. Described.

Barras, Sébastien *(continued)*

[M.] III, pp. 38–39.
Entries: 35. States.

Barraud, Henry *(1811–1874)* and William *(1810–1850)*
[Siltzer] pp. 80–86.
Entries: unnumbered, pp. 85–86, prints after. Inches (selection). Inscriptions.

Barraud, Maurice *(1889–1954)*
Cailler, Pierre, and Darel, Henri. *Catalogue illustré de l'oeuvre gravé et lithographié de Maurice Barraud.* Geneva: Albert Skira, 1944.
Entries: 254. Millimeters. Inscriptions. Illustrated. Located.

Barrett, ——— *(19th cent.?)*
[Siltzer] p. 328.
Entries: unnumbered, p. 328 (prints after). Inscriptions.

Barret, George *(1728–1784)*
[M.] III, pp. 40–41.
Entries: 5 prints by, 5 after. Paper fold measure (selection).

Barri, Giacomo [Jacques] *(c.1630–after 1682)*
[M.] III, p. 41.
Entries: 4. Paper fold measure. Inscriptions.

Barrière, Dominique *(fl. 1640–1674)*
[RD.] III, pp. 42–90; XI, pp. 6–8.
Entries: 212. Pre-metric. Inscriptions. States. Described.

[M.] III, pp. 42–44.
Entries: 208. Paper fold measure (selection). Inscriptions (selection). States. Described (selection).

Barrois, Pierre François *(b. c.1770)*
[M.] III, p. 44.

Entries: 4+. Paper fold measure (selection).

Barros, José Maria de *(18th cent.)*
Soares, Ernesto. *Francisco Bartolozzi e os seus discipulos em Portugal.* Estudos-Nacionais sob a égide do Instituto de Coimbra, 3. Gaia (Portugal): Edições Apolino, 1930.
Entries: 5. Millimeters. Inscriptions. Described. Located.

Barry, Gustave *(fl. 1848–1882)*
[Ber.] I, pp. 101–102.*

Barry, James *(1741–1806)*
[M.] III, pp. 45–46.
Entries: 11 prints by, 7 after. Paper fold measure.

[Ru.] p. 9.
Entries: 1 (portraits only). Inches. Described.

Barth, Karl *(1787–1853)*
[Ap.] p. 36.
Entries: 9.*

[M.] III, pp. 48–49.
Entries: 68. Paper fold measure.

Vontin, Walther. *Carl Barth; ein vergessener deutscher Bildniskünstler, 1787–1853.* Hildburghausen (Germany): F. W. Gadow und Sohn, 1938. (EBKk)
Entries: unnumbered, pp. 175–178.

Barthe, Gérard de la [comte J. de la?] *(18th cent.)*
[M.] III, p. 50.
Entries: 3 prints by, 12 after. Paper fold measure.

Barthelmess, Nikolaus *(1829–1889)*
[Ap.] p. 37.
Entries: 8.*

[M.] III, p. 51.
Entries: 13. Paper fold measure.

Bartholomeus, ——— *(fl. c.1460)*
[Schreiber, *Metallschneidekunst*] p. 90.
 Entries: 4.*

Bartoccini, Bartolommeo *(b. 1816)*
[Ap.] pp. 37–38.
 Entries: 4.*

[M.] III, p. 54.
 Entries: 44+. Paper fold measure.

Bartoli, Francesco *(c.1675–c.1730)*
[M.] III, p. 56.
 Entries: 1. Paper fold measure.

Bartoli, Pietro Santo *(c.1635–1700)*
[M.] III, pp. 54–56.
 Entries: 1126. Paper fold measure.

Bartolini, Luigi *(1892–1963)*
Sala Dante Alighieri, Gradisca
d'Isonzo [Giuseppe Marchiori, com-
piler]. *Storia di una vita nelle incisioni di
Luigi Bartolini.* Gradisca-Redipuglia
(Italy): Azienda Autonoma di Soggiorno
e Turismo, 1967.
 Entries: 101 (to 1962). Millimeters. Il-
 lustrated (selection).

Galleria Marino, Rome. *Catalogo aggior-
nato dell'opera grafica di Luigi Bartolini
(1892–1963).* Rome, 1972. 2000 copies.
(DLC)
 Entries: 1368. Millimeters. Illustrated
 (selection).

Bartolo, Francesco di *(19th cent.)*
[Ap.] p. 122.
 Entries: 1.*

[M.] III, p. 59.
 Entries: 7.

Bartolommeo da Brescia *(1506–after 1578)*
[B.] XV, pp. 533–535.
 Entries: 2. Pre-metric. Inscriptions.
 Described.
[M.] III, p. 74.
 Entries: 6+. Paper fold measure. In-
 scriptions (selection).

Bartolommeo, Fra *(1472–1517)*
[M.] III, pp. 63–73.
 Entries: 85 prints after; 19th century.
 Paper fold measure.

Bartolozzi, Francesco *(1727–1815)*
[Ap.] pp. 38–39.
 Entries: 17.*

Tuer, Andrew W. *Bartolozzi and his
works.* 2 vols. London: Field and Tuer;
Hamilton, Adams and Co., 1881.
 Entries: 2218. Additional entries, un-
 numbered. Ms. additions. (NN)

Tuer, Andrew W. *Bartolozzi and his
works.* 2d ed., rev. and corrected. Lon-
don: Field and Tuer, 1885. 500 copies.
 Additional information to Tuer, 1881.
 The catalogue as a whole is omitted.

[M.] III, pp. 74–77.
 Entries: 412 prints by, 4 after.

[Ber.] I, pp. 102–103.*

[Siltzer] p. 346.
 Entries: unnumbered, p. 346. Inscrip-
 tions.

Calabi, A. *Francesco Bartolozzi; catalogue
des estampes et notice biographique d'après
les manuscrits de A. de Vesme, entièrement
réformés et complétés d'une étude critique.*
Milan: Guido Modiano, 1928.
 Entries: 2553. Millimeters. Inscrip-
 tions. States. Described.

Soares, Ernesto. *Francisco Bartolozzi e os
seùs discipulos em Portugal.* Estudos-
Nacionais sob a égide do Instituto de
Coimbra, 3. Gaia (Portugal): Edições
Apolino, 1930.
 Entries: 44 (prints done in Portugal
 only). Millimeters. Inscriptions. De-
 scribed. Located.

Bartsch, Adam von *(1757–1821)*
Bartsch, Frédéric de. *Catalogue des es-
tampes de J. Adam de Bartsch.* Vienna: Im-
primerie d'Antoine Pichler, 1818.

Bartsch, Adam von *(continued)*

Entries: 505 (to 1818). Pre-metric. Inscriptions. States. Described.

[Ap.] p. 39.
Entries: 3.*

[M.] III, pp. 78–82.
Entries: 505. Paper fold measure.

Bartsch, Christian *(d. 1867)*
[M.] III, p. 82.
Entries: 5. Paper fold measure.

Bartsch, Johann Gottfried *(fl. 1674–1690)*
[M.] III, pp. 77–78.
Entries: 42.

Barutel, Fabrice *(fl. c.1816)*
[M.] III, p. 83.
Entries: 1. Paper fold measure.

Bary, Hendrick *(c.1640–1707)*
[M.] III, pp. 83–85.
Entries: 66. Millimeters (selection). Paper fold measure (selection). Inscriptions (selection). States. Described (selection).

[W.] I, pp. 61–62.
Entries: 70.*

[H. *Neth.*] I, pp. 103–142.
Entries: 84+. Illustrated (selection).*

Barye, Antoine Louis *(1796–1875)*
[Ber.] I, pp. 103–104.*

[Del.] VI.
Entries: 12 prints by, 1 rejected print. Millimeters. Inscriptions (selection). States. Described (selection). Illustrated. Located (selection).

Basan, Pierre François *(1723–1797)*
[M.] III, pp. 90–95.
Entries: 252+ prints by and published by. Paper fold measure (selection). States.

Basebe, C. *(fl. 1843–1879)*
[M.] III, p. 96.
Entries: 2. Paper fold measure.

Basiletti, Luigi *(1780–1860)*
[M.] III, p. 98.
Entries: 2. Paper fold measure.

Basire, James I *(1730–1802)*
[M.] III, pp. 99–101.
Entries: 138. Paper fold measure.

Basire, James II *(1769–1822)*
[M.] III, p. 101.
Entries: 4+. Paper fold measure (selection).

Baskett, Charles Henry *(20th cent.)*
Allhusen, E. L. "The Aquatints of C. H. Baskett, R. E." [*P. Conn.*] 4 (1924): 324–337.
Entries: unnumbered, pp. 332–337. Millimeters.

Bass, Johannes *(fl. 1616–1655)*
Bergau, R. "Johann Bass." [*N. Arch.*] 15 (1869): 95–97.
Entries: 7. Pre-metric (selection). Paper fold measure (selection). Inscriptions. Described.

[M.] III, p. 101.
Entries: 3. Paper fold measure.

Bassaget, Pierre Numa
See **Numa**

Bassano, Cesare *(b. 1584)*
[M.] III, pp. 102–103.
Entries: 29 prints by and after. Paper fold measure. Inscriptions (selection). Described (selection).

Basse, Willem *(fl. 1628–1672)*
[M.] III, pp. 103–105.
Entries: 44. Millimeters (selection). Paper fold measure (selection). Inscriptions. States. Described.

[Rov.] p. 65.
 Entries: 1. Millimeters. Inscriptions. States. Described. Illustrated. Located.

[W.] I, pp. 62–63.
 Entries: 46+ .*

[H. *Neth.*] I, pp. 143–164.
 Entries: 75+ . Illustrated (selection).*

Basselli, Daniele *(17th cent.)*
[M.] III, p. 105.
 Entries: 1. Paper fold measure.

Bassen, Bartholomaeus van *(fl. 1613–1652)*
[W.] I, p. 63.
 Entries: 2.

[H. *Neth.*] I, p. 165.
 Entries: 2 prints after.*

Basseporte, Madeleine Françoise *(1701–1780)*
[M.] III, p. 106.
 Entries: 3 prints by, 3 after. Paper fold measure.

Basset, ——— *(19th cent.)*
[Ber.] I, p. 104.*

Basset, André *(18th cent.)*
[M.] III, p. 106.
 Entries: 3+ . Paper fold measure (selection).

Basset, Françoise *(18th cent.)*
[M.] III, p. 107.
 Entries: 3+ .

Bassett, T. *(18th cent.)*
[M.] III, p. 107.
 Entries: 4. Paper fold measure (selection).

Bassiani, Bernardino *(fl. c.1631)*
[B.] XX, pp. 166–167.
 Entries: 1. Pre-metric. Inscriptions. Described.

[M.] III, p. 110.
 Entries: 1. Paper fold measure. Inscriptions.

Bassin, C. *(17th cent.?)*
[M.] III, p. 110.
 Entries: 1.

Bassinet-Daugard, P. D. *(fl. 1670–1701)*
[RD.] VIII, pp. 297–298.
 Entries: 1. Millimeters. Inscriptions. Described.

Bassini, Cornelio *(17th cent.?)*
[M.] III, p. 111.
 Entries: 1. Paper fold measure. Inscriptions.

Bassompierre, ——— *(fl. c.1779)*
[M.] III, p. 111.
 Entries: 2+ . Paper fold measure.

Bast, Pieter *(d. 1605)*
[M.] III, pp. 112–113.
 Entries: 22 prints by, 2 after. Paper fold measure. Inscriptions.

[W.] I, p. 64; III, p. 18.
 Entries: 18+ .*

[H. *Neth.*] I, pp. 166–178.
 Entries: 24. Illustrated (selection).*

Bastiani, Francesco *(17th cent.)*
[M.] III, p. 114.
 Entries: 1.

Bastien-Lepage, Jules *(1848–1884)*
[Ber.] IX, pp. 130–132.
 Entries: 11. Millimeters. Described (selection).

Bastin, ——— *(19th cent.)*
[Ber.] I, pp. 104–105.*

Bastin, John *(19th cent.)*
[M.] III, p. 116.
 Entries: 2+ . Paper fold measure.

Bastre, ——— *(18th cent.)*
[M.] III, p. 117.
Entries: 1. Paper fold measure.

Bate, J. *(fl. c.1800)*
[M.] III, pp. 117–118.
Entries: 4 prints by, 2 after. Paper fold measure.

Bathilde, Louise
See **Girard**

Batley, ——— *(fl. c.1770)*
[M.] III, p. 119.
Entries: 1. Paper fold measure.

Batoni, Pompeo Girolamo *(1708–1787)*
[M.] III, pp. 119–123.
Entries: 56 prints after. Paper fold measure.

Battem, Gerard van *(1636–1684)*
[M.] III, pp. 125–126.
Entries: 1 print by, 2 after. Paper fold measure. Inscriptions (selection). Described (selection).

[W.] I, p. 64.
Entries: 1.*

[H. *Neth.*] I, p. 179.
Entries: 1 print by, 2 after. Illustrated (selection).*

Battens, Dom. *(16th cent.)*
[M.] III, p. 126.
Entries: 1. Paper fold measure.

Batterman, Jan *(20th cent.)*
Rhebergen, Jan. "Jan Battermann, en hollandsk maler og grafiker." [*N. ExT.*] 11 (1959): 85–89.
Entries: 111 (bookplates and commercial prints only, to 1959). Described (selection). Illustrated (selection).

Rhebergen, Jan. *Jan Battermann, kunstschilder en graficus.* Amsterdam and Antwerp (Belgium): Wereld

Bibliotheek-Vereniging, 1966. (MH)
Entries: 265 (bookplates and commercial prints only, to 1967). Illustrated (selection). Unnumbered list, pp. 45–46, of other prints. Millimeters.

Battersby, ——— *(fl. c.1785)*
[M.] III, p. 126.
Entries: 1.

Battke, Heinz *(b. 1900)*
Cüppers, Joachim. *Heinz Battke; Werkkatalog.* Hamburg: Verlag Dr. Ernst Hauswedell und Co., 1970.
Entries: 72. Millimeters. Inscriptions. Illustrated.

Batty, Robert *(1789–1848)*
[M.] III, p. 128.
Entries: 1+ print by, 6+ after. Paper fold measure.

Baude, Charles *(1855–1935)*
[Ber.] I, p. 105.*

Baudeau, Jacques *(fl. c.1700)*
[M.] III, p. 129.
Entries: 1. Paper fold measure.

Baudet, Étienne *(1636–1711)*
Porcher, R. *Étienne Baudet, graveur du roi (1638–1711).* 2d ed. Blois (France): Imprimerie Lecesne, 1885. (EPBN)
Entries: 115. Millimeters. States. Described (selection).

[M.] III, pp. 129–131.
Entries: 102+. Paper fold measure (selection). Inscriptions (selection). States.

Baudewyns, Adriaen Frans *(1644–1711?)*
[M.] III, pp. 139–141.
Entries: 37 prints by and after. Paper fold measure. Inscriptions (selection).

[W.] I, p. 65.
Entries: 34+.*

Baudewyns, Frans *(fl. 1720)*
 [W.] I, p. 65.
 Entries: 1.*

Bauditz, Chr. W. *(20th cent.)*
 Rödel, Klaus. *Chr. W. Bauditz' exlibris.*
 Frederikshavn (Denmark): Privately
 printed, 1967. 60 copies. (DLC)
 Entries: 30 (bookplates only, to 1967).
 Millimeters. Described. Illustrated
 (selection).

Baudouin, ——— *(19th cent.)*
 [Dus.] p. 14.
 Entries: 2 (lithographs only, to 1821).
 Millimeters. Inscriptions. Located.

Baudouin, Pierre Antoine *(1723–1769)*
 Bocher, Emmanuel: *Pierre-Antoine Bau-*
 douin. Les graveurs français du XVIIIe
 siècle, II. Paris: Librarie des Bibliophiles,
 1875. 475 copies.
 Entries: 48 prints after. Millimeters.
 Inscriptions. States. Described.

 [Gon.] I, pp. 210–215.
 Entries: unnumbered, pp. 210–215,
 prints after. Based on Bocher.

 [M.] III, pp. 132–135.
 Entries: 1 print by, 34 after. Paper fold
 measure (selection).

Baudouin, Simon René, comte de *(b. 1723)*
 [M.] III, p. 135.
 Entries: 11+. Paper fold measure
 (selection). States.

Baudous, Robert Willemsz de
(c.1575–after 1644)
 [M.] III, pp. 135–136.
 Entries: 17+. Paper fold measure. In-
 scriptions (selection).

 [W.] I, p. 66.
 Entries: 16+.*

 [H. *Neth.*] I, pp. 180–190.
 Entries: 120. Illustrated (selection).*

Baudran, Auguste Alexandre *(b. 1823)*
 [M.] III, p. 136.
 Entries: 9+.

Baudran, Étienne Larose *(d. 1866)*
 [M.] III, p. 136.
 Entries: 3+. Paper fold measure.

 [Ber.] I, pp. 106–107.*

Baudrighem, David *(c.1581–c.1650)*
 [M.] III, p. 136.
 Entries: 5 prints after. Paper fold
 measure.

 [W.] I, p. 66.
 Entries: 5 prints after.*

 [H. *Neth.*] I, p. 191.
 Entries: 5 prints after.*

Baudry, Paul Jacques Aimé *(1828–1886)*
 [Ber.] I, pp. 105–106.*

Bauer, ——— *(19th cent.)*
 [Dus.] p. 14.
 Entries: 2 (lithographs only, to 1821).
 Millimeters. Inscriptions. Located.

Bauer, Conrad
 See **Monogram CB** [Nagler, *Mon.*] I, nos.
 2294–2317

Bauer, Johann Balthasar *(1811–1883)*
 [M.] III, p. 143.
 Entries: 3+. Paper fold measure.

Bauer, Joseph Anton *(b. 1756)*
 [M.] III, p. 141.
 Entries: 3. Paper fold measure.

Bauer, M. J. *(19th cent.)*
 [Dus.] p. 14.
 Entries: 3 (lithographs only, to 1821).
 Millimeters. Inscriptions. Described.
 Located (selection).

Bauer, Marius Alexander Jacques
(1864–1932)
E. J. van Wisselingh en Co. *M. A. J. Bauer, geillustreerde catalogus van zijne etsen alle uitgegeven door E. J. van Wisselingh en Co.—M. A. J. Bauer, illustrated catalogue of his etchings all published by E. J. van Wisselingh and Co.* Amsterdam: E. J. van Wisselingh en Co., 1926.
 Entries: 212 (etchings only, to 1925?). Millimeters. Inches. Illustrated.

B[loemkolk], *W. M. A. J. Bauer; sijn etswerk* (his etched work). Amsterdam: E. J. van Wisselingh en Co., 1927.
 Entries: unnumbered, pp. 28–161, etchings only, to 1926. Millimeters. Inches. States. Illustrated. Prints are identified by publication numbers, but these are not sequential.

E. J. van Wisselingh en Co. *Supplement; de acht laatste door den kunstenaar vervaardigde, geteekende en genummerde etsen, waarvan er zes na zijn overlijden zijn verschenen/The eight latest etchings by Bauer, signed and numbered; six of these are published after his death.* Amsterdam: E. J. van Wisselingh en Co., 1933.
 Entries: 8 (additional to Bloemkolk 1927). Millimeters. Illustrated.

Bauer, Th. *(19th cent.)*
[Dus.] p. 14.
 Entries: 3 (lithographs only, to 1821). Inscriptions. Described.

Bauernfeind, Georg Wilhelm *(d. 1763)*
[M.] III, p. 157.
 Entries: 12. Paper fold measure.

Baugean, Jean Jerôme *(1764–1819)*
[M.] III, pp. 144–145.
 Entries: 20+. Paper fold measure.

[Ber.] I, p. 107.*

Baugin, Jean *(fl. 1640–1660)*
[M.] III, p. 145.
 Entries: 6+. Paper fold measure.

Baugniet, Charles *(1814–1886)*
[H. L.]pp. 62–64.
 Entries: 2 etchings. Millimeters. Inscriptions. Described. Also, list of 10+ lithographs (titles and dimensions only).

[M.] III, p. 146.
 Entries: 12. Paper fold measure.

[Ber.] I, pp. 107–108.*

Bauhaus [Staatliches Bauhaus] *(20th cent.)*
Peters, Heinz. *Die Bauhaus-Mappen "Neue europäische Graphik," 1921–23.* Cologne: Verlag Christoph Czwiklitzer, 1957.
 Entries: unnumbered, pp. 58–84, prints published by. Millimeters. Inscriptions. Illustrated.

Wingler, Hans. *Die kunstlerische Graphik des Bauhauses; die Mappenwerke "Neue europäische Graphik."* Mainz and Berlin: Florian Kupferberg, 1965. English edition: *Graphic Work from the Bauhaus.* London: Lund Humphries, 1969.
 Entries: unnumbered, pp. 142–165, prints published by. Millimeters. Inscriptions. Described. Illustrated.

Baujean, J. L., and M. *(17th cent.)*
[M.] III, p. 147.
 Entries: 4. Paper fold measure (selection).

Baulant, Alexandre *(d. 1896)*
[Ber.] I, p. 108.*

Baum, Johann Kaspar *(1813–1877)*
[Merlo] pp. 57–59.
 Entries: unnumbered, pp. 57–59. Paper fold measure (selection). Inscriptions (selection).

Baumann, Johann Wilhelm *(19th cent.)*
[M.] III, p. 148.
 Entries: 4. Paper fold measure. States.

Baumann, Philipp *(19th cent.)*
[M.] III, p. 148.
 Entries: 6. Paper fold measure.

Baumeister, Johann Sebald *(1777–1829)*
[M.] III, p. 149.
 Entries: 6+. Paper fold measure.

Baumeister, Johann Wilhelm *(1804–1846)*
[M.] III, p. 149.
 Entries: 2+. Paper fold measure.

Baumeister, Willi *(b. 1889)*
Spielmann, Heinz. "Willi Baumeister;
das graphische Werk." *Jahrbuch der
Hamburger Kunstsammlungen* 8 (1963):
85–106; *Jahrbuch* 10 (1965): 113–162;
Jahrbuch 11 (1966): 119–156.
 Entries: 213 prints by, 3 prints after by
 Hap Grieshaber; 104 commercial
 graphics and reproductions.
 Millimeters. States. Described.
 Illustrated.

Baumgarten, Fr. *(19th cent.)*
[M.] III, p. 150
 Entries: 5+. Paper fold measure.

Baumgartner, Johann Georg *(17th cent.)*
[M.] III, pp. 150–151.
 Entries: 3. Paper fold measure (selec-
 tion).

Baumgartner, Johann Jakob *(fl. c.1720)*
[M.] III, p. 151.
 Entries: 4+ prints by, 7+ after. Paper
 fold measure. Inscriptions (selection).

Baumgartner, Johann Wolfgang
(1712–1761)
[M.] III, p. 151.
 Entries: 1+ print by, 14+ after. Milli-
 meters (selection). Paper fold measure
 (selection).

Baur, Johann Wilhelm *(fl. 1630–1641)*
[M.] III, pp. 152–155.

Entries: 44+ prints by, 14+ after.
Paper fold measure. Inscriptions
(selection). States.

[H. *Ger.*] II, pp. 160–162.
 Entries: 44+ prints by, 9 after. Illus-
 trated (selection).*

Bause, Johann Friedrich *(1738–1814)*
[Bause, J. F., or Crayen, A. (Leipzig col-
lector)]. *Verzeichniss des Kupferstichwerks
vom Herrn Johann Friedrich Bause, Mit-
gliede der Kurfurstl. Sächsischen Akademie
der bildenden Künste zu Dresden und Leip-
zig.* Leipzig, 1786. (EBKk)
 Entries: 154 (to 1785).

Keil, Georg. *Katalog des Kupferstichwerkes
von Johann Friedrich Bause.* Leipzig: Ru-
dolph Weigel, 1849. 200 copies. (MH)
 Entries: 247. Millimeters. Inscrip-
 tions. States. Described.

[Ap.] pp. 39–45.
 Entries: 82.*

[Wess.] I, pp. 123–124.
 Entries: 1 (additional to Keil). Millime-
 ters. Inscriptions. Described.

[M.] III, pp. 158–166.
 Entries: 255 (appendix with 6 doubtful
 prints). Millimeters (selection). Paper
 fold measure (selection). Inscriptions.
 States. Described. Based on Keil, with
 additions.

Bause, Juliane Wilhelmine *(1768–1837)*
Keil, Georg. *Catalog des Kupferstichwerkes
von Johann Friedrich Bause.* Leipzig: Ru-
dolph Weigel, 1849. 200 copies. (MH)
 Entries: 10. Millimeters. Inscriptions.
 States. Described.

[M.] III, p. 166.
 Entries: 10. Paper fold measure.
 States.

Bausset, Marquis de *(18th cent.)*
[M.] III, p. 167.
 Entries: 1. Paper fold measure.

Baux, Julius Raimond de *(19th cent.)*
[Dus.] pp. 14–15.
 Entries: 2 (lithographs only, to 1821).
 Paper fold measure.

Baux, B. Raymond de *(fl. 1810–1860)*
[M.] III, p. 167.
 Entries: 3. Paper fold measure.

Bawtree, W. *(18th cent.)*
[M.] III, p. 167.
 Entries: 1.

Baxter, George *(1804–1867)*
Bullock, Charles F. *Life of George Baxter,
engraver, artist and colour printer, together
with a priced list of his works.* Birmingham
(England): Charles F. Bullock, 1901.
(EBM)
 Entries: 253+. Inches. Described.

Courtney Lewis, C. T. *George Baxter
(colour printer) his life and work.* London:
Sampson Low, Marston and Company
Ltd., 1908.
 Entries: 376 prints, 111 illustrated
 books, 19 sheets of music. Inches. In-
 scriptions. States. Described.

Courtney Lewis, C. T. *The picture printer
of the nineteenth century, George Baxter
[1804–1867].* London: Sampson Low,
Marston and Company Ltd., 1911.
 Entries: 377. Inches. Inscriptions
 (selection). States. Described (selec-
 tion). Illustrated (selection).

Courtney Lewis, C. T. *The Baxter year
book, 1912.* London: Sampson Low,
Marston and Company Ltd., 1913.
(EBM)
 Additional information to Courtney
 Lewis 1911.

Clarke, H. G. *Baxter colour prints picto-
rially presented.* London: Maggs Bros.,
1920–1921.
 Entries: 136 (prints "issued on stamp
 mounts" only). Inches. Inscriptions.

States. Described. Illustrated. Ap-
 pendix with 15 additional "prints on
 stamp mounts," not fully catalogued.

Courtney Lewis, C. T. *George Baxter, the
picture printer.* London: Sampson Low,
Marston and Company Ltd., 1924. 1000
copies.
 Entries: 377 single prints, 122 books
 and 21 music sheets containing prints;
 color prints only. Inches. Inscriptions.
 States. Described. Illustrated (selec-
 tion).

Clarke, Harold George, and Rylatt, J. H.
*The centenary Baxter book, being an appreci-
ation of George Baxter . . . together with a
catalogue résumé of his Works.* Royal
Leamington Spa (England): At the Sign
of the Dove with the Griffin, 1936. 125
copies. (NN)
 Entries: 371. Inches. States. De-
 scribed. Illustrated (selection).

Bayard, Émile Antoine *(1837–1891)*
[Ber.] I, pp. 108–110.*

Bayard, Marc Henry *(19th cent.)*
[M.] III, p. 168.
 Entries: 25. Paper fold measure.

Bayard, Paul *(17th cent.)*
[M.] III, p. 168.
 Entries: 4. Paper fold measure (selec-
 tion). Inscriptions (selection).

Bayer, ———— *(19th cent.)*
[Dus.] p. 15.
 Entries: 4 (lithographs only, to 1821).
 Located.

Bayer, Hieronymus von *(1792–1876)*
[M.] III, p. 169.
 Entries: 27. Paper fold measure.

Bayeu y Subias, D. Francisco *(1734–1795)*
[M.] III, pp. 170–171.
 Entries: 1 print by, 5 after.

Bayeu y Subias, D. Ramon *(1746–1793)*
[M.] III, p. 171
　Entries: 13. Paper fold measure.

Bayly, J. *(18th cent.)*
[M.] III, pp. 171–172.
　Entries: 3+ . Paper fold measure
　(selection).

Bayot, Adolphe Jean Baptiste *(b. 1810)*
[Ber.] I, p. 110.*

Bayros, Franz von *(1866–1924)*
Hays, William R. A., and Prescott,
Winward. *The book-plate work of the Mar-
quis von Bayros.* Boston (Mass.): Privately
printed, 1913. 25 copies. (DLC)
　Entries: unnumbered, pp. 15–20
　(bookplates only, to 1913). Illustrated
　(selection).

Brettschneider, Rudolf. *Franz von Bay-
ros, Bibliographie seiner Werke und bes-
chreibendes Verzeichnis seiner Exlibris.*
Leipzig: Adolf Weigel, 1926.
　Entries: 312 (bookplates only, to
　1926?). Millimeters. Inscriptions. De-
　scribed. Also, bibliography of books
　illustrated by.

Bazel, Karel P. C. de *(1869–1923)*
Reinink, Adriaan Wessel. *K. P. C. de
Bazel—architect.* Doctoral dissertation,
University of Leiden. Leiden (Nether-
lands): Universitaire Pers, 1965.
　Entries: 103. Millimeters. States. Illus-
　trated (selection).

Bazicaluva, Ercole *(fl. c.1640)*
[B.] XX, pp. 69–73.
　Entries: 7. Pre-metric. Inscriptions.
　Described. Appendix with 12 prints
　not seen by [B.].

[Wess.] III, p. 44.
　Entries: 1 (additional to [B.]). Paper
　fold measure. States.

[M.] III, pp. 230–231.

Entries: 10+ prints by, 3+ doubtful
prints. Millimeters (selection). Paper
fold measure (selection). Inscriptions
(selection).

Bazin, Charles Louis *(1802–1859)*
[M.] III, pp. 175–176.
　Entries: 8+ . Paper fold measure.

[Ber.] I, pp. 110–111.*

Bazin, Nicolas *(1633–1710)*
[M.] III, pp. 172–175.
　Entries: 176. Paper fold measure.
　States.

[CdB.] pp. 75–80.
　Entries: 39 (profane subjects only).
　Based on [Lebl.] with 2 additions.

Bazin, Pierre Joseph *(1797–1866)*
[M.] III, p. 175.
　Entries: 1.

Bazquez, J. *(18th cent.)*
[M.] III, p. 176.
　Entries: 1. Paper fold measure.

Beale, B. *(18th cent.)*
[M.] III, pp. 231–232.
　Entries: 1. Paper fold measure.

Beard, Thomas *(18th cent.)*
[M.] III, p. 232.
　Entries: 8. Paper fold measure (selec-
　tion). States.

[Sm.] I, pp. 17–19, and "additions and
corrections" section.
　Entries: 7 (portraits only). Inches. In-
　scriptions. States. Described.

[Ru.] p. 9.
　Entries: 1 (portraits only, additional to
　[Sm.]). Inscriptions. Described. Addi-
　tional information to [Sm.].

Beatrizet, Nicolaus *(fl. 1540–1565)*
[B.] XV, pp. 237–272.

Beatrizet, Nicolaus *(continued)*

Entries: 108. Pre-metric. Inscriptions. States. Described. Copies mentioned.

[Heller] pp. 17–18.
Additional information to [B.].

[P.] VI, pp. 117–121.
Entries: 12 (additional to [B.]). Millimeters. Inscriptions. Described. Additional information to [B.].

[RD.] IX, pp. 131–179; XI, p. 8.
Entries: 114. Millimeters. Inscriptions. States. Described.

[Wess.] III, p. 44.
Entries: 1 (additional to [B.]). Paper fold measure. States. Additional information to [B.]).

[M.] III, pp. 234–239.
Entries: 118 prints by, 34 doubtful and rejected prints. Paper fold measure. Inscriptions. States. Described.

Disertori, Benvenuto. "Rami cinquecenteschi alla R. Calcografia (Notizia aggiunta al vol. XV del Bartsch)." *Bibliofilia* 34 (1932): 302–315.
Additional information to [B.].

Musée de Lunéville. *Nicolas Béatrizet, un graveur lorrain à Rome au XVIe siècle.* Lunéville (France), 1970. (EPBN)
Entries: 2 (additional to [RD.]) Millimeters. Inscriptions. Described.

Beau, Emile *(b. 1810)*
[M.] III, p. 239.
Entries: 6+.

Beaublé, ——— *(19th cent.)*
[M.] III, p. 239.
Entries: 6. Paper fold measure (selection).

[Ber.] I, p. 111.*

Beaubrun, Louis *(fl. 1609–1627)*
[RD.] VI, pp. 147–148; XI, p. 16.

Entries: 2. Millimeters. Inscriptions. Described.

[M.] III, p. 239.
Entries: 2. Paper fold measure. Inscriptions.

Beaucé, Vivant *(1818–1876)*
[Ber.] I, p. 111.*

Beauchamp, ——— *(19th cent.)*
[Ber.] I, p. 111.*

Beaucourt, ——— *(1824–c.1850)*
[M.] III, p. 241.
Entries: 1. Paper fold measure.

Beaufort, ——— *(fl. c.1685)*
[M.] III, p. 241.
Entries: 1. Paper fold measure.

Beaufrère, P. *(fl. 1661–1685)*
[M.] III, p. 241.
Entries: 8. Paper fold measure.

Beaugrand, Achille Victor *(1819–1860)*
[Ap.] p. 45.
Entries: 2.*

[M.] III, p. 241.
Entries: 2. Paper fold measure.

[Ber.] I, p. 112.
Entries: 2. Paper fold measure (selection).

Beaujoint, Alphonse *(19th cent.)*
[M.] III, p. 242.
Entries: 2. Paper fold measure.

Beaulieu, Jean Allais de *(fl. c.1680)*
[M.] III, p. 242.
Entries: 1. Paper fold measure. Inscriptions.

Beaumont, ——— de *(b. 1747)*
[M.] III, p. 245.
Entries: 4. Paper fold measure.

Beaumont, Édouard de *(1821–1888)*
[Ber.] I, pp. 112–114.*

Beaumont, Pierre François *(1719–1769)*
[M.] III, pp. 244–245.
 Entries: 29. Paper fold measure.

Beauplet, F. *(fl. 1630–1650)*
[M.] III, p. 247.
 Entries: 3. Paper fold measure.

Beaurencontre, —— *(fl. c.1698)*
[M.] III, p. 247.
 Entries: 1.

Beauvais, Charles de *(c.1730–1783)*
[M.] III, p. 248.
 Entries: 4+. Paper fold measure.

Beauvais, Jacques *(d. 1802)*
[M.] III, pp. 248–249.
 Entries: 3 prints by, 1 after.

Beauvais, Nicolas Dauphin de
(c.1687–1763)
 [M.] III, p. 248.
 Entries: 32+. Paper fold measure
 (selection).

Beauvais, Simon de *(fl. 1761–1778)*
[M.] III, p. 248.
 Entries: 3. Paper fold measure.

Beauvarlet, Catharine Françoise
(1737–1769)
 [M.] III, pp. 252–253.
 Entries: 12+. Paper fold measure
 (selection).

Beauvarlet, Jacques Firmin *(1731–1797)*
Dairaine (l'abbé). "Catalogue de
l'oeuvre de Jacques-Firmin Beauvarlet
d'Abbéville." [*Mém. Abbéville*] 1857–
1860, pp. 573–587. Separately pub-
lished. Abbéville (France): P. Briez,
1860.
 Entries: 135. Millimeters (selection).
 Located (selection).

[Ap.] pp. 45–48.
 Entries: 45.*

[M.] III, pp. 249–252.
 Entries: 133. Paper fold measure.
 States.

[L. D.] pp. 3–5.
 Entries: 6. Millimeters. Inscriptions.
 States. Described. Incomplete cata-
 logue.*

Beauvarlet, Marie Catherine *(b. 1755)*
 [M.] III, p. 253.
 Entries: 2. Paper fold measure. States.

Beauverie, Charles Joseph *(1839–1924)*
[Ber.] I, p. 114.*

Bécar, Pierre Louis *(b. 1812)*
[M.] III, p. 254.
 Entries: 4.

Beccafumi, Domenico *(1486–1551)*
[B.] XII: *See* **Chiaroscuro Woodcuts**

[P.] VI, pp. 149–152.
 Entries: 4 etchings, 19 woodcuts.
 Pre-metric. Inscriptions. Described.

[M.] III, pp. 254–258.
 Entries: 16 prints by, 35 after. Millime-
 ters (selection). Paper fold measure
 (selection). Described (selection).

Sanminiatelli, Donato. *Domenico Becca-
fumi.* Milan: Bramante Editrice, 1967.
 Entries: 12 prints by, 2 rejected prints.
 Millimeters. Described. Illustrated
 (selection). Located.

Becceni, Pietro *(1755–1829)*
[Ap.] p. 48.
 Entries: 3.*

[M.] III, p. 259.
 Entries: 5. Paper fold measure. States.

Bechellier, —— *(fl. 1640–1650)*
[M.] III, p. 262.
 Entries: 1. Paper fold measure.

Bechet, ———— *(17th cent.)*
[M.] III, p. 262.
Entries: 5. Paper fold measure.

Bechstein, Ludwig *(b. 1843)*
[M.] III, pp. 262–263.
Entries: 3 prints by, 1 after. Paper fold measure.

Bechtholt, Johannes *(fl. c.1575)*
See **Monogram BI** [Nagler, *Mon.*] I, no. 1888

Beck, A. v. d. *(18th cent.)*
[M.] III, p. 264.
Entries: 1. Paper fold measure.

Beck, August *(1823–1872)*
[M.] III, p. 264.
Entries: 3+ . Paper fold measure.

Beck, David *(1621?–1656)*
[W.] I, p. 67.
Entries: 8+ prints after.*

[H. *Neth.*] I, pp. 191–192.
Entries: 16 prints after.*

Beck, Friedrich *(19th cent.)*
[Dus.] p. 15.
Entries: 1 (lithographs only, to 1821). Inscriptions.

Beck, J. M. *(fl. c.1748)*
[M.] III, p. 263.
Entries: 1. Paper fold measure. Inscriptions.

Beck, Johann Georg *(1676–c.1722)*
[M.] III, p. 535.
Entries: 20. Paper fold measure.

Beck, Leonhard *(c.1480–1542)*
[Ge.] nos. 133–142.
Entries: 10 (single-sheet woodcuts only). Described. Illustrated. Located.

[H. *Ger.*] II, pp. 163–172.
Entries: 28+ . Illustrated (selection).*

Beck, Tobias Gabriel *(18th cent.)*
[M.] III, p. 263.
Entries: 3 (additional to [Heinecken] and [Lebl.] Paper fold measure. Inscriptions (selection).

Beckenkam, P. *(19th cent.)*
[M.] III, pp. 264–265.
Entries: 8. Paper fold measure. States.

Beckenkamp, Kaspar Benedikt *(1747–1828)*
[M.] III, p. 265.
Entries: 1 print by, 12 after. Paper fold measure. Inscriptions (selection). Described (selection).

[Merlo] pp. 59–62.
Entries: 13 prints by and after. Paper fold measure. Inscriptions. Described.

Beckenkamp, Peter *(b. 1747)*
[M.] III, p. 265.
Entries: 5. Paper fold measure. Inscriptions.

[Merlo] pp. 62–63.
Entries: 7. Paper fold measure. Inscriptions.

Becker, Alexander *(1828–1877)*
[Ap.] p. 49.
Entries: 2.*

[M.] III, pp. 269–270.
Entries: 6. Paper fold measure.

Becker, Charles *(17th cent.)*
[M.] III, p. 266.
Entries: 4+ . Paper fold measure (selection).

Becker, Christian *(1809–1885)*
[M.] III, p. 267.
Entries: 8+ . Paper fold measure.

Becker, Hugo [Ludwig] *(1833–1868)*
[M.] III, pp. 270–271.
Entries: 3. Paper fold measure.

Becker, Jakob *(1810–1872)*
[M.] III, pp. 267–268.
Entries: 6 prints by, 9 after. Paper fold measure.

Becker, Johann Wilhelm *(1744–1782)*
[M.] III, pp. 266–267.
Entries: 12. Paper fold measure. Inscriptions (selection).

Becker, Karl *(1827–1891)*
[Ap.] p. 49.
Entries: 3.*

[M.] III, p. 270.
Entries: 11. Paper fold measure (selection).

Becker, Karl Leonhard *(b. 1843)*
[M.] III, p. 271.
Entries: 5. Paper fold measure.

Becker, Léon *(1826–1909)*
[H. L.] pp. 64–65.
Entries: 2. Millimeters. Inscriptions. Described.

[M.] III, p. 271.
Entries: 2 prints by, 1 after. Paper fold measure. Described.

Becker, Peter *(1828–1904)*
[M.] III, p. 269.
Entries: 3. Paper fold measure (selection). States.

Becker, Philipp Jakob *(1759–1829)*
[Dus.] pp. 15–16.
Entries: 27 (lithographs only, to 1821). Millimeters. Located.

Beckers, J. H. (19th cent.)
[Dus.] p. 16.
Entries: 1 (lithographs only, to 1821).

Beckett, Isaak *(1653–1715/19)*
[M.] III, pp. 272–274.
Entries: 134. Paper fold measure.

[Sm.] I, pp. 20–54, and "additions and corrections" section; IV, "additions and corrections" section.
Entries: 108 (portraits only). Inches. Inscriptions. States. Described. Illustrated (selection). Located (selection).

[Ru.] pp. 10–15, 489.
Entries: 4 (portraits only, additional to [Sm.]). Inches. Inscriptions. States. Described. Additional information to [Sm.].

Beckit, Robert *(fl. c.1598)*
[Hind, *Engl.*] I, pp. 221–222.
Entries: 1+ . Inches. Inscriptions. Described. Located.

Beckmann, Max *(1884–1950)*
Glaser, Curt et al. *Max Beckmann.* Munich: R. Piper und Co., 1924.
Entries: 240 (to 1923). Illustrated (selection).

Badischer Kunstverein, Karlsruhe [K. Gallwitz, compiler]. *Max Beckmann, die Druckgraphik; Radierungen, Lithographien, Holzschnitte.* Karlsruhe (West Germany), 1962.
Entries: 305. Millimeters. Inscriptions. States. Illustrated. Located. Papers described, edition sizes given.

Jannasch, Adolf. *Max Beckmann als Illustrator.* Neu Isenburg (West Germany): Wolfgang Tiessen, 1969.
Bibliography of books with illustrations by.

Beckwith, Henry *(fl. 1830–1843)*
[M.] III p. 275.
Entries: 7. Paper fold measure.

Becx, Jaspar *(d. 1657)*
[H. *Neth.*] I, p. 192.
Entries: 1 print after.*

Bedet, C. M. *(fl. c.1761)*
[M.] III, p. 276.
Entries: 1+ .

Bedetti, R. *(19th cent.)*
[Ap.] p. 49.
 Entries: 2.*

[M.] III, p. 276.
 Entries: 6. Paper fold measure. Inscriptions.

Beecq, Jan Karel Dominicus van *(1638–1722)*
[W.] I, p. 68.
 Entries: 6 prints after.*

[H. *Neth.*] I, p. 192.
 Entries: 1+ prints after.*

Beeger, M. *(19th cent.)*
[M.] III, p. 279.
 Entries: 1. Paper fold measure. Inscriptions.

Beek, A. van der *(fl. c.1800)*
[M.] III, p. 280.
 Entries: 1. Paper fold measure. Inscriptions.

Beek, Anna *(fl. c.1700)*
[M.] III, p. 279.
 Entries: 4+. Paper fold measure.

Beek, J. L. van der *(fl. 1782–1814)*
[M.] III, p. 279.
 Entries: 2. Paper fold measure.

Beek, P. van der *(fl. c.1800)*
[M.] III, p. 280.
 Entries: 1. Paper fold measure.

Been, G. van *(fl. c.1640)*
[M.] III, p. 281.
 Entries: 3. Paper fold measure.

Beer, Johann Friedrich *(1741–1804)*
[M.] III, p. 284.
 Entries: 8 prints by, 2 after. Paper fold measure.

Beer, Johann Peter *(1782–1851)*
[M.] III, p. 284.
 Entries: 1. Paper fold measure.

Beer, Maria Eugenia de *(fl. c.1643)*
[M.] III, p. 283.
 Entries: 4+.

Beeresteijn, Claes van *(1627–1684)*
[vdK.] pp. 124–128.
 Entries: 8. Millimeters. Inscriptions. Described. Appendix with rejected prints.

[M.] III, p. 285.
 Entries: 4. Paper fold measure. Inscriptions.

[W.] I, p. 70.
 Entries: 8.*

[H. *Neth.*] I, pp. 193–201.
 Entries: 9. Illustrated.*

Beerstraten, Jan Abrahamsz *(1622–1666)*
[W.] I, p. 72.
 Entries: 2 prints by, 1 after.*

[H. *Neth.*] I, p. 202.
 Entries: 2 prints by, 17 after.*

Bega, Cornelis Pietersz *(1620–1664)*
[B.] V, pp. 223–243.
 Entries: 36. Pre-metric. Inscriptions. States. Described.

[Heller] pp. 18–19.
 Additional information to [B.].

[Weigel] pp. 281–293.
 Entries: 2 (additional to [B.]). Pre-metric. Inscriptions. States. Described.

[Dut.] IV, pp. 18–28; V, p. 585.
 Entries: 38. Millimeters. Inscriptions. States. Described.

[M.] III, pp. 290–295.
 Entries: 35 prints by, 4 doubtful prints, 36 prints after. Paper fold measure. States.

[W.] I, p. 73.
 Entries: 39 prints by, 27+ after.*

[H. *Neth.*] I, pp. 203–233.

Entries: 40 prints by, 36+ after. Illustrated (selection).*

Begas, Adalbert *(1836–1888)*
[M.] III, pp. 303–306.
Entries: 7. Paper fold measure.

Begas, Karl *(1794–1854)*
[M.] III, pp. 300–302.
Entries: 37 prints after. Paper fold measure.

Begas, Oskar *(1828–1883)*
[M.] III, pp. 302–303.
Entries: 1 print by, 4 after. Paper fold measure. Inscriptions (selection).

Begeijn, Abraham Cornelisz
(1630/37–1697)
[vdK.] p. 13–16.
Entries: 6. Millimeters. Inscriptions. Described.

[M.] III, pp. 307–308.
Entries: 10 prints by, 2 after. Paper fold measure.

[W.] I, p. 75.
Entries: 10 prints by, 2 after.*

[H. *Neth.*] I, pp. 234–242.
Entries: 11 prints by, 2 after. Illustrated (selection).*

Beger, Lorenz *(1663–1735)*
[M.] III, p. 308.
Entries: 14+ . Paper fold measure (selection).

Beggrov, Ivan Petrovich *(1793-1877)*
[M.] III, pp. 308–309.
Entries: 7+ .

Beham, Barthel *(1502–1540)*
[B.] VIII, pp. 81–112.
Entries: 64. Pre-metric. Inscriptions. States. Described. Copies mentioned.

[Heller] pp. 20–21.
Additional information to [B.].

[P.] IV, pp. 68–72.
Entries: 15+ (additional to [B.]). Pre-metric. Inscriptions. States. Described. Located. Appendix with 1 print not seen by [P.]. Additional information to [B.]. Copies mentioned.

Rosenberg, Adolf. *Sebald und Barthel Beham, zwei Maler der deutschen Renaissance.* Leipzig: E. A. Seemann, 1875.
Entries: 92 (etchings and engravings only). Millimeters. Inscriptions. States. Described. Copies mentioned.

Aumüller, Edouard. *Les petits maîtres allemands, I: Barthélemy et Hans Sebald Beham.* Munich: Librairie de l'Université M. Rieger, 1881.
Entries: 104. Millimeters. Inscriptions. States. Described. Copies mentioned.

[Wess.] I, pp. 124–125.
Additional information to [B.] and [P.].

[M.] III, pp. 311–317.
Entries: 90 prints by; 14 doubtful and rejected prints. Paper fold measure. States. Described (selection).

Pauli, Gustav. "Barthel Beham in seiner kunstlerischen Entwicklung." [MGvK.] 1905, pp. 41–49.
Entries: 6 (additional to [B.] and [M.]). Millimeters. Described. Illustrated. Located.

Pauli, Gustav. *Barthel Beham: ein kritisches Verzeichnis seiner Kupferstiche.* Studien zur deutschen Kunstgeschichte, 135. Strasbourg: J. H. Ed. Heitz, 1911.
Entries: 94 (engravings only). 48 doubtful prints (engravings). Millimeters. Inscriptions. States. Described. Located. Copies mentioned.

Röttinger, Heinrich. *Die Holzschnitte Barthel Behams.* Studien zur deutschen

Beham, Barthel *(continued)*

Kunstgeschichte, 218. Strasbourg: J. H. Ed. Heitz, 1921.
 Entries: 13+ (woodcuts only). Millimeters. Inscriptions. States. Described. Illustrated (selection). Located.

[Ge] nos. 143–162.
 Entries: 10 (single-sheet woodcuts only). Described. Illustrated. Located.

[H. *Ger.*] II, pp. 173–252.
 Entries: 132 engravings, 15+ woodcuts. Illustrated (selection).*

Muller, Jean. *Barthel Beham, kritischer Katalog seiner Kupferstiche, Radierungen, Holzschnitte.* Studien zur deutschen Kunstgeschichte, 318. Baden-Baden and Strasbourg: Verlag Heitz, 1958.
 Entries: 132. Millimeters. Inscriptions. States. Described. Illustrated. Located. Copies mentioned.

Beham, Hans "Sebald" *(1500–1550)*
[Hüsgen] pp. 31–65.
 Entries: 257 prints by, 9 after. Inscriptions. Described. Based on [Heinecken].

[B.] VIII, pp. 112–249.
 Entries: 259 engravings, 171 woodcuts, 5+ rejected prints. Pre-metric. Inscriptions. States. Described. Copies mentioned.

[Heller] p. 21.
 Entries: 1 (additional to [B.]). Premetric. Inscriptions. Described. Additional information to [B.].

[Evans] p. 24.
 Entries: 1 (additional to [B.]). Millimeters. Inscriptions. Described.

[P.] IV, pp. 72–86.
 Entries: 11+ engravings and etchings, 36+ woodcuts (additional to [B.]). Pre-metric. Inscriptions. States. Described. Located. Additional information to [B.]. Copies mentioned.

Rosenberg, Adolf. *Sebald und Barthel Beham; zwei Maler der deutschen Renaissance.* Leipzig: E. A. Seemann, 1875.
 Entries: 271 engravings, 21 doubtful and rejected engravings, 282 woodcuts, 37 doubtful and rejected woodcuts. Millimeters. Inscriptions. States. Described. Copies mentioned.

Loftie, W. J. *Catalogue of the prints and etchings of Hans Sebald Beham, painter, of Nuremberg, citizen of Frankfort, 1500–1550.* London: Mrs. Noseda, 1877. 100 copies. (CSmH)
 Entries: 312. Inches. Inscriptions. States. Described. Located (selection).

Aumüller, Edouard. *Les petits maîtres allemands, I: Barthélemy et Hans Sebald Beham.* Munich: Librairie de l'Université M. Rieger, 1881.
 Entries: 285 engravings, 311 woodcuts. Millimeters. Inscriptions. States. Described.

[Wess.] I, pp. 125–130.
 Entries: 3 (additional to [B.], [P.] and Rosenberg). Millimeters. Inscriptions. Described.

Rosenthal, Ludwig. "Hans Sebald Beham's alttestamentarische Holzschnitte und deren Verwendung zur Bücher-Illustration 1529–1612." [*Rep. Kw.*] 5 (1882): 379–405.
 Discussion of editions of Beham's biblical woodcuts; description of 63 different editions, 14 sets of copies. Concordance of illustrations published in 1534 Bible with those in *Biblische Historien* of 1536.

Seibt, G. K. Wilhelm. *Hans Sebald Beham.* Studien zur Kunst und Culturgeschichte, 1. Frankfurt am Main: Heinrich Keller, 1882.

Additional information to [B.], [P.] and Rosenberg.

Seidlitz, W. von. "Das Kupferstich- und Holzschnittwerk des Hans Sebald Beham." [JprK.] 3 (1882): 149–159, 225–235.
Additional information to [B.].

[M.] III, pp. 318–334.
Entries: 288 prints by; 31 doubtful and rejected prints. Paper fold measure. Inscriptions (selection). States. Described (selection).

Kristeller, Paul. "Notiz." [JprK.] 12 (1891): 222–223.
Entries: 2 woodcuts (additional to earlier catalogues). Described. Illustrated.

Pauli, Gustav: "Die Radierungen Hans Sebald Behams." [JprK.] 18 (1897): 46–58.
Entries: 18 (etchings only). Illustrated (selection). Located.

Pauli, Gustav. *Hans Sebald Beham: ein kritisches Verzeichniss seiner Kupferstiche, Radierungen und Holzschnitte.* Studien aur deutschen Kunstgeschichte, 33. Strasbourg: J. H. Ed. Heitz, 1901. Supplement. *Hans Sebald Beham; Nachträge zu dem kritischen Verzeichnis seiner Kupferstiche, Radierungen und Holzschnitte.* Studien zur deutschen Kunstgeschichte, 134. Strasbourg: J. H. Ed. Heitz, 1911.
Entries: 1355 (also 146 doubtful prints). Millimeters. Inscriptions. States. Described. Located. Copies mentioned.

Pauli, Gustav. "Eine Kaltnadelradierung von Hans Sebald Beham." [JprK.] 30 (1909): 220.
Entries: 1. States. Illustrated. Additional information to [B.] and [M.].

Röttinger, Heinrich. *Ergänzungen und Berichtigungen des Sebald-Beham-Kataloges Gustav Paulis.* Studien zur deutschen Kunstgeschichte, 246. Strasbourg: J. H. Ed. Heitz, 1927.
Additional information to Pauli.

[Ge.] nos. 163–349.
Entries: 187 (single-sheet woodcuts only). Described. Illustrated. Located.

[H. *Ger.*] III, pp. 1–302.
Entries: 1648 prints by, 220 after. Illustrated (selection).*

Beheim, Johann *(fl. 1762–1770)*
[M.] III, pp. 334–335.
Entries: 11. Paper fold measure.

Behmer, Marcus *(b. 1879)*
Halbey, Hans Adolf. *Marcus Behmer als Illustrator.* Monographien und Materialien zur Buchkunst, 4. Neu Isenburg (West Germany): Wolfgang Tiessen, 1970.
Bibliography of books with illustrations by.

Behringer, Joseph *(19th cent.)*
[M.] III, p. 337.
Entries: 1.

[Dus.] p. 16.
Entries: 1 (lithographs only, to 1821). Inscriptions.

Beich, Joachim Franz *(1665–1748)*
[A.] V, pp. 294–307.
Entries: 16. Pre-metric. Inscriptions. States. Described.

[M.] III, pp. 337–338.
Entries: 5+ prints by, 5+ after. Millimeters. Inscriptions.

Beichling, Hermann *(19th cent.)*
[M.] III, p. 338.
Entries: 1. Paper fold measure. Described.

Beichling, Karl *(1803–1876)*
[M.] III, p. 338.
Entries: 4+ . Paper fold measure.

Bein, Jean *(1789–1857)*
[Ap.] pp. 49–50.
Entries: 5.*

Bein, Jean *(continued)*

[M.] III, pp. 340–341.
Entries: 39+. Paper fold measure.
States.

[Ber.] I, pp. 114–116.*

Beinaschi, Giovanni Battista *(1636–1688)*
[B.] XXI, pp. 108–209.
Entries: 1. Pre-metric. Inscriptions.
Described.

[M.] III, p. 497.
Entries: 1+. Millimeters?. Inscriptions. States.

Beischlag, Johann Christoph *(1645–1712)*
[H. *Ger.*] IV, p. 1.
Entries: 1 print by, 21 after. Illustrated
(selection).*

Beisson, François Joseph Étienne
(1759–1820)
[Ap.] p. 50.
Entries: 11.*

[M.] III, pp. 343–344.
Entries: 28. Paper fold measure.
States.

[Ber.] I, pp. 116–117.*

Béjot, Eugène *(1867–1931)*
Laran, Jean. *L'Oeuvre gravé d'Eugène
Béjot.* Paris: Éditions des Bibliothèques
Nationales de France, 1937. 350 copies.
Entries: 437. Millimeters. Inscriptions. States. Described. Illustrated
(selection). Located.

Belaume, J. *(fl. c.1825)*
[F.] p. 60.*

Belbrule, Théodore *(fl. c.1580)*
[M.] III, p. 346.
Entries: 3+. Paper fold measure.

Belemo, Antonio *(18th cent.)*
[P.] VI, p. 237, no. 71.

Entries: 1. Pre-metric. Inscriptions.
Described.

[M.] III, p. 346.
Entries: 7. Paper fold measure (selection). Inscriptions (selection).

Beleske, ——— *(19th cent.)*
[Dus.] p. 16.
Entries: 1 (lithographs only, to 1821).

Belgramo, Giovanni Maria
(fl. 1665–1680)
[M.] III, p. 347.
Entries: 2.

Belhatte, Alexandre Nicolas *(b. 1811)*
[Ber.] I, p. 117.*

Belin, L. G. *(19th cent.)*
[M.] III, p. 349.
Entries: 1. Paper fold measure. Inscriptions. Described.

Belin, Nicolaus *(fl. c.1684)*
[M.] III, p. 348.
Entries: 1+. Paper fold measure.

Beljambe, Pierre Guillaume Alexandre
(1759–c.1820)
[M.] III, p. 349.
Entries: 26. Paper fold measure.

Bell, Alexander *(fl. 1750–1780)*
[Sm.] I, p. 55.
Entries: 1 (portraits only). Inches. Inscriptions. Described.

[M.] III, p. 350.
Entries: 4.

Bell, Edward *(fl. 1794–1847)*
[Sm.] I, pp. 55–60, and "additions and
corrections" section.
Entries: 20 (portraits only). Inches.
Inscriptions. States. Described.

[M.] III, p. 350.
Entries: 21. Paper fold measure.

[Siltzer] p. 346.
Entries: unnumbered, p. 346. Inscriptions.

[Ru.] pp. 15–17, 489.
Entries: 1 (portraits only, additional to [Sm.]). Inches. Inscriptions. Described. Additional information to [Sm.].

Bell, John *(1811–1895)*
[M.] III, p. 351.
Entries: 6 prints by, 2 after. Paper fold measure.

Bell, Robert Charles *(1806–1872)*
[M.] III, p. 351.
Entries: 12. Paper fold measure. States.

Bella, Giovanni della *(1802–after 1870)*
[Ap.] p. 110.
Entries: 4.*

[M.] III, p. 358.
Entries: 4. Paper fold measure. States.

Bella, Stefano della *(1610–1664)*
Jombert, Charles-Antoine. *Essai d'un catalogue de l'oeuvre d'Étienne de la Belle peintre et graveur florentin disposé par ordre historique.* Paris: Published by the author, 1772.
Entries: 228+ prints by, 1+ after. Pre-metric. Inscriptions (selection). Described.

[M.] III, pp. 352–358.
Entries: 227+ prints by, 5+ doubtful prints, 36+ prints after. Paper fold measure.

[Vesme] pp. 66–332.
Entries: 1158 prints by and after. Millimeters. Inscriptions. States. Described. Located (selection). Appendix with 188 doubtful and rejected prints.

Massar, Phyllis Dearborn. *Stefano della Bella.* 2 vols. New York: Collectors' Editions, 1971.
Entries: 1158. Millimeters. Inscriptions. States. Described. Illustrated. Reprint of [Vesme] with extensive additional information, and a volume of plates.

Bellangé, Hippolyte *(1800–1866)*
Adeline, Jules. *Hippolyte Bellangé et son oeuvre.* Paris: A. Quantin, 1880.
Entries: 488 prints by (lithographs only), 41 prints after, 16 books with prints after. Millimeters. Inscriptions.

[M.] III, pp. 361–362.
Entries: 8+ prints by, 4 illustrated books, 10+ prints after. Paper fold measure.

[Ber.] II, pp. 5–24.*

Bellange, Jacques *(fl. 1602–1617)*
[RD.] V, pp. 81–97; XI, pp. 9–12.
Entries: 50. Millimeters. Inscriptions. States. Described.

[M.] III, pp. 359–360.
Entries: 46. Paper fold measure. States.

Tietze-Conrat, Erika. "Zum Oeuvre des Jacques Bellange." [*MGvK.*] 1930, p. 15.
Additional information to [RD.].

Steiner, Eva. "Zu Jacques Bellange," [*MGvK.*] 1932, pp. 47–49.
Additional information to [RD.].

Reed, Sue Welsh. "The Etchings of Jacques Bellange." [*Pr.*] pp. 131–154.
Entries: 47. Illustrated (selection).

Walch, Nicole. *Die Radierungen des Jacques Bellange, Chronologie und kritischer Katalog.* Munich: Robert Wölfle, 1971.
Entries: 47. Millimeters. Inscriptions. States. Described. Illustrated. Located. Bibliography for each entry. Appendix with doubtful and rejected prints.

Bellanger, Jean Achille *(fl. 1745–1770)*
[M.] III, pp. 362–363.
Entries: 21. Paper fold measure.

Bellarmato, Girolamo *(1493–after 1554)*
[M.] III, p. 628.
Entries: 1. Paper fold measure.

Bellavia, Marcantonio *(fl. c.1600)*
[B.] XX, pp. 3–23.
Entries: 52. Pre-metric. Inscriptions.
States. Described.

[M.] III, pp. 366–367.
Entries: 52. Paper fold measure.
Inscriptions (selection). Described
(selection).

Bellavitis, Girolamo *(fl. c.1800)*
[M.] III, p. 367.
Entries: 1. Paper fold measure.

Bellay, ——— *(fl. 1734–1747)*
[M.] III, p. 368.
Entries: 7+ prints by, 2+ prints after.

Bellay, ——— *(18th cent.)*
[M.] III, p. 368.
Entries: 3. Paper fold measure.

Bellay, Charles Alphonse Paul *(1826–1900)*
[M.] III, p. 368.
Entries: 20. States.

[Ber.] II, pp. 25–27.
Entries: 30. Paper fold measure.
Inscriptions (selection).

Bellay, François *(c.1790–c.1850)*
[M.] III, p. 368.
Entries: 8. Paper fold measure (selec-
tion).

[Ber.] II, p. 25.*

Belle, Alexis Simon *(1674–1734)*
[M.] III, p. 369.
Entries: 3 prints by, 14 after. Paper
fold measure (selection).

Messelet, Jean. "Belle." In [Dim.] II,
pp. 283–290.
Entries: 3 prints by, 13 after lost
works.

Belle, Friedrich August Otto de la
(1787–1845)
[M.] III, pp. 369–371.
Entries: 46 etchings, 3 lithographs.
Paper fold measure. Inscriptions. De-
scribed (selection).

Bellée, Leon [le Goaêbe de] *(c.1846–1891)*
[Ber.] II, p. 27.*

Bellefonds, O. de *(fl. c.1820)*
[M.] III, p. 371.
Entries: 1. Paper fold measure.

Bellefontaine, A. de *(fl. c.1794)*
[M.] III, p. 371.
Entries: 1. Paper fold measure.

Bellekin, Cornelis *(17th cent.)*
[M.] III, p. 350.
Entries: 1. Paper fold measure.

Bellel, Jean Joseph François *(1816–1898)*
[Ber.] II, p. 27.*

Bellenger, Albert *(b. 1846)*
[Ber.] II, pp. 27–28.*

Bellenger, Clément Édouard *(1851–1898)*
[Ber.] II, pp. 29–30.*

Bellenger, Georges *(b. 1847)*
[M.] III, p. 375.
Entries: 17.

[Ber.] II, pp. 28–29.*

Beller, J. *(19th cent.)*
[M.] III, p. 375.
Entries: 1. Paper fold measure.

Bellew, L. *(19th cent.)*
[M.] III, p. 378.
Entries: 1. Paper fold measure. States.

Belliard, Zephirin Félix Jean Marius
(b. 1798)
 [M.] III, p. 384.
 Entries: 16. Paper fold measure.

 [Ber.] II, pp. 30–31.*

Bellicard, Jérôme Charles *(1726–1786)*
 [M.] III, pp. 384–385.
 Entries: 8+ . Paper fold measure
 (selection).

Bellin, Samuel *(1799–1894)*
 [M.] III, p. 385.
 Entries: 12. Paper fold measure.
 States.

Belling, Rudolf *(b. 1886)*
 Galerie Wolfgang Ketterer, Munich
 [Helga D. Hofmann, compiler]. *Rudolf
 Belling.* Munich, 1967.
 Entries: 3 (to 1967). Millimeters.
 Inscriptions. Illustrated.

Bellinger, Joseph Erasmus *(18th cent.)*
 [M.] III, pp. 385–386.
 Entries: 7+ . Paper fold measure.

Bellini, Giovanni *(fl. 1450–1516)*
 [M.] III, pp. 400–424.
 Entries: 42 prints after. Paper fold
 measure.

Bellmer, Hans *(b. 1902)*
 Kestner-Gesellschaft, Hannover [Wie-
 land Schmied, compiler]. *Bellmer.* Han-
 nover, 1967.
 Entries: 80 (to 1967). Millimeters.
 Illustrated (selection).

 Éditions Denoël. *Hans Bellmer; oeuvre
 gravé.* Preface by André Pieyre de Man-
 diargues. Paris: Éditions Denoël, 1969.
 Entries: unnumbered, pp. 11–96.
 Millimeters. Illustrated.

Bellotto, Bernardo *(1720–1780)*
 Meyer, Rudolph. *Die beiden Canaletto,
 Antonio Canale und Bernardo Belotto, Ver-*

*such einer Monographie der radierten Werke
beider Meister.* Dresden: Published by
the author, 1878.
 Entries: 37. Pre-metric. Inscriptions.
 States. Described.

 [M.] III, pp. 437–444.
 Entries: 37+ prints by, 6+ after. Paper
 fold measure.

 [Vesme] pp. 488–508.
 Entries: 37. Millimeters. Inscriptions.
 States. Described.

 Stübel, Moritz. "Der jüngere Canaletto
 und seine Radierungen." *Monatshefte für
 Kunstwissenschaft* 4 (1911): 471–501.
 Entries: 16 (etchings of Dresden only).
 Millimeters. Inscriptions. States.
 Illustrated (selection). Careful de-
 scription of states.

 Fritzsche, Hellmuth Allwill. *Bernardo Be-
 lotto genannt Canaletto.* Burg bei Magde-
 burg (Germany): August Hopfer, 1936.
 Entries: 37. Millimeters. Inscriptions.
 Described. Illustrated (selection).
 Preparatory drawings identified.

Bellows, Albert Fitch *(1829–1883)*
 [M.] III, pp. 431–432.
 Entries: 17 prints by, 20 after. Paper
 fold measure.

Bellows, George W. *(1882–1925)*
 Weitenkampf, Frank. "George W. Bel-
 lows, lithographer." [P. Conn.] 4
 (1924): 224–244.
 Entries: unnumbered, pp. 236–244 (to
 1924). Inches. Illustrated (selection).

 Bellows, Emma S. et al. *George W. Bel-
 lows; his lithographs.* New York: Alfred
 A. Knopf, 1927.
 Entries: 195. Illustrated. Revised edi-
 tion, 1928, has 196 prints.

Belloy, Auguste, Marquise de *(fl. c.1771)*
 [M.] III, p. 432.
 Entries: 2. Paper fold measure.
 Inscriptions.

Bellucci, Antonio *(1654–1726)*
[M.] III, pp. 433–435.
Entries: 1 print by, 15 after. Paper fold measure (selection).

Belly, Jacques *(1609–1674)*
[RD.] IV, pp. 2–10; XI, p. 13.
Entries: 31. Pre-metric. Inscriptions. States. Described.

[M.] III, pp. 436–437.
Entries: 2+ . Paper fold measure. States.

Belmont, Jean Antoine *(1696–after 1769)*
[M.] III, pp. 436–437.
Entries: 7. Paper fold measure (selection).

Belot, Gabriel *(b. 1882)*
Mauclair, Camille. *Gabriel Belot.* Les artistes du livre, 13. Paris: Henry Babou, 1930. 700 copies.
Bibliography of books with illustrations by.

Elder, Marc. *Gabriel-Belot, peintre imagier.* Paris: André Delpeuch, 1927.
Entries: unnumbered, pp. 79–93 (works in all media, including prints). Illustrated (selection).

Beltason, ——— *(19th cent.)*
[M.] III, p. 445.
Entries: 1. Paper fold measure.

Beltrami, Luca *(b. 1854)*
[M.] III, p. 446.
Entries: 8. Paper fold measure (selection).

Polifilo, ———. *Luca Beltrami acquafortista.* Milan: Alfieri e Lacroix, 1909. (EBKk)
Entries: 43 (to 1879). Millimeters. Illustrated (selection).

Bemme, Joannes Adriaanszoon *(1775–1840)*

[W.] I, p. 78.
Entries: 8+ .*

Bemmel, Johann Georg von *(1669–1723)*
[A.] V, pp. 308–310.
Entries: 2. Pre-metric. Inscriptions. Described.

[M.] III, pp. 429–492.
Entries: 2. Paper fold measure. Inscriptions. Described.

Bemmel, Peter von *(1685–1754)*
[A.] V, pp. 344–351.
Entries: 8. Pre-metric. Inscriptions. Described.

[M.] III, p. 493.
Entries: 8. Millimeters. Inscriptions (selection).

Bemmel, Willem van *(1630–1708)*
[M.] III, p. 492.
Entries: 1+ . Paper fold measure. Inscriptions (selection).

[W.] I, p. 79.
Entries: 6.*

[H. *Neth.*] I, pp. 243–248.
Entries: 9. Illustrated (selection).*

Benaglia, Giuseppe *(1796–1830)*
[Ap.] pp. 50–51.
Entries: 10.*

[M.] III, p. 495.
Entries: 8+ . Paper fold measure.

Bénard, Jacques François *(fl. c.1705)*
[M.] III, p. 496.
Entries: 3+ . Paper fold measure (selection).

Benardelli, Giambattista *(1819–1858)*
[M.] III, p. 497.
Entries: 1+ . Paper fold measure.

Benaschi
See **Beinaschi**

Benassit, Louis-Émile *(1833–1902)*
[Ber.] II, pp. 31–32.*

Benault, ――― *(17th cent.)*
[M.] III, p. 499.
Entries: 1+. Millimeters? Inscriptions.

Benazech, Charles *(c.1767–1794)*
[M.] III, p. 501.
Entries: 4 prints by, 6 after. Paper fold measure.

Benazech, Peter Paul *(c.1744–c.1783)*
[M.] III, pp. 500–501.
Entries: 35+. Paper fold measure.

Benazzi, Vittorio *(fl. c.1600)*
[M.] III, p. 501.
Entries: 1.

Bence, Jacques Martin Silvestre *(b. c.1770)*
[M.] III, p. 501.
Entries: 2. Paper fold measure.

[Ber.] II, p. 33.*

Bencovich, Federico *(c.1670–after 1740)*
[M.] III, p. 502.
Entries: 2 prints by, 3 after. Paper fold measure.

[Vesme] pp. 366–367.
Entries: 1. Millimeters. Inscriptions. Described.

Bendemann, Eduard Julius Friedrich
(1811–1889)
[M.] III, pp. 505–511.
Entries: 3+ prints by, 33+ after. Paper fold measure.

Bendiner, Alfred *(1899–1964)*
Philadelphia Museum of Art. *Alfred Bendiner; lithographs.* Philadelphia, 1965.
Entries: 119. Inches. Illustrated (selection). Located (selection).

Bendix, B. H. *(fl. 1788–1793)*
[M.] III, p. 511.
Entries: 15. Paper fold measure.

Bendixen, Siegfried Detlev
(1786–after 1864)
[M.] III, p. 512.
Entries: 11. Paper fold measure (selection).

[Dus.] pp. 16–17.
Entries: 10 (lithographs only, to 1821). Millimeters. Inscriptions. Located.

Bendl, Ignaz [Johann] *(fl. 1693–1710)*
[M.] III, pp. 512–513.
Entries: 10+ prints after.

Bendorp, Carel Frederik I *(1736–1814)*
[M.] III, p. 514.
Entries: 6+. Paper fold measure.

Bendorp, Carel Frederik II *(1819–1864)*
[H. L.] pp. 65–67.
Entries: 6. Millimeters. Inscriptions. States. Described.

Bendorp, Johann Christian *(1767–1849)*
[M.] III, p. 514.
Entries: 2. Paper fold measure.

Benedetti, Giuseppe *(1707–1782)*
[M.] III, p. 515.
Entries: 5.

Benedetti, Ignazio *(18th cent.)*
[M.] III, p. 515.
Entries: 3+. Paper fold measure.

Benedetti, Michele *(1745–1810)*
[Ap.] p. 51.
Entries: 4.*

[M.] III, pp. 515–516.
Entries: 13. Paper fold measure (selection).

Benedetti, Tommaso *(1796–1863)*
[Ap.] pp. 51–52.
Entries: 11.*

Benedetti, Tommaso *(continued)*

[M.] III, p. 516.
　Entries: 28. Paper fold measure (selection).

Benedicht, Lorentz *(16th cent.)*
Forening for Boghaandvaerk, Copenhagen. *Lorentz Benedicht; bogtrykker og xylograf i København i sidste halvdel af det xvi aarhundrede bibliografi med indledning af R. Paulli.* Copenhagen: Forening for Boghaandvaerk, 1920. 800 copies. (NN)
Bibliography of books printed by, some with illustrations by.

Benefial, Marco *(1684–1764)*
[M.] III, p. 531.
　Entries: 6 prints after.

Benizy, ——— *(fl. c.1760)*
[M.] III, p. 536.
　Entries: 1. Paper fold measure.

Benjamin [**Roubaud,** Benjamin]
(1811–1847)
[Ber.] II, pp. 33–36.*

Benjamin, Jakob *(fl. c.1650)*
[M.] III, p. 533.
　Entries: 1. Paper fold measure.

Benkert, Johann Peter *(1709–1769)*
[M.] III, p. 537.
　Entries: 1.

Benku, Martin *(20th cent.)*
Bálent, Boris. *Exlibrisy Martina Benku.* Bratislava (Czechoslovakia), 1968. (DLC)
　Entries: 56 (bookplates only, to 1968). Illustrated.

Bennet, Thomas *(19th cent.)*
　[Siltzer] p. 86.
　Entries: unnumbered, p. 86, prints after. Inches (selection). Inscriptions.

Bennett, William James *(1787–1844)*
[M.] III, pp. 539–540.
　Entries: 1. Paper fold measure.

[M.] III, p. 540.
　Entries: 2 prints by, 3 after. Inches.

[St.] pp. 23–28.*

[F.] pp. 60–65.*

[Siltzer] p. 346.
　Entries: unnumbered, p. 346. Inscriptions.

Benning, R. *(fl. 1740–1760)*
[M.] III, p. 541.
　Entries: 4. Paper fold measure (selection).

Benoist, Antoine *(1632–1717)*
[M.] III, pp. 543–544.
　Entries: 4 prints by, 4 after. Paper fold measure (selection).

Benoist, Antoine *(1721–1770)*
[M.] III, p. 544.
　Entries: 14+ prints by, 1+ after. Paper fold measure (selection).

Benoist, C. L. *(fl. 1712–1771)*
[M.] III, p. 544.
　Entries: 7+ . Paper fold measure (selection).

Benoist, Félix *(19th cent.)*
　[Ber.] II, p. 38.*

Benoist, Gabriel *(18th cent.)*
[M.] III, p. 545.
　Entries: 5. Paper fold measure.

Benoist, Guillaume Philippe *(1725–1800)*
[M.] III, p. 544.
　Entries: 26. Paper fold measure (selection).

Benoist, J. L. *(fl. 1800–1840)*
[M.] III, pp. 545–546.
　Entries: 37. Paper fold measure.

[Ber.] II, p. 37.*

Benoist, M. A. *(fl. 1780–1810)*
[M.] III, p. 545.
Entries: 8+ . Paper fold measure
(selection).

Benoist, Marie Guilhelmine *(1768–1826)*
[M.] III, p. 545.
Entries: 4+ .

[Ber.] II, p. 36.*

Benoist, Philippe *(fl. 1836–1879)*
[Ber.] II, pp. 37–38.*

Benossi, Stefano *(fl. c.1788)*
[M.] III, p. 547.
Entries: 2. Paper fold measure.

Benouville, François Léon *(1821–1859)*
[Ber.] II, p. 38.*

Benouville, Jean Achille *(1815–1891)*
[M.] III, p. 547.
Entries: 1. Paper fold measure.

Bensekam, Frans von
See **Beusekom**

Bensheimer, Johann *(c.1650–1692)*
[M.] III, pp. 554–555.
Entries: 20. Paper fold measure.

[H. *Ger.*] IV, p. 2.
Entries: 42.*

Benso, Giulio *(1601–1668)*
[M.] III, pp. 555–556.
Entries: 1. Paper fold measure.

Benson, Frank Weston *(1862–1951)*
Paff, Adam E. M., and Heintzelman, Arthur William. *Etchings and drypoints by Frank W. Benson; an illustrated and descriptive catalogue.* 5 vols. Boston (Mass.): Houghton Mifflin Co., 1917–1959. 275–600 copies.
Entries: 355. Inches. States. Illustrated.

Crafton Collection. *Frank W. Benson, N.A.* American etchers, 12. New York; Crafton Collection; London: P. and D. Colnaghi and Co., 1931.
Entries: 310 (to 1930). Inches. Illustrated (selection).

Benstead, J. *(1828–1847)*
[Siltzer] p. 346.
Entries: unnumbered, p. 346. Inscriptions.

Ben Sussan, René *(20th cent.)*
Bove, Emanuel. "Ben Sussan." [*AMG.*] 4 (1930–1931): 255–261.
Bibliography of books with illustrations by.

Bentely, Ludwig Rudolf *(1760–1839)*
[M.] III, p. 558.
Entries: 5. Paper fold measure.

Bentley, Joseph Clayton *(1809–1851)*
[Siltzer] p. 346.
Entries: unnumbered, p. 346. Inscriptions.

Benton, Thomas Hart *(b. 1889)*
Fath, Creekmore. *The lithographs of Thomas Hart Benton.* Austin (Tex.): University of Texas Press, 1969.
Entries: 80 (book illustrations are omitted). Inches. Described. Illustrated.

Benucci, Filippo *(1779–1848)*
[M.] III, p. 561.
Entries: 3+ prints by, 1+ after. Paper fold measure.

Benucci, Vincenzio *(19th cent.)*
[Ap.] p. 52.
Entries: 3.*

[M.] III, p. 561.
Entries: 3. Paper fold measure.

Béra, Armand Philippe Joseph *(1784–1836)*
[Ber.] II, p. 38.*

Berain, Claude *(c.1640–1729)*
[M.] III, p. 569.
 Entries: 18+ . Millimeters (selection).

Weigert, Roger Armand. "Jean I Berain, dessinateur de la chambre et du cabinet du roi." 2 vols. Doctoral thesis, Université de Paris, 1936. Reprint. Paris: Les Éditions d'Art et d'Histoire, 1937.
 Entries: 76. Millimeters. Inscriptions. States. Described. Located. Bibliography for each entry.

Berain, Jean I *(1637–1711)*
[M.] III, pp. 567–569.
 Entries: 85+ prints by and after. Paper fold measure (selection).

Weigert, Roger Armand. "Jean I Berain, dessinateur de la chambre et du cabinet du roi." 2 vols. Doctoral thesis, Université de Paris, 1936. Reprint. Paris: Les Éditions d'Art et d'Histoire, 1937.
 Entries: 345 prints by and after. Millimeters. Inscriptions. States. Described. Located. Bibliography for each entry. Appendix with doubtful and rejected prints, unnumbered, pp. 249–254.

Weigert, Roger Armand. "Jean I Berain, graveur; un état inconnu à la Bibliothèque du Musée des Arts décoratifs de Copenhague." In *Det danske Kunstindustriemuseum Virksomhed, 1954–1959,* pp. 145–147. Copenhagen, 1960.
 Entries: 1+ (previously undescribed). Illustrated (selection). Located.

Berain, Jean II *(c.1678–1726)*
[M.] III, pp. 569–570.
 Entries: 5+ . Paper fold measure (selection).

Weigert, Roger Armand. "Jean I Berain, dessinateur de la chambre et du cabinet du roi." 2 vols. Doctoral thesis, Université de Paris, 1936. Reprint. Paris. Les Éditions d'Art et d'Histoire, 1937.

 Entries: 5 (prints after). Millimeters. Inscriptions. States. Described. Located. Bibliography for each entry.

Béranger, Antoine *(1785–1867)*
[Ber.] II, p. 39.*

Berardi, Fabio *(1728–after 1765)*
[M.] III, pp. 571–572.
 Entries: 34+ . Paper fold measure (selection).

Berardier, Denis *(16th cent.)*
[M.] III, p. 572.
 Entries: 1.

Bérat, Eustache *(19th cent.)*
[Ber.] II, p. 38.*

Beraud, Jean *(b. 1849)*
[M.] III, p. 573.
 Entries: 1. Paper fold measure. Described.

[Ber.] II, pp. 39–41.*

Beraut, Abel *(17th cent.)*
[M.] III, p. 573.
 Entries: 1. Paper fold measure.

Berbe, Jan *(17th cent.)*
[M.] III, p. 573.
 Entries: 2. Paper fold measure (selection).

Berch van Heemstede, Isaac Lambertus *(1811–1879)*
[M.] III, p. 573.
 Entries: 5. Paper fold measure.

Berchem, Nicholaes Pietersz *(1620–1683)*
Winter, Hendrik de. *Beredeneerde catalogus van alle de prenten van Nicolaas Berchem.* Amsterdam: Johannes Smit, 1767. (EBr)
 Entries: 238 prints by and after. Premetric. Inscriptions. States. Described.

"Oeuvre de Nicolas Berchem." Unpublished ms. (EBM)
Entries: 56 prints by, 182 after. Inscriptions (selection). States. Described (selection). Based on Winter. Also, catalogue of prints after omitted by Winter, unnumbered, pp. 41–48. Pre-metric (selection). Inscriptions. Described.

[B.] V, pp. 247–283.
Entries: 53. Pre-metric. Inscriptions. States. Described.

[Heller] pp. 27–29.
Additional information to [B.].

[Weigel] pp. 293–303.
Entries: 2 (additional to [B.]). Pre-metric. Inscriptions. Described.

[Dut.] IV, pp. 29–49; V, p. 585.
Entries: 60+ prints by, 2 doubtful prints. Millimeters. Inscriptions. States. Described.

[Wess.] II, p. 227.
Entries: 1 (additional to [B.] and [Weigel]). Millimeters. Described. Additional information to [B.] and [Weigel].

[M.] III, pp. 573–582.
Entries: 59 prints by, 397 after. Paper fold measure.

[W.] I, p. 84.
Entries: 61.*

[H. Neth.] I, pp. 249–280.
Entries: 63 prints by, 397+ after. Illustrated (selection).*

Berchère, Narcisse (1819–1891)
Prost, Bernard. Catalogue illustré des oeuvres de N. Berchère. Paris: Librairie d'Art L. Baschet, 1885. (EPBN)
Entries: unnumbered, p. 40.

Berchet, Pierre (1659–1720)
[M.] III, pp. 582–583.

Entries: 8 prints by and after. Paper fold measure (selection).

Berchmans, Émile (b. 1867)
Ombiaux, Maurice des. Quatre artistes liégeois; A. Rassenfosse, Fr. Maréchale, A. Donnay, Ém. Berchmans. Brussels: G. van Oest et Cie, 1907. (EBrM)
Entries: unnumbered, p. 105.

Berckheyde, Gerrit Adriaensz (1638–1698)
[W.] I, p. 85.
Entries: 5 prints after.*

[H. Neth.] II, p. 1.
Entries: 11 prints after Gerrit and Job Berckheyde.*

Berckheyde, Job Adriaensz (1630–1693)
[W.] I, p. 86.
Entries: 2 prints after.*

[H. Neth.] II, p. 1.
See under Berckheyde, Gerrit.

Berckmans, Hendrik (1629–1679)
[W.] I, pp. 86–87.
Entries: 6 prints after.*

[H. Neth.] II, p. 1.
Entries: 12 prints after.*

Berckner, ——— (dates uncertain)
[M.] III, p. 588.
Entries: 1.

Bercy, N. (17th cent.)
[M.] III, p. 588.
Entries: 1. Paper fold measure. Inscriptions. Described.

Bercy, P. J. de (17th cent.)
[RD.] III, pp. 97–99.
Entries: 6. Pre-metric. Inscriptions. Described.

[M.] III, p. 588.
Entries: 6. Paper fold measure.

Berend, Edward *(19th cent.)*
[M.] III, p. 589.
 Entries: 2. Paper fold measure.

Berendrecht, Johannes Pietersz
(fl. 1614–1645)
[M.] III, pp. 284–285.
 Entries: 1. Millimeters. Described.

[W.] I, p. 87.
 Entries: 1.*

[H. *Neth.*] II, p. 2.
 Entries: 1 print by, 32 published by.*

Beresnikov, Andrei Filippovich
(1774–c.1835)
[M.] III, pp. 590–591.
 Entries: 44.

Beretta, Giuseppe *(b. 1804)*
[Ap.] p. 53.
 Entries: 8.*

[M.] III, p. 592.
 Entries: 14. Paper fold measure.

Berey, ——— *(fl. c.1700)*
[M.] III, p. 593.
 Entries: 29. Paper fold measure.

Berey, C. A. *(fl. 1700–1730)*
[M.] III, p. 593.
 Entries: 126. Paper fold measure
 (selection).

Berg, Adam *(fl. 1590–1610)*
[M.] III, pp. 593–594.
 Entries: 2. Millimeters (selection).

Berg, Albert *(1825–1884)*
[M.] III, pp. 595–596.
 Entries: 20+ prints by, 3+ after. Paper
 fold measure.

Berg, Cornelius van den *(1699–1775)*
[M.] III, p. 594.
 Entries: 3. Paper fold measure.

[W.] I, p. 87.
 Entries: 3.*

Berg, Johann van den *(17th cent.)*
[M.] III, p. 594.
 Entries: 6. Paper fold measure.

Berg, R. *(fl. c.1572)*
[M.] III, p. 593.
 Entries: 2. Paper fold measure (selec-
 tion).

Bergaz, Alf. Paz. *(18th cent.)*
[M.] III, p. 599.
 Entries: 1. Inscriptions. Described.

Bergen, Dirk van *(c.1640–c.1690)*
[W.] I, p. 88.
 Entries: 5 prints after.*

[H. *Neth.*] II, p. 3.
 Entries: 5 prints after.*

Berger, Carl Otto *(b. 1839)*
[M.] III, p. 605.
 Entries: 6. Paper fold measure.

Berger, Daniel *(1744–1824)*
*Anzeige sämmtlicher Werke von Herrn
Daniel Berger . . . mit Genehmigung des
Künstlers herausgegeben und nach der Zeit-
folge geordnet. Leipzig: Rostische
Kunsthandlung, 1792. (EBKk)*
 Entries: 825+ (to 1792). Paper fold
 measure. Inscriptions. Described. Un-
 finished or unpublished prints are
 listed separately, lettered A–L, in
 footnotes.

[M.] III, pp. 601–603.
 Entries: 107+. Paper fold measure.

Berger, Ferdinand *(19th cent.)*
[M.] III, p. 604.
 Entries: 49. Paper fold measure.

Berger, Friedrich Gottlieb *(1713–after 1797)*
[M.] III, p. 601.
 Entries: 9+. Millimeters (selection).
 Paper fold measure (selection).

Berger, G. *(19th cent.)*
[M.] III, p. 604.
　Entries: 10. Paper fold measure.

Bergeret, Pierre Nolasque *(1782–1863)*
[M.] III, pp. 606–607.
　Entries: 20 prints by, 3 after. Paper
　fold measure. States.

[Ber.] II, pp. 41–42.*

Berggold, Carl Moritz *(1759–1814)*
[M.] III, p. 608.
　Entries: 8 prints by, 12 after. Paper
　fold measure.

Bergh, Abraham van den
　See **Monogram AB** [Nagler, *Mon.*] I, nos.
　159, 160

Bergh, Adrianus van den *(fl. c.1670)*
[H. *Neth.*] II, p. 3.
　Entries: 1.*

Bergh, Jan van den *(1588–after 1649)*
[W.] I, p. 88.
　Entries: 2.*

[H. *Neth.*] II, p. 3.
　Entries: 2.*

Bergh, Mathys van den *(1617–1687)*
[H. *Neth.*] II, p. 3.
　Entries: 2 prints after.*

Bergh, Nicolas van den *(1725–1774)*
[M.] III, p. 609.
　Entries: 5. Millimeters (selection).
　Paper fold measure (selection).

[W.] I, p. 89.
　Entries: 6.*

Berghe, Arnold van den *(fl. c.1833)*
[M.] III, p. 609.
　Entries: 3. Paper fold measure.

Berghe, Ignatius Jos. van den *(1752–1824)*
[M.] III, p. 611.

Entries: 18. Paper fold measure (selec-
tion).

[W.] I, pp. 89–90.
　Entries: 12.*

Berghe, Pieter van den *(fl. 1648–1695)*
[M.] III, pp. 610–611.
　Entries: 209 prints by, 4 after. Paper
　fold measure.

[W.] I, p. 90.
　Entries: 58+ .*

Berghen, Willem van den *(19th cent.)*
[H. L.] pp. 67–68.
　Entries: 2. Millimeters. Inscriptions.
　States. Described.

[M.] III, p. 612.
　Entries: 2. Paper fold measure.

Bergler, Joseph II *(1753–1829)*
[M.] III, pp. 614–617.
　Entries: 29 prints by, 28 after. Paper
　fold measure.

Bergmann, H. *(18th cent.)*
[M.] III, p. 617.
　Entries: 2+ .

Bergmann, Ignaz *(1797–1865)*
[M.] III, p. 617.
　Entries: 28. Paper fold measure.

Bergmann, J. *(dates uncertain)*
[M.] III, p. 617.
　Entries: 3.

Bergmann, J. *(1797–1865)*
[Dus.] pp. 17–18.
　Entries: 11 (lithographs only, to 1821).
　Millimeters (selection). Inscriptions.
　Located (selection).

Bergmann, Walter *(1904–1965)*
Bergmann, Ruth. ''Liste der Holz-
schnitte, Farbholzschnitte, Linol-
schnitte, Radierungen nach Jahres-

Bergmann, Walter *(continued)*

zahlen geordnet. . ." Unpublished ms. (EBKk)
Entries: 192. Catalogue of a collection of prints given to the Kupfer-stichkabinett, Berlin-Dahlem, in 1965. Complete?

Bergmüller, Johann Baptist *(1724–1785)*
[M.] III, p. 619.
Entries: 11.

Bergmüller, Johann Georg *(1688–1762)*
Boecker, Angela. "Die Ölbilder, Zeichnungen und Druckgraphik des Augsburger Akademiedirektors Johann Georg Bergmüller." Dissertation, University of Innsbruck, 1966. (EWA)
Entries: 157 prints by and after. Millimeters. Inscriptions. Located. Bibliography for each entry.

Bergonci, Francesco Bernardino
(fl. c.1590)
[M.] III, p. 619.
Entries: 2. Paper fold measure.

Berincx, J. Hendrik *(fl. c.1690)*
[W.] III, p. 24.
Entries: 3 prints after.*

[H. *Neth.*] II, p. 3.
Entries: 3 prints after.*

Berkenrode, Balthasar Florisz *(1591–1645)*
[M.] III, pp. 624–625.
Entries: 23 prints by and after. Paper fold measure.

[W.] I, p. 91.
Entries: 18+ .*

[H. *Neth.*] II, pp. 24–35.
Entries: 21. Illustrated (selection).*

Berkenrode, Cornelius Florisz *(1608–1635)*
[M.] III, p. 624.
Entries: 2. Paper fold measure.

[W.] I, pp. 90–91.
Entries: 3.*

[H. *Neth.*] II, pp. 21–23.
Entries: 3. Illustrated.*

Berkenrode, Floris Baltesersz van
(1563–1616)
[M.] II, p. 657.
Entries: 5. Millimeters (selection). Paper fold measure (selection). Inscriptions (selection). Described (selection).

[M.] III, p. 623–624.
Entries: 14.

[W.] I, pp. 50–51.
Entries: 19+ .*

[H. *Neth.*] II, p. 4.
Entries: 25. Illustrated (selection).*

Berkenrode, Frans Florisz *(17th cent.)*
[M.] III, p. 624.
Entries: 2.

Berking
See **Borking**

Berkman, Mathäus *(fl. c.1781)*
[M.] III, p. 625.
Entries: 1 print by, 2 after. Paper fold measure. Inscriptions (selection).

[W.] I, p. 87; III, p. 23.
Entries: 2 prints by, 2 after.*

Berkowetz, Joseph *(19th cent.)*
[Ap.] p. 53.
Entries: 1.*

[M.] III, p. 625.
Entries: 5. Paper fold measure.

Berky, C. *(dates uncertain)*
[M.] III, p. 626.
Entries: 1. Paper fold measure.

Berlier, J. *(fl. c.1850)*
[M.] III, pp. 626–627.
Entries: 4. Paper fold measure.

Berlier, Louis *(fl. c.1850)*
[Ber.] II, p. 43.*

Berlin, —— *(18th cent.)*
 [M.] III, p. 627.
 Entries: 3. Paper fold measure.

Berlinghieri, Camillo *(1596–1635)*
 [B.] XX, pp. 110–112.
 Entries: 4. Pre-metric. Inscriptions.
 Described.

 [Wess.] III, p. 44.
 Entries: 1 (additional to [B.]). Paper
 fold measure. Described.

 [M.] III, p. 627–628.
 Entries: 10. Paper fold measure. De-
 scribed.

Berman, Jaque *(fl. c.1700)*
 [M.] III, p. 629.
 Entries: 6. Millimeters.

Bermann, Sigm[und] *(dates uncertain)*
 [M.] III, p. 629.
 Entries: 6. Paper fold measure.

Bernaert, Nicasius *(1620–1678)*
 [W.] I, p. 91.
 Entries: 2 prints after.*

Bernaerts, Balthasar *(fl. 1711–1737)*
 [M.] III, p. 632.
 Entries: 22. Millimeters (selection).
 Paper fold measure (selection).

 [W.] I, p. 91.
 Entries: 9+ .*

Bernard, —— *(17th cent.)*
 [M.] III, p. 634.
 Entries: 1.

Bernard, —— *(19th cent.)*
 [Ber.] II, pp. 43–44.*

Bernard, A. *(fl. c.1850)*
 [M.] III, p. 636.
 Entries: 1+ .

 [Ber.] II, p. 43.*

Bernard, Charles *(fl. 1810–1830)*
 [M.] III, p. 636.
 Entries: 9. Millimeters.

Bernard, D. *(fl. c.1850)*
 [M.] III, p. 636.
 Entries: 1. Millimeters.

Bernard, Émile *(1868–1941)*
 Untitled catalogue. *Nouvelles de l'es-
 tampe.* (1967): 84–85.
 Entries: unnumbered, pp. 84–85.
 Millimeters (selection).

Bernard, Johann *(1784–after 1821)*
 [M.] III, pp. 635–636.
 Entries: 24. Paper fold measure.
 States.

Bernard, Joseph *(fl. c.1700)*
 [M.] III, pp. 634–635.
 Entries: 1. Paper fold measure. In-
 scriptions.

Bernard, Louis *(fl. c.1700)*
 [M.] III, p. 634.
 Entries: 11. Millimeters (selection).
 Paper fold measure (selection).

 [W.] I, p. 92.
 Entries: 11.*

Bernard, Samuel *(1615–1687)*
 [RD.] VI, pp. 243–251; XI, pp. 13–14.
 Entries: 12. Pre-metric. Inscriptions.
 States. Described.

 [M.] III, pp. 633–634.
 Entries: 15. Millimeters (selection).
 States.

Bernardi, Jacopo *(b. 1808)*
 [Ap.] pp. 53–54.
 Entries: 10.*

 [M.] III, pp. 639–641.
 Entries: 80. Paper fold measure (selec-
 tion). States.

Bernards, S. *(18th cent.)*
[M.] III, p. 648.
 Entries: 1.

Bernasconi, ——— *(fl. c.1850)*
[M.] III, p. 649.
 Entries: 5. Millimeters (selection).
 Paper fold measure (selection).

Bernclau, Anton von *(19th cent.)*
[Dus.] p. 19.
 Entries: 3 (lithographs only, to 1821).
 Millimeters (selection). Inscriptions.
 Located (selection).

Berndt, Johann Christoph *(1707–1798)* and
Johann Oswald *(1736–1787)*
[M.] III, pp. 653–654.
 Entries: 17. Paper fold measure.

Berne-Bellecour, Étienne Prosper
(1838–1910)
[Ber.] III, p. 44.*

Bernhard, Andreas *(fl. c.1550)*
[M.] III, p. 656.
 Entries: 1.

Bernhardt, Sarah *(1844–1923)*
[Ber.] XII, p. 9.*

Bernier, Camille *(1823–1902/03)*
[Ber.] II, p. 44.*

Bernigeroth family *(18th cent.)*
[M.] III, pp. 659–660.
 Entries: 22. Paper fold measure.

Weidler, Wilhelm. *Die Künstlerfamilie
Bernigeroth und ihre Porträts.* Altona
(Germany): Published by the author,
1914. *Nachtrag.* Hamburg: Zentralstelle
für niedersächsische Familen-
geschichte, 1922. (NN)
 Entries: unnumbered, pp. 23–168.
 Paper fold measure. Located (selec-
 tion).

Bernini, Giovanni Lorenzo *(1598–1680)*
[M.] III, pp. 661–674.
 Entries: 81 prints after. Paper fold
 measure.

Bernsdorff, Magda *(20th cent.)*
Fogedgaard, Helmer. "Magda Berns-
dorff, en dansk exlibriskunstner."
[*N. ExT.*] 11 (1959): 90–92.
 Entries: 11 (bookplates only, to 1958).
 Illustrated (selection).

Berny, Chevalier de *(19th cent.)*
[M.] III, p. 677.
 Entries: 2. Paper fold measure.

Berr, J. F. *(fl. c.1774)*
[M.] III, p. 678.
 Entries: 2. Paper fold measure (selec-
 tion).

Berry, Duchesse de *(19th cent.)*
[Ber.] II, p. 44.*

Berry, P. J. *(fl. c.1715)*
[M.] III, p. 696.
 Entries: 1 print by, 1 after.

Berselli, Giovanni *(19th cent.)*
[Ap.] p. 54.
 Entries: 2.*

[M.] III, p. 697.
 Entries: 2. Paper fold measure.

Berseniev, Ivan Archipovich *(1762–1789)*
[M.] III, pp. 697–698.
 Entries: 10. Paper fold measure (selec-
 tion). Inscriptions.

Rovinski, Dmitri. *Odinnadtsat' gravjur"
raboty I. A. Berseneva.* St. Petersburg:
Ekspeditsija Zagotovlenija
Gosudarstvennykh" Bumag", 1886.
 Entries: 11. Millimeters. Inscriptions.
 Illustrated.

Bert, Émile *(1814–1847)*
[H. L.] p. 68.

Entries: 1. Millimeters. Inscriptions. Described.

Bertall
See **Arnoux,** Charles Albert d'

Bertaux, J. B. *(18th cent.)*
[M.] III, p. 699.
Entries: 1+.

Bertechi, Gioachio *(18th cent.)*
[M.] III, p. 701.
Entries: 1.

Bertelli, Christofano *(16th cent.)*
[M.] III, p. 701.
Entries: 7 prints by and published by. Paper fold measure (selection).

Bertelli, Domenico *(fl. c.1600)*
[M.] III, p. 701.
Entries: 2 prints by and published by. Paper fold measure. Inscriptions.

Bertelli, Donato *(fl. 1560–1570)*
[M.] III, p. 701.
Entries: 2+ prints by and published by. Paper fold measure.

Bertelli, Ferdinando *(16th cent.)*
[M.] III, pp. 701–702.
Entries: 153 prints by and published by. Paper fold measure.

[Herbet] IV, p. 310.
Entries: 6. Millimeters (selection). Inscriptions (selection). Described (selection).

Bertelli, Francesco *(17th cent.)*
[M.] III, p. 703.
Entries: 4 prints by and published by. Paper fold measure (selection).

Bertelli, Luca *(fl. 1550–1580)*
[M.] III, pp. 702–703.
Entries: 56 prints by and published by. Paper fold measure. Inscriptions (selection).

Bertelli, Orazio *(fl. c.1600)*
[M.] III, p. 703.
Entries: 2+. Paper fold measure (selection).

Bertelli, Pietro *(fl. c.1600)*
[M.] III, p. 703.
Entries: 336 prints by and published by. Paper fold measure (selection).

Berterham, Jan Baptist *(fl. c.1700)*
[M.] III, pp. 704–705.
Entries: 35. Millimeters (selection). Paper fold measure (selection). Inscriptions (selection).

Berthault, Jean Pierre *(d. 1850)*
[Ber.] II, pp. 50–51.*

Berthault, Louis Martin *(1771?–1823)*
[M.] III, p. 706.
Entries: 24 prints by, 16 after. Paper fold measure.

[Ber.] II, p. 50.*

Berthault, Pierre Gabriel *(1748–c.1819)*
[M.] III, pp. 705–706.
Entries: 16+. Paper fold measure (selection).

[Ber.] II, p. 49–50.*

Berthaut, ——— *(dates uncertain)*
[M.] III, p. 706.
Entries: 6. Paper fold measure.

Berthe, L. *(fl. c.1777)*
[M.] III, p. 706.
Entries: 1+. Paper fold measure.

Berthélemy, Pierre-Émile *(1818–1890)*
[M.] III, pp. 707–708.
Entries: 1. Paper fold measure.

[Ber.] II, p. 51.*

Berthelin, ——— *(fl. c.1800)*
[M.] III, p. 708.
Entries: 2. Paper fold measure.

Berthereau, ——— *(fl. c.1625)*
 [M.] III, p. 708.
 Entries: 1. Paper fold measure.

Berthet, Louis *(fl. c.1800)*
 [M.] III, pp. 708–709.
 Entries: 21+. Paper fold measure
 (selection).

Berthold, Carl Ferdinand *(1799–1838)*
 [A. 1800] I, pp. 60–69.
 Entries: 10. Pre-metric. Inscriptions.
 States. Described.

 [M.] III, p. 710.
 Entries: 10 prints by, 1 after. Paper fold
 measure. Inscriptions. States.

Berthold-Mahn, Charles *(20th cent.)*
 Geiger, Raymond. *Berthold Mahn. Les
 artistes du livre*, 16. Paris: Henry Babou,
 1930. 700 copies. (NN)
 Bibliography of books with illustra-
 tions by.

Berthon, ——— *(fl. c.1800)*
 [M.] III, p. 711.
 Entries: 2. Paper fold measure.

Berthoud, Auguste Henri *(1829–1887)*
 [M.] III, pp. 711–712.
 Entries: 10.

Bertin, ——— *(fl. c.1776)*
 [M.] III, p. 714.
 Entries: 2 prints by, 1 after.

Bertin, Édouard *(1797–1871)*
 [Ber.] II, p. 51.*

Bertin, G. *(17th cent.)*
 [M.] III, p. 713.
 Entries: 1.

Bertin, Jean Victor *(1775–1842)*
 [Ber.] II, p. 51.*

Bertinazzi, Antonio [called "Carlin"]
(1713–1783)

 [M.] III, p. 715.
 Entries: 1. Inscriptions.

Bertini, Angelo *(19th cent.)*
 [Ap.] pp. 54–55.
 Entries: 16.*

 [M.] III, p. 715.
 Entries: 30. Paper fold measure (selec-
 tion).

Bertinot, Gustave Nicolas *(1822–1888)*
 [Ap.] pp. 55–56.
 Entries: 15.*

 [M.] III, p. 717–718.
 Entries: 21. Paper fold measure.

 [Ber.] II, p. 51–54.
 Entries: 31 (to 1885). Paper fold
 measure.

 Bertinot, Emile. *Gustave Bertinot, graveur
 d'histoire*. Paris: P. Lethielleux, n.d.
 (EBM)
 Entries: unnumbered, pp. 187–188.

Berton, Mathurin *(fl. c.1800)*
 [M.] III, p. 723.
 Entries: 5. Inscriptions (selection).

Bertoni, Pio *(19th cent.)*
 [M.] III, p. 723.
 Entries: 8.

Bertonnier, Pierre François *(b. 1791)*
 [M.] III, pp. 723–725.
 Entries: 138. States.

 [Ber.] II, pp. 54–56.*

Bertony, ——— *(fl. c.1783)*
 [M.] III, p. 726.
 Entries: 1. Paper fold measure.

Bertram, Karl *(fl. c.1800)*
 [M.] III, p. 727.
 Entries: 1. Paper fold measure.

Bertrand, A. *(fl. c.1850)*
 [M.] III, p. 730.
 Entries: 2.

Bertrand, F. *(18th cent.)*
[M.] III, p. 728.
Entries: 1.

Bertrand, Jean Baptiste [James] *(1823–1887)*
[Ber.] II, p. 57.*

Bertrand, Noël François *(1784–1852)*
[M.] III, pp. 728–730.
Entries: 183.

[Ber.] II, pp. 56–57.*

Bertrand, Pierre *(fl. c.1650)*
[M.] III, p. 727.
Entries: 26. Inscriptions (selection).

Bertren, P. J. *(fl. c.1770)*
[M.] III, p. 731.
Entries: 1+.

Bertren, Théodore *(fl. c.1765)*
[M.] III, p. 731.
Entries: 5+.

Berveiller, ——— *(19th cent.)*
[Ber.] II, p. 57.*

Bervic, Charles Clément *(1756–1822)*
[Ap.] pp. 56–57.
Entries: 13.*

[M.] III, pp. 735–736.
Entries: 18 prints by, 2 after. States.

[Ber.] II, pp. 58–62.*

Berwinckel, Joan *(fl. c.1600)*
[M.] III, p. 736.
Entries: 5. Paper fold measure. In-
scriptions (selection).

[H. *Neth.*] II, pp. 36–37.
Entries: 7. Illustrated (selection).*

Bes, ——— *(19th cent.)*
[M.] III, p. 737.
Entries: 2+. Paper fold measure.

Beschey, Balthasar *(1708–1776)*
[W.] I, p. 93.
Entries: 4+ prints after.*

Beselin, Lukas *(17th cent.)*
[M.] III, p. 739.
Entries: 2+. Paper fold measure
(selection). Inscriptions (selection).

Besemann, L *(fl. c.1800)*
[M.] III, p. 739.
Entries: 5. Paper fold measure.

Beslinière, Gaspard de *(17th cent.)*
[M.] III, p. 740.
Entries: 1.

Besnard, Albert (Paul) *(1849–1934)*
[Ber.] II, p. 64.*

Coppier, André-Charles. *Les eaux-fortes
de Besnard.* Paris: Librairie Berger-
Levrault, 1920.
Entries: 173. Millimeters. Inscriptions.
States. Described. Illustrated (selec-
tion).

[Del.] XXX.
Entries: 202 prints by, 3 rejected
prints. Millimeters. Inscriptions
(selection). States. Described (selec-
tion). Illustrated. Located (selection).

Besnard, Étienne *(b. 1789)*
[M.] III, p. 741.
Entries: 10.

[Ber.] II, p. 63.*

Besnard, J. *(19th cent.)*
[M.] III, p. 741.
Entries: 1+.

[Ber.] II, pp. 62–63.*

Besnard, L. M. *(18th cent.)*
[M.] III, p. 741.
Entries: 1.

Besnus, Amédée *(19th cent.)*
[Ber.] II, pp. 64–66.
Entries: 14. Paper fold measure.

Besoet, Jan *(fl. c.1750)*
[M.] III, p. 742.
Entries: 11. Paper fold measure (selection).

Besozzi, Giovanni Ambrogio *(1648–1706)*
[B.] XXI, pp. 256–259.
Entries: 2. Pre-metric. Inscriptions.
Described.

[M.] III, pp. 742–743.
Entries: 2 prints by, 4 after. Inscriptions.

Besse, —— *(dates uncertain)*
[M.] III, p. 744.
Entries: 1.

Bessée, Mlle de *(fl. c.1750)*
[M.] III, pp. 744–745.
Entries: 3.

Besseling, Albertus *(18th cent.)*
[M.] III, p. 745.
Entries: 3. Paper fold measure.

Bessint, —— *(fl. c.1800)*
[M.] III, p. 745.
Entries: 2.

Best, —— *(dates uncertain)*
[M.] III, p. 748.
Entries: 1.

Best, Adolphe *(19th cent.)*
[Ber.] II, p. 69.*

Best, Alfred *(19th cent.)*
[M.] III, pp. 747–748.
Entries: 25+. Paper fold measure.

Best, Jean *(b. 1808)*
See also **Andrew, Best and Leloir**
[Ber.] II, pp. 66–69.*

Best, J. A. R. *(fl. 1823–1840)*
[H. L.] p. 70.
Entries: 2. Millimeters. Inscriptions.
Described.

Bestland, C. W. *(fl. c.1800)*
[M.] III, pp. 748–749.
Entries: 3. Paper fold measure (selection).

Bethge, Rudolphe *(fl. 1830–1842)*
[M.] III, pp. 750–751.
Entries: 2. Paper fold measure.

Betini, Pietro *(fl. c.1700)*
[B.] XIX, pp. 255–256.
Entries: 1. Pre-metric. Inscriptions.
Described.

[M.] III, p. 751.
Entries: 2. Paper fold measure (selection). Inscriptions.

Betou
See **Bettou**

Bettamini, Giovanni *(fl. c.1656)*
[M.] III, p. 752.
Entries: 4.

Bettanier, J. *(19th cent.)*
[M.] III, p. 752.
Entries: 16. Paper fold measure.

Bettazzi, Ranieri *(b. 1824)*
[Ap.] pp. 57–58.
Entries: 4.*

[M.] III, p. 752.
Entries: 5. Paper fold measure. States.

Bettelini, Pietro *(1763–1828)*
[Ap.] pp. 58–60.
Entries: 35.*

[M.] III, pp. 753–755.
Entries: 81+. Paper fold measure.
States.

Betti, Giovanni Battista *(fl. 1767–1777)*
[M.] III, p. 766.
 Entries: 12+. Paper fold measure (selection).

Bettoli, Gaetano *(fl. c.1730)*
[M.] III, p. 767.
 Entries: 1.

Bettoni, Nicolò *(19th cent.)*
[Ap.] p. 61.
 Entries: 3.*

Bettou, Alexandre *(1607/11–1693)*
[RD.] VIII, pp. 225–249.
 Entries: 93. Millimeters. Inscriptions. States. Described. Appendix with 1 doubtful print.

[M.] III, p. 751.
 Entries: 93. Paper fold measure. States.

Beucholt, L. T. *(fl. c.1670)*
[H. *Neth.*] II, p. 38.
 Entries: 1 print after.*

Beughen, D. van *(fl. c.1690)*
[M.] III, p. 770.
 Entries: 1. Paper fold measure.

Beugnet, Jean *(d. 1803)*
[M.] III, p. 770.
 Entries: 3+. Paper fold measure (selection).

Beugo, John *(1759–1841)*
[M.] III, p. 771.
 Entries: 6. Paper fold measure (selection).

Beurdeley, Jacques *(1874–1954)*
Delteil, Loys. "Jacques Beurdeley,"
[*Am. Est.*] 2 (1923): 118–125.
 Entries: 115 (to 1923). Millimeters. Photostat with ms. addition (NN); 10 additional entries.

Vallery-Radot, Jean, and Adhémar, Jean. "Catalogue de Beurdeley." Unpublished ms., 1956.
 Not seen. *See* **Laran,** Jean, *L'Estampe.* Paris: Presses Universitaires de France, 1959. Vol. I, p. 283

Beurer, Ferdinand *(1640–1667)*
[M.] III, p. 771 (as Beurez).
 Entries: 5. Paper fold measure (selection).

[H. *Ger.*] IV, p. 3.
 Entries: 9.*

Beurlier, Charles *(fl. c.1775)*
[M.] III, p. 771.
 Entries: 19+. Paper fold measure (selection).

Beurs, —— de *(19th cent.)*
[H. L.] pp. 68–69.
 Entries: 3. Millimeters. Inscriptions. Described.

Beurs Stiermans, André Paul de
(fl. c.1800)
[M.] III, pp. 771–772.
 Entries: 6.

Beusch, Ferigo *(fl. c.1730)*
[M.] III, p. 772.
 Entries: 1. Paper fold measure. Inscriptions.

Beusch, J. Fr. *(fl. c.1730)*
[M.] III, p. 772.
 Entries: 2. Paper fold measure.

Beusekom, Frans von *(fl. 1647–1665)*
[M.] III, p. 553 (as Bensekam).
 Entries: 4. Paper fold measure (selection).

[M.] III, p. 772.
 Entries: 11. Paper fold measure.

[W.] I, pp. 94–95.
 Entries: 12.*

Beuth, —— *(19th cent.)*
　[M.] III, p. 772.
　　Entries: 2. Paper fold measure.

Bevan, Robert *(1865–1925)*
　Dry, Graham. *Robert Bevan, 1865–1925;
　catalogue raisonné of the lithographs and
　other prints.* London: Maltzahn Gallery,
　Ltd., 1968.
　　Entries: 40. Millimeters. Inches. In-
　　scriptions. States. Described. Illus-
　　trated.

Beverenzi, Nicasio *(17th cent.)*
　[M.] III, p. 775.
　　Entries: 1.

Bevilacqua, Ventura
　See **Salimbeni**

Beville, —— de *(18th cent.)*
　[M.] III, p. 776.
　　Entries: 1. Paper fold measure.

Bewick, Thomas *(1753–1828)* and John
(1760–1795)
　*A descriptive and critical catalogue of works
　illustrated by Thomas and John Bewick.*
　London: John Gray Bell, 1851.
　　Bibliography of books with illustra-
　　tions by.

　Hugo, Thomas. *The Bewick collector; a de-
　scriptive catalogue of the works of Thomas
　and John Bewick . . . the whole described
　from the originals contained in the largest
　and most perfect collection ever formed.*
　London: Lovell Reeve and Company,
　1866. Reprint. Detroit (Mich.): Singing
　Tree Press, 1968; New York: Burt Frank-
　lin, 1970.
　　Entries: 4025+. Inscriptions (selec-
　　tion). States (selection). Located.
　　Numbering corresponds to items in
　　the collection; not a strict oeuvre-
　　catalogue.

　Hugo, Thomas. *The Bewick collector; a
　supplement to a descriptive catalogue of the*

works of Thomas and John Bewick . . .
London: L. Reeve and Co., 1868. Re-
print. Detroit (Mich.): Singing Tree
Press, 1968; New York: Burt Franklin,
1970.
　Entries: 1428+ (additional to Hugo
　1866).

Stephens, F. G. *Notes by F. G. Stephens
on a collection of drawings and woodcuts by
Thomas Bewick . . . also a complete list of
all works illustrated by Thomas and John
Bewick, with their various editions.* Lon-
don: The Fine Art Society, 1881.
　Bibliography of books with illustra-
　tions by.

[M.] III, pp. 777–780.
　Entries: 83+. Paper fold measure.

Roscoe, S. *Thomas Bewick; a bibliography
raisonné of editions of the general history of
quadrupeds, the history of British birds and
the fables of Aesop issued in his lifetime.*
London and New York: Oxford Univer-
sity Press, 1953.
　Bibliography: describes 48 editions of
　Bewick's 3 chief books.

Beyel, Daniel *(1760–1823)*
　[M.] III, p. 782.
　　Entries: 14+. Paper fold measure
　　(selection).

Beyer, Charles *(b. 1792)*
　[M.] III, p. 789.
　　Entries: 20. Paper fold measure.

　[Ber.] II, pp. 69–70.*

Beyer, Eduard *(19th cent.)*
　[M.] III, p. 788.
　　Entries: 2.

Beyer, Jean de *(1703–c.1785)*
　[W.] I, p. 95.
　　Entries: 4+ prints after.*

Verbeek, Albert. *Die Niederrheinan-
sichten Jan de Beyers. Die*

Kunstdenkmäler des Rheinlands, 5. Essen (West Germany): Fredebeul und Koenen, 1957.
Entries: 188 (drawings by and prints after, views of the Rhine only). Millimeters. Inscriptions. Described. Illustrated (selection).

Romers, H. J. de Beijer, oeuvre-catalogus. The Hague: Kruseman's Uitgeversmaatschappij N. V., 1969.
Entries: 619 prints after. Millimeters. Inscriptions.

Beyer, Leopold *(1784–after 1870)*
[Ap.] p. 61.
Entries: 5.*

[M.] III, pp. 788–789.
Entries: 29+ . Paper fold measure (selection).

Beyer, Lorenz *(fl. c.1699)*
[M.] III, p. 782.
Entries: 1+ . Paper fold measure.

Beyerle, Burkhart *(b. 1930)*
Haus van der Grinten, Kranenburg/ Niederrhein. *Holzschnitte. Gesamtverzeichnis 1952–1971.* Kranenburg/Niederrhein (West Germany), 1971.
Entries: 321 (to 1971). Not seen.

Beytler, Jacob *(fl. 1588–1602)*
[A.] IV, pp. 42–43.
Entries: 1+ . Pre-metric. Inscriptions (selection). Described (selection).

[M.] III, pp. 792–793.
Entries: 15+ . Paper fold measure. Inscriptions (selection). Described (selection).

[H. *Ger.*] IV, p. 4.
Entries: 34.*

Beytler, Mathias *(fl. 1582–1616)*
[B.] IX, pp. 586–589.
Entries: 17. Pre-metric. Inscriptions. Described.

[P.] IV, pp. 243–244.
Entries: 3+ (additional to [B.]). Pre-metric (selection). Inscriptions. Described (selection). Located (selection). Additional information to [B.].

[A.] IV, pp. 36–41.
Entries: 35. Pre-metric. Inscriptions. Described.

[M.] III, p. 773.
Entries: 29 prints by, 11 after. Paper fold measure (selection).

[H. *Ger.*] IV, pp. 5–6.
Entries: 52. Illustrated (selection).*

Bezoard, Claude *(fl. 1530–1560)*
See also **Monogram CB** [Nagler, *Mon.*] I, no. 2284

[M.] III, p. 794.
Entries: 5. Paper fold measure. States.

Bezombes, Roger *(b. 1913)*
"Roger Bezombes." *Bulletin d'Information des peintres de la Marine nationale,* n.s. 22 (Jan.–Feb. 1971). (EPBN)
Entries: unnumbered, 2 pp., (color lithographs only, to 1962). Millimeters. Also, bibliography of books with illustrations by, to 1970.

Biard, Pierre I *(1559–1609)*
[RD.] V, pp. 64–65.
Entries: 1. Millimeters. Inscriptions. Described.

Biard, Pierre II *(1592–1661)*
[RD] V, pp. 98–107; XI, pp. 14–15.
Entries: 26. Millimeters. Inscriptions. States. Described.

Biave
See **Mazzocchi dalle Biave**

Bichebois, Louis Pierre Alphonse *(1801–1850)*
[Ber.] II, p. 72.*

Bickart, Jodocus *(1600–1672)*
 [A.] V, pp. 213–219.
 Entries: 7. Pre-metric. Inscriptions.
 States. Described.

 [H. *Ger.*] IV, pp. 7–11.
 Entries: 9. Illustrated (selection).*

Bida, Alexandre *(1813–1895)*
 [Ber.] II, pp. 72–76.*

Bidauld, Jean Pierre Xavier *(1745–1813)*
 [Baud.] II, pp. 285–290.
 Entries: 7. Millimeters. Inscriptions.
 States. Described.

Biddle, George *(b. 1885)*
 Trotter, Massey. "Catalogue of the
 lithographs of George Biddle." *Bulletin
 of the New York Public Library* 55 (1951):
 23–29. Separately published. New York:
 New York Public Library, 1950.
 Entries: 121 (to 1950; different states of
 the same print are separately num-
 bered). Inches. Inscriptions. States.
 Ms. addition. (NN) 34 additional en-
 tries (to 1952).

Bie, Jacobus de *(1581–c.1640)*
 [W.] I, p. 97.
 Entries: 12+ .*

 [H. *Neth.*] II, p. 38.
 Entries: 12+ .*

Bie, Jens Peter *(20th cent.)*
 Arné, ———. "Jens Peter Bie." [*N.
 ExT.*] 5 (1953): 113–115.
 Entries: 19 (bookplates only, to 1953?).
 Illustrated (selection).

Bien
 See **Binn**

Bierling, Adam Alexius *(fl. c.1650)*
 [H. *Neth.*] II, p. 39.
 Entries: 2 prints after.*

Bierpfaf
 See **Birpfaf**

Bieruma Oosting, Jeanne *(20th cent.)*
 Loon, Maud van. *Jeanne Bieruma Oosting
 als grafisch kunstenares.* Rotterdam
 (Netherlands) and Antwerp (Belgium):
 Ad Donker, 1946.
 Entries: unnumbered, pp. 36–37.

Bierweiler, F. C. *(fl. c.1800)*
 [W.] I, p. 98.
 Entries: 3+ .

Biffi, Carlo *(1605–1675)*
 [B.] XIX, pp. 81–82.
 Entries: 1. Pre-metric. Inscriptions.
 States. Described.

Bigot, Georges *(19th cent.)*
 [Ber.] II, p. 76.*

Bilderdijk, Willem *(1756–1831)*
 Vosmaer, C. "Bilderdijks etsen."
 Kunstkronijk, n.s. 11 (1870): 91–94. Re-
 print. In Vosmaer, C. *Over Kunst.* 1882,
 pp. 257–267.
 Entries: 104. Inscriptions. States. De-
 scribed.

Bilen
 See **Bylert**

Bilhamer, Joost Jansz *(1541–1590)*
 Koning, Jacobus. *Historisch berigt wegens
 Joost Janszoon Beeldsnyder, en de door hem
 vervaardigde stukken.* Amsterdam, 1831.
 (EA)
 Entries: 19 (prints by and after). De-
 scribed.

Bilk, Hermann *(fl. c.1500)*
 See **Monogram BH** [Nagler, *Mon.*] I, no.
 1881

Bill, Max *(b. 1908)*
 Albrecht Dürer Gesellschaft, Nurem-
 berg [Herbert Bessel and Elizabeth
 Rücker, compilers]. *Max Bill; das
 druckgrafische Werk bis 1968.* Nuremberg,
 1968.

Entries: 93 (to 1968). Millimeters. Illustrated (selection).

Billman, Torsten *(b. 1909)*
Jungmarker, Gunnar. *Torsten Billman.*
Stockholm: Folket i Bilds Konstklubb,
1956. (MH)
 Entries: unnumbered, 3 pp. (to 1951).
Millimeters. Illustrated (selection).

Billoin, Charles *(1813–1869)*
[H. L.] pp. 70–78.
 Entries: 15 (etchings only). Millimeters. Inscriptions. Described. Also,
incomplete list of lithographs (titles
only).

Billy, Charles Bernard de *(19th cent.)*
[Ber.] II, p. 76.*

Binck, Jakob *(c.1500–1569)*
[B.] VIII, pp. 249–298.
 Entries: 97 etchings, 1 woodcut. Pre-metric. Inscriptions. Described.
Copies mentioned.

[Heller] pp. 29–31.
 Entries: 6 (additional to [B.]). Pre-metric. Inscriptions. Described. Additional information to [B.].

[Evans] pp. 11–13.
 Entries: 13 (additional to [B.]). Millimeters. Inscriptions. Described.

[P.] IV, pp. 86–97.
 Entries: 43 engravings and etchings
(additional to [B.]), 1+ woodcuts
(additional to [B.]). Pre-metric. Inscriptions. Described. Located. Additional information to [B.]. Copies
mentioned. Appendix with 3 doubtful
prints.

[Wess.] I, pp. 130–131.
 Entries: 10 (additional to [B.] and [P.]).
Millimeters. Inscriptions. Described.

Aumüller, Édouard. *Jacques Binck et
Alaart Class (Claaszen).* Les Petits maîtres

allemands, II. Munich: Librairie de
l'université M. Rieger, 1893.
 Entries: 184. Millimeters. Inscriptions.
States. Described. Copies mentioned.
Ms. notes (ERB); 1 additional entry.

[Merlo] pp. 71–90.
 Entries: 18 (additional to [B.] and [P.]).
Millimeters. Inscriptions. Described.
Illustrated (selection). Located.

Pauli, Gustav. "Jakob Binck und seine
Kupferstiche." [*Rep. Kw.*] 32 (1909):
31–48.
 Entries: 73 (additional to Aumüller).
Millimeters. Inscriptions. States. Described. Located. Additional information to Aumüller.

[H. *Ger.*] IV, pp. 12–113.
 Entries: 267. Illustrated (selection).*

Bingham, George Caleb *(1811–1879)*
Hall, Virginius C., and Bender, J. H.
"George Caleb Bingham—the Missouri
Artist." [*PCQ.*] 27 (1940): 9–25; "Catalogue of Engravings and Lithographs
after George C. Bingham." [*PCQ.*] 27
(1940): 106–108.
 Entries: 8 prints after. Inches. Inscriptions. States. Illustrated.

McDermott, John Francis. *George Caleb
Bingham; river portraitist.* Norman
(Okla.): University of Oklahoma Press,
1959.
 Entries: 12 prints after. Inches. Inscriptions. Described. Located (selection).

Bloch, E. Maurice. *George Caleb Bingham;
a catalogue raisonné.* Berkeley and Los
Angeles: University of California Press,
1967.
 Entries: 15 prints after. Inches. Inscriptions. States. Described. Bibliography for each entry. Based on Hall
and Bender, revised and expanded.

Binn, Hans *(c.1590–1632)*
[H. *Ger.*] IV, p. 113.
 Entries: 2 prints after.*

Binneman, Wouter Jansz *(fl. 1660–1688)*
[W.] I, p. 100.
Entries: 5.*

[H. *Neth.*] II, pp. 40–41.
Entries: 6. Illustrated (selection).*

Biondi, Carlo *(fl. c.1825)*
[Ap.] p. 61.
Entries: 1.*

Biondini, Vincenzio *(19th cent.)*
[Ap.] pp. 61–62.
Entries: 8.*

Biot, Gustave *(1833–1905)*
[H. L.] pp. 78–80.
Entries: 2 (etchings only). Millimeters.
Inscriptions. States. Described. Also,
incomplete list of engravings (titles
only).

[Ap.] p. 30.
Entries: 5.*

[Ber.] II, p. 77.*

Birbaum, Michel *(fl. c.1605)*
[Merlo] p. 91.
Entries: unnumbered, p. 91. Pre-
metric (selection). Inscriptions. De-
scribed.

Birch, —— *(18th cent.)*
[St.] p. 28.*

Birch, William *(1755–1834)*
[St.] pp. 28–38.*

[F.] p. 65.*

Snyder, Martin P. "William Birch, his
Philadelphia views." [*Pa. Mag.*] 73
(1949): 271–315.
Entries: 44 (views of Philadelphia
only). Inches. Inscriptions. States.

Snyder, Martin P. "William Birch, his
'Country Seats of the United States'."
[*Pa. Mag.*] 81 (1957): 225–254.

Entries: 20 (prints from series "Coun-
try Seats of the United States" only).
Inches. Inscriptions. States.

Snyder, Martin P. "Birch's Philadelphia
views; new discoveries." [*Pa. Mag.*] 88
(1964): 164–175.
Additional information to Snyder
1949.

Birche, H.
See **Earlom,** Richard

Birckenhultz, Paul *(1561–1639)*
[H. *Ger.*] IV, pp. 114–115.
Entries: 48. Illustrated (selection).*

Birckner, Wolfgang *(c.1580–after 1626)*
[H. *Ger.*] IV, p. 113.
Entries: 1 print after.*

Bird, Elisha Brown *(fl. c.1900)*
Truesdell, Winfred Porter. *A booklet de-
voted to the book plates of Elisha Brown Bird.*
Boston (Mass.): C. E. Goodspeed, 1904.
110 copies. (DLC)
Entries: 39 prints by and after (book-
plates only, to 1904? Complete?). De-
scribed. Illustrated (selection).

Birnbaum, Michael *(fl. 1608–1612)*
[H. *Ger.*] IV, p. 116.
Entries: 4.*

Birouste, —— *(fl. c.1840)*
[Ber.] II, pp. 77–78.*

Birpfaf, Johann Christian *(fl. c.1670)*
[H. *Ger.*] IV, p. 116.
Entries: 1 print after.*

Biscaino, Bartolommeo *(1632–1657)*
[B.] XXI, pp. 181–203.
Entries: 40. Pre-metric. Inscriptions.
States. Described. Appendix with 1
doubtful print.

Bischoff, Henry *(1882–1951)*
Kuenzi, André. *Henry Bischoff, 1882–1951.* Lausanne (Switzerland): Éditions du Verseau, 1962. 718 copies. (CLU)
Entries: unnumbered, pp. 99–103. Millimeters.

Biset, Karel Emmanuel *(1633–1710?)*
[W.] I, pp. 100–101.
Entries: 2 prints after.*

[H. *Neth.*] II, p. 41.
Entries: 2 prints after.*

Bishop, Isabel *(b. 1902)*
Brooklyn Museum [Una E. Johnson and Jo Miller, compilers]. *Isabel Bishop: prints and drawings, 1925–1964.* New York: Shorewood Publishers, 1964.
Entries: 45 (to 1964). Inches. Illustrated (selection).

Bisi, Fra Bonaventura *(1612–1659)*
[Vesme] pp. 334–335.
Entries: 1. Millimeters. Inscriptions. States. Described. Appendix with 1 doubtful print.

Bisi, Ernesta *(fl. c.1815)*
[Ap.] p. 62.
Entries: 2.*

Bisi, Michele *(b. c.1788)*
[Ap.] pp. 62–63.
Entries: 12.*

Bisschop, Jan de *(1628–1671)*
[W.] I, p. 102.
Entries: 6 prints by, 3 after.*

[H. *Neth.*] II, pp. 42–44.
Entries: 6 prints by, 4 after. Illustrated (selection).*

Bittheuser, Johann Pleikard *(1774–1859)*
[Ap.] pp. 63–64.
Entries: 11.*

Bizemont-Prunelé, André Gaspard Parfait *(1752–1837)*
[Ber.] II, p. 78.*

Petit-Sémonville, ———. Catalogue. In *Le Comte de Bizemont, artiste-amateur orléanais, son oeuvre et ses collections,* by E. Davoust. Orléans (France): Herluison, 1891.
Not seen. *See* [I.F.F. 1700] III, p. 8.

Bizius, Johann Jacob *(1629–1675)*
[H. *Ger.*] IV, p. 117.
Entries: 3.*

Black, T. *(18th cent.)*
[Siltzer] p. 328.
Entries: unnumbered, p. 328 (prints after). Inches. Inscriptions.

Blackmore, Thomas *(c.1740–1780)*
[Sm.] I, pp. 61–63, and "additions and corrections" section.
Entries: 8 (portraits only). Inches. Inscriptions. States. Described.

[Ru.] p. 18.
Entries: 1 (portraits only, additional to [Sm.]). Inches. Inscriptions. Described.

Blaesbjerg, Christian *(20th cent.)*
Fougt, Knud. "Christian Blaesbjerg." [*N. ExT.*] 3 (1949–50): 73–76.
Entries: 42 (bookplates only, to 1950). Illustrated (selection).

Fougt, Knud. "Christian Blaesbjerg." [*N. ExT.*] 6 (1954): 8–10.
Entries: 10 (bookplates only, 1951–1954). Illustrated (selection).

Fogedgaard, Helmer. "Christian Blaesbjerg—III." [*N. ExT.*] 8 (1956): 58–59; 9 (1957): 68–72, 77.
Entries: 48 (bookplates only, 1954–1957). Described (selection). Illustrated (selection).

Blaesbjerg, Christian *(continued)*

Rasmussen, Kristen. *Christian Blaesbjerg og hans exlibris.* Odense (Denmark): Forlaget Helio, 1960. 350 copies. (DLC)
Entries: 154 (bookplates only, to 1960). Illustrated (selection).

Fogedgaard, Helmer. "Christian Blaesbjerg—IV." [*N. ExT.*] 13 (1961): 88–89.
Entries: 61 bookplates only, 1957–1960). Illustrated (selection).

Fogedgaard, Helmer. "Christian Blaesbjerg—V; hilsen i anledning af 60-ars dagen." [*N. ExT.*] 15 (1963): 108–109.
Entries: 28 (bookplates only, 1960–1963).

Fogedgaard, Helmer. "Christian Blaesbjerg—VI." [*N. ExT.*] 16 (1964): 60.
Entries: 14 (bookplates only, 1963–1964). Illustrated (selection).

"Christian Blaesbjerg—VII." [*N. ExT.*] 18 (1966): 38–39.
Entries: 21 (bookplates only, 1964–1966). Illustrated (selection).

Schyberg, Thor. *Christian Blaesbjerg, exlibris 2. samling.* Odense (Denmark): Forlaget Helio, 1967. 350 copies. (DLC)
Entries: 95 (additional to Rasmussen; bookplates only, to 1967). Illustrated (selection).

Fogedgaard, Helmer. "Christian Blaesbjerg—VIII."[*N. ExT.*] 23 (1971): 131, 142, 144.
Entries: 76 (bookplates only, 1966–1971). Illustrated (selection).

Blaeu, Wilhelmus
See **Jansonius**

Blaisot, Eugène *(b. 1822)*
[Ber.] II, pp. 78–80.*

Blake, C. *(fl. c.1825)*
[Siltzer] p. 328.

Entries: unnumbered, p. 328 (prints after). Inches. Inscriptions.

Blake, C. S. *(18th cent.)*
[Sm.] I, p. 63.
Entries: 1 (portraits only). Inches. Inscriptions. Described.

[Ru.] p. 18.
Additional information to [Sm.].

Blake, William *(1757–1827)*
Binyon, Laurence. *William Blake; being all his woodcuts photographically reproduced in facsimile.* London: At the Sign of the Unicorn, 1902.
Entries: 17 (woodcuts only). Illustrated.

Russell, Archibald G. B. *The engravings of William Blake.* London: Grant Richards Ltd. Boston (Mass.) and New York: Houghton Mifflin Co., 1912. Reprint. New York: Benjamin Blom, 1968.
Entries: 136 (prints by and after; illuminated books are omitted). Inches. Inscriptions. States. Described. Illustrated (selection).

Keynes, Geoffrey. *A bibliography of William Blake.* New York: Grolier Club, 1921.
Bibliography of books with illustrations by. Incomplete list of single prints.

Binyon, Laurence. *The engraved designs of William Blake.* London: Ernest Benn Ltd., 1926. Reprint. New York: Da Capo Press, 1967.
Entries: 476 (prints by Blake after his own designs only). Inches. Inscriptions. States. Described. Illustrated (selection).

Keynes, Geoffrey, and Wolf, Edwin II. *William Blake's illuminated books, a census.* New York: Grolier Club, 1953. 400 copies. (NN)
Entries: 20 illuminated books; illuminations are individually described.

Millimeters. Inscriptions. Described. Illustrated (selection). Located. Location of all known impressions is given.

Keynes, Geoffrey. *Engravings by William Blake: the separate plates.* Dublin: Emery Walker Ltd., 1956. 500 copies.
Entries: 44 (single prints only). Millimeters. Inscriptions. States. Described. Illustrated (selection). Located. All prints by Blake after his own designs are illustrated.

Blampied, Edmund *(b. 1886)*
Allhusen, E. L. "The etchings of Edmund Blampied." [*PCQ.*] 13 (1926): 69–96.
Entries: 65 (to 1926). Inches. Illustrated (selection).

Dodgson, Campbell. *A complete catalogue of the etchings and dry-points of Edmund Blampied, R. E.* London: Halton and Truscott Smith Ltd., 1926. 350 copies. (MB)
Entries: 100 (to 1926). Inches. Inscriptions. States. Illustrated. Ms. additions: (MB) additional prints, unnumbered, titles only; (E Col) additional prints, unnumbered, to 1936, titles only.

Blanc, Charles *(1815–1882)*
[Ber.] II, pp. 80–81.*

Blanc, Paul *(19th cent.)*
[Ber.] II, p. 81.*

Blanc, Paul. "Catalogue des subjets de Mendiants gravés à l'eau-forte par Blanc Paul." *L'Estampe,* 22–30 August, 6 September 1896, n.p. (EPBN)
Entries: 100 (prints of beggars only; to 1896?). Millimeters. Described.

Blanchard, Auguste I *(1766–after 1832)*
[Ap.] pp. 64–65.
Entries: 9.*

[Ber.] II, pp. 81–82.*

Blanchard, Auguste Jean Baptiste Marie *(1792–1849)*
[Ap.] pp. 65–66.
Entries: 25.*

[Ber.] II, pp. 82–86.*

Blanchard, Auguste Thomas Marie *(1819–1898)*
[Ber.] II, pp. 86–94.
Entries: 61 (minor works incompletely listed). Paper fold measure. States. Described (selection).

Blanchard, Jacques *(1600–1638)*
[RD.] VIII, pp. 193–195.
Entries: 1 doubtful print; several others are mentioned in the preface, p. 194. Millimeters. Inscriptions. Described.

Sterling, Charles. "Les peintres Jean et Jacques Blanchard." *Art de France* 1 (1961): 76–118. (EPBN)
Entries: 74 (works in all media; only prints catalogued are those after lost works). Inscriptions. Described. Illustrated.

Blanchard, Pharamond *(1805–1873)*
Guinard, Paul. *Dauzats et Blanchard; peintres de l'Espagne romantique.* Paris: Presses Universitaires de France, 1967.
Entries: 207 (works in all media, Spanish subjects only). Millimeters (selection). Inscriptions. Described (selection).

Blanchard, Théophile *(1820–1849)*
[Ber.] II, p. 94.*

Blanchet, Thomas *(1614/17–1689)*
[RD.] VI, pp. 252–253; XI, pp. 15–16.
Entries: 2. Millimeters. Inscriptions. Described.

Chou Ling. *Thomas Blanchet, sa vie, ses oeuvres et son art.* Lyons: Librairie A. Badiou-Amant, 1941. (EPBN)

Blanchet, Thomas *(continued)*

Entries: 17 (prints by and after). Millimeters. Inscriptions. Illustrated (selection).

Bland, —— *(18th cent.)*
[Sm.] I, pp. 63–64.
Entries: 1 (portraits only). Inches. Inscriptions. Described.

Blank, Frederick Charles *(20th cent.)*
Lombard, Herbert Edwin. *Bookplates of Frederick Charles Blank.* Reprint from the 1934 year book of the American Society of Bookplate Collectors and Designers. Washington, D.C., 1934. (DLC)
Entries: 47 (bookplates only, 1919–1933). Inches.

Blaschke, János (Johann) *(1770–1833)*
[Ap.] p. 67.
Entries: 2.*

Blechen, Karl *(1798–1840)*
Kern, G. J. *Karl Blechen, sein Leben und seine Werke.* Berlin: Bruno Cassirer, 1911.
Entries: unnumbered, pp. 190–191. Millimeters. Inscriptions. Described.

Deutscher Verein für Kunstwissenschaft. *Karl Blechen: Leben, Würdigung, Werk.* Berlin: Deutscher Verein für Kunstwissenschaft, 1940.
Entries: 17. Millimeters. Inscriptions. Described. Illustrated (selection).

Blecher, Wilfried *(20th cent.)*
Künnemann, Horst. "Die Bilderbücher von Wilfried Blecher," *Illustration 63,* 7 (1970): 88–90.
Bibliography of books with illustrations by (to 1970).

Bleeck, Peter van *(c.1700–1764)*
[W.] I, p. 103.
Entries: 12.*

[Sm.] pp. 1397–1401, and "additions and corrections" section.
Entries: 13 (portraits only). Inches. Inscriptions. States. Described.

[Ru.] pp. 332–333.
Additional information to [Sm.].

Bleich, Georg Heinrich *(fl. 1615–1696)*
[H. Ger.] IV, p. 117.
Entries: 43.*

Bleker, Gerrit Claesz *(fl. 1628–1656)*
[B.] IV, pp. 105–113.
Entries: 12. Pre-metric. Inscriptions. Described.

[Weigel] pp. 167–168.
Entries: 1 (additional to [B.]). Pre-metric. Described.

[Dut.] IV, pp. 49–52.
Entries: 13. Millimeters. Inscriptions. States. Described.

[W.] I, pp. 104–105.
Entries: 13.*

[H. *Neth.*] II, pp. 45–57.
Entries: 14. Illustrated.*

Bléry, Eugène Stanislas Alexandre *(1805–1887)*
[Lebl.] I, pp. 359–371.
Entries: 204. Millimeters. Inscriptions (selection). States. Described.

Bléry, Eugène. "Catalogue de l'oeuvre gravé à l'eau-forte par Eugène Bléry appartenant à la Bibliothèque Nationale." Unpublished ms., 1878. (EPBN)
Entries: 205. Millimeters Inscriptions. Described. Based on a more detailed ms. catalogue by Bléry (not seen).

[Ber.] II, pp. 94–131.*

Bles, David Joseph *(1821–1899)*
[H. L.] p. 80.
Entries: 1. Millimeters. Inscriptions. Described.

Bles, Herri met de *(c.1480–after 1550)*
[W.] I, pp. 105–107.
Entries: 2 prints after.*

[H. Neth.] II, p. 58.
Entries: 1 print by, 9 after. Illustrated (selection).*

Blesendorf, Samuel *(1633–1706)*
[H. *Ger.*] IV, pp. 118–119.
Entries: 50. Illustrated (selection).*

Bleuler, Ludwig [Johann] *(1792–1850)*
[Dus.] p. 19.
Entries: 1 (lithographs only, to 1821).
Inscriptions.

Bleuze, ――― *(19th cent.)*
[Ber.] II, p. 132.*

Bloch, Carl Heinrich *(1834–1890)*
Thiele, J. R. *Beskrivende Fortegnelse over Carl Blochs 78 Raderinger.* Copenhagen: 1898.
Not seen. *See* below, Magnussen

Magnussen, Rikard. *Carl Bloch 1834–1890.* Copenhagen: G. E. C. Gads Forlag, 1931.
Entries: 78. Millimeters. Illustrated (selection). Based on Thiele.

Block, Benjamin von *(1631–1690)*
[A.] V, pp. 199–204.
Entries: 4. Pre-metric. Inscriptions. States. Described.

[H. *Ger.*] IV, pp. 120–124.
Entries: 5 prints by, 29 after. Illustrated (selection).*

Block, Eugène François de *(1812–1893)*
[H. L.] pp. 80–86.
Entries: 11 (etchings only). Millimeters. Inscriptions. Described. Also, list of 11 lithographs.

Blockhuyzen, Renier *(fl. 1709–1724)*
[W.] I, p. 108.
Entries: 9+.*

Blocklandt, Anthonie van [called "Montfort"] *(1532–1583)*
[W.] I, pp. 108–109; III, p. 29.
Entries: 14+ prints after.*

[H. *Neth.*] II, p. 59.
Entries: 40 prints after.*

Jost, Ingrid. *Studien zu Anthonis Blocklandt mit einem vorläufigen beschreibenden Oeuvre-Verzeichnis.* Cologne: University of Cologne, 1960.
Entries: 47 prints after. Millimeters. Inscriptions. States. Described. Located. Bibliography for each entry.

Blöchlinger, Anton *(b. 1885)*
Schwenke, Johan. *Een Zwitsers Kunstenaar Anton Blöchlinger.* Zaandijk (Netherlands): Stichting de Getijden Pers, 1953. 125 copies. (NN)
Entries: 178 (bookplates only, to 1951). Illustrated (selection).

Bloemaert, Abraham *(c.1564–1651)*
"Naemlijst van de konstprenten gesneden naer de schilderijen of inventien van Abraham Bloemaert." Unpublished ms., c. 1800. (ERB)
Entries: 573+.

[W.] I, pp. 109–111.
Entries: 15.*

[H. *Neth.*] II, pp. 60–69.
Entries: 10 prints by, 628 after. Illustrated (selection).*

Bloemaert, Cornelis *(1603–1684)*
[W.] I, pp. 111–112.
Entries: 37+.*

[H. *Neth.*] II, pp. 70–82.
Entries: 330+. Illustrated (selection).*

Bloemaert, Frederick *(c.1610–1669)*
[W.] I, p. 112.
Entries: 8+.*

[H. *Neth.*] II, pp. 83–95.
Entries: 293. Illustrated (selection).*

Bloemaert, Hendrik *(1601–1672)*
 [W.] I, pp. 112–113.
 Entries: 3 prints after.*

 [H. *Neth.*] II, p. 96.
 Entries: 14.*

Bloemen, Jan Frans van *(1662–1749)*
 [W.] I, p. 113.
 Entries: 6.*

Bloemen, Peter van *(1657–1720)*
 [W.] I, pp. 113–114.
 Entries: 1.*

Blois, Abraham de *(fl. 1679–1720)*
 [W.] I, p. 114.
 Entries: 21+.*

 [Sm.] I, "additions and corrections"
 section.
 Entries: 3 (portraits only). Inches.
 Inscriptions. States. Described. Lo-
 cated (selection).

 [Ru.] p. 18.
 Entries: 1 (portraits only, additional to
 [Sm.]). Inches. Inscriptions. States.
 Described. Additional information to
 [Sm.].

Blokhuyzen, Dirk Vis *(1799–1869)*
 [H. L.] pp. 86–88.
 Entries: 5. Millimeters. Inscriptions.
 Described.

Blom, Arnold
 See **Monogram AB** [Nagler, *Mon.*] I, nos.
 159, 160

Blommen, Adriaen van *(c.1650–1700)*
 [H. *Neth.*] II, p. 96.
 Entries: 1 print after.*

Blondeel, Lancelot *(1496–1561)*
 [H. *Neth.*] II, p. 158.
 Entries: 2+. Illustrated (selection).*

Blondel, Georges François [J. F.]
(1730–after 1791)
 [Sm.] I, p. 64.

Entries: 1 (portraits only). Inches.
Inscriptions. States. Described. Lo-
cated.

Dodgson, Campbell. "The mezzotints
of G. F. Blondel." [*PCQ.*] 9 (1922): 303–
314.
 Entries: 10. Inches. Millimeters.
 Inscriptions. States. Illustrated (selec-
 tion). Located (selection).

Lejeux, Jeanne. "Georges François
Blondel, engraver and draughtsman."
[*PCQ.*] 18 (1936): 260–277.
 Entries: 1 (additional to Dodgson).
 Millimeters. Inscriptions. States. Il-
 lustrated. Located.

Blondel, Laure *(19th cent.)*
 [Ber.] II, pp. 133–134.*

Bloot, Pieter de *(c.1602–1658)*
 [W.] I, p. 118.
 Entries: 1 print after.*

 [H. *Neth.*] II, p. 158.
 Entries: 1 print after.*

Blooteling, Abraham *(1640–1690)*
 [Dut.] IV, pp. 52–55; V, pp. 585–586.*

Wessely, J. E. "Abraham Blooteling,
Verzeichniss seiner Kupferstiche und
Schabkunstblätter." [*N. Arch.*] 13
(1867): 1–89. Separately published. Leip-
zig: Rudolph Weigel, 1867.
 Entries: 141 etchings, 128 mezzotints,
 31 prints described from secondary
 sources and doubtful or rejected
 prints. Pre-metric. Inscriptions.
 States. Described. Ms. notes (EL); ad-
 ditional information. Ms. notes (ERB);
 additional information.

 [Wess.] II, pp. 227–229.
 Entries: 8 (additions to Wessely
 1867). Millimeters. Inscriptions. De-
 scribed. Additional information to
 Wessely 1867.

[W.] I, pp. 118–121.
Entries: 270.*

[Sm.] I, pp. 64–70, and "additions and corrections" section; IV, "additions and corrections" section.
Entries: 24 (portraits done in England only). Inches. Inscriptions. States. Described. Illustrated (selection). Located (selection).

[Ru.] pp. 19–21.
Entries: 1 (portraits done in England only, additional to [Sm.]). Inches. Inscriptions. States. Described. Additional information to [Sm.].

[H. Neth.] II, pp. 159–268.
Entries: 284. Illustrated (selection).*

Blossfeld, Karl *(20th cent.)*
Heeren, Hanns. *Karl Blossfeld und seine Kleingrafik.* Expanded reprint from *Die Freude,* II, no. 8. Kleekamp (Germany): H. Heeren, 1926. (NN)
Entries: 92 (to 1925). Described (selection). Illustrated (selection).

Blot, Maurice *(1753–1818)*
[Ap.] pp. 67–68.
Entries: 20.*

[Ber.] II, pp. 135–137.*

[L. D.] p. 6.
Entries: 2. Millimeters. Inscriptions. States. Described. Incomplete catalogue.*

Blum, Hans *(1525–1549)*
[A.] III, pp. 279–284.
Entries: 2+. Pre-metric. Inscriptions. Described.

[H. Ger.] IV, p. 125.
Entries: 4+.*

Blum, Robert *(1857–1903)*
Sherman, Frederic Fairchild. "The etchings of Robert Blum." *Art in America* 22 (1933–1934): 37–38.
Entries: 44. Inches. States. Located.

Blyhooft, Zacharias *(fl. 1659–c.1681).*
[W.] I, p. 121.
Entries: 3 prints after.*

Bo, Lars *(20th cent.)*
Giraud, Robert, et al. *Lars Bo.* n.p. Carit Andersens Forlag, n.d. (DLC)
Entries: 79 (single prints only, to 1965). Millimeters. Illustrated. Also, bibliography of books with illustrations by.

Boba, George *(fl. 1572–1599)*
[B.] XVI, pp. 363–365.
Entries: 6. Pre-metric. Inscriptions. Described.

[Herbet] IV, pp. 310–312.
Entries: 6. Millimeters. Inscriptions. Described (selection).

Boberg, Ferdinand [Gustaf] *(b. 1860)*
Gauffin, Axel Vilhelm Reinhold. *Ferdinand Bobergs etsningar; illustrerad beskrifvande Katalog.* Stockholm: A. B. Nordiska Kompaniet, 1917.
Entries: 108. Millimeters. Inscriptions. States. Described. Illustrated (selection). Located (selection).

Boccanera, Giacinto *(1666–1746)*
[Vesme] p. 359.
Entries: 2. Millimeters. Inscriptions. Described.

Boccioni, Umberto *(1882–1916)*
Museum of Modern Art, New York [Joshua Charles Taylor, compiler]. *The Graphic Works of Umberto Boccioni.* Garden City (N.Y.): Doubleday and Co., [c.1961].
Entries: 21 (prints from one collection, complete?). Inches. Inscriptions. Described. Illustrated.

Bruno, Gianfranco. *L'opera completa di Boccioni.* Milan: Rizzoli Editore, 1969.
Entries: 202 (works in all media; a few prints). Millimeters. Inscriptions. De-

Boccioni, Umberto *(continued)*

scribed. Illustrated. Located (selection).

Bellini, Paolo. *Catalogo completa dell'opera grafica di Umberto Boccioni.* I Classici dell'incisione, 2. Milan: Salamon e Agustoni, 1972.
Entries: 32. Millimeters. Inscriptions. States. Described. Illustrated. Located.

Bocholt, Franz von
See **Monogram F V B** [Nagler, *Mon.*] II, no. 2552

Bock, Jeremias *(fl. c.1598)*
[B.] IX, pp. 598–599.
Entries: 1. Pre-metric. Inscriptions. Described.

[H. *Ger.*] IV, p. 125.
Entries: 2.*

Bockman, Gerhard *(d. 1773)*
[Sm.] I, pp. 70–80, and "additions and corrections" section; IV, "additions and corrections" section.
Entries: 25 (portraits only). Inches. Inscriptions. States. Described. Illustrated (selection).

[Ru.] pp. 21–22.
Additional information to [Sm.].

Bocksberger, Johann Melchior [Hans, Hieronymus] *(c.1520–1589)*
[B.] IX, p. 424.

[P.] IV, pp. 330–333.
Entries: 3. Pre-metric. Inscriptions. Described. Additional information to [B.].

[H. *Ger.*] IV, p. 131.
Entries: 13+ prints after.

Bockstorffer, Christoffel
see **Monogram CB** [Nagler, *Mon.*] I, nos. 2294, 2317

Bocourt, Étienne Gabriel *(b. 1821)*
[Ber.] II, p. 137.*

Bodan, Andreas II *(1656–1696)*
[H. *Ger.*] IV, p. 134.
Entries: 1.*

Bodart, Pieter *(fl. c.1712)*
[W.] I, pp. 121–122.
Entries: 3+.*

Bodding
See **Laer,** Pieter and Roeland de

Bodecker, Johannes Friedrich *(c.1660–1727)*
[W.] I, p. 122.
Entries: 5 prints by, 2 after.*

Bodenehr, Johann Georg I *(1631–1704)* and Johann Georg II *(1691–1730)*
[H. *Ger.*] IV, p. 135.
Entries: 11.*

Bodenheim, Nelly *(b. 1874)*
Veth, Cornelis. *Nelly Bodenheim illustratice.* Rotterdam (Netherlands) and Antwerp (Belgium): Ad. Donker, 1946. (EAKhI)
Bibliography of books with illustrations by.

Bodger, J. *(fl. c.1831)*
[Siltzer] pp. 328–346.
Entries: unnumbered, pp. 328, 346 (prints by and after). Inches, Inscriptions.

Bodmer, Johann [Hans] Heinrich *(1654–1706)*
[H. *Ger.*] IV, p. 135.
Entries: 3.*

Bodmer, Karl *(1809–1893)*
[Ber.] II, pp. 137–143.
Entries: 48 etchings, selection of 8 relief prints and lithographs.

Delteil, Loys. "Karl Bodmer." *L'Artiste*, n.s. 8 (1894, no. 2): 134–142.
Entries: 104. Millimeters. Inscriptions. States. Described (selection).

Bodmer, Karl
Curtis, Atherton. Catalogue. Unpublished ms. (EPPr)
Not seen.

Boecklin, Johann Christoph *(1657–1709)*
[H. *Ger.*] IV, pp. 126–130.
Entries: 128+.*

Böcksteigel, Peter August *(1889–1951)*
Thomas und Kurzberg, Bielefeld [Heinrich Becker, compiler]. *P. A. Böcksteigel; Gemälde, Aquarelle, Zeichnungen, graphische und plastische Werke.* Bielefeld (West Germany): Thomas und Kurzberg, 1969. (EOBKk)
Entries: 209. Millimeters. Inscriptions. States. Described (selection). Illustrated (selection).

Boegehold, Julie *(19th cent.)*
[Dus.] p. 19.
Entries: 7 (lithographs only, to 1821). Paper fold measure.

Boehle, Fritz *(1873–1916)*
Schrey, Rudolf. *Das graphische Werk Fritz Boehles, 1892–1912.* Frankfurt am Main: J. P. Schneider, Jr., 1914. (NN)
Entries: 57 (additional prints, unnumbered, pp. 69–75; to 1912) Millimeters. Inscriptions. States. Described. Illustrated. Located. Ms. addition (NN) adds 3 prints (1909, 1914).

Schrey, Rudolf. *Fritz Boehle: Leben und Schaffen eines deutschen Künstlers.* Frankfurt am Main: Verlag von Klimsch's Druckerei, 1925. (EBM)
Entries: 111. Millimeters. Inscriptions. States. Described. Illustrated (selection).

Boekhorst, Johan [Lange Jan] *(1605–1668)*
[H. *Neth.*] III, p. 1.
Entries: 4 prints after.*

Boel, Cornelis *(c.1576–after 1613)*
[Hind, *Engl.*] II, pp. 313–315.
Entries: 3 (prints done in England only). Inches. Inscriptions. States. Described. Illustrated. Located.

Boel, Peter *(1622–1674)*
[B.] IV, pp. 199–204.
Entries: 7. Pre-metric. Inscriptions. Described.

[Weigel] pp. 183–185.
Entries: 7 (additional to [B.]). Pre-metric. Inscriptions. States. Described.

[Dut.] IV, pp. 55–58; V. p. 586.
Entries: 14. Millimeters. Inscriptions. States. Described. Appendix with 1 doubtful print.

[Wess.] II, p. 229.
Additional information to [B.] and [Weigel].

[W.] I, pp. 123–124.
Entries: 15 prints by, 2+ after.*

[H. *Neth.*] III, pp. 57–60.
Entries: 15 prints by, 4 after. Illustrated (selection).

Bömmel, Wolfgang Hieronymus von *(fl. c.1660)*
[H. *Ger.*] IV, p. 136.
Entries: 9.*

Boener, Johann Alexander *(1647–1720)*
[H. *Ger.*] IV, pp. 136–139.
Entries: 111.*

Boerner, Amalie *(1793–1830)*
See **Boerner,** Johann Andreas

Boerner, Eleonore *(d. c.1834)*
See **Boerner,** Johann Andreas

Börner, Franz August *(b. 1861)*
Singer, Hans W. "F.A. Börner."[*Kh.*] 14 (1922): 167–172.
>Entries: 60 (to 1920). Millimeters. States.

Boerner, Johann Andreas *(1785–1862)*
[Dus.] pp. 19–20.
>Entries: 2 (lithographs only, to 1821). Pre-metric. Inscriptions. Located.

Andresen, A. "Beschreibung der von J. A. Boerner hinterlassenen radierten Blätter." [*N. Arch.*] 9 (1863): 8–19.
>Entries: 40. Pre-metric. Inscriptions. States. Described. Appendix with 5 etchings by Amalie Spiess Boerner, and 1 by Eleonore Philippine Louise Boerner.

Boetto, Giovenale *(1603–1678)*
[Vesme] pp. 26–60.
>Entries: 89 prints by, 15 prints after, 4 rejected prints. Millimeters. Inscriptions. States. Described.

Morra, Carlo. Catalogue. In *Giovenale Boetto,* by Nino Carbonari et al. Fossano (Italy): Edizione della Casa di Risparmio di Fossano, 1966.
>Entries: 115. Millimeters. Inscriptions. Described. Illustrated.

Boetto, Michele Damiano *(1647–1690)*
[Vesme] pp. 56–57.
>Entries: 2. Millimeters. Inscriptions. States. Described. Appendix with 1 doubtful print.

Boetzel, Ernest *(1830–c.1920)*
[Ber.] II, p. 143.*

Boetzel, Hélène *(19th cent.)*
[Ber.] II, p. 143.*

Bofa, Gus *(20th cent.)*
Charensol, Georges. "Dans l'atelier de Gus Bofa." *Portique* 6 (1947): 11–34.

Bibliography of books with illustrations by, to 1946.

Bogaerts, Félix *(19th cent.)*
[H. L.] pp. 88–90.
>Entries: 1. Millimeters. Inscriptions. Described.

Bogerts, C. *(fl. 1772–1815)*
[W.] I, p. 126.
>Entries: 8+.*

Boillot, Joseph *(1560–after 1603)*
[RD.] VI, pp. 70–100.
>Entries: 155. Millimeters. Inscriptions. Described.

Boilly, Alphonse *(1801–1867)*
[Ber.] II, p. 148.*

Boilly, Julien Léopold [Jules] *(1796–1874)*
[Ber.] II, pp. 146–147.*

Boilly, Louis Léopold *(1761–1845)*
[Ber.] II, pp. 144–146.*

Harrisse, Henry. *L.-L. Boilly, peintre, dessinateur et lithographe; sa vie et son oeuvre.* Paris: Société de Propagation des Livres d'Art, 1898.
>Entries: 168. Millimeters. Inscriptions. Described. Also, list of 17 lithographs painted over by Boilly.

Boilot, Alfred *(19th cent.)*
[Ber.] II, p. 148.*

Boilvin, Émile *(1845–1899)*
[Ber.] II, pp. 148–151.*

Boisfremont, Charles Boulanger de *(1773–1838)*
[Ber.] II, p. 152.*

Boissard, Robert *(fl. c.1600)*
[Hind, *Engl.*] I, pp. 187–192.
>Entries: 7. Inches. Inscriptions. States. Described. Illustrated. Located.

Boissart, Michel J. *(fl. c.1650)*
[RD.] IV, p. 25; XI, p. 17.
Entries: 3. Pre-metric. Inscriptions. Described.

Boisselat, Jean François *(b. 1812)*
[Ber.] II, p. 152.*

Boissens, Cornelis Theodorus [Dirksz] *(1567–1625)*
[W.] I, p. 126.
Entries: 3.*

[H. *Neth.*] III, pp. 1–3.
Entries: 9. Illustrated (selection).*

Boissieu, Jean Jacques de *(1736–1810)*
Boissieu, Jean-Jacques de. *Catalogue des morceaux qui composent l'oeuvre à l'eau-forte de Jean-Jacques Boissieu.* Lyon (France): J.-L. Maillet, 1801. (EPBN)
Entries: 76 (to 1800; about 30 minor early prints are omitted). Pre-metric. Described.

Regnault-Delalande. *Catalogue . . . Vente Rigal.* Paris, 1817.
Not seen. Reference in [I.F.F. 1700] II, p. 79.

[Lebl.] I, pp. 418–426.
Entries: 142. Millimeters. Inscriptions (selection). States. Described.

Guichardot: *Catalogue . . . vente van den Zande.* Paris, 1855.
Not seen. Reference in [I.F.F. 1700] II, p. 79.

Boissieu, Alphonse de. *J. J. de Boissieu, catalogue raisonné de son oeuvre.* Paris: Rapilly; and Lyon (France): Auguste Brun, 1878.
Entries: 140. Millimeters. Inscriptions. States. Described. Appendix with minor unpublished prints.

[Ber.] II, pp. 152–153.*

Boisson, Léon *(b. 1854)*
[Ber.] II, p. 153.*

Boit, Charles *(1663–1727)*
Nisser, Wilhelm. *Michael Dahl and the contemporary Swedish school of painting in England.* Uppsala (Sweden): Almqvist and Wiksell, 1927.
Entries: 3 prints after. Inscriptions. Described.

Bokhorni, —— *(19th cent.)*
[Dus.] p. 20.
Entries: 1 (lithographs only, to 1821). Paper fold measure. Inscriptions. Described.

Bol, Cornelis I *(c.1576–after 1627)*
[W.] I, p. 126.
Entries: 11+.*

[H. *Neth.*] III, pp. 4–7.
Entries: 152. Illustrated (selection).*

Bol, Cornelis IV *(fl. c.1666)*
[W.] I, p. 127.
Entries: 3.*

[H. *Neth.*] III, p. 8.
Entries: 11. Illustrated (selection).*

Bol, Coryn [Quiryn] *(1620–1688)*
[W.] I, p. 127.
Entries: 8+.*

[H. *Neth.*] III, pp. 9–14.
Entries: 54. Illustrated (selection).*

Bol, Ferdinand *(1616–1680)*
[Daulby] pp. 301–306.
Entries: 16 prints by. Inches. Inscriptions. States. Described. Also, list of 15 prints after: title, dimensions and name of engraver.

[B. *Remb.*] II, pp. 5–16, 172.
Entries: 15 prints by, 2 after. Pre-metric. Inscriptions. States. Described.

[Wess.] II, p. 230.
Additional information to [B.].

Bol, Ferdinand *(continued)*

[Dut.] IV, pp. 58–65; V, p. 586.
Entries: 20. Millimeters. Inscriptions.
States. Described.

[Rov.] pp. 17–24.
Entries: 22 prints by, 11 doubtful
prints. Millimeters. Inscriptions.
States. Described. Illustrated. Lo-
cated.

[W.] I, pp. 127–129; III, p. 32.
Entries: 32 prints by, 35 after.*

[H. *Neth.*] III, pp. 15–35.
Entries: 24 prints by, 37 after. Illus-
trated (selection).*

Bol, Hans *(1534–1593)*
[vdK.] pp. 85–97, 228–229.
Entries: 29. Millimeters. Inscriptions.
States. Described. Appendix with 17+
doubtful and rejected prints.

Thausing, M. "Van der Kellens
hollandisch-flamischer peintre-
graveur." [*ZbK.*] 8 (1873): 221–224.
Entries: 3 (additional to [vdK.]).
Millimeters. Inscriptions. Described.

[Dut.] IV, p. 65.*

[W.] I, pp. 129–131.
Entries: 29.*

[H. *Neth.*] III, pp. 36–55.
Entries: 30 prints by, 329+ after. Illus-
trated (selection).*

Bol, Jan [Jean] *(1592–1640)*
[W.] I, p. 131.
Entries: 3.*

[H. *Neth.*] III, p. 56.
Entries: 4.*

Boldini, Giovanni *(1842–1931)*
Prandi, Dino. *Giovanni Boldini, l'opera in-
cisa.* Reggio Emilia (Italy): Prandi, 1970.
Entries: 52. Millimeters. Inscriptions.
States. Described. Illustrated. Dimen-

sions are omitted for prints repro-
duced actual size.

Boldrini, Niccolò *(1510–after 1566)*
[B.] XII: *See* **Chiaroscuro Woodcuts**

Baseggio, Giambattista. *Intorno tre
celebri intagliatori in legno Vicentini
memoria.* Bassano (Italy): Tipografia
Baseggio, 1844. (EFKI)
Entries: 26. Pre-metric. Inscriptions.
Described.

[P.] VI: *See* **Chiaroscuro Woodcuts**

Korn, Wilhelm. *Tizians Holzschnitte.* Dis-
sertation, University of Breslau. Breslau
(Germany): Wilhelm Gottl. Korn, 1897.
Entries: 2 (prints after Titian only, ad-
ditional to [P.]). Millimeters. States.
Described (selection). Located. Addi-
tional information to [P.].

Bollinger, F. *(19th cent.)*
[Dus.] p. 20.
Entries: 6+ (lithographs only, to
1821). Millimeters (selection). Inscrip-
tions. Located (selection).

Bologna, Giovanni da *(1524–1608)*
[B.] XII: *See* **Chiaroscuro Woodcuts**

Bolognini, Gian Battista I *(1611–1688)*
[B.] XIX, pp. 187–189.
Entries: 4. Pre-metric. Inscriptions.
Described.

Bolomey, Benjamin *(1739–1819)*
[W.] I, p. 131.
Entries: 7.*

Bols, Hieronymus
See **Bolsi,** Girolamo

Bolsi, Girolamo *(16th cent.)*
[B.] XII: *See* **Chiaroscuro Woodcuts**

Bolswert, Boetius Adams *(1580–1633)*
[Dut.] IV, p. 65.*

[W.] I, p. 132.
 Entries: 36+.*

[H. *Neth.*] III, pp. 61–70.
 Entries: 388. Illustrated (selection).*

Bolswert, Schelte Adams *(1586–1659)*
 [Dut.] IV, pp. 66–71, V, p. 586.*

 [W.] I, pp. 132–135.
 Entries: 122+.*

 [H. *Neth.*] III, pp. 71–92.
 Entries: 346+. Illustrated (selection).*

Bolt, Johann Friedrich *(1769–1836)*
 Verzeichnis der Kupferstiche, welche Johann Friedrich Bolt in Berlin seit dem Jahre 1785 verfertigt hat. Berlin, 1794. (EBKk)
 Entries: 150 (to 1794). Paper fold measure (selection). Ms. addition. (EBKk) Nos. 151–635 (to 1831).

 [Dus.] pp. 20–21.
 Entries: 1 (lithographs only, to 1821). Millimeters. Inscriptions. Located.

Bolten, Arendt van *(fl. c.1637)*
 [H. *Neth.*] III, p. 93.
 Entries: 5 prints after.*

Bolten, Roland van *(fl. 1602–1608)*
 [W.] I, p. 135.
 Entries: 2.*

 [H. *Neth.*] III, p. 93.
 Entries: 8.*

Bolton, James *(d. 1799)*
 [Sm.] I, p. 80.
 Entries: 1 (portraits only). Inches. Inscriptions. States. Described.

Bolzani, A. M. *(fl. c.1815)*
 [Dus.] pp. 20–21.
 Entries: 2 (lithographs only, to 1821). Paper fold measure.

Bombled, Karel Frederik *(1822–1902)*
 [H. L.] pp. 90–91.

Entries: 7. Millimeters. Inscriptions. Described.

Bonafede.
See **Buonafede**

Bonaini, Gustavo *(1810–1889)*
 [Ap.] p. 68.
 Entries: 3.*

Bonajuti, Ignazio *(1787–after 1830)*
 [Ap.] pp. 68–69.
 Entries: 7.*

Bonaldi, Pietro *(1765–1820)*
 [Ap.] pp. 69–70.
 Entries: 14.*

Bonaparte, Princesse Charlotte *(19th cent.)*
 [Ber.] II, pp. 153–154.*

Bonaparte, Princesse Jeanne *(19th cent.)*
 [Ber.] II, p. 154.*

Bonasone, Giulio di Antonio *(fl. 1531—1574)*
 Cumberland, George. *Some anecdotes of the life of Julio Bonasoni, a Bolognese artist . . . accompanied by a catalogue of the engravings.* London: G. G. J. and J. Robinson, 1793. (NN)
 Entries: 377. Inches. Inscriptions. Described. Located. Also 11+ doubtful prints. Ms. addition (EBM) by Cumberland. 19 additional prints.

 [B.] XV, pp. 103–178.
 Entries: 354. Pre-metric. Inscriptions. States. Described. Copies mentioned. Appendix with 12 prints by anonymous engravers in the style of Bonasone.

 Armano, Giovanni Antonio. *Catalogo di una serie preziosa delle stampe di Giulio Bonasone pittore, e intagliatore bolognese.* Rome: Francesco Bourlie, 1820. (EFU)

Bonasone, Giulio di Antonio *(continued)*

Entries: 338. Inscriptions. Described. Catalogue of Armano's own collection.

[P.] VI, pp. 102–103.
Additional information to [B.].

[Heller] pp. 31–32.
Additional information to [B.].

[Wess.] III, pp. 44–45.
Entries: 4 (additional to [B.]). Millimeters (selection). Paper fold measure (selection). Inscriptions. Described (selection). Additional information to [B.].

[Dis. 1929]
Additional information to [B.].

Bond, William *(fl. 1799–1833)*
[Siltzer] p. 346.
Entries: unnumbered, p. 346. Inscriptions.

Bone, Muirhead *(1876–1953)*
Dodgson, Campbell. "Muirhead Bone." [*GK.*] 29 (1906): 53–65. Catalogue: "Kurzes Verzeichnis der Radierungen von Muirhead Bone 1898–1905." [*MGvK.*] 1906, pp. 55–57.
Entries: 185 (to 1905). Millimeters. Inscriptions.

Dodgson, Campbell. *Etchings and Dry-Points by Muirhead Bone, I.* London: Obach and Co., 1909. 275 copies.
Entries: 225 (to 1907). Inches. Millimeters. Inscriptions. States. Described. Ms. addition (MB, EBM, ECol) by Dodgson. 253 additional prints (to 1939).

Dodgson, Campbell. "The later drypoints of Muirhead Bone." [*PCQ.*] 9 (1922): 173–200.
Entries: unnumbered, pp. 192–200 (additional to Dodgson 1909; to 1916). Inches. States. Illustrated (selection).

Bonfils, Robert *(b. 1886)*
Thomé, J. R. *Catalogues de l'oeuvre gravé et lithographie de Bonfils, Robert; Dauchez, André; Drouart, Raphaël.* Graveurs et lithographes contemporains, I. Paris: Auguste Fontaine, 1937. 110 copies (MBMu)
Entries: 148 (single prints only, to 1935). Millimeters. Also, bibliography of books with illustrations by.

Bongard, Hermann *(20th cent.)*
Schyberg, Thor Bjorn. "Hermann Bongard." [*N. ExT.*] 3 (1949–50): 25–27.
Entries: 41 (bookplates only, to 1948). Illustrated (selection).

Bonheur, Rosa *(1822–1899)*
Baré, F. "Rosa Bonheur." [*Bull. des B. A.*] 3 (1885–86): 1–16.
Entries: 152 prints by and after. Paper fold measure (selection). Inscriptions (selection). Described (selection).

[Ber.] II, pp. 154–155.*

Klumpke, Anna. *Rosa Bonheur; sa vie, son oeuvre.* Paris: Ernest Flammarion, 1908.
Entries: unnumbered, pp. 429–434, prints by and after.

Bonhommé, Ignace François *(1809–1881)*
[Ber.] II, pp. 155–156.
Entries: 8+. Described (selection).

Boni, Paolo *(20th cent.)*
Zakarian, Gayzag. *Boni, "grafi-sculptures," oeuvre gravé 1957–1970.* Paris: Gayzag Zakarian, 1970.
Entries: 221 (to 1970). Millimeters. Described. Illustrated.

Bonington, Richard Parkes *(1801–1828)*
Bouvenne, Aglaus. *Catalogue de l'oeuvre gravé et lithographié de R. P. Bonington.* Paris: Jules Claye, 1873. 170 copies. (MBMu)

Entries: unnumbered, 33 pp. Inscriptions. States. Described. Located (selection).

[Ber.] II, pp. 156–162.
Entries: 68.

Hughes, C. E. Catalogue. In *Richard Parkes Bonington; his Life and Work*, by A. Dubuisson. London: John Lane, The Bodley Head, 1924.
Entries: 63 prints by, prints after unnumbered, pp. 147–165. Inches. Inscriptions. States. Described (selection).

Curtis, Atherton. *Catalogue de l'Oeuvre lithographié et gravé de R. P. Bonington.* Paris: Paul Prouté, 1939.
Entries: 82 prints by, 1 rejected print. Millimeters. Inscriptions. States. Described (selection). Illustrated.

Bonn, Jan de *(fl. c.1515)*
[H. *Ger.*] IV, p. 140.
Entries: 9.*

Bonnard, Pierre *(1867–1947)*
Floury, Jean. Catalogue. In *Bonnard,* by Ch. Terrasse. Paris: Henry Floury, 1927.
Entries: 64+ (to 1927). Millimeters. Inscriptions. States. Described. Ms. addition (NN). 1 additional entry.

Roger-Marx, Claude. *Pierre Bonnard.* Les artistes du livre, 19. Paris: Henry Babou, 1931. 700 copies.
Bibliography of books with illustrations by, to 1930.

Werth, Léon. "Pierre Bonnard illustrateur." *Portique* 7 (1950): 9–20.
Bibliography of books with illustrations by, to 1946.

Roger-Marx, Claude. *Bonnard lithographe.* Monte Carlo (Monaco): André Sauret, 1952.
Entries: 98+ (lithographs only). Millimeters. Described. Illustrated.

Rouir, E. "Quelques remarques sur les lithographies de Pierre Bonnard." *Le Livre et l'estampe,* no. 53–54 (1968): 27–35.
Additional information to Roger-Marx 1952.

Bonnat, Léon *(1833–1923)*
[Ber.] II, p. 162.*

Bonnecroy, Jan Baptist *(1618–1676)*
[B.] V, pp. 38–42; nos. 36–40, 43, 44.
Entries: 7. Pre-metric. Inscriptions. Described. Attributed to Lucas van Uden by [B.].

[RD.] III, pp. 32–36.
Entries: 8. Pre-metric. Inscriptions. Described.

[W.] I, p. 136.
Entries: 9.*

[H. *Neth.*] III, pp. 94–95.
Entries: 9. Illustrated (selection).*

Bonnefond, Claude Jean *(1796–1860)*
[Ber.] II, p. 162.*

Bonnefoy, ——— *(fl. c.1830)*
[Ber.] II, pp. 162–163.*

Bonnejonne, Eloi *(fl. 1650–1695)*
[W.] I, p. 136.
Entries: 5.*

[H. *Neth.*] III, p. 96.
Entries: 5.*

Bonnemer, François *(1638–1689)*
[RD.] VIII, pp. 274–275.
Entries: 1 (a second print, not seen by [RD.], is mentioned). Millimeters. Inscriptions. States. Described.

Bonnet, Louis Marin *(1743–1793)*
Hérold, Jacques. *Louis-Marin Bonnet (1756–1793) catalogue de l'oeuvre gravé.* Paris: Société pour l'étude de la gravure française, 1935.

Bonnet, Louis Marin *(continued)*

Entries: 1161. Millimeters. Inscriptions. States. Described. Illustrated (selection).

Bontemps, Mme ——— *(19th cent.)*
[Ber.] II, p. 163.*

Bontepaert, Dirck [Pieter] Dircksz
See **Santvoort**

Bonvicini, Bartolommeo
See **Buonvicini**

Bonvin, François *(1817–1887)*
[Ber.] II, pp. 163–164.*

Bonvoisin, Jean [H.] *(1752–1837)*
[Ap.] p. 70.
Entries: 2.*

[Ber.] II, p. 164.*

Bonvoisin, Maurice ["Mars"] *(1849–1912)*
[H. L.] pp. 706–708.
Entries: 5. Millimeters. Inscriptions. States. Described.

[Ber.] IX, p. 224.*

Boon, Adriaen *(fl. c.1580)*
[H. *Neth.*] III, p. 97.
Entries 1. Illustrated.*

Boon, Jan *(b. 1882)*
Greshoff, J. "Houtsneden van Jan Boon." *Onze kunst* 46 (1929): 55–59. "Gravures sur bois de Jan Boon." *Rev. d'Art* 30 (1929): 53–57.
Entries: 14 (to 1929). Millimeters. Illustrated (selection).

Boonen, Arnold *(1669–1729)*
[W.] I, pp. 137–138; III, p. 33.
Entries: 5 prints after.*

Boonen, Jasper *(1677–1729)*
[W.] I, p. 138.
Entries: 2.*

Boquet, ——— *(19th cent.)*
[F.] p. 66.*

Boquet, Mlle ——— *(fl. c.1816)*
[Ber.] II, p. 165.
Entries: 6. Paper fold measure.

Boquet, Pierre Jean *(1751–1817)*
[Ber.] II, p. 165.
Entries: 2+. Paper fold measure.

Borboni, Matteo *(1610–1667)*
[B.] XIX, pp. 194–195.
Entries: 1. Pre-metric. Inscriptions. Described.

Borchgrevink, Ridley *(b. 1898)*
Borchgrevink, Ludvig. "Ridley Borchgrevink." [N. ExT.] 3 (1949–50): 49–52.
Entries: 10 (bookplates only, to 1949?). Illustrated (selection).

Borcht, Hendrik van der I *(1583–1660)*
[W.] I, p. 139.
Entries: 1+.*

[H. *Neth.*] III, p. 97.
Entries: 24.*

Borcht, Hendrik van der II *(b. 1614)*
[W.] I, pp. 139–140.
Entries: 15+ prints by, 3 after.*

[H. *Neth.*] III, p. 98.
Entries: 53 prints by, 4 after.*

Borcht, Peter van der (4 artists of this name, *fl. 1550–1600)*
[W.] I pp. 140–141.
Entries: 16+.*

[H. *Neth.*] III, pp. 99–108.
Entries: 577 prints by, 63+ after. Illustrated (selection).*

Borcht, Pieter van der *(1545–1608)*
[P.] IV, p. 176.
Entries: 1. Pre-metric. Inscriptions. Described. Located. Watermarks described.

Borckeloo, Harman van *(fl. c.1530)*
[H. *Neth.*] III, p. 109.
 Entries: 1. Illustrated.*

Borckeloo, Nicolas van *(fl. 1608–1620)*
[N. *Neth.*] III, p. 109.
 Entries: 1 print after.*

Bordeaux, Henri, duc de *(1820–1884)*
[Ber.] II, p. 165.
 Entries: 2. Inscriptions. Located
 (selection).

Bordiga, Benedetto *(fl. c.1806)*
[Ap.] p. 70.
 Entries: 1.*

Borein, Edward *(1873–1945)*
Galvin, John. *The etchings of Edward Borein; a catalogue of his work.* San Francisco: John Howel, 1971.
 Entries: 318. Inches. Inscriptions. Illustrated.

Borgiani, Orazio *(d. 1616)*
[B.] XVII, pp. 315–321.
 Entries: 53. Pre-metric. Inscriptions.
 Described. Appendix with 3 doubtful
 prints and 1 rejected print.

[Heller] p. 32.
 Additional information to [B.].

Borglind, Stig *(b. 1892)*
Zeitler, Rudolf. *Stig Borglind; en svensk grafiker med oeuvre-katalog och 48 planscher.* Stockholm: Hugo Gebers Förlag, 1948.
 Entries: 123 (to 1948). Millimeters. Inscriptions. States. Described. Illustrated (selection).

Borking, Johann *(fl. c.1670)*
[H. *Ger.*] IV, p. 140.
 Entries: 8.*

Borrekens, Mattheus *(c.1615–1670)*
[W.] I, p. 142.
 Entries: 19.*

[H. *Neth.*] III, pp. 110–111.
 Entries: 34.*

Borselaer, Pieter *(fl. c.1665)*
[W.] I, p. 142.
 Entries: 1 print after.*

[H. *Neth.*] III, p. 111.
 Entries: 1 print after.*

Borssom, Anthony van *(1629/30–1677)*
[B.] IV, pp. 217–220.
 Entries: 4. Pre-metric. Inscriptions.
 Described.

[Heller] p. 32.
 Additional information to [B.].

[Weigel] pp. 188–190.
 Entries: 5 (additional to [B.]). Premetric. Inscriptions. Described.

[W.] I, pp. 142–143.
 Entries: 10 prints by, 2 after.*

[H. *Neth.*] III, pp. 112–115.
 Entries: 11 prints by, 2 after. Illustrated (selection).*

Borum, Andreas *(1799–1853)*
[Merlo] pp. 96–97.*

Borzone, Francesco Maria *(d. 1679)*
[Vesme] p. 343.
 Entries: 1. Millimeters. Inscriptions.
 Described.

Bos, A. van den *(19th cent.)*
[H. L.] pp. 1105–1107.
 Entries: 9. Millimeters. Inscriptions.
 Described.

Bos, Balthazar van den *(1518–1580)*
[B.] XV, p. 548.
 Entries: 1. Pre-metric. Inscriptions.
 Described.

[W.] I, p. 144.
 Entries: 10+.*

[H. *Neth.*] III, pp. 116–119.
 Entries: 71. Illustrated (selection).*

Bos, Caspar [Jaspar] van den *(1634–c.1660)*
[H. *Neth.*] III, p. 119.
 Entries: 6.*

Bos, Cornelis *(c.1510–1556)*
[W.] I, pp. 144–145.
 Entries: 51+.*

[H. *Neth.*] III, pp. 120–127.
 Entries: 147. Illustrated (selection).*

Schéle, Sune. "Catalogue of prints,
woodcuts and designs by Cornelis
Bos." Mimeographed ms. (EBM)
 Entries: 270. Millimeters. Inscrip-
 tions. Described. Located. Prepara-
 tory version of Schéle 1965, below.

Schéle, Sune. *Cornelis Bos; a study of the
origins of the Netherlands grotesque.*
Stockholm: Almqvist and Wiksell, 1965.
 Entries: 215 prints by, 69 drawings and
 doubtful and rejected work in all me-
 dia. Millimeters. Inscriptions. States.
 Described (selection). Illustrated. Lo-
 cated. Bibliography for each entry.

Bos, J. *(19th cent.)*
[H. L.] pp. 91–92.
 Entries: 2. Millimeters. Inscriptions.
 States. Described.

Bos, Jacob *(fl. 1549–1580)*
[W.] I, p. 151.
 Entries: 14+.*

[H. *Neth.*] III, pp. 148–150.
 Entries: 22. Illustrated (selection).*

Bosboom, Dirk *(1641–1682)*
[H. *Neth.*] III, p. 115.
 Entries: 1.*

Bosch, Hendrik van den *(fl. c.1736)*
[W.] I, p. 146.
 Entries: 2 prints after.*

Bosch, Hieronymus *(c.1450–1516)*
See also **Monogram H** [Nagler, *Mon.*] III,
no. 567

[M.] I, pp. 90–98.
 Entries: 35 engravings after, 3 wood-
 cuts after. Paper fold measure. In-
 scriptions.

[W.] I, pp. 146–151.
 Entries: 34 prints after.*

Gossart, M. G. *La peinture des diableries à
la fin du Moyen-Age; Jérôme Bosch, Le
"faizeur de Dyables" de Bois-le-Duc.* Lille
(France): Imprimerie Centrale du Nord,
1907. (EBM)
 Entries: 50 prints after. Dimensions
 given in various units. Inscriptions.
 (selection). States (selection). De-
 scribed (selection). Located (selec-
 tion).

Lafond, Paul. *Hieronymus Bosch; son art,
son influence, ses disciples.* Brussels and
Paris: G. van Oest et Cie, 1914.
 Entries: 48 prints after. Millimeters
 (selection). Inscriptions (selection).
 Located (selection).

[H. *Neth.*] III, pp. 129–148.
 Entries: 46 prints after. Illustrated
 (selection).*

Bosch, Johannes de *(1713–1785)*
[W.] I, p. 151.
 Entries: 6.*

Bosche, Elias van den *(fl. c.1600–1620)*
[Merlo] pp. 97–98.*

[W.] I, p. 145.
 Entries: 5+.*

[H. *Neth.*] III, p. 128.
 Entries: 5.*

Boscolo, Luigi *(b. 1824)*
[Ap.] p. 70.
 Entries: 6.*

Boselli, Tito *(19th cent.)*
[Ap.] p. 70.
 Entries: 1.*

Bosio, Jean François *(1767–1832)*
[Ber.] II, pp. 166–167.*

Bosman, ——— *(fl. c.1700)*
[W.] I, p. 153.
Entries: 1 print after.*

Bosq, Jean *(fl. c.1830)*
[Ap.] p. 71.
Entries: 2.*

[Ber.] II, p. 167.*

Bossart, Robert *(fl. c.1600)*
[H. *Neth.*] III, p. 150.
Entries: 3.*

Bosschaert, Jeronimus *(c.1600–1650)*
[W.] I, p. 153.
Entries: 2+ prints after.*

[H. *Neth.*] III, p. 150.
Entries: 2+ prints after.*

Bosschaert, Thomas
See **Willeboirts**

Bossche, Philipp van den *(fl. c.1610)*
[H. *Neth.*] III, p. 150.
Entries: 1+.*

Bosse, Abraham *(1602–1676)*
Duplessis, Georges. "Abraham Bosse; catalogue de son oeuvre." [*RUA.*] 5 (1857): 47–59, 145–163, 245–259, 347–367, 432–449), [*RUA.*] 6 (1857): 331–348, 440–460; [*RUA.*] 7 (1858): 53–68, 159–169, 531–534; [*RUA.*] 8 (1858): 256–263, 339–357.
Entries: 1506 prints by, 31 after. Millimeters. Inscriptions. States. Described.

Duplessis, Georges. *Catalogue de l'oeuvre de Abraham Bosse.* Reprint from [*RUA.*] Paris, 1859.
Entries: 1506 prints by, 31 after. Millimeters. Inscriptions (selection). States. Described (selection).

Blum, André. *L'Oeuvre gravé d'Abraham Bosse.* Paris: Editions Albert Morancé, 1924.
Entries: 1512. Millimeters. Inscriptions (selection). States. Described (selection). Illustrated (selection).

Bosse, Louis *(fl. c.1770)*
[L. D.] pp. 6–7.
Entries: 1. Millimeters. Incomplete catalogue.*

Bosselmann, ——— *(fl. 1820–1840)*
[Ber.] II, p. 167–168.*

Bossert, Otto Richard *(1874–1919)*
"Otto Richard Bossert; beschreibendes Verzeichnis seiner wichtigsten graphischen Arbeiten"; Hermann Voss. "Otto Richard Bossert." [*Kh.*] 11 (1919): 18–21.
Entries: 54. Millimeters. Described (selection).

Zeitler, Julius. *Otto Richard Bossert, Leben und Werke eines graphischen Kunstlers.* Leipzig: R. Voigtländer's Verlag, 1920.
Entries: 122 (to 1918). Millimeters. Described. Illustrated (selection).

Bossuit, Francis van *(1635–1692)*
[H. *Neth.*] III, p. 150.
Entries: 1+ prints after.*

Boström, Göran *(20th cent.)*
Rudbeck, Fredric. "Göran Boström, en svensk guldsmed och kopparstikare." [*N. ExT.*] 14 (1962): 49–52.
Entries: 21 (bookplates only, to 1962). Millimeters. Described. Illustrated (selection).

Both, Andries *(1608–before 1649)*
[B.] V, pp. 201–203, 214–217.
Entries: 10. Pre-metric. Inscriptions. Described.

[Dut.] IV, pp. 71–73; V, p. 586.
Entries: 13. Millimeters. Inscriptions. States. Described.

Both, Andries *(continued)*

[W.] I, pp. 154–155.
Entries: 13 prints by, 11+ after.*

[H. *Neth.*] III, pp. 151–157.
Entries: 19 prints by, 31+ after. Illustrated (selection).*

Both, Jan *(c.1610–1652)*
[B.] V, pp. 201–213.
Entries: 15. Pre-metric. Inscriptions. States. Described.

[Weigel] pp. 276–280.
Entries: 3 (additional to [B.]). Pre-metric (selection). Inscriptions. Described (selection). Cited by [Weigel] from other sources.

[Heller] pp. 32–33.
Additional information to [B.].

[Dut.] IV, pp. 73–80; V, p. 586.
Entries: 17. Millimeters. Inscriptions. States. Described.

[Wess.] II, p. 230.
Additional information to [B.] and [Weigel].

[W.] I, pp. 156–157.
Entries: 17.*

[H. *Neth.*] III, pp. 158–164.
Entries: 18 prints by, 27+ after. Illustrated (selection).*

Bottani, Giovanni *(1725–1804)*
[Vesme] pp. 479–480.
Entries: 4. Millimeters. Inscriptions. Described.

Bottani, Giuseppe *(1717–1784)*
[Vesme] p. 478.
Entries: 3. Millimeters. Inscriptions. Described. Located (selection).

Bottari, Giovanni Paolo *(fl. c.1650)*
[Vesme] p. 341.

Entries: 1. Millimeters. Inscriptions. Described. Located.

Botticelli, Sandro *(1437–1515)*
[B.] XIII, pp. 158–160.
Discussion of Botticelli's relation to Baccio Baldini.

[P.] V, pp. 27–48.
Additional information to [B.].

Bottschild, Samuel *(1641–1707)*
[H. *Ger.*] IV, p. 141.
Entries: 74 prints by, 13 after.*

Bouchardy *(fl. c.1800)*
[Ber.] II, p. 168.*

Bouchardy, Joseph *(1810–1870)*
[Ber.] II, pp. 168–169.*

Bouché, Frans *(fl. c.1692)*
[W.] I, p. 158.
Entries: 1.*

Bouché, Martin *(c.1640–1693)*
[W.] I, p. 158.
Entries: 6.*

[H. *Neth.*] III, p. 165.
Entries: 6.*

Bouché, Peter Paul *(c.1646–after 1693)*
[W.] I, p. 158.
Entries: 5.*

[H. *Neth.*] III, p. 166.
Entries: 5+.*

Boucher, François *(1704–1770)*
[Gon.] I, pp. 135–215.
Entries: unnumbered, pp. 185–215, prints after.

[Baud.] II, pp. 37–102.
Entries: 182. Millimeters. Inscriptions. States. Described.

Air, Paul d'. "François Boucher." [*Bull. des B. A.*] 1 (1883–1884): 22–26, 87–89.

Catalogue: "Liste des pièces graveés par et d'après François Boucher." [*Bull. des B. A.*] 2 (1884–1885): Supplément, pp. 1–55.
> Entries: 2197 prints by and after. Paper fold measure (selection). Inscriptions (selection). Described (selection).

Soullié, L., and Masson, Ch. Catalogue. In *François Boucher*, by André Michel. Paris: H. Piazza et Cie, 1906.
> Entries: unnumbered, pp. 157–172, prints by and after. Described (selection).

Boucher, Jean *(1568–after 1622)*
[RD.] V, pp. 68–70.
> Entries: 6. Millimeters. Inscriptions. Described.

Boucher-Desnoyers, Auguste Gaspard Louis, baron
See **Desnoyers**

Bouchot, Frédéric *(19th cent.)*
[Ber.] II, pp. 169–170.*

Bouckel, Anna van *(fl. c.1600)*
[H. *Neth.*] III, p. 166.
> Entries: 4.*

Bouckhorst, Jan Philipsz van *(c.1588–1631)*
[vdK.] pp. 213–216.
> Entries: 2. Millimeters. Inscriptions. States. Described. Illustrated (selection).

[W.] I, pp. 158–159.
> Entries: 2 prints by, 2 after.*

[H. *Neth.*] III, p. 167.
> Entries: 4 prints by, 2 after. Illustrated (selection).*

Boucquillon, B. *(19th cent.)*
[H. L.] pp. 92–93.
> Entries: 1. Millimeters. Inscriptions. States. Described.

Boudier, ——— *(fl. c.1800)*
[St.] p. 38.*

Boudt
See **Bout**

Bougon, Louis Étienne *(fl. 1812–1819)*
[Ber.] II, pp. 170–171.*

Bougourd, Auguste *(fl. 1868–1887)*
[Ber.] II, p. 170.*

Bouillard, Jacques *(1744–1806)*
[Ap.] p. 71.
> Entries: 7.*

[Ber.] II, p. 171.*

Bouillet, Joseph *(19th cent.)*
[Dus.] p. 21.
> Entries: 4 (lithographs only, to 1821). Millimeters. Inscriptions. Located.

Bouillon, L. *(fl. c.1820)*
[Ber.] II, p. 171.*

Bouillon, Pierre *(1776–1831)*
[Ber.] II, p. 171.*

Boulanger, Jean *(b. 1608)*
[CdB.] pp. 30–37.
> Entries: 111 prints from [Lebl.]; additions to [Lebl.], unnumbered, 1 page. Paper fold measure (selection).

Boulanger, Louis *(1807–1867)*
[Ber.] II, pp. 171–172.*

Marie, Aristide. *Le peintre poète Louis Boulanger.* Paris: H. Floury, 1925.
> Entries: unnumbered, pp. 122–127. Paper fold measure (selection). Illustrated (selection).

Boulard, Auguste *(1852–1927)*
[Ber.] II, pp. 172–173.*

Boulenger, Hippolyte *(1837–1874)*
[H. L.] pp. 93–94.

Boulenger, Hippolyte *(continued)*

Entries: 4. Millimeters. Inscriptions. States. Described.

Boullaire, Jacques *(b. 1893)*
Choussat de Swarte, Claire. "Jacques Boullaire: catalogue de son oeuvre gravé." Unpublished ms. [1959?]. (EPBN)
Entries: 193+ (to 1959). Millimeters. States. Described. Illustrated (selection).

Boullogne, Bon de *(1649–1717)*
[RD.] II, pp. 144–146; XI, pp. 17–18.
Entries: 3. Pre-metric. Inscriptions. Described.

Boullogne, Louis I de *(1609–1674)*
[RD.] I, pp. 111–124; XI, p. 18.
Entries: 40. Pre-metric. Inscriptions. States. Described.

Caix de Saint-Aymour, ———. *Une famille d'artistes et de financiers aux XVIIe et XVIIIe siècles; Les Boullongne.* Paris: Henri Laurens, 1919. 600 copies. (EPAA)
Entries: 105 (works in all media, including prints). Pre-metric (selection). Inscriptions. Described (selection). Based on [Heinecken] and [RD.].

Boullogne, Louis II de *(1654–1733)*
[RD.] III, pp. 282–284; XI, p. 18.
Entries: 2. Pre-metric. Inscriptions. Described.

Caix de Saint Aymour, ———. *Une famille d'artistes et de financiers aux XVIIe et XVIIIe siècles; les Boullongne.* Paris: Henri Laurens, 1919. 600 copies. (EPAA)
Entries: 14 prints by and after (selection only of prints after; others are listed in the accompanying catalogue of paintings and drawings). Based largely on [Heinecken].

Boultbe, J. *(1747–1812)*
[Siltzer] p. 328.
Entries: unnumbered, p. 328, prints after. Inscriptions.

Bounieu, Michel Honoré *(1740–1814)*
[Baud.] II, pp. 275–284.
Entries: 14. Millimeters. Inscriptions. States. Described.

Bouquet, Auguste *(1810–1846)*
Champfleury [Jules Fleury]. *Le peintre ordinaire de Gaspard Deburau.* Paris: Imprimerie de l'art, 1889. 120 copies. (NN)
Entries: unnumbered, pp. 38–47, prints by and after. Inscriptions.

[Ber.] II, pp. 173–174.*

[W.] I, pp. 159–160.
Entries: 1.*

Bouquet, Michel *(1807–1890)*
[Ber.] II, p. 174.*

Bouquet de Woiserie, J. I. *(fl. c.1804)*
[F.] pp. 292–293.

Bour, Charles *(fl. 1844–1880)*
[Ber.] II, pp. 174–175.*

Bourdet, Joseph Guillaume *(1799–1869)*
[Ber.] II, p. 175.*

Bourdon, Pierre *(fl. 1703–1707)*
Grézy, Eugène. "Pierre Bourdon, graveur né à Coulommiers." In *Études historiques et archéologiques sur la ville de Coulommiers,* by Anatole Dauvergne. Coulommiers (France): Alexandre Brodard, 1863. (NNMM).
Entries: 4+. Inscriptions. Described.

Bourdon, Sebastien *(1616–1671)*
[RD.] I, pp. 131–158; XI, p. 19.
Entries: 44. Pre-metric. Inscriptions. States. Described. Appendix with 3 rejected prints.

Ponsonailhe, Charles. *Sebastien Bourdon; sa vie et son oeuvre.* Paris: Aux Bureaux de l'Artiste, 1883. Reprint. Paris: Jules Rouan, 1886.
　　Entries: 45. Pre-metric. Inscriptions. States. Described. Appendix with 3 rejected prints. Based on [RD.]. Also, list of prints after, unnumbered, pp. 307–310. Paper fold measure (selection).

Bourgeois, Amédée *(1798–1837)*
　[Ber.] II, p. 175.*

Bourgeois, Constant [Florent Fidèle] *(1767–1841)*
　[Ber.] II, p. 175.*

Bourgeois, Eugène *(fl. c.1810)*
　[Ap.] p. 71.
　　Entries: 1.*

　[Ber.] II, p. 175.*

Bourgeois de la Richardière, Antoine Achille *(b. 1777)*
　[Ber.] II, p. 176.*

Boursse, Jacques *(fl. c.1668–1671)*
　[H. *Neth.*] III, p. 168.
　　Entries: 3. Illustrated (selection).*

Boussingault, Jean Louis *(b. 1883)*
　Dunoyer de Segonzac, A. "Jean Louis Boussingault, lithographe et aquafortiste." [*AMG.*] 3 (1929–30): 890–898.
　　Entries: unnumbered, p. 898 (to 1929?). Illustrated (selection).

　Thomé, J. R. "Boussingault illustrateur." *Portique* 2 (1945): 37–44.
　　Bibliography of books with illustrations by.

Bout, Cornelis de *(17th cent.)*
　[W.] I, p. 159.
　　Entries: 1.*

Bout, Peeter *(1658–1719)*
　[B.] IV, pp. 403–410.
　　Entries: 5. Pre-metric. Inscriptions. Described.

　[Weigel] p. 224.
　　Additional information to [B.].

　[Wess.] II, p. 230.
　　Additional information to [B.] and [Weigel].

　[Dut.] IV, pp. 80–82.
　　Entries: 5. Millimeters. Inscriptions. States. Described.

　[W.] I, pp. 160–161.
　　Entries: 5 prints by, 3 after.*

　[H. *Neth.*] III, pp. 169–173.
　　Entries: 5 prints by, 3 after. Illustrated (selection).*

Boutelié, ——— *(fl. c.1872)*
　[Ber.] II, p. 176.*

Boutet, Henri *(b. 1851)*
　[Ber.] II, pp. 176–177.*

　Maillard, Léon. *Henri Boutet.* 2 vols. Études sur quelques artistes originaux, 1. Paris: Succursale de la Maison Dentu, 1894–1895. Vol. 1, 425 copies. Vol. 2, 560 copies.
　　Entries: 1321 (numbered in 5 groups). Millimeters (selection). Inscriptions. Described.

Bouton, Charles Marie *(1781–1853)*
　[Ber.] II, p. 177.*

Boutray, ——— *(fl. 1822–1829)*
　[Ber.] II, p. 178.*

Boutrois, Philibert *(fl. 1775–1814)*
　[Ber.] II, p. 178.*

Bouttats, August *(fl. c.1670)*
　[Merlo] p. 99.*

　[W.] I, p. 166.
　　Entries: 3.*

Bouttats, August *(continued)*

[H. *Neth.*] III, p. 174.
Entries: 3.*

Bouttats, Caspar [Gaspar] *(1625–1695)*
[W.] I, p. 166.
Entries: 20+.*

[H. *Neth.*] III, p. 175.
Entries: 24+.*

Bouttats, Filibert [Philibertus] (two artists
of this name, *fl. c.1700)*
[W.] I, pp. 166–167.
Entries: 23.*

[H. *Neth.*] III, p. 176.
Entries: 34+.*

Bouttats, Frederik (two artists of this
name, *fl. 1610–1675)*
[Merlo] p. 99.*

[W.] I, p. 167.
Entries: 26.*

[H. *Neth.*] III, p. 177.
Entries: 42+.*

Bouttats, Gerhard *(fl. c.1650)*
[Merlo] p. 101.*

[W.] I, p. 167.
Entries: 18+.*

[H. *Neth.*] III, p. 178.
Entries: 25+.*

Bouttats, Peter Balthasar *(1660–before 1756)*
[W.] I, p. 167.
Entries: 10.*

Bouvenne, Aglaüs *(1829–1903)*
[Ber.] II, pp. 178–180.*

Bouvier, Ad. *(19th cent.)*
[Ap.] pp. 71–72.
Entries: 5.*

Bouvier, Charles *(fl. 1835–45)*
[Ber.] II, pp. 180–181.*

Bouys, André *(1656–1740)*
[RD.] IV, pp. 224–230; XI, pp. 19–20.
Entries: 12. Pre-metric. Inscriptions.
States. Described.

Bouvy, Eugène. "Graveurs français à la
manière noire: André Bouys (1656–
1740)."[*Am. Est.*] 8 (1929): 67–74, 97–106.
Entries: 12. Millimeters. Inscriptions.
States. Illustrated (selection). Follows
numbering of [RD.].

Bovie, Félix *(b. 1812)*
[H. L.] pp. 94–95.
Entries: 2. Millimeters. Inscriptions.
Described.

Bovinet, Edmonde [Edmé] *(1767–1832)*
[Ap.] p. 72.
Entries: 7.*

[Ber.] II, p. 181.*

Bowen, Abel *(1790–1850)*
[Allen] pp. 122–123.*

[St.] pp. 38–41.*

[F.] pp. 66–70.*

Bower, John *(fl. 1810–1819)*
[St.] p. 41.*

[F.] pp. 70–71.*

Bowes, Joseph *(fl. c.1796)*
[St.] p. 42.*

[F.] p. 71.*

Boy, Adolph *(1612–1680)*
[H. *Ger.*] IV, p. 141.
Entries: 19 prints after.*

Boy, Gottfried *(b. 1701)*
[Sm.] I, pp. 80–81.
Entries: 1 (portraits done in England
only). Inches. Inscriptions. De-
scribed.

Boy, Peter I *(1648–1727)*
[H. *Ger.*] IV, p. 142.
Entries: 4 prints after.*

Boyd, Arthur *(b. 1920)*
Philipp, Franz. *Arthur Boyd*. London: Thames and Hudson, 1967.
Entries: 37 (one set of prints, produced in 1963). Inches. Illustrated (selection).

Maltzahn, Imre von. *Arthur Boyd; etchings and lithographs*. London: Maltzahn Gallery, Lund Humphries, 1971.
Entries: 114 (etchings only, to 1969). Inches. Millimeters. Illustrated. Incomplete list of lithographs.

Boyd, John *(fl. 1811–1827)*
[Allen] p. 123.*

[St.] pp. 43–47.*

[F.] pp. 71–74.**

Boydell, John *(1719–1804)*
Boydell, John. *A catalogue of prints published by John Boydell engraver*. London, 1773.
Not seen.

Boydell, John. *Catalogue raisonné d'un recueil d'estampes d'après les plus beaux tableaux qui soient en Angleterre. Les planches sont dans la possession de Jean Boydell, et ont été gravées par lui, et les meilleurs artistes de Londres*. London: John Boydell, 1779. (EBr).
Entries: unnumbered, pp. 1–199, prints by and published by (to 1779?). Pre-metric. Described.

Boydell, John and Josiah. *A catalogue of historical prints, various subjects, landscapes, sea pieces, views, etc., after the most capital pictures in England, engraved by the most celebrated artists*. London: John and Josiah Boydell, 1787. (CSmH)
Not seen. Prints published by.

An alphabetical catalogue of plates engraved by the most esteemed artists . . . which compose the stock of John and Josiah Boydell. London: W. Bulmer and Co., 1803. (DLC)
Entries: unnumbered, pp. 1–60, prints published by (to 1803?). Inches.

Boydell, Josiah *(1752–1817)*
[Sm.] I, pp. 81–83.
Entries: 5 (portraits only). Inches. Inscriptions. States. Described.

[Ru.] p. 22.
Additional information to [Sm.].

Boyer, Ralph *(b. 1879)*
Daugherty, James. "Ralph Boyer: painter-etcher." [*P. Conn.*] 11 (1931): 123–138.
Entries: 34. Inches. Illustrated (selection).

Boyer-d'Aguilles, Jean Baptiste *(c.1650–1709)*
[RD.] IV, pp. 213–222; XI, pp. 20–23.
Entries: 32. Pre-metric. Inscriptions. States. Described.

Boys, Anton *(1530–1600)*
[A.] IV, pp. 293–298.
Entries: 17. Pre-metric. Inscriptions. Described.

[H. *Neth.*] III, p. 178.
Entries: 14+.*

[H. *Ger.*] IV, p. 143.
Entries: 19.*

Boys, Thomas Shotter *(1803–1874)*
Groschwitz, Gustave von. "The Prints of Thomas Shotter Boys." [*Pr.*] pp. 191–215.
Entries: 43+. Inches. Inscriptions (selection). States. Illustrated (selection). Located.

Boyvin, René *(c.1525–c.1580)*
[RD.] VIII, pp. 11–88; XI, pp. 23–24.

Boyvin, René *(continued)*

Entries: 230. Millimeters. Inscriptions. States. Described.

[Wess.] IV, p. 56.
Entries: 2 (additional to [RD.]). Paper fold measure. Described.

[Herbet] III, pp. 34–39; V, p. 82.
Entries: 43+ (additional to [RD.]). Millimeters. Inscriptions. Described. Located (selection). Additional information to [RD.].

Lieure, J. "René Boyvin; additions aux catalogues de Robert-Dummersnil, Duplessis et Félix Herbet." [*Am. Est.*] 9 (1930): 41–49.
Entries: 4 (additional to [RD.] and [Herbet]). Additional information to [RD.] and [Herbet].

Levron, Jacques. *René Boyvin, graveur angevin du XVIe siècle, avec le catalogue de son oeuvre et la reproduction de 114 estampes.* Angers (France): Les Lettres et la Vie Française. Éditions Jacques Petit, 1941.
Entries: 295 (includes works from Boyvin's studio). Millimeters. Inscriptions (selection). Described (selection). Illustrated (selection).

Bozza, Girolamo *(d. 1841)*
[Ap.] p. 72.
Entries: 1.*

Bozzetti, Cino *(20th cent.)*
Dragone, Angelo. *L'Opera incisa di Cino Bozzetti.* Turin: Centro Piemontese di Studi d'Arte Moderna e Contemporanea, 1950. 1500 copies.
Entries: 152. Millimeters. Inscriptions. States. Illustrated (selection).

Bozzolini, Mathilde *(b. 1811)*
[Ap.] p. 72.
Entries: 1.*

Bracelli, Giovanni Battista *(fl. 1624–1649)*
[B.] XX, pp. 74–76.
Entries: 1. Pre-metric. Inscriptions. Described.

Bracquemond, Félix *(1833–1914)*
[Ber.] III, pp. 1–171, and Supplement (12 pp. separately issued).
Entries: 810 (to 1889). Paper fold measure. Inscriptions. States. Described.

Delteil, Loys. "Bracquemond."
L'Artiste, n.s. 13, (1897, no. 1): 424–432.
Entries: 25 (additional to [Ber.], to 1896). Paper fold measure. Inscriptions (selection). States. Described (selection).

Bradley, William *(1801–1857)*
[Siltzer] p. 328.
Entries: unnumbered, p. 328, prints after. Inscriptions.

Bradshaw and **Blacklock** *(fl. 1839–1870)*
Courtney Lewis, C. T. *The story of picture printing in England during the nineteenth century.* London: Sampson Low, Marston and Co. Ltd., n.d.
Entries: 105 prints published by. Inches. Inscriptions. Described. Illustrated (selection).

Braekeleer, Ferdinand de *(1792–1883)*
[H. L.] pp. 95–99.
Entries: 10. Millimeters. Inscriptions. States. Described.

Braekeleer, Henri de *(1840–1888)*
[H. L.] pp. 99–107.
Entries: 27. Millimeters. Inscriptions. States. Described.

[Del.] XIX.
Entries: 80. Millimeters. States. Described (selection). Illustrated. Located (selection).

Braemt, Joseph Pierre *(1796–1864)*
[H. L.] pp. 107–108.

Entries: 1. Millimeters. Inscriptions. Described.

Braeu, Nicolas
See **Breen,** Claes van

Braüer, Karl *(1794–1866)*
[Dus.] p. 21.
Entries: 5 (lithographs only, to 1821).

Brakenburgh, Richard *(1650–1702)*
[W.] I, pp. 169–170.
Entries: 1 print by, 4 after.*

[H. *Neth.*] III, pp. 179–180.
Entries: 3 prints by, 7 after. Illustrated (selection).*

Bramante, Donato *(1444–1514)*
[P.] V, pp. 176–179.
Entries: 3 prints by and after. Premetric. Inscriptions. States. Described. Located.

Courajod, Louis, and de Geymuller, Henry. "Estampes attribués à Bramante; Nouvelles observations sur Bramante." [*GBA*] 2d ser., 10 (1874): 254–267, 379–384. Separately published. Paris: Libraire de Rapilly, 1874.
Entries: 1 print by, 3 rejected prints. Millimeters. Inscriptions. Described. Illustrated (selection).

[Hind] V, pp. 101–106.
Entries: 2 prints after, or closely related to. Millimeters. Inscriptions. Described. Illustrated. Located.

Bramer, Leonard *(1596–1674)*
[Daulby] pp. 299–300.
Entries: 1 print by. Inches, Inscriptions. Described. Also, list of 9 prints after: title, dimensions and name of engraver only.

[Rov.] pp. 65–66.
Entries: 2. Millimeters. Inscriptions. Described. Illustrated.

[W.] I, pp. 170–172.
Entries: 4 prints by, 8+ after.*

[H. *Neth.*] III, pp. 181–184.
Entries: 4 prints by, 12 after. Illustrated (selection).*

Bramer, Paulus *(fl. 1589–1598)*
[W.] I, p. 172.
Entries: 3 prints after.*

[H. *Neth.*] III, p. 184.
Entries: 4 prints after.*

Brandmüller, Gregor *(1661–1691)*
[H. *Ger.*] IV, p. 143.
Entries: 3 prints after.*

Brangwyn, Frank *(1867–1953)*
Newbolt, Frank. *The etched work of Frank Brangwyn A.R.A. R.E.* London: Fine Art Society Ltd., 1908. 100 copies. (EBM).
Entries: 133 (to 1908). Inches. Described. Illustrated (selection). Located (selection).

Catalogue of the etched work of Frank Brangwyn. London: Fine Art Society Ltd., 1912.
Entries: 200 (to 1912). Inches. Millimeters. States. Described. Illustrated (selection). Located (selection).

Sparrow, Walter Shaw, and Brangwyn, Frank. *Frank Brangwyn and his work . . . with the appendices revised and brought down to 1914.* Boston (Mass.): Page Company, 1917.
Entries: unnumbered, pp. 238–256 (to 1914).

Phillpotts, Eden, and Hubbard, E. Hesketh. *Bookplates by Frank Brangwyn R.A.* Westminster (England): Morland Press, 1920. (DLC)
Entries: 69 (bookplates only; to 1920, complete?).

Gaunt, William. *The etchings of Frank Brangwyn, R.A.* London: The Studio, Ltd., 1926.

Brangwyn, Frank *(continued)*

> Entries: 331 (to 1926). Inches. Millimeters. States. Described. Illustrated. Located.

Braque, Georges *(1882–1963)*
Buchheim, Lothar Günther. *Georges Braque; das graphische Werk; Sammlung Buchheim-Militon.* n.p., Lothar Günther Buchheim, [1951?].
> Entries: unnumbered, pp. 8–9. Millimeters. Illustrated (selection).

Wember, Paul. *Georges Braque, das graphische Gesamtwerk 1907–1955.* Chronologisch-thematischer Katalog, zugleich Verzeichnis der deutschen Ausstellungen Januar-Juli 1955. Bremen (West Germany): M. Hertz, 1955.
> Entries: 59 single prints, 10 illustrated books (to 1955). Millimeters. Illustrated. Book illustrations are not individually catalogued.

Musée d'Art et d'Histoire, Geneva [Edwin Engelberts, compiler]. *Georges Braque; oeuvre graphique original.* Geneva: Cabinet des estampes, Musée d'Art et d'Histoire; and Galerie Nicolas Rauch, 1958. 1500 copies. (MH)
> Entries: 77 single prints, 31 illustrated books (to 1958). Millimeters. Illustrated. Book illustrations are not individually catalogued.

Bibliothèque Nationale, Paris [Jean Adhémar and Jacques Lethève, compilers]. *Georges Braque, oeuvre graphique.* Paris, 1960.
> Entries: 115. Illustrated (selection). Based on Engelberts, with a few additional prints.

Hoffmann, Werner. *Georges Braque; his graphic work.* New York: Harry N. Abrams Inc., 1961.
> Entries: 101 single prints, 35 illustrated books (to 1961). Inches. Illustrated (selection).

Mourlot, Fernand. *Braque lithographe.* Preface by Francis Ponge, Monte Carlo (Monaco): André Sauret, 1963. 4125 copies.
> Entries: 146 (lithographs only, to 1962). Millimeters. States. Described. Illustrated.

Galerie Wünsche [Hermann Wünsche, compiler]. *Georges Braque: das lithographische Werk.* Bonn, 1971.
> Entries: 158 (lithographs only). Millimeters. Described. Illustrated. All but 7 prints (not in exhibition) are illustrated. Color lithographs are all illustrated in color.

Brascassat, Jacques Raymond *(1804–1867)*
Marionneau, Charles. *Brascassat, sa vie et son oeuvre.* Paris: Veuve Jules Renouard, 1872. (EBM)
> Entries: unnumbered, pp. 317–323. Millimeters (selection). Inscriptions (selection). Described (selection).

[Ber.] IV, pp. 5–6.
> Entries: 4+. Paper fold measure.

Brasiola, Giacinto *(18th cent.)*
[AN. 1968] pp. 25, 173.
> Entries: unnumbered, pp. 25, 173. Millimeters. Inscriptions. Described (selection). Illustrated (selection).

Brasser, Leendert *(1727–1793)*
[W.] I, p. 173.
> Entries: 9+.*

Brasser, P. M. *(fl. 1749–1778)*
[W.] I, p. 173.
> Entries: 1 print after.*

Brauer, Johannes *(b. 1905)*
Johannes Brauer: Originalradierungen, Originalholzschnitte. Leipzig: Scholle Verlag und Druckerei, [1960?]. (EOBKk)
> Entries: 401 etchings, 60 woodcuts (to c.1960?). Millimeters.

Braun, Augustin *(fl. 1590–1639)*
[Merlo] pp. 105–113.
 Entries: unnumbered, pp. 107–113.
 Pre-metric (selection). Paper fold
 measure (selection). Inscriptions.
 Described.

[H. *Ger.*] IV, pp. 144–146.
 Entries: 83 prints by, 34 after. Illus-
 trated (selection).*

Braun, Georg *(1542–1622)*
[H. *Ger.*] IV, p. 147.
 Entries: 1.*

Braunerová, Zdenka *(1858–1934)*
Toman, Prokop H. *Zdenka Braunerová,
popisný seznam grafického díla.* Edice
katalogy o díle, 5. Prague: Státní nak-
ladatelství krásné literatury a umění,
1963. (DLC)
 Entries: 178. Millimeters. Described.
 Illustrated (selection).

Brawere, Paschatius de *(fl. c.1630)*
[W.] I, p. 173.
 Entries: 1.*

[H. *Neth.*] III, p. 184.
 Entries: 1. Illustrated.*

Bray, Dirk de *(fl. 1651–1678)*
Blockhuijzen, D. Vis. *Description des
estampes qui forment l'oeuvre gravé de Dirk
de Bray.* Rotterdam (Netherlands): Im-
primerie De Nijgh et van Ditmar, 1870.
 Entries: 29 etchings, 146 woodcuts.
 Millimeters. Inscriptions. Described.

[W.] I, pp. 173–174.
 Entries: 11+.*

[H. *Neth.*] III, pp. 185–190.
 Entries: 146. Illustrated (selection).

Bray, Jan de *(1627–1697)*
[W.] I, pp. 174–175.
 Entries: 12 prints by, 4 after.*

[H. *Neth.*] III, pp. 191–194.

Entries: 21 prints by, 8 after. Illus-
trated (selection).*

Bray, Salomon de *(1597–1664)*
[W.] I, pp. 175–176.
 Entries: 4 prints after.*

[H. *Neth.*] III, p. 194.
 Entries: 5 prints after.*

Brayer, Yves *(b. 1907)*
Cailler, Pierre. *Catalogue raisonné de
l'oeuvre gravé et lithographié de Yves
Brayer.* Geneva: Pierre Cailler, 1970.
 Entries: 77 etchings, 95 lithographs,
 34 posters. Millimeters. States. De-
 scribed. Illustrated.

Brea, ——— de *(fl. c.1787)*
[Sm.] I, p. 169.
 Entries: 1 (portraits only). Inches.
 Inscriptions. States. Described.

Brechenmacher, Johann Martin
(17th cent.)
[H. *Ger.*] IV, p. 147.
 Entries: 4.*

Brechtel, Christoph Fabius *(1568–1622)*
[H. *Ger.*] IV, p. 147.
 Entries: 3+.*

Breckerveld, Herman *(fl. c.1623)*
[Wess.] II, p. 230.
 Entries: 2. Millimeters. Inscriptions.
 Described.

[W.] I, p. 176.
 Entries: 3.*

[H. *Neth.*] III, pp. 195–198.
 Entries: 10. Illustrated (selection).*

Bree, Mathieu Ignace van *(1773–1839)*
[H. L.] pp. 108–110.
 Entries: 4. Millimeters. Inscriptions.
 States. Described.

Bree, Philippe Jacques van *(1786–1871)*
[H. L.] p. 110.

Bree, Philippe Jacques van *(continued)*

> Entries: 2. Millimeters. Inscriptions.
> States. Described.

Breen, Adam van *(fl. 1612–1629)*
> [W.] I, p. 178.
>> Entries: 1+.*

> [H. *Neth.*] III, p. 198.
>> Entries: 1+.*

Breen, Claes (Gilles) van *(fl. c.1600)*
> [W.] I, p. 178.
>> Entries: 17+.*

> [H. *Neth.*] III, pp. 199–204.
>> Entries: 87+. Illustrated (selection).*

Breen, Daniel van *(1599–1665)*
> [H. *Neth.*] III, p. 204.
>> Entries: 1+.*

Breenbergh, Bartholomaeus
(1599/1600–1659)
> [B.] IV, pp. 159–181.
>> Entries: 28. Pre-metric. Inscriptions.
>> Described. Copies mentioned. Ap-
>> pendix with 1 doubtful print.

> [Weigel] pp. 176–181.
>> Entries: 5 (additional to [B.]). Pre-
>> metric. Inscriptions. States. De-
>> scribed. Appendix with 4 doubtful
>> prints.

> [Dut.] IV, pp. 82–92.
>> Entries: 33. Millimeters. Inscriptions.
>> States. Described. Appendix with 4
>> doubtful prints.

> [Wess.] II, p. 230.
>> Additional information to [B.] and
>> [Weigel].

> [W.] I, pp. 178–180.
>> Entries: 33 prints by, 14+ after.*

> [H. *Neth.*] III, pp. 205–216.
>> Entries: 52 prints by, 29+ after. Illus-
>> trated (selection).*

Brehmer, K. P. *(20th cent.)*
> Block, René, and Vogel, Karl. *Grafik des
> kapitalistischen Realismus: . . . Werkver-
> zeichnisse bis 1971.* Berlin: Edition René
> Block, 1971. 3000 copies.
>> Entries: 135 (to 1971). Millimeters. De-
>> scribed. Illustrated.

Breisach, Klaus von *(fl. 1450–1500)*
> [H. *Ger.*] IV, pp. 148–149.
>> Entries: 2. Illustrated.*

Brekelenkam, Quiryn *(c.1620–1668)*
> [W.] I, pp. 180–181.
>> Entries: 8 prints after.*

> [H. *Neth.*] III, p. 216.
>> Entries: 12 prints after.*

Bremden, Daniel van den *(1587–after 1663)*
> [W.] I, p. 181.
>> Entries: 11+.*

> [H. *Neth.*] III, pp. 217–218.
>> Entries: 26+. Illustrated (selection).*

Bremer, Uwe *(b. 1940)*
> Ohff, Heinz, and Ohff, Christiane. *Uwe
> Bremer; Ölbilder und Radierungen.* Einzel-
> katalog zum Oeuvreverzeichnis "7
> Jahre Werkstatt Rixdorfer Drucke Ber-
> lin." Hamburg: Merlin Verlag, 1970.
> (EBKk)
>> Entries: unnumbered, 26 pp. (to
>> 1970). Millimeters (selection). Illus-
>> trated.

Brendle, Hans
> *See* **Monogram BH** [Nagler, *Mon.*] I,
> no. 1882

Brenet, Nicolas Guy *(1728–1792)*
> [Baud.] II, pp. 179–180.
>> Entries: 2. Millimeters. Inscriptions.
>> Described.

Brenner, Elias *(1647–1717)*
> [H. *Ger.*] IV, p. 150.
>> Entries: 9.*

Brentel, David *(fl. 1584–1593)*
 [P.] IV, pp. 262–263.
 Entries: 3. Pre-metric. Inscriptions.

 [A.] IV, pp. 170–173.
 Entries: 1. Pre-metric. Inscriptions.
 Described.

 [H. *Ger.*] IV, p. 150.
 Entries: 11.*

Brentel, Friedrich *(c.1580–1651)*
 [A.] IV, pp. 185–215.
 Entries: 19+. Pre-metric. Inscriptions.
 Described. Appendix with 3 doubtful
 and rejected prints.

 [H. *Ger.*] IV, pp. 151–153.
 Entries: 200. Illustrated (selection).*

 Wegner, Wolfgang. "Unterschungen zu
 Friedrich Brentel." *Jahrbuch der Staat-
 lichen Kunstsammlungen in Baden-
 Württemburg* 3 (1966): 107–196.
 Entries: 31+. Millimeters. Inscrip-
 tions. States. Described. Illustrated
 (selection). Concordance with [A.]
 and [H. *Ger.*].

Brentel, Georg *(before 1580–1638)*
 [A.] IV, pp. 216–219.
 Entries: 2. Pre-metric. Inscriptions.
 Described.

 [H. *Ger.*] IV, p. 150.
 Entries: 2.*

Brescia, Giovanni Antonio da
(fl. 1507–1516)
 [B.] XIII, pp. 315–331.
 Entries: 24. Pre-metric. Inscriptions.
 States. Described. Copies mentioned.

 [P.] V, pp. 103–112.
 Entries: 38 (additional to [B.]). Pre-
 metric. Inscriptions. States. De-
 scribed. Located. Additional informa-
 tion to [B.]. Copies mentioned.

 [Evans] p. 13.
 Entries: 4 (additional to [B.]). Millime-
 ters. Inscriptions. Described.

[Wess.] III, p. 45.
 Entries: 1 (additional to [B.]). Millime-
 ters. Inscriptions. Described. Lo-
 cated.

[Hind] V, pp. 33–54.
 Entries: 65. Millimeters. Inscriptions.
 States. Described. Illustrated. Lo-
 cated.

Brescia, Giovanni Maria da *(fl. 1500–1512)*
 [B.] XIII, pp. 311–314.
 Entries: 2. Pre-metric. Inscriptions.
 Described.

 [P.] V, pp. 112–114.
 Entries: 3 (additional to [B.]). Pre-
 metric. Inscriptions. States. De-
 scribed. Located (selection).

 [Hind] V, pp. 55–58.
 Entries: 5. Millimeters. Inscriptions.
 States. Described. Illustrated. Lo-
 cated.

Bresciano, Prospero *(fl. c.1589)*
 [B.] XVI, pp. 106–107.
 Entries: 1. Pre-metric. Inscriptions.
 Described.

Bresdin, Rodolphe *(1825–1885)*
 Bresdin, ———. "Documents relatifs à
 Rodolphe Bresdin." Unpublished ms.
 (EPBN)
 Notes towards a catalogue by Bres-
 din's daughter.

 [Ber.] IV, pp. 6–8.*

 Bouvenne, Aglaüs. "Catalogue de
 l'Oeuvre de Bresdin." [*Am. Est.*] 1, no. 5
 (1922): 4; [*Am. Est.*] 1, no. 6 (1922): 4–5;
 [*Am. Est.*] 1, no. 7 (1922): 6–8.
 Entries: 61. Millimeters. Inscriptions.
 Described (selection).

 Neumann, J. B. *Rodolphe Bresdin.* New
 York: J. B. Neumann, 1929.
 Entries: 121. Illustrated.

 Rijksmuseum, Amsterdam [K. G. Boon,
 compiler]. *Rodolphe Bresdin etsen en litho-*

Bresdin, Rodolphe *(continued)*

*graphien, chronologisch overzicht, samen-
gesteld naar aanleiding van de expositie in
'sRijks Prentenkabinet.* Amsterdam, 1955.
Entries: 152. Inscriptions.

Bibliothèque Nationale, Paris [Jean Ad-
hémar and Alix Gambier, compilers].
Rodolphe Bresdin 1822–1885. 1963.
Entries: 76 (includes material omitted
by Neumann and Boon) Millimeters.
Illustrated (selection). Located.

Wallraf-Richartz Museum, Cologne,
and Städtisches Kunstinstitut, Frank-
furt am Main [Hans Albert Peters, com-
piler]. *Die schwarze Sonne des Traums:
Radierungen, Lithographien und
Zeichnungen von Rodolphe Bresdin.* Col-
ogne and Frankfurt am Main, 1972.
Entries: 62+. Millimeters. Inscrip-
tions. States. Described. Illustated.
Located.

Bressie, W. *(17th cent.)*
[Hind, *Engl.*] III, p. 328.
Entries: 1. Inches. Inscriptions. De-
scribed. Illustrated. Located.

Bretschneider, Andreas *(1578–1640)*
[H. *Ger.*] IV, pp. 154–156.
Entries: 46. Illustrated (selection).*

Bretschneider, Daniel *(c.1550–after 1623)*
[A.] II, pp. 1–9.
Entries: 3+. Pre-metric. Inscriptions.
Described.

[H. *Ger.*] IV, p. 156.
Entries: 3.*

Bretschneider, Friedrich W. T. *(1821–1878)*
[Ap.] p. 73.
Entries: 4.*

Breu, Jörg I *(1480–1537)*
[B.] VII, p. 448.
Entries: 1. Pre-metric. Inscriptions.
Described.

[P.] III, pp. 294–295.
Entries: 3. Pre-metric. Inscriptions.
Described.

Dodgson, Campbell. "Beiträge zur
Kenntnis des Holzschnittwerks Jörg
Breus." [*JprK.*] 21 (1900): 192–214.
Entries: unnumbered, pp. 192–214
(prints published by Erhard Ratdolt
only). Millimeters. Inscriptions.
States. Described. Illustrated (selec-
tion). Located.

Dodgson, Campbell. "Jörg Breu als
Illustrator der Ratdoltschen Offizen.
Nachtrag." [*JprK.*] 24 (1903): 335–337.
Additional information to Dodgson
1900.

[Ge.] nos. 350–389.
Entries: 40 (single-sheet woodcuts
only). Described. Illustrated. Located.

[H. *Ger.*] IV, pp. 157–184.
Entries: 696. Illustrated (selection).*

Breu, Jörg II *(c.1510–1547)*
Röttinger, Heinrich. "Das Holzschitt-
werk Jörg Breus des Jungeren."
[*MGvK.*] 1909, pp. 1–11.
Entries: 86 prints after (woodcuts
only). Paper fold measure. Inscrip-
tions. States. Described. Located.

[Ge.] nos. 390–408.
Entries: 19 (single-sheet woodcuts
only). Described. Illustrated. Located.

[H. *Ger.*] IV, pp. 185–206.
Entries: 101. Illustrated (selection).*

Breval, ——— *(fl. c.1840)*
[Ber.] IV, p. 8.*

Brévière, Louis Henri *(1797–1869)*
[Ber.] IV, pp. 8–15.*

Brey, [Hermann?] *(19th cent.)*
[Ap.] p. 73.
Entries: 2.*

Brias, Charles *(1798–1884)*
[H. L.] p. 111.
Entries: 2. Millimeters. Inscriptions.
Described.

Briccio, Domenico *(fl. c.1600)*
[B.] XII: *See* **Chiaroscuro Woodcuts**

Brice, William *(20th cent.)*
Felix Landau Gallery. *William Brice lithographs 1961–1966.* Los Angeles: Felix
Landau Gallery, n.d. 6 loose-leaf
sheets. (CSfAc)
Entries: 18. Inches. Described. Illustrated.

Bridi, Luigi *(19th cent.)*
[Ap.] p. 73.
Entries: 1.*

Bridoux, [François Eugène] Augustin
(1813–1892)
[Ap.] pp. 73–74.
Entries: 9.*

[Ber.] IV, pp. 15–16.*

Bridport, Hugh *(1794–after 1837)*
[St.] pp. 47–48.*

[F.] p. 74.*

Brie, Gabriel François Louis de
See **Debrie**

Briend, Alfred *(b. 1834)*
[Ber.] IV, pp. 16–17.*

Bril, Mathys *(c.1550–1584)*
[W.] I, p. 183.
Entries: 2+ prints after.*

[H. *Neth.*] III, p. 218.
Entries: 57 prints after.*

Bril, Paul *(1554–1626)*
[W.] I, pp. 183–185.
Entries: 6+ prints by, 14+ after.*

Mayer, Anton. *Das Leben und die Werke
der Brüder Matthäus und Paul Brill.* Leipzig: K. W. Hiersemann, 1910.
Entries: unnumbered, p. 80. Located.

[H. *Neth.*] III, pp. 219–222.
Entries: 16 prints by, 105 after. Illustrated (selection).*

Brin, Herzich von
See **Hertzog von Brin**

Brinckman, G. *(19th cent.)*
[Ap.] p. 74.
Entries: 1.*

Brion, Gustave *(1824–1877)*
[Ber.] IV, pp. 17–18.*

Briot, Isaac *(1585–1670)*
[RD.] X, pp. 198–244; XI, pp. 25–26.
Entries: 195. Millimeters. Inscriptions.
States. Described.

Briscoe, Arthur *(1873–1943)*
Laver, James. *A complete catalogue of the
etchings and dry-points of Arthur Briscoe,
A.R.E.* London: Halton and Truscott
Smith Ltd., 1930. 275 copies (MBMu)
Entries: 151 (to 1930). Inches. Inscriptions. States. Illustrated. Ms. notes by
Harold J. L. Wright (ECol); additional
information.

Wright, Harold J. L. "The etchings of
Arthur Briscoe." [*PCQ.*] 25 (1938): 284–
311. Catalogue: "Arthur Briscoe, a
chronological list of his later etchings."
[*PCQ.*] 26 (1939): 96–103.
Entries: 38 (additional to Laver; to
1938). Inches. States. Illustrated
(selection).

Brissot de Warville, Félix Saturnin
(1818–1892)
[Ber.] IV, pp. 18–19.*

Britto, Giovanni *(fl. c.1550)*
[H. *Ger.*] IV, p. 207.
Entries: 3. Illustrated (selection).

Britze, Friedrich *(b. 1870)*
F[ought], K. "Fr. Britzes exlibrispro-
duktion fra 1911 til dato." [*N. ExT.*] 4
(1951–1952): 8–14.
 Entries: unnumbered, pp. 8–14
 (bookplates only, to 1951). Illustrated
 (selection).

Rasmussen, Kristen. "Friedrich Britze."
Boekcier, 2d ser. 8 (1953): 41–49.
 Entries: 203 (bookplates only, to 1953).
 Illustrated (selection).

Britze, Johannes *(20th cent.)*
Reumert, Emmerik. *Kobberstikkeren
Johannes Britze.* Copenhagen: Areté,
1952. 100 copies. (DLC)
 Entries: unnumbered, pp. 23–25
 (bookplates only, to 1952). Illustrated
 (selection).

Rasmussen, Kristen. "Johannes Britze."
Boekcier, 2d ser. 10 (1955): 17–20.
 Entries: 120 (bookplates only, to 1955).
 Illustrated (selection).

Rasmussen, Kristen. "Johannes Britze."
[*N. ExT.*] 8 (1956): 54–57. Catalogue.
"Fortegnelse over Johannes Britzes ex-
libris." [*N. ExT.*] 9 (1957): 79–80.
 Entries: unnumbered, pp. 79–80
 (bookplates only, to 1957). Illustrated
 (selection).

Brizzi, Francesco *(1575–1623)*
[B.] XVIII, pp. 251–269.
 Entries: 31. Pre-metric. Inscriptions.
 States. Described.

Brochery family *(18th cent.)*
Vialet, ———. "Une famille de graveurs
dunkerquois au XVIIIe siècle; les
Brochery." [*Arch. Ex.-lib.*] 31 (1924): 161–
164.
 Entries: unnumbered, pp. 163–164
 (bookplates only). Inscriptions (selec-
 tion). Illustrated (selection).

Brockhurst, G. L. *(b. 1890)*
Stokes, Hugh. "The etchings of G. L.
Brockhurst." [*PCQ.*] 11 (1924): 409–443.
 Entries: 48 (to 1924). Inches. Millime-
 ters. Inscriptions. States. Described.
 Illustrated (selection).

Wright, Harold J. L. "The later etchings
by G. L. Brockhurst, A.R.A." [*PCQ.*] 21
(1934): 317–336; [*PCQ*] 22 (1935): 62–77.
 Entries: 29 (additional to Stokes; to
 1934). Inches. Inscriptions. States.
 Described. Illustrated (selection).
 Also includes summary list of prints
 catalogued by Stokes. Ms. (ECol) con-
 tains fuller description of states, and
 notes on prints published after 1934.

Broeck, Abraham van den *(b. 1617)*
[W.] I, p. 186.
 Entries: 2.*

Broeck, Barbara van den *(b. 1560)*
[W.] I, p. 186.
 Entries: 6.*

[H. *Neth.*] III, p. 222.
 Entries: 7.*

Broeck, Crispin van den
(c.1524–before 1591)
 [W.] I, pp. 186–187.
 Entries: 10+ prints by, 25+ after.*

[H. *Neth.*] III, pp. 223–226.
 Entries: 61 prints by, 145+ after. Illus-
 trated (selection).*

Broedelet, Jan *(fl. c.1690)*
[W.] I, p. 188.
 Entries: 10.*

Broek, Victorine van den *(fl. c.1880)*
[Ber.] XII, p. 175.*

Broen, Willem de *(fl. c.1710)*
[W.] I, p. 189.
 Entries: 16+.*

Bromley, Frederick *(fl. c.1840)*
[Siltzer] p. 346.
Entries: unnumbered, p. 346. Inscriptions.

Bromley, William *(1769–1842)*
[Ap.] p. 75.
Entries: 9.*

Bronchorst, Jan Gerritsz van *(1603–c.1661)*
[B.] IV, pp. 55–70.
Entries: 24. Pre-metric. Inscriptions. States. Described.

[Weigel] pp. 151–156.
Entries: 9 (additional to [B.]). Pre-metric. Inscriptions. Described.

[Wess.] II, p. 231.
Entries: 6 (additional to [B.] and [Weigel]). Millimeters. Inscriptions. Described. Additional information to Bartsch and Weigel.

[W.] I, pp. 190–191.
Entries: 39 prints by, 1 after.*

[H. *Neth.*] III, pp. 227–234.
Entries: 40 prints by, 2 after. Illustrated (selection).*

Brønsdorff von Deden, Erik *(20th cent.)*
Fougt, Knud. "Erik Brønsdorff von Deden." [*N. ExT.*] 3 (1949–50): 89–91.
Entries: 39 (bookplates only, to 1951). Illustrated (selection).

Fougt, Knud. "Erik Brønsdorff von Deden—III." [*N. ExT.*] 9 (1957): 73, 75.
Entries: 28 (bookplates only, 1951–1957). Illustrated (selection).

"E. Brønsdorff von Deden—IV." [*N. ExT.*] 12 (1960): 39.
Entries: 15 (bookplates only, 1957–1960). Illustrated (selection).

"Erik Brønsdorff von Deden—V." [*N. ExT.*] 18 (1966): 39.
Entries: 19 (bookplates only, 1960–1966). Illustrated (selection).

Fogedgaard, Helmer. "Erik Brønsdorff von Deden; ved en 60-ars dag." [*N. ExT.*] 21 (1969): 74, 77.
Entries: 8 (bookplates only, 1966–1968). Illustrated (selection).

E. Brønsdorff von Deden tegner och maler. Helsingør (Denmark): Poul A. Andersens Forlag, 1969. 200 copies (DLC)
Entries: 109 (bookplates only, to 1968). Illustrated (selection).

Bronzetti, Karl Joseph *(19th cent.)*
[Dus.] pp. 21–22.
Entries: 6 (lithographs only, to 1821). Inscriptions.

Bronzino, Agnolo *(1503–1572)*
[M.] I, pp. 494–503.
Entries: 42 prints after. Paper fold measure. Inscriptions (selection). Described (selection).

Brookes, Henry *(19th cent.)*
[Siltzer] p. 328.
Entries: unnumbered, p. 328, prints after. Inches. Inscriptions.

Brooks, John *(fl. 1730–1750)*
[Sm.] I, pp. 83–99, and "additions and corrections" section; IV, "additions and corrections" section.
Entries: 35 (portraits only). Inches. Inscriptions. States. Described. Illustrated (selection). Located (selection).

[Ru.] pp. 23–24.
Entries: 2 (additional to [Sm.]). Inches. Inscriptions. Described. Additional information to [Sm.].

Brookshaw, Richard *(1736–after 1800)*
[W.] I, p. 192; III, p. 40.
Entries: 19.*

[Sm.] I, pp. 99–105, and "additions and corrections" section.

Brookshaw, Richard *(continued)*

Entries: 29 (portraits only). Inches. Inscriptions. States. Described. Illustrated (selection). Located (selection).

[Ru.] pp. 24–26.
Entries: 1 (additional to [Sm.]). Inches. Inscriptions. Described. Additional information to [Sm.].

Brosamer, Hans *(c.1500–1552)*
[B.] VIII, pp. 455–470.
Entries: 24 engravings, 15 woodcuts. Pre-metric. Inscriptions. States. Described. Copies mentioned.

[Heller] pp. 33–34.
Entries: 1 (additional to [B.]). Pre-metric. Inscriptions. Described. Additional information to [B.].

[Evans] p. 24.
Entries: 1 (additional to [B.]). Millimeters. Inscriptions. Described.

[P.] IV, pp. 32–39.
Entries: 7+ engravings (additional to [B.]), 21+ woodcuts (additional to [B.]). Pre-metric. Inscriptions. Described. Located (selection). Additional information to [B.].

[Wess.] I, p. 132.
Entries: 2 (additional to [B.] and [P.]). Millimeters. Inscriptions. Described. Additional information to [B.] and [P.].

Röttinger, Hans. *Beiträge zur Geschichte des sächsischen Holzschnittes.* Studien zur deutschen Kunstgeschichte, 213. Strasbourg: J. H. Ed. Heitz, 1921.
Entries: 36+ (additional to earlier catalogues). Millimeters. Inscriptions (selection). Described (selection). Located.

[Ge.] nos. 409–429.
Entries: 21 (single-sheet woodcuts only). Described. Illustrated. Located.

[H. *Ger.*] IV, pp. 208–277.
Entries: 37 engravings, 621 woodcuts. Illustrated (selection).*

Brosamer, Martin *(fl. c.1554)*
[H. *Ger.*] IV, p. 278.
Entries: 7. Illustrated (selection).*

Brossette, —— *(19th cent.)*
[Ber.] IV, p. 19.*

Brosterhuisen, Jan *(c.1596–1650)*
[vdK.] pp. 129–138, 230–231.
Entries: 16. Millimeters. Inscriptions. States. Described. Appendix mentions an additional set of prints, attributed by [vdK.] to Brosterhuisen.

[Dut.] IV, pp. 93–94.
Entries: 6. Millimeters. Inscriptions. States. Described.

[W.] I, p. 193.
Entries: 16.*

[H. *Neth.*] III, pp. 235–245.
Entries: 17+. Illustrated (selection).*

Brou, Charles de *(1811–1877)*
[H. L.] pp. 111–118.
Entries: 18+. Millimeters. Inscriptions. States. Described.

Brouet, Auguste *(1872–1941)*
Geffroy, Gustave, and Boutitié, G. *Auguste Brouet; catalogue de son oeuvre gravé.* 2 vols. Paris: Gaston Boutitié et Cie, 1923. 1030 copies. (MB)
Entries: 271 (to 1923). Millimeters. States. Illustrated. Different states of the same print are separately numbered.

Hesse, Raymond. *Auguste Brouet.* Les artistes du livre, 14. Paris: Henry Babou, 1930. 700 copies. (NN)
Bibliography of books with illustrations by. To 1929.

Broutelle, Honoré *(20th cent.)*
Clement-Janin. "Honoré Broutelle, poète et tailleur d'images." *Byblis,* 1924, pp. 9–13, 2 unnumbered pages following p. 36.
Entries: 90. Millimeters (selection).

Brouwer, Adriaen *(c.1606–1638)*
[W.] I, pp. 193–201.
Entries: 25+ prints by, 96 after.*

[H. *Neth.*] III, pp. 246–249.
Entries: 180 prints after.*

Brouwer, Cornelis *(fl. c.1794)*
[W.] I, p. 201.
Entries: 1+.*

Brouwer, Jan *(1626–after 1688)*
[W.] I, pp. 201–202.
Entries: 23.*

[H. *Neth.*] III, p. 250.
Entries: 34.*

Brown, Benjamin *(fl. 1812–1819)*
[St.] p. 48.*

[F.] p. 74.*

Brown, Bolton *(1865–1936)*
Kleeman Galleries, New York. *Catalogue of lithographs by Bolton Brown.* New York, Kleemann Galleries, 1938.
Entries: 76 (to 1938?) Inches. Illustrated (selection).

Brown, George Loring *(1814–1889)*
Koehler, Sylvester R. "The works of the American etchers XXVI: George Loring Brown." [*Amer. Art Review*] 2, part 2 (1881): 192.
Entries: 10. Inches. Inscriptions.

Brown, Henry *(1816–1870)*
[H. L.] pp. 119–120.
Entries: 6 (etchings only). Millimeters (selection). Inscriptions (selection). Described (selection).

Brown, Henry Stuart *(b. 1871)*
Wright, Harold J. L. "A chronological list of the etchings and drypoints of Henry Stuart Brown." Supplement to, "The etchings of Henry Stuart Brown," by R. A. Walker [*PCQ.*] 14 (1927): 362–392.
Entries: 175 (to 1927). Inches. States.

Brown, John Lewis *(1829–1890)*
[Ber.] IV, p. 19.*

Hédiard, Germain. "Les Maîtres de la lithographie: John-Lewis Brown." *L'Artiste,* n.s. 14, (1897, no. 2): 401–409. Separately published. Chateaudun (France): Impr. de la Société Typographique, 1898.
Entries: 24 (lithographs only). Millimeters. Inscriptions. States. Described.

Bénédite, Léonce. *John Lewis Brown; étude biographique et critique suivie du catalogue de l'oeuvre lithographique et gravé de cet artiste exposé au Musée du Luxembourg.* Paris: Librairie de l'Art Ancien et Moderne, 1903.
Entries: 60 (lithographs and etchings, incomplete). Millimeters.

Brown, M. E. D. *(fl. 1832–1896)*
[Carey] pp. 204–205.
Entries: 17+ (lithographs only). Inches. Inscriptions. Described.

Browne, Alexander *(fl. 1660–1677)*
[Sm.] I, pp. 105–123, and "additions and corrections" section.
Entries: 44 (portraits only). Inches. Inscriptions. States. Described. Illustrated (selection). Located (selection).

[Ru.] pp. 26–29.
Additional information to [Sm.].

Browne, Hablôt Knight [called "Phiz"] *(1815–1882)*

Browne, Hablôt Knight *(continued)*

Thomson, David Croal. *Life and labours of Hablôt Knight Browne; "Phiz."* London: Chapman and Hall, Ltd., 1884. 200 copies.
Bibliography of books with illustrations by.

Browne, Henriette [Mme Jules de Saux] *(1829–1901)*
[Ber.] IV, pp. 19–20.
Entries: 14. Paper fold measure (selection). States.

Bruck, J. G. *(19th cent.)*
[Dus.] p. 22.
Entries: 1 (lithographs only, to 1821).

Brucker [Prucker] Nicolaus *(c.1620–1694)*
[H. *Ger.*] V, p. 1.
Entries: 4 prints after.*

Bruckmann, —— *(19th cent.)*
[Dus.] p. 22.
Entries: 1 (lithographs only, to 1821). Paper fold measure.

Brudi, Christoph *(20th cent.)*
Bartlett, Steven. "Zur illustrativen Arbeit von Christoph Brudi," *Illustration* 63, 9 (1972): 97–99.
Bibliography of books with illustrations by (to 1972).

Brücke [artists' organization] *(1906–1912)*
Bolliger, Hans, and Kornfeld, E. W. *Künstlergruppe Brücke. Jahresmappen 1906–12.* Bern: Klipstein und Kornfeld, 1958.
Entries: 62+ (prints issued by the group). Millimeters. Described. Illustrated.

Brücke, I. W. *(19th cent.)*
[Dus.] p. 22.
Entries: 1 (lithographs only, to 1821). Millimeters. Inscriptions. Located.

Brückner [Pontanus], Jakob *(d. 1610)*
[H. *Ger.*] V, p. 1.
Entries: 12.*

Brückner, Jörg *(fl. 1560–1594)*
[H. *Ger.*] V, p. 1.
Entries: 7.*

Bruegel, Pieter I *(c.1525–1569)*
[W.] I, pp. 206–210.
Entries: 6 prints by, 41+ after.

Bastelaer, René van. Catalogue. In *Peter Bruegel l'ancien son oeuvre et son temps,* by René van Bastelaer and Georges Hulin. Brussels: G. van Oest et Cie, 1907.
Entries: 1 print by, 278 after. Millimeters. Inscriptions. States. Described. Illustrated (selection).

Bastelaer, René van. *Les estampes de Peter Bruegel l'ancien.* Brussels: G. van Oest et Cie, 1908.
Entries: 1 print by, 278 after. Millimeters. Inscriptions. States. Described. Illustrated. Ms. notes (ECol); additional information.

[H. *Neth.*] III, pp. 253–312.
Entries: 1 print by, 278 after. Illustrated (selection).*

Lavalleye, Jacques. *Peter Bruegel the elder and Lucas van Leyden: the complete engravings, etchings and woodcuts.* New York: Harry N. Abrams, Inc., 1967. (Other editions in German, French and Italian.)
Illustrations of prints by and after Bruegel, with Bastelaer numbers, chronologically arranged.

Bibliothèque Royale Albert Ier, Brussels [Louis Lebeer, compiler]. *Catalogue raisonné des estampes de Bruegel l'ancien.* Flemish ed. *Beredeneerde catalogus van de prenten naar Pieter Bruegel de Oude.* Brussels, 1969.
Entries: 95 prints by and after. Millimeters. Inscriptions. States. Described. Illustrated.

Brueghel, Jan I *(1568–1625)*
[vdK.] pp. 220–224.
 Entries: 2. Millimeters. Inscriptions.
 Described. Illustrated (selection).

[W.] I, pp. 203–205.
 Entries: 3+prints by, 29+ after.*

[H. *Neth.*] III, pp. 251–252.
 Entries: 2 prints by, 64 after. Illus-
 trated (selection).*

Brühl, H. *(19th cent.)*
[Dus.] p. 22.
 Entries: 1+ (lithographs only, to 1821).
 Millimeters. Inscriptions. Located.

Brugge, Frans van
See **Monogram FVB** [Nagler, *Mon.*] II,
no. 2552

Bruggen, Jan van der *(b. 1649)*
[W.] I, pp. 211–212.
 Entries: 47+.*

Brugghen, Guillaume Anne van der
(1811–1891)
[H. L.] pp. 120–121.
 Entries: 2. Millimeters. Inscriptions.
 Described.

Brugnot, —— *(19th cent.)*
[Ber.] IV, p. 21.*

Bruining, Eugen *(16th cent.)*
[H. *Ger.*] V, p. 2.
 Entries: 38.*

Bruller, Jean [called "Vercors"]
(20th cent.)
Konstantinović, Radivoje D. *Vercors;
écrivain et dessinateur.* Paris: Librairie C.
Klincksieck, 1969. (EPBN)
 Bibliography of books with illustra-
 tions by.

Brun, D. *(fl. 1602–1628)*
[H. *Ger.*] V, p. 2.
 Entries: 3.*

Brun [**Bruynen**], Frans *(fl. 1627–1648)*
[W.] I, p. 213.
 Entries: 9.*

[H. *Neth.*] IV, pp. 1–3.
 Entries: 14. Illustrated (selection).

Brun, Franz I *(fl. 1559–1596)*
[B.] IX, pp. 443–472.
 Entries: 111. Pre-metric. Inscriptions.
 Described. Copies noted.

[P.] IV, pp. 176–178.
 Entries: 23 (additional to [B.]). Pre-
 metric. Inscriptions. Described. Lo-
 cated.

[Wess.] I, p. 132.
 Entries: 4+ (additional to [B.] and
 [P.]). Millimeters. Inscriptions (selec-
 tion). Described (selection).

[H. *Ger.*] V, pp. 3–19.
 Entries: 131. Illustrated (selection).*

Brun, Franz II *(fl. 1589–1652)*
[Merlo] p. 122.*

[H. *Ger.*] V, p. 19.
 Entries: 12.*

Brun, Isaak *(fl. 1612–1669)*
[Merlo] pp. 122–123.*

[H. *Ger.*] V, pp. 20–21.
 Entries: 82. Illustrated (selection).*

Bruna, Vincenzio della *(b. 1804)*
[Ap.] pp. 110–111.
 Entries: 6.*

Brune
See **Bruyne**

Brunellière, Prosper Aimé Marie *(b. 1803)*
[Ber.] IV, p. 21.*

Brunel-Rocque, —— *(19th cent.)*
[Ber.] IV, p. 21.*

Brunet-Debaines, Alfred [Louis] *(b. 1845)*
[Ber.] IV, pp. 22–25.
 Entries: 42+.

Bruni, Francesco *(1648–1726)*
[Vesme] p. 348.
 Entries: 2. Millimeters. Inscriptions.
 Described.

Bruni, G. *(19th cent.)*
[Ap.] p. 75.
 Entries: 1.*

Brunn, Johann zu *(fl. 1550–1600)*
[H. *Ger.*] V, p. 22.
 Entries: 1.*

Brunn, Mathias Lucas *(fl. c.1600)*
[H. *Ger.*] V, p. 22.
 Entries: 1. Illustrated.*

Brunner, Franz *(fl. c.1620)*
[H. *Ger.*] V, p. 23.
 Entries: 1+.*

Brunner, Vratislav H. *(1886–1928)*
Polívkova, Božena. *Tvůrce české knihy;*
V. H. Brunner. Prague: Nakladalelství
československých výtvarmych umélců,
1961. (DLC)
 Bibliography of books with illustra-
 tions by, and books designed by.

Brunton, Richard *(fl. c.1790)*
Bates, Albert C. *An early Connecticut en-*
graver and his work. Hartford (Conn.):
Case, Lockwood and Brainard Co., 1906.
(NN)
 Entries: unnumbered, pp. 14–45. Il-
 lustrated (with a few exceptions).

[St.] pp. 48–49.*

Brussel, Hermanus van *(1763–1815)*
[W.] I, p. 214.
 Entries: 4+.*

Brust, A. *(19th cent.)*
[Ap.] p. 75.
 Entries: 1.*

Brustolon, Giambattista *(1712–1796)*
[AN.] pp. 557–573.
 Entries: unnumbered, pp. 562–573.
 Millimeters. Inscriptions. Described
 (selection).

[AN. 1968] pp. 171–172.
 Entries: unnumbered, pp. 171–172
 (additional to [AN.]). Millimeters. In-
 scriptions.

Bruycker, Jules de *(1870–1945)*
Le Roy, Grégoire. *L'Oeuvre gravé de Jules*
de Bruycker, avec une notice critique et bio-
graphique. Brussels: Nouvelle Société
d'Éditions, 1933. 410 copies. (NN)
 Entries: 202 (to 1932). Millimeters. Il-
 lustrated. Different states of the same
 print are given different entry num-
 bers. Ms. addition (NN); 22 additional
 entries. To 1942.

Bruyn, Abraham de *(1540–1587?)*
[B.] IX, pp. 529–530.
 Entries: 1. Pre-metric. Inscriptions.
 Described.

[P.] IV, p. 266.
 Entries: 1 (additional to [B.]). Pre-
 metric. Inscriptions. Described. Lo-
 cated.

[Merlo] pp. 123–126.*

[W.] I, pp. 214–215.
 Entries: 47+.*

[H. *Neth.*] IV, pp. 4–10.
 Entries: 536. Illustrated (selection).*

Bruyn, Bartholomäus I *(1493–1555)*
[Merlo] pp. 127–137.
 Entries: unnumbered, p. 136 (prints
 after).

Bruyn, Johanna *(fl. c.1777)*
[W.] I, p. 217.
 Entries: 2.*

Bruyn, Nicolaes de *(fl. 1601–1656)*
[Dut.] IV, pp. 95–96.*

[W.] I, pp. 217–218; III, p. 42.
 Entries: 104+ prints by, 1+ after.*

[H. *Neth.*] IV, pp. 11–25.
 Entries: 274. Illustrated (selection).*

Bruyne, Pierre de *(fl. 1650–1667)*
[W.] I, p. 218.
 Entries: 3.*

[H. *Neth.*] IV, p. 26.
 Entries: 3.*

Bruynel, Jacob *(fl. 1662–1691)*
[W.] I, p. 218.
 Entries: 3+.*

Bruynen, Frans
See **Brun,** Frans

Bruyninx, Daniel *(1724–1787)*
[W.] I, p. 219.
 Entries: 2 prints after.*

Bruyns, Anna Francisca de *(1605–c.1675)*
[H. *Neth.*] IV, p. 26.
 Entries: 2 prints after.*

Bry, Auguste *(19th cent.)*
[Ber.] IV, p. 25.*

Bry, Émile *(19th cent.)*
[Ber.] IV, p. 25.*

Bry, Jan Theodor de *(1561–1623)*
[Hüsgen] pp. 109–117, 455, 456.
 Entries: 38+.

[Dut.] IV, pp. 94–95.*

[W.] I, pp. 219–220.
 Entries: 44+.*

[H. *Neth.*] IV, pp. 27–44.
 Entries: 461. Illustrated (selection).*

Bry, Theodor de *(1528–1598)*
[Hüsgen] pp. 93–109.
 Entries: 35+. Inscriptions (selection).
 Described (selection).

[W.] I, p. 220.
 Entries: 21+.*

[Hind, *Engl.*] I, pp. 124–137.
 Entries: 6+ (prints done in England
 only). Inches. Inscriptions. De-
 scribed. Illustrated (selection). Lo-
 cated.

[H. *Neth.*] IV, pp. 45–52.
 Entries: 367+. Illustrated (selection).*

Bryer, Henry *(fl. c.1770)*
[Sm.] I, pp. 123–124.
 Entries: 2 (portraits only). Inches. In-
 scriptions. States. Described. Located
 (selection).

[Ru.] pp. 29–30.
 Additional information to [Sm.].

Brylka, Andreas *(20th cent.)*
Sarkowski, Heinz. "Der Holzstecher
Andreas Brylka." *Illustration 63,* 2, no. 3
(1965), unpaginated.
 Bibliography of books with illustra-
 tions by.

Bucci, Anselmo *(b. 1887)*
Regia Calcografia, Rome. *Le Incisione di
Bucci; XXVIII mostra allestita dalla Calco-
grafia Nazionale.* Rome, 1954. (NN)
 Entries: 697 (to 1954; plates owned by
 the Calcografia Nazionale). Millime-
 ters.

Buchau, Abraham Conrad *(fl. 1666–1679)*
[H. *Ger.*] V, p. 23.
 Entries: 3 prints after.*

Buchfeld, H. *(19th cent.)*
[Dus.] p. 23.

Buchfeld, H. *(continued)*

Entries: 1 (lithographs only, to 1821). Paper fold measure.

Buchfürer, Michel *(fl. c.1550)*
[H. *Ger.*] V, p. 23.
Entries: 2. Illustrated (selection).*

Buchholz, Wolff *(20th cent.)*
Ladstetter, Gunther, and Pyroth, Rolf. *Wolff Buchholz: Werkverzeichnis der Druckgraphik 1957–1971.* Hamburg: Artoma Galerie, Thomas Levy, 1971.
Entries: unnumbered pp. 30–170 (to 1971). Millimeters. States. Described. Illustrated.

Buchhorn, Karl Ludwig Berna Christian *(1770–1856)*
[Ap.] pp. 75–76.
Entries: 11.*

Buchmayr, —— *(19th cent.)*
[Dus.] p. 23.
Entries: 1 (lithographs only, to 1821). Millimeters. Inscriptions. Located.

Buchner, G. P. *(19th cent.)*
[Dus.] pp. 23–24.
Entries: 26 (lithographs only, to 1821). Millimeters (selection). Paper fold measure (selection). Inscriptions (selection).

Buchwalt, Daniel *(fl. c.1558)*
[H. *Ger.*] V, p. 24.
Entries: 1+.*

Buck, P. von *(fl. c.1650)*
[H. *Ger.*] V, p. 24.
Entries: 4.*

Bucking, Arnold *(fl. c.1478)*
[H. *Ger.*] V, p. 24.
Entries: 27.*

Büchel, Carl Eduard *(1835–1903)*
[Ap.] pp. 76–77.
Entries: 12.*

Büchner, Joh[ann] Sigmund *(19th cent.)*
[Dus.] p. 24.
Entries: 2 (lithographs only, to 1821). Millimeters. Inscriptions. Described. Located.

Bülck, Martin *(fl. 1650–1685)*
[H. *Ger.*] V, p. 24.
Entries: 1+.*

Buell, Abel *(19th cent.)*
Wroth, Lawrence C. *Abel Buell of Connecticut; silversmith, type founder and engraver.* 2d ed. Middletown (Conn.): Wesleyan University Press, 1958. First edition, 1926.
Entries: 5. Inches. Inscriptions. Described. Illustrated (selection).

Bürkner, Hugo *(1818–1897)*
[A. 1800] V, pp. 201–258.
Entries: 168 etchings (also, summary list of woodcuts, not fully catalogued). Millimeters. Inscriptions. States. Described.

Büscher, C. *(fl. c.1820)*
[Ap.] p. 77.
Entries: 1.*

Büsinck, Ludolph *(c.1590–1669)*
Stechow, Wolfgang. "Ludolph Buesinck, a German chiaroscuro master of the seventeenth century." [PCQ.] 25 (1938): 392–419; [PCQ.] 26 (1939): 348–359.
Entries: 38 prints by and after, 5 rejected prints. Millimeters. Inscriptions. States. Described. Illustrated (selection). Located.

[H. *Ger.*] V, pp. 177–189.
Entries: 37. Illustrated (selection).*

Büttemeyer, H. *(b. 1826)*
[Ap.] p. 77.
 Entries: 2.*

Buffet, Bernard *(b. 1928)*
Reinz, Gerhard F. *Bernard Buffet; gravures, engravings, radierungen 1948–1967.*
New York: Tudor Publishing Co., 1968.
 Entries: 295 (etchings and drypoints only, to 1967). Millimeters. Inches. Described. Illustrated. Text in English, French and German.

Mourlot, Fernand. *Bernard Buffet; oeuvre gravé, lithographies 1952–1966.* Paris: A. C. Mazo, 1967. English ed. *Bernard Buffet; lithographs 1952–1966.* New York: Tudor Publishing Co., 1968.
 Entries: 66 (to 1966). Millimeters (inches in English ed.). States (selection). Illustrated. Different states of the same print are given different entry numbers.

Buhl, Jacob Ludwig *(1821–1880)*
[Ap.] p. 77.
 Entries: 1.*

Buhot, Félix *(1847–1898)*
[Ber.] IV, pp. 25–35.
 Entries: 163. Paper fold measure (selection).

Bourcard, Gustave. *Felix Buhot . . . catalogue descriptif de son oeuvre gravé.*
Paris: H. Floury, 1899. 150 copies. (MH)
 Entries: 186. Millimeters. Inscriptions. States. Described.

Bender, J.H. "Felix Buhot's Cab Stand; a rearrangement of states." [*PCQ.*] 25 (1938): 200–208.
 Additional information to Bourcard.

Filsinger, Catherine. "Felix Buhot's Cab Stand; a recently discovered ninth state." [*PCQ.*] 25 (1938): 480–481.
 Additional information to Bourcard.

Buland, Jean Marie *(fl. c.1850)*
[Ber.] IV, p. 35.*

Bulder, Nicolaas *(b. 1898)*
Schwencke, Johan. *Nico Bulder exlibris.* Wassenaar (Netherlands): Nederlandsche Exlibris-kring, 1939. 230 copies. (DLC)
 Entries: 45 (bookplates only, to 1938). Described (selection). Illustrated (selection).

Bull, Martin *(1744–1825)*
[St.] p. 49.*

Bullant, Jean II *(1510/15–1578)*
See also **Monogram ITB** [Nagler, *Mon.*] IV, no. 499

[RD.] VI, pp. 39–41; XI, pp. 26–27.
 Entries: 3. Millimeters. Inscriptions. Described.

Bundsen, Jes [Jens, Johann] *(1766–1829)*
[Dus.] p. 24.
 Entries: 1 (lithographs only, to 1821). Millimeters. Inscriptions. States. Located.

Bungter, Hans Michael *(b. 1896)*
Rödel, Klaus. *Hans Michael Bungter exlibris.* Frederikshavn (Denmark): Privately printed, 1967. 60 copies. (DLC)
 Entries: 149 (bookplates only, to 1967). Described (selection). Illustrated (selection).

Buno [Baun], Konrad *(c.1610–1671)*
[H. *Ger.*] V, p. 25.
 Entries: 24+.*

Buns, Johann *(fl. c.1670)*
[Merlo] pp. 149–151.
 Entries: 1 print after. Paper fold measure. Inscriptions. Described.

[H. *Ger.*] V, p. 26.
 Entries: 5.*

Buonafede, Giovanni *(b. 1816)*
[Ap.] pp. 77–78.
Entries: 12.*

Buonarotti
See **Michelangelo**

Buonincontro da Reggio *(fl. c.1480)*
[Evans] p. 14.
Entries: 1. Millimeters. Inscriptions.
Described.

Buonvicini, Bartolommeo
(1669–after 1738)
Davoli, Angelo. *Un incisore reggiano
sconosciuto; Bartolomeo Bonvicini (memoria
storica).* Extract from *Strenna del Pio
Istituto degli Artigianelli di Reggio-Emilia,
1930.* Reggio-Emila (Italy), 1929. (EFU)
Entries: 45. Millimeters. Inscriptions.

Burani, Francesco di Domenico *(b. 1600)*
[B.] XX, pp. 89–91.
Entries: 1. Pre-metric. Inscriptions.
States. Described.

Burch, Jacques Hippolyte van der
(1796–1854)
[Ber.] XII, p. 175.*

Burchfield, Charles *(1893–1967)*
Cleveland Museum of Art [Leona E.
Prasse and Louise Richards, compil-
ers]. *The drawings of Charles Burchfield;
catalogue of an exhibition sponsored by the
Print Club of Cleveland and the Cleveland
Museum of Art.* Cleveland (Ohio), 1953.
Entries: 26 (to 1951). Millimeters.

Burck, M. Leonard *(fl. c.1650)*
[H. *Ger.*] V, p. 26.
Entries: 8.*

Burde, Joseph Carl *(1779–1848)*
[A. 1800] V, pp. 51–77.
Entries: 78. Millimeters. Inscriptions.
States. Described.

Burdet, Augustin *(b. 1798)*
[Ap.] p. 78.
Entries: 5.*

[Ber.] IV, pp. 35–36.*

Burdett, P. P. *(18th cent.)*
[Sm.] I, "additions and corrections" sec-
tion.
Entries: 1 (portraits only). Inches. De-
scribed.

Burford, Thomas *(c.1710–c.1770)*
[Sm.] I, pp. 125–132, and "additions and
corrections" section; IV, "additions and
corrections" section.
Entries: 22+ (portraits only). Inches.
Inscriptions. States. Described. Illus-
trated (selection).

[Siltzer] p. 347.
Entries: unnumbered, p. 347. Inscrip-
tions.

[Ru.] pp. 30–31.
Entries: 4 (portraits only; additional to
[Sm.]). Inches. Inscriptions. De-
scribed. Additional information to
[Sm.].

Burg, Frans van der *(fl. c.1650)*
[W.] I, p. 223.
Entries: 1.*

[H. *Neth.*] IV, p. 52.
Entries: 1.*

Burger, Johannes *(b. 1829)*
[Ap.] pp. 78–80.
Entries: 20.*

Merz, Walther. "Joh. Burger." *Taschen-
buch der historischen Gesellschaft des Kan-
tons Aargau für das Jahr 1896,* pp. 1–21.
(EMSB)
Entries: 151.

Burger, Johann *(b. 1829)*
Roeper, Adalbert. "Johann Burger; zum
achtzigsten Geburtstage des

Künstlers." [*Bb.*] no. 122 (29 May 1909), pp. 6478–6480.
Entries: 42 (to 1896). Millimeters.

Burgh, Albertus van der *(1672–after 1729)*
[W.] I, pp. 223–224.
Entries: 1 print by, 1 after.*

Burghar, Jacob [Johannes] *(fl. c.1650)*
[H. *Neth.*] IV, p. 52.
Entries: 1.*

Burghers, Michael *(fl. 1676–1723)*
[Sm.] I, pp. 132–133.
Entries: 1 (portraits only). Inches. Inscriptions. Described. Located.

Burghstrate, Abraham van
See **Verwer,** Abraham

Burgis, William *(fl. c.1726)*
[St.] p. 49.*

Burgkmair, Hans I *(1473–1531)*
[B.] VII, pp. 197–242.
Entries: 83+. Pre-metric. Inscriptions. States. Described.

[Heller] pp. 35–39.
Entries: 3 (additional to [B.]). Pre-metric. Inscriptions. Described. Additional information to [B.].

Wiechmann-Kadow, ———. "Hans Burgkmair's (des älteren) Holzschnitt-Folgen in Büchern." [*N. Arch.*] 2 (1856): 152–168.
Bibliography of books with woodcuts by (exclusive of work for the Emperor Maximilian).

[P.] III, pp. 264–287.
Entries: 48+ woodcuts, 4+ etchings (additional to [B.]). Pre-metric. Inscriptions. States. Described. Located. Additional information to [B.]. Copies mentioned.

Muther, Richard. "Chronologisches Verzeichnis der Werke Hans Burgkmair's des Aelteren 1473–1531." [*Rep. Kw.*] 9 (1886): 410–448.
Entries: 930 (works in all media, including woodcuts). Inscriptions. Described.

[Ge.] nos. 430–536.
Entries: 107 (single-sheet woodcuts only). Described. Illustrated. Located.

Burkhard, Arthur. *Hans Burgkmair d. Ä. Meister der Graphik,* 15. Berlin: Verlag von Klinkhardt und Biermann, 1932.
Entries: 126+. Millimeters. Inscriptions. States. Described (selection). Illustrated (selection). Located. Bibliography for each entry.

Dodgson, Campbell. "Drei neue Cäsarenköpfe von Burgmair." [*MGvK.*] 1933, p. 27.
Entries: 3 (additional to previous catalogues). Described. Illustrated. Located.

[H. *Ger.*] V, pp. 27–174.
Entries: 834. Illustrated (selection).*

Burgkmair, Hans II *(c.1550–c.1559)*
[H. *Ger.*] V, p. 175.
Entries: 4+.*

Burgkmair, Thoman *(1444–1523)*
[H. *Ger.*] V, p. 175.
Entries: 1+.*

Burka, Antonín *(1896–1947)*
Schelling, H. G. J. "Antonin Burka." *Boekcier,* 2d ser. 3 (1948): 28–31.
Entries: 112 (bookplates only, to 1945). Millimeters. Illustrated (selection).

Burke, Thomas *(1749–1815)*
[Sm.] I, pp. 133–136.
Entries: 7 (portraits only). Inches. Inscriptions. States. Described.

[Siltzer] p. 347.

Burke, Thomas *(continued)*

Entries: unnumbered, p. 347. Inscriptions.

[Ru.] pp. 31–32.
Entries: 2 (portraits only; additional to [Sm.]). Inscriptions. Described. Additional information to [Sm.].

Burkhardt, Jacob *(fl. c.1660)*
[H. *Ger.*] V, p. 26.
Entries: 1 print after.*

Burn, ⸺ *(1636–1707)*
[H. *Ger.*] V, p. 176.
Entries: 10+ prints after.*

Burnand, Eugène *(b. 1850)*
[Ber.] IV, pp. 36–37.*

Burnet, John *(1784–1868)*
[Ap.] pp. 80–81.
Entries: 27.*

Burney, François Eugène *(1845–1907)*
[Ber.] pp. 37–38.
Entries: 17. Paper fold measure (selection). States.

Burnot, Philippe *(b. 1877)*
Philippe Burnot. Lyons: Audin, 1961. 200 copies. (DLC)
Entries: 427.

Burr, George Elbert *(1859–1939)*
"Catalogue raisonné of the etchings of George Elbert Burr." [*P. Conn.*] 3 (1923): 81–86. Supplement to "George Elmer [*sic*] Burr, an etcher of the desert," by Edith Williams Powell. [*P. Conn.*] 1 (1920—21): 310–321.
Entries: 225 (to 1923). Inches. Illustrated (selection).

Crafton Collection. *George Elbert Burr.* American Etchers, 7. New York: Crafton Collection, 1930.

Entries: 314 (to 1930). Inches. Illustrated (selection). Typed supplement (NN); 53 additional entries.

Seeber, Louise Combes. *George Elbert Burr; 1859–1939: catalogue raisonné and guide to the etched works.* Flagstaff (Ariz.): Northland Press, 1971.
Entries: 367. Inches. Inscriptions. Described. Illustrated (selection).

Burt, Charles *(1823–1892)*
Burt, Alice. *Catalogue of line engravings, etchings and original drawings by Charles Burt, dec'd, the property of his estate.* Brooklyn (N.Y.): Alice Burt, 1893. 125 copies. (NN)
Entries: 448 (unnumbered; ms. numbering in NN copy). Inches. Described (selection). Ms. addition (NN); 42+ additional entries.

Burty, Philippe *(1830–1890)*
[Ber.] IV, pp. 39–40.
Entries: 12. States. Described (selection).

Busch, Elias *(d. 1679)*
[H. *Ger.*] V, p. 176.
Entries: 1.*

Busch, Heinrich *(fl. c.1650)*
[H. *Ger.*] V, p. 176.
Entries: 1 print after.*

Busch, Peter *(1813–1841)*
[Merlo] p. 151.*

Busch, Wilhelm *(1832–1908)*
Vanselow, A. *Die Erstdrucke und Erstausgaben der Werke von Wilhelm Busch; ein bibliographisches Verzeichnis.* Leipzig: Adolf Weigel, 1913.
Bibliography of works written or illustrated by.

Buschmann, Frans Gustav *(1818–1852)*
[H. L.] pp. 121–124.

Entries: 5. Millimeters. Inscriptions.
States. Described.

Buschmann, Joseph Ernst *(1814–1853)*
[H. L.] pp. 124–126.
Entries: 3. Millimeters. Inscriptions.
States. Described.

Busse, Georg Heinrich *(1810–1868)*
[A. 1800] III, pp. 230–267.
Entries: 61. Pre-metric. Inscriptions.
States. Described.

Bussenmacher, Johann *(fl. 1580–1613)*
[Merlo] pp. 151–154.*

[H. *Ger.*] V, p. 190.
Entries: 16.*

Busserus, Hendrik *(1701–1781)*
[W.] I, p. 225.
Entries: 2+.*

Butavand, Louis Félix *(1808–1853)*
[Ber.] IV, p. 41.*

Butin, Ulysse *(1838–1883)*
[Ber.] IV, p. 41.*

Buttre, J. C. *(19th cent.)*
J. C. Buttre, Co. *Catalogue of Engravings
for Sale by J. C. Buttre Co., Publishers, En-
gravers and Plate Printers.* New York:
J. C. Buttre Co., 1894. (NN)
Entries: 4697 small engravings pub-
lished by; large engravings unnum-
bered, pp. 103–104. Inches.

Buys, Jacob *(1724–1801)*
[W.] I, p. 226; III, p. 44.
Entries: 4+ prints by, 3 after.*

Buysen, Andries van *(fl. c.1743)*
[W.] I, p. 226.
Entries: 16.*

Buytewech, Willem *(c.1591–1624)*
[vdK.] pp. 109–123, 230–231.

Entries: 39. Millimeters. Inscriptions.
States. Described. Appendix with 4
doubtful and rejected prints; also, list
of 41 prints after, not all fully cata-
logued.

[W.] I, pp. 227–228.
Entries: 37 prints by, 13+ after.*

van Gelder, J. G. "De etsen van Willem
Buytewech." [*Oud-Holl.*] 48 (1931):
49–72.
Entries: 36 prints by, 3 rejected prints.
Millimeters. Inscriptions. States. Il-
lustrated (selection). Located. Bibliog-
raphy for each entry. Ms. notes
(EUW); additional information.

Haverkamp-Begemann, Egbert. *Willem
Buytewech.* Amsterdam: Menno Hertz-
berger, 1959.
Entries: 36 prints by, 53 after, 18 re-
jected prints. Millimeters. Inscrip-
tions. States. Described (selection). Il-
lustrated (selection). Bibliography for
each entry.

[H. *Neth.*] IV, pp. 53–77.
Entries: 48 prints by, 52 after. Illus-
trated (selection).*

Haverkamp-Bergemann, Egbert. "The
etchings of Willem Buytewech." [*Pr.*]
pp. 55–81.
Entries: 32 prints by, 3 doubtful and 18
rejected prints. Millimeters. Inscrip-
tions. States. Described. Illustrated
(selection). Located. Slightly abridged
from 1959 catalogue, but with some
additional information. Bibliography
for each entry.

Bye, Marcus de *(1639–after 1688)*
[B.] I, pp. 73–98, i–iii.
Entries: 112. Pre-metric. Inscriptions.
States. Described.

[Weigel] pp. 8–13.
Entries: 7 (additional to [B.]). Pre-
metric. Inscriptions. Described.

Bye, Marcus de *(continued)*

[Heller] p. 39.
 Additional information to [B.].

[Dut.] IV, p. 96.*

[W.] I, pp. 97–98.
 Entries: 107+.*

[H. *Neth.*] IV, pp. 78–80.
 Entries: 118. Illustrated (selection).*

Bylaerd, Jan Jacob *(1734–1809)*

[W.] I, p. 228.
 Entries: 7.*

Bylert, Jan van *(1603–1671)*
[W.] I, pp. 228–229.
 Entries: 5 prints after.*

[H. *Neth.*] IV, p. 81.
 Entries: 6 prints after.*

Byrne, Elizabeth and John *(fl. c.1810)*
[Ap.] p. 81.
 Entries: 1+.*

C

Cabat, Nicolas-Louis *(1812–1893)*
[Ber.] IV, pp. 41–44.
 Entries: 4. Millimeters. States. De-
 scribed.

Cabel, Adrian van der
See **Kabel**

Caccia, Guglielmo *(c.1568–1625)*
[B.] XII: *See* **Chiaroscuro Woodcuts**

Caccianemici, Vicenzo *(fl. c.1530)*
[P.] VI, pp. 176–177.
 Entries: 3 Pre-metric. Inscriptions.
 Described.

[Wess.] III, p. 45.
 Entries: 1 (additional to [P.]). Paper
 fold measure.

Caccioli, Giuseppe-Antonio *(1672–1740)*
[B.] XIX, pp. 435–438.
 Entries: 3. Pre-metric. Inscriptions.
 Described.

Cadart, Alphonse *(d. 1575)*
See also **Société des Aquafortistes**

[Ber.] IV, pp. 44–46.*

Cadmus, Paul *(b. 1904)*
Johnson, Una E., and Miller, J. *Paul
Cadmus: prints and drawings 1922–1967.*
Brooklyn (N.Y.): Brooklyn Museum,
1968.
 Entries: 30 (to 1967). Inches. States.
 Illustrated (selection). Note at end of
 catalogue mentions 7 prints not listed.

Caffi, Ippolito *(1809–1866)*
[AN.] p. 703.
 Entries: unnumbered, p. 703. Millime-
 ters (selection). Inscriptions (selec-
 tion). Described (selection).

Caimox, Balthazar *(c.1593–1635)*
[H. *Ger.*] V, p. 191.
 Entries: 21.*

Calamatta, Luigi *(1802–1869)*
Ojetti, Raffaello. *Luigi Calamatta incisore.*
Rome: Tipografia Romana, 1874.
Entries: 89 engravings, 8 lithographs.
Millimeters. Catalogue of prints in the
museum at Civitavecchia only.

[Ap.] pp. 82–83.
Entries: 25.*

Alvin, Louis. "Notice sur Louis Cala-
matta, associé de l'académie." *Annuaire
de l'académie royale des sciences, des lettres
et des beaux-arts de Belgique* 48 (1882):
219–238. Separately published. Brussels:
F. Hayez, 1882.
Entries: 81 engravings, 9 lithographs.
Paper fold measure (selection).

[Ber.] IV, pp. 47–64.*

Corbucci, Vittorio. *Luigi Calamatta, inci-
sore; studio . . . con note, documenti inediti
ed elenco delle sue stampe disegnate ed incise.*
Civitavecchia (Italy): Vincenzo
Strambi, 1886.
Entries: 89 engravings, 8 lithographs.
Catalogue of prints in the museum at
Civitavecchia only. 9 other prints by
Calamatta are listed in a footnote.

Calame, Alexandre *(1810–1864)*
[Ber.] IV, p. 64.*

Calabi, A., and Schreiber-Favre, A.
"Les Eaux-fortes et les lithographies
d'Alexandre Calame." [GK.] n.s. 2
(1937): 64–77, 110–117.
Entries: 774. Millimeters. Inscriptions
(selection). States. Described (selec-
tion).

Calandrini, Francesco *(16th cent.?)*
[P.] VI: *See* **Chiaroscuro Woodcuts**

Calcar, Jan-Stephan van *(1499–1546/50)*
[W.] I, pp. 233–234.
Entries: 1+ prints by, 1 after.*

[H. *Neth.*] IV, p. 84.
Entries: 1+ prints by, 1 after. Illus-
trated (selection).*

Caldarini, Francesco
See **Calandrini**

Caldera, Polidoro
See **Caravaggio,** Polidoro da

Calendi, Giuseppe *(19th cent.)*
[Ap.] pp. 83–84.
Entries: 6.*

Caletti, Giuseppe *(c.1600–c.1660)*
[B.] XX, pp. 129–137.
Entries: 24. Pre-metric. Inscriptions.
States. Described.

Call, Jan van II *(b. 1689)*
[W.] I, p. 235.
Entries: 4+ prints after.*

Call, Pieter van *(1688–1737)*
[W.] I, p. 235.
Entries: 4 prints after.*

Callande de Champmartin, Charles Émile
(1797–1883)
[Ber.] IV, pp. 82–83.*

Callender, Benjamin *(1773–1856)*
[St.] pp. 49–50.*

[F.] p. 74.*

Callender, Joseph *(1751–1821)*
[Allen] pp. 123–126.*

[St.] pp. 50–51.*

[F.] p. 74.*

Callot, Jacques *(1592–1635)*
Green, J. H. *A catalogue and description
of the whole of the works of the celebrated*

Callot, Jacques *(continued)*

Jacques Callot; consisting of 1450 pieces, including those attributed to him, and after him. London: J. H. Green, 1804.
Entries: 197+ prints by, 7+ doubtful prints, 11+ prints after. Paper fold measure (selection). Described (selection).

Marvic, Martin. "Catalogue des oeuvres de Jacques Callot, noble lorrain." Unpublished ms., c.1804. (EPBN)
Entries: unnumbered, pp. 1–112. Pre-metric. Inscriptions. States. Described.

Meaume, Édouard. *Recherches sur la vie et les ouvrages de Jacques Callot.* 2 vols. Paris: Vve Jules Renouard, 1860. Reprint. 2 vols. Würzburg (Germany): J. Frank's Antiquariat, 1924.
Entries: 882 prints by, 93 doubtful prints, 114 rejected prints, 147 prints after, 243 prints by followers. Millimeters. Inscriptions. States. Described. Copies listed at end of catalogue.

[Wess.] IV, p. 56.
Entries: 2 (additional to Meaume). Millimeters. Described. Located. Additional information to Meaume.

Plan, Pierre-Paul. *Jacques Callot, maître graveur (1593–1635) suivi d'un catalogue raisonné et accompagné de la reproduction de 282 estampes et de deux portraits.* Paris: Librairie Nationale d'Art et d'Historie; and Brussels: G. van Oest et Cie, 1911. 312 copies. (NN). 2d ed. Brussels and Paris: G. van Oest et Cie, 1914.
Entries: 890. Millimeters. Inscriptions. States. Illustrated (selection).

Bruwaert, Edmond. *Vie de Jacques Callot, graveur lorrain 1592–1635.* Paris: Imprimerie Nationale, 1912. 450 copies. (MH)

Entries: unnumbered, pp. 213–218. Inscriptions (signatures only). Locations of the original copper plates.

Lieure, J. "Notes sur Jacques Callot," [*GBA.*] 4th ser. 14 (1918): 47–74.
Additional information to Meaume and Plan.

Bruwaert, Edmond. "Catalogue chronologique de l'oeuvre gravé de Jacques Callot." Unpublished ms., c.1920. (EPBN). "Jacques Callot; sa vie, ses oeuvres, son temps." Unpublished ms., c.1920. (EPBN)
Entries: 951. Millimeters. Inscriptions. States. Described. Located.

Lieure, J. *Jacques Callot.* 5 vols. Paris: Editions de la Gazette des Beaux-Arts, 1924–1927. Reprint. 1929. Reprint. 8 vols. New York: Collectors' Editions, 1969.
Entries: 1428. Millimeters. Inscriptions. States. Described. Illustrated. Table of watermarks at end of catalogue. Concordance with catalogues of Meaume, Plan, and Bruwaert. Different images on a single plate are given separate numbers.

Lieure, J. "Un premier état inconnu d'un cuivre de Jacques Callot." [*Am. Est.*] 11 (1932): 177–179.
Addition to Leiure 283.

Jacques Callot; das gesamte Werk in zwei Bänden. Munich: Rogner und Bernhard, 1971.
Entries: 1428. Millimeters. Illustrated.

Calvaert, Denys *(1540–1619)*
[W.] I, p. 236.
Entries: 13 prints after.*

[H. *Neth.*] IV, p. 85.
Entries: 16 prints after.*

Calvert, Edward *(1799–1883)*
Finberg, A. J. "Edward Calvert's Engravings." [*PCQ.*] 17 (1930): 138–153.

Entries: 15. Inches. Inscriptions. States. Illustrated (selection). Located.

Lister, Raymond. *Edward Calvert.* London: G. Bell and Sons Ltd., 1962. Entries: 15. Inches. Inscriptions. States. Described. Illustrated. Located (selection).

Calvert, Henry *(fl. 1826–1854)*
[Siltzer] p. 328.
Entries: unnumbered, p. 328, prints after. Inscriptions.

Calzi, Angelo *(1748–1815)*
[Ap.] p. 84.
Entries: 7.*

Camassei, Andrea *(1602–1649)*
[B.] XIX, pp. 72–73.
Entries: 2. Pre-metric. Inscriptions. Described.

Cambiaso, Luca *(1527–1585)*
[B.] XII: *See* **Chiaroscuro Woodcuts**

[P.] VI: *See* **Chiaroscuro Woodcuts**

Suida-Manning, Bertina, and Suida, William. *Luca Cambiaso, la vita e le opere.* Milan: Casa Editrice Ceschina, 1958. Entries: 9 woodcuts by or after, 8 engravings after. Millimeters (selection). Described (selection). Illustrated (selection).

Cameron, David Young *(1865–1945)*
Wedmore, Frederick. *Cameron's etchings: a study and a catalogue.* London: R. Gutekunst, 1903. 155 copies. (NN) Entries: 152 (to 1903). Inches. Inscriptions. States. Described.

Rinder, Frank. *Etchings of D. Y. Cameron and a catalogue of his etched work.* Edinburgh (Scotland): Otto Schulze and Company, 1908. (NN)

Entries: 198 (to 1908). Based on Wedmore, with additions.

Rinder, Frank. *D. Y. Cameron, an illustrated catalogue of his etched work.* Glasgow (Scotland): James Maclehouse & Sons, 1912. 700 copies. Entries: 434 (to 1912). Inches. Millimeters. Inscriptions. States. Described. Illustrated. Located (selection).

Hind, Arthur M. *The etchings of D. Y. Cameron.* London: Halton and Truscott Smith, Ltd., 1924. Entries: 470 (to 1923). Millimeters. Illustrated (selection). Based on Rinder.

Rinder, Frank. "Cameron etchings, a supplement." [PCQ.] 11 (1924): 44–68. Entries: 36 (additional to 1912 catalogue. To 1923). Inches. Millimeters. Inscriptions. States. Illustrated (selection).

Rinder, Frank. *D. Y. Cameron; reproductions with descriptive notes of the etchings and dry-points from 1912 to 1932.* Glasgow (Scotland): Jackson, Wylie and Company, 1932. 100 copies. (DLC) Entries: 65 (additional to 1912 catalogue; to 1932). Inches. Millimeters. Inscriptions. States. Described. Illustrated.

Rinder, Frank. *D. Y. Cameron, an illustrated catalogue of his etchings and dry-points, 1887–1932.* Glasgow (Scotland): Jackson, Wylie and Company, 1932. 600 copies. (MB) Entries: 500 (to 1932). Inches. Millimeters. Inscriptions. States. Described (selection). Illustrated. Located (selection). Supersedes earlier catalogues by Rinder. Ms. notes (ECol); additional information.

Caminade, Alexandre François *(1783–1862)*
[Ber.] IV, p. 64.*

Camligue, —— *(fl. c.1785)*
[L. D.] p. 7.
Entries: 1. Millimeters. Inscriptions.
States. Descriptions. Illustrated. In-
complete catalogue.*

Camp, Camille J. B. van *(1834–1891)*
[H. L.] pp. 126–128.
Entries: 6. Millimeters. Inscriptions.
States. Described.

Campagnola, Domenico *(1484–1550)*
[B.] XII: *See* **Chiaroscuro Woodcuts**

[B.] XIII, pp. 377–387.
Entries: 10 engravings, 5 woodcuts.
Pre-metric. Inscriptions. Described.
Copies noted.

[Evans] p. 15.
Entries: 1 (additional to [B.]). Millime-
ters. Inscriptions. Described.

[P.] V, pp. 167–173.
Entries: 14 engravings (additional to
[B.]), 5 woodcuts and metalcuts (addi-
tional to [B.]), 10 doubtful prints.
Pre-metric. Inscriptions. States. De-
scribed. Located (selection).

Galichon, Émile. "Domenico Campag-
nola peintre-graveur du XVIe siècle."
[GBA.] 1st ser., 17 (1864): 456–461, 536–
553. Separately published. Paris: Aux
Bureaux de la Gazette des Beaux-Arts,
1864.
Entries: 15 engravings, 14 woodcuts, 3
doubtful prints. Millimeters. Inscrip-
tions. Described.

Tietze, Hans, and Tietze-Conrat, E.
"Domenico Campagnola's graphic art.
[PCQ.] 26 (1939): 310–333, 444–469.
Entries: 12. Millimeters. Inscriptions.
Described (selection). Illustrated
(selection).

[Hind] V, pp. 207–215.
Entries: 19 prints by and attributed to,
or in the manner of Campagnola.

Millimeters. Described. Illustrated.
Located.

Campagnola, Giulio *(c.1481/82–1516)*
[B.] XIII, pp. 368–376.
Entries: 8. Pre-metric. Inscriptions.
States. Described. Copies mentioned.

Galichon, Émile. "Giulio Campagnola;
peintre-graveur du XVIe siècle." [GBA.]
1st ser., 13 (1862): 332–346. Separately
published. Paris: Imprimerie de J.
Claye, 1862.
Entries: 14. Millimeters. Inscriptions.
States. Described. Illustrated (selec-
tion). Copies mentioned.

[P.] V, pp. 162–167.
Entries: 9 (additional to [B.]). Pre-
metric. Inscriptions. States. De-
scribed. Located (selection). Addi-
tional information to [B.].

[Wess.] III, p. 45.
Entries: 3 (additional to [B.] and [P.]).
Millimeters. Located.

Kristeller, Paul. *Giulio Campagnola: Kup-
ferstiche und Zeichnungen.* Graphische
Gesellschaft V. Veröffentlichung. Ber-
lin: Bruno Cassirer, 1907.
Entries: 20. Millimeters. Inscriptions.
States. Described. Illustrated. Lo-
cated. Bibliography for each entry.
Copies described and illustrated.

Borenius, Tancred. *Four early Italian en-
gravers.* London and Boston (Mass.):
Medici Society, 1923.
Entries: 16. Millimeters. Inscriptions.
States. Described. Illustrated. Lo-
cated. Copies mentioned.

[Hind] V, pp. 189–205.
Entries: 22. Millimeters. Inscriptions.
States. Described. Illustrated. Lo-
cated.

Campantico and Conosini *(19th cent.)*
[Ap.] p. 84.
Entries: 1+.*

Campbell, Robert *(fl. 1806–1831)*
[St.] p. 52.*

[F.] pp. 75–76.*

Campen, Jacob van *(1595–1657)*
[W.] I, pp. 237–238.
Entries: 1 print by, 4+ after.*

[H. *Neth.*] IV, p. 86.
Entries: 30+ prints after.*

Campen, Jan Diricks van *(fl. c.1602)*
[H. *Neth.*] IV, p. 86.
Entries: 2.*

Campendonk, Heinrich *(1889–1957)*
Engels, Mathias T. *Campendonk Holz-schnitte; Werkverzeichnis.* Stuttgart: W. Kohlhammer, 1959.
Entries: 71+ woodcuts, 6 designs for woodcuts not carried out. Millimeters. States. Described. Illustrated.

Camper, Petrus *(1722–1789)*
[W.] I, p. 239.
Entries: 2.*

Camphuysen, Govert Dircksz I *(1623 or 1624–1672)*
[W.] I, pp. 239–240.
Entries: 1 print by, 2 after.*

[H. *Neth.*] IV, p. 86.
Entries: 2 prints by, 2 after.*

Campi, Antonio *(d. c.1591)*
[B.] XII: *See* **Chiaroscuro Woodcuts**

[P.] VI: *See* **Chiaroscuro Woodcuts**

Campion, Charles Michel *(1734–1784)*
Ceinmar, Oliver de [Olivier de Carné]. *Étude biographique et litteraire sur C.-M. Campion . . . suivie du catalogue de son oeuvre gravée.* Marseille (France): Marius Olive, 1878. (EPBN)
Entries: 151. Inscriptions.

Campion, George B. *(1796–1870)*
[Siltzer] p. 347.
Entries: unnumbered, p. 347. Inscriptions.

Canaletto, [Antonio Canal] *(1697–1768)*
Meyer, Rudolph. *Die beiden Canaletto, Antonio Canale und Bernardo Belotto, Versuch einer Monographie der radierten Werke beider Meister.* Dresden: Published by the author, 1878.
Entries: 31. Pre-metric. Inscriptions. States. Described.

Springer, Jaro. "Eine unbeschriebene Radierung Canalettos." [*JprK.*] 25 (1904): 80.
Entries: 1 (additional to Meyer). Described. Illustrated. Located.

[Vesme] pp. 445–457.
Entries: 32. Millimeters. Inscriptions. States. Described. Located (selection).

Fritzsche, Hellmuth Allwill. "Vedute altre prese da i Luoghi altre ideate da Antonio Canale; Kleine Ergänzungen zum Oeuvrekatalog der Radierungen Antonio Canals in A. de Vesme 'le Peintre-graveur italien'." [*MGvK*] 1929, pp. 49–54, 74–78.
Additional information to [Vesme].

Pallucchini, Rodolfo, and Guarnati, G. F. *Le acqueforti del Canaletto.* Venice: Edizioni Daria Guarnati, 1945. 1000 copies. French ed. *Les Eaux-fortes de Canaletto.* Venice: Edizioni Daria Guarnati, 1946. 1000 copies.
Entries: 30. Millimeters. Inscriptions. States. Described. Illustrated. Located. Bibliography for each entry. Discussion of preparatory drawings. Table of watermarks.

Constable, W. G. *Canaletto, Giovanni Antonio Canale 1697–1768.* 2 vols. Oxford: Clarendon Press, 1962.
Entries: 30. Inches. Millimeters. Inscriptions. States. Described. Illus-

Canaletto *(continued)*

trated (selection). Prints after: un-
numbered, pp. 603–626. Inscriptions.
Described (selection). Based on Pal-
lucchini, with additional information.
Concordance of Pallucchini and
[Vesme] numbers.

Kainen, Jacob. *The etchings of Canaletto.*
Washington (D.C.): Smithsonian In-
stitution Press, 1967.
Entries: 30. Inches. States. Described.
Illustrated. Based on Pallucchini.

Salamon, Harry. *Catalogo completo delle
incisioni di Giovanni Antonio Canal detto il
Canaletto.* Milan: Salamon e Agustoni,
1971.
Entries: 30. Millimeters. Inscriptions.
States. Described. Illustrated. Lo-
cated. Table of watermarks.

Candid, Peter *(1548–1628)*
Rée, Paul Johannes. *Peter Candid, sein
Leben und seine Werke.* Leipzig: E. A.
Seemann, 1885. (MH)
Entries: unnumbered, pp. 253–257
(prints after). Inscriptions (selection).
Described (selection). Located (selec-
tion).

Canini, Giovanni-Angelo *(1617–1666)*
[B.] XXI, pp. 47–48.
Entries: 1. Pre-metric. Inscriptions.
Described.

Canon, Hans *(1829–1885)*
Schöny, Heinz. "Hans Canon als Litho-
graph." *Jahrbuch des Vereins für Ges-
chichte der Stadt Wien* 17/18 (1961–62):
286–304. (EWA)
Entries: 45. Millimeters. Inscriptions.
States. Described.

Canon, Jean-Louis *(1809–1892)*
[Ber.] IV, p. 64.*

Cantagallina, Remigio *(1582–c.1630)*
[B.] XX, pp. 57–63.

Entries: 38. Pre-metric. Inscriptions.
Described.

Cantarini, Simone *(1612–1648)*
[B. *Reni*] pp. 51–73.
Entries: 35. Pre-metric. Inscriptions.
States. Described.

[B.] XIX, pp. 121–146.
Entries: 37. Pre-metric. Inscriptions.
States. Described. Copies mentioned.

[Wess.] III, p. 45.
Additional information to [B.].

Emiliani, Andrea. "Simone Cantarini
opera grafica." *Arte antica e moderna,*
1959, pp. 438–456.
Entries: 39. Described. Information
about related drawings.

Cantini, Giovacchino *(1780–1844)*
[Ap.] pp. 84–85.
Entries: 11.*

Cantré, Jan-Frans *(20th cent.)*
Philippen, Jos, and van den Wijngaert,
Frank. *Jan-Frans Cantré, vlaamsch
houtsnijder.* Diest (Belgium):
Kunstuitgeverij "Pro Arte," 1941. 500
copies. (DLC)
Entries: 332+ (to 1931). Millimeters.
Illustrated (selection).

Cantré, Joseph *(1890–1957)*
Lebeer, Louis. *L'Oeuvre gravé de Jozef
Cantré.* Brussels: Bibliothèque Royale de
Belgique, 1959.
Entries: 125+ woodcuts, 4 etchings.
Millimeters. Illustrated (selection).

Cantú, Fédérico *(b. 1908)*
*Federico Cantú; obra realizada de 1922 a
1948.* Mexico: Editorial Asbaje, 1948.
1500 copies.
Entries: 106 (works in all media, in-
cluding prints, to 1948). Millimeters.
Illustrated.

Canu, Jean Dominique Etienne *(b. 1768)*
[Ber.] IV, p. 64.*

Canuti, Domenico Maria *(1620–1684)*
[B.] XIX, pp. 222–224.
 Entries: 3. Pre-metric. Inscriptions.
 Described.

Čapek, Joseph *(1887–1945)*
Thiele, Valdimír. *Josef Čapek a kniha, soupis knizni grafiky.* Prague: Nakladatelství Ceskoslovenských Vytvarných umélcu, 1958.
 Entries: unnumbered, pp. 187–260.
 Millimeters (selection). Illustrated (selection).

Capelle, Jan van de *(1624–1679)*
[vdK.] pp. 105–108.
 Entries: 332+ (to 1931). Millimeters.
 Illustrated (selection).

[W.] I, pp. 242–243.
 Entries: 2 prints by, 5 after.*

[H. *Neth.*] IV, pp. 87–93.
 Entries: 11 prints by, 6 after. Illustrated (selection).*

Capelli, A. *(19th cent.)*
[Ap.] p. 85.
 Entries: 2.*

Capitelli, Bernardino *(1589–1639)*
[B.] XX, pp. 151–165.
 Entries: 43 prints by, 5 prints not seen by [B.]. Pre-metric. Inscriptions. Described.

[Wess.] III, p. 45.
 Entries: 1 (additional to [B.]). Millimeters. Inscriptions. Described. Located. Additional information to [B.].

Capon, Charles R. *(20th cent.)*
Allen, Francis Wilbur. *Bookplates; a selection from the work of Charles R. Capon.* Portland (Ore.): Anthoensen Press, 1950. 300 copies. (DLC)

Entries: 60 (bookplates only, to 1950). Inches. Inscriptions. Described. Illustrated (selection).

Caporali, Filippo *(1794–after 1848)*
[Ap.] pp. 85–86.
 Entries: 6.*

Caquet, Jean-Gabriel *(1749–1802)*
[L. D.] pp. 7–8.
 Entries: 2. Millimeters. Inscriptions. States. Described. Incomplete catalogue.*

Caracciolo, Giovanni Battista *(c.1570–1637)*
Voss, Hermann. "Neues zum Schaffen des Giovanni Battista Caracciolo." [*JprK.*] 48 (1927): 131–138.
 Entries: 2. Millimeters. Inscriptions. Described. Illustrated. Located.

Caraffe, Armand Charles *(1762–1822)*
[Baud.] II, pp. 315–316.
 Entries: 1. Millimeters. Inscriptions. Described.

Caraglio, Gian Jacopo *(c.1500–c.1570)*
[B.] XV, pp. 61–100.
 Entries: 64 prints by, 1 doubtful print. Pre-metric. Inscriptions. States. Described. Copies mentioned.

[P.] VI, pp. 95–98.
 Entries: 5 (additional to [B.]). Pre-metric. Inscriptions (selection). Described (selection). Additional information to [B.].

[Wess.] III, p. 46.
 Additional information to [B.].

Caran d'Ache [pseudonym of Emmanuel Poiré] *(1858–1909)*
[Ber.] IV, p. 65.*

Carattoni, Girolamo *(d. c.1809)*
[Ap.] p. 86.
 Entries: 6.*

Caravaggio, Michelangelo Merisi
(1560/65–1610)
 [M.] I, pp. 613–625.
 Entries: 2 prints by, 83 after. Paper
 fold measure. Inscriptions (selection).
 Described (selection).

 [Vesme] pp. 1–4.
 Entries: 2. Millimeters. Inscriptions.
 States. Described. Appendix with 5
 doubtful prints.

Caravaggio, Polidoro da *(1490/1500–1543)*
 [B.] XII: *See* **Chiaroscuro Woodcuts**

Carbonati, Antonio *(b. 1893)*
 Somenzi, Mino. *Antonio Carbonati; cata-*
 logo cronologico delle acqueforti e delle lito-
 grafie. Rome: A.R.T.E., 1938. (ERH)
 Entries: 34 lithographs, 252 etchings
 (to 1938). Millimeters. Illustrated
 (selection).

Carbonneau, Jean Baptiste Charles
(b. 1815)
 [Ber.] IV, p. 66.*

Cardon, Antoine *(1772–1813)*
 [W.] I, pp. 243–244.
 Entries: 34.*

 [Siltzer] p. 347.
 Entries: unnumbered, p. 347. Inscrip-
 tions.

Cardon, Antoine Alexandre Joseph
(1739–1822)
 [W.] I, p. 243.
 Entries: 18+.*

Carey, Charles Philippe Auguste
(1824–1897)
 [Ber.] IV, p. 66.*

Carjat, Etienne *(1828–1906)*
 [Ber.] IV, p. 66.*

Carlègle, Charles-Émile *(1877–1940)*
 Valotaire, Marcel. *Carlègle.* Les artistes
 du livre, 1. Paris: Henry Babou, 1928.
 700 copies.
 Bibliography of books with illustra-
 tions by.

Carlevaris, Luca *(1665–1731)*
 Mauroner, Fabio. *Luca Carlevarijs.* Ven-
 ice: Zanetti, 1931.
 Entries: 3+ prints by, 6 after. Millime-
 ters. Inscriptions (selection). States.
 Illustrated (selection).

 Mauroner, Fabio. *Luca Carlevarijs.*
 Padua: Le tre Venezie, 1945.
 Entries: 3+ prints by, 9 after. Millime-
 ters. Inscriptions. States. Illustrated
 (selection).

 Rizzi, Aldo. *Luca Carlevarijs.* Venice:
 Alfieri, 1967.
 Entries: unnumbered, pp. 102–103,
 prints by and after. Millimeters. In-
 scriptions. Described (selection). Il-
 lustrated (prints by only).

Carloni, Carlo *(19th cent.)*
 [Vesme] pp. 370–373.
 Entries: 7 prints by, 4 doubtful prints.
 Millimeters (selection). Inscriptions
 (selection). States. Described (selec-
 tion).

Carmiencke, Johan-Herman *(1810–1867)*
 [A. 1800] IV, pp. 46–61.
 Entries: 35. Millimeters. Inscriptions.
 Described.

Carmona
See **Salvador Carmona**

Carmontelle, Louis Carrogis *(1717–1806)*
 [Baud.] II, pp. 143–148.
 Entries: 6. Millimeters. Inscriptions.
 States. Described.

Carocci, Giustino *(b. 1829)*
 [Ap.] p. 87.
 Entries: 4.*

Carolus, Louis-Antoine *(1814–1865)*
 [H. L.] pp. 128–133.
 Entries: 7 etchings, 3 lithographs.
 Millimeters. Inscriptions. States. De-
 scribed.

Carolus-Duran, Emile Auguste [Charles
Emile Auguste Durand] *(1837–1917)*
 [Ber.] IV, p. 66.*

Caron, Adolphe Alexandre Joseph
(1797–1867)
 [Ap.] p. 87.
 Entries: 6.*

 [Ber.] IV, pp. 66–67.*

Caron, Antoine *(1520/21–1599)*
 [W.] III, pp. 48–49.
 Entries: 2 prints after.*

Caron, Jean Louis Toussaint *(1790–1832)*
 [Ap.] p. 88.
 Entries: 2.*

 [Ber.] IV, p. 68.
 Entries: 3. Paper fold measure.

Caronni, Paola *(1779–1842)*
 [Ap.] pp. 88–89.
 Entries: 22.*

Carpeaux, Jean Baptiste *(1827–1875)*
 [Ber.] IV, pp. 68–69.
 Entries: 2. Millimeters. Described.

 [Del.] VI.
 Entries: 11 prints by, 2 rejected prints.
 Millimeters. Inscriptions (selection).
 States. Described (selection). Illus-
 trated. Located (selection).

 Carlier, Adrien. "Carpeaux, graveur."
 [*Am. Est.*] 7 (1928): 33–36, 73–90.
 Entries: 14. Millimeters. Inscriptions.
 Described. Illustrated.

Carpi, Ugo da *(c.1480–c.1520)*
 [B.] XII: *See* **Chiaroscuro Woodcuts**

 Gualandi, Michelangelo. *Di Ugo da Carpi
 e dei Conti da Panico memorie e note.* Bo-
 logna: Societa' Tipografia Bolognese e
 ditta Sassi, 1854. 250 copies. (MBMu)
 Entries: 50. Pre-metric. Inscriptions
 (selection). States.

 [P.] VI: *See* **Chiaroscuro Woodcuts**

 Servolini, Luigi. "Ugo da Carpi." *Revista
 d'Arte* 11 (2d ser., 1) (1929): 174–194, 297–
 319. Separately published. Florence: Leo
 S. Olschki, 1930.
 Entries: 25 prints by, 5 doubtful
 prints. Inscriptions. Described. Illus-
 trated (selection).

 Servolini, Luigi. "Ugo da Carpi illustra-
 tore del libro." *Gutenberg Jahrbuch* 25
 (1950): 196–202.
 Entries: 12+ (book illustrations only).
 Inscriptions. Illustrated (selection).

 Servolini, Luigi. "Ugo da Carpi illustra-
 tore del libro." *Rassegna grafica, gazzetta
 grafica,* no. 225 (15 April 1968): 18–23.
 (EFU)
 Entries: 12 signed woodcuts for books.
 Inscriptions. States. Described. Illus-
 trated (selection). Summary of book
 illustrations attributed to, unnum-
 bered.

 Contini, Carlo. *Ugo da Carpi e il cammino
 della xilografia.* Carpi (Italy): Edizioni del
 Museo, 1969. (CSfAc)
 Entries: 50. Pre-metric. Illustrated
 (selection). Text in Italian, French,
 German, and English.

Carpioni, Giulio *(1611–1674)*
 [B.] XX, pp. 177–191.
 Entries: 26. Pre-metric. Inscriptions.
 States. Described. Copies noted.

 [Heller] p. 39.
 Additional information to [B.].

 Calabi, Augusto. "The etchings of
 Giulio Carpioni." [*PCQ.*] 11 (1924):
 133–161.

Carpioni, Giulio *(continued)*

Entries: 14. Millimeters. Inscriptions. States. Described. Illustrated (selection).

Museo Civico, Bassano del Grappa [Giuseppe Maria Pilo, compiler]. *Incisioni di Giulio Carpioni.* Bassano del Grappa (Italy), 1962. (CSfAc)
Entries: 23. Millimeters. Inscriptions. Described (selection). Illustrated. Bibliography for each entry.

Carrà, Carlo *(1881–1966)*
Galleria d'Arte Medea [Luigi Cavallo, compiler]. *Carlo Carrà, opera grafica.* Milan, 1972. (EFU)
Entries: 32 (to 1927, complete?). Millimeters. Illustrated.

Carracci, Agostino *(1557–1602)*
[B.] XVIII, pp. 31–173.
Entries: 274 prints by, 91 doubtful and rejected prints. Pre-metric. Inscriptions. States. Described. Copies noted.

[Heller] pp. 39–40.
Additional information to [B.].

[Wess.] III, p. 46.
Entries: 1 (additional to [B.]). Millimeters. Inscriptions. Described. Located. Additional information to [B.].

Calcografia Nazionale, Rome [Maurizio Calvesi and Vittorio Casale, compilers]. *Le incisioni dei Carracci.* Rome: Comunità Europea dell'Arte e della Cultura, 1965.
Entries: 185. Millimeters. Inscriptions. Described. Illustrated (selection). Located (selection). Bibliography for each entry.

Carracci, Annibale *(1560–1609)*
[B.] XVIII, pp. 177–205.
Entries: 18 prints by, 1 doubtful print, 16 rejected prints. Pre-metric. Inscriptions. States. Described. Copies mentioned.

[Heller] pp. 40–41.
Additional information to [B.].

Calcografia Nazionale, Rome [Maurizio Calvesi and Vittorio Casale, compilers]. *Le incisioni dei Carracci.* Rome: Comunità Europea dell'Arte e della Cultura, 1965.
Entries: 29. Millimeters. Inscriptions. Described. Illustrated (selection). Located (selection). Bibliography for each entry.

Posner, Donald. *Annibale Carracci, a study in the reform of Italian painting around 1500.* 2 vols. London: Phaidon Press, 1971.
Entries: 22 prints by, 8 after (catalogue of works in all media: index to prints, II, p. 338). Millimeters. Inscriptions. Described. Illustrated.

Carracci, Francesco *(1559–1622)*
[B.] XVIII, pp. 366–367.
Entries: 1. Pre-metric. Inscriptions. Described.

Carracci, Lodovico *(1555–1619)*
[B.] XVIII, pp. 23–28.
Entries: 5. Pre-metric. Inscriptions. Described. Copies mentioned.

[Wess.] III, p. 46.
Additional information to [B.].

Bodmer, Heinrich. *Lodovico Carracci.* Burg bei Magdeburg (Germany): August Hopfer Verlag, 1939.
Catalogue of paintings; prints after are mentioned where extant.

Calcografia Nazionale, Rome [Maurizio Calvesi and Vittorio Casale, compilers]. *Le incisioni dei Carracci.* Rome: Comunità Europea dell'Arte e della Cultura, 1965.
Entries: 5. Millimeters. Inscriptions. Described. Illustrated. Located. Bibliography for each entry.

Carrach, Jan
See **Kraeck**

Carré, Franciscus *(1630–1669)*
[H. *Neth.*] IV, p. 93.
Entries: 1 print after.*

Carré, Hendrick I *(1656–1721)*
[W.] I, p. 245.
Entries: 2 prints after.*

Carré, Michiel *(1657–1747)*
[W.] I, p. 246.
Entries: 1.*

Carrey, Charles *(b. 1824)*
[Ap.] p. 90.
Entries: 3.*

Carrière, Eugène *(1849–1906)*
[Del.] VIII.
Entries: 45. Millimeters. Inscriptions (selection). States. Described (selection). Illustrated. Located (selection). Appendix with prints after and facsimiles of prints by.

Carrocci, Pietro *(17th cent.)*
[Vesme] p. 24.
Entries: 2. Millimeters (selection). Inscriptions. Described.

Carstens, Asmus Jacob *(1754–1798)*
Alten, F. von. *Versuch eines Verzeichnisses der Werke und Entwürfe von Asmus Jacob Carstens . . . mit Angabe der Vervielfältigungen.* Oldenburg (Germany): Gerhard Stalling, 1866.
Catalogue of works in all media; prints after are mentioned where extant.

Cartaro, Mario *(fl. 1560–1588)*
[B.] XV, pp. 520–532.
Entries: 28. Pre-metric. Inscriptions. States. Described.

[Heller] p. 83.

Entries: 3 (additional to [B.]). Pre-metric. Inscriptions. Described.

[Evans] p. 21.
Entries: 1 (additional to [B.]). Millimeters. Inscriptions. Described.

[P.] VI, pp. 157–161.
Entries: 27 (additional to [B.]). Pre-metric (selection). Inscriptions. Described (selection).

Federici, V. "D. Mario Cartaro, incisore viterbese del secolo XVI." *Archivio della società Romana della storia patria* 21 (1898): 535–552.
Entries: unnumbered, pp. 545–551 (additional to [B.] and [P.]). Inscriptions. Described.

Caruso, Bruno *(b. 1927)*
Mercuri, Elio. *Opera grafica di Bruno Caruso.* Rome and Caltanissetta (Italy): Salvatore Sciascia, 1966.
Entries: 58 (to 1965, complete?). Millimeters. Illustrated.

Biblioteca Comunale, Piombino [Vittorio Fagone, compiler]. *Bruno Caruso; 118 acqueforti dal 1955 al 1970.* Rome: Arti grafiche l'Ambrosini, 1970. (DLC)
Entries: 118 (to 1970). Millimeters. Illustrated.

Carwitham, John *(fl. 1723–1741)*
[Sm.] I, pp. 136–137, and "additions and corrections" section.
Entries: 3 (portraits only). Inches. Inscriptions. States. Described. Located (selection).

[Ru.] p. 33.
Additional information to [Sm.].

Carzou, Jean *(b. 1907)*
Cailler, Pierre. *Catalogue raisonné de l'oeuvre gravé et lithographié de Carzou.* Geneva: P. Cailler, 1962.
Entries: 5 etchings, 97 lithographs (to 1962?). Millimeters. Inscriptions. Described. Illustrated.

Carzou, Jean *(continued)*

Furhange, Maguy. *Carzou graveur et lithographe, engraver and lithographer, graveur und lithograph, I.* Nice (France): Éditions d'art de Francony, 1971.
Entries: 85 (to 1962). Millimeters. States. Described. Illustrated.

Casa, Nicolò della *(fl. 1543–1547)*
[P.] VI, pp. 124–125.
Entries: 4. Pre-metric. Inscriptions. Described.

[RD.] IX, p. 180–183.
Entries: 5. Millimeters. Inscriptions. States. Described.

Casanova, Francesco [François Joseph] *(1727–1802)*
[Baud.] I, pp. 133–137.
Entries: 6. Millimeters. Inscriptions. Described.

Casembrot, Abraham *(17th cent.)*
[Wess.] II, p. 232.
Entries: 4 (additional to [Andresen, *Handbuch*]). Millimeters. Inscriptions. Described. Additional information to [Andresen, *Handbuch*].

[W.] I, pp. 246–247.
Entries: 23+ prints by, 1 after.*

[H. *Neth.*] IV, pp. 94–96.
Entries: 28 prints by, 5 after. Illustrated (selection).*

Casolani, Alessandro di Agostino *(1552–1606)*
[B.] XII: *See* **Chiaroscuro Woodcuts**

[B.] XVII, p. 42.
Entries: 1. Pre-metric. Inscriptions. Described.

Casorati, Felice *(1883–1963)*
Deri, Gino. "Opera grafica di Felice Cassorati." *Gutenberg Jahrbuch* 42 (1967): 225–227.

Entries: 35. Millimeters. Illustrated (selection).

Caspar, Joseph *(1799–1880)*
[Ap.] pp. 90–91.
Entries: 18.*

Caspari, Hendrik Willem *(1770–1829)*
[W.] I, p. 247.
Entries: 2+.*

Cassagne, Armand Théophile *(1823–1907)*
[Ber.] IV, p. 69.*

Cassatt, Mary *(1844–1926)*
Breeskin, Adelyn D. *The graphic work of Mary Cassatt; a catalogue raisonné.* New York: H. Bittner and Co., 1948.
Entries: 220 prints, 7 drawings used for unknown soft-ground etchings. Inches. States. Illustrated. Located (selection).

Cassinari, Bruno *(b. 1912)*
Deri, Gino. "L'Opera grafica di Bruno Cassinari." *Gutenberg Jahrbuch* 45 (1970): 349–353.
Entries: 35. Millimeters. Inscriptions. Illustrated (selection).

Castagno, Andrea dal *(c.1410–1457)*
[M.] I, pp. 693–697.
Entries: 5 (prints after, 19th cent.). Paper fold measure.

Castan, Pierre Jean Edmond *(b. 1817)*
[Ber.] IV, p. 69.*

Casteleyn, Jan *(fl. c.1653)*
[H. *Neth.*] IV, p. 97.
Entries: 3 prints after.*

Casteleyn, Vincent *(d. 1658)*
[W.] I, p. 248.
Entries: 1 print after.*

[H. *Neth.*] IV, p. 97.
Entries: 1 print after.*

Castelli, ——— *(19th cent.)*
[Ber.] IV, p. 69.*

Castelli, Cristoforo
See **Monogram GG** [Nagler, *Mon.*] I,
no. 2357

Castiglione, Giovanni Benedetto
(1616–1670)
[B.] XXI, pp. 9–42.
Entries: 67 etchings, 5 monotypes.
Pre-metric. Inscriptions. States. De-
scribed.

Calabi, Augusto. "The monotypes of
Gio. Benedetto Castiglione." [*PCQ.*] 10
(1923): 222–253.
Entries: 20 (monotypes only). Milli-
meters. Inscriptions. Described. Illus-
trated (selection). Located.

Calabi, Augusto. "Castiglione's mono-
types, a supplement." [*PCQ.*] 12 (1925):
435–442.
Entries: 3 (additional to Calabi 1923).
Millimeters. Inscriptions. Described.
Illustrated. Located. Revision of
numbering in Calabi 1923.

Delogu, Giuseppe. *G. B. Castiglione detto
il Grechetto.* Bologna: Casa Editrice
Apollo, 1928.
Entries: 20 monotypes by, 3 rejected
monotypes. Millimeters. Illustrated
(selection). Located.

Röhn, Franz. *Die Graphik des Giovanni
Benedetto Castiglione.* University of Ber-
lin, 1928. (MBMu)
Entries: 3 prints by, 2 doubtful prints
(additional to [B.]). Millimeters. In-
scriptions. Described. Located. Addi-
tional information to [B.].

Calabi, Augusto. "Castigliones mono-
types, a second supplement." [*PCQ.*] 17
(1930): 299–301.
Entries: 1 (additional to Calabi 1923
and 1925). Millimeters. Inscriptions.
Described. Illustrated. Located. Re-
ordering of catalogue numbers.

Finch College Museum of Art, New
York [Robert L. Manning, compiler].
Etchings of Giovanni Benedetto Castiglione.
New York, 1967.
Entries: 73 (etchings only). Described
(selection).

Philadelphia Museum of Art [Ann
Percy, compiler]. *Giovanni Benedetto Cas-
tiglione: master draughtsman of the Italian
Baroque.* Philadelphia, 1971.
Entries: 27. Millimeters. Inscriptions.
Described. Illustrated. Located. Fig-
ure compositions only: omits sets of
Oriental Heads and other portraits and
minor prints.

Castiglione, Salvatore *(fl. c.1645)*
[B.] XXI, p. 43.
Entries: 1. Pre-metric. Inscriptions.
Described.

Philadelphia Museum of Art [Ann
Percy, compiler]. *Giovanni Benedetto
Castiglione: master draughtsman of the Ital-
ian Baroque.* Philadelphia, 1971.
Entries: 1. Millimeters. Inscriptions.
Described. Illustrated. Located.

Castiglioni, Giani *(20th cent.)*
Zingg, P. Thaddaeus. *Giani Castiglioni;
seine Holz- und Linolschnitte.* Zurich:
Carta Verlag, 1960.
Entries: unnumbered, pp. 101–103 (to
1960). Millimeters. Illustrated (selec-
tion).

Castro, L. *(fl. c.1700)*
[W.] I, p. 248.
Entries: 4 prints after.*

Catenaro, Juan Bautista [Giovanni Battis-
ta] *(18th cent.)*
[Vesme] pp. 364–365.
Entries: 3. Millimeters. Inscriptions.
Described. Appendix with 2 doubtful
prints.

Catesby, Mark *(c.1679–1749)*
Frick, George Frederick, and Stearns, R. P. *Mark Catesby; the colonial Audubon.* Urbana (Ill.): University of Illinois Press, 1961.
Bibliography of books with illustrations by.

Catlin, George *(1796–1872)*
[Carey] p. 222.
Entries: 11 prints by and after (lithographs only). Inches (selection). Inscriptions (selection). Described (selection). Located (selection).

Cats, Jacob *(1741–1799)*
[W.] I, pp. 248–249.
Entries: 2+ prints by, 6+ after.*

Cattelain, Philippe Auguste *(b. 1838)*
[Ber.] IV, pp. 69–73.*

Catton, Charles II *(1756–1819)*
[Siltzer] p. 347.
Entries: unnumbered, p. 347. Inscriptions.

Caukercken, Cornelis van *(1626–1680)*
[W.] I, p. 249.
Entries: 22+.*

[H. *Neth.*] IV, pp. 98–99.
Entries: 23+.*

Caulo, Antonin *(19th cent.)*
[Ber.] IV, p. 73.*

Cause, Hendrik *(1648–1699)*
[W.] I, p. 249.
Entries: 3.*

[H. *Neth.*] IV, p. 99.
Entries: 9.*

Causé, Lamberecht *(17th cent.)*
[W.] I, p. 249.
Entries: 1.*

Cavalli, Nicolò *(1730–1822)*
[AN.] pp. 609–612.
Entries: unnumbered, pp. 610–612. Millimeters. Inscriptions. Described (selection).

[AN. 1968] p. 174.
Entries: unnumbered, p. 174 (additional to [AN.]). Millimeters (selection). Inscriptions (selection).

Cave, François Morellon La *(fl. 1726–1766)*
[W.] I, p. 250.
Entries: 7.*

Cavedone, Giacomo *(1577–1660)*
[B.] XVIII, pp. 330–334.
Entries: 3. Pre-metric. Inscriptions. Described.

Cay, Jacob
See **Monogram DKL** [Nagler, *Mon.*] II, no. 1186

Caylus, Anne Claude Philippe de Tubières, comte de *(1692–1765)*
Dacier, Émile. "Caylus graveur de Watteau." [*Am. Est.*] 5 (1926): 151–169; [*Am. Est.*] (1927): 1–10, 52–58, 69–77.
Entries: 60 (prints after Watteau only). Millimeters. Inscriptions. States. Described. Illustrated (selection).

Caymox, Balthazar
See **Caimox**

Cazenave, J. F. *(b. 1770)*
[Ber.] IV, p. 73.*

Cazes, Romain *(1810–1881)*
[Ber.] IV, p. 73.*

Cecchini, Francesco *(d. c.1811)*
[Ap.] pp. 91–92.
Entries: 2.*

Cecill, Thomas *(fl. 1625–1640)*
[Hind, *Engl.*] III, pp. 31–47.

Entries: 44. Inches. Inscriptions. States. Described, Illustrated (selection). Located.

Celan Lestrange, Gisèle *(b. 1927)*
Städtische Kunstgalerie Bochum. *Gisèle Celan Lestrange.* Bochum (West Germany), 1967.
Entries: 74 (to 1966). Millimeters. Illustrated (selection).

Celebrino da Udine, Eustachio *(fl. c.1523)*
Servolini, Luigi. "Eustachio Celebrino da Udine, intagliatore, calligrafo, poligrafo ed editore del sec. XVI." *Gutenberg Jahrbuch,* 1944–49, pp. 179–189.
Bibliography of books with illustrations by.

Cenci, Filippo *(b. c.1810)*
[Ap.] p. 92.
Entries: 6.*

Cermak, Jaroslav *(1831–1878)*
[H. L.] pp. 147–148.
Entries: 2. Millimeters. Inscriptions. States. Described.

Cernel, Mme de
See **Champion de Cernel**

Ceroni, Luigi *(19th cent.)*
[Ap.] p. 92.
Entries: 3.*

[Ber.] IV, pp. 73–74.*

Cervi, Bernardino *(1596–1630)*
[Vesme] pp. 18–19.
Entries: 3. Millimeters. Inscriptions. States. Described. Located (selection).

Cervicornus, Eucharius *(fl. 1528–1543)*
[H. *Ger.*] V, p. 191.
Entries: 5.*

Cesio, Carlo *(1626–1686)*
[B.] XXI, pp. 103–119.

Entries: 90 prints by, 1 doubtful print. Pre-metric. Inscriptions. Described.

Cesura, Pompeo [called "Pompeo dell'Aquila"] *(d. c.1571)*
[M.] II, pp. 200–201.
Entries: 17. Paper fold measure. Described (selection).

Ceulen, Cornelis Janssens I *(1593–1664)*
[W.] I, pp. 261–263.
Entries: 10 prints after.*

[H. *Neth.*] IV, p. 100.
Entries: 13 prints after.*

Ceulen, Cornelis Janssens II *(b. c.1622)*
[H. *Neth.*] IV, p. 100.
Entries: 1 print after.*

Cézanne, Paul *(1839–1906)*
Venturi, Lionello. *Cézanne, son art—son oeuvre.* Paris, Paul Rosenberg éditeur, 1936.
Entries: 6. Millimeters. Inscriptions. Described. Illustrated.

Gachet, Paul. *Cézanne à Auvers; Cézanne graveur.* Paris: Les Beaux Arts, Éditions d'études et de documents, 1952.
Entries: 5 (etchings only). Millimeters. Inscriptions. Described. Illustrated.

Cherpin, Jean. *L'Oeuvre gravé de Cézanne.* Arts et Livres de Provence, Bulletin no. 82. Marseille (France), 1972.
Entries: 9. Millimeters. Inscriptions. States. Described. Illustrated (selection).

Chabanne, Flavien Emmanuel *(b. 1799)*
[Ber.] IV, p. 74.*

Chabry, Léonce *(1832–1883)*
[Ber.] IV, p. 74.*

Chagall, Marc *(b. 1887)*
Ben Sussan, René. "The work of Marc Chagall in portfolio or book form, etc.

Chagall, Marc *(continued)*

published and in progress; a bibliography." *Signature,* November 1946, pp. 31–46. (EPBN)
Bibliography of books with illustrations by (to 1944).

Meyer, Franz. *Marc Chagall, das graphische Werk.* Teufen (West Germany): Verlag Arthur Niggli, 1957. English ed. *Marc Chagall, his graphic work.* New York: Harry N. Abrams, 1957.
Bibliography of books with illustrations by (to 1956).

Mourlot, Fernand. *Chagall lithographe.* [Monte Carlo (Monaco)?]: André Sauret, 1960. English ed. *The lithographs of Chagall.* New York: George Braziller, 1960.
Entries: 191 (lithographs only, to 1957). Inches. States. Illustrated.

Mourlot, Fernand. *Chagall lithographe 1957–1962.* Monte Carlo (Monaco): André Sauret, 1963. English ed. *The lithographs of Chagall 1957–1962.* Boston (Mass.): Boston Book and Art Shop, 1963.
Entries: 185 (lithographs only, 1957 to 1962). Inches. States. Illustrated.

Cramer, Gérald. *Marc Chagall monotypes 1961–1965.* Geneva: Gérald Cramer, 1966. 1350 copies.
Entries: 167 (monotypes only). Millimeters. Inches. Inscriptions. Described. Illustrated.

Foster, Joseph K. *Marc Chagall: posters and personality.* New York: Reynal and Company, and William Morrow and Company, 1966.
Entries: 26 (posters only, by and after; to 1966? Complete?). Illustrated.

Mourlot, Fernand, and Sorlier, Charles. *Chagall lithographe, 1962–1968.* Monte Carlo (Monaco): André Sauret, 1969. English ed. *The lithographs of Chagall,*

1962–1968. Boston (Mass.): Boston Book and Art Shop, 1969.
Entries: 184 (lithographs only, 1962 to 1968). Millimeters. States. Described. Illustrated.

Kornfeld, Eberhard W. *Verzeichnis der Kupferstiche, Radierungen und Holzschnitte von Marc Chagall. Band I: Werke 1922–1966.* Bern: Kornfeld und Klipstein, 1970.
Entries: 123 (engravings, etchings and woodcuts only. To 1966). Millimeters. Inscriptions. States. Described. Illustrated. Located (selection).

Chaigneau, Jean Ferdinand *(1830–1906)*
[Ber.] IV, pp. 74–75.*

Chailloux, A. *(19th cent.)*
[Ber.] IV, p. 75.*

Chalandre, Fernand *(1879–1924)*
Buriot Darsiles, H. "Ex-libris modernes, I: Fernand Chalandre." [*Arch. Ex.-lib.*] 36 (1929): 27–31.
Entries: 20 (bookplates only). Millimeters. Described. Illustrated (selection).

Challamel, Jules Robert Pierre Joseph *(b. 1813)*
[Ber.] IV, p. 75.*

Challes, Charles Michel-Ange *(1718–1778)*
[Baud.] II, pp. 149–150.
Entries: 2. Millimeters. Inscriptions. Described.

Chalon, Henry Bernard *(1770–1849)*
[Siltzer] pp. 87–93.
Entries: unnumbered, pp. 91–93, prints after. Inches (selection). Inscriptions. Illustrated (selection).

Chalon, Jan *(1738–1795)*
[W.] I, p. 270.
Entries: 9.*

Cham [Amédée Charles Henri, comte de Noé] *(1819–1879)*
[Ber.] IV, pp. 75–81.*

Chambaron, ——— *(d. 1869)*
[Ber.] IV, p. 81.*

Chamberlain, Samuel *(b. 1895)*
Childs, Charles D. "The etchings and lithographs of Samuel Chamberlain." [*P. Conn.*] 6 (1926), no. 2, part 1, unpaginated.
Entries: unnumbered, 2 pp. Inches. Illustrated (selection).

Childs, Charles D. *Samuel Chamberlain, etcher and lithographer.* Goodspeed's Monographs no. 10. Boston (Mass.): Charles E. Goodspeed and Co., 1927. (MB)
Entries: 64 (to 1927). Inches. Typed supplement (NN); 17 additional entries.

Chamberlain, Samuel. *Etched in sunlight; fifty years in the graphic arts.* Boston (Mass.): Boston Public Library, 1968.
Entries: 199 (to 1958). Inches.

Chambers, B. *(fl. c.1825)*
[F.] p. 76.*

Chambers, Jay *(fl. c.1900)*
Stone, Wilbur Macey. *Jay Chambers, his book-plates, with XXVII examples and an essay concerning them.* New York: Randolph R. Beam, 1902. (DLC)
Entries: 40 (bookplates only, to 1902). Illustrated (selection).

Champaigne, Philippe de *(1602–1674)*
[W.] I, pp. 270–272.
Entries: 2 prints by, 68 after.*

Dorival, Bernard. "Recherches sur les portraits gravés aux XVIIe et XVIIIe siècles d'après Philippe de Champaigne." [*GBA.*] 6th ser. 75 (1970): 257–323.
Entries: unnumbered, pp. 279–321 (17th and 18th century prints after, portraits only). Inscriptions. Described. Illustrated.

Dorival, Bernard. "Recherches sur les sujets sacrés et allégoriques gravés au XVIIe et au XVIIIe siècle d'après Philippe de Champaigne." [*GBA.*] 6th ser., 80 (1972): 5–60.
Entries: 95 (17th and 18th century prints after, religious and allegorical subjects only). Inscriptions. Described. Illustrated.

Champin, Jean Jacques *(1796–1860)*
[Ber.] IV, pp. 81–82.*

Champion, A. *(fl. 1810–1830)*
[Ber.] IV, p. 82.*

Champion de Cernel, Marie Jeanne Louise Françoise Suzanne *(1753–1834)*
See also **Sergent,** Antoine François

Baré, F. "Liste des pièces gravées par et d'après Antoine François Sergent, ainsi que celles gravées par Mme de Cernel (Émira Marceau)." [*Bull. des B. A.*] 2 (1884–1885): 138–162.
Entries: 426. Paper fold measure (selection). Inscriptions (selection).

Champmartin, Charles Emile
See **Callande de Champmartin**

Champollion, Eugène André *(1848–1901)*
[Ber.] IV, pp. 83–86.*

Chandelier, Jules Michel *(1813–1871)*
[Ber.] IV, p. 86.*

Chanson, L. *(19th cent.)*
[Ber.] IV, p. 86.*

Chantereau, Jérôme François *(d. 1757)*
[Baud.] I, pp. 12–13; errata p. I.
Entries: 1. Millimeters. Inscriptions. Described.

Chapin, William *(1802–1888)*
[St.] pp. 53–54.*

[F.] p. 76.*

Chaplin, Charles *(1825–1891)*
[Ber.] IV, pp. 87–97.
 Entries: 72. Millimeters (selection).
Paper fold measure. Inscriptions
(selection). States. Described.

Chapon, Léon Louis *(1836–c.1900)*
[Ber.] IV, p. 98.*

Chapron, Nicolas *(1612–c.1656)*
[RD.] VI, pp. 212–232; XI, pp. 27–30.
 Entries: 59. Millimeters. Inscriptions.
States. Described. 7 doubtful and re-
jected prints are mentioned in the
preface; VI, p. 213.

Chapront, Henry *(1876–1965)*
Gossez, A. M. *Henry Chapront, aquatin-
tiste.* Paris: Édition de Humbles, 1919.
(NN)
 Entries: unnumbered, pp. 43–49.

Chapuis, Johann Joseph *(d. c.1844)*
[Merlo] p. 159.*

Chapuy, Nicolas Marie Joseph *(1790–1858)*
[Ber.] IV, p. 98.*

Chardin, Jean Baptiste Siméon *(1699–1779)*
Bocher, Emanuel. *Jean Baptiste Siméon
Chadin.* Les gravures françaises du
XVIIIe siècle, 3. Paris: Librairie des
Bibliophiles, 1876.
 Entries: 51+ prints after, 10+ doubtful
prints after. Millimeters. Inscriptions.
States. Described.

[Gon.] I, pp. 63–131.
 Entries: unnumbered, pp. 117–131,
prints after. Described.

Guiffrey, Jean. Catalogue. In *J. B.
Siméon Chardin,* edited by Armand
Dayot. Paris: H. Piazza et Cie, n.d.

 Entries: unnumbered, pp. 97–106,
prints after. Described (selection).

Charles le Lorrain
See **Mellin**

Charles, Claude *(1661–1747)*
Beaupré, J. N. "Notice sur quelques
graveurs nancéiens du XVIII siècle et sur
leurs ouvrages." [*Mém. lorraine*] 2d ser.,
9 (1867): 220–221.
 Entries: 2. Millimeters (selection). In-
scriptions. Described (selection).

Charles, William *(d. 1820)*
[St.] pp. 54–59.*

[F.] pp. 77–81.*

Weiss, Harry B. *William Charles, early
caricaturist, engraver and publisher of chil-
dren's books, with a list of works by him in
the New York Public Library and certain
other collections.* New York: New York
Public Library, 1932.
 Bibliography of children's books pub-
lished or illustrated by Charles; list of
prints in the New York Public Library
only.

Charlet, Nicolas Toussaint *(1792–1845)*
La Combe, Joseph Félix Leblanc de.
*Charlet, sa vie, ses lettres, suivi d'une de-
scription raisonnée de son oeuvre litho-
graphique.* Paris: Paulin et Le Chevalier,
1856.
 Entries: 1089. Millimeters. Inscrip-
tions (selection). Described.

[Ber.] IV, pp. 98–136.
 Entries: 13+. Paper fold measure
(selection). Summary of the La Combe
catalogue.

Charlot, Jean *(b. 1898)*
Charlot, Jean. *Catalogue of prints by Jean
Charlot.* New York: Albert Carman, 1936.
30 copies. (MBMu)

Entries: 246 (to 1936). Inches. Illustrated. The entire catalogue was written and drawn on lithographic plates by Charlot.

Charpy, Edme or Edmond *(17th cent.)*
[CdB.] pp. 24–26.
Entries: 24. Paper fold measure (selection). Inscriptions (selection). Described (selection).

Chartier, Jean *(b. c.1500–1580)*
[RD.] V, pp. 50–55; XI, pp. 30–33.
Entries: 18. Millimeters. Inscriptions. States. Described.

Chasselat, Charles Abraham *(1782–1843)*
[Ber.] IV, p. 136.*

Chassériau, Théodore *(1819–1856)*
Bouvenne, Aglaus. "Théodore Chassériau, souvenirs et indiscrétions." [*Bull. des B. A.*] 1 (1883–84): 134–139, 145–150, 161–166. Separately published. Paris: A. Detaille [1884?]. (NN)
Entries: 55 prints by and after.

[Ber.] IV, pp. 136–137.
Entries: 26 Based on Bouvenne 1883–84.

Bouvenne, Aglaus. "Théodore Chassériau," *L'Artiste* 57 (1887, no. 2): 161–178. Separately published. *Théodore Chassériau 1819–1856.* Paris, 1887. (NN)
Entries: 57+ prints by and after.

Chevillard, Valbert. *Un peintre romantique, Théodore Chassériau.* Paris: Alphonse Lemerre, 1893.
Entries: 27.

Marx, Roger. "Théodore Chassériau et son oeuvre de graveur." *L'Estampe et l'affiche* 2 (1898): 119–124. Separately published. Paris: 1898. (NN)
Entries: 26. Illustrated (selection). Based on Bouvenne 1883–84.

Cailac, Jean. "Théodore Chassériau 1809–1856; catalogue de son oeuvre gravé et lithographié." Unpublished ms. (Paris, Mme Paule Cailac).
Entries: 29. Millimeters. Inscriptions. States. Described. Illustrated. Located.

Chastillon, Claude
See **Chatillon**

Chataigner, Alexis *(1772–1817)*
[Ber.] IV, pp. 137–138.*

Chatillon, Claude *(1547–1616)*
Lhote, Amédée. "Claude Chastillon, ingénieur topographique du roi." [*Bull. des B. A.*] 3 (1885–86): 65–80.
Entries: unnumbered, pp. 72–80.

Durnolin, Maurice. "Essai sur Claude Chastillon et son oeuvre." Unpublished ms. (EPBN)
Entries: 536 prints after. Millimeters. Inscriptions. States. Located.

Chatillon, Henri Guillaume *(1780–1856)*
[Ap.] p. 93.
Entries: 8.*

[Ber.] IV, pp. 138–139.*

Chatinière, Antonin Marie *(b. 1828)*
[Ber.] IV, p. 139.*

Chauvel, Théophile Narcisse *(1831–1910)*
[Ber.] IV, pp. 140–165.
Entries: 114. Millimeters. Inscriptions. States. Described (selection).

Delteil, Loys. "Théophile Chauvel" and "Catalogue raisonné de l'oeuvre gravé et lithographié de Théophile Chauvel." *L'Estampe et l'affiche* 3 (1899): 205–211, 235–243, 258–268. Separately published. *Théophile Chauvel; catalogue raisonné de son oeuvre gravé et lithographié.* Paris: L'Estampe et l'Affiche, and Georges Rapilly, 1900. 225 copies. (MH)

Chauvel, Théophile Narcisse *(continued)*

Entries: 148. Millimeters. Inscriptions. States. Described.

Chauvet, Jules Adolphe *(b. 1828)*
[Ber.] IV, pp. 165–166.*

Chemessov, Evgraf Petrovich *(1737–1765)*
Rovinski, Dmitri. *Tschémessoff, graveur russe, élève de G. F. Schmidt; son oeuvre, reproduit par le procédé de G. Scamoni.* St. Petersburg: Expedition pour la Confection des Papiers de l'État, 1878.
Entries: 17. States. Described (selection). Illustrated (selection).

Chenavard, Marie Antoine *(1787–1883)*
[Ber.] IV, p. 166.*

Chenay, Paul or Pierre *(1818–1906)*
[Ap.] p. 93.
Entries: 2.*

[Ber.] IV, p. 167.*

Cheney, John *(1801–1885)*
Owen, Hans C. "John Cheney, Connecticut engraver." *Antiques* 25 (1934): 172–175.
Entries: 103.

Cheney, John *(1801–1885)* and Seth Wells *(1810–1856)*
Koehler, Sylvester Rosa. *Catalogue of the engraved and lithographed work of John Cheney and Seth Wells Cheney.* Boston (Mass.): Lee and Shepard, 1891.
Entries: 103 prints by John, 10 by Seth Wells, 23 by both. Millimeters. Inches. Inscriptions. States. Described. Located. Annotated copy. (MBMu)

Chenu, Pierre *(b. 1730)*
"Nécrologue des graveurs et amateurs célèbres." *Annales de la Calcographie générale I* (1806): 147–150. (EPBN)
Entries: unnumbered, pp. 149–150.

Chéret, Jules *(1836–1932)*
[Ber.] IV, pp. 168–203; [Ber.] Supplement, pp. 1–32.
Entries: 504 posters, survey of other prints (to 1886); supplement: 186 posters, survey of other prints (to 1890). Inscriptions (selection).

Maindron, Ernest. *Les Affiches illustrées 1886–1895.* Paris: Librairie Artistique, and G. Boudet, 1896. 1025 copies. (EPBN)
Entries: 882 (posters only, to 1895). Millimeters. Inscriptions. Described. Illustrated (selection).

Chéron, Elisabeth Sophie Le Hay *(1648–1711)*
[RD.] III, pp. 239–251; XI, pp. 33–35.
Entries: 59. Pre-metric. Inscriptions. States. Described. Appendix with 1 doubtful print.

Chéron, Henri *(d. 1677/79)*
[RD.] III, p. 37.
Entries: 1. Pre-metric. Inscriptions. Described.

Chéron, Louis *(1660–1715)*
[RD.] III, pp. 285–295; XI, pp. 35–37.
Entries: 37. Pre-metric. Inscriptions. States. Described.

Cherrier, Prosper Adolphe Léon *(b. 1806)*
[Ber.] V, pp. 5–6.*

Cheskij, Ivan. Vasil'evich *(20th cent.)*
Adarjukov, Vladimir I. *Graver Ivan Vasil'evich Cheskij.* Moscow: Novaja Moskva, 1924. (DLC)
Entries: 197. Millimeters. Inscriptions.

Chevalier, William *(19th cent.)*
[Ap.] p. 93.
Entries: 2.*

Chevauchet, ——— *(19th cent.)*
[Ber.] V, p. 6.*

Chevillet, Juste *(1729–1790)*
[L. D.] p. 8.
 Entries: 1. Millimeters. Inscriptions. States. Described. Incomplete catalogue.*

Chevin, Victor Joseph *(fl. 1840–50)*
[Ber.] V, p. 6.
 Entries: 2+. Paper fold measure.

Chevrier, Jules *(1816–1883)*
[Ber.] V, pp. 7–8.
 Entries: 4+. Paper fold measure (selection). Described (selection).

Chevron, Joseph [Benoit, Joseph] *(1824–1875)*
[Ap.] p. 93.
 Entries: 2.*

[Ber.] V, p. 7.*

Chiappelli, Francesco *(1890–1947)*
Pogliaghi, Ottavia, and Chiappelli, Fredi. *Le incisioni di Francesco Chiappelli.* Florence: Leo S. Olschki, 1965. (DLC)
 Entries: 195. Millimeters. Described (selection). Illustrated (selection). Located (selection).

Chiari, Fabrizio *(1615–1695)*
[Vesme] pp. 64–65.
 Entries: 4. Millimeters. Inscriptions. States. Described.

Chiaroscuro Woodcuts
[B.] XII, pp. 2–159.
 Entries: 207. Pre-metric. Inscriptions. States. Described. Arranged by subject, not by artist. Index of artists after whom, and by whom, the prints were made, pp. 193–212.

[P.] VI, pp. 205–247.
 Entries: 115 (additional to [B.]). Pre-metric. Inscriptions. Described. Italian woodcuts, in chiaroscuro and black and white, arranged by subject.

Index of artists after whom, and by whom, the prints were made, pp. 248–252.

Chifflart, François Nicolas *(1825–1901)*
[Ber.] V, pp. 8–9.
 Entries: 5+. Paper fold measure (selection).

Childs, Cephas G. *(1793–1871)*
[Allen] p. 127.*

[St.] pp. 59–65.*

[F.] pp. 81–84.*

Chimay, Princesse Thérèse de *(1773–1835)*
[Ber.] V, p. 9.*

Chimot, Edouard *(20th cent.)*
Rat, Maurice. *Chimot. Les artistes du livre,* 20. Paris: Henry Babou, 1931. 700 copies. (NN)
 Bibliography of books with illustrations by.

Chiossone, Domenico *(b. c.1810)*
[Ap.] p. 94.
 Entries: 5.*

Chiquet, ——— *(18th cent.)*
[F.] p. 84.*

Chirico, Giorgio de *(b. 1888)*
Ciranna, Alfonso. *Giorgio de Chirico: catalogo delle opere grafichi [incisioni e litografie] 1921–1969.* Milan: Alfonso Ciranna; and Rome: Edizioni la Medusa, 1969. 1500 copies.
 Entries: 174 (to 1969). Millimeters. Described. Illustrated.

Chodowiecki, Daniel Nicolas *(1726–1801)*
Catalogue des estampes gravées par Daniel Chodowiecki. n.p., 1796. (PJRo)
 Entries: 759. Paper fold measure.

Jacoby, D. *Chodowiecki's Werke, oder; Verzeichniss sämtlicher Kupferstiche Welche*

Chodowiecki, Daniel Nicolas *(continued)*

der verstorbene Herr Daniel Chodowiecki . . . von 1758 bis 1800 verfertigt, und nach der Zeitfolge geordnet hat. Berlin: Jacoby's Bücher- und Kunst-Handlung, 1808. (MBMu)

Entries: 950. Paper fold measure. Inscriptions. Described. Annotated copy (MBMu); the annotations are in German script and date from after 1853.

Engelmann, Wilhelm. *Daniel Chodowiecki's sämmtliche Kupferstiche.* Leipzig: Verlag von Wilhelm Engelmann, 1857.

Entries: 950. Pre-metric. Inscriptions. States. Described. Copies mentioned.

Parthey, G. and Engelmann, Wilhelm. "Nachträge und Zusätze zu: Daniel Chodowiecki's sämmtliche Kupferstiche von Wilhelm Engelmann." [*N. Arch.*] 5 (1859): 233–260. Separately published. Leipzig: Wilhelm Engelmann, 1860.

Additional information to Engelmann.

Oettingen, Wolfgang von. *Daniel Chodowiecki, ein berliner Künstlerleben im achtzehnten Jahrhundert.* Berlin: G. Grote'sche Verlagsbuchhandlung, 1895.

Entries: 950 (based on Engelmann).

Hirsch, Robert. *Nachträge und Berichtigungen zu Daniel Chodowieckis sämtliche Kupferstiche beschrieben von Wilhelm Engelmann; Verzeichnis der nach Chodowiecki's Zeichnungen von andern Künstlern angefertigten Kupferstiche und Verzeichnis der Kupferstiche Gottfried und Wilhelm Chodowieckis. Zweite Auflage.* Leipzig: Wilhelm Engelmann, 1906.

Entries: not continuously numbered, pp. 63–120 (prints after). Millimeters (selection). Inscriptions (selection). Described (selection). Additional information to Engelmann 1857, incor-

porating Parthey and Engelmann 1859 and 1860.

Stechow, M. *Verzeichnis meiner Chodowiecki-Sammlung.* Berlin, 1907. (EWA)

Additional information to Engelmann.

Rümann, Arthur. *Daniel Chodowiecki.* Das Werk; Eine Sammlung praktischer Bibliographien; Erste Reihe, das graphische Werk, 2. Berlin: Kunst Kammer, and Martin Wasservogel, 1926.

Bibliography of books with illustrations by.

Engelmann, Wilhelm. *Daniel Chodowieckis sämmtliche Kupferstiche.* Berlin: S. Martin Fraenkel Verlag, 1926.

Reprint of Engelmann 1857, and Parthey and Engelmann 1859 and 1860.

Kunsthandlung Amstler und Ruthardt. *Daniel Chodowiecki: Verzeichnis der Kupferstiche von den noch erhaltenen Originalplatten.* Berlin, 1927.

Entries: 160 (modern impressions, from plates still extant in 1927). Millimeters. Illustrated.

Engelmann, Wilhelm, and Hirsch, Robert. *Daniel Chodowieckis sämtliche Kupferstiche . . . Im Anhang Nachträge und Berichtigungen von Robert Hirsch.* Hildesheim (West Germany): G. Olms, 1967.

Reprint of Engelmann 1857, and Hirsch 1906.

Chodowiecki, Gottfried *(1728–1781)*

Hirsch, Robert. *Nachträge und Berichtigungen zu Daniel Chodowieckis sämtliche Kupferstiche . . .* Leipzig: Verlag von Wilhelm Engelmann, 1906. Reprinted as appendix in *Daniel Chodowieckis sämtliche Kupferstiche,* by Wilhelm

Engelmann. Hildesheim (West Germany): G. Olms, 1967.
Entries: 18. Millimeters. Inscriptions.

Chodowiecki, Lotte *(18th cent.)*
Hirsch, Robert. *Nachträge und Berichtigungen zu Daniel Chodowieckis sämtliche Kupferstiche . . .* Leipzig: Verlag von Wilhelm Engelmann, 1906. Reprinted as appendix in *Daniel Chodowiecki's sämtliche Kupferstiche,* by Wilhelm Engelmann, Hildesheim (West Germany): G. Olms, 1967.
Entries: 1. Millimeters. Inscriptions. Described.

Chodowiecki, L. [Ludwig] Wilhelm *(1765–1805)*
Hirsch, Robert. *Nachträge und Berichtigungen zu Daniel Chodowieckis sämtliche Kupferstiche . . .* Leipzig: Verlag von Wilhelm Engelmann, 1906. Reprinted as appendix in *Daniel Chodowieckis sämtliche Kupferstiche,* by William Engelmann. Hildesheim (West Germany): G. Olms, 1967.
Entries: 54 prints by, 5 doubtful prints, 12 prints after. Millimeters. Inscriptions.

Choffard, Pierre Philippe *(1730–1809)*
[Ber.] V, pp. 9–12.*

[L. D.] pp. 8–10.
Entries: 3. Millimeters. Inscriptions. States. Described. Incomplete catalogue.*

Dacier, Émile. "Choffard décorateur de livres." *Portique* 6 (1947): 87–102.
Bibliography of books with illustrations by.

Cholet, Samuel Jean Joseph *(1786–1874)*
[Ber.] V, p. 12.*

Chollet, Antoine Joseph *(b. 1793)*
[Ber.] V, pp. 12–13.*

[Ap.] p. 94.
Entries: 4.*

Chometon, Jean Baptiste *(b. 1789)*
[Ber.] V, p. 13.*

Chorinsky, W. *(19th cent.)*
[Dus.] p. 25.
Entries: 1 (lithographs only, to 1821). Millimeters. Inscriptions. Located.

Chorley, John *(fl. 1818–1825)*
[St.] pp. 65–67.*

[F.] pp. 84–85.*

Choubard, ——— *(fl. 1810–1830)*
[Ber.] V, pp. 13–14.*

Choubrac, Léon *(1847–1885)*
[Ber.] V, pp. 14–21.*

Chrétien, Gilles Louis *(1754–1811)*
Hennequin, René. *Avant les photographies; Les portraits au physionotrace gravés de 1788 à 1830; catalogue nominatif, biographique et critique illustré des deux premières séries de ces portraits.* Troyes (France): L. J. Paton, Imprimeur de la Société Académique de l'Aube, 1932. (NN)
Entries: 600 (portraits only, to 1789). Described. Illustrated (selection). Located. Additional information to catalogue, pp. 307–338.

Chrieger, Cristoforo *(d. c.1590)*
[B.] IX, pp. 564–565.
Entries: 1. Pre-metric. Inscriptions. Described.

[P.] VI, pp. 241–242.
Entries: 1 (additional to [B.]). Pre-metric. Inscriptions. States. Described. Located.

[H. *Ger.*] V, p. 192.
Entries: 2+.*

Chrieger, Giovanni *(16th cent.)*
[H. *Ger.*]V, p. 192.
Entries: 1+.*

Christensen, Arne *(20th cent.)*
Fougt, Knud. "Arne Christensen." [*N. ExT.*] 3 (1949–50): 54–56.
Entries: 27 (bookplates only, to 1949). Illustrated (selection).

Christine, Queen of Sweden *(1626–1686)*
[H. *Ger.*] V, p. 192.
Entries: 1. Illustrated.*

Ciamberlano, Luca *(fl. 1599–1641)*
[B.] XX, pp. 27–56.
Entries: 114+ prints by, 5+ doubtful prints. Pre-metric. Inscriptions (selection). States. Described (selection).

Ciani, Giorgio *(b. 1820)*
[AN.] pp. 704–706.
Entries: unnumbered, pp. 704–706. Millimeters. Inscriptions. Described.

[AN. 1968] p. 178.
Entries: unnumbered, p. 178 (additional to [AN.]). Millimeters. Inscriptions.

Cicchino, Tobia *(fl. 1570)*
[M.] II, p. 206.
Entries: 2 (prints by and after). Millimeters. Inscriptions. Described.

Cicéri, Eugène *(1813–1890)*
[Ber.] V, pp. 21–22.*

Delteil, Loys. "Eugène Cicéri: catalogue de son oeuvre lithographique." *L'Artiste,* n.s. 2 (1891, no. 2) 216–221.
Entries: unnumbered, pp. 219–221.

Delteil, Loys. "Ciceri (Eugène)." *La Curiosité universelle,* 6th ser., 279 (23 May 1892), pp. 1–4. (EPBN)
Entries: unnumbered, p. 4.

Cicéri, Pierre Luc Charles *(1782–1868)*
[Ber.] V, p. 21.*

Cieślewski, Thaddaeus *(b. 1870)*
Grońska, Maria. *Tadeusz Cieślewski syn.* [Warsaw?]: Ossolineum, 1962. (DLC)
Entries: 634 (to 1944). Millimeters. Inscriptions. Described (selection). Illustrated (selection). Located (selection).

Banach, Napisal Andrzej. *Warszawa Cieślewskiego syna.* Warsaw: Wydawnictwa Artystyczne i Filmowe, 1962. (DLC)
Entries: 431 woodcuts, 148 bookplates. Millimeters.

Cinericius, Philippus *(16th cent.)*
[P.] V, pp. 228–229.
Entries: 2. Pre-metric. Inscriptions. Described. Located.

Cipriani, Galgano *(1775–after 1857)*
[Ap.] pp. 94–95.
Entries: 14.*

Ciry, Michel *(b. 1919)*
Passeron, Roger. *Michel Ciry, l'oeuvre gravé.* Vol. 4 of a catalogue in progress. *L'Oeuvre gravé de Michel Ciry, 1955–1963.* Vol. 5 of a catalogue in progress. Paris: La Bibliothèque des Arts, 1968.
Entries: 169 (1949 to 1963). Millimeters. States. Described. Illustrated.

Claessens, Lambert Antoine *(1763–1834)*
[Ap.] pp. 95–97.
Entries: 21.*

[Ber.] V, p. 22.*

[Dut.] IV, pp. 97–98.*

[W.] I, pp. 284–285.
Entries: 39.*

Claesz, Allaert
See **Monogram AC** [Nagler, *Mon.*] I, no. 259

Claesz van Wieringen, Cornelis
See **Wieringen**

Claeszoon, Aert *(1498–1564)*
[W.] I, p. 283.
　Entries: 1 print after.*

[H. *Neth.*] IV, p. 169.
　Entries: 3 prints after.*

Clairin, Georges *(b. 1843)*
[Ber.] V, pp. 22–23.*

Clapés, Francisco *(b. 1862)*
[Ber.] V, pp. 24–26.
　Bibliography of books with illustra-
　tions by.

Clark [of Lancaster, Pa.] *(fl. 1813–1820)*
[F.] p. 85.*

Clark, John Heaviside *(c.1771–1863)*
[Siltzer] p. 347.
　Entries: unnumbered, p. 347. Inscrip-
　tions.

Clark, John Heaviside **and Dubourg**
(19th cent.)
[Siltzer] p. 347.
　Entries: unnumbered, p. 347, prints
　by and after. Inscriptions.

Clark, John Heaviside **and Merke,** H.
(19th cent.)
[Siltzer] p. 347.
　Entries: unnumbered, p. 347. Inscrip-
　tions.

Clark, R. *(19th cent.)*
[Siltzer] p. 328.
　Entries: unnumbered, p. 328, prints
　after. Inscriptions.

Clark, Roland *(20th cent.)*
Clark, Roland. *Roland Clark's etchings.*
New York: Derrydale Press, 1938. 850
copies. (DLC)
　Entries: unnumbered, 3 p. (to 1938).
　Inches. Illustrated (selection).

Clarke, Thomas *(fl. c.1635)*
[Hind, *Engl.*] III, p. 259.

Entries: 1. Inches. Inscriptions. De-
scribed. Illustrated. Located.

Clarke, Thomas *(fl. c.1800)*
[St.] pp. 68–72.*

[F.] p. 86.*

Clarke, William *(17th cent.)*
[Sm.] I, pp. 137–138.
　Entries: 3 (portraits only). Inches. In-
　scriptions. States. Described. Located
　(selection).

[Ru.] p. 33.
　Additional information to [Sm.].

Clarus, Fabritius
See **Chiari,** Fabrizio

Claterbos, Augustus *(fl. c.1777)*
[W.] I, pp. 286–287.
　Entries: 3 prints after.*

Claude Lorrain
See **Gellée**

Clausen, George *(1852–after 1912)*
Gibson, Frank. "The etchings and
lithographs of George Clausen, R. A."
[*PCQ.*] 8 (1921): 202–227, 433.
　Entries: 30 etchings, 19 lithographs.
　Inches. Inscriptions. States. De-
　scribed. Illustrated (selection).

Clauwet, David
See **Clouet**

Clay, Edward W. *(1792–1857)*
[St.] p. 67.*

[F.] p. 86.*

Claypoole, James, Jr. *(18th cent.)*
[St.] p. 68.*

Clein, Franz *(1582–1658)*
[H. *Ger.*] V, pp. 193–194.
　Entries: 26 prints by, 87 after. Illus-
　trated (selection).*

Clein, Johann [Hans] *(c.1475–c.1550)*
[H. *Ger.*] V, p. 194.
Entries: 72.*

Clemens, Johan Frederik *(1749–1757)*
[Ap.] p. 97.
Entries: 10.*

Swane, Leo. *J. F. Clemens, biografi samt fortegnelse over hans kobberstik.* Copenhagen: Selskapet til udgivelse af danske mindesmaerker Henrik Koppel, 1929. (DLC)
Entries: 390 prints by, 12 doubtful prints. Millimeters. Inscriptions. States. Described. Illustrated (selection). Located (selection).

Clemens, Marie Jeanne *(1755–1790/91)*
Swane, Leo. *J. F. Clemens, biografi samt fortegnelse over hans kobberstik.* Copenhagen: Selskapet til udgivelse af danske mindesmaerker Henrik Koppel, 1929. (DLC)
Entries: 17. Millimeters. Inscriptions. States. Described.

Clement, A. *(fl. c.1860)*
[Ap.] p. 98.
Entries: 1.*

[Ber.] V, p. 26.*

Clement, Anne Clara
See **Lemaître**

Clennel, Luke *(1781–1840)*
[Siltzer] p. 329.
Entries: unnumbered, p. 329, prints after. Inches. Inscriptions.

Clerck, Hendrik de *(1570–1629)*
[W.] I, pp. 287–288.
Entries: 2 prints after.*

[H. *Neth.*] IV, p. 169.
Entries: 2 prints after.*

Clerck, Nicolaes de *(fl. 1614–1625)*
[W.] I, p. 288.
Entries: 2+ prints published by.

Clerget, Charles Ernest *(b. 1812)*
[Ber.] V, p. 26.*

Clerget, Hubert *(1818–1899)*
[Ber.] V, pp. 26–27.*

Clerici, Fabrizio *(b. 1913)*
Brion, Marcel. *Fabrizio Clerici.* Milan: Electa Editrice, 1955.
Bibliography of books with illustrations by.

Clerici, Francesco *(19th cent.)*
[Ap.] p. 98.
Entries: 1.*

Clerk of Eldin, John *(1728–1812)*
Lumsden, E. S. "The etchings of John Clerk of Eldin." [*PCQ.*] 12 (1925): 15–39. "A supplement to the catalogue of etchings by John Clerk of Eldin," [*PCQ.*] 13 (1926): 97.
Entries: 116. Inches. Inscriptions. States. Described. Illustrated (selection).

Clésinger, Jean Baptiste *(1814–1883)*
[Ber.] V, p. 27.*

Cletcher, Daniel *(fl. c.1633)*
[W.] I, p. 288.
Entries: 1.*

[H. *Neth.*] IV, p. 169.
Entries: 1.*

Cleter, Gregorio *(b. 1813)*
[Ap.] p. 98.
Entries: 4.*

Cleve, Hendrik III van *(1525–1589)*
[H. *Neth.*] IV, p. 170.
Entries: 50 prints after. Illustrated (selection).*

Cleve, Hendrik IV van *(d. 1646)*
[W.] I, pp. 288–289.
Entries: 5+.*

Cleve, Joos II van [Sotte Cleef] *(fl. c.1554)*
[W.] I, pp. 290–291.
Entries: 1 print by, 1 after.*

[H. *Neth.*] IV, p. 171.
Entries: 1 print by, 2 after.*

Cleve, Marten I van *(1527–1581)*
[W.] I, p. 292.
Entries: 5 prints after.*

[H. *Neth.*] IV, p. 171.
Entries: 2 prints by, 15 after.*

Clint, George *(1770–1854)*
[Ap.] p. 98.
Entries: 1.*

Clock, Claes Jansz *(b. c.1750)*
[W.] I, p. 293.
Entries: 8+.*

[H. *Neth.*] IV, p. 172.
Entries: 22. Illustrated (selection).*

Clofigl, Caspar *(fl. c.1523)*
[B.] VII, pp. 466–468.
Entries: 3. Pre-metric. Inscriptions.
Described.

[P.] III, pp. 299–300.
Additional information to [B.]. Copies
mentioned.

[H. *Ger.*] V, p. 195.
Entries: 5. Illustrated (selection).*

Clouet, Albert *(1636–1679)*
[W.] I, p. 295.
Entries: 6.*

[H. *Neth.*] IV, p. 173.
Entries: 8+.*

Clouet, David *(fl. c.1675)*
[W.] I, p. 286.
Entries: 3.*

Clouet, François *(1522–1572)*
[W.] III, pp. 61–63.
Entries: 5 prints after.*

Clouet, Jean [Jehannet] *(1486–1540)*
[W.] I, p. 295; III, pp. 63–64.
Entries: 1 print after.*

Clouet, Petrus *(1629–1670)*
[W.] I, pp. 295–296.
Entries: 37.*

[H. *Neth.*] IV, pp. 173–174.
Entries: 38.*

Clouwet
See **Clouet**

Clowes, Butler *(d. 1782)*
[Sm.] I, pp. 138–142, and "additions and
corrections" section.
Entries: 28 (portraits only). Inches. In-
scriptions. States. Described (selec-
tion).

[Ru.] p. 33.
Additional information to [Sm.].

Cluysenaer, Daniel
See **Eremita**

Coate, S. *(19th cent.)*
[F.] p. 86.*

Cochet, Joseph
See **Couchet**

Cochin, Charles Nicholas II *(1715–1790)*
Jombert, Charles Antoine. *Catalogue de
l'ouevre de Ch. Nic. Cochin fils.* Paris: De
L'Imprimerie de Prault, 1770. (NN)
Entries: 320+ prints by and after (to
1770). Pre-metric. Described.

"Supplement au catalogue de M.
Cochin, depuis 1770 jusques et compris
1780." Unpublished ms. (EWA)

Cochin, Charles Nicholas II *(continued)*

Entries: unnumbered, 42 pp. (additional to Jombert). Paper fold measure (selection).

[Gon.] II, pp. 51–136.
Entries: 3 (etchings by Cochin after his own designs only). Inscriptions. Described (selection). Illustrated (selection). Other prints by and after unnumbered, pp. 117–136.

Rocheblave, Samuel. *Charles Nicolas Cochin, graveur et dessinateur (1715–1790).* Brussels and Paris: G. Vanoest, 1927.
Entries: unnumbered, pp. 101–104. Discussion of earlier catalogues.

Prouté, Paul. *Catalogue Cochin 1962,* pp. 49–57. Paris: Paul Prouté et ses fils, 1962.
Entries: 261 prints after (portraits only). Illustrated.

Cochin, Nicolas *(1610–1686)*
[CdB.] pp. 50–64.
Entries: 211+. Based on ms. notes by Pierre Jean Mariette.

Rocheblave, S. *Les Cochin.* Paris: Librairie de l'Art, n.d.
Entries: unnumbered, pp. 211–214.

Cochin, Noël II *(1622–1695)*
[CdB.] pp. 65–69.
Entries: 13+. Paper fold measure (selection). Described (selection).

Cock, César de *(1823–1904)*
[H. L.] pp. 145–147 and addenda.
Entries: 10. Millimeters. Inscriptions. States. Described.

Cock, Hieronymus *(c.1510–1570)*
[W.] I, pp. 303–305.
Entries: 14+ prints by, 19+ published by.

[H. *Neth.*] IV, p. 175–191.

Entries: 57 prints by, 628+ published by. Illustrated (selection).*

Riggs, Timothy A. "Hieronymus Cock (1510–1570), printmaker and publisher in Antwerp at the sign of the four winds." Thesis, Yale University, 1971. Unpublished ms. (CtY)
Entries: 62 prints by, 35 prints after, 33 doubtful prints after, 291+ prints published by. Millimeters. Inscriptions. Illustrated (selection). Located (selection).

Cock, Jan Claudius de *(c.1668–1736)*
[W.] I, pp. 304–305.
Entries: 1 print by, 1 after.*

Cock, Jan Wellens de *(c.1480–c.1526)*
[H. *Neth.*] IV, pp. 192–193.
Entries: 2. Illustrated.*

Cock, Marten de *(fl. 1608–1647)*
[W.] I, p. 305.
Entries: 3.*

[H. *Neth.*] IV, p. 194.
Entries: 3. Illustrated (selection).*

Cock, Mathys *(c.1509–1548)*
[H. *Neth.*] IV, p. 194.

Cockson, Thomas *(fl. 1591–1636)*
[Hind, *Engl.*] I, pp. 239–257.
Entries: 35. Inches. Inscriptions. States. Described. Illustrated (selection). Located.

Coclers, Jean Baptiste Bernard *(1741–1817)*
Siccama, W. Hora. *Louis Bernard Coclers et son oeuvre.* Amsterdam: Frederik Muller et Cie, 1895. 100 copies. (EBr)
Entries: 70 prints by, 4 after. Millimeters. Inscriptions. States. Described.

[W.] I, pp. 308–309.
Entries: 21 prints by, 1 after.*

Coclers, Louis Bernard
See **Coclers,** Jean Baptiste Bernard

Coclers, Marie Lambertine *(d. 1761)*
Siccama, W. Hora. *Louis Bernard Coclers et son oeuvre.* Amsterdam: Frederik Muller et Cie, 1895. 100 copies. (EBr)
Entries: 31. Millimeters. Inscriptions. States. Described.

Codde, Pieter Jacobs *(1599–1678)*
[W.] I, pp. 309–310.
Entries: 2 prints after.*

[H. *Neth.*] IV, p. 200.
Entries: 2 prints after.*

Coebergher, Wenzel *(1561–1634)*
[B.] IX, pp. 578–579.
Entries: 1. Pre-metric. Inscriptions. Described.

[P.] IV, p. 240.
Additional information to [B.].

[W.] I, pp. 310–311.
Entries: 1 print by, 1 after.*

[H. *Neth.*] IV, p. 200.
Entries: 1 print by, 4 after.*

[H. *Neth.*] XIII, p. 229.
Entries: 1. Illustrated.*

Coecke van Aelst, Pieter I *(1502–1550)*
[W.] I, pp. 305–308.
Entries: 4+ prints and books by, 2 prints after.*

[N. *Neth.*] IV, pp. 195–199.
Entries: 5+ prints by, 2 after. Illustrated (selection).

Coelemans, Jacobus *(1654–c.1732)*
[W.] I, p. 313.
Entries: 18+.*

Coeler, Georg *(fl. c.1620–1650)*
[H. *Ger.*] V, p. 196.
Entries: 5+.*

Cöln, Johannes von
See **Monogram IC**[Nagler, *Mon.*] III, no. 2060

Coeman, Jacob *(d. c.1656)*
[W.] I, p. 313.
Entries: 1 print after.*

Coene, Constantin Fidèle *(1780–1841)*
[H. L.] pp. 133–134.
Entries: 1 etching, 4 lithographs. Millimeters. Inscriptions. Described.

Coets, Herman *(b. 1663)*
[W.] I, p. 314.
Entries: 1.*

Cogels, Joseph Carl *(1785–1831)*
[H. L.] pp. 134–139.
Entries: 12. Millimeters. Inscriptions. States. Described.

[Dus.] p. 25.
Entries: 8 (lithographs only, to 1821). Millimeters. Inscriptions. Located.

Cogniet, Léon *(1794–1880)*
[Ber.] V, pp. 27–28.
Entries: 15.

Cohen, Fré *(d. 1943)*
"Fré Cohen." *Boekcier,* 2d ser. 1 (1946): 3–5.
Entries: unnumbered, pp. 4–5 (bookplates only). Millimeters. Described. Illustrated (selection).

Coignet, Jules *(1798–1860)*
[Ber.] V, p. 28.*

Coindre, Jean Gaston *(19th cent.)*
[Ber.] V, pp. 28–30.

Coindre, Victor *(19th cent.)*
[Ber.] V, p. 30.*

Coiny, Jacques Joseph *(1761–1809)*
[Ap.] p. 98.
Entries: 1.*

[Ber.] V, pp. 30–31.*

Coiny, Jacques Joseph *(continued)*

"Catalogue des gravures de Jacques Joseph Coiny." Unpublished ms. (EPBN)
 Not seen.

Coiny, Joseph *(1795–1829)*
[Ap.] pp. 98–99.
 Entries: 2.*

[Ber.] V, pp. 32–33.*

Colandon, Denis *(fl. c.1674)*
[RD.] I, pp. 269–270.
 Entries: 2. Pre-metric. Inscriptions. States. Described.

Colas, Alphonse *(1818–1887)*
[Ber.] V, p. 33.*

Colasius, Johan George *(fl. c.1735)*
[W.] I, p. 317.
 Entries: 2 prints after.*

Colbenius
See **Colbenschlag,** Stephan

Colbenschlag, Stephan *(1591–c.1657)*
[H. *Ger.*] V, p. 196.
 Entries: 7.*

Cole, Ernest *(20th cent.)*
Dodgson, Campbell. "The dry-points of Ernest Cole." [PCQ.] 11 (1924): 485–501; [PCQ.] 12 (1925): 7–13.
 Entries: 16 (to 1910). Inches. Inscriptions. States. Described. Illustrated (selection).

Cole, Humfray *(b. c.1530)*
[Hind, *Engl.*] I, pp. 79–80.
 Entries: 1. Inches. Inscriptions. Described. Illustrated.

Cole, I. [probably James Cole] *(fl. 1720–1743)*

[Sm.] I, p. 143, and "additions and corrections" section.
 Entries: 2 (portraits only). Inches. Inscriptions. Described.

[Ru.] p. 34.
 Entries: 1 (portraits only, additional to [Sm.]). Inches. Inscriptions. Described. Additional information to [Sm.].

Cole, Joseph Foxcroft *(1837–1892)*
Koehler, Sylvester R. "The works of the American etchers VII: J. Foxcroft Cole." [*Amer. Art Review*] 1 (1880): 191.
 Entries: 1 (etchings only, to 1880). Inches. Inscriptions.

Carey, pp. 231–232.
 Entries: 12 prints by and after (lithographs only). Inches. Inscriptions. Described. Located (selection).

Cole, Sir Ralph *(c.1625–1704)*
[Sm.] I, pp. 143–144.
 Entries: 1 (portraits only). Inches. Inscriptions. Described. Located.

[Ru.] p. 34.
 Additional information to [Sm.].

Cole, Timothy *(1852–1931)*
Smith, Ralph Clifton. *The wood engraved work of Timothy Cole.* Washington (D.C.): Privately printed, 1925. (MB)
 Entries: 503 (to 1924). Inches. Typed supplement (NN); 11 additional entries (to 1930) and additional information.

Print Club of Philadelphia. *Timothy Cole; memorial exhibition.* Philadelphia, 1931.
 Entries: 404.

Colin, Alexandre Marie *(1798–1875)*
[Ber.] V, pp. 33–34.*

Colin, Charles Amédée *(1808–1873)*
[Ber.] V, p. 34.*

Colin, Paul Émile *(b. 1882)*
Clément-Janin, —— Preface to *Catalogue de l'oeuvre gravé de P. E. Colin.* Paris: Éditions d'Art Édouard Pelletan, and R. Helleu, 1913. 50 copies. (NN)
 Entries: 235. Millimeters.

Collaert, Adriaen *(c.1560–1618)*
[W.] I, pp. 315–316.
 Entries: 29+.*

[H. *Neth.*] IV, pp. 201–207.
 Entries: 705+. Illustrated (selection).*

Collaert, Carel *(fl. c.1650)*
[W.] I, p. 316.
 Entries: 4.*

[H. *Neth.*] IV, p. 208.
 Entries: 4.*

Collaert, Guiliam *(fl. 1627–1666)*
[W.] I, p. 316.
 Entries: 2.*

[H. *Neth.*] IV, p. 208.
 Entries: 3.*

Collaert, Hans I *(c.1530–1581)*
[H. *Neth.*] IV, pp. 209–210.
 Entries: 64. Illustrated (selection).*

Collaert, Jan Baptist I [Hans] *(1566–1628)*
[W.] I, p. 316.
 Entries: 23+.*

[H. *Neth.*] IV, pp. 211–215.
 Entries: 220. Illustrated (selection).*

Collaert, Jan Baptiste II *(1590–1627)*
[W.] I, p. 316.
 Entries: 6+.*

[H. *Neth.*] IV, p. 216.
 Entries: 16.*

Collas, Achille *(1794–1859)*
[Ber.] V, pp. 35–36.*

Colle, Pellegrino dal *(1737–1812)*
[AN.] pp. 627–644.
 Entries: unnumbered, pp. 629–644. Millimeters. Inscriptions. Described (selection).

[AN. 1968] pp. 174–75.
 Entries: unnumbered, pp. 174–175 (additional to [AN.]). Millimeters (selection). Inscriptions.

Collen, Johann von *(fl. c.1500)*
[H. *Ger.*] V, p. 196.
 Entries: 16.*

Collenius, Herman *(c.1650–c.1720)*
[W.] I, p. 317.
 Entries: 1.*

[H. *Neth.*] IV, p. 216.
 Entries: 2 prints after.*

Collette, Alexandre *(1814–1876)*
[W.] I, p. 317.
 Entries: 1.*

Collier, Arthur *(b. 1818)*
[Ber.] V, pp. 37–38.*

Collier, Eugène Jules *(b. 1846)*
[Ber.] V, p. 38.*

Collignon, François Jules *(d. 1850)*
[Ber.] V, pp. 38–39.*

Collin, Dominique *(1725–1781)*
Beaupré, J. N. "Notice sur quelques graveurs nancéiens du XVIIIe siècle et sur leurs ouvrages; Dominique Collin." [*Mém. lorraine*] 2d ser., 3 (1861): 49–93. Separately published. Nancy (France): Lucien Wiener, 1862. (EPBN)
 Entries: 123. Millimeters. Inscriptions. States. Described.

Beaupré, J. N. "Supplément à la notice sur Dominique Collin et Yves-Dominique Collin, et au catalogue de-

Collin, Dominique *(continued)*

scriptif des estampes . . . qu'ils ont
gravés." [*Mém. lorraine*] 2d ser., 4 (1862):
106–120. Separately published.
[Nancy (France): Lucien Wiener, 1862?].
(EPBN)
Entries: 20 (additional to Beaupré
1861. Millimeters. Inscriptions. De-
scribed. Additional information to
Beaupré 1861.

Beaupré, J. N. "Deuxième supplément à
la notice sur Dominique Collin et Yves-
Dominique Collin." [*Mém. lorraine*] 2d
ser., 8 (1866): 153–173. Separately pub-
lished. [Nancy (France): Lucien Wiener,
1866?]. (EPBN)
Entries: 10 (additional to Beaupré 1861
and 1862). Millimeters. Inscriptions.
Described. Additional information to
Beaupré 1861 and 1862.

Beaupré, J. N. "Notice sur quelques
graveurs nancéiens du XVIIIe siècle et
sur leurs ouvrages." [*Mém. lorraine*] 2d
ser., 9 (1867): 249–250.
Entries: 1 (additional to Beaupré 1861,
1862 and 1866). Millimeters. Inscrip-
tions. Described.

Benoit, A. "Supplément au catalogue
du conseiller Beaupré sur les Collin père
et fils 1725–1792." [*Arch. Ex.-lib.*] 2 (1895):
52–56, 74.
Entries: 5 prints by, 1 doubtful print
(additional to Beaupré). Millimeters.
Inscriptions. Described. Illustrated
(selection).

Collin, Johannes *(fl. c.1680)*
[W.] I, p. 317.
Entries: 5.*

Collin, Richard *(1627–c.1697)*
Tasset, Émile. *Catalogue raisonné de
l'oeuvre du graveur R. Collin, d'origine
luxembourgeoise (XVIIe siècle).* Extract
from *Publications de la Section historique de
l'Institut royale grand-ducal de Luxem-*

bourg, vols. 30 and 31. Luxembourg: Im-
primerie V. Buck, 1876–1877. (NN)
Entries: 89. Millimeters. Inscriptions.
Described. Incomplete; last page is
marked "à continuer."

[W.] I, pp. 317–318.
Entries: 35+.*

[H. *Neth.*] IV, pp. 217–218.
Entries: 39+.*

Collin, Yves Dominique *(1753–1815)*
Beaupré, J. N. "Notice sur quelques
graveurs nancéiens du XVIIIe siècle et
sur leurs ouvrages; Yves-Dominique
Collin." [*Mém. lorraine*] 2d ser., 3 (1861):
94–105. Separately published. Nancy
(France): Lucien Wiener, 1862. (EPBN)
Entries: 30 prints by, 1 after. Millime-
ters. Inscriptions. Described.

Beaupré, J. N. "Supplément à la notice
sur Dominique Collin et Yves-
Dominique Collin, et au catalogue de-
scriptif des estampes . . . qu'ils ont
gravés." [*Mém. lorraine*] 2d ser., 4 (1862):
106–120. Separately published. [Nancy
(France): Lucien Wiener, 1862?] (EPBN)
Entries: 12 (additional to Beaupré
1861). Millimeters. Inscriptions. De-
scribed.

Beaupré, J. N. "Deuxième supplément à
la notice sur Dominique Collin et Yves-
Dominique Collin." [*Mém. lorraine*] 2d
ser., 8 (1866): 153–173. Separately pub-
lished. [Nancy (France): Lucien Wiener,
1866?]. (EPBN)
Entries: 9 (additional to Beaupré 1861
and 1862). Millimeters. Inscriptions.
Described. Additional information to
Beaupré 1861 and 1862.

Beaupré, J. N. "Notice sur quelques
graveurs nancéiens du XVIIIe siècle et
sur leurs ouvrages." [*Mém. lorraine*] 2d
ser., 9 (1867): 250.
Entries: 1 (additional to Beaupré 1861,
1862 and 1866). Millimeters. Inscrip-
tions. Described.

Bouland, L. "Supplément sur les Collin père et fils (suite)." [*Arch. Ex.-lib.*] 2 (1895): 74.
> Entries: 1 doubtful print (additional to Beaupré). Illustrated.

Robert, Edmond des. "Un ex-libris inconnu de Y.-D. Collin (1762)." In *Edmond des Robert, ses ex-libris héraldiques*. Nancy (France): Editions de l'A[ssociation] F[rançaise des] C[ollectionneurs d'] E[x-] L[ibris], 1950. (DLC)
> Entries: 1 (additional to Beaupré and Bouland). Described. Illustrated.

Collin de Vermont, Hyacinthe *(1693–1761)*
Messelet, Jean. "Collin de Vermont." In Dim. II, pp. 257–265.
> Entries: 2 prints after lost works.

Collum, J. J. van *(fl. c.1650)*
[H. *Neth.*] IV, p. 218.
> Entries: 1 print after.*

Colom, Arnold *(17th cent.)*
[H. *Neth.*] IV, p. 219.
> Entries: 1. Illustrated.*

Colombo, Aurelio *(b. c.1785)*
[Ap.] p. 99.
> Entries: 2.*

Colomès, ——— *(19th cent.)*
[Ber.] V, p. 39.*

Colyn, David
See **Kolyns**

Comans, Michiel *(d. 1687)*
[W.] I, p. 320.
> Entries: 4 prints by, 1 after.*

[H. *Neth.*] IV, p. 220.
> Entries: 4 prints by, 1 after.*

Combes, Peter *(fl. c.1700)*
[Ber.] V, p. 39.*

[Sm.] I, p. 144.

Entries: 1 (portraits only). Inches. Inscriptions. Described.

[Ru.] p. 34.
> Additional information to [Sm.].

Compagnon, Jules *(fl. c.1843)*
[Ber.] V, pp. 39–40.*

Conder, Charles *(1868–1909)*
Gibson, Frank." Charles Conder und seine Werke." [*GK.*] 36 (1913): 57–64. Catalogue by: Dodgson, Campbell. "Verzeichnis der lithographien und Radierungen Charles Conders." [*MGvK.*] 1913, pp. 56–57.
> Entries: 41. Millimeters. Inscriptions. States.

Dodgson, Campbell. Catalogue. In *Charles Conder, his life and work,* by Frank Gibson. London: John Lane, The Bodley Head, 1914.
> Entries: 41. Inches. Inscriptions. States. Described. Illustrated (selection).

Cone, Joseph *(fl. 1814–1830)*
[St.] pp. 72–73.*

[F.] pp. 87–88.*

Congnet, Gillis I *(1535–1599)*
[W.] I, p. 321.
> Entries: 10.*

[H. *Neth.*] IV, p. 220.
> Entries: 11 prints after.*

Coninxloo, Gillis I van *(1544–1607)*
[W.] I, pp. 326–327.
> Entries: 1 print by, 19 after.*

[H. *Neth.*] IV, p. 221.
> Entries: 1 print by, 23 after.*

Conjola, Carl *(1773–1831)*
[Dus.] p. 25.
> Entries: 2 (lithographs only, to 1821). Millimeters. Inscriptions. Described. Located.

Conquy, Ephraim *(1809–1843)*
[Ber.] V, pp. 41–42.*

[Ap.] p. 99.
Entries: 5.*

Conrad, David *(1604–c.1681)*
[H. *Ger.*] V, p. 197.
Entries: 16.*

Conradus, Abraham *(1612/13–1661)*
[H. *Neth.*] IV, p. 22.
Entries: 13.*

Consorti, Bernardino *(b. c.1780)*
[Ap.] p. 100.
Entries: 6.*

Constable, John *(1776–1837)*
Holmes, C. J. *Constable and his influence on landscape painting.* Westminster (England): Archibald Constable and Company, 1902.
Entries: unnumbered, pp. 219–226, prints after. Inches. Described (selection).

Windsor, (Lord). *John Constable, R. A.* London: Walter Scott Publishing Co., 1903.
Entries: unnumbered, pp. 217–222, prints after.

Wedmore, Frederick. *Constable; Lucas; with a descriptive catalogue of the prints they did between them.* London: P. and D. Colnaghi and Co., 1904. 253 copies. (MH)
Entries: 52 prints after (by Lucas only). Inches. Inscriptions. States. Described.

Shirley, Andrew. *The published mezzotints of D. Lucas after John Constable, R. A., a catalogue and historical account.* Oxford: Clarendon Press, 1930.
Entries: 52 prints after (by Lucas only). Inches. Inscriptions. States. Described. Illustrated. Located. Annotated copy (MBMu); 1 additional entry.

Constant, Benjamin *(1845–1902)*
[Ber.] V, p. 43.*

Constantin, Frater *(fl. 1660–1691)*
[H. *Ger.*] V, p. 198.
Entries: 18.*

Constantin, Jean Antoine *(1756–1844)*
[Ber.] V, p. 44.*

[Baud.] II, pp. 304–308.
Entries: 5. Millimeters. Inscriptions. States. Described.

Conte, Antonio *(1780–1837)*
[Ap.] p. 100.
Entries: 2.*

Contour, Mlle *(19th cent.)*
[Ber.] V, p. 44.*

Cooge, Abraham de *(1597–1685?)*
[H. *Neth.*] IV, p. 222.
Entries: 3.*

Cooghen, Leendert van der *(1610–1681)*
[B.] IV, pp. 129–135.
Entries: 9. Pre-metric. Inscriptions. Described.

[Weigel] pp. 168–169.
Entries: 1 (additional to [B.]). Pre-metric. Inscriptions.

[W.] I, p. 329.
Entries: 10.*

[H. *Neth.*] IV, pp. 223–225.
Entries: 14. Illustrated (selection).*

Cook, Henry R. *(19th cent.)*
[Siltzer] p. 347.
Entries: unnumbered, p. 347. Inscriptions.

Cook, Howard *(b. 1901)*
Weyhe Gallery. *The Checkerboard, No. 3, Cook Number.* New York, 1931. (NN)
Entries: 113 (to 1931). Inches. Illustrated (selection).

Cook, T. B. *(fl. 1809–1816)*
[St.] pp. 73–74.*

Cooke, George *(1781–1834)*
[St.] pp. 74–75.*

[F.] p. 88.*

Cooke, William Bernard *(1778–1855)* and
George *(1781–1834)*
[Ap.] p. 100.
Entries: 1+.*

[Siltzer] p. 347.
Entries: unnumbered, p. 347. Inscriptions.

Cool, Pieter *(17th cent.)*
[H. *Neth.*] IV, p. 225.
Entries: 5.*

Coolhaes, Caspar *(fl. c.1590)*
[W.] III, p. 67.
Entries: 2.*

[H. *Neth.*] IV, p. 226.
Entries: 3.*

Coomans, Pierre Olivier Joseph
(1816–1889)
[H. L.] pp. 139–145.
Entries: 61+. Millimeters. Inscriptions. Described (selection).

Coombes, Peter
See **Combes**

Cooper, Abraham *(1787–1868)*
[Siltzer] pp. 94–96.
Entries: unnumbered, pp. 95–96,
prints after. Inches (selection). Inscriptions. Described (selection). Illustrated (selection).

Cooper, J. *(18th cent.)*
[Sm.] I, pp. 144–146, and "additions and corrections" section.
Entries: 6 (portraits only). Inches. Inscriptions. States. Described. Located (selection).

[Ru.] p. 34.
Additional information to [Sm.].

Cooper, J. S. *(19th cent.)*
[Siltzer] p. 329.
Entries: unnumbered, p. 329, prints after. Inches. Inscriptions.

Cooper, R. *(fl. 1793–1799)*
[Ap.] p. 100.
Entries: 3.*

Cooper, Richard *(d. 1764)*
[Sm.] I, pp. 146–147, and "additions and corrections" section.
Entries: 3 (portraits only). Inches. Inscriptions. States. Described. Located (selection).

[Ru.] p. 35.
Additional information to [Sm.].

Coopse, Pieter *(fl. c.1672–1677)*
[W.] I, p. 330.
Entries: 1.*

[H. *Neth.*] IV, p. 226.
Entries: 2 prints by, 9 after. Illustrated (selection).*

Coornhert [**Cuerenhert**], Dirck
Volckertsz *(1522–1590)*
[W.] I, pp. 330–331.
Entries: 9+.*

[H. *Neth.*] IV, pp. 227–231.
Entries: 277. Illustrated (selection).

Cootwyk, Jurriaan *(1712–after 1770)*
[W.] I, p. 332.
Entries: 35+.*

Copley, John *(b. 1875)*
Wright, Harold J. L. *The Lithographs of John Copley and Ethel Gabain.* Chicago: Albert Roullier Art Galleries, 1924.
Entries: 194 (to 1924). Inches. Illustrated (selection). Ms. addition (NN); 2 additional entries. Ms. addition (ECol); 19 additional entries.

Copley, John Singleton *(1737–1815)*
[Sm.] I, "additions and corrections" section.
 Entries: 1 (portraits only). Inches. Inscriptions. Described.

 [St.] p. 75.*

Coppens, Augustin *(b. c.1668)*
[W.] I, pp. 332–333.
 Entries: 6+.*

 [H. *Neth.*] IV, p. 232.
 Entries: 6+.*

Coqueret, Pierre Charles *(1761–1832)*
[Ber.] V, pp. 44–45.*

Coques, Gonzales *(1614–1684)*
[W.] I, pp. 333–336.
 Entries: 5 prints after.*

 [H. *Neth.*] IV, p. 232.
 Entries: 10 prints after.*

Coquin, Louis *(1627–1686)*
[CdB.] pp. 70–74.
 Entries: 48+. Paper fold measure (selection). Described (selection). Based on [Lebl.], with additions.

Corbould, George *(1786–1846)*
[Ber.] V, pp. 45–46.*

Corbutt
See **Purcell,** R.

Cordus, Philipp *(fl. 1590–1598)*
[A.] III, pp. 341–343.
 Entries: 2. Pre-metric. Inscriptions. Described.

Corinth, Lovis *(1858–1925)*
Schwarz, Karl. *Das graphische Werk von Lovis Corinth.* Berlin: Verlag von Fritz Gurlitt, 1917.
 Entries: 246 (to 1916). Millimeters. Inscriptions. States. Described. Illustrated (selection).

Schwarz, Karl. *Das Graphische Werk von Lovis Corinth.* Berlin: Fritz Gurlitt Verlag, 1922.
 Entries: 452 (to 1920). Millimeters. Inscriptions. States. Described. Illustrated (selection).

Müller, Heinrich. *Die späte Graphik von Lovis Corinth.* Hamburg: Lichtwarkstiftung, 1960.
 Entries: 466 (additional to Schwarz; different states of the same print are separately numbered). Millimeters. States. Illustrated.

[*AzB.*] Beilage B, Blatt 6.
 Entries: 1 (additional to Schwarz and Müller). Millimeters. Inscriptions. Described. Illustrated.

Corinth, Thomas. "Lovis Corinth als Buch-Illustrator." *Illustration 63, 7* (1970): 67–71.
 Bibliography of books with illustrations by.

Coriolano, Bartolomeo *(c.1599–1676)*
[B.] XII: *See* **Chiaroscuro Woodcuts**

[Heller] p. 41. Additional information to [B.].

[Evans] p. 9.
 Entries: 2 (additional to [B.]). Millimeters. Inscriptions. Described.

[P.] VI: *See* **Chiaroscuro Woodcuts**

Coriolano, Giovanni Battista *(c.1590–1649)*
[B.] XIX, pp. 35–68.
 Entries: 227 prints by, 2 doubtful prints. Pre-metric. Inscriptions. States. Described.

[P.] VI: *See* **Chiaroscuro Woodcuts**

Coriolanus, Joachim Dieterich *(fl. c.1590)*
[B.] IX, pp. 402–403.
 Entries: 4. Pre-metric. Inscriptions. Described.

[H.*Ger.*] V, p. 198.
Entries: 4.*

Cornacchia, Giovanni *(1804–1846)*
[Ap.] p. 101.
Entries: 4.*

Corneille, Jean Baptiste *(1649–1695)*
[RD.] VI, pp. 320–345; XI, pp. 37–38.
Entries: 96. Millimeters. Inscriptions.
States. Described. 10 rejected and un-
known prints mentioned in the pref-
ace; VI, p. 321.

Corneille, Michel-Ange *(1642–1708)*
[RD.] VI, pp. 285–319; XI, pp. 38–40.
Entries: 103. Millimeters. Inscriptions.
States. Described. Appendix with 3
rejected prints; others are mentioned
in the preface; VI, p. 287.

Corneille de Lyon, Claude *(d. c.1574)*
See **Monogram CC** [Nagler, *Mon.*] I,
no. 2365

Cornelis van Haarlem [Cornelis Cor-
nelisz] *(1562–1638)*
[W.] I, pp. 336–338.
Entries: 1 print by, 22+ after.*

[H. *Neth.*] V, p. 1.
Entries: 1 print by, 27 after.*

Cornelisz, Lambert *(fl. 1594–1621)*
[W.] I, p. 340.
Entries: 15.*

[H. *Neth.*] V, p. 39.
Entries: 23.*

Cornelisz Kunst, Lucas
See **Monogram LCZ**

Cornelisz Kunst, Pieter
See **Monogram PVL**

Cornelisz van Amsterdam
See **Cornelisz van Oostsanen**

Cornelisz van Oostsanen, Jacob
(c.1470–1533)
[B.] VII, pp. 444–446.
Entries: 21. Pre-metric. Inscriptions.
States. Described.

[Heller] pp. 41–42.
Entries: 1 (additional to [B.]). Pre-
metric. Inscriptions. Described. Addi-
tional information to [B.].

[P.] III, pp. 24–30.
Entries: 106 (additional to [B.]). Pre-
metric. Inscriptions (selection). De-
scribed (selection). Additional infor-
mation to [B.].

[W.] I, pp. 338–340; III, pp. 68–69.
Entries: 111.*

Steinbart, Kurt. *Das Holzschnittwerk des
Jacob Cornelisz van Amsterdam.* Burg bei
Magdeburg (Germany): August Hopfer
Verlag, 1937.
Entries: 158 prints by, 7 from work-
shop. Millimeters. Inscriptions.
States. Described. Illustrated. Lo-
cated. Copies mentioned.

[H. *Neth.*] V, pp. 2–38.
Entries: 167+ prints by, 1+ after. Illus-
trated (selection).* Bibliography of
books with illustrations by.

Peters, Heinz. "Zu Cornelisz' Marienle-
ben." [*Oud-Holl.*] 77 (1962): 55–56.
Entries: 1 (additional to Steinbart and
[H. *Neth.*]). Millimeters. Described. Il-
lustrated. Located.

Cornelius, Peter von *(1783–1867)*
[Dus.] p. 26.
Entries: 1 (lithographs only, to 1821).
Millimeters. Inscriptions. Located.

Cornilliet, Alfred *(1807–c.1895)*
[Ber.] V, pp. 46–47.*

Cornu, Sébastien Melchior *(1804–1870)*
[Ber.] V, p. 47.*

Cornuel, —— *(19th cent.)*
[Ber.] V, p. 47.*

Coron, —— *(18th cent.)*
[L. D.] p. 10.
Entries: 1. Millimeters. Inscriptions.
States. Described. Incomplete cata-
logue.*

Corona, Jacob Lucius
See **Lucius,** Jakob I

Corot, Armand *(c.1787–c.1822)*
[Ap.] p. 101.
Entries: 2.*

[Ber.] V, p. 47.*

Corot, Jean Baptiste Camille *(1796–1875)*
[Ber.] V, pp. 48–54.
Entries: 16+. Millimeters. Inscrip-
tions. States. Described.

[Del.] V.
Entries: 100. Millimeters. Inscriptions.
States. Described. Illustrated. Lo-
cated.

Angoulvent, P. J. "L'Oeuvre gravé de
Corot." *Byblis* 5 (1926): 39–55.
Entries: 100. Millimeters. Inscriptions.
States. Described. Based on [Del.]
with some additional information.

Corr, Mathieu Erin *(1805–1862)*
[Ap.] p. 101.
Entries: 4.*

[Ber.] V, p. 54.*

Correa, G. *(fl. c.1854)*
[Ber.] V, p. 54.*

Correggio, [Antonio Allegri]
(c.1494–1534)
[B.] XII: *See* **Chiaroscuro Woodcuts**

[P.] VI: *See* **Chiaroscuro Woodcuts**

Pungileoni, P. Luigi. *Memoire istoriche di
Antonio Allegri detto il Correggio.* 3 vols.
Parma (Italy): Tipografia Ducale, 1821.
Entries: unnumbered, pp. 69–127,
prints after. Paper fold measure
(selection). Described (selection).

Meyer, Julius. *Correggio.* Leipzig: Wil-
helm Engelmann, 1871.
Entries: 814 prints and photographs
after. Paper fold measure. Described
(selection).

[M.] I, pp. 335–481.
Entries: 629 prints after. Paper fold
measure. Inscriptions (selection). De-
scribed (selection).

Correns, Erich *(1821–1877)*
[Merlo] pp. 174–175.*

Cort, Cornelis *(1533 or 1536–1578)*
[W.] I, pp. 341–343.
Entries: 117+.*

Bierens de Haan, J. C. J. *L'Oeuvre gravé
de Cornelis Cort, graveur hollandais.* The
Hague: Martinus Nijhoff, 1948.
Entries: 289. Millimeters. Inscrip-
tions. States. Described. Illustrated
(selection). Located. Copies men-
tioned.

[H. *Neth.*] V, pp. 40–60.
Entries: 292+. Illustrated (selection).*

Lamalle, Edmond. "Cornelis Cort a-t-il
gravé un portrait de Saint Ignace de
Loyola?" *Archivum historicum Societatis
Jesu* 20 (1951): 300–305.
Additional information to Bierens de
Haan.

Cortona, Pietro da *(1596–1669)*
[M.] III, pp. 680–691.
Entries: 251+ prints after. Paper fold
measure (selection).

Cossiers, Jan *(1600–1671)*
[W.] I, pp. 343–344.

Entries: 3 prints after.*

[H. *Neth.*] V, p. 61.
Entries: 4 prints after.*

Cossin, Louis
See **Coquin**

Cossmann, Alfred *(b. 1870)*
Alexander, Th. *Alfred Cossmanns Exlibris
und Gebrauchsgraphik; ein kritischer Kat-
alog.* Vienna: Th. Alexander, 1930. 400
copies. (NN)
Entries: 140 prints by and after (book-
plates and commercial prints only, to
1930). Millimeters. Inscriptions. De-
scribed. Illustrated (selection).

Reisinger, Josef. *Werkverzeichnis Alfred
Cossmann.* Vienna: Verlag der Öster-
reichischen Staatsdruckerei, 1954. (MH)
Entries: 215 bookplates and commer-
cial prints, 136 other prints. Millime-
ters. Inscriptions (selection). De-
scribed (selection).

Costa, Annibale *(b. 1815)*
[Ap.] pp. 101–102.
Entries: 6.*

Costa, Giovanni Francesco *(d. 1773)*
Mauroner, Fabio. "Gianfrancesco
Costa." [*PCQ.*] 27 (1940): 470–495.
Entries: 6+. Inches. Inscriptions
(selection). States. Described (selec-
tion). Illustrated (selection).

Costa, Lorenzo *(1460–1535)*
[P.] V, pp. 203–205.
Entries: 1. Pre-metric. Described. Lo-
cated.

[Hind] V, p. 237.
Entries: 1 print after. Millimeters. In-
scriptions. Described. Illustrated. Lo-
cated.

Coster, Adam de *(1586–1643)*
[W.] I, pp. 344–345.
Entries: 1 print after.*

[H. *Neth.*] V, p. 61.
Entries: 1 print after.*

Coster, David *(fl. 1696–1744)*
[W.] I, p. 345.
Entries: 4.*

Coster, Hermanus Alardi *(fl. c.1611)*
[H. *Neth.*] V, p. 61.
Entries: 1.*

Cosway, Maria Louisa Catherine Cecilia
(1759–1838)
[Ber.] V, pp. 54–55.*

Williamson, George C. *Richard Cosway,
R.A., and his wife and pupils, miniaturists
of the eighteenth century.* London: George
Bell and Sons, 1897. 350 copies (PJRo)
Entries: unnumbered, pp. 155–160,
prints after.

Cosway, Richard *(1742–1821)*
Daniell, Frederick B. *A catalogue raisonné
of the engraved works of Richard Cosway,
R.A.* London: Fred[erick] B. Daniell,
1890.
Entries: 222 prints after. Inches. De-
scribed.

Williamson, George C. *Richard Cosway,
R.A., and his wife and pupils, miniaturists
of the eighteenth century.* London: George
Bell and Sons, 1897. 350 copies. (PJRo)
Entries: unnumbered, pp. 155–160,
prints after.

Cotelle, Jean I *(1607–1676)*
[RD.] V, pp. 128–130; XI, pp. 40–41.
Entries: 13. Millimeters. Inscriptions.
Described.

Cotelle, Jean II *(1642–1708)*
[RD.] V, pp. 317–320.
Entries: 9. Millimeters. Inscriptions.
Described.

Cotman, John Sell *(1782–1842)*
[Ber.] V, p. 55.*

Cotman, John Sell *(continued)*

Rienaecker, Victor. *John Sell Cotman (1782–1842).* Leigh-on-Sea (England): F. Lewis, 1953. 500 copies. (MH)
 Entries: 481 (etchings only). Inches.

Cottard, ——— *(19th cent.)*
 [Ber.] V, p. 55.*

Cottet, Charles *(1863–1924/25)*
Clément-Janin, ———. "Charles Cottet." [*GK.*] 32 (1909): 49–54. Catalogue: "Verzeichnis der graphischen Arbeiten Charles Cottets." [*MGvK.*] 1909, pp. 29–31.
 Entries: 42. Millimeters. Inscriptions. States. Described. Illustrated (selection).

Cottin, J. *(19th cent.)*
 [Ap.] p. 102.
 Entries: 1.*

Cottin, Pierre *(1823–1886)*
 [Ber.] V, pp. 55–56.*

Couché, François Louis *(1782–1849)*
 [Ber.] V, p. 57.*

Couché, Jacques *(b. 1750)*
 [L. D.] pp. 10–11.
 Entries: 4. Millimeters. Inscriptions. States. Described. Incomplete catalogue.*

Couchet, Anton *(dates uncertain)*
 [W.] I, p. 346.
 Entries: 4.*

Couchet, Joseph Antoine *(1630–1678)*
 [W.] I, p. 346.
 Entries: 1.*

 [H. *Neth.*] V, p. 61.
 Entries: 4.*

Coucke, Johannes *(1783–1853)*
 [H. L.] p. 148.

 Entries: 1 Millimeters. Inscriptions. Described.

Couder, Louis Charles Auguste *(1790–1873)*
 [Ber.] V, pp. 57–58.*

Couder, Stéphanie
See **Klein**

Coupé, Antoine Jean Baptiste *(b. 1784)*
 [Ap.] p. 102.
 Entries: 1.*

 [Ber.] V, p. 58.*

Coupin de la Couperie, Marie Philippe *(1773–1851)*
 [Ber.] V, p. 58.*

Courbe, Wilbrode Magloire Nicolas *(fl. c.1800)*
 [Ber.] V, p. 58.*

Courbet, Gustave *(1819–1877)*
 [Ber.] V, p. 59.*

Duret, Théodore. "Courbet graveur et illustrateur." [*GBA.*] 3d ser., 39 (1908): 421–432.
 Entries: 1 print by; prints after, unnumbered, pp. 425–432. Millimeters (selection). Described. Illustrated (selection).

Courboin, François *(b. 1865)*
 [Ber.] V, p. 60.*

Courdouan, Vincent Joseph François *(1810–1893)*
 [Ber.] V, p. 60.*

Courland, L. E. *(fl. c.1755)*
 [W.] I, p. 346.
 Entries: 1 print after.*

Cournault, Etienne *(1891–1948)*
Simon-Cournault, Mme. "Catalogue de l'oeuvre gravé d'Eugène [*sic*] Cour-

nault." *Nouvelles de l'estampe,* 1966: 51–171, 418–419.
　　Entries: 758. Millimeters. States.

Court, Johannes Franciscus de la *(18th cent.)*
　[W.] I, p. 346.
　　Entries: 2 prints after.*

Court, Olivier de la *(16th cent.)*
　[W.] III, p. 69.
　　Entries: 1+ prints after.*

Courtin, F. *(fl. 1830–1840)*
　[Ber.] V, pp. 60–61.*

Courtois, Guillaume *(1628–1679)*
　[RD.] I, pp. 211–215; XI, pp. 41–42.
　　Entries: 4. Pre-metric. Inscriptions. Described. Appendix with 1 doubtful print.

Courtois, Jacques [called "le Bourguignon"] *(1621–1675)*
　[RD.] I, pp. 199–209.
　　Entries: 16. Pre-metric. Inscriptions. States. Described.

Courtois, Jean Baptiste *(17th cent.)*
　[RD.] I, pp. 217–218; XI, p. 42.
　　Entries: 1. Pre-metric. Inscriptions. Described.

Courtois, Pierre François *(1736–1763)*
　[L. D.] p. 12.
　　Entries: 2. Millimeters. Inscriptions. States. Described. Incomplete catalogue.*

Courtry, Charles *(1846–1897)*
　[Ber.] V, pp. 61–70.
　　Entries: 400. Paper fold measure (selection).

Cousin, Charles *(1807–1887)*
　[Ap.] p. 102.
　　Entries: 3.*

　[Ber.] V, pp. 71–78.*

Cousin, Jean I *(c.1490–c.1560)*
　[P.] VI, pp. 260–262.
　　Entries: 6 prints by and after. Pre-metric (selection). Inscriptions (selection). Described (selection). Located (selection).

　[RD.] IX, pp. 4–15, 323–324.
　　Entries: 4. Millimeters. Inscriptions. Described.

　Firmin-Didot, Ambroise. *Etude sur Jean Cousin, suivie des notices sur Jean Leclerc et Pierre Woeiriot.* Paris: Ambroise Firmin-Didot, 1872. (NNMM)
　　Entries: 7 prints by, 4+ after (etchings and engravings only). Millimeters. Inscriptions. Described. Woodcuts are discussed at length but not catalogued.

　[Wess.] IV, pp. 56–57.
　　Entries: 7+ (additional to [RD.]). Millimeters. Inscriptions. Described (selection).

Cousins, Henry *(d. 1864)*
　[Ber.] V, p. 78.*

Cousins, Samuel *(1801–1887)*
　[Ber.] V, p. 78.*

　Graves, Algernon. *A catalogue of the works of Samuel Cousins, R.A., member of the Legion of Honor.* London: Henry Graves and Co., 1888. (NN)
　　Entries: 309. Ms. notes (ERB); additional information.

　Pyecroft, George. *Memoir of Samuel Cousins, R.A.* 2d ed. London: Samuel T. Temple, 1899. (PJRo) [1st ed. Exeter, (England), 1887.]
　　Entries: unnumbered, pp 18–23. Copy with Ms. notes by Howard C. Levis (PJRo); list of plates engraved by Cousins while apprentice to S. W. Reynolds.

　Whitman, Alfred. *Nineteenth century mezzotinters; Samuel Cousins.* London:

Cousins, Samuel *(continued)*

George Bell and Sons, 1904. 600 copies.
(MH)
Entries: 326. Inches. Inscriptions.
States. Described. Illustrated (selection). Ms. notes (ECol); additional information.

Coussens, Armand *(1881–1935)*
Clement-Janin, ———. "Armand Coussens, peintre-graveur provençal." *Byblis*
1 (1922): 95–98, and 2 unnumbered pages
following p. 191.
Entries: unnumbered, 2 p. (to 1922).
Millimeters.

Clement-Janin, ———, et al. *Armand Coussens, peintre-graveur 1881–
1935.* Paris: Editions des Horizons, 1936.
150 copies. (EPBN)
Entries: 140 (etchings only, prints
other than book illustrations). Millimeters. Inscriptions. Described. Illustrated (selection). Also, bibliography
of books with illustrations by and list
of color monotypes, unnumbered,
2 pp.

Coussens, Jeanne. *Armand Coussens,
1881–1935, témoignages.* Lyons: 1962. 250
copies. (NN)
Entries: 62 (to 1919). Millimeters. Inscriptions. Described. Illustrated
(selection).

Coutan, Amable Paul *(1792–1837)*
[Ber.] V. p. 78.*

Coutaud, Lucien *(b. 1904)*
Cailler, Pierre. *Catalogue raisoné de
l'oeuvre gravé et lithographié de Lucien Coutaud.* Lausanne (Switzerland): Pierre
Cailler, 1960. 350 copies. (MH)
Entries: 93 etchings, 16 lithographs (to
1959). Millimeters. States. Described.
Illustrated.

Coutil, Léon Marie *(1856–1943)*
[Ber.] V, p. 79.*

Couturier, Léon Antoine Lucien
(1842–1935)
[Ber.] V, p. 79.*

Couven, F. W. von *(19th cent.)*
[Dus.] p. 26.
Entries: 2 (lithographs only, to 1821).
Millimeters (selection). Inscriptions
(selection).

Couwenberch, Christiaen van *(1604–1667)*
and Maerten van *(c.1610–after 1639)*
See **Kouwenberg**

Couwenberch, Gillis van *(b. 1572)*
[W.] I, p. 347.
Entries: 1.*

[H. *Neth.*] V, p. 61.
Entries: 3.*

Couwenberg, Henricus Wilhelmus
(1814–1845)
[W.] I, p. 347.
Entries: 2.*

[Ap.] pp. 102–103.
Entries: 4.*

Coxie, Jan Michiel *(c.1650–1720)*
[W.] I, p. 349.
Entries: 1 print after.*

Coxie, Michiel I *(1499–1592)*
Schmidt, Wilhelm. "Michael van Coxcyen der Meister der Monogramme;
COMXK[etc.]."[*JKw.*] 5 (1873): 263–266.
Entries: 5 prints after. Pre-metric. Inscriptions. States. Described. Not
used by [H. *Neth.*].

[W.] I, pp. 349–351.
Entries: 1+ prints by, 10+ after.*

[H. *Neth.*] V, p. 62.
Entries: 1 print by, 52+ after.*

[H. *Neth.*] XIII, p. 23.
 Entries: 1. Illustrated.*

Coypel, Antoine *(1661–1722)*
[RD.] II, pp. 160–171; XI, pp. 42–44.
 Entries: 14. Pre-metric. Inscriptions. States. Described.

Dimier, Louis. "Antoine Coypel." In [Dim.] I, pp. 93–155.
 Entries: 11. Millimeters. Inscriptions. Also, list of 75 prints after lost works, and list of illustrations after, unnumbered, pp. 152–154.

Wildenstein, Daniel et al. "L'Oeuvre gravé des Coypel, II." [*GBA.*] 6th ser., 64 (1964): 141–152.
 Entries: 67 prints after (complete?). Illustrated.

Coypel, Charles Antoine *(1694–1752)*
[RD.] II, pp. 223–233; XI, p. 44.
 Entries: 31. Pre-metric. Inscriptions. States. Described.

Wildenstein, Daniel, et al. "L'Oeuvre gravé des Coypel, I." [*GBA.*] 6th ser., 63 (1964): 261–274.
 Entries: 44 prints after (complete?). Illustrated.

Coypel, Noël *(1628–1707)*
[RD.] II, pp. 85–88; XI, p. 45.
 Entries: 3. Pre-metric. Inscriptions. States. Described.

Wildenstein, Daniel et al. "L'Oeuvre gravé des Coypel, I." [*GBA.*] 6th ser., 63 (1964): 261–274.
 Entries: 21 prints after (complete?). Illustrated.

Coypel, Noël Nicolas *(1690–1734)*
Messelet, Jean. "Nicolas Coypel." In [Dim.] II, pp. 217–227.
 Entries: 5 prints by. Millimeters. Also, list of 13+ prints after (titles only).

[RD.] II, pp. 221–222; XI, pp. 45–46.
 Entries: 3. Pre-metric. Inscriptions. States. Described.

Wildenstein, Daniel et al. "L'Oeuvre gravé des Coypel, I." [*GBA.*] 6th ser., 63 (1964): 261–274.
 Entries: 6 prints after (complete?). Illustrated.

Cozza, Francesco *(1605–1682)*
[B.] XIX, pp. 78–80.
 Entries: 5. Pre-metric. Inscriptions. Described.

Cozzi, Giuseppe *(19th cent.)*
[Ap.] p. 103.
 Entries: 3.*

Crabbe van Espleghem, Frans *(d. 1552)*
[B.] VII, pp. 527–534.
 Entries: 24. Pre-metric. Inscriptions. Described.

[B.] VIII, p. 5.
 Entries: 1. Pre-metric. Inscriptions. Described.

[Evans] p. 7.
 Entries: 6 (additional to [B.]). Millimeters. Inscriptions. Described.

[P.] III, pp. 15–21.
 Entries: 40 (additional to [B.]). Pre-metric. Inscriptions. States. Described. Located. Watermarks described.

[P.] III, pp. 21–22.
 Entries: 1 (additional to [B.]). Pre-metric. Inscriptions. Described. Located. Additional information to [B.].

[Wess.] I, p. 144.
 Entries: 1 (additional to [B.] and [P.]). Millimeters. Inscriptions. Described. Located.

[W.] I, pp. 352–353.
 Entries: 50.*

Crabbe van Espleghem, Frans *(continued)*

Popham, A. E. "The engravings of Frans Crabbe van Espleghem." [*PCQ.*] 22 (1935): 92–115, 194–211.
 Entries: 55. Millimeters. Inscriptions. Described. Illustrated (selection). Located.

[H. *Neth.*] V, pp. 63–95.
 Entries: 53. Illustrated (selection).*

Crabeels, Florent Nicolas *(1829–1896)*
[H. L.] pp. 148–153.
 Entries: 10. Millimeters. Inscriptions. States. Described.

Crabeth, Wouter Pietersz II *(d. 1644)*
[W.] I, p. 354.
 Entries: 1 print after.*

[H. *Neth.*] V, p. 96.
 Entries: 1 print after.*

Craco, Johannes *(b. 1761)*
[W.] I, p. 354.
 Entries: 1 print after.*

Craesbeeck, Joos van *(1605–c.1654)*
[W.] I, pp. 355–356.
 Entries: 4+ prints after.*

[H. *Neth.*] V, p. 96.
 Entries: 9 prints after.*

Craeyvanger, Gysbertus *(1810–1895)*
[H. L.] pp. 153–157.
 Entries: 15. Millimeters. Inscriptions. States. Described.

Crafty [pseudonym of Victor Géruzez] *(1840–1906)*
[Ber.] V, pp. 79–80.*

Craig, Edward Gordon *(b. 1872)*
Carrick, E. Catalogue. In *Nothing, or the bookplate,* by Edward Gordon Craig. London: Chatto and Windus, 1924. 280 copies. (DLC)

Entries: 122 (bookplates only, to 1912). Inches. Inscriptions. Described. Illustrated (selection).

Craig, William Marshall, and **Merke,** H. *(fl. 1800–1820)*
[Siltzer] p. 347.
 Entries: unnumbered, p. 347. Inscriptions.

Cranach, Lucas I *(1472–1553)*
[B.] VII, pp. 273–301.
 Entries: 6 engravings, 155 woodcuts. Pre-metric. Inscriptions. States. Described. Copies mentioned.

[Heller] Joseph. *Lucas Cranachs Leben und Werke.* Bamberg (Germany): Carl Friedrich Kunz, 1821. (ICB)
 Entries: 6 engravings, 310 woodcuts, 16 doubtful engravings, 92 doubtful woodcuts, 90 prints after. Pre-metric. Inscriptions. States. Described. Concordance with [B.]

[Heller] Joseph. *Das Leben und die Werke Lucas Cranachs. Zweite vermehrte und gänzlich umgearbeitete Auflage.* Bamberg (Germany): J. G. Sickmüller, 1844. (EWA)
 Entries: 520 prints by, 135 doubtful prints, 137 prints after. (Copies are included in numbering.) Pre-metric. Inscriptions. States. Described.

Schuchardt, Christian. *Lucas Cranach des Aeltern Leben und Werke nach urkundlichen Quellen bearbeitet.* 3 vols. Leipzig: F. A. Brockhaus, 1851–1871. (MBMu)
 Entries: 10 engravings by, 192 woodcuts by, 77 prints after. (Copies are included in numbering.) Pre-metric. Inscriptions. Described.

Heller, Joseph. *Lucas Cranachs Leben und Werke.* 2d ed. Nuremberg: Verlag von J. L. Lotzbeck, 1854. (MBMu)
 Entries: 520 prints by, 135 doubtful prints, 130 prints after. (Copies are in-

cluded in numbering.) Pre-metric. Inscriptions. Described.

[P.] IV, pp. 3–24.
Entries: 3 engravings (additional to [B.]), 68+ woodcuts (additional to [B]). Pre-metric. Inscriptions. States. Described. Copies mentioned. Additional information to [B.].

[Wess.] I, pp. 134–135.
Additional information to [B.] and [P.].

Dodgson, Campbell. "Fünf unbeschriebene Holzschnitte Lucas Cranachs." [JprK.] 24 (1903): 284–290.
Entries: 5 (additional to previous catalogues). Millimeters. Described. Illustrated. Located.

[Ge.] nos. 537–664.
Entries: 128 (single-sheet woodcuts only). Described. Illustrated. Located.

Lucas Cranach d. Ä. das gesamte graphische Werk, mit Exempeln aus dem graphischen Werk Lucas Cranach d.J. und der Cranachwerkstatt. Munich: Rogner und Bernhard, 1972.
Entries: unnumbered, pp. 199–583. Illustrated.

[H. *Ger.*] VI, pp. 1–120.
Entries: 147+ prints by, 127 after. Illustrated (selection).*

Cranach, Lucas II *(1515–1586)*
[P.] IV, pp. 24–32.
Entries: 44+. Pre-metric. Inscriptions. Described. Copies mentioned.

[Ge.] nos. 665–685.
Entries: 21 (single-sheet woodcuts only). Described. Illustrated. Located.

[H. *Ger.*] VI, pp. 121–159.
Entries: 63+. Illustrated (selection).*

Cranach, Ulrich von *(fl. 1650–1700)*
[H. *Ger.*] VI, p. 176.
Entries: 11.*

Cranach Workshop *(16th cent.)*
[H. *Ger.*] VI, pp. 160–175.
Entries: 51. Illustrated (selection).*

Crane, ——— *(19th cent.)*
[Siltzer] p. 329.
Entries: unnumbered, p. 329, prints after. Inches. Inscriptions.

Crane, Walter *(1845–1915)*
Massé, Gertrude C. E. *A bibliography of first editions of books illustrated by Walter Crane.* London: Chelsea Publishing Co., 1923.
Bibliography of books with illustrations by.

Crawford, Ralston *(b. 1906)*
Freeman, Richard B. *The lithographs of Ralston Crawford.* Lexington (Ky.): University of Kentucky Press, 1962.
Entries: unnumbered, pp. 27–34 (to 1959). Inches. Illustrated (selection). Located (selection).

Crayer, Gaspar de *(1584–1669)*
[W.] I, pp. 357–358.
Entries: 2 prints by, 9 prints after.*

[H. *Neth.*] V, p. 97.
Entries: 12 prints after.*

Cremer, Josef *(fl. c.1846)*
[Merlo] p. 178.*

Crépy le Prince, Charles Édouard, baron *(b. 1784)*
[Ber.] V, pp. 80–81.*

Crespi, Giuseppe Maria [called "lo Spagnuolo"] *(1665–1747)*
[B.] XIX, pp. 395–411.
Entries: 42 prints by, 2 prints not seen by [B.], 5 doubtful and rejected prints. Pre-metric. Inscriptions. States. Described. Copies mentioned.

[Heller] pp. 42–43.
Additional information to [B.].

Creteur, Jakob *(fl. c.1840)*
[Merlo] p. 179.
 Entries: 4. Paper fold measure. Inscriptions.

Cretey, Jean Onuphre Philippe *(fl. c.1710)*
[RD.] IV, p. 223; XI, p. 46.
 Entries: 2. Pre-metric. Inscriptions. Described.

Creti, Donato, called Donatino *(1671–1749)*
[Vesme] pp. 360–361.
 Entries: 3. Millimeters. Inscriptions. States. Described. Located.

Crevoisier, Marie Jeanne
See **Clemens**

Croce, Teodoro della
See **Verkruys,** Theodor

Crock, Hubrecht de
See **Crook**

Croissant, Jean *(fl. 1560–1580)*
[W.] I, p. 359.
 Entries: 3.*

[H. *Neth.*] V, p. 98.
 Entries: 3+.*

Crokaert, Jean *(fl. 1774–1775)*
[W.] I, p. 359.
 Entries: 1.*

Crome, John *(1768–1821)*
Theobald, Henry Studdy. *Crome's etchings; a catalogue and an appreciation, with some account of his paintings.* London: Macmillan and Co., 1906.
 Entries: 44. Inches. Inscriptions. States. Described. Located (selection). Ms. notes (ECol); additional states.

Clifford, Derek, and Clifford, Timothy. *John Crome.* London: Faber and Faber, Ltd.; and Greenwich (Conn.): New York Graphic Society, 1968.

 Entries: 34. Inches. Inscriptions. States. Described. Located (selection).

Cromek, Robert Hartley *(1771–1812)*
Cromek, Thomas H. "Catalogue of engravings by R. H. Cromek." Unpublished ms., c.1863. (EBM)
 Entries: 49.

Cron, Hans
See **Monogram HCZA** [Nagler, *Mon.*] III, no. 803

Cronenbold, ——— *(19th cent.)*
[Dus.] p. 26.
 Entries: 1 (lithographs only, to 1821). Millimeters. Inscriptions. Described. Located.

Crook, Huberecht de *(1490–after 1546)*
[H. *Neth.*] V, p. 98.
 Entries: 7. Illustrated (selection).*

Cross, Thomas I *(fl. 1644–1682)*
[Hind, *Engl.*] III, pp. 277–326.
 Entries: 144+. Inches. Inscriptions. States. Described. Illustrated (selection). Located.

Croutelle, Louis *(1765–1829)*
[Ap.] p. 103.
 Entries: 3.*

Crozier, J. P. *(fl. c.1646)*
[RD.] II, pp. 82–84; VIII, pp. 223–224; XI, p. 47.
 Entries: 6. Pre-metric. Inscriptions. Described. [RD.] erroneously cites 2 Croziers, J. P. and J. J., actually the same artist.

Crüger, Dietrich *(c.1575–1624)*
[H. *Ger.*] VI, pp. 176–178.
 Entries: 81+.*

Cruikshank family
Torriano, Hugh Arthur [Frederick Marchmont]. *The three Cruikshanks, a bib-*

liographical catalogue describing more than 500 works London: W. T. Spencer, 1897. (ELVA)
 Bibliography of books with illustrations by.

Cruikshank, George *(1792–1878)*
See also **Cruikshank** family

Reid, G. W. *A descriptive catalogue of the works of G. Cruikshank, etchings, woodcuts, lithographs and glyphographs.* 3 vols. London: Bell and Daldy, 1871. 150 copies. (NN)
 Entries: 4595 prints by, 151 after. Inscriptions. Described. Illustrated (selection). Bibliography of books with illustrations by. Annotated copies (NN) with notes by H. W. Bruton, Edwin Truman, A. M. Cohn, and George S. Layard.

List of books illustrated by George Cruikshank from "The Bookseller" for March and April 1878, amended, and with additions by J. C., for the Paisley and Renfrewshire Gazette. n.p., 1878. 75 copies. (PJRo)
 Bibliography of books with illustrations by.

Catalogue of the collection of the works of George Cruikshank, the property of H. W. Bruton, Esq. London: Sotheby, Wilkinson and Hodge, 1897. (EBM)
 Additional information to Reid.

Douglas, R. J. H. *The works of George Cruikshank, classified and arranged with references to Reid's catalogue and their approximate values.* London: J. Davy and Sons, 1903. 1000 copies.
 Entries: 1890+. 634 books with prints by and after, 1256 single prints by and after. Inscriptions. Described (selection).

Cohn, Albert M. *A bibliographical catalogue of the printed works illustrated by George Cruikshank.* London: Longmans, Green and Co., 1914.

Bibliography of books with illustrations by.

Cohn, Albert M. *George Cruikshank; a catalogue raisonné of the work executed during the years 1806–1877.* London: Office of "The Bookman's Journal," 1924.
 Entries: 863+ book illustrations, 2114 single prints. Inscriptions. Described (selection). Bibliography of books with illustrations by. Copy with Ms. additions. (NN)

Cruikshank, Isaac *(1756–1810/11)*
See also **Cruikshank** family

Krumbhaar, E. B. *Isaac Cruikshank: a catalogue raisonné with a sketch of his life and work.* Philadelphia (Pa.): University of Pennsylvania Press, 1966.
 Entries: 1350 (includes some drawings). Inches (selection). Inscriptions. Described. Illustrated (selection). Located. Appendix with doubtful works.

Cruikshank, [Isaac] Robert *(1789–1856)*
See also **Cruikshank** family

[Siltzer] p. 348.
 Entries: unnumbered, p. 348, prints by and after. Inscriptions.

Cruyl, Lievin *(1640–1720)*
[W.] I, p. 361.
 Entries: 4+.*

[H. *Neth.*] V, p. 99.
 Entries: 76. Illustrated (selection).*

Cucinotta, Saro *(d. 1871)*
[Ber.] V, p. 81.*

Cuisinier, Léon *(b. 1832)*
[Ber.] V, p. 82.*

Curel, Chevalier de *(fl. 1775)*
Bouland, L. "Les ex-libris gravés par Zapouraph (le Chevalier de Curel)." [*Arch. Ex.-lib.*] 12 (1905): 87–91. Wiggis-

Curel, Chevalier de *(continued)*

hoff, J. C. "Supplément." [*Arch. Ex.-lib.*] 12 (1905): 109–111.
Entries: 6 (bookplates only). Inscriptions. Described. Illustrated.

Currier and Ives (Nathaniel Currier, *1813–1888;* James Merritt Ives, *1824–1895*)
Descriptive catalogue of prints published and for sale by Currier and Ives. New York: Currier and Ives, [c.1860]. (NN)
Entries: unnumbered, pp. 1–14 (prints published by, to c.1860). Inches. Described (selection).

Weaver, Warren A. *Lithographs of N. Currier and Currier and Ives.* New York: Holport Publishing Co., 1925. *Supplement No. 1.* New York: Holport Publishing Co., 1926. (NN)
Entries: 3075.

Peters, Harry T. *Currier and Ives: printmakers to the American people.* 2 vols. Garden City (N.Y.): Doubleday, Doran and Co., 1929, 1931. 501 copies. (NN)
Entries: 4317 in vol. I arranged by subject; alphabetical list in vol. II with c.1600 additional prints. Paper fold measure. Inches (selection). Ms. additions (NN); prints unknown to Peters.

Peters, Fred J. *Clipper ship prints, including other merchant sailing ships, by N. Currier and Currier and Ives, being a pictorial check list and collation.* New York: Antique Bulletin Publishing Company, 1930.
Entries: 63 (ship prints only). Inches. Inscriptions. States. Described. Illustrated. Refers to Harry T. Peters check list numbers.

Peters, Fred J. *Railroad, Indian, and pioneer prints by N. Currier and Currier and Ives, being a pictorial check list and collation.* New York: Antique Bulletin Publishing Company, 1930.

Entries: 109 (railroad, Indian and pioneer prints only). Inches. Inscriptions. States. Described. Illustrated. Refers to Harry T. Peters check list numbers.

Peters, Fred J. *Sporting prints by N. Currier and Currier and Ives, being a pictorial check list and collation.* New York: Antique Bulletin Publishing Company, 1930. 750 copies. (NN)
Entries: 210 (sporting prints only). Inches. Inscriptions. States. Described. Illustrated. Refers to Harry T. Peters check list numbers.

Conningham, Frederick Arthur. *An alphabetical list of 5735 of N. Currier and Currier and Ives prints, with dates of publication, sizes and recent auction prices.* New York: Privately printed by F. A. and M. B. Conningham, 1930. 1001 copies. (NN)
Entries: 5735. Dimensions: small, medium and large.

Conningham, Frederick Arthur. *Supplement number one to an alphabetical list of 5735 titles of N. Currier and Currier and Ives prints.* New York: Privately printed by F. A. and M. B. Conningham, 1931. (NN)
Entries: unnumbered, pp. 3–7 (additional to Conningham 1930). Dimensions: small, medium and large.

Conningham, Frederic A. *Currier and Ives prints: an illustrated check-list.* New York: Crown Publishers, Inc., 1949.
Entries: 6789. Inches. Described (selection).

Conningham, Frederic A., and Simkin, Colin. *Currier and Ives prints; an illustrated check list.* New York: Crown Publishers Inc., 1970.
Entries: 6789. Inches. Described (selection). Reprint of Conningham 1949 with a few revisions and a list of 17 additional prints, unnumbered, p. 300.

Schurre, Jacques. *Currier and Ives prints; a check list of unrecorded prints produced by Currier and Ives, N. Currier and C. Currier.* New York: Jacques Schurre, 1970.
Entries: 220 (additional to Conningham 1970). Inches. Inscriptions.

Curzon, Alfred de *(1820–1895)*
Curzon, Henri de. *Alfred de Curzon, peintre, 1820–1895; sa vie et son oeuvre d'après ses souvenirs, ses lettres, ses contemporains.* 2 vols. Paris: Librairie Renouard, and H. Laurens Éditeur, 1914. (EPAA)
Entries: 71. Millimeters. Described.

Cusseus, Cornelis Ysbrantse
See **Kussaeus**

Custos, David *(fl. c.1600–1625)*
[H. *Ger.*] VI, p. 178.
Entries: 11+. Illustrated (selection).*

Custos, Dominicus *(after 1550–1612)*
[H. *Ger.*] VI, pp. 179–183.
Entries: 70+. Illustrated (selection).*

Custos, Jacob *(fl. 1600–1650)*
[H. *Ger.*] VI, p. 184.
Entries: 7+. Illustrated (selection).*

Custos, Pieter
See **Baltens**

Custos, Raphael *(c.1590–1651)*
[H. *Ger.*] VI, pp. 185–188.
Entrïes: 45+. Illustrated (selection).*

Cutler, Jervis *(1768–1846)*
[F.] p. 88.

Cuvilliès, François I de *(1695–1768)*
Bérard, André. "Catalogue de l'oeuvre de Cuvilliés père et fils." [*RUA.*] 8 (1859): 429–449; [*RUA.*] 9 (1859): 66–82. Separately published. Paris: Veuve Jules Renouard, 1859. (NN)

Entries: 73+ prints by and after. Millimeters. Inscriptions (selection). Described (selection).

Laran, Jean. *François de Cuvilliés, dessinateur et architecte.* Paris: Henri Laurens, n.d.
Entries: unnumbered, pp. 5–13. Illustrated (selection). Copy with Ms. additions and corrections. (NNMM)

Cuvilliès, François II de *(1731–1777)*
Bérard, André. "Catalogue de l'oeuvre de Cuvilliés père et fils." [*RUA.*] 8 (1859): 429–449; [*RUA.*] 9 (1859): 66–82. Separately published. Paris: Veuve Jules Renouard, 1859. (NN)
Entries: 67+ prints by and after. Millimeters. Inscriptions (selection). Described (selection).

Cuyck, Pieter van I *(1687–1765)*
[W.] I, p. 363.
Entries: 1.*

Cuyck, Pieter van II *(1720–1787)*
[W.] I. p. 363.
Entries: 3+ prints after.*

Cuylenburg, Jan van *(fl. c.1819)*
[H. L.] pp. 157–161.
Entries: 13. Millimeters. Inscriptions. States. Described.

Cuyp, Aelbert *(1620–1691)*
[vdK.] pp. 98–104.
Entries: 8. Millimeters. Inscriptions. States. Described. Also, list of 22 prints after (incomplete).

[Dut.] IV, pp. 98–99.
Entries: 8. Millimeters. Inscriptions. States. Described. Illustrated (selection).

[W.] I, pp. 364–368.
Entries: 8 prints by, 35+ prints after.*

Hofmann, Julius. "Die Radierungen von Aelbert Cuyp." [*MGvK.*] 1906, pp. 14–16.

Cuyp, Aelbert *(continued)*

Entries: 8. Millimeters. Inscriptions. States. Described. Follows numbering of [vdK.] states more thoroughly described. Copies mentioned.

[H. *Neth.*] V, pp. 100–103.
Entries: 8 prints by, 52 after. Illustrated (selection).*

Cuyp, Jacob Gerritsz *(1594–c.1651)*
[W.] I, p. 369.
Entries: 4+ prints after.*

[H. *Neth.*] V, p. 103.
Entries: 18 prints after.*

Czermak, Jaroslav
See **Cermak**

D

Dähling, Heinrich Anton *(1773–1850)*
[Dus.] p. 26.
Entries: 1 (lithographs only, to 1821). Described.

Daffinger, Moritz Michael *(1790–1849)*
[A. 1800] IV, pp. 91–97.
Entries: 4. Millimeters. Inscriptions. States. Described. Also, list of 3 prints after (not fully catalogued).

Dague, Victor *(19th cent.)*
[Ber.] V, p. 82.*

Daguerre, Louis Jacques Mandé *(1787–1851)*
[Ber.] V, p. 82.*

Dahl, Johan Christian Clausen *(1788–1857)*
[A. 1800] I, pp. 70–75.
Entries: 4. Pre-metric. Inscriptions. States. Described.

Dahl, Michael I *(1656–1743)*
Nisser, Wilhelm. *Michael Dahl and the contemporary Swedish school of painting in England.* Uppsala (Sweden): Almqvist and Wiksell, 1927.

Entries 69+ prints after. Described. (selection). Located (selection).

Dahmen, Franz *(1790–1865)*
[Dus.] p. 26.
Entries: 1 (lithographs only, to 1821). Millimeters. Inscriptions. Located.

Dala, Giuseppe *(1788–1860)*
[Ap.] pp. 103–104.
Entries: 9.*

Dalby, D. *(19th cent.)*
[Siltzer] p. 329.
Entries: unnumbered, p. 329, prints after. Inscriptions.

Dalcò, Antonio *(1802–1888)*
[Ap.] p. 104.
Entries: 9.*

Dalen, Cornelis I van, *(1602–1665)* and Cornelis II van *(1638–1664)*
Bergau, R."Zu den Werken des C. van Dalen." [*N. Arch.*] 14 (1868): 58.
Entries: 1 (additional to [Kramm]). Pre-metric. Inscriptions. Described.

[Wess.] II, pp. 232–233.
Entries: 9 (additional to [Lebl.] and [Andresen, *Handbuch*]). Millimeters (selection), paper fold measure (selection). Inscriptions. (selection). States. Described (selection). Additional information to [Lebl.] and [Andresen, *Handbuch*.].

[Dut.] IV, pp. 90–100.*

[W.] I, pp. 372–373.
Entries: 64+.*

[Hind, *Engl.*] III, pp. 253–258.
Entries: 14+ (prints done in England only). Inches. Inscriptions. States. Described. Illustrated (selection). Located.

[H. *Neth.*] V, pp. 104–122.
Entries: 204. Illustrated (selection).*

Dalens, Dirck I *(c.1600–1676)*
[W.] I, pp. 373–374.
Entries: 3+ prints after.*

[H. *Neth.*] V. p. 123.
Entries: 8 prints after.*

Dall'Armi, Andreas von *(1788–1846)*
[Dus.] p. 27.
Entries: 5 (lithographs only, to 1821). Millimeters. Inscriptions. Located. (selection).

Dall'Armi, Franz Xavier von *(1787–1854)*
[Dus.] p. 27.
Entries: 3 (lithographs only, to 1821). Millimeters. Inscriptions. Located.

Dall'Armi, Joseph von *(fl. c.1805)*
[Dus.] p. 26.
Entries 1 (lithographs only, to 1821). Millimeters. Inscriptions. Located.

Dam, Pieter *(fl. c.1775)*
[W.] I, p. 375.
Entries: 1 print after.*

Dambacher, Jakob Joseph *(1794–1868)*
[Dus.] p. 27.
Entries: 1+ (lithographs only, to 1821). Millimeters. Located.

Dambrin, P. M. *(fl. c.1800)*
[W.] I, p. 375.
Entries: 1 print after.*

Dambrun, Jean *(1741–c.1808)*
[Ap.] p. 105.
Entries: 8.*

[L. D.] pp. 13–14.
Entries: 5. Millimeters. Inscriptions. States. Described. Illustrated (selection). Incomplete catalogue.*

Damele, E. *(19th cent.)*
[Ap.] p. 105.
Entries: 3.*

Damen, Cornelis *(fl. 1630–1640)*
[W.] I, p. 375; III, p. 71.
Entries: 1 print after.*

[H. *Neth.*] V, p. 123.
Entries: 2 prints after.*

Damery, Jacques *(1619–1685)*
[W.] I, p. 375.
Entries: 1+.*

[RD.] III, pp. 224–226.
Entries: 12. Pre-metric. Inscriptions. Described.

Damesz de Veth, Jan *(1595–1625)*
[W.] I, p. 376.
Entries: 1 print after.*

[H. *Neth.*] V, p. 123.
Entries: 1 print after.*

Damman, Benjamin *(b. 1835)*
[Ber.] V, pp. 83–84.*

Damour, Charles *(b. 1813)*
[Ber.] V, pp. 84–85.*

Damourette, Abel *(19th cent.)*
[Ber.] V, p. 85.*

Dananche, Xavier de *(b. 1828)*
[Ber.] V, p. 85.*

Danck, Gerard
See **Donck**

Danckerts, Cornelis I *(1603–1656)*
[W.] I, p. 376.
Entries: Entries: 22+.*

[H. *Neth.*] V, pp. 124–126.
Entries: 183. Illustrated (selection).*

Danckerts, Dancker *(1634–1666)*
[W.] I, pp. 376–377.
Entries: 16+.*

[H. *Neth.*] V, pp. 127–132.
Entries: 49. Illustrated (selection).*

Danckerts, Hendrik *(c.1625–1680)*
[W.] I, p. 377.
Entries: 16+.*

[H. *Neth.*] V, pp. 133–135.
Entries: 34. Illustrated (selection).*

Danckerts, Johan *(1613–c.1686)*
[W.] I, pp. 377–378.
Entries: 2+ prints after.*

[H. *Neth.*] V, p. 136.
Entries: 1 print by, 18 after.*

Danckerts, Justus *(1635–1701)*
[W.] I, p. 378.
Entries: 6+.*

[H. *Neth.*] V, p. 136.
Entries: 20.*

Danckerts de Ry, Pieter *(1605–1661)*
[W.] I, p. 378.
Entries: 3 prints after.*

[H. *Neth.*] V, p. 136.
Entries: 6+ prints after.*

Dandiran, Frédéric François
See **Andiran**

Dandré-Bardon, Michel François
(1700–1783)
[M.] III, pp. 13–14.
Entries: 2 prints by, 4 after. Paper fold measure.

Danforth, Moseley Isaac *(1800–1862)*
[Ap.] p. 105.
Entries: 2.*

[St.] pp. 75–78.*

[F.] p. 89.*

Danguin, Jean Baptiste *(1823–1894)*
[Ap.] pp. 105–106.
Entries: 6.*

[Ber.] V, pp. 86–89.
Entries: 34. Paper fold measure (selection).

Danhauser, Josef *(1805–1845)*
[A. 1800] IV, pp. 201–216.
Entries: 12. Millimeters. Inscriptions. States. Described. Also, list of 22 prints after (not fully catalogued).

T., A. "Lithographien Danhausers (Nachtrag zu Andresen)." [*MGvK.*] 1897, p. 20.
Entries: 6 (additional to [A. 1800]). Inscriptions. Described.

Daniell, Samuel *(1775–1811),* William *(1769–1837),* and Thomas *(1749–1840)*
Sutton, Thomas. *The Daniells, artists and travellers.* London: The Bodley Head, 1954.
Entries: 82+ prints by and after. Paper fold measure. Inscriptions. (selection). Illustrated (selection).

Danloux, Pierre *(1753–1809)*
Vienne, H. "Pierre Danloux" [*RUA.*] 20 (1865): 23–33.

Entries: 26 prints after. Inscriptions (selection). Described.

Dannequin, Alfred Joseph *(fl. 1869–1884)*
[Ber.] V, p. 89.*

Danoot, Peter *(fl. 1644–1692)*
[W.] I, p. 378.
Entries: 6+ .*

[H. *Neth.*] V, p. 137.
Entries: 8+ .*

Dansaert, J. *(fl. c.1755)*
[W.] I, p. 379.
Entries: 1.*

Dansaert, Léon Marie Constant *(b. 1830)*
[H. L.] p. 161.
Entries: 1. Millimeters. Inscriptions. Described.

Danse, Auguste *(b. 1829)*
[H. L.] pp. 161–171.
Entries: 30. Millimeters. Inscriptions. States. Described.

[Ber.] V, p. 89.*

Dantan, Jean Pierre [called "Dantan jeune"] *(1800–1869)*
[Ber.] V, pp. 89–90.*

Danzel, Jérôme *(before 1755–1810)*
[L. D.] p. 14.
Entries: 1. Millimeters. Inscriptions. States. Described. Incomplete catalogue.*

Daragnès, Jean Gabriel *(1886–1950)*
Catalogue de livres sur grands papiers avec dessins originaux, comprenant l'oeuvre entier de l'illustrateur Daragnès; exemplaires uniques provenant de l'atelier de l'artiste, vendus a l'hôtel Drouot, salle 9 le samedi 29 novembre 1924. Paris: G. Andrieux, 1924. (NN)

Bibliography of books with illustrations by, to 1924.

Musée des Arts Décoratifs, Paris. *L'Oeuvre de J. G. Daragnés.* Paris, 1935. (EPBN)
Bibliography of books with illustrations by, to 1935.

Jean-Aubry, G. "Jean Gabriel Daragnès illustrateur." *Halcyon* 11/12 (1942), 8 pp., unpaginated.
Bibliography of books with illustrations by, to 1942.

Jean-Aubry, G. "Dans l'atelier de J. G. Daragnès." *Portique* 2 (1945): 9–36.
Bibliography of books with illustrations by, to 1944.

Darbes, Joseph Friedrich August *(1747–1810)*
[M.] II, p. 214.
Entries: 12 prints after. Paper fold measure.

Dardani, Antonio *(1677–1735)*
[B.] XII: *See* **Chiaroscuro Woodcuts**

Daret, Jean *(1613–1668)*
[RD.] I, pp. 227–231; XI, pp. 48–49.
Entries: 14. Pre-metric. Inscriptions. Described.

[W.] I, p. 382.
Entries: 4+ prints by, 1 after.*

[H. *Neth.*] V, p. 137.
Entries: 11.*

Daret, Pierre *(1604–1678)*
[W.] I, p. 382.
Entries: 2.*

Darjou, Alfred *(1832–1874)*
[Ber.] V, p. 90.*

Darley, Felix Octavius Carr *(1822–1888)*
Bolton, Theodore. "The book illustrations of Felix Octavius Carr Darley."

Darley, Felix Octavius Carr *(continued)*

Proceedings of the American Antiquarian Society, April 1951, pp. 137–182. Separately published. Worcester (Mass.): American Antiquarian Society, 1952.
Bibliography of books with illustrations by.

Darnseldt, Joh. Adolph *(1768–1844)*
[Ap.] p. 106.
Entries: 7.*

Darodes, Louis Auguste *(1809–1879)*
[Ber.] V, p. 90.*

[Ap.] p. 106.
Entries: 1.*

Dassier, Adrien *(b. 1630)*
[M.] II, pp. 352–353.
Entries: 2 prints after. Paper fold measure. Inscriptions (selection). Described (selection).

Dassonville, Jacques *(1619–1670)*
[RD.] I, pp. 167–190; XI, pp. 49–55.
Entries: 66. Pre-metric. Inscriptions. States. Described.

[Wess.] IV, p. 57.
Entries: 1 (additional to [RD]). Millimeters. Inscriptions. Described. Additional information to [RD.].

Dasveldt, Jan *(1770–1855)*
[H. L.] p. 172.
Entries: 2. Millimeters. Inscriptions. Described.

Daubigny, Charles François *(1817–1878)*
Henriet, Frédéric. "Les paysagistes contemporains: Daubigny." [*GBA*] 2d ser., 9 (1874): 255–270, 464–475.
Entries: 104 (to 1869). Described (selection). Ms. notes (NN); additional states.

Henriet, Frédéric. *C. Daubigny et son oeuvre gravé.* Paris: A Lévy, 1875 (not seen). 2d ed. Paris: A. Lévy, 1878.
Entries: 130 etchings and clichés-verres. Millimeters. Inscriptions. States. Described. Unnumbered list of wood engravings drawn by.

[Ber.] V, pp. 91–98.
Entries: 117 (etchings only, to 1877). Paper fold measure.

[Del.] XIII.
Entries: 150 prints by, 6 doubtful and rejected prints. Millimeters. Inscriptions (selection). States. Described (selection). Illustrated. Located (selection).

Daubigny, Karl *(1846–1886)*
[Ber.] V, p. 98.*

Dauchez, André *(1870–1948)*
Clement-Janin, ———. "André Dauchez." [*GK.*] 31 (1908): 19–24. Catalogue: "Verzeichnis der Radierungen André Dauchez." [*MGvK.*] 1908, pp. 4–9, 25–27.
Entries: 149. Millimeters. Inscriptions. States. Described.

Goulinat, J. G. "André Dauchez, peintre et graveur." *Byblis* 3 (1924): 88–90; 7 unpaginated pages following p. 107.
Entries: unnumbered, 7 pp. (to 1924). Millimeters.

Thomé, J. R. *Graveurs et lithographes contemporains, I: catalogues de l'oeuvre gravé et lithographié de Bonfils, Robert; Dauchez, André; Drouart, Raphaël.* Paris: Auguste Fontaine, 1937. 110 copies. (MBMu)
Entries: 564 (to 1936). Millimeters. States.

Daudet, Robert *(1737–1824)*
[Ap.] pp. 106–107.
Entries: 9.*

Daullé, Jean *(1703–1763)*
Delignières, Émile. "Catalogue raisonné de l'oeuvre gravé de Jean Daullé d'Abbeville." [*Mém. Abbeville*] 3d ser., 1 (1869–1872): 295–459. Separately published. Abbeville (France): Briez, C. Paillart et Retaux, 1872; and Paris: Rapilly, 1873.
 Entries: 174. Millimeters. Inscriptions. Described. Located.

[Wess.] IV, pp. 57–58.
 Entries: 3 (additional to Delignières). Paper fold measure. Inscriptions. Described. Located. Additional information to Delignières.

Daumier, Honoré *(1808–1879)*
Champfleury. *Catalogue de l'oeuvre lithographié et gravé de H. Daumier.* Paris: Librairie Parisienne, 1878.
 Survey of prints by; each series of prints is listed, and the number of prints in it is given.

[Ber.] V, pp. 99–135.*
 Entries: 144+.

Hazard, N.A., and Delteil, Loys. *Catalogue raisonné de l'oeuvre lithographié de Honoré Daumier.* Orrouy/Oise (France): N. A. Hazard, 1904. 800 copies. (MB)
 Entries: 3958 prints by, 34 rejected prints. Millimeters. Inscriptions. States. Described.

Rümann, Arthur. *Honoré Daumier; sein Holzschnittwerk.* Munich: Delphin Verlag, 1914.
 Entries: 905 wood engravings drawn by. Millimeters. Inscriptions. Described.

[Del.] XX-XXIX.
 Entries: 3960. Millimeters. Inscriptions. States. Described. Illustrated. Located (selection). Appendix lists 43 prints after.

Rümann, Arthur. *Honoré Daumier. Das Werk: eine Sammlung praktischer Bibliographien, erste Reihe: Das graphische Werk.* Band I. Berlin: Kunst Kammer, and Martin Wasservogel, 1926.
 Bibliography of books with illustrations by.

Dimier, Louis. *Physionomies et physiologies; quatre-vingt-une gravures sur bois d'après Daumier exécutées par Eugène Dété, avec une préface et un catalogue de l'oeuvre gravé sur bois de Daumier.* Paris: Emile Nourry, 1930.
 Entries: 883 wood engravings drawn by. Illustrated (selection).

Bouvy, Eugène. *Honoré Daumier; l'oeuvre gravé.* Paris: Maurice Le Garrec, 1933. 550 copies. (MB)
 Entries: 991 wood engravings and chalk plate prints drawn by, 6 rejected prints. Millimeters. Inscriptions. States. Described. Illustrated.

Bouvy, Eugène. "Un curieux état non décrit de la lithographie de Daumier: Actualités, Martinet no. 294." [*Am. Est.*] 13 (1934): 91–93.
 Additional information to [Del.].

Daumont, Emile Florentin *(b. 1834)*
[Ber.] V, pp. 135–137.
 Entries: 68+. Paper fold measure (selection).

Dauphin, Olivier *(d. 1679)*
[RD.] VIII, pp. 253–258; XI, pp. 55–57.
 Entries: 15. Millimeters. Inscriptions. Described.

Dautieux, Joseph *(fl. 1800–1832)*
[Dus.] pp. 27–28.
 Entries: 2 (lithographs only, to 1821). Millimeters. Inscriptions. Located.

Dautrey, Lucien *(1851–1926)*
[Ber.] V, p. 137.*

Dauzats, Adrien *(1804–1868)*
[Ber.] V, pp. 137–139.*

Guinard, Paul. *Dauzats et Blanchard; peintres de l'Espagne romantique.* Paris: Presses Universitaires de France, 1967.
Entries: 195 prints and works in other media (Spanish subjects only). Millimeters. Inscriptions. Described.

Davent, Léon
See **Monogram LD** [Nagler, *Mon.*] IV, no. 1018

Davey, William Turner *(b. 1818)*
[Siltzer] p. 348.
Entries: unnumbered, p. 348. Inscriptions.

David, Claude *(fl. c.1700)*
[W.] I, p. 382.
Entries: 1.*

David, François Anne *(1741–1824)*
[Ap.] p. 107.
Entries: 17.*

[Ber.] V, p. 139.*

David, Jules *(1808–1892)*
[Ber.] V, pp. 139–140.*

Davidsen, Trygve M. *(20th cent.)*
Schyberg, T. B. "Trygve M. Davidsen."
[*N. Ext.*] 2 (1947–1948): 70, 73–75.
Entries: 33 (bookplates only, to 1946). Illustrated (selection).

Davies, Arthur Bowen *(1862–1928)*
Price, Frederic Newlin. *The etchings and lithographs of Arthur B. Davies.* New York: Mitchell Kennerley, 1929. 1075 copies.
Entries: 205. Inches. States. Illustrated. Different states of the same print are separately numbered. Ms. notes (NN); additional states.

Rueppel, Merrill Clement. "The graphic art of Arthur Bowen Davies and John

Sloan." Doctoral dissertation, University of Wisconsin, 1955.
Entries: 191. Inches. States. Located (selection).

Davis, Alexander Jackson *(1803–1892)*
[Carey] pp. 241–243.
Entries: 28 prints by and after (lithographs only). Inches (selection).

Davis, H. T. *(19th cent.)*
[Siltzer] p. 329.
Entries: unnumbered, p. 329, prints after. Inches. Inscriptions.

Davis, Richard Barrett *(1782–1854)*
[Siltzer] pp. 97–108.
Entries: unnumbered, pp. 106–108, prints after. Inches (selection). Inscriptions. Described (selection).

Davis, T. R. *(19th cent.)*
[Siltzer] p. 329.
Entries: unnumbered, p. 329, prints after. Inches. Inscriptions.

Dawe, George *(1781–1829)*
[Sm.] I, pp. 148–152, and "additions and corrections" section; IV, "additions and corrections" section.
Entries: 14 (portraits only). Inches. Inscriptions. States. Described.

[Siltzer] p. 348.
Entries: unnumbered, p. 348. Inscriptions.

[Ru.] pp. 35–40, 490.
Entries: 11 (portraits only, additional to [Sm]). Inches. Inscriptions. States. Described. Additional information to [Sm.].

Dawe, Philip *(c.1750–c.1785)*
[Sm.] I, pp. 152–159, and "additions and corrections" section; IV, "additions and corrections" section.
Entries: 32 (portraits only). Inches. Inscriptions. States. Described.

[Ru.] pp. 40–43.
Entries: 7 (portraits only, additional to [Sm.]). Inches. Inscriptions. States. Described. Additional information to [Sm.].

Dawes, Philip
See **Dawe**

Dawkins, Henry *(fl. 1754–1776)*
[Allen] pp. 127–132.*

[St.] pp. 78–80.*

[F.] pp. 89–91.*

Dawski, Stanisław K. *(20th cent.)*
Witz, Ignacy: Catalogue. In *stanisław K. Dawski (Wrocław) Grafika.* Warsaw: Zwiazek Polskich Artystów Plastyków, Centralne Biuro Wystaw Artystycznych, 1968.
Not seen.

Dayes, Edward *(1763–1804)*
[Siltzer] p. 348.
Entries: unnumbered, p. 348. Inscriptions.

Dean, John *(c.1750–1798)*
[Sm.] I, pp. 159–169, and "additions and corrections" section.
Entries: 30 (portraits only). Inches. Inscriptions. States. Described. Illustrated (selection). Located (selection).

[Siltzer] p. 348.
Entries: unnumbered, p. 348. Inscriptions.

[Ru.] pp. 43–45.
Additional information to [Sm.].

Dearborn, Nathaniel *(1786–1852)*
[Allen] p. 132.*

[St.] p. 81.*

[F.] p. 91.*

Debacq, Alexandre *(1804–1850)*
[Ber.] V, p. 140.*

Debenjak, Riko *(b. 1908)*
Moderna Galerija, Ljubljana [Zoran Kržišnik, compiler]. *Riko Debenjak, razstava grafike 1953–1968.* Ljubljana (Yugoslavia); 1969. (DLC)
Entries: 271 (to 1968). Millimeters. Illustrated (selection).

Deblois, Charles Alphonse
(1822–after 1873)
[Ap.] p. 108.
Entries: 8.*

[Ber.] V, pp. 140–141.*

Deblois, Charles Théodore
(1851–after 1878)
[Ber.] V, pp. 141–142.*

Debrie, Gabriel François Louis *(18th cent.)*
[W.] I, p. 387.
Entries: 2.*

Menezes Brum, José Zephyrino de. "Estampas gravadas por Guilherme Francisco Lourenzo Debrie, catalogo." *Annaes da Bibliotheca Nacional do Rio de Janeiro* 28 (1906): 1–116. Separately published. Rio de Janeiro (Brazil): Officinas de Artes Graphicas da Bibliotheca Nacional, 1908. 50 copies. (NN)
Entries: 353+. Millimeters. Inscriptions. Described (selection). Illustrated (selection).

Debucourt, Louis Philibert *(1755–1832)*
[Ber.] V, pp. 142–146.*

[Gon.] II, pp. 267–308.
Entries: unnumbered, pp. 299–310 (prints by Debucourt after his own designs only). Described (selection).

Fenaille, Maurice. *L'Oeuvre gravé de P. L. Debucourt (1755–1832).* Paris: Librairie Damascène Morgand, 1899. 315 copies. (MBMu)

Debucourt, Louis Philibert *(continued)*

Entries: 577 prints by and after. Millimeters. Inscriptions. States. Described.

Decamps, Alexandre Gabriel *(1803–1860)*
Moreau, Adolphe. *Decamps et son oeuvre.* Paris: D. Jouaust, 1869.
Entries: 133 prints by, 269 after. Millimeters. Inscriptions. States. Described. Located (selection).

[Ber.] V, pp. 147–153.
Entries: 20+ etchings, 100+ lithographs. Paper fold measure (selection).

Décaris, Albert *(b. 1901)*
Chabaneix, Philippe. "Dans l'atelier d'Albert Décaris." *Portique* 8 (1951): 29–44.
Bibliography of books with illustrations by, to 1950.

Decker, ——— *(19th cent.)*
[Dus.] p. 28.
Entries: 1 (lithographs only, to 1821). Millimeters. Inscriptions. Located.

Decker, C. *(19th cent.)*
[Dus.] p. 28.
Entries: 1 (lithographs only, to 1821).

Decker, Coenraad *(1651–1685)*
[W.] I, pp. 387–388.
Entries: 9+ .*

[H. *Neth.*] V, p. 138.
Entries: 47+ .*

Decker, Cornelis Gerritsz *(c.1620–1678)*
See also **Decker, J.**

[W.] I, p. 388.
Entries: 3 prints after.*

[H. *Neth.*] V, p. 138.
Entries: 3 prints after.*

Decker, Frans *(1684–1751)*
[W.] I, pp. 388–389.
Entries: 1 print after.*

Decker, Georg *(19th cent.)*
[Dus.] p. 28.
Entries: 11 (lithographs only, to 1821). Described.

Decker, J. *(fl. 1640–1660)*
[W.] I, p. 389.
Entries: 4 prints after.*

[H. *Neth.*] V, p. 138.
Entries: 4 prints after.* Identified by [H. *Neth.*] with Cornelis Gerristsz Decker.

Deckers, Peter *(1823–1876)*
[Merlo] pp. 183–184.*

Deckinger, Hieronymus *(16th cent.)*
[A.] II, pp. 217–219.
Entries: 1. Pre-metric. Inscriptions. Described.

[H. *Ger.*] VI, p. 189.
Entries: 1. Illustrated.*

Decleva, Mario *(b. 1930)*
Sotriffer, Kristian. *Mario Decleva; Figur und Erscheinung, mit einem Werkkatalog sämtlicher Radierungen 1961 bis 1969.* Österreichische Graphiker der Gegenwart, 3. Vienna: Anton Schroll und Co., 1970. 1000 copies. (NN)
Entries: 108 (to 1969). Millimeters. States. Illustrated (selection).

Defrance, Léonard *(1735–1805)*
[W.] I, pp. 389–390.
Entries: 1 print after.*

Degas, Hilaire Germaine Edgar *(1834–1917)*
[Ber.] V, pp. 153–154.*

[Del.] IX.

Entries: 66 (etchings and lithographs only). Millimeters. States. Described (selection). Illustrated. Located (selection).

Galerie Manzi Joyant, Paris. *Catalogue des eaux-fortes, vernis-mous, aquatintes, lithographies et monotypes par Edgar Degas et provenant de son atelier.* Paris, 1918. (CSFAc)
 Entries: 317. Millimeters. States (selection). Illustrated (selection). Sale catalogue of prints from Degas' estate.

Adhemar, Jean. "Les monotypes de Degas (liste provisoire)." Unpublished ms., 1942. (EPBN)
 Entries: 281 (monotypes only). Millimeters.

Guérin, Marcel. "Additions et rectifications au catalogue par L. Delteil des gravures de Degas." Unpublished ms., 1942. (EPBN)
 Transcription of Guerin's annotations to [Del.]; information on technique and location of impressions, etc.

University of Chicago—Renaissance Society and Department of Art [Paul Moses, compiler]. *An exhibition of etchings by Edgar Degas.* Chicago, 1964.
 Entries: 2 (additional to [Del.]). Millimeters. States. Described. Illustrated (selection). Additional information to [Del.].

Kornfeld, E. W. *Edgar Degas; Beilage zum Verzeichnis des graphischen Werkes von Loys Delteil; Vorschläge zur Ergänzung und Abänderung der Nummeru D62 bis 65.* Bern: Verlag Kornfeld und Klipstein, 1965. (ICB)
 Additional information to [Del.].

Moses, Paul. "Notes on an unpublished etching by Degas." [GBA.] 6th ser., 68 (1966): 239–240.
 Entries: 1 (additional to [Del.]). Millimeters. Described. Illustrated. Located.

Fogg Art Museum, Cambridge (Mass.) [Eugenia Parry Janis, compiler]. *Degas monotypes; essay, catalogue, and checklist.* Cambridge (Mass.), 1968.
 Entries: 321 (monotypes only). Inches. Millimeters. States. Described. Illustrated. Located.

Degenhardt, Gertrude *(b. 1940)*
 "Gertrude Degenhardt." *Antiquariat* 20 (1970): 185–192.
 Entries: unnumbered, pp. 190–192 (to 1970). Millimeters. Illustrated (selection).

Degler, Georg *(d. 1685)*
 [H. *Ger.*] VI, p. 190.
 Entries: 4 prints by, 2 after. Illustrated (selection).*

Degouy, Nelly *(20th cent.)*
 Borger, B. de. "Nelly Degouy." *Boek en grafiek* 1 (1946): 25–30.
 Bibliography of books with illustrations by.

Deininger, Jacob Friedrich *(b. 1836)*
 [Ap.] p. 108.
 Entries: 4.*

 "Jakob Friedrich Deininger." [Kh.] 8 (1916): 194.
 Entries: 20. Millimeters. States.

Dekker, Frans
See **Decker**

Delacroix, Eugène *(1798–1863)*
 Moreau, Adolphe. *E. Delacroix et son oeuvre.* Paris: Libraire des Bibliophiles, 1873. 300 copies. (MH)
 Entries: 147 prints by, 6 doubtful and rejected prints, 212 prints after. Millimeters. Inscriptions. States. Described.

 Robaut, Alfred. *L'Oeuvre complet de Eugène Delacroix; peintures, dessins, gra-*

Delacroix, Eugène *(continued)*

vures, lithographies. Paris: Charavay Frères, 1885. Reprint. New York: Da Capo Press, 1969.
>Entries: 1968 paintings, drawings, and prints by. Millimeters. Inscriptions. States. Described. Illustrated (selection). Illustrated from sketches by Robaut.

[Ber.] V, pp. 154–166.
>Summary of Robaut and Moreau.

[Del.] III.
>Entries: 131. Millimeters. Inscriptions. States. Described (selection). Illustrated. Located (selection). Appendix with 6 prints not seen by [Del.] and 12 doubtful and rejected prints.

Delacroix, Jules *(19th cent.)*
[Ber.] V, p. 166.*

Delafleur, Nicholas Guillaume *(c.1600–1663)*
[RD.] IV, pp. 11–16.
>Entries: 25. Pre-metric. Inscriptions. States. Described.

Delaforge, Ambroise *(b. 1817)*
[Ap.] p. 108.
>Entries: 1.*

[Ber.] V, p. 166.*

Delaistre, Louis Jean Désiré *(1800–1871)*
[Ap.] p. 108.
>Entries: 2.*

[Ber.] V, p. 166.*

Delanoy, Ferdinand *(fl. c.1850)*
[Ber.] V, pp. 166–167.*

Delaram, Francis *(c.1590–1627)*
[Hind, *Engl.*] II, pp. 215–242.
>Entries: 47+. Inches. Inscriptions. States. Described. Illustrated (selection). Located.

Delaroche, Hippolyte [called "Paul"] *(1797–1856)*
[Ber.] V, p. 167.*

Delarue, Fortuné *(b. 1794)*
[Ber.] V, p. 167.*

Delâtre, Auguste *(1822–1907)*
[Ber.] V, pp. 168–170.
>Entries: 113. Paper fold measure (selection). Described (selection).

Delâtre, Eugène *(b. 1864)*
Darzens, Rodolphe. "Eugène Delâtre." *Petite Revue Documentaire* 3 (Aug.–Sept. 1895): 9–10; *Petite Revue Documentaire* 4 (Nov. 1895): 3–10. (NN)
>Entries: 61 etchings, unnumbered list (2 pp.) of prints in other techniques (to 1895). States. Described (selection). Complete?

Delatre, Jean Marie
See **Delattre**

Delattre, Jean Marie *(1746–1840)*
Delignières, Émile. "Un graveur de 95 ans; Delattre (Jean Marie) d'Abbeville 1745–1840." [*Réunion Soc. B. A. dép.*] 26th session, 1902, pp. 647–677. Separately published. Paris: Typographie Plon-Nourrit et Cie., 1902.
>Entries: 59. Millimeters. Inscriptions. Described (selection).

Delaulne, Etienne
See **Delaune**

Delaunay, Nicolas *(1739–1792)*
[L. D.] pp. 37–48.
>Entries: 26. Millimeters. Inscriptions. States. Described. Illustrated (selection). Incomplete catalogue.*

Delaunay, Robert *(1749–1814)*
[Ap.] p. 109.
>Entries: 8.*

[Ber.] IX, p. 58.*

[L. D.] pp. 48–51.
Entries: 8. Millimeters. Inscriptions. States. Described. Illustrated (selection). Incomplete catalogue.*

Delaune, Etienne *(1518/19–1583)*
[RD.] IX, pp. 16–130; XI, p. 57.
Entries: 450. Millimeters. Inscriptions. States. Described.

Delauney, Alfred Alexandre *(1830–1894)*
[Ber.] V, pp. 171–179.
Entries: 305. Millimeters (selection). Paper fold measure (selection).

Delaville, Henri *(fl. 1851–1865)*
[Ber.] V, p. 179.*

Delbarre, P. J. *(19th cent.)*
[Ber.] V, p. 179.*

Delbeke, Louis *(1821–1891)*
Buckinx, René. "Kunstschilder Louis Delbeke (1821–1891)." *Memoires de l'Académie Royale de Belgique, Classe des beaux-Arts* 6, fasc. 3. Brussels, 1950.
Entries: 3+. Millimeters (selection).

Delboete, Joseph *(b. 1825)*
[Ap.] p. 109.
Entries: 2.*

[W.] I, p. 390.
Entries: 3.*

Delduc, Edouard *(b. 1864)*
[Ber.] V, p. 180.*

Delegal, James *(18th cent.)*
[Sm.] I, pp. 170–171, and "additions and corrections" section; IV, "additions and corrections" section.
Entries: 2 (portraits only). Inches. Inscriptions. States. Described. Located (selection).

[Ru.] p. 45.
Additional information to [Sm.].

Delegorgue-Cordier, Jean François Gabriel *(1781–1856)*
[Ap.] p. 109.
Entries: 4.*

[Ber.] V, pp. 180–181.*

Delff, Willem Jacobsz *(1580–1638)*
Franken, Daniel. *L'Oeuvre de Willem Jacobszoon Delff.* Amsterdam: C. M. van Gogh, 1872.
Entries: 104 prints by, 7 doubtful prints. Millimeters. Inscriptions. States. Described. Copies mentioned. Ms. notes (ERB); additional states, 1 additional entry.

[Wess.] II, p. 233.
Additional information to Franken.

[W.] I, pp. 393–395.
Entries: 106+.*

[H. *Neth.*] V, pp. 139–234.
Entries: 122. Illustrated (selection).*

Delfini, Delfino *(19th cent.)*
[Ap.] p. 110.
Entries: 2.*

Delfos, Abraham *(1731–1820)*
[W.] I, pp. 395–396.
Entries: 10+.*

Delhez, Victor *(b. 1902)*
Cultureel Centrum, Breda. *Victor Delhez, het volledige werk.* Breda (Netherlands), 1956.
Entries: 937. Millimeters. Described (selection). Illustrated (selection).

Delia-Beurny, A. *(dates uncertain)*
[M.] III, p. 771.
Entries: 1. Paper fold measure.

Delien, Jean François [Jacques François]
See **Delyen**

Delierre, Auguste *(b. 1829)*
[Ber.] V. p. 181.*

Delignon, Jean Louis *(1755–c.1804)*
[Ber.] V, p. 181.*

[L. D.] p. 15.
Entries: 3. Millimeters. Inscriptions.
States. Described. Illustrated (selec-
tion). Incomplete catalogue.*

Dellarocca, Carlo *(19th cent.)*
[Ap.] p. 111.
Entries: 4.*

Delleker, George *(fl. 1812–1824)*
[St.] pp. 81–82.*

Delorme, Pierre Claude François
(1783–1859)
[Ber.] V, p. 181.*

Delphin, Olivier
See **Dauphin**

Delvaux, Paul *(b. 1897)*
Le Bateau Lavoir, Paris. *Paul Delvaux,
dessins et premières lithographies.* Paris,
1966.
Entries: 4 (to 1966). Millimeters. De-
scribed. Illustrated.

Le Bateau Lavoir, Paris. *Paul Delvaux,
cahier no. 2; dessins et gravures 1966–1969.*
Paris, 1969.
Entries: 11 (additional to 1966
catalogue, to 1969). Millimeters. In-
scriptions. Described. Illustrated.

Delvaux, Remi Henri Joseph *(1750–1823)*
[Ber.] V, pp. 181–182.*

Delvecchio, Benjamin
See **Vecchio**

Delyen, Jean François [Jacques François]
(1684–1761)
Huard, Georges. "Delyen." In [Dim.] I,
pp. 261–266.
Entries: 2 prints by, 3 after lost works.

Demange, ——— *(19th cent.)*
[Ber.] V, p. 182.*

Demangeot, C. *(fl. 1850–1900)*
[Ber.] V, pp. 182–183.*

Demannez, Joseph Arnold *(1826–1902)*
[Ap.] p. 116.
Entries: 5.*

[Ber.] V, pp. 183–184.*

Demarcenay de Ghuy, Antoine
See **Marcenay de Ghuy,** Antoine de

De Mare, Johann
See **Mare**

Demarne, Jean Louis [called "Marnette"]
(1744–1829)
[Ber.] V, p. 184.*

[W.] I, pp. 397–398.
Entries: 38+ .*

Demarteau, Gilles *(1722–1776)*
[Demarteau, Gilles Antoine]. *Catalogue
des estampes gravées au crayon d'après diffe-
rens maîtres qui se vendent à Paris chés De-
marteau graveur du roi, et pensionnaire de sa
Majesté pour l'invention de la gravure imit-
ant les dessins . . .* [Paris, 1788?]. (EPBN)
Entries: 560.

Wittert, Adrien. *Gilles Demarteau,
graveur du roi, 1722–1776.* Brussels: G. A.
van Trigt, 1883. (DLC)
Entries: 560. Described (selection).
Reprint of Demarteau 1788. Numbers
correspond to those on the prints
themselves.

Leymarie, L. de. *L'Oeuvre de Gilles De-
marteau l'aîné graveur du roi, catalogue de-
scriptif.* Paris: Georges Rapilly, 1896.
Entries: 560. Millimeters. Inscrip-
tions. Described. Based on Demar-
teau 1788.

Demarteau, Gilles Antoine [called "Demarteau le Jeune"] *(1750–1802)*
[Demarteau, Gilles Antoine]. *Catalogue des estampes gravées au crayon d'après differens maîtres qui se vendent à Paris chés Demarteau graveur du roi, et pensionnaire de sa Majesté pour l''invention de la gravure imitant les dessins*. . . [Paris, 1788?]. (EPBN)
Entries: 104.

Wittert, Adrien. *Gilles Demarteau, graveur du roi, 1722–1776*. Brussels: G. A. van Trigt, 1883. (DLC)
Entries: 104. Described (selection). Reprint of Demarteau 1788. Numbering corresponds to numbers on the prints themselves.

Demeersmann, ——— *(19th cent.)*
[Ap.] p. 112.
Entries: 2.*

Demeulemeester, Joseph Karel *(1771–1836)*
[Ap.] p. 113.
Entries: 4.*

Demin, Giovanni *(1786–1859)*
[AN.] p. 675.
Entries: unnumbered, p. 675. Millimeters. Inscriptions. Described.

Demoussy, Augustin Luc *(1809–1880)*
[Ber.] V, p. 184.*

Denel, C. *(19th cent.)*
[Ap.] p. 113.
Entries: 2.*

Deneys, Frans *(c.1610–1670)*
[W.] I, p. 398.
Entries: 9 prints after.*

[H. *Neth.*] V, p. 235.
Entries: 11 prints after.*

Deni, [Martial?] *(18th cent.)*
[L. D.] pp. 17–18.

Entries: 1. Millimeters. Inscriptions. States. Illustrated. Incomplete catalogue.*

Denis, ——— *(19th cent.)*
[Ber.] V, p. 184.*

Denis, Maurice *(1870–1943)*
Cuignard, Jacques. "Les livres illustrés de Maurice Denis." *Portique* 4 (1946): 49–71.
Bibliography of books with illustrations by (to 1944).

Bibliothèque Municipale, Tours. *Maurice Denis illustrateur; exposition organisée au Musée des Beaux-Arts.* Tours (France), 1966.
Bibliography of books with illustrations by.

Cailler, Pierre. *Catalogue raisonné de l'oeuvre gravé et lithographié de Maurice Denis.* Geneva: Editions Pierre Cailler, 1968. 700 copies. (CSFAc)
Entries: 233. Millimeters. States. Described. Illustrated.

Denk, Conrad *(fl. c.1866)*
[Ap.] p. 113.
Entries: 1.*

Dennel, Louis *(1741–1806)* and Antoine François *(fl. 1760–1815)*
[Ap.] pp. 113–114.
Entries: 14.*

[L. D.] pp. 16–17.
Entries: 3 prints by Louis, 2 by Antoine François. Millimeters. Inscriptions. States. Described. Incomplete catalogue.*

Denon, Dominique Vivant, baron *(1747–1825)*
Catalogo di incisione di Mr Denon. n.p., n.d. (EPBN)
Entries: unnumbered, 8 pp.

Denon, Dominique Vivant, baron
(continued)

Catalogue des estampes gravées par le citoyen D. Vivant Denon, membre de l'Institut National de France, de celui de Bologne, et des Académies des Arts de Florence et de Venise; se vendent à la calcographie du Musée Centrale des Arts et chez le cit. Aubourg. Paris, 1803. (EPBN)
 Entries: unnumbered, pp. 3–15.

Fizelière, Albert de la. *L'Oeuvre originale de Vivant Denon . . . avec un notice très detaillée sur sa vie intime, ses relations et son oeuvre.* 2 vols. Paris: A. Barraud, 1873. 500 copies. (DLC)
 Entries: 317 etchings (reprinted from the original plates). Described (selection). Illustrated. Also, list of 271 lithographs (titles only).

[Ber.] V, pp. 184–185.*

Dente, Marco [called "Marco da Ravenna"] *(d. 1527)*
 [B.] XIV, pp. 3–416.
 Catalogued under Marcantonio, prints are not separately numbered.

 [Evans] pp. 18–19.
 Entries: 4 (additional to [B.]). Millimeters. Inscriptions. Described.

 [P.] VI, pp. 67–73.
 Entries: 65 (new numbering, revision of [B.]). Pre-metric. Inscriptions (selection). Described (selection). Only entries additional to [B.] are fully catalogued.

 [Dis.] 1927.
 Additional information to [B.].

Denys, Frans
 See **Deneys**

Denzler, Hans Rudolf *(1801–1857)*
 [Ap.] p. 114.
 Entries: 2.*

De Pol, John *(b. 1913)*
 State University of New York, Binghamton—University Art Gallery. *John De Pol: a retrospective.* Binghamton (N.Y.), 1969.
 Bibliography of books with illustrations by (to 1968).

Dequevauviller family *(18th cent.)*
 [Ap.] pp. 114–115.
 Entries: 23.*

Dequevauviller, François Jacques *(1793–after 1848)*
 See also **Dequevauviller** family

 [Ber.] V, pp. 185–186.*

Dequevauviller, François Nicolas Barthélemy *(1745–1807)*
 Se also **Dequevauviller** family

 [L. D.] pp. 18–21.
 Entries: 7. Millimeters. Inscriptions. States. Described. Illustrated (selection). Incomplete catalogue.*

Derain, André *(1880–1954)*
 Adhémar, Jean. *Derain.* Paris: Bibliothèque Nationale, 1955.
 Entries: 132+. Millimeters (selection). Paper fold measure (selection). Located.

Hilaire, Georges. *Derain.* Geneva: Pierre Cailler, 1959.
 Bibliography of books with illustrations by.

Diehl, Gaston. *Derain.* Paris. Flammarion, [1964?].
 Bibliography of books with illustrations by.

Derancourt, ——— *(19th cent.)*
 [Ber.] V, p. 186.*

Derlange, Jean Nicolas *(18th cent.)*
 Beaupré, J. N. "Notice sur quelques graveurs nancéiens du XVIIIe siècle et

sur leurs ouvrages." [*Mém. lorraine*] (2d ser., 9) (1867): 221–225. Separately published. n.p., n.d.
Entries: 4. Inscriptions. Described.

Dermonde, J. A. *(fl. c.1617)*
[W.] I, p. 399.
Entries: 1.*

Deroy, Laurent *(1797–1886)*
[Ber.] V, pp. 186–187.*

Derschau, Hans Albrecht von *(19th cent.)*
Horrak, Emil von. "Ergaenzungen zum Holzschnittwerk H. A. von Derschau: vier Lieferungen, Gotha 1808–1816." Unpublished, ms., 1939. (EWA)
Entries: 800. Millimeters. Inscriptions. Described. Catalogue of early woodcuts reprinted by Derschau.

Dertinger, Ernst *(1816–1865)*
[Ap.] p. 115.
Entries: 11.*

Deruet, Claude *(1588–1660)*
[RD.] V, pp. 73–77; XI, p. 58–63.
Entries: 37. Millimeters. Inscriptions. States. Described.

Meaume, Édouard. "Recherches sur la vie et les oeuvres de Claude Deruet, peintre et graveur lorrain." *Bulletins de la Société d'archéologie lorraine* 4 (1853): 135–250.
Entries: 5. Millimeters. Inscriptions. States. Described. Appendix with prints after, unnumbered, pp. 219–236.

Meaume, Edouard. *Recherches sur la vie et les ouvrages de Claude Deruet, peintre et graveur lorrain (1588–1660).* Nancy (France): A. Lepage, 1853. 2d ed. Paris: J. B. Dumoulin, 1854.
Entries: 5 prints by, 1 doubtful print, 19 prints after. Millimeters. Inscriptions. States. Described.

Desanctis, Filippo
See **Sanctis**

Desaulx, Jean *(fl. c.1800–1850)*
[Ap.] p. 116.
Entries: 4.*

[Ber.] V, p. 187.*

Desavary, Charles Paul Etienne *(1837–1885)*
[Ber.] V, pp. 187–188.*

Desbois, Martial *(1630–c.1700)*
[RD.] IV, pp. 199–212; XI, pp. 64–78.
Entries: 94. Pre-metric. Inscriptions. States. Described.

Desboutin, Marcellin Gilbert *(1823–1902)*
[Ber.] V, pp. 188–194; [Ber.] supplement, pp. 1–11.
Entries: 167. Millimeters. (selection). Paper fold measure (selection). Described.

Clément-Janin, ——— *La curieuse vie de Marcellin Desboutin, peintre, graveur, poète.* Paris: H. Floury, 1922.
Entries: 297. Millimeters. Inscriptions. States. Described. Illustrated (selection).

Desbrosses, Léopold *(b. 1821)*
[Ber.] V, pp. 194–195.*

Descaves, Alphonse *(b. 1830)*
[Ber.] V, p. 195.*

Deschamps, Emile Marie Benjamin *(fl. 1868–1878)*
[Ber.] V, p. 195.*

Desclaux, Théophile Victor *(fl. 1800–1850)*
[Ap.] p. 116.
Entries: 6.*

[Ber.] V, pp. 195–196.*

Desenne, Alexandre Joseph *(1785–1827)*
[Ber.] V, p. 196.*

Desfriches, Aignan Thomas *(1715–1800)*
Jarry, André. Catalogue. In *Un amateur orléanais au XVIIIe siècle, Aignan-Thomas Desfriches,* by Paul Ratouis de Limay. Paris: H. Champion, 1907. 300 copies. (MH)
 Entries: 4. Millimeters. Described. List of prints after, unnumbered, pp. 193–197, titles and dimensions only.

Deshayes, Célestin *(19th cent.)*
[Ber.] V, p. 196.*

Deshayes, Eugène *(19th cent.)*
[Ber.] V, p. 196. *

Deshayes, Jean *(17th cent.)*
[RD.] III, pp. 210–213; XI, p. 79.
 Entries: 7. Pre-metric. Inscriptions. Described.

Desidero, Francesco *(dates uncertain)*
[P.] VI; *See* **Chiaroscuro Woodcuts**

Desjardin, C. *(19th cent.)*
[Dus.] p. 29.
 Entries: 2 (lithographs only, to 1821). Millimeters. Inscriptions. Located.

Desjardins, Isnard *(19th cent.)*
[Ber.] V, p. 197.*

Desler, Johann *(fl. c.1650–1700)*
[H. *Ger.*] VI, p. 190.
 Entries: 2 prints after.*

Deslynes, Jean François[Jacques François]
See **Delyen**

Desmadryl, Narcisse Edmond Joseph *(b. 1801)*
[Ap.] p. 116.
 Entries: 2.*

[Ber.] V, pp. 197–198.*

Desmaisons, Emile *(1812–1880)*
[Ber.] V, pp. 198–200.*

Desmannes, Joseph Arnold
See **Demannez**

Desmannez, Joseph Arnold
See **Demannez**

Desmarées, Georg *(1697–1776)*
Hernmarck, Carl. *Georg Desmarées.* Studien über die Rokokomalerei in Schweden und Deutschland. Uppsala (Sweden): Almquist and Wiksell, 1933.
 Entries: 55 prints after. Located.

Desmarets, ——— *(19th cent.)*
[Ber.] V, p. 200.*

Desnoyers, Auguste Gaspard Louis, baron *(1779–1857)*
[Ap.] pp. 117–121.
 Entries: 44.*

[Ber.] V, pp. 200–206.
 Entries: 35 (engravings only; earliest works not included). Paper fold measure.

Desperret, ——— *(d. 1865)*
[Ber.] V, p. 206.*

Desprée, Jean Louis
See **Desprez**

Desprez, Jean Louis *(1743–1804)*
[Baud.] II, pp. 261–274.
 Entries: 23. Millimeters. Inscriptions. States. Described.

Wollin, Nils Gustaf Axelsson. *Gravures originales de Desprez ou exécutées d'après ses dessins.* Malmö (Sweden): John Kroon, A. B. Malmö Ljustrycksanstalt, 1933. 500 copies. (NN)
 Entries: 45 prints by; prints after not consecutively numbered, pp. 50–54, 59–115, 122–138. Millimeters. Inscriptions. Described. Illustrated (selection).

Wollin, Nils G. *Desprez en Italie, dessins topographiques et d'architecture, decors de théatre et compositions romantiques, executés 1777–1784.* Malmö (Sweden): John Kroon, A. B. Malmö Ljustrycksanstalt, 1935. 400 copies. (MH)
Additional information to Wollin 1933. Located.

Destappe, François Jacques Marie Maurice *(fl. 1868–1882)*
[Ber.] V, p. 207.*

Desterbecq, François *(b. 1807)*
[W.] I, p. 400.
Entries: 1.*

Desvachez, David Joseph *(1822–1902)*
[Ap.] pp. 121–122.
Entries: 9.*

[Ber.] V, p. 207.*

Desvignes, Herbert Clayton *(fl. 1833–63)*
[Siltzer] p. 329.
Entries: unnumbered, p. 329, prints after. Inscriptions.

Detaille, Edouard *(1848–1912)*
[Ber.] V, p. 208.*

Dethier [**De Thier**], Hendrik *(c.1610–after 1633)*
[W.] I, p. 400.
Entries: 3.*

[H. *Neth.*] V, p. 236.
Entries: 3.*

Detmold, Charles Maurice *(1883–1908)* and Edward Julius *(b. 1883)*
Dodgson, Campbell. "Maurice und Edward Detmold." [*GK.*] 33 (1910): 17–24.
Catalogue: "Verzeichnis der Radierungen, Holzschnitte und Lithographien von Maurice und Edward Detmold." [*MGvK.*] 1910: pp. 17–22.
Entries: 65 (to 1910). Described.

Dodgson, Campbell. "Maurice and Edward Detmold." [*PCQ.*] 9 (1922): 373–405.
Entries: 66 (to 1910). Inches. Inscriptions. States. Described. Illustrated (selection).

Detouche, Henry Julien *(1854–1913)*
[Ber.] V, p. 208.*

Détrez, Ambroise *(1811–1863)*
[Ber.] V, p. 209.*

Detroy, Jean François
See **Troy**

Dettmers, ――― *(19th cent.)*
[Dus.] p. 29.
Entries: 1 (lithographs only, to 1821). Millimeters. Inscriptions.

Deucker, Georg Heinrich Karl *(1801–1863)*
[Ap.] p. 122.
Entries: 5.*

Deutsch, Hans Rudolf Manuel [called "Deutsch the Younger"] *(1525–1571)*
[B.] IX, pp. 324–330.
Entries: 29. Pre-metric. Inscriptions. Described.

[Heller] pp. 88–89.
Entries: 1+ (additional to [B.]). Pre-metric.

[P.] III, pp. 437–439.
Entries: 4+ (additional to [B.]). Pre-metric. Inscriptions. Described. Located (selection).

[H. *Ger.*] VI, pp. 197–207.
Entries: 48+. Illustrated (selection).*

Deutsch, Nikolas Manuel [called "Deutsch the Elder"] *(c.1484–1530)*
[B.] VII, pp. 468–469.
Entries: 10. Pre-metric. Inscriptions. Described (selection).

Deutsch, Nikolas Manuel *(continued)*

[Heller] p. 88.
Additional information to [B.].

[P.] III, pp. 433–437.
Entries: 3+ (additional to [B.]). Paper fold measure. Inscriptions. Described. Located.

Koegler, Hans. "Die Holzschnitte des Niklaus Manuel Deutsch." *Jahresbericht der öffentlichen Kunstsammlung Basel*, n.s. 21 (1924): 43–75.
Entries: 4+. Millimeters. Inscriptions. Described. Illustrated.

Stumm, Lucie. *Niklaus Manuel Deutsch von Bern als bildender Künstler.* Bern: Stämpfli et Cie, 1925.
Entries: 10. Millimeters. Inscriptions. Described. Illustrated. Located.

[H. *Ger.*] VI, pp. 191–196.
Entries: 43+. Illustrated (selection).*

Devambez, ——— *(fl. c.1885)*
[Ber.] V, pp. 209–210.*

Devel, P. *(18th cent.)*
[W.] I, p. 401.
Entries: 4.*

Deventer, Jacob van *(c.1510–1575)*
[H. *Neth.*] V, p. 236.
Entries: 2+.*

Deventer, Willem Antonie van *(1824–1893)*
[H. L.] p. 192.
Entries: 1. Millimeters. Inscriptions. Described.

Devéria, Achille Jacques Jean Marie *(1800–1857)*
[Ber.] V, pp. 210–225; [Ber.] supplement pp. 1–80.
Entries: 448. Paper fold measure. Inscriptions (selection). Described.

Gauthier, Maximilien. *Achille et Eugène Devéria.* Paris: H. Floury, 1925.

List of names of persons portrayed in lithographs by.

Gusman, Pierre. "Achille Devéria, illustrateur et lithographe romantique (1800–1857)." *Byblis* 6 (1927): 34–40.
Bibliography of books with illustrations by.

Deville, Henry Wilfrid *(1871–1939)*
Musée des Beaux-Arts, Nantes. *E. Phélippes Beaulieux, H. W. Deville, R. Pinard; catalogue de l'oeuvre complet de chaque graveur.* Nantes (France), 1955. (DLC)
Entries: 213. Millimeters. States. Illustrated (selection).

Devilliers Brothers *(19th cent.)*
[Ber.] V, p. 225.*

Devis, Arthur *(1708–1787)*
Pavière, Sydney H. *The Devis family of painters.* Leigh-on-Sea (England): F. Lewis, 1950. 500 copies. (EBM)
Catalogue of paintings; prints after are mentioned where extant.

Devis, Arthur William *(1763–1822)*
Pavière, Sydney H. *The Devis family of painters.* Leigh-on-Sea (England): F. Lewis, 1950. 500 copies. (EBM)
Catalogue of paintings; prints after are mentioned where extant.

Devrits, Charles *(fl. 1800–1850)*
[Ber.] V, p. 225.*

Dewing, Francis *(fl. 1716–1722)*
[St.] p. 83.*

Dexel, Walter *(b. 1890)*
Vitt, Walter. *Walter Dexel; Werkverzeichnis der Druckgraphik von 1915–1971.* Cologne: Buchhandlung Walther König, 1971.
Entries: 73. Millimeters. Described. Illustrated.

Deyrer, Johann *(19th cent.)*
[Dus.] p. 29.
　Entries: 1 (lithographs only, to 1821).
　Millimeters. Inscriptions. Located.

Deyster, Lodewyk de *(c.1656–1711)*
[B.] V, pp. 453–462.
　Entries: 8. Pre-metric. Inscriptions.
　Described.

[Weigel] pp. 330–332.
　Entries: 6 (additional to [B.]). Pre-
　metric. Inscriptions. Described.

[Heller] p. 43.
　Additional information to [B.].

[W.] I, pp. 402–403.
　Entries: 15.*

[H. *Neth.*] V, pp. 237–240.
　Entries: 16. Illustrated (selection).*

Diamaer, Hendrik Frans *(b. 1685)*
[W.] I, p. 403.
　Entries: 4.*

Diamantini, Giuseppe *(1621–1705)*
[B.] XXI, pp. 267–288.
　Entries: 40. Pre-metric. Inscriptions.
　Described.

[Heller] p. 43.
　Entries: 1 (additional to [B.]). Pre-
　metric. Inscriptions. Described.

[Wess.] III, p. 47.
　Entries: 7 (additional to [B.]). Mil-
　limeters. Inscriptions. Described.

Calabi, Augusto. "Le acqueforti di
Giuseppe Diamantino." [GK.] n.s. 1
(1936): 25–40.
　Entries: 52. Millimeters. Inscriptions.
　States. Described (selection). Illus-
　trated (selection). All prints not illus-
　trated are described.

Diamar, Hendrik Frans
　See **Diamaer**

Diaz de la Peña, Vergilio Narcisso [called
"Narcisse Diaz"] *(1808–1876)*
[Ber.] V, pp. 225–226.*

Hediard, Germain. "Les maîtres de la
lithographie: Diaz." *L'Artiste,* n.s. 9
(1895, no. 1): 36–43. Separately pub-
lished. Le Mans (France): E. Monnoyer,
1895.
　Entries: 10. Millimeters. Inscriptions.
　States. Described.

Dich, Ole *(20th cent.)*
Fogedgaard, Helmer. "Ole Dich." [N.
ExT.] 7 (1955): 88–90.
　Entries: 13 (bookplates only, to 1955).
　Described. Illustrated (selection).

Fogedgaard, Helmer. "Ole Dich II." [N.
Ext.] 8 (1956): 3–5.
　Entries: 19 (bookplates only, addi-
　tional to 1955 catalogue; to 1956). De-
　scribed. Illustrated (selection).

Fogedgaard, Helmer. "Ole Dich III." [N.
Ext.] 9 (1957): 122–124, 126.
　Entries: 29 (bookplates only, addi-
　tional to 1955 and 1956 catalogues; to
　1957). Described. Illustrated (selec-
　tion).

Dichtl, Martin *(fl. 1675–1700)*
[A.] V, pp. 258–263.
　Entries: 10. Pre-metric. Inscriptions.
　Described.

[H. *Ger.*] VI, p. 208.
　Entries: 14.*

Dick, Hans
　See **Monogram HD** [Nagler, *Mon.*] III,
　no. 819

Dick, Thomas *(19th cent.)*
[Siltzer] p. 348.
　Entries: unnumbered, p. 348. Inscrip-
　tions.

Dickes, William *(b. 1815)*
Docker, Alfred. *The colour prints of Wil-*

Dickes, William *(continued)*

liam Dickes. London: Courier Press, 1924.
350 copies. (CSFAc)
Entries: 327+. Inches. Inscriptions.
Described (selection). Illustrated
(selection).

Dickesonn, Charles *(fl. 1619–1644)*
[Hind, *Engl.*] III, p. 216.
Entries: 1. Inches. Inscriptions. De-
scribed. Illustrated. Located.

Dickinson, Lowes Cato *(1819–1908)*
[Siltzer] p. 348.
Entries: unnumbered, p. 348. Inscrip-
tions.

Dickinson, William *(1746–1823)*
[Sm.] I, pp. 171–203, and "additions and
corrections" section; IV, "additions and
corrections" section.
Entries: 96 (portraits only). Inches. In-
scriptions. States. Described. Illus-
trated (selection). Located (selection).

[Ru.] pp. 45–53, 490.
Entries: 1 (portraits only, additional to
[Sm.]). Described. Located. Addi-
tional information to [Sm.].

Didier, Adrien *(1838–1924)*
[Ber.] V, pp. 226–228.
Entries: 54.

Didier, Jules *(1831–1892)*
[Ber.] V, p. 230.*

Diekmann, Aegidius *(fl. 1600–1625)*
[H. *Ger.*] VI, pp. 209–211.
Entries: 16. Illustrated (selection).*

Dielen, Adriaan Jacob William van
(1772–1812)
[H. L.] pp. 194–195.
Entries: 4. Millimeters. Inscriptions.
States. Described.

Diemen, C. van *(fl. c.1670)*
[W.] I, p. 403.
Entries: 1 print after.*

[H. *Neth.*] V, p. 240.
Entries: 1 print after.*

Dien, Claude Marie François *(1787–1865)*
[Ap.] pp. 122–123.
Entries: 17.*

[Ber.] V, pp. 230–235.*

Diepenbeeck, Abraham *(1596–1675)*
[Dut.] IV, p. 100.*

[W.] I, pp. 403–405.
Entries: 1 print by, 32+ after.*

[H. *Neth.*] V, pp. 241–243.
Entries: 1 print by, 233+ after. Illus-
trated (selection).*

Diepram, Abraham *(1622–1670)*
[W.] I, p. 406.
Entries: 1 print after.*

[H. *Neth.*] V, p. 244.
Entries: 1 print after.*

Dies, Albert Christoph *(1755–1822)*
[A. 1800] III, pp. 123–144.
Entries: 28. Pre-metric. Inscriptions.
States. Described.

Dietrich, Christian Wilhelm Ernst
(1712–1774)
Heinecken, Karl Heinrich von. *Nach-
richten von Künstlern und Kunst-Sachren.*
Vol. I, pp. 127–163. Leipzig: Johann Paul
Kraus, 1768.
Entries: 114+. Pre-metric. Inscrip-
tions. States. Described.

Linck, J. F. *Monographie der von . . . C.
W. E. Dietrich radierten, geschabten und in
Holz geschnittenen malerischen Vorstel-
lungen.* Berlin: Verlag von J. F. Linck,
1846. (MBMu)

Entries: 181 prints by, 9 doubtful and rejected prints. Pre-metric. Inscriptions. States. Described.

[Wess.] I, p. 135.
Additional information to Linck.

Dietrich, Friedrich Christoph *(1779–1847)*
[W.] I, p. 407.
Entries: 2+.

Dietricy, Christian Wilhelm Ernst
See **Dietrich**

Dietterlin, Bartholomaeus *(c.1590–c.1620)*
[A.] IV, pp. 278–283.
Entries: 5+. Pre-metric. Inscriptions. Described.

[H. *Ger.*] VI, p. 211.
Entries: 3.*

Dietterlin, Hilarius *(fl. 1600–1625)*
[H. *Ger.*] VI, p. 211.
Entries: 1 print after.*

Dietterlin, Peter *(fl. c.1675–1700)*
[H. *Ger.*] VI, p. 211.
Entries: 1+ prints after.*

Dietterlin, Wendel I *(1550–1599)*
[A.] II, pp. 244–280.
Entries: 16+. Pre-metric. Inscriptions. States. Described. Appendix with one doubtful print.

[H. *Ger.*] VI, pp. 212–215.
Entries: 18+ prints by, 4 after. Illustrated (selection).*

Dietterlin, Wendell II *(fl. c.1615)*
[H. *Ger.*] VI, pp. 216–219.
Entries: 4+. Illustrated (selection).*

Dietze, August *(19th cent.)*
[Dus.] p. 29.
Entries: 1 (lithographs only, to 1821). Millimeters. Inscriptions.

Diez, Julius *(b. 1870)*
[Dus.] p. 29.
Entries: 1 (lithographs only, to 1821). Millimeters. Inscriptions. Located.

Dighton, Denis *(1792–1827)*, Richard *(1795–1880)* and Robert *(1752–1814)*
Hake, Henry M. "Dighton Caricatures." [*PCQ.*] 13 (1926): 137–155, 237–247.
Entries: unnumbered, pp. 147–155, 237–247. Inscriptions. Illustrated (selection).

Dignimont, André *(1891–1965)*
Warnod, André. *Dignimont.* Les artistes du livre, 9. Paris: Henry Babou, 1929. 700 copies. (NN)
Bibliography of books with illustrations by, to 1929.

Hesse, Raymond. "Dignimont." [*AMG.*] 4 (1930–1931): 181–188.
Bibliography of books with illustrations by, to 1930.

Dilich, Johann Wilhelm *(1600–c.1660)*
[H. *Ger.*] VI, p. 220.
Entries: 1+.*

Dilich, Wilhelm *(1571–1650)*
[A.] III, pp. 303–326.
Entries: 5+. Pre-metric. Inscriptions. Described.

[H. *Ger.*] VI, pp. 220–221.
Entries: 6+. Illustrated (selection).*

Dillens, Adolf Alexander *(1821–1877)*
[H. L.] pp. 195–200.
Entries: 10. Millimeters. Inscriptions. States. Described.

Dillens, Hendrik *(1812–1872)*
[H. L.] pp. 200–201.
Entries: 2 (etchings only). Millimeters. Inscriptions. Described. Also, list of 3 lithographs (titles only).

Dillis, Georg von *(1759–1841)*
[A. 1800] IV, pp. 137–200.
Entries: 53. Millimeters. Inscriptions.
States. Described. Also, list of 5 prints
after (not fully catalogued).

[Dus.] p. 29.
Entries: 2 (litographs only, to 1821).
Millimeters. Inscriptions. Described.
Located.

Dine, Jim *(b. 1935)*
Galerie Mikro, Berlin. *Jim Dine complete
graphics.* Berlin (West Germany): Gal-
erie Mikro; Hannover (West Germany):
Kestner Gesellschaft; London: Peters-
burg Press, 1970.
Entries: 77 (to 1969). Millimeters. De-
scribed. Illustrated.

Dinger, Fritz *(1827–1904)*
[Ap.] p. 124.
Entries: 8.*

Dircksen van Campen, Johan *(fl. c.1620)*
[H. *Neth.*] V, p. 244.
Entries: 4.*

Diricks. Christian *(fl. c.1670)*
[H. *Ger.*] VI, p. 221.
Entries: 2.*

Diricksen, Dirck *(1613–1653)*
[H. *Ger.*] VI, p. 222.
Entries: 19.*

Diricksen, Jan *(fl. c.1600–1625)*
[H. *Ger.*] VI, pp. 222–224.
Entries: 19. Illustrated (selection).*

Disertori, Benvenuto *(b. 1887)*
Calabi, Augusto. "The etchings of Ben-
venuto Disertori." [*PCQ.*] 22 (1935):
41–61.
Entries: 35 (to 1934?). Millimeters. In-
scriptions. Illustrated (selection).

Diskay, Lenke *(20th cent.)*
Rödel, Klaus. *Lenke Diskay exlibris, en un-
garsk exlibriskunstner.* Frederikshavn
(Denmark): Privately published, 1967.
60 copies. (DLC)
Entries: 114 (bookplates only, to 1967).
Millimeters. Illustrated (selection).

Disteli, Martin *(1802–1844)*
Wälchli, Gottfried. *Martin Distel; 1802–
1844. Zeit—Leben—Werk.* Zurich:
Amstutz, Herdeg und Co., 1943.
Entries: unnumbered, pp. 104–108,
prints by (?) and after.

Ditmar, J. *(fl. 1775–1792)*
[W.] I, p. 438.
Entries: 1.*

Ditmar, Johannes *(c.1538–1603)*
[W.] I, p. 409.
Entries: 2.*

[H. *Neth.*] V, p. 244.
Entries: 6.*

Dittmann, Christian *(d. 1702)*
[H. *Ger.*] VI, p. 224.
Entries: 4+ prints after.*

Dittmers, Heinrich *(d. 1670)*
[H. *Ger.*] VI, p. 225.
Entries: 4 prints by, 15 after.*

Ditzinger, Ludwig *(fl. c.1600)*
[H. *Ger.*] VI, pp. 226–227.
Entries: 16. Illustrated (selection).*

Dix, Otto *(b. 1891)*
Galerie Meta Nierendorf, Berlin [Florian
Karsch, compiler]. *Otto Dix; Bilder,
Aquarelle, Zeichnungen, das graphische
Gesamtwerk 1913–1960.* Berlin, 1961.
Entries: 272 (to 1960). Millimeters. Il-
lustrated.

Karsch, Florian. *Otto Dix; das graphische
Werk.* Hannover (West Germany):

Fackelträger-Verlag Schmidt-Küster, 1970.
>Entries: 352. Millimeters. Inscriptions. States. Described. Illustrated.

Dixon, John *(1720/30–1804)*
[Sm.] I, pp. 203–218, and "additions and corrections" section.
>Entries: 40 (portraits only). Inches. Inscriptions. States. Described. Illustrated (selection). Located (selection).

[Ru.] pp. 53–58, 490.
>Entries: 1 (portraits only, addition to [Sm.]). Inches. Inscriptions. Described. Additional information to [Sm.].

Diziani, Gasparo *(1689–1767)*
[Vesme] p. 375.
>Entries: 2. Millimeters. Described. Located.

[AN.] pp. 481–482.
>Entries: 2. Millimeters. Described. Located. Based on [Vesme].

Dobbenburgh, Aert van *(20th cent.)*
Schwencke, Johan. "Overzichten II." *Boekcier* 9 (1940): 5–6.
>Entries: unnumbered p. 6 (bookplates only, to 1939). Illustrated (selection).

Dobler, Anton *(fl. c.1680)*
[H. *Ger.*] VI, p. 227.
>Entries: 1.*

Dobužinski, Mstislav Valerianovič *(1875–1957)*
Makovski, S. K., and Notgafta, F. F. *Grafika M. V. Dobužinskogo.* Berlin: Petropolis, 1924. 50 copies. (DLC)
>Entries: unnumbered, pp. 74–76 (to 1923). Illustrated (selection).

Doby, Eugen *(1834–1907)*
[Ap.] pp. 124–125.
>Entries: 7.*

Docen, Bernhard *(19th cent.)*
[Dus.] p. 30.
>Entries: 1 (lithographs only, to 1821). Millimeters. Inscriptions. Located.

Dodd, Francis *(1874–1949)*
Schwabe, Randolph. "Francis Dodd." [*PCQ.*] 13 (1926): 243–272, 369–375.
>Entries: 172 (to 1926). Inches. States.

[Wright, Harold J. L. ?]. Unfinished catalogue of prints by Francis Dodd. Unpublished ms. (ECol)
>Entries: 148. Inches. Millimeters. Inscriptions. States.

Dodd, Robert *(1748–1816)*
[Siltzer] p. 348.
>Entries: unnumbered, p. 348. Inscriptions.

Dodd, Samuel *(1797–1862)*
[F.] p. 91.*

Dodson, Richard W. *(1812–1867)*
[St.] pp. 83–87.*

[F.] p. 92.*

Döbler, Georg *(1788–1845)*
[Ap.] p. 125.
>Entries: 1.*

Doedyns, Willem *(1630–1697)*
[H. *Neth.*] V, p. 244.
>Entries: 1 print after.*

Doelen, Jacob *(fl. c.1778)*
[W.] I, p. 409.
>Entries: 2 prints after.*

Doening, Herman
See **Monogram HD** [Nagler, *Mon.*] III, no. 820

Dörinck, Daniel *(fl. 1600–1625)*
[H. *Ger.*] VI, p. 231.
>Entries: 3.*

Döring, Hans *(fl. 1514–1557)*
[H. *Ger.*] VI, pp. 229–230.
Entries: 3+. Illustrated (selection).*

Döringk, A. *(fl. 1590–1600)*
[A.] IV, pp. 232–233.
Entries: 1. Pre-metric. Inscriptions.
Described.

[H. *Ger.*] VI, p. 231.
Entries: 1.*

Does, Anthony van der *(1609–1680)*
[W.] I, pp. 409–410.
Entries: 22.*

[H. *Neth.*] V, pp. 245–247.
Entries: 68. Illustrated (selection).

Does, Jacob I van der *(1623–1673)*
[B.] IV, pp. 191–196.
Entries: 1. Pre-metric. Inscriptions.
Described.

[Weigel] pp. 182–183.
Entries: 3 (additional to [B.]). Pre-
metric. States. Described.

[Dut.] IV, pp. 100–101.
Entries: 4. Millimeters. Inscriptions.
States. Described.

[W.] I, p. 410.
Entries: 4+ prints by, 1 after.*

[H. *Neth.*] V, pp. 248–249.
Entries: 5 prints by, 1 after. Illustrated
(selection).

Does, Simon van der *(1653–1718)*
[W.] I, p. 411.
Entries: 2 prints after.*

[H. *Neth.*] V, p. 249.
Entries: 3 prints after.*

Doesburgh, Thomas *(fl. 1692–1714)*
[W.] I, p. 411.
Entries: 2.*

Doesjan, A. *(fl. c. 1786)*
[W.] I, p. 411.
Entries: 1 print after.*

Doetechum, Johannes I van
(c.1530–after 1606)
[W.] I, pp. 411–412.
Entries: 7+.*

[H. *Neth.*] V, pp. 250–254.
Entries: 11+. Illustrated (selection).

Doetechum, Johannes II van *(c.1560–1630)*
[H. *Neth.*] V, pp. 255–256.
Entries: 6+.*

Doetechum, Lucas van *(fl. c.1559)*
[W.] I, p. 412.
Entries: 3+.*

[H. *Neth.*] V, p. 256.
Entries: 15+.*

Dofin, Olivier
See **Dauphin**

Doglioni, Virginio *(b. 1896)*
[AN.] pp. 708–709.
Entries: unnumbered, pp. 708–709.
Millimeters. Inscriptions. Described.

Dolendo, Bartholomeus *(c.1571–c.1629)*
[W.] I, p. 412.
Entries: 18+.*

[H. *Neth.*] V, pp. 257–260.
Entries: 99+. Illustrated (selection).*

Dolendo, Zacharias *(1561–c.1604)*
[W.] I, pp. 412–413.
Entries: 21+.*

[H. *Neth.*] V, pp. 261–264.
Entries: 88. Illustrated (selection).*

Dombrowski, Ernst *(b. 1896)*
Dombrowski, Ernst. *Der Holzschneider
Dombrowski, Leben und Werk.* Graz
(Austria): Verlag Styria, 1964.

Entries: unnumbered, pp. 163–167 (illustrated books and sets of prints only, to 1964?).

Domenech, Francisco *(fl. c.1480)*
[W.] I, p. 413.
Entries: 1.*

[H. *Neth.*] V, p. 265.
Entries: 1.*

Domjan, Joseph *(b. 1907)*
New Jersey State Museum, Trenton. *Domjan the woodcutter.* River Edge (N.J.): Art Edge, 1966. (PPPM)
Entries: 247. Inches. Illustrated (selection). Located (selection).

Donauer, Georg *(b. 1571/72)*
[H. *Ger.*] VI, p. 228.
Entries: 1+ prints after.*

Donauer, Lorenz *(fl. c.1539?)*
See **Monogram LD** [Nagler, *Mon.*] IV, no. 1014

Donck, Gerard *(c.1610–c.1640)*
[H. *Neth.*] V, p. 265.
Entries: 1+ .*

Dongen, Dionys van *(1748–1819)*
[W.] I, p. 413.
Entries: 1 print after.*

Dongen, Kees van *(1877–1968)*
Chaumeil, Louis. *Van Dongen; l'homme et l'artiste—la vie et l'oeuvre.* Geneva: Pierre Cailler, 1967.
Bibliography of books with illustrations by.

Donnay, Jean *(b. 1897)*
Musée des Beaux-Arts, Liège. *Retrospective Jean Donnay.* Liége (Belgium). 1957.
Entries: 625 (to 1957). Millimeters. Illustrated (selection).

Donnet, Johannes *(18th cent.)*
Bergau, R. "Die Danziger Kupferstecher Samuel und Johann Donnet." [*N. Arch.*] 13 (1867): 145–151.
Entries: 8. Pre-metric. Inscriptions. Described.

Donnet, Samuel *(fl. 1699–1734)*
Bergau, R. "Die Danziger Kupferstecher Samuel und Johann Donnet." [*N. Arch.*] 13 (1867): 145–151.
Entries: 19. Pre-metric. Inscriptions. Described.

Donnhäuser, Philipp Heinrich *(fl. c.1771)*
[Merlo] p. 192.*

Donst, Franz *(fl. c.1725)*
[Merlo] p. 192.*

Donzak, Samuel *(fl. c.1678)*
[H. *Ger.*] VI, p. 228.
Entries: 1.*

Doo, George Thomas *(1800–1886)*
[Ap.] pp. 125–126.
Entries: 27.*

Doolittle, Amos *(1754–1832)*
[Allen] pp. 132–134.*

[St.] pp. 87–94.*

[F.] pp. 92–99.*

Beardsley, William A. *An old New Haven engraver and his work; Amos Doolittle.* n.p. 1910. 31 copies. (MH)
Entries: 62.

Allen, Francis W. "Notes on the bookplates of Amos Doolittle." *Old-time New England* 39 (1948): 38–44.
Entries: 17 prints by, 2 doubtful prints (bookplates only). Inches (selection). Inscriptions. Described. Illustrated (selection).

Doolittle and Munson (Amos Doolittle, *1754–1832;* Samuel B. Munson, *1806–1880)*
 [F.] p. 99.*

Doomer, Lambert *(1623–1700)*
 [W.] I, p. 414.
 Entries: 2 prints after.*

 [H. *Neth.*] V, p. 265.
 Entries: 2 prints after.*

Dooms, Johann Caspar *(1597–c.1675)*
 [H. *Neth.*] V, p. 266.
 Entries: 96.*

Dooms, Joseph Calasanz *(fl. 1675–1700)*
 [H. *Ger.*] VI, p. 228.
 Entries: 2.*

Doort, Peter van der [falsely called "Paul"]
(c.1570–c.1600)
 [W.] I, p. 415.
 Entries: 1.*

 [H. *Neth.*] V, p. 266.
 Entries: 6.*

Doost, Peter van der *(fl. c.1600)*
 [W.] I, p. 415.
 Entries: 1.*

Doppelmayr, Friedrich Wilhelm
(1776–c.1833)
 [Dus.] pp. 30–32.
 Entries: 23 (lithographs only, to 1821).
 Millimeters. Inscriptions. Located.

Dorazio, Piero *(b. 1927)*
 Cleveland Museum of Art [Leona E.
 Prasse and Louise S. Richards, com-
 pilers]. *The work of Piero Dorazio; catalogue
 of an exhibition sponsored by the Print Club
 of Cleveland and the Cleveland Museum of
 Art.* Cleveland (Ohio), 1965. 2000 copies.
 Entries: 54. Millimeters. Illustrated
 (selection).

Doré, Gustave *(1832–1883)*
 [Ber.] VI, pp. 5–49.

 Entries: 177+. Millimeters (selection).
 Paper fold measure (selection).
 States. Described (selection).

Rümann, Arthur. *Gustave Doré, Bibliog-
raphie der Erstausgaben nebst kurzer Biog-
raphie des Kunstlers.* Munich: Horst
Stobbe Verlag, 1921.
 Bibliography of books with illustra-
 tions by (first edition only).

Dézé, Louis. *Gustave Doré bibliographie et
catalogue complet de l'oeuvre.* Vol. 2 of *Gus-
tave Doré,* by J. Valmy-Baysse. Paris:
Marcel Scheur, 1930.
 Entries: 41 etchings; lithographs un-
 numbered, pp. 8–14; prints after un-
 numbered, pp. 91–92. Millimeters
 (selection). Described (selection).
 Also, bibliography of books with il-
 lustrations by.

Leblanc, Henri. *Catalogue de l'oeuvre
complet de Gustave Doré.* Paris: Ch.
Bosse, 1931. 850 copies. (MH)
 Entries: unnumbered, pp. 505–532,
 single prints by and after. Millimeters
 (selection). Paper fold measure (selec-
 tion). Inscriptions (selection). States.
 Described (selection). Bibliography of
 books with illustrations by, pp. 15–
 373. List of sheet music covers and
 posters, pp. 375–380.

Musée de l'Ain, Brou. *La ville de Bourg-
en-Bresse présente l'oeuvre de Doré.*
[Brou?], 1963.
 Bibliography of books with illustra-
 tions by. Based on Leblanc 1931.

Dorgez, ——— *(fl. 1803–1814)*
 [Ber.] VI, p. 49.*

Dorigny, Michel *(1617–1665)*
 [RD.] IV, pp. 247–300; XI, pp. 79–82.
 Entries: 144. Pre-metric. Inscriptions.
 States. Described.

 [Wess.] IV, p. 58.
 Additional information to [RD.].

Dormier, Alexandre Charles
(1788–after 1845)
[Ber.] VI, p. 49.*

Dorner, Johann Jakob II *(1775–1852)*
[Dus.] pp. 32–33.
Entries: 12+ (lithographs only, to
1821). Millimeters. Inscriptions. Lo-
cated.

Dorsey, J. S. *(fl. c.1818)*
[F.] pp. 99–100.*

Dorst, G. *(fl. c.1715)*
[W.] I, p. 416.
Entries: 1+.*

Dorst, Jacob van
See **Drost**

Dossi, Dosso *(d. 1542)*
[B.] XII: *See* **Chiaroscuro Woodcuts**

Dost, Jürgen *(b. 1939)*
Køhler, Johnny. "Jürgen Dost, en ung
tysk grafiker." [*N. ExT.*] 11 (1959): 116–
119.
Entries: 29 (bookplates only, to 1959).
Described. Illustrated (selection).

Rödel, Klaus. *Jürgen Dost, exlibris.* n.p.,
1968. 100 copies. (DLC)
Entries: 87 (bookplates only, to 1968).
Supplement; 28 further plates sepa-
rately numbered. Millimeters. De-
scribed. Illustrated (selection).

Dou, Gerard [Gerrit] *(1613–1675)*
Martin, Wilhelm. *Het leven en de werken
van Gerrit Dou, beschouwd in verband met
het schildersleven van zijn tijd.* Leiden
(Netherlands): S. C. van Doesburgh,
1901.
Catalogue of paintings; prints after
are mentioned where extant.

[W.] I, pp. 416–421.
Entries: 9 prints by, 120 after.*

[H. *Neth.*] V, pp. 267–272.
Entries: 11 prints by, 146 after. Illus-
trated (selection).

Dou, Jan Jansz *(fl. 1647–1660)*
[H. *Neth.*] V, p. 272.
Entries: 3 prints after.*

Douet, Edmond *(16th cent.)*
[B.] XII: *See* **Chiaroscuro Woodcuts**

Douffet, Gérard *(1594–1660)*
[W.] I, pp. 422–423.
Entries: 2 prints after.*

[H. *Neth.*] VI, p. 1.
Entries: 4 prints after.*

Doughty, Thomas *(1793–1856)*
Carey, p. 257.
Entries: 6 single prints (lithographs
only). Inches. Inscriptions. De-
scribed. Illustrated (selection). Also,
checklist of prints in *The Cabinet of
Natural History and American Rural
Sports,* by Doughty et al.

Doughty, William *(d. 1782)*
[Sm.] I, pp. 218–221, and "additions and
corrections" section.
Entries: 6 (portraits only). Inches. In-
scriptions. States. Described. Illus-
trated (selection). Located (selection).

[Ru.] p. 59.
Additional information to [Sm.].

Doussault, Charles *(fl. 1834–1870)*
[Ber.] VI, pp. 49–51.*

Douven, Frans Bartholomaeus *(b. 1688)*
[W.] I, pp. 423–424.
Entries: 1 print after.*

Downman, Lieutenant J. T. *(19th cent.)*
[Siltzer] p. 108.
Entries: unnumbered, p. 108, prints
after. Inches (selection). Inscriptions.

Doyle, J. *(19th cent.)*
[Siltzer] p. 329.
Entries: unnumbered, p. 329, prints
after. Inscriptions.

Dracz, Caspar *(fl. c.1600)*
[H. *Ger.*] VI, p. 231.
Entries: 2+.*

Drake, W. *(19th cent.)*
[Siltzer] p. 329.
Entries: unnumbered, p. 329, prints
after. Inches. Inscriptions.

Draner
See **Renard,** Jules

Drapentier
See **Drappentier**

Draper, John *(19th cent.?)*
[F.] p. 100.*

Drappentier, Daniel *(fl. 1674–1697)*
[W.] I, p. 424.
Entries: 1.*

Drappentier, Johannes *(fl. 1669–1700)*
[W.] I, pp. 424–425.
Entries: 1.*

Drayton, J. *(fl. c.1820)*
[St.] pp. 94–95.*

[F.] p. 100.*

Drda, Joseph Alois *(1783–1833)*
[Ap.] p. 127.
Entries: 4.*

Drebbel, Cornelis Jacobsz *(1592–1634)*
[W.] I, p. 425.
Entries: 4+.*

Tierie, Gerrit. *Cornelis Drebbel,*
1572–1633. Dissertation, University of
Leiden. Amsterdam: H. J. Paris, 1932.
(ERB)
Entries: 5+. Illustrated (selection).

[H. *Neth.*] VI, pp. 1–2.
Entries: 22. Illustrated (selection).*

Drechsel, Wolf *(fl. 1576–1602)*
[H. *Ger.*] VI, p. 232.
Entries: 5.*

Drentwett, Abraham I *(c.1647–1727)*
[H. *Ger.*] VI, p. 233.
Entries: 2+ prints by, 6+ prints after.*

Drever, Adriaen van *(fl. 1670–1680)*
[W.] I, pp. 425–426.
Entries: 2 prints after.*

[H. *Neth.*] VI, p. 2.
Entries: 2 prints after.*

Drevet, Claude *(1697–1781)*
Firmin-Didot, Ambroise. *Les Drevet*
(Pierre, Pierre-Imbert et Claude); catalogue
raisonné de leur oeuvre. Paris: Librairie de
Firmin-Didot et Cie, 1876.
Entries: 15 prints by, 3 rejected prints.
Millimeters. Inscriptions. States. De-
scribed. Located.

Drevet, Joannès *(1854–1940)*
Vial, Eugène. *Les eaux-fortes et lithog-*
raphies de Joannès Drevet. Lyons: Cumin
et Masson, 1915.
Entries: 240 etchings, 28 lithographs
(to 1915). Millimeters. Inscriptions.
States. Described. Illustrated (selec-
tion).

Drevet, Pierre, *(1663–1738)*
Firmin-Didot, Ambroise. *Les Drevet*
(Pierre, Pierre-Imbert et Claude); catalogue
raisonné de leur oeuvre. Paris: Librairie de
Firmin-Didot et Cie, 1876.
Entries: 125. Millimeters. Inscriptions.
States. Described. Located.

Drevet, Pierre Imbert *(1697–1739)*
Firmin-Didot, Ambroise. *Les Drevet*
(Pierre, Pierre-Imbert et Claude); catalogue
raisonné de leur oeuvre. Paris: Librairie de
Firmin-Didot et Cie, 1876.

Entries: 33 prints by, 8 rejected prints. Millimeters. Inscriptions. States. Described. Located.

Drielst, Egbert van *(1746–1818)*
[W.] I, p. 426.
Entries: 1 print after.*

Dries, N. *(fl. c.1790)*
[W.] I, p. 426.
Entries: 1 print after.*

Droeshout, Johannes [John] *(1596–1652)*
[Hind, *Engl.*] II, pp. 344–350.
Entries: 19+. Inches. Inscriptions. Described. Illustrated (selection). Located.

Droeshout, Martin *(1601–c.1652)*
[Hind, *Engl.*] II, pp. 351–366.
Entries: 22+. Inches. Inscriptions. States. Described. Illustrated (selection). Located.

Droeshout, Michiel [Michael]
(c.1570–after 1632)
[Hind, *Engl.*] II, pp. 342–343.
Entries: 2. Inches. Inscriptions. Described. Illustrated (selection). Located.

Droochsloot, Joost Cornelisz *(1586–1666)*
[Wess.] II, p. 233.
Entries: 1 (additional to [Nagler] III, p. 463). Millimeters. Inscriptions. Described.

[W.] I, pp. 426–427.
Entries: 1.*

[H. *Neth.*] VI, p. 3.
Entries: 2 prints by, 1 after. Illustrated (selection).*

Drost, Jacob van *(1627–1674)*
[W.] I, pp. 427–428.
Entries: 1 print by, 5 after.*

[H. *Neth.*] VI, p. 5.
Entries: 8 prints after.*

Drost, Willem *(fl. 1650–1655)*
[Rov.] pp. 66–67.
Entries: 1. Millimeters. Inscriptions. Described. Illustrated. Located.

[H. *Neth.*] VI, pp. 4–5.
Entries: 4. Illustrated (selection).*

Drouart, Raphaël *(1884–1972)*
Thomé, J. R. *Graveurs et lithographes contemporains, I; catalogues de l'oeuvre gravé et lithographié de Bonfils, Robert; Dauchez, André; Drouart, Raphaël.* Paris: Auguste Fontaine, 1937. 110 copies. (MBMu)
Entries: 288 (to 1931). Millimeters. States. Also, bibliography of books with illustrations by (to 1931).

Drouyn, [François Joseph] Leo *(1816–1896)*
[Ber.] VI, pp. 57–58.*

Drury, Paul *(b. 1903)*
Walker, R. A. "A chronological list of the etchings and drypoints of Graham Sutherland and Paul Drury." Supplement to Ogy, David. "The etchings of Graham Sutherland and Paul Drury." [*PCQ.*] 16 (1929): 75–100.
Entries: 25. Inches. States. Illustrated (selection).

Drusse, Nikolaus *(c.1584–1629)*
Hämmerle, Albert. "Die Kupferstecher Nikolaus Drusse und Andreas Gentzsch in Augsburg." [*Schw. M.*], 1925, pp. 104–113.
Entries: 6+. Millimeters. Inscriptions. Illustrated (selection).

[H. *Ger.*] VI, pp. 234–235.
Entries: 7+. Illustrated (selection).*

Dryweghen, Sebastian van *(fl. 1650–1680)*
[H. *Neth.*] VI, p. 6.
Entries: 5+ prints after.*

Dubbels, Hendrik Jacobsz *(1620/21–1676)*
[W.] I, p. 429.
Entries: 1 print after.*

Dubbels, Hendrik Jocobsz *(continued)*

[H. *Neth.*] VI, p. 6.
 Entries: 1 print after.*

Duberg, Carl *(19th cent.)*
[Dus.] p. 33.
 Entries: 1 (lithographs only, to 1821).
 Millimeters. Inscriptions. Located.

Dubois, ——— *(fl. c.1800)*
[Ber.] VI, p. 59.*

Dubois, Ambroise *(c.1543–1614)*
[H. *Neth.*] VI, p. 6.
 Entries: 1 print after.*

Dubois, Benoît *(1619–1680)*
[RD.] I, pp. 191–196.
 Entries: 6. Pre-metric. Inscriptions.
 Described.

Dubois, Carl Sylva *(1688–1753)*
[W.] I, pp. 429–430.
 Entries: 2 prints after.*

Dubois, J. *(fl. c.1650)*
[W.] I, pp. 430–431.
 Entries: 1.*

[H. *Neth.*] VI, p. 6.
 Entries: 3.*

Dubois, Martial
See **Desbois**

Dubois, Simon *(1632–1708)*
[W.] I, p. 431.
 Entries: 1 print after.*

Dubois-Drahonet, Alexandre Jean
(1791–1834)
[Ber.] VI, p. 59.*

Dubois-Tesselin, Frédéric François
(b. 1832)
[Ber.] VI, p. 59.*

Dubordieu, Pieter *(1609–c.1678)*
[W.] I, p. 431.
 Entries: 9 prints after.*

[H. *Neth.*] VI, p. 7.
 Entries: 13 prints after.*

Dubost, Antoine *(1769–1825)*
[Ber.] VI, p. 59.*

[Siltzer] p. 348.
 Entries: unnumbered, p. 348. Inscrip-
 tions.

Dubouchet, Henri Joseph *(1833–1909)*
[Ber.] VI, pp. 59–63.*

Dubourcq, Pierre Louis *(1815–1873)*
[H. L.] pp. 201—206.
 Entries: 16. Millimeters. Inscriptions.
 Described.

Dubourg, Louis Fabricius *(1693–1775)*
[W.] I, pp. 431–432.
 Entries: 18 prints by, 2 after.*

Dubourg, M. *(19th cent.)*
[Siltzer] p. 348.
 Entries: unnumbered, p. 348. Inscrip-
 tions.

Dubufe, Édouard Louis *(1820–1883)*
[Ber.] VI, p. 63.*

Dubuffet, Jean *(b. 1901)*
Silkeborg Museum [Noel Arnaud, com-
piler]. *Jean Dubuffet Grafik/Jean Dubuffet
gravures et lithographies.* Silkeborg
(Denmark), 1961.
 Entries: 517 (to 1961). Millimeters. Il-
 lustrated (selection).

Loreau, Max. *Catalogue des travaux de
Jean Dubuffet; fascicule XVI; les
Phénomènes.* Paris: Jean-Jacques Pau-
vert, 1964.
 Entries: 362 ("Phénomènes" series
 only). Millimeters. Described. Illus-
 trated.

Silkeborg Museum [Ursala Schmitt, compiler]. *Supplément au catalogue des gravures et lithographies de Jean Dubuffet/ Tilføjelse til kataloget Jean Dubuffet Grafik.* Silkeborg (Denmark), 1966.
Entries: 137 (additional to 1961 catalogue; to 1965). Millimeters. Illustrated (selection).

Dubuisson, Alexandre *(1805–1870)*
[Ber.] VI, p. 63.*

Ducasse, Jean Eugène *(19th cent.)*
[Ber.] VI, p. 63.*

Ducerceau, Jacques Androuet *(c.1510–c.1585)*
[M.] II, pp. 20–26.
Entries: 67+. Paper fold measure. Inscriptions (selection). States. Described (selection).

Geymuller, Henry de. *Les Du Cerceau, leur vie et leur oeuvre.* Paris: Librairie de l'Art, 1887. 500 copies. (NNMM)
Entries: unnumbered, pp. 285–327. Millimeters. Inscriptions (selection). States. Described (selection). Illustrated (selection).

[Herbet] IV, pp. 295–309; V, p. 85.
Entries: 8+ (prints relating to Fontainbleau only). Millimeters. Inscriptions. Described. Based on Geymuller.

Ducerceau, Paul Androuet *(17th cent.)*
[M.] II, pp. 27–30.
Entries: 32+. Millimeters. Inscriptions (selection). Described (selection).

Duchamp, Marcel *(1887–1968)*
Lebel, Robert. *Sur Marcel Duchamp.* France: Trianon Press, 1959.
Entries: 207 (works in all media, including prints, to 1958). Millimeters (selection). Inscriptions. Described (selection). Illustrated (selection).

Schwarz, Arturo. *The complete works of Marcel Duchamp.* New York: Harry N. Abrams, 1969.
Entries: 411 (works in all media, including prints). Inches. Millimeters. Inscriptions. States. Described. Illustrated.

Duchatel, François *(1625–1694)*
[W.] I, p. 432.
Entries: 2 prints after.*

[H. *Neth.*] VI, p. 7.
Entries: 5 prints after.*

Duchemin, Isaak *(fl. c.1590)*
[Merlo] p. 194.*

[W.] I, p. 433.
Entries: 2.*

[H. *Neth.*] VI, p. 8.
Entries: 6. Illustrated (selection).*

Ducis, Jean Louis *(1775–1847)*
Beaumont, Charles de. "Jean-Louis Ducis peintre (1775–1847)." *Réunion Soc. B. A. dép.,* 24th session, 1900, pp. 520–548.
Catalogue of paintings; prints after are mentioned where extant.

Duck, Jacob *(c.1600–after 1660)*
[W.] I, pp. 433–434.
Entries: 9 prints by, 4 after.*

[H. *Neth.*] VI, pp. 9–11.
Entries: 10 prints by, 7 after. Illustrated (selection).*

Duclaux, Jean Antoine *(1783–1868)*
Eymard, Paul. *Notice sur J. A. M. Duclaux, peintre, sa vie et ses oeuvres.* Lyons: Imprimerie de Pitrat ainé, 1869. (EPBN)
Entries: 36.

[Ber.] VI, pp. 63–66.
Entries: 30. Millimeters (selection). Described (selection).

Duclos, Antoine Jean *(1742–1795)*
[L. D.] pp. 21–22.
Entries: 3. Millimeters. Inscriptions. States. Illustrated. Incomplete catalogue.*

Maggs Bros. *L'Oeuvre gravé de A. J. Duclos.* Paris: Maggs Bros., 1939. 500 copies. (NN)
Entries: 158. Millimeters. Illustrated (selection).

Duclos-Cahon, Marie *(b. 1845)*
[Ber.] VI, p. 66.*

Ducq, Jan
See **Le Ducq**

Ducreux, Joseph *(1735–1802)*
[Baud.] I, pp. 194–196.
Entries: 3. Millimeters. Inscriptions. States. Described.

Lyon, Georgette. *Joseph Ducreux, premier peintre de Marie Antoinette (1735–1802), sa vie—son oeuvre.* Paris: La Nef de Paris, 1958.
Entries: 3 prints by, 30 after. Paper fold measure. Inscriptions. States. Described. Located.

Dudot, René *(fl. c.1655)*
[RD.] I, pp. 233–234.
Entries: 1. Pre-metric. Inscriptions. States. Described.

Duduy de l'Age, ———— *(fl. c.1710)*
[RD.] IV, p. 246; XI, p. 83.
Entries: 1. Pre-metric. Inscriptions. Described.

Dübyen, Franz *(d. c.1840)*
[Merlo] pp. 194–195.*

Dürer, Albrecht *(1471–1528)*
Hüsgen, Henrich Sebastian. *Raisonnierendes Verzeichnis aller Kupfer- und Eisenstiche, so durch die geschickte Hand Albrecht Dürers selbsten verfertiget worden; ans Licht gestellt und in eine systematische Ordnung gebracht, von einem Freund der schönen Wissenschaften.* Frankfurt: Ioh. Georg Fleischers Buchhandlung, 1778.
Entries: 100 (intaglio prints only). Pre-metric. Inscriptions. Described. Copies mentioned.

Comte de Lepel ["un Amateur"]. *Catalogue de l'oeuvre d'Albert Durer.* Dessau (Germany): Jean Chretien Mence, 1805.
Entries: unnumbered, pp. 12–113, prints by; pp. 114–124, prints after. Pre-metric (selection). Paper fold measure (selection). Inscriptions. States. Described (selection).

[B.] VII, pp. 5–197.
Entries: 170 prints by, 62 doubtful prints, 38 rejected prints. Pre-metric. Inscriptions. States. Described. Copies mentioned.

Heller, Joseph. *Das Leben und die Werke Albrecht Dürers.* 2 vols. Bamberg (Germany): E. F. Kunz, 1827.
Entries: 104 engravings, 2 doubtful engravings, 1 rejected engraving; 174 woodcuts, 199 doubtful woodcuts, 52 rejected woodcuts; 301 prints after, 7 prints in Dürer's style, 9 prints falsely marked with Dürer's monogram. Pre-metric. Inscriptions. Described. Copies mentioned (more extensive list than in any other Dürer catalogue).

Nagler, Georg Kasper. *Albrecht Dürer und seine Kunst.* Munich: Ernst August Fleischmann, 1837.
Entries: 104 engravings, 17 rejected engravings; 174 woodcuts, 199 rejected woodcuts; 64 additional doubtful and rejected prints. Pre-metric. Inscriptions (selection). Described. Based on Heller, with additional information.

Galichon, Émile. "Albert Dürer, sa vie et ses oeuvres IV: son oeuvre gravé." [GBA.] 1st ser. 7 (1860): 74–96.

Entries: 93 engravings, 10 etchings and drypoints; doubtful and rejected prints, unnumbered, pp. 93–94. States. Chronologically arranged.

[P.] III, pp. 144–227.
Entries: 2 engravings (additional to [B.] and Heller), 48+ woodcuts (additional to [B.] and Heller), 128 rejected prints, 1 doubtful print. Pre-metric. Inscriptions. States. Described. Located (selection). Additional information to [B.] and Heller.

Hausmann, B. *Albrecht Dürers Kupferstiche, Radierungen, Holzschnitte und Zeichnungen unter besonderer Berücksichtigung der dazu verwandten Papiere und deren Wasserzeichen.* Hannover (Germany): Hahn'sche Hof-Buchandlung, 1861.
Additional information to [B.]. Papers and watermarks discussed.

d'Orville, H. A. Cornill. "Mittheilungen über Holzschnitte von Albrecht Dürer oder solche, welche diesem Meister zugeschrieben werden." [*N. Arch.*] 9 (1863): 204–212.
Additional information to earlier catalogues.

Retberg, Ralf Leopold von. *Dürers Kupferstiche und Holzschnitte; ein kritsches Verzeichnis.* Munich: Theodor Ackermann, 1871. (NN)
Entries: 270 prints by, 73 doubtful and rejected prints. Millimeters. Inscriptions. Described. Watermarks described. Ms. notes (ECol); additional states.

Retberg, Ralf Leopold von. "Nachtrag." [*Zahn's*] *Jahrbücher für Kunstwissenschaft* 5 (1873): 192.
Additional information to Retberg 1871.

Amand-Durand, ——— and Duplessis, Georges. *Oeuvre de Albert Dürer reproduit et publié.* Paris: Amand-Durand, 1877.

Entries: 102 (intaglio prints only). Inscriptions. States. Described. Illustrated. Appendix with doubtful and rejected prints.

[Wess.] I, pp. 135–136.
Additional information to [B.] and [P.].

Middleton-Wake, Charles Henry. *Catalogue of the engraved work of Albert Dürer.* Cambridge: Fitzwilliam Museum, 1893.
Entries: 103 prints by, 7 doubtful and rejected prints, (intaglio prints only). Additional information to [B.].

Grolier Club, New York [Sylvester Rosa Koehler, compiler]. *A chronological catalogue of the engravings, dry-points, and etchings of Albrecht Dürer, as exhibited at the Grolier Club.* New York, 1897.
Entries: 102 prints by, 10 doubtful prints (intaglio prints only). Described. Description of specific impressions in major European collections.

Carrington, Fitz Roy. "A descriptive catalogue of the engravings, etchings and dry-points of Albert Dürer. By Adam Bartsch, with additions and corrections from the works of Passavant, Heller, Retberg, Thausing, Allihn, Koehler and others. Translated and compiled by Fitz Roy Carrington, Unpublished ms., 1901. (PJRo)
Entries: 109. Millimeters. Inscriptions. Described. Compiled from earlier catalogues.

Scherer, Valentin. *Dürer; des Meisters Gemälde, Kupferstiche und Holzschnitte.* Klassiker der Kunst. Stuttgart: Deutsche Verlags-Anstalt, 1908. American edition. New York: Brentano's, 1921.
Entries: unnumbered, pp. 91–383. Millimeters. Illustrated.

Hind, Arthur M. *Albrecht Dürer, his engravings and woodcuts.* New York: Frederick A. Stokes, 1911.

Dürer, Albrecht *(continued)*

Entries: unnumbered, pp. 11–15. Illustrated (selection). Chronological list, with references to [B.], [P.] and Retberg 1871.

Leitschuh, Franz Friedrich. *Albrecht Dürers sämtliche Kupferstiche im Grosse der Originale in Lichtdruck wiedergegeben.* Leipzig: Baumgärtner's Buchhandlung, 1912.
Entries: 107 (intaglio prints only). Illustrated.

Springer, Jaro. *Albrecht Dürers Kupferstiche in getreuen Nachbildungen.* Munich: Holbein-Verlag, 1914.
Entries: 102 (intaglio prints only). Illustrated. Appendix with 7 rejected prints.

Barlow, T. D. *Woodcuts and engravings by Albert Dürer collected and described by T. D. Barlow.* Cambridge: The University Press, 1926.
Entries: 294+. Millimeters. Description of a collection, supplemented with references to reproductions of prints not in the collection.

Dodgson, Campbell. *Albrecht Dürer.* London: Medici Society, 1926. Reprint. New York (N.Y.): Da Capo Press, 1967.
Entries: 104 prints by, 3 doubtful prints, (intaglio prints only). Millimeters. Inscriptions. States. Described. Illustrated. Located (selection). Ms. addition (NN); concordance with [B.], Grolier Club and Meder.

Kurth, Willi: *The complete woodcuts of Albrecht Dürer.* London: W. and G. Foyle, Ltd., 1927. 500 copies. Reprint. New York: Arden Book Co., 1936. Reprint. New York: Dover Publications, 1963.
Entries: 346. Described. Illustrated. Concordance with [B.] and [P.]. Prints are reproduced actual size in 1927 edition.

Scherer, Valentin, and Winkler, Friedrich. *Dürer, des Meisters Gemälde, Kupferstiche und Holzschnitte.* Klassiker der Kunst. 4th ed., rev. Stuttgart: Deutsche Verlags-Anstalt, [192-?].
Entries: unnumbered, pp. 99–395. Millimeters. Described (selection). Illustrated. Revised edition of Scherer 1908.

[Ge.] nos. 686–734.
Entries: 49 (single-sheet woodcuts only). Described. Illustrated. Located.

Meder, Joseph. *Dürer-Katalog; ein Handbuch über Albrecht Dürers Stiche, Radierungen, Holzschnitte, deren Zustände, Ausgaben und Wasserzeichen.* Vienna: Verlag Gilhofer und Ranschburg, 1932. Reprint. New York: Da Capo Press, 1971.
Entries: 294. Millimeters. Inscriptions. States. Described. Successive editions within individual states are described, on the basis of papers, watermarks and print quality. Table of watermarks.

Albrecht Dürer, saemtliche Kupferstiche. Introduction by Heinrich Wölfflin. Munich: Einhorn Verlag, 1936. (NN)
Entries: 102 (engravings, etchings and drypoints only). Illustrated. Located. Prints are reproduced actual size.

Musper, Th. "Ein Straszburger Holzschnitt Dürers." [*JprK.*] 58 (1937): 124–127.
Entries: 1 (additional to earlier catalogues). Inscriptions. Described. Illustrated.

[H. *Ger.*] VII, pp. 1–259.
Entries: 295 prints by, 28+ books illustrated by. Illustrated (selection).*

Gale, Ira D. "Scoperta una variante di una silografia di Dürer." [*QCS.*] 2 (Oct.-Nov. 1970): 60.
Additional information to earlier catalogues.

Albrecht Dürer, 1471 bis 1528, das gesamte graphische Werk. Introduction by Wolfgang Hütt. 2 vols. Munich: Rogner und Bernhard, 1970.
> Entries: unnumbered, pp. 1147–1957. Millimeters. Illustrated.

Dürer, Albrecht, school of
[Ge.] nos. 735–785.
> Entries: 51 (single-sheet woodcuts only). Described. Illustrated. Located.

[H. *Ger.*] VII, pp. 260–277.
> Entries: 50. Illustrated (selection).*

Dürer, Hans *(1498–c.1538)*
[Ge.], between nos. 734 and 735.
> Entries: 3 rejected prints (single-sheet woodcuts only). Described. Illustrated. Located.

[H. *Ger.*] VII, pp. 278–279.
> Entries: 7+. Illustrated (selection).*

Dürr, Ernst Caspar *(fl. 1670–1700)*
[H. *Ger.*] VIII, p. 1.
> Entries: 9.*

Dürr, Johann *(fl. 1640–1680)*
[H. *Ger.*] VIII, pp. 1–7.
> Entries: 129+.*

Duetecum
See **Doetechum**

Duflos, Claude *(1665–1727)*
Fleury, Ed. "Claude Duflos, graveur, né à Coucy-le-Château en 1665, et sa descendance." *Bulletin de la Société académique de Laon* 25 (1881–1882): 245–339.
> Entries: 441. Paper fold measure (selection). Inscriptions (selection). Described (selection). Located (selection). Based on notes by P. J. Mariette, supplemented by further information.

Dufour, Pierre
See **Furnius,** Pieter

Dufourmantelle, C. Félix *(1824–1859)*
[Ber.] VI, p. 67.*

Dufresne, Alexandre Henry *(b. 1820)*
[Ber.] VI, p. 67.*

Dufy, Raoul *(1877–1953)*
Fleuret, Fernand. "Raoul Dufy illustrateur." [*AMG.*] 1 (1927–1928): 143–152.
> Bibliography of books with illustrations by (to 1927).

Camo, Pierre. "Dans l'atelier de Dufy." *Portique* 4 (1946): 5–26.
> Bibliography of books with illustrations by (to 1944).

Courthion, Pierre. *Raoul Dufy.* Geneva: Pierre Cailler, 1951.
> Bibliography of books with illustrations by.

Dugelay, —— *(19th cent.)*
[Ber.] VI, p. 67.*

Dughet, Gaspard *(1615–1675)*
[B.] XX, pp. 232–236.
> Entries: 8. Pre-metric. Inscriptions. States. Described.

[RD.] I, pp. 125–130.
> Entries: 8. Pre-metric. Inscriptions. States. Described. Based on [B.]. Copy mentioned.

Duhameel, Alart *(c.1449–c.1509)*
[B.] VI, pp. 354–360.
> Entries: 6. Pre-metric. Inscriptions. Described.

[P.] II, pp. 284–287.
> Entries: 9 engravings (additional to [B.]), 3 woodcuts. Pre-metric. Inscriptions. Described. Located.

[Dut.] IV, pp. 102–106; V, p. 586; VI, p. 665.

Duhameel, Alart *(continued)*

Entries: 15 engravings, 3 woodcuts. Millimeters. Inscriptions. Described.

Lehrs, Max. "Verzeichnis der Kupferstiche des Alart du Hameel." [*Oud-Holl.*] 12 (1894): 15–24.
Entries: 11. Millimeters. Inscriptions. States. Described. Located. Copies mentioned.

[W.] I, pp. 643–644.
Entries: 11+.*

Gossart, M. G. *Le peinture de diableries à la fin du Moyen-Age; Jérôme Bosch, le faizeur de Dyables de Bois-le-Duc.* Lille (France): Imprimerie Centrale du Nord, 1907.
Entries: 12. Millimeters. Inscriptions. States. Described. Located.

[Lehrs] VII, pp. 219–249.
Entries: 12. Millimeters. Inscriptions. States. Described. Illustrated (selection). Locations of all known impressions are given. Copies mentioned. Watermarks described. Bibliography for each entry.

[H. *Neth.*] VI, pp. 15–26.
Entries: 12. Illustrated.*

Dujardin, ⸺ *(19th cent.)*
[Ber.] VI, p. 67.*

Dujardin, Edward *(1817–1889)*
[H. L.] pp. 206–207.
Entries: 3. Millimeters. Inscriptions. States. Described.

Dujardin, Karel *(1622–1678)*
[B.] I, pp. 161–196.
Entries: 52. Pre-metric. Inscriptions. States. Described.

[Weigel] pp. 22–23.
Additional information to [B.].

[Wess.] II, p. 234.
Additional information to [B.] and [Weigel].

[Dut.] IV, pp. 106–129; V, pp. 586–589.
Entries: 52. Millimeters. Inscriptions. States. Described.

[W.] I, pp. 435–437.
Entries: 52 prints by, 29 after.*

[H. *Neth.*] VI, pp. 27–44.
Entries: 53 prints by, 48 after. Illustrated (selection).*

Dumar, J.
See **Ditmar**

Dumonstier, Geoffroy *(d. 1573)*
[RD.] V, pp. 33–44; XI, p. 84.
Entries: 26. Millimeters. Inscriptions. Described.

[P.] VI, pp. 200–202.
Entries: 2 (additional to RD.). Pre-metric. Described (selection).

[Herbet] IV, pp. 313–314.
Summarizes [RD.] and [P.].

[Zerner] no. 4.
Entries: 26. Millimeters. Inscriptions. Described (selection). Illustrated.

Dumonstier, Louis *(b. 1641)*
[RD.] V, p. 323.
Entries: 1. Millimeters. Inscriptions. Described.

Dumont, Jacques [called "Le Romain"] *(1701–1781)*
[Baud.] I, pp. 1–11.
Entries: 9. Millimeters. Inscriptions. States. Described.

Bataille, Marie Louise. "Dumont le Romain." In [Dim.] II, pp. 229–239.
Entries: 10 prints by, 9 after lost works, 1+ illustrations after. Millimeters.

Dumoustier, or **Dumoûtier**
See **Dumonstier**

Duncan, Andrew *(1795–after 1845)*
[Ap.] p. 127.
 Entries: 2.*

Duncan, Edward *(1803–1882)*
[Siltzer] pp. 109, 349.
 Entries: unnumbered, p. 109, prints by and after. Inches (selection). Inscriptions. Described (selection).

Duning, Herman
See **Monogram HD** [Nagler, *Mon.*] III, no. 820

Dunkarton, Robert *(1744–c.1815)*
[Sm.] I, pp. 221–237, and "additions and corrections" section; IV, "additions and corrections" section.
 Entries: 46 (portraits only). Inches. Inscriptions. States. Described. Located (selection). Also, list of portraits in books (titles only), unnumbered, pp. 235–237.

[Siltzer] p. 349.
 Entries: unnumbered, p. 349. Inscriptions.

[Ru.] pp. 59–64, 490.
 Entries: 4 (portraits only, additional to [Sm.]). Inches. Inscriptions (selection). States. Described. Additional information to [Sm.].

Dunker, Balthasar Antoine *(1746–1807)*
Nicolas, Raoul. *Balthasar-Antoine Dunker . . . suivi du catalogue de l'oeuvre gravé de B. A. Dunker.* Geneva: Editions Albert Ciana, 1924. 500 copies. (NN)
 Entries: 165. Millimeters. Inscriptions.

Dunlap, William *(1766–1839)*
[St.] pp. 95–96.*

Dunouy, Alexandre Hyacinthe *(1757–1841)*
[Ber.] VI, p. 68.*

Dunoyer de Segonzac, André *(1884–1974)*
Roger-Marx, Claude. "Les dessins et les gravures de Dunoyer de Segonzac."
[*AMG.*] 1 (1927–1928): 361–368.
 Bibliography of books with illustrations by (to 1927).

Roger-Marx, Claude. Catalogue. In *Dunoyer de Segonzac,* by Paul Jamot. Paris: Librarie Floury, 1929.
 Entries: unnumbered, pp. 235–238.

Lioré, Aimée, and Cailler, Pierre. *L'Oeuvre gravé de Dunoyer de Segonzac.* 8 vols. Geneva: Pierre Cailler, 1958–1970.
 Entries: 1595. Millimeters. States. Illustrated.

V., M. P. "Quelques compléments au catalogue de l'oeuvre gravé de Dunoyer de Segonzac (tome 1ier)." *Le Livre et l'estampe* 18 (1959): 129–132. *Le Livre et l'estampe* 19 (1959): 198–200. *Le Livre et l'estampe* 20 (1959): 253–255.
 Additional information to Lioré and Cailler.

Duparc, Marie Alexandre *(fl. c.1800)*
[Ber.] VI, p. 68.*

Dupérac, Étienne *(1525–1601/04)*
[RD.] VIII, pp. 89–117; XI, pp. 85–86.
 Entries: 90. Millimeters. Inscriptions. States. Described.

Duplessi-Bertaux, Jean *(1747–1819)*
[Ber.] VI, pp. 68–73.*

Duplessis, Joseph Siffrède *(1725–1802)*
Belleudy, Jules. *J. S. Duplessis, peintre du roi, 1725–1802.* Chartres (France): Imprimerie Durand, 1913.
 Catalogue of paintings; prints after are mentioned where extant.

Duponchel, Charles Eugène *(b. 1748)*
[Ap.] p. 127.
 Entries: 2.*

Dupont, François Félix *(d. 1899)*
[Ber.] VI, pp. 73–74.*

Dupont, Gainsborough *(c.1754–1797)*
[Sm.] I, pp. 237–242, and "additions and corrections" section.
Entries: 12 (portraits only). Inches. Inscriptions. States. Described. Illustrated (selection). Located (selection).

[Ru.] pp. 64–65, 490–491.
Entries: 1 (portraits only, additional to [Sm.]). Inches. Described. Additional information to [Sm.].

Dupont, Pieter *(1870–1911)*
Dupont, W. F. *Pieter Dupont een Nederlandsch graveur, zijn leven en werken.* Oisterwijk (Netherlands): Uitgeverij "Oisterwijk," 1947.
Entries: 114 etchings and engravings, 1 lithograph. Millimeters. Inscriptions. Described. Illustrated.

Dupray, Henry Louis *(1841–1909)*
[Ber.] VI, p. 74.
Entries: 3.

Dupré, Jules *(1811–1889)*
[Ber.] VI, pp. 74–75.
Entries: 7.

Hédiard, Germain. "Les maîtres de la lithographie: Jules Dupré." *L'Artiste*, n.s. 8 (1894, no. 2): 13–19. Separately published. Châteaudun (France): Imprimerie de la Société Typographique, 1894.
Entries: 9. Millimeters. Inscriptions. States. Described.

[Del.] I.
Entries: 9. Millimeters. Inscriptions. States. Described (selection). Illustrated. 1 print, not seen by [Del.], is not illustrated.

Dupré, Louis *(1789–1837)*
[Ber.] VI, p. 75.*

Dupréel, J. D. B. *(fl. 1787–1817)*
[Ber.] VI, pp. 75–76.*

[Ap.] p. 130.
Entries: 9.*

Dupressoir, François Joseph *(1800–1859)*
[Ber.] VI, p. 76.*

Dupuis, André *(20th cent.)*
Dupuis, André. "Catalogue de l'oeuvre graphique de Jean Kerhor (pseudonyme d'André Dupuis)." *Le Vieux papier* 23 (1961–1963): 194–205.
Entries: 26 woodcuts by, 10 posters, unnumbered list of prints after.

Dupuis, Charles *(c.1752–1807)*
[Merlo] pp. 203–206.*

Dupuis, (Pierre) François *(17th cent.)*
[RD.] III, pp. 311–312.
Entries: 1. Pre-metric. Inscriptions. Described.

Duquesnoy, François [called "Il Fiammingo"] *(1594–1633)*
[W.] I, pp. 439–440.
Entries: 7 prints after.*

[H. *Neth.*] VI, p. 44.
Entries: 19 prints after.*

Durand, André *(1807–1867)*
[Ber.] VI, pp. 76–77.*

Durand, Asher Brown *(1796–1886)*
[Ap.] p. 130.
Entries: 1.*

Durand, John. *The life and times of A. B. Durand.* New York: Charles Scribner's Sons, 1894. 600 copies. (PJRo)
Entries: unnumbered, pp. 222–226.

Grolier Club, New York [C. H. Hart, compiler]. *Catalogue of the engraved work of Asher B. Durand.* New York, 1895. Regular edition, April 1895. Large paper edition with additional information, May 1895. 350 copies. (NN)

Entries: 234. Inches. Inscriptions. States. Ms. addition, (NN); additional information, additional entries.

[St.] pp. 96–117.*

[F.] pp. 100–101.*

Durand, Wright and Co. (Asher Brown Durand, *1796–1886;* Cyrus Durand, *1787–1868;* Charles Wright, *1796–1854*)
[F.] p. 101.*

Durand-Brager, Jean Baptiste Henri *(1814–1879)*
[Ber.] VI, p. 77.*

Durandeau, E. *(19th cent.)*
[Ber.] VI, p. 77.*

Durieux, Caroline *(b. 1896)*
Louisiana State University, Baton Rouge, *Anglo-American art museum catalogue.* Baton Rouge (La.), 1971.
Entries: unnumbered, 7 pp. (to 1966). Inches. Millimeters. Illustrated (selection).

Duriez, Elie Philippe Joseph *(19th cent.)*
[Ber.] VI, p. 77.*

Durlet, Franciscus Andreas *(1816–1867)*
[H. L.] pp. 208–213.
Entries: 10. Millimeters. Inscriptions. States. Described.

Durleu, A. *(fl. c.1760)*
[W.] I. p. 441.
Entries: 1.*

Dusart, Christian Jansz *(1618–1682)*
[W.] I, p. 441.
Entries: 1 print after.*

[H. *Neth.*] VI, p. 44.
Entries: 2 prints after.*

Dusart, Cornelis *(1660–1704)*
[B.] V, pp. 465–490.

Entries: 41. Pre-metric. Inscriptions. States. Described. Copies noted.

[Weigel] pp. 333–345.
Entries: 19 (additional to [B.].). Pre-metric. Inscriptions (selection) States. Described (selection). Appendix with 18 further prints cited by [Weigel] from other sources.

[Heller] pp. 43–44.
Additional information to [B.].

[Wess.] II, p. 234.
Entries: 2 (additional to [B.] and [Weigel]). Millimeters (selection). Inscriptions. Described. Additional information to [B.] and [Weigel].

[Dut.] IV, pp. 129–151; V, p. 589.
Entries: 111. Millimeters. Inscriptions. States. Described.

[W.] I, pp. 441–444.
Entries: 63+ prints by, 47+ after.*

[H. *Neth.*] VI, pp. 45–85.
Entries: 122 prints by, 89 after. Illustrated (selection).*

Duseigneur [Louis Didier Georges?] *(19th cent.)*
[Ber.] VI, p. 77.*

Dutertre, André *(1753–1842)*
[Ber.] VI, pp. 77–78.*

Duthé, J. *(fl. 1800–1840)*
[Ber.] VI, pp. 78–79.*

Duthoit, Aimé *(d. 1869)* and Louis *(1807–1874)*
[Ber.] VI, p. 79.*

Dutilleux, Henri Joseph Constant *(1807–1865)*
[Ber.] VI, pp. 79–80.*

Dutillois, Auguste *(fl. 1830–1850)*
[Ber.] VI, p. 80.*

Duttenhofer, Christian Friedrich
(1778–1846)
 [Ap.] p. 131.
 Entries: 6.*

Duval, Henri Philippe Adolphe *(19th cent.)*
 [Ber.] VI, p. 80.*

Duval, Louis H. P. *(fl. c. 1800)*
 [Ber.] VI, p. 81.*

Duval, Marc *(c.1530–1581)*
 [RD.] V, pp. 56–63.
 Entries: 10. Millimeters. Inscriptions.
 States. Described.

 Laruelle, René. "Marc et Elizabeth
 Duval." *Bull. des B. A.* 2 (1884–1885):
 185–191.
 Entries: 6. Illustrated (selection).

 [Herbet] III, p. 39; V, p. 83.
 Entries: 1 (additional to [RD.]). De-
 scribed. Located.

Duval, Robbert [or Nicolas] *(1644–1732)*
 [W.] I, p. 445.
 Entries: 1 print after.*

Duval-Lecamus, Pierre *(1790–1854)*
 [Ber.] VI, pp. 81–82.*

Duvaux, Jules Antoine *(1818–1884)*
 [Ber.] VI, p. 82.*

Duveau, Louis Jean Noël *(1818–1867)*
 [Ber.] VI, p. 82.*

Duveneck, Frank *(1848–1919)*
 Poole, Emily. "The etchings of Frank
 Duveneck." [PCQ.] 25 (1938): 312–331,
 446–463.
 Entries: 30. Inches. Inscriptions.
 States. Illustrated (selection). Lo-
 cated.

Duvet, Jean *(1485–c.1570)*
 [B.] VII, pp. 496–516.

 Entries: 45. Pre-metric. Inscriptions.
 States. Described.

 [RD.] V, pp. 1–32; XI, pp. 86–90.
 Entries: 72. Millimeters. Inscriptions.
 States. Described.

 [P.] VI, pp. 255–259.
 Entries: 12 (additional to [RD.]). Pre-
 metric. Inscriptions. Described. Lo-
 cated (selection).

 Jullien de la Boullaye, E. *Etude sur la vie et
 l'oeuvre de Jean Duvet, dit le maitre à la
 licorne.* Paris: Rapilly Libraire, 1876.
 Entries: 78. Millimeters. Inscriptions.
 States. Described. Illustrated. Lo-
 cated.

 Popham, A.E.: "Jean Duvet." [PCQ.] 8
 (1921): 122–150.
 Entries: 79 (including 6 rejected
 prints). Millimeters. Described (selec-
 tion). Illustrated (selection). Located
 (selection). Follows numbering of
 [RD.], [P.], and Jullien de la Boullaye,
 with additional information.

 Godefroy, Louis. "L'Oeuvre gravé de
 Jean Duvet 'le maître à la licorne'." Un-
 published ms., 1930. (EPBN)
 Entries: 73 prints by, 7 doubtful and
 rejected prints. Millimeters. Inscrip-
 tions. States. Described. Illustrated.
 Located.

 De Ricci, Seymour. "Notes for a
 catalogue." Unpublished ms. (EPBN)
 Entries: unnumbered, unpaginated.
 Millimeters.

Duvivier, —— *(18th cent.)*
 Advielle, Victor. Catalogue. In "Jean et
 Benjamin Du Vivier." *Réunion Soc. B. A.
 dép.,* 13th session, 1889, p. 389.
 Entries: unnumbered, p. 389. Mil-
 limeters. Inscriptions. Described.

Duvivier, Albert Ludovic Paul Emile An-
tony *(b. 1842)*
 [Ber.] VI, pp. 82–83.*

Advielle, Victor. Catalogue. In "Jean et
Benjamin Du Vivier." *Réunion Soc. B. A.
dép.*, 13th session, 1889, pp. 383–385.
Entries: unnumbered, pp. 383–385.

Duvivier, Guillaume *(fl. c.1650)*
[RD.] III, pp. 108–111; XI, p. 90.
Entries: 7. Pre-metric. Inscriptions.
Described.

[W.] I p. 445.
Entries: 9.*

[H. *Neth.*] VI, p. 85.
Entries: 10.*

Duvivier, Jean *(1687–1761)*
[W.] I, pp. 445–446.
Entries: 5.*

Duvivier, Jean Baptiste *(18th cent.)*
Advielle, Victor. Catalogue. In "Jean et
Benjamin Du Vivier." *Réunion Soc. B. A.
dép.*, 13th session, 1889, p. 388.
Entries: unnumbered, p. 388. Paper
fold measure. Inscriptions. Jean Bap-
tiste may be identical with Johannes
Bernardus Duvivier.

Duvivier, Johannes Bernardus [Jean
Pierre Bernard] *(1762–1837)*
See also **Duvivier,** Jean Baptiste

Advielle, Victor. Catalogue. In "Jean et
Benjamin Du Vivier." *Réunion Soc. B. A.
dép.*, 13th session, 1889, pp. 385–388.
Entries: unnumbered, pp. 385–388.
Paper fold measure (selection). Mil-
limeters (selection). Inscriptions.

[W.] I, p. 446.
Entries: 2 prints after.*

Duwée, Henri Joseph *(fl. 1833–1870)*
[H. L.] p. 213.
Entries: 1. Millimeters. Inscriptions.
States. Described.

Duysend, Cornelis Claesz *(fl. 1630–1640)*
[W.] I, p. 446.
Entries: 2.*

[H. *Neth.*] VI, p. 86.
Entries: 8.*

Duyster, Willem Cornelisz *(c.1599–1635)*
[W.] I, pp. 446–447.
Entries: 1 print after.*

[H. *Neth.*] VI, p. 86.
Entries: 1 print after.*

Duytsch, F. E. *(fl. c.1790)*
[W.] I, p. 447.
Entries: 1.*

Dyck, Abraham van *(c.1635–1672)*
[W.] I, pp. 447–448.
Entries: 1 print after.*

[H. *Neth.*] VI, p. 86.
Entries: 1 print after.*

Dyck, Anton [Anthony] van *(1599–1641)*
Del-Marmol, ———. *Catalogue de la plus
précieuse collection d'estampes de P. P. Ru-
bens et d'A. van Dyck qui ait jamais existée
. . . le tout recueilli . . . par Messire
Del-Marmol.* n.p., 1794, (EPBN)
Entries: 319+ prints after (different
impressions of the same print are
separately numbered).

Carpenter, William Hookham. *Pictorial
notices consisting of a memoir of Sir An-
thony van Dyck, with a descriptive catalogue
of the etchings executed by him.* London:
James Carpenter, 1844.
Entries: unnumbered, pp. 85–129
prints by, pp. 130–134 doubtful prints.
Pre-metric. Inches. Inscriptions.
States. Described.

Weber, Hermann. *Catalogue raisonné
d'une belle et nombreuse collection de por-
traits gravés par et d'après Antoine van
Dyck. Catalogue des estampes anciennes qui*

Dyck, Anton *(continued)*

*composent le magasin de Hermann Weber
. . . première partie.* Bonn: Hermann
Weber, 1852.
>Entries: 412 prints by and after. In-
scriptions. States. Described. Multi-
ple proofs of the same print are sepa-
rately numbered. All states are de-
scribed, not simply those in collec-
tion.

Szwykowski, Igz. von. "Antonj van
Dycks Bildnisse bekannter Personen."
[*N. Arch.*] 4 (1858): 197–288, 305–432. [*N.
Arch.*] 5 (1859): 33–119. Separately pub-
lished. Leipzig: Rudolph Weigel, 1859.
>Entries: 185 prints by and after. Pre-
metric. Inscriptions. States. De-
scribed.

Wolff, H. "Zur Ikonographie Ant. van
Dycks." [*N. Arch.*] 10 (1864): 289–315.
>Additional information to Weber.

Gensler, Günther. "Zu A. van Dycks
Bildnisswerke." [*N. Arch.*] 11 (1865):
68–70.
>Additional information to Weber.

Amand-Durand, ———, and Duplessis,
Georges. *Eaux-fortes de Antoine van Dyck
reproduites et publiées par Amand-Durand.*
Paris: Amand-Durand, Goupil, 1874.
(DLC).
>Entries: 21. Inscriptions. States. De-
scribed. Illustrated. Located. Prints
are reproduced actual size.

Wibiral, Fr. *L'Iconographie d'Antoine van
Dyck d'après les recherches de H. Weber.*
Leipzig: Alexander Danz, 1877.
>Entries: 190 prints by and after. Mil-
limeters (selection). Inscriptions.
States. Described. Dimensions given
only when they distinguish states.
Description of papers. Watermarks
noted. Table of watermarks.

[Wess.] II, pp. 234–235.
>Additional information to Wibiral.

Guiffrey, Jules. *Antoine van Dyck: sa vie et
son oeuvre.* Paris: A. Quantin, 1882.
>Catalogue of paintings, prints after
are mentioned where extant.

[Dut.] IV, pp. 152–292; V, pp. 589–591,
594a; VI, pp. 665–671.
>Entries: 205 (prints by, and prints after
from the *Iconographia*). Millimeters.
Inscriptions. States. Described.

Sparrow, Walter Shaw. *Etchings by Van
Dyck; twenty-four plates in Rembrandt
photogravure the full size of the rare first
states.* London: Hodder and Stoughton,
1905.
>Entries: 21. Illustrated. Located. Re-
production of first or early states of
prints by.

[W.] I, pp. 448–475.
>Entries: 18+ prints by, 541+ after.*

Hind, Arthur M. *Van Dyck; his original
etchings and his iconography.* Boston
(Mass.): Houghton Mifflin, 1915.
>Entries: unnumbered, pp. 101–104.
Described. Illustrated. General dis-
cussion of etchings by.

Mauquoy-Hendrickx, Marie. *L'Iconog-
raphie d'Antoine van Dyck, catalogue
raisonné.* 2 vols. Memoires de
l'Academie Royale de Belgique; classe
des beaux-arts, 9. Brussels: Palais des
Académies, 1956.
>Entries: 201 prints by and after
(*Iconography* only). Millimeters. In-
scriptions. States. Described. Illus-
trated. Located. Table of watermarks.
Ms. notes (ECol); information relating
to the Laudau-Finaly collection.

[H. *Neth.*] VI, pp. 87–129.
>Entries: 21 prints by, 856+ after. Illus-
trated (selection).*

Dyck, Daniel van den *(c.1610–1670)*
[RD.] III, pp. 16–18; XI, pp. 90–92.
>Entries: 10. Pre-metric. Inscriptions.
Described.

[W.] I, p. 475.
Entries: 11.*

[H. *Neth.*] VI, p. 130.
Entries: 11.*

Dyk, Jan van *(fl. 1730–1756)*
[W.] I, p. 476.
Entries: 1 print after.*

Dyk, Philip van *(1680–1753)*
[W.] I, pp. 476–477.
Entries: 4 prints after.*

Dyk, Willem Cornelis van *(1825–1881)*
[H. L.] p. 214.

Entries: 1. Millimeters. Inscriptions.
Described.

Dzhaparidze, Ucha *(b. 1906)*
Dzhanelidze, D. *Ucha Dzhaparidze.* Tiflis
(USSR): Gosudarstvennoe Izdatel'stvo
"Sabchota Sakartvelo," 1962.
Entries: unnumbered, pp. 65–68, pp.
73–76 (to 1961). Millimeters. Illus-
trated (selection).

Dzimbowski, A. von *(19th cent.)*
[Dus.] pp. 33–34.
Entries: 2+ (lithographs only, to 1821).
Millimeters (selection). Inscriptions.
Described (selection).

E

Earle, A. *(fl. c.1820)*
[F.] p. 101.*

Earlom, Richard *(1743–1822)*
[Sm.] I, pp. 242–261, and "additions and
corrections" section.
Entries: 53 (portraits only). Inches. In-
scriptions. States. Described. Illus-
trated (selection). Located (selection).
Also, list of portraits in books (titles
only), unnumbered, p. 261.

Wessely, Josef Eduard. *Richard Earlom;
Verzeichniss seiner Radirungen und Schab-
kunstblätter.* Hamburg Haendcke: und
Lehmkuhl, 1886.
Entries: 492 prints by, 7 prints not
seen by Wessely. Millimeters. Inscrip-
tions (selection). States. Described.

[Siltzer] p. 349.
Entries: unnumbered, p. 349. Inscrip-
tions.

[Ru.] pp. 65–72.
Entries: 3 (portraits only, additional to
[Sm.]). Inches (selection). Inscrip-
tions (selection). States. Described
(selection). Additional information to
[Sm.].

Earlom, Richard [under pseudonym of
Henry Birche]
[Sm.] I, pp. 60–61.
Entries: 1 (portraits only). Inches. In-
scriptions. States. Described.

[Siltzer] p. 346.
Entries: unnumbered, p. 346 (prints
after). Inscriptions.

[Ru.] p. 489.
Additional information to [Sm.].

Earp, G. *(19th cent.)*
[Siltzer] p. 330.

Earp, G. *(continued)*

Entries: unnumbered, p. 330, prints after. Inches. Inscriptions.

Easling, J. C. *(19th cent.)*
[Siltzer] p. 349.
Entries: unnumbered, p. 349. Inscriptions.

Eastman, Seth *(1808–1875)*
McDermott, John Francis. *Seth Eastman; pictorial historian of the Indian.* Norman (Okla.): University of Oklahoma Press, 1961.
Entries: 100 prints after. Inscriptions.

Ebbius, N. *(fl. c.1658)*
[W.] I, p. 478.
Entries: 1 print after.*

Ebelmann, Hans Jacob *(fl. c. 1600)*
[A.] III, pp. 292–302.
Entries: 8+ (prints by Ebelmann, Veit Eck, and Jacob Guckeisen). Pre-metric. Inscriptions. States. Described (selection).

[H. *Ger.*] VIII, p. 8.
Entries: 6+.*

Eberhard, ——— *(fl. c.1800)*
[Merlo] p. 210.*

Eberhard, Heinrich Wilhelm *(fl. c.1820)*
[Dus.] pp. 33–34.
Entries: 2+ (lithographs only, to 1821). Millimeters. Inscriptions. Located.

Eberhard, Konrad *(1768–1859)*
[Dus.] pp. 35–36.
Entries: 1 (lithographs only, to 1821). Millimeters. Inscriptions. Located.

Eberle, Robert *(1815–1860)*
[A. 1800] IV, pp. 238–248.
Entries: 7. Millimeters. Inscriptions. States. Described. Also, list of 5 prints after (not fully catalogued).

Ebers, Emil *(1807–1884)*
[A. 1800] IV, pp. 217–221.
Entries: 2. Millimeters. Inscriptions. States. Described. Also, list of 3 prints after (not fully catalogued).

Eby, Kerr *(b. 1889)*
Weitenkampf, Frank. "Kerr Eby; artist in black and white." [*P. Conn.*] 4 (1924): 36–55.
Entries: 64 (to 1923?). Illustrated (selection).

Crafton Collection. *Kerr Eby, A.N.A. with an appreciation by Dorothy Noyes Arms.* American etchers, 8. New York: Crafton Collection, 1930.
Entries: 99 (to 1929). Inches. Illustrated (selection).

Etchings and drypoints by Kerr Eby. New York: Frederick Keppel and Co., 1930.
Entries: 106 (to 1930). Inches. Illustrated (selection). Based on Crafton Collection catalogue.

Hays, Mrs. David. "The Frances Sheldon Eby Collection, presented to the New York Public Library by Kerr Eby." Unpublished ms., 1935. (NN)
Entries: 145 (to 1932). Supplementary page with 10 additional entries (prints after 1935). Autograph letter from Eby describing collection and catalogue.

Echter, Matthias *(before 1642–after 1700)*
[H. *Ger.*] VIII, p. 9.
Entries: 4+ prints by, 3 after.*

Eck, Veit *(fl. c.1587)*
[A.] III, pp. 292–302.
Entries: 8+ (prints by Eck, Hans Jacob Ebelmann and Jacob Guckeisen). Pre-metric. Inscriptions. States. Described (selection).

[H. *Ger.*] VIII, p. 9.
Entries: 1+.*

Eckstein, John[Johannes] I *(fl. 1750–1800)*
[Sm.] I, p. 262; IV, "additions and cor-
rections" section.
Entries: 1 (portraits only). Inches. In-
scriptions. Described.

Eckstein, John [Johannes] II *(fl. c.1772)*
[St.] pp. 117–118.*

Edard-Delaplante, ——— *(fl. c.1835)*
[Ber.] VI, p. 83.*

Eddy, Isaac *(19th cent.)*
[St.] p. 118.*

[F.] p. 102.*

Eddy, James *(fl. c.1827–1830)*
[F.] pp. 102–103.*

Eddy, Oliver Tarbell *(1799–1868)*
Newark Museum [Edith Bishop, com-
piler]. *Oliver Tarbell Eddy 1799–1868; a
catalogue of his works.* Newark (N.J.),
1950.
Entries: 40 (works in various media,
including prints by and after). Inches.
Inscriptions. Described. Illustrated
(selection). Located.

Edelinck, Gérard *(1640–1707)*
[RD.] VII, pp. 169–336; XI, pp. 92–100.
Entries: 341. Millimeters. Inscriptions.
States. Described. Preface mentions
23 doubtful, rejected and unknown
prints.

[Wess.] IV, p. 58.
Entries: 1 (additional to [RD.]). Mil-
limeters. Inscriptions. Described. Lo-
cated. Additional information to
[RD.].

[W.] I, pp. 478–480.
Entries: 139+.*

Edelinck, Nicolas Etienne *(1681–1767)*
Baré, F. "Nicolas Edelinck." *Bull. des
B. A.* 2 (1884–1885): 37–39.

Entries: 34. Paper fold measure. In-
scriptions (selection). Described
(selection).

Edge, J. A. *(19th cent.)*
[Siltzer] p. 349.
Entries: unnumbered, p. 349. Inscrip-
tions.

Edler, Anton *(fl. 1820–1860)*
[Dus.] p. 36.
Entries: 3 (lithographs only, to 1821).
Millimeters (selection). Inscriptions
(selection). Located (selection).

Edwards, Edwin *(1823–1879)*
"Catalogue of dry points and etchings
by Edwin Edwards." Unpublished ms.
(EBM)
Entries: 372.

[Ber.] VI, pp. 83–86.
Entries: 376.

Edwards, R. *(fl. c.1795)*
[Ru.] p. 72.
Entries: 1 (portraits only). Inches. In-
scriptions. States. Described.

Edwards, Samuel Arlent *(b. 1861)*
E. L. Knoedler, New York. *List of mezzo-
tint engravings by S. Arlent-Edwards.* New
York, 1910.
Entries: 67. Illustrated.

Anderson Galleries, New York. *The Max
Rosenberg Collection; mezzotints engraved
and printed in colors at one printing and a
few prints in pure mezzotint by S. Arlent-
Edwards, to be sold Monday, December 17,
1917.* New York, 1917. (NN)
Entries: 134. Illustrated (selection).
Ms. addition (NN); additional infor-
mation, 47 additional entries.

Edwin, David *(1776–1841)*
Hildeburn, Charles R. "A Contribution
to a catalogue of the engraved works of
David Edwin."[*Pa. Mag.*] 18 (1894–1895):

Edwin, David *(continued)*

97–118, 223–238. Separately published. n.p., 1894.
 Entries: 199. Inches. Inscriptions. States. Described.

Fielding, Mantle. "Engraved works of David Edwin (not mentioned in Mr. Hildeburn's list)." [*Pa. Mag.*] 28 (1904): 420–427. Separately published. *Catalogue of the engraved works of David Edwin.* [Philadelphia?] 1904.
 Entries: 43 (additional to Hildeburn). Inches. Inscriptions. States. Described (selection).

Fielding, Mantle. "David Edwin, engraver," [*Pa. Mag.*] 29 (1905): 79–88, 320–325. Separately published. Philadelphia, 1905.
 Entries: 17 (additional to Fielding 1904). Inches. Inscriptions. Described.

Rupp, George P. "Description of a Masonic certificate engraved by David Edwin." [*Pa. Mag.*] 29 (1905): 109–110.
 Entries: 1 (additional to Fielding, "David Edwin, engraver," 1905). Inscriptions. Described.

Fielding, Mantle. *Catalogue of the engraved work of David Edwin.* Philadephia. Privately printed, 1905. 100 copies. (NN)
 Entries: 263. Inches. Inscriptions. States. Described. Ms. addition (NN); additional entries.

Fielding, Mantle. "Rare Edwin prints." [*Pa. Mag.*] 30 (1906): 353–354, 503–504.
 Entries: 2 (additional to Fielding 1905). Inches. Inscriptions. States. Described.

[St.] pp. 118–161.*

[F.] pp. 103–105.*

Fielding, Mantle. "Engravings by David Edwin hitherto undescribed." [*Pa. Mag.*] 32 (1908): 219–222.

Entries: unnumbered, pp. 219–222 (additional to Fielding 1905 and 1906). Inches. Inscriptions. Described.

Edy, John William *(fl. 1780–1820)*
[Siltzer] p. 350.
 Entries: unnumbered, p. 350. Inscriptions.

Eeckhout, Gerbrandt van den *(1621–1674)*
[Rov.] pp. 67–68.
 Entries: 3 prints by, 2 doubtful prints. Millimeters. Inscriptions. States. Described. Illustrated. Located.

[W.] I, pp. 481–483.
 Entries: 5 prints by, 39+ after.*

[H. *Neth.*] VI, pp. 131–136.
 Entries: 9 prints by, 114 after. Illustrated (selection).*

Eeckhout, Jakob Joseph *(1793–1861)*
[H. L.] pp. 214–215.
 Entries: 2. Millimeters. Inscriptions. States. Described.

Eeckhout, Paul *(b.1917)*
Schellaert, A. "Paul Eeckhout." *Boekcier,* 2d ser. 2 (1947): 32–35.
 Entries: 31 (bookplates and commercial prints only; to 1947). Millimeters. Described. Illustrated (selection).

Eeckhout, Victor *(1821–1879)*
[H. L.] p. 215.
 Entries: 1. Millimeters. Inscriptions. Described.

Egelmann, Carl Friederich *(fl. c.1820)*
[F.] p. 105.*

Egerton, Daniel Thomas *(d. 1842)*
[Siltzer] p. 330.
 Entries: unnumbered, p. 330, prints after. Inscriptions.

Egerton, M. *(fl. c.1825)*
[Siltzer] p. 109.

Entries: unnumbered, p. 109, prints after. Inches (selection). Inscriptions.

Eggeling, Viking *(1880–1925)*
O'Konor, Louise. *Viking Eggeling, 1880–1925, artist and filmmaker; life and work.* Stockholm studies in history of art, 23. Stockholm: Almquist and Wiksell, 1971.
Entries: 1. Millimeters. Described. Illustrated.

Eggers, W. P. Eberhard *(20th cent.)*
Behrens, Reinhold. *W. P. E. E.; W. P. Eberhard Eggers; das graphische Werk 1961–1970.* Burgdorf/Hannover (West Germany): Steintor Verlag, 1971. 1050 copies. (EBKk)
Entries: 95 linocuts, 19 lithographs, 1 silkscreen, 243 etchings. Millimeters. Described. Illustrated (selection).

Eglau, Otto *(b. 1917)*
Flemming, Hanns Theodor. *Otto Eglau; das grafische Werk.* Flensburg (West Germany): Christian Wolff Verlag, 1966.
Entries: 366. Millimeters. Illustrated (selection).

Egloffstein, Julie von *(1792–1869)*
[Dus.] p. 36.
Entries: 2 (lithographs only, to 1821). Millimeters. Inscriptions. Located.

Egmont, Justus van *(1601–1674)*
[W.] I, pp. 485–486.
Entries: 10.*

[H. *Neth.*] VI, p. 137.
Entries: 13 prints after.*

Ehinger, Gabriel *(1652–1736)*
[H. *Ger.*] VIII, p. 10.
Entries: 18+ .*

Ehren, Julius von *(b. 1864)*
[Sch.] p. 7ff.
Not seen.

Ehrenstrahl, David Klöcker von *(1629–after 1698)*
[H. *Neth.*] VI, p. 137.
Entries: 8 prints after.*

Ehrentraut, ———— *(19th cent.)*
See **Hoppe, Grosspietsch and Ehrentraut**

Eichens, Friedrich Eduard *(1804–1877)*
Eichens, Eduard. "Beschreibendes Verzeichniss der gestochenen und radierten Platten des Zeichners und Kupferstechers Prof. Friedrich Eduard Eichens." [*N. Arch.*] 16 (1870): 123–150.
Entries: 171. Millimeters. Inscriptions. States. Described.

[Ap.] pp. 131–134.
Entries: 36.*

Eichens, Hermann *(1813–1886)*
[Ap.] p. 134.
Entries: 1.*

[Ber.] VI, pp. 86–87.
Entries: 41 (engravings only).

Eichler, Carl Gottfried *(19th cent.)*
[Dus.] p. 36.
Entries: 2 (lithographs only, to 1821).

Hämmerle, Albert. "Die Lithographie in Augsburg." [*Schw. M.*] 1927, pp. 184–196.
Entries: 1 (lithographs only, to 1821). Millimeters. Inscriptions. Described. Illustrated. Located.

Eick, J. F. *(d. 1820)*
[W.] I, p. 487.
Entries: 2 prints after.*

Eickmann, Heinrich *(1870–1911)*
Pickardt, Ernst, and Curdt, Rudolf. *Heinrich Eickmann; sein Werk und sein Leben.* Lübeck (Germany): Ludwig Moller, 1912.
Entries: 93. Millimeters. Illustrated (selection). 2d ed. 1915, not seen.

Eilers, Gustav *(1834–1911)*
[Ap.] p. 134.
Entries: 9.*

Roeper, A. "Gustav Eilers und sein graphisches Werk." [*Bb.*] 76 (1909): 8782–8787.
Entries: 88 (to 1909). Millimeters. States.

Roeper, Adalbert. [*Kh.*] 7 (1915): 147ff.
Not seen.

Eillarts, Joannes [called "Frisius"] *(fl. 1600–1650)*
[W.] I, pp. 487.
Entries: 24.*

[H. *Neth.*] VI, pp. 138–141.
Entries: 61. Illustrated (selection).*

Eillarts, Laurens *(fl. c.1618)*
[H. *Neth.*] VI, p. 141.
Entries: 12.*

Eimmart, Georg Christoph *(1638–1704)*
[H. *Ger.*] VIII, pp. 11–16.
Entries: 113+.*

Einslie, S. *(fl. 1785–1808)*
[Sm.] I, pp. 262–263, and "additions and corrections" section.
Entries: 2 (portraits only). Inches. Inscriptions. States. Described.

[Ru.] p. 72.
Additional information to [Sm.].

Eisen, Charles *(1720–1778)*
[Baud.] II, pp. 152–157.
Entries: 9. Millimeters. Inscriptions. States. Described.

[Gon.] II, pp. 139–180.
Entries: 13. Inscriptions. Described. Also, prints after, unnumbered, pp. 165–180. Described (selection).

Baudicour, Prosper de. "L'Oeuvre gravé de Charles Eisen." [*Am. Est.*] 1, no. 9 (1922): 9–10.
Reprint of [Baud.].

Carlier, Adrien: "Charles Eisen graveur (1720–1778)." [*Am. Est.*] 2 (1923): 84–87.
Additional information to [Baud.].

Carlier, Adrien. "Biographie de Charles Eisen, dessinateur, peintre, graveur du XVIIIe siècle." Unpublished ms., 1947. (EPBN)
Entries: unnumbered list of single prints after, pp. 198–239. Bibliography of books with illustrations by.

Carlier, Adrien. "Charles Eisen de Valenciennes, dessinateur, peintre, graveur, 1720–1778." *Mémoires du Cercle archéologique et historique de Valenciennes* 6 (1966).
Entries: unnumbered, pp. 249–269, single prints by and after. Millimeters (selection). Inscriptions (selection). Also, bibliography of books with illustrations by.

Eisen, François *(1695–after 1778)*
[W.] I, p. 487.
Entries: 2.*

Eisenhoit, Anton *(1553–1603)*
Lessing, Julius. *Die Silberarbeiten von Anton Eisenhoit aus Warburg.* Berlin: Paul Bette, 1879–1880.
Entries: 46. Millimeters (selection). Inscriptions. Described.

Kesting, Anna Maria. *Anton Eisenhoit, ein Westfälischer Kupferstecher und Goldschmied.* Mitteilungen des Vereins für Geschichte und Altertumskunde Westfalens . . . 16. Sonderheft. Münster (West Germany): Aschendorf'sche Verlagsbuchhandlung, 1964.
Entries: 25. Millimeters. Inscriptions. Described. Illustrated. Located.

[H. *Ger.*] VIII, pp. 17–23.
Entries: 25+. Illustrated (selection).*

Eisenhout, Anton
See **Eisenhoit**

Eisenhut, Anton
See **Eisenhoit**

Eisfeld, A. *(19th cent.)*
[Dus.] p. 36.
 Entries: 1 (lithographs only, to 1821).
 Millimeters. Inscriptions. Located.

Eissenhardt, Johannes Kaspar *(1824–1896)*
[Ap.] p. 135.
 Entries: 5.*

Eitel, A. *(fl. c.1864)*
[Ap.] p. 135.
 Entries: 1.*

Eitner, Ernst *(b. 1867)*
[Sch.] p. 17ff.
 Not seen.

Ekeland, Axel Werner *(20th cent.)*
"Axel Werner Ekelund, en interessant
konstmålare, exlibristecknare och
grafiker." [*N. ExT.*] 6 (1954): 6.
 Entries: unnumbered, p. 6
 (bookplates only, to 1954).

Ekemann-Alleson, Lorenz *(1791–1828)*
[Dus.] pp. 37–38.
 Entries: 15+ (lithographs only, to
 1821). Millimeters. Inscriptions. Lo-
 cated.

Elandt, Hendrik *(d. 1705)*
[W.] I, p. 488.
 Entries: 3+.*

[H. *Neth.*] VI, p. 142.
 Entries: 19+.*

Elandts, Cornelis *(fl. 1660–1670)*
[W.] I, p. 488.
 Entries: 5+.*

[H. *Neth.*] VI, p. 142.
 Entries: 30+.*

Elgersma, Michiel *(d. 1764)*
[W.] I, p. 488.
 Entries: 4+.*

Elias [Pickenoy], Nicolas *(1590–1653/56)*
[H. *Neth.*] VI, p. 142.
 Entries: 2 prints after.*

Eliasberg, Paul *(b. 1907)*
Kurpfälzisches Museum, Heidelberg
[Jens Christophe Jensen, compiler].
Paul Eliasberg, das druckgraphische Werk.
Heidelberg (West Germany), 1965.
 Entries: 34 (to 1965). Millimeters. Illus-
 trated (selection).

Elkan, David Levy *(1808–1865)*
[Merlo] pp. 217–220.*

Elkjaer, Ole *(20th cent.)*
F[ougt], K[nud]. "Ole Elkjaer." [*N.
ExT.*] 5 (1953): 120–122.
 Entries: 12 (bookplates only, to 1953?).
 Illustrated (selection).

Fogedgaard, Helmer. "Ole Elkjaer—II,
en dansk exlibristegner." [*N. ExT.*] 23
(1971): 72–75.
 Entries: 5 (bookplates only, additional
 to Fougt; to 1970). Illustrated (selec-
 tion).

Elle, Ferdinand [called "Ferdinand"]
(c.1585–1637)
[W.] I, pp. 489–490.
 Entries: 4+ prints after.*

[H. *Neth.*] VI, p. 142.
 Entries: 8 prints after.*

Ellenrieder, Maria *(1791–1863)*
[A. 1800] IV, pp. 30–45.
 Entries: 25. Millimeters. Inscriptions.
 States. Described. Also, list of 22
 prints after (not fully catalogued).

Andresen, Andreas. "Andresens
Nachträge zu seinen 'Deutschen Maler-
radierern.' " [*MGvK.*] 1907: 43.
 Entries: 2 (additional to [A. 1800]). Mil-
 limeters. Inscriptions. Described.

Ellenrieder, Rudolf *(1781–1838)*
[Dus.] p. 38.

Ellenrieder, Rudolf *(continued)*

Entries: 1 (lithographs only, to 1821). Inscriptions.

Elliger, Ottmar II *(1666–1735)*
[W.] I, p. 490.
Entries: 1+.*

Elliott, W. *(17th cent.)*
[Hind, *Engl.*] III, p. 327.
Entries: 1. Inches. Inscriptions. Described. Located.

Elliott, William *(1727–1766)*
[Siltzer] p. 350.
Entries: unnumbered, p. 350. Inscriptions.

Ellis, Edwin M. *(fl. c.1844)*
[F.] p. 105.*

Ellis, George B. *(fl. 1821–1838)*
[St.] pp. 161–164.*

[F.] pp. 105–110.*

Ellis, W. *(19th cent.)*
[Siltzer] p. 330.
Entries: unnumbered, p. 330, prints after. Inscriptions.

Ellmer, Peter *(1785–1873)*
[Dus.] pp. 38–39.
Entries: 4 (lithographs only, to 1821). Millimeters. Inscriptions. Located.

Elluin, François Rolland *(1745–1810)*
[L. D.] pp. 22–23.
Entries: 2. Millimeters. Inscriptions. States. Described. Incomplete catalogue.*

Elmer, Stephen *(d. 1796)*
[Siltzer] pp. 109–110.
Entries: unnumbered, pp. 109–110, prints after. Inches. Inscriptions. States.

Elmerich, Charles Edouard *(1813–1889)*
[Ber.] VI, p. 88.*

Elsheimer, Adam *(1578–1610)*
[Hüsgen] pp. 88–92.
Entries: 57 prints after. Paper fold measure. Described.

Passavant, J. D. "Adam Elsheimer, Maler aus Frankfurt am Main." *Archiv für Frankfurts Geschichte und Kunst* 4 (1847): 44–85.
Entries: 81 prints by and after. Premetric (selection). Paper fold measure (selection). Inscriptions. Described.

Hind, Arthur M. "Adam Elsheimer, II; his original etchings." [*PCQ.*] 13 (1926): 9–29.
Entries: 17. Millimeters. Inscriptions. Illustrated (selection). Located.

Weizsäcker, Heinrich. "Adam Elsheimers Originalradierungen." [*JprK.*] 48 (1927): 58–72.
Entries: 13 prints by, 5 doubtful and rejected prints. Millimeters. Inscriptions. Described. Illustrated (selection). Located.

Drost, Willi. *Adam Elsheimer und sein Kreis.* Potsdam (Germany): Akademische Verlagsgesellschaft Athenaion, 1933.
Entries: unnumbered, pp. 189–190, prints after.

Weizsäcker, Heinrich. *Adam Elsheimer, der Maler von Frankfurt.* 3 vols. Berlin: Deutscher Verein für Kunstwissenschaft, 1936, 1952.
Entries: 14 prints by, 4 doubtful and rejected prints, 78 prints after. Millimeters. Inscriptions. Described. Located. Bibliography for each entry.

[H. *Neth.*] VI, pp. 143–151.
Entries: 18 prints by, 58 after. Illustrated (selection).*

Elster, Johann Christian *(1792–1854)*
[Dus.] p. 39.
 Entries: 2 (lithographs only, to 1821).
 Millimeters. Inscriptions. Located.

Elstrack, Renold *(1570–after 1625)*
[Hind, *Engl.*] II, pp. 163–214.
 Entries: 99. Inches. Inscriptions.
 States. Described. Illustrated (selection). Located.

Elten, Kruseman van
See **Kruseman van Elten**

Eltz, Johann Friedrich von *(1632–1686)*
[H. *Ger.*] VIII, p. 24.
 Entries: 2. Illustrated (selection).*

Elven, Pierre Henri Théodore Tetar van
See **Tetar van Elven**

Emaus de Micault, Gerhardus *(1789–1863)*
[H. L.] pp. 216–233.
 Entries: 52. Millimeters. Inscriptions.
 States. Described.

Emili, Giovanni *(b. 1770)*
[Ap.] p. 135.
 Entries: 1.*

Emmert, Ludwig *(20th cent.)*
[Dus.] p. 39.
 Entries: 3 (lithographs only, to 1821).
 Millimeters. Inscriptions. Located.

Emmes, Thomas *(fl. c.1700)*
[St.] pp. 164–165.*

Emmett, William II *(fl. c.1715)*
[Sm.] I, pp. 263–264.
 Entries: 4 (portraits only). Inches. Inscriptions. Described. Located (selection).

[Ru.] p. 73.
 Additional information to [Sm.].

Émy, Henri *(fl. c.1845)*
[Ber.] VI, p. 88.*

Enchius
See **Nicholas,** Jan

Ende, Hans am *(b. 1864)*
"Original-Radierungen von Hans am Ende, Worpswede." [*Kh.*] 9 (1917): 90–91; Supplement, no. 4.
 Entries: 173. Millimeters. States. Illustrated.

Ende, Jan van den *(fl. c.1710)*
[W.] I, p. 491.
 Entries: 1 print after.*

Enderlein, Jacob *(fl. 1650–1700)*
[H. *Ger.*] VIII, p. 25.
 Entries: 2+.*

Enderlein, Veit *(17th cent.)*
[H. *Ger.*] VIII, p. 25.
 Entries: 1.*

Endlich, Philippus *(b. c.1700)*
[W.] I, p. 492.
 Entries: 10.*

Enfantin, Auguste *(1793–1827)*
[Ber.] VI, p. 88.*

Engelbrecht, Martin *(1684–1756)*
Schott, Friedrich. *Der Augsburger Kupferstecher und Kunstverleger Martin Engelbrecht und seine Nachfolger.* Augsburg (Germany): J. A. Schlossersche Buch- und Kunsthandlung, 1924.
 Entries: 4734 prints by and published by. Millimeters. Inscriptions. Described (selection).

Engelmann, Gottfried [Godefroy] *(1788–1839)*
[Ber.] VI, p. 89.*

Engels, Alexander *(d. 1857)*
[Merlo] p. 222.*

Engels, Wilhelm *(fl. 1824–1840)*
[Merlo] p. 223.*

Engelheart, Francis *(1775–1849)*
[Ap.] p. 135.
Entries: 3.*

Engleheart, George *(1750–1829)*
Williamson, George C., and Engleheart,
Henry L.D. *George Engleheart 1750–1829,
miniature painter to George III.* London:
George Bell and Sons, 1902. 360 copies.
(PJRo)
Entries: unnumbered, p. 153, prints
after.

Engleheart, Timothy Stansfeld *(1803–1879)*
[Ap.] p. 135.
Entries: 1.*

Engramelle, Marie Dominique Joseph
(1727–1780/81)
Beaupré, J. N. "Notcce sur quelques
graveurs nancéiens du XVIIIe siècle et
sur leurs ouvrages." [*Mém. lorraine*], 2d
ser. 9 (1867): 226–227. Separately pub-
lished. n.p., n.d.
Entries: 2. Millimeters. Inscriptions.
Described.

Enslen, Carl Georg *(1792–1866)*
[Dus.] pp. 39–40.
Entries: 3 (lithographs only, to 1821).
Millimeters (selection). Paper fold
measure (selection). Inscriptions. Lo-
cated (selection).

Ensor, James *(1860–1949)*
[Del.] XIX.
Entries: 132. Millimeters (selection).
Inscriptions (selection). States. De-
scribed (selection). Illustrated (selec-
tion). Located (selection).

Garvens-Garvensburg, H. von. *James
Ensor; Maler, Radierer, Komponist; ein
Hinweis mit dem vollständigen Katalog*

seines radierten Werkes als Anhang. Han-
nover (Germany): Ludwig Ey, 1913.
Entries: unnumbered, pp. 26–29 (to
1904)

Croquez, Albert. *L'Oeuvre gravé de James
Ensor, catalogue raisonné.* Paris: Maurice
le Garrec, 1935. 200 copies. (NN)
Entries: 133 (etchings and drypoints
only, to 1934). Millimeters. Inscrip-
tions. States. Described. Also, list of
4+ prints after (lithographic repro-
ductions).

Croquez, Albert. *L'Oeuvre gravé de James
Ensor.* Geneva: Éditions Pierre Cailler,
1947.
Entries: 134 (etchings and drypoints
only). Millimeters. Inscriptions.
States. Described (selection). Illus-
trated. Lacks some of the information
in Croquez 1935.

Perre, Paul van der. "Quelques notes de
portée practique sur l'oeuvre gravé de
James Ensor; de la discrimination à faire
entre les divers tirages; compléments
aux catalogues methodiques de
l'oeuvre." *Le Livre et l'estampe,* no. 4
(1955): 22–32. Separately published.
n.p., n.d.
Additional information to [Del.] and
Croquez 1935 and 1947. Many addi-
tional states, notes on Ensor's print-
ers.

I., P. "Où James Ensor donne des préci-
sions sur la rareté de certaines de ses
gravures," *Le Livre et l'estampe,* nos.
13–14 (1958): 67.
Additional information to Croquez
1935 and 1947.

*The Prints of James Ensor, from the collec-
tion of H. Shickman.* Introduction by
Louis Lebeer. New York: Da Capo Press,
1971.
Entries: 121. Millimeters. Inscriptions.
Illustrated. Catalogue of an almost
complete collection of Ensor's prints.

Appendix with 11 prints not in the collection.

Enzing-Müller, Johann Michael
(1804–after 1855)
[Ap.] p. 136.
Entries: 6.*

Epper, Ignaz *(b. 1892)*
Epper-Quarles, Mischa. Catalogue. In
Die Holzschnitte von Ignaz Epper, by Erwin
Brüllmann. Kradolf (Switzerland): Verlag Albert Boretti, 1965.
Entries: 187. Millimeters. Illustrated
(selection).

Erasmus, Georg Caspar *(fl. 1650–1700)*
[H. *Ger.*] VIII, p. 25.
Entries: 2+ prints after.*

Erasmus, Johann Georg *(1659–1710)*
[H. *Ger.*] VIII, p. 25.
Entries: 1 print by, 4+ after.*

Eremita, Daniel *(fl. 1584–1613)*
[H. *Neth.*] VI, p. 152.
Entries: 1 print after.*

Erhard, Johann Christoph *(1795–1822)*
Apell, Aloys. *Das Werk von Johann Christophe Erhard, Maler und Radierer.* Dresden: Aloys Apell, 1866.
Entries: 195 prints by, 17 prints after.
Pre-metric. Inscriptions. States. Described.

Apell, Aloys. *Nachträge und Berichtigungen zum Werk des Malers und Radierers Johann Christoph Erhard.* Leipzig: Alexander Danz, 1875.
Entries: 5 prints after. Additional information to Apell 1866.

[Dus.] pp. 40–41.
Entries: 16 (lithographs only, to 1821).
Millimeters. Inscriptions. Located
(selection).

Erhardt, Martin
See **Monogram EM** [Nagler, *Mon.*] II,
no. 1677

Erich, August *(fl. 1620–1644)*
[H. *Ger.*] VIII, p. 26.
Entries: 7+ prints after.*

Erlinger, Georg *(d. 1542)*
[B.] VII, pp. 471–472.
Entries: 1. Pre-metric. Inscriptions.
Described.

[Heller] p. 44.
Entries: 1 (additional to [B.]). Pre-
metric. Inscriptions. Described.

Heller, Joseph. *Leben Georg Erlinger's,
Buchdruckers und Formschneiders zu Bamberg, nebst einer vollständigen Aufzählung
und Beschreibung seiner sämmtlichen gedruckten Schriften und Holzschnitte.* Bamberg (Germany): J. G. Sickmüller, 1837.
Entries: unnumbered, pp. 5–30.
Pre-metric. Inscriptions. Described.

[Ge.] nos. 809–812.
Entries: 4 (single-sheet woodcuts
only). Described. Illustrated. Located.

[H. *Ger.*] VIII, pp. 27–30.
Entries: 6. Illustrated (selection).*

Ermels, Georg Paul *(fl. c.1697)*
[A.] V, pp. 255–257.
Entries: 2. Pre-metric. Inscriptions.
Described.

[H. *Ger.*] VIII, p. 31.
Entries: 2. Illustrated (selection).*

Ermels, Johann Franciscus *(1641–1693)*
[A.] V, pp. 230–241.
Entries: 14. Pre-metric. Inscriptions.
States. Described.

[Merlo] pp. 224–226.*

[H. *Ger.*] VIII, pp. 32–34.
Entries: 14 prints by, 2+ after. Illustrated (selection).*

Erni, Hans *(b. 1909)*
Rosner, Charles. *L'Oeuvre graphique de Hans Erni.* Geneva: Éditions Pierre Cailler, 1957.
Bibliography of books with illustrations by (to 1957).

Cailler, Pierre. *Catalogue raisonné de l'oeuvre lithographié et gravé de Hans Erni, tome premier; lithographies de 1930 à 1957.* Geneva: Éditions Pierre Cailler, 1969.
Entries: 227 (to 1957). Millimeters. Described. Illustrated.

Cailler, Pierre. *Catalogue raisonné de l'oeuvre lithographié et gravé de Hans Erni, tome deuxième; lithographies de 1958 à 1970.* Geneva: Éditions Pierre Cailler, 1971.
Entries: 228 (additional to Cailler 1969; to 1970). Millimeters. Described. Illustrated.

Ernst, Julius *(1830–1861)*
[Ap.] pp. 136–137.
Entries: 10.*

Ernst, Karl Mathias *(1758–1830)*
[Dus.] p. 41.
Entries: 2 (lithographs only, to 1821). Millimeters. Inscriptions. Located.

Ernst, Max *(b. 1891)*
Bibliothèque Municipale, Tours [——— Hugues and ——— Poupard-Lieussou, compilers]. *Max Ernst; ecrits et oeuvre gravé.* Tours, n.d.
Entries: 34 (single prints only, to 1963). Millimeters. Illustrated (selection). Also, bibliography of books with illustrations by.

Musée d'Art et d'Histoire, Geneva. *Max Ernst, oeuvre gravé.* Geneva, 1970.
Entries: 97 (to 1970). Millimeters. Inscriptions. Described. Illustrated. Located.

Galerie Brusberg, Hannover [Dieter Brusberg and Brigitte Völker, compilers]. *Max Ernst; Jenseits der Malerei—*

das grafische Oeuvre, eine Ausstellung im Kestner-Museum, Hannover, vom 16. April bis 15. Juli, 1972. Brusberg Dokumente, 3. Hannover (West Germany), 1972. 5555 copies.
Entries: 176+ (to 1972). Millimeters. States. Described (selection). Illustrated (selection).

Errani, Luigi *(19th cent.)*
[Ap.] p. 137.
Entries: 3.*

Errard, Charles II *(c.1606–1689)*
[RD.] I, pp. 97–98; XI, pp. 101–102.
Entries: 20. Pre-metric. Inscriptions. Described.

Granges de Surgères, Marquis de. "Errard." In: "Les artistes nantais." *Nouvelles archives de l'art français,* 3d ser. 14 (1898): 176–215.
Entries: 218 prints by and after. Millimeters. Inscriptions. Described.

Ertinger, Franz *(1640–c.1710)*
[W.] I, pp. 494–495.
Entries: 5+.*

Ertvelt, Andries van *(1590–1652)*
[W.] I, p. 495.
Entries: 1 print by, 1 after.*

[H. *Neth.*] VI, p. 152.
Entries: 1.*

Eschbach, Joseph *(d. 1847)*
[Merlo] p. 227.*

Eschenburgk, Nicolaus *(fl. 1550–1600)*
[H. *Ger.*] VIII, p. 34.
Entries: 1+.*

Escher, Maurits Cornelis *(1898–1972)*
Escher, M. C. *Grafiek en tekeningen M. C. Escher.* Zwolle (Netherlands): De Erven J. J. Tijl N. V., 1962. English ed. *The graphic work of M. C. Escher.* London: Oldbourne Press, 1961.

Entries: unnumbered, pp. 62–64 (to 1961). Millimeters. Illustrated (selection).

Locher, J. L. et al. *De Werelden van M. C. Escher.* Amsterdam: Meulenhoff, 1971. English ed. *The world of M. C. Escher.* New York: Harry N. Abrams, Inc. 1971.
Entries: 270 (all prints after 1937, selection of drawings and earlier prints). Millimeters. Inscriptions. Described. Illustrated.

Eschini, Angelo Maria d' *(d. 1678)*
[B.] XX, p. 296; XXI, pp. 165–166.
Entries: 2 (2 listings under different names).

Eskrich, Pierre *(1520?–1590)*
Rondot, Natalis. *P. Eskrich, peintre et tailleur d'histoires à Lyon.* Extract from *Revue du Lyonnais,* 1901. Lyons: Imprimerie Mougin-Rusand, Waltener et Cie, Sucrs., 1901.
Entries: unnumbered, pp. 37–57. Not in catalogue format, but apparently covers all prints by.

Esplens, Charles and John *(fl. c.1740)*
[Sm.] I, pp. 264–265.
Entries: 4 (portraits only). Inches. Inscriptions. Described.

[Ru.] p. 73.
Additional information to [Sm.].

Esquivel Sotomayor, Manuel *(1777–after 1842)*
[Ap.] pp. 137–138.
Entries: 8.*

Esselens, Jacob *(1626–1687)*
[W.] I, p. 496.
Entries: 2 prints by, 4 after.*

[H. *Neth.*] VI, p. 152.
Entries: 2 prints by, 7 after.*

Essen, Johannes von *(fl. c.1561)*
See **Monogram HE** [Nagler, *Mon.*] III, no. 853

Esser, Hermann *(19th cent.)*
[Merlo] p. 227.*

Esteve y Villella, Raphael *(1772–1847)*
[Ap.] p. 138.
Entries: 6.*

[Ber.] VI, p. 89.*

Estorges, Jean *(fl. c.1660)*
[RD.] III, p. 112; XI, p. 102.
Entries: 1. Pre-metric. Inscriptions. States. Described.

Estvad, Leo *(20th cent.)*
Bärenholdt, H. C. "Leo Estvads exlibris." [*N. ExT.*] 2 (1947–1948): 43–45.
Entries: 32 (bookplates only, to 1947). Illustrated (selection).

Etex, Antoine *(1808–1856)*
[Ber.] VI, pp. 89–90.*

Ethiou, Adèle *(fl. c.1820)*
[Ber.] VI, p. 90.*

Evans, Edmund *(1826–1905)*
McLean, Ruari. Bibliography. In *The reminiscences of Edmund Evans edited and introduced by Ruari McLean.* Oxford: Clarendon Press, 1967.
Bibliography of books with illustrations by.

Evans, John William *(b. 1855)*
"Artist's proofs; engravings on wood by John W. Evans." Unpublished ms., Brooklyn (N.Y.), [1895?]. (NN)
Entries: 77 (to 1895?). Ms. addition (NN); 44 additional entries.

Eve, George William *(b. 1855)*
Viner, George H. *A descriptive catalogue of the bookplates designed and etched by George W. Eve, R. E.* Kansas City (Mo.): American Bookplate Society, 1916. 250 copies. (NN)

Eve, George William *(continued)*

Entries: 256 (bookplates only, to 1914). Inches. Inscriptions. States. Described. Ms. notes (NN); additional information.

Evenepoel, Henri Jacques Edouard *(1872–1899)*

Lambotte, Paul. *Henri Evenepoel*. Brussels: G. van Oest, 1908.
Entries: unnumbered, pp. 106–108. Illustrated (selection).

Everaerts, Johann *(d. c.1766)*
[Merlo] pp. 227–228.*

Everdell, ——— *(fl. c.1816)*
[F.] p. 111.*

Everdingen, Adriaen van *(1832–c.1910)*
[H. L.] p. 234.
Entries: 3. Millimeters. Inscriptions. States. Described.

Everdingen, Allart van *(1621–1675)*
[B.] II, pp. 157–246 and addenda.
Entries: 163. Pre-metric. Inscriptions. States. Described.

[Weigel] pp. 78–81.
Entries: 1 (additional to [B.]). Premetric.

[Heller] pp. 44–45.
Additional information to [B.].

Frenzel, ———. "Albert oder Aldert van Everdingen." [*N. Arch.*] 1 (1855): 104–122.
Entries: 2 (additional to [B.] and [Weigel]). Pre-metric. Inscriptions. Described. Illustrated (selection). Located.

Drugulin, W. *Allart van Everdingen; catalogue raisonné de toutes les estampes qui forment son oeuvre gravé; supplément au peintre-graveur de Bartsch*. Leipzig: W. Drugulin, 1873.

Entries: 166. Millimeters. Inscriptions. States. Described. Ms. notes (EA); extensive additional information.

[Wess.] II, p. 235.
Additional information to [B.] and Drugulin.

[Dut.] IV, pp. 293–382; V, pp. 591–592; VI, pp. 671–672.
Entries: 167. Millimeters. Inscriptions. States. Described.

[W.] I, pp. 497–500.
Entries: 109+ prints by, 7 after.*

[H. *Neth.*] VI, pp. 153–204.
Entries: 173 prints by, 26 after. Illustrated (selection).*

Everdingen, Caesar van *(c.1617–1678)*
[H. *Neth.*] VI, p. 204.
Entries: 2 prints after.*

Everdsdyck, Willem *(c.1610–1671)*
[W.] I, p. 501.
Entries: 4 prints after.*

[H. *Neth.*] VI, p. 204.
Entries: 6 prints after.*

Evergood, Philip *(b. 1901)*
A. C. A. Gallery, New York. *20 years; Evergood*. New York: A. C. A. Gallery, 1946.
Entries: 35 etchings, 5 lithographs, 4 etched illustrations (to 1944). Inches.

Lippard, Lucy R. *The graphic work of Philip Evergood; selected drawings and complete prints*. New York: Crown Publishers, 1966.
Entries: 60. Inches. Illustrated.

Evershed, Arthur *(b. 1836)*
[Ber.] VI, p. 90.*

Ewart, T. *(18th cent.)*
[Sm.] I, p. 265, and "additions and corrections" section.

Entries: 1 print published by (portraits only). Inches. Inscriptions. Described.

Ewoutsone, Jan *(fl. c.1546)*
[H. *Neth.*] VI, p. 205.
Entries: 4+.*

Exilious, John G. *(fl. 1810–1814)*
[St.] p. 165.*

[F.] p. 111.*

Exshaw, Charles *(d. 1771)*
[Sm.] I, pp. 265–266, and "additions and corrections" section.
Entries: 4 (portraits only). Inches. Inscriptions (selection). Described (selection). Illustrated (selection).

[W.] I, pp. 501–502.
Entries: 6 prints by, 1 after.*

[Ru.] p. 73.
Entries: 1 (portraits only, additional to [Sm.]). Inches. Inscriptions. Described.

Eyck, Jan van *(1381/86–1441)*
[W.] I, pp. 509–521.
Entries: 12 prints after.*

[H. *Neth.*] VI, p. 205.
Entries: 22 prints after.*

Eyck, Mathias van der *(fl. 1723–1737)*
[W.] I, p. 521.
Entries: 2 prints after.*

Eykens, Peter
See **IJkens**

Eymar, Joseph *(fl. 1809–1824)*
[Ber.] VI, p. 90.

Eynhoudts, Remoldus *(1613–1680)*
[W.] I, p. 523.
Entries: 18.*

[H. *Neth.*] VI, p. 206.
Entries: 20.*

Ezdorf, Friedrich *(1807–1858)*
[A. 1800] IV, pp. 249–261.
Entries: 19. Millimeters. Inscriptions. States. Described.

F

Fabbrini, E. *(fl. c.1840)*
[Ap.] p. 138.
Entries: 1.*

Faber, Frédéric Théodore *(1782–1844)*
H[illemacher], F. *Catalogue des estampes qui composent l'oeuvre de Frédéric Théodore Faber, peintre flamand, graveur à l'eau-forte.* Paris: H. Fournier, 1843. 50 copies. (NN)

Entries: 108 etchings, 2 lithographs. Millimeters. Pre-metric. Inscriptions. States. Described. Entries 106–108 are in a one-page appendix, with notice of Faber's death in April 1844.

[H. L.] pp. 235–270.
Entries: 108 etchings, 2 lithographs. Millimeters (selection). Inscriptions. States. Described. Dimensions are given only for etchings.

Faber, Frédéric Théodore *(continued)*

[W.] I, 524.
Entries: 1+ .*

Faber, Johan *(fl. 1592–1617)*
[A.] IV, pp. 325–330.
Entries: 3+. Pre-metric (selection).
Paper fold measure (selection). In-
scriptions. Described.

[H. *Ger.*] VIII, p. 35.
Entries: 4+ .*

Faber, John I *(c.1650–1721)*
[Sm.] I, pp. 266–299, and "additions
and corrections" section.
Entries: 85 (portraits only). Inches. In-
scriptions. States. Described. Illus-
trated (selection). Located (selection).

[W.] I, p. 524.
Entries: 7.*

[Ru.] pp. 73–79, 491.
Entries: 6 (portraits only, additional to
[Sm.]). Inches. Inscriptions. States.
Described. Additional information to
[Sm.].

Faber, John II *(1684–1756)*
[Sm.] I, pp. 299–460, and "additions and
corrections" section; IV, "additions and
corrections" section.
Entries: 427+ (portraits only). Inches.
Inscriptions. States. Described. Illus-
trated (selection). Located (selection).

[Siltzer] p. 350.
Entries: unnumbered, p. 350. Inscrip-
tions.

[Ru.] pp. 79–100, 491.
Entries: 4 (portraits only, additional to
[Sm.]). Inches. Inscriptions (selec-
tion). States. Described. Additional
information to [Sm.].

Faber, Martin *(1587–1648)*
[A.] IV, pp. 237–238.

Entries: 1. Pre-metric. Inscriptions.
Described.

[Wess.] I, p. 137.
Entries: 1 (additional to [A.]). Mil-
limeters. Inscriptions. Described.

[W.] I, p. 524.
Entries: 2 prints by, 1 after.*

[H. *Neth.*] VI, p. 207.
Entries: 4 prints after.*

[H. *Ger.*] VIII, p. 35.
Entries: 2 prints by, 2 after.*

Faber, Theodor *(fl. c.1750)*
[H. *Neth.*] VI, p. 207.
Entries: 2 prints after.*

Fabre, François Xavier *(1766–1837)*
[Baud.] II, pp. 319–325.
Entries: 12. Millimeters. Inscriptions.
States. Described.

Fabri, Aloisio [Luigi] *(1778–1835)*
[Ap.] pp. 138–139.
Entries: 20.*

Fabritius, Barent *(1624–1672)*
[H. *Neth.*] VI, p. 207.
Entries: 6 prints after.*

Fabritius, Carel *(1622–1654)*
[W.] I, pp. 525–526.
Entries: 1.*

[H. *Neth.*] VI, p. 208.
Entries: 1 print by, 6 after.*

Fabritius, Chilian *(fl. 1620–1633)*
[H. *Ger.*] VIII, p. 36.
Entries: 3.*

Fabry, Thomas *(b. c.1810)*
[Merlo] p. 234.
Entries: 1. Paper fold measure. In-
scriptions.

Facchetti, Pietro *(1535–1619)*
[B.] XVII, pp. 15–18.
Entries: 2. Pre-metric. Inscriptions.
States. Described.

[Wess.] III, p. 47.
Additional information to [B.].

Faccini, Pietro *(1562–1602)*
[B.] XVIII, pp. 270–273.
Entries: 3. Pre-metric, Inscriptions.
Described.

Facius, Georg Sigmund and Johann
Gottlieb *(both b. 1750)*
[W.] I, p. 527.
Entries: 4.*

Faed, James *(1821–1911)*
[Siltzer] p. 350.
Entries: unnumbered, p. 350. Inscriptions.

Faget de Vans, ——— du *(19th cent.)*
[Ber.] XII, p. 177.*

Fagnion, Jules *(fl. c.1861)*
[Ber.] VI, p. 90.*

Fairburn, T. *(19th cent.)*
[Siltzer] p. 350.
Entries: unnumbered, p. 350. Inscriptions.

Fairland, Thomas *(1804–1852)*
[Siltzer] p. 350.
Entries: unnumbered, p. 350. Inscriptions.

Fairman, David *(1782–1815)*
[F.] p. 111.*

Fairman, Gideon *(1774–1827)*
[Allen] p. 134.*

[St.] pp. 165–168.*

[F.] pp. 111–114.*

Faithorne, William I *(1616–1691)*
"A catalogue of portraits engraved by
W. Faithorne Senior." Unpublished
ms., early 19th cent. (EBM)
Entries: unnumbered, 9 pp.

"Catalogue of the works of William
Faithorne." Unpublished ms. (EBM)
Entries: unnumbered, pp. 1–127.
States. Described.

Fagan, Louis. *A descriptive catalogue of the
engraved works of William Faithorne.* Lon-
don: Bernard Quaritch, 1888.
Entries: unnumbered, pp. 3–98, prints
by and after. Inches. Inscriptions.
States. Described. Copy with ms.
numbering (NN); 433 entries. Ms.
notes (ECol) by John Charrington;
additional information.

Faithorne, William II *(1656–1710)*
[Sm.] II, pp. 461–476, and "additions
and corrections" section.
Entries: 44 (portraits only). Inches. In-
scriptions. States. Described. Illus-
trated (selection). Located (selection).

[Ru.] pp. 101–103, 492.
Entries: 1 (portraits only, additional to
[Sm.]). Inches. Inscriptions. De-
scribed. Additional information to
[Sm.].

Faivre, ——— *(19th cent.)*
[Ber.] VI, p. 90.*

Faivre-Duffer, Louis Stanislas *(1818–1897)*
[Ber.] VI, p. 91.*

Fajans, Maximilan *(1827–1890)*
[Ber.] VI, p. 91.*

Falcieri, Biagio *(1628–1703)*
[B.] XXI, pp. 135–137.
Entries: 1. Pre-metric. Inscriptions.
Described.

Falck, Jeremias *(c.1619–1677)*
Upmark, Gustaf. *Jeremias Falck; drottning Christinas hofkopparstickare, med beskrifvande förteckning på Falcks svenska stick.* Stockholm: Ivar Haeggströms Boktryckeri, 1884.
> Entries: 26 (works done in Sweden only). Millimeters. Inscriptions. States. Described.

Upmark, Gustaf. "Jeremias Falck in Schweden und seine schwedischen Stiche." *[Rep. Kw.]* 8 (1885): 306–324.
> Entries: 26 (works done in Sweden only). Millimeters Inscriptions. States. Described.

Block, J. C. *Jeremias Falck; sein Leben und seine Werke, mit vollständigem alphabetischen und chronologischen Register sämmtlicher Blätter.* Danzig (Germany): Carl Hinstorff's Verlagsbuchhandlung, 1890.
> Entries: 295. Millimeters. Inscriptions. States. Described. Located. Ms. addition. (MBMu)

[W.] I, pp. 527–528.
> Entries: 15.*

[H. *Neth.*] VI, pp. 209–227.
> Entries: 299+. Illustrated (selection).*

Falckeisen, Theodor
See **Falkeisen**

Falco, Angelo *(fl. c.1619)*
[B.] XX, pp. 95–109.
> Entries: 20. Pre-metric. Inscriptions. States. Described. Copies mentioned.

Falda, Giovanni Battista *(d. 1678)*
[B.] XXI, pp. 237–253.
> Entries: 80 prints by, 8 prints not seen by [B.]. Pre-metric. Inscriptions. States. Described.

Falens, Carel van *(1683–1733)*
[W.] I, p. 527.
> Entries: 7 prints after.*

Falgas, Luis Garcia *(20th cent.)*
Catasús, Juan. *Luis Garcia Falgás.* Copenhagen: Areté, 1953. 175 copies. (DLC)
> Entries: 70 (bookplates only). Illustrated (selection).

Falger, Anton *(1791–after 1855)*
[Dus.] pp. 42–43.
> Entries: 12+ (lithographs only, to 1821). Millimeters (selection). Inscriptions. Located (selection).

Falguière, Jean Alexandre Joseph *(1831–1900)*
[Ber.] VI, p. 91.*

Falileev, Vadim Dmitrievich *(1879–1948)*
Romanov, Nikolaj I. *V. Falileev.* Moscow: Gosudarstvennoe Izdatel'stvo, 1923. (DLC)
> Entries: 445 (to 1922). Millimeters. Illustrated (selection).

Falk, Jeremias
See **Falck**

Falké, Pierre *(1884–1947)*
Druart, René. "Pierre Falké." *Portique* 5 (1947): 23–41.
> Bibliography of books with illustrations by (to 1946).

Falkeisen, Theodor *(1765–1814)*
[Ap.] p. 139.
> Entries: 1.*

Falmagne, Louis *(1829–1871)*
[Ap.] p. 140.
> Entries: 1.*

Famer, Johann *(17th cent.)*
[H. *Ger.*] VIII, p. 36.
> Entries: 1.*

Fanoli, Michele *(1807–1876)*
[Ber.] VI, p. 91.*

Fanti, Girolamo *(1818–1860)*
[Ap.] p. 140.
Entries: 1+.*

Fantin-Latour, Henri *(1836–1904)*
[Ber.] VI, pp. 91–94.
Entries: 67 (to 1887). Paper fold measure (selection).

Hédiard, Germain: "Les maîtres de la lithographie; Fantin-Latour." *L'Artiste,* n.s. 3 (1892, no. 1): 240–251, 433–457.
Entries: 104. Millimeters. Inscriptions. States. Described.

Hédiard, Germain. *Fantin-Latour; étude suivie du catalogue de son oeuvre.* Les maîtres de la lithographie. Paris: Edmond Sagot, 1892.
Entries: 2 etchings, 105 lithographs (to 1892). Millimeters. Inscriptions. States. Described.

Hédiard, Germain. *Les lithographies nouvelles de Fantin-Latour (octobre 1892– décembre 1898).* Paris: Edmond Sagot, 1899.
Entries: 42 (additional to Hédiard 1892). Millimeters. Inscriptions. States. Described.

Bénédite, Léonce. *Fantin-Latour.* Paris: Librairie de l'Art Ancien et Moderne, 1903.
Entries: 149. Illustrated (selection).

Hédiard, Germain, and Bénédite, Léonce. *Fantin-Latour; catalogue de l'oeuvre lithographique du maître . . . nouvelle édition revue, corrigée et complétée.* Les maîtres de la lithographie. Paris: Librairie de l'Art Ancien et Moderne, 1906. 250 copies.
Entries: 2 etchings, 193 lithographs. Millimeters. Inscriptions. States. Described.

Bénédite, Léonce. *L'Oeuvre lithographique de Fantin-Latour; collection complète de ses lithographies, reproduites et réduites en fac-similé.* Paris: Loys Delteil, 1907. 125 copies. (MH)

Entries: 2 etchings, 193 lithographs. Millimeters. Illustrated.

Fantin-Latour, Mme. *Catalogue de l'oeuvre complet (1849–1904) de Fantin-Latour.* Paris: Henri Floury, 1911.
Entries: 2451 (works in all media). Millimeters. Chronological list. Hédiard numbers are given for prints.

Fantuzzi, Antonio *(c.1510–after 1550)*
[B.] XVI, pp. 334–354.
Entries: 37. Pre-metric. Inscriptions. States. Described. Copies mentioned.

[Evans] p. 23.
Entries: 2 (additional to [B.]). Millimeters. Inscriptions. Described.

[P.] VI, pp. 195–198.
Entries: 10 (additional to [B.]). Pre-metric (selection). Paper fold measure (selection). Inscriptions. Described. Additional information to [B.].

[Herbet] II, pp. 257–291; V, pp. 80–81.
Entries: 106. Millimeters. Inscriptions. Described. Located (selection). Appendix with 3 rejected prints.

[Zerner] no. 1.
Entries: 111. Millimeters. Inscriptions. States. Described (selection). Illustrated.

Farinato, Orazio *(1559–after 1616)*
[B.] XVI, pp. 161–163, 168–172.
Entries: 5 prints by, 1 doubtful print. Pre-metric. Inscriptions. States. Described.

Farinato, Paolo *(1524–1606)*
[B.] XVI, pp. 161–168.
Entries: 10. Pre-metric. Inscriptions. States. Described.

[P.] VI, p. 179.
Entries: 1 (additional to [B.]). Pre-metric. Inscriptions. Described.

[P.] VI: *See* **Chiaroscuro Woodcuts**

Farrugia, Giovanni *(b. 1810)*
[Ap.] p. 140.
Entries: 1.*

Fassbender, P. J. *(fl. c.1838)*
[Merlo] p. 234.*

Fassianos, Alexandre *(b. 1935)*
Galerie Paul Facchetti, Paris. *Catalogue de gravures, lithographies, sérigraphies, xylographies de Fassianos executées entre 1968 et 1971.* Paris, 1971. (DLC)
Entries: 51 (to 1971). Millimeters. Described. Illustrated.

Fatoure, P. *(fl. c.1609)*
[RD.] VI, p. 143
Entries: 6 prints by or after. Millimeters. Inscriptions. Described.

Fattori, Giovanni *(1825–1908)*
Servolini, Luigi. *177 Acqueforti di Giovanni Fattori.* Milan: Editrice IGIS, 1966.
Entries: 177 (complete?). Illustrated.

Mencarini, Giuseppe. "Postilla sulle acqueforti di Giovanni Fattori." *Gutenberg Jahrbuch* 45 (1970): 343–348.
Additional information to Servolini.

Fauchery, Augustin *(1800–1843)*
[Ap.] p. 140.
Entries: 2.*

[Ber.] VI, pp. 94–95.*

Fauquignon, ——— *(c.1800–c.1850)*
[Ber.] VI, p. 95.*

Faure, Amédée *(1801–1878)*
[Ber.] VI, p. 95.*

Faure, Louis *(1785–1879)*
[Dus.] pp. 43–44.
Entries: 1 (lithographs only, to 1821). Millimeters. Inscriptions. Located.

Faure-Delcourt, Henri *(19th cent.)*
[Ber.] VI, p. 95.
Entries: 12. Paper fold measure.

Faurtoft, Inge *(20th cent.)*
Fogedgaard. Helmer. "Inge Faurtoft, en ny dansk exlibriskunster." [*N. ExT.*] 19 (1967): 65–66, 71.
Entries: 13 (bookplates only, to 1967?). Illustrated (selection).

Fautrier, Jean *(1898–1964)*
Galerie Engelberts, Geneva [Edwin Engelberts, compiler]. *Jean Fautrier; oeuvre gravé, oeuvre sculpté, essai d'un catalogue raisonné.* Geneva, 1969.
Entries: unnumbered, 27 pp. (to 1964). Millimeters. Illustrated.

Favet, Charles *(20th cent.?)*
Darbot, Jean. "Charles Favet, graveur troyen." [*Vieux P.*] 25 (1967–1969): 349–354.
Entries: unnumbered, pp. 350–354. (complete?).

Favorskii, Vladimir Andreevich *(1886–1964)*
Gosudarstvenny Muzei Izobratitel'nykh Iskusstvo, Moscow. *Laureat Leninskoi premii, Vladimir Andreevich Favorskii katalog vistavki proijvedenii.* Moscow, 1964.
Entries: unnumbered, pp. 19–41.

Kravcov, G. A. *V. A. Favorskij.* Moscow, Izdatel'stvo "Kniga," 1969.
Entries: 25 (bookplates only). Illustrated (selection).

Favre, Louis *(20th cent.)*
Louis Favre et l'estampe en couleurs contemporian. Preface by Marc Sandoz. The Hague: Éditions Mouton et Cie, 1953.
Entries: unnumbered, p. 26 (to 1953). Millimeters.

Fawcett, Benjamin *(1808–1893)*
Morris, M. C. F. *Benjamin Fawcett; colour printer and engraver.* London: Oxford University Press, 1925.
Bibliography of books with illustrations by.

Féart, Adrien *(b. 1813)*
[Ber.] VI, pp. 95–96.*

Féau, Amédée *(b. 1872)*
Clément-Janin, ———. "Amédée Féau, graveur-aquafortiste parisien." *Byblis* 1 (1922): 49–51, and 2 unnumbered pages following p. 130.
Entries: unnumbered, 2 pp. (to 1922). Millimeters.

Clément-Janin, ———. "The etchings of Amédée Féau." [*P. Conn.*] 4 (1924): 21–35.
Entries: unnumbered, pp. 30–34 (to 1923). Inches. Illustrated (selection).

Fechner, Eduard Clemens *(1799–1861)*
[A. 1800] IV, pp. 222–227.
Entries: 11. Millimeters. Inscriptions. States. Described.

Feddes Van Harlingen, Petrus
(1586–c.1634)
[vdK.] pp. 139–162, 231–232.
Entries: 119. Millimeters. Inscriptions. States. Described. Appendix with 5 doubtful and rejected prints; also, list of 14 prints after, not all fully catalogued.

Kellen, J. Ph. van der. *Petrus Feddes, peintre-graveur frison, extrait du peintre-graveur hollandais et flamand.* Utrecht: Kemink et Fils, 1866.
Separate publication of [vdK.].

Thausing, M. "Van der Kellen's hollandisch-flamischer Peintre-Graveur." [*ZbK.*] 8 (1873): 221–224.

Entries: 2 (additional to [vdK.]). Millimeters. Inscriptions. Described.

[W.] I, p. 530.
Entries: 118+ prints by, 7 after.*

[H. *Neth.*] VI, pp. 228–243.
Entries: 120 prints by, 22 after. Illustrated (selection).*

Fehr, F. *(fl. c.1817)*
[Dus.] p. 44.
Entries: 4 (lithographs only, to 1821). Millimeters (selection). Inscriptions (selection). Located (selection).

Feilner, Johann Everhard *(1802–1869)*
[Merlo] p. 236.*

Feininger, Lyonel *(1871–1956)*
Prasse, Leona E. *Lyonel Feininger; das graphische Werk, Radierungen, Lithographien, Holzschnitte/a definitive catalogue of his graphic work, etchings, lithographs, woodcuts.* Berlin: Gebrüder Mann Verlag; Cleveland (Ohio): Cleveland Museum of Art, 1972.
Entries: 65 etchings, 20 lithographs, 320 woodcuts, 3 doubtful prints, 14 prints after, 4 rejected prints. Millimeters. Inscriptions. States. Described. Illustrated. Located. Description of papers and editions, publishers stamps, signatures.

Feinlein, Johann Christoph *(fl. 1650–1700)*
[H. *Ger.*] VIII, p. 36.
Entries: 2+.*

Fekete, Esteban *(b. 1924)*
Galerie am Grasholz, Rottendorf [Hans Kufner, compiler]. *Esteban Fekete; Werkverzeichnis der Druckgraphik 1956–1971.* Rottendorf (West Germany), 1971. 1200 copies. (ENGM)
Entries: 308 (to 1971). Millimeters. Described. Illustrated.

Felbinger, Caspar *(fl. 1550–1600)*
[H. *Ger.*] VIII, p. 36.
Entries: 3+.*

Felix, Florentin *(19th cent.)*
[Ber.] VI, p. 96.*

Felixmüller, Konrad *(b. 1897)*
Boettger, Fritz. *Felixmüller; Katalog seiner Holzschnitte, Lithographien, Radierungen.* Dresden: Verlag Emil Richter, 1919.
Entries: 73+. Millimeters. Illustrated (selection).

Fellows, W. M. *(19th cent.)*
[Siltzer] p. 350.
Entries: unnumbered, p. 350. Inscriptions.

Félon, Joseph *(1818–1896)*
[Ber.] VI, p. 96.*

Felsing, Jacob [Georg Jacob] *(1803–1883)*
[Ap.] pp. 141–144.
Entries: 32.*

Felsing, Johann Konrad *(1766–1819)*
Franke, Willibald. *100 Jahre im Dienste der Kunst; Erinnerungsgabe der Firma O. Felsing.* Berlin: O. Felsing, 1897.
Entries: unnumbered, pp. 155–158. Millimeters. Inscriptions. Described.

Fenderich, Charles *(fl. c.1841)*
Carey, pp. 270–278.
Entries: 130 (lithographs only). Inches. Inscriptions. Described (selection).

Parker, Alice Lee, and Kaplan, Milton. *Charles Fenderich, lithographer of American statesmen; a catalog of his work.* Washington (D.C.): Library of Congress, Prints and Photographs Division, 1959.
Entries: 261 (works in various media, including prints by). Inches. Inscriptions. Described.

Fendi, Peter *(1796–1842)*
Adolph, Hubert. "Die Druckgraphik Peter Fendis." *Mitteilungen der Osterreichischen Galerie* 7, no. 51 (1963): 54–89.
Entries: 79 etchings, 39 lithographs, 1 wood engraving. Millimeters. Inscriptions (selection). States. Illustrated (selection). Located.

Fendt, Tobias *(d. 1576)*
[A.] II, pp. 32–49.
Entries: 125. Pre-metric. Inscriptions. States. Described.

[H. *Ger.*] VIII, p. 37.
Entries: 1+. Illustrated (selection).*

Fenn, ——— *(19th cent.)*
[Dus.] p. 44.
Entries: 1+ (lithographs only, to 1821).

Fenn, George *(19th cent.)*
[Siltzer] p. 330.
Entries: unnumbered, p. 330, prints after. Inches. Inscriptions.

Fennitzer, Georg *(fl. 1675–1700)*
[H. *Ger.*] VIII, pp. 38–43.
Entries: 166.*

Fennitzer, Johann Philipp *(17th cent.)*
[H. *Ger.*] VIII, p. 44.
Entries: 5.*

Fennitzer, Michael *(1641–1702)*
[H. *Ger.*] VIII, pp. 44–45.
Entries: 48.*

Fentzel, Gregorius *(fl. c.1650)*
[H. *Ger.*] VIII, p. 46.
Entries: 31.*

Ferdinand, ——— *(fl. c.1850)*
[Ber.] VI, p. 96.*

Ferdinandus *(19th cent.)*
[Ber.] VI, p. 96.*

Ferguson, William Gouw *(1633–after 1695)*
[H. *Neth.*] VI, p. 243.
 Entries: 1 print after.*

Fernandez Saez, Julio *(20th cent.)*
Catasús, Juan. *El grabador Julio Fernandez Saez.* Biblioteca del exlibrista, 8. Barcelona, 1961. 125 copies. (DLC)
 Entries: 223 (bookplates only, to 1961). Illustrated (selection).

Fernando II, King of Portugal *(1816–1885)*
[Ber.] VI, p. 96.*

Ferneley, ―――― *(19th cent.)*
[Siltzer] p. 350.
 Entries: unnumbered, p. 350. Inscriptions.

Ferneley, John E. *(1781–1860)*
[Siltzer] pp. 111–121.
 Entries: unnumbered, pp. 120–121, prints after. Inches (selection). Inscriptions.

Ferogio, Fortuné *(1805–1888)*
[Ber.] VI, pp. 96–97.*

Ferreira, António Paris *(20th cent.)*
Rocha Madahil, António Gomes da. *Integração do gravador António Pais Ferreira, abridor e desenhador de ex-libris, na tradição nacional da gravura artística.* Braga (Portugal): Oficinas Gráficas de Livraria Pax, 1962. (DLC)
 Entries: 63 (bookplates only, to 1962). Inscriptions. Described. Illustrated (selection).

Ferreri, Cesare *(1802–1859)*
[Ap.] pp. 144–145.
 Entries: 10.*

Ferretti, Giuseppe *(fl. 1800–1850)*
[Ap.] p. 145.
 Entries: 2.*

Ferretti, Lodovico *(fl. c.1850)*
[Ap.] p. 145.
 Entries: 7.*

Ferri, ―――― *(fl. c.1838)*
[Ber.] VI, p. 97.*

Ferroni, Girolamo *(1687–1730)*
[B.] XXI, pp. 325–330.
 Entries: 9. Pre-metric. Inscriptions. States. Described.

Fresquet, Jules *(b. 1836)*
[Ber.] VI, p. 97.*

Fessard, Etienne *(1714–1777)*
[L. D.] p. 23.
 Entries: 1. Millimeters. Inscriptions. States. Described. Incomplete catalogue.*

Feuchère, Jean *(1807–1852)*
[Ber.] VI, p. 97.*

Feuille, Daniel de la *(c.1640–1709)*
[W.] I, pp. 531–532.
 Entries: 2+.*

Feuille, Jacob de la *(fl. c.1650)*
[H. *Neth.*] VI, p. 243.
 Entries: 1.*

Feuillet, Théodore *(fl. 1750–1797)*
Dauvergne, Anatole. "Théodore Feuillet, graveur né à Coulommiers." In *Études historiques et archéologiques sur la ville de Coulommiers,* by Anatole Dauvergne. Coulommiers (France): Alexandre Brodard, 1863. (NNMM)
 Entries: 4. Millimeters. Inscriptions. Described.

Feyen-Perrin, François Nicolas Auguste *(1826–1888)*
[Ber.] VI, pp. 97–98.
 Entries: 34.

Fialetti, Odoardo *(1573–1638)*
[B.] XVII, pp. 263–301.
Entries: 243. Pre-metric. Inscriptions.
States. Described. Copies mentioned.

Fichot, Charles *(1817–1903)*
[Ber.] VI, p. 98.*

Ficke, Nicolas *(c.1620–1702)*
[W.] I, p. 533.
Entries: 2.*

[Wess.] II, p. 235.
Entries: 2. Millimeters (selection).
Inscriptions. Described.

[H. *Neth.*] VI, p. 244.
Entries: 3. Illustrated (selection).*

Ficquet, Etienne *(1719–1794)*
Faucheux, L. E. "Catalogue raisonné de
l'oeuvre d'Etienne Ficquet." [*RUA*] 19
(1864): 5–22, 73–104, 145–202.
Entries: 176. Millimeters. Inscriptions.
States. Described.

Faucheux, L. E. *Catalogue raisonné de
toutes les estampes qui forment les oeuvres
gravés d'Étienne Ficquet, Pierre Savart, J. B.
de Grateloup.* Paris: Veuve Jules Re-
nouard; Brussels: A. Mertens et Fils,
1864. 100 copies. (NJP)
Entries: 176 prints by, 2 doubtful
prints. Millimeters. Inscriptions.
States. Described.

Andrews, William Loring. *A trio of
eighteenth century French engravers of
portraits in miniature; Ficquet, Savart,
Grateloup.* New York: William Loring
Andrews, 1899.
Entries: unnumbered, pp. 111–117
(portraits only).

Field, Robert *(d. 1819)*
[Sm.] II, p. 477, and "additions and cor-
rections" section.
Entries: 1 (portraits only). Inches. In-
scriptions. States. Described.

[St.] pp. 168–169.*

[F.] p. 114.*

[Ru.] p. 103.
Additional information to [Sm.].

Piers, Harry. *Robert Field; portrait painter
in oils, miniature and water-colours and en-
graver.* New York: Frederick Fairchild
Sherman, 1927.
Entries: 10. Inches. Inscriptions. De-
scribed. Located.

Fielding, Newton Smith *(1799–1856)*
[Ber.] VI, pp. 98–99.*

[Siltzer] p. 351.
Entries: unnumbered, p. 351, prints
by and after. Inscriptions.

Fielding, Theodore Henry Adolphus
(1781–1851)
[Siltzer] p. 351.
Entries: unnumbered, p. 351. Inscrip-
tions.

Filhol, Antoine Michel *(1759–1812)*
[Ber.] VI, p. 98.*

Filla, Emil *(1882–1953)*
Berka, Čestmír. *Grafícke dílo Emila Filly.*
Prague: Odeon, 1969.
Entries: 176. Millimeters. Inscriptions.
Illustrated.

Fincke, Hans *(1800–1849)*
[Ap.] p. 146.
Entries: 2.*

Finden, Edward Francis *(1791–1857)*
[Ap.] p. 146.
Entries: 4.*

[Ber.] VI, pp. 99–100.*

Finden, William *(d. 1852)*
[Ap.] p. 146.
Entries: 7.*

[Ber.] VI, pp. 99–100.*

Finiguerra, Maso *(1426–1464)*
Dodd, Thomas. "Manuscript description of engravings ascribed to Tomaso Finiguerra." Unpublished ms. (EBM)
Entries: unnumbered, pp. 7–30. Described.

[B.] XIII, pp. 155–157.
Discussion of Finiguerra, no catalogue.

[Dut.] II, pp. 285–286.
Entries: 2 prints by, 3 rejected prints (niello prints only). Millimeters. Inscriptions. Described. Illustrated (selection).

Colvin, Sidney. *A Florentine picture chronicle; being a series of ninety-nine drawings representing scenes and personages of ancient history, sacred and profane, by Maso Finiguerra.* London: B. Quaritch, 1898.
General discussion of what prints can be attributed to Finiguerra.

[Hind] I, pp. 1–2.
Discussion of the possibility of attributing prints to Finiguerra.

Finlayson, John *(c.1730–c.1776)*
[Sm.] II, pp. 477–485, and "additions and corrections" section.
Entries: 20 (portraits only). Inches. Inscriptions. States. Described. Located (selection).

[Ru.] pp. 104–106.
Entries: 1 (portraits only, additional to [Sm.]). Inches. Described. Additional information to [Sm.].

Finne, Henrik *(20th cent.)*
Schyberg, Thor Bjorn. "Henrik Finne." [*N. ExT.*] (1957): 88–89.
Entries: 15 (bookplates only, to 1946). Illustrated (selection).

Finson, Ludovicus
See **Finsonius**

Finsonius, Ludovicus *(c.1580–1617)*
[W.] I, p. 534.
Entries: 6 prints after.*

[H. *Neth.*] IV, p. 245.
Entries: 7 prints after.*

Fiordini, Adolfo *(19th cent.)*
[Ap.] p. 147.
Entries: 2.*

Fiorentino, Il
See **Vajani,** Alessandro

Fiorentino, Luca
See **Giunta,** Luca Antonio de

Fiorini, ——— *(20th cent.)*
Galerie Jeanne Bucher, Paris. *Fiorini— gravures pour les heures.* Paris, 1965.
Entries: unnumbered, 9 pp. Millimeters. Illustrated (selection).

Firens, Jodocus *(fl. c.1620)*
[W.] I, p. 534.
Entries: 2 prints after.*

[H. *Neth.*] VI, p. 245.
Entries: 3+ prints after.

Firens, Petrus *(c.1580–c.1639)*
[W.] I, pp. 534–535.
Entries: 1.*

[H. *Neth.*] VI, p. 245.
Entries: 25.*

Fischbach, Johann *(1797–1871)*
[A. 1800] V, pp. 78–88.
Entries: 25. Millimeters. Inscriptions. Described.

Fischer, Carl *(fl. c.1600–1610)*
[H. *Ger.*] VIII, p. 47.
Entries: 1 print after.*

Fischer, Georg Peter *(fl. 1600–1650)*
[H. *Ger.*] VIII, p. 47.
Entries: 1+ prints after.*

Fischer, Georges *(fl. c.1850)*
[Ber.] VI, p. 101.*

Fischer, Hans *(1909–1958)*
Scheidegger, Alfred. *Hans Fischer 1909–1958; das druckgraphische Werk; Gesamtkatalog.* Bern: Verlag Stämpfli, 1968.
Entries: 357 (single prints only). Millimeters. Inscriptions. States. Described. Illustrated. Also, bibliography of books with illustrations by.

Fischer, Johann Wilhelm *(fl. c.1680)*
[H. *Ger.*] VIII, p. 47.
Entries: 1 print after.*

Fischer, Joseph Martin *(1769–1822)*
[Ap.] p. 147.
Entries: 2.*

Fischer, L. H. *(fl. c.1900?)*
Roeper, Adalbert. [*Kh.*] 7 (1915): 135ff.
Not seen.

Fischer, Otto *(b. 1870)*
Singer, Hans W. "Otto Fischer," [*GK.*] 24 (1901): 72–80.
Entries: 63 (to 1901). Millimeters. Inscriptions. States. Described.

Singer, Hans W. "Otto Fischers graphische Werke 1901–1909." *Original und Reproduktion* I (1909): 14–15, 57–68.
Entries: 84 (additional to Singer 1901; to 1909.) Millimeters. Inscriptions. States. Described. Additional information to Singer 1901.

Fischer, William Edgar *(fl. c.1900)*
"Designs of William Edgar Fischer." *The Book-plate Booklet* 2 (1908): 3–9.
Entries: 125 (to 1907). Ms. addition (NN); 4 additional prints.

Fisches, Isaac I *(1638–1706)*
[H. *Ger.*] VIII, p. 47.
Entries: 1 print after.*

Fisches, Isaac II *(1677–1705)*
[H. *Ger.*] VIII, p. 47.
Entries: 17+ prints after.*

Fisher, Edward *(1722–1785)*
[Sm.] II, pp. 485–510, and "additions and corrections" section.
Entries: 67+ (portraits only). Inches. Inscriptions. States. Described. Illustrated (selection). Located (selection).

[Ru.] pp. 106–111.
Entries: 1 (portraits only, additional to [Sm.]. Inches. Inscriptions. Described. Additional information to [Sm.].

Fitch, John *(fl. c.1800)*
[F.] p. 114.*

Fittler, James *(1758–1835)*
[Ap.] pp. 147–148.
Entries: 28.*

Fitton, Hedley *(b. 1859)*
Dunthorne, Robert. *Illustrated catalogue of etchings by Hedley Fitton, R. E., with descriptions.* London: Robert Dunthorne, 1911. 350 copies. (MH)
Entries: 36 (to 1911). Inches. Described. Illustrated.

Flach, Johann Georg *(1660–1675)*
[H. *Ger.*] VIII, p. 47.
Entries: 1 print after.*

Flachenecker, Ferdinand Wolfgang *(1792–1847)*
[Dus.] p. 44.
Entries: 2+ (lithographs only, to 1821). Millimeters. Inscriptions. Located.

Flamel, —— *(19th cent.)*
[Ber.] VI, p. 101.*

Flamen, Albert *(fl. 1620–1669)*
[B.] V, pp. 169–198.

Entries: 152. Pre-metric. Inscriptions. States. Described.

[RD.] V, pp. 135–244; XI, pp. 103–105. Entries: 587. Millimeters. Inscriptions. States. Described.

[Weigel] pp. 271–275. Entries: 17 (additional to [B.] and [RD.]). Pre-metric. Inscriptions. Described.

[W.] I, p. 535. Entries: 3 prints after.*

[H. Neth.] VI, p. 246. Entries: 1+.*

Flameng, François *(b. 1856)* [H. L.] pp. 306–307. Entries: 2. Millimeters. Inscriptions. Described.

[Ber.] VI, pp. 134–135.*

Flameng, Léopold *(1831–1911)* [H. L.] pp. 270–306. Entries: 210 (to 1873?). Millimeters. Inscriptions (selection). States. Described (selection).

[Ap.] pp. 148–149. Entries: 11.*

[Ber.] VI, pp. 101–134. Entries: 700. Paper fold measure (selection).

Flamet, Eugène Jacques Marie *(d. 1887)* [Ber.] VI, p. 135.*

[Ap.] p. 149. Entries: 2.*.

Flandrin, Auguste *(1804–1843)* [Ber.] VI, p. 136.*

Flandrin, Hippolyte *((1809–1864)* [Ber.] VI, p. 136.*

Flandrin, Paul *(1811–1902)* [Ber.] VI, p. 137.*

Flattner, Peter *See* **Flötner**

Flaxman, John *(1755–1826)* Bently, G. E., Jr. *The early engravings of Flaxman's classical designs; a bibliographical study.* New York: New York Public Library, 1964.
Bibliography of books with illustrations by (Homer, Aeschylus, Hesiod and Dante).

Fleck, I. V. *(19th cent.)* [Dus.] p. 44. Entries: 1 (lithographs only, to 1821). Millimeters. Inscriptions. Located.

Fleischberger, J. F. *(fl. 1650–1700)* [H. Ger.] VIII pp. 48–49. Entries: 30+.*

Fleischmann, Andreas *(1811–1878)* [Ap.] p. 148. Entries: 4.*.

Fleischmann, Friedrich *(1791–1834)* [Ap.] pp. 149–150. Entries: 6.*

Fleischmann, Jacob *(1816–1866)* [Ap.] p. 3. Entries: 3.*

[Ber.] VI, p. 137.*

Flémalle, Bertholet *(1614–1675)* [W.] I, pp. 535–536. Entries: 8+ prints after.*

[H. Neth.] VI, p. 246. Entries: 10 prints after.*

Flessiers, Balthasar *(before 1575–1626)* [W.] I, pp. 536–537. Entries: 2 prints after.*

[H. Neth.] VI, p. 246. Entries: 3 prints after.*

Fletner, Peter
See **Flötner**

Flettner, Peter
See **Flötner**

Fleury, Robert
See **Robert-Fleury**

Fliegerbauer, Max Joseph *(fl. c.1910)*
Dobsky, Arthur. "Max Joseph Flieger-
bauer." [*Kh.*] 9 (1917): 152–156; and
Beilage no. 7. Separately published.
Lübeck (Germany), 1917.
 Entries: 104 (to 1917). Millimeters. Il-
 lustrated.

Flight, J. *(fl. 1802–1806)*
[Sm.] II, "additions and corrections"
section.
 Entries: 1 (portraits only). Inches. In-
 scriptions. Described.

Flinck, Govaert *(1615–1660)*
[W.] I, pp. 537–539.
 Entries: 42 prints after.*

Moltke, J. W. von. *Govaert Flinck
1615–1660.* Amsterdam: Menno
Hertzberger and Co., 1965.
 Catalogue of paintings; engravings
 after are mentioned where extant.

[H. *Neth.*] VI, pp. 247–248.
 Entries: 50 prints after.*

Flinck, Nicolas Anthoni *(1646–1723)*
[H. *Neth.*] VI, p. 248.
 Entries: 1.*

Flindt, Paul *(fl. 1601–1618)*
[H. *Ger.*] VIII, pp. 50–115.
 Entries: 172+. Illustrated (selection).*

Flint, Paul
See **Flindt**

Flint, William Russell *(1880–1969)*
Wright, Harold J. L. *Etchings and dry
points by Sir William Russell Flint.* Lon-
don: P. and D. Colnaghi and Co. Ltd.,
1957. 135 copies. (MH)
 Entries: 66 (to 1954). Inches. States.
 Described. Illustrated. Located.

Flipart, Jean Jacques *(1719–1782)*
[L. D.] pp. 23–25.
 Entries: 5. Millimeters. Inscriptions.
 States. Described. Incomplete
 catalogue.*

Flockenhaus, Richard *(b. 1876)*
Zürcher, Karl. *Das graphische Werk
Richard Flockenhaus; Holzschnitte,
Radierungen, Steinzeichnungen.* Berlin:
1936. 200 copies (EBKk)
 Entries: 25 woodcuts, 139 etchings, 10
 lithographs. Millimeters. Inscrip-
 tions. States. Described. Illustrated
 (selection).

Flodner, Peter
See **Flötner**

Flötner, Peter *(c.1485–1546)*
[B.] IX, pp. 162–163.
 Entries: 3. Pre-metric. Inscriptions.
 Described.

[Heller] pp. 45–47.
 Entries: 7 (additional to [B.]). Pre-
 metric. Inscriptions. Described.

[P.] III, pp. 253–257.
 Entries: 32+. Pre-metric. Inscriptions.
 Described. Located (selection).

Reimers, J. *Peter Flötner nach senen
Handzeichnungen und Holzschnitten.*
Munich: G. Hirth's Kunstverlag, 1890.
 Entries: 82 (woodcuts only). Inscrip-
 tions. Described. Illustrated (selec-
 tion).

Röttinger, Heinrich. *Peter Flettners
Holzschnitte.* Studien zur deutschen
Kunstgeschichte 186. Strasbourg: J. H.
Ed. Heitz, 1916.

Entries: 71 prints by and after (wood-cuts only). Millimeters. Inscriptions. Described. Illustrated (selection). Located (selection).

[Ge.] nos. 813–873.
Entries: 61 (single-sheet woodcuts only). Described. Illustrated. Located.

Bange, E. F. *Peter Flötner*. Meister der Graphik, 14. Leipzig: Verlag von Klinkhardt und Biermann, 1926.
Entries: 57 (woodcuts only). Millimeters. Inscriptions. States. Described. Illustrated. Located.

[H. *Ger.*] VIII, pp. 116–156.
Entries: 90+. Illustrated (selection).*

Florentin, Dominique
See **Barbiere,** Domenico del

Floridi, Francesco *(fl. c.1830)*
[Ap.] p. 150.
Entries: 3.*

Floris, Cornelis II *(1514–1575)*
[P.] III, pp. 105–106.
Entries: 7+. Pre-metric. Inscriptions. Described. Located (selection).

[W.] I, pp. 540–541.
Entries: 3 prints by, 3 after.*

[H. *Neth.*] VI, pp. 249–250.
Entries: 86 prints after. Illustrated (selection).*

Floris, Frans I *(1519/20–1570)*
[W.] I, pp. 541–543.
Entries: 3 prints by, 19+ after.*

[H. *Neth.*] VI, pp. 251–255.
Entries: 4 prints by, 107 after. Illustrated (selection).*

Velde, Carel van de. "Frans Floris (1519–20—1570) leven en werken." Doctoral dissertation, University of Ghent, 1969–1970. (EUW)
Entries: 145. Inscriptions. Bibliography for each entry.

Floris, Jacob *(1524–1581)*
[W.] I, pp. 543–544.
Entries: 3+ prints after.*

[H. *Neth.*] VI, p. 256.
Entries: 70 prints after.*

Florisz van Berkenrode, Balthazar
See **Berkenrode**

Flury, Paul *(b. 1878)*
Olivier, E. "Paul Flury, dessinateur et graveur d'ex-libris." [*Arch. Ex.-lib.*] 31 (1924): 35–37.
Entries: 58 (bookplates only, to 1924?).

Flygenring, Hans *(20th cent.)*
Reumert, Emmerik. "Hans Flygenring." [*N. ExT.*] 4 (1951–1952): 41–42.
Entries: unnumbered, p. 42 (bookplates only, to 1950). Illustrated (selection).

Focillon, Victor Louis *(1849–1918)*
[Ber.] VI, p. 138.*

Fock, Harmanus *(1766–1822)*
[H. L.] pp. 307–331.
Entries: 81 (complete?) Millimeters. Inscriptions. States. Described.

[W.] I, p. 544.
Entries: 4+.*

Focus, Georges *(1641–1708)*
[RD.] I, pp. 235–242; XI, p. 105.
Entries: 9. Pre-metric. Inscriptions. States. Described.

Fogolino, Marcello *(c.1470–after 1550)*
[B.] XIII, pp. 212–214.
Entries: 3. Pre-metric (selection). Described (selection).

[P.] V, pp. 145–147.
Entries: 5. Pre-metric. Inscriptions. Described. Located.

[Hind] V, pp. 217–219.

Fogolino, Marcello *(continued)*

Entries: 7. Millimeters. Inscriptions. Described. Illustrated. Located.

Fohr, Carl Philipp *(1795–1818)*
[Dus.] pp. 44–45.
Entries: 2 (lithographs only, to 1821). Millimeters. Inscriptions. Located.

Fokke, A. Williamsz *(fl. c.1781)*
[W.] I, p. 544.
Entries: 2.*

Fokke, Simon *(1712–1784)*
[W.] I, pp. 544–545.
Entries: 25+.*

Folio, Adriaen
See **Foly**

Folkema, Anna *(1695–1768)*
[W.] I, p. 545.
Entries: 1+.*

Folkema, Jacob *(1692–1767)*
[W.] I, p. 545.
Entries: 27+.*

Follet, Edouard *(1824–after 1879)*
[Ber.] VI, pp. 138–139.*

Folo, Giovanni *(1764–1836)*
[Ap.] pp. 150–153.
Entries: 37.*

Folo, Pietro *(1790–1867)*
[Ap.] p. 153.
Entries: 6.*

Folwell, Samuel *(1765–1813)*
[St.] pp. 169–170.*

[F.] pp. 114–115.*

Foly, Adriaen *(fl. c.1669)*
[W.] I, p. 545.
Entries: 1 print after.*

Fonbonne, Quirijn *(c.1680–after 1734)*
Beaupré, J. N. "Notice sur quelques graveurs nancéiens du XVIIIe siècle et sur leurs ouvrages." [*Mém. lorraine*] 2d ser. 9 (1867): 227–232. Separately published. n.p., n.d.
Entries: 29 (work produced in Nancy, France, only). Millimeters. Inscriptions. Described (selection).

Fontaine, Jean Mathias *(1791–1853)*
[Ber.] VI, p. 139.*

Fontallard, Henri Gérard
See **Gerard-Fontallard**

Fontana, Carlo *(1865–1956)*
Mencarini, Giuseppe. "Grafica inedita di Carlo Fontana, l'autore della 'Quadriga' sull'altare della patria in Roma." *Gutenberg Jahrbuch*, 1966, pp. 304–309.
Entries: 48. Millimeters. Inscriptions. Described. Illustrated (selection).

Fontana, Francesco *(19th cent.)*
[Ap.] p. 153.
Entries: 2.*

Fontana, Giovanni Battista *(c.1524–1587)*
[B.] XVI, pp. 211–239.
Entries: 67 prints by, 1 doubtful print. Pre-metric. Inscriptions. Described.

[P.] VI, pp. 182–183.
Entries: 4 (additional to [B.]). Pre-metric. Inscriptions. Described. Additional information to [B.].

[Wess.] III, p. 47.
Entries: 4 (additional to [B.]). Millimeters. Inscriptions. Described. Additional information to [B.].

Fontana, Pietro *(1762–1837)*
[Ap.] pp. 154–155.
Entries: 26.*

Fontebasso, Francesco *(1709–1768/69)*
[Vesme] pp. 474–477.

Entries: 11. Millimeters. Inscriptions. States. Described.

Fonville, Horace Antoine *(b. 1832)*
[Ber.] VI, p. 139.*

Foolio, Adriaen
See **Foly**

Fora, Gherardo del
See **Gherardo del Fora**

Forain, Jean Louis *(1852–1931)*
Guérin, Marcel. *J.-L. Forain aquafortiste; catalogue raisonné de l'oeuvre gravé de l'artiste.* Paris: H. Floury, 1912. 300 copies. (MB)
 Entries: 122 etchings, 3 monotypes (to 1910). Millimeters. Inscriptions. States. Described (selection). Illustrated. Located (selection).

Guérin, Marcel. *J. L. Forain lithographe; catalogue raisonné.* Paris: H. Floury, 1912. 125 copies. (MB)
 Entries: 89 lithographs (to 1910). Millimeters. Inscriptions. States. Illustrated. Located.

Forberg, Carl Ernst *(1844–1915)*
[Ap.] p. 155.
 Entries: 7.*

Forbes, Elizabeth Adela Stanhope, née Armstrong *(1859–1912)*
Sabin, Arthur K. "The dry-points of Elizabeth Adela Forbes, formerly E. A. Armstrong (1859–1912)." [PCQ.] 9 (1922): 75–100.
 Entries: 41. Inches. Inscriptions. Described. Illustrated (selection).

Forbin, Louis Nicolas Philippe Auguste, comte de *(1777–1841)*
[Ber.] VI, pp. 139–140.*

Ford, Michael *(d. 1765)*
[Sm.] II, pp. 510–515, and "additions and corrections" section.

Entries: 12 (portraits only). Inches. Inscriptions. States. Described. Illustrated (selection). Located (selection). Also, list of prints not seen by [Sm.], unnumbered, pp. 510–511.

Ford, Thomas *(d. 1746)*
[Sm.] II, p. 515, and "additions and corrections" section.
 Entries: 1 (portraits only).

Forel, Alexis *(b. 1852).*
[Ber.] VI, pp. 140–141.
 Entries: 59. Paper fold measure (selection).

Forest, Eugène Hippolyte *(b. 1808)*
[Ber.] VI, pp. 141–142.*

Forgues, ——— *(19th cent.)*
[Ber.] VI, p. 142.*

Fornazeris, Jacques de *(fl. 1594–1622)*
[RD.] X, pp. 169–197; XI, pp. 105–106.
 Entries: 57. Millimeters. Inscriptions. States. Described.

Forsblom, Yngve *(20th cent.)*
Fogedgaard, Helmer. "Yngve Forsblom, en svensk exlibris-kunstner." [N. ExT.] 9 (1957): 97–99.
 Entries: 24 (bookplates only, to 1957). Illustrated (selection).

Forssell, Christian Didrik *(1777–1852)*
[Ber.] VI, p. 142.*

[W.] I, p. 547.
 Entries: 3+.*

Forster, ——— *(fl. c.1799)*
[Siltzer] p. 330.
 Entries: unnumbered, p. 330, prints after. Inscriptions.

Forster, A. *(19th cent.)*
[Dus.] p. 45.

Forster, A. *(continued)*

Entries: 1 (lithographs only, to 1821).
Millimeters. Inscriptions. Described.
Located.

Forster, François *(1790–1872)*
[Ap.] pp. 156–159.
Entries: 28.*

[Ber.] VI, pp. 142–149.
Entries: 80. Paper fold measure.

Forster, Hans *(d. 1584)*
See **Monogram HF** [Nagler, *Mon.*] III,
no. 906

Fortier, Claude *(1775–1835)*
[Ap.] p. 159.
Entries: 4.*

[Ber.] VI, p. 149.*

Fortin, Auguste Félix *(1763–1832)*
[Ber.] VI, p. 149.*

Fortuna, Giovanni *(1535–1611)*
[B.] XII: *See* **Chiaroscuro Woodcuts**

Fortuny y Carbo, Mariano *(1838–1874)*
[Ber.] VI, pp. 149–151.
Entries: 29. Millimeters.

Forty, Jean François *(fl. 1775–1790)*
Gélis-Didot, P. *L'Oeuvre de J.-Fr. Forty
dessinateur et graveur.* Paris: Librairies-
Imprimeries Réunies, 1896.
Entries: 110. Illustrated.

Fosella, Giovanni *(b. 1814)*
[Ap.] p. 159.
Entries: 7.*

Fosseyeux, Jean Baptiste *(1752–1824)*
[Ber.] VI, pp. 151–152.*

Foster, John *(1648–1681)*
[St.] pp. 170–171.*

Green, Samuel Abbott. *John Foster: the
earliest American engraver and the first Bos-
ton printer.* Boston (Mass.): Mas-
sachusetts Historical Society, 1909.
Entries: 6. Described. Illustrated
(selection).

Fouceel, Jan *(fl. c.1670)*
[W.] I, p. 546
Entries: 3.*

[H. *Neth.*] VII, pp. 1–5.
Entries: 5. Illustrated.*

Fouché, Nicolas *(1653–1733)*
[RD.] V, pp. 321–322.
Entries: 1. Millimeters. Inscriptions.
Described.

Foucher, Nicolas
See **Fouché**

Foulquier, Valentin *(1822–1896)*
[Ber.] VI, pp. 152–159.
Entries: 359. Millimeters (selection).
Paper fold measure (selection).

Fouquet, Henri *(b. 1826)*
[H. L.] p. 332.
Entries: 2. Millimeters.

Fouquier, Jacques *(c.1580–1659)*
[W.] I, pp. 547–548.
Entries: 7 prints after.*

[H. *Neth.*] VII, p. 6.
Entries: 23 prints after.*

Fourmois, Théodore *(1814–1871)*
[H. L.] pp. 332–333.
Entries: 2. Millimeters. Inscriptions.
Described.

Fournier, Daniel *(c.1710–c.1766)*
[Sm.] II, p. 515.
Entries: 1 (portraits only). Inches.
Inscriptions. Described.

Fournier, Félicie *(1797–1879)*
[Ber.] VI, p. 160.*

Fournier, Fortuné de *(1798–1864)*
[Ber.] VI, p. 160.*

Fournier, Nicolas Amable *(1789–1854)*
[Ber.] VI, pp. 159–160.*

Fournier, Paul Albert *(1847–after 1896)*
[Ber.] VI, p. 160.*

Foute, Michael *(fl. c.1620)*
[Merlo] p. 244.*

Fowler, H. *(18th cent.)*
[Sm.] II, pp. 515–516.
 Entries: 1 (portraits only). Inches. Inscriptions. States. Described.

Fox, Charles *(1794–1849)*
[Ap.] p. 160.
 Entries: 3.*

Fox, Gilbert *(c.1776–after 1820)*
[St.] pp. 171–172.*

[F.] p. 115.*

Fragonard, Alexandre Evariste *(1780–1850)*
[Ber.] VI, pp. 160–162.*

Fragonard, Jean Honoré *(1732–1806)*
[Baud.] I, pp. 157–170. Reprint in [*Am. Est.*] 1 (1922): 4–7.
 Entries: 24. Millimeters. Inscriptions. States. Described.

[Gon.] II, pp. 311–381.
 Entries: 26 prints by; prints after unnumbered, pp. 366–381. Described (selection).

[L. D.] p. 25.
 Entries: 1. Millimeters. Inscriptions. States. Described. Incomplete catalogue.*

Guimbaud, Louis. *Saint-Non et Fragonard.* La gravure et ses maîtres. Paris: Le Goupy, 1928. 975 copies. (NN)
 Entries: 21. Millimeters. Inscriptions. States. Appendix with 6 rejected prints.

Wildenstein, Georges. *Fragonard acquafortiste.* Paris: Les Beaux-Arts, 1956.
 Entries: 25 prints by, 5 prints in collaboration with Marguerite Gérard, 5 doubtful prints. Millimeters. Inscriptions. States. Described. Illustrated. Located. Bibliography for each entry.

Wildenstein, Georges. *Fragonard.* n.p., Editions Phaidon, 1960.
 Catalogue of paintings; prints after are mentioned where extant.

Ananoff, Alexandre. "Monsieur Fanfan; découverte d'une nouvelle gravure." [*GBA.*] 6th ser. 77 (1971): 179–182.
 Entries: 1 (additional to Wildenstein 1956). Millimeters. Inscriptions. States. Described. Illustrated.

Fragonard, Théophile *(1806–1876)*
[Ber.] VI, p. 162.*

Fraipont, Gustave *(b. 1849)*
[Ber.] VI, p. 163.*

Fraisinger, Caspar *(fl. 1580–1600)*
[B.] IX, pp. 584–585.
 Entries: 2. Pre-metric. Inscriptions. Described.

[Heller] p. 47.
 Entries: 3 (additional to [B.]). Premetric.

[P.] IV, pp. 241–242.
 Entries: 5 (additional to [B.]). Premetric. Inscriptions. Described.

[A.] II, pp. 239–243.
 Entries: 5. Pre-metric. Inscriptions. Described.

Fraisinger, Caspar *(continued)*

[H. *Ger.*] VIII, p. 161.
 Entries: 5. Illustrated (selection).*

Fraisseix-Bonnin, le marquis de
(19th cent.)
 [Ber.] VI, p. 163.*

Français, François Louis *(1814–1897)*
 [Ber.] VI, pp. 163–164.*

Franceschini, Baldassare *(1611–1689)*
 [Vesme] p. 333.
 Entries: 2. Millimeters. Inscriptions.
 States. Described. Located (selection).

Franceschino
See **Caracci,** Francesco

Franchois, Lucas II *(1616–1681)*
 [W.] I, pp. 548–549.
 Entries: 7 prints by, 2 after.*

 [H. *Neth.*] VII, p. 6.
 Entries: 10.*

Franchois, Peeter *(1606–1654)*
 [W.] I, p. 549.
 Entries: 6.*

 [H. *Neth.*] VII, p. 7.
 Entries: 7.*

Francia, Alexandre *(d. 1884)*
 [H. L.] p. 333.
 Entries: 1. Millimeters. Inscriptions.
 Described.

Francia, Francesco *(c.1450–1517)*
 [P.] V, pp. 197–202.
 Entries: 9 nielli, 4 engravings, 1 re-
 jected print. Pre-metric. States. De-
 scribed. Located. Copies mentioned.

 [Dut.] II, pp. 287–291.
 Entries: 10 prints by, 4 rejected prints
 (niello prints only). Millimeters. In-

scriptions. Described. Illustrated
(selection).

 [Hind.] V, pp. 227–228.
 Entries: 4. Millimeters. Inscriptions.
 States. Described Illustrated. Lo-
 cated.

Francia, Jacopo *(before 1486–1557)*
 [B.] XV, pp. 455–460.
 Entries: 9. Pre-metric. Inscriptions.
 States. Described.

 [P.] V, pp. 222–225.
 Entries: 11 (additional to [B.]). Pre-
 metric. Inscriptions. States. De-
 scribed. Located (selection). Copies
 mentioned.

 [Hind] V., pp. 229–235.
 Entries: 19. Millimeters. Inscriptions.
 States. Described. Illustrated. Lo-
 cated.

Francis, ——— *(fl. c.1831)*
 [Ber.] VI, p. 164.*

Francis, Sam *(b. 1923)*
 Kestner Gesellschaft, Hannover. *Sam
 Francis.* Hannover (West Germany),
 1963.
 Entries: 19 (to 1961). Millimeters. Illus-
 trated (selection).

Franck, Franz Friedrich *(1627–1687)*
 [H. *Ger.*] VIII, p. 162.
 Entries: 8 prints after.*

Franck, Hans *(fl. 1505–1522)*
 See **Monogram HF** [Nagler, *Mon.*] III,
 no. 896

Franck, I. H.
 See **Francken,** Frans II

Franck, Joseph *(1825–1883)*
 [Ap.] p. 161.
 Entries: 7.*

 [Ber.] VI, pp. 165–166.*

Franck, Maximilian *(c.1780–after 1830)*
[Dus.] pp. 45–48.
 Entries: 21+ (lithographs only, to 1821). Millimeters. Inscriptions. Located.

Franck, Sebastian
See **Vrancx**

Franck de Langgraffen, Johann *(c.1675–1700)*
[H. *Ger.*] VIII, p. 162.
 Entries: 2+.*

Francken, Ambrosius I *(1544–1618)*
[W.] I, p. 550.
 Entries: 1+ prints by, 8+ after.*

 [H. *Neth.*] VII, pp. 7–8.
 Entries: 2 prints by, 22 after. Illustrated (selection).*

Francken, Frans I *(1542–1616)*
[W.] I, pp. 550–551.
 Entries: 3 prints after.*

 [H. *Neth.*] VII, p. 8.
 Entries: 4 prints after.*

Francken, Frans II *(1581–1642)*
[vdK.] pp. 177–178.
 Entries: 1. Millimeters. Inscriptions. States. Described. Illustrated.

 [W.] I, pp. 551–553.
 Entries: 1.*

 [H. *Neth.*] VII, pp. 9–10.
 Entries: 2 prints by, 14 after. Illustrated (selection).*

Francken, Hieronymus I *(1540–1610)*
[W.] I, pp. 553–554.
 Entries: 2 prints after.*

 [H. *Neth.*] VII, p. 10.
 Entries: 3 prints after.*

Franckenberger, Tobias I *(fl. c.1662)*
[H. *Ger.*] VIII, p. 163.
 Entries: 2+. Illustrated (selection).*

Franckh, Hans Ulrich *(1602–1680)*
[A.] V. pp. 32–42.
 Entries: 25. Pre-metric. Inscriptions. Described.

Hämmerle, Albert. *Die Radierungen des Hanns Ulrich Franckh, Malers aus Kaufbeuren 1603 bis 1675.* Augsburg (Germany): Dr. Benno Filser Verlag, 1923.
 Entries: 28. Millimeters. Inscriptions. States. Described. Illustrated. Located (selection).

 [H. *Ger.*] VIII, pp. 164–179.
 Entries: 28. Illustrated.*

Franckh, Johannes *(fl. 1650–1700)*
[H. *Ger.*] VIII, pp. 180–182.
 Entries: 74+.*

Franco, [Giovanni] Battista [called "Il Semolei"] *(1498?–1561)*
 [B.] XII: *See* **Chiaroscuro Woodcuts**

 [B.] XVI, pp. 111–160.
 Entries: 93 prints by, 16 doubtful or rejected prints. Pre-metric. Inscriptions. States. Described. Copies mentioned.

 [P.] VI: *See* **Chiaroscuro Woodcuts**

 [P.] VI, pp. 177–179.
 Entries: 5 prints by (additional to [B.]), 1 rejected print. Pre-metric. Inscriptions. Described. Additional information to [B.].

 [Wess.] III, p. 48.
 Additional information to [B.].

Franco, Giacomo *(1556–1620)*
Pasero, Carlo. "Giacomo Franco, editore, incisore, calcografo nei secoli XVI e XVII." *Bibliofilia* 37 (1935): 332–356. Separately published. Florence: Leo S. Olschki, 1935.
 Entries: 51 (single prints only). Inscriptions (selection). Described (selection). Also bibliography of books with illustrations by.

François, Alphonse *(1814–1888)*
[Ap.] pp. 161–162.
 Entries: 13.*

[Ber.] VI, pp. 168–173.
 Entries: 30. Paper fold measure.

François, Jean *(17th cent.)*
[W.] III, p. 88.
 Entries: 1.*

[H. *Neth.*] VII, p. 12.
 Entries: 1.*

François, Jean Charles *(1717–1769)*
Hérold, Jacques. *Gravure en manière de crayon; Jean Charles François (1717–1769), catalogue de l'oeuvre gravé.* Paris: Société pour l'Étude de la Gravure Française, 1931.
 Entries: 311. Millimeters. Inscriptions. States. Described. Illustrated (selection).

François, Jules Charles Remy *(1809–1861)*
[Ap.] p. 162.
 Entries: 8.*

[Ber.] VI, pp. 166–167.
 Entries: 17+. Paper fold measure.

François, Pierre Joseph Celestin *(1759–1851)*
[H. L.] pp. 334–341.
 Entries: 25. Millimeters. Inscriptions. Described.

François, Simon [called "le Petit François"] *(1606–1671)*
[RD.] III, pp. 19–20; XI, p. 106.
 Entries: 2. Pre-metric. Inscriptions. Described.

Francquart, Jacques *(1582–1651)*
[W.] I, pp. 555–556.
 Entries: 2+ prints after.*

[H. *Neth.*] VII, p. 11.
 Entries: 100+ prints after.*

Frangk, Fabian *(fl. 1500–1550)*
[H. *Ger.*] VIII, p. 182.
 Entries: 1+.*

Frank
See also **Franck, Franckh, Frangk**

Frank, Hans *(b. 1884)*
Ankwicz-Kleehoven, Hans. "Hans und Leo Frank." [*GK.*] 45 (1922): 41–56. Catalogue: "Verzeichnis der graphischen Arbeiten der Brüder Hans und Leo Frank." [*MGvK.*] 1922, pp. 52–60.
 Entries: 133 (to 1922). Millimeters. Inscriptions. States. Described (selection). Illustrated (selection). All prints not illustrated are described.

Frank, Leo *(b. 1884)*
Ankwicz-Kleehoven, Hans. "Hans und Leo Frank," [*GK.*] 45 (1922): 41–56. Catalogue: "Verzeichnis der graphischen Arbeiten der Brüder Hans und Leo Frank." [*MGvK.*] 1922, pp. 52–60.
 Entries: 24 (to 1922). Millimeters. Inscriptions. States. Described (selection). Illustrated (selection). All prints not illustrated are described.

Frank, Paul *(fl. 1570–1610)*
[H. *Ger.*] VIII, p. 183.
 Entries: 1+.*

Franken Pzn, Jan *(20th cent.)*
Stols, A. M. M. "Iets over de houtsneden van Jan Franken Pzn." *De Witte mier* n.s. 2 (1925): 264–274. Separately published. Maastricht (Netherlands): 1925. 150 copies. (EA)
 Entries: 39 (to 1925). Millimeters. Illustrated (selection).

Frankendaal, N. van *(fl. c.1765)*
[W.] I, p. 556.
 Entries: 2.*

Frankl, Gerhart *(b. 1901)*
Tietze, Hans. *Gerhart Frankl, mit einem*

Oeuvrekatalog der Radierungen des Künstlers. Vienna: Verlag der Neuen Galerie, 1930.
>Entries: 51 (to 1929). Millimeters. States. Described. Ms. addition (EWA); 25 additional entries.

Frankland, Robert *(1784–1849)*
[Siltzer] pp. 121–122.
>Entries: unnumbered, pp. 121–122, prints after. Inches. Inscriptions.

Franque, Jean Pierre *(1774–1860)*
[Ber.] VI, p. 173.*

Frasconi, Antonio *(b. 1919)*
Cleveland Museum of Art [Leona E. Prasse, Elaine A. Evans, and Louise S. Richards, compilers]. *The work of Antonio Frasconi; catalogue of an exhibition sponsored by the Print Club of Cleveland and the Cleveland Museum of Art.* Cleveland (Ohio), 1952.
>Entries: 263 (to 1952). Inches. Located (selection).

Baltimore Museum of Art. *The work of Antonio Frasconi 1952–1963; woodcuts, lithographs, and books.* Baltimore (Md.), 1963.
>Entries: 259 (additional to Cleveland catalogue, 1952; to 1963). Inches.

Fraser, Claud Lovat *(20th cent.)*
Millard, Christopher. *The printed work of Claud Lovat Fraser.* London: Henry Danielson, 1923. 275 copies. (NN)
>Entries: 743 prints by and after (process reproductions of drawings). Inches. Inscriptions. Described (selection). Ms. notes (NN); additional entries.

Driver, Clive E. *The art of Claud Lovat Fraser; book illustrator, theatrical designer and commercial artist.* Philadelphia: Philip H. and A. S. W. Rosenbach Foundation, 1972.

>Entries: 267 (works in all media, including prints). Millimeters. Inscriptions. Illustrated (selection).

Fratrel, Joseph I *(1730–1783)*
[Baud.] II, pp. 189–190.
>Entries: 16. Millimeters. Inscriptions. States. Described.

Freddi, Vittorio *(19th cent.)*
[Ap.] p. 163.
>Entries: 1.*

Frederick, John L. *(d. c.1880)*
[St.] p. 172.*

Frédou, Jean Martial *(1711–1795)*
[Baud.] I, pp. 82–83.
>Entries: 1. Millimeters. Inscriptions. States. Described.

Fredriks, Johannes Hendrik *(d. 1822)*
[W.] I, p. 556.
>Entries: 1 print after.*

Freeman, William Henry *(fl. 1839–1875)*
[Ber.] VI, p. 173.*

[F.] p. 116.*

Freiberger, Johann *(1571–1631)*
[H. *Ger.*] VIII, p. 183.
>Entries: 2 prints after.*

Frélaut, Jean *(1879–1954)*
[Del.] XXXI.
>Entries: 281. Millimeters. States. Described (selection). Illustrated. Located (selection).

Frélaut, Jean. "Catalogue de l'oeuvre de Jean Frélaut; gravures de 1926 à 1951." Unpublished ms. (EPBN)
>Entries: 273 (additional to [Del.]; to 1951). Millimeters. Also, list of book illustrations, unnumbered.

Freminet, Martin *(1567–1619)*
[RD.] VIII, pp. 170–172.

Freminet, Martin *(continued)*

Entries: 1. Millimeters. Inscriptions. Described.

French, Edwin Davis *(1851–1906)*
Lemperly, Paul. *A list of bookplates engraved on copper by Mr. Edwin Davis French.* Cleveland (Ohio): Paul Lemperly, 1899. 120 copies. (NN)
Entries: 133 (bookplates only). Ms. addition (NN); 151 additional entries.

Brainerd, Ira. *Edwin Davis French; a memorial.* New York: Privately printed [De Vinne Press], 1908. 475 copies. (NN)
Entries: 299 bookplates, 31 other prints. Inscriptions. States. Ms. notes and addition (NN); list of prints after (bookplates only).

Grolier Club, New York. *Edwin Davis French 1851–1906, a catalogue of an exhibition of his engraved work.* New York, 1909.
Entries: 340.

Heartmans Auction Rooms, New York. *284 bookplates engraved by Edwin Davis French sold at auction Monday, Feb'y 16 1914, at Heartman's Auction Rooms, 36 Lexington Avenue, New York City, with prices realized: also a short list of other bookplates engraved by French, and a list of dealers and collectors interested in bookplates.* New York, 1914.
Entries: 476 (different impressions of the same print are given separate numbers).

French, William *(c.1815–1898)*
[Ap.] p. 163.
Entries: 2.*

Frenzel, Johann Gottfried Abraham *(1782–1855)*
[Ap.] p. 163.
Entries: 3.*

[Dus.] pp. 48–49.

Entries: 8 (lithographs only, to 1821). Millimeters. Inscriptions. Located.

Frère, Pierre Edouard *(1819–1886)*
[Ber.] VI, pp. 173–174.*

Frey, ——— *(19th cent.)*
[Ber.] VI, p. 174.*

Frey, Johann Michael *(1750–1813)*
[Dus.] p. 49.
Entries: 2 (lithographs only, to 1821). Millimeters. Inscriptions. Located.

Frey, Johannes Pieter de *(1770–1834)*
[Dut.] IV, pp. 383–401.
Entries: 65. Millimeters. Inscriptions. States. Described.

[W.] I, pp. 557–558.
Entries: 48+.*

Frey, Martin *(1769–1831)*
[Ap.] p. 163.
Entries: 5.*

Frey, Reparatus Martin
See **Frey,** Martin

Friant, Émile *(1863–1932)*
[Ber.] VI, p. 174.*

Germain, Alphonse. "Les pointes sèches et les eaux-fortes de M. Émile Friant. [*GBA.*] 4th ser. 9 (1913): 37–44.
Entries: unnumbered, p. 44. Illustrated (selection).

Frick, Winifred Austen *(20th cent.)*
Sturges, Lucy Hale. "Winifred Austen; an etcher of animals."[*P. Conn.*] 3 (1923): 42–58.
Entries: unnumbered, pp. 51–54 (to 1922). Inches. Described. Illustrated (selection).

Fricke, E. A. *(19th cent.)*
[Dus.] p. 49.
Entries: 1 (lithographs only, to 1821).

Fridell, Axel *(1894–1935)*
Asplund, Karl. *Axel Fridell, ett konstnär-liv.* Malmö (Sweden): John Kroon/A.-B. Malmö Ljustrycksanstalt, 1937. 500 copies. (NN)
Entries: 341. Millimeters. Inscriptions. States. Described (selection). Illustrated (selection). Prints not illustrated are described.

Friedländer, Johnny *(b. 1912)*
Städtisches Museum, Brunswick [Rolf Schmücking, compiler]. *Johnny Friedländer.* Brunswick (West Germany), 1960. 750 copies. (MH)
Entries: 74 (to 1960). Millimeters. Illustrated.

Hänssel, Roland. *Johnny Friedlaender, oeuvre 1961–1965.* New York: Touchstone Publishers Ltd., 1967. (DLC)
Entries: 83 (prints from 1961 to 1965 only). Millimeters. Described. Illustrated. Also, list of 5 pre-1961 prints (incomplete).

Friedlein, Johann *(fl. 1685–1706)*
[H. *Ger.*] VIII, pp. 183–184.
Entries: 24+.*

Friedrich, Franz *(fl. 1550–1583)*
[P.] IV, pp. 228–230.
Entries: 3 etchings, 4 woodcuts. Premetric. Inscriptions. Described. Copies mentioned.

[A.] II, pp. 70–82, 424.
Entries: 9 etchings, 8 woodcuts. Premetric. Inscriptions. Described.

[H. *Ger.*] VIII, pp. 185–188.
Entries: 30. Illustrated (selection).*

Friedrich, Gotthelf Louis Emil *(b. 1827)*
[Ap.] p. 164.
Entries: 6.*

Fries, Ernst *(1801–1833)*
[Dus.] pp. 49–50.

Entries: 10 (lithographs only, to 1821). Millimeters. Inscriptions. Located.

Frilley, Jean Jacques *(b. 1797)*
[Ber.] VI, pp. 174–175.*

Frisch, ——— *(19th cent.)*
[Dus.] pp. 50–51.
Entries: 3 (lithographs only, to 1821). Millimeters. Inscriptions. Located.

Frisius, Lorenz *(fl. c.1522)*
[H. *Neth.*] VII, p. 12.
Entries: 1. Illustrated.*

Frisius, Simon Wynouts *(c.1580–1629)*
[Burch.], pp. 128–137.
Entries: 26+ (major prints only). Millimeters. Inscriptions. States. Described (selection). Located (selection).

[W.] I, p. 558.
Entries: 18+.*

[H. *Neth.*] VII, pp. 13–39.
Entries: 234+. Illustrated (selection).*

Fritz, Friedrich *(19th cent.)*
[Dus.] p. 51.
Entries: 1 (lithographs only, to 1821). Millimeters. Inscriptions. Located.

Fritz, Martin *(fl. c.1700)*
[Merlo] p. 250.*

Fritzsch, Christian F. *(1695–1747)*
See also **Fritzsch** family

[W.] I, p. 558.
Entries: 4.*

Fritzsch family [Christian *(1695–1747)*, Christian Friedrich *(c.1719–before 1774)*, and Johan Christian Gottlieb *(c.1720–c.1802)*]
Weidter, Wilhelm. *Die Bildnisse der Hamburger Kupferstecher Fritzsch; ein Beitrag.* Hamburg: Zentralstelle für nieder-

Fritzsch family *(continued)*

sächsische Familienkund, 1933–1934.
(Reprinted, with additions, from
*Zeitschrift für niedersächsische Familien-
kunde* 15 (1933): 113–120, 169–182;
Zeitschrift 16 (1934): 75–83. (NN)
Entries: unnumbered, pp. 4–27. Paper
fold measure (selection). Inscriptions
(selection). Located (selection).

Frölich, Lorens *(1820–1908)*
[Ber.] VI, p. 175.*

Krohn, Pietro. *Fortegnelse over L.
Frølichs illustrationer raderinger M. M.*
Copenhagen: Forening for
Boghaandvaerk, 1900. 115 copies.
(EBKb)
Entries: 365+ prints by and after. Il-
lustrated (selection).

Froen, P. G. *(fl. c.1837)*
[Ber.] VI, p. 175.*

Fröschle, I. G. *(19th cent.)*
[Dus.] p. 51.
Entries: 1 (lithographs only, to 1821).
Millimeters. Inscriptions. Located.

Frohner, Adolf *(b. 1934)*
Sotriffer, Kristian. *Adolf Frohner; das
vulgäre Ballett, mit einem Werkkatalog
sämtlicher Radierungen 1959 bis 1968.*
Vienna: Anton Schroll und Co., 1969.
1000 copies. (MH)
Entries: 103. Millimeters. States. Illus-
trated (selection).

Frol, A *(fl. c.1664)*
[Merlo], p. 251.*

Froment, Eugène *(1844–1900)*
[Ber.] VI, p. 175.*

Froment-Delormel, Jacques Victor
Eugène *(1820–1900)*
[Ber.] VI, p. 175.*

Frommel, Carl *(1789–1863)*
[Ap.] p. 164.
Entries: 13.*

Fronius, Hans *(b. 1903)*
Hofmann, Werner. *Hans Fronius:
Zeichnung—Graphik—Buchillustration.*
Graz (Austria): Leykam-Verlag, 1953.
Entries: 92 (to 1952). Illustrated (selec-
tion).

Tiessen, Wolfgang. "Verzeichnis der
von Hans Fronius illustrierten Bücher
und Mappenwerke 1943–1962."
*Rundbrief für Freunde moderner Buchkunst
und Graphik.* No. 2 (n.d.): 16–18.
Bibliography of books with illustra-
tions by.

Neue Galerie am Landesmuseum
Johanneum, Graz: [Wilfred Skreiner
and Horst G. Haberl, compilers]. *Hans
Fronius Archiv.* Graz (Austria), 1968.
Bibliography of books with illustra-
tions by.

"Hans Fronius; Verzeichnis der illus-
trierten Bücher und Mappenwerke
1943–1969." *Antiquariat* 19, no. 5 (1969):
75–76. (EWNb)
Bibliography of books with illustra-
tions by.

Koschatzky, Walter, and Rethi, Leo-
pold. *Hans Fronius, Bilder und Gestalten.*
Vienna: Edition Tusch, 1972.
Entries: 132 woodcuts, 208 litho-
graphs, 55 etchings (to 1972). Millime-
ters. States. Illustrated.

Frontier, Jean Charles *(1701–1763)*
Messelet, Jean. "Frontier." In [Dim.] II,
pp. 251–256.
Entries: unnumbered, p. 254, book il-
lustrations after.

Frühauf, Johann *(1791–after 1843)*
[Dus.] p. 51.
Entries: 1 (lithographs only, to 1821).
Paper fold measure.

Fruytiers, Lodewyk Joseph *(1713–1782)*
[W.] I, p. 559.
Entries: 3.*

Fruytiers, Philip *(1610–1666)*
[W.] I, pp. 559–560.
Entries: 11 prints by, 5 after.*

[H. *Neth.*] VII, pp. 40–43.
Entries: 17 prints by, 48 after. Illustrated (selection).*

Fry, —— *(19th cent.)*
[Ber.] VI, p. 175.*

Frye, Thomas *(1710–1762)*
[Sm.] II, pp. 516–522, and "additions and corrections" section.
Entries: 25 (portraits only). Inches. Inscriptions. States. Described. Located (selection).

[Ru.] pp. 111–113.
Entries: 1 (portraits only, additional to [Sm.]). States. Described. Additional information to [Sm.].

Fryg, Ludwig *(fl. c.1580)*
[B.] IX, pp. 416–417.
Entries: 1. Pre-metric. Inscriptions. Described.

[B.] IX, p. 422 (Monogram FL).

Frys, Adriaen de
See **Vries**

Fuchs, Adam *(d. 1606)*
[P.] IV, pp. 257–259.
Entries: 7 prints by, 2+ reworked by. Pre-metric (selection). Paper fold measure (selection). Inscriptions. States. Described.

[A.] V, pp. 43–51.
Entries: 34. Pre-metric. Inscriptions. Described (selection).

Fuchs, Ernst *(b. 1930)*
Weis, Helmut. *Ernst Fuchs; das graphische Werk.* Munich: Galerie

Wolfgang Ketterer; Vienna: Verlag für Jugend und Volk, 1967.
Entries: 117. Millimeters. Inscriptions. States. Described. Illustrated.

Fuchs, Louis Joseph Gustave *(19th cent.)*
[H. L.] pp. 342–343.
Entries: 4. Millimeters. Inscriptions. States. Described.

Fuchs, Maximilian Heinrich *(c.1767–1846)*
[Merlo] pp. 252–254.*

Füger, Heinrich *(1751–1818)*
[A. 1800] II, pp. 89–100.
Entries: 15. Pre-metric. Inscriptions. States. Described.

Andresen, Andreas. "Andresens Nachträge zu seinen 'Deutschen Malerradierern.' " [*MGvK.*] 1907, p. 41.
Additional information to [A. 1800].

Fürstenberg, Theodor Caspar, Baron von *(d. 1675)*
[A.] V, pp. 177–183.
Entries: 9. Pre-metric. Inscriptions. States. Described. Appendix with 1 doubtful print.

Fues, Christian Friedrich *(1772–1836)*
[A. 1800] IV, pp. 280–291.
Entries: 17. Pre-metric. Inscriptions. States. Described.

[Dus.] p. 51.
Entries: 4 (lithographs only, to 1821). Paper fold measure (selection).

Füssli, Heinrich
See **Fuseli,** Henry

Fugère, Jean Marie *(1818–1882)*
[Ber.] VI, p. 175.*

Fuhr, Charles Jérémie *(b. 1832)*
[Ber.] VI, p. 176.*

Fullwood, Thomas *(17th cent.)*
[Hind, *Engl.*] III, p. 194.
 Entries: 1. Inches. Inscriptions. Described. Illustrated. Located.

Funcke, Johann Heinrich *(fl. c.1818)*
[Ap.] p. 165.
 Entries: 1.*

Furck, Sebastian *(c.1600–1655)*
Müller, Bernhard. "Sebastian Furck, Kupferstecher und Contrafaiter von Frankfurt a. M." *Archiv für Frankfurts Geschichte und Kunst* 3d ser. 6 (1899): 187–252.
 Entries: 188+. Millimeters. Inscriptions. Described.

Furnass, John Mason *(fl. c.1785)*
[Allen] pp. 134–136.*

Furnius, Pieter Jalhea *(c.1545–1626)*
[W.] I, p. 560.
 Entries: 11+.*

[H. *Neth.*] VII, p. 44.
 Entries: 42.*

Furtenbach, Hans *(16th cent.)*
See **Monogram HF** [Nagler, *Mon.*] III, no. 896

Fuseli, Henry [Heinrich Füssli] *(1741–1825)*
"Eighteenth-century English illustrators: Henry Fuseli R. A." *The Book Collector* 6 (1957): 350–360.

Bibliography of books with illustrations by.

Fusinati, Giuseppe *(1803–1883)*
[Ap.] p. 165.
 Entries: 7.*

[An.] pp. 684–689.
 Entries: unnumbered, pp. 687–689. Millimeters. Inscriptions. Described.

[AN. 1968] pp. 176–177.
 Entries: unnumbered, pp. 176–177 (additional to [AN.]). Millimeters. Inscriptions.

Fyt, Jan *(1611–1661)*
[B.] IV, pp. 207–214.
 Entries: 16. Pre-metric. Inscriptions. States. Described.

[Weigel] pp. 185–187.
 Entries: 3 (additional to [B.]). Pre-metric. Inscriptions. Described.

[Heller] pp. 47–48.
 Additional information to [B.].

[Dut.] IV, pp. 401–404; V, p. 594b.
 Entries: 20. Millimeters. Inscriptions. States. Described.

[W.] I, pp. 560–562.
 Entries: 19+ prints by, 5 after.*

[H. *Neth.*] VII, pp. 45–48.
 Entries: 20 prints by, 5 after. Illustrated (selection).*

G

Gaab, Hannes *(20th cent.)*
Gerke, Friedrich. *Hannes Gaab; Buchillustration, Graphik, Malerei.* Kleine Schriften der Gesellschaft für bildende Kunst in Mainz, 7. Mainz (West Germany): Gesellschaft für bildende Kunst in Mainz, 1962.
Bibliography of books with illustrations by.

Gaal, Jacobus Cornelis *(1796–after 1858)*
[H. L.] pp. 345–361.
Entries: 51. Millimeters. Inscriptions. States. Described.

Gabain, Ethel Léontine *(b. 1883)*
Wright, Harold J. L. "The lithographs of Ethel Gabain." [*PCQ.*] 10 (1923): 254–287.
Entries: 255 (to 1923). Inches. States.

Wright, Harold J. L. *The lithographs of John Copley and Ethel Gabain.* Chicago: Albert Roullier Art Galleries, 1924.
Entries: 264 (to 1924). Inches. Ms. addition (NN); 1 additional entry.

Gabbiani, Anton Domenico *(1652–1726)*
[B.] XXI, pp. 260–262.
Entries: 4. Pre-metric. Inscriptions. Described.

Gabelsberger, Franz Xavier *(1789–1849)*
[Dus.] p. 51.
Entries: 1 (lithographs only, to 1821). Inscriptions. Located.

Gabet, Franz *(1765–1847)*
[Ber.] VI, p. 176.*

Gabriel, E. *(fl. c.1840)*
[Ber.] VI, p. 176.*

Gachet, Paul *(1828–1909)*
[Ber.] XII, p. 177.*

Gachet, Paul Jr. Unpublished catalogue, c.1954 (not seen). Reference in *Deux amis des Impressionistes; le docteur Gachet et Murer,* by Paul Gachet. Paris: Éditions des Musées Nationaux, 1956.

Gaertner, Eduard *(1801–1877)*
Kiewitz, Werner. *Eduard Gaertner: 1801–1877; beschreibendes Verzeichnis seiner Originallithographien.* Berlin: Georg Messow, 1928.
Entries: 9. Millimeters. Inscriptions. States. Described. Illustrated (selection). Located.

Gärtner, Friedrich von *(1792–1847)*
[Dus.] p. 52.
Entries: 2+ (lithographs only, to 1821). Millimeters. Inscriptions. Located.

Gärtner, Georg I *(d. 1612)*
[A.] IV, pp. 270–277.
Entries: 4+. Pre-metric. Inscriptions. States. Described.

Gärtner, Johann *(fl. c.1607)*
[A.] IV, pp. 287–288.
Entries: 1. Pre-metric. Inscriptions. Described.

Gág, Wanda *(1893–1946)*
Weyhe Gallery, New York. *The Checkerboard, published on occasion by the Weyhe Gallery, Gág number.* New York, 1930.

Gág, Wanda *(continued)*

Entries: 65 (to 1930). Inches. Illustrated (selection).

Gagarin, Grigorii Grigorievich, Prince *(1810–1893)*
[Ber.] VI, p. 176.*

Gagliardo, Alberto Helios *(b. 1893)*
Balbi, Giorgio. *Un mistico tra gli incisori moderni; Alberto Helios Gagliardo.* Milan: Editoriale Italiana, 1945. 500 copies. (DLC)
Entries: 63 (bookplates only). Millimeters. Inscriptions. Illustrated (selection).

Gail, Wilhelm *(1804–1890)*
[Dus.] p. 52.
Entries: 5 (lithographs only, to 1821). Millimeters (selection). Inscriptions (selection). Located (selection).

Gaildrau, Charles Valentin *(19th cent.)*
[Ber.] VI, p. 177.*

Gaildrau, Jules *(1816–1898)*
[Ber.] VI, p. 177.*

Gaillard, Aimée *(19th cent.)*
[Ber.] VI, p. 178.*

Gaillard, Ferdinand *(1834–1887)*
[Ap.] p. 166.
Entries: 3.*

[Ber.] VI, pp. 179–216.
Entries: 84. Millimeters (selection). Paper fold measure (selection). States.

Leclerq, Henri. *Ferdinand Gaillard, maître graveur 1834–1887.* Paris: Letouzey et Ané, 1934. 100 copies. (EPBN)
Entries: 83. Millimeters. Inscriptions (selection). States.

Gaillard, Robert *(1722–1785)*
[L. D.] p. 25.

Entries: 1. Millimeters. Inscriptions. States. Described. Incomplete catalogue.*

Gaillot, Bernard *(1780–1847)*
[Ber.] VI, p. 217.*

Gainer, J. *(fl. 1772–1779)*
[Sm.] II, pp. 522–523.
Entries: 2 (portraits only). Inches. Inscriptions. States. Described.

Gainsborough, Thomas *(1727–1788)*
Armstrong, Walter. *Gainsborough and his place in English art.* London: William Heinemann, 1898.
Catalogue of paintings; prints after are mentioned where extant.

Horne, Henry Percy. *An illustrated catalogue of engraved portraits and fancy subjects painted by Thomas Gainsborough, R. A., published between 1760 and 1820, and by George Romney, published between 1770 and 1830, with the variations of the state of the plates.* London: Eyre and Spottiswoode, 1891.
Entries: 88 prints after. Inches. Inscriptions. States. Illustrated (selection). Ms. addition (EBM), additional entries.

Hayes, John Trevor. *Gainsborough as printmaker.* London: A. Zwemmer, 1972.
Entries: 22. Inches. Millimeters. Inscriptions. States. Described. Illustrated. Located. Bibliography for each entry.

Gaitte, Antoine Joseph *(b. 1753)*
[Ber.] VI, p. 217.*

Gajani, Antonio *(d. 1820)*
[Ap.] p. 165.
Entries: 4.*

Galaktionov, Stepan Filippovich *(c.1779–1854)*

[Ap.] p. 181.
Entries: 1.*

Adaryukov, Vladimir Yakovlevich. *Stepan Filippovich Galaktionov i ego proizvedeniya, sostav.* Saint Petersburg: Kruzhok" Lyubitelej Russkikh' Izyashchnykh', 1910. (NNMM)

Galanis, Demetrius Emmanuel *(1882–1966)*
Malraux, André. "À Propos des illustrations de Galanis." [*AMG*.] 1 (1927–28): 225–232.
Bibliography of books with illustrations by.

Arland, Marcel. "L'Oeuvre de Galanis." *Halcyon* 11/12 (1942): unpaginated (10 pp.).
Bibliography of books with illustrations by.

Galard, Gustave, comte de *(1779–1841)*
Labat, Gustave. *Gustave de Galard, sa vie et son oeuvre (1799–1841).* Bordeaux (France): Feret et Fils; Paris: Libraries Associés, 1896. 240 copies. Supplement, 1898. (EBM)
Entries: unnumbered, pp. 49–225. Millimeters. Inscriptions. Described.

Galatin, Hans *(fl. c.1550)*
See **Monogram CH** [Nagler, *Mon.*] II, no. 160

Galestruzzi, Giovanni Battista *(1615–c.1669)*
[B.] XXI, pp. 51–84.
Entries: 333 prints by, 2 prints not seen by [B.]. Pre-metric. Inscriptions. States. Described (selection).

[Heller] pp. 48–49.
Additional information to [B.].

Galimard, Nicolas Auguste *(1813–1880)*
[Ber.] VI, p. 217.*

Galinilo, ——— *(19th cent.)*
[Siltzer] p. 330.
Entries: unnumbered, p. 330, prints after. Inches. Inscriptions.

Gallagher, Sears *(b. 1869)*
Holman, Louis A. *Sears Gallagher's etchings of Boston; with notes on the man and a complete list of his etched work.* Goodspeed's Monographs, 2. Boston (Mass.): Charles E. Goodspeed and Co., 1920.
Entries: 138. Inches.

Gallais, ——— *(19th cent.)*
[Ber.] VI, p. 217.*

Gallait, Louis *(1810–1887)*
[H. L.] pp. 362–364.
Entries: 5. Millimeters. Inscriptions. States. Described.

Galland, John *(fl. c.1800)*
[St.] p. 173.*

[F.] p. 116.*

Gallaudet, Edward *(fl. c.1800)*
Allen, p. 137.*

Gallaudet, Elisha *(b. c.1730)*
[Allen] pp. 136–137.*

Galle, Cornelis I *(1576–1650)*
[W.] I, pp. 565–566.
Entries: 73+.*

[H. *Neth.*] VII, pp. 49–61.
Entries: 419+. Illustrated (selection).*

Galle, Cornelis II *(1615–1678)*
[W.] I, p. 566.
Entries: 39+.*

[H. *Neth.*] VII, pp. 62–72.
Entries: 344. Illustrated (selection).*

Galle, Joannes *(1600–1676)*
[W.] I, p. 566.
Entries: 5.*

Galle, Joannes *(continued)*

[H. *Neth.*] VII, p. 73.
Entries: 16.*

Galle, Philip *(1537–1612)*
Dinaux, A. "Philippe Galle." *Archives historiques et littéraires du Nord de la France et du Midi de la Belgique* 3d ser., 2 (185–): 385–407.
Entries: 98+ prints by, 54+ published by. Paper fold measure (selection). Inscriptions (selection).

[W.] I, pp. 566–567.
Entries: 33+ prints by, 4+ after.*

[H. *Neth*] VII, pp. 74–83.
Entries: 901+ prints by, 21 after. Illustrated (selection).*

Galle, Theodor *(c.1571–1633)*
[W.] I, p. 567.
Entries: 17+.*

[H. *Neth.*] VII, pp. 84–88.
Entries: 438+. Illustrated (selection).*

Galliari, Gaspare *(c.1760–1818)*
Ferrero, Mercedes Viale. *La scenografia del '700 e i fratelli Galliari.* Turin: Fratelli Pozzo, 1963.
Entries: unnumbered, p. 278, prints after (complete?). Millimeters (selection). Inscriptions (selection).

Gallina, Sigismundo *(fl. c.1827)*
[Ap.] p. 166.
Entries: 3.*

Gallinari, Giacomo *(fl. 1677–1685)*
[B.] XIX, pp. 247–248.
Entries: 2. Pre-metric. Inscriptions. Described.

Gallo, Giovanni *(16th cent.)*
[B.] XII: *See* **Chiaroscuro Woodcuts**

Gallus, Jean
See **Gallo,** Giovanni

Gamble, F. *(fl. c.1800)*
[Siltzer] p. 351.
Entries: unnumbered, p. 351, prints by and after. Inscriptions.

Gamelin, Jacques *(1738–183)*
[Baud.] II, pp. 200–224.
Entries: 52. Millimeters. Inscriptions. States. Described.

Gampert, Otto *(b. 1842)*
Verzeichnis der Radierungen von Dr. Otto Gampert. Munich: F. Bruckmann, 1912.
Entries: 164 (to 1911). Millimeters. Described.

Gandini, Alessandro *(fl. 1550–1600)*
[B.] VI: *See* **Chiaroscuro Woodcuts**

Gandini, Domenico *(fl. c.1853)*
[Ap.] p. 166.
Entries: 1.*

Gandolfi, Gaetano *(1734–1802)*
[Vesme] pp. 510–516.
Entries: 22. Millimeters. Inscriptions. States. Described. Located (selection).

Bianchi, Lidia. *I Gandolfi, pittori del settecento bolognese.* Rome: Istituto Beato Angelico di Studi per l'Arte Sacra, 1938.
Entries: 20 prints by, 47 after. Millimeters (selection). Inscriptions (selection). Located.

Gandolfi, Mauro *(1764–1834)*
[Ap.] pp. 166–168.
Entries: 23.*

Gandolfi, Ubaldo *(1728–1781)*
Bianchi, Lidia. *I Gandolfi, pittori del settecento bolognese.* Rome: Istituto Beato Angelico di Studi per l'Arte Sacra, 1938.
Entries: 3.

Garavaglia, Giovita *(1790–1835)*
 [Ap.] pp. 168–171.
 Entries: 27.*

Gardner, Daniel *(1750–1805)*
 Williamson, G. C. *Daniel Gardner, painter in pastel and gouache; a brief account of his life and works.* London: John Lane, the Bodley Head, 1921.
 Entries: unnumbered, pp. 135–146, prints after. Inches. Inscriptions (selection). States. Described. Illustrated (selection). Located (selection).

Garen, Georges *(b. 1854)*
 [Ber.] VI, pp. 217–218.*

Garneray, Louis *(1783–1857)*
 [Ber.] VI, pp. 218–219.*

Garnerey, Auguste *(1785–1824)*
 [Ber.] VI, pp. 219–220.*

Garnerey, François *(1755–1837)*
 [Ber.] VI, p. 218.*

Garnerey, Hippolyte *(1787–1858)*
 [Ber.] VI, p. 220.*

Garnier, Antoine *(1611–1694)*
 [RD.] VIII, pp. 196–222; XI, p. 107.
 Entries: 71. Millimeters. Inscriptions. States. Described.

Garnier, Auguste François *(fl. 1836–1848)*
 [Ber.] VI, p. 221–222.*

Garnier, François *(fl. 1824–1850)*
 [Ap.] pp. 171–172.
 Entries: 8.*

 [Ber.] VI, p. 221.*

Garnier, Hippolyte Louis *(1802–1855)*
 [Ber.] VI, pp. 222–224.*

Garnier, Noël *(1470/75–after 1544)*
 [B.] VIII, pp. 10–11.

Entries: 1. Pre-metric. Inscriptions. Described.

 [RD.] VII, pp. 1–17; XI, pp. 107–108.
 Entries: 56. Millimeters. Inscriptions. Described.

Garrard, George *(1760–1826)*
 [Siltzer] p. 123.
 Entries: unnumbered, p. 123, prints after. Inches (selection). Inscriptions. States.

Garrett, Edmund Henry *(b. 1853)*
 Downes, William Howe. *Book-plates selected from the works of Edmund H. Garrett, and a notice of them by William Howe Downes.* Boston (Mass.): Troutsdale Press, 1904. 35 copies. (PJRo)
 Entries: 52 (bookplates only, to 1903). Illustrated (selection).

 Downes, William Howe. *Book-plates selected from the works of Edmund H. Garrett,* Boston (Mass.): Troutsdale Press, 1904. 200 copies. (DLC)
 Entries: 57 (bookplates only, to 1904). Illustrated (selection).

Garron, Jules Paul de *(fl. 1861–1882)*
 [Ber.] VI, p. 224.*

Garson, ——— [called "Garson ainé"] *(fl. 1825–1844)*
 Seguin, J.-P. "Un grand imagier parisien, Garson ainé; son oeuvre et notes sur les canards et canardiers parisiens de le première moitié du XIXe siècle." *Arts et traditions populaires* 2 (Apr.–June 1954): 97–146. (NN)
 Entries: 126. Millimeters. Inscriptions. Described. Illustrated (selection). Located.

Gascar, Henri *(1634/35–1701)*
 [Sm.] II, pp. 523–528, and "additions and corrections" section.

Gascar, Henri *(continued)*

Entries: 11 (portraits only). Inches. Inscriptions. States. Described. Illustrated (selection). Located (selection).

[W.] I, p. 568.
Entries: 1 print after.*

[Ru.] pp. 113, 492.
Additional information to [Sm.].

Gaskell, Percival *(b. 1868)*
Konody, P. G. *The original etchings and mezzotints of Percival Gaskell.* London: L. H. Lefèvre and Son, n.d.
Entries: 28. Inches. Illustrated.

Gassel, Lucas *(c.1500–c.1570)*
[P.] III, p. 109.
Entries: 1 print after. Pre-metric. Inscriptions. Described. Located.

[W.] I, pp. 568–569.
Entries: 1 print after.*

[H. *Neth.*] VII, p. 89.
Entries: 4 prints after. Illustrated (selection).*

Gastebois, Émile Louis *(19th cent.?)*
Menu, Henri. *Un artiste sézannais; Émile Louis Gastebois, notice biographique.* Sézanne (France): A. Patoux, 1883. (EPBN)
Entries: 44+ prints by and after. Paper fold measure. Inscriptions. States.

Gatier, Pierre *(1878–1944)*
Paillard, Jean. "Les graveurs de Paris; Pierre Gatier." *Société d'Iconographie parisienne* 3 (1910): 69–72. (EPBN)
Entries: 24 (prints of Paris only; to 1910). Millimeters. Described. Illustrated (selection).

Gatine, Georges Jacques *(1773–after 1824)*
[Ber.] VI, pp. 225–236.
Entries: 13+. Paper fold measure.

Gatteaux, Jacques Édouard *(1788–1881)*
[Ber.] VI, p. 236.*

Gatti, Giovanni Battista *(fl. 1800–1850)*
[Ap.] p. 172.
Entries: 1.*

Gatti, Oliviero *(fl. 1602–1626)*
[B.] XIX, pp. 3–32.
Entries: 139 prints by, 2 prints not seen by [B.]. Pre-metric. Inscriptions. States. Described.

Gaubert, ——— *(fl. c.1820)*
[Ber.] VI, p. 236.*

Gauchard, Félix Jean *(1825–1872)*
[Ber.] VI, p. 236.*

Gauché, Eugène *(19th cent.)*
[Ber.] VI, p. 237.*

Gaucher, Charles Étienne *(1741–1804)*
Portalis, Roger, and Beraldi, Henri [Henri Draibel]. *Charles Étienne Gaucher, graveur, notice et catalogue.* Paris: Damascène Morgand et Charles Fatout, 1879.
Entries: 274. Paper fold measure (selection). Inscriptions (selection). States. Described. Located (selection).

[L. D.] p. 26.
Entries: 1. Millimeters. Inscriptions. States. Described. Incomplete catalogue.*

Gaucherel, Léon *(1816–1886)*
[Ber.] VI, pp. 237–243.*

Gauci, Paul *(fl. 1834–1866)*
[Siltzer] p. 330.
Entries: unnumbered, p. 330, prints after. Inches. Inscriptions.

Gauermann, Friedrich *(1807–1862)*
[A. 1800] III, pp. 1–23.

Entries: 26. Pre-metric. Inscriptions. States. Described. Also, list of 6 engravings and 74 lithographs after (not fully catalogued).

Feuchtmüller, Rupert. *Friedrich Gauermann, 1807–1862; der Tier-und Landschaftsmaler des österreichischen Biedermeier.* Vienna: Österreiche Staatsdruckerei, 1962. (EOBMB)
Entries: 24 etchings, 3 lithographs. Millimeters. Inscriptions. States. Described. Also, list of prints after (titles and dimensions only): 15 etchings and engravings, 123 lithographs, 11 photographs.

Gauermann, Jacob *(1773–1843)*
[A. 1800] V, pp. 268–310.
Entries: 94. Millimeters. Inscriptions. States. Described.

Frimmel, Theodor. "Ergänzungen zum Radirwerk Jacob Gauermann's." *Berichte und Mittheilungen des Alterthums-Vereines zu Wien* 25 (1889): 11–26.
Entries: unnumbered, pp. 12–25 (additional to [A. 1800]). Millimeters. Inscriptions. States. Described.

Gauguin, Paul *(1848–1903)*
Guérin, Marcel. *L'Oeuvre gravé de Gauguin.* 2 vols. Paris: H. Floury, 1927. 600 copies. (MBMu)
Entries: 96 (different states of the same print are separately numbered). Millimeters. Inscriptions. States. Illustrated. Located. Ms. notes (MBMu); additional information.

Petiet, H. Appendix to Cogniat, R. *La vie ardente de Paul Gauguin,* Paris: Gazette des Beaux-Arts, n.d.
Additional information to Guérin.

Sýkorová, Libuše. *Gauguin woodcuts.* London: Paul Hamlyn, 1963.

Entries: 13. Millimeters. Inscriptions. Described. Illustrated. Catalogue of modern impressions from blocks preserved in Prague, National Gallery. Nos. 11–13 are not in Guérin.

"La Femme aux figues, acquaforte de Paul Gauguin ed Armand Seguin," and "Una silografia inedita di Paul Gauguin."[*QCS.*] 2 (Oct.–Nov. 1970): 62–65.
Entries: 2 (additional to Guérin). Described. Illustrated.

Gaujean, Eugène *(1850–1900)*
[Ber.] VI, pp. 243–246.
Entries: 50+.

Gaultier, Léonard *(1561–1641)*
Baré, F. "Léonard Gaultier." *Bull. des B. A.* 1 (1883–1884): 38–41, 54–60, 72–75, 81–86, 107–111, 142–144; and Supplément, pp. 1–12.
Entries: 924. Paper fold measure. Inscriptions (selection). Described (selection).

[Hind, *Engl.*] II, p. 304.
Entries: 1 (prints done in England only). Inches. Inscriptions. Described. Located.

Gautherot, Pierre *(1765/9–1825)*
[Ber.] VI, p. 247.*

Gautier, André *(19th cent.)*
[Ber.] VI, p. 250.*

Gautier, Armand Désiré *(1825–1894)*
[Ber.] VI, pp. 248–249.*

Gautier, F. *(19th cent.)*
[Ber.] VI, p. 247.*

Gautier, Jean Baptiste *(fl. 1789–1820)*
[Ber.] VI, p. 247.*

Singer, Hans Wolfgang. "Der Vierfarbendruck in der Gefolgschaft Jacob

Gautier, Jean Baptiste *(continued)*

Christoffel Le Blons." *Monatsheft für Kunstwissenschaft* 10 (1917): 281–292.
　　Entries: 98. Millimeters. Inscriptions. States. Described. Illustrated (selection). Located.

Gautier, Leonard
See **Gaultier**

Gautier, Louis Joseph Antoine Désiré *(1789–after 1824)*
　　[Ber.] VI, p. 248.
　　Entries: 5. Inscriptions (selection).

Gautier, Lucien Marcelin *(b. 1850)*
　　[Ber.] VI, pp. 250–252.
　　Entries: 58.

Gautier, Saint Elme *(b. 1849)*
　　[Ber.] VI, p. 250.*

Gautier, Théophile *(1811–1872)*
　　[Ber.] VI, p. 248.*

Gautier d'Agoty, Arnauld Eloi *(1741–before 1780)*
　　Singer, Hans W. "Der Vierfarbendruck in der Gefolgschaft Jacob Christoffel Le Blons." *Monatsheft für Kunstwissenschaft* 10 (1917): 301–303.
　　Entries: 27. Millimeters. Inscriptions. States. Described. Located.

Gautier d'Agoty, Edouard *(d. 1784)*
　　Singer, Hans W. "Der Vierfarbendruck in der Gefolgschoft Jacob Christoffel Le Blons." *Monatsheft für Kunstwissenschaft* 10 (1917): 303–309.
　　Entries: 21. Millimeters. Inscriptions. States. Described. Located.

Gautier d'Agoty, Fabien *(b. 1747)*
　　Singer, Hans W. "Der Vierfarbendruck in der Gefolgschaft Jacob Christoffel Le Blons." *Monatsheft für Kunstwissenschaft* 10 (1917): 312–314.

Entries: 25. Millimeters. Inscriptions. States. Described. Illustrated (selection). Located.

Gautier d'Agoty, Honoré Louis [erroneously called "Louis Charles"] *(b. 1746)*
　　Singer, Hans W. "Der Vierfarbendruck in der Gefolgschaft Jacob Christoffel Le Blons." *Monatsheft für Kunstwissenschaft* 10 (1917): 309–311.
　　Entries: 8. Millimeters. Inscriptions. States. Described. Illustrated (selection). Located.

Gautier d'Agoty, Jacques Fabien *(1710–1781)*
　　Singer, Hans W. "Der Vierfarbendruck in der Gefolgschaft Jacob Christoffel Le Blons." *Monatsheft für Kunstwissenschaft* 10 (1917): 177–199.
　　Entries: 251. Millimeters. Inscriptions. States. Described. Illustrated (selection). Located.

Gauw, Gerrit Adriaensz
See **Gouw**

Gavard, ——— *(b. 1794)*
　　[Ber.] VI, pp. 252–253.*

Gavarni, Paul [Hippolyte Guillaume Sulpice Chevalier] *(1804–1866)*
　　Maherault, J. [J. Armelhaut], and Bocher, E. *L'Oeuvre de Gavarni, lithographies originales et essais d'eau-forte et de procedés nouveaux.* Paris: Librairie des Bibliophiles, 1873. 300 copies.
　　Entries: 2740. Millimeters. Inscriptions. States. Described.

　　[Ber.] VII, pp. 5–82.
　　Entries: 318+. Paper fold measure (selection).

Bouvy, Eugène. "Un état non decrit de la série 'Par-ci par-là' de Gavarni." [*Am. Est.*] 7 (1928): 123–124.
　　Additional information to Maherault [Armelhaut] and Bocher.

Gavin, Hector *(fl. 1780–1820)*
[St.] p. 174.*

Gaw, R. M. *(fl. c.1825)*
[St.] pp. 174–175.*

Gebhardt, Wolfgang Magnus
(fl. 1720–1750)
[A.] V, pp. 314–326.
Entries: 17. Pre-metric. Inscriptions.
States. Described.

Geddes, Andrew *(1783–1844)*
Laing, David. *Etchings by Sir David Wilkie, R. A., limner to H. M. for Scotland, and by Andrew Geddes, A. R. A., with biographical sketches.* Edinburgh (Scotland): 1875. 100 copies.
Not seen.

Dodgson, Campbell. "The etchings of Andrew Geddes." *The Walpole Society Annual* 5 (1915–1916 and 1916–1917): 19–45.
Entries: 50. Inches. Millimeters. Inscriptions. States. Described. Illustrated (selection). Located. Off-prints with ms. notes (EBM and ECol); additional states.

Dodgson, Campbell. "Additional notes on the etchings of Andrew Geddes." [*Burl. M.*] 35 (1919): 116.
Additional informatin to Dodgson 1917.

Sanderson, Kenneth. "Engravings after Andrew Geddes." [*PCQ.*] 16 (1929): 109–131.
Entries: 25 prints after. Inches. Inscriptions. States. Described. Illustrated (selection).

Dodgson, C. *The etchings of David Wilkie and Andrew Geddes; a catalogue.* London: Print Collectors' Club, 1936. 425 copies. (MB)
Entries: 50 prints by, 2 doubtful prints. Inches. Millimeters. Inscriptions. States. Described. Illustrated.

Located. Ms. notes (ECol); additional information.

Geefs, Fanny *(1807–1883)*
[H. L.] pp. 364–365.
Entries: 1. Millimeters. Inscriptions. Described.

Geel, Joost van *(1631–1698)*
[W.] I, pp. 569–570.
Entries: 1 print after.*

[H. *Neth.*] VII, p. 89.
Entries: 19 prints by and after.*

Geerards, Marcus
See **Gheeraerts**

Geertjen tot Sint Jans *(1465–1495)*
[W.] I, pp. 570–571.
Entries: 1 print after.*

[H. *Neth.*] VII, p. 90.
Entries: 1 print after. Illustrated.*

Geest, Wybrand Simonsz de *(1592–1659)*
[W.] I, p. 572.
Entries: 3 prints after.*

[H. *Neth.*] VII, p. 90.
Entries: 3 prints after.*

Geets, Willem *(b. 1838)*
[H. L.] pp. 365–372.
Entries: 16. Millimeters. Inscriptions. Described.

Geffels, Franz *(b. c.1615)*
[W.] I, pp. 572–573.
Entries: 3+ prints by, 2 after.*

[H. *Neth.*] VII, p. 91.
Entries: 11 prints by and after.*

Gegenbaur, Anton von *(1800–1876)*
[Dus.] p. 53.
Entries: 1 (lithographs only, to 1821). Millimeters. Inscriptions. Located.

Gehlin, Hugo *(1889–1953)*
Bergquist, Eric. "Hugo Gehlin." [*N. ExT.*] 12 (1960): 12, 16.
 Entries: 19 (bookplates only). Illustrated (selection).

Geiger, Peter Johann Nepomuk *(1805–1880)*
Wiesböck, Carl L. "Peter Joh. Nep. Geigers Werke." [*N. Arch.*] 13 (1867): 153–336.
 Entries: 434 prints by and after. Pre-metric. Inscriptions. States. Described.

Wiesboeck, Carl L. *Peter J. N. Geiger's Werke, oder Verzeichniss saemmtlicher Radierungen, lithographischen Feder- und Kreidezeichnungen, nebst einem Anhang von Xylographien welche nach den Zeichnungen des Meisters geschnitten wurden.* Leipzig: Verlag von Rudolph Weigel, 1867.
 Entries: 434 prints by and after. Pre-metric. Inscriptions. Described.

Geiger, Ruprecht *(b. 1908)*
Geiger, Monika, *Rupprecht Geiger; Werkverzeichnis Druckgraphik 1948–1972.* Düsseldorf: Art Press Verlag, 1972.
 Entries: 171 (to 1972). Millimeters. Described. Illustrated

Geiger, Willy *(b. 1878)*
Roessler, A. *Exlibris Monografie Willi Geiger.* 2 vols. Leipzig: F. Rothbarth Verlag, 1905–1906. 250 copies (DLC)
 Entries: 72. Illustrated.

Schulz-Euler, Carl Fr. *Willi Geiger.* n.p., 1909. (NN)
 Entries: 125 (bookplates only, to 1909). Illustrated (selection).

Geikie, Walter *(1795–1837)*
Lauder, Thomas Dick. *Etchings illustrative of Scottish character and scenery executed after his own designs by the late Walter*

Geikie, Esq. R. S. A. Edinburgh (Scotland): John Stewart, 1841.
 Entries: 80. Described (selection). Illustrated (selection).

Geilkercken, Nicolas van *(c.1600–1657)*
[*W.*] I, p. 573.
 Entries: 5.*

[*H. Neth.*] VII, pp. 91–94.
 Entries: 20+. Illustrated (selection).

Geille, Amédée Félix Barthélémy *(19th cent.)*
[*Ber.*] VII, p. 83.*

Geiser, Karl *(1898–1957)*
Naef, Hans. *Karl Geiser; das graphische Werk.* Zurich: Manesse, 1958. 550 copies. (MH)
 Entries: 100. Millimeters. Inscriptions. States. Described (selection). Illustrated.

Geissler, Paul *(b. 1881)*
Roeper, Adalbert. "Paul Geissler und sein graphisches Werk." [*Kh.*] 9 (1917): 101–112 and Beilage Nr. 5.
 Entries: 179 (to 1916). Millimeters. States. Described (selection). Illustrated (selection).

Max, Johannes. *Paul Geissler; 82 Abbildungen seiner Original-Radierungen mit Text von Johannes Max.* Neue Graphik, 5. Lübeck (Germany): Ludwig Möller Kunstverlag, [1920?]. (NN)
 Entries: 82 (to 1920?). Millimeters. Illustrated. Additional list of 80 more recent prints, titles only.

Braungart, Richard. *Paul Geissler, Original-Radierungen.* Neue Graphik, 7. Lübeck (Germany): Ludwig Möller, 1922. (EWA)
 Entries: 284 (to 1922?). Millimeters. Illustrated.

Geissler, Wilhelm [called "Willi"] *(b. 1895)*
Wilhelm Geissler; Holzschnitte, ein
Werkbuch. Wuppertal (West Germany):
Woensampresse, 1960–1961. 500 copies.
(NN)
> Entries: 377 (to 1960). Millimeters. Il-
> lustrated (selection).

Geist, August Christian *(1835–1868)*
[A. 1800] III, p. 207–221.
> Entries: 20. Pre-metric. Inscriptions.
> Described. Also, list of prints after,
> unnumbered, pp. 213–214 (not fully
> catalogued).

Gelbke, Georg Hermann *(b. 1882)*
Boettger, Fritz. *Georg Gelbke; Verzeichnis*
seiner Radierungen und Steinzeichnungen.
Dresden: Emil Richter, 1919. (EOBKk)
> Entries: 277 (to 1919). Millimeters. De-
> scribed (selection). Illustrated (selec-
> tion).

Singer, Hans W. "George Gelbke."
[*Kh.*] 13 (1921): 125–130.
> Entries: 339 (to 1919). Millimeters. De-
> scribed. Illustrated (selection).

Gelder, Aert de *(1645–1727)*
[W.] I, pp. 573–574.
> Entries: 1 print by, 10 after.*

[H. *Neth.*] VII, p. 95.
> Entries: 12 prints after.*

Gelder, Dirk van *(b. 1907)*
Asselbergs, C. J. Catalogue. In
"Grafisch werk van Dirk van Gelder,"
by W. Jos. de Gruyter. *Gedenkboek 1947*
van de Nederlandsche ex-libris kring, pp.
32–42. Separately published. Breda
(Netherlands): J. v. Poll Suykerbuyk, de
Eenhorn-Pers, 1948. (ERB)
> Entries: 41 (bookplates and commer-
> cial prints only; to 1947). Millimeters.
> Described. Illustrated (selection).

Geldorp, Georg II
See **Geldorp,** Jorge II

Geldorp, Gortzius *(1553–1616)*
[Merlo] pp. 264–271.
> Entries: 24 prints after. Paper fold
> measure (selection). Inscriptions. De-
> scribed.

[W.] I, p. 575.
> Entries: 10 prints after.*

[H. *Neth.*] VII, p. 96.
> Entries: 21 prints after.*

Geldorp, Jorge II *(c.1589–1653)*
[W.] I, pp. 575–576.
> Entries: 1 print after.*

[H. *Neth.*] VII, p. 96.
> Entries: 2 prints after.*

Geldorp, Melchior *(fl. 1615–1637)*
[Merlo] pp. 271–273.*

[W.] I, p. 576.
> Entries: 3 prints after.*

[H. *Neth.*] VII, p. 96.
> Entries: 3 prints after.*

Gelée, Antoine François *(1796–1860)*
[Ap.] pp. 172–173.
> Entries: 8.*

[Ber.] VII, pp. 83–84.*

Gelius, Aegidius *(fl. c.1616)*
[Hind, *Engl.*] II, p. 306.
> Entries: 1 print done for an English
> book. Inches. Inscriptions. Described.
> Illustrated. Located.

Gelle, Johannes *(c.1580–1625)*
[Merlo] pp. 273–274.*

[W.] I, p. 576.
> Entries: 3+.*

[H. *Neth.*] VII, p. 97
> Entries: 23+.*

Gellée, Claude [called "Claude Lorrain"]
(1600–1682)

Lepel, Wilhelm Heinrich Ferdinand
von. *Oeuvre de Claude Gelée dit le lorrain.*
Dresden: Charles G. Gaertner, 1806.
 Entries: 28. Pre-metric. Inscriptions.
 Described.

Amand-Durand, ———, and Duplessis,
Georges. *Eaux fortes de Claude le Lorrain,*
reproduites et publiées par Amand-Durand;
texte par Georges Duplessis. Paris:
Amand-Durand, n.d.
 Entries: 44. Inscriptions. States. De-
 scribed. Illustrated. Located.

[RD.] I, pp. 3–38; XI, pp. 129–188.
 Entries: 44 prints by, 1 doubtful print.
 Pre-metric. Inscriptions. States. De-
 scribed. The catalogue is entirely re-
 worked in volume XI on the basis of
 research by Édouard Meaume.

Piot, Eugène. "Claude Gellée, dit le Lor-
rain," and "Catalogue raisonné des es-
tampes gravées à l'eau-forte par Claude
Gellée."[*Cab. am. ant.*] 2 (1843): 433–466.
 Entries: 43. Millimeters. Inscriptions.
 States. Described.

Meaume, Édouard, and Duplessis,
Georges. *Catalogue des estampes gravées*
par Claude Gellée dit le Lorrain, précédé
d'une notice sur cet artiste. Extract from
[RD.] XI. Paris: Veuve Bouchard-
Huzard, 1870. 50 copies. (DLC)
 Entries: 45. Millimeters. Inscriptions.
 States. Described.

[Wess.] IV, pp. 58–59.
 Additional informtion to [RD.].

Blum, André. *Les eaux-fortes de Claude*
Gellée dit le Lorrain. Paris. Éditions Albert
Morancé, 1923.
 Entries: 44. Millimeters. Inscriptions.
 States. Described. Illustrated.

Gelsdorp, Gortzius
See **Geldorp**

Gemeli, ——— *(18th cent.)*
[Ru.] p. 113.
 Entries: 1 (portraits only). Inches. De-
 scribed.

Gemignani, Giacinto
See **Gimignani**

Gemini G.E.L. [print publishing house]
(20th cent.)
Museum of Modern Art, New York
[Riva Castleman, compiler]. *Technics*
and creativity; Gemini GEL, with an essay
by Riva Castleman. New York, 1971.
 Entries: 285 prints published by (to
 1971). Inches. States. Described. Illus-
 trated.

Gemini G.E.L. *Catalogue Raisonné.* Los
Angeles (Calif.), 1971–.
 Entries: 334 prints published by (to
 1971). Inches. Described. Illustrated.
 A continuing publication in loose-leaf
 format.

Geminus, Thomas *(c.1500–c.1570)*
[Hind, *Engl.*] I, pp. 39–58.
 Entries: 8+. Inches. Inscriptions. De-
 scribed. Illustrated (selection). Lo-
 cated.

Genelli, Janus *(1761–1813)*
[Dus.] p. 53.
 Entries: 2 (lithographs only, to 1821).
 Millimeters. Inscriptions. Located.

Gengembre, Joseph Zephyris
(fl. 1839–1870)
[Ber.] VII, p. 84.*

Geniani, Girolamo *(b. c.1800)*
[Ap.] p. 6.
 Entries: 6.*

Geniole, Alfred André *(1813–1861)*
[Ber.] VII, p. 84.*

Genkinger, Fritz *(b. 1934)*
Galerie Wolfgang Ketterer, Munich.
*Fritz Genkinger; Gemälde, Zeichnungen,
Graphik.* Munich, 1970. (NNMM)
Entries: 94 (to 1970). Millimeters. De-
scribed. Illustrated.

Galerie Wolfgang Ketterer, Munich.
Fritz Genkinger; Gemälde—Graphik.
Munich, 1972. (EBKk)
Entries: 14 (additional to Galerie
Wolfgang Ketterer, 1970). Milli-
meters. States. Described. Illustrated.

Gennari, Benedetto II *(1633–1715)*
[B.] XIX, pp. 264–265.
Entries: 1. Pre-metric. Inscriptions.
Described.

Genoels, Abraham II [called "Archi-
medes"] *(1640–1723)*
[B.] IV, pp. 319–375.
Entries: 73. Pre-metric. Inscriptions.
Described. Copies mentioned.

[Weigel] pp. 209–223.
Entries: 31 (additional to [B.]). Pre-
metric. Inscriptions. Described.

[H. *Neth.*] VII, pp. 98–99.
Entries: 108. Illustrated (selection).*

Gensler, Günther *(1803–1884)*
Bürger, Fritz. *Die Gensler, drei Hamburger
Malerbrüder des 19. Jahrhunderts.* Studien
zur deutschen Kunstgeschichte, 190.
Strasbourg: J. H. Heitz (Heitz und
Mündel), 1916.
Entries: 122 (works in various media,
including prints after). Millimeters.
Inscriptions.

Gensler, Jacob *(1808–1845)*
[A. 1800] III, pp. 42–51.
Entries: 6. Pre-metric. Inscriptions.
States. Described.

Bürger, Fritz. *Die Gensler; drei Hamburger
Malerbrüder des 19. Jahrhunderts.* Studien

zur deutschen Kunstgeschichte, 190.
Strasbourg: J. H. Heitz (Heintz und
Mündel), 1916.
Entries: 327 (works in various media,
including prints). Millimeters. In-
scriptions. States. Based on [A. 1800].

Gensler, Martin *(1811–1881)*
[A. 1800] III, pp. 52–59.
Entries: 6. Pre-metric. Inscriptions.
States. Described.

Bürger, Fritz. *Die Gensler; drei Hamburger
Malerbrüder des 19. Jahrhunderts.* Studien
zur deutschen Kunstgeschichte, 190.
Strasbourg: J. H. Heitz (Heitz und
Mündel), 1916.
Entries: 609 (works in various media,
including prints). Millimeters. In-
scriptions. States. Based on [A. 1800].

Gent, Anton *(fl. c.1639)*
[W.] I, p. 577.
Entries: 1+.*

[H. *Neth.*] VII, p. 97.
Entries: 25.*

Gentzsch, Andreas *(fl. c.1616)*
Hämmerle, Albert. "Die Kupferstecher
Nicolaus Drusse und Andreas Gentzsch
in Augsburg." [*Schw. M.*] 1925, pp. 104–
113.
Entries: 29. Millimeters. Inscriptions.
Described. Illustrated (selection).

Geoffroy, Charles *(1819–1882)*
[Ap.] p. 173.
Entries: 3.*

[Ber.] VII, pp. 84–87.*

Geoffroy, Jean *(1793–after 1848)*
[Ber.] VII, p. 84.*

Geraers
See **Zyl**[l], Gerard Pietersz van

Gérard, Alphonse *(b. 1820)*
[Ber.] VII, p. 87.*

Gérard, Francis Pascal Simon, Baron
(1770–1837)
[Ber.] VII, p. 87.*

Gérard, Jean Ignace Isidore
See **Grandville**

Gérard, Joseph *(1821–1895)*
[H. L.] pp. 372–373.
Entries: 3. Millimeters. Inscriptions.
Described.

Gérard, Marguerite *(1761–1837)*
[Baud.] I, pp. 305–310.
Entries: 4. Millimeters. Inscriptions.
States. Described.

Gérard, Théodore *(1829–1895)*
[H. L.] p. 373.
Entries: 1. Millimeters. Inscriptions.
Described.

Gérard-Fontallard, Henri *(fl. c.1830)*
[Ber.] VII, pp. 87–88.*

Gerards, Marcus
See **Gheeraerts**

Géraut, Pierre Nicolas *(1786–1851)*
[Ap.] p. 173.
Entries: 3.*

[Ber.] VII, pp. 88–89.*

Gerbel, Anton *(fl. 1480–1510)*
See **Monogram AG** [Nagler, *Mon.*] I,
no. 613

Gerhard, Hubert *(d. 1620)*
[W.] I, p. 580.
Entries: 3 prints after.*

[H. *Neth.*] VII, p. 103.
Entries: 3 prints after.*

Gerhardt, Eduard *(1813–1888)*
[Merlo] pp. 289–291.*

Géricault, [Jean Louis André] Théodore
(1791–1824)
Clément, Charles. "Catalogue de
l'oeuvre de Géricault." [*GBA.*] 1st ser.
20 (1866): 521–541. [*GBA.*], 1st ser. 21
(1866): 72–78.
Entries: 101. Millimeters. Inscriptions.
States. Described. Also, list of prints
after, unnumbered, pp. 72–78. De-
scribed (selection).

Clément, Charles. *Géricault; étude bio-
graphique et critique avec le catalogue
raisonné de l'oeuvre du maître.* Paris:
Didier et Cie, 1868.
Entries: 101. Millimeters. Inscriptions.
States. Described. Also, list of prints
after, unnumbered, pp. 410–423.
Millimeters. Inscriptions.

Clément, Charles. *Géricault; étude biog-
raphique et critique avec le catalogue
raisonné de l'oeuvre du maître.* Paris:
Didier et Cie, 1879.
Entries: 101 lithographs, 1 etching.
Millimeters. Inscriptions. States. De-
scribed. Located (selection). Also, list
of prints after, unnumbered, pp.
410–423. Inscriptions (selection). De-
scribed (selection).

[Ber.] VII, pp. 89–102.
Entries: 102. Paper fold measure. De-
scribed (selection).

[Del.] XVIII.
Entries: 97 prints by, 8 doubtful and
rejected prints. Millimeters. Inscrip-
tions (selection). States. Described
(selection). Illustrated. Located (selec-
tion).

Yale University Art Gallery [Kate
Spencer, compiler]. *The graphic art of
Gericault.* New Haven (Conn.), 1969.
Additional information to [Del.].

Gerlier, ——— *(b. 1826)*
 [Ber.] VII, p. 102.*

Gérôme, Jean Léon *(1824–1904)*
 [Ber.] VII, p. 103.
 Entries: 4. Paper fold measure.

Gerrit van Haarlem
 See **Geertjen tot Sint Jans**

Gerrits, Hessel *(1581–1632)*
 [W.] I, p. 581.
 Entries: 5+.*

 [H. *Neth.*] VII, pp. 104–107.
 Entries: 20. Illustrated (selection).*

Gerung, Matthias *(c.1500–1568/70)*
 [B.] IX, pp. 158–160.
 Entries: 8. Pre-metric. Inscriptions.
 Described.

 [P.] III, pp. 307–309.
 Entries: 7 prints by (additional to[B.]),
 10 doubtful prints. Pre-metric. In-
 scriptions. States. Described. Located
 (selection). Additional information to
 [B.].

 Dodgson, Campbell. "Eine Holz-
 schnittfolge Matthias Gerungs." [*JprK.*]
 29 (1908): 195–216.
 Entries: 60. Millimeters. Inscriptions.
 Described. Illustrated (selection). Lo-
 cated.

Gervais, Eugéne *(19th cent.)*
 [Ber.] VII, pp. 103–104.*

Gervex, Henri *(1852–1929)*
 [Ber.] VII, p. 104.*

Gery-Bichard, Adolphe Alphonse
(b. 1841)
 [Ber.] II, pp. 70–72.
 Entries: 14+ (to 1885).

Gessé, Henri
 See **Gissey**

Gessner, Salomon *(1730–1788)*
 Leemann-van Elck, P. *Salomon Gessner;
 sein Lebensbild mit beschreibenden Ver-
 zeichnissen seiner literarischen und
 künstlerischen Werke.* Monographien zur
 schweizer Kunst. Zurich: Orell Füssli
 Verlag, 1930.
 Entries: 470. Millimeters. Inscrip-
 tions. States. Described.

Gethin, Percy Francis *(1874–1916)*
 Wright, Harold J. L. "The etchings and
 lithographs of Percy Francis Gethin."
 [*PCQ.*] 14 (1927): 69–93; [*PCQ.*] 17 (1930):
 106.
 Entries: 19 etchings, 9 lithographs.
 Inches. Inscriptions. States. De-
 scribed. Illustrated (selection).

Geyer, Conrad *(1816–1893)*
 [Ap.] p. 174.
 Entries: 11.*

Gheeraerts, Marcus I *(1521–c.1604)*
 [W.] I, pp. 578–579.
 Entries: 2+ prints by, 14+ after.*

 [H. *Neth.*] VII, pp. 100–102.
 Entries: 197 prints by, 127 after. Illus-
 trated (selection). *

 [Hind, *Engl.*] I, pp. 104–123.
 Entries: 3+ (prints done in England
 only). Inches. Inscriptions. States.
 Described. Illustrated (selection). Lo-
 cated.

 Hodnett, Edward. *Marcus Gheeraerts the
 Elder of Bruges, London and Antwerp.*
 Utrecht: Haentjens Dekker and Gum-
 bert, 1971.
 Entries: unnumbered, pp. 68–73,
 prints by and after. Inches. Milli-
 meters. Illustrated (selection).

Gheeraerts, Marcus II *(1561–1635)*
 [W.] I, p. 579.
 Entries: 3+ prints by, 2+ after.*

Gheeraerts, Marcus II *(continued)*

[H. *Neth.*] VII, p. 103.
 Entries: 72 prints by and after.*

Ghémar, Louis Joseph *(1820–1873)*
[H. L.] p. 374.
 Entries: 2. Millimeters. Inscriptions.
 Described.

Ghendt, Emmanuel Jean Nepomucène de
(1738–1815)
[W.] I, pp. 581–582.
 Entries: 5.*

[Ber.] VII, p. 104.*

[L. D.] pp. 26–28.
 Entries: 4. Millimeters. Inscriptions.
 States. Described. Incomplete
 catalogue.*

Gherardi, Antonio [called "Reatino"]
(1644–1702)
[B.] XXI, pp. 254–256.
 Entries: 6. Pre-metric. Inscriptions.
 Described.

Gherardini, Melchiorre *(d. 1675)*
[B.] XXI, pp. 126–134.
 Entries: 51. Pre-metric. Inscriptions.
 Described.

Gherardo del Fora *(c.1432–c.1495)*
[P.] V, pp. 55–57.
 Entries: 3. Pre-metric. Inscriptions.
 States. Described. Located (selec-
 tion).

[W.] I, pp. 577–578.
 Entries: 3.*

[Hind] I, pp. 215–216.
 Entries: 1. Millimeters. Inscriptions.
 Described. Illustrated. Located. Gen-
 eral discussion of the problem of at-
 tributions to Gherardo del Fora.

Gheyn, Jacob [Jacques] Jansz I de
(c.1532–1582)

[W.] I, p. 582.
 Entries: 1.*

[H. *Neth.*] VII, p. 108.
 Entries: 4. Illustrated (selection).*

Gheyn, Jacob [Jacques] II de *(1565–1629)*
[P.] III, pp. 115–126.
 Entries: 209+ prints by, 9 prints after.
 Pre-metric (selection). Paper fold
 measure (selection). Inscriptions
 (selection). Described (selection).

[Wess.] II, p. 235.
 Entries: 3 (additional to [P.]). Milli-
 meters. Inscriptions. Described.

[W.] I, pp. 582–584.
 Entries: 209+ prints by, 18+ after.*

[Burch.] pp. 171–175.
 Entries: 9+ (etchings only). Milli-
 meters. Inscriptions. States.

[H. *Neth.*] VII, pp. 109–192.
 Entries: 438 prints by, 63 after. Illus-
 trated (selection).*

Gheyn, Jacob [Jacques] III de
(c.1596–c.1644)
[W.] I, p. 584.
 Entries: 7+.*

[H. *Neth.*] VII, pp. 193–200.
 Entries: 25 prints by, 3 after. Illus-
 trated (selection).

Gheyn, Willem de *(b. 1610)*
[W.] I, p. 584.
 Entries: 5+.*

[H. *Neth.*] VII, p. 201.
 Entries: 9.*

Ghezzi, Pier Leone *(1674–1755)*
[B.] XXI, pp. 299–308.
 Entries: 33. Pre-metric. Inscriptions.
 Described.

[Heller] p. 49.
 Additional information to [B.].

Ghiberti, Antonio
See **Gibert**

Ghigi, Pietro *(fl. c.1830)*
[Ap.] p. 175.
Entries: 8.*

Ghisi, Adamo
See **Scultori**

Ghisi, Diana
See **Scultori**

Ghisi, Giorgio *(1520–1582)*
[B.] XV, pp. 374–375; 384–416.
Entries: 71 prints by, 2 doubtful prints.
Pre-metric. Inscriptions. States. De-
scribed. Copies mentioned.

[P.] VI, pp. 137–139.
Additional information to [B.].

[Wess.] III, p. 49.
Additional informtion to [B.].

Mariette, Pierre-Jean. "Catalogue de
l'oeuvre gravé des Ghisi." *Nouvelles
de l'estampe,* 1968, pp. 367–385.
Entries: 74+ prints by Giorgio Ghisi,
Adamo Scultori, Diana Scultori, and
Giovanni Battista Scultori. Described
(selection). Catalogue based on the
print collection delivered by Mariette
to Prince Eugene of Savoy.

Ghisi, Giovanni Battista
See **Scultori**

Ghitti, Pompeo *(1631–1703)*
[B.] XXI, pp. 169–172.
Entries: 4. Pre-metric. Inscriptions.
Described.

Giacomelli, ——— *(fl. c.1813)*
[Ber.] VII, p. 105.*

Giacomelli, Hector *(1822–1904)*
[Ber.] VII, pp. 105–107.*

Giacomelli, Sophie *(b. 1775/80)*
[Ber.] VII, p. 104.*

Giacometti, Alberto *(1901–1966)*
Lust, Herbert C. *Giacometti; the complete
graphics.* New York: Tudor Publishing
Co., 1970.
Entries: 353. Inches. Described. Illus-
trated. Located (selection).

Giacomotti, Félix Henri *(1828–1909)*
[Ber.] VII, pp. 107–108.*

Giaconi, Vincenzo *(1760–1829)*
Meneghelli, Antonio. *Notizie dell'in-
tagliatore Vincenzo Giaconi padovano.* Pa-
dua: Tipografia Crescini, 1829. (EFKI)
Entries: 153. Paper fold measure.

[Ap.] p. 175.
Entries: 1.*

Giampiccoli, Giuliano *(1698–1759)*
[AN.] pp. 482–500.
Entries: unnumbered, pp. 487–500.
Millimeters. Inscriptions. States. De-
scribed.

[AN. 1968] p. 169.
Entries: unnumbered, p. 169 (addi-
tional to [AN.]). Millimeters. Inscrip-
tions (selection). Described (selec-
tion).

Giampiccoli, Marco Sebastiano
(1706–1782)
[AN.] pp. 500–523.
Entries: unnumbered, pp. 504–523.
Millimeters. Inscriptions. Described.

[AN. 1968] pp. 169–171.
Entries: unnumbered, pp. 169–171
(additional to [AN.]). Millimeters. In-
scriptions.

Gibbings, Robert *(b. 1889)*
Empson, Patience. *The wood engravings
of Robert Gibbings with some recollections
by the artist.* London: J. M. Dent and
Sons, 1959.

Gibbings, Robert (*continued*)

Bibliography of books with illustrations by.

Kirkus, A. Mary; Empson, Patience; and Harris, John. *Robert Gibbings, a bibliography.* London: J. M. Dent and Sons, 1962. 975 copies. (MH)
Bibliography of books with illustrations by.

Gibbon, Benjamin Phelps *(1802–1851)*
[Ap.] p. 175.
Entries: 9.*

Gibel, ———— *(fl. 1830–1836)*
[Ber.] VII, p. 108.*

Gibelin, Esprit Antoine *(1739–1813)*
[Baud.] II, pp. 225–238.
Entries: 23. Millimeters. Inscriptions. States. Described.

Gibert, Antonio *(19th cent.)*
[Ap.] p. 174.
Entries: 3. States.

Gibert, Henri Émile *(b. 1818)*
[Ber.] VII, p. 109.*

Giboy, Alexandre *(b. 1786)*
[Ber.] VII, p. 109.*

Gichzer, F. *(19th cent.)*
[Dus.] p. 53.
Entries: 1 (lithographs only, to 1821).

Giebel, Ch. *(19th cent.)*
[Dus.] p. 53.
Entries: 1+ (lithographs only, to 1821). Millimeters. Inscriptions. Located.

Giese, Gottlieb Christian Johannes *(1787–1838)*
[Dus.] p. 53.

Entries: 1.(lithographs only, to 1821). Described.

Gietleughen, Josse van *(fl. c.1545)*
[W.] I, p. 585.
Entries: 2.*

[H. *Neth.*] VII, p. 201.
Entries: 135+.*

Gifford, George *(fl. c.1640)*
[Hind, *Engl.*] III, p. 261.
Entries: 4. Inches. Inscriptions. States. Described. Illustrated (selection). Located.

Gigas, Johann *(b. 1580)*
[Merlo] pp. 291–292.*

Gigoux, Jean François *(1806–1894)*
[Ber.] VII, pp. 109–128.
Entries: 193+. Paper fold measure. Described (selection).

Gil, José Pedro *(b. 1892)*
Galerie J. Alexis, Paris. *Gravures de José Pedro Gil.* Paris, n.d. (ICB)
Entries: 87. Illustrated (selection).

Gilbert, Achille Isidore *(1828–1899)*
[Ber.] VII, pp. 128–133.
Entries: 134. Paper fold measure (selection).

Gilbert, Auguste *(b. 1822)*
[H. L.] p. 374.
Entries: 2. Millimeters.

Gilbert, Charles *(19th cent.)*
[Ber.] VII, p. 133.*

Gilbert, Joseph Francis *(1792–1855)*
[Siltzer] p. 330.
Entries: unnumbered, p. 330, prints after. Inscriptions.

Gilbert-Miriel, ———— *(19th cent.)*
[Ber.] VII, p. 133.*

Giles, John West *(19th cent.)*
[Siltzer] p. 351.
Entries: unnumbered, p. 351. Inscriptions.

Gill, André *(1840–1885)*
Lods, Armand. *André Gill, sa vie; bibliographie de ses oeuvres.* Paris: Leon Vanier, 1887.
Bibliography of books and periodicals with illustrations by.

[Ber.] VII, pp. 134–144.*

Fontane, Charles. *Un maître de la caricature; André Gill.* 2 vols. Paris: Aux Éditions de l'Ibis, 1927. (EPBN)
Entries: unnumbered, Vol. 1, pp. 169–311; Vol. 2, pp. 1–206; prints after. Inscriptions (selection). Described (selection). Illustrated (selection).

Gill, E. *(19th cent.)*
[Siltzer] p. 330.
Entries: unnumbered, p. 330, prints after. Inches. Inscriptions.

Gill, Eric *(1882–1940)*
Cleverdon, Douglas. *Engravings by Eric Gill; a selection of engravings on wood and metal, representative of his work to the year 1927, with a complete chronological list of engravings.* Bristol (England): Douglas Cleverdon, 1929.
Entries: 455 (to 1927). Inches. Illustrated (selection).

Cleverdon, Douglas. "A list of books with lettering or illustrations engraved by Eric Gill." *The Fleuron* 7 (1930): 52–59.
Bibliography of books with illustrations by (to 1930).

Gill, Eric. *Engravings 1928–1933.* London: Faber and Faber, 1934.
Entries: 329 (additional to Cleverdon 1929; to 1933). Inches. Illustrated (selection).

Gill, Evan R. *Bibliography of Eric Gill.* London: Cassell and Co., Ltd., 1953.
Entries: 136 (additional to Gill 1934; to 1940). Also, bibliography of books with illustrations by.

Physick, J. F. *The engraved work of Eric Gill.* London: Her Majesty's Stationery Office, 1963.
Entries: 993. Inches. States (selection). Located. Based chiefly on a collection of prints given to the Victoria and Albert Museum.

Gillberg, Jakob *(1724–1793)*
Jungmarker, Gunnar. "Jacob Gillberg." *Meddelanden från föreningen för grafisk konst* 8 (1929): 9–86.
Entries: 265. Millimeters. Inscriptions. States. Described. Illustrated (selection).

Giller, William *(fl. 1825–1868)*
[Siltzer] p. 351.
Entries: unnumbered, p. 351. Inscriptions.

Gilli, Alberto Maso *(1840–1894)*
[Ber.] VII, pp. 144–145.
Entries: 24. Paper fold measure.

Gillig, Michiel *(b. 1661)*
[W.] I, p. 586.
Entries: 4 prints by, 1 after.*

[H. *Neth.*] VII, p. 202.
Entries: 7 prints by and after. Illustrated (selection).*

Gillot, Claude *(1673–1722)*
Dacier, Emile. "Gillot." In [Dim.] I, pp. 157–215.
Entries: 218 prints by, 10 after lost works. Inscriptions (selection). States.

Populus, Bernard. *Claude Gillot (1673–1722), catalogue de l'oeuvre gravé.* Paris: Société pour l'Étude de la Gravure Française, 1930.

Gillot, Claude (*continued*)

Entries: 500 prints by and after. Millimeters. Inscriptions. States. Described. Illustrated (selection). Copies mentioned. Appendix with doubtful and rejected prints.

Gillray, James *(1757–1815)*
M'Lean, Thomas. *Illustrative description of the genuine works of Mr. James Gillray.* London: Thomas M'Lean, 1830.
Entries: 557. Text to accompany a new edition of all Gillray's prints, with notes explaining each.

Wright, Thomas, and Evans, R. H. *Historical and descriptive account of the caricatures of James Gillray.* London: Henry G. Bohn, 1851. Reprint. New York: Benjamin Blom, Inc., 1968.
Entries: 582. Text to accompany a new edition of all Gillray's prints, with notes explaining each. Ms. notes (NN); additional information, additional entries.

Grego, James. *The works of James Gillray, the caricaturist, with the story of his life and times.* Edited by Thomas Wright. London: Chatto and Windus, n.d.
Entries: unnumbered, pp. 27–371. Inscriptions (selection). Described. Illustrated (selection).

Wright, Thomas, and Evans, R. H. *The works of James Gillray, 582 plates and a supplement containing the 45 so-called "suppressed plates."* New York: Benjamin Blom, Inc., 1968
Entries: 627. Illustrated. Reproduction of the collection of Gillray's prints issued in 1851.

Gilpin, Sawrey *(1733–1807)*
[Siltzer] pp. 124–125.
Entries: unnumbered, pp. 124–125, prints after. Inches (selection). Inscriptions. States. Described (selection).

Gimbrede, Thomas *(1781–1832)*
[St.] pp. 175–187.*

[F.] pp. 117–118.*

Gimignani, Giacinto *(1611–1681)*
[B.] XX, pp. 195–210.
Entries: 27. Pre-metric. Inscriptions. States. Described.

[Wess.] III, p. 49.
Entries: 1 (additional to [B.]). Millimeters. Inscriptions. Described. Located.

Gimmi, Wilhelm *(1886–1960)*
Cailler, Pierre. *Catalogue raisonné de l'oeuvre lithographié de Wilhelm Gimmi.* Geneva: P. Cailler, 1956. 300 copies. (NN)
Entries: 81 (to 1955). Millimeters. Described. Illustrated.

Gingelen, Jacques van *(b. 1801)*
[H. L.] pp. 375–378.
Entries: 10. Millimeters. Inscriptions. States. Described.

Giolito De'Ferrari, Gabriele *(fl. 1536–1578)*
[P.] VI: *See* **Chiaroscuro Woodcuts**

Giordano, Luca *(1632–1705)*
[B.] XXI, pp. 173–177.
Entries: 6. Pre-metric. Inscriptions. States. Described.

Ferrari, Oreste, and Scavizzi, Giuseppe. *Luca Giordano.* 3 vols. Naples: Edizioni Scientifiche Italiane, 1966.
Entries: 7. Millimeters. Inscriptions. Illustrated (selection). Bibliography for each entry.

Giorgione [Giorgio da Castelfranco] *(c.1478–1510)*
[M.] II, pp. 692–706.
Entries: 49+ prints after. Paper fold measure.

Giovane, G.
See **Fatoure,** P.

Giovani, Francesco *(1611–1669)*
[B.] XXI, pp. 97–100.
 Entries: 3. Pre-metric. Inscriptions.
 Described. Copies noted.

Giovanni Antonio da Brescia
See **Brescia**

Giovanni Maria da Brescia
See **Brescia**

Giovannini, Giacomo Maria *(1667–1717)*
[B.] XIX, pp. 420–431.
 Entries: 44+ prints by, 1 print not seen
 by [B.]. Pre-metric. Inscriptions. De-
 scribed.

[Heller] p. 49.
 Additional information to [B.].

Girard, Alexis François *(1787–1870)*
[Ap.] p. 176.
 Entries: 6.*

[Ber.] VII, pp. 145–149.*

Girard, Louise *(19th cent.)*
[Ber.] VII, pp. 149–150.*

Girard, P. *(19th cent.)*
[Ap.] p. 176.
 Entries: 1.*

Girard, Romain *(b. 1751)*
[Ber.] VII, p. 145.*

Girarde, Ed. *(19th cent.)*
[Ap.] p. 177.
 Entries: 1.*

Girardet family *(19th cent.)*
[Ber.] VII, pp. 150–160.*

Girardet, Abraham *(1764–1823)*
[Ap.] p. 176.
 Entries: 8.*

Girardet, Charles Samuel *(1780–1863)*
[Ap.] p. 177.
 Entries: 1.*

Girardet, Jean *(1709–1778)*
Beaupré, J. N. "Notice sur quelques
graveurs nancéiens du XVIIIe siècle et
sur leurs ouvrages." [*Mém. lorraine*], 2d
ser. 9 (1867): 232–234. Separately pub-
lished. n.p., n.d.
 Entries: 2. Millimeters. Inscriptions.
 Described.

Girardet, Paul *(1821–1893)*
[Ber.] VII, pp. 156–159.*

Varin, Adolphe. "Liste des gravures
executées par Paul Girardet." *La Curios-
ité universelle 7,* no. 326 (April 17, 1893): 2;
no. 329 (May 8, 1893): 2; no. 332 (May 29,
1893): 3; no. 336 (June 26, 1893): 4; and
no. 339 (July 17, 1893): 3. (EPBN)
 Entries: unnumbered, about 2 pp. in
 all.

Giraud, Eugène *(1806–1881)*
[Ber.] VII, pp. 160–161.*

Giraud, Victor Julien *(1840–1871)*
[Ber.] VII, p. 161.*

Girodet, Anne Louis *(1767–1824)*
[Baud.] II, pp. 326–327.
 Entries: 1 (etchings only). Millimeters.
 Inscriptions. Described.

[Ber.] VII, pp. 161–162.*

Girolamo Da Treviso [Girolamo
Pennacchil] *(1496–1544)*
[P.] VI: *See* **Chiaroscuro Woodcuts**

Giroux, Achille *(1820–1854)*
[Ber.] VII, p. 163.*

Giroux, Charles *(b. 1861)*
[Ber.] VII, p. 163.*

Girsch, F. *(19th cent.)*
 [Ap.] p. 177.
 Entries: 2.*

Girtin, Thomas *(1775–1802)*
 Mayne, Jonathan. *Thomas Girtin.*
 Leigh-on-Sea (England): F. Lewis, 1949.
 Entries: 20. Inscriptions. States. Located.

 Girtin, Thomas, and Loshak, David. *The art of Thomas Girtin.* London: Adam and Charles Black, 1954.
 Entries: unnumbered, pp. 213–215 (prints after missing drawings only). Inches.

Gisborne, John *(fl. c.1800)*
 [Sm.] II, p. 528.
 Entries: 2 (portraits only). Inches. Inscriptions. Described. Located (selection).

 [Ru.] pp. 113–114.
 Entries: 3 (portraits only, additional to [Sm.]). Inches. Inscriptions. Described. Additional information to [Sm.].

Gissey, Henri *(1621–1673)*
 [RD.] IV, pp. 22–24; XI, p. 108.
 Entries: 3. Pre-metric. Inscriptions. States. Described.

Giuliani, Felice
 See **Zuliani**

Giuliani, Giovanni *(20th cent.)*
 Opera Bevilacqua la Masa, Venice [Giovanni Trentin, compiler]. *Opera incisoria di Giovanni Giuliani.* Venice: Comune di Venezia, 1964. 350 copies. (MH)
 Entries: 71 etchings, 10 woodcuts, 16 bookplates, (to 1963). Millimeters. Illustrated (selection).

Giulio Romano *(1499–1546)*
 [B.] XII: *See* **Chiaroscuro Woodcuts**

Giunta, Luca Antonio de *(fl. 1506–1522)*
 [B.] XIII, pp. 388–391.
 Entries: 2. Pre-metric. Inscriptions. Described.

 [P.] V, pp. 62–66.
 Entries: 15+ (additional to [B.]). Pre-metric (selection). Paper fold measure (selection). Inscriptions. Described. Located (selection).

Giunti, Luca Antonio de
 See **Giunta**

Glackens, William J. *(1870–1938)*
 De Gregorio, Vincent John. "The life and art of William Glackens." Doctoral dissertation, Ohio State University, 1955. Ann Arbor, Mich.: University Microfilms, 1956. (DLC)
 Entries: 4. Inches. Inscriptions. Described. Located.

Glänzner, Ludwig *(d. 1887)*
 [Merlo] p. 293.*

Glaeser, G. *(19th cent.)*
 [Dus.] p. 53.
 Entries: 1 (lithographs only, to 1821). Millimeters. Inscriptions. Located.

Glairon-Mondet, E. J. *(fl. c.1800)*
 [Ber.] VII, p. 163.*

Glaize, Auguste Barthélemy *(1807–1893)*
 [Ber.] VII, p. 163.*

Glaser, Adam Goswin *(1815–1900)*
 [Ap.] p. 177.
 Entries: 1.*

Glauber, Johannes (called "Polidoro") *(1646–1726)*
 [B.] V, pp. 380–398.
 Entries: 26 (landscapes only). Pre-metric. Inscriptions. States. Described.

[Weigel] pp. 314–315.
Entries: 1 (additional to [B.]). Pre-metric. Inscriptions. Described.

[W.] I, p. 587.
Entries: 27+ prints by, 2 after.*

Glauber, Johannes Gottlieb [Jan Gotlief] *(1656–1703)*
[B.] V, pp. 398–399.
Entries: 2. Pre-metric. Inscriptions. Described.

[Weigel] pp. 315–316.
Entries: 1 (additional to [B.]). Pre-metric. Inscriptions. Described.

[W.] I, pp. 587–588.
Entries: 3.*

Glauwe, A. *(17th cent.)*
[H. *Neth.*] VII, p. 202.
Entries: 1 print after.*

Gleadah, Joshua *(fl. 1815–1836)*
[Siltzer] p. 352.
Entries: unnumbered, p. 352. Inscriptions.

Gleiditsch, Paul *(b. 1793)*
[Ap.] p. 178.
Entries: 15.*

Glen, Jan de *(fl. 1597–1631)*
[W.] I, p. 588.
Entries: 5+.*

[H. *Neth.*] VII, pp. 202–203.
Entries: 5+.*

Glimes, P. de *(18th cent.)*
[W.] I, p. 588.
Entries: 1 print after.*

Glockendon, Albrecht I *(fl. c.1480)*
See **Monogram AG** [Nagler, *Mon.*] I, no. 613

Glockendon, Georg I *(fl. 1484–1515)*
See **Monogram GG** [Nagler, *Mon.*] II, no. 2992

Glockendon, H. W.
See **Monogram HWG** [Nagler, *Mon.*] III, no. 1722

Glover, George *(fl. 1634–1652)*
[Hind, *Engl.*] III, pp. 225–250.
Entries: 68. Inches. Inscriptions. States. Described. Illustrated (selection). Located.

Gmelin, Wilhelm Friedrich *(1760–1820)*
[Ap.] pp. 178–179.
Entries: 18.*

Gobel, Bartholomäus
See **Monogram BG** [Nagler, *Mon.*] I, no. 2079

Gobô, Georges *(b. 1876)*
Angoulvent, P. J. "Georges Gobô; peintre-graveur moderne." *Byblis,* 1923, pp. 121–125, 2 pp. unpaginated following p. 158.
Entries: unnumbered, 2 pp. (to 1923). Millimeters.

Angoulvent, P. J. "The etchings of Georges Gobô." [*P. Conn.*] 4 (1924): 246–259.
Entries: unnumbered, pp. 256–259 (to 1923). Millimeters.

Gobrecht, Christian *(1785–1844)*
[St.] pp. 187–188.*

[F.] p. 118.*

Godard d'Alençon, ———, I and II *(18th–19th cent.)*
[Ber.] VII, pp. 163–164.*

Goddard, John *(fl. 1645–1654)*
[Hind, *Engl.*] III, pp. 333–339.
Entries: 17+. Inches. Inscriptions. Described. Illustrated (selection). Located.

Goddé, Jules *(1812–1876)*
[Ber.] VII, pp. 164–165.*

Godefroy, Adrien Pierre François [called "Godefroy jeune"] *(1777–1865)*
[Ber.] VII, pp. 165–166.*

Godefroy, François *(1743–1819)*
[Ber.] VII, p. 165.*

[L. D.] pp. 28–29.
Entries: 3. Millimeters. Inscriptions. States. Described. Incomplete catalogue.*

Godefroy, Jean *(1771–1839)*
Lacroix, P. [P. L. Jacob]. "Jean Godefroy, peintre et graveur." [*RUA*] 16 (1862): 22–34, 96–107. Separately published. Paris: Veuve Jules Renouard; Brussels: A. Labrove et Mertens, 1872. (EPBN)
Entries: 110+. Millimeters (selection). Inscriptions (selection). States. Described (selection).

[Ap.] p. 180.
Entries: 10.*

[Ber.] VII, pp. 166–170.*

Godefroy, Louis François *(20th cent.)*
Lemoisne, P. A. "Louis Godefroy, painter etcher." [*P. Conn.*] 3 (1923): 111–129.
Entries: 90 (to 1922). Millimeters. Illustrated (selection).

Godefroy Batavus *(fl. c.1520)*
[W.] III, p. 92.
Entries: 1+.*

[H. *Neth.*] VII, p. 203.
Entries: 20.*

Godewyk, Margareta van *(1627–1677)*
[H. *Neth.*] VII, p. 203.
Entries: 1 print after.*

Godwin, Abraham *(1763–1835)*
[Allen] p. 137.*

[St.] p. 189.*

[F.] pp. 118–119.*

Goebel, Angilbert Wunibald *(1821–1882)*
[Ap.] p. 180.
Entries: 4.*

Goebels, [Johann Wilhelm] *(1804–1827)*
[Merlo] pp. 297–298.*

Göding, Heinrich I *(1531–1606)*
[P.] IV, pp. 232–235.
Entries: 7+. Pre-metric (selection). Paper fold measure (selection). Inscriptions. Described.

[A.] I, pp. 71–98.
Entries: 18+. Pre-metric. Inscriptions. Described.

Singer, Hans W. "Zusätze zum Werk des Heinrich Gödig." [*Rep. Kw.*] 15 (1892): 353–356.
Entries: 15 woodcuts, 146 etchings (additional to [A.]). Millimeters (selection). Located.

Goeimare, Joos *(c.1575–1618)*
[W.] I, p. 589.
Entries: 2 prints after.*

[H. *Neth.*] VII, p. 203.
Entries: 3 prints after.*

Goeneutte, Norbert *(1854–1894)*
[Ber.] VII, pp. 170–172.
Entries: 101 (to 1888).

Goeree, Jan *(1670–1731)*
[W.] I, pp. 589–590.
Entries: 4 prints after.*

Goerg, Édouard *(1893–1969)*
Thieffry, M. "Édouard Goerg; catalogue de son oeuvre gravé." Thesis, École du Louvre, 1953. Ms. (EPBN)
Entries: 813 (to 1953). Millimeters. States.

Goeteeris, Anthoni
See **Gouteris**

312

Goethals, Jules Marie Armand, baron *(1844–1902)*
　[H. L.] pp. 378–382.
　　Entries: 12. Millimeters. Inscriptions. States. Described.

Goethe, Johann Wolfgang *(1749–1832)*
Münz, Ludwig. *Goethes Zeichnungen und Radierungen.* Vienna: Österreichische Staatsdruckerei, 1949.
　Entries: 6 prints after. Described. Illustrated.

Göttich, M. *(fl. c.1596?)*
See **Monogram MG** [Nagler, *Mon.*] IV, no. 1826

Goff, Robert Charles *(b. 1837)*
Catalogue of the etchings of Colonel R. Goff. London: Fine Art Society, 1912.
　Entries: 214 (to 1911?).

Goffart, Johann Peter *(18th cent.)*
　[Merlo] p. 298.*

Goglet, ⸻ *(fl. c.1836)*
　[Ber.] VII, p. 172.*

Gois, Etienne Pierre Adrien *(1731–1823)*
　[Baud.] I, pp. 142–151.
　　Entries: 16. Millimeters. Inscriptions. Described.

Goldfriedrich, Ernst Albert *(1832–1868)*
　[Ap.] p. 181.
　　Entries: 2.*

Golding, Richard *(1785–1865)*
　[Ap.] p. 181.
　　Entries: 3.*

Gole, Jacob *(c.1660–1737)*
Wessely, Joseph Eduard. *Jacob Gole; Verzeichniss seiner Kupferstiche und Schabkunstblätter.* Kritische Verzeichnisse von Werken hervorragender Kupferstecher, 6. Hamburg: Haendcke und Lehmkuhl, 1889.

　Entries: 433 prints by, 10 prints not seen by Wessely. Millimeters. Inscriptions. States. Described. Ms. notes (NN); additional entries. Ms. notes (EA); additional states.

　[W.] I, pp. 595–597.
　　Entries: 433+.*

　[H. *Neth.*] VII, pp. 204–240.
　　Entries: 476+. Illustrated (selection).*

Goljakhovski, Evgenii Nikolaevich *(b. 1902)*
Perkin, D. W., and Rödel, Klaus. *Jevgeni Goljachowski, en russisk exlibriskunstner.* Copenhagen: Privately printed, 1968. 75 copies. (DLC)
　Entries: 205 (book plates only, to 1968). Millimeters. Described. Illustrated (selection).

Gols, Conrad
See **Goltzius**

Golter, Leonard
See **Gaultier**

Goltzius, Conrad *(fl. 1580–1600)*
　[Merlo] pp. 299–300.*

　[W.] I, p. 597.
　　Entries: 6+.*

　[H. *Neth.*] VIII, p. 143.
　　Entries: 16+.*

Goltzius, Hendrik *(1558–1617)*
　[B.] III, pp. 3–127 and addenda.
　　Entries: 308 prints by, 27 doubtful and rejected prints, 152 prints after. Premetric. Inscriptions. States. Described. Copies mentioned.

　[Weigel] pp. 92–119.
　　Entries: 40 (additional to [B.]). Premetric. Inscriptions. Described.

　[Heller] pp. 49–55.
　　Additional information to [B.].

Goltzius, Hendrik (*continued*)

[Wess.] II, pp. 236–237.
Entries: 4 (additional to [B.] and [Weigel]). Millimeters (selection). Inscriptions. Described. Additional information to [B.] and [Weigel].

[Dut.] IV, pp. 405–520; V, pp. 592–593, 594b; VI, p. 673.
Entries: 375 prints by; prints after, unnumbered, pp. 458–512. Millimeters. Inscriptions. States. Described.

[W.] I, pp. 597–602.
Entries: 302+.*

Hirschmann, Otto. *Verzeichnis des graphischen Werks von Hendrick Goltzius (1558–1617) mit Benutzung der durch E. W. Moest hinterlassenen Notizen zusammengestellt.* Leipzig: Verlag von Klinkhardt und Biermann, 1921.
Entries: 383. Millimeters. Inscriptions. States. Described. Located (selection). Copies mentioned. Ms. notes (EA); additional information.

[H. *Neth.*] VIII, pp. 1–138.
Entries: 388 prints by, 574 after. Illustrated (selection).*

Strauss, Walter L. "The chronology of Hendrick Goltzius chiaroscuro prints." *Nouvelles de l'estampe,* no. 5 (1972): 9–13.
Additional information to previous catalogues.

Goltzius, Hubert *(1526–1583)*
[H. *Neth.*] VIII, p. 139.
Entries: 9+.*

Goltzius, Jacob *(c.1535–1609)*
[W.] I, p. 602.
Entries: 3.*

[H. *Neth.*] VIII, p. 140.
Entries: 6. Illustrated (selection).*

Goltzius, Julius *(c.1550–c.1595)*
[W.] I, p. 603.
Entries: 14.*

[H. *Neth.*] VIII, pp. 140–142.
Entries: 53. Illustrated (selection).*

Golz, G. *(19th cent.)*
[Dus.] p. 54.
Entries: 2 (lithographs only, to 1821). Millimeters (selection). Inscriptions (selection). Located (selection).

Goncourt, Edmond de *(1822–1896)*
[Ber.] VII, p. 172–173.
Entries: 10.

Goncourt, Jules de *(1830–1870)*
Burty, Philippe. *Eaux-fortes de Jules de Goncourt, notice et catalogue.* Paris: Librairie de l'Art, 1876. 300 copies. (CLU)
Entries: 86. Millimeters. Inscriptions. States. Described. Illustrated (selection). 20 etchings are published with the catalogue.

[Ber.] VII, pp. 173–178.
Entries: 86. Summary of Burty.

Gonzenbach, Carl Arnold *(1806–1895)*
[Ap.] pp. 181–182.
Entries: 33.*

Gooch, T. *(fl. 1778–1802)*
[Siltzer] p. 125.
Entries: unnumbered, p. 125, prints after. Inches (selection). Inscriptions.

Goodall, Edward *(1795–1870)*
[Ap.] p. 183.
Entries: 8.*

Goodby, James, and H. Merke *(19th cent.)*
[Siltzer] p. 352.
Entries: unnumbered, p. 352. Inscriptions.

Goode, John *(19th cent.)*
[Siltzer] pp. 330–331.
Entries: unnumbered, pp. 330–331, prints after. Inscriptions.

Gooden, Stephen *(b. 1892)*
Dodgson, Campbell. "The engravings of Stephen Gooden." [*PCQ.*] 28 (1941): 140–163, 292–321, 478–495.
Entries: 180 engravings, 12 prints in other media. Inches. Inscriptions. States. Described. Illustrated (selection).

Dodgson, Campbell. *An iconography of the engravings of Stephen Gooden.* London: Elkin Mathews Ltd, 1944. 500 copies. (MBMu)
Entries: 186 engravings, 12 prints in other media (to 1944). Inches. Inscriptions (selection). States. Described (selection). Illustrated.

Goodman, Charles *(1790–1830)*
[St.] pp. 189–190.*

[F.] p. 119.*

Goodman and Piggot *(19th cent.)*
[St.] pp. 190–196.*

[F.] pp. 119–120.*

Goodyear, Joseph *(1797–1839)*
[Ap.] p. 183.
Entries: 1.*

Goos, Abraham *(fl. 1614–1629)*
[H. *Neth.*] VIII, p. 143.
Entries: 1.*

Goos, Pieter *(1616–1672)*
[W.] I, p. 604.
Entries: 2.*

[H. *Neth.*] VIII, p. 144.
Entries: 2.*

Goossens, Jan Baptist *(c.1650–after 1680)*
[Merlo] pp. 301–304.*

[H. *Neth.*] VIII, p. 144.
Entries: 19+.*

Goss, Jan *(fl. c.1650)*
[H. *Neth.*] VIII, p. 144.
Entries: 1.*

Gossaert, Jan [called "Mabuse"] *(1478–c.1535)*
[B.] VII, pp. 546–547.
Entries: 3. Pre-metric. Inscriptions. Described.

[P.] III, pp. 22–23.
Entries: 1 (additional to [B.]). Pre-metric. States. Described. Located.

[W.] II, pp. 78–86.
Entries: 5 prints by, 5 after.*

[H. *Neth.*] VIII, pp. 145–150.
Entries: 5 prints by, 6 after. Illustrated (selection).*

Museum Boymans-van Beuningen, Rotterdam, and Musée Communale Groeninge, Bruges [H. Pauwels, H. R. Hoetink and S. Herzog, compilers]. *Jean Gossaert dit Mabuse.* Dutch ed. *Jan Gossaert genaamd Mabuse.* Rotterdam (Netherlands) and Bruges (Belgium), 1965.
Entries: 6 prints by, 4 after. Millimeters. States. Illustrated (selection). Located.

Gosselin, Henri *(1833–1867)*
[H. L.] p. 382.
Entries: 1. Millimeters. Inscriptions. Described.

Gosset de Guines
See **Gill,** André

Goting, Jan van *(c.1638–1697)*
[H. *Neth.*] VIII, p. 150.
Entries: 1 print after.*

Gottlandt, Peter *(fl. 1548–1572)*
[B.] IX, pp. 233–237.
Entries: 6. Pre-metric. Inscriptions.
States. Described.

[B.] IX, pp. 436–437.
Entries: 1. Pre-metric. Inscriptions.
Described.

[Heller] p. 105.
Additional information to [B.]. Artist
is wrongly identified as Paul Reffler.

Schuchardt, Chr. "Ueber Peter Rod-
delstet genannt Peter Gottlandt,
Schuler Lucas Cranach des Aelteren."
[*N. Arch.*] 1 (1855): 87–93.
Entries: 15. Pre-metric. Inscriptions.
Described.

Schuchardt, Christian. *Lucas Cranach des
Aelteren Leben und Werke nach ur-
kundlichen Quellen bearbeitet.* Vol. III, pp.
92–116. Leipzig: F. A. Brockhaus, 1851–
1871. (MBMu)
Entries: 16+. Pre-metric. Inscriptions.
Described.

[P.] IV, pp. 57–59.
Entries: 6 engravings (additional to
[B.]), 4 woodcuts. Pre-metric. Inscrip-
tions. Described.

[Wess.] I, p. 137.
Additional information to [B.] and
[P.].

Gottschick, Johann Christian Benjamin
(1776–1844)
[Ap.] p. 184.
Entries: 13.*

Goubau, Alexandre *(c.1600–after 1645)*
[W.] I, p. 604.
Entries: 1.*

[H. *Neth.*] VIII, p. 150.
Entries: 2.*

Goubau, Antoon *(1616–1698)*
[W.] I, p. 604–605.
Entries: 1 print by, 1 after.*

[H. *Neth.*] VIII, p. 150.
Entries: 2.*

Goudt, Hendrik *(1585–1630)*
[A.] V, pp. 11–22.
Entries: 7. Pre-metric. Inscriptions.
Described.

[Dut.] IV, pp. 520–523.
Entries: 7. Millimeters. Inscriptions.
States. Described.

[W.] I, pp. 605–606.
Entries: 7.*

Reitlinger, Henry Scipio. "Hendrik,
Count Goudt."[*PCQ.*] 8 (1921): 230–245.
Entries: 7. Inches. Inscriptions. De-
scribed. Illustrated (selection). Copies
mentioned.

[H. *Neth.*] VIII, pp. 151–157.
Entries: 7. Illustrated.*

Goudtsbloem, Cornelis
See **Goutsbloem**

Goujon, Jean *(d. c.1567)*
[RD.] VI, pp. 33–38.
Entries: 27. Millimeters. Inscriptions.
Described.

Goulding, Frederick *(1842–1909)*
Hardie, Martin. *Frederick Goulding; mas-
ter printer of copper plates.* Stirling (Scot-
land): Eneas Mackay, 1910. 350 copies.
(MB)
Entries: 32. Inches. Inscriptions.
States. Described.

Goulu, Ferdinand Sébastien *(b. 1796)*
[Ap.] p. 184.
Entries: 2.*

Goupil [print publishers] *(19th cent.)*
[Ber.] VII, pp. 178–179.*

Gourcy, Henri Antoine Gaston, comte de
(19th cent.)
[Ber.] VII, pp. 180–181.*

Gourdelle, Pierre *(c.1530–after 1588)*
[P.] VI, p. 271.
　　Entries: 1+. Pre-metric. Inscriptions.
　　Described.

Gourlier, —— *(fl. c.1830)*
[Ber.] VII, p. 182.*

Gourmont, Jean de *(fl. 1565–1581)*
[B.] IX, pp. 143–149.
　　Entries: 16. Pre-metric. Inscriptions.
　　Described.

[RD.] VII, pp. 18–27; XI, pp. 204–206.
　　Entries: 31. Millimeters. Inscriptions.
　　Described.

[P.] VI, pp. 266–268.
　　Entries: 7 (additional to [B.] and
　　[RD.]). Pre-metric. Inscriptions. De-
　　scribed.

Gousbloom, Cornelis
See **Goutsbloem**

Gout, Anton
See **Gent**

Gouteris, Anthoni *(c.1574–c.1660)*
[H. *Neth.*] VIII, p. 158.
　　Entries: 1+ prints after.*

Goutière, Tony *(1808–1890)*
[Ber.] VII, pp. 183–188.*

Varin, Adolphe. "Tony-Goutière,
graveur au burin à Paris." *La Curiosité
universelle*, 3, no. 104 (January 14, 1889):
4–5. (EPBN)
　　Entries: unnumbered, p. 5.

Goutsbloem, Cornelis *(fl. 1635–1653)*
[W.] I, p. 606.
　　Entries: 6.*

[H. *Neth.*] VIII, p. 158.
　　Entries: 7.*

Gouw, Gerrit Adriaensz *(c.1590–1638)*
[W.] I, p. 606.
　　Entries: 5+ prints after.*

[H. *Neth.*] VIII, p. 159.
　　Entries: 13+.*

Gouwem, Willem van der *(fl. 1650–c.1720)*
[W.] I, p. 606.
　　Entries: 2.*

[H. *Neth.*] VIII, p. 159.
　　Entries: 3+.*

Gouwy, Jacob Peter *(c.1600–after 1644)*
[W.] I, p. 606.
　　Entries: 2 prints after.*

[H. *Neth*] VIII, p. 159.
　　Entries: 2 prints after.*

Gowi, Jacob Peter
See **Gouwy**

Goya, Francisco *(1746–1828)*
Piot, E. "Catalogue raisonné de l'oeuvre
gravé de Franco Goya y Lucientes." [*Cab.
am. ant.*] 1 (1842): 346–366.
　　Entries: 163. Millimeters. Inscriptions.
　　States. Described.

Lefort, Paul. "Essai d'un catalogue
raisonné de l'oeuvre gravé et lithog-
raphié de Francesco Goya." [*GBA.*] 1st
ser. 22 (1867): 191–205, 382–395; [*GBA.*]
1st ser. 24 (1868): 169–186, 385–399;
[*GBA.*] 1st ser. 25 (1868): 165–180.
　　Entries: 279. Millimeters. Described.

Lefort, Paul. *Francisco Goya, étude biog-
raphique et critique suivie de l'essai d'un
catalogue raisonné de son oeuvre gravé et
lithographié.* Paris: Librairie Renouard,
1877.
　　Entries: 278. Millimeters. Inscrip-
　　tions. Described.

Viñaza, Cipriano, conde de la. *Goya; su
tiempo, su vida, sus obras.* Madrid: Man-
uel G. Hernandez, 1887. (MH)
　　Entries: 278. Millimeters. Inscrip-
　　tions. States. Described.

[Ber.] VII, pp. 188–200.*

Goya, Francisco (*continued*)

Lafond, Paul. *Goya*. Paris: Librairie de l'Art Ancien et Moderne, [1902–1903?].
Entries: 284. Millimeters. Inscriptions. Described.

Loga, Valerian von. *Francisco de Goya*. Berlin: G. Grote'sche Verlagsbuchhandlung, 1903.
Entries: 140+. Millimeters. States.

[Del.] XIV–XV.
Entries: 289 prints by, 4 doubtful and rejected prints. Millimeters. Inscriptions. States. Described (selection). Illustrated. Located (selection).

Hofmann, Julius. *Francisco de Goya; Katalog seines graphischen Werkes*. Vienna: Gesellschaft für vervielfältigende Kunst, 1907.
Entries: 284. Millimeters. Inscriptions. States. Described (selection). Located. Table of watermarks.

Dodgson, Campbell. "Bemerkungen zu den Radierungen und Lithographien Goyas im Britischen Museum." [*MGvK.*] 1907, pp. 59–61.
Additional information to Hofmann.

Beruetey Moret, A. de. *Goya grabador*. Madrid: Blass y Cía, 1918.
Entries: 290. Millimeters. Inscriptions. States. Described. Illustrated (selection).

Vindel, Pedro. *Los Caprichos, La Tauromaquia, Los Desastres de la Guerra, Los Proverbios de Don Francisco Goya; descripcion de las diversas tiradas hechas hasta nuestros dias con los precios que alcanzan en la actualidad*. Madrid: Libreria de Pedro Vindel, 1928.
Description of the various editions of Goya's 4 sets of etchings: paper used, condition of plates, etc. Prints are not individually described; title pages and watermarks are illustrated.

Hofer, Philip. "Some undescribed states of Goya's Caprichos." [*GBA.*] 6th ser. 28 (1945): 163–180.
Additional information to [Del.].

Sanchez Canton, F. J. *Los Caprichos de Goya y sus dibujos preparatorios*. Barcelona: Instituto Amatiller de Arte Hispanico, 1949. 950 copies. (MH)
Entries: 86 (*Caprichos* series and related prints). Described. Illustrated. Preliminary drawings are identified and reproduced.

Boelcke-Astor, A. Catharina. "Die Drucke der Desastres de la Guerra von Francisco Goya." *Müncher Jahrbuch der bildenden Künste*, 3d ser. 3/4 (1952/1953): 253–334.
Additional information to earlier catalogues. Catalogue of early proofs of the *Desastres* series, in Berlin.

Crispolti, Enrico. "Alcuni stati inediti delle copie di Velasquez incise da Goya." *Emporium*, 128 (Dec. 1958): 249–258.
Additional information to [Del.].

Ferrari, Enrique Lafuente. *Goya; his complete etchings, aquatints and lithographs*. New York: Harry N. Abrams, Inc., 1962.
Entries: unnumbered, pp. 1–288. Inches (dimensions given only for prints not reproduced actual size). Illustrated.

Harris, Tomás. *Goya; engravings and lithographs*. 2 vols. Oxford: Bruno Cassirer, 1964.
Entries: 292. Millimeters. Inscriptions. States. Described. Illustrated. Located (selection). Description of inks and papers used in different editions. Comparative illustrations of early and late states of certain prints. Discussion of Goya's technique.

Goyen, Jan van *(1596–1656)*
[Dut.] IV, pp. 523–524.

Entries: 5. Millimeters. Inscriptions. States. Described.

[W.] I, pp. 607–610.
Entries: 7 prints by, 21+ after.*

[H. *Neth.*] VIII, pp. 160–163.
Entries: 10 prints by, 79 after. Illustrated (selection).*

Graadt van Roggen, Johannes Mattheus *(b. 1867)*
von Regteren Altena, Mia. *J. M. Graadt van Roggen als grafisch kunstenaar.* Rotterdam (Netherlands): Ad. Donker, 1948. (DLC)
Entries: unnumbered, pp. 35–39 (to 1947). Millimeters. Illustrated (selection).

Graat, Barent *(1628–1709)*
[W.] I, pp. 610–611.
Entries: 1 print by, 17+ after.*

[H. *Neth.*] VIII, p. 164.
Entries: 1 print by, 121 after. Illustrated (selection).*

Graauw, Hendrik *(c.1627–1693)*
[H. *Neth.*] VIII, p. 163.
Entries: 1.*

Gracht, Jacob van der *(1593–1652)*
[H. *Neth.*] VIII, p. 163.
Entries: 19.*

Gradmann, ——— *(19th cent.)*
[Dus.] p. 54.
Entries: 2 (lithographs only, to 1821). Millimeters. Located.

Gradnauer, Ludwig *(19th cent.)*
[Dus.] p. 54.
Entries: 2+ (lithographs only, to 1821). Paper fold measure.

Graf, Caecilie *(b. 1868)*
Berolzheimer, Michael. *Oskar und Cäcilie Graf, Maler-Radierer, Katalog ihres radier-ten, lithographierten und monotypierten Werkes.* Munich: Hugo Helbing, 1903. (DLC)
Entries: 38+ (to 1903). Millimeters. Inscriptions. States. Described. Illustrated (selection).

Graf, Johann Andreas *(1637–1701)*
[Hüsgen] pp. 456–458.
Entries: unnumbered, pp. 456–458, prints by and after.

[A.] V, pp. 205–212.
Entries: 6. Pre-metric. Inscriptions. States. Described.

Graf, Oscar *(b. 1870)*
Berolzheimer, Michael. *Oskar und Cäcilie Graf Maler-Radierer, Katalog ihres radierten, lithographierten und monotypierten Werkes.* Munich: Hugo Helbing, 1903. (DLC)
Entries: 96+ (to 1903). Millimeters. Inscriptions. States. Described.

Graf, Urs *(c.1485–1527/28)*
[B.] VI, p. 390.
Entries: 1. Pre-metric. Inscriptions. Described.

[B.] VII, pp. 456–466.
Entries: 18+. Pre-metric. Inscriptions. Described.

[Evans] p. 41.
Entries: 1 (additional to [B.]). Millimeters. Inscriptions. Described.

[Evans] p. 43.
Entries: 1 (additional to [B.]). Millimeters. Inscriptions. Described.

[P.] II, pp. 139–142.
Entries: 25 (additional to [B.]). Pre-metric. Inscriptions. Described. Located. Additional information to [B.].

[P.] III, pp. 425–432.
Entries: 13 engravings and etchings, 145 woodcuts and metalcuts. Pre-

Graf, Urs (*continued*)

metric. Inscriptions. Described. Located (selection). Additional information to [B.].

His-Heusler, Ed. "Einiges über den Goldschmied, Medailleur, Zeichner und Formschneider Urs Graf von Basel." [*N. Arch.*] 11 (1865): 81–92.
Entries: 4 (additional to [P.] and [Nagler, *Mon.*] III, no. 414; V, 1175). Pre-metric. Inscriptions. Described.

His, Eduard. "Urs Graf." Catalogue: "Beschreibendes Verzeichniss des Werks von Urs Graf." [*JKw.*] 5 (1873): 257–262; [*JKw.*] 6 (1874): 145–187.
Entries: 27 engravings and etchings, 327+ woodcuts. Millimeters. Inscriptions. Described.

Koegler, Hans. "Beiträge zum Holzschnittwerk des Urs Graf." *Anzeiger für schweizerische Altertumskunde,* n.s. 9 (1907): 43–57, 132–143, 213–229.
Entries: 6 engravings (additional to His), 85+ woodcuts (additional to His). Millimeters (selection). Inscriptions. Described. Illustrated (selection). Additional information to His.

Koegler, H. "Andachtsbild des Klosters und Spitals zum heiligen Geist in Bern, ein Holzschnitt von Urs Graf." *Anzeiger für schweizerische Altertumskunde* 9 (1906–1907): 326–329.
Entries: 1 woodcut (additional to His). Millimeters. Inscriptions. Described. Illustrated.

Lüthi, Walter. *Urs Graf und die Kunst der alten Schweizer.* Zurich: Orell Füssli Verlag, 1928.
Entries: 67+. Illustrated (selection). Located (selection).

Koegler, Hans. "Zwei Kupferstiche und eine Zeichnung von Urs Graf." *Anzeiger für schweizerische Altertumskunde,* n.s. 32 (1930): 38–43.

Entries: 2 (additional to His and to Koegler, 1907). Millimeters. Inscriptions. Described. Illustrated. Located.

Grafenstein, M. von *(19th cent.)*
[Dus.] p. 54.
Entries: 1 (lithographs only, to 1821). Millimeters. Inscriptions.

Graff, Anton *(1736–1813)*
Muther, Richard. *Anton Graff; ein Beitrag zur Kunstgeschichte des achtzehnten Jahrhunderts.* Beiträge zur Kunstgeschichte, 4. Leipzig: E. A. Seemann, 1881. (MH)
Entries: 3. Millimeters. Inscriptions. States. Described. Also, catalogue of paintings; prints after are mentioned where extant.

Graham, George *(fl. 1788–1813)*
[Sm.] II, pp. 528–529, and "additions and corrections" section.
Entries: 5 (portraits only). Inches. Inscriptions. States. Described.

[St.] pp. 196–199.*

[F.] p. 120.*

[Ru.] pp. 114–115.
Additional information to [Sm.].

Grale, Conrad *(d. 1630)*
[B.] IX, p. 399.
Entries: 1. Pre-metric. Inscriptions. Described.

Grall, Conrad
See **Grale**

Gramatté, Walter *(1897–1929)*
Eckhardt, Ferdinand. *Das graphische Werk von Walter Gramatté.* Zurich: Amalthea-Verlag, 1932. (NN)
Entries: 241. Millimeters. Inscriptions. States. Described (selection). Illustrated (selection). All prints not illustrated are described.

Granara, Raffaele *(fl. c.1836)*
[Ap.] p. 184.
Entries: 5.*

Grandi, Ferdinando *(19th cent.)*
[Ap.] p. 184.
Entries: 1.*

Grandi, Girolamo *(fl. 1530–1548)*
[P.] VI: *See* **Chiaroscuro Woodcuts**

Grandjean, Jean *(1755–1781)*
[W.] I, p. 612.
Entries: 2.*

Grandmaison, Henri de *(b. 1834)*
[Ber.] VII, p. 201.*

Grandville (Jean Ignace Isidore Gérard)
(1803–1847)
Meixmoron de Dombasle, Ch. de. *J. J. Grandville.* Extract from *Mémoires de l'Académie de Stanislas,* 1893. Nancy (France): Imprimerie Berger-Levrault et Cie., 1894. (EPBN)
Bibliography of books with illustrations by.

[Ber.] VII, pp. 201–222.*

Grandville; das gesamte Werk, Einleitung von Gottfried Sello. Munich: Rogner und Bernhard, 1969.
Entries: unnumbered, pp. 19–1510, prints by and after. Millimeters. Illustrated. Prints for *La Caricature, Le Charivari* and for 3 books are all reproduced: selection of other prints.

Granger, Geneviève *(1877–1967)*
Buriot-Darsiles, H. "Ex-Libris modernes, III: Geneviève Granger-Chanlaine." [*Arch. Ex-lib.*] 36 (1929): 138–144.
Entries: unnumbered, pp. 141–144 (bookplates only, to 1929). Millimeters. Described. Illustrated (selection).

Granges, David des *(c.1611–1675)*
[Hind, *Engl.*] III, pp. 266–267.
Entries: 3. Inches. Inscriptions. Described. Illustrated (selection). Located.

Grant, Francis *(1803–1878)*
[Siltzer] pp. 126–131.
Entries: unnumbered, pp. 130–131, prints after. Inches (selection). Inscriptions. Described (selection). Illustrated (selection).

Granthomme, Jacques *(fl. 1588–1613)*
[RD.] X, pp. 245–270; XI, pp. 108–110.
Entries: 92. Millimeters. Inscriptions. States. Described.

Grass, Barth and Co. *(19th cent.)*
[Dus.] p. 54.
Entries: 4 (lithographs only, to 1821). Paper fold measure. Inscriptions.

Grasset, Eugène Samuel *(1841–1917)*
[Ber.] VII, p. 222.*

Grassi, Josef *(1758–1838)*
[Dus.] p. 55.
Entries: 1 (lithographs only, to 1821). Millimeters. States. Described. Located.

Grateloup family *(18th cent.)*
Andrews, William Loring. *A trio of eighteenth century French engravers of portraits in miniature; Ficquet, Savart, Grateloup.* New York: William Loring Andrews, 1899.
Entries: unnumbered, p. 93. Paper fold measure.

Grateloup, Jean Baptiste de *(1735–1817)*
Faucheux, L.-E. *Catalogue raisonné de toutes les estampes qui forment les oeuvres gravés d'Étienne Ficquet, Pierre Savart, J. B. de Grateloup et J. P. S. de Grateloup.* Paris, Veuve Jules Renouard; Bruxelles, A. Mertens et fils, 1864. 100 copies. (NJP)

Grateloup, Jean Baptiste de (*continued*)

Entries: 9. Millimeters. Inscriptions. States. Described.

Faucheux, L.-E. "Catalogue raisonné de l'oeuvre de J. B. de Grateloup," [*RUA.*] 20 (1865) pp. 5–22.
Entries: 9. Millimeters. Inscriptions. States. Described.

Grateloup, Jean Pierre Silvestre de (*1782–1862*)
Faucheux, L.-E. *Catalogue raisonné de toutes les estampes qui forment les oeuvres gravés d'Étienne Ficquet, Pierre Savart, J. B. de Grateloup et J. P. S. de Grateloup.* Paris, Veuve Jules Renouard; Bruxelles, A. Mertens et fils, 1864. 100 copies. (NJP)
Entries: 16. Millimeters. Inscriptions. States. Described.

Faucheux, L.-E. "Catalogue raisonné de l'oeuvre de J. P. S. de Grateloup," [*RUA.*] 20 (1865) pp. 73–78.
Entries: 16. Millimeters. Inscriptions. States. Described.

[Ber.] VII, p. 223.*

Graumann, Erwin (*b. 1902*)
Städtisches Kunsthaus, Bielefeld. *Erwin Graumann; Malerei und Grafik.* Bielefeld (West Germany), 1966.
Entries: 92 etchings, 11 woodcuts, 2 monotypes. Millimeters. Inscriptions. Illustrated (selection).

Grave, Jan Evert (*1759–1805*)
[W.] I, p. 613.
Entries: 2+.*

Gravelot, Hubert François (*1699–1773*)
[Gon.] II, pp. 7–47.
Entries: 6. Inscriptions. Described (selection). Illustrated (selection). Also, prints after, unnumbered, pp. 32–47. Described (selection).

Oehler, Richard. "Gravelots Werk als Bücherillustrator." *Gutenberg Jb.*, 1927, pp. 105–115.
Bibliography of books with illustrations by.

Graves, Robert (*1798–1873*)
[Ap.] pp. 184–185.
Entries: 13.*

Gravesande, Charles Storm van's
See **Storm van 's-Gravesande**

Greatbach, William (*b. 1802*)
[Ap.] p. 185.
Entries: 3.*

Grebber, Adriaen de (*1576–1661?*)
[W.] I, p. 613.
Entries: 1.*

[H. *Neth.*] VIII, p. 165.
Entries: 2. Illustrated (selection).*

Grebber, Anthony de (*c.1622–1683*)
[W.] I, p. 613.
Entries: 1 print after.*

[H. *Neth.*] VIII, p. 165.
Entries: 1 print after.*

Grebber, Frans Pietersz de (*1573–1649*)
[W.] I, pp. 613–614.
Entries: 1 print after.*

[H. *Neth.*] VIII, p. 165.
Entries: 1 print after.*

Grebber, Pieter Fransz de (*c.1600–c.1655*)
[Rov.] pp. 68–69.
Entries: 4 prints by, 6 doubtful prints. Millimeters. Inscriptions. States. Described. Illustrated. Located.

[W.] I, pp. 614–615.
Entries: 12 prints by, 7 after.*

[H. *Neth.*] VIII, pp. 166–179.
Entries: 19 prints by, 14 after. Illustrated (selection).*

Grébert, Jules *(fl. 1837–1870)*
[Ap.] p. 185.
Entries: 2.*

[Ber.] VII, p. 229.*

Greche, Domenico dalle *(fl. 1543–1558)*
[P.] VI: *See* **Chiaroscuro Woodcuts**

Greco, El [Domenikos Theotokopoulos]
(1541–1614)
Wethey, Harold E. *El Greco and his school.* 2 vols. Princeton (N.J.): Princeton University Press, 1962.
Entries: 4 prints after. Inches. Millimeters. Described. Illustrated. Located. Prints made by Diego de Astor, probably under El Greco's supervision. Bibliography for each entry.

Greco, Michele *(fl. 1553–1604)*
[P.] VI, pp. 166–168.
Entries: 18. Pre-metric (selection). Paper fold measure (selection). Inscriptions. Described.

[Wess.] III, p. 50.
Entries: 3 (additional to [P.]). Millimeters (selection). Paper fold measure (selection).

Green, Benjamin *(c.1736–1800)*
[Sm.] II, pp. 529–531, and "additions and corrections" section.
Entries: 3 (portraits only). Inches. Inscriptions. States. Described.

[Siltzer] p. 352.
Entries: unnumbered, p. 352. Inscriptions.

[Ru.] p. 115.
Additional information to [Sm.].

Green, F. *(fl. c.1797)*
[Sm.] II, p. 531.
Entries: 1 (portraits only). Inches. Inscriptions. Described.

Green, James *(1771–1834)*
[Siltzer] p. 331.
Entries: unnumbered, p. 331, prints after. Inches. Inscriptions.

Green, Rupert *(1768–1804)*
[Sm.] II, pp. 531–532.
Entries: 1 (portraits only). Inches. Inscriptions. Described.

[Ru.] p. 115.
Additional information to [Sm.].

Green, Valentine *(1739–1813)*
[Sm.] II, pp. 532–599, and "additions and corrections" section; IV, "additions and corrections" section.
Entries: 174 (portraits only). Inches. Inscriptions. States. Described. Illustrated (selection). Located (selection).

Whitman, Alfred. *British mezzotinters; Valentine Green.* London: A. H. Bullen, 1902. 520 copies. (MH)
Entries: 325. Inches. Inscriptions. States. Described.

[Siltzer] p. 352.
Entries: unnumbered, p. 352. Inscriptions.

[Ru.] pp. 115–136, 492.
Entries: 9 (portraits only, additional to [Sm.]). Inches (selection). Inscriptions (selection). States. Described (selection). Additional information to [Sm.].

Greenwood, John *(1727–1792)*
[Sm.] II, pp. 599–602.
Entries: 9 (portraits only). Inches. Inscriptions. States. Described. Illustrated (selection).

[W.] I, p. 615.
Entries: 22.*

[Ru.] pp. 136–138.
Entries: 2 (portraits only, additional to [Sm.]). Inches. Inscriptions (selec-

Greenwood, John (*continued*)

tion). Described. Additional informa-
tion to [Sm.].

Weitenkampf, Frank. "John Green-
wood; an American-born artist in
eighteenth century Europe with a list of
his etchings and mezzotints." *Bulletin of
the New York Public Library* 31 (1927):
623–634. Separately published. New
York: New York Public Library, 1927.
Entries: 38. Inches. Inscriptions.
States. Described. Located. Ms. addi-
tion (MBMu); 4 additional entries. Ms
addition (NN); additional informa-
tion, 2 additional entries.

Burroughs, Alan. *John Greenwood in
America 1745–1752; a monograph with
notes and a check list.* Andover (Mass.):
Addison Gallery of American Art, 1943.
500 copies. (MH)
Entries: unnumbered, pp. 74–78. In-
scriptions (selection).

Greeve, S. (*fl. 1797–1811*)
[W.] I, p. 615.
Entries: 1 print after.*

Grégoir, Henry (*1818–1853*)
[H. L.] pp. 413–414.
Entries: 3. Millimeters. Inscriptions.
States. Described.

Greiner, Otto (*1869–1916*)
Vogel, Julius. *Otto Greiners graphische
Arbeiten in Lithographie, Stich und
Radierung; wissenschaftliches Verzeichnis.*
Dresden: Ernst Arnold (Ludwig Gut-
bier), 1917. (NN)
Entries: 112 (to 1916). Millimeters. In-
scriptions. States. Described. Illus-
trated. Appendix lists reproductions
which could be mistaken for prints by.

Grellet, François (*b. 1838*)
[Ber.] VII, p. 229.*

Grenaud, Henri (*1830–1893*)
[Ber.] VII, p. 229.*

Grenier, François (*1793–1867*)
[Ber.] VII, p. 229.*

Grethe, Carlos (*1864–1913*)
Halm, Peter. *Das graphische Werk von
Carlos Grethe.* Schriften der Staatlichen
Kunsthalle Karlsruhe, 2. Karlsruhe
(Germany): Staatliche Kunsthalle
Karlsruhe, 1938.
Entries: 22. Millimeters. Inscriptions.
States. Described.

Greuter, W. [called "Greuter d'Amster-
dam"] (*fl. c.1845*)
[H. L.] pp. 414–416.
Entries: 6. Millimeters. Inscriptions.
Described.

Greux, Amédée Paul (*b. 1836*)
[Ber.] VII, p. 231.*

Greux, Gustave (*1838–1919*)
[Ber.] VII, pp. 229–231.*

Greuze, Jean Baptiste (*1725–1805*)
[Baud.] I, pp. 128–129; errata p. II.
Entries: 2. Millimeters (selection). In-
scriptions. Described.

[Gon.] I, pp. 292–360.
Entries: 1 print by, prints after un-
numbered, pp. 345–360.

Martin, J. Catalogue. In *Jean-Baptiste
Greuze,* by Camille Mauclair. Paris: H.
Piazza, 1905. 525 copies. (MH)
Entries: unnumbered, pp. 105–115,
prints after. Millimeters. Described
(selection).

Martin, Jean. *Oeuvre de J.-B. Greuze;
catalogue raisonné suivi de la liste des gra-
vures exécutées d'après ses ouvrages.* Paris:
G. Rapilly, 1908.
Entries: unnumbered, pp. 105–114,
prints after. Millimeters. Also,

catalogue of paintings; prints after are mentioned where extant.

Grevedon, Henri *(1776–1860)*
[Ber.] VII, pp. 232–238.*

Grevenbroeck, Orazio *(17th cent.)* or Charles Leopold van *(fl. c.1750)*
[W.] I, p. 616.
 Entries: 2 prints after.*

Grévin, Alfred *(1827–1892)*
[Ber.] VII, pp. 238–260.*

Gridley, Enoch C. *(fl. 1803–1818)*
[St.] pp. 199–201.*

[F.] pp. 120–121.*

Grient, Cornelis I Ouboter van der *(b. 1797)*
 [H. L.] pp. 416–417.
 Entries: 3. Millimeters. Inscriptions. Described.

Grient, Cornelis II van der *(19th cent.)*
"Etswerk van C. der Grient C. O. zn." Unpublished ms. (EA)
 Entries: 18. Inscriptions. States. Catalogue of a collection. Complete?

Grieshaber, Helmut A. P. *(b. 1909)*
Boeck, Wilhelm. *Hap Grieshaber.* Pfullingen (West Germany): Verlag Günther Neske, 1959.
 Entries: 314 (woodcuts only, to 1958). Millimeters. Illustrated (selection). Colors of color woodcuts are listed.

Fuerst, Margot. *Hap Grieshaber der Holzschneider.* Stuttgart: Verlag Gerd Hatje, 1964.
 Bibliography of books printed or illustrated by. Millimeters. Described.

Museum für Kunst und Gewerbe, Hamburg [Margot Fuerst, compiler]. *Grieshaber, der Drucker und Holzschneider.* Stuttgart: Verlag Gerd Hatje, 1965.

Entries: 272 (to 1965). Millimeters. Described. Illustrated.

Griffier, Jan I [John] *(1645–1718)*
[Sm.] II, pp. 602–604, and "additions and corrections" section.
 Entries: 11 (portraits only). Inches. Inscriptions. Described. Located (selection).

[W.] I, pp. 616–617.
 Entries: 6.*

[Ru.] pp. 138–139.
 Entries: 1 (portraits only, additional to [Sm.]). Described. Additional information to [Sm.].

[H. *Neth.*] VIII, p. 180.
 Entries: 19 prints by, 7 after.*

Griggs, Frederick Landseer Maur *(1876–1938)*
Alexander, Russell George. *The engraved work of F. L. Griggs, A. R. A., R. E.* Stratford-upon-Avon (England): Shakespeare Head Press, 1928. 325 copies. (MB)
 Entries: 38. Inches. Inscriptions. States. Described.

Dodgson, C. "The latest etchings of F. L. Griggs, R. A." [*PCQ.*] 26 (1939): 264–291.
 Entries: 19 (additional to Alexander). Inches. Inscriptions. States. Illustrated (selection).

Dodgson, Campbell. Catalogue. In *The etched work of F. L. Griggs,* by Harold J. L. Wright. London: Print Collectors' Club, 1941. 400 copies. (MB)
 Entries: 57. Inches. Inscriptions. States. Described. Illustrated (selection). Based on Alexander and on Dodgson 1939.

Comstock, Francis Adams. *A Gothic vision; F. L. Griggs and his work.* Boston (Mass.): Boston Public Library; and Oxford (England): Ashmolean Museum, 1966. 600 copies. (MB)

Griggs, Frederick Landseer Maur (*continued*)

Entries: 57. Inches. Inscriptions. States. Described. Illustrated.

Grimaldi, Alessandro *(c.1630–1663)*
[B.] XIX, pp. 262–263.
Entries: 1. Pre-metric. Inscriptions. Described.

Grimaldi, Giovanni Francesco [called "Bolognese"] *(1606–1680)*
[B.] XIX, pp. 85–117.
Entries: 57. Pre-metric. Inscriptions. States. Described. Copies mentioned.

[Wess.] III, p. 49.
Entries: 1 (additional to [B.]). Millimeters. Inscriptions. Located. Additional information to [B.].

Grimm, Leo *(1889–1916)*
Strohmer, Erich. "Leo Grimm," [GK.] 43 (1920): 13–23. Catalogue: "Die Radierungen Leo Grimms." [MGvK.] 1920: pp. 5–10.
Entries: 45. Millimeters. Inscriptions. States. Described. Illustrated (selection).

Grimm, Ludwig Emil *(1790–1863)*
[A. 1800] V, pp. 117–196.
Entries: 229. Millimeters. Inscriptions. States. Described.

Stoll, Adolf. Catalogue. In *Erinnerungen aus meinem Leben . . . herausgegeben und ergänzt von Adolf Stoll . . . neu durchgesehene und vermehrte Ausgabe,* by Ludwig Emil Grimm. Leipzig: Hesse und Becker, 1913.
Entries: 244. Millimeters. Inscriptions. States. Described.

[Dus.] p. 55.
Entries: 1 (lithographs only, to 1821). Millimeters. Inscriptions. Located.

Preime, Eberhard. "Nachtrage und Zusätze zu dem Stollschen Verzeichnis der Radierungen von L. E. Grimm." [GK.] n.s. 7 (1942/1943): 50–62.
Entries: 5 (additional to Stoll). Millimeters. Inscriptions. States. Described. Illustrated (selection). Additional information to Stoll.

Grimmer, Jacob *(c.1526–1590)*
[W.] I, p. 618.
Entries: 1+ prints by, 1 after.*

[H. *Neth.*] VIII, p. 180.
Entries: 16 prints after.*

Gris, Juan *(1887–1927)*
Kahnweiler, Daniel-Henry. *Juan Gris, sa vie, son oeuvre, ses écrits.* Paris: Gallimard, 1946. English edition. *Juan Gris, his life and work.* New York: Curt Valentin, 1947.
Entries: unnumbered, pp. 294–295.

Kahnweiler, Daniel-Henry. *Juan Gris; sa vie, son oeuvre, ses écrits.* Paris: Gallimand, 1968. German edition. *Juan Gris; Leben und Werk.* Stuttgart: Gerd Hatje, 1968. English edition. *Juan Gris, his life and work.* New York: Harry N. Abrams, 1969.
Entries: 34. Millimeters. Described. Illustrated.

Grobon, François Frédéric *(1815–1901/02)*
[Ber.] VII, p. 260.*

Gröger, Friedrich Karl *(1766–1838)*
[Dus.] pp. 55–57.
Entries: 15 (lithographs only, to 1821). Millimeters. Inscriptions. States. Located.

Groenendyk, J. *(fl. c.1780)*
[W.] I, p. 619.
Entries: 2.*

Groeneveld, Cornelis *(fl. c.1800)*
[W.] I, p. 619.
Entries: 3 prints after.*

Groenewegen, Gerrit *(1754–1826)*
 [W.] I, p. 619.
 Entries: 2+ prints by, 1 after.*

Groenning, Gerard P. [Paludanus?]
(fl. 1560–1590)
 [W.] II, p. 301.
 Entries: 4+ prints by, 2 after.*

Groensveld, Jan *(c.1660–1728)*
 [W.] I, p. 619.
 Entries: 20+.*

 [H. *Neth.*] VIII, pp. 180–181.
 Entries: 68.*

Groiseilliez, Marcelin de *(1837–1880)*
 [Ber.] VII, p. 260.*

Groll, Albert Lorey *(b. 1866)*
 Sherman, Frederic Fairchild. "The etchings of Albert Lorey Groll." *Art in America* 19 (1930–1931): 122–125.
 Entries: 28. Inches.

Groot, Johannes de *(fl. 1752–1776)*
 [W.] I, p. 620.
 Entries: 19.*

Gros, Antoine Jean, baron *(1771–1835)*
 [Ber.] VII, p. 260.*

Grospietsch, Florian *(b. 1789)*
 [Dus.] p. 57.
 Entries: 1 (lithographs only, to 1821).
 Millimeters. Inscriptions. Located.

Gross, Anthony *(b. 1905)*
 Victoria and Albert Museum, London
 [Graham Reynolds]. *The etchings of Anthony Gross.* London, 1968.
 Entries: 226 (to 1968). Illustrated (selection).

Gross, Henning
 See **Monogram HG** [Nagler, *Mon.*] III, no. 962

Gross, P. *(fl. 1800–1825)*
 [Dus.] p. 55.
 Entries: 2 (lithographs only, to 1821).
 Millimeters. Inscriptions. Located.

Grossman, Rudolf *(1882–1941)*
 Staatliche Kunsthalle Karlsruhe. *Rudolf Grossmann; Zeichnungen und Druckgraphik.* Karlsruhe (West Germany), 1963.
 Bibliography of books with illustrations by.

Grosspietsch, ———— *(19th cent.)*
 See **Hoppe, Grosspietsch and Ehrentraut**

Grosz, Georg *(1893–1959)*
 Lang, Lothar. "George Grosz—bibliographie." *Marginalien, Zeitschrift für Buchkunst und Bibliophilie,* no. 30 (July 1968): 1–42.
 Bibliography of books with graphic or written contributions by Grosz, and portfolios of prints.

Groux, Charles de *(1825–1870)*
 [H. L.] pp. 417–421.
 Entries: 7 (etchings only). Millimeters. Inscriptions. States. Described. Also, list of 12 lithographs (titles only).

Groux, Henry Jules Charles Corneille de
(1867–1930)
 Ferniot, Paul. Catalogue. In "Henry de Groux," by Leon Souguenet et al. *La Plume* 11, nos. 239–240 (1–15 April 1899): 193–287.
 Entries: 69 (to 1899?). Millimeters. Illustrated (selection).

Grozer, Joseph *(fl. 1784–1797)*
 [Sm.] II, pp. 604–614, and "additions and corrections" section; IV, "additions and corrections" section.
 Entries: 28 (portraits only). Inches. Inscriptions. States. Described. Located (selection).

Grozer, Joseph (*continued*)

[Siltzer] p. 352.
Entries: unnumbered, p. 352. Inscriptions.

[Ru.] pp. 139–143.
Entries: 2 (portraits only, additional to [Sm.]). Inches. Inscriptions. States. Described. Additional information to [Sm.].

Gruben, Michael (*1805–1852*)
[Merlo] p. 313.*

Gruenwald, Gustavus (*d. 1878*)
[Carey] p. 283.
Entries: 5 (lithographs only). Inches (selection). Inscriptions (selection). Illustrated (selection). Located.

Gruithuisen, Franz (*1774–1852*)
[Dus.] p. 59.
Entries: 2 (lithographs only, to 1821). Millimeters. Inscriptions. Located.

Grundherr, C. S. von (*19th cent.*)
[Dus.] p. 59.
Entries: 1 (lithographs only, to 1821). Millimeters. Inscriptions. Located.

Gruner, Ludwig (*1801–1882*)
[Ap.] pp. 185–187.
Entries: 27.*

Gruson, I. D. (*19th cent.*)
[Dus.] pp. 57–59.
Entries: 21 (lithographs only, to 1821). Millimeters. Inscriptions. Located.

Gruyter, Willem II (*1817–1880*)
[H. L.] p. 422.
Entries: 2. Millimeters. Inscriptions. Described.

Gryef, Adriaen de (*c.1670–1715*)
[W.] I, p. 621.
Entries: 1+ prints after.*

[H. *Neth.*] VIII, p. 181.
Entries: 2 prints after.*

Grypmoed, Geerlig (*1760–1788*)
[W.] I, p. 621.
Entries: 1+.*

Guadagnini, Gaetano (*c.1800–1860*)
[Ap.] p. 187.
Entries: 6.*

Guarana, Jacopo (*1720–1808*)
[Vesme] pp. 484–487.
Entries: 9. Millimeters. Inscriptions. States. Described. Appendix with 2 rejected prints.

Guazzo, Federico (*b. c.1623*)
[Vesme] p. 347.
Entries: 2. Millimeters. Inscriptions. Described.

Gucht, Benjamin van der (*d. 1794*)
[W.] I, p. 621.
Entries: 4 prints after.*

Gucht, Gerard van der (*c.1696–1776*)
[W.] I, p. 621.
Entries: 3+.*

Guckeisen, Jacob (*fl. c.1600*)
[A.] III, pp. 292–302.
Entries: 8+ (prints by Guckeisen, Hans Jacob Ebelmann and Veit Eck). Pre-metric. Inscriptions. States. Described (selection).

[Merlo] pp. 313–314.*

Gudin, Jean Marie (*b. 1782*)
[Ap.] pp. 187–188.
Entries: 8.*

[Ber.] VII, p. 261.*

Gudin, Louis (*1799–1823*)
[Ber.] VII, p. 261.*

Gudin, Théodore *(1802–1880)*
[Ber.] VII, p. 261.*

Gué, Julien Michel *(1789–1843)*
[Ber.] VII, p. 262.*

Günther, Christian August *(1760–1824)*
[Ap.] p. 188.
Entries: 3.*

Günther, Matthaeus *(1705–1788)*
Hämmerle, Albert. "Die Radierungen des Mathaeus Günther." [*Schw. M.*] 1925, 84–87.
Entries: 15 prints by, 1 doubtful print. Millimeters. Inscriptions. States. Described. Located (selection).

Guérard, Amédée *(1824–1908)*
[Ber.] VII, p. 262.*

Guérard, Charles François
See **Guérard,** Eugène

Guérard, Eugène [Charles François]
(1821–1866)
[Ber.] VII, p. 262.*
[Ber.] describes 2 artists, Charles François and Eugène, actually the same person.

Meixmoron de Dombasle, Charles de. "Eugène Guérard." *Revue lorraine illustrée* 2 (1907): 41–64.
Entries: unnumbered, pp. 61–64. Millimeters.

Guérard, Henri *(1846–1897)*
[Ber.] VII, pp. 262–273.
Entries: 602.

Guercino [Giovanni Francesco Barbieri]
(1591–1666)
[B.] XVIII, pp. 361–365.
Entries: 2 prints by, 3 doubtful prints. Pre-metric. Inscriptions. Described.

[P.] VI: *See* **Chiaroscuro Woodcuts**

[M.] III, pp. 1–9.
Entries: 2+ prints by, 3+ doubtful prints, 111+ prints after. Paper fold measure. Inscriptions (selection).

Guérin, Christophe *(1758–1830)*
[Ap.] p. 188.
Entries: 7.*

[Ber.] VIII, p. 5.*

Guérin, Pierre Narcisse *(1774–1833)*
[Ber.] VIII, p. 6.*

Guerolt du Pas, J. P. *(fl. c.1710)*
Dally, Ph. "Oeuvre de Gueroult du Pas." Unpublished ms., 1913. (EPBN)
Entries: 20+. Millimeters. Inscriptions. Described.

Guerreschi, Giuseppe *(b. 1929)*
Crispolti, Enrico. *Le aqueforti di Guerreschi, 1952–1966.* Milan: Lerici Editori, 1967. (NNMM)
Entries: 79 (to 1966). Millimeters. Inscriptions. States. Described. Illustrated.

Guerrieri, Giovanni Francesco
(1589–1655/9)
[Vesme] pp. 6–7.
Entries: 2. Millimeters. Inscriptions. Described. Located (selection). Appendix with 1 doubtful print.

Guersant, E. *(18th cent.)*
[L. D.] p. 29.
Entries: 1. Millimeters. Inscriptions. States. Described. Incomplete catalogue.*

Guesdon, Alfred *(1808–1876)*
[Ber.] VIII, p. 6.*

Guesnu, [Marie] Hilaire *(1802–1868?)*
[Ber.] VIII, pp. 6–7.*

Guest, H. *(19th cent.)*
[Siltzer] p. 352.
 Entries: unnumbered, p. 352. Inscriptions.

Guiard, Laurent *(1723–1788)*
Roserot, Alphonse. "Laurent Guiard, premier sculpteur du Duc de Parme (1723–1788)." [*Réunion Soc. B. A. Dép.*] 38th session, 1914, pp. 368–397.
 Entries: 2 prints after. Millimeters. Inscriptions. Described.

Guiaud, Jacques *(1811–1876)*
[Ber.] VIII, p. 7.*

Guichard, E. *(19th cent.)*
[Ber.] VIII, p. 7.*

Guidetti, Niccolò *(19th cent.)*
[Ap.] p. 189.
 Entries: 5.*

Guidi, Giovanni Citosibio *(fl. 1626–1635)*
[B.] XXI, pp. 3–5.
 Entries: 2. Pre-metric. Inscriptions. Described.

Guidobono, Bartolommeo *(1657–1709)*
[Vesme] p. 349.
 Entries: 1. Millimeters. Inscriptions. Described. Located.

Guignet, Adrien *(1816–1854)*
Bulliot, J. G. *Le peintre Adrien Guignet; sa vie et son oeuvre.* Extract from *Mémoires de la Société Éduenne,* n.s. 7, 8. Autun (France): Imprimerie Dejussieu Père et Fils, 1878. (EPBN)
 Entries: 34 prints after. Millimeters. Inscriptions.

Guigon, Charles Louis *(1807–1882)*
[Ber.] VIII, p. 7.*

Guigou, Paul Camille *(1834–1871)*
[Ber.] VIII, p. 8.*

Guilbaut, —— *(fl. 1830–1850)*
[Ber.] VIII, p. 8.*

Guillaume, —— *(19th cent.)*
[Ber.] VIII, p. 8.*

Guillaumet, Gustave *(1840–1887)*
[Ber.] VIII, pp. 8–9.
 Entries: 11. Millimeters. Inscriptions. Described.

Guillaumin, [Jean Baptiste] Armand *(1841–1927)*
[Ber.] VIII, p. 9.*

Guillaumot, Auguste Alexandre *(1815–1892)*
[Ber.] VIII, pp. 9–10.*

Guillaumot, [Auguste] Étienne *(d. 1890)*
[Ber.] VIII, p. 10.*

Guillaumot, Louis Étienne *(fl. 1855–1869)*
[Ber.] VIII, p. 10.*

Guillemin, Émile Marie Auguste *(fl. 1848–1870)*
[Ber.] VIII, p. 11.*

Guillemot, —— *(19th cent.)*
[Ber.] VIII, p. 11.*

Guillet, Aristide *(fl. c.1857)*
[Ber.] VIII, p. 11.*

Guillier, Émile Antoine *(fl. 1870–1882)*
[Ber.] VIII, p. 11.*

Guillon, —— *(19th cent.)*
[Ber.] VIII, p. 11.*

Guillon, Pierre Ernest *(19th cent.)*
[Ber.] VIII, p. 11.*

Guldenmund, Hans *(d. 1560)*
[B.] IX, pp. 150–151.
 Entries: 1. Pre-metric. Inscriptions. Described.

[Heller] pp. 55–63.
 Entries: 33 (additional to [B.]). Pre-metric. Inscriptions. Described.

[P.] III, p. 247–251.
Entries: 38 (additional to [B.]). Pre-metric. Inscriptions. Described.

Gullby, Folke *(20th cent.)*
Boethius, Sten. *Folke Gullby.* Svenska Mästargrafiker, 3. Stockholm: Folket i Bilds Konstklubb, 1955. (DLC)
Entries: 186 (to 1955). Millimeters. Illustrated (selection).

Möller, Svenfredrik. *Beskrivande förteckning över Folke Gullbys grafiska Verk.* Örebro (Sweden): Ludvig Larsson Boktryckeri, 1951–1960. 100 copies. (NN)
Entries: 196. Millimeters. Inscriptions. States. Described. Illustrated (selection).

Gunst, Pieter Stevens van *(1659–1724?)*
[W.] I, pp. 622–623.
Entries: 60+.*

Gusman, Adolphe *(1811–1905)*
[Ber.] VIII, p. 11.*

Gusman, Pierre *(b. 1862)*
Angoulvent, P. J. "Pierre Gusman, peintre-graveur et historien d'art." *Byblis* 2 (1923): 85–90, 4 pp. unpaginated following p. 120.
Entries: 118 woodcuts, 27 etchings and engravings; reproductive prints and clichés-verres, unnumbered (to 1923). Millimeters.

Gutbier, Christoph *(1766–1840)*
[Dus.] p. 59.
Entries: 1 (lithographs only, to 1821). Millimeters. Inscriptions. Located.

Guttenberg, Carl Gottfried *(1743–1790)*
Verein nürnbergischer Künstler und Kunstfreunde. *Die nürnburgischen Künstler, geschildert nach ihrem Leben und ihren Werken . . . II Heft; Carl Guttenberg und Heinrich Guttenberg, Kupferstecher.* Nuremberg: Joh. Leonh. Schrag, 1823. (EBKk)

Entries: 79 prints by, 2 prints not seen by the compilers. Pre-metric. Inscriptions. States. Described.

[L. D.] p. 29.
Entries: 1. Millimeters. Inscriptions. States. Illustrated. Incomplete catalogue.*

Guttenberg, Heinrich *(1749–1818)*
Verein nürnburgischer Künstler und Kunstfreunde. *Die nürmburgischen Künstler, geschildert nach ihrem Leben und ihren Werken . . . II Heft; Carl Guttenberg und Heinrich Guttenberg, Kupferstecher.* Nuremberg: Joh. Leonh. Schrag, 1823. (EBKk)
Entries: 179 prints by, 1 print partly by. Pre-metric. Inscriptions. States. Described.

[Ap.] pp. 189–190.
Entries: 17.*

[Ber.] VIII, p. 12.*

[L. D.] p. 30.
Entries: 4. Millimeters. Inscriptions. States. Described. Illustrated. Incomplete catalogue.*

Guy, [Jean Baptiste] Louis *(1824–1888)*
[Ber.] VIII, p. 12.*

Guyard, Jean Baptiste *(b. 1787)*
[Ber.] VIII, p. 12.*

Guyot, ——— *(fl. c.1830)*
[Ber.] VIII, p. 12.*

Guyot, Laurent *(1756–c.1808)*
[Ber.] VIII, p. 12.*

Guzzi, Giuseppe *(fl. c.1840)*
[Ap.] p. 190.
Entries: 1.*

Gwynn, W. *(19th cent.)*
[Siltzer] p. 331.
Entries: unnumbered, p. 331, prints after. Inscriptions.

H

Haach, —— *(19th cent.)*
[Dus.] pp. 59–60.
 Entries: 1 (lithographs only, to 1821).
 Millimeters. Inscriptions. Located.

Haach, Ludwig *(1813–1842)*
[A. 1800] I, pp. 44–59.
 Entries: 8 etchings, 2 lithographs. Millimeters. Inscriptions. States. Described.

Andresen, Andreas. "Andresens Nachträge zu seinen 'Deutschen Malerradierern.' " [MGvK.] 1907, p. 40.
 Additional information to [A. 1800].

Haag, Tethart Philip Christian *(1737–1812)*
[W.] I, p. 625.
 Entries: 2 prints by, 1 after.*

Haanen, Remigius Adrianus *(1812–1894)*
[H. L.] pp. 428–429.
 Entries: 2. Millimeters. Inscriptions. Described.

Haas, Georg
See **Has**

Haas, [Johann] Meno *(1752–1833)*
[Ap.] pp. 190–191.
 Entries: 7.*

Haasbroek, Geraerd *(fl. 1775–1784)*
[W.] I, p. 626.
 Entries: 1 print after.*

Haastert, Izaak van *(1753–1834)*
[W.] I, p. 627.
 Entries: 2+ prints after.*

Habelmann, Paul Sigmund *(1823–1890)*
[Ap.] p. 191.
 Entries: 6.*

Habenschaden, Sebastian *(1813–1868)*
[A. 1800] III, pp. 193–202.
 Entries: 15. Pre-metric. Inscriptions. States. Described.

Haberbusch, Theodor *(19th cent.)*
[Dus.] p. 60.
 Entries: 1 (lithographs only, to 1821).
 Millimeters. Located.

Habert-Dys, Jules Auguste *(b. 1850)*
[Ber.] VIII, pp. 12–13.*

Hablitschek, Franz *(1824–1867)*
[Ap.] p. 191.
 Entries: 1.*

Hackaert, Jan *(1629–1700)*
[B.] IV, pp. 287–294.
 Entries: 6. Pre-metric. Inscriptions. Described.

[Weigel] p. 201.
 Entries: 1 (additional to [B.]). Pre-metric. Described.

[Dut.] V, pp. 1–4.
 Entries: 7. Millimeters. Inscriptions. States. Described.

[W.] I, p. 628.
 Entries: 7 prints by, 5 after.*

[H. *Neth.*] VIII, pp. 182–184.
 Entries: 7 prints by, 7 after. Illustrated (selection).*

Hacker, Edward *(1813–1905)*
[Siltzer] p. 352.
 Entries: unnumbered, p. 352. Inscriptions.

Hackert, [Jacob] Philipp *(1737–1807)*
[Siltzer] p. 331.
 Entries: unnumbered, p. 331, prints after. Inches. Inscriptions.

Hackius, Johannes *(d. 1659)*
[W.] I, p. 628.
 Entries: 1.*

Hackhausen, Johann Jacob *(19th cent.)*
[Merlo] p. 319.*

Haden, Francis Seymour *(1818–1910)*
Burty, Philippe: "L'Oeuvre de M. Francis Seymour-Haden." [*GBA.*] 1st ser. 17 (1864): 271–287, 356–366.
 Entries: 54 (to 1864). Millimeters. Inscriptions. States. Described.

Drake, Sir William. *A descriptive catalogue of the etched work of Francis Seymour Haden.* London: Macmillan and Co., 1880.
 Entries: 185 (to 1879). Inches. Inscriptions. States. Described. Ms. copy (CSfAc) with notes by Haden; additional information.

[Ber.] VIII, pp. 13–56.
 Entries: 199. Paper fold measure.

Museum of Fine Arts, Boston. *Catalogue of a collection of etchings, dry-points and mezzotints by Francis Seymour Haden, formerly the private property of the artist.* Boston (Mass.), 1896.
Additional information to Drake.

Harrington, H. Nazeby. *A supplement to Sir William Drake's catalogue of the etched work of Sir Francis Seymour Haden, P.R.E.* London: Macmillan and Co., 1903.
 Entries: 56 (additional to Drake). Inches. Inscriptions. States. Described.

Harrington, H. Nazeby. *The engraved work of Sir Francis Seymour Haden, P.R.E., an illustrated and descriptive catalogue.* Liverpool (England): Henry Young and Sons, 1910. 225 copies.
 Entries: 251. Inches. Inscriptions. States. Described. Illustrated. Ms. notes (NN, NNMM, ECol); additional information.

Dodgson, Campbell. "Etchings by Seymour Haden (undescribed states)." [*Burl. M.*] 19 (1911): 325–326.
 Additional information to Harrington.

Salaman, Malcolm C. *The etchings of Sir Francis Seymour Haden, P.R.E.* London: Halton and Truscott Smith, Ltd., 1923.
 Entries: 251. Inches. Illustrated (selection). Based on Harrington. One woodcut, unknown to Harrington, is mentioned but not illustrated.

Hadol, Paul *(d. 1875)*
[Ber.] VIII, p. 56.*

Haecht, Godefried *(16th cent.)* and Willem I van *(c.1530–after 1552)*
[H. *Neth.*] VIII, p. 185.
 Entries: 1 print published by.*

Haecht, Tobias van
See **Verhaecht**

Haecht, Willem I van *(c.1530–after 1552)*
[W.] I, p. 628.
 Entries: 4+.*

[H. *Neth.*] VIII, p. 185.
 Entries: 4+.*

Haecht, Willem II van *(1593–1637)*
[W.] I, p. 628.
 Entries: 7.*

[H. *Neth.*] VIII, p. 185.
 Entries: 8.*

Haecken, Alexander van *(1701?–1758)*
[Sm.] III, pp. 1407–1415, and "additions and corrections" section.
 Entries: 24 (portraits only). Inches. Inscriptions. States. Described. Illustrated (selection). Located (selection).

[W.] I, p. 628.
 Entries: 16.*

[Ru.] pp. 334–335.
 Entries: 1 (portraits only, additional to [Sm.]). Inches. Inscriptions. Described. Additional information to [Sm.].

Haeften, Nicholas Walraven van *(c.1663–1715)*
[B.] V, pp. 443–450.
 Entries: 9. Pre-metric. Inscriptions. Described.

[Weigel] pp. 321–330.
 Entries: 30 (additional to [B.]). Pre-metric. Inscriptions. States. Described.

[Heller] pp. 63–64.
 Entries: 2 (additional to [B.]) Pre-metric. Inscriptions. Described.

[Wess.] II, p. 237.
 Entries: 3 (additional to [B.] and [Weigel]). Millimeters (selection). Inscriptions (selection). Described (selection). Additional information to [B.] and [Weigel].

[Dut.] V, pp. 4–15, 593.
 Entries: 42. Millimeters. Inscriptions. States. Described.

[W.] I, pp. 631–632.
 Entries: 46+ prints by, 5+ after.*

[H. *Neth.*] VIII, pp. 186–196.
 Entries: 53 prints by, 6 after. Illustrated (selection).*

Hägg, Axel Herman
See **Haig**

Haelbeck, Jan van *(c.1600–c.1630)*
[W.] I, p. 629.
 Entries: 3.*

[H. *Neth.*] VIII, p. 197.
 Entries: 122. Illustrated (selection).*

Haelwegh, Adriaen *(1637–c.1696)*
[W.] I, p. 629.
 Entries: 7.*

[H. *Neth.*] VIII, p. 197.
 Entries: 37.*

Haelwegh, Albert van *(c.1600–1673)*
[W.] I, p. 629.
 Entries: 15.*

Sthyr, Jörgen. "Kobberstikkeren Albert Haelwegh." *Kunstmuseets Aarsskrift* 25 (1938): 5–69.
 Entries: 286. Millimeters. Inscriptions. Described (selection). Illustrated (selection).

[H. *Neth.*] VIII, pp. 198–205.
 Entries: 148+. Illustrated (selection).*

Sthyr, Jørgen. *Kobberstikkeren Albert Haelwegh.* Copenhagen: Gyldendal, 1965.
 Entries: 286. Millimeters. Inscriptions. Illustrated.

Haen, Abraham II de *(1707–1748)*
[W.] I, p. 629.
 Entries: 3.*

Haen, Anthony de *(1640–c.1675)*
[Rov.] p. 69.
 Entries: 1. Illustrated. Located.

[W.] I, p. 629; III, p. 97.
 Entries: 2.*

[H. *Neth.*] VIII, p. 206.
 Entries: 2. Illustrated.*

Haen, Willem de *(17th cent.)*
[Merlo] pp. 319–320.*

[W.] I, p. 630.
Entries: 7.*

[H. *Neth*.] VIII, p. 208.
Entries: 27.*

Haensbergen, Jan van *(1642–1705)*
[W.] I, p. 630.
Entries: 2.*

[H. *Neth*.] VIII, p. 209.
Entries: 6.*

Haer, Anthony van der *(d. c.1783)*
[W.] I, p. 631.
Entries: 9+.*

Haerpin, ——
See **Herpin**

Haert, Hendrik Anna Victoria van der
(1790–1846)
[H. L.] pp. 429–433.
Entries: 11. Millimeters. Inscriptions.
Described.

Haestar, Leendert van *(d. 1675)*
[H. *Neth*.] VIII, p. 209.
Entries: 1 print after.*

Haetsch, C. W. *(19th cent.)*
[Dus.] p. 60.
Entries: 2 (lithographs only, to 1821).
Millimeters. Inscriptions. Located.

Häublin, Nicolaus
See **Werd,** N. van

Haeyler, J. *(fl. 1570)*
[W.] I, p. 631.
Entries: 2.*

[H. *Neth*.] VIII, p. 209.
Entries: 14.*

Hafner, Josef *(1799–1891)*
Giordani, Else. *Die Linzer Hafner Offizin.*
Linz (Austria): Kulturverwaltung der
Stadt Linz, 1962.

Entries: unnumbered, pp. 69–250,
prints published by. Millimeters. In-
scriptions. Described. Illustrated
(selection). Located.

Hafner, Melchior II *(fl. 1670–1689)*
[Merlo] p. 320.*

Hagen, Christiaen van der *(c.1635–c.1680)*
[W.] I, p. 632.
Entries: 16+.*

[H. *Neth*.] VIII, pp. 210–211.
Entries: 25+.*

Hagen, Cornelis van der *(1651–1690)*
[W.] I, p. 633.
Entries: 1 print after.*

Hagen, Johan C. van der *(c.1676–1745)*
[H. *Neth*.] VIII, p. 211.
Entries: 1 print after.*

Hagen, Joris van der *(c.1615–1669)*
[W.] I, p. 633.
Entries: 1 print after.*

[H. *Neth*.] VIII, p. 212.
Entries: 3. Illustrated (selection).*

Haghe, Louis *(1806–1885)*
[Ber.] VIII, p. 57.*

Hahn, H. *(20th cent.)*
[Sch.] p. 49ff.
Not seen.

Haid, John Gottfried *(1730–1776)*
[Sm.] II, pp. 614–617, and "additions
and corrections" section.
Entries: 10 (portraits only). Inches. In-
scriptions. States. Described.

[Ru.] pp. 143–144.
Additional information to [Sm.].

Haig, Axel Hermann *(1835–1921)*
[Ber.] VIII, p. 57.*

Haig, Axel Hermann (*continued*)

Armstrong, E. A. *Axel Herman Haig and his work.* London: Fine Art Society, 1905. Entries: 160. Inches. Described. Illustrated (selection). Ms. addition (NN); additional information, 26 additional entries.

Hailer, Daniel I (*d. c.1630*)
Hämmerle, Albert. "Daniel Hailler." [*Schw. M.*] 1931, pp. 42–47. Entries: 6. Millimeters. Inscriptions. Described. Illustrated. Located. Copies mentioned.

Haines, D. (*19th cent.*)
[F.] p. 121.*

Haines, William (*1778–1848*)
[St.] pp. 201–206.*

[F.] pp. 121–123.*

Haizmann, Richard (*20th cent.*)
Richard Haizmann, Wandlung des Geistes; Holzschnitte 1950–1962. Hamburg: Verlag Hans Christians, [1962?]. Entries: 32 single prints, 11 sets of prints (woodcuts only, to 1962). Millimeters. Illustrated.

Halberstadt, —— (*19th cent.*)
[Dus.] p. 60. Entries: 1 (lithographs only, to 1821). Located.

Halbou, Louis Michel (*1730–1809*)
[L. D.] p. 31. Entries: 3. Millimeters. Inscriptions. States. Described. Incomplete catalogue.*

Haldenwang, Christian (*1824–1867*)
[Ap.] pp. 191–192. Entries: 7.*

[Ber.] VIII, p. 57.*

Halen, Arnoud van (*c.1650–1732*)
[W.] I, p. 634. Entries: 14.*

[H. *Neth.*] VIII, p. 213. Entries: 16+.*

Hall, Frederick Garrison (*b. 1879*)
Rihani, Ameen. "The etchings of Frederick Garrison Hall." [*P. Conn.*] 1 (1921): 218–235. Entries: 16 (to 1921). Illustrated (selection).

Hall, Harry (*fl. 1838–1882*)
[Siltzer] pp. 131–133. Entries: unnumbered, pp. 131–133, prints after. Inches (selection). Inscriptions.

Hall, Ralph (*fl. c.1635*)
[Hind, *Engl.*] III, p. 263. Entries: 1+. Inches. Inscriptions. Described. Located.

Hallbrock, Jo. (*fl. c.1620*)
[Hind, *Engl.*] II, p. 308. Entries: 1. Inches. Inscriptions. States. Described. Illustrated. Located.

Halle, Christen (*20th cent.*)
Schyberg, Thor Bjørn: "Christen Halle." [*N. ExT.*] 11 (1959): 81–84. Entries: 49 (bookplates only, to 1959?). Illustrated (selection).

Hallé, Claude Guy (*1652–1736*)
Estournet, O. "La famille des Hallé." [*Réunion Soc. B. A. dép.*] 29th session, 1905, pp. 107–150. Entries: 145 (works in various media, including prints by and after). Millimeters. Inscriptions (selection). Described (selection). Located (selection).

Hallé, Daniel (*1614–1675*)
Estournet, O. "La famille des Hallé," [*Réunion Soc. B. A. dép.*] 29th session, 1905, pp. 86–107.

Entries: 39 (works in various media, including prints by and after). Millimeters. Described. Located.

Hallé, Noël *(1711–1781)*
[Baud.] I, pp. 14–24.
Entries: 9. Millimeters. Inscriptions. States. Described.

Estournet, O. "La famille des Hallé." [*Réunion Soc. B. A. dép.*] 29th session, 1905, pp. 150–226.
Entries: 15 prints by. Millimeters (selection). Inscriptions (selection). Described (selection). Also, catalogue of 178 works in various media, including prints after.

Haller von Hallerstein, Christoph Jakob Wilhelm Carl Joachim, Freiherr *(1771–1839)*
Ms. catalogue. (EBKk)
Entries: 168. Inscriptions (selection). Described (selection).

[A. 1800] III, pp. 268–332.
Entries: 189. Pre-metric. Inscriptions. States. Described.

[Dus.] pp. 60–61.
Entries: 6 (lithographs only, to 1821). Millimeters (selection). Paper fold measure (selection). Inscriptions. Described. Located (selection).

Hallet, Gilles *(1620–1694)*
[W.] I, p. 635.
Entries: 1 print after.*

[H. *Neth.*] VIII, p. 213.
Entries: 1 print after.*

Hallirsch, A. *(19th cent.)*
[Merlo] p. 322.*

Halm, Peter *(1854–1923)*
Roeper, Adalbert. "Peter Halm und sein graphisches Werk." Bb. 76 (1909): 7685–7690, 7729–7733.
Entries: 209 (to 1909). Millimeters. States.

Roeper, Adalbert. [*Kh.*] 6 (1914): 134ff., 158ff., 172ff.
Not seen.

Luthardt, Ernst. "Katalog der Sammlung graphischer Arbeiten von Peter Halm im Besitze des Herrn Oberregierungsrats Ernst Luthardt." Ms., c.1929. (xerox copy, EMSGS)
Entries: 283. Millimeters. States (selection). Described. Catalogue of a collection; complete? Different states of the same print are separately numbered.

Halneren, Johann
See **Halver**

Hals, Dirk *(1591–1656)*
[W.] I, p. 636.
Entries: 1 print by, 4+ after.*

[H. *Neth.*] VIII, p. 214.
Entries: 33 prints after.*

Hals, Frans *(c.1580–1666)*
[W.] I, pp. 640–641.
Entries: 62 prints after.*

[H. *Neth.*] VIII, pp. 215–218.
Entries: 108 prints after.*

Hals, Jan Fransz *(c.1620–1674)*
[W.] I, p. 642.
Entries: 1 print after.*

[H. *Neth.*] VIII, p. 214.
Entries: 1 print after.*

Halver, Johann *(fl. c.1599)*
[P.] IV, p. 136.
Entries: 1+. Paper fold measure. Inscriptions. Located.

Hamel, Victor *(1832–1895)*
[Ber.] VIII, pp. 57–58.
Entries: 21.

Hamer, Stefan *(fl. 1534–1554)*
[B.] IX, pp. 151–152.

Hamer, Stefan (*continued*)

Entries: 2. Pre-metric. Inscriptions. Described.

Hamersvelt, Evert Symonsz *(1591–1648)*
[H. *Neth.*] VIII, p. 219.
Entries: 40.*

Hamilton, Richard *(b. 1922)*
Onnasch Galerie, Berlin. *Richard Hamilton.* Berlin, 1970.
Entries: 20 (to 1969?) Inches. Millimeters. Illustrated.

Stedelijk Museum, Amsterdam.
Catalogus van de prenten en multiples van Richard Hamilton / Catalogue of the prints and multiples by Richard Hamilton; Tentoonstelling ter gelegenheid van de toekenning van de Talensprijs Internationaal 1970 / Exhibition in connection with the award of the Talens Prize International 1970.
Amsterdam, 1971.
Entries: 35 (to 1970?) Millimeters. Described. Illustrated.

Whitworth Art Gallery, Manchester [Richard Hamilton, compiler]. *Richard Hamilton; prints, multiples and drawings.* Manchester (England), 1972.
Entries: 37 (to 1971). Millimeters. Described. Illustrated.

Hamilton, William *(1751–1801)*
[Siltzer] p. 331.
Entries: unnumbered, p. 331, prints after. Inscriptions.

Hamlin, William *(1772–1869)*
[St.] pp. 206–211.*

[F.] p. 123.*

Lane, Gladys R. ''Rhode Island's earliest engraver.'' *Antiques* 7 (1925): 133–137.
Entries: 45. Inches. Inscriptions. States. Described. Illustrated (selection). Located. Different states of the same print are separately numbered.

Hamm, Phineas E. *(fl. 1822–1845)*
[St.] pp. 211–212.*

[F.] pp. 123–125.*

Hamman, Édouard *(1819–1888)*
[H. L.] pp. 433–436.
Entries: 7. Millimeters. Inscriptions. States. Described.

Hammel, —— *(19th cent.)*
[Dus.] p. 61.
Entries: 1 (lithographs only, to 1821). Inscriptions.

Hammer, Christian Gottlob *(1779–1864)*
[Dus.] p. 61.
Entries: 2 (lithographs only, to 1821). Millimeters, Inscriptions. Located (selection).

[Ap.] p. 192.
Entries: 3.*

Hammer, Wolf *(fl. 1475–1500)*
See **Monogram WH** [Nagler, *Mon.*] V, no. 1699

Hampe, Karl Friedrich *(1772–1848)*
[Dus.] pp. 61–62.
Entries: 8 (lithographs only, to 1821). Millimeters (selection). Paper fold measure (selection). Inscriptions (selection). Located (selection).

Hampfelmeyer, Georg *(fl. 1822–1826)*
[Ap.] p. 192.
Entries: 1.*

Hancock, Charles *(fl. 1819–1868)*
[Siltzer] pp. 133–134.
Entries: unnumbered, pp. 133–134, prints after. Inches (selection). Inscriptions. States.

Hancock, Robert *(1730–1817)*
[Sm.] II, pp. 617–619, and ''additions and corrections'' section.

Entries: 7 (portraits only). Inches. Inscriptions. States. Described. Located (selection).

Ballantyne, A. Randall. *Robert Hancock and his works.* London: Chiswick Press, 1885. 150 copies. (NNMM)
Entries: 53 (portraits only). Inscriptions. States. Described. Illustrated (selection).

[Ru.] pp. 144–145.
Additional information to [Sm.].

Cook, Cyril. *The life and work of Robert Hancock.* London: Chapman and Hall, 1948. (MH)
Entries: 120 (prints used for transfer to china only). Described. Illustrated. Located. "Minor work" is omitted.

Handasyde, Charles *(fl. 1760–1780)*
[Sm.] II, p. 619, and "additions and corrections" section.
Entries: 3 (portraits only). Inches. Described.

[Ru.] p. 145.
Entries: 1 (portraits only, additional to [Sm.]). Inches. Described. Additional information to [Sm.].

Hands, T. *(19th cent.)*
[Siltzer] p. 331.
Entries: unnumbered, p. 331, prints after. Inches. Inscriptions.

Hannas, Marc Anton *(d. 1676)*
[B.] IX, pp. 560–561.
Entries: 2. Pre-metric. Inscriptions. Described.

[P.] IV, pp. 253–257.
Entries: 4 engravings, 27 woodcuts (additional to [B.]). Pre-metric. Inscriptions. Described. Located (selection).

[Wess.] I, p. 137.
Entries: 4 (additional to [B.] and [P.]). Millimeters. Inscriptions. Described.

Hanneman, Adriaen *(1601–1671)*
[W.] I, p. 647.
Entries: 4 prints after.*

[H. *Neth.*] VIII, p. 219.
Entries: 10 prints after.*

Hanriot, Jules *(1853–after 1921)*
[Ber.] VIII, p. 58.*

Hansen, Carel Lodewijk *(1765–1840)*
[H. L.] pp. 436–439.
Entries: 18. Millimeters. Inscriptions. States. Described (selection).

[W.] I, p. 648.
Entries: 1+.*

Hansen, Erling *(20th cent.)*
Fogedgaard, Helmer. "Erling Hansens exlibris." [*N. ExT.*] 1 (1946–1947): 69–70.
Entries: 7 (bookplates only, to 1947). Described. Illustrated (selection).

Hansen, Hans Nikolaj *(1853–1923)*
Hansen, Ella H. N., and Hjejle, Bernt Hansen. *Hans Nikolaj Hansen og hans raderinger udgivet af den danske radeerforening.* Copenhagen: Egmont H. Petersens Kgl. Hofbogtrykkeri, 1931.
Entries: 150 etchings, 8 lithographs. Millimeters. Inscriptions. States. Illustrated (selection).

Hansen, Sophus *(b. 1871)*
[Sch.] p. 57ff.
Not seen.

Hansen-Bahia, K. *(20th cent.)*
Kothé, Peter. *Hansen-Bahia, Holzschnitte aus 25 Jahren.* Hamburg: Hans Christians Verlag, [1971?].
Entries: 263+ (to 1970). Millimeters. Illustrated (selection). Complete?

Happel, Friedrich *(1825–1854)*
[A. 1800] V, pp. 197–200.
Entries: 2. Millimeters. Inscriptions. Described. Also, list of 3+ prints after (not fully catalogued).

Hardenberg, J. *(19th cent.)*
[H. L.] p. 443.
Entries: 2. Millimeters. Inscriptions.
States. Described.

Hardenbergh, Cornelis van *(1755–1843)*
[W.] I, p. 648.
Entries: 1+.*

Hardie, Martin *(1875–1952)*
The etched work of Martin Hardie with an appreciation by Sir Frederick Wedmore, R.E. (Hon.) and a note by Sir Frank Short R.A.
n.p., n.d.
Entries: 32 (to 1913). Inches. Illustrated.

Laver, James. "The etchings and drypoints of Martin Hardie." [PCQ.] 24 (1937): 121–143. "Catalogue of the etchings and drypoints of Martin Hardie, C.B.E., R.E." [PCQ] 25 (1938): 80–98, 217–234.
Entries: 164 (to 1938). Inches. Millimeters. Inscriptions. States (selection). Illustrated (selection).

Hardie, Martin. "A catalogue of the etchings and dry-points of Martin Hardie, C.B.E., R.E., R.S.W., 1875–1952, photographed by permission from the original manuscript catalogue compiled by the artist in the possession of his family." (photocopy, ECol)
Entries: 189. Inches. Millimeters. Inscriptions. Illustrated (with sketches of the prints).

Harding, James Duffield *(1798–1863)*
[Ber.] VIII, p. 58.*

Hardiviller, Charles Achille d' *(fl. c.1830)*
[Ber.] VIII, pp. 59–60.*

Hardivillier, —— *(fl. c.1830)*
[Ber.] VIII, p. 60.*
Perhaps identical with Charles Achille d'Hardiviller (see above).

Hardorff, Gerdt I *(1769–1864)*
[Dus.] pp. 63–64.
Entries: 6 (lithographs only, to 1821). Millimeters. (selection). Inscriptions (selection). Located (selection).

Hardy, Thomas *(fl. 1778–1798)*
[Sm.] II, pp. 619–622, and "additions and corrections" section.
Entries: 8 (portraits only). Inches. Inscriptions. States. Described.

[Ru.] pp. 145–146.
Entries: 1 (portraits only, additional to [Sm.]). Inches. Inscriptions. Described. Additional information to [Sm.].

Hari, Johannes I *(1772–1849)*
[W.] I, p. 649.
Entries: 1.*

Harings, Mathys *(c.1580–c.1636)*
[W.] I, p. 649.
Entries: 3 prints after.*

[H. *Neth.*] VIII, p. 220.
Entries: 2 prints after.*

Harleston, —— *(18th cent.)*
[L. D.] pp. 31–32.
Entries: 2. Millimeters. Inscriptions. States. Described. Illustrated (selection). Incomplete catalogue.*

Harlingue, Gustave d' *(1832–1909)*
[Ber.] VIII, p. 60.*

Harpignies, Henri *(1819–1916)*
[H. L.] pp. 423–428.
Entries: 15. Millimeters. Inscriptions. States. Described.

[Ber.] VIII, pp. 61–63.
Entries: 34 etchings, 1 lithograph. Millimeters. Inscriptions. Described (selection).

Harpin, ———
See **Herpin**

Harrewyn, Franz *(b. c.1680)*
[W.] I, p. 649.
Entries: 9.*

[H. *Neth.*] VIII, p. 220.
Entries: 14.*

Harrewyn, Jacobus *(c.1660–c.1740)*
[W.] I, p. 649.
Entries: 3+.*

Heurck, Emile H. van. *Les Harrewijn;
Jacques, Jacques-Gerard, François, Jean-
Baptiste et leurs descendants.* Antwerp: J.
E. Buschmann, 1920.
Entries: 111. Millimeters. Inscriptions.
Described (selection). Located (selec-
tion).

[H. *Neth.*] VIII, p. 221.
Entries: 7+.*

Harris, ——— *(fl. c.1890)*
[Ber.] VIII, p. 63.*

Harris, John *(19th cent.)*
[Siltzer] pp. 352–354.
Entries: unnumbered, pp. 352–354.
Inscriptions.

Harris, Moses *(1731–after 1785)*
[Sm.] II, p. 622.
Entries: 1 (portraits only). Inches. In-
scriptions. Described.

Harris, Samuel *(1783–1810)*
[Allen] p. 137.*

[St.] pp. 213–214.*

[F.] p. 125.*

Harrison, Charles P. *(1783–after 1850)*
[Allen] p. 138.*

[St.] pp. 214–215.*

[F.] p. 126.*

Harrison, Richard G. I *(fl. 1814–1845)*
[St.] pp. 219–220.*

[F.] p. 126.*

Harrison, Richard G. II *(fl. 1860–1865)*
[St.] pp. 218–219.*

Harrison, Samuel *(d. 1818)*
[St.] p. 220.*

Harrison, William I *(d. 1803)*
[F.] pp. 126–127.*

Harrison, William II *(fl. 1797–1819)*
[St.] pp. 216–218.*

[F.] pp. 127–128.*

Harrod, Stanley *(b.1881)*
Fowler, Alfred. *A catalogue of bookplates
designed by Stanley Harrod.* The Bookplate
Brochures Series, 1. Kansas City (Mo.):
Alfred Fowler, 1919. 250 copies. (NN)
Entries: 51 (bookplates only, to 1919).
Inches. Inscriptions. Described. Ms.
addition (NN); additional informa-
tion, 5 additional entries.

Harscher, Ferdinand von *(fl. 1800–1850)*
[Dus.] p. 64.
Entries: 6 (lithographs only, to 1821).
Millimeters (selection). Inscriptions
(selection). Located (selection).

Hart, George Overbury ["Pop"]
(1868–1933)
Downtown Gallery, New York [Holger
Cahill, compiler]. *George O. "Pop" Hart;
twenty-four selections from his work.* New
York, 1928.
Entries: 82 (to 1928). Inches. Illus-
trated (selection).

Newark Museum [Elinor B. Robinson
and Margaret A. Jarden, com-
pilers]. *George Overbury "Pop" Hart,
1868–1933; catalogue of an exhibition of oils,*

Hart, George Overbury (*continued*)

watercolors, drawings and prints. Newark 1935.
> Entries: 80. Inches. States. Illustrated (selection). Complete?

Hart, Jeanne Overbury. *Works of art and documentation of the artist George Overbury "Pop" Hart; the Hart collection.* 4 vols. [New York?], 1964. (microfilm, DLC)
> Entries: 81. Inches. Illustrated (selection). Complete?

Hartfeldt, Bernard *(fl. 1641–1670)*
[Merlo] p. 330.*

Hartley, Marsden *(1877–1943)*
University of Kansas Museum of Art, Lawrence. *Marsden Hartley; lithographs and related works.* Lawrence (Kans.), 1972.
> Entries: 17. Inches. Illustrated. Located.

Hartmann, Carl Heinrich *(b. 1840)*
[Ap.] p. 193.
> Entries: 3.*

Hartmann, Mathias Christoph *(1791/92–c.1850)*
[Dus.] p. 64.
> Entries: 2 (lithographs only, to 1821). Millimeters (selection). Inscriptions. Located (selection).

Hartmann, [Johann Daniel] Wilhelm *(1793–1862)*
[Dus.] pp. 64–65.
> Entries: 2 (lithographs only, to 1821). Millimeters. Inscriptions. Located.

[Dus.] p. 126.
> Entries: 1 (lithographs only, to 1821).

Hartogensis, Joseph *(1822–1865)*
[H. L.] pp. 439–442.

> Entries: 9. Millimeters. Inscriptions. Described.

Hartung, Hans *(b. 1904)*
Schmücking, Rolf. *Hans Hartung, Werkverzeichnis der Graphik 1921–1965.* Brunswick (West Germany): Verlag Galerie Schmücking, 1965. 1000 copies. (CSfAc)
> Entries: 191. Millimeters. Described. Illustrated.

Hartwig, E. Bert *(b. 1907)*
Piechorowski, Arno. *E. B. Hartwig, 3 Holzschnittfolgen, Werkverzeichnis I.* Trollenberg (West Germany): Arno Piechorowski, 1967. 500 copies. (DLC)
> Entries: 60 (to 1966). Millimeters. Illustrated (selection).

Has, Georg *(fl. c.1583)*
[A.] III, pp. 276–278.
> Entries: 1+. Millimeters. Inscriptions. Described (selection).

Haskell, Ernest *(b. 1876)*
Pousette-Dart, Nathaniel. *Ernest Haskell, his life and work.* New York: T. Spencer Hutson, 1931.
> Entries: unnumbered, pp. 25–37. Inches. Inscriptions. States. Described. Illustrated (selection). Ms. addition (NN); additional entries, unnumbered, 2 pp.

Hassall, Joan *(b. 1906)*
McLean, Ruari. *The wood engravings of Joan Hassall.* London: Oxford University Press, 1960.
> Bibliography of books with illustrations by.

Hassall, John *(1767–1825)*
[Siltzer] p. 354.
> Entries: unnumbered, p. 354. Inscriptions.

Hassam, Childe *(1859–1935)*
Zigrosser, Carl. *Childe Hassam.* New
York: Frederick Keppel and Co., 1916.
Entries: 114 (etchings only, to 1916).
Inches. Inscriptions. States. Illus-
trated (selection).

Cortissoz, R. *The etchings and dry-points
of Childe Hassam, N.A.* New York:
Charles Scribner's Sons, 1925. 400
copies. (MB)
Entries: 238 (etchings only, to 1924).
Inches. Inscriptions. States. De-
scribed. Illustrated (selection).

Crafton Collection. *Childe Hassam, N.A.*
American etchers, 3. New York: T.
Spencer Hutson and Company, 1929.
Entries: 91 (etchings only, additional
to Cortissoz). Inches. Illustrated
(selection).

Leonard Clayton Gallery, New York.
*Handbook of the complete set of etchings and
drypoints, with 25 illustrations, of Childe
Hassam, N.A.* New York, 1933.
Entries: 376 (to 1933). Inches. De-
scribed. Ms. addition (NN); additional
information, 1 additional entry.

Griffith, Fuller. *The lithographs of Childe
Hassam.* U.S. National Museum,
Bulletin 232. Washington (DC): Smith-
sonian Institution, 1962.
Entries: 45 (lithographs only). Inches.
Inscriptions. States. Illustrated. Lo-
cated (selection).

Hasse, Julius *(d. 1846)*
[Ap.] p. 193.
Entries: 3.*

Hasselriis, Else *(1878–1953)*
Fougt, Knud. "Else Hasselriis 1878–
1953." [*N. ExT.*] 5 (1953): 84–86.
Entries: unnumbered, p. 86
(bookplates only). Illustrated (selec-
tion).

Hastrel, Adolphe d' *(fl. 1845–1853)*
[Ber.] VIII, p. 63.*

Hauber, Joseph *(1766–1834)*
[Dus.] pp. 65–66.
Entries: 14 (lithographs only, to 1821).
Millimeters. Inscriptions. Located
(selection).

Haudebourt, Antoinette Cécile Hortense
(1784–1845)
[Ber.] VIII, pp. 63–64.*

Hauer, Georg
See **Hayer**

Haufstaengl, Franz *(1804–1877)*
[Dus.] pp. 62–63.
Entries: 8+ (lithographs only, to 1821).
Millimeters. Inscriptions (selection).
Located (selection).

Hauser, Eric *(b. 1930)*
Defet, Hansfried. *Erich Hauser,
Werkverzeichnis; Plastik 1962 bis 1969,
Druckgrafik 1961 bis 1969 (erweiterte Aus-
gabe).* Nuremberg: Institut für moderne
Kunst, 1970. 2200 copies.
Entries: 135 (to 1969). Millimeters. Il-
lustrated. Catalogue of prints is only
in the second, expanded edition.

Haussoullier, William *(1818–1891)*
[Ber.] VIII, pp. 64–65.*

Hautel, Pauline d' *(fl. c.1829)*
[Ber.] VIII, p. 66.*

Havell, Frederick James *(1801–1840)*
[Siltzer] p. 354.
Entries: unnumbered, p. 354. Inscrip-
tions.

Havell, George *(fl. 1826–1833)*
[Siltzer] p. 134.
Entries: unnumbered, p. 134, prints
after. Inches. Inscriptions.

Havell, Robert *(19th cent.)*
[Siltzer] pp. 134–135; 354.
Entries: unnumbered, pp. 134–135,
prints by and after. Inches (selection).
Inscriptions.

Haverkamp, Gerard Christian *(b. 1872)*
J. H. de Bois. *G. C. Haverkamp; zijn etsen
tot 1915.* Introduction by M. W. van der
Valk. Haarlemsche Kunstboekjes, 1.
Haarlem (Netherlands): J. H. de Bois,
1915. (ERB)
Entries: 235 (to 1915). Millimeters.

Haward, Francis *(1759–1797)*
[Sm.] II, pp. 622–624, and "additions
and corrections" section.
Entries: 3 (portraits only). Inches. In-
scriptions. States. Described. Illus-
trated (selection).

[Ru.] p. 146.
Additional information to [Sm.].

Hawer, Georg
See **Hayer**

Hawke, Pierre *(1801–1887)*
[Ber.] VIII, p. 66.*

Hawksworth, J. *(fl. c.1824)*
[F.] p. 128.*

Hay, James Hamilton *(1874–1916)*
Marriott, Charles. "The drypoints of J.
Hamilton." [PCQ.] 14 (1927): 163–188.
Entries: 53. Inches. Inscriptions.
States. Described. Illustrated (selec-
tion).

Hay, William H. *(fl. 1822–1830)*
[F.] p. 129.*

Haydock, Richard *(c.1570–c.1640)*
[Hind, *Engl.*] I, pp. 231–235.
Entries: 3+. Inches. Inscriptions. De-
scribed. Illustrated (selection). Lo-
cated.

Haye, Aelbert [van Haarlem] *(fl. c.1585)*
[H. *Neth.*] VIII, p. 221.
Entries: 1. Illustrated.*

Haye, Reinier de la
See **La Haye**

Hayer, Georg *(1559–1614)*
[A.] IV, pp. 174–184.
Entries: 6+. Pre-metric. Inscriptions.
Described.

Schultz, Alwin. "Ergänzungen zu
Andresen's Peintre-Graveur." [*Rep.
Kw.*] 6 (1883): 65–66.
Entries: 8+ (additional to [A.]). Mil-
limeters. Inscriptions. Described
(selection).

Hayes, Michael Angelo *(1820–1877)*
[Siltzer] p. 331.
Entries: unnumbered, p. 331, prints
after. Inches. Inscriptions.

Hayman, Francis *(1708–1776)*
Hammelmann, H. A. "Eighteenth cen-
tury English illustrators; Francis
Hayman R.A." *The Book Collector* 2
(1953): 116–132.
Bibliography of books with illustra-
tions by.

Hazard, Jacob
See **Hazard,** James

Hazard, James *(1748–1787)*
[W.] I, p. 652.
Entries: 41.*

Hazelhurst, E. *(19th cent.)*
[Siltzer] p. 331.
Entries: unnumbered, p. 331, prints
after. Inscriptions.

Head, Guy *(1753–1800)*
[Siltzer] p. 331.
Entries: unnumbered, p. 331, prints
after. Inches. Inscriptions.

Hearne, Thomas *(1744–1817)*
[Siltzer] p. 331.
Entries: unnumbered, p. 331, prints after. Inscriptions.

Heath, Charles *(1785–1848)*
[Ap.] pp. 193–194.
Entries: 16.*

[Ber.] VIII, pp. 66–67.*

Heath, James *(1757–1834)*
[Ap.] pp. 194–195.
Entries: 19.*

Heath, William *(1795–1840)*
[Siltzer] p. 135.
Entries: unnumbered, p. 135, prints by and after. Inches. Inscriptions.

"Etched caricatures and book illustrations by William Heath ('Paul Pry') in the New York Public Library; a list." Unpublished ms., 1933. (NN)
Entries: 234 (prints in NN only; complete?). Inscriptions. Located. Ms. addition (NN); additional information.

Hébert, Cesar Auguste *(fl. 1841–1851)*
[Ber.] VIII, p. 67.*

Hébert, Jules *(1812–1897)*
[Ber.] VIII, p. 67.*

Hecht, Guillaume van der *(fl. 1850–1863)*
[H. L.] pp. 1053–1054.
Entries: 2. Millimeters. Inscriptions. States. Described.

Hecht, Henri van der *(1841–1901)*
[H. L.] p. 1054.
Entries: 2. Millimeters. Inscriptions. States. Described.

Heck, Nicolas [Claes] Dirckz van der *(fl. 1610–1649)*
[H. *Neth.*] VIII, p. 225.
Entries: 1.*

Hecke, Jan I van den *(1620–1684)*
[B.] I, pp. 101–109.
Entries: 14 prints by, 1 rejected print. Pre-metric. Inscriptions. Described.

[Weigel] pp. 13–15.
Entries: 9 (additional to [B.]). Pre-metric. Inscriptions. Described (selection).

[Dut.] V, pp. 15–21.
Entries: 23. Millimeters. Inscriptions. States. Described. Appendix with doubtful prints, unnumbered, p. 21.

[W.] I, pp. 653–654.
Entries: 13+ prints by, 3+ after.*

[H. *Neth.*] VIII, pp. 222–224.
Entries: 13 prints by, 21 after. Illustrated (selection).*

Hecke, Jan II van den *(b. 1661)*
[W.] I, p. 654.
Entries: 5+.*

[H. *Neth.*] VIII, p. 225.
Entries: 13. Illustrated (selection).*

Heckel, Erich *(1883–1970)*
Dube, Annemarie, and Dube, Wolf-Dieter. *Erich Heckel—das graphische Werke.* 2 vols. New York: Ernest Rathenau, 1964, 1965. 600 copies. (NN)
Entries: 447 woodcuts, 196 etchings, 374 lithographs, (to 1963). Millimeters. Inscriptions. States. Illustrated.

[*AzB.*] Beilage B, Blatt 3.
Entries: 1 (additional to Dube). Millimeters. Inscriptions. Described. Illustrated.

Hecken, Abraham I van den
See **Heckius,** Abraham

Heckius, Abraham *(fl. 1600–1650)*
[W.] I, p. 654.
Entries: 4+.*

[H. *Neth.*] VIII, p. 226.
Entries: 35.*

Heda, Willem Claesz *(1594–c.1682)*
[W.] I, p. 655.
 Entries: 1 print after.*

[H. *Neth.*] VIII, p. 226.
 Entries: 1 print after.*

Hedlund, Bull *(1893–1950)*
Lindgren, Nils. *Bertil Bull Hedlund.*
Stockholm: P. A. Norstedt & Söners For-
lag, 1952.
 Entries: 154. Millimeters. Described
 (selection). Illustrated (selection).

Hédouin, Edmond *(1820–1889)*
[Ap.] p. 195.
 Entries: 3.*

[Ber.] VIII, pp. 68–74.
 Entries: 195. Paper fold measure
 (selection).

Hée, Jules *(fl. c.1864)*
[Ber.] VIII, p. 74.*

Heeck, Abraham I van den
See **Heckius**

Heem, Jan Davids de *(1606–1684)*
[W.] I, p. 658.
 Entries: 3+ prints after.*

[H. *Neth.*] VIII, p. 226.
 Entries: 18 prints after.*

Heemskerck, Egbert I van *(1624?–1704)*
and Egbert II van *(1645?–1744?)*
[W.] I, p. 659.
 Entries: 2 prints by, 12 after.*

[H. *Neth.*] VIII, p. 227.
 Entries: 20 prints after.*

Heemskerck, Maarten van *(1498–1574)*
Kerrich, Thomas. *A catalogue of the prints
which have been engraved after Martin
Heemskerck; or rather, an essay towards
such a catalogue.* Cambridge: J. Rodwell,
1829. (MBMu)

Entries: unnumbered, pp. 25–126.
Inches. Inscriptions. States. De-
scribed. Ms. notes (EA); extensive
additional information. Ms. addition
(NN); 1 additional entry. Ms. notes by
J. C. J. Bierens de Haan (ERB); addi-
tional states, other information.

[W.] I, p. 661.
 Entries: 12+ prints by, 10+ after.*

[H. *Neth.*] VIII, pp. 228–248.
 Entries: 55 prints by, 636 after. Illus-
 trated (selection).*

Heer, Gerrit Adriaensz de *(c.1610–c.1660)*
[W.] I, p. 662.
 Entries: 3.*

[H. *Neth.*] IX, pp. 1–3.
 Entries: 5. Illustrated (selection).*

Heerschop, Hendrik *(1620/21–after 1672)*
[Rov.] p. 69.
 Entries: 6 prints by, 4 doubtful prints.
 Millimeters (selection). Inscriptions
 (selection). Described (selection). Il-
 lustrated (selection). Located (selec-
 tion).

[W.] I, p. 667.
 Entries: 7.*

[H. *Neth.*] IX, pp. 4–7.
 Entries: 11. Illustrated (selection).*

Hegenbarth, Josef *(1884–1962)*
Deutsche Akademie der Künste, Berlin.
*Josef Hegenbarth; Zeichnungen und
Gemälde aus den Jahren zwischen 1920 und
1962.* Berlin, n.d.
 Bibliography of books with illustra-
 tions by.

Meissenburg, Egbert: "Josef Hegen-
barth, Bibliographie des Illustration-
werks." [*Bb.*] 26 (January 1968): 165–172.
 Bibliography of books with illustra-
 tions by.

Hegi, Franz *(1774–1850)*
Appenzeller, Heinrich. *Der Kupferstecher Franz Hegi von Zürich, 1774–1850, sein Leben und seine Werke, beschreibendes Verzeichnis seiner sämtlichen Kupferstiche.* Zürich: H. Appenzeller, 1906. 350 copies. (MH)
 Entries: 1182. Millimeters. Inscriptions. States. Described. Illustrated (selection).

Heideck, Carl Wilhelm von *(1788–1861)*
[Dus.] pp. 66–67.
 Entries: 4+ (lithographs only, to 1821). Millimeters. Inscriptions. Located.

Heil, Daniel van *(c.1604–1662)*
[H. *Neth.*] IX, p. 7.
 Entries: 1 print after.*

Heil, Jan Baptist van *(1609–after 1661)*
[W.] I, pp. 667–668.
 Entries: 1.*

[H. *Neth.*] IX, p. 7.
 Entries: 7 prints after.*

Heil, Leo van *(1605–c.1661)*
[W.] I, p. 668.
 Entries: 1 print by, 2 after.*

[H. *Neth.*] IX, p. 8.
 Entries: 4.*

Heilbroeck, Michael
See **Heylbroeck**

Heim, François Joseph *(1787–1865)*
[Ber.] VIII, pp. 74–75.*

Heim, Matthias *(1782–1827)*
[Dus.] p. 67.
 Entries: 4 (lithographs only, to 1821). Millimeters. Inscriptions. Located.

Heina, —— *(fl. c.1820)*
[Ber.] VIII, p. 75.*

Heince, Zacharie *(1611–1669)*
[B.] XVI, pp. 368–369.
 Entries: 1. Pre-metric. Inscriptions. Described.

[RD.] V, pp. 131–134; XI, p. 110.
 Entries: 4. Millimeters. Inscriptions. Described.

Heinel, Philipp *(1800–1843)*
[A. 1800] I, pp. 164–176.
 Entries: 7 etchings, 11 lithographs. Pre-metric. Inscriptions. States. Described.

Andresen, Andreas. "Andresens Nachträge zu seinen 'Deutschen Malerradieren.'" [*MGvK.*] 1907, pp. 40–41.
 Entries: 1 (additional to [A. 1800]). Millimeters. Inscriptions. Described. Additional information to [A. 1800].

Heinrigs, Friedrich *(c.1815–1840)*
[Merlo] p. 336.*

Heins, Armand Jean *(b. 1856)*
Bergmans, Paul. *Catalogue sommaire des eaux-fortes de Armand Heins, deuxième édition.* Gand (Belgium): C. Vyt, 1900.
 Entries: 168 (to 1899). Millimeters.

Bergmans, Paul. *Un aquafortiste belge; les eaux-fortes d'Armand Heins (1884–1910).* Ghent (Belgium): I. Vanderpoorten, 1915.
 Entries: 201. Millimeters. Inscriptions. States. Described. Illustrated (selection).

Heins, D. *(fl. 1725–1756)*
[Sm.] II, pp. 624–625.
 Entries: 3 (portraits only). Inches. Inscriptions. States. Described.

[Ru.] p. 146.
 Additional information to [Sm.].

Heinsius, A. *(fl. c.1767)*
[W.] I, p. 668.
 Entries: 1 print after.*

Heintzelman, Arthur William *(b. 1891)*
Holman, Louis A. *Arthur William Heintzelman, etcher.* Goodspeed's Monographs, 1. Boston (Mass.): Charles E. Goodspeed and Co., 1920.
>Entries: 72 (to 1919). Inches. Illustrated (selection). Located (selection).

Eglington, Guy C. "The etchings of Arthur William Heintzelman," [*P. Conn.*] 2 (1922): 172–195.
>Entries: 80 (to 1921). Inches. Illustrated (selection).

Arms, John Taylor. *Arthur William Heintzelman.* Modern American Etchers. New York: Minton Balch and Company, 1927.
>Entries: 123 (to 1926?). Inches. Illustrated (selection).

Guiot, Marcel. *Arthur Wm. Heintzelman aquafortiste.* 2 vols. Paris: Marcel Guiot, 1928. 325 copies. (MBMu)
>Entries: 132 (to 1927). Millimeters. Inches. Inscriptions. States. Described. Illustrated.

Crafton Collection. *Arthur Wm. Heintzelman; with an appreciation by Robert Rey.* American etchers, 6. New York: Crafton Collection, 1930.
>Entries: 118 (published prints only, to 1929). Inches. Illustrated (selection).

Heintzelman, Arthur William. "Checklist of prints by Arthur W. Heintzelman." [*PCQ.*] 24 (1937): 422–439.
>Entries: 80 (additional to Guiot; to 1937). Inches. States. Illustrated (selection).

"Etchings and drypoints 1938–1962." Unpublished ms. (MB)
>Entries: 40 (additional to Guiot and to Heintzelman 1937). Inches. States. Based on the print collection of the Boston Public Library. Complete?

Heinze, Albert *(b. 1826)*
>[Ap.] p. 195.
>Entries: 2.*

Heinzmann, Carl Friedrich *(1795–1846)*
>[Dus.] pp. 67–70.
>Entries: 21 (lithographs only, to 1821). Millimeters. Inscriptions. States. Described (selection). Located.

Heis, L. *(19th cent.)*
>[Merlo] p. 338.*

Helbig, Jules Chrétien Charles Joseph Henri *(1821–1906)*
>[H. L.] pp. 443–444.
>Entries: 2. Millimeters. Inscriptions. Described.

Hellemans, K. A. *(fl. 1650–1700)*
>[H. *Neth.*] IX, p. 8.
>Entries: 11.*

Heller, Bert *(1912–1970)*
Gemäldegalerie neue Meister Dresden. *Bert Heller 1912–1970; Gemälde, Zeichnungen, Plakate, Illustrationen.* Dresden, 1972. (EOBKk)
>Entries: 56 posters designed by. Located.

Hellwig, Hans *(fl. c.1582)*
>[A.] II, pp. 110–111.
>Entries: 1. Pre-metric. Inscriptions. Described.

Helman, Isidore Stanislas Henri *(1743–1806?)*
Vienne, H. "Helman (Isidore-Stanislas) 1743–1806." [*RUA.*] 20 (1865): 263–274.
>Entries: 67. Paper fold measure.

>[Ber.] VIII, p. 75.*

>[L. D.] pp. 32–34.
>Entries: 8. Millimeters. Inscriptions. States. Described. Illustrated (selection). Incomplete catalogue.*

Helmbreker, Dirk *(1633–1696)*
[H. *Neth.*] IX, p. 8.
 Entries: 1 print after.*

Helmlehner, M. G. *(19th cent.)*
[Dus.] p. 70.
 Entries: 2 (lithographs only, to 1821).
 Millimeters. Inscriptions. Located.

Helmont, Zeger Jacob van *(1683–1726)*
[W.] I, p. 670.
 Entries: 2 prints after.*

Helmsauer, Carl August *(1789–c.1844)*
[Dus.] p. 70.
 Entries: 9 (lithographs only, to 1821).
 Millimeters. Inscriptions. Located.

Helst, Bartholomäus van der *(1613–1670)*
[W.] I, pp. 670–673; III, p. 100.
 Entries: 11 prints after.*

[H. *Neth.*] IX, pp. 9–11.
 Entries: 58 prints after.*

Helst, Lodewyk van der *(1642–c.1680)*
[H. *Neth.*] IX, p. 11.
 Entries: 2 prints after.*

Helt-Stokade, Nicolaes de *(1614–1669)*
[vdK.] pp. 33–36, 227.
 Entries: 5. Millimeters. Inscriptions.
 States. Described. Appendix with 2
 rejected prints.

[W.] I, pp. 673–674.
 Entries: 7 prints by, 1 after.*

[H. *Neth.*] IX, pp. 12–14.
 Entries: 8 prints by, 5 after. Illustrated
 (selection).*

Hemard, Joseph *(1880–1961)*
Valotaire, Marcel. *Joseph Hemard*. Les ar-
tistes du livre, 3. Paris: Henry Babou,
1928. 700 copies. (EPBN)
 Bibliography of books with illustra-
 tions by.

Henderson, Charles Cooper *(1803–1877)*
[Siltzer] pp. 136–138.
 Entries: unnumbered, pp. 137–138,
 prints after. Inches (selection). In-
 scriptions.

Hendrickx, L. Henri *(1817–1894)*
[H. L.] p. 445.
 Entries: 1. Millimeters. Inscriptions.
 Described.

Hendriks, Wybrand *(1744–1831)*
[W.] I, p. 677.
 Entries: 3.*

Hennebutte, Blanche *(19th cent.)*
[Ber.] VIII, p. 75.*

Hennequin, Philippe Auguste *(1763–1833)*
[H. L.] p. 445.
 Entries: 1. Millimeters. Described.

[Ber.] VIII, pp. 75–76.*

Henning, Christian *(1741–1822)*
[W.] I, p. 678.
 Entries: 1+.*

Henriet, Charles Louis d' *(b. 1829)*
[Ber.] VIII, p. 77.*

Henriet, Charles Frédéric *(1826–1918)*
[Ber.] VIII, pp. 76–77.
 Entries: 15. Paper fold measure (selec-
 tion). Inscriptions (selection).

Henriot [Henri Maigrot] *(b. 1857)*
[Ber.] VIII, p. 77.*

Henriquel-Dupont, Louis Pierre
(1797–1892)
[Ap.] pp. 127–130.
 Entries: 34.*

[Ber.] VIII, pp. 77–109.
 Entries: 115. Paper fold measure.
 States.

Henriquel-Dupont, Louis Pierre *(continued)*

Lostalot, Alfred de. "Henriquel-Dupont." [*GBA.*] 3d ser. 7 (1892): 177–195.
Entries: 115. Illustrated (selection). Based on [Ber.].

Henriquez, Benoît Louis *(1732–1806)*
[Ap.] p. 196.
Entries: 17.*

Henry, J. *(19th cent.)*
[St.] p. 220.*

Hensberg, Gerhard *(fl. c.1550)*
[Merlo] pp. 342–343.*

Henschel brothers *(19th cent.)*
[Dus.] pp. 70–71.
Entries: 3+ (lithographs only, to 1821). Millimeters. Inscriptions. Located.

Henschel, H. *(19th cent.)*
[Dus.] p. 71.
Entries: 2 (lithographs only, to 1821). Millimeters. Inscriptions. Located.

Henshawe, William *(fl. c.1775)*
Booth, W. H. "Bookplates." Unpublished ms. (DLC)
Not seen.

Herckenrath, Antoon *(20th cent.)*
Horemans, Karel. *Antoon Herckenrath houtsnijder.* Diest (Belgium): Kunstuitgeverij "Pro Arte," 1941. 525 copies. (EBr)
Entries: unnumbered, pp. 89–90. Millimeters. Illustrated (selection).

Héreau, Jules *(1839–1879)*
[Ber.] VIII, p. 109.*

Herinckx, F. *(fl. c.1863)*
[H. L.] pp. 446–447.
Entries: 4. Millimeters. Inscriptions. Described.

Herkomer, Hubert von *(1849–1914)*
[Ber.] VIII, p. 109.*

Roeper, Adalbert. "Hubert von Herkomer und sein graphisches Werk." [*Kh.*] 1 (1909): 97–104.
Entries: 98 (to 1909?). Millimeters. States.

Herluison, Edme *(1660–1701)*
[CdB.] pp. 87–90.
Entries: 4. Pre-metric (selection). Inscriptions (selection). Described (selection).

Herman, Georg *(1579-after 1603)*
[A.] III, pp. 269–275.
Entries: 38+. Pre-metric. Inscriptions. Described.

Herman, J. *(fl. 1600–1650)*
[W.] I, p. 680.
Entries: 2.*

[H. *Neth.*] IX, p. 15.
Entries: 23.*

Herman, Stephan *(fl. 1568–1596)*
[A.] III, pp. 263–268.
Entries: 25+. Pre-metric. Inscriptions. Described.

Héroux, Bruno *(1868–1944)*
Mestern, Erwin. "Professor Bruno Heroux." [*Bb.*] 76 (1909): 12799–12801.
Entries: 180 (to 1909). Millimeters. States.

Liebsch, Artur. *Bruno Héroux; Verzeichnis der graphischen Arbeiten von 1900 bis 1910, umfassend die Blätter 1 bis 200.* Leipzig: 1910. 500 copies. (NN)
Entries: 200 (to 1910). Millimeters. Ms. addition (NN); additional information, 25 additional entries.

Weber, Ludwig. "Bruno Heroux." [*Kh.*] 9 (1917): 132–139.
Entries: 403 (to 1916). Millimeters. States.

Liebsch, Arthur. *Bruno Heroux; sein graphisches Werk bis Op. 501.* Introduction by Egbert Delpy. Berlin: Rich. Bong Verlag, 1922. (EOBKk)
Entries: 501 (to 1922?). Millimeters. Illustrated (selection).

Herp, Willem van *(c.1614–1677)*
[W.] I, p. 681.
Entries: 3 prints after.*

[H. *Neth.*] IX, p. 15.
Entries: 4 prints after.*

Herpin, ——— *(fl. 1783–1796)*
Beaupré, J. N. "Notice sur quelques graveurs nancéiens du XVIIIe siècle; Hoerpin ou Harpin 1783–1796." [*Mém. lorraine*] 2d ser. 3 (1861): 7–21. Separately published. Nancy (France): Lucien Wiener, 1862.
Entries: 13 Millimeters. Inscriptions. Described.

Herregouts, Hendrik *(1633–before 1704)*
[W.] I, pp. 681–682.
Entries: 1 print after.*

[H. *Neth.*] IX, p. 15.
Entries: 2 prints after.*

Herregouts, Jan Baptist *(c.1640–1721)*
[Wess.] II, p. 237.
Entries: 1 (additional to [Andresen, *Handbuch*]). Millimeters. Inscriptions. Described. Additional information to [Andresen, *Handbuch*].

[W.] I, p. 682.
Entries: 5.*

[H. *Neth.*] IX, p. 16.
Entries: 5.*

Herreyns, Daniel *(fl. c.1625)*
[W.] I, p. 682.
Entries: 5.*

[H. *Neth.*] IX, p. 16.
Entries: 5.*

Herring, John Frederick I *(1795–1865)*
Muir, J. B. *A descriptive catalogue of the engraved works of J. F. Herring, senior (1795 to 1865).* London: J. B. Muir, Sporting Fine Art Gallery, 1893.
Entries: unnumbered, pp. 25–102, prints after. Inches.

[Siltzer] pp. 139–152.
Entries: unnumbered, pp. 145–152, prints after. Inches (selection). Inscriptions. States.

Herreyns, Jacob *(1643–1732)*
[W.] I, p. 682.
Entries: 3.*

[H. *Neth.*] IX, p. 16.
Entries: 4.*

Herrmann, Paul *(b. 1864)*
Singer, Hans W. *Das graphische Werk des Maler-Radierers Paul Herrmann (Henri Héran), wissenschaftliches Verzeichnis.* Berlin: Oskar Rauthe, 1914. 590 copies. (NN)
Entries: 183 (to 1914). Millimeters. Inscriptions. States. Described. Illustrated (selection).

Hersbach, Hans *(fl. 1558–1565)*
See **Monogram HHB** [Nagler, *Mon.*] III, no. 1064

Hersent, Louis *(1777–1860)*
[Ber.] VIII, p. 110.*

Hédiard, Germain. *Louis Hersent.* Les maîtres de la lithographie. Paris: Edmond Sagot, 1901.
Entries: 27. Millimeters. Inscriptions. States. Described.

Herterich, Heinrich Joachim *(1772–1852)*
[Dus.] pp. 71–72.
Entries: 4 (lithographs only, to 1821). Paper fold measure (selection). Inscriptions. Located (selection).

Hertocks, A. *(fl. 1626–1672)*
 [W.] I, pp. 682–683.
 Entries: 12.*

 [H. *Neth.*] IX, p. 17.
 Entries: 19+.*

Hertzog Von Brin *(fl. 1589–1606)*
 [H. *Ger.*] IV, p. 206.
 Entries: 12.*

Hervier, Adolphe *(1821–1879)*
 [Ber.] VIII, pp. 110–116.
 Entries: 94. Paper fold measure (selection). States. Described (selection).

Herwegen, Peter *(1814–1893)*
 [Merlo] pp. 345–346.*

Heseltine, John Postle *(b. 1843)*
 [Ber.] VIII, p. 116.*

Hess brothers *(19th cent.)*
 [Dus.] p. 72.
 Entries: 1 (lithographs only, to 1821). Millimeters. Inscriptions. Located.

Hess, Carl Ernst *(1755–1828)*
 [Ap.] pp. 196–198.
 Entries: 22.*

Hess, Eugen *(1824–1862)*
 [A. 1800] III, pp. 203–206.
 Entries: 4. Pre-metric. Inscriptions. Described. Also, list of 4 prints after (not fully catalogued).

Hess, Heinrich Maria von *(1798–1863)*
 [Dus.] p. 72.
 Entries: 4+ (lithographs only, to 1821). Millimeters (selection). Inscriptions (selection). Located (selection).

Hess, Peter von *(1792–1871)*
 [Dus.] p. 72.
 Entries: 3+ (lithographs only, to 1821). Millimeters. Inscriptions. Located.

Hesse, Daniel *(19th cent.)*
 [Dus.] pp. 72–73.
 Entries: 3 (lithographs only, to 1821). Millimeters. Inscriptions. Located.

Hesse, Henri Joseph *(1781–1849)*
 [Ber.] VIII, pp. 116–117.*

Hesslöhl, Wilhelm *(b. 1810)*
 [Ap.] p. 198.
 Entries: 5.*

Hester, Edward Gilbert *(d. 1903)*
 [Siltzer] p. 355.
 Entries: unnumbered, p. 355. Inscriptions.

Heuer, Wilhelm *(1813–1890)*
 [Ber.] VIII, p. 117.*

Heulz, Henri *(19th cent.)*
 [Ber.] VIII, p. 117.*

Heus, Willem
 See **Heusch**

Heusch, Jacob [Giacomo] de *(1657–1701)*
 [W.] I, p. 684.
 Entries: 1.*

Heusch, Willem [Guillaume] de *(c.1620–1692)*
 [B.] I, pp. 323–334.
 Entries: 10. Pre-metric. Inscriptions. Described.

 [Weigel] pp. 42–43.
 Entries: 2 (additional to [B.]). Pre-metric. Inscriptions. Described.

 [Dut.] V, pp. 21–25.
 Entries: 14. Millimeters. Inscriptions. States. Described.

 [W.] I, p. 684.
 Entries: 12+ prints by, 1 after.*

 [H. *Neth.*] IX, pp. 18–22.
 Entries: 14 prints by, 1 after. Illustrated (prints by only).*

Heuvel, Anton van den *(c.1600–1677)*
[W.] I, p. 685.
 Entries: 4 prints after.*

[H. *Neth.*] IX, p. 23.
 Entries: 5 prints after.*

Hewitt, —— *(fl. c.1820)*
[St.] pp. 220–221.*

[F.] p. 129.*

Heyboer, Anton *(b. 1924)*
Galerie der Spiegel, Cologne. *Geh durch den Spiegel; Anton Heyboer.* Cologne, 1960. 200 copies. (CSfAc)
 Entries: 62 (1959 and 1960). Millimeters. Described. Illustrated.

Gemeentemuseum, The Hague [J. L. Locher, compiler]. *Anton Heyboer.* The Hague, 1967.
 Entries: 171 (to 1967; complete?). Millimeters. Inscriptions. Described. Illustrated.

Heyden, Jacob van der *(1573–1645)*
Kreplin, B. C. "Jacob von der Heyden." In [*ThB.*] XVII, pp. 17–19.
 Entries: unnumbered, pp. 17–19.

Heyden, Jacob van der *(1636–1678)*
[H. *Neth.*] IX, p. 23.
 Entries: 1+ prints after.*

Heyden, Jan van der *(1637–1712)*
[W.] I, pp. 685–687.
 Entries: 2+ prints by, 3+ after.*

[H. *Neth.*] IX, pp. 24–25.
 Entries: 24 prints by, 15+ after. Illustrated (selection).*

Heyden, Pieter van der *(b. c.1530)*
[W.] II, pp. 146–147.
 Entries: 29+.*

[H. *Neth.*] IX, pp. 26–32.
 Entries: 159. Illustrated (selection).*

Heylan, Franciscus *(c.1590–c.1650)*
[W.] I, p. 687.
 Entries: 1.*

[H. *Neth.*] IX, p. 32.
 Entries: 46.*

Heylan, Gonzales van *(1661–1720)*
[W.] I, p. 687.
 Entries: 1.*

[H. *Neth.*] IX, p. 33.
 Entries: 2+. Illustrated (selection).*

Heylbroeck, Michael *(1635–1733)*
[W.] I, p. 687.
 Entries: 6+.*

Heyman, Charles *(1881–1915)*
Barrier, André. "Catalogue de l'oeuvre gravé de Ch. Heyman." Unpublished ms. (EPBN)
 Entries: unnumbered, about 150. Millimeters. Inscriptions. States.

Heymans, J. *(fl. c.1670)*
[W.] I, p. 688.
 Entries: 1 print after.*

[H. *Neth.*] IX, p. 33.
 Entries: 2 prints after.*

Heymhoweck, Rombout *(fl. c.1675)*
[W.] I, p. 688.
 Entries: 3.*

Hiback, —— *(fl. c.1840)*
[Ber.] VIII, p. 117.*

Hibon, Auguste *(1780–1857)*
[Ber.] VIII, p. 117.*

Hilarides, Johannes *(1648–1725/26)*
[W.] I, p. 688.
 Entries: 2.*

Hildebrand, Henri Théophile *(b. 1824)*
[Ber.] VIII, p. 117.*

Hilgers, Michael *(18th cent.)*
[Merlo] p. 348.*

Hilhorst Gerardus Pieter Lambert
(b. 1886)
"Overzichten IV." *Boekcier* 9 (1940):
22–23.
 Entries: pp. 22–23, (bookplates only,
 to 1940). Illustrated (selection).

Hill, James *(fl. c.1803)*
[St.] p. 228.*

[F.] p. 129.*

Hill, John *(1770–1850)*
[St.] pp. 221–227.*

[F.] pp. 130–139.*

Koke, Richard J. *A checklist of the Ameri-
can engravings of John Hill (1770–1850).*
New York: New York Historical Society,
1961.
 Entries: 161 (prints done in America
 only). Inches. Inscriptions. States.
 Described. Illustrated (selection). Lo-
 cated (selection).

Hill, John William *(1812–1879)*
[St.] pp. 227–228.*

[F.] pp. 129–130.*

Hill, Samuel *(fl. 1789–1803)*
[Allen,] p. 138.*

[St.] pp. 228–236.*

[F.] pp. 139–143.*

Hill, Sara B. *(20th cent.)*
Hunt, Rachel McM. M. *The work of Sara
B. Hill with check-list of her bookplates.* Re-
printed from *The 1924 year book of the
American Society of Bookplate Collectors
and Designers.* Washington (D.C.), 1924.
 Entries: 39 (to 1924). Inscriptions. De-
 scribed. Ms. addition (NN); additional
 information, 8 additional entries.

Hillegaert, Paulus I van *(c.1595–1658)*
[B.] I, pp. 110–119.
 Entries: 10. Pre-metric. Inscriptions.
 Described.

[Weigel] pp. 15–17.
 Additional information to [B.].

[W.] I, pp. 688–689.
 Entries: 12+.*

[H. *Neth.*] IX, pp. 34–35.
 Entries: 13. Illustrated (selection).*

Hillemacher, Frédéric Désiré *(1811–1886)*
[H. L.] pp. 447–486.
 Entries: 95 (to 1873). Millimeters. In-
 scriptions. States. Described. Also,
 incomplete list of books with illustra-
 tions by.

[Ber.] VIII, pp. 118–123.*

Hiller, Joseph *(1777–1795)*
[F.] p. 144.*

Hillyard, [J. W.?] *(19th cent.)*
[Siltzer] p. 331.
 Entries: unnumbered, p. 331, prints
 after. Inscriptions.

Hilten, Hendrik van *(fl. 1750–1773)*
[W.] I, p. 689.
 Entries: 1.*

Hilton, T. *(19th cent.)*
[Siltzer] p. 331.
 Entries: unnumbered, p. 331, prints
 after. Inscriptions.

Hiltrop, J. van *(fl. c.1750)*
[W.] I, p. 689.
 Entries: 2.*

Himbsel, Johann Ulrich *(1787–1860)*
[Dus.] p. 73.
 Entries: 1+ (lithographs only, to 1821).
 Millimeters. Inscriptions. Located.

Himely, Sigismond *(1801–1872)*
[Ber.] VIII, p. 123.*

Himpel, Aarnout ter *(1634–1686)*
[W.] I, p. 689.
Entries: 5+ prints after.*

[H. *Neth.*] IX, p. 36.
Entries: 12 prints after.*

Hinshelwood, Robert *(b. 1812)*
Ms. catalogue. (NN)
Entries: 193+. Inscriptions (selection).

Hirsch, Alphonse *(1843–1884)*
[Ber.] VIII, p. 124.*

Hirsch, Auguste Alexandre *(1833–1912)*
[Ber.] VIII, p. 124.*

Hirsch, Joseph *(b. 1910)*
Cole, Sylvan. *The graphic work of Joseph Hirsch.* New York: Associated American Artists, 1970.
Entries: 66 (to 1969). Inches. Described. Illustrated.

Hirschvogel, Augustin *(c. 1503–1553)*
[B.] IX, pp. 170–207.
Entries: 136+. Pre-metric. Inscriptions. Described. Copies mentioned.

[P.] III, pp. 257–259.
Entries: 9 (additional to [B.]). Pre-metric. Inscriptions. Described. Located.

[Wess.] I, p. 137.
Entries: 1 (additional to [B.] and [P.]). Millimeters. Inscriptions. Described.

Nehring, Alfred. *Über Herberstain und Hirsfogel; Beiträge zur Kenntnis ihres Lebens und ihrer Werke.* Berlin: Fred Dümmler, 1897.
Bibliography of books (published by Herberstain) with illustrations by.

Schwarz, K. *Augustin Hirschvogel; ein deutscher Meister der Renaissance.* Berlin:

Julius Bond, 1917. Reprint. 2 vols. New York: Collectors Editions, 1971.
Entries: 156. Millimeters. Inscriptions. States. Described. Illustrated (selection in 1917 edition, complete in 1971 reprint). Located. 1971 reprint has additional information.

Hirzel, Hermann *(fl. c.1900)*
Hirzel, Hermann. *Exlibris von Hermann Hirzel.* Berlin: Fischer und Franke Verlag, [1901?]. 500 copies. (DLC)
Entries: 98 (bookplates only, to 1901). Illustrated (selection).

Hixon, [William J.?] *(19th cent.)*
[Siltzer] p. 331.
Entries: unnumbered, p. 331, prints after. Inscriptions.

Hjortzberg, Olle *(1872–1959)*
Bergquist, Eric. "Professor Olle Hjortzberg (1872–1959), en svensk målare och grafiker." [*N. ExT.*] 16 (1964): 56–59.
Entries: unnumbered, p. 59 (bookplates only). Illustrated (selection).

Hobbema, Meindert *(1638–1709)*
[W.] I, pp. 690–692.
Entries: 13 prints after.*

[H. *Neth.*] IX, p. 36.
Entries: 16 prints after.*

Hockney, David *(b. 1937)*
Bonin, Wibke von. *David Hockney Oeuvrekatalog—Graphik.* Berlin: Galerie Mikro and Petersburg Press, 1968.
Entries: 29+ (to 1968?). Millimeters. Inscriptions. Described. Illustrated.

Whitechapel Art Gallery, London. *David Hockney; paintings, prints and drawings 1960–1970.* London, 1970. Reprint. London: Lund Humphries, 1970.
Entries: 46+ (to 1970). Millimeters. Inscriptions. Described (selection). Il-

Hockney, David (*continued*)

lustrated. Reprint contains additional information.

Kestner-Gesellschaft, Hannover. *David Hockney.* Hanover (West Germany), 1970.
Entries: 46+ (to 1970). Millimeters. Described. Illustrated. Based on Bonin and Whitechapel Art Gallery catalogues.

Hodges, Charles Howard *(1764–1837)*
[Sm.] II, pp. 531, 625–640, and "additions and corrections" section; IV, "additions and corrections" section.
Entries: 42 (portraits only). Inches. Inscriptions. States. Described. Located (selection).

[W.] I, p. 692.
Entries: 51.*

[Siltzer] p. 355.
Entries: unnumbered, p. 355. Inscriptions.

[Ru.] pp. 146–151, 493.
Entries: 5 (portraits only, additional to [Sm.]). Inches. Inscriptions (selection). States. Described. Additional information to [Sm.].

Hodges, W. P. *(19th cent.)*
[Siltzer] pp. 153–159.
Entries: unnumbered, pp. 158–159, prints after. Inches. Inscriptions.

Hoecht, K. *(19th cent.)*
[Dus.] p. 73.
Entries: 1 (lithographs only, to 1821). Millimeters. Inscriptions. Located.

Höck, Franz *(16th cent.)*
See **Monogram FH** [Nagler, *Mon.*] II, no. 2148

Hoecke, Jan van den *(1611–1651)*
[W.] I, p. 693.
Entries: 2 prints by, 18 after.*

[H. *Neth.*] IX, p. 37.
Entries: 2 prints by, 22 after. Illustrated (selection).*

Hoecke, Robert van den *(1622–1668)*
[B.] V, pp. 149–165.
Entries: 21. Pre-metric. Inscriptions. States. Described.

[Weigel] pp. 269–271.
Entries: 1 (additional to [B.]). Pre-metric. Inscriptions. Described.

[Wess.] II, pp. 237–238.
Additional information to [B.] and [Weigel].

[W.] I, pp. 693–694.
Entries: 22+ prints by, 1 after.*

[H. *Neth.*] IX, pp. 38–43.
Entries: 22 prints by, 2 after. Illustrated (prints by only).*

Hoeckgeest, Gerard *(c. 1600–1661)*
[vdK.] pp. 82–84.
Entries: 1. Millimeters. Inscriptions. States. Described. Illustrated.

[H. *Neth.*] IX, p. 44.
Entries: 3. Illustrated (selection).*

Hödicke, K. H. *(20th cent.)*
Block, René, and Vogel, Karl. *Graphik des Kapitalistischen Realismus; . . . Werkverzeichnisse bis 1971.* Berlin: Edition René Block, 1971. 3000 copies.
Entries: 7 (to 1971). Millimeters. Inscriptions. Described. Illustrated.

Hoedt, J. H. *(fl. c.1800)*
[W.] I, p. 694.
Entries: 1.*

Höfel, Blasius *(1792–1863)*
[Ap.] pp. 198–199.
Entries: 12.*

Wünsch, Josef. *Blasius Höfel: Geschichte seines Lebens und seiner Kunst und Verzeichnis seiner Werke.* Vienna, 1910.

Entries: 229 prints by, 9 doubtful prints. Millimeters. Inscriptions. States. Described. Illustrated (selection). Located (selection).

Hoefnagel, Georg [Joris] *(1542–1600)*
[W.] I, pp. 694–696.
Entries: 4.*

[H. *Neth.*] IX, p. 45.
Entries: 7+.*

Hoefnagel, Jacob *(1575–c.1630)*
[W.] I, p. 696.
Entries: 3+ prints by, 1 after.*

[H. *Neth.*] IX, p. 46.
Entries: 66. Illustrated (selection).*

Hoel, Arne *(20th cent.)*
Schyberg, Thor Bjørn. "Arne Hoel's produksjonsliste."[*N. Ext.*] 17 (1965): 66, 71, 80, 84, 90.
Entries: unnumbered, pp. 66, 71, 80, 84, 90 (bookplates only).

Hörberg, Pehr *(1746–1816)*
Cnattingius, Bengt. *Pehr Hörberg.* Stockholm: P. A. Norstedt och Söner, 1937.
Entries: 116. Millimeters. Inscriptions. States. Described. Different states of the same print are separately numbered.

Hörmann, Joseph Ignatz *(c.1775–1820)*
Hämmerle, Albert. "Die Lithographie in Augsburg."[*Schw. M.*] 1927, pp. 184–196.
Entries: 2 (lithographs only). Millimeters. Inscriptions. Described. Illustrated (selection). Located.

Hoerpin, ——
See **Herpin**

Hoet, Gerard I *(1648–1733)*
[W.] I, pp. 696–697.
Entries: 28 prints by, 4 after.*

Hoet, H. *(fl. c.1659)*
[W.] I, p. 697.
Entries: 1 print after.*

Hoevenaar, Willem Pieter *(1808–1863)*
[H. L.] p. 487.
Entries: 2. Millimeters. Inscriptions. Described.

Hoey, Jan de *(1545–1615)*
[W.] I, p. 698.
Entries: 2.*

[H. *Neth.*] IX, p. 47.
Entries: 2. Illustrated (selection).*

Hoey, Nicolas II de *(fl. 1590–1611)*
[W.] I, p. 698.
Entries: 4 prints after.*

[H. *Neth.*] IX, p. 48.
Entries: 4+ prints after.*

Hoey, Nicolas IV de *(1631–1679)*
[W.] I, p. 699.
Entries: 11+ prints by, 2+ after.*

[H. *Neth.*] IX, p. 48.
Entries: 18 prints by, 54 after.*

Hoeye, Franciscus van *(1591–1636)*
[W.] I, p. 698.
Entries: 2.*

[H. *Neth.*] IX, p. 47.
Entries: 11.*

Hoeye, Rombout van den *(b. 1622)*
[W.] I, p. 699.
Entries: 2.*

[H. *Neth.*] IX, p. 49.
Entries: 5.*

Hofer, Franz *(1885–1915)*
Breitfelder, Franz. "Franz Hofer."[*GK.*] 39 (1916): 11–24. Catalogue: "Das radierte Werk von Franz Hofer." [*MGvK.*]1916, pp. 8–13.
Entries: 63. Millimeters. States. Described.

Hofer, Karl *(1878–1955)*
Rathenau, Ernest. *Karl Hofer; das graphische Werk.* New York: Ernest Rathenau, 1969. 600 copies. DLC.
Entries: 17 woodcuts, 69 etchings, 190 lithographs, 4 doubtful prints. Millimeters. Inscriptions. States. Described. Illustrated.

[*AzB.*] Beilage B, Blatt 4.
Entries: 1 (additional to Rathenau). Millimeters. Inscriptions. Described. Illustrated.

Hoff, Johann Nicolas *(1798–1873)*
[Ap.] p. 199.
Entries: 7.*

Hoffman, August *(1810–1873)*
[Ap.] pp. 200–201.
Entries: 20.*

Hoffman, Irwin D. *(b. 1901)*
Irwin D. Hoffman. New York: Associated American Artists, 1936.
Entries: 49 (to 1936). Inches. Illustrated (selection).

Hoffman, M. *(19th cent.)*
[Ap.] p. 201.
Entries: 3.*

Hoffmann, Felix *(20th cent.)*
Hoffman, Felix. "Über den Farbholzschnitt." *Illustration 63* 5 (1968): 44–45.
Bibliography of books with illustrations by (color woodcuts only).

Hoffmann, Joseph *(1764–1812)*
[Merlo] pp. 354–357.*

Hoffmeister, Christian *(1818–1871)*
[Ap.] p. 201.
Entries: 2.*

Hoffnass, Lorenz *(1772–1837)*
[Dus.] p. 73.

Entries: 1 (lithographs only, to 1821). Millimeters. Inscriptions. Located.

Hoflehner, Rudolf *(b. 1916)*
Sotriffer, Kristian. Catalogue. In *Rudolf Hoflehner; Krieauer Kreaturen, mit einem Werkkatalog sämtlicher Radierungen und Lithographien 1965–1970,* by Werner Spies. Österreichische Graphiker der Gegenwart, 4. Vienna: Anton Schroll, 1971. 1200 copies. (MH)
Entries: 126 etchings, 28 lithographs (to 1970). Millimeters. Described. Illustrated.

Hofmann, Georg *(19th cent.)*
[Dus.] p. 73.
Entries: 1 (lithographs only, to 1821). Millimeters. Inscriptions. States. Located.

Hofnass, Lorenz
See **Hoffnass**

Hofreuter, Kaspar
See **Monograms HK and IK** [Nagler, *Mon.*] III, nos. 1170, 2682

Hogarth, William *(1697–1764)*
Trusler, John. *Hogarth moralized; being a complete edition of Hogarth's works; containing near fourscore copper-plates, most elegantly engraved; with an explanation pointing out the many beauties that may have hitherto escaped notice; and a comment on their moral tendency.* London: Jane Hogarth and S. Hooper, 1768.
Entries: 78. Described. Illustrated.

Walpole, Horace. *Anecdotes of painting in England; with some account of the principal artists; and incidental notes on other arts; collected by the late Mr. George Vertue; and now digested and published from his original mss.* Vol. IV, pp. 68–89 and appendix. Strawberry-Hill (England): Thomas Kirgate, 1771. (Several later editions).

Entries: 117+. Described (selection). List of additional prints, 2 pp. [27+ prints].

Nichols, John, et al. *Biographical anecdotes of William Hogarth; and a catalogue of his works chronologically arranged.* London: J. Nichols, 1781.
Entries: unnumbered, pp. 67–148, prints by and after. Inscriptions. States. Described (selection).

Ireland, John. *Hogarth illustrated.* 2 vols. London: J. and J. Boydell, 1791. *A supplement to Hogarth illustrated.* London: John Ireland, 1798. 2d eds., 1793, 1804. 3d eds., 1806, 1812.
Entries: unnumbered, vol. III, pp. 322–368, prints by and after. Described (selection). Illustrated (selection).

Nichols, John, and Steevens, George. *The genuine works of William Hogarth; illustrated with biographical anecdotes, a chronological catalogue and commentary.* 3 vols. London: Longman, Hurst, Rees and Orme, 1808–17.
Entries: unnumbered, vol. II, pp. 19–318, prints by and after. Inscriptions. States. Described. Illustrated (selection). Chronological catalogue to 1809; 54+ prints of uncertain date, 7 doubtful prints. Catalogue is principally by Steevens.

Nichols, J. B. *Anecdotes of William Hogarth, written by himself; with essays on his life and genius, and criticisms on his works, selected from Walpole, Gilpin, J. Ireland, Lamb, Philips, and others; to which are added a catalogue of his prints; account of their variations, and principal copies; lists of paintings, drawings, etc.* London: J. B. Nichols and son, 1833.
Entries: unnumbered, pp. 159–305, prints by and after; pp. 306–316, doubtful prints. Inscriptions. States. Described. Illustrated.

Dobson, Austin. *William Hogarth.* London, Sampson Low, Marston and Co., Ltd., 1879. Many later, expanded editions. Final ed. London: William Heinemann, 1907.
Entries: unnumbered, pp. 227–289 (1907 edition), prints by and after. Inches. Inscriptions. States. Illustrated (selection). Catalogue in 1879 edition, p. 113–120, lists titles only.

Fagan, Louis. "A list of the engravings by and after Hogarth." Unpublished ms. (EBM)
Entries: 355+ prints by and after. Inches. Inscriptions. States. Described. Copies mentioned.

Paulson, Ronald. *Hogarth's graphic works; first complete edition.* New Haven (Conn.): Yale University Press, 1965. 2d ed., rev., 1970.
Entries: 250 prints by and after, 39 doubtful prints. Inches. Inscriptions. States. Described. Illustrated. Revised edition incorporates the information in Paulson, 1967.

Paulson, Ronald. "New light on Hogarth's graphic works." [*Burl. M.*] 109 (1967): 281–286.
Additional information to Paulson, 1965.

Burke, Joseph, and Caldwell, Colin. *Hogarth; the complete engravings.* New York: Harry N. Abrams, Inc., 1968. German ed. *William Hogarth, das graphische Werk.* Vienna: Schroll, 1968.
Entries: 267 prints by and after. Inches. Described. Illustrated.

Hogeboom, A.
[H. *Neth.*] IX, p. 49.
Entries: 8.*

Hogenberg, Abraham *(fl. 1608–1653)*
[Merlo] pp. 358–363.

Hogenberg, Abraham (*continued*)

Entries: 27+. Paper fold measure (selection). Inscriptions (selection). Described (selection).

[W.] I, p. 713.
Entries: 6+.*

[H. *Neth.*] IX, p. 49.
Entries: 25.*

Hogenberg, Frans (*c.1540–c.1590*)
[Merlo] pp. 363–377.
Entries: 35+. Pre-metric (selection). Paper fold measure (selection). Inscriptions (selection). Described (selection).

[W.] I, pp. 713–714.
Entries: 14+.*

[Hind, *Engl.*] I, pp. 64–72.
Entries: 8+ (prints done in England only). Inches. Inscriptions. States. Described. Illustrated (selection). Located.

[H. *Neth.*] IX, pp. 50–55.
Entries: 131+. Illustrated (selection).*

Hogenberg, Hans [Johann] II (*b. c.1550*)
[Merlo] pp. 377–381.
Entries: 34+. Paper fold measure (selection). Inscriptions (selection). Described (selection).

[W.] I, p. 714.
Entries: 10+.*

[H. *Neth.*] IX, p. 56.
Entries: 77+.*

Hogenberg, Nicolas (*c.1500–1539*)
[H. *Neth.*] IX, pp. 57–64.
Entries: 75. Illustrated (selection).*

Hogenberg, Remigius (*c.1536–c.1588*)
See **Monogram RB** [Nagler, *Mon.*] IV, no. 3559

[W.] I, p. 714.
Entries: 9+.*

[Hind, *Engl.*] I, pp. 64–68, 73–78.
Entries: 11 (prints done in England only). Inches. Inscriptions. States. Described. Illustrated (selection).

[H. *Neth.*] IX, pp. 65–69.
Entries: 22+. Illustrated (selection).*

Holbein, Ambrosius (*1494?–c.1520*)
[P.] III, pp. 421–424.
Entries: 7+. Pre-metric. Inscriptions. Described.

Ms. catalogue. (EBM)
Entries: 21. Inscriptions. Described. Based on [P.], with some additions.

Woltmann, Alfred. *Holbein und seine Zeit; des Kunstlers Familie, Leben und Schaffen.* 2 vols. Leipzig: E. A. Seemann, 1874, 1876.
Entries: 42+. Millimeters. Inscriptions. States. Described. Located (selection).

Koegler, Hans. "Ergänzungen zum Holzschnittwerk des Hans und Ambrosius Holbein." [*JprK.*] 28 (1907): Beiheft, pp. 85–109.
Entries: 33+. Millimeters. Described (selection). Illustrated (selection).

Hes, Willy. *Ambrosius Holbein.* Studien zur deutschen Kunstgeschichte, Heft 145. Strasbourg: J. H. Ed. Heitz, 1911.
Entries: 24+ (woodcuts only). Millimeters. States. Described. Illustrated (selection).

Holbein, Hans I (*c.1465–1524*)
[Ge.] no. 874.
Entries: 1 (single-sheet woodcuts only). Described. Illustrated. Located.

Leib, Norbert, and Stange, Alfred. *Hans Holbein der ältere.* Munich: Deutscher Kunstverlag, 1960.
Entries: 1. Millimeters. Inscriptions. Described. Illustrated. Bibliography for each entry.

Holbein, Hans II *(1497/98–1543)*
[P.] III, pp. 353–421.
Entries: 114+ prints by, 29+ doubtful prints, 29+ rejected prints. Premetric (selection). Paper fold measure (selection). Inscriptions (selection). States. Described (selection). Located (selection). Copies mentioned.

Unpublished ms. catalogue. (EBM) Based on [P.] with additional information.

Woltmann, Alfred. *Holbein und seine Zeit; des Künstlers Familie, Leben und Schaffen.* 2 vols. Leipzig: E. A. Seemann, 1866, 1868). Millimeters. Inscriptions. 1876.
Entries (1874, 1876 edition): 270+. Millimeters. Inscriptions. States. Described (selection). Located (selection).

Woltmann, Alfred. "Nachträge zu dem Verzeichniss der Holzschnitte nach Hans Holbein dem Jüngeren." [*JKw.*] 4 (1871): 251–252.
Entries: 2 (additional to Woltmann 1866, 1868). Millimeters. Inscriptions. Described. Additional information to Woltmann 1866, 1868.

Duplessis, Georges. *Essai bibliographique sur les différentes éditions des "Icones veteris testamenti" d'Holbein.* Extract from *Mémoires de la Société nationale des antiquaires de France,* 44. Paris, 1884. (EPBN)
Additional information to previous catalogues.

Schmid, Heinrich Alfred. "Holbeins Thätigkeit für die Baseler Verleger." [*JprK.*] 20 (1899): 233–261.
Entries: unnumbered pp. 248–259 (early work for Basel publishers only). Millimeters (selection).

Schneeli, Gustav, and Heitz, Paul. *Initialen von Hans Holbein.* Strasbourg: J. H. Ed. Heitz, 1900. (NNMM)

Entries: 55+ (woodcut initials only). Illustrated (actual size). 55 complete or fragmentary alphabets of woodcut initials. Not all are given to Holbein II; some are attributed to Ambrosius Holbein and to Urs Graf.

Koegler, Hans. "Ergänzungen zum Holzschnittwerk des Hans und Ambrosius Holbein." [*JprK.*] 28 (1907): Beiheft, pp. 85–109.
Additional information to Schmid and Schneeli.

Koegler, Hans. "Hans Holbeins d. J. Holzschnitte für Sebastian Münsters 'Instrument über die zwei Lichter.' " [*JprK.*] 31 (1910): 247–268.
Entries: unnumbered, pp. 256–264 (additional to earlier catalogues). Millimeters Inscriptions. Described. Illustrated. Located.

Johnson, A. F. "The title-borders of Hans Holbein." *Gutenberg Jahrbuch* 12 (1937): 115–120.
Entries: 39 (title-borders only). Millimeters. Described. Copies mentioned.

Dodgson, Campbell. "Woodcuts designed by Holbein for English printers." *The Walpole Society Annual Volume* 27 (1938–1939): 1–11. "Additional note," *Annual Volume* 28 (1939–1940): 94.
Entries: unnumbered, pp. 1–10 (woodcuts and metalcuts done in England only). Millimeters. Inscriptions. States. Described. Illustrated (selection).

Hole, William *(fl. 1607–1624)*
[Hind, *Engl.*] II, pp. 316–340.
Entries: 35+. Inches. Inscriptions. States. Described. Illustrated (selection). Located.

Holl, Elias *(1573–1646)*
Hämmerle, Albert. "Der Kupferstecher und Maler Elias Holl." [*Schw. M.*] 1930, pp. 11–17.

Holl, Elias (*continued*)

Entries: 12. Millimeters. Inscriptions. Illustrated.

Holl, Francis (*1815–1884*)
[Ap.] pp. 201–202.
Entries: 5.*

Holl, William (*1807–1871*)
[Ap.] p. 202.
Entries: 4.*

Hollar, Wenzel (*1607–1677*)
Vertue, George. *A description of the works of the ingenious delineator and engraver Wenceslaus Hollar, disposed into classes of different sorts; with some account of his life.* London: G[eorge] V[ertue], 1745. 2d ed. London: William Bathoe, 1759.
Entries: 2383 (1759 edition). Paper fold measure (selection). Inscriptions (selection). Described. Additional information in 1759 edition.

Parthey, Gustav. *Wenzel Hollar; beschreibendes Verzeichniss seiner Kupferstiche.* Berlin: Verlag der Nicolaischen Buchhandlung, 1853. Reprint. Amsterdam: Meridian Publishing Co., 1963.
Entries: 2733. Pre-metric. Inscriptions. States. Described. Ms. notes by Parthey (EBKk, 2 copies); additional information. Ms. notes by the Rev. J. Burleigh-Jones (ECol); additional information. Ms. notes by J. C. J. Bierens de Haan (ERB); additional information.

Parthey, Gustav. *Kurzes Verzeichnis der Hollarschen Kupferstiche, Auszug aus dem grösseren Werke von G. Parthey.* Berlin: Verlag der Nicolaischen Buchhandlung, 1853.
Entries: 2733. Pre-metric. Abridged edition of Parthey 1853.

Parthey, Gustav. *Nachträge und Verbesserungen zum Verzeichnisse der Hollarschen Kupferstiche.* Berlin: Verlag der Nicolaischen Buchhandlung, 1858.
Additional information to Parthey 1853.

Sollmann, August. "Die Hollarsammlung des Herzogl. Kupferstichcabinets auf der Veste Coburg." [*N. Arch.*] 11 (1865): 224–255.
Entries: not consecutively numbered; additional to Parthey 1853. Pre-metric. Inscriptions. States. Described. Additional information to Parthey 1853. Discussion of papers used by Hollar.

Brunet, Gustave. "Catalogue raisonné de l'oeuvre de Wenzel Hollar, par Gustave Parthey." [*RUA.*] 20 (1865): 217–239.
Resumé of Parthey's catalogue, without numbers.

Parthey, Gustav. "Neue Nachträge zu Wenzel Hollar." [*N. Arch.*] 12 (1866): 189–191.
Entries: 11 (additional to Parthey 1853). Pre-metric. Inscriptions. Described.

[Wess.] I, pp. 137–139.
Entries: 1 (additional to Parthey 1853). Millimeters. Inscriptions. Described. Additional information to Parthey 1853.

[Merlo] pp. 382–421.
Entries: 70 (prints relating to Cologne only). Millimeters. Inscriptions. Described. Based on Parthey 1853.

Hiersemann, Karl W. *Wenzel Hollar, Verzeichniss einer Sammlung seltener Kupferstiche Wenzel Hollar's.* Leipzig: Karl W. Hiersemann, 1895. (EBr)
Additional information to Parthey 1853.

Borovský, F. A. *Wenzel Hollar; Ergänzungen zu G. Parthey's beschreibendem Verzeichniss seiner Kupferstiche.* Prague

(Bohemia): Landausschusse des König-
reichs Böhmen, 1898. (MBMu) Czech ed.
*Václav Hollar; doplůky ku G. Partheyovu
popisnému seznamu jeho rytin.*
Additional information to Parthey
1853.

Hind, Arthur M. *Wenceslaus Hollar and
his views of London and Windsor in the
seventeenth century.* London: John Lane,
The Bodley Head, 1922.
Entries: 132 (views of London and
Westminster only). Inches. Inscrip-
tions. States. Described. Illustrated.
Ms. notes by Hind (Dr. Maurice
Bloch, Los Angeles); additional in-
formation.

[H. *Neth.*] IX, pp. 70–74.
Entries: unnumbered, pp. 70–74
(prints after Dutch and Flemish artists
only).*

Hollenberg, Felix *(b. 1868)*
Schahl, Adolf. *Felix Hollenberg, das
graphische Werk, mit dem Werkverzeichnis
und 38 Abbildungen.* Schriftenreihe der
Hans-Thoma-Gesellschaft. Munich:
Karl Thiemig, 1968. (NN)
Entries: 362 etchings, 6 lithographs, 8
bookplates reproduced from draw-
ings. Millimeters. Inscriptions. Illus-
trated (selection).

Holloway, Thomas *(1748–1827)*
[Ap.] p. 202.
Entries: 1+.*

[Sm.] II, pp. 640–641.
Entries: 2 (portraits only). Inches. In-
scriptions. States. Described.

Holm, Åke *(20th cent.)*
Bergquist, Eric. "Åke Holm 70 År."
[*N. ExT.*] 22 (1970): 72–75.
Entries: 28 (bookplates only, to 1969).
Illustrated (selection).

Holm, Ebba *(20th cent.)*
Nyholm, Poul. "Ebba Holm" and
"Kronologisk Fortegnelse over Ebba
Holms exlibris." [*N. ExT.*] 2 (1947–1948):
21–23, 27–29.
Entries: 123 (bookplates only, to 1947).
Illustrated (selection).

Holroyd, Charles *(1861–1917)*
Dodgson, Campbell. "Sir Charles Hol-
royd's etchings." [*PCQ.*] 10 (1923):
309–344, 346–367.
Entries: 286. Inches. States. Described
(selection). Illustrated (selection).

Holsteyn, Cornelis *(1618–1658)*
[W.] I, pp. 701–702.
Entries: 1 print by, 5+ after.*

[H. *Neth.*] IX, p. 75.
Entries: 1 print by, 35 after. Illustrated
(prints by only).*

Holsteyn, Pieter II *(c.1614–1687)*
[W.] I, p. 702.
Entries: 27.*

[H. *Neth.*] IX, pp. 76–79.
Entries: 48. Illustrated (selection).*

Holtmann, Theodor *(fl. 1615–1630)*
[Merlo] p. 421.*

[Hind, *Engl.*] III, pp. 223–224.
Entries: 3 (prints done in England
only). Inches. Inscriptions. De-
scribed. Illustrated (selection). Lo-
cated.

Holzer, Johann Evangelist *(1709–1740)*
Hämmerle, Albert. "Joh. Evangelist
Holzer als Radierer." [*Schw. M.*] 1928,
pp. 147–158.
Entries: 22 prints by, 2 doubtful
prints. Millimeters. Inscriptions. De-
scribed. Illustrated. Located.

Holtzmüller, Heinrich *(fl. 1545–1559)*
[B.] IX, p. 400.

Holtzmüller, Heinrich (*continued*)

Entries: 3. Pre-metric. Inscriptions. Described.

[B.] IX, pp. 408–411.
Entries: 27. Pre-metric. Inscriptions. States. Described.

[P.] III, pp. 451–453.
Entries: 3 (additional to [B.]). Pre-metric. Inscriptions. Described.

Holzmeyer, Peter (*fl. 1551–1578*)
[P.] IV, pp. 230–231.
Entries: 6. Pre-metric (selection). Paper fold measure (selection). Inscriptions. Described (selection).

Homer, Winslow (*1836–1910*)
Richardson, E. P. "Winslow Homer's drawings in *Harper's Weekly.*" *Art in America* 19 (1930–1931): 38–47.
Entries: unnumbered, pp. 45–47, prints after (from *Harper's Weekly* only). Offprint (NN) with ms. notes; additional entries (from *Harper's Weekly* and from other sources); additional information (letters from Frank Jewett Mather and Frank Weitenkampf).

Foster, Allen Evarts." A check list of illustrations by Winslow Homer in *Harper's Weekly* and other periodicals." *Bulletin of the New York Public Library* 40 (1936): 842–852. Separately published. New York: New York Public Library, 1936.
Entries: 247 prints after (wood engravings only). Inscriptions.

Mather, Frank Jewett, Jr. "Winslow Homer as a book illustrator, with a descriptive checklist." *Princeton University Library Chronicle* 1 (November, 1938). Separately published. Princeton (N.J.), 1939.
Entries: 75 prints after (book illustrations only). Described (selection).

Foster, Allen Evarts. "A check list of illustrations by Winslow Homer appearing in various periodicals; a supplement." *Bulletin of the New York Public Library* 44 (1940): 537–539.
Entries: 34 prints after (wood engravings in periodicals only; additional to Foster 1936). Inscriptions.

Smith College Museum of Art [Mary Bartlett Cowdrey, compiler]. *Winslow Homer, illustrator; catalogue of the exhibition with a checklist of wood engravings and a list of illustrated books.* Northampton (Mass.), 1951.
Entries: 190 prints after (wood engravings in periodicals only). Inscriptions. Bibliography of books with illustrations by.

[Carey] p. 294.
Entries: 38 prints by, 1 after, (lithographs only). Inches (selection). Inscriptions. Described. Illustrated (selection). Located.

Museum of Graphic Art, New York [Lloyd Goodrich, compiler]. *The graphic art of Winslow Homer.* New York, 1968.
Entries: 16 (etchings only). Inches. Inscriptions. States. Illustrated. Located.

Gelman, Barbara. *The wood engravings of Winslow Homer.* New York: Bounty Books (Crown Publishers), 1969.
Entries: 284 prints after (wood engravings only). Inches. Illustrated (selection).

Tatham, David. "Some apprentice lithographs of Winslow Homer; ten pictorial pages for sheet music." *Old-time New England* 59, no. 4 (Spring 1969): 87–104.
Entries: 10 (apprentice lithographs only). Inches. Inscriptions. Described. Illustrated (selection). Located.

Homius, Joan *(fl. c.1686)*
[W.] I, p. 703.
Entries: 1.*

Hondecoeter, Gillis d' *(c.1580–1638)*
[W.] I, p. 703.
Entries: 1 print by, 5 after.*

[H. *Neth.*] IX, p. 80.
Entries: 2 prints by, 5 after.*

Hondecoeter, Melchior d' *(1636–1695)*
[W.] I, pp. 704–705.
Entries: 2 prints by, 2 after.*

[H. *Neth.*] IX, p. 81.
Entries: 2 prints by, 5 after. Illustrated (selection).*

Hondius, Abraham *(1625/30–1695)*
[B.] V, pp. 313–321.
Entries: 9. Pre-metric. Inscriptions. Described.

[Weigel] pp. 310–312.
Entries: 2 (additional to [B.]). Pre-metric. Inscriptions. Described.

[Dut.] V, pp. 25–28.
Entries: 12. Millimeters. Inscriptions. States. Described.

[W.] I, pp. 705–706.
Entries: 11+ prints by, 5 after.*

[H. *Neth.*] IX, pp. 81–84.
Entries: 14 prints by, 6 after. Illustrated (selection).

Hondius, Hendrik I *(1573–after 1648)*
[W.] I, pp. 706–707.
Entries: 35+ prints by, 4+ after.*

[H. *Neth.*] IX, pp. 85–91.
Entries: 162+ prints by, 18 after. Illustrated (selection).*

Hondius, Hendrik II *(1597?–1644)*
[W.] I, p. 707.
Entries: 43+.*

[H. *Neth.*] IX, pp. 92–95.
Entries: 63. Illustrated (selection).*

Hondius, Jodocus *(1563–c.1611)*
[W.] I, pp. 707–708.
Entries: 7.*

[Hind, *Engl.*] I, pp. 154–177; II, pp. 76–90.
Entries: 23+ (prints done in England only). Inches. Inscriptions. States. Described. Illustrated (selection). Located.

[H. *Neth.*] IX, pp. 96–99.
Entries: 99+. Illustrated (selection).*

Hondius, Willem *(c.1597–c.1660)*
Block, J. C. *Das Kupferstich-Werk des Wilhelm Hondius, mit alphabetischem und chronologischem Register.* Danzig (Germany): A. W. Kafemann, 1891.
Entries: 69. Millimeters. Inscriptions. States. Described. Located (selection). Ms. notes by J. C. J. Bierens de Haan (ERB); additional states, other information.

[W.] I, pp. 708–709.
Entries: 38+.*

[H. *Neth.*] IX, pp. 100–109.
Entries: 78+. Illustrated (selection).*

Hone, Nathaniel *(1718–1784)*
[Sm.] II, pp. 641–643, and "additions and corrections" section.
Entries: 4 (portraits only). Inches. Inscriptions. States. Described.

[Ru.] p. 151.
Additional information to [Sm.].

Honkanen, Helmiritta *(20th cent.)*
Mäkelä-Henriksson, Eeva. "Helmiritta Honkanen, en finsk exlibriskonstnär."
[N. *ExT.*] 20 (1968): 6–9, 16.
Entries: 68 (bookplates only, to 1967). Illustrated (selection).

Honthorst, Gerard [Gerrit] van *(1590–1656)*
[W.] I, pp. 709–712; III, p. 102.

Honthorst, Gerard van (*continued*)

Entries: 3 prints by, prints after are unnumbered, p. 712.*

[H. *Neth.*] IX, pp. 110–114.
Entries: 3 prints by, 88 after. Illustrated (selection).*

Judson, J. Richard. *Gerrit van Honthorst, a discussion of his position in Dutch art.* The Hague: Martinus Nijhoff, 1959.
Catalogue of paintings; prints after are mentioned where extant. Also, list of prints after, pp. 139–140, additional to [W.] and [H. *Neth.*].

Honthorst, Willem van (*1594–1666*)
[H. *Neth.*] IX, p. 114.

Hooch, Carel Cornelisz de (*c.1590–1638*)
[vdK.] pp. 179–180, 232.
Entries: 2. Millimeters. Inscriptions. Described. Illustrated (selection).

[W.] I, p. 715.
Entries: 3+.*

[H. *Neth.*] IX, pp. 115–116.
Entries: 32. Illustrated (selection).*

Hooch, Pieter de (*1629–after 1683*).
[W.] I, pp. 716–718.
Entries: 5 prints after.*

[H. *Neth.*] IX, p. 117.
Entries: 13 prints after.*

Hood, Thomas (*fl. 1582–1598*)
[Hind, *Engl.*] I, p. 150.
Entries: 1. Inches. Inscriptions. Described. Located.

Hoogerheyden, Engel (*1739–1809*)
[W.] I, pp. 714–715.
Entries: 1+.*

Hoogh
See **Hooch**

Hooghe, Cornelis de (*fl. 1563–1583*)
[Hind, *Engl.*] I, pp. 96–97.
Entries: 1 (prints done in England only). Paper fold measure. Inscriptions. Described. Located.

[H. *Neth.*] IX, p. 117.
Entries: 39.*

Hooghe, Romeyn de (*1645/46–1708*)
[Dut.] V, pp. 28–29, 593.*

[W.] I, pp. 718–719.
Entries: 60+ prints by, 2 after.*

[H. *Neth.*] IX, pp. 118–132.
Entries: 1136+. Illustrated (selection).*

Landwehr, John. *Romeyn de Hooghe (1645–1708) as book illustrator; a bibliography.* Amsterdam: Vangendt and Co., 1970.
Bibliography of books with illustrations by. Books are described; one or more prints from each are illustrated.

Hoogland, William (*fl. 1826–1841*)
[St.] pp. 236–240.*

[F.] pp. 144–145.*

Hoogstraten, Dirk van (*c.1596–1640*)
[W.] I, p. 720.
Entries: 3.*

[H. *Neth.*] IX, pp. 133–134.
Entries: 15. Illustrated (selection).*

Hoogstraten, S. van (*fl. c.1580*)
[H. *Neth.*] IX, p. 135.
Entries: 2. Illustrated.*

Hoogstraten, Samuel van (*1627–1678*)
[Wess.] II, pp. 238–239.
Entries: 6+ (additional to [Nagler] VI, p. 295). Millimeters. Inscriptions. Described.

[Rov.] pp. 69–70.

Entries: 6. Millimeters (selection). Inscriptions. States. Illustrated. Located.

[W.] I, pp. 720–722.
Entries: 15+ prints by, 12 after.*

[H. *Neth.*] IX, pp. 136–143.
Entries: 31+ prints by, 15 after. Illustrated (selection).*

Hooker, William *(fl. 1805–1840)*
[St.] pp. 240–241.*

[F.] pp. 146–147.*

Hoopwood, James *(fl. 1828–1850)*
[Ber.] VIII, pp. 124–125.*

Hoorbecke, Willem van *(fl. c.1584)*
[H. *Neth.*] IX, p. 143.
Entries: 1.*

Hoorn, Melchisedech van *(fl. 1550–1575)*
Hymans, Henri. "Un artiste anversois ignoré; Melchisedech van Hooren 1552–1570; notice accompagnée de reproductions." *Annales de l'Academie royale d'archéologie de Belgique* 51 (1898): 367–387. Separately published. Antwerp: Veuve de Backer, 1898. Reprint. In *Oeuvres,* by Henri Hymans. Vol. I, pp. 312–330. Brussels: M. Hayez, 1920–1921.
Entries: 7. Millimeters. Inscriptions. Described. Illustrated. Located. Not arranged as a catalogue, but describes all work known to the compiler.

[W.] I, p. 722.
Entries: 1.*

[H. *Neth.*] IX, p. 144.
Entries: 5. Illustrated (selection).*

Hoove, Frederik Hendrik van den *(c.1628–1698)*
[W.] I, p. 730.
Entries: 6.*

[H. *Neth.*] IX, pp. 145–146.
Entries: 38.*

Hopfer, Daniel I *(c.1470–1536)*
[B.] VIII, pp. 471–505.
Entries: 133. Pre-metric. Inscriptions. States. Described. Copies mentioned.

[Heller] pp. 64–66.
Entries: 2 (additional to [B.]). Pre-metric. Inscriptions. Described.

[P.] III, pp. 288–290.
Entries: 7 etchings (additional to [B.]), 1 woodcut. Pre-metric. Inscriptions. Described.

Eyssen, Ed. *Daniel Hopfer von Kaufbeuren, Meister zu Augsburg, 1493 bis 1536.* Dissertation, Heidelberg University. Heidelberg (Germany): Karl Rössler, 1904. (DLC)
Entries: 9+ woodcuts, 136 etchings. Millimeters. Inscriptions. States. Described.

"Zwei Inkunabeln der deutschen Radierung, I; eine Eisenradierung Daniel Hopfers." [*MGvK.*] 1910, pp. 35–36.
Entries: 1 (additional to Eyssen). Inscriptions. Described. Illustrated.

Hopfer, Hieronymus *(fl. 1525–1550)*
See also **Monogram IH** [Nagler, *Mon.*] III, no. 2503

[B.] VIII, pp. 471–472; 506–525.
Entries: 77. Pre-metric. Inscriptions. States. Described. Copies mentioned.

[P.] III, p. 288, 291.
Entries: 1 (additional to [B.]).

Hopfer, Lambert *(fl. c.1525)*
[B.] VIII, pp. 471–472; 526–533.
Entries: 34. Pre-metric. Inscriptions. Described.

Hopfer, Lambert (*continued*)

[P.] III, pp. 288, 291.
Entries: 1 (additional to [B.]). Pre-
metric. Inscriptions.

Hoppe, Grosspeitsch and Ehrentraut
(*19th cent.*)
[Dus.] p. 73.
Entries: 3 (lithographs only, to 1821).
Paper fold measure (selection).

Hopper, Edward (*1882–1967*)
Zigrosser, Carl. "The etchings of Ed-
ward Hopper." [*Pr.*] pp. 155–173. Sepa-
rately published. Philadelphia:
Philadelphia Museum of Art, 1962.
Entries: 52. Inches. States. Described.
Illustrated (selection). Located. Sepa-
rate publication has slightly different
selection of illustrations.

Hoppner, John (*1758–1810*)
[Sm.] II, pp. 643–644.
Entries: 2 (portraits only). Inches. In-
scriptions. Described.

McKay, William, and Roberts, W. *John
Hoppner, R.A.* London: P. and D. Col-
naghi and Co., George Bell and Sons,
1909.
Catalogue of paintings; prints after
are mentioned where extant.

Hopson, William Fowler (*b. 1849*)
Allen, Charles Dexter. *The book-plates of
William Fowler Hopson.* Extract from *The
Bookplate Booklet,* May 1910. Berkeley
(Calif.), 1910. 50 copies. (NN)
Entries: 102 (bookplates only; to
1910?).

Seymour, George Dudley. *William F.
Hopson and his bookplates.* Extract from
*The 1928 year book of the American Society of
Bookplate Collectors and Designers*
(Washington, D.C., 1928). Washington
(D.C.): Privately printed, 1929.

Entries: 201 (bookplates only, to 1929).
Ms. addition (NN); 1 additional entry.

Allen, Francis W. *The bookplates of Wil-
liam Fowler Hopson, a descriptive check list.*
New Haven (Conn.): Yale University
Library, 1961. 200 copies. (DLC)
Entries: 205 (bookplates only). Inches.
Inscriptions. Described. Illustrated
(selection).

Horemans, Jan Josef I (*1682–1759*)
[W.] I, pp. 722–723.
Entries: 1.*

Horemans, Jan Josef II (*1714–after 1790*)
[W.] I, p. 723.
Entries: 1 print after.*

Horenbault, Jacques (*fl. c.1608*)
[H. *Neth.*] IX, p. 146.
Entries: 1. Illustrated.*

Horlor, George W. (*19th cent.*)
[Siltzer] p. 331.
Entries: unnumbered, p. 331, prints
after. Inscriptions.

Hornby, Lester G. (*b. 1882*)
Holman, Louis Arthur. *Hornby's etchings
of the Great War, with a complete authorita-
tive list of all his plates, 1906–1920.*
Goodspeed's Monographs, 3. Boston
(Mass.): Charles E. Goodspeed and Co.,
1921.
Entries: 205. Located (selection).

Hornes, Jacques de (*c.1620–1674*)
[W.] I, p. 725.
Entries: 1 print after.*

Hornick, Erasmus (*fl. 1559–1582*)
[B.] IX, p. 499.
Entries: 1+. Pre-metric. Inscriptions.
Described.

[P.] IV, pp. 189–190.

Entries: 2+ (additional to [B.]). Premetric. Inscriptions. Described. Located.

Horst, Gerard van der *(1581–1629)*
[W.] I, p. 725.
 Entries: 3+ prints after.*

[H. *Neth.*] IX, p. 147.
 Entries: 12 prints after.*

Horst, Nicholaes van der *(1587–1646)*
[W.] I, p. 726.
 Entries: 17 prints after.*

[H. *Neth.*] IX, pp. 147–148.
 Entries: 71+ prints after.*

Horton, J. S. *(fl. 1830–1835)*
[St.] p. 242.*

[F.] p. 147.*

Hosemann, Theodor *(1807–1875)*
Hobrecker, Karl. Catalogue. In *Theodor Hosemann; ein Altmeister Berliner Malerei,* by Lothar Brieger. Munich: Delphin Verlag, 1920.
 Entries: 76 prints by, 96 commercial prints by. Paper fold measure. Described (selection). Also, bibliography of books with illustrations by.

Hostein, Édouard Jean Marie *(1804–1889)*
[Ber.] VIII, p. 126.*

Hoster, ——— *(19th cent.)*
[Ber.] VIII, p. 126.*

Hotelin, ——— *(19th cent.)*
[Ber.] VIII, p. 126.*

Hottinger, C. *(fl. c.1813)*
[Dus.] p. 74.
 Entries: 1+ (lithographs only, to 1821). Millimeters. Inscriptions. Located.

Houbigant, Armand Gustave *(1789–1862)*
[Ber.] VIII, pp. 126–127.*

Houbraken, Arnold *(1660–1719)*
[H. *Neth.*] IX, pp. 149–151.
 Entries: 168 prints by, 13 after. Illustrated (selection).*

Houbraken, Jakob *(1698–1780)*
Ver Huell, A. *Jacobus Houbraken et son oeuvre.* Arnhem (Netherlands): P. Gouda Quint, 1875. 2d ed. Arnhem (Netherlands): P. Gouda Quint, 1877.
 Entries: 490 portraits issued singly; other prints and sets of portraits unnumbered, pp. 92–129. Paper fold measure. Inscriptions. States (selection). Described. Ms. notes (EA); additional information.

Ver Huell, A. *Jacobus Houbraken et son oeuvre: supplément.* Arnhem (Netherlands): P. Gouda Quint, 1877.
 Additional information to Ver Huell 1875.

[Wess.] II, p. 239.
 Additional information to Ver Huell.

Distel, Theo. "Ein Nachtrag zum Houbraken-Kataloge." [ZbK.] n.s. 14 (1903): 22.
 Entries: 1 (additional to Ver Huell). Millimeters. Illustrated.

Houckgeest, Gerard
See **Hoeckgeest**

Houel, Jean Pierre Louis Laurent *(1735–1813)*
[Ber.] VIII, p. 127.*

Houlton, J. *(fl. c.1795)*
[St.] p. 242.*

Housman, R. *(18th cent.)*
[Ru.] p. 152.
 Entries: 1 (refers to [Sm.] IV, p. 1507).

Houston, H. H. *(fl. 1791–1798)*
[St.] pp. 242–245.*

[F.] p. 148.*

Houston, Richard *(c.1721–1775)*
[Sm.] II, pp. 644–702, and "additions and corrections" section; IV, "additions and corrections" section.
> Entries: 162 (portraits only). Inches. Inscriptions. States. Described. Illustrated (selection). Located (selection).

[Siltzer] p. 355.
> Entries: unnumbered, p. 355. Inscriptions.

[Ru.] pp. 152–164.
> Entries: 6 (portraits only, additional to [Sm.]). Inches. Inscriptions (selection). States. Described (selection). Additional information to [Sm.].

Houten, Barbara van *(b. 1862)*
Knuttel, Ir. G., Jr. *Barbara van Houten.* Amsterdam: Holland Uitgeversmaatschappij, 1948.
> Entries: 169. Millimeters. Described (selection). Illustrated (selection).

Houten, C. ten *(fl. 1600–1650)*
[H. *Neth.*] IX, p. 151.
> Entries: 1 print after.*

Houten, Jan Jacobsz van *(fl. c.1640)*
[H. *Neth.*] IX, p. 151.
> Entries: 3.*

Houtman, M. *(fl. c.1790)*
[W.] I, p. 730.
> Entries: 1.*

Houve, Paul de la *(17th cent.)*
[W.] I, p. 730.
> Entries: 1.*

Hove, Frederik Hendrik van den
See **Hoove**

Hove, Hubertus van *(1814–1865)*
[H. L.] pp. 487–488.
> Entries: 2 (etchings only). Millimeters. Inscriptions. States. Described.

How, R. *(19th cent.)*
[Siltzer] p. 355.
> Entries: unnumbered, p. 355. Inscriptions.

Howard, Frank *(1805–1866)*
[Siltzer] p. 331.
> Entries: unnumbered, p. 331. Inscriptions.

Howarth, Albany E. *(fl. 1906–1918)*
P. and D. Colnaghi and Obach. *Catalogue of original etchings, drypoints and mezzotints by Albany E. Howarth A.R.E.* London: P. and D. Colnaghi and Obach, 1912. (PJRo)
> Entries: 60 (to 1911). Inches. Illustrated.

Howe, James *(1780–1836)*
[Siltzer] p. 331.
> Entries: unnumbered, p. 331, prints after. Inches. Inscriptions.

Howen, C., chevalier de *(fl. 1808–1839)*
[H. L.] pp. 488–492.
> Entries: 12 (etchings only). Millimeters. Inscriptions. Described.

[W.] I, p. 731.
> Entries: 1 print after.*

Howitt, Samuel *(c.1765–1822)*
[Siltzer] pp. 160–165.
> Entries: unnumbered, pp. 162–165, prints by and after. Inches (selection). Inscriptions. States. Illustrated (selection). Located (selection).

Hoytema, Theo van *(1863–1917)*
Knuttel, Ir. G. *Theo van Hoytema.* The Hague: W. P. van Stockum en zoon, 1953.
> Entries: 90 single prints; prints for books and calendars unnumbered, pp. 37–40. Described (selection). Illustrated (selection).

Hrdlicka, Alfred *(b. 1928)*
Koller, Ernst et al. *Alfred Hrdlicka, Druckgraphik und Steinsculpturen mit Werk-Katalog von 1949–1963.* Salzburg (Austria): Verlag Galerie Welz, 1963.
Entries: 62 (to 1963). Millimeters. Described (selection). Illustrated (selection).

Prechtel, Michael Mathias et al. *Alfred Hrdlicka, das druckgraphische Werk.* Nuremberg: Albrecht Dürer Gesellschaft e. V., 1968.
Entries: 72 (to 1967). Millimeters. Illustrated.

Sotriffer, Kristian. *Alfred Hrdlicka, Randolectil; mit einem Werkkatalog sämtlicher Radierungen 1947 bis 1968.* Vienna: A. Schroll, 1969. 1200 copies. (DLC)
Entries: 201. Millimeters. States. Illustrated (selection).

Hubbuch, Karl *(20th cent.)*
Riester, Rudolf. *Karl Hubbuch, das graphische Werk.* Freiburg i. Br. (West Germany): Stadthalle, 1969.
Entries: 198. Millimeters. Inscriptions. States. Described (selection). Illustrated (selection). All prints not illustrated are described.

Huber, Wolfgang *(c.1490–1553)*
[B.] VII, pp. 485–486.
Entries: 9. Pre-metric. Inscriptions. Described.

[P.] III, pp. 305–306.
Entries: 6 (additional to [B.]). Pre-metric. Inscriptions. Described.

[Ge.] nos. 875–889.
Entries: 15 (single-sheet woodcuts only). Described. Illustrated. Located.

Heinzle, Erwin. *Wolf Huber; um 1485–1553.* Innsbruck (Austria): Universitätsverlag Wagner, [1953?].
Entries: 14. Millimeters. Inscriptions.

Illustrated (selection). Located. Bibliography for each entry.

Hubert, ——— *(fl. c.1835)*
[Ber.] VIII, p. 127.*

Hubert, Alfred *(1830–1902)*
[H. L.] pp. 492–497.
Entries: 9 (etchings only). Millimeters. Inscriptions. States. Described.

Huberti, Adriaen
See **Huybrechts**

Huchtenburg, Jan van *(1647–1733)*
[B.] V, pp. 403–433.
Entries: 50. Pre-metric. Inscriptions. Described.

[Dut.] V, pp. 29–30.*

[Weigel] pp. 316–320.
Entries: 1 (additional to [B.]). Pre-metric. Inscriptions.

[W.] I, pp. 731–733.
Entries: 50+ prints by, 2 after.*

[H. *Neth.*] IX, pp. 152–154.
Entries: 78 prints by, 4 after. Illustrated (selection).*

Hudson, Henry *(fl. 1782–1800)*
[Sm.] II, pp. 703–708, and "additions and corrections" section.
Entries: 13 (portraits only). Inches. Inscriptions. States. Described.

[Ru.] pp. 164–166, 493.
Entries: 1 (portraits only, additional to [Sm.]). Inches. Described. Additional information to [Sm.].

Hue, Charles Désiré *(fl. 1857–1883)*
[Ber.] VIII, pp. 127–128.*

Hueber, Johann Joseph Anton
Hämmerle, Albert. "Johann Joseph Anton Hueber als Radierer." [*Schw. M.*] 1925, pp. 125–129.

Hueber, Johann Joseph Anton (*continued*)

Entries: 4. Millimeters. Inscriptions. Described. Illustrated. Located.

Hübschmann, Donat (*before 1540–1583*)
Wünsch, Josef. "Der Wiener Maler und Formschneider Donat Hübschman und sein Holzschnittwerk." [*MGvK.*] 1913, pp. 1–13.
Entries: 52 prints by, 1 doubtful print. Millimeters. Inscriptions. Described. Illustrated (selection). Located.

Huell, Alexander Willem Maurits Carel ver (*1822–1897*)
Gouda Quint, P. *Alexander ver Huell en zijn werken; catalogus eener (op 3 platen na) geheel volledige verzameling van alle zoowel uitgegeven als niet in den handel gebrachte platen . . . bijeengebracht en beschreven door P. Gouda Quint, te Arnhem.* Arnhem (Netherlands): P. Gouda Quint, 1899.
Entries: 116+ prints after. Paper fold measure. Inscriptions (selection). Described (selection). Different editions of the same print are separately numbered.

Hürlimann, Johann (*1793–1850*)
[Ber.] VIII, p. 147.*

Huet, Hippolyte (*fl. c.1830*)
[Ber.] VIII, p. 128.*

Huet, Jean Baptiste (*b. 1772*)
Gabillot, C. *Les artistes célèbres; Les Huet.* Paris: L. Allison et Cie, 1892.
Entries: 12+. Paper fold measure.

Huet, Paul (*1803–1869*)
[Ber.] VIII, pp. 128–136.
Entries: 86 (etchings and lithographs only). Paper fold measure. Described (selection).

Hédiard, Germain. "Les maîtres de la lithographie; Paul Huet." *L'Artiste,* n.s.

1 (1891, no. 1): 1–13, 127–137. Separately published. Le Mans (France): E. Monnoyer, 1891.
Entries: 56 (lithographs only). Millimeters. Inscriptions. States. Described.

[Del.] VII.
Entries: 98 prints by, 2 doubtful and rejected prints. Millimeters. Inscriptions (selection). States. Described. Illustrated. Located (selection).

Huet, René Paul (*b. 1844*)
[Ber.] VIII, p. 137.*

Hueter, Simon (*b. c.1550*)
See **Monogram SF** [Nagler, *Mon.*] IV, no. 4082

Hützer, Johann Baptist (*c.1806–1871*)
[Merlo] p. 426.*

Huffam, A. W. (*fl. 1828–1832*)
[Siltzer] p. 355.
Entries: unnumbered, p. 355. Inscriptions.

Huguenet, Jacques Joseph (*b. 1815*)
[Ber.] VIII, pp. 137–138.*

Huguet, Jean Charles (*b. 1815*)
[Ber.] VIII, p. 138.*

Huijser, Carel Jacob de (*fl. 1766–1803*)
[W.] I, p. 739.
Entries: 1.*

Hulk, Abraham Jacobsz (*fl. 1772–1817*)
[Ber.] VIII, p. 138.

Hull, ――― (*19th cent.*)
[Siltzer] p. 332.
Entries: unnumbered, p. 332, prints after. Inches. Inscriptions.

Hull, Edward (*fl. 1827–1874*)
[Siltzer] p. 355.

Entries: unnumbered, p. 355, prints by and after. Inscriptions.

Hulle, Anselmus van *(1601–c.1674)*
[H. *Neth.*] IX, p. 154.
 Entries: 131 prints after.*

Hullmandel, Charles Joseph *(1789–1850)*
[Siltzer] p. 355.
 Entries: unnumbered, p. 355. Inscriptions.

Hulsen, Esaias van *(c.1570–before 1626)*
[W.] I, p. 735.
 Entries: 7+.*

[H. *Neth.*] IX, pp. 155–157.
 Entries: 199. Illustrated (selection).*

Hulsen, Frederik van *(c.1580–1665)*
[Hind, *Engl.*] III, pp. 213–215.
 Entries: 6+ (prints done in England). Inches. Inscriptions. Described. Illustrated (selection). Located.

[H. *Neth.*] IX, p. 158.
 Entries: 20+.*

Hulsman, Jan [Johann] *(fl. 1634–1644)*
[Merlo] pp. 427–434.
 Entries: 1 print by, 8 after. Paper fold measure (selection). Inscriptions (selection). Described (selection).

[W.] I, p. 735.
 Entries: 1.*

[H. *Neth.*] IX, p. 159.
 Entries: 8. Illustrated (selection).*

Hulst, Jan Baptist van der *(1790–1862)*
[W.] I, p. 736.
 Entries: 1 print after.*

Hulst, Pieter van der *(1651–1727)*
[vdK.] pp. 37–39.
 Entries: 1. Millimeters. Inscriptions. States. Described. Illustrated.

[W.] I, p. 736–737.
 Entries: 1 print by, 1 after.*

[H. *Neth.*] IX, p. 160.
 Entries: 2. Illustrated (selection).*

Hulstkamp, J. *(fl. c.1786)*
[W.] I, p. 736.
 Entries: 2.*

Hult, Pieter van der
See **Hulst**

Humbert, ——— *(19th cent.)*
[Dus.] p. 74.
 Entries: 1 (lithographs only, to 1821). Millimeters. Inscriptions. Located.

Humbert, Albert *(1835–1886)*
[Ber.] VIII, p. 139.*

Hummel, ——— *(19th cent.)*
[Dus.] p. 74.
 Entries: 1 (lithographs only, to 1821). Millimeters. Inscriptions. Described. Located.

Hummel, Carl *(c.1769–1840)*
Ruland, C. *Die Radierungen Carl Hummels.* Radierungen Weimarischer Künstler, 2. Weimar (Germany): Herman Böhlaus Nachfolger, 1905.
 Entries: 50. Millimeters. Inscriptions. States. Described.

Humphrey, William *(c.1740–c.1810)*
[Sm.] II, pp. 708–716, and "additions and corrections" section.
 Entries: 26 (portraits only). Inches. Inscriptions. States. Described.

[Ru.] pp. 166–168.
 Entries: 1 (portraits only, additional to [Sm.]). Inches. Inscriptions. Described. Additional information to [Sm.].

Humphry, Ozias *(1742–1810)*
Williamson, George C. *Life and works of Ozias Humphry, R.A.* London: John Lane, 1898. 400 copies. (PJRo)
Entries: unnumbered, p. 251, prints after. Inches. Described.

Humphrys, William *(1794–1865)*
[Ap.] p. 203.
Entries: 5.*

[St.] pp. 245–246.*

[F.] pp. 148–149.*

[Siltzer] p. 355.
Entries: unnumbered, p. 355. Inscriptions.

Hundertwasser, Friedrich *(b. 1928)*
Kestner-Gesellschaft, Hannover [Wieland Schmied, compiler]. *Hundertwasser; vollständiger Oeuvre-Katalog mit 100 farbigen Reproduktionen.* Hannover (West Germany), 1964.
Entries: 589 (works in various media, including prints, to 1964). Millimeters.

Hundeshagen, Bernhard *(1784–1858)*
[Dus.] p. 130.
Entries: 1+ (lithographs only, to 1821). Millimeters. Inscriptions. Located.

Hungermüller, Joseph *(1777–1820)*
[Dus.] p. 74.
Entries: 1 (lithographs only). Millimeters. Inscriptions. Described. Located.

Hunt, Charles *(fl. c.1840)*
[Ber.] VIII, p. 139.*

[Siltzer] pp. 165–166, 355–358.
Entries: unnumbered, pp. 165–166, 355–358, prints by and after. Inches (selection). Inscriptions.

Hunt, Charles and George *(19th cent.)*
[Siltzer] p. 359.

Entries: unnumbered, p. 359. Inscriptions.

Hunt, George *(fl. c.1825)*
[Siltzer] pp. 358–359.
Entries: unnumbered, pp. 358–359, prints by and after. Inscriptions.

Hunt, George, and **Mackrell,** J. R. *(19th cent.)*
[Siltzer] p. 359.
Entries: unnumbered, p. 359. Inscriptions.

Huot, Adolph *(1839–1883)*
[Ap.] p. 203.
Entries: 5.*

[Ber.] VIII, pp. 142–147.
Entries: 28. Paper fold measure. States. Described (selection).

Huot, François *(fl. 1782–1803)*
[L. D.] pp. 34–35.
Entries: 2. Millimeters. Inscriptions. States. Described. Incomplete catalogue.*

Huot, Georges Eugène *(fl. c.1875)*
[Ber.] VIII, p. 147.*

Huot, Gustave *(fl. 1854–1857)*
[Ber.] VIII, pp. 140–141.*

Hurd, Nathaniel *(1730–1770)*
[Allen] pp. 104–116.*

[St.] pp. 246–247.*

[F.] pp. 149–150.*

French, Hollis. *Jacob Hurd and his sons Nathaniel and Benjamin, silversmiths 1701–1781.* Cambridge: Walpole Society, 1939.
Entries: 15 prints other than bookplates. Inches. Inscriptions (selection). Described (selection). Bookplates, unnumbered, pp. 92–137.

Inscriptions. States. Described. Illustrated (selection).

French, Hollis. *Nathaniel Hurd's bookplates*. Extract from *The 1940–41 year book of the American Society of Bookplate Collectors and Designers*. Washington (D.C.), 1941. 100 copies. (NN)
 Entries: unnumbered, pp. 7–46 (bookplates only). Inscriptions. Described. Based on bookplate catalogue in French 1939.

Hurd, Peter *(b. 1904)*
 Meigs, John. *Peter Hurd; the lithographs*. Lubbock (Tex.): Baker Gallery Press, 1968. 2d ed., 1969.
 Entries: 58. (60 in second edition). Inches. States. Described. Illustrated. Different states of the same print are separately numbered.

Hurel, Charles *(fl. c.1643)*
 [RD.] VIII, p. 250.
 Entries: 1. Millimeters. Inscriptions. Described.

Hussenot, Joseph *(1827–1896)*
 [Ber.] VIII, p. 147.*

Hustin, G. *(fl. c.1625)*
 [Merlo] pp. 434–435.*

Hutin, Charles François *(1715–1776)*
 [Baud.] I, pp. 113–134.
 Entries: 36. Millimeters. Inscriptions. States. Described.

Hutin, François *(d. 1758)*
 [Baud.] II, pp. 135–142.
 Entries: 11. Millimeters. Inscriptions. States. Described.

Hutter, Wolfgang *(b. 1928)*
 Breicha, Otto. *Wolfgang Hutter, Essay und Werkkatalog*. Vienna: Verlag Jugend und Volk, 1969.
 Entries: 27. Millimeters. Illustrated.

Hutton, J. *(fl. c.1795)*
 [F.] p. 150.*

Hutty, Alfred *(b. 1878)*
 Crafton Collection. *Alfred Hutty*. American etchers, 2. New York: T. Spencer Hutson, 1929.
 Entries: unnumbered, 1 p. (to 1929). Inches. Illustrated (selection).

Huyberts, Cornelis *(1669/70–c.1712)*
 [W.] I, pp. 737–738.
 Entries: 2+.*

Huybrechts, Adriaen I *(fl. 1573–1614)*
 [W.] I, p. 731.
 Entries: 1.*

Huybrechts, Nicolas *(fl. c.1673)*
 [H. *Neth.*] IX, p. 161.
 Entries: 1 print after.*

Huybrechts, Pieter *(1614–c.1660)*
 [W.] I, p. 738.
 Entries: 2.*

 [H. *Neth.*] IX, p. 161.
 Entries: 9+.*

Huygens, Christian *(1629–1695)*
 [W.] I, p. 738.
 Entries: 1 print after.*

 [H. *Neth.*] IX, p. 161.
 Entries: 1 print after.*

Huyot, Jules *(b. 1821)*
 [Ber.] VIII, p. 148.*

Huys, Frans *(1522–1562)*
 [W.] I, pp. 738–739.
 Entries: 21+.*

 [H. *Neth.*] IX, pp. 162–168.
 Entries: 133. Illustrated (selection).*

Ramaix, Isabelle de. "Catalogue de l'oeuvre gravé de Frans Huys." *Le livre et l'estampe*, nos. 55–56 (1968): 258–293; *Le livre et l'estampe*, nos. 57–58 (1969):

Huys, Frans *(continued)*

23–54. Separately published. *Frans
Huys, catalogue de l'oeuvre gravé.* n.p.,
n.d. (NNMM)
Entries: 117. Millimeters. Inscriptions.
States. Described. Illustrated (selec-
tion). Located.

Huys, Pieter *(fl. 1545–1577)*
[B.] IX, pp. 86–88.
Entries: 12. Pre-metric. Inscriptions.
Described.

[P.] III, pp. 107–108.
Entries: 2 (additional to [B.]). Pre-
metric. Inscriptions. Described. Lo-
cated.

[W.] I, p. 739.
Entries: 5+.*

[H. *Neth.*] IX, pp. 169–172.
Entries: 26. Illustrated (selection).*

Huyser, Carel Jacob
See **Huijser**

Huysmans, Constantinus Cornelis
(1810–1886)
[H. L.] pp. 497–498.
Entries: 2. Millimeters. Inscriptions.
States. Described.

Huysmans, Cornelis *(1648–1727)*
[W.] I, p. 739.
Entries: 2 prints after.*

[H. *Neth.*] IX, p. 173.
Entries: 4.*

Huysmans, Jacob *(1633–1696)*
[W.] I, pp. 739–740.
Entries: 1 print after.*

[H. *Neth.*] IX, p. 173.
Entries: 2 prints after.*

Huyssens, Pieter *(1577–1637)*
[H. *Neth.*] IX, p. 173.
Entries: 1 print after.*

Huysum, Caspar van *(fl. c.1682)*
[H. *Neth.*] IX, p. 173.
Entries: 1.*

Huysum, Jan van *(1682–1749)*
[W.] I, pp. 740–741.
Entries: 13+ prints after.*

[H. *Neth.*] IX, p. 174.
Entries: 31 prints after.*

Huysum, Justus II van *(1685–1707)*
[W.] I, p. 742.
Entries: 1 print after.*

[H. *Neth.*] IX, p. 175.
Entries: 1 print after.*

Hyde, Helen *(1868–1919)*
Jacques, Bertha E. *Helen Hyde and her
work.* Chicago (Ill.): Libby Company
Printers, 1922.
Entries: unnumbered, pp. 32–40. De-
scribed.

Hymans, Henri *(1836–1912)*
Rooses, Max. Catalogue. In *Oeuvres,* by
Henri Hymans. Vol. I, pp. 41–42. Brus-
sels: M. Hayez, 1920–1921.
Entries: 24.

Hyning, Hans
See **Hysing**

Hyrtl, Jacob *(1799–1868)*
[Ap.] p. 203.
Entries: 1.*

Hysing, Hans *(1678–1752/53)*
[W.] I, p. 742.
Entries: 1 print after.*

Nisser, Wilhelm. *Michael Dahl and the
contemporary Swedish school of painting in
England.* Uppsala (Sweden): Almquist
and Wiksell, 1927.
Entries: 22 prints after. Described.

I

Ibbetson, Julius Caesar *(1759–1817)*
[Siltzer] p. 166.
 Entries: unnumbered, p. 166, prints
 after. Inscriptions.

Ibbot, R. *(fl. c.1783)*
[Ru.] p. 168.
 Entries: 1 (portraits only). Inches. In-
 scriptions. Described.

Ihle, Johann Eberhard *(1727–1814)*
[A.] V, pp. 327–331.
 Entries: 2. Pre-metric. Inscriptions.
 States. Described.

Ihle, Svend Erik *(20th cent.)*
Mollerup, Svend Aage. "Svend Erik
Ihle, en jydsk exlibriskunstner."
[*N. ExT.*] 7 (1955): 120–122.
 Entries: 17 (bookplates only, to 1955).
 Illustrated (selection).

Ijkens, Peter *(1648–1695)*
[H. *Neth.*] IX, p. 196.
 Entries: 2 prints after.*

Illaire, H. *(19th cent.)*
[Dus.] p. 74.
 Entries: 1 (lithographs only, to 1821).
 Paper fold measure.

Illies, Arthur *(b. 1870)*
[Sch.] p. 65ff.
 Entries: 92 (to 1904). Not seen. Infor-
 mation taken from Schiefler and
 Schack 1970.

Duve-Stockholm, Helmuth. "Arthur Il-
lies, der Graphiker." [*Kh.*] 14 (1922):
8–15, 30–34.
 Entries: 199 (to 1921). Millimeters.

Schiefler, G., and Schack, Gerhard.
*Das graphische Werk von Arthur Illies,
1894–1904.* Hamburg: H. Christians,
1970.
 Entries: 92 (to 1904). Millimeters. In-
 scriptions. States. Described. Illus-
 trated. Based on [Sch.] with addi-
 tional information. Also, list of 283
 prints after 1904, to 1950 (titles and
 dimensions only), compiled by Illies.

Imhoff, ——— von *(19th cent.)*
[Dus.] pp. 74–75.
 Entries: 3 (lithographs only, to 1821).
 Millimeters (selection). Paper fold
 measure (selection). Inscriptions
 (selection). Located (selection).

Immenraet, Jan [Carel] *(fl. c.1662)*
[Wess.] II, p. 239.
 Entries: 2. Millimeters. Inscriptions.
 Described.

[H. *Neth.*] IX, p. 196.
 Entries: 2. Illustrated.*

Immenraet, Philips Augustyn *(1627–1679)*
[W.] I, p. 757.
 Entries: 9 prints by, 2 after.*

[H. *Neth.*] IX, pp. 197–198.
 Entries: 8 prints by, 2 after. Illustrated
 (prints by only).*

Immerzeel, Christiaan *(1808–1886)*
[H. L.] p. 498.
> Entries: 1. Millimeters. Inscriptions.
> States. Described.

Immstraet, J.
See **Immenraet,** Jan [Carel]

Imperiale, Gerolamo *(d. c.1639)*
[B.] XX, pp. 119–122.
> Entries: 4. Pre-metric. Inscriptions.
> Described.

Imschoot, Jules [A. J.] *(1821–1884)*
[H. L.] pp. 499–500.
> Entries: 5. Millimeters. Inscriptions.
> States. Described.

Indiana, Robert *(b. 1928)*
St. Mary's College. *Robert Indiana, graphics; an exhibition organized by the Department of Art of Saint Mary's College.* Notre Dame (Ind.), 1969.
> Entries: 50 (prints by, and posters by and after; to 1969). Inches. Illustrated (selection).

Katz, William, and Indiana, Robert. *Robert Indiana; Druckgraphik und Plakate 1961–1971; the prints and posters 1961–1971.* Stuttgart and New York: Domberger, 1971.
> Entries: 40 prints by, 21 posters by and after (to 1971). Inches. Millimeters. Illustrated.

Ingelrams, Cornelis *(c.1527–1580)*
[W.] I, pp. 757–758.
> Entries: 1+ prints after.*

[H. *Neth.*] IX, p. 198.
> Entries: 4 prints after.*

Ingen, Willem [Guilelmo] van *(1651–1708)*
[W.] I, p. 758.
> Entries: 1 print after.*

[H. *Neth.*] IX, p. 198.
> Entries: 3 prints after.*

Ingouf, François Robert *(1747–1812)*
[Ap.] pp. 208–209.
> Entries: 13.*

[Ber.] VIII, p. 148.*

[L. D.] pp. 35–36.
> Entries: 6. Millimeters. Inscriptions.
> States. Described. Illustrated (selection). Incomplete catalogue.*

Ingres, Jean Auguste Dominique *(1780–1867)*
Blanc, Charles. *Ingres, sa vie et ses ouvrages.* Paris: Veuve Jules Renouard, 1870.
> Entries: unnumbered, pp. 245–247, prints after. Described.

Delaborde, Henri. *Ingres, sa vie, ses travaux, sa doctrine.* Paris: Henri Plon, 1870.
> Entries: 4. Inscriptions. States. Described.

Duplessis, Georges. "Une lithographie inconnue de J. A. D. Ingres." [*GBA.*] 2d ser. 24 (1881): 273–275.
> Entries: 1 (additional to Delaborde). Described. Illustrated.

[Ber.] VIII, pp. 148–151.
> Entries: 5. Paper fold measure. Inscriptions. States. Also, list of prints after, unnumbered, pp. 150–151 (complete?).

[Del.] III.
> Entries: 9. Millimeters. Inscriptions. States. Described (selection). Illustrated (selection). Located (selection). Appendix adds 2 states to [Del.] 6.

Schwarz, Heinrich. Die Lithographien J. A. D. Ingres." [*MGvK.*] 1926: 74–79.
> Additional information to [Del.].

Schwarz, Heinrich. "Ingres graveur." [*GBA.*] 6th ser. 54 (1959): 329–342.
> Additional information to [Del.].

Naef, Hans. "Ingres as Lithographer."
[Burl. M.] 108 (1966): 476–479.
Additional information to [Del.].

Inman, Henry *(1801–1846)*
Bolton, Theodore. "A catalogue of the
paintings of Henry Inman." *Art Quar-
terly* 3 (1940): 401–418.
Catalogue of paintings and drawings;
prints after are mentioned where
extant.

[Carey], p. 302.
Entries: 6 (lithographs only). Inches.
Inscriptions. Described. Located.

Iordan, Fedor Ivanovich *(1800–1883)*
Vinogradov'', S. P. *Zapiski rektora i pro-
fessora Akademii Khudozestv'' Fedora
Ivanovicha Iordan''.* Moscow:
Gosudarstvennaja Tipografija, 1918.
Entries: 72. Millimeters. Inscriptions.
States. Described. Illustrated (selec-
tion).

Isaacsz, Isaac *(1599–1649)*
[W.] I, pp. 774–775.
Entries: 2 prints after.*

[H. *Neth.*] IX, p. 231.
Entries: 9 prints after.*

Isaacsz, Jasper de *(d. 1654)*
[W.] I, p. 774.
Entries: 4.*

[H. *Neth.*] IX, pp. 229–230.
Entries: 62+.*

Isaacsz, Pieter Fransz *(1569–1625)*
[W.] I, p. 775.
Entries: 6 prints after.*

[H. *Neth.*] IX, p. 231.
Entries: 7 prints after.*

Isabey, Eugène *(1803–1886)*
[Ber.] VIII, pp. 157–159.*

Hédiard, Germain. *Les Maîtres de la
lithographie; Eugène Isabey, étude suivie du
catalogue de son oeuvre.* Paris: Loys Del-
teil, 1906.
Entries: 83 prints by, 1 doubtful print.
Millimeters. Inscriptions. States. De-
scribed.

Curtis, Atherton. *Catalogue de l'oeuvre
lithographié de Eugène Isabey.* Paris: Paul
Prouté, 1939. 300 copies. (MBMu)
Entries: 109. Millimeters. Inscriptions.
States. Described. Illustrated. Lo-
cated (selection).

Isabey, Jean Baptiste *(1767–1855)*
Villars, F. de. "Oeuvre lithographique
de J. Isabey." [*RUA.*] 17 (1863): 73–89.
Entries: 78. Millimeters (selection).
Described.

[Ber.] VIII, pp. 151–156.*

Hédiard, Germain. "Les Maîtres de la
lithographie; J. B. Isabey." *L'Artiste*, n.s.
10 (1895, no. 2): 81–90, 214–231. Sepa-
rately published. Chateaudun (France):
Imprimerie de la Société Typogra-
phique, 1896.
Entries: 92. Millimeters. Inscriptions.
States. Described.

Basily-Callimaki, Mme. de. *J. B. Isabey,
sa vie, son temps, suivi du catalogue de
l'oeuvre gravé par et d'apres Isabey.* 2 vols.
Paris: Frazier-Soye, 1909. 550 copies.
(MH)
Entries: 291 prints by and after. Milli-
meters. Inscriptions. States. De-
scribed.

Isenburg, Karl von *(19th cent.)*
[Dus.] p. 75.
Entries: 1 (lithographs only, to 1821).
Millimeters. Inscriptions. Located.

Iserenhodt, Anton
See **Eisenhoit**

Israëls, Jozef *(1824–1911)*
[Ber.] VIII, p. 159.*

Zilcken, Ph. *Essai de catalogue descriptif des eaux-fortes de Jozef Israels.* The Hague: 1890.
 Entries: 25 (to 1890?). Millimeters. Inscriptions. States. Described.

Zilcken, Ph. Catalogue. In *Jozef Israels, l'homme et l'artiste . . . avec un essai de catalogue descriptif des eaux-fortes,* by Fr. Netscher. Amsterdam: J. M. Schalekamp, 1890. 2d ed. Buiksloot (Netherlands), 1903.
 Entries: 25 (to 1890). Millimeters. Inscriptions. States. Described.

Zilcken, Ph. *Peintres hollandais modernes.* Amsterdam: J. M. Schalekamp, 1893.
 Entries: 25 (to 1890). Millimeters. Inscriptions. Described.

Hubert, H. J. *De etsen van Jozef Israels, een catalogus.* Amsterdam: Scheltema en Holkema's Boekhandel, 1909. 275 copies. (EUD). English ed. *The etched work of Jozef Israels, an illustrated catalogue.* Amsterdam: Scheltema en Holkemas Boeckhandel, 1910. 280 copies. (NN)
 Entries: 37 (etchings only). Millimeters. Inscriptions. States. Described.

Illustrated. Appendix mentions lithographs by; 1 is reproduced.

Roeper, Adalbert. [*Kh.*] 3 (1911): 14ff. Not seen.

Isselburg, Peter *(c.1580–c.1630)*
[Merlo] pp. 453–473.
 Entries: 429. Pre-metric (selection). Paper fold measure (selection). Inscriptions. Described (selection).

Isselsteyn, Adriaen van *(fl. 1653–1684)*
[H. *Neth.*] IX, p. 232.
 Entries: 1 print after.*

Italia, Salomon *(1619–1655?)*
Narkiss, M. "Yetsuruto shel shalom BKMR Mordechai Italia (1619–1655?) [The oeuvre of the Jewish engraver Salom Italia (1619–1655?)]." *Tarbiz* 25 (1955–1956): 441–451; *Tarbiz* 26 (1956–1957): 87–101.
 Entries: 18. Millimeters. Inscriptions. Described. Illustrated (selection). Detailed summary in English: *Tarbiz,* 26: v–viii.

Ivara, Filippo
See **Juvara**

J

Jaapix, Jan *(fl. c.1687)*
[W.] I, p. 743.
 Entries: 1.*

[H. *Neth.*] IX, p. 175.
 Entries: 1.*

Jaccop *(fl. c.1522)*
[P.] III, p. 287.

 Entries: 1. Pre-metric. Inscriptions. Described. Located.

Jáck, ——— *(19th cent.)*
[Dus.] p. 75.
 Entries: 1 (lithographs only, to 1821).

Jackson, ——— *(fl. c.1826)*
[F.] p. 150.*

Jackson, John Baptist *(1701–1780)*
Kainen, Jacob. *John Baptist Jackson; 18th-century master of the color woodcut,* Smithsonian Institution Bulletin 222. Washington (D.C.): Smithsonian Institution, 1962.
Entries: 58 prints by, 16 workshop prints, 5 prints not seen by Kainen. Inches. Inscriptions. States. Described. Illustrated. Located.

Jackson, Michael *(fl. 1736–1753)*
[Sm.] II, pp. 716–718.
Entries: 4 (portraits only). Inches. Inscriptions. States. Described.

[Ru.] p. 169.
Entries: 1 (portraits only, additional to [Sm.]). Inches. Inscriptions. Described. Additional information to [SM.].

Jacob, Max *(fl. 1907–1923)*
Thomé, J. R. "Max Jacob illustrateur." *Portique* 5 (1947): 51–64.
Bibliography of books with illustrations by (to 1946).

Jacob, Nicolas Henri *(1782–1871?)*
[Ber.] VIII, p. 159.*

Jacobé, Johann [John] *(1733–1797)*
[Sm.] II, pp. 719–722, and "additions and corrections" section.
Entries: 7 (portraits only). Inches. Inscriptions. States. Described. Located (selection).

[Ru.] pp. 169–170.
Additional information to [Sm.].

Jacobi, Abraham
See **Jacobsz**

Jacobsen, Carl Otto *(20th cent.)*
Fogedgaard, Helmer. "Carl Otto Jacobsen og hans portraet-exlibris." [*N. ExT.*] 19 (1967): 91–93.

Entries: 13 (bookplates only, to 1967?). Illustrated (selection).

Jacobsz, Abraham *(fl. c.1639)*
[W.] I, p. 743.
Entries: 2.*

[H. *Neth.*] IX, p. 175.
Entries: 2. Illustrated (selection).*

Jacobsz, Jan *(b. 1649)*
[H. *Neth.*] IX, p. 176.
Entries: 5. Illustrated (selection).*

Jacobsz, Lambert *(c.1600–1637)*
[W.] I, pp. 744–745.
Entries: 2 prints after.*

[H. *Neth.*] IX, p. 176.
Entries: 2 prints after.*

Jacoby, Louis *(1828–1918)*
[Ap.] pp. 204–205.
Entries: 19.*

Roeper, Adalbert. "Louis Jacoby; zum achtzigsten Geburtstage des Künstlers." [*Bb.*] 75, no. 131 (9 June 1908): 6367–6371. Separately bound copy. (NN)
Entries: 63. Millimeters. States.

Roeper, Adalbert. "Louis Jacoby und sein Werk." [*Kh.*] 11 (1919): 6–10.
Entries: 63. Millimeters. States. Described.

Jacomin, Jean Marie *(1789–1858)*
[Ber.] VIII, p. 160.*

Jacott, Jean Julien *(fl. 1845–1884)*
[Ber.] VIII, p. 160.*

Jacottet, Jean *(b. 1806)*
[Ber.] VIII, pp. 160–162.*

Jacquand, Claude *(1805–1878)*
[Ber.] VIII, p. 162.*

Jacquard, Antoine *(d. c.1640)*
Clouzot, Henri. *Antoine Jacquard et les graveurs poitevins au XVIIe siècle.* Extract from *Bulletin du Bibliophile.* Paris: Librarie Henri Leclerc,1906. 100 copies. (EPBN)
> Entries: 90. Millimeters. Inscriptions (selection). Described (selection). Located.

Jacquart, Claude II *(1686–1736)*
Beaupré, J. N. "Notice sur quelques graveurs nancéiens du XVIIIe siècle et sur leurs ouvrages." [*Mém. lorraine*] 2d ser. 9 (1867): 234–240. Separately published. n.p., n.d.
> Entries: 4. Millimeters. Inscriptions. Described.

Jacque, Charles Émile *(1813–1894)*
Guiffrey, J. J. *L'Oeuvre de Ch. Jacque; catalogue de ses eaux-fortes et pointes sèches.* Paris: Mlle Lemaire, 1866.
> Entries: 420 (to 1866). Millimeters. Inscriptions. States. Described. Copy (EBM) extensively illustrated with marginal sketches of the prints.

Nouvelles eaux-fortes et pointes sèches de Charles Jacque; 1884; supplément au catalogue dressé par J. J. Guiffrey. Paris: Imprimerie Jouaust et Sigaux, [1884?].
> Entries: 35 etchings, 8 drypoints (additional to Guiffrey, to 1884). Millimeters. Inscriptions. States. Described.

[Ber.] VIII, pp. 162–192.
> Entries: 487 (to 1889?). Paper fold measure. States. Based largely on Guiffrey.

Prouté, Paul. Catalogue in preparation. Not seen.

Jacque, Frédéric *(b. 1859)*
[Ber.] VIII, p. 192.*

Jacquelart, Lambert *(b. 1820)*
[H. L.] pp. 501–505.
> Entries: 15. Millimeters. Inscriptions. States. Described.

Jacquemart, Jules Ferdinand *(1837–1880)*
Gonse, Louis. "Les graveurs contemporains; Jules Jacquemart." [*GBA.*] 2d ser. 11 (1875): 559–572; [*GBA.*] 2d ser. 12 (1875): 69–80, 240–250, 326–340, 527–540; [*GBA.*] 2d ser. 13 (1876): 471–482, 671–685. Separately published. *L'Oeuvre de Jules Jacquemart.* Paris: Gazette des Beaux-Arts, 1876. 60 copies. (MBMu)
> Entries: 378. Millimeters. States. Described. Illustrated (selection).

Gonse, Louis: "L'Oeuvre de Jules Jacquemart; appendice." [*GBA.*] 2d ser. 22 (1880): 530–535; [*GBA.*] 2d ser. 23 (1881): 218–224; [*GBA.*] 2d ser. 24 (1881): 433–450. Separately published. Paris: *Gazette des Beaux-Arts,* 1881. 60 copies. (MBMu)
> Entries: 17 (additional to Gonse 1876). Millimeters. States. Described. Illustrated (selection).

[Ber.] VIII, pp. 192–213.
> Entries: 396. Paper fold measure. Based on Gonse.

Jacquemin, Cyprien *(fl. 1836–1859)*
[Ber.] VIII, pp. 213–214.*

Jacquemin, Raphaël *(1821–1881)*
[Ber.] VIII, p. 214.*

Jacquet, Achille *(1846–1908)*
[Ber.] VIII, pp. 217–219.
> Entries: 27. Paper fold measure.

Jacquet, Jules *(1841–1913)*
[Ap.] p. 205.
> Entries: 4.*

[Ber.] VIII, pp. 214–216.

Entries: 39 (to 1889). Paper fold measure.

Jacquinot, Louise Françoise *(fl. c.1800)*
[Ber.] VIII, p. 219.*

Jadin, [Louis] Godefroy *(1805–1882)*
[Ber.] VIII, p. 220.*

Jaern, Albert *(fl. c.1937)*
Schyberg, Thor Bjørn. "Kunstner fortegnelser I; Albert Jaern." [*N. ExT.*] 10 (1958): 39.
Entries: 417 (bookplates only, to 1945?). Illustrated (selection).

Schyberg, Thor Bjørn. "Ny-oppdagede exlibris av Albert Jaern." [*N. ExT.*] 16 (1964): 15–16.
Entries: 13 (bookplates only, additional to Schyberg 1958).

Jager, Michel de *(d. 1684)*
[W.] I, pp. 745–746.
Entries: 1.*

Jahn, Georg *(b. 1869)*
Mestern, Erwin. "Georg Jahn." [*Bb.*] 77 (1910): 13696–13698.
Entries: 120 (to 1910). Millimeters. States.

Roeper, Adalbert. [*Kh.*] 2 (1910): 122ff.
Not seen.

Jaime, Ernest *(c.1802–1884)*
[Ber.] VIII, pp. 220–221.*

Jakac, Božidar [Theodor] *(b. 1899)*
Moderna Galerija, Ljubljana [Karel Dobida, compiler]. *Božidar Jakac grafika; retrospektivna izložba.* Ljubljana (Yugoslavia), 1954.
Entries: 166 (to 1953; complete?). Illustrated (selection).

Jalhea, Pierre
See **Furnius,** Pieter

Jamaer, Hendrik Frans
See **Diamaer**

James, J. *(fl. 1750–1800)*
[Sm.] II, p. 722.
Entries: 2 (portraits only). Inches. Inscriptions. Described.

James, P. *(18th cent.)*
[Ru.] p. 170.
Entries: 1 (portraits only). Inches. Inscriptions. Described.

James, W. *(fl. c.1750)*
[Sm.] II, p. 723.
Entries: 1 (portraits only). Inches. Inscriptions. Described.

Jammers, Hendrik Frans
See **Diamaer**

Jamnitzer, Christoph *(1563–1618)*
[A.] IV, pp. 242–264.
Entries: 62. Pre-metric. Inscriptions. Described.

Jandelle, Eugène Claude *(fl. 1848–1870)*
[Ber.] VIII, p. 221.*

Janet, Ange Louis *(1815–1872)*
[Ber.] VIII, pp. 221–222.*

Janet, Gustave *(b.1829)*
[Ber.] VIII, p. 222.*

Janinet, Jean François *(1752–1814)*
[Ber.] VIII, p. 222.*

Janinet, Sophie
See **Giacomelli**

Janousek, Dusan *(20th cent.)*
Zakravsky, Stepan: "Dusan Janousek, en czekisk grafiker." [*N. ExT.*] 15 (1963): 68–71.
Entries: 40 (bookplates only, to 1963). Millimeters. Illustrated (selection).

Janscha, Laurenz
See **Schütz,** Karl

Jansen, Gerhard *(1636–1725)*
[W.] I, p. 749.
Entries: 7.*

Seyler, Alfred. "Neues zu Gerard
Janssen." [*GK.*] n.s. 4 (1939): 5–7.
Entries: 2 (additional to [Nagler,
Mon.] II, no. 3100). Millimeters. In-
scriptions. Illustrated.

Jansen, Johann Philip *(fl. c.1630)*
[W.] I, p. 751.
Entries: 3.*

[H. *Neth.*] IX, p. 180.
Entries: 4.*

Janson, Jacobus
See **Janson,** Johannes

Janson, Johannes *(1729–1784)*
Auction catalogue; J. van Buren collec-
tion. The Hague, November 7, 1808.
([Lugt, *Ventes*] II, 7474). Ms. copy. (EA)
Entries: 39+. Described (selection).
Includes prints not in [H. L.].

[H. L.] pp. 505–518.
Entries: 44. Millimeters. Inscriptions.
Described.

[W] I, p. 751.
Entries: 4+.*

Janson, Johannes Christianus *(1763–1823)*
Auction catalogue; J. van Buren collec-
tion. The Hague, November 7, 1808.
([Lugt, *Ventes*] II, 7474). Ms. copy. (EA)
Entries: 20+. Described (selection).
Includes prints not in [H. L.].

[H. L.] pp. 518–521.
Entries: 11. Millimeters. Inscriptions.
States. Described.

Janson, Pieter *(1768–after 1820)*
Auction catalogue; J. van Buren collec-
tion. The Hague, November 7, 1808
([Lugt, *Ventes*] II, 7474). Ms. copy. (EA)
Entries: 12+. Described (selection).
Includes prints not in [H. L.].

[H. L.] pp. 521–526.
Entries: 20. Millimeters. Inscriptions.
Described.

Jansonius, Wilhelmus *(fl. 1616–1620)*
[W.] I, pp. 752–753.
Entries: 2.

[H. *Neth.*] IX, p. 180.
Entries: 2.

Janssen, Broer *(fl. c.1614)*
[W.] I, p. 749.
Entries: 1.*

Janssen, Gerhard
See **Jansen**

Janssen, Hans *(b. 1605)*
[W.] I, pp. 749–750.
Entries: 15+.*

[H. *Neth.*] IX, pp. 178–179.
Entries: 59 prints by, 25 after. Illus-
trated (selection).*

Janssen, Hendrik
See **Janssen,** Hans

Janssen, Horst *(b. 1929)*
Kestner-Gesellschaft, Hannover. [Carl
Vogel, compiler]. *Horst Janssen.* Han-
nover, (West Germany), 1965.
Entries: 410 (to 1965). Millimeters. In-
scriptions. Described (selection). Il-
lustrated.

Janssen, Pieter I *(1612–1672)*
[W.] I, p. 751.
Entries: 1 print after.*

Janssen, [Tamme Weyerd] Theodor *(1816–1894)*
[Ap.] pp. 205–206.
Entries: 7.*

Janssens, Abraham I *(c.1575–1632)*
[W.] I, p. 748.
Entries: 4 prints after.*

[H. *Neth.*] IX. p. 177.
Entries: 5 prints after.*

Janssens, Abraham II *(b. 1616)*
[W.] I, p. 748.
Entries: 2.*

Janssens, Victor Honoré *(1658–1736)*
[W.] I, p. 752.
Entries: 1 print after.*

Janssens van Nuyssen, Abraham I
See **Janssens**

Jansz, Egbert *(fl. c.1598)*
[W.] I, p. 749.
Entries: 1+.*

[H. *Neth.*] IX, p. 177.
Entries: 13.*

Janszen, Pieter I
See **Janssen**

Jaquemot, George François Louis *(1806–1880)*
[Ap.] p. 206.
Entries: 3.*

Jaquet, Jules
See **Jacquet**

Jark, Jørgen *(20th cent.)*
Langhorn, Peter. "Jørgen Jark, en dansk amatør-grafiker." [*N. ExT.*] 21 (1969): 122–125.
Entries: 11 (bookplates only, to 1969). Illustrated (selection).

Jarry, Alfred *(1873–1907)*
Arrivé, Michel. *Peintures, gravures et dessins de Alfred Jarry.* Charleville-Mézières (France): College de Pataphysique et Cercle français du Livre, 1968.
Entries: 82 (works in various media, including prints). Millimeters. Described. Illustrated.

Jarvis, John Wesley *(1780–1840)*
[St.] p. 247.*

Dickson, Harold E. *John Wesley Jarvis; American painter, 1780–1840.* New York, 1949.
Entries: 5. Inches. Inscriptions.

Jasinski, Félix Stanislas *(1862–1901)*
[Ber.] VIII, pp. 236–237.
Entries: 20 (to 1889). Paper fold measure.

Wellisz, Léopold. *Félix-Stanislas Jasiński graveur, sa vie et son oeuvre.* Paris: G. van Oest, 1934. 550 copies. (MH)
Entries: 144 prints by, 12 doubtful prints. Millimeters. Inscriptions. States. Described (selection). Illustrated (selection). Located.

Jaspers, Jan Baptist *(c.1620–1691)*
[W.] I, p. 753.
Entries: 4.*

[H. *Neth.*] IX, p. 180.
Entries: 4 prints by, 6 after.*

Jazet, Alexandre Jean Louis *(b. 1814)*
[Ber.] VIII, pp. 234–235.*

Jazet, Eugène Pontus *(1815–1856)*
[Ber.] VIII, p. 235.*

Jazet, Jean Pierre Marie *(1788–1871)*
[Ber.] VIII, pp. 223–234.*

Jazinski, Félix Stanislas
See **Jasinski**

Jeanneret, Charles *(19th cent.)*
　[Ap.] p. 206.
　　Entries: 1.*

Jeanneret, Charles Édouard
　See **Le Corbusier**

Jeannin, Frédéric Émile *(b. 1859)*
　[Ber.] VIII, p. 237.*

Jeanniot, [Pierre] Georges *(1848–1934)*
　[Ber.] VIII, p. 237.*

Jeanron, André *(19th cent.)*
　[Ber.] VIII, p. 239.*

Jeanron, Philippe Auguste *(1809–1877)*
　[Ber.] VIII, pp. 237–239.
　　Entries: 18+. Paper fold measure
　　(selection).

Jeckel, Bernhard Maria *(1824–1884)*
　[Ap.] p. 206.
　　Entries: 10.*

Jegher, Christoffel *(1596–1652/53)*
　[W.] I, pp. 753–754.
　　Entries: 20.*

　[H. *Neth.*] IX, pp. 181–192.
　　Entries: 21. Illustrated (selection).*

Jegher, Jan Christoffel *(1618–1667)*
　[W.] I, p. 754.
　　Entries: 3.*

　[H. *Neth.*] IX, pp. 193–194.
　　Entries: 501+. Illustrated (selection).*

Jehenne, ―――― *(19th cent.)*
　[Ber.] VIII, pp. 239–240.*

Jehner, Isaak *(1750–after 1806)*
　[Sm.] II, pp. 723–728, and "additions
　and corrections" section.
　　Entries: 16 (portraits only). Inches. In-
　　scriptions. States. Described. Illus-
　　trated (selection).

　[Ru.] pp. 170–172.
　　Entries: 3 (portraits only, additional to
　　[Sm.]). Inches. Inscriptions. De-
　　scribed. Additional information to
　　[Sm.].

Jéhotte, Arnold *(1789–1836)*
　[Ber.] VIII, p. 240.*

Jéhotte, Léonard *(1772–1851)*
　[Ber.] VIII, p. 240.*

Jelgerhuis, Johannes *(1770–1836)*
　[W.] I, p. 754.
　　Entries: 4.*

　Nijmeegs museum voor schone
　kunsten, Nijmegen. *Johannes Jelgerhuis
　rzn.; acteurschilder 1770–1836.* Nijmegen
　(Netherlands), 1969.
　　Entries: 32 prints by and after. Milli-
　　meters. Inscriptions. Described
　　(selection).

Jelgerhuis, Rienk *(1729–1806)*
　[W.] I, p. 754.
　　Entries: 11+.*

Jelgersma, Tako Hajo *(1702–1795)*
　[W.] I, p. 754.
　　Entries: 4 prints after.*

Jelissen, Meynert *(fl. c.1612)*
　[W.] I, pp. 754–755.
　　Entries: 2.*

　[H. *Neth.*] IX, p. 195.
　　Entries: 18. Illustrated (selection).*

Jenet, Johannes *(fl. c.1625)*
　[H. *Neth.*] IX, p. 196.
　　Entries: 5.*

Jenichen, Balthasar *(d. before 1621)*
　[B.] IX, pp. 532–544.
　　Entries: 33. Pre-metric. Inscriptions.
　　Described.

[Heller] pp. 66–82.
 Entries: 81 (additional to [B.]). Pre-metric. Inscriptions. Described.

[P.] IV, pp. 200–207.
 Entries: 52+ (additional to [B.]). Pre-metric. Inscriptions. States. Described. Located (selection). Copies mentioned.

[A.] II, pp. 118–203.
 Entries: 291. Pre-metric. Inscriptions. Described. Appendix with 1 doubtful print.

[Wess.] I, p. 139.
 Entries: 3 (additional to [B.] and [P.]). Millimeters (selection). Paper fold measure (selection). Inscriptions. Described.

Jenkins, D. *(fl. 1750–1800)*
 [Siltzer] p. 359.
 Entries: unnumbered, p. 359. Inscriptions.

Jenkins, Joseph John *(1811–1885)*
 [Ap.] p. 207.
 Entries: 3.*

Jenner, Isaak
 See **Jehner**

Jenner, Thomas *(fl. 1621–1662)*
 [Hind, *Engl.*] III, p. 252.
 Entries: 1. Inches. Inscriptions. Described. Illustrated. Located.

Jennys, Richard II *(fl. 1766–1799)*
 [Sm.] II, p. 729, and "additions and corrections" section.
 Entries: 1 (portraits only). Inches. Inscriptions. Described.

 [St.] p. 248.*

Jensen, Paul *(20th cent.)*
 Högdahl, Hugo. "Paul Jensen, en romantiker blandt norske exlibris

kunstnere." [*N. ExT.*] 4 (1951–1952): 33–40.
 Entries: unnumbered, p. 40 (bookplates only, to 1944). Illustrated (selection).

Jequier, Jules *(1834–1898)*
 [Ber.] VIII, p. 240.*

Jesi, Samuele *(1788–1853)*
 [Ap.] pp. 207–208.
 Entries: 13.*

 [Ber.] VIII, pp. 240–241.*

Jessé, Henri
 See **Gissey**

Jettmar, Rudolf *(b. 1869)*
 Weixlgärtner, Arpad. "Rudolf Jettmars graphische Arbeiten." [*GK.*] 43 (1920): 94–102. Catalogue: "Verzeichnis von Rudolf Jettmars graphischen Arbeiten," [MGvK.] 1920, pp. 55–70. Separately published. Vienna: Gesellschaft für vervielfältigende Kunst, n.d.
 Entries: 90 etchings, 8 lithographs, 12 woodcuts, (to 1920). Millimeters. States. Described.

 Wiener Sezession, Vienna. *Rudolf Jettmar.* Vienna, 1969.
 Entries: 134 etchings, 8 lithographs, 14 woodcuts. Millimeters. Illustrated (selection).

Joannis, Léon de *(fl. c.1835)*
 [Ber.] VIII, p. 241.*

Jocelyn, Nathaniel *(1796–1881)*
 [St.] p. 256.*

 [F.] p. 150.*

Jocelyn, Simeon Smith *(1799–1879)*
 [Allen] p. 138.*

 [St.] pp. 256–261.*

 [F.] p. 151.*

Jochum, Alexandre Édouard *(b. 1839)*
[Ber.] VIII, p. 241.*

Jode, Gerard de *(1509/17–1591)*
See also **Jode,** Gerard and Cornelis de

[W.] I, pp. 758–759.
Entries: 10.*

[H. *Neth.*] IX, p. 199.
Entries: 12.*

Jode, Cornelis de *(1568–1600)*
See also **Jode,** Gerard and Cornelis de

[H. Neth.] IX, p. 200.
Entries: 1.*

Jode, Gerard de *(1509/17–1591)*
See also **Jode,** Gerard and Cornelis de

[W.] I, pp. 758–759.
Entries: 14+.*

[H. *Neth.*] IX, pp. 200–202.
Entries: 457. Illustrated (selection).*

Jode, Gerard and Cornelis de
Ortroy, Fernand van. *L'Oeuvre car-
tographique de Gerard et Corneille de Jode.*
Ghent (Belgium): Librairie Scientifique,
E. van Goethem et Cie, 1914. (EUD)
Entries: 160 prints published by (maps
only). Millimeters. Inscriptions.
States. Described. Also, summary de-
scription of other prints published by.

Jode, Hans de *(fl. 1647–1662)*
[H. *Neth.*] IX, p. 202.
Entries: 1.*

Jode, Pieter I de *(c.1570–1634)*
[W.] I, p. 759.
Entries: 31+.*

[H. *Neth.*] IX, pp. 203–209.
Entries: 265 prints by, 87 after. Illus-
trated (selection).*

Jode, Pieter II de *(1606–after 1674)*
[Dut.] V, p. 36.*

[W.] I, pp. 759–760.
Entries: 55.*

[H. *Neth.*] IX, pp. 210–220.
Entries: 530. Illustrated (selection).*

Joets, Jules Arthur *(1884–1959)*
Turpin, Georges. *L'Oeuvre gravé et
lithographié de Jules Joets.* Saint-Omer
(France): Joly-Thuilliez, 1938.
Entries: 202 (to 1938). Millimeters.
States. Described. Ms. addition
(EPBN); additional information, 48
additional entries (to 1950).

Joffroy, Jean Barthélemy *(1669–1740)*
[W.] I, p. 760.
Entries: 2+ prints after.*

Johannot, Alfred *(1800–1837)*
[Ap.] p. 209.
Entries: 3.*

[Ber.] VIII, pp. 243–245.*

Marie, Aristide. *Alfred et Tony Johannot,
peintres, graveurs et vignettistes.* Paris:
H. Floury, 1925.
Entries: unnumbered, pp. 84–90. List
of prints by, and bibliography of
books with illustrations by. Paper fold
measure.

Johannot, Charles *(1798–1825)*
[Ap.] p. 209.
Entries: 1.*

[Ber.] VIII, pp. 241–242.*

[Dus.] p. 75.
Entries: 1 (lithographs only, to 1821).
Inscriptions.

Johannot, François *(fl. c.1800)*
[Dus.] p. 75.
Entries: 3+ (lithographs only, to 1821).
Inscriptions.

Johannot, Tony *(1803–1852)*
[Ber.] VIII, pp. 245–277.

Entries: 91 (to 1969). Millimeters. Described. Illustrated.

Jones, E. *(19th cent.)*
[Siltzer] p. 359.
Entries: unnumbered, p. 359. Inscriptions.

Jones, G. *(19th cent.)*
[Siltzer] p. 167.
Entries: unnumbered, p. 167, prints after. Inches (selection). Inscriptions.

Jones, John *(c.1745–1797)*
[Sm.] II, pp. 740–776, and "additions and corrections" section.
Entries: 94+ (portraits only). Inches. Inscriptions. States. Described. Illustrated (selection). Located (selection).

[Siltzer] p. 359.
Entries: unnumbered, p. 359. Inscriptions.

[Ru.] pp. 176–187, 493.
Entries: 2 (portraits only, additional to [Sm.]). Inches (selection). Inscriptions. States. Described. Additional information to [Sm.].

Jones, John Paul *(b. 1924)*
Brooklyn Museum [Una E. Johnson and Jo Miller, compilers]. *John Paul Jones prints and drawings 1948–1963.* New York: 1963.
Entries: 82 (to 1963). Inches. States. Illustrated (selection).

Jones, Richard *(1767–1840)*
[Siltzer] p. 167.
Entries: unnumbered, p. 167, prints after. Inches. Inscriptions. Described (selection).

Jones, Samuel John Egbert *(fl. 1820–1845)*
[Siltzer] pp. 167–168.
Entries: unnumbered, pp. 167–168, prints after. Inches (selection). Inscriptions.

Jones, William R. *(fl. 1810–1824)*
[St.] pp. 253–256.*

[F.] pp. 153–154.*

Jong, Dirk de *(fl. 1779–1802)*
[W.] I, p. 761.
Entries: 3.*

Jong, Maarten II de *(20th cent.)*
Veth, D. Giltay. *Grafisch werk van Maarten de Jong, Jr.* Zaandijk (Netherlands): Stichting de Getijden Pers, 1952. 225 copies. (CtW)
Entries: 31 (to 1951). Illustrated (selection).

Jong, Mar de *(20th cent.)*
Zwiers, Wim, and de Jong, Mar. *Grafiek Miniatuur.* [Rotterdam (Netherlands), 1949?)]. (CtW)
Entries: 16 (to 1948). Millimeters. Described.

Jongh, Joannes de *(fl. c.1684)*
[W.] I, p. 762.
Entries: 4.*

[H. *Neth.*] IX, pp. 221–222.
Entries: 6+. Illustrated (selection).*

Jongh, Ludolf de *(1616–1679)*
[W.] I, p. 762.
Entries: 2 prints after.*

[H. *Neth.*] IX, p. 222.
Entries: 3 prints after.*

Jonghe, Clement de *(fl. 1640–1670)*
[W.] I, p. 761.
Entries: 1.*

[H. *Neth.*] IX, p. 221.
Entries: 6.*

Jonghe, Jan Baptiste de *(1785–1844)*
[H. L.] p. 527.
Entries: 2. Millimeters. Inscriptions. States. Described.

Jonghelinck, Jacques *(1530–1606)*
[W.] I, p. 763.
 Entries: 1 print after.*

[H. *Neth.*] IX, p. 222.
 Entries: 9 prints after.*

Jongkind, Johan Barthold *(1819–1891)*
[Ber.] VIII, pp. 278–279.
 Entries: 17.

[Del.] I.
 Entries: 20. Millimeters. Inscriptions.
 States. Described (selection). Illus-
 trated. Located (selection). Appendix
 with 2 prints not seen by [Del.] and 1
 rejected print.

Delteil, Loys. "Une rectification à
l'oeuvre gravé de Jongkind." [*Am. Est.*]
2 (1923): 145–146.
 Entries: 1 (additional to [Del.]). De-
 scribed. Illustrated.

Jongman, Wouter *(fl. 1712–1744)*
[W.] I, p. 763.
 Entries: 1.*

Jonson, Bjorn *(20th cent.)*
Asklund, Erik. *Bjorn Jonson.* Svenska
mästargrafiker, 5. Stockholm: Folket i
Bilds Konstklubb, 1953.
 Entries: unnumbered, pp. 47–48.
 Millimeters. Illustrated (selection).

Jontsch, ——— *(19th cent.)*
[Dus.] p. 76.
 Entries: 1 (lithographs only, to 1821).
 Paper fold measure.

Jonxis, Pierre Etienne Lambert *(b. 1787)*
[W.] I, p. 763.
 Entries: 1.*

Jonynas, Vytautas K. *(b. 1907)*
Rannit, Aleksis. *V. K. Jonynas; un xylo-
graphe lithuanien, a Lithuanian wood-
engraver, Ein litauischer Holzschneider.*

Baden-Baden: Verlag für Kunst und
Wissenschaft, [c.1947]. (DLC)
 Entries: 84+ prints and drawings (to
 1947). Millimeters. Illustrated (selec-
 tion). Text in English, French and
 German.

Jordaens, Hans I *(c.1550–1630)*
[W.] I, pp. 764–765.
 Entries: 1 print after.*

[H. *Neth.*] IX, p. 229.
 Entries: 1 print after.*

Jordaens, Hans III *(c.1600–1643)*
[W.] I, p. 765.
 Entries: 2 prints after.*

[H. *Neth.*] IX, p. 229.
 Entries: 6 prints after.*

Jordaens, Jacob *(1593–1678)*
Hecquet, R. *Catalogue des estampes
gravées d'après Rubens, auquel on a joint
l'oeuvre de Jordaens et celle de Visscher.*
Paris: Briasson, 1751.
 Entries: 31 prints after. Pre-metric. In-
 scriptions. Described.

Basan, F. *Dictionaire des graveurs anciens
et modernes . . . suivi des catalogues des
oeuvres de Jacques Jordans, et de Corneille
Visscher.* 2 vols. Paris: De Lormel [etc.],
1767. (MH)
 Entries: 33 prints by and after. Pre-
 metric. Inscriptions. Described (selec-
 tion). Based on Hecquet with addi-
 tional information.

Del-Marmol, ———. *Catalogue de la plus
précieuse collection d'estampes de P. P. Ru-
bens et d' A. van Dyck qui ait jamais existée
. . . le tout recueilli . . . par Messire
Del-Marmol.* n.p., 1794. (EPBN)
 Entries: 51+ prints after.

[W.] I, pp. 765–772.
 Entries: 9 prints by, 40 after.*

[H. *Neth.*] IX, pp. 223–228.

Entries: 9 prints by, 56 after. Illustrated (selection).*

Jordaens, L. (*fl. c.1650*)
[W.] I, p. 772.
Entries: 2 prints after.*

[H. *Neth.*] IX, p. 229.
Entries: 60 prints after.*

Jordan, Theodor (*b. 1815*)
[Ap.] p. 209.
Entries: 2.*

Jorisz van Delft, Augustin (*fl. after 1550*)
[P.] III, p. 15.
Entries: 1. Pre-metric. Inscriptions. Described. Located.

[H. *Neth.*] XIII, p. 5.
Entries: 3. Illustrated (selection).*

Jou, Louis (*1882–1968*)
Cogniat, Raymond. Catalogue. In *Notre ami Louis Jou,* by Francis Carco and Jean Cassou. Paris: M. P. Trémois, 1929. 495 copies. (NN)
Bibliography of books with illustrations by (to 1929).

Jouanin, Auguste Adrien (*1806–1887*)
[Ber.] VIII, pp. 279–280.*

Jouas, Charles (*1866–1942*)
Saunier, Charles. "Les graveurs de Paris; Charles Jouas." *Société d'iconographie parisienne* 3 (1910): 73–79. (EPBN)
Entries: 11 (single prints of Paris only, to 1911). Millimeters. Described. Illustrated (selection). Also, bibliography of books with illustrations by.

Joubert, Ferdinand (*1810–1884*)
[Ap.] p. 210.
Entries: 4.*

[Ber.] VIII, p. 280.*

Jouve, Paul (*1880–1973*)
Mauclair, Camille. *Paul Jouve.* Les artistes du livre, 22. Paris: Henry Babou, 1931. 700 copies. (EPBN)
Bibliography of books with illustrations by (to 1931).

Jouvet, Dominique (*20th cent.*)
Clement-Janin, and Desdevises du Dezert, G. "Dominique Jouvet-Magron." [*P. Conn.*] 3 (1923): 90–97.
Entries: 42 (to 1923). Illustrated (selection).

Jouy, Joseph Nicolas (*b. 1809*)
[Ber.] VIII, p. 280.*

Jovanović, Anastas (*1817–1899*)
Galerija Matice Srpske, Novi Sad. [Pavle Vasić, compiler]. *Anastas Jovanović (1817–1899) katalog radova.* Novi Sad (Yugoslavia), 1964. (DLC)
Entries: 663 (works in various media including prints). Millimeters. Inscriptions. Described. Illustrated (selection). Located.

Joyant, Jules Romain (*1803–1854*)
[Ber.] VIII, p. 281.*

Joyau, Amédée (*1871–1913*)
Curtis, Atherton. *Catalogue de l'oeuvre gravé de Amédée Joyau.* Paris: Paul Prouté, 1938. 300 copies. (MBMu)
Entries: 135. Millimeters. States. Described. Illustrated.

Juarra, Filippo
See **Juvara**

Juchtzen, C. F. (*19th cent.*)
[Dus.] p. 76.
Entries: 1 (lithographs only, to 1821). Millimeters. Inscriptions. Located.

Judkins, Elizabeth (*fl. 1772–1814*)
[Sm.] II, pp. 776–778, and "additions and corrections" section.

Judkins, Elizabeth (*continued*)

Entries: 7 (portraits only). Inches. Inscriptions. States. Described. Illustrated (selection). Located (selection).

Goodwin, Gordon. *British mezzotinters; Thomas Watson, James Watson, Elizabeth Judkins.* London, 1904. 520 copies. (MH) 2d ed., 1914.
Entries: 9. Inches. Inscriptions. States. Described. Located.

[Ru.] pp. 187–188.
Entries: 2 (portraits only, additional to [Sm.]). Inches (selection). Inscriptions (selection). Described. Additional information to [Sm.].

Juhel *(1806–1830)*
[Ber.] VIII, p. 281.*

Jukes, Francis *(1747–1812)*
[Siltzer] p. 359.
Entries: unnumbered, p. 359. Inscriptions.

Jukes, Francis, and **Clark,** ——
[Siltzer] p. 359.
Entries: unnumbered, p. 359. Inscriptions.

Jukes, Francis, and **Pollard,** R.
[Siltzer] p. 359.
Entries: unnumbered, p. 359, prints by and after. Inscriptions.

Julien, —— *(b. 1802?)*
[Ber.] VIII, p. 281–282.*

Julien, —— [called "Julien de Paris"] *(fl. c.1810)*
[Ber.] VIII, p. 281.*

Julien, Simon *(1735–1800)*
[Baud.] I, pp. 185–193; errata, p. II.
Entries: 9. Millimeters. Inscriptions. States. Described.

Julienne, Eugène *(fl. 1836–1842)*
[Ber.] VIII, p. 282.*

Julius, Friedrich *(19th cent.)*
[Dus.] p. 76.
Entries: 4 (lithographs only, to 1821). Millimeters. Inscriptions. Located.

Jullien, Amédée Marie Antoine *(d. 1887)*
[Ber.] VIII, p. 283.*

Jundt, Gustave *(1830–1884)*
[Ber.] VIII, p. 283.*

Jungermayr, —— *(19th cent.)*
[Dus.] pp. 76–77.
Entries: 8 (lithographs only, to 1821). Millimeters (selection). Paper fold measure (selection). Inscriptions. Located (selection).

Jungnickel, Ludwig Heinrich *(b. 1881)*
Reichel, Anton. "L. H. Jungnickel als Meister des Exlibris." *Österreichisches Jahrbuch für Exlibris and Gebrauchsgraphik*, 1924–1925, pp. 27–29. (DLC)
Entries: 17 (bookplates only, to 1925). Millimeters. Described. Illustrated (selection).

Jurkunas, Vytautas *(20th cent.)*
Jasiulis, Leonas. *Vytautas Jurkunas.* Vilnius (USSR). 1969. (DLC)
Entries: unnumbered, pp. 47–49 (to 1969). Millimeters. Illustrated (selection).

Juste, Juste de *(1505–1559)*
[Herbet] IV, pp. 318–322.
Entries: 5. Millimeters. Inscriptions. Described.

Lieure, J. "Un graveur florentin en France au XVIe siècle; Juste de Juste (Giusto Betti)." [Am. Est.] 7 (1928): 36–46. Supplement. "A propos de Juste de Juste." [Am. Est.] 7 (1928): 122.

Entries: 18. Millimeters. Inscriptions. Described. Illustrated (selection).

[Zerner] no. 6.
Entries: 17. Millimeters. Illustrated.

Justice, Joseph *(fl. 1804–1833)*
[St.] p. 261.*

[F.] p. 154.*

Juvanis, Francesco
See **Giovani**

Juvara, Aloisio *(1809–1875)*
[M.] I, pp. 523–525.
Entries: 22. Paper fold measure (selection).

[Ap.] p. 210.
Entries: 2.*

Juvara, Filippo *(1676–1736)*
Rovere, L., and Viale, E. *Filippo Juvarra.* Milan: Casa editrice Oberdan Zucchi, 1937.
Entries: 3+ prints by, 9+ after. Located.

Ferrero, M. Viale. *Filippo Juvarra, scenografo e architetto teatrale.* New York: Benjamin Blom Inc., n.d.
Entries: unnumbered, pp. 378–382, prints by and after. Millimeters (selection). Inscriptions. Illustrated (selection). Located.

Juvarra, Filippo
See **Juvara**

K

Kabel, Adrian van der *(1630/31–1705)*
[B.] IV, pp. 223–267.
Entries: Pre-metric. Inscriptions. States. Described.

[Weigel] pp. 190–197.
Entries: 12 (additional to [B.]). Pre-metric. Inscriptions. Described.

[Heller] pp. 82–83.
Additional information to [B.].

[Wess.] II, pp. 231–232.
Entries: 2 (additional to [B.] and [Weigel]). Millimeters. Inscriptions. Described.

Cazenove, Raoul de. *Le peintre van der Kabel et ses contemporains avec le catalogue de son oeuvre peinte et gravée 1631–1705.* Paris: F. A. Rapilly; Lyons: Henri Georg, 1888.
Reprints [B.], [Lebl.], and [Weigel].

[W.] I, pp. 230–232.
Entries: 65 prints by, 8+ after.*

[H. *Neth.*] IV, pp. 82–83.
Entries: 69 prints by, 10 after. Illustrated (selection).*

Kälde, Bengt Olof *(20th cent.)*
Walter, Jan Erik. "Bengt Olof Kälde, en svensk heraldiker och konstnär."
[*N. ExT.*] 19 (1967): 120–123.
Entries: 26 (bookplates only, to 1967). Illustrated (selection).

Kaeser, Max von *(19th cent.)*
[Dus.] pp. 77–78.
Entries: 5 (lithographs only, to 1821).
Millimeters (selection). Inscriptions
(selection). Located (selection).

Kätelhön, Hermann *(b. 1884)*
Gosebruch, ————. "Hermann
Kätelhön." [*Kh.*] 12 (1920): 33–36.
Entries: 85 etchings, 7 portrait etch-
ings, 14 commercial prints. Milli-
meters. Described. Illustrated (selec-
tion).

Kager, Johann Mathias *(1575–1634)*
[A.] IV, pp. 351–364.
Entries: 15. Pre-metric. Inscriptions.
States. Described. Appendix with 5
doubtful and rejected prints.

Kai, Jakob *(fl. 1566–1590)*
[A.] III, pp. 327–329.
Entries: 1. Pre-metric. Inscriptions.
Described.

Kaiser, Jaroslav *(20th cent.)*
Kaizl, Mirko. "Jaroslav Kaiser, en
czekisk grafiker." [*N. ExT.*] 22 (1970):
21–26, 28.
Entries: 49 (bookplates only, to 1970).
Illustrated (selection).

Kaiser, Johan Wilhelm *(1813–1900)*
[H. L.] p. 528.
Entries: 2. Millimeters. Inscriptions.
Described.

[Ap.] p. 211.
Entries: 7.*

[W.] I, pp. 232–233.
Entries: 12+.*

Kalashnikov, Anatoli *(20th cent.)*
Perkin, W. D., and Rödel, Klaus. *Anatoli
Kalaschnikow, exlibris.* Frederikshavn
(Denmark). Privately printed, 1968. 75
copies. (DLC)

Entries: 110 (bookplates only, to 1968).
Millimeters. Described. Illustrated
(selection).

Kalckreuth, Leopold Karl Walter, Graf
von *(1855–1928)*
Hakon-Hamburg, E. "Graf Kalckreuths
Graphik." [*Kh.*] 4 (1912): 42, 48–49.
Entries: unnumbered, pp. 48–49.
Millimeters.

Kaldenbach, Johan Anthoni *(1760–1818)*
[W.] I, p. 234.
Entries: 2 prints after.*

Kalf, Willem *(1622–1693)*
[W.] I, p. 234.
Entries: 6 prints after.*

[H. *Neth.*] IX, p. 232.
Entries: 8 prints after.*

Kaltner, Joseph *(c.1758–after 1824)*
[Dus.] p. 78.
Entries: 4 (lithographs only, to 1821).
Millimeters (selection). Paper fold
measure (selection). Inscriptions. Lo-
cated (selection).

Kampmann, Gustav *(1859–1917)*
Ammann, Edith. *Das graphische Werk von
Gustav Kampmann.* Schriften der Staat-
lichen Kunsthalle Karlsruhe, 3.
Karlsruhe (Germany): Staatliche
Kunsthalle Karlsruhe, 1944. (ICB)
Entries: 18 etchings, 95 lithographs.
Millimeters. Inscriptions. States. De-
scribed.

Kandel, David *(fl. 1538–1587)*
[B.] IX, pp. 392–395.
Entries: 20. Pre-metric. Inscriptions.
Described.

[Heller] p. 83.
Additional information to [B.].

[P.] III, p. 348.
Entries: 6+ (additional to [B.]). Pre-
metric. Inscriptions. Described.

Kandinsky, Wassily *(1866–1944)*
Roethel, Hans Konrad. *Kandinsky, das graphische Werk.* Schauberg (West Germany): Verlag M. Du Mont, 1970. 1500 copies.
> Entries: 203. Millimeters. Inscriptions. States. Described. Illustrated. Located. Appendix discusses posthumous editions of prints, and prints after.

Kanits, Felix *(1829–1904)*
Kanits'', Zhak''. *B''lgaria v' obrazite na Feliks'' Kanits'' izdava se s'' izhdivenieto na Zhak'' Kanits''.* Sofia (Bulgaria): D''rzhavna pechatnica, 1939.
> Entries: unnumbered, pp. 31–180 (complete?). Described. Illustrated (selection).

Kanoldt, Alexander *(1881–1939)*
Ammann, Edith. *Das graphische Werk von Alexander Kanolt.* Schriften der Staatlichen Kunsthalle Karlsruhe, 7. Karlsruhe (West Germany): Staatliche Kunsthalle Karlsruhe, 1963.
> Entries: 67 lithographs, 2 etchings, 1 woodcut. Millimeters. Inscriptions. States. Described. Illustrated (selection).

Kappel, Philip *(b. 1901)*
Crafton Collection. *Philip Kappel.* American etchers, 4. New York: T. Spencer Hutson and Company, 1929.
> Entries: unnumbered, 1 p. (to 1929). Inches. Illustrated (selection).

Kappes, Karl *(1821–1857)*
[Ap.] p. 211.
> Entries: 3.*

Karcher, Anton *(c.1760–after 1814)*
[Ap.] p. 211.
> Entries: 3.*

Karl, Johann *(b. 1776)*
[Dus.] p. 78.

> Entries: 1 (lithographs only, to 1821). Paper fold measure.

Karolus *(fl. c.1550)*
[H. *Neth.*] IX, p. 232.
> Entries: 6+.*

Kasemann, Rutger *(17th cent.)*
[Merlo] pp. 447–478.*

Kate, [Johann] Mari Henri ten *(1831–1910)*
[H. L.] pp. 528–529.
> Entries: 3. Millimeters. Inscriptions. Described.

Katte, C. von *(19th cent.)*
[Dus.] p. 86.
> Entries: 1 (lithographs only, to 1821). Millimeters. Inscriptions. Located.

Katzfeld, ——— *(19th cent.)*
[Dus.] p. 87.
> Entries: 2 (lithographs only, to 1821). Paper fold measure. Inscriptions.

Katzheimer, Lorentz *(fl. 1480–1505)*
[B.] VI, pp. 361–362.
> Entries: 2. Pre-metric. Inscriptions. Described.

[P.] II, pp. 288–290.
> Entries: 8 (additional to [B.]). Pre-metric. Inscriptions. Described. Located.

[Dut.] V, pp. 174–177; VI, p. 674.
> Entries: 10. Millimeters. Inscriptions. Described. Located (selection).

[W.] III, p. 225.
> Entries: 11.*

Lehrs, Max. *Der Meister LCz und der Meister* ꝡ֍ß : *Nachbildung ihrer Kupferstiche.* Graphische Gesellschaft, XXV Veröffentlichung. Berlin: Bruno Cassirer, 1922.
> Entries: 12. Millimeters. Inscriptions. States. Illustrated. Located. Watermarks described.

Katzheimer, Lorentz (*continued*)

[Lehrs] VI, pp. 314–342.
Entries: 12. Millimeters. Inscriptions. States. Described. Illustrated (selection). Located. Locations of all known impressions are given. Copies mentioned. Watermarks described. Bibliography for each entry.

Kauffmann, Angelica *(1741–1807)*
[A.] V, pp. 373–399.
Entries: 36. Pre-metric. Inscriptions. States. Described.

Kaufmann, ———— *(19th cent.)*
[Dus.] p. 87.
Entries: 1 (lithographs only, to 1821). Millimeters. Inscriptions. Located.

Kaukol, Maria Joseph Clemens *(fl. c.1729)*
[Merlo] pp. 478–479.*

Kauperz family *(18th cent.)*
Wibiral, Fr. *Das Werk der Grazer Stecherfamilie Kauperz.* Graz (Austria): Ulr. Mosers Buchhandlung (J. Meyerhoff), 1909.
Entries: 5 prints by Jakob Melchior Kauperz, 45 by Johann Michael Kauperz, 216 by Johann Veit Kauperz, 7 by Michael Kauperz. Millimeters. Inscriptions. States. Described (selection).

Kay, A. *(19th cent.)*
[Siltzer] p. 332.
Entries: unnumbered, p. 332, prints after. Inscriptions.

Kayser, [Jean] Paul *(b. 1869)*
[Sch.] p. 111ff.
Not seen.

Kearney, Francis *(b. c.1780)*
[Allen] pp. 139–140.*

[St.] pp. 261–265.*

[F.] pp. 154–162.*

Keating, George *(1762–1842)*
[Sm.] II, pp. 778–782, and "additions and corrections" section.
Entries: 12 (portraits only). Inches. Inscriptions. States. Described. Located (selection).

[Siltzer] p. 359.
Entries: unnumbered, p. 359. Inscriptions.

[Ru.] pp. 188–189.
Additional information to [Sm.].

Keelen, ———— van der
See **Kellen,** David II and III van der

Keene, Charles Samuel *(1823–1891)*
[Ber.] VIII, pp. 283–284.
Entries: 20. Paper fold measure. Described.

Chesson, W. H. Catalogue. In *The work of Charles Keene,* by Joseph Pennell. London: T. Fisher Unwin and Bradbury, Agnew and Co., 1897.
Entries: 45 prints by, 2 doubtful prints (etchings only). Inches. Inscriptions. Described. Also, bibliography of books with illustrations by.

Emanuel, Frank L. *Charles Keene; etcher, draughtsman and illustrator 1823–1891.* London: Print Collectors' Club, 1935.
Entries: 34. Inches. Inscriptions. Based on Chesson.

Keere, Pieter van der *(1570/71–after 1645)*
[W.] I, pp. 250–251.
Entries: 7+.*

[Hind, *Engl.*] I, pp. 203–209.
Entries: 7+ (prints done in England only). Inches. Inscriptions. Described.

[H. *Neth.*] IX, p. 233.
Entries: 15+. Illustrated (selection).*

Keerincx, Alexander *(1600–1652)*
[W.] I, pp. 251–252.
Entries: 2 prints by, 1 after.*

[H. *Neth.*] IX, p. 234.
Entries: 5.*

Kehr, Johann Philipp *(b. c.1800)*
[Merlo] pp. 479–480.*

Kelder, C. *(fl. 1650–1700)*
[W.] I, p. 252.
Entries: 1 print after.*

[H. *Neth.*] IX, p. 234.
Entries: 1 print after.*

Keldermans, Frans *(d. 1673/74)*
[W.] I, p. 253.
Entries: 1.*

Kellen, David II van der [called "David senior"] *(1804–1879)*
[H. L.] pp. 530–532.
Entries: 6. Millimeters. Inscriptions. States. Described.

Kellen, David III van der [called "David junior"] *(1827–1895)*
[H. L.] p. 532.
Entries: 1. Millimeters. Inscriptions. Described.

Kellen, David II and III van der
[H. L.] pp. 529–530.
Entries: 2 (mistakenly attributed to a "van der Keelen"). Millimeters. Described.

Keller, Franz *(1821–1896)*
[Ap.] p. 212.
Entries: 5.*

Keller, Joseph von *(1811–1873)*
[Ap.] pp. 212–214.
Entries: 22.*

[Ber.] VIII, p. 284.*

Horn, Paul. *Der Kupferstecher Joseph von Keller, sein Leben, sein Werk und seine Schule.* Düsseldorf: Verlag des Kunst-

vereins für die Rheinlande und Westfalen, 1931.
Entries: 43. Millimeters. Inscriptions. States. Illustrated (selection).

Kellerhoven, F. *(19th cent.)*
[Dus.] p. 87.
Entries: 2 (lithographs only, to 1821). Millimeters (selection). Inscriptions (selection).

Kellerhoven, Franz *(1814–1872)*
[Ber.] VIII, p. 284.*

[Merlo] pp. 480–482.*

Kellerhoven, Joseph *(1798–1840)*
[Dus.] p. 87.
Entries: 2 + (lithographs only, to 1821). Millimeters (selection). Inscriptions. Located.

Kelly, Ellsworth *(b. 1923)*
Bianchini, Paul. *Ellsworth Kelly, drawings, collages, prints.* Greenwich (Conn.): New York Graphic Society Ltd., 1971.
Entries: 78 (to 1970). Inches. Described. Illustrated.

Kelly, Thomas *(d. c.1841)*
[St.] pp. 265–272.*

[F.] pp. 162–166.*

Kempen, B. van *(18th cent.)*
[H. *Neth.*] IX, p. 234.
Entries: 1.*

Kempener, Jacob *(fl. c.1650)*
[H. *Neth.*] IX, p. 234.
Entries: 6 prints after.*

Kennedy, James *(fl. 1797–1812)*
[St.] pp. 272–273.*

[F.] pp. 166–167.*

Kennedy, S. *(19th cent.?)*
[F.] p. 167.*

Kensett, Thomas *(1786–1829)*
[St.] p. 273.*

[F.] p. 167.*

Kent, Rockwell *(1882–1971)*
Zigrosser, Carl. *Rockwellkentiana.* New
York: Harcourt, Brace and Company,
1933.
 Entries: 88 "major" prints, 18
 "minor" prints. Inches. Described.
 Illustrated (selection). Located
 (selection).

Jones, Dan Burne. "A check list of the
written and illustrated work of Rockwell
Kent" and "Books illustrated by
Rockwell Kent." *American Book Collector*
14, no. 10 (Summer 1964): 21–24, 43–50.
 Bibliography of books by and books
 with illustrations by.

Kerkhoven, Leonard van den
(c.1828–1898)
 [H. L.] p. 1055.
 Entries: 1. Millimeters. Inscriptions.
 Described.

Kerseboom, Frederic *(1632–1690)*
 [W.] I, pp. 256–257.
 Entries: 3 prints after.*

Kerseboom, Johan *(d. 1708)*
 [H. *Neth.*] IX, p. 235.
 Entries: 11 prints after.*

Kertes-Kollmann, Jenö *(20th cent.)*
 Rödel, Klaus. *Jenö Kertes-Kollmann, exli-
 bris, en ungarsk exlibris-kunstner.* Fred-
 erikshavn (Denmark): Privately printed,
 1967. 60 copies. (DLC)
 Entries: unnumbered, 15 pp.
 (bookplates only, to 1967?). De-
 scribed.

Kerver, Jacob *(d. 1583)*
 Wiechmann-Kadow, ———. "Jacob
 Kerver, Zeichner, Formschneider und

Buchdrucker." [*N. Arch.*] 1 (1855): 49–54;
[*N. Arch.*] 2 (1856): 230.
 Entries: 9. Paper fold measure (selec-
 tion). Pre-metric (selection). Inscrip-
 tions. Described. Also, bibliography
 of books with illustrations by.

Kessel, Hieronymus van *(1578–after 1636)*
 [W.] I, pp. 257–258.
 Entries: 2 prints after.*

 [H. *Neth.*] IX, p. 235.
 Entries: 2 prints after.*

Kessel, Theodor van *(1620–after 1660)*
 [W.] I, pp. 259–260.
 Entries: 25+.*

 [H. *Neth.*] IX, pp. 236–239.
 Entries: 165. Illustrated (selection).*

Kesselstadt, Franz von *(1753–1841)*
 [Dus.] p. 87.
 Entries: 1 (lithographs only, to 1821).
 Millimeters. Inscriptions. Located.

Kessler, Aloys *(1777–1820)*
 [Ap.] p. 214.
 Entries: 11.*

Kestner, Michael *(fl. 1656–1674)*
 [A.] V, pp. 292–293.
 Entries: 2. Pre-metric. Inscriptions.
 Described.

Kestner Gesellschaft *(20th cent.)*
 Schmied, Wieland. *Wegbereiter zur mod-
 ernen Kunst; 50 Jahre Kestner-Gesellschaft.*
 Hannover (West Germany):
 Fackelträger-Verlag, 1966.
 Entries: unnumbered, pp. 286–308,
 prints published by (to 1966). Milli-
 meters. Illustrated.

Ket, Dick *(1902–1940)*
 Gemeentemuseum Arnhem [Joh. Mek-
 kink, compiler]. *Dick Ket.* Arnhem
 (Netherlands), 1962.

Entries: 35 (complete?). Millimeters. Inscriptions. Illustrated (selection). Located.

Ketel, Cornelis *(1548–1616)*
[W.] I, pp. 260–261.
Entries: 9 prints after.*

[H. *Neth.*] IX, p. 240.
Entries: 21 prints after.*

Ketterlinus, Christian Wilhelm *(1766–1803)*
[Ap.] p. 215.
Entries: 5.*

Keun, Hendrik *(1738–1788)*
[W.] I, p. 263.
Entries: 3.*

Key, Adriaen Thomasz *(c.1554–1589)*
[B.] IX, pp. 406–407.
Entries: 1. Pre-metric. Inscriptions. Described.

[W.] I, p. 264.
Entries: 2 prints after.*

[H. *Neth.*] IX, p. 241.
Entries: 2. Illustrated (selection).*

Keyert, Ruik *(fl. c.1728–1750)*
[W.] I, p. 266.
Entries: 1 print after.*

Keyser, Hendrik de *(1565–1621)*
[H. *Neth.*] IX, p. 242.
Entries: 57 prints after.*

Keyser, Jacob *(fl. c.1738)*
[W.] I, p. 267.
Entries: 1.*

Keyser, Thomas de *(1596/97–1667)*
[W.] I, pp. 268–269.
Entries: 5 prints after.*

[H. *Neth.*] IX, p. 242.
Entries: 12 prints after.*

Keysere, Pieter de *(fl. c.1524)*
[H. *Neth.*] IX, p. 242.
Entries: 1 print published by.*

Kidder, James *(fl. 1813–1823)*
[St.] p. 274.*

Kiers, Petrus *(1807–1875)*
[H. L.] pp. 532–533.
Entries: 1. Millimeters. Inscriptions. Described.

Kiessling, Gottlieb *(fl. c.1840)*
[Ap.] p. 215.
Entries: 4.*

Kihm, ——— *(19th cent.)*
[Dus.] p. 87.
Entries: 1+ (lithographs only, to 1821). Millimeters. Inscriptions. Located.

Kikkert, Pieter *(fl. c.1798)*
[W.] I, p. 277.
Entries: 2+.*

Killingbeck, Benjamin *(fl. 1769–1789)*
[Sm.] II, pp. 782–783, and "additions and corrections" section.
Entries: 3 (portraits only). Inches. Inscriptions. Described.

Kimball, Charles F. *(b. 1835)*
Koehler, Sylvester R. "The works of the American etchers XXI; C. F. Kimball." [*Amer. Art Review*] 2, no. 1 (1881): 244.
Entries: 3. Inches. Inscriptions.

Kinderen, Antoon Johannes der *(1859–1925)*
Hammacher, A. *De Levenstijd van Antoon der Kinderen.* Amsterdam: H. J. Paris, 1932. (ERB)
Entries: unnumbered, pp. 121–122.

Polak, Bettina. *Het fin-de-siècle in de nederlandse schilderkunst.* The Hague: Martinus Nijhoff, 1955.

Kinderen, Antoon Johannes der *(continued)*

Entries: 27+ (works in various media including prints; 1889 to 1898). Millimeters. Inscriptions. Described. Illustrated (selection).

King, G. B. *(fl. c.1817)*
[F.] pp. 167–168.*

King, Giles *(fl. 1744–1746)*
[Sm.] II, pp. 783–784.
Entries: 1 (portraits only). Inches. Inscriptions. Described.

Kingsbury, Henry *(fl. 1775–1798)*
[Sm.] II, pp. 784–788, and "additions and corrections" section; IV, "additions and corrections" section.
Entries: 18 (portraits only). Inches. Inscriptions. States. Described. Located (selection).

[Siltzer] p. 360.
Entries: unnumbered, p. 360. Inscriptions.

[Ru.] pp. 190–191, 494.
Entries: 2 (portraits only, additional to [Sm.]). Inches. Inscriptions (selection). Described. Additional information to [Sm.]).

Kingsley, Elbridge *(1841–1915)*
Dwight, M. E. *Catalogue of the works of Elbridge Kingsley . . . compiled & arranged for Mt. Holyoke College.* South Hadley (Mass.): Mount Holyoke College, 1901. 52 copies. (MH)
Entries: 322. Ms. notes (NN); additional information, 6+ additional entries.

Kinney, Troy *(b. 1871)*
Kinney, Troy. Catalogue. Supplement to "Troy Kinney; etchings that dance," by Robert J. Cole. [*P. Conn.*] 1 (1921): 136–157. Separately published. *Catalogue*

of the etchings of Troy Kinney, with an introductory sketch "etchings that dance" by Robert J. Cole. New York: W. E. Rudge, [1921?].
Entries: 31 (to 1920). Inches. Illustrated (selection).

Kinney, Margaret West. Catalogue. In: *The etchings of Troy Kinney.* Garden City (N.Y.): Doubleday, Doran and Co., Inc., 1929. 990 copies.
Entries: 50 (to 1929). Inches. Illustrated (selection). Ms. addition (NN); 12 additional entries.

Crafton Collection. *Troy Kinney.* American etchers, 9. New York: Crafton Collection, 1930.
Entries: 52 (to 1930). Inches. Illustrated (selection).

Kints, Pieter *(fl. c.1610–1620)*
[W.] I, p. 278.
Entries: 3+.*

[H. *Neth.*] IX, p. 243.
Entries: 6. Illustrated (selection).*

Kip, Johannes *(1652/53–1722)*
[W.] I, p. 278.
Entries: 4+.*

[H. *Neth.*] IX, pp. 244–245.
Entries: 15+. Illustrated (selection).*

Kip, Willem [William] *(fl. 1598–1635)*
[Hind, *Engl.*] I, pp. 210–211; II, pp. 17–34.
Entries: 9+. Inches. Inscriptions. States. Described. Illustrated (selection). Located.

[H. *Neth.*] IX, p. 245.
Entries: 43. Illustrated (selection).*

Kirchhoff, Johann Jakob *(1796–1848)*
[Dus.] pp. 87–88.
Entries: 5+ (lithographs only, to 1821). Millimeters (selection). Paper fold measure (selection). Inscriptions (selection). Located (selection).

Kirchhoffer, Rudolph *(fl. 1840–1858)*
[Ap.] p. 215.
 Entries: 1.*

Kirchner, Ernst Ludwig *(1880–1938)*
Schiefler, Gustav. *Die Graphik Ernst Ludwig Kirchners bis 1924; Band I bis 1916.* Berlin-Charlottenburg (Germany): Euphorion-Verlag, 1926. 620 copies. (DLC)
 Entries: 270 woodcuts, 311 lithographs, 206 etchings, (to 1916). Millimeters. Inscriptions. States. Described.

Schiefler, Gustav. *Die Graphik Ernst Ludwig Kirchners; Band II 1917–1927.* Berlin-Charlottenburg (Germany): Euphorion-Verlag, 1927–1931. 620 copies. (NN)
 Entries: 316 woodcuts, 127 lithographs, 350 etchings (additional to Schiefler 1926; to 1927). Millimeters. Inscriptions. States. Described.

Dube, Annemarie, and Dube, Wolf-Dieter. *E. L. Kirchner; das graphische Werk.* 2 vols. Munich: Prestel-Verlag, 1967.
 Entries: 971 woodcuts, 665 etchings, 458 lithographs. Millimeters. Inscriptions. States. Illustrated.

Wentzel, Hans. "Unbekannte gebrauchsgraphische Arbeiten von Ernst Ludwig Kirchner." *Jahrbuch der Hamburger Kunstsammlungen* 13 (1968): 137–146.
 Additional information to Schiefler, 1926, 1927–1931. Independent of Dube.

Wentzel, Hans. "Rezension; Annemarie und Wolf-Dieter Dube, E. L. Kirchner, das graphische Werk." *Kunstchronik* 21 (1968): 245–259.
 Additional information to Dube.

Kirkall, Elisha *(c.1682–1742)*
[Sm.] II, pp. 788–789.

Entries: 1 (portraits only). Inches. Inscriptions. Described.

Kirkley, Caroline *(fl. c.1796)*
[Sm.] II, p. 789.
 Entries: 1 (portraits only). Inches. Inscriptions. States. Described.

[Ru.] p. 191.
 Additional information to [Sm.].

Kirmer, Michel [Michael] *(fl. 1552–1570)*
[B.] IX, p. 430.
 Entries: 1. Pre-metric. Inscriptions. Described.

[P.] IV, p. 188.
 Entries: 2 (additional to [B.]). Pre-metric. Inscriptions. Described. Located (selection).

Kitaj, R. B. *(b. 1933)*
Galerie Mikro, Berlin. *R. B. Kitaj, complete graphics 1963–1969.* Berlin, 1969.
 Entries: 27+ (to 1969). Inches. Millimeters. Illustrated.

Kestner Gesellschaft, Hannover. *R. B. Kitaj.* Hannover (West Germany), 1970. Dutch ed. Rotterdam (Netherlands): Museum Boymans-van Beuningen, 1970.
 Entries: 29+ (to 1969). Millimeters. Illustrated. Based on Galerie Mikro catalogue, with additions.

Kitsen, G. *(fl. c.1793–1807)*
[W.] I, pp. 278–279.
 Entries: 3.*

Kittensteyn, Cornelis van *(b. c.1600)*
[W.] I, p. 279.
 Entries: 18+.*

[H. *Neth.*] IX, pp. 246–251.
 Entries: 36+. Illustrated (selection).*

Kiwitz, Heinz *(1910–1938?)*
Bender, Paul. *Heinz Kiwitz, Holzschnitte.* Duisburg (West Germany): Carl Lange, 1963. 1000 copies.

Kiwitz, Heinz (*continued*)

Entries: 262 woodcuts, 8 linocuts, 12 commercial prints. Millimeters. Illustrated (selection).

Klauber, Ignaz Sebastian (*1754–1820*)
[Ap.] pp. 215–217.
Entries: 26.*

Klee, Paul (*1879–1940*)
Kornfeld, Eberhard W. *Verzeichnis des graphischen Werkes von Paul Klee.* Bern: Verlag Kornfeld und Klipstein, 1963. 1400 copies. (MH) English ed., 1964. 800 copies (not seen). French ed., 1964. 300 copies (not seen).
Entries: 109 prints by, 40 reproductions and drawings on transfer paper. Millimeters. Inscriptions. States. Described. Illustrated. Located.

Kleeman, Johann Jakob (*1739–1790*)
[A.] V, pp. 354–358.
Entries: 6. Pre-metric. Inscriptions. States. Described.

Kleiber, Franz Xaver (*1794–1872*)
[Dus.] pp. 88–89.
Entries: 7 (lithographs only, to 1821). Millimeters (selection). Inscriptions (selection). Located (selection).

Klein, Georg Gottfried Christian (*1805–1826*)
Andresen, A. "Georg Gottfried Christian Klein." [*N. Arch.*] 9 (1863): 231–236.
Entries: 27. Pre-metric. Inscriptions. States. Described.

Klein, Hans (*d. 1632*)
See **Monogram HK** [Nagler, *Mon.*] III, no. 1148

Klein, Johann Adam (*1792–1875*)
[Ebner, L.] *Verzeichniss der von Johann Adam Klein, Maler und Kupferstecher,*

Mitglied der K. preuss. Academie der Künste in Berlin, gezeichneten und radierten Blätter (vom Jahr 1805 bis 1846). Stuttgart: Ebner und Seubert, 1853. (EBKk)
Entries: unnumbered, pp. 3–16. Paper fold measure.

Jahn, C. *Das Werk von Johann Adam Klein Maler und Kupferätzer zu München.* Munich: Verlag der Montmorrilon'schen Kunsthandlung, 1863. (MBMu)
Entries: 366 (to 1862). Pre-metric. Inscriptions. States. Described. Copies mentioned.

[Dus.] pp. 89–91.
Entries: 14+ (lithographs only, to 1821). Millimeters. Inscriptions. Located.

Klein, Stéphanie (*d. c.1864*)
[Ber.] VIII, p. 284.*

Kleinenbroich, Wilhelm (*1814–1895*)
[Merlo] p. 494.*

Klemke, Werner (*20th cent.*)
Kunze, Horst. *Werner Klemkes gesammelte Werke.* Dresden (East Germany): Verlag der Kunst, 1968.
Entries: unnumbered, pp. 264–292 (works in various media, including prints; to 1967). Illustrated (selection).

Klengel, ——— (*19th cent.*)
[Dus.] p. 91.
Entries: 3 (lithographs only, to 1821). Millimeters. Inscriptions. Located.

Klimsch, F. (*19th cent.*)
[Merlo] p. 495.*

Klinger, Max (*1857–1920*)
Roeper, Adalbert. "Max Klinger." [*Kh.*] 1 (1909): 150–153, 165–168, 181–184.
Entries: 15 sets of prints, 63 single prints. Millimeters. States. Described (selection).

Singer, Hans W. *Klinger, Radierungen Stiche und Steindrucke; wissenschaftliches Verzeichnis.* Berlin: Amsler und Ruthardt, 1909.
Entries: 331. Millimeters. Inscriptions. States. Described. Illustrated. Located (selection).

Beyer, Carl. *Max Klingers graphisches Werk von 1909 bis 1919; eine vorläufige Zusammenstellung in Anschluss an den Oeuvre-Katalog von Hans W. Singer.* Leipzig: F. H. Beyer und Sohn, 1930. (NN)
Entries: 122 (additional to Singer). Millimeters. Inscriptions. States. Described.

Klinsmann, ——— *(19th cent.)*
[Dus.] p. 92.
Entries: 5+ (lithographs only, to 1821). Millimeters (selection). Inscriptions (selection). Located (selection).

Klöcker von Ehrenstrahl, David
See **Ehrenstrahl**

Kloeting, Symon *(fl. c.1645)*
[W.] I, p. 294.
Entries: 1.*

Klomp, Albert Jansz *(c.1618–1688)*
[W.] I, p. 294.
Entries: 1 print after.*

[H. *Neth.*] IX, p. 251.
Entries: 1 print after.*

Klopper, Johannes *(d. 1734)*
[H. *Neth.*] IX, p. 252.
Entries: 3.*

Klotz, Joseph *(1785–1830)*
[Dus.] pp. 92–93.
Entries: 4 (lithographs only, to 1821). Millimeters (selection). Inscriptions (selection). Located (selection).

Klotz, Matthias *(1748–1831)*
[Dus.] p. 93.

Entries: 2 (lithographs only, to 1821). Millimeters (selection).

Klotz, Simon Petrus *(1776–1824)*
[Dus.] pp. 93–97.
Entries: 52 (lithographs only, to 1821). Millimeters. Inscriptions. Located.

Kluge, Moritz Edwin *(b. 1802)*
[Ap.] pp. 217–218.
Entries: 7.*

Knapton, Charles
See **Pond,** Arthur

Kneass, William *(1781–1840)*
[St.] pp. 274–278.*

[F.] pp. 168–172.*

Kneass, Young and Co. *(19th cent.)*
[F.] pp. 172–173.*

Kneller, Gottfried [Godfrey] *(1646–1723)*
[W.] I, pp. 296–298.
Entries: 147+ prints after.*

[H. *Neth.*] IX, p. 252.
List of artists who made prints after. No catalogue.

Knight, Charles *(1743–c.1846)*
[Ap.] p. 218.
Entries: 1.*

[Siltzer] p. 360.
Entries: unnumbered, p. 360. Inscriptions.

Knöpfle, ——— *(19th cent.)*
[Dus.] p. 97.
Entries: 1 (lithographs only, to 1821). Millimeters. Inscriptions.

Knolle, E. *(19th cent.?)*
[Ap.] p. 218.
Entries: 1.*

Knolle, [Johann Heinrich] Friedrich *(1807–1877)*
 [Ap.] pp. 218–219.
 Entries: 18.*

Knüpfer, Nicolaus *(c.1603–c.1660)*
 [W.] I, pp. 300–301.
 Entries: 2 prints after.*

 [H. *Neth.*] IX, p. 252.
 Entries: 6 prints after.*

Kobel, —— van *(fl. c.1843)*
 [Ber.] VIII, p. 284.*

Kobell, Anna *(c.1795–1847)*
 [W.] I, p. 301.
 Entries: 1.*

Kobell, Ferdinand *(1740–1799)*
 Stengel, Etienne, baron de. *Catalogue raisonné des estampes de Ferdinand Kobell.* Nuremberg: Chez Riegel et Wiesner, 1822. (MBMu)
 Entries: 240 prints by, 1 rejected print. Appendix with 27 additional prints separately numbered. Pre-metric. Inscriptions. States. Described.

Kobell, Hendrik *(1751–1779)*
 [W.] I, p. 302.
 Entries: 19 prints by, 7+ after.*

Kobell, Jan I *(1756–1833)*
 [W.] I, p. 302.
 Entries: 6+.*

Kobell, Jan II *(1778–1814)*
 [vdK.] pp. 198–203.
 Entries: 10 Millimeters. Inscriptions. States. Described. Appendix with 2 doubtful and rejected prints.

Kobell, Wilhelm Alexander Wolfgang von *(1766–1855)*
 [A. 1800] I, pp. 114–163.
 Entries: 124. Pre-metric. Inscriptions. States. Described.

Pückler-Limpurg, S., Graf. "Wilhelm von Kobell (Ergänzungen zu Andresens Verzeichnis seiner Radierungen)." [*MGvK.*] 1907: 16–18.
 Entries: 15 additional to [A. 1800]). Millimeters. States. Described. Located. Additional information to [A. 1800].

Lessing, Waldemar. *Wilhelm von Kobell.* Munich: F. Bruckmann, 1923.
 Entries: 124 etchings, 10 lithographs. Millimeters. Inscriptions. States. Described. Illustrated (selection). Etchings after Kobell's own designs, and lithographs, are fully catalogued: etchings after other artists are listed with title and dimensions.

Koch, Joseph Anton *(1768–1839)*
 [A. 1800] I, pp. 9–36.
 Entries: 29+ etchings, 2+ lithographs. Pre-metric. Inscriptions. States. Described.

 Andresen, Andreas. "Andresens Nachträge zu seinen 'Deutschen Maler-radierern.'" [*MGvK.*] 1907, pp. 39–40. Additional information to [A. 1800].

 [Dus.] p. 97.
 Entries: 1 (lithographs only, to 1821). Millimeters. Inscriptions. Located.

Koch, Matthias *(fl. 1802–1804)*
 [Dus.] p. 97.
 Entries: 3 (lithographs only, to 1821). Millimeters (selection). Paper fold measure (selection). Inscriptions. Located.

Koch, Rudolf *(1876–1934)*
 Rödel, Klaus. *Rudolf Koch exlibris.* 2 vols. Frederikshavn (Denmark): Privately printed, 1967.
 Entries: 246 (bookplates only, to 1967). Described. Illustrated (selection).

Köbel, Jacob *(c.1460–1533)*
See **Monogram IK** [Nagler, *Mon.*] III, no. 2682

Koeck, Christian *(c.1759–c.1825)*
[Dus.] p. 97.
Entries: 1 (lithographs only, to 1821). Millimeters. States. Located.

Koedyck, Dirk *(b. 1681)*
[W.] I, p. 311.
Entries: 5.*

[H. *Neth.*] IX, p. 253.
Entries: 9. Illustrated (selection).*

Koellner, Auguste
See **Kollner**

Koenig, ⸻ *(fl. c.1840)*
[Ber.] VIII, pp. 284–285.*

König, F. *(19th cent.)*
[Merlo] p. 496.*

König, [Franz] Niklaus *(1765–1832)*
Bernoulli, Rudolf. *Franz Niklaus König Originalgraphik.* Zurich: Eidg. Technische Hochschule, 1932.
Entries: 127+. Millimeters.

Koenig, J. C. *(b. 1800)*
[Ap.] p. 220.
Entries: 3.*

Köning, G. de *(fl. c.1750)*
[Sm.] I, pp. 169–170.
Entries: 1 (portraits only). Inches. Inscriptions. Described.

Koeppen, A. *(19th cent.)*
[Dus.] pp. 97–98.
Entries: 1 (lithographs only, to 1821). Millimeters. Inscriptions. Located.

Koeppen, W. *(19th cent.)*
[Dus.] p. 98.
Entries: 1 (lithographs only, to 1821). Millimeters. Inscriptions. Located.

Koepping, Karl *(1848–1914)*
[Ber.] VIII, pp. 285–286.
Entries: 25 Paper fold measure (selection).

Graul, Richard. "Die Ausstellung von Werken graphischer Kunst in Wien, 1894; Karl Koepping." [*GK.*] 17 (1894): 28–35.
Entries: 35 (to 1894).

Roeper, Adalbert. "Karl Koepping; zum sechzigsten Geburtstag des Kunstlers." [*Bb.*] 75 (1908): 6855–6859.
Entries: 56 (to 1907). Millimeters. States.

Verlag Emil Richter. *Carl Koepping; Verzeichnis seiner nachgelassenen Radierungen.* Introduction by H. W. Singer. Dresden: Kunsthandlung und Verlag Emil Richter, 1915–1916.
Entries: 64 (complete?). Illustrated (selection).

Koeser, F. *(19th cent.)*
[Dus.] p. 98.
Entries: 1 (lithographs only, to 1821). Millimeters.

Koets, Roelof II *(before 1650–1725)*
[W.] I, p. 314.
Entries: 1 print after.*

Kohl, Clemens *(1754–1807)*
[Ap.] p. 220.
Entries: 15.*

Kohlschein, Joseph I *(1841–1915)*
[Ap.] pp. 220–221.
Entries: 4.*

Roeper, Adalbert. [*Kh.*] 7 (1915): 69ff.
Not seen.

Kohn, Misch *(b. 1916)*
American Federation of Arts [Carl Zigrosser, compiler]. *Misch Kohn.* New York, 1961.

Kohn, Misch (*continued*)

Entries: 161. Inches. Illustrated (selection).

Koker, Anna Maria de (*c.1650–1698*)
[H. *Neth*.] IX, pp. 254–261.
Entries: 20. Illustrated (selection).*

Kokoschka, Oskar (*b. 1886*)
Haus der Kunst, Munich [Wilhelm F. Arntz, compiler]. *Oskar Kokoschka; aus seinem Schaffen 1907–1950*. Munich: Prestel Verlag, 1950.
Entries: 163 (to 1950). Millimeters. Inscriptions. Ms. addition (CSfAc); additional information.

Neue Galerie der Stadt Linz [Wolfgang Gurlitt, compiler]. *Oskar Kokoschka*. Linz (Austria), 1951.
Entries: 273 (to 1951). Millimeters.

Kolb, ——— (*fl. c.1840*)
[Ber.] VIII, p. 286.*

Kolb, J. C. (*18th cent.*)
[Merlo] p. 498.*

Kolbe, Carl Wilhelm I (*1757–1835*)
Jentsch, Ernst. "Der Radierer Carl Wilhelm Kolbe, 1757 Berlin–1835 Dessau." Dissertation, University of Breslau, 1920. Ms. (ICB)
Entries: 329 prints by, 4 doubtful prints. Millimeters. Inscriptions. States. Described. Copy with ms. notes (EOBKk); additional states.

[Dus.] p. 98.
Entries: 3 (lithographs only, to 1821). Paper fold measure. Inscriptions (selection).

Koller, Johann Jakob (*1746–c.1805*)
[W.] I, p. 317.
Entries: 4+.*

Kollmann, Karl Ivanovich (*1788–1846*)
[Dus.] p. 98.
Entries: (lithographs only, to 1821). Millimeters. Inscriptions. Located.

Kollner, Auguste (*1813–1897*)
[Carey] pp. 311–314.
Entries: 37+ prints by, 1+ after, (lithographs only). Inches. Inscriptions (selection). Described (selection). Illustrated (selection). Located.

Kollwitz, Käthe (*1867–1945*)
Lehrs, Max. "Käthe Kollwitz." [*GK*.] 26 (1903): 55–67.
Entries: 50 (to 1902). Millimeters. Inscriptions. States.

Sievers, Johannes. *Die Radierungen und Steindrucke von Käthe Kollwitz, innerhalb der Jahre 1890 bis 1912*. Dresden: Herrmann Holst, 1913.
Entries: 122. Millimeters. Inscriptions. States. Described. Illustrated.

Wagner, A. *Die Radierungen, Holzschnitte und Lithographien von Käthe Kollwitz; eine Zusammenstellung der seit 1912 entstandenen graphischen Arbeiten*. Dresden: Emil Richter, 1927.
Entries: 75 (additional to Sievers; to 1927). Millimeters. States. Described. Illustrated.

Klipstein, August. *Käthe Kollwitz, Verzeichnis des graphischen Werkes . . . für die Jahre 1890–1912 unter Verwendung des 1913 erschienenen Oeuvrekataloges von Prof. Dr. Johannes Sievers*. Bern: Klipstein und Co., 1955. Ed. with English title-page. *The graphic work of Käthe Kollwitz*. New York: Galerie St. Etienne, 1955.
Entries: 267. Millimeters. Inscriptions. States. Described. Illustrated. Based on Sievers for prints up to 1912.

Kolyns, David (*1582–after 1668*)
[H. *Neth*.] IV, p. 220; IX, p. 261.
Entries: 1 print after.*

Krafft, Johann August (*continued*)

Entries: 1 (lithographs only, to 1821). Millimeters. Inscriptions. Located.

Krall, Conrad
See **Grale**

Kramer, Gabriel (*d. 1608*)
[P.] III, p. 477.
Entries: 2+. Pre-metric. Inscriptions (selection). Described (selection).

[A.] III, pp. 289–291.
Entries: 2+. Pre-metric. Inscriptions. States. Described (selection).

[Merlo] pp. 501–503.*

Kratké, Charles Louis (*1848–1921*)
[Ber.] VIII, pp. 286–287.
Entries: 20. Paper fold measure (selection).

Kraus, ——— (*19th cent.*)
[Dus.] p. 99.
Entries: 2 (lithographs only, to 1821). Inscriptions. Located.

Kraus, Gustav Wilhelm (*1804–1852*)
[Dus.] p. 99.
Entries: 1 (lithographs only, to 1821). Inscriptions.

Krauskopf, Wilhelm (*b. 1847*)
Roeper, A. "Das Lebenswerk des Radierers Wilhelm Krauskopf." [*Bb.*] 74 (1907): 6641ff.
Entries: 138 (to 1897). Inscriptions. States.

Krauss, Philipp Joseph (*1789–1864*)
[Dus.] pp. 98–99.
Entries: 3 (lithographs only, to 1821). Millimeters. Inscriptions. Located.

Krausse, [Lorenz] Alfred (*1829–1894*)
[Ap.] p. 222.
Entries: 4.*

Krautle, Carl (*b. 1834*)
[Ap.] p. 222.
Entries: 3.*

Kravchenko, Aleksej Il'ich (*1889–1940*)
Razumovskaja, S. *A.I. Kravchenko.* Moscow: Ogiz-Izogiz, 1935.
Entries: unnumbered, pp. 77–81 (to 1934). Illustrated (selection).

Panov, Mikhail Juz'evich. *A. I. Kravchenko.* Moscow: Izdvatelshtvo "Kniga," 1969.
Entries: 56 (bookplates only, to 1939). Millimeters. Illustrated (selection).

Kravtsov, Gershon (*20th cent.*)
Perkin, W. D. *Gerschon Krawzow, en russisk exlibriskunstner; opusliste.* n.p.: Exlibristen, 1970. 50 copies. (NN)
Entries: 140 (bookplates only, to 1968). Millimeters. Described. Illustrated (selection).

Kremer, Gerhard
See **Mercator**

Kremser-Schmidt, Martin Johann
See **Schmidt,** Martin Johann

Kressel, Diether (*20th cent.*)
Kulturgeschichtliches Museum, Osnabrück. *Diether Kressel, Radierungen und Holzschnitte; Ausstellung in der Dominikanerkirche.* Osnabrück (West Germany), 1972. (EBKk)
Entries: 97 etchings, 37 woodcuts (to 1972). Millimeters. Described. Illustrated (selection).

Kretschmann, Carl Clemens (*fl. c.1680*)
[A.] V, pp. 220–224.
Entries: 3. Pre-metric. Inscriptions. States. Described.

Kreutz, Heinz (*b. 1923*)
Kunsthalle, Bremen [Heinz Kreutz, compiler]. *Heinz Kreutz; Die Holzschnitte von 1960 bis mai 1962.* Bremen (West

Germany), 1962. (EMZK) Supplement. 1963 (EMZK) Supplement. 1964. (EMZK) Entries: 47 (to 1962). Supplement 1963 adds 13 (to 1963). Supplement 1964 adds 34 (to 1964). Millimeters. States.

Kriegstötter, F. *(fl. c.1800)*
[Dus.] p. 99.
 Entries: 1 (lithographs only, to 1821). Millimeters. Inscriptions. Located.

Kriehuber, Josef *(1800–1876)*
Wurzbach, Wolfgang von. *Josef Kriehuber; Katalog der von ihm lithographierten Portraits.* Munich: H. Helbing, 1902. 300 copies. (NN)
 Entries: 2358. Paper fold measure. Described.

Wurzbach, Wolfgang von. *Josef Kriehuber und die Wiener Gesellschaft seiner Zeit . . . 1. Band; Katalog der Porträtlithographien Josef Kriehubers mit einer biographischen Einleitung und verschiedenen Registern zur Identifizierung unbestimmer Porträts. 2. vermehrte und vollständig neu bearbeitete Ausgabe.* Vienna, Bad Bocklet (West Germany), and Zürich: Walter Krieg, 1955.
 Entries: 2544. Inscriptions. Described.

Kröner, Christian *(1838–1911)*
Roe, ———. "Christian Kröner." [*Bb.*] 75 (1908): 1233–1239.
 Entries: unnumbered, pp. 1233–1238, prints after; pp. 1238–1239, prints by; (to 1880). Millimeters. States.

Krol, Abram *(b. 1919)*
École Estienne, Paris. *X années de livres.* Paris: École Estienne, 1959. (CSfAc)
 Bibliography of books with illustrations by (1949–1959).

Éditions Estienne. *De Livre en livre, Krol.* Preface by Robert Rauc. Paris: Éditions Estienne, 1966. (CSfAc)

 Bibliography of books with illustrations by (1959–1966).

Cailler, P. *Catalogue raisonné de l'oeuvre gravé de Abram Krol, tome 1er, 1948–1957.* Geneva, P. Cailler, 1969.
 Entries: 356 (to 1957). Millimeters. States. Described. Illustrated.

Kroll, Hans *(fl. c.1560)*
See **Monogram HK** [Nagler, *Mon.*] III, no. 1156

Krostewitz, Fritz *(1860–1913)*
Roeper, Adalbert. *Fritz Krostewitz.* [*Bb.*] 75, no. 277 (28 November 1908): 13794–13800. Separately bound copy. (NN)
 Entries: 138 (to 1908). Millimeters. States.

Roeper, Adalbert. [*Kh.*] 3 (1911): 30ff. Not seen.

Kroymann, Carl Friedrich *(1781–1848)*
[Dus.] p. 99.
 Entries: 1 (lithographs only, to 1821). Millimeters. Inscriptions. Located.

Kršić, Bogdan *(20th cent.)*
Galerija Grafički Kolektiv, Belgrade [Dragoslav Đorđević, compiler]. *Bogdan Kršić; dramsko kazivanje o grafici i humanizmu.* Belgrade (Yugoslavia), 1968. (DLC)
 Entries: 168 (to 1968). Millimeters. Illustrated (selection).

Krsmanović, Marko *(20th cent.)*
Galerija Grafički Kolektiv [Dragoslav Đorđević, compiler]. *Marko Krsmanović.* Belgrade (Yugoslavia), 1968. (DLC)
 Entries: 57 (to 1967). Millimeters. Illustrated (selection).

Krüger, ——— *(fl. c.1807)*
[Dus.] p. 99.
 Entries: 2 (lithographs only, to 1821). Millimeters. Inscriptions. Located.

Krüger, Albert *(b. 1858)*
Roeper, Adalbert. "Albert Krüger; zum fünfzigsten Geburtstage des Künstlers."[*Bb.*] 75, no. 156 (8 July 1908): 7435–7440. Separately bound copy. (NN)
> Entries: 95+ (to 1908?) Millimeters. States.

Roeper, Adalbert. "Albert Krüger." [*Kh.*] 10 (1918): 129–133.
> Entries: 96. Millimeters. States. Described.

Krüger, [Ferdinand] Anton *(1795–1857)*
[Ap.] pp. 222–223.
> Entries: 24.*

Krüger, Ephraim Gottlieb *(1756–1834)*
[Ap.] pp. 223–224.
> Entries: 8.*

Krüger, Franz *(1797–1857)*
Cohn, Margarete. *Franz Krüger, Leben und Werke.* Breslau (Germany): Th. Schatzky, 1909.
> Entries: 84 prints by, 64 prints after paintings by, 346+ prints after drawings by. Described. Ms. notes in photostat copy of catalogue (NN); additional information.

Kruell, Gustav *(1843–1907)*
Smith, Ralph Clifton. "Gustav Kruell, wood engraver." [*P. Conn.*] 6, no. 1, part 3 (1926): 1–27.
> Entries: unnumbered, pp. 23–27.

Smith, Ralph Clifton. *Gustav Kruell, American portrait engraver on wood.* Champlain (N.Y.): Winfred Porter Truesdell, 1929.
> Entries: 530. Inches. Ms. notes (NN); additional information, a few additional entries.

Krug, Ludwig *(c.1488/90–1532)*
[B.] VII, pp. 535–541.
> Entries: 12. Pre-metric. Inscriptions. States. Described. Copies mentioned.

[Heller] p. 84.
> Additional information to [B.].

[Evans] pp. 24, 45.
> Entries: 3 (additional to [B.]). Millimeters. Inscriptions. Described.

[P.] III, pp. 132–135.
> Entries: 4 engravings (additional to [B.]), 1 woodcut. Pre-metric. Inscriptions. Described. Located. Copies mentioned. Additional information to [B.].

[Wess.] I, p. 139.
> Additional information to [B.] and [P.].

[Ge.] nos. 890–891.
> Entries: 2 (single-sheet woodcuts only). Described. Illustrated. Located.

Bock, Elfried. "The engravings of Ludwig Krug of Nuremberg." [*PCQ.*] 20 (1933): 87–115.
> Entries: 16 engravings, 2 woodcuts, 2 rejected prints. Millimeters. Inscriptions. States. Described (selection). Illustrated (selection).

Krukenberg, Karl *(1794–1831)*
[Ap.] p. 224.
> Entries: 1.*

Kruseman, Cornelis *(1797–1857)*
[H. L.] pp. 533–534.
> Entries: 3 (etchings only). Millimeters. Inscriptions. Described. Also, list of 2 lithographs (titles only).

Kruseman van Elten, Hendrik Dirk *(1829–1904)*
Koehler, Sylvester R. "The works of the American etchers, XIII: Kruseman van Elten." [*Amer. Art Review*] 1 (1880): 475–476.
> Entries: 12 (to 1880). Inches. Inscriptions.

Koehler, Sylvester R. "New etchings by
Kruseman van Elten." [*Amer. Art Re-
view*] 2, no. 2 (1881): 198.
 Entries: 7 (additional to Koehler 1880,
 to 1881). Inches. Inscriptions.

Kubin, Alfred *(1877–1959)*
Horodisch, Abraham. *Alfred Kubin als
Buchillustrator.* New York: Verlag der
Aldus-Buch-Compagnie, 1949.
 Bibliography of books with illustra-
 tions by.

Horodisch, A. "Exlibris van Alfred Ku-
bin." *Boekcier,* 2d ser. 5 (1950): 1–4.
 Entries: 24 (bookplates only; to 1949).
 Illustrated (selection).

Raabe, Paul. *Alfred Kubin; Leben, Werk,
Wirkung.* Hamburg: Rowohlt Verlag,
1957.
 Entries: 778+ prints by and after.
 Millimeters. Described (selection). Il-
 lustrated (selection).

Kuczyński, Edward *(1905–1958)*
Uniwersytet Mikołaja Kopernika w
Toruniu. *Wystawa pośmiertna prac Ed-
warda Kuczyńskiego, 1905–1958.* Toruń
(Poland): Toruńska Drukarnia
Dzielowa, 1958.
 Entries: 174 (complete?). Millimeters.
 Illustrated (selection).

Küchler, Balthasar *(d. 1641)*
[A.] IV, pp. 220–231.
 Entries: 2+. Pre-metric. Inscriptions.
 Described.

Kügelgen, [Ferdinand] Carl von
(1772–1832)
[Dus.] pp. 99–100.
 Entries: 2+ (lithographs only, to 1821).
 Millimeters. Inscriptions. Located.

Kühlen, Franz *(fl. 1820–1854)*
[Dus.] p. 100.
 Entries: 2 (lithographs only, to 1821).
 Millimeters. Inscriptions. Located.

Kühn, Ludwig *(b. 1859)*
Roeper, Adalbert. "Ludwig Kühn und
sein graphisches Werk." [*Bb.*] 76, no. 82
(10 April 1909): 4368–4375.
 Entries: 169 (to 1907). Millimeters.
 States.

Roeper, Adalbert. "Ludwig Kühn und
sein graphisches Werk." [*Kh.*] 8 (1916):
170–178.
 Entries: 174 (to 1916). Millimeters.
 States. Described. Illustrated (selec-
 tion).

Kuhnen, Pieter Lodewyk *(1812–1877)*
[H. L.] pp. 534–535.
 Entries: 2. Millimeters. Inscriptions.
 States. Described.

Kuhnert, Wilhelm *(1865–1926)*
Hirzel, Hermann. Catalogue. In *Meine
Tiere,* by Wilhelm Kuhnert. Berlin:
Reimar Hobbing, [1925?]. (EBKb)
 Entries: 115 (to 1925). Millimeters. In-
 scriptions. States. Described. Illus-
 trated.

Amsler und Ruthardt, Berlin. *Wilhelm
Kuhnert, vollständiger Katalog der
Originalradierungen des Künstlers.* Berlin:
Amsler und Ruthardt, 1927.
 Entries: 115. Millimeters. Illustrated
 (selection).

Kuipers, H. Czn. *(fl. c.1789)*
[W.] I, p. 362.
 Entries: 3.*

Kulmbach, Hans Suess von *(c.1480–1522)*
See also **Master of the Comedies of
HROSVITHA**

Winckler, Friedrich. "Die Holzschnitte
des Hans Suess von Kulmbach." [*JprK.*]
62 (1941): 1–28.
 Entries: unnumbered, pp. 24–28. De-
 scribed (selection). Illustrated (selec-
 tion).

Kumberger, Heinrich *(fl. c.1605)*
[A.] IV, pp. 11–13.
 Entries: 1. Pre-metric. Inscriptions.
 Described.

Kuniyoshi, Yasuo *(1893–1953)*
Davis, Richard A. "The graphic work of
Yasuo Kuniyoshi 1893–1953." *Archives of
American Art,* 5, no. 3 (July 1965): 1–19.
 Entries: 47 etchings, 81 lithographs.
 Inches. States. Described. Illustrated.
 Located (selection).

Kunst, Pieter Cornelisz *(fl. 1514–1527)*
See **Monogram PVL** [Nagler, *Mon.*] IV,
no. 3390

Kuntz, [Johann] Rudolf *(1797–1848)*
[Dus.] p. 100.
 Entries: 1 (lithographs only, to 1821).
 Millimeters. Inscriptions. Located.

Kupezky, Joannes [Johann] *(1667–1740)*
Šafařík, Eduard. *Joannes Kupezky 1667–
1740.* Prague (Czechoslovakia): Orbis,
1928.
 Entries: 154 prints after. Millimeters.
 Inscriptions. States. Described (selec-
 tion). Illustrated (selection).

Kurzweil, Max *(1867–1916)*
Novotny, Fritz, and Adolph, Hubert.
*Max Kurzweil, ein Maler der Wiener Sezes-
sion.* Vienna: Jugend und Volk, 1969.
 Entries: 26. Millimeters. Inscriptions.
 States. Illustrated (selection). Bibliog-
 raphy for each entry.

Kussaeus [**Kussens**], Cornelis Ysbrantsz
(fl. 1597–1618)
 [W.] I, p. 362.
 Entries: 1 print after.*

 [H. *Neth.*] IX, p. 276.
 Entries: 1 print after.*

Kustodiev, Boris M. *(1878–1927)*
Gollerbakh, E. *Grafika B. M. Kustodieva.*
Moscow and Leningrad:
Gosudarstvennoe Izdatel'stvo, 1929.
 Entries: lithographs unnumbered, pp.
 59–61, 6 posters, 13 bookplates. In-
 scriptions (posters and bookplates
 only). Described (posters and
 bookplates only). Also, bibliography
 of books with illustrations by.

Kuyck, Louis van *(1821–1871)*
[H. L.] pp. 535–536.
 Entries: 2. Millimeters. Inscriptions.
 States. Described.

Kuyl, Gysbert van der *(c.1625–1673)*
[H. *Neth.*] IX, p. 276.
 Entries: 1 print after.*

Kuyper, Jaap *(b. 1906)*
Schwencke, Johan. "Overzichten VI."
Boekcier, 2d ser. 1 (1946): 19–22.
 Entries: unnumbered, pp. 21–22
 (bookplates and commercial prints
 only; to 1946). Millimeters. Described.
 Illustrated (selection).

Kuyper, Jacques *(1761–1808)*
[W.] I, p. 370.
 Entries: 2 prints by, 41 prints after.*

Kuytenbrouwer, Martinus Antonius II
[called "Martinus"] *(1821–1897)*
 [H. L.] pp. 536–547.
 Entries: 34. Millimeters. Inscriptions.
 States. Described.

Kuzminskis, Jonas *(20th cent.)*
Korsakitė, Ingrida. *Jonas Kuzminskis.*
Vilna (USSR), 1966. (DLC)
 Entries: unnumbered, p. 95 (to 1965).
 Millimeters. Illustrated (selection).

Lietuvos T S R Dailės Muziejus, Vilnius
[B. Pakštas, compiler]. *Jonas Kuzminskis,*

dailes parodos katalogas/Jonas Kuzminskis, katalog khydozhestvennoj vystavki. Vilna (USSR), 1966. (DLC)
Entries: unnumbered pp. 17–30, 43–56 (to 1966). Millimeters. Illustrated (selection). Text in Lithuanian and Russian.

Kyte, Francis *(fl. 1710–1745)*
[Sm.] II, pp. 789–796.
Entries: 13+ (portraits only). Inches. Inscriptions. States. Described. Located (selection).

[Ru.] pp. 191–192.
Additional information to [Sm.].

L

Laage, Wilhelm *(1868–1930)*
Schiefler, Gustav. *Das graphische Werk Wilhelm Laages bis 1912.* Hamburg: Hamburger Liebhaber-Bibliothek Lütke und Wulff, 1912.
Entries: 140 (to 1912). Millimeters. Inscriptions. States. Described. 115 to 132 are woodcuts printed in the catalogue.

Zoepf, Ludwig. *Wilhelm Laage, Holzschnittmeister und Maler.* Tübingen (Germany): Ludwig Zoepf, 1934.
Entries: unnumbered, pp. 101–106 (to 1924).

Hagenlocher, Alfred. *Wilhelm Laage, das graphische Werk mit dem vollständigen Werkverzeichnis.* Munich: Karl Thiemig, 1969.
Entries: 436. Millimeters. Inscriptions. States. Illustrated.

Laan, Adolf van der *(c.1690–after 1755)*
[W.] II, p. 1.
Entries: 6+.*

Labacco, Antonio da *(b. c.1495)*
[P.] VI: *See* **Chiaroscuro Woodcuts**

Labbé, ——— *(fl. c.1852)*
[Ber.] VIII, p. 287.*

La Bertonnière, H. F. de *(18th cent.)*
[M.] III, pp. 725–726.
Entries: 12.

Laborde, Chas [Charles] *(1886–1941)*
Kunstler, Charles. "Chas Laborde, gentilhomme illustrateur." [*AMG.*] 2 (1928–1929): 665–672.
Bibliography of books with illustrations by (to 1928).

Thomé, J. R. "Chas Laborde illustrateur." *Portique* 3 (1946): 13–34.
Bibliography of books with illustrations by (to 1944).

Laborde, Léon de *(1807–1869)*
[Ber.] VIII, p. 287.*

Labouchère, Pierre Antoine *(1807–1873)*
[Ber.] VIII, p. 288.*

Laboureur, Jean Émile *(1877–1943)*
Lotz-Brissonneau, A. *Nomenclature des gravures sur bois, eaux-fortes et lithographies exécutées à ce jour par J.-E.*

Laboureur, Jean Émile (*continued*)

Laboureur. Nantes (France) and Paris:
Sagot, 1909. 130 copies. (NN)
 Entries: 62 etchings, 95 woodcuts, 14
 lithographs (to 1909). Millimeters. In-
 scriptions. States.

Roger-Marx, Cl. "J.-É. Laboureur,
graveur modern." *Byblis* 3 (1924): 5–8;
4 unnumbered pages following p. 36.
 Entries: unnumbered, 4 pp. (to 1923).
 Millimeters.

Istel, Paul. "J. E. Laboureur, illus-
trator." *The Fleuron* 5 (1926): 35–61.
 Bibliography of books with illustra-
 tions by (to 1926).

Valotaire, Marcel. *Laboureur.* Les artistes
du livre, 4. Paris: Henry Babou, 1929. 700
copies. (NN)
 Bibliography of books with illustra-
 tions by.

Godefroy, Louis. *L'Oeuvre gravé de
Jean-Emile Laboureur.* Paris: Published by
the author, 1929. 525 copies. (MBMu)
 Entries: 391+ (engravings and etch-
 ings only, to 1929). Millimeters.
 States. Described (selection). Illus-
 trated (selection). Located.

Prinet, Jean. "Les illustrations de J.-
Émile Laboureur." *Portique* 1 (1945):
7–25.
 Bibliography of books with illustra-
 tions by (to 1938).

Loyer, Jacqueline. *Laboureur, oeuvre
gravé et lithographié.* Paris: Marcel
Lecomte, 1962. 500 copies. (MBMu).
 Entries: 383 (engravings and etchings
 additional to Godefroy; all woodcuts
 and lithographs). Millimeters. In-
 scriptions. States. Illustrated (selec-
 tion.

Lacauchie, Alexandre (*fl. 1833–1846*)
 [Ber.] VIII, p. 288.*

Lachair, Salomon (*fl. c.1654*)
 [W.] II, p. 1.
 Entries: 1.*

Lachaussée, ——— (*19th cent.*)
 [Ber.] VIII, p. 289.*

Lacombe, ——— de (*19th cent.*)
 [Ber.] VIII, p. 289.*

Lacoste, Louis Conil (*b. 1774*) and Jean
Louis Joseph Camille (*1809–1866*)
 [Ber.] VIII, p. 289.*

La Croix, J. G. de (*18th cent.*)
 [W.] I, p. 359.
 Entries: 1.*

La Croix, Pieter Frederik de (*1709–1782*)
 [W.] I, p. 359.
 Entries: 4 prints after.*

Ladenspelder, Johann (*1512–after 1561*)
 [B.] IX, pp. 15–16, 21–22, 57–67, 67, 486.
 Entries: 25 (5 separate listings under
 different monograms). Pre-metric. In-
 scriptions. Described.

 [Evans] p. 25.
 Entries: 1 (additional to [B.]). Mil-
 limeters. Inscriptions. Described.

 [P.] IV, pp. 142–148.
 Entries: 61 (revision of [B.]). Pre-
 metric. Inscriptions (selection). De-
 scribed (selection). Located. Addi-
 tional information to [B.]).

 [P.] IV, pp. 166–167, 170–171; V, p. 127.
 Entries: 20+ (additional to [P.] IV, pp.
 142–148; 3 separate listings under dif-
 ferent monograms). Pre-metric. In-
 scriptions. Described. Located.

 [Wess.] I, pp. 139–140.
 Entries: 4 (additional to [B.] and [P.]).
 Millimeters. Inscriptions. Described.

[Merlo] pp. 514–517.
 Entries: 61. Pre-metric. Inscriptions.
 Described (selection). Based on [P.].

L'Admiral, Johannes *(1699–1773)*
Singer, Hans W. "Der Vierfarbendruck
in der Gefolgschaft Jacob Christoffel Le
Blons." *Monatsheft für Kunstwissenschaft*
11 (1918): 55–57.
 Entries: 62. Millimeters. Inscriptions.
 States. Described. Located.

[W.] II, p. 2.
 Entries: 6.*

[H. *Neth.*] X, pp. 1–2.
 Entries: 64. Illustrated (selection).*

Laegh, Willem van der *(b. 1615)*
[W.] II, p. 2.
 Entries: 5.*

[H. *Neth.*] X, p. 3.
 Entries: 10.*

Laemlein, Alexander *(1813–1871)*
[Ber.] IX, pp. 5–8.
 Entries: 15. Paper-fold measure.

Laer, Pieter Jacobsz van *(1592/93–1642)*
[B.] I, pp. 3–17.
 Entries: 20 prints by, 1 after. Pre-
 metric. Inscriptions. Described.

[Weigel] pp. 1–3.
 Entries: 1 (additional to [B.]). Pre-
 metric. Inscriptions. Described.

[Wess.] II, p. 239.
 Additional information to [B.] and
 [Weigel].

[Dut.] V, pp. 37–42, 593–594.
 Entries: 21. Millimeters. Inscriptions.
 States. Described.

[W.] II, pp. 2–5.
 Entries: 21+ prints by, 21 after.*

[H. *Neth.*] X, pp. 4–10.

Entries: 21 prints by, 24 after. Illus-
trated (prints by only).*

Janeck, Axel. *Untersuchung über den hol-
ländischen Maler Pieter van Laer, genannt
Bamboccio.* Dissertation, University of
Würzburg. Würzburg (West Germany),
1968. (MH)
 Entries: 5+ prints by, 8 after. Mil-
 limeters. Inscriptions. States. De-
 scribed (selection). Bibliography for
 each entry.

Laer, Roeland van *(d. c.1635)*
[W.] II, p. 5.
 Entries: 1.*

[H. *Neth.*] X, p. 11.
 Entries: 1. Illustrated.*

Laermans, Eugène Jules Joseph
(1864–1940)
Colin, Paul. *Eugène Laermans.* Brussels:
Éditions des Cahiers de Belgique, 1929.
 Entries: 43. Millimeters. Inscriptions.
 States. Described.

La Fage, Nicolas *(d. 1655)*
[RD.] III, pp. 91–96; XI, pp. 111–112.
 Entries: 9. Pre-metric. Inscriptions.
 States. Described.

La Fage, Raymond *(1656–1690)*
[RD.] II, pp. 148–159; XI, pp. 112–113.
 Entries: 25. Pre-metric. Inscriptions.
 States. Described.

La Fargue, Maria M. *(18th cent.)*
[W.] I, p. 528.
 Entries: 2 prints after.*

La Fargue, Paulus Constantin
(c.1732–1782)
[W.] I, p. 528.
 Entries: 7+.*

Lafeuille, Daniel de *(c.1640–1709)*
Obreen, Fr. D. O. "Notice sur Daniel de Lafeuille, graveur, horloger et libraire à Amsterdam." *Commission de l'histoire des églises wallonnes, bulletin,* 6 (2d ser. no. 1) (1894): pp. 42–57.
 Entries: 21+. Millimeters. Inscriptions (selection). States. Described (selection). Illustrated (selection). Different states of the same print are separately numbered.

La Fleur, Nicolas Guillaume de
See **Delafleur**

La Fontaine, ——— *(fl. 1689–1705)*
[W.] II, p. 5.
 Entries: 2 prints after.*

Lafosse, Adolphe *(1810–1879)*
[Ber.] IX, pp. 9–13.*

Lafrensen, Niclas
See **Lavreince,** Nicolas

Lafrery, Antonio *(1512–1577)*
Ehrle, Francesco. *Roma prima di Sisto V; la pianta di Roma du Perac-Lafréry del 1577.* Rome: Danesi editore, 1908.
 Entries: unnumbered, pp. 54–58, prints published by. Reprint of Lafrery's own list (Rome, 1572, 1 copy in Florence, Biblioteca Marucelliana); followed by a chronological list of dated prints.

Huelsen, Christian. "Das Speculum Romanae Magnificentiae des Antonio Lafreri." In *Collectanea variae doctrinae Leoni S. Olschki, bibliopolae florentino, sexagenario obtulerunt,* pp. 121–170. Munich: Jacques Rosenthal, 1921.
 Entries: 167 prints published by (Speculum Romanae Magnificentiae series only). Inscriptions. States. Described (selection). Copies mentioned.

Fischer, Marianne. "Lafreris 'Speculum

Romanae Magnificentiae'; Addenda zu Hülsens Verzeichnis." *Berliner Museen: Berichte aus den staatlichen Museen preussischer Kulturbesitz,* n.s. 22 (1972): 10–17.
 Additional information to Huelsen.

Lagnel, Pierre Sébastien *(20th cent.)*
Quantin, Léon. "Pierre Sébastien Lagnel et les exlibris gravés par lui." [*Arch. Ex.-lib.*] 20 (1913): 51–57.
 Entries: 5 (bookplates only). Millimeters. Inscriptions. Described. Illustrated.

Lagoor, Johan *(fl. 1645–1670)*
[vdK.] pp. 10–12.
 Entries: 6. Millimeters. Inscriptions. Described.

[W.] II, p. 6.
 Entries: 6+.*

[H. *Neth.*] X, pp. 12–15.
 Entries: 8. Illustrated.*

Lagrenée, Jean Jacques *(1739–1821)*
[Baud.] I, pp. 200–230.
 Entries: 53. Millimeters. Inscriptions. States. Described.

La Guestière, François de *(b. 1624)*
[RD.] IV, pp. 32–34.
 Entries: 17. Pre-metric. Inscriptions. States. Described.

Laguillermé, ——— *(19th cent.)*
[Ber.] IX, p. 13.*

Laguillermie, Fréderic Auguste *(b. 1841)*
[Ber.] IX, pp. 13–14.*

La Haye, Raymond de *(1882–1914)*
Cordemans, M. *Raymond de la Haye; Herinneringen.* Louvain (Belgium): Drukkerij Ceuterick, 1956.
 Entries: unnumbered, pp. 131–132 (complete?) Millimeters. Located.

La Haye, Reinier de *(c.1640–c.1684)*
[H. *Neth.*] X, pp. 12–15.
Entries: 1.*

La Hire, Laurent de *(1606–1656)*
[RD.] I, pp. 75–96; XI, pp. 113–116.
Entries: 46. Pre-metric. Inscriptions.
States. Described.

Laindor, —— [called "Laindor de
Toulouse"] *(fl. c.1800)*
[Ber.] IX, p. 15.*

Lairesse, Abraham de *(1666–1726/27)*
[W.] II, p. 6.
Entries: 1 print after.*

Lairesse, Gérard de *(1641–1711)*
[W.] II, pp. 6–8.
Entries: 34+ prints after.*

Timmers, J. M. *Gérard Lairesse.* Amster-
dam: H. J. Paris, 1942.
Entries: 245. Millimeters. Inscrip-
tions. Illustrated (except for one set of
prints after antique sculpture).

[H. *Neth.*] X, pp. 16–21.
Entries: 245 prints by, 118+ after. Illus-
trated (selection).*

Lairesse, Renier de *(c.1596–1667)*
[W.] II, p. 9.
Entries: 1 print after.*

[H. *Neth.*] X, p. 21.
Entries: 1 print after.*

Laisné family *(fl. c.1840)*
[Ber.] IX, p. 15.*

Lajoue, Jacques II de *(1686–1761)*
Bataille, Marie Louise. "Lajoue." In
[Dim.] II, pp. 347–361.
Entries: 12 prints after lost works, 17+
other prints after.

Lalaisse, Charles de *(b. 1811)*
[Ber.] IX, p. 15.*

Lalaisse, Hippolyte *(1812–1884)*
[Ber.] IX, pp. 15–17.
Entries: 32. Paper fold measure.

Lalanne, Maxime *(1827–1886)*
[Ber.] IX, pp. 17–23.
Entries: 153 (etchings only). Paper fold
measure (selection).

Gutekunst, R. *Catalogue of the etched work
of Maxime Lalanne.* London: R.
Gutekunst, 1905.
Entries: 196. Inches. States. Based on
[Ber.] with additions. Catalogue of
Lalanne's own collection; description
of states is based only on those rep-
resented in the collection.

Frederick Keppel and Co. *Maxime
Lalanne.* The Print-Collector's Bulletin.
New York: Frederick Keppel and Co.,
1909.
Entries: 161. Inches. Illustrated (selec-
tion). Based on [Ber.], with additions.

Curtis, Atherton. Unpublished ms.
catalogue (rough draft). (EPPr). Not
seen.

Lalauze, Adolphe *(1838–1905)*
[Ber.] IX, pp. 23–28.
Entries: 693. Paper fold measure
(selection).

Lale, —— *(19th cent.)*
[Ber.] IX, p. 29.*

Lalleman
See **Lallemand**

Lallemand, Armand Joseph
(1810–after 1871)
[Ber.] IX, p. 29.*

Lallemand, Georges *(d. c.1640)*
Meaume, Édouard. "George Lalleman
et Jean le Clerc, peintres et graveurs lor-
rains." [*Mém. lorraine*] 3d ser. 4 (1876):

Lallemand, Georges (*continued*))

29–90. Separately published. Nancy (France): Lucien Wiener, 1876.
Entries: 28 prints by and after. Millimeters. Inscriptions. States. Described.

Laluye, Léopold Charles Adolphe *(1826–1899)*
[Ber.] IX, p. 29.*

La Mare-Richart, Florent de *(1630–1718)*
[RD.] I, pp. 219–225; XI, p. 117–118.
Entries: 20. Pre-metric. Inscriptions. States. Described.

Lambert, E. F. *(fl. 1823–1846)*
[Siltzer] p. 168.
Entries: unnumbered, p. 168, prints after. Inches (selection). Inscriptions.

Lambert, [Louis] Eugène *(1825–1900)*
[Ber.] IX, p. 31.*

Lambert, Mark *(1791–1855)*
Vinycomb, John. *Lambert (of Newcastle-upon-Tyne) as an engraver of book-plates.* Extract from *Journal of the Ex Libris Society;* revised and corrected. Newcastle-upon-Tyne (England): Andrew Reid and Co., 1896. 150 copies. (NN)
Entries: 124 (bookplates only). Inscriptions (selection). Described (selection). Illustrated (selection).

Lambert, Wenzeslaus *(1783–1843)*
[Dus.] pp. 100–101.
Entries: 5 (lithographs only, to 1821). Millimeters. Inscriptions. Located.

Lambert brothers *(fl. c.1825)*
[Ber.] IX, pp. 29–30.*

Lambertini, C. *(19th cent.?)*
[Ap.] p. 224.
Entries: 1.*

Lamberts, Gerrit *(1776–1850)*
[H. L.] pp. 547–548.
Entries: 2. Millimeters. Inscriptions. States. Described.

Lamblotte, Maria Elisabeth
See **Wyon,** Maria Elisabeth

L'Ambre, Jacob de *(fl. 1672)*
[H. *Neth.*] X, p. 22.
Entries: 2.*

Lambrecht, Jodocus [Joos] *(fl. 1536–1556)*
[H. *Neth.*] X, p. 21.
Entries: 13.*

Lambrichs, Edmond Alphonse Charles *(1830–1887)*
[H. L.] p. 548.
Entries: 1. Millimeters. Inscriptions. Described.

Lamen, Christoffel Jacobsz van der *(c.1606–c.1652)*
[W.] II, p. 10.
Entries: 1 print after.*

[H. *Neth.*] X, p. 22.
Entries: 1 print after.*

Lami, Eugène Louis *(1800–1890)*
[Ber.] IX, pp. 31–40.
Entries: 344. Paper fold measure (selection).

Lemoisne, Paul André. *L'Oeuvre d'Eugène Lami (1800–1890), lithographies, dessins, aquarelles, peintures; essai d'un catalogue raisonné.* Paris: H. Champion, 1914.
Entries: 1599 (work in various media, including prints). Millimeters. Inscriptions. Described.

Lamme, Arie Johannes *(1812–1900)*
[H. L.] p. 549.
Entries: 2. Millimeters. Inscriptions. Described.

Lamme, P. J.
See **Lamme,** Arie Johannes

Lamorinière, [Jean Pierre] François
(1828–1911)
[H. L.] pp. 550–557.
Entries: 23. Millimeters. Inscriptions.
States. Described.

Lamotte, Alphonse *(1844–1914)*
[Ap.] p. 224.
Entries: 1.*

[Ber.] IX, pp. 40–42.
Entries: 130. Paper fold measure.

Lampugnani, Giovanni Battista
(fl. 1619–1653)
[Vesme] pp. 10–11.
Entries: 5. Millimeters. Inscriptions.
Described.

Lampugnani, Giovanni Francesco
(fl. 1619–1644)
[Vesme] pp. 8–9.
Entries: 4. Millimeters. Inscriptions.
Described. Located.

Lamsvelt, Joannes *(1664/65–after 1725)*
[W.] II, p. 11.
Entries: 6.*

Lamsweerde, Steven [Simon Anton] van
(c.1630–1686)
[W.] II, pp. 11–12.
Entries: 14.*

[H. *Neth.*] X, pp. 23–24.
Entries: 23+. Illustrated (selection).*

Lamy, Pierre Auguste *(b. 1827)*
[Ber.] IX, p. 42.*

Lana, Lodovico *(1597–1646)*
[B.] XVIII, pp. 368–372.
Entries: 6. Pre-metric. Inscriptions.
Described.

Lancedelli, Joseph [Guiseppe] *(1774–1832)*
[AN. 1968] p. 176.
Entries: unnumbered, p. 176. Mil-
limeters (selection).

Lancelot, Dieudonné Auguste *(1822–1894)*
[Ber.] IX, pp. 42–43.*

Lanceni, Giovanni Battista *(c.1660–1737)*
[Vesme] p. 350.
Entries: 1. Millimeters. Inscriptions.
Described.

Lançon, Auguste André *(1836–1887)*
[Ber.] IX, pp. 43–46.*

Lancrenon, Joseph Ferdinand *(1794–1874)*
[Ber.] IX, p. 46.*

Lancret, Nicolas *(1690–1743)*
Guiffrey, J. "Nicolas Lancret, sa vie et
son oeuvre 1690–1743." In *Eloge de Lan-
cret, peintre du roi, par Ballot de Sovot,
accompagné de diverses notes sur Lancret, de
pièces inédites et du catalogue de ses tableaux
et de ses estampes.* Paris: J. Baur, 1874. 200
copies. (NNMM)
Entries: 87+ prints after. Inscriptions
(selection). States.

Bocher, Emmanuel. *Nicolas Lancret.* Les
gravures françaises du XVIIIe siècle, 4.
Paris: Librairie des Bibliophiles, 1877.
475 copies. (MBMu)
Entries: 87+ prints after. Millimeters.
Inscriptions. States. Described.

Wildenstein, Georges. *Lancret, biog-
raphie et catalogue critiques.* Paris:
Georges Servant, 1924.
Catalogue of paintings; prints after
are mentioned where extant.

Lande, Willem van *(c.1610–after 1650)*
[W.] II, p. 12.
Entries: 4+.*

[H. *Neth.*] X, pp. 25–26.
Entries: 23. Illustrated (selection).*

Landon, Charles Paul *(1760–1826)*
[Ber.] IX, pp. 46–47.*

Landrin, Henry Charles *(1829–1898)*
[Ber.] IX, p. 47.*

Landseer, Edwin Henry *(1802–1873)*
Henry Graves and Co. *A complete catalogue of the engraved works of Sir Edwin Landseer, R.A. (corrected to December 31, 1863) published by Messrs. Henry Graves and Company . . . to which is added a list of the more important of the productions of this eminent artist, published by other firms.* London: Henry Graves and Co., 1864.
Entries: unnumbered, pp. 4–10, prints after. Inches.

Dafforne, James. *Pictures by Sir Edwin Landseer, royal academician.* London: Virtue and Co. Ltd., 1873.
Entries: unnumbered, pp. 85–92, prints after.

Graves, Algernon. *Catalogue of the works of the late Sir Edwin Landseer, R.A.* London: Henry Graves and Co., [c.1875].
Entries: 434 prints after.

Landseer, John *(1763–1852)*
[Ap.] p. 225.
Entries: 4.*

Landsheer, J. de *(18th cent.)*
[W.] II, p. 12.
Entries: 1 print after.*

Landshut, Mair von
See **Mair von Landshut**

Lane, Fitz Hugh *(1804–1865)*
[Carey] pp. 327–329.
Entries: 27 (lithographs only). Inches (selection). Inscriptions (selection). Described (selection). Located.

Lane, Richard *(1800–1872)*
[Ap.] p. 225.
Entries: 1.*

Lanfranco, Giovanni *(1582–1647)*
[B.] XVIII, pp. 344–351.
Entries: 31 prints by, 2 doubtful prints. Pre-metric. Inscriptions. States. Described.

Lang, Ferdinand *(fl. 1750–1758)*
[Merlo] pp. 518–519.*

Lang, George S. *(1799–after 1883)*
[St.] pp. 278–279.*

[F.] p. 173.*

Lange, Hans *(fl. 1558–1571)*
See **Monogram HL** [Nagler, *Mon.*] III, no. 1202

Lange, Johannes Philippus *(1810–1849)*
[W.] II, p. 12.
Entries: 10.*

Langendijk, Dirk *(1748–1805)*
[W.] II, pp. 12–13.
Entries: 8 prints by, 7+ after.*

Langendijk, Jan Antony *(1780–1818)*
[W.] II, p. 13.
Entries: 3.*

Langendijk, Pieter *(1683–1756)*
[W.] II, p. 13.
Entries: 3+.*

Langer, Sebastian *(1772–1841)*
[Ap.] p. 225.
Entries: 10.*

Langer, [Carl Hermann] Theodor *(1819–1895)*
[Ap.] pp. 226–227.
Entries: 34.*

Langeval, Jules Louis Laurent *(fl. 1868–1882)*
[Ber.] IX, p. 47.*

Langhans, Carl Ferdinand *(1782–1869)*
[Dus.] p. 101.
 Entries: 1 (lithographs only, to 1821).
 Inscriptions.

Langlois, Eustache Hyacinthe *(1777–1837)*
Coutil, Léon. *Eustache-Hyacinthe Langlois de Pont de l'Arche, graveur et archéologue.* Extract from *Revue Normande,* May-June 1924, and from *Bulletin de la Société d'études diverses de Louviers,* 1924. Rouen (France): Imprimerie Lecerf fils, 1924. (EPBN)
 Entries: unnumbered, pp. 37–53, prints by and after. Inscriptions. Described (selection). Illustrated (selection).

Langlois, Philibert *(fl. 1834–1839)*
[Ber.] IX, p. 49.*

Langlois, Pierre Gabriel [called "Langlois l'aîné"] *(1754–c.1810)*
[Ber.] IX, p. 47.*

Langlois, Vincent Marie [called "Langlois le jeune"] *(b. 1756)*
[Ber.] IX, p. 47.*

[L. D.] pp. 36–37.
 Entries: 1. Millimeters. Inscriptions. States. Described. Incomplete catalogue.*

Langnouwer, Jochem *(d. 1653)*
[W.] II, p. 14.
 Entries: 1 print after.*

[H. *Neth.*] X, p. 26.
 Entries: 1 print after.*

Langot, François *(fl. 1661–1679)*
Grésy, Eugène. "Catalogue raisonné de l'oeuvre de Langot, graveur mélunois." [*RUA.*] 5 (1857): 520–522. Separately published. Melun (France): H. Michelin, 1858. (NN)

 Entries: 21. Millimeters. Inscriptions. States. Described. Separately published version has 1 additional entry.

[ThB.] XXII, pp. 351–352.
 Entries: unnumbered, pp. 351–352.

Langren, Arnoldus Floris van *(d. c.1644)*
[H. *Neth.*] X, p. 26.
 Entries: 6+.*

Langren, Jacob van *(fl. c.1635)*
[Hind, *Engl.*] III, pp. 269–272.
 Entries: 7+. Inches. Inscriptions. Described. Illustrated (selection). Located.

Lankes, Julius J. *(b. 1884)*
Whitaker, Charles Harris. "The work of J. J. Lankes." [*P. Conn.*] 4 (1924): 302–321.
 Entries: unnumbered, pp. 314–321 (to 1924). Inches.

Osburn, Burl N. *A descriptive checklist of the woodcut bookplates of J. J. Lankes; foreword by Charles Harris Whitaker.* Millersville (Pa): Burl N. Osburn, 1937. 250 copies. (NN)
 Entries: 96. Inches. Described. Illustrated (selection). Ms. addition (NN); 8 additional entries.

Lankes, J. J. "The woodcut record." Unpublished ms. (Vi).
 Not seen.

Lankrink, Prosper Henricus *(1628–1692)*
[W.] II, p. 14.
 Entries: 1 print after.*

La Noue, J. [F.] de *(fl. c.1634)*
[H. *Neth.*] XIV, p. 184.
 Entries: 2.*

Lansere, Evgenij E. *(b. 1875)*
Babenchikov, M. V. *E. E. Lansere.* Moscow: Izdatel'stvo gosudarstvennogo Muzeja izobrazitel'nykh iskusstv imeni A. S. Pushkina, 1949.

Lansere, Evgenij E. (*continued*)

Entries: unnumbered, pp. 87–97,
(work in various media, including
prints). Millimeters.

Lansyer, Emmanuel *(1835–1893)*
[Ber.] IX, p. 49.*

Lantarat, Simon Mathurin [called "Lanta-
ra"] *(1729–1778)*
[Baud.] I, pp. 131–132.
Entries: 1. Millimeters. Inscriptions.
Described.

Lante, Giuseppe *(1737–1779)*
[AN] pp. 644–650.
Entries: unnumbered, pp. 647–650.
Millimeters. Inscriptions. Described.

[AN. 1968] p. 175.
Entries: unnumbered, p. 175 (addi-
tional to [AN.]). Millimeters. Inscrip-
tions.

Lanzeni, Giovanni Battista
See **Lanceni**

La Pegna, Hyacinthe de *(1706–1772)*
[W.] II, p. 315.
Entries: 6.*

Lapi, Angelo Emilio *(c.1769–1852)*
[Ap.] p. 227.
Entries: 5.*

La Pinelais, Benoît *(b. 1836)*
[Ber.] IX, pp. 49–50.
Entries: 27.

Lapis, Hieronymus [Girolamo]
(fl. 1758–1795)
[W.] II, p. 14.
Entries: 1 print after.*

La Plante, ⸺ de *(fl. c.1850)*
[Ber.] IX, p. 50.*

La Plante, Charles *(d. 1903)*
[Ber.] IX, p. 50.*

Laporte, Eugène *(19th cent.)*
[Ber.] IX, p. 50.*

Laporte, George Henry *(1799–1873)*
[Siltzer] p. 169.
Entries: unnumbered, p. 169, prints
after. Inches (selection). Inscriptions.

Laporterie, Franz Xaver *(b. 1754)*
[Merlo] pp. 522–523.*

Laquy, Willem Joseph *(1738–1798)*
[W.] II, pp. 14–15.
Entries: 2 prints after.*

Larbalestrier, G. *(fl. 1835–1841)*
[Ber.] IX, p. 51.*

Larcher, Jean Pierre *(b. 1795)*
[Ber.] IX, p. 51.*

Larivière, Eugénie *(19th cent.)*
[Ber.] IX, p. 51.*

Laroche, Léon Barthélemy Adrien *(b. 1817)*
[Ber.] IX, pp. 51–52.*

Laroon, Marcellus I *(1653–1702)*
[W.] II, pp. 15–16.
Entries: 17+ prints by, 8 after.*

[H. *Neth.*] X, pp. 27–33.
Entries: 28 prints by, 71 after. Illus-
trated (selection).*

Raines, Robert. *Marcellus Laroon.*
Studies in British art. London: Rout-
ledge & Kegan Paul, 1966.
Entries: 2+ after ("Cries of London,"
and "The Art of Defense" series only).
Paper fold measure. Inscriptions.
States. Described. Illustrated (selec-
tion). Located.

Larsen, Johannes *(b. 1867)*
Rasmussen, Holger M. *Johannes Larsens grafiske arbejder, en illustreret fortegnelse.* Copenhagen: Fischers Forlag, 1938.
Entries: 174 (to 1938). Millimeters. States. Described. Illustrated (one set of book illustrations is not reproduced in its entirety).

Larsen, Johannes *(20th cent.)*
Due-Nielsen, Johan. "Johannes Larsen og hans exlibris." [*N. ExT.*] 8 (1956): 29–32.
Entries: 13 (bookplates only, 1948–1956). Illustrated (selection). Additional to a book published by the Dansk Exlibrisselskab, 1952 (not seen).

Due-Nielsen, Johan. "Johannes Larsen-II." [*N. ExT.*] 15 (1963): 77–78.
Entries: 78 (bookplates only, to 1962). Described. Illustrated (selection).

Larsson, Carl *(1853–1919)*
Kruse, John. "Carl Larsson als Maler, Zeichner und Graphiker." [*GK.*] 28 (1905): 53–77. Catalogue: "Das graphische Werk Carl Larssons." [*MGvK.*] 1905, pp. 54–57.
Entries: 45 (to 1904). Millimeters. Inscriptions. States. Described.

Romdahl, A. *Carl Larsson som etsare.* Sveriges Allmänna Konstforenings Publikation, 21. Stockholm, 1913.
Entries: 91 (etchings only, to 1912). Millimeters. States. Described. Illustrated. Located.

Allhusen, E. L. "The etched work of Carl Larsson." [*PCQ.*] 10 (1923): 196–219.
Entries: 15 (etchings only, additional to Romdahl). Millimeters. Inscriptions. States. Described.

Lasansky, Mauricio *(b. 1914)*
American Federation of Arts [Carl Zigrosser, compiler]. *Mauricio Lasansky.* New York, 1960.

Entries: 96 (to 1959). Inches. Illustrated (selection).

Lasinio, Carlo *(1759–1838)*
[Ap.] p. 228.
Entries: 1+.*

Singer, Hans W. "Der Vierfarbendruck in der Gefolgschaft Jacob Christoffel Le Blons." *Monatsheft für Kunstwissenschaft* 11 (1918): 58–73.
Entries: 446. Millimeters. Inscriptions. States. Described.

Lasinio, Giovanni Paolo *(1789–1855)*
[Ap.] p. 228.
Entries: 1+.*

Laske, Oskar *(1874–1951)*
Tietze-Conrat, Erika. *Oskar Laske.* Vienna: Rikola Verlag, 1921.
Entries: 98 (to 1921). Millimeters.

Lasne, Jean Étienne *(1596–c.1645)*
Marionneau, Charles. "Lasne (Jean Étienne) maître graveur en taille-douce, illumineur de la ville de Bordeaux au dix-septième siècle." [*Réunion Soc. B. A. dép.*] 11th session, 1887, pp. 631–647.
Entries: unnumbered, pp. 638–644. Millimeters. Inscriptions. Described.

Lasne, Michel *(before 1590–1667)*
Decauville-Lachênée, Abel. "Le graveur caennais Michel Lasne; notice sur sa vie et son oeuvre, et catalogue des gravures que possède de lui la Bibliothèque municipale de Caen." *Bulletin de la Société des Beaux-Arts de Caen* 8 (1888): 133–196. Separately published. Caen (France): Henri Delesques, 1889.
Entries: unnumbered, pp. 149–194 (prints in City Library of Caen only). Millimeters (selection). Paper fold measure (selection). Inscriptions. Described. Located.

Lasne, Michel *(continued)*

Hotel d'Escoville, Caen. *Exposition Michel Lasne (Caen vers 1590–Paris 1667) illustrateur de son temps.* Caen (France), 1967.
Bibliography of books with illustrations by.

Lasnier, Louis Pierre *(fl. 1857–1878)*
[Ber.] IX, p. 52.*

Lassalle, Émile *(1813–1871)*
[Ber.] IX, pp. 52–53.*

Lassouquère, Jean Paulin *(b. 1810)*
[Ber.] IX, p. 54.*

Lasterie, Charles Philibert de *(1759–1849)*
[Ber.] IX, pp. 54–55.*

Lastman, Claes Pietersz *(c.1586–1625)*
[W.] II, p. 16.
Entries: 7.*

[H. *Neth.*] X, p. 34.
Entries: 9+. Illustrated (selection).*

Lastman, Pieter Pietersz *(1583–1633)*
[Rov.] pp. 72–73.
Entries: 3 prints by, 2 doubtful prints. Inscriptions. Described. Illustrated. Located.

[W.] II, pp. 16–17.
Entries: 3 prints by, 8 after.*

Freise, Kurt. *Pieter Lastman, sein Leben und seine Kunst.* Leipzig: Klinkhardt und Biermann, 1911.
Discusses and rejects all attributions of prints to Lastman.

[H. *Neth.*] X, pp. 35–37.
Entries: 4 prints by, 23 after. Illustrated (selection).*

Latenay, Gerard de *(d. c.1860)*
"Check list of the etchings of Gerard de Latenay." [*P. Conn.*] 4 (1924): 130–136.
Entries: 46. Millimeters.

Later, Jacob *(fl. 1696–1705)*
[W.] II, p. 17.
Entries: 5.*

[H. *Neth.*] X, p. 38.
Entries: 77+.*

Later, Jan de *(fl. c.1700)*
[W.] II, p. 17.
Entries: 3.*

Latouche, Gaston *(1854–1913)*
[Ber.] IX, p. 56.*

Latour, Alfred *(1888–1964)*
Forthuny, Paul. "Le graveur Alfred Latour." [*AMG.*] 2 (1928–1929): 421–428.
Bibliography of books with illustrations by (to 1928).

Latour, [Elizabeth] Marie
See **Simons,** [Elizabeth] Marie

La Tour, Maurice Quentin de *(1704–1788)*
[Gon.] I, pp. 219–288.
Entries: unnumbered, pp. 287–288. prints after. Described.

Besnard, Albert, and Wildenstein, Georges. *La Tour; la vie et l'oeuvre de l'artiste.* Paris, Édition d'Études et de Documents, 1928.
Catalogue of paintings; prints after are mentioned where extant.

Lauderer, M. *(18th cent.)*
[Merlo] pp. 526–527.*

Laugée, Désiré François *(1823–1896)*
[Ber.] IX, p. 56.*

Laugier, Jean Nicolas *(1785–1875)*
[Ap.] pp. 228–230.
Entries: 28.*

[Ber.] IX, pp. 56–58.
Entries: 40. Paper fold measure (selection).

Lautenberger, F. (*continued*)

Entries: 2. Millimeters. Inscriptions. States. Described.

Lautensack, Adolf (*b. 1561*)
[A.] II, pp. 56–61.
Entries: 5. Pre-metric. Inscriptions. Described.

Lautensack, Hanns (*1524–1561/66*)
[B.] IX, pp. 207–231.
Entries: 59 engravings, 2 woodcuts, 1 rejected print. Pre-metric. Inscriptions. States. Described.

[P.] III, pp. 260–261.
Entries: 10 engravings and etchings (additional to [B.]), 2 woodcuts (additional to [B.]). Pre-metric. Inscriptions. Described. Located. Additional information to [B.].

[Wess.] I, p. 140.
Entries: 1 (additional to [B.] and [P.]). Millimeters. Described. Additional information to [B.] and [P.].

Schmitt, Annegrit. *Hanns Lautensack.* Nürnberger Forschungen, 4. Nuremberg: Verein für Geschichte der Stadt Nürnberg, 1957.
Entries: 92 prints by, 4 doubtful and rejected prints. Millimeters. Inscriptions. States. Described. Illustrated (selection). Located. Copies mentioned. Bibliography for each entry.

Schwarz, Heinrich. "A unique woodcut by Hanns Lautensack," *Pantheon* 22 (1964): 143–150.
Entries: 1 (identification of a print known to Schmitt only from old catalogue references). Millimeters. Described. Illustrated. Located.

Lautensack, Heinrich (*1522–1568*)
See **Monogram HL** [Nagler, *Mon.*] III, no. 1202

Lauter, Florentin (*fl. 1820–1830*)
[Dus.] p. 101.
Entries: 2 (lithographs only, to 1821). Millimeters. Inscriptions. Located.

Lauters, Paulus (*1806–1876*)
[H. L.] pp. 558–563.
Entries: 12. Millimeters. Inscriptions. States. Described.

Lauvergne, Barthélemy (*1805–1871*)
[Ber.] IX, p. 65.*

Lauwers, Conrad (*c.1632–c.1685*)
[W.] II, pp. 18–19.
Entries: 29.*

[H. *Neth.*] X, pp. 39–40.
Entries: 56.*

Lauwers, Frans (*b. 1854?*)
[H. L.] p. 564.
Entries: 1. Millimeters. Inscriptions. Described.

Lauwers, Nicolaes (*1600–1652*)
[Dut.] V, p. 42.*

[W.] II, p. 19.
Entries: 16.*

[H. *Neth.*] X, pp. 41–42.
Entries: 24+.*

Lavaerts, Adolphe (*d. 1862*)
[H. L.] p. 563.
Entries: 1. Millimeters. Inscriptions. States. Described.

Lavallé, Jacques (*fl. 1790–1830*)
[Ap.] p. 231.
Entries: 8.*

[Ber.] IX, p. 65.*

Lavieille, Jacques Adrien (*1818–1862*)
[Ber.] IX, pp. 65–67.*

Lavigne, R. *(fl. c.1814)*
[St.] p. 279.*

[F.] p. 173.*

Laviron, Gabriel Joseph Hippolyte
(1806–1849)
[Ber.] IX, p. 67.*

Lavoignat, Hippolyte *(fl. 1835–1860)*
[Ber.] IX, pp. 67–69.*

La Volpe, Niccolo *(1789–1876)*
[Ap.] p. 231.
Entries: 1.*

Lavrate, ——— *(d. 1888)*
[Ber.] IX, pp. 69–70.*

Lavreince, Nicolas *(1737–1807)*
Bocher, Emmanuel. *Nicolas Lavreince.*
Les gravures françaises du XVIIIe siècle,
1. Paris: Librairie des Bibliophiles, 1875.
500 copies. (MH)
Entries: 63+ prints after, 10 prints
perhaps after. Millimeters. Inscrip-
tions. States. Described.

Asplund, Karl. *Två Gustavianska Mäs-
tare, Niklas Lafrensen D. Y. och Elias Mar-
tin i samtida gravyrer.* Stockholm: A. B.
Wahlström och Widstrand, 1925.
Entries: 54 prints after. Described. Il-
lustrated.

Lawranson, William *(fl. 1760–1780)*
[Sm.] II, pp. 810–811.
Entries: 2 (portraits only). Inches. In-
scriptions. States. Described. Located
(selection).

[Ru.] p. 196.
Additional information to [Sm.].

Lawrence, John *(20th cent.)*
"John Lawrence." *Illustration 63* 9 (1972):
80–83.
Bibliography of books with illustra-
tions by (to 1972).

Lawrence, Thomas *(1769–1830)*
Graves, Algernon. Catalogue. In *Sir
Thomas Lawrence,* by Lord Ronald
Sutherland. London: Goupil and Co.,
and Jean Boussod, Manzi, Joyant and
Co., 1900.
Catalogue of paintings; prints after
are mentioned where extant.

Garlick, Kenneth. *Sir Thomas Lawrence.*
London: Routledge and Kegan Paul,
1954.
Catalogue of paintings; prints after
are mentioned where extant.

Lawson, Alexander *(1773–1846)*
[St.] p. 178.*

[F.] pp. 173–178.*

Lawson, Helen E. *(fl. c.1830)*
[St.] p. 178.*

Layr, Franz Xaver *(1812–1875)*
[Ap.] p. 232.
Entries: 1.*

Lazerges, Jean Raymond Hippolyte
(1817–1887)
[Ber.] IX, p. 70.*

Lazius, Wolfgang *(1514–1565)*
[A.] II, pp. 62–69, 420–424.
Entries: 9 etchings, 3+ woodcuts.
Pre-metric. Inscriptions. Described.

Lazzerini, Giuseppe *(19th cent.?)*
[Ap.] p. 232.
Entries: 3.*

Leader, S. *(18th cent.?)*
[Sm.] II, pp. 811–812.
Entries: 1 (portraits only). Inches. In-
scriptions. Described. Illustrated.

[Ru.] p. 197.
Additional information to [Sm.].

Lear, Edward *(1812–1888)*
Thomas, Thomas H. "The lithographs of Edward Lear." [*P. Conn.*] 4 (1924): 262–284.
> Bibliography of books with illustrations by.

Field, William B. Osgood. *Edward Lear on my shelves.* Munich: Privately printed [by the Bremer Press], 1933. 155 copies. (NN). Reprint. New York: Collector's Editions, n.d.
> Entries: unnumbered, pp. 361–429. Inscriptions. Catalogue of a collection. Complete?

Le Bas, Jacques Philippe *(1707–1783)*
Catalogue de tableaux, sculptures, estampes encadrées, en feuilles et en receuils; d'un precieux fonds de planches gravées avec leurs épreuves . . . le tout provenant de la succession de feu M. Le Bas . . . dont la vente se sera dans les premiers jours du mois prochain. Paris: Clousier, Imprimeur-Libraire, 1783. (NN)
> Entries: 278.

Lebeau, Chris *(1878–1945)*
"Chris Lebeau." *Boekcier,* 2d ser. 1 (1946): 6–7.
> Entries: unnumbered, p. 7 (bookplates only). Millimeters. Described. Illustrated (selection).

Lebeau, Pierre Adrien *(1748–after 1800)*
[Ber.] IX, pp. 70–71.*

[L. D.] pp. 51–52.
> Entries: 4. Millimeters. Inscriptions. States. Described. Incomplete catalogue.*

Lebedeff, Jean *(b. 1884)*
Dubray, Jean Paul. *L'Ymaigier Jean Lebedeff.* Paris: Jean Paul Dubray, 1939. 565 copies. (EPBN)
> Entries: unnumbered, pp. 96–102 (to 1939). Ms. additions (EPBN); additional entries, to 1960.

Remy, Tristan. *Jean Lebedeff, faiseur d'images.* Nancy (France): Éditions de l'A[ssociation] F[rançaise des] C[ollectionneurs d'] E[x] L[ibris], 1951. (DLC)
> Entries: 77 (bookplates only, to 1948). Millimeters. Illustrated (selection). Also, bibliography of books with illustrations by (to 1950).

Le Beuf, Jean *(17th cent.)*
[M.] III, p. 770.
> Entries: 3+. Paper fold measure (selection).

Leblanc, Théodore *(1800–1837)*
[Ber.] IX, pp. 71–72.
> Entries: 4+.

Le Blon, Christian [Christoph] *(1593/1604–1665)*
[Hind, *Engl.*] III, pp. 217–218.
> Entries: 2 (prints done in England only). Inches. Inscriptions. States. Described. Illustrated (selection). Located.

[H. *Neth.*] II, p. 96.
> Entries: 2+.*

Le Blon, Jakob Christof [Jacques Christophe] *(1667–1741)*
Ms. catalogue. (EBM)
> Entries: 14 ("liste de ce qui a été Imprimé en Couleurs, jusques à present"), 4 ("pièces où l'on travaille"), 9 (pièces qu'on a Dessein d'imprimer"). Pre-metric.

[Hüsgen] pp. 287–296.
> Entries: 27 prints by, 5 after.

Singer, Hans W. "Jakob Christoffel Le Blon." [*MGvK.*] 1901, pp. 1–21. Separately published. Vienna: Gesellschaft für vervielfältigende Kunst, 1901.
> Entries: 49 prints by, 7 doubtful and rejected prints. Millimeters. Inscriptions. Described. Illustrated (selection). Located.

[W.] I, pp. 114–115.
Entries: 39+ prints by, 2 after.*

[H. *Neth.*] II, pp. 97–128.
Entries: 56 prints by, 10 attributed to, 3 after. Illustrated (selection).*

Le Blon, Michel *(1587–1656)*
van der Kellen, J. Ph. *Michel Le Blon; receuil d'ornements accompagné d'une notice biographique et d'un catalogue raisonné de son oeuvre.* Reproductions d'anciennes gravures d'orfevrerie hollandaise, 3. The Hague: Martinus Nijhoff, 1900.
Entries: 230. Millimeters. Inscriptions. States. Described. Illustrated (selection).

[W.] I, p. 116.
Entries: 20+.*

[H. *Neth.*] II, pp. 129–157.
Entries: 236. Illustrated (selection).*

Le Blond and Co. *(fl. 1849–1894)*
Courtney Lewis, C. T. *The Le Blond book 1920, being a history and detailed catalogue of the work of Le Blond and Co. by the Baxter Process.* London: Sampson Low, Marston and Co. Ltd., 1920.
Entries: 127 prints published by. Inches. Inscriptions. Described.

Courtney Lewis, C. T. *The story of picture printing in England during the nineteenth century.* London: Sampson Low, Marston and Co. Ltd., 1928.
Entries: 130 prints published by. Inches. Inscriptions. Described. Illustrated (selection).

Leborne, Louis *(1796–1865)*
[Ber.] IX, p. 72.*

Leboroni, Maria Elisa *(20th cent.)*
Fogedgaard, Helmer. "Maria Elisa Leboroni, en italiensk grafiker." [*N. ExT.*] 12 (1960): 1–3.
Entries: 47 (bookplates only, to 1960). Illustrated (selection).

Lebour, Alexandre Xavier *(b. 1801)*
[Ber.] IX, p. 72.*

Le Brun, Charles *(1619–1690)*
[RD.] I, pp. 161–165; XI, p. 118.
Entries: 6. Pre-metric. Inscriptions. States. Described.

[Recherches publiées sous la direction de Daniel Wildenstein]. "Les oeuvres de Charles Le Brun, d'après les gravures de son temps." [*GBA.*] 6th ser. 66 (1965): 1–58.
Entries: 303 prints after (17th century prints only). Illustrated.

Lebrun, Cl. *(19th cent.)*
[Ber.] IX, p. 73.*

Lebschée, Carl August *(1800–1877)*
Holland, H. *Carl August Lebschée Architektur- und Landschaftsmaler.* Munich: C. Wolff und Sohn, 1879.
Entries: 308 prints by and after. Millimeters (selection). Inscriptions. Described (selection).

Le Campion, Valentin *(20th cent.)*
Jean-Aubry, G. "Valentin Le Campion." *Halcyon* 9–10 (1942), 12 pp. (unpaginated).
Bibliography of books with illustrations by (to 1942).

Lecarpentier, Charles Louis François *(1744–1822)*
[Ber.] IX, p. 73.*

Lecerf, Jacques Louis Constant *(fl. 1814–1824)*
[Ber.] IX, p. 73.*

Lecler, Auguste Toussaint *(b. 1788)*
[Ber.] IX, p. 73.*

Leclerc, Auguste
See **Lecler**

Leclerc, Edmond *(19th cent.)*
[Ber.] IX, p. 74.*

Leclerc, Jean *(1587/88–1633)*
[RD.] V, pp. 78–80.
Entries: 2. Millimeters. Inscriptions.
States. Described.

Meaume, Édouard. "George Lalleman
et Jean Le Clerc, peintres et graveurs
lorrains." [*Mém. lorraine*] 3d ser. 4
(1876): 29–90. Separately published.
Nancy (France): Lucien Wiener, 1876.
Entries: 2. Millimeters. Inscriptions.
States. Described.

Leclerc, Sébastien *(1637–1714)*
Vallemont, [l'Abbé de]. *Eloge de Mr. Le
Clerc, chevalier romain, dessinateur, et
graveur ordinaire du cabinet du roi, avec le
catalogue de ses ouvrages.* Paris: Nicolas
Caillou, Jean Musier, 1715.
Description of prints by, in chronolog-
ical order but without numbering or
catalogue format.

Jombert, Charles Antoine. *Catalogue
raisonné de l'oeuvre de Sébastien Le Clerc,
chevalier romain, dessinateur et graveur du
cabinet du roi.* 2 vols. Paris: Published by
the author, 1774.
Entries: 336+ prints by and after.
Pre-metric. Inscriptions (selection).
States (selection). Described. Lo-
cated.

Meaume, Édouard. *Étude bibliographique
sur les livres illustrés par Sébastien Le Clerc.*
Extract from *Le Bulletin du Bibliophile.*
Paris: Léon Techner, 1877. 100 copies.
(NN)
Bibliography of books with illustra-
tions by.

Meaume, Édouard. *Sébastien Le Clerc et
son oeuvre.* Paris: Baur, Rapilly, 1877. 205
copies. (MBMu) Reprint. Amsterdam:
G. W. Hissink en Co., 1969.
Additional information to Jombert.

Leclère, —— *(fl. c.1827)*
[Ber.] IX, p. 74.*

Lecoeur, Louis *(fl. 1780–after 1800)*
[Ber.] IX, p. 74.*

Lecompte, François Louis *(b. 1795)*
[Ap.] p. 232.
Entries: 1.*

Lecomte, Hippolyte *(1781–1857)*
[Ber.] IX, pp. 74–75.*

Le Comte, Marguerite *(c.1719–after 1786)*
Laruelle, René. "Marguerite Le Comte."
[*Bull. des B. A.*] 3 (1885–1886): 130–135.
Entries: 26. Paper fold measure (selec-
tion).

Lecomte, Narcisse *(1794–1882)*
[Ap.] pp. 232–233.
Entries: 8.*

[Ber.] IX, pp. 75–76.*

Le Corbusier [Charles Édouard Jeanneret]
(1887–1965)
Weber, Heidi. *Oeuvre lithographique; Le
Corbusier.* Zurich: Centre Le Corbusier,
Heidi Weber, [1966?]. 2d ed., 1971.
Entries: 25+ (lithographs only). Mil-
limeters. Illustrated.

Galerie Wolfgang Ketterer, Munich. *Le
Corbusier, Lithographien—Radierungen.*
Munich, 1970.
Entries: 34+. Millimeters. Described.
Illustrated. Sale catalogue, complete?

Lecouteux, Lionel Aristide *(1847–1909)*
[Ber.] IX, pp. 77–79.
Entries: 50. Paper fold measure.

Lecouturier, —— *(fl. 1840–1880)*
[Ber.] IX, p. 79.*

Lecurieux, Jacques Joseph *(1801–after 1870)*
[Ber.] IX, pp. 79–80.*

Ledeboer, Isack *(c.1691–after 1757)*
[W.] II, p. 20.
 Entries: 3.*

Ledoux, François *(19th cent.)*
[Ber.] IX, p. 80.*

Le Ducq, Jan [Jean, Johan] *(1629/30–1676)*
[B.] I, pp. 201–208.
 Entries: 10. Pre-metric. Inscriptions.
 Described. Copies mentioned.

[Weigel] pp. 23–26.
 Entries: 3 (additional to [B.]). Pre-
 metric. Inscriptions. Described.

[Wess.] II, p. 233.
 Entries: 1 (additional to [B.] and
 [Weigel]). Millimeters. Inscriptions.
 Described.

[Dut.] V, pp. 42–48.
 Entries: 14. Millimeters. Inscriptions.
 States. Described. Appendix with 7
 doubtful prints.

[W.] I, p. 434.
 Entries: 14+ by, 2 after.*

[H. *Neth.*] VI, pp. 12–14.
 Entries: 14 prints by, 3 after. Illus-
 trated (selection).*

Lee-Hankey, William *(1869–1952)*
Hardie, Martin. *The etched work of Wil-
liam Lee-Hankey, R.E. from 1904 to 1920.*
London: L. H. Lefevre and Son, 1920.
350 copies. (MB)
 Entries: 187 (monochrome prints only,
 to 1920). Inches. Millimeters. Inscrip-
 tions (selection). States. Described. Il-
 lustrated. Also, list of 48 color prints
 (not described or illustrated).

Leech, John *(1817–1864)*
Chambers, Charles Edward Stuart. *A list
of works containing illustrations by John
Leech.* Edinburgh (Scotland): William
Brown, 1892. 285 copies. (NN)
 Bibliography of books with illustra-
 tions by.

Field, William B. Osgood. *John Leech on
my shelves.* New York: Privately printed,
1930. 155 copies. (NN). Reprint. New
York: Collector's Editions, 1970.
 Entries: unnumbered, pp. 257–294,
 prints by and after (catalogue of a col-
 lection. Complete?).

Leenhoff, Ferdinand *(1841–1914)*
[Ber.] IX, pp. 80–81.*

Lees, Charles *(1800–1880)*
[Siltzer] p. 332.
 Entries: unnumbered, p. 332, prints
 after. Inches. Inscriptions.

Leest, Anthony van *(c.1545–1592)*
[H. *Neth.*] X, pp. 42–43.
 Entries: 18+. Illustrated (selection).*

Leeuw, Govaert [Gabriel] van der
(1645–1688)
[vdK.] pp. 25–32.
 Entries: 24. Millimeters. Inscriptions.
 Described. Appendix with 1 rejected
 print.

[W.] II, p. 22.
 Entries: 5+.*

[H. *Neth.*] X, p. 44.
 Entries: 29. Illustrated (selection).*

Leeuw, Jan van der *(b. 1660)*
[W.] II, p. 22.
 Entries: 1+.*

[H. *Neth.*] X, p. 45.
 Entries: 5+.*

Leeuw, Willem van der *(c.1603–c.1665)*
[W.] II, p. 23.
 Entries: 17+.*

[H. *Neth.*] X, pp. 45–46.
 Entries: 22.*

Lefaure, L. *(19th cent.)*
[Dus.] p. 101.
Entries: 3 (lithographs only, to 1821.)
Millimeters. Inscriptions. States. Located.

Lefebvre, Claude *(1632–1675)*
[RD.] II, pp. 92–95; XI, p. 119.
Entries: 3. Pre-metric. Inscriptions
States. Described.

Lhuillier, Th. "Le peintre Claude
Lefebvre de Fontainebleau." [*Réunion
Soc. B. A. dép.*] 16th session, 1892, pp.
487–511.
Entries: 1. Inscriptions. States. Described. Also, catalogue of paintings;
prints after are mentioned where extant.

(Editorial staff of the [*GBA.*], under the
direction of Daniel Wildenstein).
"Claude Lefebvre restitué par l'estampe." [*GBA.*] 6th ser. 62 (1963): 305–
313.
Entries: 50 prints after. Illustrated.

Lefebvre, Jules Joseph *(1836–1912)*
[Ber.] IX, p. 81.
Entries: 9.

Lefèvre, Achille Désiré *(1798–1864)*
[Ap.] pp. 233–234.
Entries: 16.*

[Ber.] IX, pp. 82–83.*

Lefèvre, Ernest Assuérus *(b. 1814)*
[Ber.] IX, p. 83.*

Lefèvre, Hubert *(fl. 1800–1820)*
[Ber.] IX, p. 81.*

Le Fevre, Valentin *(1642–1680/82)*
Villot, Frédéric. "Valentin Lefebre,
peintre et graveur à l'eau-forte." [*Cab.
am. ant.*] 3 (1844): 169–197.
Entries: 53. Millimeters. Inscriptions.
Described.

[W.] I, p. 532.
Entries: 2.*

[H. *Neth.*] X, p. 46.
Entries: 54.*

Lefèvre-Marchand, ———— *(fl. c.1810)*
[Ber.] IX, p. 83.*

Lefils, ———— *(fl. c.1852)*
[Ber.] IX, p. 83.*

Lefman, Ferdinand *(fl. 1848–1870)*
[Ber.] IX, p. 84.*

Lefort, Henri Émile *(b. 1852)*
[Ber.] IX, pp. 84–86.*

Lefranc, Victor *(b. 1812)*
[Ber.] IX, p. 86.*

Lefrancq, Léon *(fl. c.1850)*
[Ber.] IX, p. 86.*

Legénisel, Gabriel Hubert Alexandre
(fl. 1860–1875)
[Ber.] IX, p. 86.*

Legentil, Alexandre *(19th cent.)*
[Ber.] IX, pp. 86–87.*

Leger-Chérelle, ———— *(fl. c.1850)*
[Ber.] IX, p. 87.*

Leger-Larbouillat, ———— *(19th cent.)*
[Ber.] IX, p. 87.*

Legnani, Stefano Maria *(1660–1715)*
[B.] XIX, pp. 332–333.
Entries: 2. Pre-metric. Inscriptions.
Described.

Legrand, André *(1902–1947)*
Meyer, Daniel. *André Legrand illustrateur
et graveur d'ex-libris 1902–1947.* Nancy
(France): Edition de l'Association Française des Collectionneurs d'ExLibris,
1948. (EPBN)
Entries: 12. Described. Illustrated.

Legrand, Augustin [Auguste] Claude
Simon *(1765–after 1815)*
 [Ber.] IX, p. 87.*

Legrand, Eugénie *(fl. c.1848)*
 [Ber.] IX, p. 87.*

Legrand, Louis *(1863–1951)*
 [Ber.] IX, pp. 88–92.*

Ramiro, Erastène. *Louis Legrand,
peintre-graveur.* Paris: H. Floury, 1896.
250 copies. (MBMu)
 Entries: 112 (to 1895). Millimeters. In-
 scriptions. States. Described. Illus-
 trated (selection).

Exteens, Maurice. "Catalogue de
l'oeuvre gravé et lithographié de Louis
Legrand." Unpublished ms., c.1920–
1939. (EPBN)
 Entries: 374. States. Described.

Faust, Camille [Camille Mauclair]. *Louis
Legrand.* Les artistes du livre, 21. Paris:
Henry Babou, 1931. 700 copies. (NN)
 Bibliography of books with illustra-
 tions by.

Le Grand, Paul *(fl. c.1820)*
 [Ber.] IX, p. 87.*

Legrip, Frédéric *(1817–1871)*
 [Ber.] IX, p. 92.*

Legros, Alphonse *(1837–1911)*
Poulet-Malassis, A., and Thibaudeau,
A. W. *Catalogue raisonné de l'oeuvre gravé
et lithographié de M. Alphonse Legros.*
Paris: J. Baur, 1877. 180 copies. (MBMu)
 Entries: 168 (to 1877). Millimeters. In-
 scriptions. States. Described. Lo-
 cated. Ms. addition (EPBN); 89 addi-
 tional entries. Ms. addition (EBM); 90
 additional entries. Ms. addition
 (ECol); 342 additional entries. Ms.
 notes (ECol); additional states, etc.

[Ber.] IX, pp. 93–105.
 Entries: 258.*

Legros, Lucien A. Catalogue. In
*L'Oeuvre gravé et lithographié de Alphonse
Legros,* by Gustave Soulier. Paris: Ch.
Hessèle, 1904.
 Entries: 631. Millimeters. Based on
 Poulet-Malassis and Thibaudeau and
 [Ber.], with additions by Lucien A.
 Legros.

Legros, L. A. Ms. catalogue, c.1905.
(EPBN)
 Entries: 400 (additional to Poulet-
 Malassis and Thibaudeau). Inches.
 States.

Legros, L. A., et al. "Copie des notes
additionelles au catalogue Malassis-
Thibaudeau, la continuation par H. Be-
raldi et les notes tenu depuis par L. A.
Legros." Unpublished ms., 1911. (2
copies, ECol)
 Entries: 534 (additional to Poulet-
 Malassis and Thibaudeau). Millime-
 ters. States. Additional information to
 Poulet-Malassis and Thibaudeau.

Dodgson, Campbell. *A catalogue of the
etchings, drypoints and lithographs by Pro-
fessor Alphonse Legros (1837–1911) in the
collection of Frank E. Bliss.* London: Pri-
vately printed, 1923.
 Entries: 704. States. Illustrated (selec-
 tion). Located. Based on Poulet-
 Malassis and Thibaudeau, [Ber.], Le-
 gros (in Soulier), and ms. additions by
 L. A. Legros. The Bliss Collection
 (now in Boston Public Library) was a
 virtually complete collection of prints
 by Legros in all states. Ms. notes
 (ECol); additional states. Ms. notes
 (EBM); additional information.

Legros, L. A. "Oeuvre gravé d'Al-
phonse Legros. Album of photo-
graphs." (EPPr; photographic copy,
EPBN)
 Entries: 571. States. Illustrated. The
 most complete of several such al-
 bums. Others in EPBN, NNMM,
 ECol.

Legros, [Jean] Sauveur *(1754–1834)*
Hillemacher, Frédéric. "L'Oeuvre de
Sauveur Legros, graveur à l'eau-forte."
[*RUA.*] 6 (1857): 146–160.
Entries: 132. Millimeters. Inscriptions.
States. Described.

[H. L.] pp. 564–598.
Entries: 132. Millimeters. Inscriptions.
States. Described. Based on Hille-
macher.

[Ber.] IX, pp. 92–93.*

Leguay, Étienne Charles *(1762–1846)*
[Ber.] IX, p. 105.*

Leguay, Eugène *(b. 1822)*
[Ber.] IX, p. 106.*

Leheutre, Gustave *(1861–1932)*
Clément-Janin, ———. "Gustave
Leheutre." [*GK.*] 29 (1906): 85–90.
Catalogue: "Verzeichnis der graphis-
chen Arbeiten G. Leheutres 1892–1904."
[*MGvK.*] 1906, pp. 71–75.
Entries: 78. Millimeters. States.

[Del.] XII.
Entries: 137+ (to 1920). Millimeters
(selection). Inscriptions. States. De-
scribed. Illustrated. Located (selec-
tion).

Lecomte, Marcel: Ms. catalogue. (EP
Lecomte)
Entries: 53 (additional to [Del.]). Mil-
limeters. Inscriptions. States. De-
scribed. Illustrated.

Lehman, George *(d. 1870)*
[F.] pp. 178–179.*

Carey, pp. 335–337.
Entries: 22 (lithographs only). Inches.
Inscriptions (selection). Described
(selection). Located.

Lehmann, A. *(19th cent.)*
[Dus.] pp. 101–102.

Entries: 2 (lithographs only, to 1821).
Millimeters (selection). Inscriptions
(selection). Located (selection).

Lehmann, Auguste *(1822–1872)*
[Ap.] p. 235.
Entries: 5.*

[Ber.] IX, p. 106.
Entries: 9.

Lehmann, G. W. *(fl. 1830–1842)*
[Ap.] p. 235.
Entries: 7.*

Lehmann, Walther *(20th cent.)*
Fogedgaard, Helmer. "Walther
Lehmann, en ny dansk exlibristegner."
[*N. ExT.*] 13 (1961): 90–91.
Entries: 11 (bookplates only, to 1961).
Illustrated (selection).

Lehmbruck, Wilhelm *(1881–1919)*
Petermann, Erwin. *Die Druckgraphik von
Wilhelm Lehmbruck; Verzeichnis.*
Stuttgart: Verlag Gerd Hatje, 1964.
Entries: 183 etchings; 17 lithographs.
Millimeters. Inscriptions. States. De-
scribed. Illustrated. Located.

Lehmden, Anton *(b. 1929)*
Stock, Sigrun. "Die Graphik Anton
Lehmdens." Dissertation, University of
Salzburg, 1970. Ms. (xerox copy, EWA)
Entries: unnumbered, pp. 124–153.
Millimeters. Inscriptions. Described.

Stock, Sigrun. Catalogue. In *Anton
Lehmden; die Graphik,* by Walter Kos-
chatzky and Sigrun Stock. Salzburg
(Austria): Residenz Verlag, 1970.
Entries: 101 (to 1970). Millimeters. In-
scriptions. States. Described. Illus-
trated.

Lehnert, Pierre Frédéric *(b. 1811)*
[Ber.] IX, pp. 106–107.*

Le Hon, Henri *(1809–1872)*
[H. L.] pp. 598–599.
 Entries: 1. Millimeters. Inscriptions.
 Described.

Leibl, Wilhelm Maria Hubertus
(1844–1900)
 Gronau, Georg. *Leibl.* Künstlermono-
 graphien . . . Herausgegeben von H.
 Knackfuss, 50. Bielefeld (Germany):
 Velhagen und Klasing, 1901.
 Entries: 19. Millimeters. Inscriptions.
 Described. Illustrated (selection).

 Roeper, Adalbert. "Wilhelm Leibl."
 [*Kh.*] 1 (1909): 118–123.
 Entries: 19. Millimeters. States. De-
 scribed. Also, list of 71 prints after.

Leigebe, Gottfried
 See **Leygebe**

Leigel, Gottfried
 See **Lemberger,** Georg and **Monogram
 GL** [Nagler, *Mon.*] III, no. 120

Leighton, Clare *(b. 1899)*
 Hardie, Martin. "The wood engravings
 of Clare Leighton." [*PCQ.*] 22 (1935):
 139–165.
 Entries: 258 (to 1934). Inches.

Leinberger, Hans *(fl. 1510–1530)*
 See **Monogram HL** [Nagler, *Mon.*] III,
 nos. 1201, 1224

Leisener, Nicolas Auguste *(b. 1787)*
 [Ap.] p. 236.
 Entries: 3.*

Leisnier, Auguste *(1787–1858)*
 [Ber.] IX, pp. 107–108.*

Leitch, William Leighton *(1804–1883)*
 MacGeorge, A. *Wm. Leighton Leitch,
 landscape painter, a memoir.* London:
 Blackie and Son, 1884.

 Entries: unnumbered, pp. 120–125,
 prints after.

Leitenstorffer, Franz Anton von
(1721–1795)
 [A.] V, pp. 311–313.
 Entries: 4. Pre-metric. Inscriptions.
 Described.

Lejeune, E. *(19th cent.)*
 [Ber.] IX, pp. 108–109.*

Lejeune, Louis François, baron *(1775–1848)*
 [Ber.] IX, p. 108.
 Entries: 2. Paper fold measure (selec-
 tion).

Lejeune, Nicolas *(c.1750–after 1804)*
 [Baud.] I, pp. 300–301.
 Entries: 2. Millimeters. Inscriptions.
 Described.

Le Juge, G. *(fl. c.1650)*
 [RD.] IV, pp. 26–31; XI, pp. 119–122.
 Entries: 19. Pre-metric. Inscriptions.
 States. Described.

Le Keux, Henry *(1787–1868)*
 [Ap.] p. 236.
 Entries: 3.*

Le Keux, John *(1783–1846)*
 [Ap.] p. 146.
 Entries: 1.*

Leleu, L. D. *(19th cent.)*
 [Ber.] IX, p. 109.*

Leleux, Adolphe Pierre *(1812–1891)*
 [Ber.] IX, p. 109.*

Leleux, Armand Hubert Simon *(1818–1885)*
 [Ber.] IX, p. 110.*

Lelius, ——— *(18th cent.)*
 [Sm.] II, p. 812.

Lelius, ——— (*continued*)

Entries: 1 (portraits only). Inches. Inscriptions. Described.

[Ru.] p. 197.
Additional information to [Sm.].

Lelli, Lucio *(1824–1896)*
[Ap.] p. 236.
Entries: 1.*

Leloir, ——— *(fl. 1830–1845)*
See also **Andrew, Best and Leloir**

[Ber.] IX, p. 110.*

Leloir, [Alexandre] Louis *(1843–1884)*
[Ber.] IX, pp. 110–111.*

Leloir, Maurice *(b. 1853)*
[Ber.] IX, pp. 111–113.
Entries: 16+.

Lelu, Pierre *(1741–1810)*
[Baud.] I, pp. 231–286; errata, p. III.
Entries: 75. Millimeters. Inscriptions.
States. Described.

[Ber.] IX, p. 113.*

Lely, Peter [Pieter van der Faes]
(1618–1680)
[W.] II, pp. 24–26.
Entries: unnumbered, p. 26, prints after.*

[H. *Neth.*] X, pp. 47–51.
Entries: 227 prints after.*

Lemagny, Paul *(b. 1905)*
Jean Richard, P. "La gravure au burin en France de 1914 à nos jours; l'oeuvre gravé de P. P. Lemagny." Thesis, École du Louvre, 1957. Ms. (EPBN)
Entries: 194 (to 1957). Millimeters. Located (selection).

Lemaire, Louis Marie *(1824–1910)*
[Ber.] IX, p. 114.*

Lemaire, Madeleine Jeanne *(1845–1928)*
[Ber.] IX, p. 114.*

Le Maire, Pierre *(1612–1688)*
[RD.] VI, pp. 204–211.
Entries: 15. Pre-metric. Inscriptions.
States. Described.

Lemaître, Anne Clara *(1826–after 1880)*
[Ber.] IX, p. 115.*

Lemaitre, Augustin François *(1797–1870)*
[Ap.] p. 237.
Entries: 3.*

[Ber.] IX, pp. 114–115.*

Le May, Olivier *(1734–1790)*
[W.] II, p. 127.
Entries: 1+.*

Le Mayeur, Adrien *(b. 1844)*
[H. L.] p. 599.
Entries: 1. Millimeters. Inscriptions.
Described.

Lemberger, Georg *(c.1495–c.1540)*
[B.] IX, p. 434.
Entries: 16. Pre-metric.

Schuchardt, Christian. *Lucas Cranach des Aelteren Leben und Werke nach urkundlichen Quellen bearbeitet.* Vol. III, pp. 116–122. Leipzig: F. A. Brockhaus, 1851–1871. (MBMu)
Bibliography of books with illustrations by.

Röttinger, Heinrich. "Zum Holzschnittwerk Georg Lemburgers." [*MGvK.*] 1906, pp. 1–9.
Bibliography of books with illustrations by (additional to Schuchardt).

Lembke, Johann Philip *(1631–1711)*
[A.] V, pp. 193–198.
Entries: 7. Pre-metric. Inscriptions.
Described.

[H. *Neth.*] X, p. 52.
Entries: 3.* Prints after Dutch and Flemish artists only.

Lemens, Balthazar van *(1637–1704)*
[W.] II, p. 26.
Entries: 6 prints after.*

[H. *Neth.*] X, p. 52.
Entries: 6 prints after.*

Lemercier, Antoine *(fl. c.1633)*
[RD.] II, pp. 3–8; XI, pp. 122–123.
Entries: 24. Pre-metric. Inscriptions. Described.

Lemercier, Jacques *(c.1585–1654)*
[RD.] VI, pp. 151–153.
Entries: 3. Millimeters. Inscriptions. Described.

Lemercier, Joseph *(b. 1803)*
[Ber.] IX, pp. 115–116.*

Le Met, L. *(fl. c.1805)*
[St.] p. 283.*

[F.] pp. 179–180.*

Le Mire, Louis *(c.1738–1757)*
Hédou, Jules. *Noël Le Mire et son oeuvre, suivi du catalogue de l'oeuvre gravé de Louis Le Mire.* Paris: J. Baur, 1875. 350 copies. (MH). Reprint. Amsterdam: G. W. Hissink, 1968.
Entries: 5. Millimeters. Inscriptions. States. Described.

Le Mire, Noël *(1724–1801)*
Hédou, Jules. *Noël Le Mire et son oeuvre, suivi du catalogue de l'oeuvre gravé de Louis Le Mire.* Paris: J. Baur, 1875. 350 copies. (MH). Reprint. Amsterdam: G. W. Hissink, 1968.
Entries: 530 prints by, 4 after. Millimeters. Inscriptions. States. Described.

Lemoine, Alfred *(1824–1881)*
[Ber.] IX, p. 117.*

Lemoine, Auguste Charles *(1822–1869)*
[Ber.] IX, p. 117.*

Lemoine, Charles *(fl. 1861–1869)*
[Ber.] IX, p. 118.*

Lemoine, François *(1688–1737)*
Saunier, Charles. "Lemoine." In [Dim.] I, pp. 60–92.
Entries: 15 prints after lost works.

Lemon, Henry *(fl. 1855–1866)*
[Ap.] p. 237.
Entries: 5.*

Lemud, Aimé de *(1816–1887)*
[Ber.] IX, pp. 118–130.
Entries: 80. Paper fold measure.

Bouvenne, Agläus. *Catalogue de l'oeuvre lithographié et gravé de A. de Lemud.* Paris: Baur, 1881. 327 copies. (MBMu)
Entries: 82 prints by and after. Millimeters. Inscriptions. Described.

Lemud, Ferdinand de *(fl. c.1853)*
[Ber.] IX, p. 130.*

Leney, William Satchwell *(1769–1831)*
[St.] pp. 283–315.*

[F.] pp. 180–183.*

[Siltzer] p. 360.
Entries: unnumbered, p. 360. Inscriptions.

Lenfant, Jean *(1615–1674)*
Lamy-Lassalle, Colette. *Jean Lenfant, graveur abbevillois.* Extract from *Bulletin de la Société des Antiquaires de Picardie,* 1st trimester, 1938. Amiens (France): Yvert et Cie, 1938.
Entries: 188. Millimeters. Inscriptions. Described. Illustrated (selection). Located.

Lengele, Maerten [Martinus] *(d. 1668)*
[W.] II, pp. 26–27.
 Entries: 1 print after.*

[H. *Neth.*] X, p. 52.
 Entries: 1 print after.*

Lengerke, Gustav von *(b. 1801)*
[Dus.] p. 102.
 Entries: 3 (lithographs only, to 1821).
 Millimeters. Inscriptions. Located.

Lenk, Thomas *(b. 1933)*
Kunstverein Bochum e. V., and
Museum Bochum. *Thomas Lenk.*
Bochum (West Germany), 1970.
 Entries: 65 (to 1970). Millimeters. Illus-
 trated (selection).

Lens, Andries Cornelis *(1739–1822)*
[W.] II, p. 27.
 Entries: 1 print after.*

Lens, Bernard II *(1659–1725)*
[Sm.] II, pp. 813–821, and "additions
and corrections" section.
 Entries: 31 (portraits only). Inches. In-
 scriptions. States. Described. Illus-
 trated (selection). Located (selection).

[Ru.] pp. 197–198, 494.
 Entries: 3 (portraits only, additional to
 [Sm.]). Inches. Inscriptions. De-
 scribed. Additional information to
 [Sm.].

Léonard, Jules *(1827–1897)*
[Ber.] IX, p. 130.*

Leonardo da Vinci
See **Vinci,** Leonardo da

Leonart, Johann Friedrich *(1633–1680)*
Andresen, A. "Johann Friedrich
Leonart." [*N. Arch.*] 7–8 (1861–1862):
133–194.
 Entries: 245. Pre-metric. Inscriptions.
 States. Described.

[W.] II, pp. 27–28.
 Entries: 6+.*

[H. *Neth.*] X, p. 53.
 Entries: 18.*

Leone, Gabriel de
See **Leeuw,** Govaert van der

Leonetti, Giovanni Battista *(d. before 1830)*
[Ap.] p. 237.
 Entries: 3.*

Leoni, Ottavio *(1578–1630)*
[B.] XVII, pp. 246–259.
 Entries: 40. Pre-metric. Inscriptions.
 Described.

[Heller] p. 84.
 Additional information to [B.].

[Wess.] III, p. 50.
 Additional information to [B.].

Leopold, Franz Joseph *(1783–1832)*
[Dus.] pp. 102–103.
 Entries: 8 (lithographs only, to 1821).
 Millimeters. Inscriptions. Located.

Lepelletier, ——— *(19th cent.)*
[F.] p. 184.*

Lepère, Auguste *(1849–1918)*
[Ber.] IX, pp. 132–134.*

Lotz-Brissonneau, A. *L'Oeuvre gravé de
Auguste Lepère; catalogue descriptif et
analytique.* Paris: Edmond Sagot, 1905.
125 copies. (MBMu)
 Entries: 311 (etchings, lithographs and
 hand-printed woodcuts only). Mil-
 limeters. Inscriptions. States. De-
 scribed. Also, bibliography of books
 and periodicals with illustrations by.

Texier-Bernier, G. M. Catalogue. In *Au-
guste Lepère, peintre et graveur décorateur
de livres,* by Charles Saunier. Paris:
Maurice Le Garrec, 1931. 650 copies.
(CSfAc)

Entries: 105 etchings, 39 woodcuts, 5 lithographs, (additional to Lotz-Brissonneau). Millimeters. Inscriptions. States. Described.

Le Petit, Alfred *(1841–1909)*
[Ber.] IX, pp. 135–142.*

Lepic, Ludovic Napoléon, vicomte *(1839–1889)*
[Ber.] IX, pp. 143–145.*

Lépine, Félix de *(19th cent.)*
[Ber.] IX, p. 145.*

Le Poitevin, Eugène Modeste Edmond *(1806–1870)*
[Ber.] IX, pp. 145–146.*

Le Poutre, Jean A. *(fl. c.1696)*
[W.] II, p. 361.
Entries: 7.*

Lepri, Gioacchino *(fl. c.1810)*
[Ap.] p. 237.
Entries: 4.*

Le Prince, Jean Baptiste *(1734–1781)*
Hédou, Jules. *Jean Le Prince et son oeuvre.* Paris: Baur, Rapilly, 1879. Reprint. Amsterdam: G. W. Hissink, 1968.
Entries: 179. Millimeters. Inscriptions. States. Described.

Leprince, Xavier *(1799–1826)*
[Ber.] IX, pp. 146–147.*

Leprix, Paul Denis *(fl. 1847–1868)*
[Ber.] IX, p. 147.*

Le Rat, Paul Edme *(1849–1892)*
[Ber.] IX, pp. 148–150.*

Lerberghe, Jan van *(c.1755–c.1810)*
[W.] II, p. 29.
Entries: 1.*

Lerouge, Édouard *(fl. c.1864)*
[Ber.] IX, p. 151.*

Le Rouge, Guillaume *(fl. 1489–1517),* Nicolas *(fl. 1496–1531),* Pierre *(fl. 1478–1493)*
Monceaux, Henri: *Les Le Rouge de Chablis; calligraphes et miniaturistes, graveurs et imprimeurs.* 2 vols. Paris: A. Claudin, 1896.
Bibliography of books published by; special attention given to illustrated books.

Lerouge, Jean Nicolas *(b. c.1776)*
[Ber.] IX, p. 151.*

Leroux, A. *(fl. c.1855)*
[Ber.] IX, p. 153.*

Leroux, Edmond *(fl. c.1860)*
[Ber.] IX, p. 155.*

Leroux, Eugène *(1807–1863)*
[Ber.] IX, pp. 153–154.*

Leroux, Jean Marie *(1788–1870)*
[Ap.] pp. 238–239.
Entries: 25.*

[Ber.] IX, pp. 151–153.
Entries: 46. Paper fold measure (selection).

Leroux, Louis *(fl. 1698–1703)*
[RD.] VIII, pp. 288–296.
Entries: 26. Millimeters. Inscriptions. States. Described.

Leroy, Alphonse *(b. 1821)*
[Ap.] p. 239.
Entries: 1.*

[Ber.] IX, pp. 158–159.*

Leroy, Louis *(1812–1885)*
[Ber.] IX, pp. 155–158.
Entries: 48 (etchings only). Paper fold measure. Described (selection). Also, unnumbered list of lithographs.

Leroy, Nicolas Auguste *(fl. c.1820)*
[Ber.] IX, p. 155.*

Le Roy, Pierre *(1784–1862)*
[H. L.] pp. 599–602.
Entries: 13. Millimeters. Inscriptions.
States. Described.

Le Royer, Olivier Aubin and Jean
(fl. c.1560)
[RD.] VII, pp. 28–42.
Entries: 60. Millimeters. Inscriptions.
Described.

Lesaché, Émile Eugène *(b. 1818)*
[Ber.] IX, pp. 159–164.*

Lesage, Louis Ernest
See **Sahib**

Lescot, Antoinette Cécile Hortense
See **Haudebourt**

Lesecq, Henri *(b. 1818)*
[Ber.] IX, p. 164.*

Lesire, Paul *(1611–after 1656)*
[W.] II, pp. 29–30.
Entries: 2 prints after.*

[H. *Neth.*] X, p. 53.
Entries: 2 prints after.*

Lespinasse, Herbert *(1884–1972)*
Bibliothèque d'art et d'archéologie de
l'université, Paris [Suzanne Damiron,
compiler]. *Herbert Lespinasse.* Paris, 1964.
(EPAA)
Entries: 93+.

Lessore, Émile Aubert *(1805–1876)*
[Ber.] IX, p. 165.*

Lessore, Henri Émile *(b. 1830)*
[Ber.] IX, p. 165.*

Lestudier-Lacour, Gabriel Louis
(1800–1849)
[Ber.] IX, p. 165.*

Le Sueur, Eustache *(1617–1655)*
[RD.] I, pp. 159–160.
Entries: 1. Pre-metric. Inscriptions.
States. Described.

Dussieux, L. "Nouvelles recherches sur
la vie et les ouvrages de Le Sueur."
Archives de l'art français; documents 2
(1852–1853): 1–124.
Entries: 1. Pre-metric. Inscriptions.
States. Also, list of prints after, un-
numbered, pp. 109–111, 122–123.

Leterrier, Paul Émile *(fl. c.1890)*
[Ber.] IX, p. 166.*

Leth, Hendrik de *(fl. 1700–1759)*
[W.] II, p. 30.
Entries: 6+.*

Lethière, Guillaume Guillon *(1760–1832)*
[Ber.] IX, p. 166.*

Letoula, Jules *(b. 1832)*
[Ber.] IX, pp. 166–167.
Entries: 39. Paper fold measure.

Letuaire, Pierre *(1799–1884)*
[Ber.] IX, p. 167.*

Leu, Thomas de *(fl. 1576–1614)*
[RD.] X, pp. 1–168; XI, pp. 123–127.
Entries: 512. Millimeters. Inscriptions.
States. Described. Preface, pp. 4–6,
contains a list of prints attributed to
Leu by Mariette, not seen by [RD.].

[Wess.] IV, p. 59.
Entries: 2 (additional to [RD.]). Mil-
limeters. Inscriptions. Described.
Additional information to [RD.].

Leuchte, Paul *(1798–1854)*
[Dus.] pp. 103–104.
Entries: 4 (lithographs only, to 1821).
Millimeters (selection). Inscriptions.
Located (selection).

Leuchtenberg, Auguste de *(1810–1835)*
[Ber.] IX, p. 167.
Entries: 11. Paper fold measure (selection).

Leudner, Joseph *(1813–1853)*
[Ap.] p. 239.
Entries: 3.*

Leuler, ——— *(fl. c.1830)*
[Ber.] IX, p. 168.*

Leupenius, Johannes *(1647–1693)*
[W.] II, p. 30; III, p. 108.
Entries: 5.*

[H. *Neth.*] X, pp. 54–55.
Entries: 7. Illustrated (selection).*

Leux, Frans [**Luycx von Leuxenstein**]
(1604–1668)
[W.] II, pp. 30–31.
Entries: 4 prints after.*

[H. *Neth.*] X, p. 56.
Entries: 8 prints after.*

Levachez, Charles François Gabriel, and
son *(fl. 1760–1820)*
[Ber.] IX, pp. 168–169.*

Levasseur, ——— *(fl. c.1830)*
[Ber.] IX, p. 169.*

Levasseur, Jean Charles *(1734–1816)*
Delignières, Émile. "Catalogue raisonné
de l'oeuvre gravé de Jean Charles Le
Vasseur d'Abbeville." [*Mém. Abbéville*]
10, 2d part (1861–1866): 1–86. Separately
published. Abbéville (France): Im-
primerie P. Briez, 1865. 2d ed. Paris,
1866.
Entries: 166. Millimeters. Inscriptions.
Described.

[L. D.] pp. 53–54.
Entries: 4. Millimeters. Inscriptions.
States. Described. Incomplete
catalogue.*

Levasseur, Jules Gabriel *(b. 1823)*
[Ap.] p. 240.
Entries: 17.*

[Ber.] IX, pp. 169–171.*

Le Veau, Jean Jacques André *(1729–1786)*
Hédou, Jules. *J. J. A. Le Veau, sa vie et son
oeuvre (1729–1786)*. Paris: Noel
Charavay, A. Durel, 1903. 200 copies.
(MH)
Entries: 272. Millimeters. Inscrip-
tions. States. Described. Illustrated
(selection).

[L. D.] pp. 54–55.
Entries: 2. Millimeters. Inscriptions.
States. Described. Incomplete
catalogue.*

Léveillé, Auguste Hilaire *(1840–1900)*
[Ber.] IX, pp. 171–172.*

Léveillé, Ernest *(19th cent.)*
[Ber.] IX, p. 172.*

Levieux, Renaud *(c.1620–c.1690)*
[RD.] VIII, pp. 271–273.
Entries: 1. Millimeters. Inscriptions.
Described.

Levigne, Hubert *(20th cent.)*
Schwencke, Johan. "Hubert Levigne."
Boekcier, 2d ser. 7 (1952): 44–52. Sepa-
rately published. *Grafisch werk van
Hubert Levigne*. The Hague: Neder-
landsche Exlibris-kring, 1952.
Entries: 85 bookplates, 48 commercial
prints (to 1952). Illustrated (selec-
tion).

Le Villain, Gérard René *(c.1740–after 1800)*
[L. D.] pp. 55–56.
Entries: 1. Millimeters. Inscriptions.
States. Described. Incomplete
catalogue.*

Levilly, Philéad Salvator *(b. 1803)*
[Ber.] IX, p. 172.*

Lévy, Émile *(1826–1890)*
[Ber.] IX, p. 174.*

Levy, Gustave *(1819–1894)*
[Ap.] p. 241.
Entries: 15.*

[Ber.] IX, pp. 172–174.*

Lewis, Charles George *(1808–1880)*
[Siltzer] p. 360.
Entries: unnumbered, p. 360. Inscriptions.

Lewis, Frederick Christian I *(1779–1856)*
[Siltzer] p. 360.
Entries: unnumbered, p. 360. Inscriptions.

Lewis, J. O. *(fl. 1831–1835)*
[St.] pp. 315–316.*

[F.] p. 184.*

Lewis, Martin *(1882–1962)*
Crafton Collection. *Martin Lewis.* Introduction by Charles Lemon Morgan. American etchers, 11. New York: Crafton Collection, 1931.
Entries: 72 (to 1930). Inches. Illustrated (selection).

Leybold, [Heinrich] Gustav Adolf *(b. 1794)*
[Ap.] p. 242.
Entries: 3.*

Leybold, Johann Friedrich *(1755–1838)*
[Ap.] p. 242.
Entries: 10.*

[Dus.] p. 104.
Entries: 2 (lithographs only, to 1821). Millimeters. Inscriptions. Located.

Leyden, Aertgen van
See **Claeszoon,** Aert

Leyden, Lucas van *(1494–1533)*
Bartsch, Adam. *Catalogue raisonné de toutes les estampes qui forment l'oeuvre de Lucas de Leyde.* Vienna: J. V. Degen, 1798.
Entries: 172. Pre-metric. Inscriptions. Described.

[B.] VII, pp. 331–443.
Entries: 174 engravings, 17 woodcuts, 4 doubtful prints. Pre-metric. Inscriptions. States. Described. Copies mentioned.

[Heller] p. 84.
Additional information to [B.].

[Evans] pp. 42–43.
Entries: 3 (additional to [B.]). Millimeters. Inscriptions. Described.

[P.] III, pp. 3–11.
Entries: 3 engravings (additional to [B.], 15 woodcuts (additional to [B.]). Pre-metric. Inscriptions. Described. Located. Copies mentioned. Additional information to [B.].

[Wess.] II, pp. 239–240.
Additional information to [B.].

[Dut.] V, pp. 48–102; VI, p. 673.
Entries: 179 engravings, 3 etchings, 31 woodcuts, 1 doubtful print. Millimeters. Inscriptions. States. Described.

Evrard, M. W. *Lucas de Leyde et Albert Dürer.* Brussels: G. A. van Trigt, 1884.
Entries: 237 prints by, 31 doubtful prints. Pre-metric. Millimeters. Inscriptions. Described. Based on [B.], with additions from [P.], [Lebl.], [Dut.] and other sources.

Volbehr, Th. *Lucas van Leyden; Verzeichniss seiner Kupferstiche, Radierungen und Holzschnitte.* Kritische Verzeichnisse von Werken hervorragender Kupferstecher, 4. Hamburg, Haendcke und Lehmkuhl, 1888.
Entries: 205 prints by, 17+ doubtful prints and prints not seen by Volbehr.

Millimeters. Inscriptions. States. Described. Copies mentioned.

Dodgson, Campbell. "Aristoteles und Phyllis; ein unbeschriebener Holzschnitt des Lucas van Leyden." [JprK.] 18 (1897): 184–186.
Entries: 1 (additional to earlier catalogues). Millimeters. Described. Illustrated. Located.

Dodgson, Campbell. "Beschreibendes Verzeichniss der Buchillustrationen Lucas van Leyden's." [Rep. Kw.] 23 (1900): 143–153.
Entries: 61 (woodcut book illustrations only). Millimeters. States. Described. Located.

[W.] II, pp. 31–40; III, p. 108.
Entries: 210+ prints by, 20+ after.*

Kahn, Rosy. Die Graphik des Lucas van Leyden. Strasbourg: J. H. Ed. Heitz, 1918.
Chronological list of undated prints, pp. 142–143.

Friedländer, Max J. Lucas van Leyden. Meister der Graphik, 13. Leipzig: verlag von Klinkhardt und Biermann, 1924.
Chronological list of prints, with [B.] numbers. Illustrated (selection).

Dodgson, Campbell. "Zwei unbeschriebene Holzschnitte des Lucas van Leyden." In Festschrift für Max J. Friedländer zum 60. Geburtstage. pp. 109–110. Leipzig: E. A. Seeman, 1927.
Entries: 2 (additional to Dodgson 1900). Millimeters. Described. Illustrated. Located.

[H. Neth.] X, pp. 57–244. Separately published. The graphic art of Lucas van Leyden (1494–1533). Amsterdam: Menno Hertzberger, n.d.
Entries: 322+ prints by, 102 after. Illustrated (selection).*

Lavalleye, Jacques. Pieter Bruegel the Elder and Lucas van Leyden; the complete engravings, etchings and woodcuts. New York: Harry N. Abrams Inc., 1967. (French and German editions as well.)
Entries: 287. Inches (selection). Illustrated. Located.

Leygebe, Gottfried Christian (1630–1683)
[A.] V, pp. 184–188.
Entries: 3. Pre-metric. Inscriptions. States. Described.

Leypolt, Johann (fl. 1603–1619)
[Merlo] p. 538.*

Leys, Henri (1815–1869)
[H. L.] pp. 603–608.
Entries: 12. Millimeters. Inscriptions. States. Described.

[Ber.] IX, pp. 174–178.
Entries: 20. Paper fold measure. Inscriptions. Described (selection).

[Del.] XIX.
Entries: 20 prints by, 1 rejected print. Millimeters. Inscriptions (selection). States. Described (selection). Illustrated. Located (selection).

Leyster, Judith (c.1609–1660)
[H. Neth.] XI, p. 1.
Entries: 1 print after.*

Lhérie, Ferdinand Benchet (1803–1848)
[Ber.] IX, p. 178.*

Lhermitte, Léon Augustin (1844–1925)
[Ber.] IX, pp. 179–181.*

Henriet, Frédéric. Les eaux-fortes de Léon Lhermitte. Paris: Alphonse Lemerre, 1905. 570 copies. (CSfAc)
Entries: 44 (to 1903). Millimeters. Inscriptions. States. Described. Illustrated (selection).

Lhomme, Jacques (1600–after 1650)
[RD.] VIII, pp. 251–252.
Entries: 1. Millimeters. Inscriptions. Described.

Lhomme, Jacques (*continued*)

[CdB.] pp. 43–44.
Entries: 1. Inscriptions. Described.
Based on [RD.].

Lhotellier, ——— (*fl. c.1867*)
[Ber.] IX, p. 181.*

Lhuillier, Victor Gustave (*fl. c.1877*)
[Ber.] IX, p. 181.*

Liaño, Felipe (*d. 1625*)
[B.] XVII, pp. 199–206.
Entries: 30. Pre-metric. Inscriptions.
Described.

Liberatore, Niccolò di
See **Niccolò di Liberatore**

Licherie de Beuron, Louis (*1629–1687*)
Bellier de la Chavignerie, Em. *Recherches sur Louis Licherie, peintre normand.* Extract from *Le Bulletin de la Société des Beaux-Arts de Caen*, 1860. Caen (France): A. Hardel, 1860.
Entries: 31 prints after. Millimeters.
Inscriptions. Described.

Lichtenstein, Roy (*b. 1923*)
Bianchini, Paul. *Roy Lichtenstein; drawings and prints.* New York: Chelsea House Publishers, 1970.
Entries: 37 (to 1969). Inches. Inscriptions. Described. Illustrated.

Lid, George (*17th cent.*)
[Hind, *Engl.*] III, p. 251.
Entries: 1. Inches. Inscriptions. Described. Illustrated. Located.

Liebermann, Max (*1847–1935*)
Schiefler, Gustav. *Das graphische Werk von Max Liebermann.* Berlin: Bruno Cassirer, 1907. 300 copies. (DLC)
Entries: 63 (to 1907). Millimeters. Inscriptions. States. Described. Illus-

trated (selection). Appendix with drawings made by Liebermann for reproduction, unnumbered, pp. 59–75.

Schiefler, Gustav. *Das graphische Werk von Max Liebermann; zweite durchgesehene und um das doppelte vermehrte Auflage.* Berlin: Bruno Cassirer, 1914.
Entries: 169 (to 1913). Millimeters. Inscriptions. States. Described. Numbering differs from Schiefler 1907.

Schiefler, Gustav. *Max Liebermann; sein graphisches Werk.* 3rd ed. Berlin: Bruno Cassirer, 1923.
Entries: 367 etchings and lithographs by, 73 wood engravings after (to 1923). Millimeters. Inscriptions. States. Described. Illustrated (selection).

Liebmann, Alexander (*b. 1871*)
Liebmann, Alexander. "Alexander Liebmann." [*Kh.*] 13 (1921): 445–447.
Entries: 121+ (to 1921). Millimeters. Illustrated (selection).

Liedts, Abraham
See **Liets**

Liefland, Johannes van (*1809–1861*)
[H. L.] p. 608.
Entries: 1. Millimeters. Inscriptions. Described.

Liefrinck, Cornelis I (*c.1480–before 1545*)
[W.] II, p. 42.
Entries: 1.*

[H. *Neth.*] XI, p. 1.
Entries: 1.*

Liefrinck, Cornelis II (*c.1581–c.1640*)
[W.] II, p. 42.
Entries: 2.*

[H. *Neth.*] XI, p. 1.
Entries: 3. Illustrated (selection).*

Liefrinck, Hans I *(1518–1573)*
[W.] II, pp. 42–43.
Entries: 46+.*

[H. *Neth.*] XI, pp. 2–3.
Entries: 135+. Illustrated (selection).

Liefrinck, Hans II *(d. 1599)*
[H. *Neth.*] XI, p. 3.
Entries: 1.*

Liefrinck, Mynken [Wilhelmine]
(fl. 1567–1582)
[H. *Neth.*] XI, p. 3.
Entries: 1.*

Liefrinck, Willem *(1490–1542)*
[W.] II, p. 43; p. 325 (as Anton **Phillery**).
Entries: 3+.*

[H. *Neth.*] XI, p. 3.
Entries: 5.*

Liénard, ——— *(fl. c.1856)*
[Ber.] IX, pp. 181–182.*

Liender, Paul [Paulus] van *(1731–1797)*
[W.] II, p. 43.
Entries: 3.*

Lier, Abraham van *(fl. 1603–1618)*
[H. *Neth.*] XI, p. 4.
Entries: 2. Illustrated (selection).*

Liere, Josse van *(d. 1583)*
[W.] II, pp. 43–44.
Entries: 2 prints after.*

[H. *Neth.*] XI, p. 4.
Entries: 3 prints after.*

Lies, Jozef Hendrik Hubert *(1821–1865)*
[H. L.] pp. 608–609.
Entries: 2. Millimeters. Inscriptions.
States. Described.

Liets, Abraham *(fl. 1653–1658)*
[W.] II, p. 44.
Entries: 1 print after.*

[H. *Neth.*] XI, p. 4.
Entries: 2 prints after.*

Lievens, Dirk *(1612–1651)*
[H. *Neth.*] XI, p. 81.
Entries: 1 print after.*

Lievens, Jan *(1607–1674)*
Daulby, pp. 307–321.
Entries: 81 prints by. Inches. Inscriptions. States. Described. Also, list of 28 prints after: title, dimensions and name of engraver only.

[B. *Remb.*] II, pp. 19–58, 173–179.
Entries: 66 prints by, 12 after. Premetric. Inscriptions. States. Described.

Linck, J. F. "Bemerkungen und Zusätze zu dem Verzeichnisse von A. Bartsch über die Radirungen und Holzschnitte des Jan Lievens." [N. *Arch.*] 5 (1859): 269–284.
Entries: 7 prints by, 2 doubtful prints, (additional to [B. *Remb.*]). Pre-metric. Inscriptions. States. Described.

[Wess.] II, p. 240.
Entries: 1 (additional to [B. *Remb.*] and Linck). Millimeters. Inscriptions. Described. Located. Addtional information to [B. *Remb.*] and Linck.

[Dut.] V, pp. 102–127.
Entries: 85. Millimeters. Inscriptions. States. Described. Appendix with 5 rejected prints.

[Rov.] pp. 23–42.
Entries: 98 prints by, 11 doubtful prints. Millimeters. Inscriptions. States. Described. Illustrated. Located.

[W.] II, pp. 44–51.
Entries: 89+ prints by, 47 after.*

Schneider, H. *Jan Lievens, sein Leben und seine Werke.* Haarlem (Netherlands): De Erven F. Bohn, 1932.

Lievens, Jan (*continued*)

Additional information to [Rov.] and earlier catalogues. Also, catalogue of paintings; prints after are mentioned where extant.

[Hind. *Engl.*] III, p. 212.
Entries: 1 (prints done in England only). Inches. Inscriptions. States. Described. Illustrated. Located.

[H. *Neth.*] XI, pp. 5–80.
Entries: 109 prints by, 59 after. Illustrated (prints by only).*

Lievens, Jan André *(1644–1680)*
[W.] II, pp. 51–52.
Entries: 1 print after.*

[H. *Neth.*] XI, p. 81.
Entries: 1 print after.*

Lièvre, Édouard *(1829–1886)*
[Ber.] IX, p. 182.*

Lievre, Justin *(b. 1828)*
[Ber.] IX, p. 182.*

Ligari, [Giovanni] Pietro *(1686–1752)*
[B.] XXI, pp. 322–324.
Entries: 2. Pre-metric. Inscriptions. States. Described.

Lightfoot, Anthony *(17th cent.)*
[Hind, *Engl.*] III, p. 268.
Entries: 1. Inches. Inscriptions. Described. Illustrated. Located.

Lignon, Étienne Frédéric *(1779–1833)*
[Ap.] pp. 243–244.
Entries: 30.*

[Ber.] IX, pp. 182–185.
Entries: 44+. Paper fold measure (selection).

Ligozzi, Giacomo [Jacopo] *(c.1547–1626)*
[B.] XII: *See* **Chiaroscuro Woodcuts**

Lilien, Ephraim Mose *(1874–1925)*
E. M. Lilien, sein Werk. Introduction by Stefan Zweig. Berlin: Schuster und Loeffler, 1903.
Bibliography of books with illustrations by.

Harz, Benjamin. *List of the original etchings of E. M. Lilien.* Berlin: Benjamin Hartz, 1922. (NN)
Entries: 229 (to 1923). Inches. Illustrated (selection).

Verzeichnis der Radierungen von E. M. Lilien. Preface by Koo Bickenbach. Berlin: Landsberg Kunst- und Buchhandlung, 1924.
Entries: 235 (to 1923). Illustrated (selection).

Lima, Teodoro Antonio de *(fl. c.1800)*
Soares, Ernesto. *Francisco Bartolozzi e os seus discipulos em Portugal.* Estudos-Nacionais sob a égide do Instituto de Coimbra no. 3. Gaia (Portugal): Edicões Apolino, 1930.
Entries: 14. Millimeters. Inscriptions. Described. Located.

Limborch, Hendrik van *(1681–1759)*
[Wess.] II, p. 240.
Entries: 1 (additional to [Nagler, *Mon.*] I, no. 436 and [Andresen, *Handbuch*]). Millimeters. Inscriptions. Described. Additional information to [Nagler, *Mon.*] and [Andresen, *Handbuch*].

[W.] II, p. 52.
Entries: 2 prints by, 1 after.*

Limborch, Michiel D. van *(fl. 1647–1685)*
[W.] II, p. 53.
Entries: 1 print after.*

[H. *Neth.*] XI, p. 81.
Entries: 4 prints after.*

Limosin, Léonard *(c.1505–1575/77)*
[RD.] V, pp. 45–49; XI, pp. 127–128.

Entries: 6. Millimeters. Inscriptions. Described.

[Herbet] IV, pp. 322–329.
Entries: 8. Millimeters. Inscriptions.

[Zerner] no. 5.
Entries: 8. Millimeters. Inscriptions. Illustrated.

Lin, Herman van *(fl. 1650–1675)*
[W.] II, p. 53.
Entries: 1 print after.*

Lindberg, Niels *(b. 1886)*
B[ärenholdt], H. C. "Niels Lindberg."
[*N. ExT.*] 2 (1947–1948): 64–66.
Entries: 22 (bookplates only, to 1948). Illustrated (selection).

Fougt, Knud. "Niels Lindberg II."
[*N. ExT.*] 7 (1955): 72–74.
Entries: 4 (bookplates only, 1948–1954). Illustrated (selection).

[Fogedgaard, Helmer]. "Niels Lindberg fylder 75." [*N. ExT.*] 13 (1961): 92–93.
Entries: 8 (bookplates only, 1955–1960). Illustrated (selection).

Lindmeier, Daniel *(fl. c.1600)*
[B.] IX, pp. 420–421.
Entries: 1. Pre-metric. Inscriptions. Described.

[Heller] pp. 85–86.
Entries: 6 (additional to [B.]). Pre-metric. Inscriptions. Described.

[P.] III, pp. 471–472.
Entries: 3 engravings and etchings, 5 woodcuts (additional to [B.]). Pre-metric. Inscriptions. Described.

[A.] IV, pp. 163–169.
Entries: 8. Pre-metric. Inscriptions. Described.

Lindenberg, J. *(fl. c.1715)*
[W.] II, p. 54.
Entries: 1 print after.*

Lindmitz, Jacob *(1623–1676)*
Schultz, Alwin. "Ergänzungen zu Andresen's *Peintre-Graveur.*" [*Rep. Kw.*] 6 (1883): 66–67.
Entries: 7. Millimeters. Inscriptions. Described (selection).

Linder, Johann *(1839–1906)*
[Ap.] p. 245.
Entries: 13.*

Roeper, Adalbert: "Johann Lindner," [*Bb.*] 73 (1906): 8391–8393, 9054.
Entries: 223. Millimeters. States.

Lindsay, Norman *(20th cent.)*
The etchings of Norman Lindsay. London: Constable and Co. Ltd., 1927. 129 copies. (DLC)
Entries: 84 (to 1925). Inches. Illustrated (selection).

Lindtmayer, Daniel II *(1552–1606)*
[A.] III, pp. 1–6.
Entries: 2 etchings, 7 woodcuts. Pre-metric. Inscriptions. Described.

Lingée, Charles Louis *(1748–1819)*
[L. D.] p. 56.
Entries: 3. Millimeters. Inscriptions. States. Illustrated. Incomplete catalogue.*

Lingelbach, Johannes *(1622–1674)*
[W.] II, pp. 54–55.
Entries: 2 prints by, 11+ after.*

[H. *Neth.*] XI, p. 82.
Entries: 2 prints by, 25 after.*

Linke, L. *(19th cent.)*
[Ap.] p. 244.
Entries: 2.*

Linnig, Egidius *(1821–1860)*
[H. L.] pp. 661–693.
Entries: 56 etchings, 1 lithograph. Millimeters. Inscriptions. States. Described.

Linnig, Jan Theodor *(1815–1891)*
[H. L.] pp. 609–658.
 Entries: 149 etchings, 14 engravings.
 Millimeters. Inscriptions. States. De-
 scribed (selection).

Linnig, Willem II *(1842–1890)*
[H. L.] pp. 658–660.
 Entries: 8. Millimeters. Inscriptions.
 Described.

Linnig, Ben. Catalogue. In *Le peintre Willem Linnig, Junior,* by Paul André. Brussels: Éditions de la Belgique Artistique et Litteraire, 1907.
 Entries: 123. Millimeters. States.

Linschoten, Adriaen Cornelisz van *(1590–1677)*
[W.] II, pp. 55–56.
 Entries: 1 print after.*

[H. *Neth.*] XI, p. 83.
 Entries: 2.*

Lint, D. de *(fl. c.1680)*
[H. *Neth.*] XI, p. 83.
 Entries: 1 print after.*

Lint, Hendrik Frans van [called "Studio"] *(1684–1763)*
[Wess.] II, p. 240.
 Entries: 1 (additional to [Andresen, *Handbuch*]). Millimeters. Inscriptions. Described.

[W.] II, p. 56.
 Entries: 2.*

[H. *Neth.*] XI, p. 83.
 Entries: 2. Illustrated (selection).*

Lint, Herman [Hans] van [called "Stilheid"] *(fl. 1659–1668)*
[H. *Neth.*] XI, p. 83.
 Entries: 1 print after.*

Lint, Peter van *(1609–1690)*
[W.] II, pp. 56–57.
 Entries: 1 print by, 7 after.*

[H. *Neth.*] XI, p. 84.
 Entries: 2 prints by, 15+ after.*

Lion, Alexandre Louis *(1823–1852)*
[H. L.] pp. 693–694.
 Entries: 2. Millimeters. Inscriptions. States. Described.

Lion, Jules *(fl. 1831–1836)*
[Ber.] IX, p. 185.*

Lion, Pierre Joseph *(1729–1809)*
[W.] II, p. 57.
 Entries: 3 prints after.*

Liotard, Jean Étienne *(1702–1789)*
Humbert, Ed.; Revilliod, Alphonse; and Tilanus, J. W. R. *La vie et les oeuvres de Jean Étienne Liotard (1702–1789).* Amsterdam: C. M. Van Gogh, 1897.
 Entries: 15 prints by, 123 prints after. Millimeters. Inscriptions. Described. Illustrated (selection). Located.

Lipinsky, Sigmund *(1873–1940)*
Lipinsky, Angelo. "Sigmund Lipinsky und sein graphisches Werk." *Maso Finiguerra* 5 (1940): 104–166. Separately published. n.p., n.d.
 Entries: 83 (to 1935). Millimeters. Illustrated (selection).

Lippi, Fra Filippo *(c.1406–1469)*
[P.] V, pp. 51–52.
 Entries: 15 doubtful prints. Premetric.

Lips, Johann Heinrich *(1758–1817)*
[Ap.] pp. 245–246.
 Entries: 14.*

Lips, Johann Jakob *(1791–1833)*
[Ap.] pp. 246–247.
 Entries: 7.*

Lisebetten, Peter van *(1630–c.1678)*
[W.] II, pp. 57–58.
 Entries: 7.*

[H. *Neth.*] XI, p. 85.
Entries: 17+.*

Liss, Johann *(c.1590–1629)*
[Burch.] pp. 145–146.
Entries: 3. Millimeters. Inscriptions.
States. Described. Located. Appendix
with 2 rejected prints.

[W.] II, pp. 76–77.
Entries: 4 prints by, 12+ after.*

Steinbart, Kurt. *Johann Liss, der Maler aus
Holstein.* Berlin: Deutscher Verein für
Kunstwissenschaft, 1940.
Entries: 2 prints by, 18 after, 3 rejected
prints. Millimeters. Inscriptions.
States. Illustrated. Located.

[H. *Neth.*] XI, pp. 146–148.
Entries: 5 prints by, 25 after. Illus-
trated (selection).*

Livy, Filippo *(19th cent.)*
[Ap.] p. 247.
Entries: 3.*

Ljunggren, Reinhold *(b. 1920)*
Asklund, Erik. *Reinhold Ljunggren.*
Stockholm: Folket i Bilds Konstklubb,
1961.
Entries: 37. Millimeters. Illustrated
(selection).

Llanta, Jacques François Gauderique
(1807–1864)
[Ber.] IX, pp. 185–186.*

Lloyd, John *(fl. c.1700)*
[Sm.] II, pp. 821–823.
Entries: 4 (portraits only). Inches. In-
scriptions. States. Described. Located
(selection).

[Ru.] p. 198.
Entries: 1 (portraits only, additional to
[Sm.]). Inches. Inscriptions. De-
scribed.

Lobeck, Tobias *(18th cent.)*
[Merlo] p. 539.*

Lobel-Riche, Alméry *(b. 1880)*
Boissy, Gabriel. *Lobel-Riche.* Les artistes
du livre, 2. Paris: Henry Babou, 1930. 700
copies. (NN)
Bibliography of books with illustra-
tions by.

Margerit, Robert. *Lobel-Riche.* Paris: Le
Livre de Plantin, 1946. 515 copies.
(EPBN)
Bibliography of books with illustra-
tions by.

Lobisser, Switbert *(b. 1878)*
Egger, Hermann. *Switbert Lobisser, Ver-
zeichnis seiner Holzschnitte.* Beiträge zur
Kunstgeschichte Steiermarks und
Kärntens, 7. Graz (Austria): Leykam
Verlag, 1947. (DLC)
Entries: 673 woodcuts, 5 etchings, 1+
lithographs (to 1943). Millimeters. Il-
lustrated (selection).

Locatelli, Antonio *(b. 1800)*
[Ap.] p. 247.
Entries: 5.*

Loche, Étienne *(b. 1786)*
[Ber.] IX, pp. 186–187.*

Lochom, Bartholomaeus van *(b. 1607)*
[W.] II, p. 58.
Entries: 4+.*

[H. *Neth.*] XI, p. 86.
Entries: 40. Illustrated (selection).*

Lochom, Hans van *(fl. c.1550)*
[W.] II, pp. 58–59.
Entries: 4.*

[H. *Neth.*] XI, p. 87.
Entries: 4.*

Lochom, Michiel van *(1601–1647)*
[W.] II, p. 59.
Entries: 8+.*

Lochom, Michiel van (*continued*)

[H. *Neth.*] XI, pp. 87–88.
Entries: 286+.*

Lochon, Pierre (*fl. 1675–1710*)
Morinerie, M. de la. "Pierre Lochon,
graveur." *Archives de l'art français; docu-
ments* 4 (1855–1856): 133–134.
Entries: 10.

Lockhorst, Jan van
See **Lokhorst,** Johan Nicolaus

Loder, J. (*19th cent.*)
[Siltzer] p. 332.
Entries: unnumbered, p. 332, prints
after. Inches (selection). Inscriptions.

Lodewycks van der Vecht, Hendrik
(*c.1600–1652*)
[W.] II, p. 59.
Entries: 2+.*

[H. *Neth.*] XI, p. 88.
Entries: 2+.*

Lodewycx, Lodowyck (*fl. c.1655*)
[W.] II, p. 59.
Entries: 1.*

[H. *Neth.*] XI, p. 88.
Entries: 2 prints published by.*

Lodi, Giacomo (*fl. 1618–1624*)
[B.] XIX, pp. 69–71.
Entries: 1 print by, 2+ prints not seen
by [B.]. Pre-metric. Inscriptions. De-
scribed.

Löbel, J. F. (*17th cent.*)
[Merlo] p. 539.*

Loeblein, A. C. (*19th cent.*)
[Dus.] p. 104.
Entries: 1 (lithographs only, to 1821).
Paper fold measure.

Lödel, Heinrich Burkhart (*1798–1861*)
[Ap.] p. 247.
Entries: 2.*

Löffler, August (*1822–1866*)
[A. 1800] IV, pp. 262–279.
Entries: 20. Millimeters. Inscriptions.
States. Described.

Löffler, D. (*fl. c.1688*)
[Merlo] pp. 539–540.*

Löffler, Johann Eckhard (*fl. 1630–1675*)
[Merlo] pp. 540–547.*

Löffler, Johann Heinrich (*b. c.1604*)
[Merlo] pp. 548–555.*

Loeillot-Hartwig, Karl (*1798–after 1841*)
[Ber.] IX, p. 187.*

Loelinck, Baltazar (*fl. c.1650*)
[H. *Neth.*] XI, p. 89.
Entries: 2.*

Loemans, Arnout (*fl. 1632–1656*)
[W.] II, p. 59.
Entries: 5.*

[H. *Neth.*] XI, p. 89.
Entries: 8+.*

Loeninga, Allaert van (*c.1600–c.1656*)
[H. *Neth.*] XI, p. 89.
Entries: 1 print after.*

Loevy, Ladislas (*19th cent.*)
[Ber.] IX, pp. 187–188.*

Loewenstam, Leopold (*1842–1898*)
[Ap.] p. 254.
Entries: 2.*

Loewig, Roger (*20th cent.*)
Loewig, Roger. *Roger Loewig, das litho-
graphische Werk 1965–1971.* Bonn: Roger
Loewig Gesellschaft, 1972. 500 copies.
(DLC)

Entries: 195 (to 1971). Millimeters. Inscriptions. Described. Illustrated.

Loff, Johannes de *(fl. c.1668)*
[W.] II, p. 65.
Entries: 3.*

[W.] II, p. 60.
Entries: 1.*

Man, M.G.A. de. "Het leven en de werken van Johannes Loof, stempelsnijder en graveur te Middleburg." *Archief. Vroegere en latere mededeelingen voornamelijk in betrekking tot Zeeland,* 1925, pp. 1–72. Separately published. Middleburg (Netherlands): J. C. en W. Altorffer, 1925.
Entries: 4. Millimeters (selection). Paper fold measure (selection). Inscriptions. Described. Illustrated (selection). Ms. note (ERB); 1 additional entry.

[H. *Neth.*] XI, p. 89.
Entries: 1.*

Loffredo, Silvio *(b. 1920)*
Galleria Pananti, Florence. *Silvio Loffredo, acqueforti.* Florence, 1970.
Entries: 112 (to 1962; complete?). Illustrated.

Logan, Robert Fulton *(b. 1889)*
Catalogue. Supplement to "The etchings and drypoints by Robert Fulton Logan," by Charles Lemon Morgan.
[*P. Conn.*] 9 (1929): 10–25, 133–138.
Entries: 41. Inches. Illustrated (selection).

Loggan, David *(1633/35–1693)*
[W.] II, p. 60.
Entries: 6+.*

[Sm.] II, pp. 823–825.
Entries: 6 (portraits only). Inches. Inscriptions. States. Described. Illustrated (selection). Located (selection).

[Ru.] p. 198.
Additional information to [Sm.].

[H. *Neth.*] XI, pp. 90–92.
Entries: 172+.*

Loir, Nicolas Pierre *(1624–1679)*
[RD.] III, pp. 182–209; XI, p. 128.
Entries: 114. Pre-metric. Inscriptions. States. Described.

[Wess.] IV, p. 59.
Entries: 1 (additional to [RD.]). Inscriptions. Described. Additional information to [RD.].

Loire, Léon Henri Antoine *(1821–1898)*
[Ber.] IX, p. 188.*

Lois, Jacob *(1620–1676)*
[Wess.] II, p. 241.
Entries: 3 (additional to [Nagler, *Mon.*] III, no. 2723 and [Andresen, *Handbuch*]). Millimeters. Inscriptions. Described.

[W.] II, p. 60.
Entries: 5.*

[H. *Neth.*] XI, p. 92.
Entries: 5. Illustrated (selection).*

Loiseau-Rousseau, Paul Louis Émile *(b. 1861)*
[Ber.] IX, p. 188.*

Loisy, Claude Joseph de *(1644–c.1709)*
Gauthier, Jules. "L'Oeuvre des de Loisy, orfèvres-graveurs bisontins du XVIIe siècle." [*Réunion Soc. B. A. dép.*], 18th session, 1894, pp. 509–553.
Entries: 16+. Millimeters. Inscriptions (selection). Described (selection). Located (selection).

Loisy, Jean de *(b. 1603)*
Gauthier, Jules. "L'Oeuvre des de Loisy, orfèvres-graveurs bisontins du

Loisy, Jean de *(continued)*

XVIIe siècle." [*Réunion Soc. B. A. dép.*] 18th session, 1894, pp. 509–553.
Entries: 61+. Millimeters. Inscriptions (selection). Described (selection). Located (selection).

Loisy, Pierre I de *(d. 1639)*
Gauthier, Jules. "L'Oeuvre des de Loisy, orfèvres-graveurs bisontins du XVIIe siècle." [*Réunion Soc. B. A. dép.*] 18th session, 1894, pp. 509–553.
Entries: 145+. Millimeters. Inscriptions (selection). Described (selection). Located (selection).

Loisy, Pierre II de *(d. c.1659)*
Gauthier, Jules. "L'Oeuvre des de Loisy, orfèvres-graveurs bisontins du XVIIe siècle." [*Réunion Soc. B. A. dép.*] 18th session, 1894, pp. 509–553.
Entries: 164+. Millimeters. Inscriptions (selection). Described (selection). Located (selection).

Loizelet, Eugène *(1842–1882)*
[Ber.] IX, p. 188.
Entries: 13.

Lokhorst, Johan Nicolaus *(b. 1837)*
[H. L.] pp. 694–695.
Entries: 4. Millimeters. Inscriptions. Described.

Loli, Lorenzo *(1612–1691)*
[B. *Reni*] pp. 89–105.
Entries: 27. Pre-metric. Inscriptions. States. Described.

[B.] XIX, pp. 163–182.
Entries: 31. Pre-metric. Inscriptions. Described.

Lombard, Lambert *(1506–1566)*
[W.] II, pp. 60–62.
Entries: 24+ prints after.*

Goldschmidt, Adolph. "Lambert Lombard." [*JprK.*] 40 (1919): 206–240.
Entries: 52 prints after. Millimeters. Inscriptions. Illustrated (selection).

[H. *Neth.*] XI, pp. 93–94.
Entries: 1 print by, 69 after. Illustrated (print by only).*

Lombard, Louis *(b. 1831)*
[Ber.] IX, p. 188.*

Lommelin, Adriaen *(1637–c.1673)*
[W.] II, p. 63.
Entries: 42.*

[H. *Neth.*] XI, pp. 95–99.
Entries: 77. Illustrated (selection).*

Lon, F. A. van *(fl. 1727–1764)*
[Merlo] pp. 557–558.*

Londerseel, Assuerus van *(1572–1635)*
[W.] II, p. 63.
Entries: 8+.*

[H. *Neth.*] XI, p. 99.
Entries: 45+.*

Londerseel, Jan van *(c.1570/75–1624/25)*
[W.] II, pp. 63–64.
Entries: 9.*

[H. *Neth.*] XI, pp. 100–102.
Entries: 102. Illustrated (selection).*

Long, Sydney *(b. 1878)*
Paul, Dorothy Ellsmore. *The etched work of Sydney Long, A.R.E.; a complete catalogue of his etchings.* Sydney (Australia): Attic Press, 1928. 300 copies. (NN)
Entries: 88 (to 1928). Inches. Illustrated. Located (selection). Appendix with 7 "rare prints"; unnumbered and unillustrated.

Longacre, ——— *(fl. c.1820)*
[Ber.] IX, p. 188.*

Longacre, James Barton *(1794–1869)*
[St.] pp. 316–356.*

[F.] pp. 184–186.*

Longeuil, Joseph de *(1730–1792)*
Panhard, F. *Joseph de Longueil, sa vie—son oeuvre.* Paris: Morgand et Fatout, 1880. 200 copies. (NN)
Entries: 507. Millimeters. Inscriptions. States. Described. Illustrated (selection).

[L. D.] pp. 56–57.
Entries: 3. Millimeters. Inscriptions. States. Described. Incomplete catalogue.*

Longhi, Giuseppe *(1766–1831)*
Longhena, Francesco. *Notizie biografiche di Giuseppe Longhi.* Milan: dall'Imp. Regia Stamparia, 1831. (EFKI)
Entries: unnumbered, pp. 46–48.

Beretta, Giuseppe. *Della vita delle opere ed opinioni del cavaliere Giuseppe Longhi.* Milan: Co. torchi di Omobono Manini, 1837.
Entries: unnumbered, pp. 183–186.

[Ap.] pp. 247–252.
Entries: 47.*

[Ber.] IX, p. 189–190.*

Longhi, Pietro *(1702–1785)*
[Vesme] p. 465.
Entries: 4. Millimeters. Inscriptions. Described. Located.

Longueville, Charles *(b. 1829)*
[Ber.] IX, p. 190.*

Lons, Dirk Eversen *(b. c.1599)*
[W.] II, p. 64.
Entries: 6+.*

[H. *Neth.*] XI, pp. 103–104.
Entries: 35. Illustrated (selection).*

Lonsing, F. J. *(1743–1799)*
[W.] II, p. 64.
Entries: 3.*

Loo, Charles André [Carle] van *(1705–1765)*
[Baud.] II, pp. 103–110.
Entries: 9. Millimeters. Inscriptions. States. Described.

Réau, Louis. "Carle Vanloo (1705–1765)." *Archives de l'art français,* n.s. 19 (1938): 1–96.
Entries: 3 prints by, 62 prints after. Millimeters (selection).

Loo, Jacob van *(1614–1670)*
[W.] II, pp. 64–65.
Entries: 9 prints after.*

[H. *Neth.*] XI, p. 105.
Entries: 1 print by, 11 after.*

Looff, Johannes *(fl. 1627–1651)*
[H. *Neth.*] XI, p. 105.
Entries: 3.*

Looff, Johannes de
See **Loff**

Loon, Theodor I van *(c.1585–c.1660)*
[W.] II, p. 66.
Entries: 1+ prints after.*

[H. *Neth.*] XI, p. 105.
Entries: 22 prints after.*

Loon, Theodor II van *(1629–1678)*
[W.] II, p. 66.
Entries: 1.*

Loos, Friedrich *(1797–1890)*
[A. 1800] II, pp. 198–220.
Entries: 36 (to 1878?). Pre-metric. Inscriptions. States. Described.

Andresen, Andreas. "Andresens Nachträge zu seinen 'Deutschen Malerradieren.' "[*MGvK.*] 1907, p. 42.
Entries: 1 (additional to [A. 1800]).

Lopez y Portaña, Vincente *(1772–1850)*
Catañeda Alcover, Vicente. *D. Vicente López Portaña, ilustrador del libro; notas bibliográficas artísticas.* Extract from *Boletín de la Sociedad española de escursiones,* May 15, 1943. Madrid: Hauser y Menet, 1943. 250 copies. (NN)
Bibliography of books and broadsides with prints by (complete?).

Lorch, Melchior
See **Lorichs**

Lordon, Jean Abel *(b. 1801)*
[Ber.] IX, p. 190.*

Lorentz, Aleide Joseph *(b. 1813)*
[Ber.] IX, p. 190.*

Lorenzini, Giov. Antonio *(1665–1740)*
[B.] XIX, pp. 412–417.
Entries: 8. Pre-metric. Inscriptions. States. Described.

Lorenzo, Tommaso di *(1841–1922)*
[Ap.] p. 123.
Entries: 3.*

Lorichon, Constant Louis Antoine *(b. 1800)*
[Ap.] pp. 252–253.
Entries: 7.*

[Ber.] IX, pp. 190–191.*

Lorichs, Melchior *(c.1527–c.1583)*
[B.] IX, pp. 500–512.
Entries: 16 engravings, 4+ woodcuts. Pre-metric. Inscriptions (selection). States. Described (selection). Copies mentioned.

[Heller] pp. 86–88.
Entries: 2 (additional to [B.]). Pre-metric. Inscriptions. Described. Additional information to [B.].

[P.] IV, pp. 180–184.
Entries: 12 engravings (additional to [B.]), 18+ woodcuts (additional to [B.]). Pre-metric (selection). Paper fold measure (selection). Inscriptions (selection). States. Described (selection). Located (selection). Copies mentioned. Additional information to [B.].

[Wess.] I, pp. 140–141.
Entries: 5 (additional to [B.] and [P.]). Millimeters. Inscriptions. Described. Additional information to [B.] and [P.].

Harbeck, Hans. *Melchior Lorichs, ein Beitrag zur deutschen Kunst des 16. Jahrhunderts.* Dissertation, Königl. Christian Albrechts-Universität zu Kiel. Hamburg: Niemann und Moschinski, 1911.
Entries: unnumbered, pp. 29–128. Millimeters. Inscriptions. Described.

Lorme, Antonis de *(c.1600–1673)*
[W.] II, pp. 67–68.
Entries: 2 prints after.*

[H. *Neth.*] XI, p. 105.
Entries: 2 prints after.*

Lorrain, Charles le
See **Mellin**

Lorrain, Claude
See **Gellée,** Claude

Lorsay, Louis Alexandre Eustache *(1822–after 1859)*
[Ber.] IX, p. 191.*

Lory, Gabriel I *(1763–1840)* and II *(1784–1846)*
Mandach, Conrad de. *Deux peintres suisses; Gabriel Lory le père (1763–1840) et Gabriel Lory le fils (1784–1846).* Lausanne (Switzerland): Haeschel Dufey, 1920.
Entries: 479 prints by and after. Millimeters. Inscriptions. States. Illustrated (selection).

Los Rios
See **Rios**

Loubon, Émile *(1809–1863)*
[Ber.] IX, p. 194.*

Louis, Aristide *(c.1815–1852)*
[Ap.] pp. 253–254.
Entries: 9.*

[Ber.] IX, pp. 194–195.
Entries: 9. Paper fold measure.

Louis d'Avignon, Jean *(fl. c.1600)*
[P.] VI, p. 272.
Entries: 1. Pre-metric. Inscriptions.
Described.

Loutherbourg, Philippe Jacques II
(1740–1813)
[Baud.] II, pp. 239–260.
Entries: 44. Millimeters. Inscriptions.
States. Described.

Loutrel, Victor *(1821–1908)*
[Ber.] IX, p. 195.*

Louveau-Rouveyre, Marie *(fl. 1873–1877)*
[Ber.] IX, p. 195.*

Louw, Pieter *(c.1720–c.1800)*
[W.] II, p. 69.
Entries: 8 prints by, 1 after.*

Louys, Jacob *(b. 1595)*
[W.] II, p. 68.
Entries: 18.*

[H. *Neth.*] XI, p. 106.
Entries: 13.*

Louys, Jacob *(1620–c.1673)*
[H. *Neth.*] XI, p. 106.
Entries: 7.*

Lownes, Caleb *(fl. c.1775)*
[St.] p. 356.*

Lowry, Wilson *(1762–1824)*
[Ap.] p. 254.
Entries: 2.*

Loybos, Jan Sebastian van *(c.1635–c.1703)*
[W.] II, p. 69.
Entries: 1 print after.*

[H. *Neth.*] XI, p. 107.
Entries: 2 prints after.*

Lubienitzki, Christoffel *(c.1660–after 1728)*
[W.] II, pp. 69–70.
Entries: 1 print by, 1 after.*

[H. *Neth.*] XI, p. 107.
Entries: 2 prints by, 3 after.*

Lubienitzki, Theodorus *(1653–c.1729)*
[W.] II, p. 70.
Entries: 1+.*

[H. *Neth.*] XI, p. 107.
Entries: 6.*

Lucas, —— *(19th cent.)*
[Ber.] IX, p. 195.*

Lucas, Alfred *(19th cent.)*
[Siltzer] p. 360.
Entries: unnumbered, p. 360. Inscriptions.

Lucas, David *(1802–1881)*
Leggett, E. E. *Catalogue of the complete works of David Lucas, engraver.* London: Gordon and Fox's Gallery, 1903. (PJRo)
Entries: 149.

Wedmore, Frederick. *Constable; Lucas; with a descriptive catalogue of the prints they did between them.* London: P. and D. Colnaghi and Co., 1904. 253 copies. (MH)
Entries: 52 (prints after Constable only). Inches. Inscriptions. States. Described. Ms. notes (NN); additional states.

Lucas, David (*continued*)

Shirley, Andrew. *The published mezzotints of D. Lucas after John Constable, R.A.; a catalogue and historical account.* Oxford: Clarendon Press, 1930.
Entries: 52 (prints after Constable only). Inches. Inscriptions. States. Described. Illustrated. Located. Ms. addition (MBMu); 1 additional entry.

Lucas, Louis (*fl. c.1880*)
[Ber.] IX, p. 195.*

Lucchese, Michele
See **Greco,** Michele

Lucchesino, Il
See **Testa,** Pietro

Lucien, Jean Baptiste (*c.1748–1806*)
[Ber.] IX, p. 196.*

Lucius, Jakob (*c.1530–1597*)
Röttinger, Hans. *Beiträge zur Geschichte des sächsischen Holzschnittes.* Studien zur deutschen Kunstgeschichte, 213. Strasbourg: J. H. Ed. Heitz, 1921.
Entries: 35. Millimeters. Inscriptions. Described. Located.

[Ge.] nos. 899–902.
Entries: 4 (single-sheet woodcuts only). Described. Located.

Ludwig I, king of Bavaria (*1786–1868*)
[Dus.] p. 104.
Entries: 1 (lithographs only, to 1821). Inscriptions. Located.

Ludwiger, W. (*fl. c.1814*)
[Dus.] p. 104.
Entries: 1 (lithographs only, to 1821).

Ludy, Friedrich August (*b. 1823*)
[Ap.] pp. 254–255.
Entries: 10.*

Lüderitz, [Karl Friedrich] Gustave (*1803–1884*)
[Ap.] p. 255.
Entries: 7.*

Lueg, Konrad (*20th cent.*)
Block, René, and Vogel, Karl. *Graphik des Kapitalistischen Realismus; . . . Werkverzeichnisse bis 1971.* Berlin: Edition René Block, 1971. 3000 copies.
Entries: 5 (to 1971). Millimeters. Inscriptions. Described. Illustrated.

Lütgendorff, Ferdinand von (*1785–1858*)
Lütgendorff, W. Leo von. *Der Maler und Radierer Ferdinand von Lütgendorff 1785–1858, sein Leben und seine Werke.* Frankfurt am Main: Heinrich Keller, 1906.
Entries: 3028 (works in various media, including prints). Inscriptions (selection).

Lütz, S. (*19th cent.*)
[Dus.] p. 104.
Entries: 1 (lithographs only, to 1821). Millimeters. Inscriptions. Located.

Lützelburger, Hans (*fl. 1522–1526*)
[P.] III, pp. 445–447.
Entries: 1 (prints after Hans Holbein and Master N. H. are omitted). Premetric. Described. Located.

Lützenkirchen, Peter Joseph (*1775–1820*)
[Merlo] pp. 559–560.*

Lugardon, Jean Léonard (*1801–1884*)
[Ber.] IX, p. 196.*

Luginbühl, Bernard (*b. 1929*)
Musée d'Art et d'Histoire, Cabinet des Estampes, Geneva. *Bernhard Luginbühl, oeuvre gravé (graphisches Werk).* Geneva, 1971.
Entries: 62 (to 1970). Millimeters. States. Described. Illustrated.

Lugo, Emil *(1840–1902)*
Graf Pückler-Limpurg, Siegfried. "Emil Lugo als Zeichner und Graphiker." [*MGvK.*] 1903, pp. 60–64. "Nachtrag." [*MGvK.*] 1906, p. 33.
Entries: 21 (to 1901). Millimeters. Inscriptions. States. Described. Illustrated (selection). Located.

Beringer, Joseph August. *Emil Lugo, Geschichte seines Lebens und Schaffens.* Mannheim (Germany): Joseph August Beringer, 1912.
Entries: unnumbered, p. 109.

Luini, Bernardino *(c.1485–1532)*
[B.] XII: *See* **Chiaroscuro Woodcuts**

Luining, Andreas *(fl. c.1589)*
[B.] IX, pp. 550–551.
Entries: 1. Pre-metric. Inscriptions. Described.

[P.] IV, pp. 224–225.
Entries: 7+ (additional to [B.]). Pre-metric. Inscriptions. Described.

[Wess.] I, p. 141.
Entries: 2 (additional to [B.] and [P.]). Millimeters. Inscriptions. Described.

Lukomski, Stanislaus *(1835–1867)*
[Ap.] p. 255.
Entries: 2.*

Luminais, Évariste Vital *(1822–1896)*
[Ber.] IX, p. 196.*

Lumley, George *(d. 1768)*
[Sm.] II, pp. 825–828.
Entries: 7 (portraits only). Inches. Inscriptions. States. Described. Located (selection).

[Ru.] p. 199.
Additional information to [Sm.].

Lumsden, Ernest S. *(b. 1883)*
Salaman, Malcolm C. "The etchings of E. S. Lumsden, R.E." [*PCQ.*] 8 (1921): 91–119.
Entries: 184 (to 1921). Based on Lumsden's own list.

Allhusen, E. L. "Some etched portraits by R.E. [*sic*] Lumsden, R.E." [*P. Conn.*] 4 (1924): 2–20.
Entries: 23 (portraits only). Inches. Illustrated (selection).

Lumsden, E. S. "Chronological list 1905–1935." Supplement to "The later etchings of E. S. Lumsden," by John Copley. [*PCQ.*] 23 (1936): 211–238.
Entries: 336 (to 1935). Inches. States.

Lundquist, Birger *(1910–1952)*
Möller, Svenfredrik. *Birger Lundquist, grafikern, bokkonstnären; förteckningar över hans etsningar, torrnälsgravyrer, illustrerade böcker och bokomslag.* Stockholm: Sällskapet Bokvännerna, 1953. 500 copies. (MH)
Entries: 122. Millimeters. Inscriptions. States. Described. Illustrated (selection). Also, bibliography of books with illustrations or book jackets by.

Lunghi, Antonio Maria *(c.1680–1757)*
[Vesme] p. 368.
Entries: 2. Millimeters. Inscriptions. Described.

Lunois, Alexandre *(1863–1916)*
[Ber.] IX, pp. 196–197.
Entries: 13. Paper fold measure.

André, Édouard. *Alexandre Lunois; peintre, graveur et lithographe.* Paris: H. Floury, 1914.
Entries: unnumbered, pp. 211–240. Paper fold measure. States.

Lupresti, Giacinto *(fl. c.1675)*
[Vesme] pp. 345–346.

Lupresti, Giacinto (*continued*)

Entries: 4. Millimeters. Inscriptions. States. Described. Located (selection).

Lupton, Thomas Goff *(1791–1873)*
[Siltzer] p. 360.
Entries: unnumbered, p. 360. Inscriptions.

Luque, Manuel *(b. 1854)*
[Ber.] IX, p. 197.*

Lurat, Abel *(1829–1890)*
[Ber.] IX, p. 197.*

Lusy, Marino M. *(b. 1880)*
Nash, A. Y. "Catalogue de l'oeuvre gravé de M. Lusy." Unpublished ms. (EPBN)
Entries: 115. Inches. Translation of a catalogue printed in Chicago, 1934–1935. (Not seen).

Lutgers, P. J. *(fl. c.1836)*
[W.] II, pp. 71–72.
Entries: 2+.*

Lutma, Abraham *(fl. c.1650)*
[W.] II, p. 72.
Entries: 3.*

[H. *Neth.*] XI, p. 108.
Entries: 4. Illustrated (selection).*

Lutma, Jacob *(d. 1654)*
[W.] II, p. 72.
Entries: 4+.*

[H. *Neth.*] XI, pp. 109–110.
Entries: 19. Illustrated (selection).*

Lutma, Janus I *(c.1584–1669)*
[W.] II, p. 72.
Entries: 1.*

[H. *Neth.*] XI, p. 110.
Entries: 1. Illustrated.*

Lutma, Janus II *(1624–1685)*
[Rov.] pp. 73–74.
Entries: 56. Millimeters (selection). Inscriptions (selection). Described (selection). Illustrated (selection).

[W.] II, p. 72.
Entries: 11+.*

[H. *Neth.*] XI, pp. 111–116.
Entries: 49. Illustrated (selection).*

Lutterell, Edward *(c.1650–after 1723)*
[Sm.] II, pp. 828–834; IV, "additions and corrections" section.
Entries: 21 (portraits only). Inches. Inscriptions. States. Described. Illustrated (selection). Located (selection).

[Ru.] p. 199.
Additional information to [Sm.].

Luttichuys, Izaac *(1616–1673)*
[H. *Neth.*] XI, p. 116.
Entries: 2 prints by, 1 after.*

Luttichuys, Simon *(1610–c.1662)*
[H. *Neth.*] XI, p. 117.
Entries: 4 prints after.*

Lutz, A. *(fl. 1809–1822)*
[W.] II, p. 73.
Entries: 1+.*

Lutz, Peter *(1799–1867)*
[Ap.] p. 256.
Entries: 13.*

[Dus.] p. 104.
Entries: 1 (lithographs only, to 1821). Millimeters. Inscriptions. Located.

Lux, Ignatius *(1649/50–after 1694)*
[W.] II, p. 73.
Entries: 3.*

[H. *Neth.*] XI, p. 117.
Entries: 5.*

Luyck, Hans [Jan] van *(fl. c.1580)*
[W.] II, p. 73.
Entries: 4.*

[H. *Neth.*] XI, p. 117.
Entries: 5.*

Luyken, Jan *(1649–1712)* and Caspar
(1672–1708)
Vlugt, J. van der. *Lijst van werken, waarin door Jan en Caspar Luyken de prenten zijn vervaardigd, benevens eenige losse prenten, vignetten enz. door dezelfde meesters, verzameld door J. van der Vlugt.* Haarlem (Netherlands): De Erven Loosjes, 1867. (ERKD)
Bibliography of books with illustrations by, in one collection. Appendix mentions books not in the collection.

[W.] II, pp. 73–75.
Entries: 11+ prints by Caspar, 14+ prints by Jan, 14 prints after Jan.*

Eeghen, P. van, and van der Kellen, J. Ph. *Het werk van Jan en Caspar Luyken.* 2 vols. Amsterdam: Frederik Muller en Co., 1905.
Entries: 513+ prints by and after (4488 prints by in all; prints after are unnumbered.) Millimeters. Inscriptions. States. Described.

[H. *Neth.*] XI, pp. 118–144.
Entries: 500+ prints by, 27 after. Illustrated (selection).*

Luzzi, Filippo *(1665–1720)*
[Vesme] pp. 357–358.
Entries: 3. Millimeters. Inscriptions. Described.

Lybrand, J. *(fl. c.1828)*
[F.] p. 186.*

Lydis, Mariette *(1890–1970)*
Montherlant, Henri de. "Mariette Lydis." [*AMG.*] 4 (1930–1931): 81–87.
Bibliography of books with illustrations by (to 1929).

Mariette Lydis. Preface by Henri de Montherlant. Paris: Mariette Lydis, 1938. (ICB)
Entries: unnumbered, pp. 18–20. Illustrated (selection).

Lynch, James Henry *(d. 1868)*
[Siltzer] p. 360.
Entries: unnumbered, p. 360. Inscriptions.

Lyne, Richard *(fl. c.1574)*
[Hind, *Engl.*] I, pp. 81–84.
Entries: 4. Inches. Inscriptions. Described. Illustrated. Located.

Lynhoven, Nicolas van *(d. before 1702)*
[W.] II, p. 76.
Entries: 1.*

[H. *Neth.*] XI, p. 145.
Entries: 14.*

Lyon, Gabriel de
See **Leeuw,** Govaert van der

Lyser, ——— Baron von *(19th cent.)*
[Dus.] p. 105.
Entries: 1 (lithographs only, to 1821). Millimeters. Inscriptions. Located.

Lyser, Johann Peter *(1803–1870)*
Hirth, Friedrich. *Johann Peter Lyser, der Dichter, Maler, Musiker.* Munich: Georg Muller, 1911. (NN)
Entries: unnumbered, pp. 582–587. prints after. Illustrated (selection).

M

Maas
See **Maes**

Maaskamp, E. *(fl. c.1800)*
[W.] II, p. 78.
Entries: 1 print after.*

Maassen, Heinrich Wilhelm *(d. c.1790)*
[Merlo] p. 562.*

Maassen, Peter *(fl. c.1784)*
[Merlo] pp. 562–563.*

Maaten, Jacob Jan van der *(1820–1879)*
[H. L.] p. 695.
Entries: 1. Millimeters. Inscriptions.
States. Described.

Mabuse
See **Gossaert,** Jan

MacArdell, James *(1728/29–1765)*
"Portraits in mezzotinto by James
MacArdel, taken from two lists fur-
nished by him to Sir W. M. in 1763."
Unpublished ms. (EBM)
Entries: unnumbered, 21 pp.

[Sm.] II, pp. 834–907, and "additions
and corrections" section; IV, "additions
and corrections" section.
Entries: 201 (portraits only). Inches.
Inscriptions. States. Described. Illus-
trated (selection). Located (selection).

Goodwin, Gordon. *British mezzotinters;
James McArdell.* London: A. H. Bullen,
1903. 520 copies. (MH)

Entries: 227 prints by, 5 doubtful
prints. Inches. Inscriptions. States.
Described. Located.

[Ru.] pp. 199–223.
Entries: 7 (portraits only, additional to
[Sm.]). Inches (selection). Inscrip-
tions (selection). States. Described.
Additional information to [Sm.].

Macarrol, ——— *(18th cent.)*
[Ru.] p. 223.
Entries: 1 (portraits only). Inches. In-
scriptions. Described.

McBey, James *(1883–1959)*
Hardie, Martin. *Etchings and drypoints
from 1902 to 1924 by James McBey.* London:
P. and D. Colnaghi and Co., 1925. 500
copies. (MB)
Entries: 223 (to 1924). Inches. Mil-
limeters. Inscriptions. States. De-
scribed. Illustrated.

Hardie, Martin. "The etched work of
James McBey 1925–1937." [PCQ.] 25
(1938): 420–445.
Entries: 50 (additional to Hardie, to
1937). Inches. Millimeters. Inscrip-
tions. States. Illustrated (selection).

Carter, Charles. *Etchings and dry points
from 1924 by James McBey.* Aberdeen:
Aberdeen Art Gallery, 1962. (MB)
Entries: 68 (additional to Hardie).
Inches. Millimeters. Inscriptions.
States. Described. Illustrated. Addi-
tional information to Hardie.

Maccari, Enrico *(19th cent.)*
[Ap.] p. 257.
Entries: 1.*

MacDonald, Arthur N. *(20th cent.)*
Carver, Clifford Nickels. *Check-list of book plates engraved on copper by Arthur N. MacDonald.* Princeton (N.J.): Privately printed, 1914. 250 copies. (NN)
Entries: 121 (bookplates only, to 1913). Inscriptions. Described. Ms. addition (NN); additional states, 183 additional entries (bookplates only, to 1940); list of prints other than bookplates (complete?).

Macé, Charles *(1631–after 1665)*
[RD.] VI, pp. 254–284.
Entries: 123. Millimeters. Inscriptions. States. Described.

McGarrell, James *(20th cent.)*
Allan Frumkin Gallery, Chicago. *The graphic works of James McGarrell 1953–1965, woodcuts, etchings, lithographs.* Chicago, 1966.
Entries: 81. Inches. Illustrated.

Machereau, ——— *(fl. c.1830)*
[Ber.] IX, p. 197.*

Macintosh, J. *(18th cent.)*
[Sm.] II, p. 908.
Entries: 1 (portraits only). Inches. Inscriptions. Described.

Mack, Georg *(fl. c.1600)*
[A.] II, pp. 204–209.
Entries: 3 etchings, 3 woodcuts. Premetric. Inscriptions. Described.

Mackrell, James R. *(19th cent.)*
[Siltzer] pp. 360–361.
Entries: unnumbered, pp. 360–361. Inscriptions.

McLachlan, Thomas Hope *(1845–1897)*
Dodgson, Campbell. "Die Radierungen von T. H. McLachlan." [*MGvK.*] 1904, pp. 18–20.
Entries: 11. Millimeters. Inscriptions. Described.

MacLaughlan, Donald Shaw *(1876–1952)*
Albert Roullier Art Galleries, Chicago [Marie Bruette, compiler]. *A descriptive catalogue of the etched work of Donald Shaw MacLaughlan.* Chicago, 1924. 125 copies. (NN)
Entries: 253 (to 1920). Inches. Inscriptions. States. Described. Illustrated (selection).

Macret, Charles François Adrien *(1751–1789)*
[L. D.] p. 57.
Entries: 1. Millimeters. Inscriptions. States. Illustrated. Incomplete catalogue.*

Délignières, Émile, and Macqueron, Henri. *Les Macret, graveurs abbevillois; Charles François Adrien Macret (1751–1783), Jean César Macret (1768–181–); catalogue raisonné de leur oeuvre.* Abbéville (France): Imprimerie A. Lafosse, 1914.
Entries: 48. Millimeters. Inscriptions. States. Described. Illustrated (selection).

Macret, Jean César *(b. 1768)*
[Ber.] IX, p. 198.*

Délignières, Émile, and Macqueron, Henri. *Les Macret, graveurs abbevillois; Charles François Adrien Macret (1751–1783), Jean César Macret (1768–181-); catalogue raisonné de leur oeuvre.* Abbéville (France): Imprimerie A. Lafosse, 1914.
Entries: 109. Millimeters. Inscriptions. States. Described. Illustrated (selection).

Madec, ——— *(fl. c.1850)*
[Ber.] IX, p. 198.*

Madou, Jean Baptiste *(1796–1877)*
[Ber.] IX, pp. 198–199.*

Maeght Editeur *(20th cent.)*
Maeght Editeur. *Derrière le Miroir et af-fiches.* Paris: Maeght Editeur, 1971.
Entries: 186+ prints published by (prints issued in *Derrière le Miroir,* and accompanying posters, only, to 1970). Millimeters (selection). Illustrated (selection).

Maeler, Ernst *(fl. 1537–1558)*
[A.] II, pp. 54–55.
Entries: 1. Pre-metric. Inscriptions. Described.

Maes, Aert *(c.1620–1664)*
[H. *Neth.*] XI, p. 153.
Entries: 1.*

Maes, Dirk *(1656–1717)*
Börner, Johann Andr. "Das Werk des Dirk Maas." [*N. Arch.*] 9 (1863): 391–400.
Entries: 26. Pre-metric. Inscriptions. Described.

[vdK.] pp. 163–172.
Entries: 28 prints by, 5 doubtful and rejected prints. Millimeters. Inscriptions. States. Described.

[W.] II, pp. 87–88.
Entries: 28+.*

[H. *Neth.*] XI, pp. 149–152.
Entries: 30 prints by, 6 after. Illustrated (selection).*

Maes, Everard Quirinsz van der *(1577–1656)*
[W.] II, p. 88.
Entries: 3 prints by, 2 after.*

[H. *Neth.*] XI, p. 153.
Entries: 3 prints by, 2 after. Illustrated (selection).*

Maes, Godfried *(1649–1700)*
[vdK.] pp. 173–176.

Entries: 4. Millimeters. Inscriptions. States. Described.

[W.] II, pp. 88–89.
Entries: 4 prints by, 3 after.*

[H. *Neth.*] XI, pp. 154–155.
Entries: 4 prints by, 10 after. Illustrated (prints by only).*

Maes, Johannes *(1655–1690)*
[H. *Neth.*] XI, p. 155.
Entries: 1 print after.*

Maes, Nicolaes *(1632–1693)*
[W.] II, pp. 89–91.
Entries: 19 prints after.*

[H. *Neth.*] XI, p. 156.
Entries: 30 prints after.*

Maes, Peter *(fl. 1577–1591)*
[W.] II, p. 91.
Entries: 37+.*

[H. *Neth.*] XI, pp. 157–158.
Entries: 50.*

Maffei, Francesco *(c.1620–1660)*
Ivanoff, Nicola. *Francesco Maffei.* Padua: Le Tre Venezie, 1942.
Entries: 1 print after.

Maganza, Giovanni Battista *(16th cent.)*
[P.] VI: *See* **Chiaroscuro Woodcuts**

Magdeburg, Hiob *(c.1518–1595)*
[B.] IX, p. 397.
Entries: 1. Pre-metric. Inscriptions. Described.

[Heller] p. 88.
Additional information to [B.].

[P.] IV, pp. 231–232.
Entries: 1 (additional to [B.]). Pre-metric.

Magn, F. *(16th cent.)*
[W.] II, p. 91.
Entries: 1 print after.*

Magne, Eugène *(b. 1802)*
 [Ber.] IX, p. 199.*

Magnus, F. *(17th cent.)*
 [H. *Neth.*] XI, p. 158.
 Entries: 1 print after.*

Magonni, ——— *(19th cent.)*
 [Ap.] p. 257.
 Entries: 1.*

Magron, Dominique
 See **Jouvet**

Mahler, Ernst
 See **Maeler**

Mahn, Berthold
 See **Berthold-Mahn**

Maier, Ernst R. *(19th cent.)*
 [Dus.] p. 105.
 Entries: 1 (lithographs only, to 1821).

Maile, Georges *(fl. 1824–1840)*
 [Ber.] IX, pp. 199–201.*

 [Siltzer] p. 361.
 Entries: unnumbered, p. 361. Inscriptions.

Maillol, Aristide *(1861–1944)*
 Rewald, John. *The woodcuts of Aristide Maillol, a complete catalogue with 176 illustrations.* New York: Pantheon Books, 1943. 2d ed. New York, 1951.
 Entries: 162 (woodcuts only, to 1943). Described. Illustrated.

 Rewald, John. ''Maillol illustrateur.'' *Portique* 1 (1945): 27–38.
 Bibliography of books with illustrations by (to 1940).

 Guérin, Marcel. *Catalogue raisonné de l'oeuvre gravé et lithographié de Aristide Maillol.* 2 vols. Geneva: Pierre Cailler, 1965, 1967.

 Entries: 379. Millimeters. Inscriptions. States. Described. Illustrated. Located (selection).

 Busch, Günter. *Aristide Maillol als Illustrator.* Monographien und Materialien zur Buchkunst, 3. Neu-Isenberg (West Germany): Verlag Wolfgang Tiessen, 1970.
 Bibliography of books with illustrations by.

Mailly, Hippolyte *(b. 1829)*
 [Ber.] IX, p. 201.*

Main, William *(fl. c.1820)*
 [St.] pp. 356–357.*

 [F.] p. 187.*

Mair, Alexander *(fl. 1600–1616)*
 [B.] IX, pp. 597–598.
 Entries: 3. Pre-metric. Inscriptions. Described.

 [Heller] p. 91.
 Additional information to [B.].

 [Evans] p. 41.
 Entries: 1 (additional to [B.]). Millimeters. Inscriptions. Described.

 [P.] IV, pp. 246–253.
 Entries: 58 (additional to [B.]). Pre-metric. Paper fold measure (selection). Inscriptions. States. Described (selection). Located (selection).

 [A.] III, pp. 344–391.
 Entries: 83 etchings, 2 rejected etchings, 8 woodcuts. Pre-metric. Inscriptions. Described.

Mair, Johann Ulrich
 See **Mayr**

Mair von Landshut *(fl. 1485–1510)*
 [B.] VI, pp. 362–370.
 Entries: 12 prints by, 1 doubtful print. Pre-metric. Inscriptions. Described.

Mair von Landshut (*continued*)

[P.] II, pp. 156–159.
Entries: 6 (additional to [B.]). Pre-
metric. Inscriptions. Described. Lo-
cated. Copies mentioned. Additional
information to [B.].

[Wess.] I, p. 141.
Entries: 2 (additional to [B.] and [P.]).
Millimeters. Inscriptions. Described.

Schubert, Franz. *Mair von Landshut; ein
nieder bayerischer Stecher und Maler des
ausgehenden XV. Jahrhunderts.* Disserta-
tion, University of Munich. Landshut
(Germany): Jos. Thomann'sche Buch-
und Kunstdruckerei, 1930.
Entries: 22 engravings, 3 woodcuts.
Millimeters. Inscriptions. Located.

[Lehrs] VIII, pp. 282–329.
Entries: 25. Millimeters. Inscriptions.
States. Described. Illustrated (selec-
tion). Located. Locations of all known
impressions are given. Copies men-
tioned. Watermarks described. Bib-
liography for each entry.

Malapeau, Charles (*1795–c.1878*)
[Ber.] IX, pp. 201–202.*

Malardot, Charles André (*b. 1817*)
[Ber.] IX, p. 202.
Entries: 7.

Malbeste, Georges (*1754–1843*)
[Ber.] IX, p. 202.*

[L. D.] p. 57.
Entries: 1. Millimeters. Inscriptions.
States. Illustrated. Incomplete
calalogue.*

Malcho, Simon (*fl. 1763–1800*)
[Sm.] II, pp. 908–909, and "additions
and corrections" section.
Entries: 2 (portraits only). Inches. In-
scriptions. States. Described.

[Ru.] p. 224.
Additional information to [Sm.].

Malcolm, James Peller (*1767–1815*)
[St.] pp. 357–358.*

[F.] p. 187.*

Malcontenti, Antonio Giuseppe (*b. 1670*)
[Vesme] p. 363.
Entries: 1. Millimeters. Inscriptions.
Described. Located.

Maldeghem, Romain Eugène van
(*1813–1867*)
[H. L.] pp. 696–698.
Entries: 9 (complete?). Millimeters.
Inscriptions. Described.

Maleck, F. de (*fl. c.1817*)
[H. L.] p. 698.
Entries: 1. Millimeters. Inscriptions.
Described.

Malécy, Alexis Joseph Louis de
(*1799–1842*)
[Ber.] IX, pp. 202–203.*

Maleuvre, Pierre (*1740–1803*)
[Ber.] IX, p. 203.*

[L. D.] pp. 57–58.
Entries: 3. Millimeters. Inscriptions.
States. Described. Illustrated (selec-
tion). Incomplete catalogue.*

Malgo, Simon
See **Malcho**

Mallebranche, Louis Claude (*1790–1838*)
[Ber.] IX, p. 203.*

Mallery, Karel van (*1571–after 1635*)
[W.] II, p. 93.
Entries: 21+.*

[H. *Neth.*] XI, pp. 159–160.
Entries: 162+. Illustrated (selection).*

Mallery, Philip de *(b. 1598)*
 [W.] II, p. 93.
 Entries: 7+.*

 [H. *Neth.*] XI, p. 161.
 Entries: 74+.*

Mallet, ——— *(fl. c.1817)*
 [Ber.] IX, p. 203.*

Malm, Harry A. *(20th cent.)*
 Malm, Harry A. "Vara samlare—
 XXXIII." [*N. ExT.*] 18 (1966): 59–61.
 Entries: 56 (bookplates only, to 1966).
 Illustrated (selection).

Malo, Vincent *(c.1600–1645)*
 [W.] II, p. 93.
 Entries: 1 print by, 1 after.*

 [H. *Neth.*] XI, p. 161.
 Entries: 2.*

Malpizzi, Bernardo *(1553–1623)*
 [B.] XII: *See* **Chiaroscuro Woodcuts**

Malthain [Malthan], Johan *(fl. c.1595)*
 [W.] II, p. 94.
 Entries: 2 prints after.*

Malval, ——— *(fl. c.1880)*
 [Ber.] IX, p. 203.*

Man, Anthony Willem Hendrik
Nolthenius de *(1793–1839)*
 [H. L.] pp. 698–700.
 Entries: 8. Millimeters. Inscriptions.
 Described.

Man, Cornelis de *(1621–1706)*
 [vdK.] pp. 47–50, 227.
 Entries: 4 prints by, 1 doubtful print.
 Millimeters. Inscriptions. Described.

 [W.] II, pp. 94–95.
 Entries: 6.*

 [H. *Neth.*] XI, p. 162.

Entries: 5 prints by, 1 print after. Illus-
trated (selection).*

Man, T. *(18th cent.)*
 [Sm.] II, p. 910.
 Entries: 1 (portraits only). Inches. In-
 scriptions. Described.

Manaresi, Paolo *(b. 1908)*
 Pallucchini, Rodolfo. *L'Opera grafica di*
 Paolo Manaresi. Reggio Emilia (Italy):
 Prandi, 1969. 850 copies. (DLC)
 Entries: 273 etchings, 7 lithographs (to
 1968). Millimeters. Illustrated. Di-
 mensions are not given for prints re-
 produced natural size.

Manceau, Alexandre Damien *(1817–1865)*
 [Ber.] IX, pp. 203–204.*

Manceau, François *(b. 1786)*
 [Ber.] IX, p. 203.*

Manche, Édouard *(1819–1861)*
 [H. L.] p. 701.
 Entries: 1. Millimeters. Inscriptions.
 States. Described.

Manchon, Gaston Albert *(b. 1855)*
 [Ber.] IX, pp. 204–205.*

Mancion, Petrus [Pietro] *(1803–1888)*
 [Ap.] p. 257.
 Entries: 3.*

Mandel, Joh. Aug. Eduard *(1810–1882)*
 [Ap.] pp. 257–261.
 Entries: 40.*

 [Ber.] IX, p. 205.*

Mander, Karel I van *(1548–1606)*
 [W.] II, pp. 95–97.
 Entries: 31+ prints after.*

 Paatz, Elizabeth Valentiner. *Karel van*
 Mander als Maler. Strasbourg: J. H. Ed.
 Heitz, 1930.

Mander, Karel I van *(continued)*

Entries: 158 prints after. Millimeters. Inscriptions. States.

[H. *Neth.*] XI, pp. 163–165.
Entries: 175 prints after.*

Mander, Karel III van *(c.1610–1670)*
[W.] II, pp. 97–98; III, p. 113.
Entries: 2 prints by, 23 after.*

[H. *Neth.*] XI, pp. 166–167.
Entries: 2 prints by, 27 prints after. Illustrated (prints by only).*

Manesse, [Georges] Henri *(b. 1854)*
[Ber.] IX, pp. 205–206.

Manet, Édouard *(1832–1883)*
[Ber.] IX, pp. 206–211.
Entries: 72. Paper fold measure. Inscriptions (selection).

Moreau-Nelaton, Étienne. *Manet graveur et lithographe.* Paris: Éditions du "Peintre-graveur illustré," L. Delteil, 1906. 225 copies. (DLC)
Entries: 104. Millimeters. Inscriptions. States. Described. Illustrated.

Bouvy, Eugène. "Une lithographie inconnue de Manet." [*Am. Est.*] 7 (1928): 22–29.
Entries: 1 (additional to Moreau-Nelaton). Millimeters. Inscriptions. States. Described. Illustrated. Located.

Guérin, Marcel. *L'Oeuvre gravé de Manet.* Paris: Librairie Floury, 1944. 600 copies (MH)
Entries: 93. Millimeters. Inscriptions. States. Described. Illustrated. Located.

Harris, Jean C. *Édouard Manet, graphic works; a definitive catalogue raisonné.* New York: Collector's Editions, 1970.

Entries: 88. Millimeters. Inscriptions. States. Described. Illustrated. Located. Bibliography for each entry.

Manglard, Adrien *(1695–1760)*
[RD.] II, pp. 234–254; XI, p. 189.
Entries: 45. Pre-metric. Inscriptions. States. Described.

Mangstl, Carl von *(fl. c.1800)*
[Dus.] pp. 106–107.
Entries: 5 (lithographs only, to 1821). Millimeters. Inscriptions. Located.

Manigaud, [Jean] Claude *(b. 1825)*
[Ber.] IX, pp. 211–212.*

Manini, Bartolomeo *(fl. c.1678)*
[B.] XX, pp. 293–295.
Entries: 5. Pre-metric. Inscriptions. Described.

Mankes, Jan *(1889–1920)*
Mankes-Zernike, A., and Roland Holst, R. N. *Jan Mankes.* Utrecht: J. A. A. M. van Es, 1923.
Entries: unnumbered, pp. 59–63. Millimeters. Illustrated (selection).

Manly, John *(fl. 1772–1800)*
[St.] p. 358.*

Mannfeld, Bernhard *(1848–1925)*
Königliche National-Galerie, Berlin [Lionel von Donop, compiler]. *Ausstellung der Radirungen von Bernhard Mannfeld in der kgl. National-Galerie.* Berlin: R. Wagners Kunst- und Verlagshandlung, 1890. 2d ed. *Ausstellung der Radierungen von Bernhard Mannfeld im Walraf–Richartz-Museum zu Cöln.* Berlin, 1891.
Entries: 275 (to 1890).

Fuchs, Friedrich. *Ausstellung der Radirungen von Bernhard Mannfeld.* Berlin: Paul Koehler, 1893. (ENGM)

Entries: 293 (to 1893?). Different states of the same print are separately numbered.

Roeper, Adalbert. "Bernhard Mannfeld, zum sechzigsten Geburtstag des Künstlers." [Bb.] 75 (1908): 2683–2688, 2781–2785, 2822–2824. Separately bound copy. (NN)
Entries: 344 (to 1908). Millimeters. States.

Mannini, Giacomo Antonio *(1646–1732)*
[B.] XIX, pp. 322–327.
Entries: 16. Pre-metric. Inscriptions. Described.

Manning, [William] Westley *(b. 1868)*
The aquatints of W. Westley Manning. London: P. and D. Colnaghi and Co., 1929. 250 copies. (NN)
Entries: 17 (to 1929. Complete?). Inches. Illustrated.

Mannlich, [Johann] Christian von *(1741–1822)*
[Dus.] pp. 105–106.
Entries: 6+ (lithographs only, to 1821). Millimeters. Inscriptions. Located (selection).

Mannozzi, Giovanni *(1592–1636)*
Giglioli, Edoardo H. *Giovanni da San Giovanni (Giovanni Mannozzi 1592–1636).* Florence: Leo S. Olschki, 1949. 1000 copies. (EBM)
Entries: unnumbered, pp. 156–157, prints after lost works.

Manskirch, Franz Joseph *(1768–1830)*
[Dus.] p. 106.
Entries: 4 (lithographs only, to 1821). Millimeters. Inscriptions.

[Merlo] pp. 564–565.*

Mansson, Théodore Henri *(1811–1850)*
[Ber.] IX, p. 213.*

Mansvelt, Jan Izaak van *(1761–1802)*
[H. L.] pp. 701–703.
Entries: 5. Millimeters. Inscriptions. Described.

Mantegna, Andrea *(1431–1506)*
[B.] XII: *See* **Chiaroscuro Woodcuts**

[B.] XIII, pp. 222–243.
Entries: 23 prints by, 2 rejected prints. Pre-metric. Inscriptions. States. Described. Copies mentioned.

"Beitrag zur Kupferstichkunde." [N. Arch.] 6 (1860): 220–222.
Additional information to [B.].

[P.] V, pp. 73–79.
Entries: 1 print by (additional to [B.]), 2 rejected prints. Pre-metric. Inscriptions. States. Described. Located. Copies mentioned. Additional information to [B.].

Amand-Durand, —— and Duplessis, Georges. *Oeuvre de A. Mantegna reproduit et publié par Amand-Durand; texte par Georges Duplessis.* Paris: Amand-Durand, 1878.
Entries: 26. Inscriptions. States. Described. Illustrated.

Kristeller, Paul. *Andrea Mantegna.* Berlin: Cosmos Verlag für Kunst und Wissenschaft, 1902. English ed. London: Longmans Green and Co., 1901.
Entries: 7 prints by, 20 doubtful prints. Millimeters. States. Located (selection). Bibliography for each entry. Questions of attribution discussed; copies and related drawings identified.

Knapp, Fritz. *Andrea Mantegna, des Meisters Gemälde und Kupferstiche in 200 Abbildungen.* Klassiker der Kunst. Stuttgart: Deutsche Verlags-Anstalt, 1910.
Entries: unnumbered, pp. 130–145, prints by and after. Millimeters. Illustrated.

Mantegna, Andrea (*continued*)

Borenius, Tancred. *Four early Italian engravers.* London: Medici Society, 1923.
Entries: 7 prints by, 27 prints "school of." Millimeters. Inscriptions. States. Described. Illustrated. Located. Copies mentioned.

[Hind] V, pp. 3–31.
Entries: 7 prints by, 20 after. Millimeters. Inscriptions. States. Described. Illustrated. Located. Copies mentioned.

Tietze-Conrat, Erika. *Mantegna; paintings, drawings, engravings.* London: Phaidon, 1955.
Entries: 14 (all considered "school of Mantegna"). Inches. Millimeters. Described. Illustrated.

Palazzo ducale, Mantua [Amalia Mezzetti, compiler]. *Andrea Mantegna, catalogo della mostra. 1961.* Venice: Neri Pozza, 1961.
Entries: 22 prints by and after. Millimeters. States. Described. Illustrated (selection). Located. Bibliography for each entry.

Musper, H. T. "Ein 'Etat' bei Mantegna." In *Festschrift Dr.h.c. Eduard Trautscholdt zum siebzigsten Geburtstag.* pp. 84–87. Hamburg: Dr. Ernst Hauswedell und Co., 1965.
Additional information to [Hind].

Mantuano, Giorgio
See **Ghisi**

Manwaring, Robert *(18th cent.)*
[Sm.] II, pp. 910–911.
Entries: 2 (portraits only). Inches. Inscriptions. Described.

Manzù, Giacomo *(b. 1908)*
Opera Bevilacqua la Masa, Venice [Giorgio Trentin, compiler]. *Giacomo*

Manzù acqueforti e litografie. Venice, 1958. 1000 copies. (MH).
Entries: 78 etchings, 22 lithographs. Millimeters. Illustrated (selection).

Ciranna, Alfonso. *Giacomo Manzù; catalogo delle opere grafiche* [*incisioni e litografie*] *1929–1968, con un' appendice relativa ai libri illustrati con riproduzioni di disegni dell'artista.* Milan: Alfonso Ciranna, 1968.
Entries: 195 (to 1968). Millimeters. Inscriptions. Described. Illustrated. Located (selection). Also, bibliography of books with illustrations by.

Mar, Léopold *(b. 1825)*
[Ber.] IX, p. 212.*

Marangoni, Tranquillo *(b. 1912)*
Mantero, Gianni. "Tranquillo Marangoni, en italiensk traesnit-kunstner." [*N. ExT.*] 3 (1948–1949): 1–4.
Entries: 55 (bookplates only, to 1949). Illustrated (selection).

Schwencke, Johan. "Tranquillo Marangoni." *Boekcier* 2d ser. 4 (1949): 1–6.
Entries: 49 (bookplates only, to 1948). Millimeters. Illustrated (selection).

Schwencke, Johan. *Tranquillo Marangoni en italiensk traeskaerer / een italiaanse xylograaf / an Italian woodengraver.* Copenhagen: Areté, 1957. 500 copies. (DLC)
Entries: 107 (bookplates only, to 1955). Illustrated (selection).

Maratti, Carlo *(1625–1713)*
[B.] XXI, pp. 89–96.
Entries: 14 prints by, 3 rejected prints. Pre-metric. Inscriptions. Described.

[Heller] p. 89.
Additional information to [B.].

Marc, Franz *(1880–1916)*
Schardt, Alois. J. *Franz Marc.* Berlin: Rembrandt Verlag, 1936.

Entries: 17 lithographs, 21 woodcuts. Millimeters.

Berner Kunstmuseum [Hans Christoph von Tavel, compiler]. *Franz Marc; das graphische Werk.* Bern, 1967.
Entries: 54. Millimeters. Inscriptions. Described. Illustrated. Located.

Lankheit, Klaus. *Franz Marc; Katalog der Werke.* Cologne: M. DuMont Schauberg, 1970.
Entries: 63. Millimeters. Inscriptions. Described. Illustrated.

Marcantonio
See **Raimondi,** Marcantonio

Marceau-Desgraviers, Marie
See **Sergent,** Antoine François

Marcelin [Émile Planat] *(1825–1887)*
[Ber.] IX, pp. 212–213.*

Marcenay de Ghuy, Antoine de *(1724–1811)*
Marcenay de Ghuy, Antoine de. *Idée de la gravure, lettre sur l'encyclopédie du mot graveur, et catalogue raisonné des planches de Marcenay de Ghuy.* Paris: D'Houry, 1764. (NN)
Entries: 21. Described.

Morand, Louis. *Antoine de Marcenay de Ghuy, peintre et graveur 1724–1811, catalogue de son oeuvre.* Paris: Georges Rapilly, 1901.
Entries: 71. Millimeters. Inscriptions. States. Described.

Marcette, Henri Joseph *(1824–1890)*
[H. L.] pp. 703–705.
Entries: 11. Millimeters. Inscriptions (selection). States. Described (selection).

Marchais, Jean Baptiste Étienne *(b. 1818)*
[Ber.] IX, p. 214.*

Marchand, Cécile *(19th cent.)*
[Ber.] IX, pp. 214–215.*

Marchand, Gabriel *(b. c.1755)*
[L. D.] p. 58.
Entries: 1. Millimeters. Inscriptions. States. Described. Incomplete catalogue.*

Marchand, Jacques *(b. 1769)*
[Ber.] IX, p. 214.*

Marchand, Jean *(b. 1883)*
Cros, Guy Charles. "L'Oeuvre gravé de Jean Marchand." [AMG.] 2 (1928–1929): 481–486.
Bibliography of books with illustrations by (to 1928).

Marchant, B. *(19th cent.)*
[St.] p. 358.*

Marchesi, Agostino *(1810–1867)*
[Ap.] p. 261.
Entries: 1.*

Marchesini, Alessandro *(1664–1738)*
[Vesme] pp. 355–356.
Entries: 4. Millimeters. Inscriptions. Described. Located (selection).

Marchesini, Pietro
See **Ortolanino**

Marchetti, Domenico *(1780–1844)*
[Ap.] pp. 262–263.
Entries: 24.*

Marchetti, Pietro *(fl. c.1850)*
[Ap.] p. 263.
Entries: 4.*

Marchi, Antonio *(19th cent.)*
[Ap.] p. 263.
Entries: 1.*

Marchi, Joseph Philip Liberati [Giuseppe Filippo] *(1752–1808)*
[Sm.] II, pp. 911–916, and "additions and corrections" section.
Entries: 13 (portraits only). Inches. Inscriptions. States. Described. Illustrated (selection). Located (selection).

[Ru.] pp. 224–225.
Additional information to [Sm.].

Marcke de Lummen, Émile van *(1827–1890)*
[Ber.] XII, p. 175.*

Marcke de Lummen, Jean *(1875–1917)*
[Ber.] XII, p. 175.*

Marckl, Louis *(b. 1807)*
[Ap.] p. 263.
Entries: 2.*

[Ber.] IX, p. 215.*

Marco da Ravenna
See **Dente,** Marco

Marco da Siena
See **Pino,** Marco dal

Marcolini, Francesco *(c.1500–after 1559)*
[P.] VI: *See* **Chiaroscuro Woodcuts**

Marconi, Rocco *(fl. 1504–1529)*
[B.] XVI, pp. 102–103.
Entries: 1. Pre-metric. Inscriptions. Described.

Marcoussis, Louis *(1883–1941)*
Lafranchis, Jean. *Louis Marcoussis; sa vie, son oeuvre.* Paris, Les Éditions du Temps, 1961.
Entries: 210. Millimeters. Inscriptions. Illustrated (selection).

Marcucci, Giuseppe *(1807–1876)*
[Ap.] p. 264.
Entries: 15.*

Marcucci, Tullio *(18th cent.)*
[Ap.] p. 264.
Entries: 1.*

Marcus, Jacob Ernst *(1774–1826)*
[W.] II, p. 100.
Entries: 8+.*

Mare, Johannes de *(1806–1889)*
[Ap.] p. 112.
Entries: 8.*

[Ber.] IX, p. 215.*

[W.] II, p. 100.
Entries: 10.*

Mare, Pieter de *(1757–1796)*
[W.] II, pp. 100–101.
Entries: 8+.*

Mare, Tiburce de *(1840–1900)*
[Ber.] IX, pp. 215–216.*

Marebeek, Matthys *(fl. c.1686)*
[W.] II, p. 101.
Entries: 3.*

[H. *Neth.*] XI, p. 168.
Entries: 8.*

Maréchal, Cécile
See **Marchand**

Maréchal, François *(b. 1861)*
Neuville, Albert. *François Maréchale, peintre, dessinateur et graveur liégeois.* Extract from *Wallonia* 14, 1906. n.p., 1906. (EPBN)
Entries: 260 prints done in Liège, 77 done in Italy. Millimeters.

Ombiaux, Maurice des. *Quatre artistes liégeois; A. Rassenfosse, Fr. Maréchale, A. Donnay, Ém. Berchmans.* Brussels: G. van Oest et Cie, 1907.
Entries: 276 prints done in Liège, 80 done in Italy. Millimeters.

Kunel, Maurice. *François Maréchal aquafortiste.* Liège (Belgium): Éditions de l'Oeuvre des Artistes, 1931. 345 copies. (EBr)
 Entries: 525 prints done in Liège, 91 done in Italy. Millimeters. Illustrated (12 prints only).

Marèe, Hendrik Godaert de *(b. 1742)*
 Auction catalog; J. van Buren collection. The Hague, November 7, 1808 ([Lugt, *Ventes*] II, 7474). Ms. copy. (EA)
 Entries: 5 (complete?). Described.

Mares, Peter de *(fl. c.1517)*
 [H. *Neth.*] XI, p. 168.
 Entries: 1 print after.*

Mareschal, Aegidius *(fl. c.1580)*
 [W.] II, p. 101.
 Entries: 1+ prints after.*

Margelidon, Lucien *(b. 1857)*
 [Ber.] IX, pp. 216–217.*

Margo, Boris *(b. 1902)*
 Brooklyn Museum. *Boris Margo; a catalogue of his graphic work 1934–1947.* New York, 1947.
 Entries: 52 (to 1947). Inches.

 Syracuse University School of Art [Jan Gelb and Alexandra Schmeckbier, compilers]. *Boris Margo; graphic work 1932–1968.* Syracuse (N.Y.), 1968.
 Entries: 157 (to 1968). Inches. States. Illustrated (selection).

Margotti, Luigi *(1813–1872)*
 [Ap.] p. 265.
 Entries: 1.*

Mari, Giuseppe *(b. 1798)*
 [Ap.] p. 266.
 Entries: 10.*

Mariage, Louis François *(fl. 1785–1811)*
 [Ap.] p. 265.
 Entries: 9.*

 [Ber.] IX, p. 217.*

Mariani, —— *(19th cent.)*
 [Ber.] IX, p. 217.*

Marie Christine Caroline, Princess *(1813–1839)*
 [Ber.] IX, p. 217.*

Marienhof, J. A. *(c.1620–c.1677)*
 [W.] II, p. 101.
 Entries: 1 print after.*

 [H. *Neth.*] XI, p. 168.
 Entries: 1 print after.*

Marieschi, Michele *(1696–1743)*
 Mauroner, Fabio. "Michiel Marieschi." [PCQ.] 27 (1940): 178–215.
 Entries: 22 original prints by, 3 reproductive prints by, 8 prints after. Millimeters. Inscriptions. Described (selection). Illustrated (selection).

Marilhat, Prosper *(1811–1847)*
 [Ber.] IX, pp. 217–218.
 Entries: 2.

Marillier, Clement Pierre *(1740–1808)*
 Lhuillier, Th. *Le dessinateur Marillier, étude biographique suivie d'un essai de catalogue chronologique de son oeuvre.* Paris: E. Plon, Nourrit et Cie, 1886.
 Entries: unnumbered, pp. 23–39. Paper fold measure.

 [L. D.] p. 59.
 Entries: 1. Millimeters. Inscriptions. Described. Incomplete catalogue.*

 M——, G. "Un dessinateur dijonnais; C. P. Marillier 1740–1808, notice et essai de catalogue de son oeuvre d'illustration." Unpublished ms. 1922. (Dijon,

Marillier, Clement Pierre (*continued*)

Bibliothèque publique; photocopy
EPBN)
 Bibliography of books with illustrations by.

Marin, John (*1870–1953*)
Philadelphia Museum of Art [Carl Zigrosser, compiler]. *The complete etchings of John Marin; catalogue raissoné.* Philadelphia, 1969.
 Entries: 180. Inches. Millimeters. Inscriptions. States. Described. Illustrated. Located.

Marini, Marino (*b. 1901*)
Philadelphia Museum of Art. *Marino Marini; graphics and related works.* Philadelphia, 1969.
 Entries: 127 (1942–1965). Millimeters. Illustrated (selection).

Toninelli, L. F. *Le litografie di Marino Marini 1942–1965.* Milan: Romero Toninelli, 1966. English ed. *Marino Marini lithographs.* New York: Harry N. Abrams, n.d.
 Entries: 89 single prints, 13 book illustrations (lithographs only). Millimeters. Described. Illustrated.

San Lazzaro, G. di. Catalogue. In *Marino Marini; l'opera completa,* by Patrick Walderg and G. di San Lazzaro. Milan: Silvana Editoriale d'Arte, 1970. English ed. *Marino Marini; complete works.* New York: Tudor Publishing Company, 1970.
 Entries: 108+ lithographs, 53+ etchings. Inches. Described. Illustrated.

Marin-Lavigne, Louis Stanislas (*1797–1860*)
 [Ber.] IX, pp. 218–219.*

Marinus, Ignatius Cornelis (*1599–1639*)
 [Dut.] V, pp. 180–181.
 Entries: 1. Millimeters. Inscriptions. States. Described.

[W.] II, p. 103.
 Entries: 13.*

[H. *Neth.*] XI, pp. 169–170.
 Entries: 20. Illustrated (selection).*

Maris, Jacob Henricus (*1837–1899*)
Zilcken, Ph. *Peintres hollandais modernes.* Amsterdam: J. M. Schalekamp, 1893.
 Entries: 6 (to 1893?). Millimeters. Described.

Maris, Matthijs (*1839–1917*)
Zilcken, Ph. *Peintres hollandais modernes.* Amsterdam: J. M. Schalekamp, 1893.
 Entries: 8 (to 1893?). Millimeters (selection). Described (selection).

Mark, Quirin (*1753–1811*)
 [Ap.] pp. 265–266.
 Entries: 12.*

Markland, Ralph (*17th cent.*)
 [Hind, *Engl.*] III, p. 219.
 Entries: 1. Inches. Inscriptions. Described. Illustrated. Located.

Marks, W. (*fl. c.1853*)
 [Ber.] IX, p. 219.*

Marlet, Jean Henri (*1770–1847*)
 [Ber.] IX, pp. 220–223.
 Entries: 65.

Marne, Jean Louis de (*1752–1829*)
 [H. L.] pp. 173–188.
 Entries: 37 (etchings only). Millimeters. Inscriptions. States. Described.

Watelin, Jacques. *Le Peintre J.-L. de Marne (1752–1829).* Paris: La Bibliothèque des Arts, 1962. 500 copies. (MH)
 Entries: 39.

Marny, Paul (*fl. 1857–1890*)
 [Ber.] IX, p. 223.*

Marohn, Ferdinand (*fl. 1839–1859*)
 [Ber.] IX, p. 223.*

Marot, Daniel I *(c.1663–1752)*
Bérard, A. "Catalogue de toutes les estampes qui forment l'oeuvre de Daniel Marot, architecte et graveur français." [*RUA.*] 20 (1865): 289–319, 361–390. Separately published. Brussels: A. Mertens et Fils, 1865. (DLC)
Entries: unnumbered, pp. 294–319 and pp. 361–390. Millimeters. Inscriptions. Described.

[W.] II, p. 106.
Entries: 9+.*

[H. *Neth.*] XI, p. 171.
Entries: 16+.*

Marot, Jean *(1619?–1679)*
Mauban, A. *Jean Marot; architecte et graveur parisien.* Paris: Les Éditions d'Art et d'Histoire, 1944. 400 copies. (MH)
Entries: unnumbered, pp. 36–211. Paper fold measure (selection). Described (selection). Illustrated (selection).

Marotta, Nicola *(fl. 1630–1665)*
[Vesme] p. 338.
Entries: 1. Millimeters. Inscriptions. Described.

Marquet, Aimé Benoît *(1797–1865)*
[Ber.] IX, p. 223.*

Marquis, Elie *(fl. c.1870)*
[Ber.] IX, pp. 223–224.*

Marracci, Ippolito *(17th cent.)*
[B.] XXI, pp. 210–211.
Entries: 1. Pre-metric. Inscriptions. Described.

Marrel, Jacob *(1614–1681)*
[W.] II, p. 107.
Entries: 1.*

[H. *Neth.*] XI, p. 171.
Entries: 3.*

Mars
See **Bonvoisin,** Maurice

Marsh, Reginald *(1898–1954)*
Sasowsky, Norman. *Reginald Marsh; etchings, engravings, lithographs.* New York: Praeger, 1956.
Entries: 236. Inches. Illustrated (selection).

Marshall, Benjamin *(1767–1835)*
[Siltzer] pp. 170–179.
Entries: unnumbered, pp. 177–179, prints after. Inches (selection). Inscriptions. States. Illustrated (selection).

Marshall, L. *(19th cent.)*
[Siltzer] p. 332.
Entries: unnumbered, p. 332, prints after. Inscriptions.

Marshall, William *(fl. 1617–1649)*
[Hind, *Engl.*] III, pp. 102–192.
Entries: 254+. Inches. Inscriptions. States. Described. Illustrated (selection). Located.

Martelli, Luigi *(19th cent.)*
[Ap.] p. 267.
Entries: 4.*

Martenasie, Pierre François *(1729–1789)*
[W.] II, p. 108.
Entries: 10.*

Martens, Frédéric *(c.1809–1875)*
[Ber.] IX, p. 224.*

Marthelot, E. *(19th cent.)*
[Ber.] IX, p. 224.*

Martial
See **Potémont,** Adolphe Martial

Martin, A. A. *(19th cent.)*
[Siltzer] p. 332.

Martin, A. A. *(continued)*

Entries: unnumbered, p. 332, prints after. Inscriptions.

Martin, Charles *(20th cent.)*
Valotaire, Marcel. *Charles Martin. Les artistes du livre, 2.* Paris: Henry Babou, 1928. 700 copies. (NN)
Bibliography of books with illustrations by (to 1928).

Martin, D. *(fl. c.1796)*
[St.] pp. 358–359.*

[F.] p. 187.*

Martin, David *(1736–1798)*
[Sm.] II, pp. 916–919, and "additions and corrections" section.
Entries: 7 (portraits only). Inches. Inscriptions. States. Described.

[Ru.] p. 225.
Additional information to [Sm.].

Martin, E. *(19th cent.)*
[Ap.] p. 267.
Entries: 3.*

Martin, Elias *(1739–1818)*
Asplund, Karl. *Två Gustavianska Mästare, Niklas Lafrensen D. Y. och Elias Martin i samtida gravyrer.* Stockholm: A. B. Wahlström och Widstrand, 1925.
Entries: 42 prints after. Described. Illustrated.

Frölich, Hans. *Bröderna Elias och Johan Fredrik Martins gravyrer.* Akademisk avhandling—Stockholms högskola. Stockholm, 1939. 300 copies. (MH)
Entries: 116. Millimeters. Inscriptions. States. Described. Illustrated (selection). Located.

Martin, Eugène Prosper *(fl. 1864–1880)*
[Ber.] IX, pp. 224–225.*

Martin, J. B. *(fl. 1810–1822)*
[St.] p. 359.*

[F.] p. 187.*

Martin, Jean Baptiste II *(b. 1700)*
[Baud.] II, pp. 1–4.
Entries: 2. Millimeters. Inscriptions. States. Described.

Martin, Johan Fredrik *(1755–1816)*
Frölich, Hans. *Bröderna Elias och Johan Fredrik Martins gravyrer.* Akademisk avhandling—Stockholms högskola. Stockholm, 1939. 300 copies. (MH)
Entries: 291. Millimeters. Inscriptions. States. Described. Illustrated (selection). Located.

Martin, John *(1789–1854)*
Balston, Thomas. *John Martin 1789–1854, his life and works.* London: Gerald Duckworth and Co., 1947.
Entries: 23 prints by, 22 after (single prints only). Inches. Also, bibliography of books with illustrations by.

Martinet, ⸺ *(publisher, 19th cent.)*
[Ber.] IX, pp. 225–229.*

Martinet, Achille Louis *(1806–1877)*
[Ap.] pp. 267–269.
Entries: 25.*

[Ber.] IX, pp. 231–233.
Entries: 37. Paper fold measure.

Martinet, Alphonse *(1821–1861)*
[Ber.] IX, pp. 233–234.*

Martinet, Pierre *(b. 1781)*
[Ber.] IX, pp. 229–230.*

Martini, B. *(fl. c.1790)*
[W.] II, p. 109.
Entries: 7.*

Martini, Martin *(1566/67–1610)*
[A.] IV, pp. 65–79.

Entries: 31. Pre-metric. Inscriptions. Described.

Rahn, J. R. "Der Kupferstecher Martinus Martini und sein Werk." *Anzeiger für schweizerische Altertumskunde*, n.s. 7 (1905–1906): 38–43, 139–153. Separately published. Zurich: Gebr. Leemann und Co., 1906.
Entries: 57. Inscriptions. Described. Illustrated (selection).

Martini, Michelangelo *(1806–1882)*
[Ap.] pp. 269–270.
Entries: 6.*

Martini, Pietro Antonio *(1738–1797)*
[L. D.] pp. 59–60.
Entries: 6. Millimeters. Inscriptions. States. Described. Illustrated (selection). Incomplete catalogue.*

Martino da Udine *(c.1470–1545/48)*
See **Monogram PP** [Nagler, *Mon.*] IV, no. 3204

Martsz de Jonge, Jan [Jacob] *(1609?–after 1647)*
[B.] IV, pp. 47–52.
Entries: 6. Pre-metric. Inscriptions. Described.

[Weigel] pp. 150–151.
Additional information to [B.].

[Wess.] II, p. 241.
Entries: 1 (additional to [B.] and [Weigel]). Paper fold measure. Inscriptions. Described. Additional information to [B.] and [Weigel].

[Dut.] V, pp. 181–183.
Entries: 8. Millimeters. Inscriptions. States. Described.

[W.] II, pp. 109–110.
Entries: 9+ prints by, 7+ after.*

[H. *Neth.*] XI, pp. 173–174.
Entries: 11 prints by, 8 after. Illustrated (prints by only).*

Marty, André E. *(1882–1974)*
Dulac, Jean. *André E. Marty.* Les artistes du livre, 12. Paris: Henry Babou, 1930. 700 copies. (NN)
Bibliography of books with illustrations by (to 1930).

Marville, Charles *(fl. c.1850)*
[Ber.] IX, p. 234.*

Marvy, Louis *(1815–1850)*
[Ber.] IX, pp. 234–238.*

Masereel, Frans *(1889–1971)*
Gabelenz, Hanns-Conon von der. Catalogue. In *Frans Masereel*, by Luc Durtain. Paris: Pierre Vorms, 1931.
Entries: unnumbered, pp. 61–68 (to 1931). Millimeters. Illustrated (selection).

Ziller, Gerhart. *Frans Masereel.* Dresden: Sachsenverlag, 1949.
Bibliography of books with illustrations by.

Masereel, Frans. *Clef des songes; trente bois originaux suivis d'un repertoire de l'oeuvre gravé de l'auteur.* Lyons: Les écrivains réunis; Armand Henneuse éditeur, 1950. 715 copies. (NN)
Entries: unnumbered, 17 pp. Millimeters.

McGill, William A. "L'Oeuvre xylographique de Frans Masereel." *Le livre et l'estampe*, no. 10 (1957): 17–148; *Le Livre et l'estampe*, no. 11 (1957): 221–244.
Entries: 181 single prints, 26 sets of prints, 77 illustrated books, (to 1957). Millimeters. Inscriptions (selection). Described (selection).

Gabelentz, Hanns-Conon von der. Catalogue. In *Frans Masereel, mit Beitragen von Stefan Zweig, Pierre Vorms, Gerhard Pommeranz-Liedke und einer Bibliographie . . .* 2d ed. Dresden: V. E. B. Verlag der Kunst, 1961.

Masereel, Frans (*continued*)

Entries: 50 sets of prints, 116 illustrated books, 258 single prints, 20 bookplates. Millimeters. Illustrated (selection). First edition (1959) has a slightly less complete catalogue.

Masi, ——— *(19th cent.?)*
[Ap.] p. 270.
Entries: 1.*

Masjutin, Vassily Nicolaievich *(b. 1884)*
Hoentzsch, Alfred. "Wassili Nikolajewitsch Masjutin." *Illustration* 63, 9 (1972): 100–102.
Bibliography of books with illustrations by.

Kabinet Graviur Gosudarstvennogo, Moscow. *Rumjancovskogo muzeja: Ofort'i V. N. Masjutina (1908–1918).* Moscow: Gosudarstvennoe izdatel'stvo, 1920.
Entries: 158. Millimeters. Described (selection). Illustrated (selection).

Mason, W. *(fl. c.1786)*
[Siltzer] p. 332.
Entries: unnumbered, p. 332, prints after. Inches (selection). Inscriptions.

Mason, William G. *(fl. 1829–1845)*
[F.] p. 188.*

Masquelier, Claude Louis *(1781–1852)*
[Ap.] p. 270.
Entries: 7.*

[Ber.] IX, pp. 238–239.*

Masquelier, Louis Joseph *(1741–1811)*
[L. D.] p. 60.
Entries: 2. Millimeters. Inscriptions. States. Described. Incomplete catalogue.*

Masquelier, Nicolas François Joseph *(1760–1809)*
[Ap.] p. 270.
Entries: 5.*

Masquerier, John James *(1778–1855)*
Grundy, C. Reginald. Catalogue. In *Masquerier and his circle,* by R.R.M. See. London: Connoisseur, 1922.
Entries: unnumbered, pp. 259–260, prints after. Inches. Described.

Massard, Alexandre *(b. 1777)*
[Ber.] IX, pp. 242–243.*

Massard, Félix *(b. 1773)*
[Ber.] IX, p. 240.*

Massard, Horace *(b. 1854)*
[Ber.] IX, p. 245.*

Massard, Jean *(1740–1822)*
[Ap.] pp. 271–272.
Entries: 22.*

[Ber.] IX, pp. 239–240.*

[L. D.] pp. 61–62.
Entries: 3. Millimeters. Inscriptions. States. Described. Incomplete catalogue.*

Massard, Jean Baptiste Louis *(1772–1810)*
[Ap.] p. 272.
Entries: 2.*

[Ber.] IX, p. 240.*

Massard, Jean Baptiste Raphael Urbain *(1775–1843)*
[Ap.] pp. 272–274.
Entries: 21.*

[Ber.] IX, pp. 240–242.
Entries: 21+. Paper fold measure.

Massard, Jules Louis *(b. 1848)*
[Ber.] IX, pp. 244–245.*

Massard, Léopold *(1812–1889)*
[Ap.] p. 274.
Entries: 6.*

[Ber.] IX, pp. 243–244.*

MASTERS KNOWN BY DATES
OR NICKNAMES

Master of 1446
> [P.] II, pp. 3–6.
>> Entries: 7. Pre-metric. Inscriptions. Described. Paper and watermarks described.

> [Lehrs] I, pp. 208–225.
>> Entries: 19. Millimeters. Inscriptions. Described. Illustrated. Located. Locations of all known impressions are given. Copies mentioned. Watermarks described. Blibliography for each entry.

Master of 1457
> [P.] II, pp. 8–9.
>> Entries: 27. Pre-metric. Inscriptions. Described (selection). Located. Papers described.

> [Schreiber, *Metallschneidekunst*] p. 87.
>> Entries: 5.*

Master of 1488
> [RD.] VI, pp. 1–6.
>> Entries: 7. Millimeters. Inscriptions. Described.

Master of 1515
> [B.] XIII, pp. 408–422.
>> Entries: 36. Pre-metric. Inscriptions. Described.

> [P.] V, pp. 89–91.
>> Entries: 9 prints by, 1 doubtful print, (additional to [B.]). Pre-metric. Inscriptions. Described. Located. Additional information to [B.].

> [Wess.] III, p. 50.
>> Entries: 1 (additional to [B.] and [P.]). Millimeters. Described. Located.

Baumeister, Engelbert. "Zum Meister von 1515." [*MGvK.*] 1911: 45–46.

>> Entries: 2 (additional to previous catalogues). Described. Illustrated. Located.

Kristeller, Paul. *Der Meister von 1515; Nachbildungen seiner Kupferstiche.* Graphische Gesellschaft, 22. Veröffentlichung. Berlin: Bruno Cassirer, 1916.
>> Entries: 43 prints by, 1 doubtful print. States. Described. Illustrated. Located.

> [Hind] V, pp. 279–290.
>> Entries: 44. Millimeters. Inscriptions. Described. Illustrated. Located.

Master of 1527
> *See* **Monogram GI** [Nagler, *Mon.*] II, no. 3116

Master of the AACHEN Madonna
(fl. 1460–1470)
> [Schreiber, *Metallschneidekunst*] pp. 87–88.
>> Entries: 32 prints by, 23 doubtful prints.*

Master of the ACORN *(16th cent.)*
> [P.] IV, pp. 169–170.
>> Entries: 2. Pre-metric. Inscriptions. Described. Located.

Master of the ADORATION of the Kings
(fl. c.1550)
> [H. *Neth.*] XIII, p. 53.
>> Entriee: 1. Illustrated.*

Master of the AMSTERDAM Cabinet
See **Master of the HOUSEBOOK**

Master of BALAAM *(fl. 1440–1450)*
> [Lehrs] I, pp. 327–336.

Entries: 9. Millimeters. Inscriptions. Described. Illustrated. Located. Locations of all known impressions are given. Copies mentioned. Watermarks described. Bibliography for each entry.

[W.] III, pp. 196–197.
Entries: 9.*

[H. *Neth.*] XII, pp. 9–17.
Entries: 13. Illustrated.*

Master of the BANDEROLES
(fl. 1450–1500)
[P.] II, pp. 9–32.
Entries: 51 prints by, 4 prints by followers, 1 rejected print. Pre-metric. Inscriptions. Described. Located. Watermarks described.

Dehio, Georg. *Kupferstiche des Meisters von 1464.* Munich: Jos. Aumüller, 1881. (NN)
Entries: 26. Illustrated. Located.

Gugenbauer, Gustav: "Ein neuer Stich des Bandrollen meisters."[*MGvK.*] 1912, pp. 4–5.
Entries: 1 (additional to [P.]). Millimeters. Described. Illustrated.

[W.] III, pp. 195–196.
Entries: 50.*

[Lehrs] IV, pp. 1–164, 321–324.
Entries: 112. Millimeters. Inscriptions. States. Described. Illustrated (selection). Located. Locations of all known impressions are given. Copies mentioned. Watermarks described. Bibliography for each entry.

[H. *Neth.*] XII, pp. 18–77.
Entries: 135. Illustrated (selection).*

Master of the BEHEADING of St. John the Baptist *(early 16th cent.)*
[Hind] V, pp. 97–99.
Entries: 5. Millimeters. Inscriptions. Described. Illustrated. Located.

Master of Jacob BELLAERT
(fl. 1483–1486)
[H. *Neth.*] XII, p. 78.
Entries: 53. Illustrated (selection).*

Master of the BERGWOLKEN [Mountainous Clouds] *(fl. c.1475)*
[Schreiber, *Metallschneidekunst*] p. 90.
Entries: 23 prints by, 8 doubtful prints.*

Master of the BERLIN Passion
See **Meckenem,** Israhel I van

Master of the BOCCACCIO Illustrations
(15th cent.)
[P.] II, pp. 272–279.
Entries: 25. Pre-metric. Inscriptions. States. Described. Located. Copies mentioned.

[Dut.] V, pp. 150–163; VI, pp. 673–674.
Entries: 27. Millimeters. Inscriptions. States. Described. Located (selection).

Lehrs. Max. "Der Meister der Boccaccio-Bilder." [*JprK.*] 23 (1902): 124–141.
Entries: 10. Millimeters. Inscriptions. States. Described. Illustrated (selection). Located. Bibliography for each entry.

[W.] III, pp. 197–199.
Entries: 12+.*

[Lehrs] IV, pp. 165–187; VII, pp. 392–400.
Entries: 24. Millimeters. Inscriptions. States. Described. Illustrated. Locations of all known impressions are given. Copies mentioned. Watermarks described. Bibliography for each entry.

[H. *Neth.*] XII, pp. 114–122.
Entries: 24. Illustrated.*

Master of the Portrait of BOCCACCIO
(fl. c.1476)
[W.] III, p. 219.
Entries: 1.*

Master of the CALTROP
See **Monogram GA** with the caltrop
[Nagler, *Mon.*] II, no. 2679

Master of CALVARY *(early 15th cent.)*
[Lehrs] I, pp. 288–303.
 Entries: 9. Millimeters. Inscriptions.
 Described. Illustrated (selection). Lo-
 cated. Locations of all known impres-
 sions are given. Copies mentioned.
 Watermarks described. Bibliography
 for each entry.

[W.] III, p. 199.
 Entries: 9.*

[H. *Neth.*] XII, pp. 123–130.
 Entries: 9. Illustrated.*

Master of CASSANDRA *(15th cent.)*
Stadler, Franz J. *Michael Wolgemut und
der nürnberger Holzschnitt im letzten Drit-
tel des XV. Jahrhunderts.* Studien zur
deutschen Kunstgeschichte, 161. Stras-
bourg: J. H. Ed. Heitz, 1913.
 Entries: unnumbered, pp. 126–138.
 Millimeters (selection). Described
 (selection).

Master of the CHEVALIER Délibéré
(fl. c.1486)
[H. *Neth.*] XII, pp. 131–134.
 Entries: 17. Illustrated.*

Master with the Arms of COLOGNE
(fl. c.1475)
[Schreiber, *Metallschneidekunst*] p. 90.
 Entries: 13 prints by, 5 doubtful
 prints.*

**Master of the Patron of Saints of
COLOGNE** *(fl. mid-15th cent.)*
[Schreiber, *Metallschneidekunst*] p. 91.
 Entries: 1 print by, 8 doubtful prints.*

Master of the CRAYFISH
See **Crabbe,** Frans

Master of the DEATH of the Virgin
(fl. 1430–1440)
[Lehrs] I, pp. 279–287.
 Entries: 6. Millimeters. Inscriptions.
 Described. Illustrated. Located. Loca-
 tions of all known impressions are
 given. Copies mentioned. Water-
 marks described. Bibliography for
 each entry.

[W.] III, pp. 222–223.
 Entries: 6.*

[H. *Neth.*] XII, pp. 192–199.
 Entries: 11. Illustrated.*

**Master of the DELBECQ-SCHREIBER
Passion** *(fl. c.1500)*
[H. *Neth.*] XII, p. 138.
 Entries: 46. Illustrated (selection).*

Master of the DIE *(fl. c.1530)*
[B.] XV, pp. 181–233.
 Entries: 85. Pre-metric. Inscriptions.
 States. Described. Copies mentioned.

[Heller] pp. 132–133.
 Additional information to [B.].

[P.] VI, pp. 98–102.
 Entries: 3 (additional to [B.]). Pre-
 metric. Inscriptions. States. De-
 scribed. Additional information to
 [B.].

[Wess.] III, pp. 50–51.
 Entries: 2 (additional to [B.]). Mil-
 limeters (selection). Paper fold mea-
 sure (selection). States. Located. Ad-
 ditional information to [B.].

[Dis. 1927]
 Additional information to [B.].

[Dis. 1929]
 Additional information to [B.].

Master of the DUTUIT Mount of Olives
(mid-15th cent.)
[Lehrs] III, pp. 282–348.

Entries: 112. Millimeters. Inscriptions. States. Described. Illustrated (selection). Located. Locations of all known impressions are given. Copies mentioned. Watermarks described. Bibliography for each entry.

Workshop of the Borders with the FATHERS of the Church *(15th cent.)*
[Schreiber, *Metallschneidekunst*] p. 90.
Entries: 7 prints by, 7 doubtful prints.*

Master of the FLORAL Borders
(mid-15th cent.)
[Lehrs] III, pp. 140–232.
Entries: 126. Millimeters. Inscriptions. States. Described. Illustrated (selection). Located. Locations of all known impressions are given. Copies mentioned. Watermarks described. Bibliography for each entry.

Master of the FRANKFURT Passion
(fl. 1465–1475)
[Schreiber, *Metallschneidekunst*] p. 90.
Entries: 4.*

Master of the GARDENS of Love
(fl. 1440–1450)
[P.] II, pp. 252–254.
Entries: 6. Pre-metric. Described. Located. Papers described.

[Dut.] V, pp. 130–132.
Entries: 6. Millimeters. Described. Located.

Lehrs, Max. *Der Meister der Liebesgärten; ein Beitrag zur Geschichte des ältesten Kupferstichs in den Niederlanden.* Leipzig: Karl W. Hiersemann, 1893.
Entries: 17. Millimeters. Described (selection). Illustrated (selection). Located. Bibliography for each entry.

[Lehrs] I, pp. 304–326.
Entries: 22. Millimeters. Inscriptions. Described. Illustrated (selection). Lo-

cated. Locations of all known impressions are given. Copies mentioned. Watermarks described. Bibliography for each entry.

[W.] III, pp. 212–213.
Entries: 21.*

[H. *Neth.*] XII, pp. 168–181.
Entries: 24. Illustrated.*

Master of the GOLDSCHMIDT Calvary
(15th cent.)
[Schreiber, *Metallschneidekunst*] p. 91.
Entries: 1 print by, 2 doubtful prints.*

Master of HEDERLEIN *(fl. 1535–1548)*
[Ge.] nos. 903–904.
Entries: 2 (single-sheet woodcuts only). Described. Illustrated. Located.

Master of the HEILIGENTAFELN
(fl. c.1500)
[H. *Neth.*] XII, p. 182.
Entries: 1. Illustrated.*

Master of the HOROLOGIUM *(fl. c.1489)*
Stadler, Franz J. *Michael Wolgemut und der nürnberger Holzschnitt im letzten Drittel des XV. Jahrhunderts.* Studien zur deutschen Kungstgeschichte, 161. Strasbourg: J. H. Ed. Heitz, 1913.
Entries: unnumbered, pp. 118–126. Millimeters (selection). Described (selection).

Master of the HOROLOGIUM Passion
(15th cent.)
[Schreiber, *Metallschneidekunst*] p. 91.
Entries: 30.*

Master of the HORSE-HEADS
(early 16th cent.)
[H. *Neth.*] XIII, pp. 54–60.
Entries: 20. Illustrated (selection).*

Master of the HOUSEBOOK *(fl. c.1480)*
Klinkhamer, H. A. "Les estampes indécrites du Musée d'Amsterdam (supplé-

Master of the HOUSEBOOK (*continued*)

ment au Xe volume de Bartsch)." [*RUA.*] 4 (1856): 409–420.
Entries: 73. Pre-metric. Inscriptions. Described. Identifies prints classed as anonymous in [B.] X.

[P.] II, pp. 254–264.
Entries: 62. Pre-metric. Inscriptions. Described. Located. Copies mentioned.

[Dut.] V, pp. 132–144.
Entries: 63. Millimeters. Inscriptions. Described. Located.

Lehrs, Max. *Der Meister des Amsterdamer Kabinets.* Berlin: Internationale Chalkographische Gesellschaft, 1893, 1894.
Entries: 89. Millimeters. Described. Illustrated. Located. Copies mentioned. Also, list of 30 copies after lost prints by. Millimeters.

Naumann, Hans. *Die Holzschnitte des Meisters vom Amsterdamer Kabinett zum Spiegel Menschlicher Behaltnis (gedruckt zu Speier bei Peter Drach) mit einer Einleitung über ihre Vorgeschichte.* Studien zur deutschen Kunstgeschichte, 126. Strasbourg: J. H. Ed. Heitz, 1910.
Entries: 267 (woodcuts attributed to the Master of the Housebook). Illustrated.

[W.] III, pp. 201–211.
Entries: 90.*

[Lehrs] VIII, pp. 1–164, 379–382.
Entries: 91 prints by, 5 copies of lost Described. Illustrated (selection). Located. Locations of all known impressions are given. Copies mentioned. Watermarks described. Bibliography for each entry.

Bierens de Haan, J.C.J. *De Meester van het Amsterdamsch kabinet, met reproducties in lichtdruk van het geheele gegravierde*

werk. Amsterdam: A. A. Balkema, 1947. (NN)
Entries: 91 prints by, 5 copies of lost prints by. Millimeters. Illustrated. Located.

Stange, Alfred. *Der Hausbuchmeister, Gesamtdarstellung und Katalog seiner Gemälde, Kupferstiche und Zeichnungen.* Studien zur deutschen Kunstgeschichte, 316. Baden-Baden and Strasbourg: Verlag Heitz GmbH, 1958.
Entries: 91. Millimeters. Illustrated (selection). Located.

Hutchison, Jane C. *The Master of the Housebook.* New York: Collectors' Editions, 1972.
Entries: 91 prints by, 28 after (by Monogrammist BG). Described. Illustrated. Located.

Master of the Woodcuts for the Comedies of HROSVITHA (*fl. c.1500*)
Röttinger, Heinrich. *Dürers Doppelgänger.* Studien zur deutschen Kunstgeschichte, 235. Strasbourg: J. H. Ed. Heitz, 1926.
Entries: unnumbered, p. 286. Illustrated (selection).

Master of the Arms of JESUS (*15th cent.*)
[Schreiber, *Metallschneidekunst*] p. 91.
Entries: 2.*

Master of JESUS in Bethany (*fl. 1465–1485*)
[Schreiber, *Metallschneidekunst*] pp. 89–90.
Entries: 19 prints by, 2 doubtful prints.*

[H. *Neth.*] XII, p. 182.
Entries: 1. Illustrated.*

Master of JOHN the Baptist (*fl. c.1470*)
[Lehrs] I, pp. 263–272.
Entries: 11. Millimeters. Inscriptions. Described. Illustrated (selection). Lo-

cated. Locations of all known impressions are given. Copies mentioned. Watermarks described. Bibliography for each entry.

[W.] III, p. 211.
Entries: 11.*

Master of the KAHLENBERGER-GESCHICHTE *(fl. c.1488)*
Stadler, Franz J. *Michael Wolgemut und der nürnberger Holzschnitt im letzten Drittel des XV. Jahrhunderts.* Studien zur deutschen Kunstgeschichte, 161. Strasbourg: J. H. Ed. Heitz, 1913.
Entries: unnumbered, pp. 87–118. Millimeters (selection). Described (selection).

Master with the KEULEN [**Crossed Staves**] *(fl. c.1460)*
[Schreiber, *Metallschneidekunst*] p. 88.
Entries: 5 prints by, 3 doubtful prints.*

Master of the LAMENTATION of Christ *(15th cent.)*
[Schreiber, *Metallschneidekunst*] p. 89.
Entries: 2.*

Master of the LAUBWERKBORDÜRE [**Foliate Borders**] *(15th cent.)*
[Schreiber, *Metallschneidekunst*] p. 92.
Entries: 2 prints by, 1 doubtful print.*

Master of the LÜBECK Bible of 1494 *(fl. c.1494)*
[H. *Neth.*] XII, p. 184.
Entries: 97+. Illustrated (selection).*

Master of the Life of LYDWINA *(fl. c.1498)*
[H. *Neth.*] XII, pp. 185–188.
Entries: 26. Illustrated.*

Master of MALINES *(fl. c.1500)*
[H. *Neth.*] XIII, p. 92.
Entries: 1. Illustrated.*

Master of the MARTYRDOM of the Ten Thousand *(mid-15th cent.)*
[Lehrs] III, pp. 349–410.
Entries: 93. Millimeters. Inscriptions. States. Described. Illustrated (selection). Located. Locations of all known impressions are given. Copies mentioned. Watermarks described. Bibliography for each entry.

Master with the MASCHENHINTERGRUND [**Network Background, Fond Maillé**] *(15th cent.)*
[Schreiber, *Metallschneidekunst*] p. 88.
Entries: 22 prints by, 3 doubtful prints.*

Master of the MEINRADLEGENDE *(fl. c.1490)*
Stadler, Franz J. *Michael Wolgemut und der nürnberger Holzschnitt im letzten Drittel des XV. Jahrhunderts.* Studien zur deutschen Kunstgeschichte, 161. Strasbourg: J. H. Ed. Heitz, 1913.
Entries: unnumbered, pp. 139–169.

Master of the NAME of Jesus
See **Monogram IHS** [Nagler, *Mon.*] III, no. 2602

Master of the NUREMBERG Passion *(mid-15th cent.)*
[Lehrs] I, pp. 249–262.
Entries: 16. Millimeters. Inscriptions. Described. Illustrated (selection). Located. Locations of all known impressions are given. Copies mentioned. Watermarks described. Bibliography for each entry.

Master of the OBERLIPPENRINNE [**Cleft Upper Lip**] *(15th cent.)*
[Schreiber, *Metallschneidekunst*] p. 91.
Entries: 5 prints by, 1 doubtful print.*

Master of PETRARCH *(fl. c.1530)*
Röttinger, Heinrich. *Hans Weiditz der Petrarkameister.* Strasbourg: J. H. Ed. Heitz, 1904.

Master of PETRARCH (*continued*)

Entries: 90+. Millimeters. Inscriptions (selection). States. Described (selection). Illustrated (selection). Located. Bibliography for each entry.

"Die Holzschnittwerke von Hans Weiditz." [*Bb.*] 78 (28 March 1911): 3865–3869; [*Bb.*] 78 (29 March 1911): 3924–3927; [*Bb.*] 78 (30 March 1911): 3976–3980. (Separately bound copy, NN)
Bibliography of books with illustrations by.

[Ge.] nos. 1499–1550.
Entries: 52 (single-sheet woodcuts only). Described. Illustrated. Located.

Röttinger, Heinrich. "Neues zum Werke Hans Weiditz." [*MGvK.*] 1911, pp. 46–52.
Entries: 17 (additional to previous catalogues). Millimeters. Inscriptions. Described. Illustrated (selection). Located.

Stuhlfauth, Georg. "Neues zum Werke Hans Weiditz." [*MGvK.*] 1920, pp. 1–5.
Entries: 15 (additional to previous catalogues). Millimeters. Inscriptions. Described. Illustrated (selection).

Musper, Theodor. *Die Holzschnitte des Petrarkameisters; ein kritisches Verzeichnis mit Einleitung und 28 Abbildungen.* Munich: Verlag der Münchner Drucke, 1927.
Entries: 733. Millimeters. Described. Illustrated (selection). Also, bibliography of books in which the prints appeared.

Master of the PLAYING Cards
(fl. c.1435–1455)
[P.] II, pp. 70–80.
Entries: 5+. Pre-metric. Inscriptions. Described. Located. Copies mentioned. Watermarks described.

[Lehrs] I, pp. 63–207.
Entries: 106 prints by, 88 prints by pupils. Millimeters. Inscriptions. States. Described. Illustrated (selection). Located. Locations of all known impressions are given. Copies mentioned. Watermarks described. Bibliography for each entry.

Master of the POWER of Women
(fl. c.1462)
[Lehrs] I, pp. 226–248.
Entries: 20. Millimeters. Inscriptions. Described. Illustrated (selection). Located. Locations of all known impressions are given. Copies mentioned. Watermarks described. Bibliography for each entry.

Master of the ROUND Playing Cards
(fl. 1461–1483)
[P.] II, pp. 176–177.
Entries: 1+ (identification of prints classed as anonymous in [B.] X, pp. 70–76). Located. Copies mentioned.

Master of the Revelations of ST. BRIDGET
See **Visscher,** Peter I

Master of ST. CATHARINE *(fl. c.1450)*
[Schreiber, *Metallschneidekunst*] p. 88.
Entries: 3 prints by, 7 doubtful prints.*

Master of ST. DIONYSUS *(late 15th cent.)*
[Lehrs] IV, pp. 200–205.
Entries: 4. Millimeters. Inscriptions. Described. Illustrated (selection). Locations of all known impressions are given. Copies mentioned. Watermarks described. Bibliography for each entry.

Master of ST. ERASMUS *(15th cent.)*
[Lehrs] III, pp. 233–281.
Entries: 91. Millimeters. Inscriptions. Described. Illustrated (selection). Lo-

cated. Locations of all known impressions are given. Copies mentioned. Watermarks described. Bibliography for each entry.

Master of ST. FRANCIS *(15th cent.)*
[Schreiber, *Metallschneidekunst*] p. 89.
 Entries: 3 prints by, 2 doubtful prints.

Master of ST. GEORGE *(15th cent.)*
[Schreiber, *Metallschneidekunst*] p. 88.
 Entries: 1 print by, 1 doubtful print.*

Master of ST. ROCH *(15th cent.)*
[Schreiber, *Metallschneidekunst*] p. 91.
 Entries: 5 prints by, 3 doubtful prints.*

Master of ST. SEBASTIAN
(late 15th cent.)
[Lehrs] IV, pp. 188–199.
 Entries: 10. Millimeters. Inscriptions. Described. Illustrated (selection). Located. Locations of all known impressions are given. Copies mentioned. Watermarks described. Bibliography for each entry.

Master of ST. VERONICA and St. Helena
(15th cent.)
[Schreiber, *Metallschneidekunst*] p. 91.
 Entries: 3 prints by, 2 doubtful prints.*

Master of ST. WENDELIN *(15th cent.)*
[Schreiber, *Metallschneidekunst*] p. 89.
 Entries: 1.*

Master of ST. WOLFGANG
(early 16th cent.)
[Lehrs] I, pp. 273–278.
 Entries: 3. Millimeters. Inscriptions. Described. Illustrated. Located. Locations of all known impressions are given. Copies mentioned. Watermarks described. Bibliography for each entry.

Master of a Set of SAINTS *(15th cent.)*
[Schreiber, *Metallschneidekunst*] p. 91.
 Entries: 5 prints by, 4 doubtful prints.*

Master of the SFORZA Book of Hours
(late 15th cent.)
Kristeller, Paul. "Fra Antonio da Monza, incisore." *Rassegna d'arte* 1 (1901): 161–164.
 Entries: 7. Millimeters. Inscriptions. Described. Illustrated (selection). Located.

[Hind] V, pp. 73–81.
 Entries: 10+. Millimeters. Inscriptions. Described. Illustrated. Located.

Master of the SIBYL
See **Monogram ES** [Nagler, *Mon.*] II, no. 1763

Master of the STICKMUSTERBORDÜRE
[Embroidery-pattern Borders]
(fl. c.1450)
[Schreiber, *Metallschneidekunst*] p. 88.
 Entries: 3 prints by, 1 doubtful print.*

Workshop of the STOEGER Copies
(15th cent.)
[Schreiber, *Metallschneidekunst*] p. 89.
 Entries: 16.*

Workshop of the STOEGER Passion
(15th cent.)
[Schreiber, *Metallschneidekunst*] p. 87.
 Entries: 9 prints by, 5 doubtful prints.*

Master of the Passion with the
TAPESTRY Backgrounds *(fl. c.1460)*

[Schreiber, *Metallschneidekunst*] p. 90.
 Entries: 4.*

Master of the UNICORN Hunt
See **Monogram D** [Nagler, *Mon.*] II, no. 902

Master of the VIRGO inter Virgines
(fl. 1480–1495)
 [H. *Neth.*] XII, pp. 200–202.
 Entries: 146+. Illustrated (selection).*

Matará, Ewald *(1887–1965)*
 Peters, Heinz. *Ewald Matará, das graphische Werk.* 2 vols. Cologne: Verlag Christophe Czwiklitzer, 1957–1958.
 Entries: 328 (to 1958). Millimeters. Inscriptions. States. Described. Illustrated. Volume 2 includes additional information to volume 1.

Matham, Adriaen Jacobsz *(c.1600–1660)*
 [W.] II, p. 121.
 Entries: 12+.*

 [H. *Neth.*] XI, pp. 212–214.
 Entries: 65+ prints by, 1 after. Illustrated (selection).*

Matham, Jacob *(1571–1631)*
 [B.] III, pp. 131–213, and addenda.
 Entries: 245 prints by, 76 prints partially by, 17 prints after. Pre-metric. Inscriptions. States. Described. Copies mentioned.

 [Weigel] pp. 120–128.
 Entries: 5 (additional to [B.]). Pre-metric. Inscriptions. States. Described.

 [Heller] pp. 89–90.
 Additional information to [B.].

 [Wess.] II, pp. 241–242.
 Entries: 6 (additional to [B.] and [Weigel]). Millimeters (selection). Paper fold measure (selection). Inscriptions (selection). Described (selection). Additional information to [B.] and [Weigel].

 [W.] II, pp. 121–124.
 Entries: 239+ prints by, 12+ after.*

 [H. *Neth.*] XI, pp. 215–251.
 Entries: 417 prints by, 20 after. Illustrated (selection).*

Master with the WEAVER'S Shuttle
 See **Monogram IAM** of Zwolle [Nagler, *Mon.*] III, no. 1774

Matham, Jan *(1600–1648)*
 [H. *Neth.*] XI, p. 251.
 Entries: 6. Illustrated (selection).*

Matham, Theodor [Dirk] *(1605/06–1676)*
 [W.] II, pp. 124–125.
 Entries: 66+.*

 [H. *Neth.*] XI, pp. 252–262.
 Entries: 164. Illustrated (selection).*

Matheu, Cornelis
 See **Matteus**

Matheus, Anna *(16th cent.)*
 See **Monogram ANNA R 1568**
 [Nagler, *Mon.*] I, no. 1049

Matheus, Georg *(fl. 1554–1572)*
 [B.] IX, p. 426.
 Entries: 1. Pre-metric. Inscriptions. States. Described.

 [B.] XII: *See* **Chiaroscuro Woodcuts**

 [P.] IV, pp. 312–313.
 Entries: 8 (additional to [B.]). Pre-metric. Inscriptions. Described. Additional information to [B.].

Mathey, Paul *(b. 1844)*
 [Ber.] IX, p. 248.
 Entries: 5. Paper fold measure (selection).

 Clement-Janin. "Paul Mathey, painter-etcher." [P. *Conn.*] 3 (1923): 23–41.
 Entries: 67 (to 1922?). Illustrated (selection).

Mathey-Doret, Armand *(b. 1854)*
 [Ber.] IX, pp. 248–249.*

Mathiesen, Broder *(d. 1666)*
 [W.] II, p. 126.
 Entries: 1.*

[H. *Neth.*] XI, p. 263.
Entries: 1.*

Mathieu, Balthazar *(fl. 1647–1654)*
[H. *Neth.*] XI, p. 263.
Entries: 1 print after.*

Mathieu, Jean *(1749–1798)*
[L. D.] p. 62.
Entries: 1. Millimeters. Inscriptions.
States. Described. Incomplete
catalogue.*

Mathilde Bonaparte, Princess *(1820–1904)*
[Ber.] IX, p. 249.*

Mathys, Jan *(fl. 1657–1685)*
[H. *Neth.*] XI, pp. 263–264.
Entries: 9+. Illustrated (selection).*

Mathysen, P. *(19th cent.)*
[H. L.] pp. 708–709.
Entries: 1. Millimeters. Inscriptions.
States. Described.

Matta [Roberto Matta Echauren] *(b. 1911)*
Silkeborg Museum [Ursala Schmitt,
compiler]. *Matta; Kataloget over en naesten
komplet samling af Mattas grafiske arbejder.*
Silkeborg (Sweden), 1969.
Entries: 173. Millimeters. Described.
Illustrated.

Mattenheimer, Theodor *(1787–1856)*
[Dus.] p. 107.
Entries: 1 (lithographs only, to 1821).
Millimeters. Inscriptions. Located.

Matteus [Mattue], Cornelis *(b. c.1610)*
[B.] V, pp. 75–77.
Entries: 3. Pre-metric. Inscriptions.
Described.

[Weigel] pp. 234–236.
Entries: 6 (additional to [B.]). Pre-
metric. Inscriptions. States. De-
scribed.

[Wess.] I, p. 142.
Additional information to [B.].

[W.] II, p. 126.
Entries: 9.*

[H. *Neth.*] XI, pp. 265–268.
Entries: 10. Illustrated.*

Matthes, Nikolaus Christoph
(1729–after 1796)
See also **Monogram CM** [Nagler, *Mon.*]
II, no. 391

See also **Monogram MF** [Nagler, *Mon.*]
IV, no. 1788

[A.] V, pp. 332–343.
Entries: 22. Pre-metric. Inscriptions.
Described.

Matthey, ――― *(17th cent.)*
[H. *Neth.*] XI, p. 264.
Entries: 2.*

Mattioli, Lodovico *(1662–1747)*
[B.] XIX, pp. 337–391
Entries: 140. Pre-metric. Inscriptions.
States. Described. Appendix with
23+ prints not seen by [B.].

Mattis, C. *(fl. 1815–1820)*
[Dus.] p. 107.
Entries: 2+ (lithographs only, to 1821).
Paper fold measure.

Maturino da Firenze *(16th cent.)*
[B.] XII: *See* **Chiaroscuro Woodcuts**

Mauch, Johann Mathäus *(1792–1856)*
[Dus.] p. 107.
Entries: 2 (lithographs only, to 1821).
Millimeters. Inscriptions. Located.

Maucourt, Charles *(1718–1768)*
[Sm.] II, pp. 919–920, and "additions
and corrections" section.
Entries: 2 (portraits only). Inches. In-
scriptions. Described. Located (selec-
tion).

Maucourt, Charles (*continued*)

[Ru.] p. 226.
Additional information to [Sm.].

Mauduison, Léon (*fl. 1848–1886*)
[Ap.] p. 275.
Entries: 1.*

[Ber.] IX, p. 249.*

Mauduit, Charles Louis Victor (*b. 1788*)
[Ap.] p. 275.
Entries: 4.*

[Ber.] IX, pp. 249–250.*

Maufra, Maxime Camille Louis (*1861–1918*)
Michelet, Victor Émile. *Maufra, peintre et graveur.* Paris: H. Floury, 1908.
Entries: unnumbered, pp. 83–84. Illustrated (selection).

Maugendre, [François] Adolphe
(*1809–1895*)
[Ber.] IX, p. 250.*

Maulbertsch, Franz Anton (*1724–1796*)
Garas, Klara. *Franz Anton Maulbertsch 1724–1796.* Budapest: Verlag der Ungarischen Akademie der Wissenschaften, 1960.
Entries: 397 (works in various media, including prints by and after). Millimeters. Inscriptions. Illustrated (selection).

Maulet, Amédée (*1810–1835*)
[Ber.] IX, p. 250.*

Mauperché, Henri (*1602–1686*)
[RD.] I, pp. 39–73; XI, pp. 198–202.
Entries: 52. Pre-metric. Inscriptions. States. Described. Appendix with 2 doubtful prints and 1 rejected print.

[Wess.] IV, p. 61.
Entries: 1 (additional to [RD.]). Millimeters. Described. Located.

Maurer
See **Murer**

Maurin, Antonine (*fl. 1843–1864*)
[Ber.] IX, p. 250.*

Maurin, Charles (*1854–1914*)
Rouchon, Ulysse. *Charles Maurin (1856–1914).* Le Puy-en-Velay (France), 1922.
Entries: unnumbered, pp. 86–98 (complete?). Millimeters (selection).

Maurin, Nicolas Eustache (*1799–1850*)
[Ber.] IX, p. 251.*

Maurisset, Théodore (*fl. 1834–1859*)
[Ber.] IX, p. 251.*

Maurou, Paul (*b. 1848*)
[Ber.] IX, p. 252.*

Mauve, Anton (*1838–1888*)
Zilcken, Ph. "De etsen van A. Mauve." In *Anton Mauve,* by H. L. Berckenhoff. pp. 25–28. Amsterdam: J. M. Schalekamp, 1890.
Entries: 18 (to 1890?). Millimeters. Inscriptions. States. Described.

Zilcken, Ph. *Peintres hollandais modernes.* Amsterdam: J. M. Schalekamp, 1893.
Entries: 19 (to 1893?). Millimeters. Inscriptions. Described.

Mauzaisse, Jean Baptiste (*1784–1844*)
[Ber.] IX, pp. 252–253.*

Maverick family (*19th cent.*)
Stephens, Stephen DeWitt. *The Mavericks, American engravers.* New Brunswick (N.J.): Rutgers University Press, 1950.
Entries: 3 prints by Ann Maverick, née Anderson, 2 by Catherine Maverick, 10 by Emily Maverick Stoutenburgh, 14 by Maria Ann Maverick Townsend, 3 by Octavia Maverick Spafard, 679 by Peter Maverick, 3 by Peter Maverick

II, 70 by Peter Rushton Maverick, 111 by Peter Rushton Maverick and Peter Maverick. Inches. Inscriptions. Described. Located (selection).

Stephens, Stephen DeWitt. *Documentation, corrections and additions to the Mavericks, American engravers.* n.p. Privately printed, The Press of the Stepping Hen, 1964. 50 copies. (MH)
Additional information to Stephens 1950.

Maverick, Emily *(fl. c.1830)*
See also **Maverick** family

[St.] pp. 359–360.*

Maverick, Maria Ann *(fl. c.1830)*
See also **Maverick** family

[St.] p. 360.*

Maverick, Peter *(1780–1831)*
See also **Maverick** family

[St.] pp. 360–371.*

[F.] pp. 189–194.*

Maverick, Peter and Durand
[F.] p. 194.*

Maverick, Durand and Co.
[F.] p. 194.*

Maverick [Peter], Peter Rushton *(1755–1811)*
See also **Maverick** family

[Allen] pp. 140–145.*

[St.] pp. 371–372.*

Maverick, Samuel
See also **Maverick** family

[St.] p. 373.*

[F.] pp. 195–196.*

Maviez, N. F. *(fl. c.1800)*
[Ap.] p. 276.
Entries: 2.*

Mavignier, Almir *(20th cent.)*
Kestner-Gesellschaft, Hannover [Wieland Schmied, compiler]. *Ausstellung Almir Mavignier.* Hannover (West Germany), 1968.
Entries: unnumbered, pp. 104–114. Millimeters. Illustrated (selection).

May, Édouard *(c.1807–1881)*
[Ber.] IX, pp. 253–254.*

May, Matthias *(1884–1923)*

Schmidt, Justus. *Der Maler Matthias May und seine Linzer Schule.* Vienna: Anton Schroll und Co., 1954.
Entries: 74. Millimeters. Described. Illustrated (selection).

May, Walo van *(1879–1928)*
Schütz, Hermann. "Der Illustrator Walo von May." *Illustration 63,* 9 (1972): 93–96.
Bibliography of books with illustrations by.

Mayer, Carl *(1798–1868)*
[Ap.] p. 276.
Entries: 5.*

Mayer, Harmen de *(1624–1701)*
[W.] II, p. 157.
Entries: 3.*

[H. *Neth.*] XIV, p. 24.
Entries: 18+. Illustrated (selection).*

Mayer, Lucas *(fl. 1566–1590)*
See **Monogram MF** [Nagler, *Mon.*] IV, no. 1777

Mayerhoffer, Johann *(1764–1832)*
[Dus.] pp. 107–110.
Entries: 12+ (lithographs only, to 1821). Millimeters (selection). Located (selection).

Mayr, Alexander
See **Mair**

Mayr, C. von *(19th cent.)*
[Dus.] p. 111.
 Entries: 1 (lithographs only, to 1821).

Mayr, Carl Friedrich *(1823–1884)*
[Ap.] p. 276.
 Entries: 1.*

Mayr, Jacob *(fl. 1575–1587)*
[A.] IV, pp. 341–342.
 Entries: 1. Inscriptions. Described.

Mayr, Johan Ulrich *(c.1630–1704)*
[W.] II, p. 157.
 Entries: 2 prints by, 10 after.*

Mayr, Simon *(fl. c.1806)*
[Dus.] p. 111.
 Entries: 3 (lithographs only, to 1821).
 Millimeters. Inscriptions. Located.

Mazel, Jan Zacharie *(1792–1884)*
[H. L.] p. 709.
 Entries: 3. Millimeters. Inscriptions.
 Described.

Mazzocati, Peregrino *(fl. c.1650)*
[Vesme] p. 342.
 Entries: 1. Millimeters. Inscriptions.
 Described.

Mazzocchi Dalle Biave, Dante *(1798–1853)*
[AN.] pp. 678–679.
 Entries: unnumbered, p. 679. Mil-
 limeters. Inscriptions. Described.

[AN. 1968] p. 176.
 Entries: unnumbered, p. 176 (addi-
 tional to [AN.]). Millimeters. Inscrip-
 tions.

Mazzola, Francesco
See **Parmigianino**

Mazzoli, Ferdinand *(b. 1821)*
[Ber.] IX, p. 254.*

Mazzoni, Cesare Giuseppe *(1678–1763)*
[B.] XIX, pp. 452–453.
 Entries: 1. Pre-metric. Inscriptions.
 Described.

Mazzuoli, Francesco
See **Parmigianino**

Meadows, Christian *(fl. 1839–1859)*
Ormsbee, Thomas H. "Christian
Meadows, engraver and counterfeiter."
American collector 13, no. 12 (January
1945): 6–9, 18.
 Entries: 8. Illustrated (selection).

Méaulle, Fortuné Louis *(b. 1844)*
[Ber.] IX, p. 254.*

Mechel, Christian von *(1737–1817)*
Wüthrich, Lukas Heinrich. *Das Oeuvre
des Kupferstechers Christian von Mechel,
vollständiges Verzeichnis der von ihm
geschaffenen und verlegten graphischen
Arbeiten.* Basel: Helbing und Lichten-
hahn, 1959.
 Entries: 392 single prints by and prints
 published by, 11 sets of prints by and
 prints published by. Millimeters. In-
 scriptions. Described. Illustrated
 (selection). Located. Bibliography for
 each entry. Also, bibliography of
 books with illustrations by and illus-
 trations published by.

Meckenem, Israhel I van *(fl. 1457–1466)*
[P.] II, pp. 202–203.
 Entries: 7. Pre-metric. Inscriptions.
 Described. Located.

[W.] III, pp. 215–218.
 Entries: 115.*

Lehrs, Max. "Der Meister der Berliner
Passion." [JprK.] 21 (1900): 135–159.
 Entries: 115. Millimeters. States. De-
 scribed (selection). Illustrated (selec-
 tion). Located. Bibliography for each
 entry.

[Lehrs] III, pp. 1–139.
Entries: 117. Millimeters. Inscriptions. States. Described. Illustrated (selection). Located. Locations of all known impressions are given. Copies mentioned. Watermarks described. Bibliography for each entry.

[H. *Neth.*] XII, pp. 79–113.
Entries: 117. Illustrated (selection).*

Meckenem, Israhel II van (*c.1445–1503*)
[B.] VI, pp. 184–308.
Entries: 236 prints by, 35 doubtful prints, 45 rejected prints. Pre-metric. Inscriptions. States. Described.

[Evans] pp. 39–40.
Entries: 7 (additional to [B.]). Millimeters. Inscriptions. Described.

[P.] II, pp. 190–199.
Entries: 31 (additional to [B.]). Pre-metric. Inscriptions. Described. Located. Copies mentioned. Additional information to [B.].

[Wess.] I, pp. 142–143.
Entries: 1 (additional to [B.] and [P.]). Millimeters. Inscriptions. Described. Located. Additional information to [B.] and [P.].

Geisberg, Max. *Verzeichnis der Kupferstiche Israhels van Meckenem †1503.* Studien zur deutschen Kunstgeschichte, 58. Strasbourg: J. H. Ed. Heitz, 1905.
Entries: 569. Millimeters. Inscriptions. States. Described. Located. Bibliography for each entry. Appendices with lists of prints by other artists reworked by Van Meckenem, doubtful and rejected prints.

Lehrs, M. ''Neues über Israhel van Meckenem (gelegentlich des Buches von Max Geisberg).'' [*MGvK.*] 1906, pp. 38–44.
Entries: 20 (additional to Geisberg). Millimeters. Inscriptions. Described. Illustrated (selection). Located.

[W.] III, pp. 115–124.
Entries: 46+ prints by, 1+ after.*

[Lehrs] IX, pp. 1–487.
Entries: 624. Millimeters. Inscriptions. States. Described. Illustrated (selection). Located. Locations of all known impressions are given. Copies mentioned. Watermarks described. Bibliography for each entry.

Meckseper, Friedrich (*b. 1936*)
Friedrich Meckseper Radierungen. Hagen (West Germany): Karl Ernst Osthaus Museum, 1968.
Entries: 98 (to 1968). Millimeters. Illustrated (selection).

Galerie Schmücking, Braunschweig [Rolf Schmücking, compiler]. *Meckseper, Werkverzeichnis der Radierungen 1956–1969.* Braunschweig (West Germany), 1969. 1000 copies.
Entries: 116. Millimeters. Described. Illustrated.

Mécou, Joseph (*1771–1837*)
[Ap.] pp. 276–277.
Entries: 3.*

[Ber.] IX, pp. 254–255.*

Medicis, Marie de (*1573–1642*)
[RD.] V, pp. 66–67; XI, pp. 189–190.
Entries: 1. Millimeters. Inscriptions. Described.

Medina, John Baptist (*1655/60–1710*)
[W.] II, p. 127.
Entries: 6 prints after.*

Meer, Jan van der, de Jonghe (*1656–1705*)
[B.] I, pp. 231–233.
Entries: 2. Pre-metric. Inscriptions. Described.

[Weigel] pp. 30–31.
Entries: 2 (additional to [B.]). Pre-metric. Described.

Meer, Jan van der, de Jonghe (*continued*)

[Dut.] V, pp. 183–185, 594.
Entries: 4. Millimeters. Inscriptions.
Described.

[W.] II, pp. 128–129.
Entries: 4 prints by, 1 after.*

[H. *Neth.*] XIV, pp. 1–3.
Entries: 5 prints by, 9 after. Illustrated
(selection).*

Meer, Noach van der (*b. 1713*)
[W.] II, p. 129.
Entries: 11+.*

Meeren, Aegidius van der (*fl. c.1675*)
[W.] II, p. 129.
Entries: 1.*

Meerhoud, Jan (*c.1620–1677*)
[W.] II, pp. 129–130.
Entries: 1 print after.*

[H. *Neth.*] XIV, p. 4.
Entries: 1 print after.*

Meerman, Hendrik (*fl. 1640–1650*)
[W.] II, p. 130.
Entries: 3 prints after.*

[H. *Neth.*] XIV, p. 4.
Entries: 3 prints after.*

Meers, J. (*18th cent.*)
[Sm.] II, "additions and corrections"
section.
Entries: 1 (portraits only). Inches. In-
scriptions. States. Described.

Meersman, François de (*1830–c.1905*)
[W.] II, p. 130.
Entries: 4.*

Meerte, Peeter (*c.1620–1669*)
[W.] II, p. 130.
Entries: 2 prints after.*

[H. *Neth.*] XIV, p. 4.
Entries: 3 prints after.*

Megan, Reinier (*1637–c.1703*)
[W.] II, pp. 130–131.
Entries: 1+.*

[H. *Neth.*] XIV, p. 5.
Entries: 6. Illustrated (selection).*

Megen, Pieter Willem van (*1750–1785*)
[W.] II, p. 131; III, p. 124.
Entries: 8.*

Méheut, Mathurin (*b. 1882*)
Valotaire, M. "Mathurin Méheut, de-
corateur de livres." *Byblis* 3 (1924): 45–48,
1 unnumbered page following p. 80.
Entries: unnumbered, 1 p., (to 1924).
Millimeters.

Hesse, Raymond. *Mathurin Méheut.* Les
artistes du livre, 7. Paris: Henry Babou,
1929. 750 copies. (NN)
Bibliography of books with illustra-
tions by (to 1929).

Meheux, Francis (*b. 1644*)
[W.] II, p. 131.
Entries: 3.*

Mehus, Lieven (*1630–1691*)
[W.] II, p. 131.
Entries: 2 prints by, 2 after.*

[H. *Neth.*] XIV, p. 5.
Entries: 3 prints by, 5 after.*

Mei, Bernardino (*c.1615–1676*)
[Vesme] pp. 12–15.
Entries: 11. Millimeters. Inscriptions.
Described. Located (selection).

Meichsner, Hans (*fl. 1619–1625*)
[A.] IV, pp. 265–269.
Entries: 3. Pre-metric. Inscriptions.
States. Described.

Meier, Christoph (*fl. 1586–1604*)
See **Monogram CM** [Nagler, *Mon.*] II,
nos. 393, 414

Meier, H. *(19th cent.)*
[Ap.] p. 277.
Entries: 1.*

Meier, Melchior, *(fl. c.1582)*
[Evans] p. 22.
Entries: 1. Millimeters. Inscriptions.
Described.

[P.] III, pp. 474–476.
Entries: 6 prints by, 3+ doubtful
prints. Pre-metric (selection). Paper
fold measure (selection). Inscriptions.
Described. Located (selection).

Meijer, Agta *(1908–1944)*
"Agta Meijer." *Boekcier,* 2d ser. 1 (1946):
7–8.
Entries: unnumbered, pp. 7–8. Milli-
meters. Described. Illustrated (selec-
tion).

Meil, Johann Wilhelm *(1751–1802)*
Höpffer, Ferdinand Ludwig. *Verzeichnis
sämmtlicher Titelkupfer und Vignetten-
Abdrucke von Johann Wilhelm Meil, Direk-
tor ker Königl. Preuss. Akademie der Künste
zu Berlin, von seinen ersten bis zu seinen
letzten Arbeiten.* Berlin: C. A. Platen,
1809. (EBKk)
Entries: 996. Inscriptions (selection).
States. Described (selection). Based
on Meil's notes.

"Katalog der Kupferstiche und
Vignetten-Abdrücke von Johann
Wilhelm Meil, 1751–1802." Unpublished
ms. (EBKk)
Entries: 1033. Inscriptions. Described.
Refers to Höpffer numbers.

Dorn, Wilhelm. *Meil-Bibliographie, Ver-
zeichnis der von dem Radierer Johann
Wilhelm Meil illustrierten Bücher und Al-
manache.* Berlin: Gsellius, 1928.
Bibliography of books with illustra-
tions by.

Meilhac, Henri
See **Talin**

Mein, Étienne *(1865–1938)*
Mein, Jean. *Étienne Mein, peintre-graveur
1865–1938.* Marseille (France): "SOPIC,"
1952. 375 copies. (EPBN)
Entries: 75. Millimeters. Inscriptions.
States. Described.

Meinders, Ipe *(fl. c.1650)*
[H. *Neth.*] XIV, p. 6.
Entries: 1.*

Meinderstma, D. *(fl. c.1675)*
[W.] II, p. 131.
Entries: 1 print after.*

[H. *Neth.*] XIV, p. 6.
Entries: 1 print after.*

Meinhold, Karl *(19th cent.)*
[Dus.] p. 111.
Entries: 2+ (lithographs only, to 1821).
Millimeters (selection). Inscriptions.

Meissonier, Jean Louis Ernest *(1815–1891)*
Burty, Philippe. "Les eaux-fortes et les
bois de M. Meissonier." [*GBA.*] 1st ser.
12 (1862): 429–439.
Entries: 11 etchings, 1 photomechani-
cal process print (to 1862). Millime-
ters (selection). Inscriptions. States.
Described. Also, bibliography of
books with illustrations by (to 1862).

Burty, Philippe. "Das Werk E. Meis-
soniers." [*N. Arch.*] 7–8 (1861–1862):
266–267.
Entries: 10 etchings. Millimeters.
States. From [*GBA.*] catalogue.

[Ber.] X, pp. 5–25.
Entries: 37 etchings, 323 wood engrav-
ings, prints after (selection only) un-
numbered, pp. 23–25. Paper fold
measure. Described (selection).

Schaus, William. *Collection of etchings
and engravings by and after the work of J. L.
E. Meissonier.* New York: William
Schaus, [1896?].

Meissonier, Jean Louis Ernest (*continued*)

Entries: 18 prints by, 194 after. Millimeters. Described (selection).

Gréard, Octave. *Jean Louis Ernest Meissonier; ses souvenirs, ses entretiens.* Paris: Librairie Hachette et Cie, 1897. English ed. *Meissonier, his life and his art.* 2 vols. London: William Heinemann, 1897. American ed. New York: A. C. Armstrong, 1897.
Entries: unnumbered, pp. 445–449 (French edition), prints by and after. Millimeters (selection). Paper fold measure (selection). States.

Roeper, Adalbert. "Meissonier." [*Bb.*] 76 (1909): 9836–9840, 9873–9877, 9916–9920. Separately bound copy. (NN)
Entries: 24 prints by, prints after unnumbered, pp. 9837–9840, 9873–977. 9916–9920. Millimeters (selection). Paper fold measure (selection). States. Described.

Meissonnier, Juste Aurèle (*c.1695–1750*)
Bataille, Marie Louise. "Meissonnier." In [Dim.] II, pp. 363–378.
Entries: 42+ prints after.

Meister, Simon (*1796–1844*)
[Merlo] pp. 574–578.
Entries: 9 prints after. Paper fold measure. Inscriptions. Described.

Melar, Adriaen (*1633–1667*)
[W.] II, p. 133.
Entries: 15+.*

[H. *Neth.*] XIV, pp. 6–7.
Entries: 30+.*

Melchior, Georg Wilhelm (*1780–1826*)
[Dus.] pp. 111–112.
Entries: 8+ (lithographs only, to 1821). Millimeters. Inscriptions. Located.

Meldemann, Nicolaus (*fl. c.1530*)
[B.] VII, pp. 481–484.
Entries: 2. Pre-metric. Inscriptions. Described.

[Heller] pp. 91–94.
Entries: 13 (additional to [B.]). Pre-metric. Inscriptions. Described.

[P.] III, pp. 244–247.
Entries: 14 (additional to [B.]). Pre-metric. Inscriptions. Described. Located (selection).

Melder, Gerard (*1693–1754*)
[Wess.] II, p. 243.
Entries: 5+. Millimeters. Inscriptions. Described.

[W.] II, p. 133.
Entries: 1+.*

Meldolla, Andrea [called "Andrea Schiavone"] (*d. 1563*)
[B.] XVI, pp. 31–73.
Entries: 87. Pre-metric. Inscriptions. States. Described.

[B.] XVI, pp. 77–92.
Entries: 33. Pre-metric. Inscriptions. States. Described.

[P.] VI, pp. 175–176.
Additional information to [B.].

Frölich-Bum, Lili. "Andrea Meldolla, genannt Schiavone." [*WrJ.*] 31 (1913–1914): 137–220.
Entries: 15 (additional to [B.]). Millimeters. Inscriptions. Described. Illustrated (selection). Located (selection). Additional information to [B.].

Mélingue, Etienne Marin (*1808–1875*)
[Ber.] X, p. 26.*

Mellan, Claude (*1598–1688*)
Montaiglon, Anatole de. "Catalogue raisonné de l'oeuvre de Claude Mellan d'Abbeville." [*Mém. Abbéville*] 8 (1852–

1857): 291–559. Separately published.
Abbéville (France): P. Briez, 1856.
Entries: 378. Millimeters. Inscriptions. States. Described. Appendix with list of prints after. Ms. addition (ECol); additional information based on prints in the Chatsworth collection.

[Wess.] IV, p. 61.
Additional information to Montaiglon.

Mellin, Charles *(1597–1649)*
[RD.] II, pp. 1–2; XI, p. 202.
Entries: 1. Pre-metric. Inscriptions. Described.

Melois, Laurent *(fl. c.1880)*
[Ber.] X, p. 26.*

Meloni, Altobello *(fl. 1497–1517)*
[P.] V, pp. 147–149.
Entries: 3. Pre-metric. Inscriptions. Described. Copies mentioned.

[M.] I, pp. 559–561.
Entries: 4 prints by (doubtful), 2 after. Millimeters (selection). Paper fold measure (selection). Inscriptions (selection). Described (selection).

[Hind] V, pp. 221–223.
Entries: 3. Millimeters. Inscriptions. Described. Illustrated. Located.

Meloni, Francesco Antonio *(1676–1713)*
[B.] XIX, pp. 442–451.
Entries: 16 prints by, 6 doubtful prints. Pre-metric. Inscriptions. Described.

Meltzer, E. *(19th cent.)*
[Dus.] pp. 112–113.
Entries: 1 (lithographs only, to 1821). Millimeters. Inscriptions. Described. Located.

Memet, ——— *(19th cent.)*
[Ber.] X, p. 26.*

Memling, Hans *(c.1433–1494)*
[W.] II, pp. 134–144.
Entries: 1 print after.*

[H. *Neth.*] XIV, p. 7.
Entries: 9 prints after.*

Mengardi, Giovanni Battista *(1738–1796)*
[Vesme] p. 517.
Entries: 2. Millimeters. Inscriptions. Described.

Mengazzino
See **Santi,** Domenico

Menge, ——— *(19th cent.)*
[Dus.] p. 113.
Entries: 1 (lithographs only, to 1821). Millimeters. Inscriptions. Located.

Mengelberg, Otto *(1818–1890)*
[Merlo] pp. 585–587.*

Mennig, Christoph *(18th cent.)*
[Merlo] p. 587.*

Mennig, Franz Xaver *(19th cent.)*
[Merlo] p. 588.*

Menozzi, Pietro *(1813–1878)*
[Ap.] p. 277.
Entries: 1.*

Menton, Frans *(fl. 1570–1615)*
[W.] II, p. 145.
Entries: 1+ prints by, 1 after.*

[H. *Neth.*] XIII, p. 35.
Entries: 1. Illustrated.*

[H. *Neth.*] XIV, p. 8.
Entries: 4 prints by, 2 after. Illustrated (selection).*

Menut
See **Alophe**

Menyhart, Josef *(20th cent.)*
Rethy, Istvan, and Rödel, Klaus. *Josef Menyhart, en ungarsk exlibriskunstner.*

Menyhart, Josef (*continued*)

Frederikshavn (Denmark): Privately printed, 1968. 75 copies. (DLC)
Entries: 256 bookplates and commercial prints (to 1968). Described. Illustrated (selection).

Menzel, Adolf Friedrich Erdmann *(1815–1905)*
[A. 1800] V, pp. 1–50.
Entries: 181. Millimeters. Inscriptions. States. Described. Also, list of 32 prints after, not fully catalogued.

Wessely, Joseph Eduard. *Adolph Menzel, sein Leben und seine Werke.* Extract from [A. 1800]. Leipzig: Alexander Danz, 1875.
Entries: 180. Millimeters (selection). Paper fold measure (selection). Inscriptions. States. Described.

Dorgelöh, A. *Verzeichnis der durch Kunstdruck vervielfältigten Arbeiten Adolf Menzels.* Leipzig: Verlag von E. A. Seeman, 1896.
Entries: 1393 prints by and after. Millimeters. Inscriptions. States. Described.

Bock, Elfried. *Adolph Menzel, Verzeichnis seines graphischen Werkes.* Berlin: Verlag von Amsler und Ruthardt, 1923.
Entries: 1160 prints by, 58 prints after and rejected prints. Millimeters. Inscriptions. States. Described. Illustrated (selection). Located (selection).

Brockerhoff, Jurt. "Eine unbekannte Gebrauchsgraphik Adolf Menzels." *Zeitschrift des Vereins für die Geschichte Berlins* 54 (1937): 86–90.
Entries: 1 (additional to Bock). Millimeters. Inscriptions. Described. Illustrated. Located.

Menzel, C. E. *(19th cent.)*
[Dus.] pp. 113–114.

Entries: 10 (lithographs only, to 1821). Inscriptions. Located (selection).

Mera, Pietro [called "il Fiammingo"] *(fl. 1570–1611)*
[W.] II, p. 145.
Entries: 1 print after.*

[H. *Neth.*] XIV, p. 8.
Entries: 1 print after.*

Merano, Giovanni Battista *(1632–1698)*
[Vesme] p. 344.
Entries: 1. Millimeters. Inscriptions. Described. Located.

Mercati, Giovanni Battista *(b. 1600)*
[B.] XX, pp. 138–148.
Entries: 64 prints by, 1 doubtful print, 2 prints not seen by [B.]. Pre-metric. Inscriptions. States. Described.

Mercator, Gerhard *(1512–1594)*
[H. *Neth.*] XIV, p. 9.
Entries: 1+.*

Mercey, Frédéric Bourgeois de *(1805–1860)*
[Ber.] X, pp. 26–27.*

Mercier, ——— *(19th cent.)*
[Ber.] X, p. 27.*

Mercier, Charles André *(18th cent.)*
Dacier, Émile. "Un graveur ignoré du XVIIIe siècle, Charles-André Mercier." [*Am. Est.*] 8 (1929): 161–174.
Entries: 7. Millimeters (selection). Inscriptions. Described. Illustrated.

Mercier, Gustave *(c.1858–1898/99)*
[Ber.] X, p. 27.*

Mercier, Philippe *(1689–1760)*
"Essai de catalogue de pièces gravées par et d'après Mercier." *Nouvelles de l'estampe,* 1969, pp. 397–398.

Entries: 30 prints by and after. Inscriptions (selection). Described (selection).

Merck, B. *(19th cent.)*
[Dus.] p. 114.
Entries: 1 (lithographs only, to 1821). Millimeters. Inscriptions. Located.

Merck, Jacob Frans van der *(c.1610–1664)*
[H. *Neth.*] XIV, p. 9.
Entries: 1 print after.*

Merck, P. *(fl. c.1650)*
[W.] II, p. 145.
Entries: 1 print after.*

[H. *Neth.*] XIV, p. 9.
Entries: 2 prints after.*

Mercoli, Michelangelo *(1773–1802)*
[Ap.] p. 277.
Entries: 1.*

Mercuri, Paolo *(1804–1884)*
[Ap.] pp. 277–278.
Entries: 6.*

[Ber.] X, pp. 27–33.
Entries: 14+. Paper fold measure.

Merello, L. *(19th cent.?)*
[Ap.] p. 278.
Entries: 1.*

Merian, Kaspar *(1627–1686)*
[Hüsgen] pp. 173–189.
Entries: 36+. Paper fold measure. Also, bibliography of books published by, pp. 179–189.

Merian, Maria Sibylla *(1647–1717)*
Stuldreher-Nienhuis, J. *Verborgen paradijzen; het leven en de werken van Maria Sibylla Merian 1647–1717.* 2d ed., rev. Arnhem (Netherlands): Van Loghum Slaterus' Uitgeversmaatschappij, 1945. 1st ed. Arnhem, 1944, not seen.

Bibliography of books with illustrations by.

Merian, Matthäus I *(1593–1650)*
Eckardt, H. *Matthaeus Merian; Skizze seines Lebens und ausführliche Beschreibung seiner "Topographia Germaniae," nebst Verzeichniss der darin enthaltenen Kupferstiche.* 1st ed. 1887 (not seen). Reprint. Amsterdam: Meridian Publishing Co., 1963.
Entries: unnumbered, pp. 48–170 (prints in *Topographia Germaniae* only). Also, overall catalogue based on [Nagler]: Entries: 87+. Pre-metric. Inscriptions (selection).

Eckhardt, H. *Matthaeus Merian, eine kulturhistorische Studie.* Kiel (Germany): H. Eckhardt, 1892.
Entries: 87+. Pre-metric. Inscriptions (selection). Based on [Nagler].

Schuchhard, C. "Die Zeiller-Merianischen Topographieen, bibliographisch beschreiben." *Centralblatt für Bibliothekswesen* 13 (1896): 193–232. Reprint. *Philobiblon* 3 (1959): 293–339. Separately published. Philobiblon-Schriften 3. Hamburg: Dr. Ernst Hauswedell und Co., 1960. 600 copies. Reprint (appendix to Eckhardt 1887). Amsterdam: Meridian Publishing Co., 1963.
Bibliography of books with illustrations by (topographical works only).

Wüthrich, Lukas Heinrich. *Das druckgraphische Werk von Matthaeus Merian d. Ae.* 2 vols. Vol. I, *Einzelblätter und Blattfolgen.* Vol. II, *die weniger bekannten Bücher und Buchillustrationen.* Basel: Bärenreiter-Verlag, 1966, 1972.
Entries: 677 single prints and prints in sets (not including book illustrations). Millimeters. Inscriptions. States. Described. Illustrated (selection). Also, bibliography of books with illustrations by and books published by

Merian, Matthäus (*continued*)

(lesser-known books only). To be completed by a third volume.

Merian, Matthäus II *(1621–1687)*
[Hind, *Engl.*] III, pp. 329–331.
Entries: 5+ (prints done in England only). Inches. Inscriptions. Described. Illustrated (selection). Located.

Merica, Petrus a
See **Heyden,** Pieter van der

Merke, Henri *(fl. 1800–1820)*
See also **Goodby,** James
[Siltzer] p. 361.
Entries: unnumbered, p. 361. Inscriptions.

Merke and Nichols *(19th cent.)*
[Siltzer] p. 361.
Entries: unnumbered, p. 361. Inscriptions.

Merlen, Abraham van *(1579–1660)*
[W.] II, p. 147.
Entries: 5.*

[H. *Neth.*] XIV, pp. 10–11.
Entries: 35.*

Merlen, Cornelis van *(c.1654–1723)*
[W.] II, p. 147.
Entries: 3.*

[H. *Neth.*] XIV, p. 11.
Entries: 16.*

Merlen, Theodor I and II van *(17th cent.)*
[W.] II, p. 147.
Entries: 18.*

[H. *Neth.*] XIV, pp. 12–13.
Entries: 50.*

Merlot, Pierre *(1713–1782)*
Pas, Justin de. "Pierre Merlot, graveur à Saint-Omer." [*Arch. Ex.-lib.*] 13 (1903): 24–28.

Entries: 4 (bookplates only). Millimeters. Inscriptions. Described. Illustrated.

Pas, J. de. "Pierre Merlot; graveur à Saint-Omer (1713–1782)." *Bulletin historique de la société des antiquaires de la Morinie* 11 (1902–1906): 473–480, 560; *Bulletin* 12 (1907–1911): 62, 813–815; *Bulletin* 13 (1912–1922): 218–221.
Entries: 16. Millimeters (selection). Inscriptions. Described. Illustrated (selection).

Merritt, Anna Lea *(19th cent.)*
Koehler, Sylvester R. "The works of the American etchers, VIII; Anna Lea Merritt." [*Amer. Art Review*] 1 (1880): 229–230.
Entries: unnumbered, p. 230 (to 1880). Inches (selection). Inscriptions (selection).

Merson, Luc Olivier *(1846–1920)*
[Ber.] X, p. 33.*

Mertz, B. *(19th cent.)*
[Dus.] p. 114.
Entries: 1 (lithographs only, to 1821). Millimeters. Located.

Merwen, S. F. van *(fl. 1590)*
[H. *Neth.*] XIV, p. 14.
Entries: 1.*

Méryon, Charles *(1821–1868)*
Burty, Philippe. "L'Oeuvre de M. Charles Méryon." [*GBA.*] 1st ser. 14 (1863): 518–533; [*GBA.*] 1st ser. 15 (1863): 75–88.
Entries: 84 (to 1863?). Millimeters. Inscriptions. States. Described.

Méryon, Charles. "Mes observations sur l'article de la Gazette des Beaux-Arts (livraison du 1er juin 1863)." Unpublished ms. (copy, NNMM)
Additional information to Burty 1863.

Burty, Philippe. *Charles Méryon; sailor, engraver, and etcher, a memoir and complete descriptive catalogue of his works, translated . . . by Marcus B. Huish.* London: Fine Art Society, 1879. 125 copies. (CSfAc)
Entries: 97. Inches. Inscriptions. States. Described (selection).

Wedmore, Frederick. *Méryon and Méryon's Paris, with a descriptive catalogue of the artist's work.* London: A. W. Thibaudeau, 1879. 113 copies. 2d ed., rev. and enl. London: Deprez and Gutekunst, 1892. 129 copies. (NN)
Entries: 94 (second edition includes 1 additional print). Inches. Inscriptions. States. Described.

Ellis, F. S. *A descriptive catalogue of a collection of drawings and etchings by Charles Meryon formed by the Rev. J. J. Heywood.* London: Ellis and White, 1880. 75 copies. (EBM)
Additional information to Wedmore and Burty. Ms. notes (ECol); additional information.

Keppel, Frederick. *Catalogue of the etched work of Charles Méryon.* New York: Frederick Keppel and Co., 1886.
Entries: 132. States (selection). Different states of the same print are separately numbered.

[Ber.] X, pp. 33–53.
Entries: 97. Paper fold measure. Inscriptions (selection). Described (selection).

[Del.] II.
Entries: 102. Millimeters. Inscriptions. States. Described (selection). Illustrated. Located (selection). Appendix with 3 rejected prints, and list of copies after Meryon.

P. and D. Colnaghi and Obach. "Catalogue of the B. B. MacGeorge collection of Méryon's etchings; lately in Glasgow, but sold in 1916, and since dispersed in America; with notes on the states, including many not described by Delteil, and a list of states represented in the British Museum. Compiled and presented by Messrs. P. & D. Colnaghi & Obach." London, 1917. Unpublished ms. (EBM)
Entries: 103. States.

Wright, Harold J. "Some undescribed states of Meryon etchings." [*PCQ.*] 8 (1921): 171–201.
Additional information to [Del.].

Delteil, Loys, and Wright, Harold J. L. *Catalogue raisonné of the etchings of Charles Meryon.* New York: Winfred Porter Truesdell, 1924.
Entries: 102. Millimeters. Inches. Inscriptions. States. Described. Illustrated. Located. Revised edition of [Del.] with additional states and other information. Ms. notes (ECol) by Harold J. L. Wright; additional states. Ms. notes (NN); a few additional states.

Delteil Loys, and Wright, Harold J. L. *Catalogue raisonné of the etchings of Charles Meryon, 1924; addenda and errata.* London, 1925. (EBM)
Additional information to Delteil and Wright 1924.

Merz, Jakob *(1783–1807)*
[Ap.] p. 280.
Entries: 3.*

Merz, Kaspar Heinrich *(1806–1875)*
[Ap.] pp. 278–280.
Entries: 25.*

Mesdach, Salomon *(fl. c.1628)*
[W.] II, p. 148.
Entries: 2 prints after.*

[H. *Neth.*] XIV, p. 14.
Entries: 2 prints after.*

Mesdag, Jodocus A.W.Y.
See **Misdacq**

Meslin, Charles
See **Mellin**

Mesplès, Eugène Paul *(b. 1849)*
[Ber.] X, p. 54.*

Messagier, Jean *(b. 1920)*
Stadthalle, Freiburg im Breisgau
[Rudolf Riester, compiler]. *Jean Messagier, das graphische Werk 1944–1970.*
Freiburg im Breisgau (West Germany),
1970.
Entries: 177. Millimeters. Described.
Illustrated.

Mestrum, Paul *(1778–1825)*
[Merlo] pp. 591–592.*

Metayer, Ph. *(fl. c.1753)*
[W.] II, p. 148.
Entries: 1 print after.*

Métivier, Jean-Baptiste *(1781–1853)*
[Dus.] p. 119.
Entries: 1+ (lithographs only, to 1821).
Millimeters. Located.

Metour, Eugene Paul *(20th cent.)*
Brown, Warren Wilmer. "Eugene Paul
Metour, and his etchings of Annapolis."
[*P. Conn.*] 3 (1923): 178–193.
Entries: 57 (to 1922). Inches. States.
Illustrated (selection).

Metsu, Gabriel *(1629–1667)*
[W.] II, pp. 149–152.
Entries: unnumbered, pp. 151–152,
prints after.*

[H. *Neth.*] XIV, pp. 15–17.
Entries: 76 prints after.*

Mettel, Nikolaus *(fl. 1739–1772)*
[Merlo] pp. 592–596.*

Metteli, V. *(fl. c.1778)*
[W.] II, p. 152.
Entries: 3 prints after.*

Mettenleiter, Franz Xaver I *(1791–1873)*
[Dus.] pp. 118–119.
Entries: 1 (lithographs only, to 1821).
Inscriptions. Located.

Mettenleiter, Johann Evangelist
(1792–1870)
[Dus.] pp. 114–115.
Entries: 9 (lithographs only, to 1821).*
Millimeters (selection). Inscriptions
(selection). Located (selection).

Mettenleiter, Johann Michael *(1765–1853)*
[Dus.] pp. 114–118.
Entries: 43+ (lithographs only, to
1821). Millimeters (selection). Inscriptions (selection). Located (selection).

Metz, Conrad Martin *(1749–1827)*
[Merlo] pp. 599–600.*

Metzger, Christoph *(fl. 1653–1681)*
[Hüsgen] pp. 230–232.
Entries: unnumbered, pp. 231–232.

Metzger, L. *(19th cent.)*
[Dus.] p. 119.
Entries: 1+ (lithographs only, to 1821).
Millimeters. Inscriptions. Located.

Metzmacher, Pierre Guillaume
(1815–after 1872)
[Ap.] pp. 280–281.
Entries: 28.*

[Ber.] X, pp. 54–55.*

Meulemans, Adriaan *(1766–1835)*
[W.] II, p. 152.
Entries: 1.*

Meulemeester, Joseph Charles de
(1771–1836)
Busscher, Edmond de. *Biographie historique et artistique de J.-C. de Meulemeester de Bruges, graveur en taille-douce,
éditeur des loges de Raphael d'Urbin.*
Ghent (Belgium): De Busscher frères,
1837. (EBrM)

Entries: 12+. Paper fold measure. Inscriptions. States.

[Ber.] X, p. 55.*

Meulen, Adam Frans van der *(1632–1690)*
[W.] II, pp. 152–154.
Entries: unnumbered, p. 153, prints after.*

[H. *Neth.*] XIV, pp. 18–20.
Entries: 122 prints after. Illustrated (selection).*

Meulen, P.H.L. van der *(fl. 1803–1830)*
[W.] II, p. 155.
Entries: 2.*

Meulen, Sieuwert van der *(c.1698–1730)*
[W.] II, p. 155.
Entries: 4+ prints by, 1+ after.*

Meulener, Pieter *(1602–1654)*
[H. *Neth.*] XIV, p. 20.
Entries: 1 print after.*

Meunier, Constantin Émile *(1831–1905)*
[H. L.] p. 710.
Entries: 2. Millimeters. Inscriptions. Described.

Meunier, Jean Baptiste *(1821–1900)*
[Ap.] p. 281.
Entries: 1.*

[Ber.] X, pp. 55–56.*

Meunier, Louis *(fl. 1665–1668)*
[RD.] V, pp. 245–299; XI, p. 203.
Entries: 88. Millimeters. Inscriptions. States. Described.

[Ber.] X, p. 56.*

Meurs, Cornelis Hubert van *(fl. 1675–1678)*
[W.] II, p. 155.
Entries: 5.*

[H. *Neth.*] XIV, p. 21.
Entries: 9.*

Meurs, Jacob I van *(c.1619–c.1680)*
[W.] II, pp. 155–156.
Entries: 10.*

[H. *Neth.*] XIV, pp. 21–22.
Entries: 31+. Illustrated (selection).*

Mey, Raphael de *(16th cent.)*
[Merlo] pp. 600–601.*

Meyer, Aldert *(fl. c.1688)*
[W.] II, p. 156.
Entries: 2+.*

[H. *Neth.*] XIV, p. 23.
Entries: 6.*

Meyer, August *(1759–1838)*
[Merlo] p. 601.*

[Dus.] p. 119.
Entries: 1+ (lithographs only, to 1821).

Meyer, Corneles *(c.1650–after 1708)*
[H. *Neth.*] XIV, p. 23.
Entries: 2+. Illustrated (selection).*

Meyer, F. W. *(fl. c.1864)*
[H. L.] p. 711.
Entries: 1. Millimeters. Inscriptions. Described.

Meyer, Hans *(1846–1919)*
[Ap.] p. 281.
Entries: 7.*

Meyer, Heinrich *(1623–1694)*
See **Monogram HM** [Nagler, *Mon.*] III, no. 1250

Meyer, Hendrik II de *(1737–1793)*
[W.] II, p. 157.
Entries: 1+.*

Meyer, Henry *(1783–1847)*
[Siltzer] p. 361.
Entries: unnumbered, p. 361. Inscriptions.

Meyer, L. *(19th cent.)*
[Dus.] p. 119.
Entries: 2 (lithographs only, to 1821).
Millimeters (selection). Inscriptions.
Located (selection).

Meyer, Rudolph *(1605–1638)*
Matt, Hansjakob von. *Der Radierer Rudolf Meyer von Zürich 1605–1638, mit einem kritischen Katalog seines druckgraphischen Werkes.* Dissertation, Freiburg University. Immensee (West Germany): Calendaria A. G., 1948.
Entries: 296 prints by, 11 doubtful prints. Millimeters. Inscriptions (selection). States. Described (selection). Illustrated (selection). Located.

Meyer-Heine, Théodore *(19th cent.)*
[Ber.] X, pp. 56–57.*

Meyeringh, Aelbert *(1645–1714)*
[B.] V, pp. 353–376.
Entries: 26. Pre-metric. Inscriptions. Described.

[Weigel] pp. 313–314.
Entries: 1 (additional to [B.]). Pre-metric. Inscriptions. Described.

[Wess.] II, p. 243.
Additional information to [B.] and [Weigel].

[W.] II, p. 158.
Entries: 1+.*

[H. *Neth.*] XIV, p. 25.
Entries: 27. Illustrated (selection).*

Meyerpeck, Wolfgang *(fl. 1550–1600)*
[A.] IV, pp. 137–153.
Entries: 15+. Pre-metric. Inscriptions. Described.

Meyling, J. *(fl. c.1800)*
[W.] II, p. 208.
Entries: 1.*

Meys, —— de *(fl. c.1790)*
[W.] II, p. 158.
Entries: 1 print after.*

Meyssens, Cornelis *(c.1640–after 1673)*
[W.] II, pp. 158–159.
Entries: 17+.*

[H. *Neth.*] XIV, p. 26.
Entries: 178.*

Meyssens, Joannes *(1612–1670)*
[W.] II, p. 159.
Entries: 28+ prints by, 5 after.*

[H. *Neth.*] XIV, pp. 27–29.
Entries: 293 prints by, 16 after.*

Meyster, Everhard *(1620–1679)*
[H. *Neth.*] XIV, p. 30.
Entries: 5+. Illustrated (selection.)*

Miccerus, Henric Johan
See **Micker**

Michaelis, Gerrit Jan *(1775–1857)*
[H. L.] pp. 711–712.
Entries: 2. Millimeters. Inscriptions. States. Described.

Michalek, Ludwig *(b. 1859)*
Meder, Josef. "Ludwig Michalek," [*GK.*] 24 (1901): 119–124.
Entries: unnumbered, p. 124 (to 1901).

Roeper, Adalbert. "Ludwig Michalek und sein graphisches Werk." [*Bb.*] 76, no. 93 (24 April 1909): 4946–4951.
Entries: 133 (to 1908). Millimeters. States.

Roeper, Adalbert. "Ludwig Michalek und sein graphisches Werk." [*Kh.*] 8 (1916): 5–11.
Entries: 160 (to 1915). Millimeters. States. Described (selection). Illustrated (selection).

Michallon, Achille Etna *(1796–1822)*
[Ber.] X, p. 57.*

Micheelzen, Dirick *(fl. c.1597)*
[H. *Neth.*] XIV, p. 30.
 Entries: 1 print after.*

Michel, Charles *(fl. c.1880)*
[Ber.] X, p. 57.*

Michelangelo Buonarroti *(1475–1564)*
[B.] XII: *See* **Chiaroscuro Woodcuts**

[P.] VI: *See* **Chiaroscuro Woodcuts**

Heinecken, Karl Heinrich von. "Das
Kupferstichwerk von Michelangelo
Bonaroti." In: *Nachrichten von Künstlern
und Kunst-Sachen.* Vol. I, pp. 355–436.
Leipzig: Johann Paul Kraus, 1768–1769.
(MH)
 Entries: 150+ prints after. Inscriptions
(selection). Described (selection).

Passerini, Luigi. *La Bibliografia di
Michelangelo Buonarroti e gli incisori delle
sue opere.* Florence: M. Cellini e C., 1875.
(NNMM)
 Entries: unnumbered, pp. 157–307,
prints after. Inscriptions (selection).
Described (selection).

Michelet, —— *(fl. c.1850)*
[Ber.] X, p. 57.*

Micheli, Guglielmo *(1866–1926)*
Servolini, Luigi. "Acqueforti e disegni
di Guglielmo Micheli." *Gutenberg
Jahrbuch* 42 (1967): 216–220.
 Entries: 6. Millimeters. Inscriptions.
Illustrated (selection).

Michelin, Jules *(1815–1870)*
[Ber.] X, pp. 57–58.
 Entries: 33 etchings, 1 lithograph.
Paper fold measure (selection).

*Catalogue des objets d'art et de curiosité,
faiences de Rouen, Moustiers, Delft
etc. . . . oeuvre complet de Jules Michelin
. . . Hotel Drouot . . . 21–23 avril 1898.*
Paris: E. Moreau et Cie, 1898.

Entries: 63. Auction catalogue: lot no.
491 is the complete graphic oeuvre of
Michelin.

Michelis, Alexander *(1823–1868)*
[A. 1800] V, pp. 259–267.
 Entries: 12. Millimeters. Inscriptions.
States. Described.

Michetti, Francesco Paolo *(1851–1929)*
[Ber.] X, p. 58.*

Michieli, Andrea *(1539?–1614)*
[M.] I, pp. 709–711.
 Entries: 9 prints after. Paper fold mea-
sure. Described (selection).

Michielszoon, Dirick
See **Micheelzen**

Miciol, Pierre *(1833–1905)*
[Ber.] X, p. 59.*

Micker, Hendrik *(fl. c.1610)*
[W.] II, p. 160.
 Entries: 1.*

[H. *Neth.*] XIV, p. 30.
 Entries: 3.*

Micker, Laurent Jansz *(fl. c.1610)*
[H. *Neth.*] XIV, p. 30.
 Entries: 24.*

Midderigh, —— *(fl. 1848–1870)*
[Ber.] X, p. 59.*

Middiman, Samuel *(c.1750–1831)*
[Ap.] p. 282.
 Entries: 10.*

Middleton, Thomas *(1797–1863)*
[St.] pp. 373–374.*

Midy, Adolphe I *(1797–1874)*
[Ber.] X, pp. 59–60.*

Midy, Eugène Edmond *(1852–1868)*
[Ber.] X, p. 60.*

Miele, Jan *(c.1599–1663)*
[B.] I, pp. 337–346.
Entries: 9. Pre-metric. Inscriptions.
Described.

[Weigel] pp. 43–46.
Entries: 5 (additional to [B.]). Pre-metric. Inscriptions. States. Described.

[Heller] p. 94.
Entries: 1 (additional to [B.]). Pre-metric. Inscriptions. Described.

[Dut.] V, pp. 185–189.
Entries: 14. Millimeters. Inscriptions.
States. Described.

[W.] II, pp. 160–161.
Entries: 13 prints by, 12 after.*

[H. *Neth.*] XIV, pp. 31–37.
Entries: 19 prints by, 19 after. Illustrated (selection).*

Mielich, Hans
See **Müelich**

Miereveld, Leopold *(fl. 1550–1600)*
[H. *Neth.*] XIV, p. 38.
Entries: 2.*

Miereveld, Michiel Jansz van *(1567–1641)*
[W.] II, pp. 162–164.
Entries: 2 prints by, 20+ after.*

[H. *Neth.*] XIV, pp. 38–43.
Entries: 3 prints by, 120 after.*

Miereveld, Pieter van *(1596–1623)*
[W.] II, p. 164.
Entries: 1 print after.*

[H. *Neth.*] XIV, p. 43.
Entries: 1 print after.*

Mieris, Frans I van *(1635–1681)*
[W.] II, pp. 164–167.
Entries: 1 print by, 57 after.*

[H. *Neth.*] XIV, pp. 44–46.
Entries: 1 print by, 71 after. Illustrated (print by only).*

Mieris, Frans II van *(1689–1763)*
[vdK.] p. 18.
Entries: 3. Millimeters. Inscriptions.
Described.

[W.] II, p. 167.
Entries: 3 prints by, 1 after.*

[H. *Neth.*] XIV, pp. 47–48.
Entries: 4 prints by, 5+ after. Illustrated (prints by only).*

Mieris, Jan van *(1660–1690)*
[W.] II, p. 167.
Entries: 3 prints after.*

[H. *Neth.*] XIV, p. 48.
Entries: 5 prints after.*

Mieris, Willem van *(1662–1747)*
[vdK.] pp. 17–19.
Entries: 1. Millimeters. Inscriptions.
States. Described. Illustrated.

[W.] II, pp. 167–169.
Entries: 1 print by, 5 after.*

[H. *Neth.*] XIV, p. 49.
Entries: 1 print by, 12 after. Illustrated (print by only).*

Miesse, Gabriel *(b. 1807)*
Drepperd, Carl W. "New delvings in old fields; found, a 'new' early American engraver." *Antiques* 42 (1942): 204–205.
Entries: 4. Inches. Inscriptions. Described. Illustrated. Located (selection).

Miger, Simon Charles *(1736–1820)*
Bellier de La Chavignerie, Émile. *Biographie et catalogue de l'oeuvre du graveur Miger.* Paris: J. B. Dumoulin, 1856.
Entries: 298. Millimeters. Inscriptions. States.

[Ber.] X, pp. 60–61.*

[L. D.] p. 62.
Entries: 1. Millimeters. Inscriptions. States. Described. Incomplete catalogue.*

Mignard, Nicolas *(1606–1668)*
[RD.] I, pp. 99–108; XI, pp. 203–204.
Entries: 11. Pre-metric. Inscriptions. States. Described.

[Wess.] IV, p. 61.
Additional information to [RD.].

[CdB.] pp. 38–40.
Entries: 10. Abridged from [RD.].

Mignard, Pierre *(1612–1695)*
[RD.] I, pp. 98–99, 109; XI, p. 204.
Entries: 1. Pre-metric. Inscriptions. Described.

[CdB.] pp. 41–42.
Entries: 1. Pre-metric. Described.

Migneret, ―――― *(fl. c.1815)*
[Ber.] X, p. 61.*

Migneret, Adrien *(1786–1840)*
[Ap] p. 282.
Entries: 5.*

[Ber.] X, p. 61.*

Mignon, Jean *(fl. 1537–1540)*
[B.] XVI, pp. 366–367.
Entries: 1. Pre-metric. Inscriptions. Described.

[Herbet] IV, pp. 329–338; V, pp. 85–86.
Entries: 27. Millimeters. Inscriptions. States. Described. Located (selection).

Lieure, Jules. "Recherches de l'oeuvre de Jean Mignon." Unpublished ms. (EPBN) "École de Fontainebleau." Unpublished ms. (EPBN)
Ms. notes towards a catalogue.

[Zerner] no. 3.
Entries: 60. Millimeters. Inscriptions. Described. Illustrated.

Mignot, Daniel *(fl. c.1590)*
Hämmerle, Albert. "Daniel Mignot." [*Schw. M.*] 1930, pp. 33–75.
Entries: 100 prints by and after. Millimeters. Inscriptions. States. Described. Illustrated. Located. Copies mentioned.

Mihes, Julie *(1786–1855)*
[Dus.] p. 119.
Entries: 1 (lithographs only, to 1821). Paper fold measure.

Milan, Pierre *(16th cent.)*
[Zerner] no. 7.
Entries: 7 (securely documented prints only). Millimeters. Inscriptions. Described. Illustrated.

Milani, Aureliano *(1675–1749)*
[B.] XIX, pp. 439–441.
Entries: 2. Pre-metric. Inscriptions. Described.

Milheuser, Julius *(c.1611–1680)*
[Merlo] pp. 604–605.*

[W.] II, p. 170.
Entries: 2.*

[H. *Neth.*] XIV, p. 50.
Entries: 12 prints by, 2 after. Illustrated (selection).*

Milius, Félix *(1843–1894)*
[Ber.] X, pp. 62–63.*

Miljuš, Branko N. *(b. 1936)*
Galerija Grafički Kolektiv, Belgrade. *Branko N. Miljuš.* Belgrade (Yugoslavia), 1968.
Entries: 105. Millimeters. Illustrated (selection).

Millais, John Everett *(1829–1896)*
Millais, John Guille. *The life and letters of Sir John Everett Millais.* 2 vols. London: Methuen and Co.; New York: Frederick A. Stokes Co., 1899.

Millais, John Everett (*continued*)

Entries: unnumbered, pp. 495–497, prints after.

Millan, Pierre
See **Milan**

Miller, Andrew (*d. 1763*)
[Sm.] II, pp. 920–940, and "additions and corrections" section.
Entries: 67 (portraits only). Inches. Inscriptions. States. Described. Illustrated (selection). Located (selection).

[Siltzer] p. 361.
Entries: unnumbered, p. 361. Inscriptions.

[Ru.] pp. 226–227.
Entries: 3 (portraits only, additional to [Sm.]). Inches (selection). Inscriptions. Described. Additional information to [Sm.].

Miller, Charles H. (*1842–1922*)
Koehler, Sylvester R. "The works of the American etchers, XVII; Charles H. Miller," [*Amer. Art Review*] 2, no. 1 (1881): 102.
Entries: 13 (to 1880). Inches. Inscriptions.

Miller, William (*1796–1882*)
[Ap.] p. 282.
Entries: 6.*

M———, W. F. *A catalogue of engravings by William Miller H.R.S.A., 1818 to 1871.* London: Simmons and Botten, 1886. (PJRo)
Entries: unnumbered, pp. 7–35. Inches (selection). Paper fold measure (selection).

Millet, Aimé (*1819–1891*)
[Ber.] X, p. 63.*

Millet, Eugène Henri
[Ber.] X, p. 71.*

Millet, Jean François I [called "Francisque"] (*1642–1679*)
[B.] V, pp. 325–350.
Entries: 1 print by, 28 after (by A. Théodore). Pre-metric. Inscriptions. States. Described.

[RD.] I, pp. 243–268; XI, p. 310.
Entries: 3 prints by, 28 after (by A. Théodore). Pre-metric. Inscriptions. States. Described. Concordance with [B.].

[Weigel] pp. 312–313.
Additional information to [B.].

[W.] II, pp. 170–171.
Entries: 3 prints by, 4 after.*

[H. *Neth.*] XIV, p. 51.
Entries: 4 prints by, 32 after. Illustrated (selection).*

Millet, Jean François (*1814–1875*)
Burty, Philippe. "Les eaux-fortes de M. J. F. Millet." [*GBA.*] 1st ser. 11 (1861): 262–266.
Entries: 11 (etchings only, to 1861?). Millimeters. Inscriptions. States. Described (selection).

Piedagnel, Alexandre. *J. F. Millet, souvenirs de Barbizon.* Paris: Vve A. Cadart, 1876.
Entries: 14 etchings, 2 woodcuts, 3 lithographs. Millimeters. Inscriptions. States. Described.

Lebrun, Alfred. Catalogue. In *La vie et l'oeuvre de J. F. Millet,* by Alfred Sensier. Paris: A Quantin, 1881.
Entries: 34 prints by, 2+ after. Millimeters. Inscriptions. States. Described. Illustrated (selection).

Lebrun, Alfred. *Alfred Lebrun's catalogue of the etchings, heliographs, lithographs, and woodcuts done by Jean François Millet.* Translated by Frederick Keppel. New York: Frederick Keppel and Co., 1887. 250 copies. (NN)

Entries: 34. Inches. Inscriptions. States. Described. Illustrated (selection). Appendix with 14 prints after (wood engravings by Lavieille).

[Ber.] X, pp. 63–71.
Entries: 34. Paper fold measure. Inscriptions. States. Described (selection). Based on Lebrun.

[Del.] I.
Entries: 34. Millimeters. Inscriptions. States. Described (selection). Illustrated. Appendix with 3 copies and facsimiles.

Millin, Denis Armand *(1803–1866)*
[Ber.] X, pp. 71–72.*

Minckh, Michael *(fl. 1546–1552)*
[P.] IV, p. 175.
Entries: 1. Pre-metric. Inscriptions. Described. Located.

Minderhout, Hendrik van *(1632–1696)*
[W.] II, p. 171.
Entries: 1 print after.*

[H. *Neth.*] XIV, p. 52.
Entries: 1 print by, 2 after.*

Minette, J. *(fl. c.1700)*
[W.] II, p. 171.
Entries: 1.*

Minne, Joris *(20th cent.)*
Bibliothèque royale de Belgique, Brussels [Louis Lebeer, compiler]. *Expositions de l'oeuvre gravé de Joris Minne.* Brussels, 1933.
Entries: 157+ (to 1933). Millimeters. Illustrated (selection).

Wijngaert, Frank van den. "Joris Minne." *Kunst* 11–12 (1934): 333–408.
Entries: unnumbered, p. 408 (sets of prints only, to 1934). Illustrated (selection).

Mirko (Mirko **Basaldella**) *(1910–1969)*
Gramiccia, Valeria, and Corà, Bruno. *Mirko, opera grafica.* Rome: Editalia, 1972.
Entries: unnumbered, pp. 16–101. Millimeters. States. Described. Illustrated.

Miró, Joan *(b. 1893)*
Kaiser-Wilhelm-Museum, Krefeld [Paul Wember, Jacques Dupin et al., compilers]. *Miro.* Krefeld (West Germany), 1957.
Entries: 184 single prints, 44 illustrated books, (to 1957?). Millimeters. States. Illustrated (almost all single prints; sample book illustrations). Text in English, French and German; the different texts give different, and sometimes conflicting, information.

Kestner Gesellschaft, Hannover. *Joan Miró; das graphische Gesamtwerk.* Hannover (West Germany), 1957.
Entries: 184 single prints, 44 illustrated books (to 1957?). Millimeters. Illustrated (selection). Abbreviated version of Krefeld catalogue.

Mourlot, Fernand. *Joan Miró lithographe, I.* Preface by Michel Lieris. Paris: A. C. Mazo et Cie, 1972. English ed. *Joan Miró lithographs.* New York: Tudor Publishing Co., 1972.
Entries: 121+ (lithographs only, to 1952). Millimeters. States. Described. Illustrated. A set of prints, #107 in the French edition, is numbered 107–175 in the English edition. From this point on there is a discrepancy of 68 between the numbering of the two editions: e.g. #121 (French edition) is #189 (English edition).

Mirou, Anthonie *(c.1586–1661)*
[W.] II, p. 172.
Entries: 1 print after.*

[H. *Neth.*] XIV, p. 52.
Entries: 26 prints after.*

Misdacq, Jodocus A.W.Y. *(fl. c.1697)*
[H. *Neth.*] XIV, p. 52.
Entries: 1.*

Mitan, James *(1776–1822)*
[Ap.] p. 283.
Entries: 2.*

Mitchell, James *(19th cent.)*
[Ap.] p. 283.
Entries: 2.*

Mitchell, John Ames *(b. 1845)*
Koehler, Sylvester R. "The works of the American etchers, XXIII; John Ames Mitchell." [*Amer. Art Review*] 2, no. 2 (1881): 57–58.
Entries: 7+ (to 1880). Inches.

Mitchell, Robert *(1820–1873)*
[Ap.] p. 283.
Entries: 1.*

Mitelli, Guiseppe Maria *(1634–1718)*
[B.] XIX, pp. 269–307.
Entries: 162 prints by, 1+ prints not seen by [B.]. Pre-metric. Inscriptions. States. Described.

Bertarelli, Achille. *Le incisioni di Giuseppe Maria Mitelli, catalogo critico.* Milàn: Comune di Milano, 1940.
Entries: 679 prints by, 9 doubtful and rejected prints. Millimeters. Inscriptions. Described. Illustrated (selection). Bibliography for each entry.

Mitrokhin, Dmitri Isidorovich *(b. 1883)*
Voinov, Vsevolod. *Kniznye znaki D. I. Mitrokhina.* Peterburg (USSR): V 15-j Gosudarstvennoj tipografii (byvsh. Golike i Bil'borg), 1921. 200 copies. (DLC)
Entries: 30 (bookplates only, to 1921). Illustrated (selection).

Kuzmin, M., and Voinov, Vsevold. *D. I. Mitrokhin.* Moscow: Gosudarstvennoe Izdatel'stvo, 1922.

Entries: unnumbered, pp. 125–131 (to 1921). Illustrated (selection).

Rusakov, Iv. A. *Dmitrii Isidorovich Mitrokhin.* Leningrad: Izdatel'stvo Isskustvo, 1966.
Entries: unnumbered, pp. 193–201 (to 1951). Millimeters.

Mitterer, Hermann Joseph *(1764–1829)*
[Dus.] pp. 120–121.
Entries: 11+ (lithographs only, to 1821). Millimeters (selection). Located (selection).

Mixelle, Jean Marie *(fl. 1750–1800)*
[Ber.] X, p. 72.*

Mocchetti, Giuseppe *(19th cent.?)*
[Ap.] p. 283.
Entries: 7.*

Mocetto, Girolamo *(c.1458–c.1531)*
[B.] XIII, pp. 215–221.
Entries: 8. Pre-metric. Inscriptions. States. Described. Copies mentioned.

Galichon, Émile. *Girolamo Mocetto; peintre et graveur venitien.* Paris: Imprimerie de J. Claye, 1859.
Entries: 21. Millimeters. Inscriptions. States. Described.

[P.] V, pp. 134–139.
Entries: 11 (additional to [B.]). Pre-metric. Inscriptions. States. Described. Located (selection).

[Wess.] III, p. 51.
Additional information to [B.] and [P.].

[Hind] V, pp. 159–171.
Entries: 22. Millimeters. Inscriptions. States. Described. Located.

Modena, Nicoletto da
See **Nicoletto da Modena**

Modersohn-Becker, Paula *(1876–1907)*
Pauli, Gustav. *Paula Modersohn-Becker.*
Leipzig: Kurt Wolff Verlag, 1919.
 Entries: 10. Millimeters. Described.

Graphisches Kabinett, Bremen
[Wolfgang Werner, compiler.] *Paula
Modersohn-Becker, Gemälde,
Zeichnungen, Oeuvreverzeichnis der
Graphik.* Bremen (West Germany):
Kunsthandlung V. Voigt K. G., 1968.
 Entries: 11. Millimeters. Inscriptions.
 States. Described. Illustrated. Lo-
 cated. Preparatory drawings iden-
 tified.

Werner, Wolfgang. *Paula Modersohn-
Becker, 1876–1907, Oeuvreverzeichnis der
Graphik.* Bremen (West Germany):
Graphisches Kabinett, 1972.
 Entries: 12. Millimeters. Inscriptions.
 States. Described. Illustrated. Lo-
 cated.

Moe, Louis *(1857–1945)*
Bartram-Jensen, Haagen. "Louis Moe
og hans exlibris." [*N. ExT.*] 11 (1959):
74–75.
 Entries: 21 (bookplates only). Illus-
 trated (selection).

Moerenhout, Josephus Jodocus
(1801–1875)
 [H. L.] pp. 712–713.
 Entries: 2. Millimeters. Inscriptions.
 States. Described.

Moermans, Jacques *(1602–1653)*
 [W.] II, p. 173.
 Entries: 1 print by, 1 after.*

 [H. *Neth.*] XIV, p. 52.
 Entries: 2.*

Mössmer, Joseph *(1780–1845)*
 [Dus.] p. 121.
 Entries: 5 (lithographs only, to 1821).
 Millimeters. Inscriptions. Located.

Moeyaert, Claes Cornelisz *(1592/93–1655)*
 [vdK.] pp. 58–69, 227–228.
 Entries: 26. Millimeters. Inscriptions.
 States. Described. Appendix with
 doubtful and rejected prints, unnum-
 bered, pp. 68–69.

 [Wess.] II, p. 243.
 Additional information to [vdK.]

 [W.] II, pp. 173–174.
 Entries: 25+ prints by, 4+ after.*

 [H. *Neth.*] XIV, pp. 53–61.
 Entries: 35+ prints by, 14 after. Illus-
 trated (selection).*

Mohn, Ernst Fürchtegott *(1835–1912)*
 [Ap.] p. 283.
 Entries: 4.*

Moillon, Nicolas *(d. 1619)*
 [W.] II, p. 174.
 Entries: 1+.*

 [H. *Neth.*] XIV, p. 62.
 Entries: 5. Illustrated.*

Moine, Antonin Marie *(1796–1849)*
 [Ber.] X, pp. 72–73.*

Moisy, Alexandre *(1763–1827)*
 [Ber.] X, p. 73.*

Moithey, Pierre Joseph *(fl. c.1815)*
 [Ber.] X, p. 73.*

Moitte, [François] Auguste *(1748–c.1790)*
 [L. D.] pp. 64–65.
 Entries: 2. Millimeters. Inscriptions.
 States. Described. Incomplete
 catalogue.*

Moitte, Pierre Etienne *(1722–1780)*
 [L. D.] pp. 63–64.
 Entries: 4. Millimeters. Inscriptions.
 States. Described. Incomplete
 catalogue.*

Mol, Adolphe Léonard *(b. 1834)*
[H. L.] pp. 713–714.
Entries: 3. Millimeters. Inscriptions.
Described.

Mol, Pieter van *(1599–1650)*
[W.] II, p. 175.
Entries: 9 prints after.*

[H. *Neth.*] XIV, p. 63.
Entries: 14 prints after.*

Mol, Robert de *(d. 1680)*
[W.] II, p. 175.
Entries: 1+.*

[H. *Neth.*] XIV, p. 63.
Entries: 12.*

Mola, Pier Francesco *(1612–1666)*
[B.] XIX, pp. 202–208.
Entries: 8. Pre-metric. Inscriptions.
States. Described.

[Heller] p. 95.
Additional information to [B.].

Cocke, Richard. *Pier Francesco Mola.* Ox-
ford: Clarendon Press, 1972.
Catalogue of paintings; prints after
are mentioned where extant.

Molé, ———— *(19th cent.)*
[H. L.] p. 715.
Entries: 1. Millimeters. Inscriptions.
Described.

Mole, Jean Baptiste *(1616–1661)*
[B.] XIX, pp. 209–212.
Entries: 6. Pre-metric. Inscriptions.
Described.

Molenaer, Claesz (Nicolaes) *(1630–1676)*
[H. *Neth.*] XIV, p. 63.
Entries: 2.*

Molenaer, Jan Miense *(1610–1668)*
[B.] IV, pp. 3–6.
Entries: 1. Pre-metric. Inscriptions.
States. Described.

[Weigel] p. 146.
Entries: 1 (additional to [B.]). Pre-
metric. Inscriptions. Described.

[Wess.] II, pp. 243–244.
Entries: 1 (additional to [B.] and
[Weigel]). Millimeters. Inscriptions.
Described.

[W.] II, pp. 176–178.
Entries: 3 prints by, 4+ after.*

[H. *Neth.*] XIV, pp. 64–68.
Entries: 9 prints by, 10 after. Illus-
trated (selection).*

Molenaer, Pieter
See **Meulener**

Moles, Pascual Pedro *(1741–1797)*
[L. D.] p. 65.
Entries: 1. Millimeters. Inscriptions.
States. Described. Incomplete
catalogue.*

Molitor, I. *(fl. 1772–1800)*
[Merlo] p. 607.*

Molitor, Martin von *(1759–1812)*
Bartsch, Adam von. *Catalogue raisonné de
l'oeuvre d'estampes de Martin de Molitor,
peintre et dessinateur de paysages.* Nurem-
berg: J. F. Frauenholz et Comp., 1813.
Entries: 52 prints by; prints after un-
numbered, pp. 43–71. Pre-metric. In-
scriptions. Described.

Moll, Carl *(1861–1945)*
Fritz, Monika. "Der Wiener Maler Carl
Moll (1861–1945)." Dissertation, Univer-
sity of Innsbruck, 1962. Unpublished
ms. (carbon copy, EWA)
Entries: 3+ (complete?). Millimeters.
Described (selection). Illustrated
(selection). Copy in EWA lacks illus-
trations.

Mollard, Joseph Gabriel Hippolyte
(d. 1888)
[Ber.] X, p. 73.*

Mollerup, Svend Aage *(20th cent.)*
Fogedgaard, Helmer. "Svend Aage
Mollerup." [*N. ExT.*] 6 (1954): 54–55.
Entries: unnumbered, p. 55
(bookplates only, to 1955). Illustrated
(selection).

Fogedgaard, Helmer. "Svend Aage
Mollerup—II." [*N. ExT.*] 9 (1957): 65–67.
Entries: 35 (bookplates only; addi-
tional to Fogedgaard 1954; to 1956).
Described (selection). Illustrated
(selection).

Mollinger, Gerrit Alexander Goedart Filip
(1825–1860)
[H. L.] pp. 715–716.
Entries: 3. Millimeters. Inscriptions.
Described.

Molijn, Petrus Marius *(1819–1849)*
[H. L.] pp. 716–717.
Entries: 4 (etchings only). Millimeters.
Inscriptions. States. Described.

Moloch [B. Colomb] *(1849–1909)*
[Ber.] X, p. 74.*

Molyn, Pieter *(1595–1661)*
[B.] IV, pp. 9–12.
Entries: 4. Pre-metric. Inscriptions.
States. Described.

[Weigel] p. 147.
Additional information to [B.].

[W.] II, pp. 178–180.
Entries: 16+.*

[H. *Neth.*] XIV, pp. 70–72.
Entries: 8 prints by, 31+ after. Illus-
trated (prints by only).*

Molyns, Jan I *(fl. 1532–1565)*
[H. *Neth.*] XIV, p. 69.
Entries: 3+. Illustrated (selection).*

Momal, Jacques François *(1754–1832)*
[Ber.] X, p. 74.*

Mommorency, B.
See **Monmorency**

Momper, Bartholomäus de *(b. 1535)*
[W.] II, p. 180.
Entries: 1.*

Momper, Jodocus II de *(1564–1635)*
[W.] II, pp. 181–182.
Entries: 1 print by, 4 after.*

[H. *Neth.*] XIV, p. 73.
Entries: 1 print by, 28 after.*

Monaco, Francesco *(1733–1795)*
[AN.] pp. 613–616.
Entries: unnumbered, pp. 614–616.
Millimeters. Inscriptions. Described
(selection).

[AN. 1968] p. 174.
Entries: unnumbered, p. 174 (addi-
tional to [AN.]). Millimeters (selec-
tion).

Monaco, Jacopo *(18th cent.)*
[AN.] pp. 650–651.
Entries: unnumbered, p. 651. Mil-
limeters. Inscriptions. Described
(selection).

[AN. 1968] p. 175.
Entries: unnumbered, p. 175 (addi-
tional to [AN.]). Millimeters. Inscrip-
tions.

Monaco, Pietro *(1707–1772)*
[AN.] pp. 524–557.
Entries: unnumbered, pp. 530–557.
Millimeters. Inscriptions. Described.

[AN. 1968] p. 171.
Entries: unnumbered, p. 171 (addi-
tional to [AN.]). Millimeters. Inscrip-
tions.

Moncel, Théodore Achille Louis, vicomte
du *(1821–1884)*
[Ber.] VI, p. 67.*

Monchy, Martin de *(b. 1746)*
[L. D.] pp. 66–67.
Entries: 4. Millimeters. Inscriptions.
States. Described. Incomplete
catalogue.*

Mondekens, Paulus *(16th cent?)*
[H. *Neth.*] XIV, p. 74.
Entries: 2.*

Moneta, Nicola *(19th cent.)*
[Ap.] p. 284.
Entries: 3.*

Mongez, Angélique *(1775–1855)*
[Ber.] X, p. 74.*

[Baud.] II, p. 328.
Entries: 1. Millimeters. Inscriptions.
Described.

Mongin, Augustin *(1843–1911)*
[Ber.] X, pp. 74–77.
Entries: 200.

Mongin, Pierre Antoine *(1761/62–1827)*
[Ber.] X, p. 74.*

Monmorency, B. *(fl. c.1742)*
[W.] II, p. 180.
Entries: 1 print after.*

Monnavilla, Frans [called "Jeugt"]
(b. c.1620)
[W.] II, p. 183.
Entries: 1 print after.*

[H. *Neth.*] XIV, p. 74.
Entries: 1 print after.*

Monnier, Antoine *(19th cent.)*
[Ber.] X, p. 107.*

Monnier, Henry Bonaventure *(1805–1877)*
Champfleury. *Henry Monnier, sa vie, son
oeuvre avec un catalogue complet de l'oeuvre.*
Paris: E. Dentu, 1889.
Entries: unnumbered, pp. 316–386,
prints by and after. Described.

[Ber.] X, pp. 77–107.
Entries: 772. Paper fold measure
(selection).

Marie, Aristide, and Deglatigny, Louis.
Henry Monnier (1799–1877). Paris: Li-
braire Floury, 1931.
Entries: 629 prints by, 214 after. In-
scriptions (selection).

Monnier, Louis Gabriel *(1733–1804)*
Mercier, J. B. "Louis Gabriel Monnier,
graveur du XVIIIe siècle, et ses ex-
libris." [*Arch. Ex.-lib.*] 27 (1920): 63–69.
Entries: 36 (bookplates only). Illus-
trated (selection).

Monnik, Lorenzo *(1606–1686)*
[W.] II, p. 183.
Entries: 1.*

[H. *Neth.*] XIV, p. 74.
Entries: 1.*

Monnin, Ernest *(19th cent.)*
[Ber.] X, pp. 107–108.*

Monnin, Marc Antoine Claude *(b. 1806)*
[Ber.] X, p. 108.*

Monnoyer, Jean Baptiste *(1635/36–1699)*
[RD.] III, pp. 229–238.
Entries: 34. Pre-metric. Inscriptions.
States. Described.

MONOGRAMS AND FIGURES

A *(fl. c.1500)* [Nagler, *Mon.*] I, no. 2
[P.] II, pp. 200–202.
 Entries: 6. Pre-metric. Inscriptions.
 Described. Located.

 [Lehrs] VII, pp. 332–347.
 Entries: 17. Millimeters. Inscriptions.
 States. Described. Illustrated (selection). Located. Locations of all known
 impressions are given. Copies mentioned. Watermarks described. Bibliography for each entry.

 [H. *Neth.*] XII, pp. 1–8.
 Entries: 17. Illustrated (selection).*

A *(fl. c.1579)* [Nagler, *Mon.*] I, no. 25
[B.] IX, pp. 549–550.
 Entries: 1. Pre-metric. Inscriptions.
 Described.

A *(fl. c.1560)* [Nagler, *Mon.*] I, no. 30
[B.] IX, p. 239.
 Entries: 1. Pre-metric. Inscriptions.
 Described.

 [P.] IV, pp. 266–267.
 Entries: 2 (additional to [B.]). Pre-metric. Inscriptions. States. Described.

A *(fl. c.1500)* [Nagler, *Mon.*] I, no. 37
[B.] VII, pp. 487–488.
 Entries: 1. Pre-metric. Inscriptions.
 Described.

 [P.] III, pp. 298–299.
 Entries: 2 (additional to [B.]). Pre-metric. Inscriptions. Described. Located.

A [Nagler, *Mon.*] I, no. 46
See **Altdorfer,** Eberhard

A *(fl. c.1517)* [Nagler, *Mon.*] I, no. 47
[B.] VII, p. 473.
 Entries: 1. Pre-metric. Inscriptions.
 Described.

A *(fl. c.1500)* [Nagler, *Mon.*] I, no. 49
[Hind] V, p. 241.
 Entries: 1. Millimeters. Inscriptions.
 Described. Illustrated. Located.

A *(fl. c.1599)* [Nagler, *Mon.*] I, no. 727
[H. *Neth.*] XIII, p. 7.
 Entries: 1. Illustrated.*

A *(fl. after 1500)* [Nagler, *Mon.*] I, appendix no. 2522
 [P.] III, p. 94.
 Entries: 1. Pre-metric. Inscriptions.
 Described. Located.

 [H. *Neth.*] XIII, p. 1.
 Entries: 1. Illustrated.*

A *(15th cent.)*
 [Lehrs] VII, pp. 348–349.
 Entries: 1. Millimeters. Inscriptions.
 Described. Located. Locations of all
 known impressions are given. Copies
 mentioned. Watermarks described.
 Bibliography for each entry.

 [H. *Neth.*] XII, p. 8.
 Entries: 1. Illustrated.*

A *(16th cent.?)*
 [Evans] p. 29.
 Entries: 1. Millimeters. Inscriptions.
 Described.

A *(17th cent.)*
 [Hind, *Engl.*] III, p. 212.

Monogram A (*continued*)

Entries: 1. Inches. Inscriptions. Described. Illustrated. Located.

A (*19th cent.*)
[Dus.] p. 121.
Entries: 1 (lithographs only, to 1821). Millimeters. Inscriptions. Located.

AA (*fl. 1500–1550*) [Nagler, *Mon.*] I, no. 101
[B.] VIII, p. 540.
Entries: 1. Pre-metric. Inscriptions. Described.

AA (*fl. c.1526*) [Nagler, *Mon.*] I, no. 108
[B.] XV, p. 549.
Entries: 1. Pre-metric. Inscriptions. Described.

[P.] VI, p. 125.
Entries: 2 (additional to [B.]). Pre-metric. Inscriptions. Described.

[Hind] V, pp. 241, 301.
Additional information to [B.] and [P.].

AB (*fl. c.1539*) [Nagler, *Mon.*] I, no. 130
[P.] VI, p. 154.
Entries: 1. Pre-metric. Inscriptions. Described.

AB (*fl. c.1650*) [Nagler, *Mon.*] I, nos. 159, 160
[H. *Neth.*] XIII, p. 1.
Entries: 2. Illustrated.*

AB (*19th cent.*)
[Dus.] p. 121.
Entries: 1 (lithographs only, to 1821). Millimeters. Inscriptions.

ABK (*fl. c.1650*) [Nagler, *Mon.*] I, no. 225
[H. *Neth.*] XIII, p. 2.
Entries: 6. Illustrated (selection).*

AC (*fl. 1520–1555*) [Nagler, *Mon.*] I, no. 259
[B.] IX, pp. 117–143.

Entries: 59. Pre-metric. Inscriptions. States. Described. Copies mentioned.

[Heller] p. 41.
Entries: 1 (additional to [B.]). Pre-metric. Inscriptions. Described. Additional information to [B.].

[Evans] pp. 1–5.
Entries: 28 (additional to [B.]). Millimeters. Inscriptions. Described.

[P.] III, pp. 34–46.
Entries: 81 prints by (additional to [B.]), and 2 doubtful prints. Pre-metric. Inscriptions. States. Described. Located. Additional information to [B.].

[Wess.] I, pp. 132–134.
Entries: 28 (additional to [B.] and [P.]). Millimeters. Inscriptions (selection). Described (selection). Additional information to [B.] and [P.].

Aumüller, Édouard. *Les Petits maîtres allemands, II: Jacques Binck et Alaart Claas (Claaszen).* Munich: Librairie de l'Université M. Rieger, 1893. (MBMu)
Entries: 200. Millimeters. Inscriptions. States. Described. Copies mentioned. Ms. notes by J.C.J. Bierens de Haan (ERB). Additional states, 2 additional entries.

[W.] I, pp. 279–283.
Entries: 200.*

[H. *Neth.*] IV, pp. 101–168.
Entries: 236. Illustrated (selection).*

AC 1562 (*fl. c.1562*) [Nagler, *Mon.*] I, no. 260
[B.] IX, pp. 482–484.
Entries: 9. Pre-metric. Inscriptions. Described.

AC 1549 (*fl. c.1549*) [Nagler, *Mon.*] I, no. 279
[B.] IX, pp. 166–167.

Entries: 1. Pre-metric. Inscriptions. Described.

AC *(fl. c.1569)* [Nagler, *Mon.*] I, no. 286
[B.] IX, p. 532.
Entries: 1. Pre-metric. Inscriptions. Described.

AC *(fl. 1500–1550)*
[H. *Neth.*] XIII, p. 3.
Entries: 1. Illustrated.*

ACH *(fl. before 1550)* [Nagler, *Mon.*] I, no. 322
[B] VIII, pp. 539–540.
Entries: 2. Pre-metric. Inscriptions. Described.

[P.] IV, pp. 129–130.
Entries: 6 (additional to [B.]). Paper fold measure (selection). Pre-metric (selection). Inscriptions. Described. Located (selection).

ACI *(fl. c.1530)* [Nagler, *Mon.*] I, no. 324
[B.] IX, p. 492.
Entries: 1. Pre-metric. Inscriptions. Described.

AD *(fl. after 1550)* [Nagler, *Mon.*] I, no. 364
[P.] IV, p. 263.
Entries: 1. Pre-metric. Inscriptions. Described.

AD *(16th cent.)* [Nagler, *Mon.*] II, no. 916
[P.] IV, p. 168.
Entries: 2. Pre-metric (selection). Inscriptions. Described.

AD *(17th cent.)*
[Merlo] p. 1113.*

ADB [Nagler, *Mon.*] I, no. 409
See **Bruyn,** Abraham de

ADB [Nagler, *Mon.*] I, no. 410
See **Bruyn,** Abraham de

ADM *(fl. before 1550)* [Nagler, *Mon.*] I, no. 438
[P.] VI, pp. 132–133.
Entries: 3. Pre-metric. Inscriptions. Described. Located (selection).

ADT *(fl. c.1545)* [Nagler, *Mon.*] I, no. 450
[B.] IX, p. 162.
Entries: 1. Pre-metric. Inscriptions. Described.

ADV *(fl. c.1525)* [Nagler, *Mon.*] I, no. 452
[P.] IV, p. 168.
Entries: 3 (under 2 versions of the monogram). Pre-metric. Inscriptions. Described.

AE [Nagler, *Mon.*] I, no. 462
See **Key,** Adriaen Thomasz

AF *(fl. c.1500)* [Nagler, *Mon.*] I, no. 525
[B.] XV, pp. 536–537.
Entries: 2. Pre-metric. Inscriptions. Described.

[P.] VI, pp. 130–131.
Entries: 2 (additional to [B.]). Pre-metric. Inscriptions. Described. Located. Appendix with 3 prints not seen by [P.].

[Wess.] III, p. 51.
Entries: 1 (additional to [B.] and [P.]). Millimeters. Inscriptions. Described. Located.

[Hind] V, pp. 241–243.
Entries: 4. Millimeters. Inscriptions. Described. Illustrated. Located.

AF [Nagler, *Mon.*] I, nos. 533, 541
See **FA** [Nagler, *Mon.*] II, no. 1864

AF *(fl. c.1550)*
[H. *Neth.*] XIII, p. 4.
Entries: 1. Illustrated.*

AF *(fl. c.1550)*
[H. *Neth.*] XIII, p. 4.
Entries: 2. Illustrated.*

AG [Nagler, *Mon.*] I, no. 585
See **AC** [Nagler, *Mon.*] I, no. 260

AG *(fl. before 1550)* [Nagler, *Mon.*] I, no. 586
[P.] IV, pp. 164–165.
Entries: 2. Inscriptions. Described. Located (selection).

AG *(fl.1479–1491)* [Nagler, *Mon.*] I, no. 613
[B.] VI, pp. 344–354.
Entries: 27. Pre-metric. Inscriptions. States. Described.

[P.] II, pp. 126–129.
Entries: 6 (additional to [B.]). Pre-metric. Inscriptions. States. Described. Located.

Lehrs, Max. "Die Monogrammisten AG und W H in ihrem Verhältniss zu einander." [*Rep. Kw.*] 9 (1886): 1–20, 377–382.
Entries: 34. Millimeters. Inscriptions. States. Described. Located.

[Lehrs] VI, pp. 84–130.
Entries: 34. Millimeters. Inscriptions. States. Described. Illustrated (selection). Located. Locations of all known impressions are given. Copies mentioned. Watermarks described. Bibliography for each entry.

AG *(16th cent.)*
[Hind] V, pp. 93, 243.
Entries: 1. Millimeters. Inscriptions. Described. Illustrated. Located.

AG 1511 *(fl. c.1511)*
[P.] V, p. 227.
Entries: 1. Pre-metric. Inscriptions. Described. Located. See [Hind] V, p. 333.

AH *(fl. c.1500)* [Nagler, *Mon.*] I, no. 655
[P.] IV, p. 263.
Entries: 1. Pre-metric. Inscriptions. Described.

AH *(fl. 1589–1596)* [Nagler, *Mon.*] I, no. 656
[B.] IX, pp. 589–590.
Entries: 1. Pre-metric. Inscriptions. Described.

[P.] IV, p. 263.
Entries: 1. (additional to [B.]). Pre-metric. Inscriptions. Described.

AH 1538 *(fl. c.1538)* [Nagler, *Mon.*] I, no. 665
[B.] IX, pp. 81–82.
Entries: 1. Pre-metric. Inscriptions. Described.

AH *(fl. c.1550)* [Nagler, *Mon.*] I, no. 677
[B.] XV, p. 543.
Entries: 1. Pre-metric. Inscriptions. Described.

AHM [Nagler, *Mon.*] I, no. 703
See **Magdeburg,** Hiob

AHNSV *(16th cent.)*
[Evans] p. 27.
Entries: 1. Millimeters. Inscriptions. Described.

AI 1516 *(fl. c.1516)* [Nagler, *Mon.*] I, nos. 718, 719, 721.
[P.] IV, pp. 155–156.
Entries: 3. Pre-metric. Inscriptions. Described.

[H. *Neth.*] XIII, pp. 6–7.
Entries: 13. Illustrated (selection).*

AI [Nagler, *Mon.*] I, nos. 720, 734
See **Jorisz van Delft,** Augustin

AI *(fl. c.1550)* [Nagler, *Mon.*] I, no. 721
[P.] VI, pp. 170–171.
Entries: 2. Pre-metric. Inscriptions. Described.

AI 1552 *(fl. c.1552)* [Nagler, *Mon.*] I, no. 722
[P.] IV, p. 342.
Entries: 1. Pre-metric. Inscriptions. Described.

[H. *Neth.*] XIII, pp. 8–9.
 Entries: 3. Illustrated. *

AI *(16th cent.?)* [Nagler, *Mon.*] I, no. 735
 [P.] VI, p. 171.
 Entries: 1. Pre-metric. Inscriptions.
 Described.

AI *(fl. c.1554)*
 [H. *Neth.*] XIII, p. 10.
 Entries: 2. Illustrated.*

AK *(early 16th cent.)*
 [P.] III, p. 95.
 Entries: 1. Pre-metric. Inscriptions.
 Described. Located.

 [H. *Neth.*] XIII, p. 11.
 Entries: 1. Illustrated.*

AL 1579 [Nagler, *Mon.*] I, no. 794
 See **Luining,** Andreas

AL *(fl. 1540–1550)* [Nagler, *Mon.*] I, no. 795
 [B.] IX, pp. 40–41.
 Entries: 1. Pre-metric. Inscriptions.
 Described.

 [H. *Neth.*] XIII, p. 11.
 Entries: 1. Illustrated.*

AL 1535 *(fl. c.1535)* [Nagler, *Mon.*] I, no. 797
 [B.] IX, pp. 38–40.
 Entries: 3. Pre-metric. Inscriptions.
 Described.

 [P.] IV, p. 159.
 Entries: 1 (additional to [B.]). Pre-
 metric. Inscriptions. Described. Lo-
 cated.

ALHS *(fl. c.1570)* [Nagler, *Mon.*] III, no. 1499
 [P.] IV, p. 188.
 Entries: 1. Pre-metric. Inscriptions.
 Described.

ALM *(fl. c.1543?)* [Nagler, *Mon.*] I, no. 869
 [B.] IX, p. 80.
 Entries: 1. Pre-metric. Inscriptions.
 Described.

AM *(fl. 1562–1563)* [Nagler, *Mon.*] I, no. 902
 [B.] IX, pp. 496–497.
 Entries: 4. Pre-metric. Inscriptions.
 Described.

AM *(fl. c.1812)*
 [Dus.] p. 123.
 Entries: 1 (lithographs only, to 1821).
 Millimeters. Inscriptions.

AMF *(fl. c.1568)* [Nagler, *Mon.*] I, no. 961
 See also **Monogram MA** [Nagler, *Mon.*]
 IV, no. 1526

 [B.] IX, pp. 516–517.
 Entries: 2. Pre-metric. Inscriptions.
 Described.

AMI *(early 16th cent.)*
 [H. *Neth.*] XIII, p. 11.
 Entries: 1. Illustrated.*

AMR *(fl. c.1566)* [Nagler, *Mon.*] I, no. 981
 [B.] IX, pp. 517–518.
 Entries: 1. Pre-metric. Inscriptions.
 Described.

 [P.] IV, p. 262.
 Entries: 1 (additional to [B.]). Pre-
 metric. Inscriptions. Described.

AN *(fl. before 1550)* [Nagler, *Mon.*] I, no. 992
 [P.] IV, p. 165.
 Entries: 1. Described. Located.

ANNA R 1568 *(fl. c.1568)* [Nagler, *Mon.*] I, no. 1049
 [P.] IV, pp. 264–265.
 Entries: 1. Pre-metric. Inscriptions.
 Described.

AO *(16th cent.)* [Nagler, *Mon.*] I, nos. 1084, 1085
 [P.] IV, p. 162.
 Entries: 2. Pre-metric. Inscriptions. Described.

AP *(16th cent.)* [Nagler, *Mon.*] I, no. 1102
 [B.] XV, p. 546.
 Entries: 1. Pre-metric. Inscriptions. Described.

 [P.] VI, p. 130.
 Entries: 3 (additional to [B.]). Pre-metric. Inscriptions. Described. Located.

AP [Nagler, *Mon.*] I, no. 1108
 See **Prestel,** Johann Gottlieb

AP *(fl. c.1555)* [Nagler, *Mon.*] I, no. 1109
 [B.] XV, pp. 509–510.
 Entries: 5. Pre-metric. Inscriptions. States. Described.

 [P.] VI, pp. 154–155.
 Entries: 3 (additional to [B.]). Pre-metric. Inscriptions. Described.

 [Herbet] III, p. 40.
 Entries: 1 (additional to [B.] and [P.]). Millimeters. Inscriptions. Described. Located.

AP *(16th cent.?)*
 [Evans] p. 29.
 Entries: 1. Millimeters. Inscriptions. Described.

AP *(fl. 1536–1537)*
 [H. *Neth.*] XIII, pp. 12–16.
 Entries: 9. Illustrated.*

APB *(fl. c.1525)* [Nagler, *Mon.*] I, no. 1137
 [P.] IV, p. 156.
 Entries: 1. Pre-metric. Inscriptions. Described.

AR *(19th cent.)*
 [H. L.] p. 936.

Entries: 2. Millimeters. Inscriptions. States. Described.

AS *(fl. 1538–1540)* [Nagler, *Mon.*] I, no. 1222
 [P.] IV, p. 160.
 Entries: 4 (supposedly additional to [B.]; [Nagler, *Mon.*] I, no 1223). Pre-metric. Inscriptions. Described. Located (selection).

 [H. *Neth.*] XIII, p. 17.
 Entries: 4. Illustrated (selection).*

AS *(fl. 1538–1540)* [Nagler, *Mon.*] I, no. 1223
 [B.] IX, pp. 50–51.
 Entries: 3. Pre-metric. Inscriptions. Described.

 [Heller] p. 132.
 Additional information to [B.].

AS *(fl. c.1600)* [Nagler, *Mon.*] I, no. 1281
 [H. *Neth.*] XIII, p. 18.
 Entries: 2. Illustrated.*

AS *(early 16th cent.)*
 [P.] III, p. 95.
 Entries: 1. Pre-metric. Inscriptions. Described. Located.

 [H. *Neth.*] XIII, p. 17.
 Entries: 1. Illustrated.*

AS *(19th cent.)*
 [Dus.] p. 124.
 Entries: 1 (lithographs only, to 1821). Millimeters. Inscriptions. Located.

ASF *(fl. c.1626)* [Nagler, *Mon.*] I, no. 1308
 [P.] IV, p. 165.
 Entries: 1. Pre-metric. Inscriptions. Described.

ASG [Nagler, *Mon.*] I, no. 1312
 See **Summer,** Andreas

AT *(fl. c.1525)* [Nagler, *Mon.*] I, no. 1334
[B.] VIII, pp. 537–538.
 Entries: 2. Pre-metric. Inscriptions.
 Described.

[P.] IV, pp. 113–115.
 Entries: 9 (additional to [B.]). Pre-
 metric. Inscriptions. Described. Lo-
 cated.

[Wess.] I, p. 146.
 Entries: 1 (additional to [B.] and [P.]).
 Described.

AT *(19th cent.)*
[Dus.] p. 126.
 Entries: 1 (lithographs only, to 1821).
 Millimeters. Inscriptions. Located.

ATEK [Nagler, *Mon.*] I, no. 1362
See **Key,** Adriaen Thomasz

AV *(15th cent.)*
[Evans] p. 15.
 Entries: 1. Millimeters. Inscriptions.
 Described.

AW *(fl. c.1529)* [Nagler, *Mon.*] I, no. 1485
[B.] VII, pp. 488–491.
 Entries: 11+. Pre-metric. Inscriptions.
 States. Described.

[P.] IV, pp. 149–153.
 Entries: 12 (additional to [B.]). Pre-
 metric. Inscriptions. Described. Lo-
 cated (selection).

AW *(fl. 1525–1545)* [Nagler, *Mon.*] I, no.
1486
[B.] IX, pp. 427–428.
 Entries: 2. Pre-metric. Inscriptions.
 Described.

[P.] IV, pp. 62–64.
 Entries: 3 engravings, 3 woodcuts
 (additional to [B.]). Pre-metric. In-
 scriptions. Described. Located (selec-
 tion).

AW *(fl. c.1526)* [Nagler, *Mon.*] I, no. 1487
[P.] II, p. 167.
 Entries: 1. Pre-metric. Inscriptions.
 Described. Located.

AW *(fl. before 1524)* [Nagler, *Mon.*] I, no.
1501
[P.] IV, pp. 326–327.
 Entries: 1. Pre-metric. Inscriptions.
 Described.

AW *(19th cent.)*
[Dus.] p. 126.
 Entries: 1 (lithographs only, to 1821).
 Millimeters. Inscriptions. Located.

AZ [Nagler, *Mon.*] I, no. 1542
See **Zeller,** Adam

B [Nagler, *Mon.*] I, no. 1563
See **Master of the DIE**

B *(fl. c.1544)* [Nagler, *Mon.*] I, no. 1564
[B.] XV, pp. 504–507.
 Entries: 9. Pre-metric. Inscriptions.
 Described.

B *(15th cent.)* [Nagler, *Mon.*] I, no. 1573
[P.] II, p. 166.
 Entries: 1. Pre-metric. Inscriptions.
 Described. Located.

[Lehrs] VII, pp. 350–351.
 Entries: 1. Millimeters. Inscriptions.
 Described. Located. Locations of all
 known impressions are given. Copies
 mentioned. Watermarks described.
 Bibliography for each entry.

B [Nagler, *Mon.*] I, no. 1575
See **Jenichen,** Balthasar

B *(15th cent.)* [Nagler, *Mon.*] I, no. 1589
[Lehrs] VII, pp. 349–350.
 Entries: 1. Millimeters. Inscriptions.
 Described. Located. Locations of all
 known impressions are given. Copies

Monogram B (*continued*)

mentioned. Watermarks described. Bibliography for each entry.

B [Nagler, *Mon.*] I, no. 1602
See **Monogram D** [Nagler, *Mon.*] II, no. 902

B [Nagler, *Mon.*] I, nos. 1604–1606
See **Breu,** Jörg

B (*15th cent.*)
[Lehrs] VII, pp. 351–352.
 Entries: 1. Millimeters. Inscriptions. Described. Located. Locations of all known impressions are given. Copies mentioned. Watermarks described. Bibiliography for each entry.

B (*early 16th cent.*)
[H. *Neth.*] XIII, p. 20.
 Entries: 1. Illustrated.*

BAD (*fl. c.1560*) [Nagler, *Mon.*] I, no. 1669
[B.] IX, pp. 51–52.
 Entries: 1. Pre-metric. Inscriptions. Described.

[P.] IV, p. 173.
 Entries: 1 (additional to [B.]). Pre-metric. Inscriptions. Described. Located.

BB [Nagler, *Mon.*] I, no. 1711
See **Bos,** Balthasar

BC (*fl. c.1562*) [Nagler, *Mon.*] I, no. 1732
[B.] IX, pp. 487–488.
 Entries: 1. Pre-metric. Inscriptions. Described.

BF (*15th cent.*) [Nagler, *Mon.*] I, no. 1821
[Hind] V, p. 246.
 Entries: 1. Millimeters. Inscriptions. Described. Illustrated. Located.

BF (*16th cent.*) [Nagler, *Mon.*] I, no. 1828
[B.] XV, p. 545.
 Entries: 1. Pre-metric. Inscriptions. Described.

BF (*fl. c.1599*)
[H. *Neth.*] XIII, p. 19.
 Entries: 1. Illustrated.*

BF (*fl. c.1644*)
[Merlo] p. 1114.*

BG (*fl. c.1589*) [Nagler, *Mon.*] I, no. 1850
[B.] IX, p. 575.
 Entries: 1. Pre-metric. Inscriptions. Described.

[P.] IV, p. 261.
 Entries: 1 (additional to [B.]). Pre-metric. Inscriptions. Described.

BG (*15th cent.*) [Nagler, *Mon.*] I, no. 2079
[B.] VI, pp. 68–76.
 Entries: 22. Pre-metric. Inscriptions. Described.

[Evans] p. 38.
 Entries: 4 (additional to [B.]). Millimeters. Inscriptions. Described.

[P.] II, pp. 118–123.
 Entries: 18 (additional to [B.]). Pre-metric. Inscriptions. Described. Located. Appendix with 6 prints not seen by [P.].

[Lehrs] VIII, pp. 165–219.
 Entries: 44. Millimeters. Inscriptions. States. Described. Illustrated (selection). Located. Locations of all known impressions are given. Copies mentioned. Watermarks described. Bibliography for each entry.

BH (*fl. c.1550*) [Nagler, *Mon.*] I, no. 1576
[H. *Neth.*] XIII, p. 49.
 Entries: 2.*

BH [Nagler, *Mon.*] I, no. 1868
See **Jenichen,** Balthasar

BH *(16th cent.)* [Nagler, *Mon.*] I, no. 1881
[B.] IX, p. 42.
 Entries: 1. Pre-metric. Inscriptions.
 Described.

 [P.] IV, pp. 148–149.
 Additional information to [B.].

BH *(15th/16th cent.)* [Nagler, *Mon.*] I, no.
1882
[B.] VI, pp. 398–399.
 Entries: 1. Pre-metric. Inscriptions.
 Described.

BHKGYF [Nagler, *Mon.*] I, no. 1922
See **Monogram GWYAHB** [Nagler,
Mon.] III, no. 485

BHVT *(fl. c.1570)*
[Merlo] p. 1114.*

BI *(16th cent.)* [Nagler, *Mon.*] I, no. 1888
[P.] VI: *See* **Chiaroscuro Woodcuts**

B I [Nagler, *Mon.*] I, nos. 1891, 1896
See **Jenichen,** Balthasar

BIM *(16th cent.)* [Nagler, *Mon.*] I, no. 1908
[P.] IV, p. 165.
 Entries: 1. Pre-metric. Inscriptions.
 Described.

BL *(fl. c.1575)* [Nagler, *Mon.*] I, no. 1931;
IV, no. 951
[H. *Neth.*] XIII, p. 35.
 Entries: 2. Illustrated.*

BM *(15th cent.)* [Nagler, *Mon.*] I, no. 1957
[B.] VI, pp. 392–394.
 Entries: 4. Pre-metric. Inscriptions.
 Described.

 [Evans] p. 42.
 Entries: 1 (additional to [B.]). Mil-
 limeters. Inscriptions. Described.

 [P.] II, pp. 124–126.
 Entries: 7 (additional to [B.]). Pre-
 metric. Inscriptions. Described. Lo-

cated. Additional information to [B.].
Copies mentioned.

[Wess.] I, p. 144.
 Entries: 1 (additional to [B.] and [P.]).
 Described.

[W.] III, pp. 224–225.
 Entries: 11.*

[Lehrs] VI, pp. 64–83.
 Entries: 10. Millimeters. Inscriptions.
 States. Described. Illustrated (selec-
 tion). Located. Locations of all known
 impressions are given. Copies men-
 tioned. Watermarks described. Bib-
 liography for each entry.

BP *(fl. c.1571)* [Nagler, *Mon.*] I, no. 1994
[B.] IX, p. 544.
 Entries: 1. Pre-metric. Inscriptions.
 Described.

BP *(fl. 1540–1550)* [Nagler, *Mon.*] I, no. 2000
[B.] VIII, pp. 20–21.
 Entries: 1. Pre-metric. Inscriptions.
 Described.

BP *(16th cent.)* [Nagler, *Mon.*] I, no. 2003
[Ge.] nos. 921–925.
 Entries: 5 (single-sheet woodcuts
 only). Described. Illustrated. Located.

BP *(15th cent.)*
[Lehrs] VII, p. 352.
 Entries: 1. Millimeters. Inscriptions.
 Described. Located. Locations of all
 known impressions are given. Copies
 mentioned. Watermarks described.
 Bibliography for each entry.

BP *(early 16th cent.)*
[H. *Neth.*] XIII, p. 19.
 Entries: 1. Illustrated.*

BR *(fl. c.1537)* [Nagler, *Mon.*] I, no. 2020
[RD.] VIII, p. 10.
 Entries: 1. Millimeters. Inscriptions.
 Described.

BR *(15th cent.)* [Nagler, *Mon.*] I, no. 2033
[B.] VI, pp. 394–397.
 Entries: 5. Pre-metric. Inscriptions.
 States. Described.

[Evans] pp. 6–7.
 Entries: 1 (additional to [B.]). Mil-
 limeters. Inscriptions. Described.

[P.] II, p. 145.
 Entries: 1 (additional to [B.]). Pre-
 metric. Inscriptions. Described. Lo-
 cated. Additional information to [B.].
 Appendix with 1 rejected print.

[W.] III, p. 225.
 Entries: 8.*

[Lehrs] VI, pp. 291–313.
 Entries: 17. Millimeters. Inscriptions.
 States. Described. Illustrated (selec-
 tion). Locations of all known impres-
 sions are given. Copies mentioned.
 Watermarks described. Bibliography
 for each entry.

BS [Nagler, *Mon.*] I, no. 2079
See **Monogram BG** [Nagler, *Mon.*] I, no.
2079

BS *(16th cent.)*
See **Zeitblom,** Bartholomäus

BS *(fl. c.1650)*
[H. *Neth.*] XIII, p. 20.
 Entries: 1. Illustrated.*

BSB *(fl. c.1570)* [Nagler, *Mon.*] I, no. 2080
[B.] IX, p. 545.
 Entries: 1. Pre-metric. Inscriptions.
 Described.

BT *(fl. c.1500)* [Nagler, *Mon.*] I, no. 2088
[P.] IV, p. 164.
 Entries: 2. Pre-metric. Inscriptions.
 Described. Located.

BTH *(fl. c.1565)* [Nagler, *Mon.*] I, no. 2091
[B.] IX, pp. 485–486.

 Entries: 2. Pre-metric. Inscriptions.
 Described.

BV [Nagler, *Mon.*] I, no. 2096
See **Bocksberger,** Johan Melchior

C *(16th cent.)* [Nagler, *Mon.*] I, no. 2148
[P.] VI, p. 148.
 Entries: 1. Pre-metric. Inscriptions.
 Described.

[Hind] V, p. 243.
 Entries: 1. Millimeters. Inscriptions.
 Described. Illustrated. Located.

C *(early 16th cent.)*
[H. *Neth.*] XIII, p. 20.
 Entries: 1. Illustrated.*

C *(16th cent.)*
[Herbet] IV, p. 338.
 Entries: 1. Millimeters. Inscriptions.
 Described. Located.

CA *(16th cent.)* [Nagler, *Mon.*] I, no. 2182
[P.] VI, p. 173.
 Entries: 1. Pre-metric. Inscriptions.
 Described. Located.

CA *(fl. c.1509)* [Nagler, *Mon.*] I, no. 2186
[P.] III, p. 343.
 Entries: 6. Pre-metric. Inscriptions.
 Described.

CAF *(16th cent.)*
[Evans] p. 23.
 Entries: 1. Millimeters. Inscriptions.
 Described.

CAII [Nagler, *Mon.*] I, no. 2231
See **Monogram IICA** [Nagler, *Mon.*] III,
no. 2634

CAMS *(fl. c.1520)*
[Hind] V, pp. 243–244.
 Entries: 1. Millimeters. Inscriptions.
 Described. Illustrated. Located.

CB *(fl. c.1550)* [Nagler, *Mon.*] I, no. 2284
[B.] IX, p. 431.
 Entries: 1. Pre-metric. Inscriptions.
 Described.

CB *(fl. c.1531)* [Nagler, *Mon.*] I, no. 2294
[B.] VIII, pp. 533–535.
 Entries: 5. Pre-metric. Inscriptions.
 Described.

 [Heller] p. 133.
 Additional information to [B.].

 [P.] III, pp. 288–289, 291–292.
 Entries: 2 (additional to [B.]). Pre-
 metric. Inscriptions. Described. Lo-
 cated.

 [Wess.] I, p. 146.
 Entries: 1 (additional to [B.] and [P.]).
 Described.

 [H. *Ger.*] IV, pp. 132–134.
 Entries: 8 prints by, 12 after. Illus-
 trated (selection).*

CB *(fl. c.1543)* [Nagler, *Mon.*] I, no. 2296
[P.] IV, p. 166.
 Entries: 2. Pre-metric. Inscriptions.
 Described. Located.

CC [Nagler, *Mon.*] I, no. 2357
See **Monogram GG** [Nagler, *Mon.*] I, no.
2357

CC *(fl. c.1547)* [Nagler, *Mon.*] I, no. 2365
[B.] IX, pp. 44–48.
 Entries: 11. Pre-metric. Inscriptions.
 Described.

 [RD.] VI, pp. 7–32.
 Entries: 86. Millimeters. Inscriptions.
 Described.

 [P.] VI, pp. 263–264.
 Additional information to [B.] and
 [RD.].

CC [Nagler, *Mon.*] I, no. 2372
See **Clofigl,** Caspar

CD *(19th cent.)*
[Dus.] p. 122.
 Entries: 1 (lithographs only, to 1821).
 Inscriptions.

CE *(fl. c.1562)* [Nagler, *Mon.*] I, no. 2487
[B.] IX, pp. 425–426.
 Entries: 2+. Pre-metric. Inscriptions.
 Described.

 Wiechmann-Kadow, ———.
 "Holzschnitte altdeutscher Meister."
 [*N. Arch.*] I (1855): 126–128.
 Entries: 11 (additional to [B.]). Paper
 fold measure. Inscriptions. De-
 scribed.

 [P.] IV, pp. 65–66.
 Entries: 4+ (additional to [B.]). Paper
 fold measure. Pre-metric. Inscrip-
 tions. Described (selection).

CEB *(fl. c.1630)*
[H. *Neth.*] XIII, p. 22.
 Entries: 1. Illustrated.*

CF [Nagler, *Mon.*] I, no. 2518
See **Fraisinger,** Caspar

C FL *(19th cent.)*
[Dus.] p. 122.
 Entries: 1 (lithographs only, to 1821).
 Paper fold measure. Inscriptions.

CG *(fl. 1534–1539)* [Nagler, *Mon.*] II, no. 55
[B.] IX, pp. 17–21.
 Entries: 10. Pre-metric. Inscriptions.
 States. Described.

 [P.] IV, pp. 41–44.
 Entries: 19+ (additional to [B.]). Pre-
 metric. Inscriptions. Described (selec-
 tion). Located.

 [Wess.] I, pp. 147–148.
 Entries: 4 (additional to [B.] and [P.]).
 Millimeters. Inscriptions. Described.

CG *(fl. c.1530)* [Nagler, *Mon.*] II, no. 56
[B.] IX, pp. 16–17.
Entries: 7. Pre-metric. Inscriptions. Described.

[P.] IV, pp. 171–172.
Entries: 2 (additional to [B.]). Pre-metric. Inscriptions. Described. Located.

[H. *Neth.*] XIII, p. 21.
Entries: 8. Illustrated.*

CG *(fl. c.1520)* [Nagler, *Mon.*] II, no. 65, 2795
[B.] VII, p. 472.
Entries: 1. Pre-metric. Inscriptions. Described.

[P.] IV, pp. 302–303.
Entries: 6 (additional to [B.]). Pre-metric. Inscriptions. Described. Located (selection).

CG *(fl. 1572?–1584?)* [Nagler, *Mon.*] II, p. 71
[P.] IV, pp. 336–337.
Entries: 1+.

CG [Nagler, *Mon.*] II, no. 76
See **Grale,** Conrad

CG *(fl. c.1610)*
[Hind, *Engl.*] II, p. 305.
Entries: 1. Inches. Inscriptions. Described. Illustrated. Located.

CH *(fl. c.1515)* [Nagler, *Mon.*] II, no. 113
[B.] VII, p. 494.
Entries: 1. Pre-metric. Inscriptions. Described.

CH *(fl. c.1540)* [Nagler, *Mon.*] II, no. 160
[P.] III, pp. 439–440.
Entries: 1. Pre-metric. Inscriptions. Described.

CHK [Nagler, *Mon.*] II, no. 169
See **Coxie,** Michael

CHMRZO I VEN *(fl. c.1539)*
[Evans] p. 21.
Entries: 1. Millimeters. Inscriptions. Described.

CHRO *(fl. c.1632)*
[H. *Neth.*] XIII, p. 22.
Entries: 1. Illustrated.*

CI *(fl. c.1547)* [Nagler, *Mon.*] II, nos. 208, 234
[B.] IX, pp. 404–405.
Entries: 5. Pre-metric. Inscriptions. Described.

CI *(fl. c.1550)* [Nagler, *Mon.*] II, no. 214
[H. *Neth.*] XIII, p. 23.
Entries: 2. Illustrated (selection).*

CK *(fl. c.1534)* [Nagler, *Mon.*] II, no. 287
[B.] IX, p. 37.
Entries: 1. Pre-metric. Inscriptions. Described.

CKFC *(fl. c.1750)*
[Merlo] p. 1115.*

CL *(fl. c.1560)* [Nagler, *Mon.*] II, no. 344
[B.] IX, p. 435.
Entries: 1. Pre-metric. Inscriptions.

CLM *(16th cent.)*
[P.] III, p. 109.
Entries: 1. Pre-metric. Inscriptions. Described. Located.

CLT *(19th cent.)*
[Dus.] p. 126.
Entries: 1 (lithographs only, to 1821). Millimeters. Inscriptions. Located.

CM *(b. 1729)* [Nagler, *Mon.*] II, no. 391
[B.] IX, pp. 490–492.
Entries: 5. Pre-metric. Inscriptions. States. Described.

CM *(1558–1614)* [Nagler, *Mon.*] II, no. 393
[B.] IX, pp. 417–418.
 Entries: 1. Pre-metric. Inscriptions.
 Described.

CM *(16th cent.)* [Nagler, *Mon.*] II, no. 423;
III, no. 179
 [P.] II, p. 291.
 Entries: 1. Pre-metric. Inscriptions.
 Described. Located.

 [H. *Neth.*] XII, p. 181.
 Entries: 1. Illustrated.*

CM *(16th cent.)* [Nagler, *Mon.*] IV, no. 1699
 [P.] III, pp. 469–470.
 Entries: 2 (allegedly additional to [B.],
 Monogram CM; [Nagler, *Mon.*] II, no.
 393). Paper fold measure. Pre-metric.
 Inscriptions. Described. Located
 (selection).

CP *(fl. c.1565)* [Nagler, *Mon.*] II, no. 521
 [P.] III, pp. 91–93.
 Entries: 11. Pre-metric. Inscriptions.
 Described. Located.

 [H. *Neth.*] XIII, pp. 24–29.
 Entries: 11. Illustrated (selection).*

CPP *(fl. c.1600)* [Nagler, *Mon.*] II, no. 565
 [B.] XIX, pp. 183–186.
 Entries: 7. Pre-metric. Inscriptions.
 Described.

CR *(fl. c.1560)* [Nagler, *Mon.*] II, no. 570
 [B.] VII, p. 474.
 Entries: 1. Pre-metric. Inscriptions.
 Described.

CR *(fl. c.1616)* [Nagler, *Mon.*] II, no. 588
 [H. *Neth.*] XIII, p. 30.
 Entries: 8. Illustrated (selection).*

CR *(fl. c.1544)* [Nagler, *Mon.*] II, no. 589
 [P.] IV, p. 185.
 Entries: 8. Pre-metric. Inscriptions.
 States. Described. Located.

CR *(16th cent.?)*
 [Evans] p. 29.
 Entries: 1. Millimeters. Inscriptions.
 Described.

CRF *(19th cent.)*
 [Merlo] pp. 1115–1116.*

CS *(fl. c.1550)* [Nagler, *Mon.*] II, no. 669
 [B.] IX, pp. 412–413.
 Entries: 5. Pre-metric. Inscriptions.
 Described.

 [P.] IV, pp. 211–212.
 Entries: 3+. Paper fold measure.
 Pre-metric. Inscriptions (selection).
 States. Described (selection).

CS *(fl. c.1513)* [Nagler, *Mon.*] IV, no. 3991
 [P.] IV, p. 155.
 Entries: 1. Pre-metric. Inscriptions.
 Described.

CS *(fl. c.1583)*
 [B.] IX, p. 558.
 Entries: 2. Pre-metric. Inscriptions.
 Described.

 [Wess.] I, p. 150.
 Addtional information to [B.].

CS *(19th cent.)*
 [Dus.] p. 124.
 Entries: 1 (lithographs only, to 1821).
 Millimeters. Inscriptions. Located.

C. Str. *(19th cent.)*
 [Dus.] p. 125.
 Entries: 1 (lithographs only, to 1821).
 Millimeters. Inscriptions. Located.

CT *(15th cent.)* [Nagler, *Mon.*] II, no. 732
 [P.] IV, p. 163.
 Entries: 1. Pre-metric. Inscriptions.
 Described. Located.

CV [Nagler, *Mon.*] II, no. 752
 [B.] XII: *See* **Chiaroscuro Woodcuts**

CVF *(fl. c.1654)*
[H. *Neth.*] XIII, p. 30.
Entries: 1. Illustrated.*

CW *(fl. c.1564)* [Nagler, *Mon.*] II, no. 825
[P.] III, p. 317.
Entries: 2. Pre-metric. Inscriptions.
Described. Located.

CW *(16th cent.)* [Nagler, *Mon.*] V, no. 1582
[B.] VIII, p. 18.
Entries: 1. Pre-metric. Inscriptions.
Described.

[P.] IV, pp. 109–110.
Entries: 4 (additional to [B.]). Pre-
metric. Inscriptions. Described. Lo-
cated.

[Wess.] I, p. 145.
Entries: 2 (additional to [B.] and [P.]).
Millimeters. Inscriptions. Described.

CW *(16th cent.)* [Nagler, *Mon.*] V, no. 1583
[P.] IV, p. 342.
Entries: 1. Pre-metric. Inscriptions.
Described.

D *(fl. 1450–1465)* [Nagler, *Mon.*] II, no. 902
[H. *Neth.*] XII, pp. 135–137.
Entries: 12. Illustrated (selection).*

D with the arrow *(late 15th cent.)*
[Nagler, *Mon.*] III, no. 2175
[Lehrs] VI, pp. 2–3.
Entries: 1. Millimeters. Inscriptions.
Described. Located. Locations of all
known impressions are given. Copies
mentioned. Watermarks described.
Bibliography for each entry.

D *(fl. 1450–1465)*
[Schreiber, *Metallschneidekunst*] p. 89.
Entries: 22 prints by, 7 doubtful
prints.*

DA *(15th cent.)* [Nagler, *Mon.*] I, no. 396
[P.] V, pp. 227–228.

Entries: 1. Pre-metric. Inscriptions.
Described. Located. Watermarks de-
scribed. *See* [Hind] V, p. 333.

DA with the anchor
See **Master of JESUS in Bethany**

DB [Nagler, *Mon.*] II, no. 969
See **Brentel,** David

DDC *(fl. 1526–1556)* [Nagler, *Mon.*] II, no.
1041
[H. *Neth.*] XIII, p. 31.
Entries: 2. Illustrated.*

DH *(fl. c.1559)* [Nagler, *Mon.*] II, no. 1122
[B.] IX, pp. 432–433.
Entries: 1. Pre-metric. Inscriptions.
Described.

[P.] IV, pp. 319–320.
Entries: 6 (additional to [B.]). Pre-
metric (selection). Inscriptions. De-
scribed.

DK [Nagler, *Mon.*] II, nos. 1173, 1177, 1181,
1189
See **Kandel,** David

DKL *(fl. c.1588)* [Nagler, *Mon.*] II, no. 1186
[B.] IX, pp. 579–580.
Entries: 1. Pre-metric. Inscriptions.
Described.

DR *(fl. 1563–1578)* [Nagler, *Mon.*] II, no.
1328
[B.] IX, p. 495.
Entries: 1. Pre-metric. Inscriptions.
Described. Perhaps the same artist as
Monogram DR ([Nagler, *Mon.*] II, no.
1339).

DR *(fl. c.1588)* [Nagler, *Mon.*] II, no. 1339
[B.] IX, p. 398.
Entries: 2. Pre-metric. Inscriptions.
Described. Perhaps the same artist as
Monogram DR ([Nagler, *Mon.*] II, no.
1328).

DS *(fl. c.1559)* [Nagler, *Mon.*] II, no. 1353
[B.] IX, pp. 479–480.
 Entries: 4. Pre-metric. Inscriptions.
 Described.

DS *(fl. 1503–1515)* [Nagler, *Mon.*] II, nos.
1355, 1368, 1369
 [P.] IV, pp. 311–312.
 Entries: 2 prints by, 1 doubtful print.
 Pre-metric. Inscriptions. Described.

 [P.] IV, p. 338.
 Entries: 1. Pre-metric. Described.

Dodgson, Campbell. "Die Holzschnitte
des Baseler Meisters D.S." [*JprK.*] 28
(1907): 21–33.
 Entries: 33. Millimeters. States. Illus-
 trated (selection). Located (selection).
 Bibliography for each entry.

Bock, Elfried. *Holzschnitte des Meisters
DS.* Berlin: Deutscher Verein für
Kunstwissenschaft, 1924.
 Entries: 41. Inscriptions. States. De-
 scribed. Illustrated. Prints are repro-
 duced in natural size. Appendix with
 21 rejected prints.

Fischel, Lilli. "Neue Mitteilungen über
den Basler Monogrammisten DS."
Münchner Jahrbuch, 3d ser. 5 (1954): 111–
119.
 Entries: 12 (additional to earlier
 catalogues). Millimeters. Described.
 Illustrated (selection). Located.

DS *(late 15th cent.)* [Nagler, *Mon.*] II, no.
1380
 [P.] II, pp. 81–82.
 Entries: 2. Pre-metric. Inscriptions.
 Described. Located.

DT *(16th cent.)* [Nagler, *Mon.*] II, no. 1395
 [P.] III, pp. 85–86.
 Entries: 4. Pre-metric. Inscriptions.
 Described. Located.

 [H. *Neth.*] XIII, pp. 32–33.
 Entries: 5. Illustrated (selection).*

DVB *(16th cent.)* [Nagler, *Mon.*] II, no. 1419
 [P.] III, pp. 86–87.
 Entries: 1. Pre-metric. Inscriptions.
 Described. Located.

 [H. *Neth.*] XIII, p. 31.
 Entries: 1. Illustrated.*

DW [Nagler, *Mon.*] II, no. 1459
See **Winhart,** Dietrich

DW *(fl. c.1550)* [Nagler, *Mon.*] V, no. 1609
 [P.] IV, p. 175.
 Entries: 1. Pre-metric. Inscriptions.
 Described. Located.

 [P.] IV, p. 176.
 Entries: 1.

E *(15th cent.)*
 [P.] II, p. 165.
 Entries: 1. Pre-metric. Inscriptions.
 States. Described. Located.

EA 1536
 See **Monogram AL 1535** [Nagler, *Mon.*]
 I, no. 797

EA *(fl. c.1506)* [Nagler, *Mon.*] II, no. 1498
 [B.] VI, p. 416.
 Entries: 1. Pre-metric. Inscriptions.
 Described.

 [P.] IV, p. 40.
 Additional information to [B.].

EFGW *(fl. c.1517)* [Nagler, *Mon.*] II, no.
1581
 [P.] III, pp. 342–343.
 Entries: 2. Pre-metric. Inscriptions.
 Described. Located.

EK *(fl. c.1808)*
 [Dus.] p. 123.
 Entries: 1 (lithographs only, to 1821).
 Inscriptions.

EM *(d. 1531)* [Nagler, *Mon.*] II, no. 1677
 [P.] IV, p. 156.

Monogram EM (*continued*)

Entries: 1. Pre-metric. Inscriptions. Described.

EP (*fl. c.1750*)
[Merlo] p. 1116.*

ER (*fl. c.1619*)
[Merlo] pp. 1116–1117.*

ER (*16th cent.*) [Nagler, *Mon.*] II, no. 1739
[B.] IX, pp. 240–241.
Entries: 1. Pre-metric. Inscriptions. Described.

[P.] IV, pp. 168–169.
Entries: 1 (additional to [B.]). Pre-metric. Inscriptions. Described. Located.

ES (*fl. 1440–1468*) [Nagler, *Mon.*] II, no. 1763
[B.] VI, pp. 1–52.
Entries: 113. Pre-metric. Inscriptions. States. Described. Copies mentioned. Appendix with 11 doubtful prints.

Frenzel, ———. "Die Blätter des alten Meisters E.S. 1466." [*N. Arch.*] I (1855): 15–49.
Entries: 74 (additional to [B.]). Pre-metric. Inscriptions. Described. Copies mentioned. Additional information to [B.].

Nagler, G. K. "Nachtrag über den alten Meister E. S. von 1466." [*N. Arch.*] I (1855): 189–193.
Entries: 13 (additional to earlier catalogues). Pre-metric. Inscriptions. Described.

[Evans] pp. 23, 30–35.
Entries: 4 (additional to [B.]). Millimeters. Inscriptions. Described.

[P.] II, pp. 33–103.
Entries: 99+ prints by (additional to [B.]), 106 prints by followers. Pre-

metric. Inscriptions. States. Described. Located. Papers and watermarks described. Copies mentioned. Additional information to [B.].

[P.] II, p. 68.
Entries: 7 (attributed by [P.] to Master of the Sibyl). Pre-metric. Inscriptions. Described. Located. Copies mentioned. Watermarks described.

[Lehrs] II, pp. 1–432.
Entries: 314. Millimeters. Inscriptions. States. Described. Illustrated (selection). Located. Locations of all known impressions are given. Copies mentioned. Watermarks described. Bibliography for each entry.

Lehrs, Max. "Neue Funde zum Werk des Meisters E.S." [*JprK.*] 33 (1912): 275–283.
Additional information to [Lehrs].

Geisberg, Max. *Die Kupferstiche des Meisters E.S.* Berlin: Bruno Cassirer, 1924. 300 copies. (NN)
Entries: 317. States. Illustrated. Located. Also, reproductions of all known copies after lost prints by: plates 223–248.

Geisberg, Max. *Der Meister E.S.* Meister der Graphik, 10. Leipzig: Klinkhardt und Bierman, 1924.
Entries: 317 (based on Lehrs, with 3 additions). Illustrated (selection). Located (selection).

Huth, Hans. "Ein verlorener Stich des Meisters E.S." In *Adolph Goldschmidt zu seinem siebenzigsten Geburtstag.* pp. 74–76. Berlin: Würfel Verlag, 1935.
Additional information to [Lehrs] (identification from copies of a lost print).

ES (*fl. c.1519*) [Nagler, *Mon.*] IV, no. 4042
[P.] III, pp. 84–85.
Entries: 1. Pre-metric. Inscriptions. Described. Located.

[Merlo] p. 1117.*

[H. *Neth.*] XIII, p. 34.
Entries: 1. Illustrated.*

EWA *(18th cent.)*
[Sm.] I, p. 4.
Entries: 1 (portraits only). Inches. Inscriptions. Described.

F [Nagler, *Mon.*] II, no. 1830
See **Monogram T** [Nagler, *Mon.*] II, no. 1830

F *(fl. c.1551)* [Nagler, *Mon.*] II, no. 1834
[P.] IV, 260.
Entries: 1. Pre-metric. Inscriptions. Described. Located.

F *(15th cent.)* [Nagler, *Mon.*] II, no. 3137
[P.] II, pp. 290–291.
Entries: 1. Pre-metric. Inscriptions. Described. Located.

[Lehrs] VII, pp. 353–354.
Entries: 3. Millimeters. Inscriptions. Described. Located. Locations of all known impressions are given. Copies mentioned. Watermarks described. Bibliography for each entry.

[H. *Neth.*] XII, p. 139.
Entries: 3. Illustrated (selection).*

F *(15th cent.)*
[Schreiber, *Metallschneidekunst*] p. 88.
Entries: 1.*

FA *(fl. 1560–1570)* [Nagler, *Mon.*] II, no. 1864
[B.] IX, p. 481.
Entries: 1 (as Monogram FT). Pre-metric. Inscriptions. Described.

[B.] IX, pp. 481–482.
Entries: 1 (as Monogram FA). Pre-metric. Inscriptions. Described.

[P.] IV, pp. 185–186.

Entries: 3 (additional to [B.] IX, p. 481.). Pre-metric. Inscriptions. Described. Additional information to [B.].

[P.] IV, pp. 186–188.
Entries: 6+ (additional to [B.] IX, pp. 481–482). Paper fold measure. Pre-metric. Inscriptions. Described.

FA *(fl. 1500–1510)*
[Hind] V, pp. 245–246.
Entries: 1. Millimeters. Inscriptions. Described. Illustrated. Located.

FA *(fl. c.1810)*
[Dus.] p. 121.
Entries: 1 (lithographs only, to 1821). Millimeters. Inscriptions. Located.

FAN *(fl. c.1507)* [Nagler, *Mon.*] II, no. 1892
[B.] XIII, pp. 351–352.
Entries: 1. Pre-metric. Inscriptions. Described.

[P.] p. 92.
Additional information to [B.].

[Hind] V, pp. 244–245.
Entries: 1. Millimeters. Inscriptions. Described. Illustrated. Located.

FB [Nagler, *Mon.*] II, nos. 1910, 1926
See **Brun,** Franz

FB *(16th cent.)* [Nagler, *Mon.*] II, no. 1927
[Herbet] IV, p. 339.
Entries: 1. Millimeters. Inscriptions. Described.

FB
See **Monogram BF** [Nagler, *Mon.*] I, no. 1821

FB
See **Monogram RQL** [Nagler, *Mon.*] IV, no. 3765

FB *(fl. c.1550)*
[H. *Neth.*] XIII, p. 34.
Entries: 1. Illustrated.*

FC [Nagler, *Mon.*] II, no. 1983
See **Crabbe,** Frans

FCZ *(16th cent.)* [Nagler, *Mon.*] II, no. 2014
[P.] IV, p. 44.
 Entries: 3+. Pre-metric. Inscriptions.
 Described. Located.

FF *(fl. c.1580)* [Nagler, *Mon.*] II, no. 2073
[H. *Neth.*] XIII, p. 34.
 Entries: 14.*.

FFF *(fl. c.1584)* [Nagler, *Mon.*] II, no. 2098
[Merlo] p. 1117.*

FG *(fl. 1534–1537)* [Nagler, *Mon.*] II, nos.
2115, 2914
 [B.] IX, pp. 24–33.
 Entries: 22. Pre-metric. Inscriptions.
 States. Described.

 [Evans] pp. 24–25.
 Entries: 2 (additional to [B.]). Milli-
 meters. Inscriptions. Described.

 [P.] IV, pp. 107–108.
 Entries: 5 (additional to [B.]). Pre-
 metric. Inscriptions. Described. Lo-
 cated.

 [Wess.] I, p. 147.
 Entries: 1 (additional to [B.]). Milli-
 meters. Inscriptions. Described.

 [Herbet] III, pp. 14–33; V, p. 82.
 Entries: 12. Millimeters. Inscriptions.
 Described. Located (selection).

FH *(fl. c.1548)* [Nagler, *Mon.*] II, no. 2148
[B.] IX, p. 89.
 Entries: 1. Pre-metric. Inscriptions.
 Described.

FH *(16th cent.)*
 [P.] VI, pp. 131–132.
 Entries: 1. Pre-metric. Inscriptions.
 Described.

FHB *(16th cent.)* [Nagler, *Mon.*] II, no. 2169
[H. *Neth.*] XIII, p. 53.
 Entries: 1.*

FHS [Nagler, *Mon.*] II, no. 2179
See **Monogram CW** [Nagler, *Mon.*] V,
no. 1583

FI *(15th cent.)*
 [Lehrs] VII, p. 355.
 Entries: 1. Millimeters. Inscriptions.
 Described. Located. Locations of all
 known impressions are given. Copies
 mentioned. Watermarks described.
 Bibliography for each entry.

FI *(fl. c.1675)*
 [Merlo] p. 1117.*

FJ *(19th cent.)*
 [Dus.] p. 123.
 Entries: 1 (lithographs only, to 1821).
 Millimeters. Inscriptions. Described.
 Located.

FL [Nagler, *Mon.*] II, no. 2238
See **Fryg,** Ludwig

FL *(fl. c.1520)* [Nagler, *Mon.*] II, no. 2244
[B.] VIII, p. 12.
 Entries: 1. Pre-metric. Inscriptions.
 Described.

 [P.] IV, p. 109.
 Entries: 2 (additional to [B.]). Pre-
 metric. Inscriptions. Described. Lo-
 cated.

FME [Nagler, *Mon.*] II, no. 2287
See **Menton,** Frans

FN *(fl. c.1515)* [Nagler, *Mon.*] II, no. 2300
[B.] XIII, p. 367.
 Entries: 1. Pre-metric. Inscriptions.
 Described.

 [P.] V, p. 175.
 Additional information to [B.].

[Hind] V, pp. 246–247.
Entries: 1. Millimeters. Inscriptions. Described. Illustrated. Located.

FO *(fl. 1560–1570)* [Nagler, *Mon.*] II, no. 2313
[B.] IX, pp. 415–416.
Entries: 1. Pre-metric. Inscriptions. Described.

[P.] III, pp. 352–353.
Entries: 2+ (additional to [B.]). Paper fold measure. Inscriptions. Described.

FP *(16th cent.)* [Nagler, *Mon.*] II, no. 2333
[B.] XVI, pp. 19–27.
Entries: 26. Pre-metric. Inscriptions. Described. Copies mentioned.

FP *(fl. c.1640)* [Nagler, *Mon.*] II, no. 2338
[H. *Neth.*] XIII, p. 35.
Entries: 1.*.

FR
See **Monogram ILDRF** [Nagler, *Mon.*] III, no. 2752

FRK *(fl. c.1580)* [Nagler, *Mon.*] II, no. 2466
[B.] IX, pp. 575–576.
Entries: 1. Pre-metric. Inscriptions. Described.

FT [Nagler, *Mon.*] II, no. 2515
See **Monogram FA** [Nagler, *Mon.*] II, no. 1864

FT *(fl. c.1573)* [Nagler, *Mon.*] II, no. 2523
[B.] IX, p. 547.
Entries: 1. Pre-metric. Inscriptions. Described.

FVB *(fl. 1455–1500)* [Nagler, *Mon.*] II, no. 2552
[B.] VI, pp. 77–90.
Entries: 38. Pre-metric. Inscriptions. Described.

[Evans] pp. 38–39.
Entries: 4 (additional to [B.]). Millimeters. Inscriptions. Described.

[P.] II, pp. 186–189.
Entries: 17 (additional to [B.]). Pre-metric. Inscriptions. States. Described. Located. Copies mentioned. Additional information to [B.].

[Wess.] I, p. 131.
Entries: 1 (additional to [B.] and [P.]). Millimeters. Inscriptions. Described.

[W.] III, pp. 30–31.
Entries: 55+.*

[Lehrs] VII, pp. 102–164.
Entries: 59. Millimeters. Inscriptions. States. Described. Illustrated (selection). Located. Locations of all known impressions are given. Copies mentioned. Watermarks described. Bibliography for each entry.

[H. *Neth.*] XII, pp. 140–167.
Entries: 59. Illustrated (selection).*

FWD *(fl. c.1577)* [Nagler, *Mon.*] II, no. 2599
[B.] IX, pp. 548–549.
Entries: 1. Pre-metric. Inscriptions. Described.

G *(16th cent.)* [Nagler, *Mon.*] II, no. 2615
[B.] VIII, p. 10.
Entries: 1. Pre-metric. Inscriptions. Described.

G *(fl. 1500–1520)* [Nagler, *Mon.*] II, no. 2616
[B.] VIII, pp. 11–12.
Entries: 1. Pre-metric. Inscriptions. Described.

G *(fl. c.1536)* [Nagler, *Mon.*] II, no. 2619
[P.] IV, pp. 299–300.
Entries: 6. Pre-metric. Inscriptions. Described.

GA with the caltrop *(fl. c.1538)*
[Nagler, *Mon.*] II, no. 2679
　[B.] XV, p. 540.
　　Entries: 1. Pre-metric. Inscriptions.
　　Described.

　[P.] VI, pp. 161–164.
　　Entries: 37 (additional to [B.]). Pre-
　　metric (selection). Inscriptions. De-
　　scribed. Located (selection).

GADH *(fl. c.1579)* [Nagler, *Mon.*] II, no.
2696
　[B.] IX, pp. 494–495.
　　Entries: 1. Pre-metric. Inscriptions.
　　Described.

　[Wess.] I, p. 150.
　　Entries: 1 (additional to [B.]). Inscrip-
　　tions. States. Described.

GC [Nagler, *Mon.*] II, no. 2795
See **Monogram CG** [Nagler, *Mon.*] II, no.
65

GD *(16th cent.)*
　[RD.] IX, pp. 1–3.
　　Entries: 1. Millimeters. Inscriptions.
　　Described.

GDW *(16th cent.)* [Nagler, *Mon.*] II, no.
2882
　[H. *Neth.*] XIII, p. 36.
　　Entries: 8. Illustrated (selection).*

GF [Nagler, *Mon.*] II, nos. 2914, 2931
See **Monogram FG** [Nagler, *Mon.*] II, no.
2115

GG *(16th cent.)* [Nagler, *Mon.*] I, no. 2357
　[P.] V, p. 226.
　　Entries: 1. Pre-metric. Inscriptions.
　　Described. Located. *See* [Hind] V,
　　p. 333.

GG *(16th cent.)* [Nagler, *Mon.*] II, no. 2992
　[B.] IX, pp. 428–429.
　　Entries: 5. Pre-metric. Inscriptions.
　　Described.

GH *(16th cent.)* [Nagler, *Mon.*] II, no. 3069
　[H. *Neth.*] XIII, p. 37.
　　Entries: 1. Illustrated.*

GH *(early 16th cent.)*
　[H. *Neth.*] XIII, p. 37.
　　Entries: 1. Illustrated.*

GI *(fl. 1522–1530)* [Nagler, *Mon.*] II, no.
3116
　[B.] VIII, p. 6.
　　Entries: 1. Pre-metric. Inscriptions.
　　Described.

　[H. *Neth.*] XIII, pp. 38–45.
　　Entries: 29. Illustrated (selection).*

GI *(15th cent.)* [Nagler, *Mon.*] III, no. 18
　[P.] II, p. 146.
　　Entries: 3. Pre-metric. Inscriptions.
　　Described. Located.

　[Lehrs] VI, pp. 3–4.
　　Entries: 3. Millimeters. Inscriptions.
　　Described. Located. Locations of all
　　known impressions are given. Copies
　　mentioned. Watermarks described.
　　Bibliography for each entry.

GK *(16th cent.)* [Nagler, *Mon.*] III, no. 74
　[P.] VI, p. 172.
　　Entries: 1. Pre-metric. Inscriptions.
　　Described.

GKP [Nagler, *Mon.*] III, no. 87
See **Proger,** Gilich Kilian

GL [Nagler, *Mon.*] III, no. 93
See **Leigel,** Gottfried

GL [Nagler, *Mon.*] III, no. 95
See **Gassell,** Lucas

GL *(fl. 1523–1540)* [Nagler, *Mon.*] III, no.
120
　[B.] VII, p. 487.
　　Entries: 1. Pre-metric. Inscriptions.
　　Described.

[P.] IV, pp. 59–60.
 Entries: 6 (additional to [B.]).

GLM *(17th cent.)* [Nagler, *Mon.*] III, no. 154
[H. *Neth.*] XIII, p. 46.
 Entries: 1. Illustrated.*

GM [Nagler, *Mon.*] III, no. 179
See **Monogram CM** [Nagler, *Mon.*] II,
no. 423

GM *(fl. c.1586)*
[H. *Neth.*] XIII, p. 46.
 Entries: 1. Illustrated.*

GN *(18th cent.)*
[Sm.] III, p. 950; IV, "additions and cor-
rections" section.
 Entries: 1 (portraits only.) Inches. In-
 scriptions. Described.

GR *(fl. c.1550)*
[P.] IV, pp. 313–314.
 Entries: 1. Pre-metric. Inscriptions.
 Described.

GR Verone *(16th cent.)* [Nagler, *Mon.*]
III, no. 304
[Herbet] IV, pp. 344–346; V, p. 86.
 Entries: 3. Millimeters. Inscriptions.
 Described.

GS *(fl. 1540–1550)* [Nagler, *Mon.*] III, no.
341
[B.] IX, pp. 160–161.
 Entries: 1+. Pre-metric. Inscriptions.
 Described.

GS [Nagler, *Mon.*] III, nos. 344, 359
See **Scharffenberg,** Crispin

GS *(15th cent.?)*
[P.] IV, p. 148.
 Entries: 1. Pre-metric. Inscriptions.
 Described. Located.

GSF *(fl. c.1705)* [Nagler, *Mon.*] III, no. 367
[Merlo] p. 1118.*

GT [Nagler, *Mon.*] III, no. 388
See **Monogram NTG** [Nagler, *Mon.*] II,
no. 714; III, no. 388

GV *(15th cent.)* [Nagler, *Mon.*] III, no. 419
[P.] II, pp. 165–166.
 Entries: 1. Pre-metric. Inscriptions.
 Described. Located.

[H. *Neth.*] XIII, p. 48.
 Entries: 2. Illustrated.*

GVG *(fl. c.1520)* [Nagler, *Mon.*] III, no. 446
[P.] IV, p. 164.
 Entries: 1. Pre-metric. Described.

GW [Nagler, *Mon.*] III, nos. 461, 462
See **Weiditz,** Christophe II

GWYAHB *(fl. c.1569)* [Nagler, *Mon.*] III,
no. 485
[B.] IX, p. 500.
 Entries: 1. Pre-metric. Inscriptions.
 Described.

[P.] IV, pp. 259–260.
 Entries: 3 (additional to [B.]). Pre-
 metric. Inscriptions. Described. Lo-
 cated (selection).

GZ *(f. c.1518)* [Nagler, *Mon.*] III, no. 493
[P.] IV, p. 301.
 Entries: 4. Pre-metric. Inscriptions.
 Described.

H *(fl. 1529–1548)* [Nagler, *Mon.*] III, no. 511
[P.] III, p. 94.
 Entries: 2 (listed under separate but
 similar monograms). Pre-metric. In-
 scriptions. Described. Located.

[H. *Neth.*] XIII, p. 49.
 Entries: 3. Illustrated (selection).*

H *(15th cent.)* [Nagler, *Mon.*] III, no. 512
[P.] II, pp. 205–206.
 Entries: 2. Pre-metric. Inscriptions.
 States. Described. Located. Copies
 mentioned.

Monogram H (*continued*)

[Lehrs] VII, pp. 355–358.
Entries: 2. Millimeters. Inscriptions. States. Described. Illustrated (selection). Located. Locations of all known impressions are given. Copies mentioned. Watermarks described. Bibliography for each entry.

H (*fl. c.1528*) [Nagler, *Mon.*] III, no. 530
[P.] IV, p. 157.
Entries: 1. Pre-metric. Inscriptions. Described.

H (*15th cent.*) [Nagler, *Mon.*] III, no. 567
[Lehrs] VII, pp. 362–366.
Entries: 5. Millimeters. Inscriptions. Described. Located. Locations of all known impressions are given. Copies mentioned. Watermarks described. Bibliography for each entry.

[H. *Neth.*] XII, p. 183.
Entries: 5. Illustrated (selection).*

H (*fl. c.1564*) [Nagler, *Mon.*] III, nos. 569, 570
[B.] IX, pp. 419–420.
Entries: 1.

[P.] IV, pp. 315–316.
Entries: 15+. Paper fold measure (selection). Pre-metric (selection). Inscriptions. Described (selection).

[Merlo] pp. 1121–1122.
Entries: unnumbered, pp. 1121–1122. Pre-metric. Inscriptions (selection). Described (selection).

H (*fl. c.1525*)
[Ge.] nos. 926–928.
Entries: 3 (single-sheet woodcuts only). Described. Illustrated. Located.

H (*fl. c.1533*)
[Evans] pp. 27–28.
Entries: 1. Millimeters. Inscriptions. Described.

HA (*fl. 1550–1553*) [Nagler, *Mon.*] III, no. 587
[B.] IX, pp. 431–432.
Entries: 1. Pre-metric. Inscriptions. Described.

[P.] IV, pp. 318–319.
Entries: 5. Pre-metric. Inscriptions. Described.

HA (*fl. c.1526*)
[Merlo] pp. 1118–1119.*

HAFE (*fl. c.1652*) [Nagler, *Mon.*] III, no. 584
[H. *Neth.*] XIII, p. 5.
Entries: 1. Illustrated.*

HAK [Nagler, *Mon.*] III, no. 626
See **Monogram HK** [Nagler, *Mon.*] III, no. 1160

HAR (*16th cent.*) [Nagler, *Mon.*] III, no. 638
[B.] VIII, pp. 5–6.
Entries: 1. Pre-metric. Inscriptions. Described.

[P.] IV, pp. 159–160.
Entries: 1. Pre-metric. Inscriptions. Described. Located.

HB (*16th cent.*) [Nagler, *Mon.*] III, no. 665
[B.] VIII, pp. 536–537.
Entries: 2. Pre-metric. Inscriptions. Described.

HB (*fl. c.1530*) [Nagler, *Mon.*] III, no. 671
[B.] IX, p. 41.
Entries: 1. Pre-metric. Inscriptions. Described.

HB (*fl. c.1490*) [Nagler, *Mon.*] III, no. 706
[P.] II, p. 144.
Entries: 3. Pre-metric. Inscriptions. Described. Located.

[Lehrs] VII, pp. 358–360.
Entries: 3. Millimeters. Inscriptions. Described. Located. Locations of all

known impressions are given. Copies mentioned. Watermarks described. Bibliography for each entry.

HCB *(fl. c.1575)* [Nagler, *Mon.*] III, no. 782
[H. *Neth.*] XIII, p. 50.
Entries: 1.*

HCC *(19th cent.)*
[Dus.] p. 122.
Entries: 1 (lithographs only, to 1821).
Inscriptions.

HCF *(fl. 1575–1590)* [Nagler, *Mon.*] III, no. 786
[H. *Neth.*] XIII, p. 50.
Entries: 1. Illustrated.*

HCWC [Nagler, *Mon.*] III, no. 802
See **Wörle,** Hans Conrad

HCZA *(15th cent.)* [Nagler, *Mon.*] III, no. 803
[B.] VII, pp. 495–496.
Entries: 1. Pre-metric. Inscriptions.
Described.

HD *(fl. c.1550)* [Nagler, *Mon.*] III, no. 806
[Merlo] p. 1119.*

HD *(fl. 1511–1517?)* [Nagler, *Mon.*] III, no. 819
[P.] IV, pp. 160–162.
Entries: 3+. Paper fold measure.
Pre-metric. Inscriptions. Described (selection). Located.

HD *(fl. c.1600)* [Nagler, *Mon.*] III, no. 820
[H. *Neth.*] XIII, p. 51.
Entries: 1. Illustrated.*

HD *(16th cent.)*
[H. *Neth.*] XIII, p. 51.
Entries: 1. Illustrated.*

HE *(16th cent.)* [Nagler, *Mon.*] III, no. 853
[B.] IX, pp. 565–566.

Entries: 3. Pre-metric. Inscriptions.
Described.

[P.] IV, pp. 322–324.
Entries: 15. Pre-metric. Inscriptions.
Described.

[Merlo] pp. 1119–1121.
Entries: unnumbered, pp. 1119–1121.
Pre-metric (selection). Inscriptions (selection). Described (selection).

HE *(16th cent.)* [Nagler, *Mon.*] III, no. 859
[B.] IX, pp. 42–43.
Entries: 1. Pre-metric. Inscriptions.
Described.

[P.] IV, p. 157.
Entries: 1 (additional to [B.]). Pre-metric. Inscriptions. Described.

[Wess.] I, p. 148.
Entries: 1 (additional to [B.]). Millimeters. Inscriptions. Described.

HEUY or **HEINZE** [Nagler, *Mon.*] III, no. 877
See **Heince,** Zacharie

HF *(fl. 1510–1520)* [Nagler, *Mon.*] III, no. 896
[B.] VII, pp. 452–454.
Entries: 7. Pre-metric. Inscriptions.
Described.

[P.] III, pp. 440–442.
Entries: 8 (additional to [B.]). Pre-metric. Inscriptions. Described.

Schmid, Heinrich Alfred. "Der Monogrammist HF und der Maler Hans Frank." [*JprK.*] 19 (1898): 64–76.
Entries: 25+. Millimeters. Inscriptions (selection). Described (selection).

HF *(fl. 1517–1537)* [Nagler, *Mon.*] III, no. 898
[B.] VIII, p. 19.
Entries: 1. Pre-metric. Inscriptions.
Described.

Monogram HF (*continued*)

[P.] IV, p. 111.
Entries: 1 (additional to [B.]). Pre-metric. Inscriptions. States. Described. Located. Additional information to [B.].

[Wess.] I, p. 145.
Entries: 1 (additional to [B.] and [P.]). Millimeters. Inscriptions. Described.

HF (*fl. c.1560*) [Nagler, *Mon.*] III, no. 899
[B.] IX, p. 475.
Entries: 1. Pre-metric. Inscriptions. Described.

HF (*fl. c.1572*) [Nagler, *Mon.*] III, no. 905
[B.] IX, p. 546.
Entries: 1. Pre-metric. Inscriptions. Described.

[P.] III, p. 108.
Entries: 1 (additional to [B.]). Pre-metric. Inscriptions. Described.

[H. *Neth.*] XIII, p. 52.
Entries: 6. Illustrated (selection).*

HF (*fl. c.1570*) [Nagler, *Mon.*] III, no. 906
[P.] IV, pp. 329–330.
Entries: 1+.

HF (*fl. c.1558*) [Nagler, *Mon.*] III, no. 909
[Merlo] p. 1122.
Entries: 2. Pre-metric. Inscriptions. Described.

HFB
See **Monogram FHB** [Nagler, *Mon.*] II, no. 2169

HFE (*16th cent.*) [Nagler, *Mon.*] III, no. 925
See also **Aspertini,** Amico

[B.] XV, pp. 461–464.
Entries: 5. Pre-metric. Inscriptions. States. Described.

[P.] VI, pp. 153–154.

Entries: 1 (additional to [B.]). Pre-metric. Inscriptions. Described. Located.

HFVAS (*fl. c.1580*) [Nagler, *Mon.*] III, no. 939
[P.] IV, pp. 328–329.
Entries: 1 engraving, 2 woodcuts. Pre-metric. Inscriptions. Described.

HG (*d. 1641*) [Nagler, *Mon.*] III, no. 962
[B.] IX, p. 436.
Entries: 1. Pre-metric. Inscriptions. Described.

[Heller] p. 134.
Additional information to [B.].

HG (*fl. c.1550*) [Nagler, *Mon.*] III, no. 973
[Ge.] nos. 929–931.
Entries: 3 (single-sheet woodcuts only). Described. Illustrated. Located.

HGD (*fl. c.1818*)
[Dus.] p. 122.
Entries: 1 (lithographs only, to 1821). Millimeters. Inscriptions. Located.

HGF (*16th cent.*) [Nagler, *Mon.*] III, no. 999
[B.] IX, p. 49.
Entries: 1. Pre-metric. Inscriptions. Described.

HH (*16th cent.*) [Nagler, *Mon.*] III, no. 1031
[P.] IV, p. 169.
Entries: 1. Pre-metric. Inscriptions. Described. Located.

HH [Nagler, *Mon.*] III, no. 1042
See **Holtzmüller,** Heinrich

HHB [Nagler, *Mon.*] III, no. 1064
See **Monogram HFVAS** [Nagler, *Mon.*] III, no. 939

HHF [Nagler, *Mon.*] III, no. 1071
See **Holtzmüller,** Heinrich

HHS *(16th cent.)* [Nagler, *Mon.*] III, no. 1084
[B.] VI, pp. 406–408.
Entries: 12. Pre-metric. Inscriptions. Described.

HHV *(fl. c.1543)*
[P.] IV, pp. 162–163.
Entries: 1. Pre-metric. Inscriptions. Described. Located.

HIW *(fl. 1586–1588)* [Nagler, *Mon.*] III, no. 1145
[B.] IX, p. 404.
Entries: 1. Pre-metric. Inscriptions. Described.

HK *(16th cent.)* [Nagler, *Mon.*] III, no. 1148
[B.] VII, p. 484.
Entries: 1. Pre-metric. Inscriptions. Described.

[B.] VII, p. 493.
Entries: 2. Pre-metric. Inscriptions. Described.

[P.] IV, pp. 128–129.
Entries: 2 (additional to [B.]). Pre-metric (selection), paper fold measure (selection). Inscriptions. Described.

HK *(fl. c.1560)* [Nagler, *Mon.*] III, no. 1156
[B.] IX, pp. 433–434.
Entries: 1. Pre-metric. Inscriptions. Described.

HK *(fl. 1527–1528)* [Nagler, *Mon.*] III, no. 1160
[B.] VIII, pp. 538–539.
Entries: 2. Pre-metric. Inscriptions. Described.

[Wess.] I, p. 146.
Entries: 1 (additional to [B.]). Described.

HK [Nagler, *Mon.*] III, no. 1170
See **Monogram IK** [Nagler, *Mon.*] III, no. 2682

HL *(fl. 1410–1533)* [Nagler, *Mon.*] III, nos. 1201, 1224
[B.] VIII, pp. 35–40.
Entries: 12. Pre-metric. Inscriptions. States. Described.

[P.] III, pp. 336–341.
Entries: 13 engravings, 7 woodcuts (additional to [B.]). Pre-metric. Inscriptions. Described. Located.

[Wess.] I, pp. 145–146.
Entries: 1 (additional to [B.] and [P.]). Millimeters. Inscriptions. Described. Additional information to [B.] and [P.].

Lossnitzer, Max. *Hans Leinberger; Nachbildungen seiner Kupferstiche und Holzschnitte.* Graphische Gesellschaft, 18. Berlin: Veröffentlichung Bruno Cassirer, 1913.
Entries: 30. Millimeters. Inscriptions. States. Described. Illustrated. Located.

[Ge.] nos. 892–898.
Entries: 7 (single-sheet woodcuts only). Described. Illustrated. Located.

HL *(fl. 1558–1570)* [Nagler, *Mon.*] III, no. 1202
[B.] IX, pp. 473–474.
Entries: 3. Pre-metric. Inscriptions. Described.

[P.] IV, pp. 178–179.
Entries: 2 (additional to [B.]). Pre-metric. Inscriptions. Described.

[Wess.] I, p. 149.
Entries: 3 (additional to [B.]). Millimeters (selection). Inscriptions. Described. Additional information to [B.].

HM *(16th cent.)* [Nagler, *Mon.*] III, no. 1245
[P.] II, p. 147.
Entries: 1. Pre-metric. Inscriptions. Described. Located.

HM *(fl. c.1543)* [Nagler, *Mon.*] III, no. 1250
[B.] IX, pp. 79–80.
 Entries: 3. Pre-metric. Inscriptions.
 Described.

 [P.] IV, pp. 54–56.
 Entries: 12 engravings (additional to
 [B.]), 3+ woodcuts. Pre-metric. In-
 scriptions (selection). Described
 (selection). Located.

 [Wess.] I, p. 149.
 Entries: 1 (additional to [B.] and [P.]).
 Millimeters. Inscriptions. Described.

HMVP *(16th cent.)* [Nagler, *Mon.*] III, no.
1282
 [B.] IX, pp. 85–86.
 Entries: 1. Pre-metric. Inscriptions.
 Described.

HN *(16th cent.)* [Nagler, *Mon.*] III, no. 1284
[B.] VII, p. 544.
 Entries: 1. Pre-metric. Inscriptions.
 Described.

HN [Nagler, *Mon.*] III, no. 1292
See **Monogram NH** [Nagler, *Mon.*] IV,
no. 2408

HN *(16th cent.)*
 [H. *Neth.*] XIII, p. 53.
 Entries: 1. Illustrated.*

HNF *(fl. 1592–1596)* [Nagler, *Mon.*] III, no.
1297
 [B.] IX, pp. 581–582.
 Entries: 3. Pre-metric. Inscriptions.
 Described.

HNS
 See **Monogram HS** [Nagler, *Mon.*] III,
 no. 1486

HO *(fl. 1536–1543)* [Nagler, *Mon.*] III, no.
1307
 [B.] IX, pp. 237–238.
 Entries: 3+. Pre-metric. Inscriptions
 (selection). Described (selection).

HP *(fl. 1650–1670)* [Nagler, *Mon.*] III, no.
1339
 [H. *Neth.*] XIII, p. 60.
 Entries: 6.*

HP *(fl. c.1550)*
 [P.] IV, pp. 316–317.
 Entries: 2. Pre-metric. Inscriptions.
 Described.

 [Merlo] pp. 1123–1124.
 Entries: 2. Pre-metric. Inscriptions.
 Described.

HR *(fl. 1559–1563)* [Nagler, *Mon.*] III, no.
1390
 [B.] IX, pp. 488–489.
 Entries: 3. Pre-metric. Inscriptions.
 Described.

HR *(fl. c.1511)* [Nagler, *Mon.*] III, no. 1427
[B.] VI, pp. 409–411.
 Entries: 12. Pre-metric. Inscriptions.
 Described.

HS [Nagler, *Mon.*] III, no. 1449
See **Vogtherr,** Heinrich

HS *(fl. c.1566)* [Nagler, *Mon.*] III, no. 1460
[B.] IX, p. 526.
 Entries: 1. Pre-metric. Inscriptions.
 Described.

 [P.] IV, p. 223.
 Entries: 2 (additional to [B.]). Pre-
 metric. Inscriptions. Described. Lo-
 cated (selection).

HS *(fl. 1495–1514)* [Nagler, *Mon.*] III, no.
1463
 [B.] VI, pp. 386–390.
 Entries: 5. Pre-metric. Inscriptions.
 Described.

 [Evans] p. 41.
 Entries: 1 (additional to [B.]). Mil-
 limeters. Inscriptions. Described.

 [P.] II, pp. 207–208.

Entries: 5 (additional to [B.]). Pre-metric. Inscriptions. Described. Located. Copies mentioned. Additional information to [B.].

[P.] IV, pp. 131–133.
Entries: 14 engravings (additional to [B.]), 7 engravings with the same monogram but by a different hand (second half of 16th cent.), 1 woodcut. Pre-metric. Inscriptions. Described. Located (selection). Additional information to [B.]; revision of [P.] II, pp. 207–208.

[Lehrs] VII, pp. 366–375.
Entries: 11. Millimeters. Inscriptions. States. Described. Located. Locations of all known impressions are given. Copies mentioned. Watermarks described. Bibliography for each entry.

HS [Nagler, *Mon.*] III, nos. 1482, 1498
See **Strohmayer,** Hans

HS *(late 15th cent.)* [Nagler, *Mon.*] III, no. 1486
[P.] II, p. 288.
Entries: 2. Pre-metric. Inscriptions. Described. Located. Watermark described.

[Lehrs] VII, pp. 360–362.
Entries: 2. Millimeters. Inscriptions. Described. Illustrated (selection). Located. Locations of all known impressions are given. Copies mentioned. Watermarks described. Bibliography for each entry.

HS *(fl. 1582–1592)* [Nagler, *Mon.*] III, no. 1503
[B.] IX, p. 425.

[P.] III, p. 473.
Entries: 2. Pre-metric. Inscriptions. Described. Additional information to [B.].

HS *(15th cent.)* [Nagler, *Mon.*] IV, no. 4127
[P.] II, p. 147.
Entries: 1. Pre-metric. Described. Located.

[Lehrs] VI, pp. 4–5.
Entries: 1. Millimeters. Inscriptions. Described. Located. Locations of all known impressions are given. Copies mentioned. Watermarks described. Bibliography for each entry.

HS *(fl. 1534–1569)*
[Ge.] nos. 932–936.
Entries: 5 (single-sheet woodcuts only). Described. Illustrated. Located.

HSB *(16th cent.)* [Nagler, *Mon.*] III, no. 1514
[B.] IX, pp. 239–240.
Entries: 2. Pre-metric. Inscriptions. Described.

HSD *(fl. c.1550)* [Nagler, *Mon.*] III, no. 1518
[B.] IX, pp. 395–396.
Entries: 1. Pre-metric. Inscriptions. Described.

HSD *(fl. 1570–1580)* [Nagler, *Mon.*] III, no. 1519
[B.] IX, p. 545.
Entries: 1+.

[Heller] p. 134.
Entries: 3 (additional to [B.]). Pre-metric. Inscriptions. Described.

[P.] III, pp. 96–97.
Entries: 4. Inscriptions. Described. According to [P.], a different artist from the one described by [B.] and by [P.] IV, p. 224.

[P.] IV, p. 224.
Entries: 3+. Pre-metric. Inscriptions (selection). Described (selection). Located (selection).

[H. *Neth.*] XIII, p. 61.
Entries: 78. Illustrated (selection).*

HSE *(fl. c.1570)* [Nagler, *Mon.*] III, no. 1521
[B.] IX, p. 486.
 Entries: 1. Pre-metric. Inscriptions.
 Described.

 [Wess.] I, pp. 149–150.
 Entries: 4 (additional to [B.]). Mil-
 limeters. Inscriptions. Described.

HSE *(fl. c.1547)* [Nagler, *Mon.*] III, no. 1526
[B.] IX, p. 232.
 Entries: 1. Pre-metric. Inscriptions.
 Described.

HSV *(fl. c.1560)* [Nagler, *Mon.*] III, no. 1560
[P.] IV, p. 264.
 Entries: 1. Pre-metric. Inscriptions.
 Described.

HSV *(fl. 1595–1625)* [Nagler, *Mon.*] III, no. 1561
 [H. *Neth.*] XIII, p. 61.
 Entries:. 1.*

HSW *(fl. 1570–1571)* [Nagler, *Mon.*] III, no. 1562
 [B.] IX, p. 546.
 Entries: 1. Pre-metric. Inscriptions.
 Described.

HTA [Nagler, *Mon.*] III, no. 646
 [Dis. 1927]
 Additional information to [B.] XIV, p.
 163, no. 199D (copy of a print by Mar-
 cantonio).

HTVA *(16th cent.)* [Nagler, *Mon.*] III, no. 1592
 [P.] II, p. 146.
 Entries: 1. Pre-metric. Inscriptions.
 Described.

HV *(d. 1621)* [Nagler, *Mon.*] III, no. 1603
[B.] IX, p. 52.
 Entries: 1. Pre-metric. Inscriptions.
 Described.

HV [Nagler, *Mon.*] V, no. 1199
 See **Monogram VH** [Nagler, *Mon.*] V,
 no. 1199

HVD *(fl. c.1600)*
 [Merlo] p. 1124.*

HVE *(fl. c.1544)* [Nagler, *Mon.*] III, no. 1638
[P.] III, p. 448.
 Entries: 2. Paper fold measure. In-
 scriptions. Described.

HW *(fl. c.1540)* [Nagler, *Mon.*] III, no. 1673
[B.] IX, pp. 518–520.
 Entries: 1. Pre-metric. Inscriptions.
 Described.

 [P.] IV, p. 169.
 Entries: 1 (additional to [B.]). Pre-
 metric. Inscriptions. Described. Lo-
 cated.

 [Wess.] I, p. 150.
 Entries: 1 (additional to [B.] and [P.]).
 Millimeters. Inscriptions. Described.

HW [Nagler, *Mon.*] III, no. 1680
See **Wagenknecht,** Hans

HW *(fl. 1481–1482)* [Nagler, *Mon.*] III, no. 1691
 [B.] VI, pp. 312–313.
 Entries: 3. Pre-metric. Inscriptions.
 Described.

 [P.] II, pp. 154–156.
 Entries: 4 (additional to [B.]). Pre-
 metric. Inscriptions. Described. Lo-
 cated.

 [Lehrs] VIII, pp. 220–242.
 Entries: 17. Millimeters. Inscriptions.
 Described. Illustrated (selection). Lo-
 cated. Locations of all known impres-
 sions are given. Copies mentioned.
 Watermarks described. Bibliography
 for each entry.

HW *(16th cent.)* [Nagler, *Mon.*] III, no. 1695
 [B.] IX, pp. 441–442.
 Entries: 1 engraving, 1 woodcut.
 Pre-metric. Inscriptions. Described.

 [P.] IV, p. 309.
 Entries: 1 woodcut (additional to [B.]).
 Pre-metric. Inscriptions. Described.
 Located.

HW [Nagler, *Mon.*] III, no. 1696
See **Clofigl,** Caspar

HW [Nagler, *Mon.*] III, no. 1697
See **Wandereisen,** Hans

HW [Nagler, *Mon.*] III, no. 1702
See **Weigel,** Hans

HWG *(16th cent.)* [Nagler, *Mon.*] III, no. 1722
 [P.] IV, p. 303.
 Entries: 2. Pre-metric. Inscriptions.
 Described. Located.

HZ [Nagler, *Mon.*] III, no. 1734
See **Monogram HN** [Nagler, *Mon.*] III, no. 1284

I *(fl. c.1500)*
 [H. *Neth.*] XIII, p. 62.
 Entries: 2. Illustrated.*

I *(16th cent.)*
 [P.] IV, p. 163.
 Entries: 1. Pre-metric. Inscriptions.
 Described. Located.

IA *(16th cent.)* [Nagler, *Mon.*] III, no. 1776
 [P.] VI, p. 171.
 Entries: 1. Pre-metric. Inscriptions.
 Described.

IA *(early 16th cent.)*
 [H. *Neth.*] XIII, p. 63.
 Entries: 1. Illustrated.*

IADC [Nagler, *Mon.*] III, no. 1843
 [B.] XII: *See* **Chiaroscuro Woodcuts**

IAM of Zwolle *(fl. 1480–1490)* [Nagler, *Mon.*] III, no. 1774
 [B.] VI, pp. 90–103.
 Entries: 18. Pre-metric. Inscriptions.
 Described.

 [Evans] p. 39.
 Entries: 1 (additional to [B.]). Millimeters. Inscriptions. Described.

 [P.] II, pp. 178–186.
 Entries: 58 prints by, 1 doubtful print (additional to [B.]). Pre-metric. Inscriptions. States. Described. Located. Copies mentioned. Additional information to [B.].

 [Wess.] I, pp. 143–144.
 Entries: 1 (additional to [B.] and [P.]). Millimeters. Described. Located.

 [W.] III, pp. 168–169.
 Entries: 77+.*

 [Lehrs] VII, pp. 165–218.
 Entries: 26. Millimeters. Inscriptions. States. Described. Illustrated (selection). Located. Locations of all known impressions are given. Copies mentioned. Watermarks described. Bibliography for each entry.

 [H. *Neth.*] XII, pp. 252–280.
 Entries: 27. Illustrated.*

IB with the bird *(fl. c.1502)* [Nagler, *Mon.*] III, no. 1944
 [B.] XIII, pp. 244–251.
 Entries: 7 engravings, 3 woodcuts. Pre-metric. Inscriptions. Described. Copies mentioned.

 Galichon, Émile. "Giovanni Battista del Porto dit le maître à l'oiseau; peintre graveur du XVIe siècle." [*GBA.*] 1st ser. 4 (1859): 257–274.
 Entries: 14 engravings, 8 woodcuts. Millimeters. Inscriptions. States. De-

Monogram IB with the bird (*continued*)

scribed. Illustrated (selection). Copies mentioned.

[P.] V, pp. 149–153.
Entries: 9 engravings, 5 woodcuts and metal cuts (additional to [B.]), 2 doubtful prints. Pre-metric. Inscriptions. States. Described. Located. Copies mentioned.

Lippmann, F. *The woodcuts of the Master I.B. with the Bird*. London, Berlin, Paris and New York: International Chalcographical Society, 1894.
Entries: 11 (woodcuts only). Illustrated. Located. Prints are reproduced in actual size.

Byam Shaw, James. "The Master IB with the Bird." [*PCQ.*] 19 (1932): 272–297; [*PCQ.*] 20 (1933): 9–33, 168–177.
Entries: 26. Millimeters. Inscriptions. States. Described. Illustrated (selection). Located.

[Hind] V, pp. 248–260.
Entries: 16 (engravings only). Millimeters. Inscriptions. States. Described. Illustrated. Located.

Byam Shaw, James. "An undescribed woodcut by the Master IB with the Bird." In *Festschrift Dr. h.g. Eduard Trautscholdt zum siebzigsten Geburtstag am 13. Januar, 1963*. pp. 66–67. Hamburg: Hauswedell, 1965.
Entries: 1 (additional to Byam Shaw 1932). Millimeters. Inscriptions. Described. Illustrated. Located.

IB *(fl. 1523–1530)* [Nagler, *Mon.*] III, no. 1950
[B.] VIII, pp. 299–319.
Entries: 52. Pre-metric. Inscriptions. Described. Copies mentioned.

[Evans] p. 28.
Entries: 2 (additional to [B.]). Millimeters. Inscriptions. Described.

[P.] IV, pp. 97–101.
Entries: 7 (additional to [B.]). Pre-metric (selection). Inscriptions. States. Described. Located (selection). Copies mentioned. Appendix with 1 woodcut. Additional information to [B.].

[Wess.] I, p. 146.
Entries: 4 (additional to [B.] and [P.]). Millimeters (selection). Inscriptions. Described. Additional information to [B.] and [P.].

IBC *(16th cent.)*
[P.] VI, p. 146.
Entries: 1. Pre-metric. Inscriptions. Described.

IBH *(15th cent.)* [Nagler, *Mon.*] III, no. 2027
[P.] II, p. 167.
Entries: 1. Inscriptions. Described. Located.

[Lehrs] VII, pp. 376–377.
Entries: 2. Millimeters. Inscriptions. Described. Illustrated (selection). Located. Locations of all known impressions are given. Copies mentioned. Watermarks described. Bibliography for each entry.

IC *(15th cent.)* [Nagler, *Mon.*] III, no. 2060
[B.] VI, pp. 382–386.
Entries: 14. Pre-metric. Inscriptions. States. Described.

[Evans] p. 41.
Entries: 1 (additional to [B.]). Millimeters. Inscriptions. Described.

[P.] II, pp. 138–139.
Entries: 2 (additional to [B.]). Pre-metric. Inscriptions. Described. Located.

[Merlo] pp. 1125–1126.
Entries: 16. Described (selection).

[Lehrs] VI, pp. 160–177.

Entries: 18. Millimeters. Inscriptions. States. Described. Located. Locations of all known impressions are given. Copies mentioned. Watermarks described. Bibliography for each entry.

IC *(16th cent.)*
[P.] IV, p. 315.
Entries: 1. Pre-metric. Inscriptions. Described.

IC and **NH** *(16th cent.)*
[Herbet] IV, p. 339.
Entries: 3. Millimeters. Inscriptions. Described. Located (selection).

ID *(fl. 1488–1517)* [Nagler, *Mon.*] III, no. 2171
Dalbanne, Claude. "Le maître I.D."
Maso Finiguerra 4 (1939): 215–252.
Entries: 21 (first half of catalogue; no more published). Millimeters. Inscriptions. Described. Illustrated (selection).

ID [Nagler, *Mon.*] III, no. 2175
See **Monogram D** with the arrow

ID *(fl. c.1530)* [Nagler, *Mon.*] III, no. 2177
[B.] VIII, pp. 540–541.
Entries: 2. Pre-metric. Inscriptions. Described.

[Wess.] I, p. 146.
Additional information to [B.].

ID *(fl. c.1617)*
[H. *Neth.*] XIII, p. 63.
Entries: 1. Illustrated. *

IE *(15th cent.)*
[Lehrs] VI, pp. 19–54.
Entries: 55. Millimeters. Inscriptions. States. Described. Illustrated (selection). Located. Locations of all known impressions are given. Copies mentioned. Watermarks described. Bibliography for each entry.

IF *(fl. c.1542)* [Nagler, *Mon.*] III, no. 2299
[B.] XV, pp. 502–503.
Entries: 1. Pre-metric. Inscriptions. States. Described. Copies mentioned.

IF [Nagler, *Mon.*] III, no. 2300
See **Francia,** Jacopo

IF *(16th cent.)* [Nagler, *Mon.*] III, no. 2301
[B.] VIII, p. 24.
Entries: 1. Pre-metric. Inscriptions. Described.

IF *(17th cent.)* [Nagler, *Mon.*] III, no. 2307
[H. *Neth.*] XIII, p. 64.
Entries: 6. Illustrated (selection).*

IFT *(15th cent.)* [Nagler, *Mon.*] III, no. 2364
[Hind] V, p. 260.
Entries: 1. Millimeters. Inscriptions. Described. Illustrated. Located.

IG *(fl. c.1572)*
[B.] IX, p. 406.
Entries: 1. Pre-metric. Inscriptions. Described.

IH *(fl. c.1530)* [Nagler, *Mon.*] III, no. 2503
[B.] XV, pp. 492–493.
Entries: 2. Pre-metric. Inscriptions. Described.

IHG *(15th cent.)* [Nagler, *Mon.*] III, no. 2573
[P.] II, p. 142.
Entries: 1. Pre-metric. Inscriptions. Described.

[Lehrs] VII, pp. 377–378.
Entries: 1. Millimeters. Inscriptions. Described. Located. Locations of all known impressions are given. Copies mentioned. Watermarks described. Bibliography for each entry.

IHS [Master of the Name of Jesus]
(fl. 1561–1572) [Nagler, *Mon.*] III, no. 2602
[B.] XV, pp. 511–519.

Monogram IHS (*continued*)

Entries: 18. Pre-metric. Inscriptions. Described.

[P.] VI, pp. 155–157.
Entries: 10 (additional to [B.]). Pre-metric. Inscriptions.

IHS (*15th cent.*)
[Schreiber, *Metallschneidekunst*] p. 88.
Entries: 3 prints by, 2 doubtful prints.*

II with a skull (*early 16th cent.*)
[H. *Neth.*] XIII, p. 65.
Entries: 2. Illustrated.*

IICA (*early 16th cent.*) [Nagler, *Mon.*] III, no. 2634
[B.] XV, p. 539.
Entries: 1. Pre-metric. Inscriptions. Described.

[P.] V, pp. 160–162.
Entries: 2 prints by, 1 rejected print. Pre-metric. Inscriptions. Described. Located (selection). Additional information to [B.].

[Hind] V, pp. 260–262.
Entries: 2 prints by, 1 rejected print. Millimeters. Inscriptions. Described. Illustrated. Located.

IK (*fl. 1536–1545*) [Nagler, *Mon.*] III, no. 2682
[B.] IX, p. 157.
Entries: 2+. Pre-metric. Inscriptions (selection). Described (selection).

[B.] IX, p. 401.
Entries: 1. Pre-metric. Inscriptions. Described.

[Heller] p. 84.
Additional information to [B.].

[P.] IV, pp. 304–308.
Entries: 14+. Paper fold measure. Pre-metric. Inscriptions (selection). Described (selection).

ILCT [Nagler, *Mon.*] III, no. 2747
See **Lucius,** Jakob I

ILDRF (*fl. 1575–1600*) [Nagler, *Mon.*] III, no. 2752
[P.] IV, pp. 317–318.
Entries: 2. Pre-metric. Inscriptions. Described.

[Merlo] p. 1126.*

IP (*fl. c.1525*)
[Merlo] pp. 1126–1127.*

IPC 1570 (*fl. c.1570*) [Nagler, *Mon.*] IV, no. 274
[P.] VI, p. 272.
Entries: 1. Pre-metric. Inscriptions. Described.

IPS (*fl. c.1539*) [Nagler, *Mon.*] IV, no. 306
[P.] III, pp. 306–307.
Entries: 1. Paper fold measure. Inscriptions. Described.

IR (*16th cent.*) [Nagler, *Mon.*] IV, no. 323
[P.] IV, pp. 334–336.
Entries: 1. Pre-metric. Inscriptions. Described. Located. Additional prints are mentioned by [P.] but not catalogued.

IR 1554 (*fl. c.1554*) [Nagler, *Mon.*] IV, no. 334
[P.] IV, p. 261.
Entries: 1. Pre-metric. Inscriptions. Described.

IR (*16th cent.*) [Nagler, *Mon.*] IV, no. 338
[P.] IV, p. 262.
Entries: 1. Pre-metric. Inscriptions. Described.

IRS (*fl. 1680–1690*) [Nagler, *Mon.*] IV, no. 374
[H. *Neth.*] XIII, p. 65.
Entries: 1. Illustrated.*

Monogram JK (*continued*)

Entries: 1 (lithographs only, to 1821). Millimeters. Inscriptions. States. Located.

JP *(17th cent.)*
[Rov.] p. 70.
Entries: 1. Illustrated.

JS *(19th cent.)*
[Dus.] p. 125.
Entries: 1 (lithographs only, to 1821). Millimeters. Inscriptions. Located.

JW *(fl. c.1650)*
[H. *Neth.*] XIII, p. 68.
Entries: 1. Illustrated.*

KGHNSBVF [Nagler, *Mon.*] IV, no. 791
See **Monogram GWYAHB** [Nagler, *Mon.*] III, no. 485

L *(16th cent.)* [Nagler, *Mon.*] IV, no. 860
[B.] IX, pp. 10–14.
Entries: 8. Pre-metric. Inscriptions. Described.

[P.] IV, p. 134.
Entries: 3 (additional to [B.]). Pre-metric. Inscriptions. Described. Located. Appendix with 1 doubtful print.

"Death and the lady." *The Portfolio* 7 (1876): 184.
Entries: 1 (additional to [B.]). Illustrated.

[Wess.] I, p. 147.
Entries: 1 (additional to [B.] and [P.]). Millimeters. Inscriptions. Described.

[H. *Neth.*] XIII, pp. 71–72.
Entries: 27. Illustrated (selection).*

L *(fl. c.1500)*
[Hind] V, pp. 262–263.
Entries: 1. Millimeters. Inscriptions. Described. Illustrated. Located.

LA [Nagler, *Mon.*] IV, nos. 894, 895, 903
See **Giunta,** Luca Antonio de

LA *(fl. c.1512)* [Nagler, *Mon.*] IV, no. 896
[B.] VII, p. 447.
Entries: 1. Pre-metric. Inscriptions. Described.

LAFF [Nagler, *Mon.*] IV, no. 908
See **Giunta,** Luca Antonio de

LAN *(15th cent.)* [Nagler, *Mon.*] IV, no. 922
[P.] II, p. 175.
Entries: 1. Pre-metric. Inscriptions. Described. Located.

[Lehrs] VII, pp. 378–379.
Entries: 1. Millimeters. Inscriptions. Described. Illustrated. Located. Locations of all known impressions are given. Copies mentioned. Watermarks described. Bibliography for each entry.

LAS *(15th cent.)* [Nagler, *Mon.*] IV, no. 922
[P.] II, p. 175.
Entries: 1. Pre-metric. Inscriptions. Described. Located.

LB [Nagler, *Mon.*] IV, no. 951
See **Monogram BL** [Nagler, *Mon.*] I, no. 1931

LB *(16th cent.)* [Nagler, *Mon.*] IV, no. 961
[B.] IX, p. 43.
Entries: 1. Pre-metric. Inscriptions. Described.

[Wess.] I, p. 148.
Entries: 1 (additional to [B.]). Millimeters. Inscriptions. Described.

[H. *Neth.*] XIII, p. 73.
Entries: 3. Illustrated.*

LCPH *(16th cent.)* [Nagler, *Mon.*] IV, no. 1007
[B.] VII, pp. 542–543.

Entries: 1. Pre-metric. Inscriptions. Described.

[P.] III, p. 15.
Entries: 1. Pre-metric. Described. Located.

[H. *Neth.*] XIII, p. 73.
Entries: 1.*

LCZ [Nagler, *Mon.*] IV, no. 1008
See **Katzheimer,** Lorentz

LD *(fl. c.1539)* [Nagler, *Mon.*] IV, no. 1014
[B.] IX, pp. 82–83.
Entries: 1. Pre-metric. Inscriptions. Described.

LD *(fl. 1540–1565)* [Nagler, *Mon.*] IV, no. 1018
[B.] XVI, pp. 307–333.
Entries: 69. Pre-metric. Inscriptions. States. Described. Copies mentioned.

[P.] VI, pp. 189–195.
Entries: 51 (additional to [B.]). Pre-metric. Inscriptions. Described. Additional information to [B.].

Lieure J. "École de Fontainebleau." Unpublished ms. (EPBN)
Notes towards a catalogue.

[Herbet] I, pp. 56–102; V, pp. 78–80.
Entries: 228. Millimeters. Inscriptions. Described.

[Zerner] no. 2.
Entries: 98. Millimeters. Inscriptions. States. Described (selection). Illustrated. Costume and landscape prints are omitted except for a few examples.

LF [Nagler, *Mon.*] IV, no. 1072
See **Fryg,** Ludwig

LFO *(19th cent.)*
[Dus.] p. 123.
Entries: 1 (lithographs only, to 1821). Millimeters. Inscriptions. States. Located.

LG *(fl. c.1515)* [Nagler, *Mon.*] IV, no. 1096
[P.] III, p. 341.
Entries: 1. Pre-metric. Inscriptions. Described. Located.

LH *(fl. c.1806)*
[Dus.] p. 123.
Entries: 1 (lithographs only, to 1821). Located.

LI *(fl. c.1527)*
[H. *Neth.*] XIII, p. 74.
Entries: 6. Illustrated (selection).*

LM *(16th cent.)* [Nagler, *Mon.*] IV, nos. 1197, 1218
[B.] IX, p. 420.
Entries: 1.

[P.] IV, pp. 337–338.
Entries: 1. Pre-metric. Inscriptions. Described.

LO *(fl. c.1534)* [Nagler, *Mon.*] IV, nos. 1231, 1232
[P.] III, p. 342.
Entries: 1. Pre-metric. Inscriptions. Described. Located.

LP *(fl. c.1565)* [Nagler, *Mon.*] IV, no. 1273
[P.] VI, p. 172.
Entries: 1. Pre-metric. Inscriptions. Described.

LR *(fl. c.1757)* [Nagler, *Mon.*] IV, no. 1317
[Merlo] p. 1128.*

LR *(fl. c.1510)*
[Merlo] pp. 1127–1128.
Entries: 1. Pre-metric. Inscriptions. Described.

LV
See **VL** *(16th cent.)*

LZ *(fl. c.1497)* [Nagler, *Mon.*] IV, no. 1434
[P.] II, pp. 143–144.
Entries: 1. Pre-metric. Inscriptions. Described. Located.

M *(16th cent.)* [Nagler, *Mon.*] IV, no. 1439
[B.] XV, pp. 541–542.
 Entries: 1. Pre-metric. Inscriptions.
 Described.

M *(15th/16th cent.)* [Nagler, *Mon.*] IV, no.
1462
[B.] VI, pp. 412–413.
 Entries: 2. Pre-metric. Inscriptions.
 Described.

[P.] II, pp. 163–164.
 Entries: 2 (additional to [B.]). Pre-
 metric. Inscriptions. Described. Lo-
 cated.

[H. *Neth.*] XIII, pp. 75–92.
 Entries: 48. Illustrated (selection).*

M *(16th cent.)* [Nagler, *Mon.*] IV, no. 1463
[P.] III, pp. 88–90.
 Entries: 11. Pre-metric. Inscriptions.
 Described. Located.

M *(15th cent.)* [Nagler, *Mon.*] IV, no. 1470
[B.] VI, p. 315.
 Entries: 1. Pre-metric. Inscriptions.
 Described.

M *(fl. c.1534)* [Nagler, *Mon.*] IV, no. 1473
[Ge.] nos. 945–952.
 Entries: 8 (single-sheet woodcuts
 only). Described. Located.

M *(16th cent.)* [Nagler, *Mon.*] IV, no. 1492
[B.] VII, p. 475.
 Entries: 1. Pre-metric. Inscriptions.
 Described.

M *(16th cent.)* [Nagler, *Mon.*] IV, no. 1493
[B.] VII, p. 474.
 Entries: 1. Pre-metric. Inscriptions.
 Described.

M *(16th cent.?)*
[Evans] p. 27.
 Entries: 1. Millimeters. Inscriptions.
 Described.

MA *(fl. c.1576)* [Nagler, *Mon.*] IV, no. 1526
[B.] IX, p. 548.
 Entries: 1. Pre-metric. Inscriptions.
 Described.

[Evans] p. 22.
 Entries: 1 (additional to [B.]). Mil-
 limeters. Inscriptions. Described.

[P.] IV, p. 192.
 Entries: 5 engravings (additional to
 [B.]), 1 woodcut. Pre-metric. Inscrip-
 tions. Described. Located (selection).

MA *(fl. c.1524)* [Nagler, *Mon.*] IV, no. 1537
[P.] V, pp. 229–230.
 Entries: 3. Pre-metric. Inscriptions.
 Described. Located.

MAF *(16th cent.)* [Nagler, *Mon.*] IV, no.
1561
[B.] XV, p. 544.
 Entries: 1. Pre-metric. Inscriptions.
 Described.

MB *(15th cent.)* [Nagler, *Mon.*] IV, no. 1437
[B.] VI, pp. 314–315.
 Entries: 1. Pre-metric. Inscriptions.
 Described.

[P.] II, p. 167.
 Entries: 1. Pre-metric. Described. Lo-
 cated.

[Lehrs] VII, pp. 380–382.
 Entries: 3. Millimeters. Inscriptions.
 Described. Located. Locations of all
 known impressions are given. Copies
 mentioned. Watermarks described.
 Bibliography for each entry.

MB *(fl. c.1554)* [Nagler, *Mon.*] IV, no. 1650
See also **Brosamer,** Martin

[B.] IX, pp. 413–415.
 Entries: 7. Pre-metric. Inscriptions.
 Described.

MB *(fl. c.1490)* [Nagler, *Mon.*] IV, no. 1660
[Lehrs] VI, p. 6.

Entries: 1. Millimeters. Inscriptions. Described. Located. Locations of all known impressions are given. Copies mentioned. Watermarks described. Bibliography for each entry.

MB *(early 16th cent.)* [Nagler, *Mon.*] IV, no. 1661
[P.] IV, p. 148.
Entries: 1. Pre-metric. Inscriptions. Described. Located.

MB *(fl. c.1805)*
[Dus.] p. 122.
Entries: 1 (lithographs only, to 1821). Millimeters. Inscriptions.

MD *(16th cent.)* [Nagler, *Mon.*] IV, no. 1722
[P.] IV, p. 262.
Entries: 1. Pre-metric. Inscriptions. Described.

ME *(fl. c.1545)* [Nagler, *Mon.*] IV, no. 1757
[B.] IX, p. 565.
Entries: 1. Pre-metric. Inscriptions. Described.

MF *(fl. 1579–1589)* [Nagler, *Mon.*] IV, no. 1777
[B.] IX, p. 424.
Entries: 6.

MF *(fl. c.1536)* [Nagler, *Mon.*] IV, no. 1787
[B.] IX, pp. 14–15.
Entries: 3. Pre-metric. Inscriptions. Described.

[P.] IV, p. 136.
Entries: 2 (additional to [B.]). Pre-metric. Inscriptions. Described. Located.

MF *(b. 1729)* [Nagler, *Mon.*] IV, no. 1788
[B.] IX, pp. 520–522.
Entries: 3. Pre-metric. Inscriptions. Described.

MG *(16th cent.)* [Nagler, *Mon.*] IV, no. 1822
[H. *Neth.*] XIII, p. 47.
Entries: 3. Illustrated.*

MG *(fl. 1590–1597)* [Nagler, *Mon.*] IV, no. 1826
[B.] IX, pp. 585–586.
Entries: 2. Pre-metric. Inscriptions. Described.

[P.] IV, pp. 242–243.
Entries: 15 (additional to [B.]). Inscriptions.

MG *(15th cent.)* [Nagler, *Mon.*] IV, no. 1838
[P.] II, p. 291.
Entries: 1. Pre-metric. Described. Located.

[H. *Neth.*] XII, p. 189.
Entries: 2. Illustrated (selection).*

MG *(fl. 1550–1590)* [Nagler, *Mon.*] IV, no. 1841
[B.] IX, p. 423.
Entries: 1. Pre-metric. Inscriptions. Described.

[P.] IV, pp. 301–302.
Entries: 1 (additional to [B.]). Pre-metric. Inscriptions. Described.

[Wess.] I, p. 150.
Entries: 2 (additional to [B.]). Millimeters (selection). Inscriptions. Described.

MG *(fl. c.1650)*
[H. *Neth.*] XIII, p. 93.
Entries: 1. Illustrated.*

MGF *(16th cent.?)*
[Evans] p. 23.
Entries: 1. Millimeters. Inscriptions. Described.

MH *(16th cent.)*
[H. *Neth.*] XIII, p. 93.
Entries: 2. Illustrated.*

MH *(fl. c.1548)*
 [B.] IX, p. 161.
 Entries: 1. Pre-metric. Inscriptions.
 Described.

MHF *(fl. c.1550)* [Nagler, *Mon.*] IV, no.
1896
 [B.] IX, pp. 407–408.
 Entries: 1. Pre-metric. Inscriptions.
 Described.

MHI *(16th cent.)* [Nagler, *Mon.*] IV, no.
1898
 [B.] IX, p. 84.
 Entries: 1. Pre-metric. Inscriptions.
 Described.

MI *(fl. 1594–1602)* [Nagler, *Mon.*] IV, no.
1910
 [P.] IV, pp. 333–334.
 Entries: 1. Pre-metric. Inscriptions.
 Described. Additional prints (book il-
 lustrations) are mentioned but not
 catalogued.

MIC *(early 16th cent.)* [Nagler, *Mon.*] IV,
no. 1701
 [P.] III, p. 90.
 Entries: 2. Pre-metric. Inscriptions.
 Described. Located.

 [H. *Neth.*] XIII, p. 94.
 Entries: 2. Illustrated (selection).*

MK [Nagler, *Mon.*] IV, no. 1945
See **Kirmer,** Michel

ML *(early 16th cent.)*
 [H. *Neth.*] XIII, p. 94.
 Entries: 1. Illustrated.*

MLF *(fl. c.1570)*
 [Merlo] pp. 1128–1129.
 Entries: 1. Pre-metric. Inscriptions.
 Described.

MM [Nagler, *Mon.*] IV, no. 1991
See **Minckh,** Michael

MMA *(19th cent.)*
 [Dus.] p. 121.
 Entries: 1 (lithographs only, to 1821).

MMLO *(fl. c.1750)*
 [Merlo] p. 1129.*

MP [Nagler, *Mon.*] IV, no. 2045
See **Monogram PM** [Nagler, *Mon.*] IV,
no. 3124

MR *(fl. c.1547)* [Nagler, *Mon.*] IV, no. 2088
 [B.] IX, p. 156.
 Entries: 1. Pre-metric. Inscriptions.
 Described.

 [Ge.] nos. 942–944.
 Entries: 3 (single-sheet woodcuts
 only). Described. Illustrated. Located.

MR *(15th cent.)* [Nagler, *Mon.*] IV, no. 2103
 [B.] VI, pp. 413–415.
 Entries: 2. Pre-metric. Inscriptions.
 Described.

 [P.] II, p. 164.
 Entries: 3 (additional to [B.]). Pre-
 metric. Inscriptions. Described. Lo-
 cated.

 [H. *Neth.*] XIII, pp. 95–103.
 Entries: 19. Illustrated.*

MR *(fl. c.1518)* [Nagler, *Mon.*] IV, no. 2104
 [P.] III, pp. 95–96.
 Entries: 3. Pre-metric. Inscriptions.
 Described. Located.

MS *(16th cent.)*
 Röttinger, Hans. *Beiträge zur Geschichte
 des sächsischen Holzschnittes.* Studien
 zur deutschen Kunstgeschichte 213.
 Strasbourg: J. H. Ed. Heitz, 1921.
 Entries: 9 (additional to Bible illustra-
 tions discussed in Röttinger's intro-
 duction). Millimeters. Inscriptions.
 Described. Located.

MS *(19th cent.)*
[Dus.] p. 125.
Entries: 1 (lithographs only, to 1821).

MT *(fl. 1540–1543)* [Nagler, *Mon.*] IV, no. 2180
[B.] IX, pp. 68–78.
Entries: 42. Pre-metric. Inscriptions. States. Described.

[Evans] p. 25.
Entries: 1 (additional to [B.]). Millimeters. Inscriptions. Described.

[P.] IV, pp. 52–54.
Entries: 9 (additional to [B.]). Pre-metric. Inscriptions. Described. Located. Additional information to [B.].

[Wess.] I, p. 156.
Entries: 3 (additional to [B.] and [P.]). Millimeters. Described.

MTAP *(fl. c.1519)* [Nagler, *Mon.*] IV, no. 2195
[Merlo] p. 1129.
Entries: 1. Pre-metric. Inscriptions. Described.

MTR *(fl. c.1519)*
[Ge.] no. 953.
Entries: 1 (single-sheet woodcut only). Described. Illustrated. Located.

MV *(16th cent.)* [Nagler, *Mon.*] IV, no. 2201
[B.] VIII, pp. 22–23.
Entries: 12. Pre-metric. Inscriptions. Described.

[P.] IV, p. 67.
Entries: 1 (additional to [B.]). Pre-metric. Inscriptions. Described. Located.

MVZ *(15th cent.)* [Nagler, *Mon.*] IV, no. 2231
[P.] II, pp. 174–175.
Entries: 1. Pre-metric. Inscriptions. Described. Located.

MW *(fl. 1555–1558)* [Nagler, *Mon.*] IV, no. 2253
[P.] IV, p. 39.
Entries: 1. Pre-metric. Inscriptions. Described.

MW *(fl. c.1560)* [Nagler, *Mon.*] IV, no. 2256
[B.] IX, pp. 434–435.
Entries: 1. Pre-metric. Inscriptions.

[P.] IV, pp. 340–341.
Entries: 12+ (additional to [B.]). Pre-metric (selection). Paper fold measure (selection). Inscriptions. States. Described (selection). Located (selection).

MW *(16th cent.)* [Nagler, *Mon.*] IV, no. 2258
[P.] III, pp. 287–288.
Entries: 1. Pre-metric. Inscriptions. Described. Located.

MWL *(fl. c.1559)*
[P.] III, pp. 87–88.
Entries: 2. Pre-metric. Inscriptions. Described. Located.

[H. *Neth.*] XIII, p. 104.
Entries: 2. Illustrated.*

MZ [Nagler, *Mon.*] IV, no. 2277
See **Saagmolen,** Martin

MZ [Nagler, *Mon.*] IV, no. 2278
See **Zasinger,** Matthäus

MZ *(16th cent.)* [Nagler, *Mon.*] IV, no. 2279
[P.] II, pp. 172–174.
Entries: 14. Pre-metric. Inscriptions. Described. Located.

MZ [Nagler, *Mon.*] IV, no. 2280
See **Zündt,** Mathis

MZG *(16th cent.)* [Nagler, *Mon.*] IV, no. 1468
[B.] XV, p. 538.

Monogram MZG (*continued*)

Entries: 1. Pre-metric. Inscriptions.
Described.

N (*15th cent.*)
[P.] II, p. 169.
Entries: 1. Pre-metric. Inscriptions.
Described. Located.

[Lehrs] VII, pp. 383–384.
Entries: 2. Millimeters. Inscriptions.
Described. Located. Locations of all
known impressions are given. Copies
mentioned. Watermarks described.
Bibliography for each entry.

NADAT TN (*fl. c.1512*) [Nagler, *Mon.*] IV,
no. 2312
[B.] XIII, pp. 362–366.
Entries: 2. Pre-metric. Inscriptions.
States. Described. Copies mentioned.

[P.] V, pp. 173–174.
Entries: 1 (additional to [B.]). Pre-
metric. Inscriptions. Described. Lo-
cated.

[Hind] V, pp. 265–268.
Entries: 3. Millimeters. Inscriptions.
States. Described. Illustrated. Lo-
cated.

NAR [Nagler, *Mon.*] IV, no. 2316
See **Rillaer,** Jan van

NAR (*fl. c.1579*) [Nagler, *Mon.*] IV, no.
2318
[P.] IV, p. 261.
Entries: 1. Pre-metric. Inscriptions.
Described.

NB (*fl. c.1520*) [Nagler, *Mon.*] IV, no. 2327
[P.] IV, p. 299.
Entries: 1. Pre-metric. Inscriptions.
Described.

NB (*16th cent.*)
[B.] XII: *See* **Chiaroscuro Woodcuts**

ND (*fl. c.1656*) [Nagler, *Mon.*] IV, no. 2364
[Merlo] p. 1133.
Entries: 1. Inscriptions. Described.

NDB (*fl. c.1544*) [Nagler, *Mon.*] IV, no.
2372
[B.] XII: *See* **Chiaroscuro Woodcuts**

NERO (*16th cent.*)
[B.] IX, pp. 48–49.
Entries: 1. Pre-metric. Inscriptions.
Described.

NF (*fl. c.1804*)
[Dus.] p. 122.
Entries: 1 (lithographs only, to 1821).

NH (*16th cent.*) [Nagler, *Mon.*] IV, no. 2406
[B.] VII, pp. 545–546.
Entries: 1. Pre-metric. Inscriptions.
Described.

[P.] III, p. 444.
Entries: 1. Pre-metric. Inscriptions.
Described. Located.

NH (*fl. c.1522*) [Nagler, *Mon.*] IV, no. 2408
[P.] III, pp. 442–444.
Entries: 3. Pre-metric. Inscriptions.
Described. Located (selection).

[Ge.] no. 954.
Entries: 1 (single-sheet woodcut
only). Described. Illustrated. Located.

NH (*fl. 1523–1525*) [Nagler, *Mon.*] IV, no.
2416
[B.] VII, pp. 547–552.
Entries: 13. Pre-metric. Inscriptions.
States. Described.

[Evans] p. 46.
Entries: 2 (additional to [B.]). Mil-
limeters. Inscriptions. Described.

[P.] III, pp. 46–47.
Entries: 3 (additional to [B.]). Pre-
metric. Inscriptions. Described. Lo-
cated.

NH and **IC**
See **Monogram IC and NH**

NI *(16th cent.)* [Nagler, *Mon.*] IV, no. 2428
[P.] IV, p. 163.
Entries: 1. Pre-metric. Inscriptions.
Described. Located.

NLVM *(16th cent.)*
[P.] IV, pp. 225–226.
Entries: 1. Inscriptions. Described.

NOE or **NOEL** [Nagler, *Mon.*] IV, no. 2498
See **Garnier,** Noel

NOI (or No. 1) *(16th cent.)*
[Herbet] IV, p. 339.
Entries: 1. Millimeters. Inscriptions.
Described. Located.

NS [Nagler, *Mon.*] IV, no. 2540
See **Solis,** Nikolaus

NS *(fl. c.1530)* [Nagler, *Mon.*] IV, no. 2544
[B.] VII, pp. 494–495.
Entries: 1. Pre-metric. Inscriptions.
Described.

NSN *(16th cent.)* [Nagler, *Mon.*] IV, no. 2551
[B.] VII, p. 542.
Entries: 1. Pre-metric. Inscriptions.
Described.

[P.] IV, pp. 40–41.
Entries: 2 (additional to [B.]). Pre-metric. Inscriptions. Described. Additional information to [B.].

NTG *(16th cent.)* [Nagler, *Mon.*] II, no. 714;
III, no. 388
[P.] IV, p. 165.
Entries: 2. Pre-metric. Inscriptions.
Described.

NW [Nagler, *Mon.*] IV, no. 2574
See **Wilborn,** Nikolaus

OOVIVEN *(fl. c.1542)* [Nagler, *Mon.*] IV, no. 2661
[Evans] pp. 21–22.
Entries: 1. Millimeters. Inscriptions.
Described.

[P.] VI, p. 132.
Entries: 1. Pre-metric. Inscriptions.
Described. Located.

OW *(15th cent.)*
[B.] VI, pp. 316–317.
Entries: 1. Pre-metric. Inscriptions.
Described.

P *(fl. c.1451)* [Nagler, *Mon.*] IV, no. 2723
[P.] II, pp. 6–8.
Entries: 1. Pre-metric. Inscriptions.
Described. Located.

P *(15th cent.)* [Nagler, *Mon.*] IV, no. 2724
[P.] II, pp. 291–292.
Entries: 1. Pre-metric. Inscriptions.
Described. Located.

[H. *Neth.*] XII, p. 190.
Entries: 1. Illustrated.*

P *(fl. c.1511)* [Nagler, *Mon.*] IV, no. 2728
[P.] V, pp. 220–222.
Entries: 2 (additional to [B.] XIII, p. 205, no. 1, print classed by [B.] as Peregrino da Cesena). Pre-metric. Inscriptions. Described. Located. Additional information to [B.] XIII, p. 205, no. 1.

[Hind] V, pp. 268–270.
Entries: 3. Millimeters. Inscriptions.
States. Described. Illustrated. Located.

P *(16th cent.)* [Nagler, *Mon.*] IV, no. 2731
[H. *Neth.*] XIII, p. 110.
Entries: 2. Illustrated (selection).*

P *(fl. c.1490)*
[Lehrs] VII, pp. 384–385.
Entries: 1. Millimeters. Inscriptions.
Described. Illustrated. Located. Loca-

Monogram P (*continued*)

tions of all known impressions are given. Copies mentioned. Watermarks described. Bibliography for each entry.

[H. *Neth.*] XII, p. 191.
Entries: 1. Illustrated.*

P *(19th cent.)*
[Dus.] p. 123.
Entries: 1 (lithographs only, to 1821). Millimeters. Inscriptions.

PA *(16th cent.)* [Nagler, *Mon.*] IV, no. 2773
[P.] VI, p. 155.
Entries: 1. Pre-metric. Inscriptions. Described. Located.

PB *(16th cent.)*
[Herbet] IV, p. 340.
Entries: 1. Millimeters. Inscriptions. Described. Located.

PB *(fl. c.1550)* [Nagler, *Mon.*] IV, no. 2816
[P.] VI, p. 126.
Entries: 3. Pre-metric. Inscriptions. Described.

PBR *(fl. c.1490)*
[P.] II, p. 143.
Entries: 1. Pre-metric. Inscriptions. Described. Located.

PCH *(fl. c.1600)*
[H. *Neth.*] XIII, p. 111.
Entries: 1. Illustrated.*

PG [Nagler, *Mon.*] IV, no. 2967
See **Gottlandt,** Peter

PH *(16th cent.)* [Nagler, *Mon.*] IV, no. 2987
[B.] IX, pp. 489–490.
Entries: 1. Pre-metric. Inscriptions. Described.

PHCH *(fl. c.1636)*
[H. *Neth.*] XIII, p. 111.
Entries: 1. Illustrated.*

PHL *(fl. c.1516)* [Nagler, *Mon.*] IV, no. 3029
[B.] VII, p. 455.
Entries: 1. Pre-metric. Inscriptions. Described.

PHLPT *(16th cent.)* [Nagler, *Mon.*] IV, no. 3032
[P.] V, p. 184.
Entries: 1. Pre-metric. Inscriptions. Described. Copies mentioned.

[Hind] V, p. 270.
Entries: 2. Millimeters. Inscriptions. Described.

PI *(fl. c.1600)*
[H. *Neth.*] XIII, p. 112.
Entries: 1. Illustrated.*

PL [Nagler, *Mon.*] IV, no. 1273
See **Monogram LP** [Nagler, *Mon.*] IV, no. 1273

PL *(15th cent.)* [Nagler, *Mon.*] IV, no. 3086
[P.] II, p. 169.
Entries: 1. Pre-metric. Inscriptions. Described. Located.

PM *(fl. 1577–1586)* [Nagler, *Mon.*] IV, no. 3124
[B.] IX, pp. 567–573.
Entries: 26. Pre-metric. Inscriptions. Described.

[Heller] p. 135.
Entries: 1 (additional to [B.]). Pre-metric. Inscriptions. Described.

[P.] IV, pp. 226–227.
Entries: 5 (additional to [B.]). Pre-metric (selection). Paper fold measure (selection). Inscriptions. Described. Located (selection).

PM *(16th cent.)* [Nagler, *Mon.*] IV, no. 3129
[B.] IX, p. 83.
 Entries: 1. Pre-metric. Inscriptions.
 Described.

 [P.] IV, pp. 227–228.
 Entries: 3 (additional to [B.]). Pre-
 metric. Paper fold measure. Inscrip-
 tions. Described. Located.

PM *(16th cent.)* [Nagler, *Mon.*] IV, no. 3137
[B.] XIII, p. 353.
 Entries: 1. Pre-metric. Inscriptions.
 Described.

 [Hind] V, pp. 270–271.
 Entries: 1. Millimeters. Inscriptions.
 Described. Illustrated. Located.

PM *(16th cent.)* [Nagler, *Mon.*] IV, no. 3138
[B.] VI, p. 415.
 Entries: 1. Pre-metric. Inscriptions.
 Described.

PM *(fl. 1524–1535)* [Nagler, *Mon.*] IV, no. 3139
[B.] VIII, pp. 19–20.
 Entries: 1. Pre-metric. Inscriptions.
 Described.

 [P.] IV, pp. 111–113.
 Entries: 13 (additional to [B.]). Pre-
 metric (selection). Inscriptions. De-
 scribed.

 [Lehrs] VI, pp. 281–290.
 Entries: 5. Millimeters. Inscriptions.
 Described. Illustrated (selection). Lo-
 cated. Locations of all known impres-
 sions are given. Copies mentioned.
 Watermarks described. Bibliography
 for each entry.

PP *(1470–1545/48)* [Nagler, *Mon.*] IV, no. 3204
[B.] XIII, pp. 354–361.
 Entries: 3 prints by, 1 print not seen by
 [B.]. Pre-metric. Inscriptions. States.
 Described. Copies mentioned.

 [P.] V, pp. 140–145.
 Entries: 8. Pre-metric. Inscriptions.
 States. Described. Located (selec-
 tion).

Hoffmann, Julius. *Die Kupferstiche des
Meisters PP: ein Beitrag zur Geschichte des
italienischen Kupferstiches.* Vienna:
Gesellschaft für vervielfältigende
Kunst, 1911.
 Entries: 8 prints by, 1 doubtful print.
 Millimeters. Inscriptions. States. De-
 scribed. Illustrated. Located.

 [Hind] V, pp. 273–277.
 Entries: 9. Millimeters. Inscriptions.
 States. Described. Illustrated. Lo-
 cated.

PPW [Nagler, *Mon.*] IV, no. 3233
See **Monogram PW** [Nagler, *Mon.*] IV,
no. 3233

PR [Nagler, *Mon.*] IV, no. 3238
See **Gottlandt,** Peter

PR *(fl. c.1573)* [Nagler, *Mon.*] IV, no. 3239
[B.] IX, pp. 547–548.
 Entries: 1. Pre-metric. Inscriptions.
 Described.

PRK *(fl. c.1609)* [Nagler, *Mon.*] IV, no. 3260
[H. *Neth.*] XIII, p. 112.
 Entries: 13. Illustrated (selection).*

PT [Nagler, *Mon.*] V, no. 810
See **Monogram TP** [Nagler, *Mon.*] V, no.
810

PVB [Nagler, *Mon.*] IV, no. 3367
See **Uffenbach,** Philipp

PVH [Nagler, *Mon.*] IV, no. 3387
See **Hillegaert,** Paulus van, and
Jonckheer, Jacob de

PVK *(16th cent.)* [Nagler, *Mon.*] IV, no. 3389
[B.] IX, p. 562.
Entries: 1. Pre-metric. Inscriptions. Described.

PVL *(16th cent.)* [Nagler, *Mon.*] IV, no. 3390, 3395
[B.] VIII, pp. 24–26.
Entries: 3. Pre-metric. Inscriptions. Described.

[P.] III, pp. 12–13.
Entries: 3 (additional to [B.]). Pre-metric. Inscriptions. Described. Located.

[H. *Neth.*] XIII, pp. 113–117.
Entries: 7. Illustrated.*

PVO *(16th cent.)* [Nagler, *Mon.*] IV, no. 3400
[B.] XV, p. 547.
Entries: 1. Pre-metric. Inscriptions. Described.

PW *(fl. c.1499)* [Nagler, *Mon.*] IV, no. 3233
[P.] II, pp. 159–161.
Entries: 1. Pre-metric. Inscriptions. Described. Located. Watermarks described.

[Merlo] pp. 1134–1136.
Entries: 85. Millimeters. Inscriptions.

[W.] III, pp. 225–226.
Entries: 87.*

[Lehrs] VII, pp. 250–330.
Entries: 97. Millimeters. Inscriptions. Described. Illustrated (selection). Located. Locations of all known impressions are given. Copies mentioned. Watermarks described. Bibliography for each entry.

Schleuter, Ernst. *Der Meister PW*. Studien zur deutschen Kunstgeschichte, 305. Strasbourg and Leipzig: J. H. Ed. Heitz, 1935.

Entries: 95 prints by, 12 doubtful prints. Millimeters. Inscriptions. Described. Located (selection). Bibliography for each entry.

Bonacker, Wilhelm. "Die sogenannte Bodenseekarte des Meisters PW bzw. PPW vom Jahre 1505." *Die Erde* 6 (1954): 1–29.
Additional information to Schleuter.

PW *(15th cent.)* [Nagler, *Mon.*] IV, no. 3429
[B.] VI, pp. 309–310.
Entries: 3. Pre-metric. Inscriptions. Described.

[P.] II, pp. 161–163.
Entries: 6 prints by (additional to [B.]), 1 doubtful print. Pre-metric. Inscriptions. Described. Located.

[Wess.] I, p. 144.
Entries: 2 (additional to [B.] and [P.]). Millimeters. Inscriptions. Described.

Q *(fl. c.1585)* [Nagler, *Mon.*] IV, no. 3452
[P.] IV, p. 264.
Entries: 2. Pre-metric. Inscriptions. Described. Located (selection).

R *(16th cent.)* [Nagler, *Mon.*] IV, no. 3513
[B.] VIII, pp. 541–543.
Entries: 3. Pre-metric. Inscriptions. Described.

[Wess.] I, pp. 146–147.
Entries: 2 (additional to [B.]). Millimeters. Inscriptions. Described.

[H. *Neth.*] XIII, p. 118.
Entries: 5. Illustrated (selection).*

R *(15th cent.)* [Nagler, *Mon.*] IV, no. 3516
[P.] II, pp. 175–176.
Entries: 1. Inscriptions. Described. Located.

RB [Nagler, *Mon.*] I, no. 2020
See **Monogram BR** [Nagler, *Mon.*] I, no. 2020

RB *(16th cent.)* [Nagler, *Mon.*] IV, nos. 3559, 3567, 3662
 [H. *Neth.*] XIII, p. 119.
 Entries: 6. Illustrated (selection).*

RB *(fl. 1530–1550)* [Nagler, *Mon.*] IV, no. 3566
 [B.] IX, pp. 5–10.
 Entries: 11. Pre-metric. Inscriptions. Described.

 [Evans] p. 29.
 Entries: 2 (additional to [B.]). Millimeters. Described.

 [P.] IV, pp. 134–135.
 Entries: 8 (additional to [B.]). Premetric. Inscriptions. Described. Located (selection).

 [Wess.] I, p. 147.
 Entries: 7 (additional to [B.]). Millimeters. Inscriptions. Described.

R et W *(19th cent.)*
 [Dus.] p. 126.
 Entries: 1 (lithographs only, to 1821). Millimeters. Inscriptions.

RF
 See **Monogram ILDRF** [Nagler, *Mon.*] III, no. 2752

RF *(19th cent.)*
 [Dus.] p. 122.
 Entries: 1 (lithographs only, to 1821).

RG *(fl. c.1635)*
 [Hind, *Engl.*] III, p. 260.
 Entries: 1. Inches. Inscriptions. Described. Illustrated. Located.

RHB [Nagler, *Mon.*] IV, no. 3662
 See **Monogram RB** [Nagler, *Mon.*] IV, no. 3559

RK [Nagler, *Mon.*] II, no. 2466
 See **Monogram FRK** [Nagler, *Mon.*] II, no. 2466

RKF *(16th cent.)* [Nagler, *Mon.*] IV, no. 3701
 [B.] IX, p. 241.
 Entries: 1. Pre-metric. Inscriptions. Described.

 [P.] IV, p. 175.
 Entries: 1 (additional to [B.]). Described.

RM *(17th cent.)*
 [Hind, *Engl.*] III, p. 222.
 Entries: 1. Inches. Inscriptions. Described. Illustrated. Located.

ROP with the soldering box [Lötbüchschen] *(16th cent.)*
 [Lehrs] VI, pp. 6–7.
 Entries: 1. Millimeters. Inscriptions. Described. Located. Locations of all known impressions are given. Copies mentioned. Watermarks described. Bibliography for each entry.

RP *(fl. 1513)* [Nagler, *Mon.*] IV, no. 3758
 [P.] IV, p. 155.
 Entries: 1. Pre-metric. Inscriptions. Described. Located.

RQL *(fl. c.1544)* [Nagler, *Mon.*] IV, no. 3765
 [B.] IX, pp. 84–85.
 Entries: 1. Pre-metric. Inscriptions. Described.

RR *(16th cent.)* [Nagler, *Mon.*] IV, no. 3766
 [B.] VIII, pp. 551–552.
 Entries: 2. Pre-metric. Inscriptions. Described.

 [P.] IV, p. 130.
 Entries: 2 (additional to [B.]). Premetric. Described. Located.

 [H. *Neth.*] XIII, p. 120.
 Entries: 5. Illustrated (selection).*

S *(fl. c.1520)* [Nagler, *Mon.*] IV, no. 3862
 [B.] VIII, pp. 13–18.

Monogram S (*continued*)

Entries: 11. Pre-metric. Inscriptions. Described.

[Evans] pp. 28, 46–50.
Entries: 74 (additional to [B.]). Millimeters. Inscriptions. Described (selection).

Sotzmann, ———. "Der altdeutsche Zeichner und Kupferstecher mit dem

Monogramm S auch 🖋 oder E.S."

[*N. Arch.*] III (1857): 21–36.
Entries: 50. Pre-metric. Inscriptions. Described. Located.

[P.] III, pp. 47–83.
Entries: 289 prints by, 1 doubtful print. Pre-metric. Inscriptions. Described (selection). Located. Copies mentioned.

[Wess.] I, p. 145.
Entries: 7 (additional to [B.] and [P.]). Millimeters. Inscriptions. Described.

[Dut.] V, pp. 177–180.
Entries: 21. Millimeters. Inscriptions. Described. Located.*

Waldmann, E. "Kopien vom Meister S." [*MGvK.*] 1910: 1–3.
Entries: 3 (prints after Dürer). Millimeters. Described. Illustrated.

[H. *Neth.*] XIII, pp. 121–223.
Entries: 476. Illustrated (selection).*

S [Nagler, *Mon.*] IV, no. 3869
See **Swart van Groeningen,** Jan

SAP (*16th cent.*) [Nagler, *Mon.*] IV, no. 3946
[P.] IV, p. 265.
Entries: 1. Pre-metric. Inscriptions. Described.

SB (*fl. c.1515*) [Nagler, *Mon.*] IV, no. 3957
[B.] VIII, p. 9.

Entries: 1. Pre-metric. Inscriptions. Described.

[P.] IV, p. 109.
Entries: 1. Pre-metric. Inscriptions. Described. Located.

SB (*fl. c.1650*)
[H. *Neth.*] XIII, p. 224.
Entries: 1. Illustrated.*

SC (*fl. 1519–1521*) [Nagler, *Mon.*] IV, no. 3979
[B.] VIII, pp. 8–9.
Entries: 2. Pre-metric. Inscriptions. Described.

[P.] IV, pp. 108–109.
Entries: 1 (additional to [B.]). Pre-metric. Inscriptions. Described. Located.

[Wess.] I, pp. 144–145.
Entries: 2 (additional to [B.] and [P.]). Millimeters. Inscriptions. Described.

SE [Nagler, *Mon.*] IV, no. 4042
See **Monogram ES** [Nagler, *Mon.*] IV, no. 4042

SE (*16th cent.*) [Nagler, *Mon.*] IV, no. 4048
[P.] III, p. 84.
Entries: 5. Paper fold measure (selection). Pre-metric (selection). Inscriptions. Described. Located.

SF (*fl. 1560–1580*) [Nagler, *Mon.*] IV, no. 4082
[B.] IX, pp. 401–402, 419.
Entries: 2+. Pre-metric. Inscriptions.

[P.] IV, pp. 325–326.
Additional information to [B.].

[Merlo] pp. 425–426.*

SF (*fl. c.1575*) [Nagler, *Mon.*] IV, no. 4089
[P.] IV, p. 262.
Entries: 1. Pre-metric. Inscriptions. Described.

SG *(fl. c.1524)* [Nagler, *Mon.*] IV, no. 4102
[B.] VIII, p. 21.
 Entries: 1. Pre-metric. Inscriptions.
 Described.

[P.] IV, p. 113.
 Entries: 1 (additional to [B.]). Pre-
 metric. Inscriptions. Described. Lo-
 cated.

SG *(fl. 1550–1570)* [Nagler, *Mon.*] IV, no. 4104
[B.] IX, pp. 438–439.
 Entries: 3. Pre-metric. Inscriptions.

SGA *(16th cent.?)* [Nagler, *Mon.*] IV, no. 4115
[P.] IV, p. 164.
 Entries: 1. Pre-metric. Described.

SH [Nagler, *Mon.*] IV, no. 4127
See **Monogram HS** [Nagler, *Mon.*] IV, no. 4127

SH *(16th cent.?)*
[B.] VI, pp. 391–392.
 Entries: 2. Pre-metric. Inscriptions.
 Described.

[P.] II, p. 168.
 Entries: 2 (additional to [B.]). Pre-
 metric. Inscriptions. Described. Lo-
 cated.

[Lehrs] VI, pp. 7–10.
 Entries: 3. Millimeters. Inscriptions.
 States. Described. Located. Locations
 of all known impressions are given.
 Copies mentioned. Watermarks de-
 scribed. Bibliography for each entry.

SI *(fl. 1519–1525)* [Nagler, *Mon.*] V, no. 16
[B.] VII, p. 543.
 Entries: 2. Pre-metric. Inscriptions.
 Described.

SI *(16th cent.?)* [Nagler, *Mon.*] V, no. 29
[P.] II, p. 147.

Entries: 1. Pre-metric. Inscriptions.
Described. Located.

SI *(16th cent.)* [Nagler, *Mon.*] V, no. 50
[B.] IX, p. 419.
 Entries: 1.

SI *(fl. c.1570)* [Nagler, *Mon.*] V, no. 71
[B.] IX, p. 423.
 Entries: 1.

[P.] III, p. 473.
 Entries: 1. Pre-metric. Inscriptions.
 Described.

SID *(fl. c.1584)*
[B.] IX, p. 573.
 Entries: 1. Pre-metric. Inscriptions.
 Described.

SIG *(16th cent.?)*
[B.] IX, p. 518.
 Entries: 1. Pre-metric. Inscriptions.
 Described.

SIV *(15th cent.?)*
[Lehrs] VII, pp. 386–387.
 Entries: 1. Millimeters. Inscriptions.
 States. Described. Located. Locations
 of all known impressions are given.
 Copies mentioned. Watermarks de-
 scribed. Bibliography for each entry.

SK *(16th cent.)* [Nagler, *Mon.*] V, no. 118
[P.] VI, pp. 164–166.
 Entries: 9+. Pre-metric. Inscriptions
 (selection). Described (selection).

SL *(fl. c.1570)* [Nagler, *Mon.*] V, no. 136
[P.] IV, pp. 265–266.
 Entries: 3. Pre-metric. Inscriptions.
 Described. Located.

SM *(fl. c.1592)* [Nagler, *Mon.*] V, no. 168
[H. *Neth.*] XIII, p. 224.
 Entries: 1. Illustrated.*

SP *(fl. c.1513)* [Nagler, *Mon.*] V, no. 240
[P.] IV, p. 155.

Monogram SP (*continued*)

Entries: 1. Pre-metric. Inscriptions. Described. Located.

SP *(fl. c.1490)*
[Lehrs] VII, pp. 385–386.
Entries: 1. Millimeters. Inscriptions. Described. Located. Locations of all known impressions are given. Copies mentioned. Watermarks described. Bibliography for each entry.

SP *(19th cent.)*
[Dus.] p. 124.
Entries: 1 (lithograph only, to 1821). Inscriptions. Located.

SR *(16th cent.)* [Nagler, *Mon.*] V, no. 271
[P.] IV, p. 170.
Entries: 1. Pre-metric. Described. Located.

SR [Nagler, *Mon.*] V, no. 278
See **Monogram HR** [Nagler, *Mon.*] III, no. 1427

SR *(fl. c.1650)*
[H. *Neth.*] XIII, p. 225.
Entries: 1.*

SRVHE *(fl. c.1547)* [Nagler, *Mon.*] V, no. 293
[B.] IX, pp. 232–233.
Entries: 1. Pre-metric. Inscriptions. Described.

[H. *Neth.*] XIII, p. 225.
Entries: 3. Illustrated (selection).*

SS *(fl. c.1544)* [Nagler, *Mon.*] V, no. 299
[P.] VI, p. 174.
Entries: 2. Pre-metric. Inscriptions. Described.

SS *(15th/16th cent.)* [Nagler, *Mon.*] V, no. 300
[B.] VI, pp. 408–409.

Entries: 1. Pre-metric. Inscriptions. Described.

[P.] II, pp. 164–165.
Entries: 4. Pre-metric. Inscriptions. Described. Located. Additional information to [B.].

[Wess.] I, p. 144.
Additional information to [B.] and [P.].

[Lehrs] VI, pp. 10–11.
Entries: 2. Millimeters. Inscriptions. Described. Located. Locations of all known impressions are given. Copies mentioned. Watermarks described. Bibiliography for each entry.

SSP *(fl. c.1534)* [Nagler, *Mon.*] V, no. 306
[P.] IV, pp. 64–65.
Entries: 1 print by, 1 doubtful print. Pre-metric. Inscriptions. Described. Located (selection). Copies mentioned.

SW *(fl. c.1520)* [Nagler, *Mon.*] V, no. 433
[B.] VIII, pp. 7–8.
Entries: 12. Pre-metric. Inscriptions. Described.

[Lehrs] VI, pp. 11–12.
Entries: 2. Millimeters. Inscriptions. Described. Located. Locations of all known impressions are given. Copies mentioned. Watermarks described. Bibliography for each entry.

T *(15th cent.)* [Nagler, *Mon.*] II, no. 1830
[B.] VI, p. 399.
Entries: 1. Pre-metric. Inscriptions. Described.

TA
See **Monogram A** [Nagler, *Mon.*] I, no. 37

TB *(fl. 1541–1565)* [Nagler, *Mon.*] V, no. 529
[B.] IX, pp. 522–524.

Entries: 5. Pre-metric. Inscriptions. Described.

[P.] IV, p. 193.
Entries: 3 (additional to [B.]). Paper fold measure. Pre-metric. Inscriptions. Described. Located (selection).

TB *(16th cent.?)* [Nagler, *Mon.*] V, no. 537
[B.] IX, pp. 437–438.
Entries: 1. Pre-metric. Inscriptions. Described.

TBK *(15th cent.)*
[Lehrs] VII, pp. 387–388.
Entries: 1. Millimeters. Inscriptions. Described. Illustrated. Located. Locations of all known impressions are given. Copies mentioned. Watermarks described. Bibliography for each entry.

TF *(17th cent.?)*
[H. *Neth.*] XIII, p. 226.
Entries: 4. Illustrated (selection).

TFW *(late 15th cent.)* [Nagler, *Mon.*] V, no. 630
[B.] VI, pp. 411–412.
Entries: 1. Pre-metric. Inscriptions. Described.

[Lehrs] VI, pp. 15–16.
Entries: 1. Millimeters. Inscriptions. Described. Located. Locations of all known impressions are given. Copies mentioned. Watermarks described. Bibliography for each entry.

TH *(fl. c.1504)* [Nagler, *Mon.*] V, no. 641
[P.] IV, p. 154.
Entries: 1. Pre-metric. Inscriptions. Described.

THVB *(fl. 1560–1580)* [Nagler, *Mon.*] V, no. 703
[B.] IX, pp. 524–525.
Entries: 2. Pre-metric. Inscriptions. Described.

[P.] IV, pp. 193–194.
Entries: 4. Pre-metric. Inscriptions. Described. Located (selection).

TI *(16th cent.)* [Nagler, *Mon.*] V, no. 714
[P.] III, p. 87.
Entries: 1. Pre-metric. Inscriptions. Described. Located.

[H. *Neth.*] XIII, p. 226.
Entries: 1. Illustrated.*

TON *(16th cent.)* [Nagler, *Mon.*] V, no. 802
[B.] IX, pp. 562–563.
Entries: 1. Pre-metric. Inscriptions. Described.

TP *(16th cent.)* [Nagler, *Mon.*] V, no. 810
[P.] V, p. 228.
Entries: 1. Pre-metric. Inscriptions. Described. Located.

[Hind] V, pp. 277, 305.
Entries: 1. Millimeters. Inscriptions. Described. Illustrated. Located.

TS *(15th cent.?)*
[Lehrs] VI, p. 12.
Entries: 1. Millimeters. Inscriptions. Described. Located. Locations of all known impressions are given. Copies mentioned. Watermarks described. Bibliography for each entry.

TT *(fl. c.1521)* [Nagler, *Mon.*] V, no. 876
[P.] IV, p. 156.
Entries: 1. Pre-metric. Inscriptions. Described.

TU with the orb *(early 16th cent.)*
[H. *Neth.*] XIII, p. 226.
Entries: 1. Illustrated.*

TVIN *(fl. c.1563)* [Nagler, *Mon.*] V, no. 892
[P.] VI, p. 133.
Entries: 2. Pre-metric. Inscriptions. Described.

TVSP *(fl. c.1560)* [Nagler, *Mon.*] V, no. 896
[B.] IX, pp. 525–526.
Entries: 1. Pre-metric. Inscriptions.
Described.

[P.] IV, p. 194.
Entries: 1 (additional to [B.]). Pre-
metric. Inscriptions. Described.

TW *(fl. c.1516)* [Nagler, *Mon.*] V, no. 900
See also **Monogram HF** [Nagler, *Mon.*]
III, no. 896

[P.] IV, p. 173.
Entries: 1. Pre-metric. Inscriptions.
Described. Located.

TW *(fl. 1530–1540)* [Nagler, *Mon.*] V, no.
909
[P.] IV, pp. 327–328.
Entries: 3+. Pre-metric. Inscriptions.
Described.

TW [Nagler, *Mon.*] V, no. 910
See **Telman von Wesel**

V *(fl. 1759–1776)* [Nagler, *Mon.*] V, no. 982
[Merlo] p. 1138.*

VE *(fl. c.1595)* [Nagler, *Mon.*] V, no. 1118
[H. *Neth.*] XIII, p. 227.
Entries: 1.*

VE *(16th cent.)* [Nagler, *Mon.*] V, no. 1119
[B.] IX, p. 422.
Entries: 1.

VG [Nagler, *Mon.*] V, no. 1175
See **Graf,** Urs

VG *(fl. c.1534)* [Nagler, *Mon.*] V, no. 1177
[B.] IX, pp. 22–24.
Entries: 3. Pre-metric. Inscriptions.
Described.

[P.] IV, pp. 157–158.
Entries: 3 (additional to [B.]). Pre-
metric. Inscriptions. Described. Lo-
cated.

[Wess.] I, p. 147.
Entries: 1 (additional to [B.]). De-
scribed.

VGF *(17th cent.)* [Nagler, *Mon.*] V, no. 1185
[H. *Neth.*] XIII, p. 227.
Entries: 1. Illustrated.*

VGP *(fl. c.1534)*
[H. *Neth.*] XIII, p. 227.
Entries: 1. Illustrated.*

VH *(16th cent.)* [Nagler, *Mon.*] V, no. 1199
[H. *Neth.*] XIII, p. 61.
Entries: 1.*

VH *(fl. c.1557)* [Nagler, *Mon.*] V, no. 1202
[B.] IX, pp. 475–476.
Entries: 1. Pre-metric. Inscriptions.
Described.

[P.] IV, p. 179.
Entries: 1 (additional to [B.]). Pre-
metric. Inscriptions. Described.

[Evans] p. 27.
Entries: 1 (additional to [B.]). Milli-
meters. Inscriptions. Described.

VH *(fl. c.1650)*
[H. *Neth.*] XIII, p. 228.
Entries: 2. Illustrated.*

VIF *(fl. c.1650)* [Nagler, *Mon.*] V, no. 1237
[H. *Neth.*] XIII, p. 227.
Entries: 1. Illustrated.*

VL *(16th cent.)*
[P.] VI, p. 126.
Entries: 1. Pre-metric. Inscriptions.
Described.

VM *(15th cent.?)*
[Lehrs] VI, pp. 12–13.
Entries: 1. Millimeters. Inscriptions.
Described. Located. Locations of all
known impressions are given. Copies
mentioned. Watermarks described.
Bibliography for each entry.

VPR *(16th cent.)* [Nagler, *Mon.*] V, no. 1335
[P.] IV, p. 261.
> Entries: 1. Pre-metric. Inscriptions.
> Described.

VR *(fl. c.1660)* [Nagler, *Mon.*] V, no. 1340
[Merlo] p. 1139.*

VW *(16th cent.)* [Nagler, *Mon.*] V, no. 1423
[B.] IX, p. 564.
> Entries: 1. Pre-metric. Inscriptions.
> Described.

Bielke, Axel. "Beiträge zu den
Holzschnitten des Meister V. W."
[*N. Arch.*] 2 (1856): 253–254.
> Entries: 9. Paper fold measure. In-
> scriptions.

[P.] IV, pp. 320–322.
> Entries: 15. Pre-metric (selection). In-
> scriptions.

W *(15th cent.)* [Nagler, *Mon.*] V, no. 1432
[P.] II, pp. 167–168.
> Entries: 1. Pre-metric. Inscriptions.
> Described. Located.

W ⚷ [W with the key] *(15th cent.)*
[Nagler, *Mon.*] V, no. 1441
[B.] VI, pp. 56–66.
> Entries: 31. Pre-metric. Inscriptions.
> Described.

[Evans] pp. 37–38.
> Entries: 9 (additional to [B.]). Milli-
> meters. Inscriptions. Described.

[P.] II, pp. 279–284.
> Entries: 35 engravings (additional to
> [B.]), 4 engravings not seen by [P.], 1
> woodcut. Pre-metric. Inscriptions.
> Described. Located. Watermarks de-
> scribed.

[Dut.] V, pp. 164–174; VI, p. 674.
> Entries: 67. Millimeters. Inscriptions.
> States. Described.

Lehrs, Max. *Der Meister W* ⚷ *, ein
Kupferstecher der Zeit Karls des Kühnen.*
Leipzig: Karl W. Hiersemann, 1895.

> Entries: 77 prints by, 3 prints not seen
> by Lehrs. Millimeters. States. De-
> scribed. Illustrated. Located. Copies
> mentioned. Bibliography for each en-
> try. Appendix with 15 prints by E.S.
> [Nagler, *Mon.*] II, no. 1763 retouched
> by W ⚷ (not illustrated).

[W.] III, pp. 227–230.
> Entries: 77.*

Geisberg, Max. "Ein neuer Stich des
Meisters W ⚷ ."

[*MGvK.*] 1909, pp. 26–28.
> Entries: 1 (additional to Lehrs 1895).
> Millimeters. Described. Illustrated.

[Lehrs] VII, pp. 1–101, 401–407.
> Entries: 83. Millimeters. Inscriptions.
> States. Described. Illustrated (selec-
> tion). Located. Locations of all known
> impressions are given. Copies men-
> tioned. Watermarks described. Bib-
> liography for each entry.

[H. *Neth.*] XII, pp. 203–251.
> Entries: 83. Illustrated.*

W [Nagler, *Mon.*] V, no. 1452
See **Monogram IW** [Nagler, *Mon.*] V, no.
1452

W *(16th cent.)* [Nagler, *Mon.*] V, no. 1453
[B.] IX, p. 53.
> Entries: 1. Pre-metric. Inscriptions.
> Described.

W *(fl. c.1527)* [Nagler, *Mon.*] V, no. 1454
[P.] III, p. 96.
> Entries: 2. Pre-metric. Inscriptions.
> Described. Located.

[H. *Neth.*] XIII, p. 228.
> Entries: 2. Illustrated.*

WA 1502 *(fl. c.1502)*
[P.] IV, p. 40.
> Entries: 2. Pre-metric. Inscriptions.
> Described.

WB *(15th cent.)* [Nagler, *Mon.*] V, no. 1557
Lehrs, Max. *Der Meister LCz und der Meis-*
ter ꞷ⚮ß *Nachbildung ihrer Kup-*
ferstiche. Graphische Gesellschaft, XXV.
Veröffentlichung. Berlin: Bruno Cas-
sirer, 1922.
 Entries: 4. Millimeters. States. Illus-
 trated. Located. Watermarks de-
 scribed.

[Lehrs] VI, pp. 343–349.
 Entries: 4. Millimeters. Inscriptions.
 States. Described. Illustrated. Loca-
 tions of all known impressions are
 given. Copies mentioned. Water-
 marks described. Bibliography for
 each entry.

WCIEF [Nagler, *Mon.*] V, no. 1597
See **Coeberger,** Wenzel

WENHG 1509 *(fl. c.1509)*
[Hind] V, p. 277.
 See **Master of 1515**

WG *(16th cent.)*
[H. *Neth.*] XIII, p. 229.
 Entries: 1.*

W GRGB *(19th cent.)*
[Dus.] p. 122.
 Entries: 1 (lithographs only, to 1821).
 Paper fold measure.

WH *(16th cent.)* [Nagler, *Mon.*] V, no. 1692
[B.] IX, p. 421.
 Entries: 4.

WH *(fl. c.1483)* [Nagler, *Mon.*] V, no. 1699
[B.] VI, pp. 400–405.
 Entries: 26. Pre-metric. Inscriptions.
 States. Described.

[P.] II, pp. 129–132.
 Entries: 7 (additional to [B.]). Pre-
 metric. Inscriptions. Described. Lo-
 cated. Additional information to [B.].

Lehrs, Max. "Die Monogrammisten AG
und WH in ihrem Verhältniss zu einan-
der." [*Rep. Kw.*] IX (1886): 1–20, 377–382.
 Entries: 27. Millimeters. Inscriptions.
 States. Described. Located.

[Lehrs] VI, pp. 131–159.
 Entries: 27. Millimeters. Inscriptions.
 States. Described. Illustrated (selec-
 tion). Located. Locations of all known
 impressions are given. Copies men-
 tioned. Watermarks described. Bib-
 liography for each entry.

WH *(fl. c.1551)*
[Evans] p. 43.
 Entries: 3. Millimeters. Inscriptions.
 Described.

WI *(16th cent.)* [Nagler, *Mon.*] V, no. 1736
[B.] IX, pp. 53–57.
 Entries: 10. Pre-metric. Inscriptions.
 Described.

[Evans] p. 25.
 Entries: 2 (additional to [B.]). Milli-
 meters. Inscriptions. Described.

[P.] IV, pp. 173–174.
 Entries: 9 (additional to [B.]). Pre-
 metric. Inscriptions. Described. Lo-
 cated.

[Wess.] I, pp. 148–149.
 Entries: 5 (additional to [B.] and [P.]).
 Millimeters. Inscriptions. Described.

[H. *Neth.*] XIII, pp. 69–70.
 Entries: 2. Illustrated (selection).*

WK *(fl. c.1550)* [Nagler, *Mon.*] V, no. 1792
[Merlo] p. 1140.*

WL *(16th cent.)* [Nagler, *Mon.*] V, no. 1802
[P.] IV, p. 175.
 Entries: 1. Pre-metric. Inscriptions.
 Described. Located.

WL *(16th cent.)*
[Ge.] unnumbered.

Entries: 1 rejected print (single-sheet woodcuts only). Described. Illustrated. Located.

WO *(early 16th cent.)*
[H. *Neth.*] XIII, p. 230.
Entries: 1. Illustrated.*

WO *(19th cent.)*
[Dus.] p. 123.
Entries: 2 (lithographs only, to 1821). Inscriptions.

WR *(fl. c.1551)* [Nagler, *Mon.*] V, no. 1871
[B.] IX, p. 170.
Entries: 1. Pre-metric. Inscriptions. Described.

WRK *(16th cent.)* [Nagler, *Mon.*] V, no. 1892
[B.] IX, p. 427.
Entries: 12. Pre-metric. Inscriptions. Described.

WS *(fl. c.1587)* [Nagler, *Mon.*] V, no. 1899
[B.] IX, p. 574.
Entries: 2. Pre-metric. Inscriptions. Described.

[Heller] pp. 121–122.
Entries: 12 (additional to [B.]). Pre-metric. Inscriptions. Described.

[P.] IV, pp. 221–223.
Entries: 4+ engravings (additional to [B.]), 3 woodcuts. Pre-metric. Inscriptions (selection). States. Described (selection). Located (selection).

[A.] IV, pp. 14–21.
Entries: 33. Pre-metric. Inscriptions. States. Described.

WS *(fl. c.1547)* [Nagler, *Mon.*] V, no. 1904
[B.] IX, pp. 396–397.
Entries: 1. Pre-metric. Inscriptions. Described.

WTG [Nagler, *Mon.*] II, no. 714
See **Monogram NTG** [Nagler, *Mon.*] II, no. 714; III, no. 388

WW *(fl. c.1557)* [Nagler, *Mon.*] V, no. 1972
[B.] IX, pp. 478–479.
Entries: 1. Pre-metric. Inscriptions. Described.

XAR
See **Monogram AP** [Nagler, *Mon.*] I, no. 1102

XR
See **Monogram AP** [Nagler, *Mon.*] I, no. 1102

YHS [Nagler, *Mon.*] V, no. 2031
[B.] XII: *See* **Chiaroscuro Woodcuts**

ZBM *(fl. c.1557)* [Nagler, *Mon.*] V, no. 2065
[Evans] p. 22.
Entries: 1. Millimeters. Inscriptions. Described.

[P.] VI, p. 173.
Entries: 1. Pre-metric. Inscriptions. Described.

ZW *(fl. 1571–1612)* [Nagler, *Mon.*] V, no. 2126
[B.] IX, p. 561.
Entries: 1. Pre-metric. Inscriptions. Described.

[P.] IV, pp. 338–339.
Entries: 1 (additional to [B.]). Pre-metric. Inscriptions. States. Described.

[A.] III, pp. 334–338.
Entries: 2. Pre-metric. Inscriptions. Described.

⚥ *(15th cent.)* [Nagler, *Mon.*] I, no. 44
[B.] VI, pp. 53–56.
Entries: 6. Pre-metric. Inscriptions. Described.

�ֆ (*continued*)

[P.] II, pp. 80–81.
Entries: 2 (additional to [B.]). Pre-metric. Inscriptions. Described. Located. Also mentions 1 print not seen by [P.].

↷▼ (*15th cent.*) [Nagler, *Mon.*] II, no. 235
[Lehrs] VI, pp. 5–6.
Entries: 1. Millimeters. Inscriptions. Described. Located. Locations of all known impressions are given. Copies mentioned. Watermarks described. Bibliography for each entry.

↬ℛ [Nagler, *Mon.*] IV, no. 560
See **Lucius,** Jakob I

⚔ (*15th cent.*)
[B.] VI, pp. 397–398.
Entries: 1. Pre-metric. Inscriptions. Described.

[P.] II, p. 143.
Entries: 3. Pre-metric. Inscriptions. Described. Located. Additional information to [B.].

⚔ ⚓ (*15th cent.*)
[Lehrs] VI, pp. 16–18.
Entries: 4. Millimeters. Inscriptions. Described. Located. Locations of all known impressions are given. Copies mentioned. Watermarks described. Bibliography for each entry.

ℬ (*15th cent.*)
[Lehrs] VI, pp. 13–15.
Entries: 6. Millimeters. Inscriptions. States. Described. Located. Locations of all known impressions are given. Copies mentioned. Watermarks described. Bibliography for each entry.

ℛ (*15th cent.*)
[Lehrs] VI, p. 2.

Entries: 1. Millimeters. Inscriptions. Described. Located. Locations of all known impressions are given. Copies mentioned. Watermarks described. Bibliography for each entry.

⚔ (*15th cent.*)
[Lehrs] VII, pp. 388–389.
Entries: 1. Millimeters. Inscriptions. Described. Located. Locations of all known impressions are given. Copies mentioned. Watermarks described. Bibliography for each entry.

⚜ (*15th cent.*)
[P.] II, p. 166.
Entries: 1. Pre-metric. Inscriptions. Described. Located.

⚔ (*15th cent.*)
[P.] II, p. 81.
Entries: 1. Pre-metric. Described.

⚓ (*early 16th cent.*)
[P.] V, p. 228.
Entries: 1. Pre-metric. Inscriptions. Described. Located.

⚓ (*early 16th cent.*)
[H. *Neth.*] XIII, p. 231.
Entries: 3. Illustrated.*

⚓ (*fl. c.1523*)
[H. *Neth.*] XIII, p. 230.
Entries: 1. Illustrated.*

⚓ (*fl. c.1525*)
[Merlo] pp. 1140–1141.
Entries: 4. Pre-metric. Inscriptions. Described.

⚓ (*fl. c.1526*)
[P.] IV, p. 157.
Entries: 1. Pre-metric. Inscriptions. Described. Located.

⚓ (*fl. c.1537*)
[P.] IV, p. 166.

Entries: 1. Pre-metric. Inscriptions. Described.

⧪ *(fl. 1562–1565)*
[P.] IV, pp. 60–62.
Entries: 7+. Pre-metric. Inscriptions. Described (selection).

✠ *(fl. c.1568)*
[P.] IV, p. 326.
Entries: 1+.

 (15th cent.)
[Schreiber, *Metallschneidekunst*] p. 91.
Entries: 6 prints by, 1 doubtful print.*

▢ *(15th cent.)*
[Schreiber, *Metallschneidekunst*] p. 91.
Entries: 1.*

Monsaldy, Antoine Maxime *(1768–1816)*
[Ber.] X, pp. 108–109.*

Montagna, Benedetto *(c.1481–before 1558)*
[B.] XIII, pp. 332–350.
Entries: 33. Pre-metric. Inscriptions. States. Described. Copies mentioned.

[Evans] pp. 8–9, 14–15.
Entries: 6 (additional to [B.]). Millimeters. Inscriptions. Described.

[P.] V, pp. 153–160.
Entries: 23 engravings (additional to [B.]), 1 doubtful print, 1 metal cut. Pre-metric. Inscriptions. States. Described. Located. Copies mentioned. Additional information to [B.].

[Hind] V, pp. 173–188.
Entries: 53. Millimeters. Inscriptions. States. Described. Illustrated. Located.

Montagne, Michel and Nicolas
See **Plattenberg,** Matthieu and Nicolas

Montaner, Francisco *(1743–1805)*
[Ap.] p. 313.
Entries: 2.*

Montarlot, Paul *(19th cent.)*
[Ber.] X, p. 109.*

Montaut, Gabriel Xavier called ["Montaut d'Oléron"] *(1798–after 1852)*
[Ber.] X, pp. 109–110.*

Montaut, Henri de *(19th cent.)*
[Ber.] X, p. 110.*

Montbard, Georges [Charles Auguste Loye] *(b. 1841)*
[Ber.] X, pp. 100–111.
Entries: 17.

Montefiore, Edward Levy *(1820–1894)*
[Ber.] X, pp. 111–112.*

Montenat, J. *(17th cent.)*
[RD.] IV, p. 1.
Entries: 1. Pre-metric. Inscriptions. Described.

Montfort, Antoine Alphonse *(1802–1884)*
[Ber.] X, p. 112.*

Montgomorie, W. C. *(b. 1881)*
Brinton, Selwyn. "A modern etcher."
Art in America 9 (1921): 128–130.
Entries: 33. Inches. Illustrated (selection).

Monthelier, Alexandre Jules *(b. 1804)*
[Ber.] X, p. 112.*

Monti, Antonio Maria *(fl. 1680–1696)*
[B.] XIX, pp. 257–261.
Entries: 12. Pre-metric. Inscriptions. Described.

Montiero, Antonio Maria de Oliviera *(1785–1845)*
Soares, Ernesto. *Francisco Bartolozzi e os seus discipulos em Portugal.* Estudos-Nacionais sob a egide do Instituto de Coimbra, 3. Gaia (Portugal): Edições Apolino, 1930.
Entries: 2+. Millimeters. Inscriptions. Described. Located.

Montigneul, Émile *(fl. 1840–1850)*
[Ber.] X, pp. 112–113.*

Montmorillon, Ludwig Albert von *(1794–1854)*
[Ap.] p. 284.
Entries: 4.*

[Dus.] pp. 126–128.
Entries: 20 (lithographs only, to 1821). Millimeters. Inscriptions. Located.

Monvoisin, Domenica *(d. 1881)*
[Ber.] X, p. 114.*

Monvoisin, Pierre [Monvoison ainé] *(fl. 1824–1831)*
[Ber.] X, p. 113.*

Monvoisin, Raymond Quinsac *(1794–1870)*
[Ber.] X, p. 113.*

Monziès, Louis *(b. 1849)*
[Ber.] X, pp. 114–116.*

Moor, Carel de *(1656–1738)*
[vdK.] pp. 1–9, 225–226.
Entries: 18. Millimeters. Inscriptions. States. Described. Appendix with 7 doubtful and rejected prints.

[Dut.] V, pp. 189–190.*

[W.] II, pp. 184–185.
Entries: 18 prints by, 5 after.*

[H. *Neth.*] XIV, pp. 75–86.
Entries: 21 prints by, 15 after. Illustrated (selection).*

Moor, Carel Isaak de *(b. 1695)*
[W.] II, p. 185.
Entries: 4 prints by, 1 after.*

Moore, Henry *(b. 1898)*
Galerie Gérald Cramer, Geneva. *Henry Moore: oeuvre gravé et lithographié 1939–1967.* Geneva, 1968. 1500 copies. (CSfAc)
Entries: 48 (to 1967). Millimeters. Inches. States. Illustrated (selection).

Moore, Isaac W. *(fl. 1831–1833)*
[St.] p. 374.*

Moore, James *(fl. c.1763)*
[Sm.] III, p. 941.
Entries: 1 (portraits only). Inches. Inscriptions.

[Ru.] p. 228.
Entries: 1 (portraits only, additional to [Sm.]). Inscriptions. Described.

Moorees, Christiaan Willem *(b. 1801)*
[H. L.] pp. 718–719.
Entries: 5. Millimeters. Inscriptions. Described.

Mor, Anthonis
See **Moro,** Antonio

Morace, Ernst *(1766–c.1820)*
[Ap.] pp. 284–285.
Entries: 22.*

[Ber.] X, p. 116.*

Moraine, Louis Pierre René de *(b. 1816)*
[Ber.] X, p. 117.*

Moran, Mary Nimmo *(1842–1899)*
Koehler, Sylvester. "The works of the American etchers, XX; Mrs. M. Nimmo Moran." [*Amer. Art Review*] 2, no. 1 (1881): 183.
Entries: 12, (to 1881?). Inches. Inscriptions.

A catalogue of the complete etched work of Thomas Moran, N.A.; and M. Nimmo Moran, S.P.E. New York: C. Klackner's, 1889.
> Entries: 58. Inches. Described (selection). Ms. notes (NN); a few additional entries.

Moran, Peter *(1841–1914)*
Koehler, Sylvester R. "The works of the American etchers, IV; Peter Moran." [*Amer. Art Review*] 1 (1880): 149–151.
> Entries: 35 (to 1879). Inches. Inscriptions.

Koehler, Sylvester R. "New etchings by Peter Moran." [*Amer. Art Review*] 2, no. 2 (1881): 164.
> Entries: 8 (additional to Koehler 1880; to 1881?). Inches. Inscriptions.

Frederick Keppel & Co. *Catalogue of the etched work of Peter Moran.* New York: Frederick Keppel and Co., 1888.
> Entries: 105 etchings, 8 monotypes. Ms. addition (NN); additional information, 3 additional entries.

Moran, Thomas *(1837–1926)*
Koehler, Sylvester R. "The works of the American etchers, V; Thomas Moran." [*Amer. Art Review*] 1 (1880): 151.
> Entries: 9 (to 1880). Inches. Inscriptions.

Koehler, Sylvester R. "New etchings by Thomas Moran." [*Amer. Art Review*] 2, no. 2 (1881): 104.
> Entries: 12 (additional to Koehler 1880; to 1881?). Inches. Inscriptions.

A catalogue of the complete etched work of Thomas Moran, N.A.; and M. Nimmo Moran, S.P.E. New York: C. Klackner's, 1889.
> Entries: 70. Inches. Described (selection). Ms. addition (NN); additional information, 4 additional entries.

Wilson, James Benjamin. "The significance of Thomas Moran as an American landscape painter." Dissertation, Ohio State University, 1955. (Not seen).
> Entries: 76 etchings, 78 wood engravings, 22 lithographs.

Morandi, Giorgio *(1890–1964)*
Vitali, Lamberto. *L'Opera grafica di Giorgio Morandi.* Turin: Giulio Einaudi, 1957. 2d ed., rev., 1964.
> Entries: 131 (1964 edition; first edition has 14 fewer entries). Millimeters. Inscriptions. States. Described. Illustrated.

Ente bolognese manifestazioni artistiche. *L'Opera di Giorgio Morandi; catalogo della mostra, Bologna, Palazzo dell'Archiginnasio.* Bologna: Edizioni Alfa, 1966.
> Entries: 131. Millimeters. Illustrated.

Marchiori, Giuseppe. *Giorgio Morandi, le incisioni.* Quaderni di grafica. Rome: A. Ronzon, 1969.
> Entries: 131. Millimeters. Inscriptions. Illustrated.

Morandi, Giovanni Maria *(1622–1717)*
[B.] XXI, pp. 85–86.
> Entries: 1. Pre-metric. Inscriptions. Described.

Mordant, Daniel Charles Marie *(c.1853–1914)*
[Ber.] X, pp. 117–118.*

Moreau, Achille *(fl. 1825–1842)*
[Ber.] X, p. 118.*

Moreau, Adolphe Ferdinand *(1827–1882)*
[Ber.] X, p. 119.*

Moreau, Adrien *(1843–1906)*
[Ber.] X, p. 119.*

Moreau, Gustave *(1826–1898)*
[Ber.] X, pp. 118–119.*

Moreau, Jean Michel [called "Moreau le jeune"] *(1741–1814)*

[Gon.] II, pp. 183–266.
Entries: 9 prints by. Inscriptions. Described. Prints after, unnumbered, pp. 240–263. Inscriptions (selection). Described (selection).

Beraldi, Henri [Henri Draibel]. *L'Oeuvre de Moreau le jeune, notice et catalogue.* Paris: P. Rouquette, 1874.
Entries: 252 prints by and after. Paper fold measure. Described (selection).

Mahérault, Marie Joseph François. *L'Oeuvre de Moreau le jeune, catalogue raisonné et descriptif.* Paris: Adolphe Labitte, 1880.
Entries: 150+ prints by, 269+ after. Millimeters. Inscriptions. States. Described.

Bocher, Emmanuel. *Jean Michel Moreau le jeune.* Les gravures françaises du XVIIIe siècle, 6. Paris: Damascène Morgand et Charles Fatout, 1882. 500 copies. (MBMu)
Entries: 1961. Millimeters. Inscriptions. States. Described.

Schéfer, Gaston. *Moreau le jeune 1741–1814.* Paris: Goupil et Cie, 1915.
Entries: unnumbered, pp. 109–161.

Moreau, Louis Gabriel [called "Moreau l'ainé"] *(1740–1806)*
Prouté, Paul. *Les eaux-fortes de Louis Moreau l'ainé; essai de catalogue.* Paris: Published by the author, 1956.
Entries: 69. Millimeters. Inscriptions. States. Illustrated. Located.

Wildenstein, Georges. "Sur les eaux-fortes de Moreau l'ainé." [*GBA.*] 6th ser. 52 (1958): 369–378.
Additional information to Prouté.

Moreau, Luc Albert *(1882–1948)*
Dunoyer de Segonzac, A. "Luc Albert Moreau." [*AMG*] 3 (1929–1930): 958–966.
Entries: 30 (single lithographs only, to 1929). Also, bibliography of books with illustrations by (to 1929).

Thomé, J. R. *Catalogue de l'oeuvre lithographié et gravé de Luc-Albert Moreau.* Graveurs et lithographes contemporains, 2. Paris: Auguste Fontaine, 1938. 110 copies. (MBMu)
Entries: 64 (single prints only, to 1938). Millimeters. States. Described. Also, bibliography of books with illustrations by.

Thomé, J. R. "Luc-Albert Moreau." *Portique* 7 (1950): 21–38.
Bibliography of books with illustrations by.

Bibliothèque Nationale, Paris [Jean Adhémar, compiler]. *Luc-Albert Moreau 1882–1948, exposition de ses estampes et livres illustrés.* Paris, 1949.
Entries: 80 (single prints only, additional to Thomé; to 1948). Also, bibliography of books with illustrations by; additional to Thomé.

Moreelse, Paulus *(1571–1638)*
[W.] II, pp. 186–187.
Entries: 2 prints by, 16 after.*

Jonge, C. H. de. *Paulus Moreelse, portret en genre schilder te Utrecht 1571–1638.* Assen (Netherlands): Van Gorcum en Comp., 1938.
Entries: 42 prints and drawings by and after. Millimeters. Inscriptions. Described. Illustrated (selection). Located.

[H. *Neth.*] XIV, pp. 87–89.
Entries: 4 prints by, 22 after. Illustrated (selection).*

Morel, Antoine Alexandre *(1765–1829)*
[Ap.] pp. 285–286.
Entries: 21.*

[Ber.] X, pp. 119–120.*

Morel, François *(c.1768–after 1830)*
 [Ap.] p. 286.
 Entries: 5.*

Morel, Pierre *(fl. c.1883)*
 [Ber.] X, p. 121.*

Morel-Fatio, Léon *(1810–1871)*
 [Ber.] X, p. 121.*

Morel-Retz, Louis Pierre Gabriel Bernard
 See **Stop**

Morell, Pit *(b. 1939)*
 Brockstedt, Hans. *Pit Morell, Werkverzeichnis der Radierungen (1963–1971).*
 Hamburg: Galerie Brockstedt, 1971.
 Entries: 353 (to 1971). Millimeters. Illustrated.

Morelli, ———
 [Ap.] p. 287.
 Entries: 2.*

Morelli, Francesco
 See **Morel,** François

Morère, René *(1907–1942)*
 Morère, Augusta. *Catalogue des oeuvres de René Morère laissées en ses ateliers en 1943.* [n.p., 1944?]. (EPBN)
 Entries: unnumbered, pp. 49–57.

Moretti, G. *(17th cent.)*
 [P.] VI, p. 236, no. 66a.
 Entries: 1. Pre-metric. Inscriptions. Described. Located.

Morgenstern, Christian Ernst Bernhard *(1805–1867)*
 [A. 1800] II, pp. 221–249.
 Entries: 14. Pre-metric. Inscriptions. States. Described. Also, list of 6 prints after (not fully catalogued).

 Andresen, Andreas. "Andresens Nachträge zu seinen 'Deutschen Malerradierern.' " [*MGvK.*] 1907, p. 42.

 Entries: 2 (additional to [A. 1800]). Millimeters. Inscriptions. Described.

Morghen, Antonio *(1788–1853)*
 [Ap.] pp. 287–288.
 Entries: 16.*

Morghen, Guglielmo *(18th cent.)*
 [Ap.] p. 288.
 Entries: 10.*

Morghen, Raphael *(1758–1833)*
 Palmerini, Niccolò. *Catalogo delle opere d'intaglio di Raffaello Morghen.* Florence: Molini Landi e Comp., 1810.
 Entries: 201. Millimeters.

 Palmerini, Niccolò. *Opere d'intaglio del cav. Raffaello Morghen.* Florence: Presso Niccolò Pagni, 1824.
 Entries: 252. Millimeters. Described.

 L., E. "Raphael Morghen." [*Cab. am. ant.*] 1 (1842): 97–118.
 Entries: 254. Millimeters. States.

 [Ap.] pp. 288–301.
 Entries: 146.*

 Maskell, Alfred. *A catalogue of the engraved works of Raphael Morghen in the possession of Sir Thomas Brassey, K.C.B., M.P., forming the second part of the life and engraved work of Raphael Morghen.* n.p., Chiswick Press, 1882. 125 copies. (PJRo)
 Entries: 273. Millimeters. States. Described. Located. Ms. notes (EBM); additional information.

 Halsey, Frederic Robert. *Raphael Morghen's engraved works, being a descriptive catalogue.* New York: G. P. Putnam's Sons, 1885. 250 copies.
 Entries: 182+. Inches. Inscriptions. States. Described.

 [Ber.] X, pp. 122–124.*

Morin, Edmond *(1824–1882)*
 [Ber.] X, pp. 125–148.*

Morin, Gustave François *(1809–1886)*
Hédou, Jules. *Gustave Morin et son oeuvre.* Rouen (France): E. Augé, 1877. 250 copies. (NN)
 Entries: 33 prints by, 69 after, (to 1874). Millimeters. Inscriptions. States. Described.

 [Ber.] X, pp. 124–125.*

Morin, J. F. *(fl. 1810–1831)*
[F.] p. 196.*

Morin, Jean *(before 1600–1650)*
[RD.] II, pp. 32–79; XI, pp. 210–218.
 Entries: 109. Pre-metric. Inscriptions. States. Described. Appendix with 4 doubtful prints.

 [Wess.] IV, p. 61.
 Additional information to [RD.].

 Geoffroy, A. "Un état non signalé du portrait de Philippe II par Jean Morin (R-D. 71)." [*Am. Est.*] 4 (1925): 184.
 Additional information to [RD.].

 Hornibrook, Murray, and Petitjean, Charles. *Catalogue of the engraved portraits by Jean Morin (c.1590–1650).* Cambridge: University Press, 1945. 350 copies. (MBMu)
 Entries: 49. Inscriptions. States. Described. Illustrated (selection). Table of watermarks; editions established by watermarks.

Morin, Louis *(b. 1855)*
[Ber.] X, pp. 148–149.*

 Hesse, Raymond. *Louis Morin.* Les artistes du livre, 18. Paris: Henry Babou, 1930. 750 copies. (NN)
 Bibliography of books with illustrations by (to 1930).

Morland, George *(1763–1804)*
Hassell, John. *Memoirs of the life of the late George Morland, with critical and descriptive observations on the whole of his works.*

London: Albion Press printed, published by James Cundee . . . and C. Chapple, 1806. (MH)
 Entries: unnumbered, pp. 166–177, prints after. Inches. Described.

Buckley, Francis. "George Morland's sketch books and their publishers." Unpublished ms. (EBM)
 Entries: unnumbered, pp. 4–129 (prints after sketches only). Inscriptions. Described. Located.

Richardson, Ralph. *George Morland, painter, London (1763–1804).* London: E. Stock, 1895.
 Entries: unnumbered, pp. 144–160.

Richardson, Ralph. Catalogue. In *George Morland, his life and works,* by George C. Williamson. London: George Bell and Sons, 1904. 2d ed. 1907.
 Entries: unnumbered, pp. 131–147 (1904 edition), prints after. Located (selection).

Baily, J. T., and Hardie, Martin. *George Morland, a biographical essay, with a catalogue of the engraved pictures.* "Connoisseur" extra number. London: Otto, limited, 1906.
 Entries: unnumbered, pp. 125–136. Inches. Illustrated (selection). ("A Note upon Morland engravings" by Martin Hardie, pp. 46–50 of this book.)

Foster, J. J. Catalogue. In *The life of George Morland with an introduction and notes by J. J. Foster,* by George Dawe. London: Dickensons, 1904. 2d ed. London: T. Werner Laurie, [1909?].
 Entries: unnumbered, pp. 137–157, prints after. Inches. Described (selection).

Gilbey, Sir Walter, and Cuming, E. D. *George Morland; his life and works.* London: Adam and Charles Black, 1907.
 Entries: unnumbered, pp. 246–263, prints after. Engraver and publisher

named for each print; no further description. Located (selection). Based on Richardson.

[Siltzer] pp. 180–191.
Entries: unnumbered, pp. 189–191, prints after. Inches (selection). Inscriptions. States.

Morlin, ——— *(fl. c.1860)*
[Ber.] X, p. 149.*

Moro, Antonio [Anthonis Mor van Dashorst] *(c.1519–1575)*
[W.] II, pp. 188–193.
Entries: 12 prints after.*

[H. *Neth.*] XIV, pp. 89–90.
Entries: 33 prints after.*

Moro, Battista Angolo del and Marco Angolo del
See **Angolo del Moro**

Moro, Marco *(1817–1885)*
Alberici, Clelia. "Marco Moro, litografo vedutista." *Ce fastu?* 41–43 (1965–1967): 407–452. Separately published. Udine (Italy): Societa Filologica Friulana, 1968. (EFU)
Entries: unnumbered, pp. 413–450. Millimeters. Inscriptions. Described (selection). Illustrated (selection). Located.

Morosini, G. *(19th cent.)*
[Ap.] p. 301.
Entries: 1.*

Morret, Jean Baptiste *(fl. 1790–1820)*
[Ber.] X, pp. 149–150.*

Morris, T. *(fl. c.1780)*
[Siltzer] p. 361.
Entries: unnumbered, p. 361. Inscriptions.

Morse, ——— *(19th cent.)*
[Ap.] p. 302.
Entries: 1.*

Morse, Auguste Achille *(fl. 1863–1900)*
[Ber.] X, pp. 150–151.
Entries: 61. Paper fold measure (selection).

Morse, Nathaniel *(1668–1748)*
[St.] p. 374.*

Morstadt, Vincenc [Vincenz] *(1802–1875)*
Bužgová-Rambouskova, Eva. *Vincenc Morstadt, popisný seznam grafického díla sestavila a uvod napsala.* Prague: Státní Nakladatelstvi Krásné Literatury, Hudby a Uméní, 1958.
Entries: 226. Millimeters. Inscriptions. Described. Illustrated (selection). Located (selection).

Mortel, Jan [Johannes] *(c.1650–1719)*
[H. *Neth.*] XIV, p. 91.
Entries: 1 print after.*

Morton, G. *(19th cent.)*
[Siltzer] p. 332.
Entries: unnumbered, p. 332, prints after. Inscriptions.

[Siltzer] p. 361.
Entries: unnumbered, p. 361. Inscriptions.

Moser, Carl II *(1873–1939)*
Fussenegger, Eugen. *Holzschneider Carl Moser, Gestaltung, Farb und Form.* Bolzano (Italy): Verlags Anstalt Vogelweider, 1930.
Entries: unnumbered, pp. 27–29. Millimeters. Illustrated (selection).

Moser, Lorenz *(fl. 1784–1813)*
[Merlo] p. 608.*

Mosolov'', Nikolai S. *(1847–1914)*
Sajkevich, S. S. *N. S. Mosolov''; ocherk'' ego khudozestvennoj dejatel'nosti, s'' prilozheniem'' kataloga vsekh'' ego proizvedenij.* St. Petersburg: 1885. (EPBN)

Mosolov", Nikolai (*continued*)

Entries: 199. Millimeters. Inscriptions. Described.

[Ber.] IX, p. 239.*

Mostaert, Gillis [Aegidius] *(c.1534–1598)*
[W.] II, pp. 194–195.
Entries: 16 prints after.*

[H. *Neth.*] XIV, p. 91.
Entries: 34 prints after.*

Mostaert, Jan *(c.1475–1555/56)*
[H. *Neth.*] XIV, p. 92.
Entries: 6 prints after. Illustrated (selection).*

Mote, W. H. *(fl. c.1850)*
[Ap.] p. 302.
Entries: 2.*

Motta, Raffaello
See **Raffaellino da Reggio**

Motte, Charles Étienne Pierre *(1785–1836)*
[Dus.] p. 129.
Entries: 1 (lithographs only, to 1821).
Millimeters. Inscriptions. Located.

Mottram, Charles *(1807–1876)*
[Siltzer] p. 361.
Entries: unnumbered, p. 361. Inscriptions.

Mottu, Friedrich August *(1786–1828)*
[Merlo] pp. 609–610.*

Mottu, Hermann Joseph *(c.1818–1842)*
[Merlo] p. 610.*

Motz, L. von *(fl. c.1820)*
[Dus.] p. 129.
Entries: 1 (lithographs only, to 1821).
Millimeters. Inscriptions. Located.

Mouard, Eugène *(fl. 1859–1869)*
[Ber.] X, p. 151.*

Moucheron, Frédéric de *(1633–1686)*
[W.] II, pp. 199–200.
Entries: 5 prints after.*

[H. *Neth.*] XIV, p. 93.
Entries: 6 prints after.*

Moucheron, Isaac de [called "Ordonantie"] *(1667–1744)*
[W.] II, pp. 200–201.
Entries: 46+ prints by, 6 after.*

[H. *Neth.*] XIV, pp. 94–95.
Entries: 53 prints by, 12 after. Illustrated (selection).*

Mouchon, Eugène Louis *(1843–1914)*
[Ber.] X, p. 152.*

Mouilleron, Adolphe *(1820–1881)*
[Ber.] X, pp. 152–157.*

Moulijn, Simon *(20th cent.)*
Moulijn, Simon. "Lyst van myn Lithografieën." Unpublished ms. (EA)
Entries: 87 (to 1922).

Nijland, D. V. *Simon Moulijn, lithograaf en schilder.* Rotterdam (Netherlands): Ad Donker, 1946.
Entries: unnumbered, pp. 34–39. Millimeters. Illustrated (selection).

Museum Boymans, Rotterdam.
Catalogus, tentoonstelling grafisch werk van S. Moulijn 1866–1948. Rotterdam (Netherlands): 1951.
Entries: 182 lithographs, 3 woodcuts, 7 etchings. Millimeters. States.

Moulin, Sainte Marie Ludovic Hardouin Hippolyte *(fl. 1848–1879)*
[Ber.] X, p. 157.*

Mountaine, Richard *(fl. 1750–1760)*
Booth, W. H. "Bookplates." Unpublished ms. (DLC)
Not seen.

Mountin, Gerrit *(fl. 1623–1635)*
[Hind, *Engl.*] II, pp. 309–312.
 Entries: 4. Inches. Inscriptions.
 States. Described. Illustrated (selection). Located.

Mourlan, Alexandre *(1789–1860)*
[Ber.] X, p. 157.*

Mousyn, Michiel *(17th cent.)*
[W.] II, p. 201.
 Entries: 21+.*

[H. *Neth.*] XIV, pp. 96–98.
 Entries: 96. Illustrated (selection).*

Moynet, Jean Pierre *(1819–1876)*
[Ber.] X, pp. 157–158.*

Mozin, Charles *(1806–1862)*
[Ber.] X, p. 158.*

Mozyn, Michiel
See **Mousyn**

Mucchi, Gabriele *(b. 1899)*
Ragghianti, Carlo L., and Ragghianti,
Francesco. *Gabriele Mucchi, opera grafica
fino al 1970.* Milan: Vangelista, 1971. 1100
copies. (DLC)
 Entries: unnumbered, pp. 221–238, (to
 1970). Millimeters. Described. Illustrated (selection).

Muche, Georg *(b. 1895)*
Schiller, Peter H. *Georg Muche; das
druckgraphische Werk.* Darmstadt (West
Germany): Bauhaus-Archiv, 1970.
 Entries: 65. Millimeters. Inscriptions.
 States. Described. Illustrated.

Mücke, H. *(19th cent.)*
[Dus.] p. 129.
 Entries: 1+ (lithographs only, to 1821).
 Paper fold measure.

Müelich, Hans *(1516–1573)*
[P.] III, p. 316.

 Entries: 1. Pre-metric. Inscriptions.
 Described. Located.

[Ge.] nos. 905–920.
 Entries: 16 (single-sheet woodcuts
 only). Described. Illustrated. Located.

Müller, A. L. *(19th cent.)*
[Dus.] p. 129.
 Entries: 1 (lithographs only, to 1821).
 Millimeters. Inscriptions. Located.

Müller, E. *(18th cent.)*
[Merlo] p. 610.*

Müller, Franz Heinrich *(fl. c.1814)*
[Dus.] p. 130.
 Entries: 4 (lithographs only, to 1821).
 Millimeters. Inscriptions. Located.

Müller, Friedrich *(1749–1825)*
See also **Müller,** Johann Friedrich
Wilhelm

Unverricht, Konrad. *Die Radierungen des
Maler Müller.* Veröffentlichungen der
Pfälzischen Gesellschaft zur Förderung
der Wissenschaften, 12. Speyer am
Rhein (Germany): Pfälzische
Gesellschaft zur Förderung der Wissenschaften, 1930.
 Entries: 40. Millimeters. Inscriptions.
 States. Described.

Müller, Friedrich Theodor *(b. 1797)*
[Ap.] pp. 302–303.
 Entries: 14.*

Müller, G. *(fl. c.1809)*
[Dus.] pp. 130–131.
 Entries: 2 (lithographs only, to 1821).
 Millimeters (selection). Inscriptions.

Müller, Georg Wilhelm *(1807–1868)*
[Ap.] p. 307.
 Entries: 6.*

Müller, Gerhard Kurt *(20th cent.)*
Lang, Lothar. "Der Holzstecher
Gerhard Kurt Müller." *Illustration 63* 8
(1971): 25–27.
Bibliography of books with illustrations by (to 1970).

Müller, H. *(19th cent.)*
[Dus.] p. 131.
Entries: 1 (lithographs only, to 1821).
Millimeters. Inscriptions. Located.

Müller, Hans Alexander *(b. 1888)*
Bielschowsky, Ludwig. "Der Buchillustrator Hans Alexander Müller." *Illustration 63* 7 (1970): 6–14.
Bibliography of books with illustrations by.

Müller, Heinrich *(fl. c.1820)*
[Dus.] p. 131.
Entries: 2 (lithographs only, to 1821).
Millimeters (selection). Inscriptions (selection). Located (selection).

Müller, Henri Charles *(1784–1846)*
[Ap.] p. 308.
Entries: 11.*

[Ber.] X, pp. 160–161.*

Müller, Johann Friedrich Wilhelm
(1782–1816)
Andresen, A. "Leben und Werke der
beiden Kupferstecher Johann Gotthard
von Müller und Johann Friedrich
Wilhelm Müller. [*N. Arch.*] II (1865):
1–41. Separately published. Leipzig:
Verlag von Rudolph Weigel, 1865.
Entries: 18. Pre-metric. Inscriptions.
States. Described.

[Ap.] pp. 303–306.
Entries: 19.*

[Ber.] X, pp. 159–160.*

Müller, Johann Gotthard von *(1747–1830)*
Andresen, A. "Leben und Werke der
beiden Kupferstecher Johann Gotthard

von Müller und Johann Friedrich
Wilhelm Müller." [*N. Arch.*] 11 (1865):
1–41. Separately published. Leipzig:
Verlag von Rudolph Weigel, 1865.
Entries: 41. Pre-metric. Inscriptions.
States. Described.

[Ap]. pp. 308–313.
Entries: 41.*

[Ber.] X, p. 159.*

Müller, Johann Sebastian
(1715–after 1785)
[Sm.] III, pp. 941–942.
Entries: 3 (portraits only). Inches. Inscriptions. States. Described.

[Ru.] p. 228.
Additional information to [Sm.].

Müller, K. *(19th cent.)*
[Dus.] pp. 129–130.
Entries: 2+ (lithographs only, to 1821).
Millimeters. Inscriptions. Located (selection).

Müller, Karl *(fl. 1805–1809)*
[Dus.] p. 131.
Entries: 1 (lithographs only, to 1821).
Millimeters. Inscriptions. Described.
Located.

Müller, Karl Friedrich *(19th cent.)*
[Dus.] pp. 131–132.
Entries: 7 (lithographs only, to 1821).
Millimeters (selection). Paper fold
measure (selection). Inscriptions
(selection). Described (selection). Located (selection).

Müller, L. L. *(19th cent.)*
[Dus.] p. 132.
Entries: 1 (lithographs only, to 1821).
Millimeters. Inscriptions. Described.
Located.

Müller, Michael *(fl. c.1552)*
See **Monogram M** [Nagler, *Mon.*] IV,
no. 1493

Müller, Moritz
See **Steinla,** Franz Anton Erich Moritz

Müller, Otto *(1874–1930)*
Galerie Ferdinand Möller. "Otto Muellers Graphik." *Blätter der Galerie Ferdinand Möller* 2, no. 2 (May 1931).
Entries: 108 (to 1931?). Illustrated (selection).

Karsch, Florian. Catalogue. In *Otto Mueller, Leben und Werk,* by Lothar Gunther Buchheim. Feldafing (West Germany): Buchheim Verlag, 1963.
Entries: 168. Millimeters. States. Illustrated.

Müller, Théodore *(1819–1879)*
[Ber.] X, p. 162.*

Münch, Armin *(20th cent.)*
Kunsthalle, Rostock. [Förster, Gerburg et al., compilers]. *Armin Münch, Druckgraphik, Oeuvrekatalog 1947–1971.* Rostock (East Germany), 1972. (EOBKk)
Entries: 584 (to 1971). Millimeters. Inscriptions. States. Described. Illustrated (selection).

Münter, Gabriele *(1877–1962)*
Helms, Sabine. *Gabriele Münter; das druckgraphische Werk.* Städtische Galerie im Lenbachhaus; Sammlungskatalog 2. Munich: Städtische Galerie im Lenbachhaus, 1967.
Entries: 88 prints by, 3 doubtful prints. Millimeters. Inscriptions. Described. Illustrated. Located.

Münz, M. Dr. *(19th cent.)*
[Dus.] p. 177.
Entries: 3+ (lithographs only, to 1821). Millimeters (selection). Paper fold measure (selection). Inscriptions (selection). Located (selection).

Muguet, Félix
See **Pérèse,** Léon

Mulder, Joseph *(1659/60–after 1718)*
[W.] II, p. 202.
Entries: 11+.*

[H. *Neth.*] XIV, p. 99.
Entries: 45+.*

Mulheuser, Julius
See **Milheuser**

Mulier, Pieter II *(c.1637–1701)*
[W.] II, pp. 202–203.
Entries: 3 prints after.*

Muller, Cornelis *(fl. 1561–1579)*
[H. *Neth.*] XIV, p. 100.
Entries: 6+. Illustrated (selection).*

Muller, Harman Jansz *(c.1540–1617)*
[W.] II, pp. 203–204. (Entered twice, as Herman Müller and as Harman Jansz Muller).
Entries: 1+, 33+.*

[H. *Neth.*] XIV, pp. 101–104.
Entries: 175. Illustrated (selection).*

Muller, J. F. *(fl. c.1800)*
[W.] II, p. 205.
Entries: 1 print after.*

Muller, Jan Harmensz *(1571–1628)*
[B.] III, pp. 263–294, and addenda.
Entries: 88. Pre-metric. Inscriptions. States. Described. Copies mentioned.

[Weigel] pp. 138–145.
Additional information to [B.].

[Heller] pp. 95–96.
Additional information to [B.].

[Wess.] II, p. 244.
Additional information to [B.] and [Weigel].

[W.] II, pp. 204–205.
Entries: 87+.*

[H. *Neth.*] XIV, pp. 105–115.
Entries: 100. Illustrated (selection).*

Muller, Louis Jean *(19th cent.)*
[Ber.] X, p. 162.
Entries: 4+ (to 1890?).

Mulliken, Jonathan *(1746–1782)*
[F.] p. 196.*

Multz, Andreas Paul *(17th cent.)*
[A.] V, pp. 264–291.
Entries: 46. Pre-metric. Inscriptions.
States. Described.

Mumford, Edward William *(fl. 1835–1840)*
[F.] p. 197.*

Mumprecht, Rudolf *(b. 1918)*
Schneebeli, Hans Rudolf. *Rudolf Mumprecht; catalogue de l'oeuvre gravé sur cuivre 1944–1964.* Paris, 1965. (EPBN)
Entries: 249 (to 1964). Millimeters. Illustrated (selection).

Munch, Edvard *(1863–1944)*
Schiefler, Gustav. *Verzeichnis des graphischen Werks Edvard Munchs bis 1906.* Berlin: Verlag Bruno Cassirer, 1907. 400 copies. (MBMu)
Entries: 247 (to 1906). Millimeters. Inscriptions. States. Described.

Schiefler, Gustav. *Edvard Munch; das graphische Werk 1906–1926.* Berlin: Euphorion Verlag, [1928?]. 600 copies. (NN)
Entries: 272 (additional to Schiefler 1907). Millimeters. Inscriptions. States. Described. Illustrated (selection).

Willoch, Sigurd. *Edvard Munchs Raderinger.* Oslo: Johan Grundt Tanum, 1950. English ed. *Edvard Munch etchings.* Oslo: Johan Grundt Tanum, 1950.
Entries: 198 (etchings only). Millimeters. Inscriptions. States. Described. Illustrated. Located.

McNulty, Kneeland. *Holdings of prints by Edvard Munch in museum print collections in the United States as of May–June 1962.* New York: Print Council of America, 1962.
Checklist of prints by Munch in American museums. Prints are identified by Schiefler number, where possible; otherwise title and dimensions are given.

Greve, Eli. *Edvard Munch; Liv og verk i lys av tresnittene.* Oslo: J. W. Cappelens Forlag, 1963.
Entries: unnumbered, pp. 161–192, (woodcuts only). Millimeters. States. Described. Illustrated. Editions and variants within editions are noted.

[AzB.] Beilage B, Blatt 5.
Entries: 1 (additional to Schiefler and Willoch.) Millimeters. Inscriptions. States. Described. Illustrated. Located.

Munger, George *(1783–1824)*
[St.] p. 375.*

Munnichhoven, Hendrik *(fl. c.1650)*
[H. *Neth.*] XIV, p. 116.
Entries: 2 prints after.*

Munnickhuysen, Johannes van *(1654/55–after 1701)*
[W.] II, p. 206.
Entries: 24.*

[H. *Neth.*] XIV, pp. 116–117.
Entries: 36. Illustrated (selection).*

Munson, Samuel B. *(1806–1880)*
See also **Doolittle and Munson**

[St.] p. 375.*

Muntaner, Francisco
See **Montaner**

Muntinck, Adriaen *(fl. 1597–1617)*
[H. *Neth.*] XIV, p. 118.
Entries: 45. Illustrated (selection).*

Muntinck, Gerrit *(c.1600–after 1660)*
[W.] II, p. 206.
 Entries: 2.*

 [H. *Neth.*] XIV, p. 119.
 Entries: 4.*

Murant, Emanuel *(1622–c.1700)*
[W.] II, pp. 206–207.
 Entries: 1 print after.*

 [H. *Neth.*] XIV, p. 119.
 Entries: 1 print after.*

Murer, Christoph *(1558–1614)*
See also **Monogram CM** [Nagler, *Mon.*]
II, nos. 393, 414

 [B.] IX, pp. 383–391.
 Entries: 3 etchings, 17+ woodcuts, 1+
 prints not seen by [B.]. Pre-metric. In-
 scriptions. Described.

 [P.] III, pp. 465–468.
 Entries: 7 etchings (additional to [B.]),
 20 woodcuts (revision of [B.]). Pre-
 metric (selection). Paper fold measure
 (selection). Inscriptions (selection).
 Described (selection). Located (selec-
 tion). Additional information to [B.].

 [A.] III, pp. 224–255.
 Entries: 52 etchings, 15 woodcuts.
 Pre-metric. Inscriptions. States. De-
 scribed. Appendix with 1 rejected
 print.

 [Wess.] I, p. 142.
 Entries: 1 (additional to [B.]). Mil-
 limeters. Inscriptions. Described.

Murer, Josias *(1564–1630)*
[A.] III, pp. 218–223.
 Entries: 5+. Pre-metric. Inscriptions.
 States. Described.

Muret, Jean Baptiste *(1795–1866)*
[Ber.] X, p. 162.*

Murillo, Bartolomé Esteban *(1618–1682)*
Stirling-Maxwell, Sir William. *Essay to-
wards a catalogue of prints engraved from the
works of Diego Rodriguez de Silva y Velas-
quez and Bartolomé Esteban Murillo.* Lon-
don: Privately printed, 1873. 100 copies.
(NN)
 Entries: unnumbered, pp. 49–137,
 prints after. Inches. Described (selec-
 tion).

Curtis, Charles B. *Velasquez and Murillo; a
descriptive and historical catalogue.* Lon-
don: Sampson Low, Marston, Searle
and Rivington, 1883.
 Catalogue of paintings; prints after
 are mentioned where extant.

Murphy, John *(c.1748–c.1800)*
[Sm.] III, pp. 943–950, and "additions
and corrections" section.
 Entries: 20 (portraits only). Inches. In-
 scriptions. States. Described.

 [Siltzer] p. 361.
 Entries: unnumbered, p. 361. Inscrip-
 tions.

 [Ru.] pp. 228–230.
 Entries: 2 (portraits only, additional to
 [Sm.]). Inches. Inscriptions. De-
 scribed. Additional information to
 [Sm.].

Murray, George *(d. 1822)*
[St.] pp. 375–378.*

 [F.] pp. 197–198.*

Murrer, Johann *(1644–1713)*
[A.] V, pp. 242–246.
 Entries: 3. Pre-metric. Inscriptions.
 States. Described.

Musculus, T. W. *(17th cent.)*
[W.] II, pp. 207–208.
 Entries: 3.*

 [H. *Neth.*] XIV, p. 119.
 Entries: 5.*

Musi, Agostino dei
See **Veneziano,** Agostino

Musi, Giulio de *(fl. c.1554)*
[B.] XV, p. 508.
 Entries: 1. Pre-metric. Inscriptions.
 Described.

Musi, Lorenzo de *(fl. c.1535)*
[B.] XV, p. 498.
 Entries: 1. Pre-metric. Inscriptions.
 Described.

[P.] VI, pp. 103–104.
 Entries: 2 (additional to [B.]). Pre-
 metric. Inscriptions. Described.

Music, Antonio Zoran *(b. 1909)*
Schmücking, Rolf. *Music; Das graphische
Werk 1947 bis 1962.* Brunswick (West
Germany): Verlag Galerie Schmücking,
1962. 1000 copies. (MB)
 Entries: 84 (to 1962). Millimeters. De-
 scribed. Illustrated.

Musscher, Michiel van *(1645–1705)*
[W.] II, p. 207.
 Entries: 3 prints by, 6 after.*

[H. *Neth.*] XIV, pp. 120–121.
 Entries: 8 prints by, 13 after. Illus-
 trated (selection).*

Mutzbauer, C. *(fl. c.1820)*
[Dus.] p. 177.
 Entries: 1 (lithographs only, to 1821).
 Millimeters. Inscriptions. Located.

Muxel, Johann Nepomuk *(1790–1870)*
[Dus.] pp. 177–179.
 Entries: 16+ (lithographs only, to
 1821). Millimeters. Inscriptions. Lo-
 cated.

Muyckens, Jan Barendsz *(fl. 1637–1648)*
[W.] II, p. 208.
 Entries: 4.*

[H. *Neth.*] XIV, pp. 122–123.
 Entries: 5. Illustrated (selection).*

Muyden, Evert van *(1853–1922)*
[Ber.] XII, p. 176.
 Entries: 32 (to 1892?). Paper fold mea-
 sure.

Curtis, Atherton. *Catalogue of the etched
work of Evert van Muyden.* New York:
Frederick Keppel and Co., 1894. 230
copies. (MBMu)
 Entries: 298 (to 1893). Millimeters. In-
 scriptions. States. Described.

Muys, Robert *(1742–1825)*
[W.] II, p. 208.
 Entries: 9+.*

Muzelle, Emile Raphael *(b. 1840)*
[Ber.] X, p. 163.*

Muziano, Girolamo *(1528–1592)*
Como, Ugo da. *Girolamo Muziano 1528–
1592 note e documenti.* Bergamo (Italy):
Istituto Italiano d'Arti Grafiche, 1930.
 Entries: unnumbered, pp. 212–215,
 prints after. Millimeters (selection).
 Located (selection).

Myn, Andreas van der *(b. 1714?)*
[W.] II, p. 208.
 Entries: 1.*

[Sm.] III, pp. 1401–1402.
 Entries: 6 (portraits only). Inches. In-
 scriptions. Described.

[Ru.] p. 333.
 Additional information to [Sm.].

Myn, Gerard van der *(b. 1706)*
[W.] II, p. 209.
 Entries: 5 prints after.*

[Sm.] III, pp. 1402–1403.
 Entries: 1 (portraits only). Inches. In-
 scriptions. Described.

Myn, Herman van der *(1684–1741)*
[W.] II, p. 209.
Entries: 1 print after.*

Mytens, Aert [Arnold, called "Renaldo Fiammingo"] *(c.1541–1602)*
[W.] II, p. 210.
Entries: 1 print after.*

[H. *Neth.*] XIV, p. 124.
Entries: 1 print after.*

Mytens, Daniel I *(c.1590–c.1648)*
[W.] II, pp. 210–211.
Entries: 3 prints after.*

[H. *Neth.*] XIV, pp. 124–125.
Entries: 29 prints after.*

Mytens, Isaac *(1602–1666)*
[W.] II, p. 212.
Entries: 2 prints after.*

[H. *Neth.*] XIV, p. 125.
Entries: 2 prints after.*

Mytens, Jan [Johannes] *(1614–1670)*
[W.] II, p. 211–212.
Entries: 2 prints after.*

[H. *Neth.*] XIV, p. 125.
Entries: 5 prints after.*

Mytens, Martinus I *(1648–1736)*
[H. *Neth.*] XIV, p. 125.
Entries: 1.*

N

Nachtglas, Jacobus *(fl. 1701–1703)*
[W.] II, p. 213.
Entries: 1.*

Nachtmann, Franz Xaver *(1799–1846)*
[Dus.] p. 179.
Entries: 1 (lithographs only, to 1821).

Nadar, [Felix Tournachon] *(1820–1910)*
[Ber.] X, pp. 163–164.*

Nadelman, Elie *(1885–1946)*
Kirstein, Lincoln. Catalogue. In *The dry points of Elie Nadelman, twenty-two unpublished prints by the sculptor, proofed from the original zinc and copper plates by the master-printer Charles S. White.* New York: Curt Valentin, 1952. 50 copies. (NNMM)

Entries: 27 (drypoints only). Inches. States. Described.

Nadorp, Franz *(1794–1876)*
[A. 1800] II, pp. 278–287.
Entries: 15. Pre-metric. Inscriptions. Described.

Andresen, Andreas. "Andresens Nachträge zu seinen 'Deutschen Maler-radierern.'" [*MGvK.*] 1907, pp. 42–43.
Entries: 1 (additional to [A. 1800]). Millimeters. Inscriptions. Described.

Nagel, Heinrich *(fl. c.1600)*
[Merlo] p. 612.*

Nagel, Peter *(b. 1941)*
Galerie Walther, Düsseldorf. *Peter Nagel, Galerie Walther; Verzeichnis der*

Nagel, Peter (*continued*)

Druckgraphik 1965–1971. Düsseldorff, 1971. (DLC)
 Entries: 52 (to 1971). Millimeters. States. Described. Illustrated.

Nagel, Pieter (*fl. 1569–1604*)
 [W.] II, p. 213.
 Entries: 3+.*

 [H. *Neth.*] XIV, p. 126.
 Entries: 9.*

Nageoires, Jean de
See **Vinne,** Jan I

Naghtegaal, Aernout (*c.1659–after 1719*)
 [W.] II, pp. 213–214.
 Entries: 2.*

 [H. *Neth.*] XIV, p. 126.
 Entries: 8.*

Naghtegael, Clemens (*fl. c.1650*)
 [H. *Neth.*] XIV, p. 126.
 Entries: 3.*

Nahl, Johann August II (*1752–1825*)
 Preime, Eberhard. "Die Radierungen von Johann August Nahl D.J." [*GK.*] n.s. 6 (1941): 63–70.
 Entries: 7. Millimeters. Inscriptions. Described. Illustrated (selection).

Nahuys, Cecile Dorothea, comtesse (*1800–1866*)
 [H. L.] p. 766.
 Entries: 1. Millimeters. Inscriptions. Described.

Naigeon, Jean Claude (*1753–1832*)
 Morand, Louis. *Une famille d'artistes; les Naigeon; notices biographiques et catalogues de leurs oeuvres.* Paris: Georges Rapilly, 1902. 100 copies. (EPBN)
 Entries: 10 prints after.

Naigeon, [Jean Guillaume] Elsidore (*1797–1867*)
 [Ber.] X, p. 164.*

Naiwincx, Herman
See **Naywincx,** Harmen

Nalli, C. (*19th cent.?*)
 [Ap.] p. 314.
 Entries: 1.*

Nani, Antonio (*1803–1870*)
 [AN.] pp. 689–703.
 Entries: unnumbered, pp. 692–703. Millimeters. Inscriptions. Described.

 [AN. 1968] pp. 177–178.
 Entries: unnumbered, pp. 177–178 (additional to [AN.]). Millimeters. Inscriptions.

Naning, Jan (*fl. c.1670*)
 [W.] II, p. 214.
 Entries: 1+.*

 [H. *Neth.*] XIV, p. 126.
 Entries: 4.*

Nanteuil, Célestin François (*1813–1873*)
 [Ber.] X, pp. 164–188.*

 Marie, Aristide. *Un imagier romantique; Célestin Nanteuil, peintre, aquafortiste et lithographe.* Paris: L. Carteret, 1924. 300 copies. (MH)
 Entries: unnumbered, pp. 120–131. Illustrated (selection).

Nanteuil, Charles François (*1792–1865*)
 [Ber.] X, p. 164.*

Nanteuil, Paul Célestin Louis Leboeuf (*1837–1901*)
 [Ber.] X, p. 188.*

Nanteuil, Robert (*1623?–1678*)
 [RD.] IV, pp. 35–189; XI, pp. 218–231.

Entries: 234. Pre-metric. Inscriptions. States. Described. Appendix with 7 rejected prints.

[Wess.] IV, p. 62.
Additional information to [RD.].

Petitjean, Ch., and Wickert, Ch. *Catalogue de l'oeuvre gravé de Robert Nanteuil.* Paris: Loys Delteil et Maurice Le Garrec, 1925. 750 copies. (MB)
Entries: 230 prints by, 10+ doubtful and unfinished prints. Millimeters. Inscriptions (selection). States. Described. Illustrated. Located. Ms. notes (ECol); additional states.

Nanto, Francesco de *(fl. c.1530)*
[P.] VI, pp. 213–214, 225–227.
Entries: 15. Pre-metric. Inscriptions. Described.

Nardini, Giovanni *(19th cent.)*
[Ap.] p. 314.
Entries: 1.*

Nargeot, Adrien Jean *(b. 1837)*
[Ap.] p. 314.
Entries: 2.*

[Ber.] X, p. 190.*

Nargeot, Jean Denis *(1795–after 1865)*
[Ap.] p. 314.
Entries: 3.*

[Ber.] X, pp. 188–190.*

Nas, Karl *(19th cent.)*
[Dus.] p. 179.
Entries: 1 (lithographs only, to 1821). Paper fold measure.

Nash, Paul *(1889–1946)*
Fletcher, John Gould. "The wood engravings of Paul Nash." [PCQ.] 15 (1928): 209–233.
Entries: 84 (to 1927). Inches. States. Illustrated (selection).

Graham, Rigby. *A note on the book illustrations of Paul Nash.* Wyemondham (England): Brewhouse Press, 1965. Reprint. 1966.
Bibliography of books with illustrations by.

Nasini, Giuseppe Nicola *(1657–1736)*
[B.] XXI, pp. 263–264.
Entries: 1. Pre-metric. Inscriptions. Described.

Nason, Pieter *(c.1612–before 1691)*
[W.] II, pp. 214–215.
Entries: 4 prints after.*

[H. *Neth.*] XIV, p. 127.
Entries: 4 prints after.*

Nast, Thomas *(1840–1902)*
"Thomas Nast; drawings published in *Harper's Weekly* 1859–1886, a list." Unpublished ms. (NN)
Entries: unnumbered, pp. 2–27, wood engravings after (in *Harper's Weekly* only).

Natalis, Hendrik Noel *(fl. c.1637)*
[W.] II, p. 215.
Entries: 1.*

[H. *Neth.*] XIV, p. 131.
Entries: 4.*

Natalis, Michael *(1610–1668)*
Renier, J. S. "Catalogue de l'oeuvre de Michel Natalis, graveur liégeois." *Bulletin de l'Institut archéologique liégois* 8 (1868): 359–392; *Bulletin 9* (1869): 89–134; *Bulletin* 10 (1870): 195–225. Separately published. Liège (Belgium): H. Vaillant-Carmanne et Cie, 1871.
Entries: 200. Millimeters. Inscriptions. Described. Located.

[Merlo] p. 613.*

[W.] II, pp. 215–216.
Entries: 36 prints by, 1 after.*

Natalis, Michael (*continued*)

[H. *Neth.*] XIV, pp. 127–131.
Entries: 189.*

Nathe, Christoph (*1753–1808*)
Rümann, Arthur. *Christophe Nathe.*
Dresden: Wilhelm Limpert, 1932.
Entries: 77 prints by, 25 after. Millimeters. Inscriptions. States. Described. Illustrated (selection). Located.

Natoire, Charles Joseph (*1700–1777*)
[RD.] III, pp. 315–320; XI, pp. 231–232.
Entries: 10. Pre-metric. Inscriptions.
States. Described.

Boyer, Ferdinand. "Catalogue raisonné de l'oeuvre de Charles Natoire." *Archives de l'art français*, n.s. 21 (1949): 31–106.
Entries: 9. Millimeters. Inscriptions.
Described. Illustrated (selection).
Also, catalogue of paintings and drawings; prints after are mentioned where extant.

Nattier, Jean Marc (*1685–1766*)
Nolhac, Pierre de. *J. M. Nattier, peintre de la cour de Louis XV.* Paris: Goupil et Cie, Manzi Joyant et Cie, 1905. 425 copies. (MH). 2d ed., 1910.
Entries: unnumbered, pp. 135–153, prints after. Inscriptions.

Huard, Georges. "Nattier." In [Dim.] II, pp. 93–133.
Entries: 4 prints after lost works. Inscriptions (selection).

Naudet, Caroline (*1775–1839*)
[Ber.] X, pp. 193–194.*

Naudet, Thomas Charles ((*1773–1810*)
[Ber.] X, pp. 191–192.*

Naudin, Bernard (*1876–1946*)
Poncetton, François. *Essai d'un catalogue des eaux-fortes de Bernard Naudin.* Paris: R. Heller, 1918. 550 copies. (NN)
Entries: 60 (to 1914). Millimeters. Inscriptions. States. Described. Illustrated.

Heine, Maurice. "Bernard Naudin."
[*AMG.*] (1927–1928): 177–284.
Bibliography of books with illustrations by (to 1927).

Benoist, Luc. "Bernard Naudin, illustrator." *The Fleuron* 6 (1928): 132–164.
Bibliography of books with illustrations by (to 1927).

Roger-Marx, Claude. "Bernard Naudin illustrateur." *Portique* 6 (1947): 73–86.
Bibliography of books with illustrations by (to 1944).

Nauwens, Josephus (*1830–after 1886*)
[Ap.] p. 315.
Entries: 2.*

Nauwinck, J. G. (*fl. c.1691*)
[W.] II, p. 217.
Entries: 1.*

Navlet, Joseph (*1821–1889*)
[Ber.] X, p. 194.*

Naywincz, Harman (*c.1624–c.1651*)
[B.] IV, pp. 79–88.
Entries: 16. Pre-metric. Inscriptions.
States. Described.

[Heller] p. 96.
Additional information to [B.].

[Weigel] p. 157.
Additional information to [B.].

[Wess.] II, p. 244.
Entries: 1 (additional to [B.] and [Weigel]). Paper fold measure. Inscriptions. Described.

[Dut.] V, pp. 190–194; VI, p. 674.
Entries: 17. Millimeters. Inscriptions.
States. Described.

[W.] II, pp. 216–217.
Entries: 17+.*

[H. *Neth.*] XIV, pp. 132–135.
Entries: 18. Illustrated.*

Nazari, Bartolommeo *(1699–1758)*
[Vesme] p. 464.
Entries: 2. Millimeters. Inscriptions.
Described.

Neagle, James *(c.1769–1822)*
[St.] p. 378.*

[F.] pp. 198–199.*

Neagle, John B. *(1796–1866)*
[St.] pp. 378–381.*

[F.] pp. 199–205.*

Neck, B. van *(fl. c.1628)*
[H. *Neth.*] XIV, p. 136.
Entries: 1. Illustrated.*

Neck, Jan van *(1635–1714)*
[W.] II, p. 217.
Entries: 1 print by, 3 after.*

[H. *Neth.*] XIV, p. 136.
Entries: 1 print by, 3 after. Illustrated
(prints by only).*

Necker, Jost de
See **Negker**

Ned
See **Sahib** (Louis Ernest **Lesage**)

Née, François Denis *(c.1739–1817)*
[Ber.] X, p. 197.*

Neeffs, Jacob [Jacques] *(1610–after 1660)*
[W.] II, pp. 218–219.
Entries: 51+.*

[H. *Neth.*] XIV, pp. 137–140.
Entries: 110+. Illustrated (selection).*

Neeffs, Peeter II *(1620–after 1675)*
[W.] II, pp. 220–221.
Entries: 4 prints after.*

[H. *Neth.*] XIV, p. 140.
Entries: 4 prints after.*

Neer, Aert van der *(c.1603–1677)*
[W.] II, pp. 221–223.
Entries: 21 prints after.*

[H. *Neth.*] XIV, p. 141.
Entries: 29 prints after.*

Neer, Eglon Hendrick van der *(1634–1703)*
[W.] II, pp. 223–225.
Entries: 3 prints after.*

[H. *Neth.*] XIV, p. 142.
Entries: 6 prints after.*

Neering, W. *(fl. c.1800)*
[W.] II, p. 225.
Entries: 1 print after.*

Neetesonne, L. Ad. *(fl. 1870–1876)*
[H. L.] pp. 719–720.
Entries: 2. Millimeters. Inscriptions.
Described.

Negker, Jost de *(c.1485–c.1544)*
[B.] VII, pp. 243–244.
Entries: 1. Pre-metric. Inscriptions.
Described.

[Heller] pp. 96–98.
Entries: 3 (additional to [B.]). Pre-
metric. Inscriptions. Described.

[P.] III, pp. 295–298.
Entries: 7. Pre-metric. Inscriptions.
Described. Located.

[W.] II, pp. 217–218; III, p. 129.
Entries: 14+.*

[Ge.] nos. 955–963.

Negker, Jost de (*continued*)

Entries: 9 (single-sheet woodcuts only.) Described. Illustrated. Located.

Negre, Nicolaes van (*fl. 1645–1663*)
[W.] II, p. 225.
Entries: 4 prints after.*

[H. *Neth.*] XIV, p. 142.
Entries: 4 prints after.*

Nelli, Niccolò (*fl. c.1530*)
[P.] VI: *See* **Chiaroscuro Woodcuts**

Néraudan, Alexandre (*fl. c.1850*)
[Ber.] X, p. 195.*

Neroni, Bartolommeo [called "il Riccio"] (*1500?–1571/73*)
[B.] XII: *See* **Chiaroscuro Woodcuts**

[B.] XVII, pp. 40–41.
Entries: 1. Pre-metric. Inscriptions. Described.

Nes, Johan Dircksz van (*d. 1650*)
[W.] II, p. 226.
Entries: 1 print after.*

[H. *Neth.*] XIV, p. 142.
Entries: 1.*

Nesch, Rolf (*1893–1951*)
Detroit Institute of Arts. *The graphic art of Rolph Nesch.* Detroit (Mich.), 1969.
Entries: 94 (prints in sets only, between 1931 and 1936). Millimeters. Illustrated. Located.

Nesmith, J. H. (*fl. 1805–1828*)
[St.] pp. 382–383.*

[F.] p. 205.*

Netscher, Caspar (*1639–1684*)
[W.] II, pp. 226–229.
Entries: 2 prints by, 48+ after.*

[H. *Neth.*] XIV, pp. 143–146.

Entries: 3 prints by, 71 after. Illustrated (selection).*

Netscher, Constantyn (*1668–1723*)
[W.] II, p. 229.
Entries: 1 print after.*

[H. *Neth.*] XIV, p. 146.
Entries: 1 print after.*

Netscher, Theodor (*1661–1732*)
[W.] II, p. 229.
Entries: 2 prints after.*

[H. *Neth.*] XIV, p. 146.
Entries: 5 prints after.*

Netten, C. van der (*fl. c.1858*)
[H. L.] pp. 721–722.
Entries: 4. Millimeters. Inscriptions. Described.

Neuberger, Friedrich Sebastian (*d. 1821*)
[Dus.] p. 179.
Entries: 1 (lithographs only, to 1821). Millimeters. Inscriptions. Located.

Neukens, P. J. (*fl. c.1872*)
[H. L.] p. 720.
Entries: 1. Millimeters. Inscriptions. Described.

Neumann, [Friedrich Gustav] Adolf (*1825–1884*)
[Ap.] p. 315.
Entries: 6.*

Neumans, P. J. (*fl. c.1841*)
[H. L.] p. 721.
Entries: 1. Millimeters. Inscriptions. Described.

Neureuther, Eugen (*1806–1882*)
[Dus.] p. 179.
Entries: 1 (lithographs only, to 1821). Millimeters. Inscriptions. Located.

Schuberth, Max. *Eugen Napoleon Neureuthers Leben und graphisches Werk.*

Dissertation, University of Munich. Munich, 1926.
> Entries: 108 lithographs, 101 etchings, 13+ woodcuts. Millimeters. Inscriptions (selection). States. Described (selection).

Neuvelt
See **Novellanus**

Neuville, Alphonse Marie Adolphe de *(1835–1885)*
[Ber.] X, pp. 195–196.*

Neve, Franciscus de *(1606–after 1688)*
[B.] IV, pp. 117–126.
> Entries: 14. Pre-metric. Inscriptions. Described.

[W.] II, p. 231.
> Entries: 14+ prints by, 2+ after.*

[H. *Neth.*] XIV, p. 147.
> Entries: 14 prints by, 5 after. Illustrated (selection).*

Nevelson, Louise *(b. 1900)*
Brooklyn Museum [Una E. Johnson and Jo Miller, compilers]. *Louise Nevelson; prints and drawings 1953–1966.* New York: Shorewood Publishers, 1967.
> Entries: 68 (to 1966). Inches. Illustrated (selection).

Newcomb, D. *(fl. c.1820)*
[St.] p. 383.*

Newhouse, C. B. *(19th cent.)*
[Siltzer] pp. 191–192.
> Entries: unnumbered, pp. 191–192, prints after. Inches (selection). Inscriptions.

Newmarsh, G. B. *(19th cent.)*
[Siltzer] p. 332.
> Entries: unnumbered, p. 332, prints after. Inscriptions.

Newsam, Albert *(1809–1864)*
Stauffer, David McNeely. "Lithographic portraits of Albert Newsam." [*Pa. Mag.*] 24 (1900–1901): 267–289, 430–452; [*Pa. Mag.*] 25 (1901): 109–113. Separately published. Philadelphia, 1901.
> Entries: unnumbered, 44 pp. Inches. Inscriptions. Described. Ms. notes (NN); a few additional entries. Extra-illustrated copy (PPPM); many lithographs by Newsam bound in.

Newton, Robert *(fl. 1809–1835)*
[Ap.] p. 315.
> Entries: 1.*

Neys, Jacobus de *(fl. c.1692)*
[W.] II, p. 232.
> Entries: 27.*

Neyts, Gilles [Aegidius] *(1623–1687)*
[B.] IV, pp. 305–316.
> Entries: 10. Pre-metric. Inscriptions. States. Described.

[Weigel] pp. 202–209.
> Entries: 16 (additional to [B.]). Pre-metric. Inscriptions. States. Described.

[Wess.] II, p. 245.
> Entries: 1 (additional to [B.] and [Weigel]). Millimeters. Inscriptions. Described. Additional information to [B.] and [Weigel].

[Dut.] V, pp. 194–202.
> Entries: 27. Millimeters. Inscriptions. States. Described.

[H. *Neth.*] XIV, pp. 148–159.
> Entries: 30. Illustrated (selection).*

Niccolò di Liberatore *(c.1425–1502)*
[M.] I, pp. 565–570.
> Entries: 3+ prints after. Paper fold measure.

Niccolò Vincentino
See **Vincentino**

Nichols, Catherine Maude *(1847–1923)*
[Ber.] X, pp. 196–197.
 Entries: 26. Paper fold measure.

Nichols and Bluck *(19th cent.)*
[Siltzer] p. 361.
 Entries: unnumbered, p. 361. Inscriptions.

Nickelen, Jan van
See **Nikkelen**

Nicolai, Arnaud *(fl. 1550–1596)*
[H. *Neth.*] XIV, pp. 160–161.
 Entries: 14+.*

Nicolas, Jan [called "Enchius"] *(fl. c.1615)*
[W.] I, p. 491; II, p. 233.
 Entries: 1 print after.*

[H. *Neth.*] XIV, p. 161.
 Entries: 1 print after.*

Nicole, Claude François I *(1700–1783)*
Beaupré, J. N. "Notice sur quelques graveurs nancéiens du XVIIIe siècle et sur leurs ouvrages." [*Mém. lorraine*] 2d ser. 9 (1867): 169–216. Separately published. n.p., n.d.
 Entries: 205. Millimeters. Inscriptions. States. Described (selection).

Nicole, Claude François II *(18th cent.)*
Beaupré, J. N. "Notice sur quelques graveurs nancéiens du XVIIIe siècle et sur leurs ouvrages." [*Mém. lorraine*] 2d ser. 9 (1867): 169–216. Separately published. n.p., n.d.
 Entries: 17. Millimeters. Inscriptions. Described (selection).

Nicolet, Hercule *(fl. c.1840)*
[Ber.] X, p. 197.*

Nicoletto da Modena *(fl. 1500–1512)*
[B.] XIII, pp. 252–292.
 Entries: 65 prints by, 3 doubtful prints. Pre-metric. Inscriptions. States. Described. Copies mentioned.

[P.] V, pp. 92–103.
 Entries: 44 prints by (additional to [B.]), 4 doubtful prints (additional to [B.]). Pre-metric. Inscriptions. Described. Located. Additional information to [B.].

Galichon, Émile. "Oeuvre de Rosex dit Nicoleto de Modene." [*GBA.*] 2d ser. 2 (1869): 145–156; [*GBA*] 2d ser. 4 (1870): 244–266.
 Entries: 84. Millimeters. Inscriptions. Described. Illustrated (selection).

[Wess.] III, p. 54.
 Entries: 3 (additional to [B.] and [P.]). Millimeters. Inscriptions. Described. Located (selection).

[Hind] V, pp. 107–139.
 Entries: 121+. Millimeters. Inscriptions. States. Described. Illustrated. Located.

Nicolié, Paul Émile *(1828–1894)*
[H. L.] pp. 722–723.
 Entries: 3. Millimeters. Inscriptions. States. Described.

Nicolle, Émile Frédéric *(1830–1894)*
[Ber.] X, p. 197.
 Entries: 26.

Nicolle, Victor Jean *(1754–1826)*
[Baud.] II, pp. 309–312.
 Entries: 4. Millimeters. Inscriptions. Described.

Niedermayer, Franz Anton *(b. 1779)*
[Dus.] pp. 179–180.
 Entries: 6+ (lithographs only, to 1821).

Niedlich, Johann Gottfried *(1766–1837)*
[Dus.] pp. 180–181.
 Entries: 4 (lithographs only, to 1821). Millimeters. Inscriptions. Located.

Niel, Gabrielle Marie *(b. c.1840)*
[Ber.] X, pp. 197–198.*

Niels, Theodor [Dirk] *(fl. c.1630)*
[H. *Neth.*] XIV, p. 161.
Entries: 1+ prints after.*

Nielsen, Jørgen Brockdorff *(20th cent.)*
Fogedgaard, Helmer. "Jørgen
Brockdorff Nielsen, en dansk exlibris-
kunstner." [*N. ExT.*] 18 (1966): 1–4.
Entries: 34 (bookplates only, to 1966).
Illustrated (selection).

Niessen, Johannes *(1821–1910)*
[Merlo] pp. 620–622.*

Nieuhoff, A. R. *(fl. c.1665)*
[H. *Neth.*] XIV, p. 161.
Entries: 1 print after.*

Nieuhoff, Jan *(1618–1672)*
[H. *Neth.*] XIV, p. 161.
Entries: 1+.*

Nieulandt, Adriaen van *(1587–1658)*
[W.] II, p. 234.
Entries: 5+ prints after.*

[H. *Neth.*] XIV, p. 161.
Entries: 19 prints after.*

Nieu[landt], Jan van *(16th cent.)*
[H. *Neth.*] XIV, p. 167.
Entries: 1. Illustrated.*

Nieulandt, Willem II van *(c.1584–1635/36)*
[W.] II, pp. 235–236.
Entries: 7+.*

[H. *Neth.*] XIV, pp. 162–167.
Entries: 114. Illustrated (selection).*

Nieuwenhuizen, Adrianus Willem
(1814–after 1885)
[H. L.] pp. 723–724.
Entries: 2. Millimeters. Inscriptions.
States. Described.

Nieuwenkamp, Wynand Otto Jan *(b. 1874)*
Hubert, H. J. *Twee honderd etsen en hout-*
sneden van W. O. J. Nieuwenkamp; een geïl-
lustreerde catalogues. Amsterdam: Wed.
G. Dorens en zoon, 1912. 200 copies.
(NN)
Entries: 125 etchings, 75 woodcuts (to
1911). Millimeters. States. Described.
Illustrated (selection).

La Faille, J. B. de. *Vijftig nieuwe etsen van*
W. O. J. Nieuwenkamp; geïllustreerde
catalogus. Amsterdam: Eisenloeffel's
Kunsthandel, 1916.
Entries: 50 (additional to Hubert, to
1916?). Millimeters. Inscriptions.
States. Described. Illustrated. Addi-
tional information to Hubert.

L'Oeuvre gravé de W. O. J. Nieuwenkamp
. . . vente publique à Amsterdam les 18 et 19
octobre 1927. Amsterdam: A. Mak, 1927.
(EA)
Entries: 13 lithographs, 76 woodcuts
(to 1927?). States (selection). De-
scribed (selection). Also, incomplete
list of etchings, including 14 addi-
tional to Hubert and La Faille.

Nieuwhoff, W. *(fl. c.1820)*
[W.] II, p. 233.
Entries: 5.*

Nieuwland, L. F. van *(fl. 1761–1767)*
[W.] II, p. 234.
Entries: 4.*

Nikkelen, Jan van *(1656–1721)*
[B.] V, pp. 437–440.
Entries: 2. Pre-metric. Inscriptions.
Described.

[Weigel] pp. 320–321.
Entries: 2 (additional to [B.]). Pre-
metric. Inscriptions. Described. Ap-
pendix with 2 doubtful prints.

[Wess.] II, p. 245.
Entries: 1 (additional to [B.] and
[Weigel]). Millimeters. Described.

[Dut.] V, pp. 202–204.

Nikkelen, Jan van (*continued*)

Entries: 6. Millimeters. Inscriptions. States. Described. Appendix with 2 doubtful prints.

[W.] II, p. 236.
Entries: 6.*

[H. *Neth.*] XIV, p. 168.
Entries: 9. Illustrated (selection).*

Nilson, Johann Esaias *(1721–1788)*
Schuster, Marianne. *Johann Esaias Nilson, ein Kupferstecher des süddeutschen Rokoko 1721–1788*. Munich: Neuer Filser-Verlag, 1936.
Entries: 493. Millimeters. Inscriptions. States. Described.

Nipho, Hieronymus
See **Nypho**

Niquet, Claude *(c.1760–after 1831)*
[Ap.] p. 315.
Entries: 3.*

[Ber.] X, pp. 198–199.*

Nisbet, Robert H. *(b. 1879)*
Sherman, Frederic Fairchild." Robert H. Nisbet, painter-etcher." *Art in America* 19 (1930–1931): 176–177.
Entries: 95. Inches.

Nisp, Nikolaus van *(b. c.1693)*
[W.] II, p. 237.
Entries: 1 print after.*

Nitot-Dufresne, Michel *(b. 1759)*
[Ber.] X, p. 199.*

Nittis, Giuseppe de *(1846–1884)*
[Ber.] X, pp. 199–200.
Entries: 12. Paper fold measure. Described (selection).

Nixon, Job *(b. 1891)*
Wright, Harold J. L. "A chronological list of the etchings, drypoints and en-gravings of Job Nixon, A.R.E." Supplement to "The etchings of Job Nixon," by Hugh Stokes. [*PCQ.*] 14 (1927): 271–293.
Entries: 43 (to 1927). Inches. States. Illustrated (selection). Located (selection).

Nocchi, Giovanni Battista *(fl. c.1843)*
[Ap.] pp. 315–316.
Entries: 6.*

Nocchi, Pietro *(d. 1855)*
[Ap.] p. 316.
Entries: 2.*

Nocret, ——— *(fl. c.1835)*
[Ber.] X, p. 200.*

Nocret, Jean *(1615–1672)*
[RD.] II, pp. 80–81.
Entries: 1. Pre-metric. Inscriptions. States. Described.

Noé, Michel *(fl. 1665–1684)*
[H. *Neth.*] XIV, p. 168.
Entries: 26.*

Noël, Alphonse Léon *(1807–1884)*
[Ber.] X, pp. 200–217.*

Noël, Peter Paul Joseph *(1789–1822)*
[H. L.] p. 724.
Entries: 2. Millimeters. Inscriptions. Described.

[W.] II, p. 237.
Entries: 2.*

Nölken, Franz *(1884–1918)*
Robinow, Richard. "Verzeichnis der graphischen Arbeiten von Franz Nölken." *Jahrbuch der Gesellschaft Hamburger Bücherfreunde* 2 (1930): 262–275.
Entries: 82. Millimeters. Inscriptions. States. Described. Illustrated (selection).

Nördlinger, Karl J. *(1812–1896)*
　[Ap.] p. 316.
　　Entries: 2.*

Noirot, Louis *(1820–1902)* and Émile *(b. 1853)*
　[Ber.] X, p. 217.*

Nolde, Emil [Emil Hansen] *(1867–1956)*
　Schiefler, Gustav. *Das graphische Werk Emil Noldes bis 1910.* Berlin: Verlag von Julius Bard, 1911. 435 copies. (MBMu)
　　Entries: 147 etchings, 31 lithographs, 39 woodcuts, (to 1910). Millimeters. Inscriptions. States. Described.

　Schiefler, Gustav. *Das graphische Werk von Emil Nolde, 1910–1925.* Berlin: Euphorion Verlag, 1926–1927. 520 copies. (NN)
　　Entries: 84 etchings, 30 lithographs, 152 woodcuts, 4 "hectographs," (additional to Schiefler 1911; to 1925). Millimeters. Inscriptions. States. Described.

　Schiefler, Gustav, and Mosel, Christel. *Emil Nolde; das graphische Werk . . . neu bearbeitet, ergänzt und mit Abbildungen versehen.* 2 vols. Cologne: Verlag M. Du Mont Schauberg, 1966, 1967. 900 copies. (MBMu)
　　Entries: 231 etchings, 197 woodcuts, 83 lithographs, 4 "hectographs." Millimeters. Inscriptions. States. Described. Illustrated.

Nolpe, Pieter *(1613/14–1652/53)*
　[Dut.] V, pp. 204–205.*

　Dozy, Ch. M. "Pieter Nolpe." [*Oud-Holl.*] 15 (1897): 24–50, 94–120, 139–158, 220–244.
　　Entries: 223 prints by, 29 doubtful prints. Millimeters. Inscriptions. States. Described.

　[W.] II, pp. 239–240.
　　Entries: 192+ prints by, 1 after.*

　[H. *Neth.*] XIV, pp. 169–180.
　　Entries: 319 prints by, 2 after. Illustrated (selection).*

Nonnius, P. *(fl. c.1650)*
　[H. *Neth.*] XIV, p. 181.
　　Entries: 1 print after.*

Nonot, François *(18th cent.?)*
　Advielle, Victor. "Les graveurs d'ex-libris; François Nonot et Charlotte Nonot, sa fille." [*Arch. Ex.-lib.*] 7 (1900): 3–10.
　　Entries: 17. Inscriptions. Described. Illustrated (selection).

　Bouland, L. "Les Nonot, documents complémentaires." [*Arch. Ex.-lib.*] 7 (1900): 27–30.
　　Additional information to Advielle.

Nooms, Reinier
　See **Zeeman**

Noorde, Cornelis van *(1731–1795)*
　[W.] II, pp. 240–241.
　　Entries: 50+.*

Noort, Adam van *(1562–1641)*
　[W.] II, pp. 241–242.
　　Entries: 8+ prints after.*

　[H. *Neth.*] XIV, p. 181.
　　Entries: 73 prints after.*

Noort, Johannes IV van *(c.1620–c.1676)*
　[B.] I, pp. 16–17.
　　Entries: 2. Pre-metric (selection). Inscriptions (selection). Described (selection).

　[Heller] p. 98.
　　Additional information to [B.].

　[Dut.] V, pp. 205–206.
　　Entries: 2. Millimeters. Inscriptions. States. Described.

　[W.] II, pp. 242–243.
　　Entries: 2 prints by, 1 after.*

Noort, Johannes IV van *(continued)*

[H. *Neth.*] XIV, pp. 182–183.
Entries: 10. Illustrated (selection).*

Noort, Juan van *(d. 1652)*
[W.] II, p. 242.
Entries: 6.*

[H. *Neth.*] XIV, p. 183.
Entries: 11.*

Noort, Lambert van *(c.1520–1571)*
[W.] II, pp. 243–244.
Entries: 1 print after.*

[H. *Neth.*] XIV, p. 181.
Entries: 2 prints after.*

Norblin de la Gourdaine, Jean Pierre
(1745–1830)
H[illemacher], F[rédéric]. *Catalogue des estampes qui composent l'oeuvre de Jean Pierre Norblin.* Paris: Lacrampe et Fertiaux, 1848. 50 copies. (EBM). Reprint. Cracow (Poland): Imprimerie du "Czas" V. Kirchmayer, 1865. 25 copies. (EWA)
Entries: 93. Millimeters. Inscriptions. States. Described.

Hillemacher, Frédéric. *Catalogue des estampes qui composent l'oeuvre de Jean Pierre Norblin, peintre français, graveur à l'eauforte. Deuxième édition avec des modifications et additions receuillies sur la collection qui appartient à la Bibliothèque nationale.* Extract from *La Revue de Champagne et de Brie,* Aug. 1877. Paris: Henri Menu, 1877.
Entries: 93. Millimeters. Inscriptions. States. Described. Revised edition of Hillemacher 1848.

Franke, Willibald. *Das radirte Werk des Jean Pierre Norblin de la Gourdaine, beschreibendes Verzeichniss einer Sammlung sämmtlicher Blätter dieses Maler-Radierers.* Leipzig: Verlag von Karl W. Hiersemann, 1895. 150 copies. (MBMu)

Entries: 94. Millimeters. Inscriptions. States (selection). Described. Catalogue of a collection.

Simon, Karl. "Unbekannte Radierungen von Jean Pierre Norblin." [GK.] n.s. 4 (1939): 115–119.
Entries: 14 (additional to Hillemacher and Franke). Millimeters. Inscriptions. Described. Illustrated. Located.

Norden, John *(c.1546–c.1626)*
[Hind, *Engl.*] I, pp. 195–202.
Entries: 2. Inches. Inscriptions. States. Described. Illustrated.

Nordheim, Johann Georg *(1804–1853)*
[Ap.] p. 316.
Entries: 4.*

Norman, John *(c.1748–1817)*
[St.] pp. 383–391.*

[F.] pp. 205–209.*

Normand, Charles Pierre Joseph
(1765–1840)
[Ber.] X, pp. 217–221.*

Normand, Charles Victor *(b. 1814)*
[Ber.] X, pp. 222–223.*

Normand, Louis Marie *(1789–1874)*
[Ber.] X, pp. 221–222.*

Normand, Victor *(fl. c.1865)*
[Ber.] X, p. 223.*

Normann, [Carl Friedrich] Rudolf Ernst
(1806–1882)
[A. 1800] IV, pp. 80–90.
Entries: 5. Millimeters. Inscriptions. States. Described.

Northcote, James *(1746–1831)*
[Siltzer] p. 332.
Entries: unnumbered, p. 332, prints after. Inches. Inscriptions.

Noter, David Emil Joseph de *(b. 1825)*
[H. L.] pp. 741–743.
 Entries: 7. Millimeters. Inscriptions.
 States. Described.

Noter, Hermann Auguste de *(1806–1838)*
[H. L.] pp. 732–741.
 Entries: 27 etchings, 3 lithographs.
 Millimeters. Inscriptions. States. De-
 scribed.

Noter, Pieter Frans II de *(1779–1843)*
[H. L.] pp. 725–731.
 Entries: 16 etchings, 2 lithographs.
 Millimeters. Inscriptions. States. De-
 scribed.

Noterman, Emmanuel *(1808–1863)*
[H. L.] pp. 743–744.
 Entries: 4. Millimeters. Inscriptions.
 States. Described.

Nothnagel, Johann Andreas Benjamin
(1729–1804)
[Hüsgen] pp. 395–403.
 Entries: 60+. Inscriptions (selection).
 Described (selection).

Gwinner, F. "Johann Andreas Benjamin
Nothnagel, berichtigtes Verzeichniss
seines Werks." [*N. Arch.*] 11 (1865): 256–
264.
 Entries: 65. Millimeters. Inscriptions.
 Described (selection).

Freiherr von Tettau, W. "Nachträge zu
dem Verzeichnisse des Werkes J. A. B.
Nothnagel's vom Senator Dr. Gwin-
ner." [*N. Arch.*] 16 (1870): 150–164.
 Entries: 34 (additional to Gwinner).
 Millimeters. Inscriptions. Described.
 Additional information to Gwinner.

Noue, J. or S. de la *(fl. c.1634)*
[W.] II, p. 245.
 Entries: 2.*

Noury, —— *(fl. c.1845)*
[Ber.] X, p. 223.*

Novellanus, Aegidius *(17th cent.)*
[Merlo] p. 624.*

Novellanus, Simon *(fl. 1560–1590)*
[Merlo] pp. 624–626.*

[H. *Neth.*] XIV, p. 184.
 Entries: 75+.*

Novion, —— de *(fl. 1819–1824)*
[Ber.] X, p. 223.*

Nüsser, Heinrich *(1821–1883)*
[Ap.] p. 317.
 Entries: 5.*

Nützel, Hieronymus *(fl. 1584–1593)*
[A.] II, pp. 101–109.
 Entries: 13. Pre-metric. Inscriptions.
 Described.

Numa [Pierre Numa Bassaget] *(fl. c.1830)*
[Ber.] X, pp. 223–231.*

Numans, Auguste *(b. 1823)*
[H. L.] pp. 745–765.
 Entries: 87 (etchings only). Millime-
 ters. Inscriptions. States. Described.

Nunes, Antonio José *(1840–1905)*
[Ap.] p. 317.
 Entries: 2.*

Nutting, Benjamin F. *(d. 1878)*
[Carey] pp. 351–352.
 Entries: 12 (lithographs only). Inches.
 Inscriptions. Described. Illustrated
 (selection). Located.

Nuvolone, Carlo Francesco *(1608–1661)*
[P.] VI: *See* **Chiaroscuro Woodcuts**

Nygaard, Axel *(1877–1953)*
Fougt, Knud. "Axel Nygaard 1877–
1953." [*N. ExT.*] 5 (1953): 81–84.
 Entries: unnumbered, pp. 83–84
 (bookplates only). Illustrated (selec-
 tion).

Nyhoff, A. P. *(fl. c.1658)*
[W.] II, p. 246.
 Entries: 1 print after.*

[H. *Neth.*] XIV, p. 184.
 Entries: 1 print after.*

Nyhoff, Hendrik *(c.1629–1656)*
[W.] II, p. 246.
 Entries: 1 print after.*

[H. *Neth.*] XIV, p. 184.
 Entries: 1 print after.*

Nymegen, Gerard van *(1735–1808)*
[W.] II, p. 247.
 Entries: 5+.*

Nymegen, Tobias van *(fl. c.1700)*
[H. *Neth.*] XIV, p. 184.
 Entries: 1 print after.*

Nyon, Eugène *(fl. 1834–1848)* and Pierre Marie *(fl. 1859–1866)*
[Ber.] X, pp. 231–232.*

Nypho, Hieronymus *(fl. c.1658)*
[H. *Neth.*] XIV, p. 184.
 Entries: 13 prints after.*

Nypoort, Justus van den *(c.1625–1692)*
[A.] V, pp. 163–176.
 Entries: 18. Pre-metric. Inscriptions. Described. Appendix with 5 prints not seen by [A.].

[Wess.] II, pp. 245–246.
 Entries: 2 (additional to [A.]). Millimeters. Inscriptions. Described. Additional information to [A.].

[W.] II, pp. 247–248.
 Entries: 30+.*

[H. *Neth.*] XIV, pp. 185–186.
 Entries: 41.*

O

Ober, Hermann *(b. 1920)*
 Galerie Schmücking, Brunswick [Rolf Schmücking, compiler]. *Hermann Ober, Werkverzeichnis der Graphik 1951–1968.* Brunswick (West Germany), 1969. 500 copies.
 Entries: 163+. Millimeters. Described. Illustrated.

Oberman, Antonis *(1781–1845)*
[H. L.] pp. 769–770.
 Entries: 10. Millimeters. Inscriptions. Described (selection).

Oberthur, François Jacques *(1793–1863)*
[Ap.] p. 317.
 Entries: 3.*

Ochtervelt, Jacob *(c.1635–1708/10)*
[W.] II, p. 249.
 Entries: 2 prints after.*

[H. *Neth.*} XIV, p. 187.
 Entries: 5 prints after.*

O'Connell, Frederike Emilie Auguste *(1823–1885)*
 Burty, Philippe. "L'Atelier de Madame O'Connell." [*GBA.*] 1st ser. 5 (1860): 349–355.
 Entries: 9. Millimeters. Inscriptions. States. Described. Illustrated (selection).

[H. L.] pp. 767–769.

Entries: 9. Millimeters. Inscriptions. States. Described.

[Ber.] X, pp. 232–233.
Entries: 10. Paper fold measure. Described (selection).

Octavien, François *(1682–1740)*
Messelet, Jean: "Octavien" in [Dim.] II, pp. 335–340.
Entries: 5. Millimeters.

Oddi, Mauro *(1639–1702)*
[B.] XXI, pp. 212–213.
Entries: 2. Pre-metric. Inscriptions. Described.

Odiardi, ——— *(fl. c.1840)*
[Ber.] X, p. 233.*

Oechsle, ——— *(19th cent.?)*
[Ap.] p. 318.
Entries: 1.*

Oedenthal, [Johann Adam] Heinrich *(1791–1876)*
[Merlo] pp. 628–630.*

Oelschig, Wilhelm *(b. 1814)*
[Ap.] p. 318.
Entries: 4.*

Oeser, Adam Friedrich *(1717–1799)*
Dürr, Alphons. *Adam Friedrich Oeser, ein Beitrag zur Kunstgeschichte des 18. Jahrhunderts.* Leipzig: Alphons Dürr, 1879.
Entries: 89 prints by and after. Millimeters (selection). Paper fold measure (selection). Inscriptions. Described (selection).

Rümann, Arthur. *Adam Friedrich Oeser Bibliographie.* Berlin: A. Horodisch und E. F. Tuchmann, 1931. 550 copies. (NN)
Bibliography of books with illustrations by.

Oesterley, Carl Wilhelm Friedrich *(1805–1891)*
[A. 1800] III, pp. 168–186.
Entries: 31. Pre-metric. Inscriptions. States. Described. Also, list of prints after, unnumbered, p. 175 (not fully catalogued).

Senf, Renate. *Das künstlerische Werk von Carl Oesterly.* Göttinger Studien zur Kunstgeschichte, 2. Göttingen (West Germany): Musterschmidt-Verlag, 1957.
Entries: 82 (works in various media, including prints). Millimeters. Located.

Oesterreicher, J. Dr. *(19th cent.)*
[Dus.] p. 181.
Entries: 1 (lithographs only, to 1821). Millimeters. Inscriptions. Located.

Oets, Pieter *(1720–1790)*
[W.] II, p. 250.
Entries: 1.*

Offenbach, Philipp
See **Uffenbach**

Offermans, Josua *(18th cent.)*
[W.] II, p. 251.
Entries: 1.*

Oger, Ferdinand Henri *(1872–1929)*
Clement-Janin. "Ferdinand Henri-Oger." [P. Conn.] 4 (1924): 56–63.
Entries: 46. Millimeters. Illustrated (selection).

Ohmann, C. *(fl. c.1817)*
[Dus.] p. 181.
Entries: 2+ (lithographs only, to 1821).

Okey, Samuel *(fl. 1765–1780)*
[Sm.] III, pp. 950–954.
Entries: 12 (portraits only). Inches. Inscriptions. States. Described.

[St.] pp. 391–392.*

Okey, Samuel *(continued)*

[Ru.] p. 231.
Entries: 1 (portraits only, additional to [Sm.]). Inches. Inscriptions. Described. Additional information to [Sm.].

Oldach, Julius *(1804–1830)*
Lichtwark, Alfred. *Julius Oldach.* Hamburg: Kunsthalle zu Hamburg, 1899.
Entries: 4 prints after. Millimeters. Inscriptions. Described (selection).

Oldeland, Hendrik *(fl. 1636–1643)*
[W.] II, p. 251.
Entries: 2.*

[H. *Neth.*] XIV, p. 187.
Entries: 3. Illustrated (selection).*

Oldenburg, Claes *(b. 1929)*
Baro, Gene. *Claes Oldenburg, drawings and prints.* London: Chelsea House Publishers, 1969.
Entries: 9 (to 1967). Inches. Illustrated (selection).

Oldenburgh, Augustin *(fl. 1690–1706)*
[W.] II, p. 251.
Entries: 1.*

Olesen, Arne *(20th cent.)*
Fogedgaard, Helmer. "Arne Olesen, en dansk exlibriskunstner." [*N. ExT.*] 22 (1970): 50–51.
Entries: 26 (bookplates only, to 1970). Illustrated (selection).

Oleszczyński, Antoni *(1794–1879)*
[Ap.] p. 318.
Entries: 7.*

Olio, G. dall' *(19th cent.)*
[Ap.] p. 104.
Entries: 1.*

Olis, Jan *(c.1610–1676)*
[W.] II, pp. 251–252.
Entries: 1+ prints after.*

[H. *Neth.*] XIV, p. 187.
Entries: 15 prints after.*

Oliver, John *(c.1616–1701)*
[Sm.] III, pp. 954–956, and "additions and corrections" section.
Entries: 10 (portraits only). Inches. Inscriptions. States. Described. Located (selection).

[Ru.] pp. 231–232, 494–495.
Entries: 2 (portraits only, additional to [Sm.]). Inches. Inscriptions. States. Described. Additional information to [Sm.].

Olivier, Jean Joseph *(fl. 1831–1834)*
[Ber.] X, p. 233.*

Oliviera, Nathan *(20th cent.)*
Felix Landau Gallery, Los Angeles. *Nathan Oliviera, lithographs 1963–1966.* Los Angeles (Calif.), n.d. 5 loose-leaf sheets. (CSfAc)
Entries: 18. Inches. Described. Illustrated.

Ollion, Émile *(fl. c.1839)*
[Ber.] X, p. 233.*

Ollivier, Émile Edmond *(1800–1864)*
[Ber.] X, pp. 233–234.*

Ollivier, Michel Barthélémy *(c.1712–1784)*
[Baud.] I, pp. 25–36.
Entries: 16. Millimeters. Inscriptions. States. Described.

Olmutz, Wenzel von
See **Wenzel von Olmutz**

Omiccioli, Giovanni *(b. 1901)*
Galleria Astrolabio Arte, Rome [Carlo Giacomozzi, compiler]. *L'Opera grafica di Giovanni Omiccioli.* Rome, 1969.

Entries: 80 (to 1969). Millimeters. Illustrated.

Onghers, Jacob [Jan] *(1651–1735)*
[H. *Neth.*] XIV, p. 187.
Entries: 4 prints after.*

Onghers, Oswald *(1628–1706)*
[W.] II, p. 253.
Entries: 1 print by, 1 after.*

[H. *Neth.*] XIV, p. 188.
Entries: 2 prints after.*

Onofrij, Crescenzio *(1632–1698)*
[B.] XX, pp. 237–244.
Entries: 12. Pre-metric. Inscriptions.
Described.

Oort
See **Noort**

Oortman, Joachim Jan *(1777–1818)*
[Ber.] X, p. 234.*

[W.] II, p. 254.
Entries: 32+.*

Oost, A. van *(fl. c.1595)*
[H. *Neth.*] XIV, p. 188.
Entries: 4 prints after.*

Oost, Jacques I van *(1601–1671)*
[W.] II, pp. 254–255.
Entries: 5 prints after.*

[H. *Neth.*] XIV, p. 188.
Entries: 2 prints by, 6 after. Illustrated
(selection).*

Oost, Jacques II van *(1637–1713)*
[W.] II, p. 255.
Entries: 1 print by, 2 after.*

[H. *Neth.*] XIV, p. 189.
Entries: 1 print by, 2 after. Illustrated
(prints by only).*

Oosterhoudt, Dirk van *(1756–1830)*
[H. L.] p. 771.

Entries: 1. Millimeters. Inscriptions.
States. Described.

Oosterhuis, H. P. *(b. 1785)*
[W.] II, p. 256.
Entries: 2 prints after.*

Oostrum, Gerard van *(fl. 1740–1743)*
[W.] II, p. 256.
Entries: 2 prints after.*

Oostrum, W. de *(fl. c.1609)*
[H. *Neth.*] XIV, p. 189.
Entries: 1.*

Oostsanen, Jacob Cornelisz
See **Cornelisz van Oostsanen,** Jacob

Op de Beeck, Antoine *(1709–1759)*
[W.] II, p. 257.
Entries: 3.*

Opel, Peter *(fl. 1580–1595)*
[A.] II, pp. 112–117.
Entries: 10 engravings and etchings, 1
woodcut. Pre-metric. Inscriptions.
States. Described.

Opie, John *(1761–1807)*
Rogers, John J. *Opie and his works; being a
catalogue of 760 pictures by John Opie, R.A.
preceded by a biographical sketch.* London:
Paul and Dominic Colnaghi and Co.,
1878.
Catalogue of paintings; prints after
are mentioned where extant.

Opitz, Georg Emanuel *(1775–1841)*
[Dus.] p. 181.
Entries: 1+ (lithographs only, to 1821).
Paper fold measure.

Oppel, Nikolaus Michael *(19th cent.)*
[Dus.] p. 181.
Entries: 1+ (lithographs only, to 1821).
Inscriptions. Located.

Oppenheim, Moritz Daniel *(1800–1882)*
[Dus.] p. 181.
 Entries: 1 (lithographs only, to 1821).
 Millimeters. Inscriptions. Located.

Oppenheimer, Max *(1885–1954)*
Stix, Alfred, and Osborn, Max. *Das graphische Werk von Max Oppenheimer; Mopp.* Berlin: Verlag Bruno Cassirer, 1931.
 Entries: 64 etchings, 14 lithographs, 3 woodcuts (to 1931). Illustrated (selection).

Oppenort, Gilles Marie *(1672–1742)*
Huard, Georges. "Oppenord." In [Dim.] I, pp. 311–329.
 Entries: 3 prints after lost works, 12+ other prints after.

Oppler, Ernst *(1867–1929)*
Ludwig Möller Verlag. *Das graphische Werk Ernst Opplers; Katalog der Radierungen und Lithographien des Kunstlers.* Introduction by Karl Schaefer. 2 vols. Neue Graphik, zweites Bändchen. Lübeck (Germany): Ludwig Möller Verlag, n.d. (CSfAc)
 Entries: 122. Illustrated.

Opstal, Gaspard Jacob van *(1654–1717)*
[H. *Neth.*] XIV, p. 190.
 Entries: 3.*

Opstal, Gerard van *(c.1595–1668)*
[W.] II, pp. 257–258.
 Entries: 2+ prints after.*

[H. *Neth.*] XIV, p. 190.
 Entries: 13 prints after.*

Ordonie, Edouard van *(fl. 1638–1695)*
[Merlo] p. 631.*

[H. *Neth.*] XIV, p. 190.
 Entries: 1+.*

Orléans, Ferdinand Philippe, duc d' *(1810–1842)*
[Ber.] X, pp. 234–236.

Entries: 13. Paper fold measure. Inscriptions. Described (selection).

Orley, Barent van *(c.1491–1542)*
[H. *Neth.*] XIV, p. 190.
 Entries: 4 prints after.*

Orley, Hieronymus van *(b. 1590)*
[H. *Neth.*] XIV, p. 190.
 Entries: 1 print after.*

Orley, Jacob *(fl. c.1620)*
[H. *Neth.*] XIV, p. 191.
 Entries: 1 print after.*

Orley, Jan II van *(1665–1735)*
[W.] II, p. 269.
 Entries: 1 print by, 1 after.*

[H. *Neth.*] XIV, p. 191.
 Entries: 4 prints by, 12 after.*

Orley, Richard van *(1663–1732)*
[W.] II, pp. 269–270.
 Entries: 11+.*

[H. *Neth.*] XIV, pp. 191–192.
 Entries: 71. Illustrated (selection).*

Orlovski, Aleksandr *(1777–1832)*
[Dus.] pp. 181–182.
 Entries: 2 (lithographs only, to 1821). Millimeters (selection). Paper fold measure (selection). Inscriptions (selection). Located (selection).

Orlowski, Hans Otto *(b. 1894)*
Holten, Otto von. *Hans Orlowski; illustrierte Bücher und Mappenwerke von 1923 bis 1961.* Berlin: Otto von Holten, 1963. 500 copies. (EWA)
 Bibliography of books with illustrations by (to 1961).

Schwarzenberger, Fritz. *Werkverzeichnis Hans Orlowski.* 5 vols. Berlin: Hans-Orlowski-Kreis, 1965–1972. (EBKb)
 Entries: 719. Millimeters. States. Illustrated (selection). Volume I covers

1955–1964, II covers 1944–1954, III covers 1932–1943, IV covers 1914–1931, V covers 1965–1967.

Orme, ——— *(18th cent.)*
[Sm.] III, "additions and corrections" section.
 Entries: 1 (portraits only). Inches. Inscriptions. Described.

Orovida
See **Pissarro,** Orovida

Orozco, Jose Clemente *(1883–1949)*
Hopkins, Jon H. *Orozco; a catalogue of his graphic work.* Flagstaff (Ariz.): Northern Arizona University Publications, 1967.
 Entries: 47. Inches. Inscriptions. Described (selection). Illustrated.

Orozco V., Clemente, and Marrozzini, Luigi. *Catalogo completo de la obra grafica de Orozco.* San Juan (Puerto Rico): Instituto de Cultura Puertorriqueña, Universidad de Puerto Rico, 1970.
 Entries: 48. Millimeters. Inches. Inscriptions. States. Described. Illustrated. Text in Spanish and English. Concordance with Hopkins.

Orr, Louis *(b. 1879)*
Eglington, Guy C. "The etchings of Louis Orr." [*P. Conn.*] 2 (1921–1922): 68–90.
 Entries: 54 (to 1921). Inches. States. Described (selection). Illustrated (selection).

Orsay, [Gédéon Gaspard] Alfred, comte d' *(1801–1852)*
[Ber.] X, p. 236.*

[Siltzer] p. 348.
 Entries: unnumbered, p. 348. Inscriptions.

Orschwiller, Henry Boug d' *(b. 1783)*
[Ber.] X, p. 237.*

Orszagh, ——— *(19th cent.)*
[Ber.] X, p. 237.*

Orth, J. P. van *(fl. c.1792)*
[W.] II, p. 270.
 Entries: 1 print after.*

Ortolan, C. *(fl. c.1860)*
[Ber.] X, p. 237.*

Ortolanino [Pietro Marchesini] *(1692–1757)*
[B.] XXI, pp. 331–332.
 Entries: 1. Pre-metric. Inscriptions. Described.

Os, Georg Jakob Johann *(1782–1861)*
[Ber.] XII, p. 177.*

Os, Pieter Gerardus van *(1776–1839)*
[H. L.] pp. 771–773.
 Entries: 10 (incomplete). Millimeters. Inscriptions. Described.

[W.] II, p. 271.
 Entries: 5+.*

Osborn, M. *(fl. 1812–1820)*
[St.] pp. 392–393.*

[F.] p. 209.*

Osborne, Malcolm *(b. 1880)*
Salaman, Malcolm C. "The etchings of Malcolm Osborne, A.R.A., R.E." [*PCQ.*] 12 (1925): 285–313.
 Entries: 86. Illustrated (selection).

Ossenbeeck, Jan *(c.1624–1674)*
[B.] V, pp. 287–310.
 Entries: 58. Pre-metric. Inscriptions. Described.

[Weigel] pp. 303–310.
 Entries: 3 (additional to [B.]). Pre-metric. Inscriptions. Described. Appendix with 3 doubtful prints.

[Heller] pp. 98–99.
 Additional information to [B.].

Ossenbeeck, Jan *(continued)*

[Wess.] II, p. 246.
Additional information to [B.] and [Weigel].

[Dut.] V, pp. 206–207.*

[W.] II, pp. 271–273.
Entries: 58+ prints by, 1+ after.*

[H. *Neth.*] XIV, pp. 193–212.
Entries: 80. Illustrated (selection).*

Ostade, Adriaen van *(1610–1684)*
[B.] I, pp. 349–388, and addenda.
Entries: 51 prints by, 1 doubtful print. Pre-metric. Inscriptions. States. Described.

[Weigel] pp. 46–65.
Additional information to [B.].

[Heller] pp. 99–100.
Entries: 1 (additional to [B.]). Pre-metric. Inscriptions. States. Described. Additional information to [B.].

Faucheux, L. E. *Catalogue raisonné de toutes les estampes qui forment l'oeuvre gravé d'Adrien van Ostade.* Paris: Veuve Jules Renouard, 1862. 150 copies. (DLC)
Entries: 49 prints by, 6 doubtful and rejected prints. Millimeters. Inscriptions. States. Described.

Gaedertz, Theodor. *Adrian van Ostade; sein Leben und sein Kunst.* Lübeck (Germany): von Rohden'sche. Buchhandlung, 1869.
Entries: 50 prints by, 5 rejected prints.

Amand-Durand, ⸻. *Eaux-fortes de van Ostade reproduites et publiées par Amand-Durand.* Paris: Amand-Durand, Goupil, n.d.
Entries: 50. Illustrated.

[Wess.] II, pp. 246–248.
Entries: 1 (additional to Faucheux). Paper fold measure. Inscriptions. De-

scribed. Additional information to Faucheux.

[Dut.] V, pp. 207–269.
Entries: 50. Millimeters. Inscriptions. States. Described. Appendix with 6 doubtful prints.

Wessely, J. E. *Adriaen van Ostade; Verzeichniss seiner Original-Radierungen und der graphischen Nachbildungen nach seinen Werken.* Hamburg: Haendke und Lehmkuhl, 1888.
Entries: 50. Millimeters. Inscriptions. States. Described. Also, list of 298 prints after. Paper fold measure.

Springer, Jaro: *Das radierte Werk des Adriaen van Ostade in Nachbildungen.* Berlin: Fischer und Franke Buch- und Kunstverlag, 1900.
Entries: 50. Illustrated.

[W.] II, pp. 273–287; III, p. 130.
Entries: 57 prints by, 281+ after.*

Rovinski, Dmitri, and Tchetchouline, Nicolas. *Polnoe sobranie gravjur" Adriana van"-Ostade, 221 fototipija bez" retushi. Sobral" D. A. Rovinskij, privel" v" poorjadok" i snabdil" predisloviem N. A. Chechulin".| L'oeuvre gravé d'Adrien van Ostade; reproduction des planches originales dans leurs états successifs; 221 phototypies sans retouches avec un catalogue raisonné par Dmitri Rovinski et Nicolas Tchétchouline.* Leipzig: Karl W. Hiersman; St. Petersburg: S. N. Kotov, 1912. (NN)
Entries: 50 prints by, 1 doubtful print. Millimeters. States. Described. Illustrated. Located. Almost every state is illustrated for each print.

Bremmer, H. P. *Het compleete etswerk van Adriaen van Ostade in facsimile lichtdruk naar de origineelen uit het rijksprentencabinet.* Utrecht Levensverzekering maatschappij "Utrecht," [1920?].
Entries: 50. Illustrated.

C. G. Boerner, Leipzig. *Sammlung Paul Davidsohn: Kupferstiche alter Meister zweiter Teil, G-Ra. Versteigerung . . . den 22.-26. November 1920.* pp. 160–186. Leipzig, 1920.
Entries: 53 (188 impressions). States. Illustrated (selection). Different states of the same print are separately numbered. Includes states unknown to [Dut.].

Bock, Elfried. *Adriaen van Ostade, die Radierungen des Meisters in originalgetreuen Nachbildungen mit einer Einführung.* Berlin: Amsler und Ruthardt, 1922.
Entries: 50. Illustrated.

Davidsohn, Paul. *Adriaen van Ostade, 1610–1685, Verzeichnis seiner Original-Radierungen.* Leipzig: C. G. Boerner, 1922.
Entries: 50. Millimeters. Inscriptions. States. Careful description of states, including some not in Dutuit, based on Davidsohn's collection, and originally published in sale cat. of his collection [Boerner 1920].

Godefroy, Louis. "Notes sur un état inconnu d'une estampe d'Adrien van Ostade." [*Am. Est.*] 4 (1925): 170–173.
Additional information to [B.] ([B.] 43).

Godefroy, Louis. *L'Oeuvre gravé de Adriaen van Ostade.* Paris: Published by the author, 1930. 990 copies. (MBMu)
Entries: 50 prints by, 5 rejected prints. Millimeters. Inscriptions. States. Described. Illustrated. Located. Copies mentioned.

[H. *Neth.*] XV, pp. 1–70.
Entries: 50 prints by, 6 doubtful prints. Illustrated.*

Rouir, E. "A la découverte d'un graveur, Adrien van Ostade."*Le Livre et l'estampe*, no. 32 (1962): 305–323.
Entries: 50. States. Described. Lo-

cated. Special attention to editions, states and water marks.

Ostade, Izaac van *(1621–1649)*
[W.] II, pp. 287–289.
Entries: 1+ prints by, 16+ after.*

Ostendorfer, Michael *(c.1490–1559)*
[B.] IX, pp. 154–156.
Entries: 4 woodcuts. Pre-metric. Inscriptions. Described.

[Heller] pp. 100–102.
Entries: 6 (additional to [B.]). Pre-metric. Inscriptions. Described.*

[P.] III, pp. 310–315.
Entries: 1 etching, 46+ woodcuts (additional to [B.]). Pre-metric (selection). Paper fold measure (selection). Inscriptions. States. Described. Located (selection). Additional information to [B.].

[Wess.] I, p. 150.
Entries: 2 (additional to [B.] and [P.]). Millimeters. Inscriptions. States. Described. Additional information to [B.] and [P.].

[Ge.] nos. 964–984.
Entries: 21 (single-sheet woodcuts only). Described. Illustrated. Located.

Winzinger, Franz. *Albrecht Altdorfer, Graphik; Holzschnitte, Kupferstiche, Radierungen.* Munich: R. Piper und Co. Verlag, 1963.
Entries: 3 (prints stylistically close to Altdorfer only). Millimeters. Inscriptions. States. Described. Illustrated. Located. Bibliography for each entry. Table of watermarks.

Osterberger, ——— *(fl. c.1849)*
[Ber.] X, p. 237.*

Osterwald, Georg *(1803–1884)*
[Merlo] pp. 632–639.*

Ostroumova-Ljebedeva, Anna Petrovna *(b. 1871)*
　Benois, Alexander, and Ernst, Sergey. *Ostraoomova-Ljebedeva.* Moscow and Petrograd: Gosudarstvennoe Izdatel'stvo, [1924?].
　　Entries: unnumbered, pp. 85–89 (to 1923). Millimeters (selection).

　Sinicyn, Nikolai V. *Gravjury Ostroumovoi-Lebedevoi.* Moscow: Izdatel'stvo Iskusstvo, 1964.
　　Entries: unnumbered, pp. 139–141. Millimeters. Illustrated (selection).

Otis, Bass *(1784–1861)*
　[St.] pp. 393–394.*

　[F.] p. 209.*

Ott, Norbert H. *(20th cent.)*
　Rödel, Klaus. *Norbert H. Ott Exlibris.* Frederikshavn (Denmark): Privately printed, 1968. 100 copies. (DLC)
　　Entries: 116 (bookplates only, to 1968). Described. Illustrated (selection).

Ottavia, Giovanni *(1735–1808)*
　[Ap.] p. 319.
　　Entries: 2.*

Ottens, Frederik *(18th cent.)*
　[W.] II, p. 289.
　　Entries: 9.*

Ottens, Jan *(fl. c.1700?)*
　[W.] II, p. 289.
　　Entries: 2.*

Ottens, Joachim *(1663–1722)*
　[H. *Neth.*] XV, p. 71.
　　Entries: 3.*

Otteren, Hubertus van *(1671–1713)*
　[H. *Neth.*] XV, p. 71.
　　Entries: 8. Illustrated (selection).*

Otteren, Leonardus Henricus van *(fl. c.1684)*
　[W.] II, p. 290.
　　Entries: 2+.*

　[H. *Neth.*] XV, p. 72.
　　Entries: 5.*

Ottino, Pasquale [called "Pasqualotto"] *(1580–1630)*
　[B.] XVII, pp. 207–208.
　　Entries: 1. Pre-metric. Inscriptions. Described.

Otto, —— *(19th cent.)*
　[Dus.] p. 182.
　　Entries: 2+ (lithographs only, to 1821). Millimeters (selection). Inscriptions. Located.

Otto, G. *(fl. c.1860)*
　[H. L.] p. 773.
　　Entries: 3. Millimeters. Inscriptions. Described.

Otto, Georg Philipp *(b. 1814)*
　[Ap.] p. 319.
　　Entries: 2.*

Oudart, Félix *(fl. c.1874)*
　[Ber.] X, p. 238.*

Oudart, Paul Louis *(b. 1796)*
　[Ber.] X, p. 238.*

Oudendijck, Adriaen *(1648–c.1700)*
　[W.] II, p. 290.
　　Entries: 2.*

　[H. *Neth.*] XV, pp. 72–73.
　　Entries: 4. Illustrated (selection).*

Oudot, Roland *(b. 1897)*
　Daulte, François. *L'Oeuvre lithographique de Roland Oudot* I; 1930–1958. Paris: La Bibliothèque des Arts, 1972. 700 copies. (NN)

Entries: 125 (to 1958). Millimeters. Described. Illustrated.

Oudry, Jean Baptiste *(1686–1755)*
[RD.] II, pp. 188–206; XI, pp. 233–234.
Entries: 69. Pre-metric. Inscriptions. States. Described. Appendix with 3 doubtful prints.

Locquin, Jean. "L'Oeuvre gravé du peintre Jean-Baptiste Oudry." *Annuaire de la gravure française,* 1912, pp. 173–176. Additional information to [RD.].

Locquin, Jean. "Catalogue raisonné de l'oeuvre de Jean-Baptiste Oudry." *Archives de l'art français,* n.s. 6 (1912): i–viii, 1–209. Separately published. Paris: Jean Schemit, 1912.
Entries: 17. Millimeters. Inscriptions. Also, catalogue of works in all media; prints after are mentioned where extant.

Vergnet-Ruiz, Jean. "Oudry." In [Dim.] II, pp. 135–194.
Entries: 24 prints after lost works, 6+ other prints after.

Oury, Charles *(fl. 1847–1881)*
[Ber.] X, p. 239.*

Outgers, Guilhelmus *(fl. c.1620)*
[H. *Neth.*] XV, p. 74.
Entries: 1. Illustrated.*

Outhwaite, Jean Jacques *(fl. 1836–1877)*
[Ber.] X, pp. 239–240.*

Outkine
See **Utkin**

Outrim, John *(fl. 1840–1874)*
[Ap.] p. 319.
Entries: 1.*

Ouwater, Albert van *(fl. c.1422)*
[W.] II, pp. 291–293.
Entries: 3 prints after.*

Ovens, Jürgen [Juriaen] *(1623–1678)*
[A.] V, pp. 23–31.
Entries: 4. Pre-metric. Inscriptions. Described.

[Rov.] pp. 74–75.
Entries: 1. Millimeters. Inscriptions. Described. Illustrated. Located.

[W.] II, pp. 293–295.
Entries: 7 prints by, 6 after.*

Schmidt, Harry. *Jürgen Ovens, sein Leben und sein Werk.* Kiel (Germany): Published by the author, 1922.
Entries: 10 prints by, 8 after. Millimeters. Described. Illustrated (selection). Located Appendix with numerous rejected prints.

Overbeck, Carl Wilhelm *(1820–1860)*
[Ap.] p. 320.
Entries: 4.*

Overbeek, Bonaventura Jansz *(c.1660–1705)*
[H. *Neth.*] XV, p. 75.
Entries: 1+ prints by, 2 after. Illustrated (selection).*

Overbeek, Leendert *(1752–1815)*
[H. L.] pp. 774–777.
Entries: 13. Millimeters. Inscriptions. Described.

[W.] II, p. 295.
Entries: 6+.*

Overlaet, Antoon *(1720–1774)*
[H. L.] pp. 777–778.
Entries: 2. Millimeters. Inscriptions. States. Described.

[W.] II, pp. 295–296.
Entries: 4+.*

Oye, D. van *(fl. c.1700)*
[H. *Neth.*] XV, p. 76.
Entries: 1. Illustrated.*

Ozanne, Nicolas Marie *(1728–1811)*
Auffret, Charles. *Une famille d'artistes brestois au XVIIIe siècle; les Ozanne.* Rennes (France): Hyacinthe Caillière, 1891.
 Entries: 9+ prints by, 25+ prints after. Millimeters (selection). Inscriptions (selection). Described (selection). Illustrated (selection).

Ozanne, Pierre *(1737–1818)*
Auffret, Charles. *Une famille d'artistes brestois au XVIIIe siècle; les Ozanne.* Rennes (France): Hyacinthe Caillière, 1891.
 Entries: prints by, unnumbered, pp. 113–114; 11+ prints after. Millimeters (selection). Described (selection). Illustrated (selection).

P

Pace, Giovanni Battista *(fl. c.1650)*
[B.] XX, pp. 299–300.
 Entries: 1. Pre-metric. Inscriptions. Described.

Pader, Hilaire *(1607–1677)*
[RD.] VIII, pp. 260–270; XI, p. 234.
 Entries: 54. Millimeters. Inscriptions. States. Described.

Padtbrugge, Dionysius *(1628–1685)*
[H. *Neth.*] XV, p. 77.
 Entries: 12+. Illustrated (selection).*

Padtbrugge, Herman *(1656–1686)*
[H. *Neth.*] XV, pp. 78–80.
 Entries: 15+. Illustrated (selection).*

Päringer, Joseph *(19th cent.)*
[Dus.] p. 183.
 Entries: 17+ (lithographs only, to 1821). Millimeters (selection). Inscriptions (selection). Located (selection).

Paets, Willem *(1638–1715)*
[H. *Neth.*] XV, p. 81.
 Entries: 1. Illustrated.*

Pagani, Gregorio *(1558–1605)*
Galerie Valentien, Stuttgart [Christel Thiem, compiler]. *Gregorio Pagani; ein Wegbereiter der florentiner Barockmalerei.* Stuttgart, 1970.
 Entries: 6 prints after. Millimeters (selection). Inscriptions. Illustrated (selection). Located (selection).

Pagano, Matteo *(fl. 1543–1555)*
[P.] VI, p. 243, no. 98.
 Entries: 1. Pre-metric. Inscriptions. Described.

Pagès, Aimée *(1803–1860)*
[Ber.] X, p. 240.*

Paillard, Henri Pierre *(1844–1912)*
[Ber.] X, p. 240.*

Pajol, Charles Pierre Victor *(1812–1891)*
[Ber.] X, p. 241.*

Pajou, Augustin Desiré *(1800–1878)*
[Ber.] X, p. 241.*

Palamedesz, Anthonie *(1601–1673)*
[W.] II, pp. 297–299.
 Entries: 5 prints after.*

Palamedesz, Palamedes *(1607–1638)*
[W.] II, p. 299.
 Entries: 1 print after.*

Palizzi, Giuseppe *(c.1812–c.1888)*
[Ber.] X, p. 241.*

Palma, Jacopo [called "Palma il Giovane"]
(1544–1628)
[B.] XVI, pp. 286–295.
 Entries: 27 prints by, 1 rejected print.
 Pre-metric. Inscriptions. States. De-
 scribed. Copies mentioned.

Palmer, Joseph *(fl. c.1820)*
[F.] pp. 209–210.*

Palmer, Samuel *(1805–1881)*
Palmer, A. H. *The life and letters of Samuel
Palmer, painter and etcher.* London: See-
ley and Co. Ltd., 1892.
 Entries: 13.

Hardie, Martin. "The etched work of
Samuel Palmer." [PCQ.] 3 (1913): 207–
240.
 Entries: 13. Inches. Millimeters. In-
 scriptions. States. Illustrated.

Alexander, R. G. *A catalogue of the etch-
ings of Samuel Palmer.* London: Print Col-
lectors' Club, 1937.
 Entries: 17. Inches. Inscriptions.
 States. Described. Illustrated. Ms.
 notes (ECol); additional states.

Lister, Raymond. *Samuel Palmer and his
etchings.* New York: Watson-
Guptill Publications, 1969.
 Entries: 13 prints by, 4 prints partly by
 and partly after. Inches. Inscriptions.
 States. Described. Illustrated. In-
 cludes states not in Alexander, and
 describes posthumous editions.

Palmerini, Nicolò *(1779–1839)*
[Ap.] p. 320.
 Entries: 2.*

Palombo, Ascanio
See **Monogram AP** [Nagler, *Mon.*] I, no.
1102

Pals, Gerrit van der *(1754–1839)*
[H. L.] p. 778.
 Entries: 1. Millimeters. Inscriptions.
 Described.

Palthe, Jan *(1719–1769)*
[W.] II, p. 300.
 Entries: 3 prints by, 2 after.*

Panderen, Egbert van *(c.1581–1617)*
[W.] II, pp. 301–302.
 Entries: 27+.*

[H. *Neth.*] XV, pp. 82–107.
 Entries: 60. Illustrated (selection).*

Panneels, Herman *(fl. 1638–1650)*
[H. *Neth.*] XV, p. 108.
 Entries: 5.*

Panneels, Johannes *(17th cent.)*
[H. *Neth.*] XV, p. 108.
 Entries: 1. Illustrated.*

Panneels, Willem *(c.1600–after 1632)*
[W.] II, p. 302.
 Entries: 33.*

[H. *Neth.*] XV, pp. 109–127.
 Entries: 36. Illustrated (selection).*

Pannemaker, Adolphe François *(b. 1822)*
[Ber.] X, pp. 241–242.*

Pannemaker, Stéphane *(1847–1930)*
[Ber.] X, pp. 242–246.*

Pannetier, ——— *(fl. c.1830)*
[Ber.] X, p. 246.*

Pannier, Jacques Étienne *(1802–1869)* and
Marie Louise *(fl. 1839–1847)*
[Ap.] pp. 320–321.
 Entries: 12.*

[Ber.] X, pp. 246–248.*

Paoletti, Pietro *(1801–1847)*
[AN.] pp. 683–684.
　Entries: unnumbered, pp. 683–684.
　Millimeters. Inscriptions. Described.

[AN. 1968] p. 176.
　Entries: unnumbered, p. 176 (additional to [AN.]).

Paolozzi, Eduardo *(b. 1924)*
University of California, Berkeley.
Eduardo Paolozzi: a print retrospective.
London: Editions Alecto, 1968.
　Entries: unnumbered, 2 pp., (1950–1968). Millimeters. Inches. Illustrated (selection).

Galerie Mikro, Berlin. *Eduardo Paolozzi; complete graphics.* Berlin: Galerie Mikro; London: Petersburg Press, 1969.
　Entries: unnumbered, 13 pp. Millimeters. Illustrated.

Pape, Joss [Jodocus] de *(fl. 1633–1646)*
[H. *Neth.*] XV, p. 128.
　Entries: 2. Illustrated.*

Papety, Dominique Louis Ferréol
(1815–1849)
[Ber.] X, p. 248.*

Papillon family
Papillon, Jean Michel. "Oeuvres des Papillon." Unpublished ms. (EPBN, 2 copies)
　Entries: 100 prints by Jean Papillon I (1639–1710), 640 prints by Jean Papillon II (1661–1723), 16 prints by Jean Nicolas Papillon (1663–1714), 6762 prints by Jean Michel Papillon (1698–1776). Described (selection).

Papin, ——— *(19th cent.)*
[Ber.] X, p. 248.*

Papprill, H. A. *(19th cent.)*
[Siltzer] p. 361.
　Entries: unnumbered, p. 361. Inscriptions.

Paradis, Nicolas Michel *(b. 1792)*
[Ber.] X, p. 249.*

Paradise, John Wesley *(1809–1862)*
[St.] pp. 394–399.*

[F.] pp. 210–211.*

Paradisi, Luigi *(d. 1893)*
[Ap.] p. 321.
　Entries: 2.*

Parboni, Achille *(19th cent.)*
[Ap.] p. 321.
　Entries: 1+.*

Parboni, Pietro *(19th cent.)*
[Ap.] p. 322.
　Entries: 9.*

Pardon, J. *(19th cent.)*
[Siltzer] p. 332.
　Entries: unnumbered, p. 332, prints after. Inscriptions.

Parigi, Alfonso II di *(d. 1656)*
[B.] XX, pp. 64–67.
　Entries: 12. Pre-metric. Inscriptions. Described.

Parigi, Giulio *(d. 1635)*
[B.] XX, p. 68.
　Entries: 2. Pre-metric. Inscriptions.

Paris, Léon *(19th cent.)*
[Ber.] X, p. 249.*

Park, Thomas *(1759–1834)*
[Sm.] III, pp. 956–960, and "additions and corrections" section.
　Entries: 13 (portraits only). Inches. Inscriptions. States. Described. Located (selection).

[Ru.] pp. 232–233.
Additional information to [Sm.].

Parkyns, George Isham *(c.1750–after 1820)*
[St.] p. 399.*

Parmigianino [Francesco Mazzola]
(1503–1540)

[B.] XII: *See* **Chiaroscuro Woodcuts**

[B.] XVI, pp. 3–15.
Entries: 15 (etchings only). Pre-metric.
Inscriptions. States. Described.
Copies mentioned.

[P.] VI, pp. 174–175.
Entries: 1 (etchings only, additional to
[B.]). Pre-metric. Inscriptions. De-
scribed. *See also* **Chiaroscuro Wood-
cuts**

Copertini, Giovanni. *Il Parmigianino.*
Parma (Italy): Mario Fresching, 1932.
Entries: 12 (etchings only). Millime-
ters. Illustrated (selection).

Quintavalle, Armando Ottaviano. *Il
Parmigianino.* Milan: Istituto Editoriale
Italiano, 1948.
Entries: 9 (etchings only). Located
(selection).

Oberhuber, Konrad. "Parmigianino als
Radierer." *Alte und moderne Kunst* 8, no.
68 (May–June 1963): 33–36.
Additional information to earlier
catalogues; special attention to at-
tributions and distinction between
original and copy.

Popham, A. E. "Observations on Par-
migianino's designs for chiaroscuro
Woodcuts." In *Miscellanea J.Q. van
Regteren Altena*, pp. 48–51. Amsterdam:
Scheltema en Holkema, 1969.
Additional information to [B.] and
[P.]. Discussion of chiaroscuro prints
by and after.

Parolini, Giacomo *(1663–1733)*
[Vesme] pp. 351–354.
Entries: 13. Millimeters (selection). In-
scriptions. Described. Located (selec-
tion).

Parr, Richard *(19th cent.)*
[Ap.] p. 322.
Entries: 1.*

Parrette, —— *(fl. c.1853)*
[Ber.] X, p. 249.*

Parrish, Stephen *(b. 1846)*
[Parrish, Stephen]. *A catalogue of etchings
by Stephen Parrish, 1879–1883, with de-
scriptions of the plates and ten etchings made
for this work, nine of which are reduced
copies of plates mentioned in the text.* n.p.,
[1883?]. 50 copies. (NN)
Entries: 86 (to 1883). Inches. Inscrip-
tions. States. Described. Illustrated
(selection). Ms. addition (NN); 72 ad-
ditional entries.

H. Wunderlich and Co., New York.
*Catalogue of S. Parrish's complete etched
work on exhibition at the gallery of H. Wun-
derlich and Co.* New York, 1886. (NN)
Entries: 117 (to 1886?). Inches. Based
on Parrish 1883, with additions.

[Ber.] X, p. 249.*

Parrocel, Charles *(1688–1752)*
[RD.] II, pp. 207–220; XI, p. 235.
Entries: 41. Pre-metric. Inscriptions.
States. Described.

Parrocel, Joseph *(1646–1704)*
[RD.] III, pp. 252–281; XI, pp. 235–245.
Entries: 95. Pre-metric. Inscriptions.
States. Described.

Parrocel, Joseph François *(1704–1781)*
[Baud.] II, pp. 30–36.
Entries: 8. Millimeters. Inscriptions.
States. Described.

Parrocel, Pierre *(1670–1739)*
[RD.] II, pp. 172–180; XI, pp. 245–252.
Entries: 52. Pre-metric. Inscriptions.
States. Described. Appendix with 2
doubtful prints.

Parrocel, Pierre Ignace *(1702–c.1775)*
[Baud.] II, pp. 5–20.
Entries: 35. Millimeters. Inscriptions.
Described.

Paruit, Peter *(1814–1862)*
[Merlo] p. 642.*

Pas, J. Tho *(17th cent.)*
[W.] II, p. 304.
Entries: 1 print after.*

Pascal, Jacques *(b. 1809)*
[Ap.] p. 322.
Entries: 1.*

Pascal, Jean Barthélemy *(b. 1774)*
[Dus.] p. 184.
Entries: 3 (lithographs only, to 1821).
Millimeters. Inscriptions. Located.

Pascati, ——— *(19th cent.)*
[Ap.] p. 322.
Entries: 1.*

Pascin, Jules *(1885–1930)*
Voss, Hans. "Julius Pincas dit Pascin,
Versuch einer Analyse und eines
Katalogs seines druckgraphischen
Werkes." Dissertation, University of
Frankfurt, 1956.
Entries: 67. Millimeters. Inscriptions.
Described. Ms. addition (NN); 1 addi-
tional entry.

Riester, Rudolf. "Jules Pascin." *Illustra-
tion 63* 7 (1970): 36–39.
Bibliography of books with illustra-
tions by.

Pasinger, Joseph *(19th cent.)*
[Dus.] p. 184.
Entries: 1 (lithographs only; to 1821).
Inscriptions.

Pasini, Alberto *(1826–1899)*
[Ber.] X, p. 250.*

Pasquin [——— Coutan] (b. 1853)
[Ber.] X, pp. 250–251.*

Passari, Bernardino
See **Passeri**

Passarotti, Bartolomeo *(1529–1592)*
[B.] XVIII, pp. 1–9.
Entries: 15 prints by, 3 doubtful prints.
Pre-metric. Inscriptions. Described.

Passe, van de, family *(16th–17th cent.)*
Franken, D. *L'Oeuvre gravé des van de
Passe.* Paris: F. Muller et Cie, 1881.
Entries: 1383 prints by Crispin van de
Passe I, Crispin II, Simon, Willem and
Magdalena. Unnumbered lists of the
work of each artist are given at the
beginning of the catalogue. Millime-
ters. Inscriptions. States. Described.
Ms. notes (EA); additional states and
other information. Ms. notes (ECol);
additional states. Ms. notes (EBr); en-
tries additional to both Franken and
Laschitzer.

Wessely, J. E. "Literaturbericht." [*Rep.
Kw.*] 5 (1882): 250–254.
Entries: 50 (additional to Franken).
Millimeters. Inscriptions. Described
(selection). Additional information to
Franken.

Laschitzer, Simon. "Berichtigungen,
Ergänzungen und Nachträge zu
l'oeuvre gravé des van de Passe." [*Rep.
Kw.*] 8 (1885): 439–483.
Entries: 225 (additional to Franken).
Millimeters. Inscriptions. Described.
Located. Additional information to
Franken.

Henkel, M. D. "Onbekend werk van de
De Passe's in de verzameling van het
Kon. Oudheidkundig Genootschap."
*Jaarsverslag van het Koninklijk Oudheid-
kundig Genootschap,* 1932, pp. 39–42.
Entries: 1 (additional to Franken). Mil-
limeters. Described. Illustrated. Lo-
cated.

Passe, Crispin I de *(1564–1637)*
See also **Passe,** van de, family

[Merlo] pp. 643–657.

Entries: 214+ (prints done in Cologne only). Paper fold measure. Inscriptions. Based on Franken.

[W.] II, pp. 304–306.
Entries: 118+ prints by, 4+ after.*

[H. *Neth.*] XV, pp. 129–296.
Entries: 860+. Illustrated (selection).*

Passe, Crispin II de *(1597/98–after 1670)*
See also **Passe,** van de, family

[W.] II, pp. 306–307.
Entries: 14.*

Passe, Crispin III de *(fl. 1643–1680)*
[W.] II, p. 307.
Entries: 3.*

Passe, Magdalena van de *(1600–1638)*
See also **Passe,** van de, family

[W.] II, p. 307.
Entries: 14+.*

[Hind, *Engl.*] II, p. 302.
Entries: 1 (prints done in England only). Inches. Inscriptions. Described. Illustrated. Located.

Passe, Simon de *(1595?–1647)*
See also **Passe,** van de, family

[W.] II, pp. 307–308.
Entries: 55.*

[Hind, *Engl.*] II, pp. 247–284.
Entries: 63 (prints done in England only). Inches. Inscriptions. States. Described. Illustrated (selection). Located. Also, 33 engraved medals by de Passe.

Verbeek, ———. "Zeldzame vorsten-portretten door de De Passes in het Rijksprentenkabinet." *Bulletin van het Rijksmuseum Amsterdam* 10 (1962): 76–84.
Additional information to Franken and [Hind, *Engl.*].

Passe, Willem de *(1598?–before 1637)*
See also **Passe,** van de, family

[W.] II, p. 308.
Entries: 21+.*

[Hind, *Engl.*] II, pp. 285–301.
Entries: 19 (prints done in England only). Inches. Inscriptions. States. Described. Illustrated (selection). Located.

Verbeek, ———. "Zeldsame vorsten-portretten door de De Passes in het Rijksprentenkabinet." *Bulletin van het Rijksmuseum Amsterdam* 10 (1962): 76–84.
Additional information to Franken and [Hind, *Engl.*].

Passeri, Bernardino *(d. c.1590)*
[B.] XVII, pp. 27–39.
Entries: 78. Pre-metric. Inscriptions. States. Described.

Passini, Johann Nepomuk *(1798–1874)*
[Ap.] pp. 322–323.
Entries: 7.*

Pasteur, Louis *(1822–1895)*
[Ber.] X, p. 251.*

Patas, Charles Emmanuel [Jean Baptiste] *(1744–1802)*
[L. D.] pp. 67–69.
Entries: 8. Millimeters. Inscriptions. States. Described. Illustrated (selection). Incomplete catalogue.*

Patch, Thomas *(c.1720–1782)*
Watson, F. J. B. "Thomas Patch (1725–1782), notes on his life with a catalogue of his known works." *The Walpole Society Annual Volume* 28 (1939–1940): 15–50.
Entries: 18+. Inches. Inscriptions. Described (selection).

Patel, Pierre II [Pierre Antoine] *(1648–1707)*
[RD.] II, pp. 140–143.

Patel, Pierre II (*continued*)

Entries: 2. Pre-metric. Inscriptions. Described.

Pater, Jean Baptiste (*1695–1736*)
Ingersoll-Smouse, Florence: *Pater; biographie et catalogue critiques.* Paris: Les Beaux-arts; Édition d'Études et de Documents, 1928.
Catalogue of paintings; prints after are mentioned where extant.

Patin, Jacques (*d. before 1604*)
[RD.] VII, pp. 141–147.
Entries: 27. Millimeters. Inscriptions. Described.

Patocchi, Aldo (*b. 1907*)
Cavalleris, Vincenzo. *Aldo Patocchi.* Collection artistes suisses, 3. Neuchâtel (Switzerland): Éditions de la Baconnière, 1941. 686 copies. (MH)
Entries: unnumbered, pp. 191–194 (commerical prints are omitted; to 1941?). Millimeters.

Musée d'Art et d'Histoire, Geneva, *Aldo Patocchi; catalogue raisonné de l'oeuvre gravé.* Geneva, 1968.
Entries: 299 (to 1968). Millimeters. Illustrated (selection).

Patout, —— (*fl. 1840–1880*)
[Ber.] X, pp. 251–252.*

Patte, Pierre (*1723–1814*)
Mathieu, Mae. *Pierre Patte, sa vie et son oeuvre.* Paris: Presses universitaires de France, 1940.
Entries: unnumbered, pp. 346–369, prints by, after, and published by. Inscriptions (selection). Described (selection).

Patton, F. (*fl. 1745–1764*)
[Sm.] III, pp. 960–961, and "additions and corrections" section.

Entries: 1 (portraits only). Inches. Inscriptions. Described.

Paudiss, Christoph (*c.1618–1666/67*)
[W.] II, pp. 311–312.
Entries: 7 prints after.*

Paul, Hermann (*1864–1940*)
Lefuel, Hector. "Quatre ex-libris par Hermann-Paul." [*Arch. Ex.-lib.*] 31 (1924): 29–31.
Entries: 4 (bookplates only; to 1924?). Inscriptions. Described. Illustrated.

Geiger, Raymond. *Hermann Paul.* Les artistes du livre, 5. Paris: Henry Babou, 1929. 750 copies. (NN)
Bibliography of books with illustrations by (to 1929).

Geiger, Raymond. "Hermann Paul, ou l'artiste déplaisant." [*AMG.*] 3 (1929–1930): 765–772.
Bibliography of books with illustrations by (to 1929).

Paul, J. S. (*18th cent.*)
[Sm.] III, pp. 961–963.
Entries: 10 (portraits only). Inches. Inscriptions. Described.

[Ru.] p. 233.
Additional information to [Sm.].

Paul, John Dean (*1775–1852*)
[Siltzer] p. 193.
Entries: unnumbered, p. 193, prints after. Inches. Inscriptions.

Pauli, Andries I (*1600–1639*)
[W.] II, p. 312.
Entries: 10+.*

Pauli, Fritz (*b. 1891*)
Klipstein, August. *F. Pauli Radierungen; Einleitung und Text von Dr. Paul Schaffner.* Erlenbach-Zurich: Eugen Rentsch, 1926.
Entries: 160. Millimeters. Inscriptions. States. Described (selection). Illus-

trated (selection). All prints are either described or illustrated.

Aargauer Kunsthaus, Aarau. *Fritz Pauli, Radierungen.* Aargau (Switzerland), 1966.
Entries: 107. Illustrated (selection).

Paulsen, Ingwer *(b. 1883)*
Das graphische Werk des Maler-Radierers Ingwer Paulsen. Introduction by Hans W. Singer. Berlin: August Scherl, 1921.
Entries: 149 (to 1920). Millimeters. Described. Illustrated (selection).

Paulus, Petrus *(fl. c.1657)*
[W.] II, p. 312.
Entries: 1.*

Paumgartner, Hans *(fl. c.1580)*
[P.] IV, p. 238.
Entries: 1. Pre-metric. Inscriptions. Described. Located.

Pauquet, [Jean] Louis Charles *(1759–c.1824)* and Hippolyte Louis Émile *(b. 1797)*
[Ap.] p. 323.
Entries: 6.*

[Ber.] X, pp. 252–254.*

Pauquet, Polydor *(b. 1800)*
[Ber.] X, pp. 253–254.*

Pauwels, Ferdinand Wilhelm *(1830–1904)*
[H. L.] p. 779.
Entries: 1. Millimeters. Inscriptions. States. Described.

Pauwelsz, Claes
See **Pouwelsz**

Pavlov, Ivan Nikolaevich *(1872–1951)*
Kabinet Graviur Gosudarstvennogo Rumjancovskogo Muzeja, Moscow [V. Ia. Adarjukov, compiler]. *Gravjury I. N. Pavlova, 1886–1921.* Moscow: Gosudarstvennoe Izdatel'stvo, 1922.

Entries: 2735. Millimeters. Illustrated (selection).

Sokol'nikov, M. P. *Ivan Pavlov.* Ogiz (USSR): Gosudarstvennoe Izdatel'stvo izobrazitel'nykh iskusstv, 1937. (DLC)
Bibliography of books with illustrations by (to 1934).

Pavon, Ignazio *(d. 1858)*
[Ap.] pp. 323–325.
Entries: 17.*

Payne, John *(fl. 1600–1640)*
[Hind, *Engl.*] III, pp. 6–30.
Entries: 53. Inches. Inscriptions. States. Described. Illustrated (selection). Located.

Peabody, M. M. *(fl. c.1835)*
[St.] pp. 399–400.*

[F.] p. 211.*

Peale, Charles Willson *(1741–1827)*
[Sm.] III, p. 963.
Entries: 3 (portraits only). Inches. Inscriptions. Described.

[St.] pp. 400–402.*

Sellers, Horace Wells. "Engravings by Charles Willson Peale, limner." [*Pa. Mag.*] 57 (1933): 153–174, 284–285. Separately published. n.p., Historical Society of Pennsylvania, 1933.
Entries: 8. Inches. Inscriptions. Described.

Sellers, Charles Coleman. *Portraits and miniatures by Charles Willson Peale.* Philadelphia: Transactions of the American Philosophical Society, vol. 42, part 1, 1952.
Catalogue of works in various media, including 3 prints (portraits only). Inches. Inscriptions. Described. Illustrated (selection). Located (selection).

Peale, Rembrandt *(1778–1860)*
[Carey] pp. 361–362.

Peale, Rembrandt (*continued*)

Entries: 14+ (lithographs only). Inches (selection). Inscriptions. Described (selection). Located.

Mahey, John A. "Lithographs by Rembrandt Peale." *Antiques* 97 (1970): 236–242.
Entries: 25. Inches. Inscriptions. Described. Illustrated (selection). Located.

Pearlstein, Philip (*b. 1924*)
Staatliche Museen preussischer Kulturbesitz, Kupferstichkabinett, Berlin [Alexander Dückers, compiler]. *Philip Pearlstein; Zeichnungen und Aquarelle, die Druckgraphik.* Berlin, 1972.
Entries: 32 (to 1972). Millimeters. Inscriptions. States. Described. Illustrated.

Peasley, A. M. (*fl. c.1804*)
[F.] p. 211.*

Pecham, Georg (*d. 1604*)
[A.] IV, pp. 154–162.
Entries: 12. Pre-metric. Inscriptions. Described. Appendix with 1 doubtful print.

Peche, Dagobert (*1887–1923*)
Ankwicz Kleehoven, Hans. "Dagobert Peche als Graphiker." [*GK.*] 49 (1926): 51–60. Catalogue: "Verzeichnis der graphischen Arbeiten Dagobert Peches." [*MGvK.*] 1926, p. 48.
Entries: 76 prints by and after. Millimeters. Inscriptions. Described.

Pecheux, Benoît (*1779–after 1831*)
[Ber.] X, p. 254.*

Pechstein, Max (*1881–1955*)
Fechter, Paul. *Das graphische Werk Max Pechsteins.* Berlin: Fritz Gurlitt Verlag, 1921. 500 copies. (MBMu)

Entries: 113 etchings, 225 lithographs, 165 woodcuts, (to 1920). Millimeters. Inscriptions. States. Described.

Altonaer Museum, Hamburg [Christine Knupp, compiler]. *Max Pechstein 1881–1955; Graphik.* Hamburg, 1972.
Entries: 213. Millimeters. Illustrated (selection). Not an oeuvre-catalogue, but contains many prints not in Fechter, both before and after 1920.

Pedersen, Frank (*20th cent.*)
Fogedgaard, Helmer. "Frank Pedersens kvinde-exlibris." [*N. ExT.*] 11 (1959): 104–105, 109.
Entries: 13 (bookplates only, to 1959). Illustrated (selection).

Rödel, Klaus. *Frank Pedersen exlibris.* Frederikshavn (Denmark): Privately printed, 1967. 60 copies. (DLC)
Entries: 75 (bookplates only, to 1967). Described. Illustrated (selection).

Pedersen, Hans Jørgen (*20th cent.*)
Fogedgaard, Helmer. "Hans Jørgen Pedersen, en ny dansk exlibriskunstner." [*N. ExT.*] 10 (1958): 58–59.
Entries: 13 (bookplates only, to 1958). Illustrated (selection).

Pedersen, Thomas (*20th cent.*)
Arné. "Ipse fecit." and "Thomas Pedersen." [*N. ExT.*] 5 (1953): 104, 116–119.
Entries: 13 (to 1953). Illustrated (selection).

Fogedgaard, Helmer. "Exlibris i fotografik; Thomas Pedersens nyeste exlibris." [*N. ExT.*] 16 (1964): 10–11, 13, 14.
Entries: 17 (bookplates only, additional to Arné; to 1963). Illustrated (selection).

"Thomas Pedersen-III." [*N. ExT.*] 22 (1970): 29.
Entries: 41 (bookplates only, additional to 1964 catalogue; to 1969). Illustrated (selection).

Pelletier, [Joseph] Laurent *(1811–1892)*
[Ber.] X, p. 256.*

Pelli, Lodovico *(1814–1876)*
[Ap.] p. 326.
Entries: 1.*

Pellicot, Louis Alexis Léon de *(b. 1787)*
[Ber.] X, p. 256.*

Pelton, Oliver *(1799–1882)*
[Allen] p. 145.*

[St.] pp. 410–419.*

[F.] pp. 213–215.*

Peltro, John *(c.1760–1808)*
[Siltzer] p. 362.
Entries: unnumbered, p. 362. Inscriptions.

Pelz, Bruno *(20th cent.)*
Kunsthalle, Bremen. *Bruno Pelz;
Radierungen, Aquatinten, 1958–1968.*
Bremen (West Germany), 1968.
Entries: 241 (to 1968). Millimeters.
States.

Penauille, Edmé *(d. 1871)*
[Ber.] X, pp. 256–257.*

Pénavère, Henriette *(fl. 1831–1839)*
[Ber.] X, p. 257.*

Pencz, Georg *(c.1500–1550)*
[B.] VIII, pp. 319–362.
Entries: 126 prints by, 2 rejected
prints. Pre-metric. Inscriptions.
States. Described. Copies mentioned.

[Heller] pp. 102–103.
Additional information to [B.].

[P.] IV, pp. 101–102.
Additional information to [B.].

[Wess.] I, p. 151.
Additional information to [B.] and
[P.].

Röttinger, Heinrich. *Die Holzschnitte des
Georg Pencz.* Leipzig: Karl W. Hierse-
mann, 1914.
Entries: 40. Millimeters. Inscriptions.
Described. Illustrated (selection). Lo-
cated. Bibliography for each entry.

[Ge.] nos. 985–1015.
Entries: 31 (single-sheet woodcuts
only). Described. Illustrated. Located.

Penel, [Louis] Félix *(fl. 1853–1877)*
[Ber.] X, pp. 257–258.*

Penel, Jules *(b. 1833)*
[Ber.] X, p. 258.*

Penet, Lucien François *(1834–1901)*
[Ber.] X, p. 258.*

Penguilly-L'Haridon, Octave *(1811–1870)*
[Ber.] X, p. 259.*

Penna, Agostino *(fl. 1827–1846)*
[Ap.] p. 326.
Entries: 1.*

Pennacchi, Girolamo [called "Girolamo da
Treviso"]
[P.] VI: *See* **Chiaroscuro Woodcuts**

Pennautier, Amédée, comte de
(fl. 1837–1843)
[Ber.] X, p. 259.*

Pennell, Joseph *(1860–1926)*
[Ber.] X, pp. 259–260.*

"A tentative catalogue of the etchings
and lithographs of Joseph Pennell."
Unpublished ms., 1914. (NN)
Entries: 215.

Print Club of Philadelphia. *Memorial
exhibition of the works of the late Joseph
Pennell, held under the auspices of the
Philadelphia Print Club and the Pennsyl-
vania Museum.* Philadelphia, 1926.
Entries: 853 etchings, 410 lithographs.

Wuerth, Louis A. *Catalogue of the etchings of Joseph Pennell.* Boston (Mass.): Little, Brown and Co., 1928. 465 copies. 2d ed. 1931. 425 copies. (MB)
Entries: 854 (etchings only). Inches. Illustrated. Located (selection).

Wuerth, Louis A. *Catalogue of the lithographs of Joseph Pennell.* Boston (Mass.): Little, Brown and Co., 1931. 425 copies. (MB)
Entries: 621. Inches. Illustrated. Located (selection).

Penni, Luca *(d. 1556)*
[B.] XII: See **Chiaroscuro Woodcuts**

Pensée, Charles François Joseph *(1799–1871)*
[Ber.] X, p. 260.*

Pepyn, Marten *(1575–1643)*
[W.] II, pp. 316–317.
Entries: 1 print after.*

Péquegnot, Auguste *(1819–1878)*
[Ber.] X, pp. 260–261.
Entries: 17 (original etchings only).

Perdoux, Joseph *(b. 1759)*
[Ber.] X, p. 262.*

Perée, Jacques Louis *(b. 1769)*
[Ber.] X, p. 262.*

Peregrino da Cesena *(16th cent.)*
See also **Monogram P** [Nagler, *Mon.*] IV, no. 2728

[B.] XIII, pp. 205–211.
Entries: 10. Pre-metric. Inscriptions. Described.

[P.] V, pp. 205–220.
Entries: 73 prints by, 5 doubtful prints. Pre-metric. Inscriptions. States. Described. Located (selection). Copies mentioned.

Pérèse, Léon *(19th cent.)*
[Ber.] X, p. 262.*

Perez, Henri *(c.1635–1671)*
[W.] II, p. 317.
Entries: 1 print after.*

Perfetti, Antonio *(1792–1872)*
[Ap.] pp. 326–328.
Entries: 19.*

Perfetti, Elena *(b. 1828)*
[Ap.] p. 328.
Entries: 4.*

Pergolesi, Michelangelo *(18th cent.)*
[Sm.] III, p. 978.
Entries: 1 (portraits only). Inches. Inscriptions. States. Described.

Pérignon, Alexis Nicolas *(1785–1864)*
[Ber.] X, p. 262.*

Perignon, Nicolas *(1726–1782)*
[Baud.] II, pp. 158–178.
Entries: 43. Millimeters. Inscriptions. States. Described.

Perilli, Achille *(b. 1927)*
Le incisione di Achille Perilli. Rome: Edizione Grafica Romero, 1969.
Entries: 44 (1961–1969, complete?). Millimeters. Illustrated.

Périn, Alphonse Henri *(1798–1874)*
[Ber.] X, p. 262.*

Perino del Vaga *(1500–1546/47)*
[B.] XII: See **Chiaroscuro Woodcuts**

Perkins, Joseph *(1788–1842)*
[St.] pp. 419–420.*

Perkois, Jacobus *(1756–1804)*
[W.] II, p. 317.
Entries: 2 prints by, 1 after.*

Perktold, P. P. *(19th cent.)*
[Dus.] p. 184.
　Entries: 5 (lithographs only, to 1821).
　Millimeters. Inscriptions. Located.

Perlet, Pétrus [Pierre Etienne] *(1804–1843)*
[Ber.] X, p. 263.*

Pernot, François Alexandre *(1793–1865)*
[Ber.] X, p. 263.*

Peronard, Melchior *(fl. 1831–1880)*
[Ber.] X, pp. 263–264.*

Peroux, Joseph Nicolaus *(1771–1849)*
[Dus.] pp. 184–185.
　Entries: 2+ (lithographs only, to 1821).
　Millimeters (selection). Inscriptions.
　Located (selection).

Perrassin, Alexis *(fl. 1850–1870)*
[Ber.] X, p. 264.*

Perret, Pieter *(1555–1639)*
[W.] II, p. 318.
　Entries: 28+.*

Perret, Steven *(fl. c.1577)*
[W.] II, p. 318.
　Entries: 1+.*

Perrichon, Georges Léon Alfred *(d. 1907)*
and Paul *(fl. 1866–1870)*
[Ber.] X, p. 264.*

Perrichon, Jules Léon *(1866–1946)*
Pontramier, Pierre. *J. L. Perrichon.* Les
artistes du livre, 24. Paris: Henry Babou,
1933. 750 copies. (NN)
　Bibliography of books with illustra-
　tions by (to 1932).

Perrier, François *(1590–1650)*
[RD.] VI, pp. 159–201; XI, pp. 252–254.
　Entries: 195. Millimeters. Inscriptions.
　States. Described.

[Wess.] IV, p. 62.
　Additional information to [RD.].

Perrier, Guillaume I *(d. 1656)*
[RD.] III, pp. 39–41; XI, pp. 254–256.
　Entries: 7. Pre-metric. Inscriptions.
　Described.

Lex, L., and Martin, P. "Guillaume Per-
rier, peintre et graveur du dix-septième
siècle."[*Réunion Soc. B. A. dép.*] 12th ses-
sion, 1888, pp. 173–187.
　Entries: 9. Inscriptions (selection).

Perrissin, Jean *(c.1536–before 1611)* and
Jacques **Tortorel** *(fl. 1568–1592)*
[RD.] VI, pp. 42–69; XI, pp. 256–281.
　Entries: 42. Millimeters. Inscriptions.
　Described. The catalogue is entirely
　reworked in volume XI. Copies men-
　tioned.

[P.] VI, pp. 264–266.
　Entries: 1 (additional to [RD.]). Paper
　fold measure. Inscriptions. De-
　scribed.

*Nicolas Castellin de Tournay, refugié à
Genève (1564–1576) auteur du receuil de
gravures historiques connu sous le nom de
Perrissin et Tortorel publié à Genève en
1570.* Extract from *La France protestante,*
2d ed., III. Libourne (France): Im-
primerie libournaise, 1881. 100 copies.
(EPBN)
　Entries: 40 prints after. Inscriptions.

Perronneau, Jean Baptiste *(1715–1783)*
Vaillat, Léandre, and Limay, Paul
Ratouis de. *J. B. Perronneau (1715–1783) sa
vie et son oeuvre.* Paris: Frédéric Gittler,
n.d. 2d ed., rev. Paris: G. van Oest et
Cie, 1923.
　Entries: unnumbered, pp. 113–118 (pp.
　159–164 in second edition) prints by
　and after. Inscriptions (selection).

Perrot, Ferdinand Victor *(1808–1841)*
[Ber.] X, p. 264.*

Perrottet, George David *(20th cent.)*
M ———, H. B. *The bookplates of G. D.
Perrottet.* Adelaide (Australia):

Wakefield Press, 1942. 275 copies. (DLC)
Entries: 177 (bookplates only, to 1942).
Described. Illustrated (selection).

Persichini, Raffaello *(b. c.1790)*
[Ap.] pp. 328–329.
Entries: 10.*

Persoy, Pieter *(b. 1668)*
[W.] II, p. 318.
Entries: 1.*

Persson, Karin *(20th cent.)*
Palmgren, Nils. *Karin Persson.* Stock-
holm: Folket i Bilds Konstklub, 1954.
Entries: unnumbered, pp. 30–31, (to
1954). Millimeters. Illustrated (selec-
tion).

Bergquist, Eric. "Karin Persson, en
svensk grafiker och exlibris-konstnär."
[*N. ExT.*] 12 (1960): 40–43.
Entries: 24 (bookplates only, to 1956).
Described. Illustrated (selection).

Persyn, Reinier van *(c.1614–c.1668)*
[W.] II, pp. 318–319.
Entries: 35+.*

Peruzzi, Baldassare Tommaso *(1481–1536)*
[B.] XII: *See* **Chiaroscuro Woodcuts**

Peruzzini, Domenico *(fl. 1640–1660)*
[B.] XXI, pp. 138–148.
Entries: 11 prints by, 1 doubtful print.
Pre-metric. Inscriptions. Described.

Pesne, Antoine *(1683–1757)*
Colombier, Pierre du. "Pesne." In
[Dim.] II, pp. 291–325.
Entries: 16 prints after lost works.

Berckenhagen, Ekhart. Catalogue. In
Antoine Pesne, by Ekhart Berckenhagen
et al. Berlin: Deutscher Verein für
Kunstwissenschaft, 1958.
Catalogue of paintings; prints after
are mentioned where extant. De-
scribed.

Pesne, Jean *(1623–1700)*
[RD.] III, pp. 113–181; XI, pp. 281–288.
Entries: 170. Pre-metric. Inscriptions.
States. Described. Appendix with 2
doubtful prints, 1 not seen by [RD.].

Pestrini, Carlo *(b. c.1780)*
[Ap.] p. 329.
Entries: 2.*

Peter, Edmund *(20th cent.)*
Fogedgaard, Helmer: "Edmund Peter."
[*N. ExT.*] 9 (1957): 90–93.
Entries: 35 (bookplates only, to 1957).
Illustrated (selection).

"Edmund Peter." [*N. ExT.*] 15 (1963): 75.
Entries: 16 (additional to Fogedgaard
1957; to 1962). Illustrated (selection).

Franke, Liselotte. "Edmund Peter fylder
70 År." [*N. ExT.*] 19 (1967): 88–89, 93.
Entries: 24 (bookplates only, addi-
tional to earlier catalogues, to 1967).
Illustrated (selection).

Fogedgaard, Helmer. "Edmund Peter-
IV." [*N. ExT.*] 22 (1970): 53.
Entries: 26 (bookplates only, addi-
tional to earlier catalogues; to 1970).
Illustrated (selection).

Riis, Kaj Welsch. *En dansk tegner og maler;
Edmund Peter.* Frederikshavn (Den-
mark): Exlibristen, 1971. 200 copies.
(DLC)
Entries: 104 (bookplates only, to 1971).
Illustrated (selection).

Peter, Leopold von *(fl. c.1817)*
[Dus.] p. 185.
Entries: 2+ (lithographs only, to 1821).
Millimeters. Inscriptions. Located.

Peterdi, Gabor *(b. 1915)*
Brooklyn Museum [Una E. Johnson,
compiler]. *Gabor Peterdi; twenty-five years
of his prints 1934–1959.* New York, 1959.
Entries: 148 (to 1959). Inches. Illus-
trated (selection).

Peterdi, Gabor (*continued*)

Johnson, Una E. *Gabor Peterdi; graphics 1934–1969.* New York: Touchstone Publishers, Ltd., 1970.
 Entries: 282 (to 1969). Inches. Illustrated.*

Peters, Frans Lucas
See **Peters,** Johann Anton de

Peters, Johann Anton de *(1725–1795)*
 [Baud.] II, p. 151.
 Entries: 1. Millimeters. Inscriptions. Described.

 [Merlo] pp. 643–657.
 Entries: 4 prints by, 9 after. Pre-metric (selection). Paper fold measure (selection). Inscriptions (selection). Described (selection). Illustrated (selection).

 [W.] II, p. 321.
 Entries: 1 print by, 1 after.*

Peters, Mathias *(d. 1676)*
 [W.] III, p. 131.
 Entries: 4.*

Peters, Matthew William *(1742–1814)*
 Manners, Victoria. *Matthew William Peters, R.A., his life and work.* London: Connoisseur, 1913.
 Entries: unnumbered, pp. 59–65, prints after. Inches. Inscriptions. States. Described. Illustrated (selection).

Petersen, Heinrich Ludwig *(1806–1874)*
 [Ap.] p. 329.
 Entries: 4.*

Pether, William *(1731–c.1795)*
 [Sm.] III, pp. 978–995, and "additions and corrections" section.
 Entries: 50 (portraits only). Inches. Inscriptions. States. Described. Illustrated (selection).

 [Siltzer] p. 362.
 Entries: unnumbered, p. 362. Inscriptions.

 [Ru.] pp. 236–238.
 Entries: 1 (portraits only, additional to [Sm.]). Additional information to [Sm.].

Petit, [Jacques] Louis *(1760–1812)*
 [Ap.] p. 330.
 Entries: 3.*

 [Ber.] X, p. 265.*

Petit, Léonce Justin Alexandre *(1839–1884)*
 [Ber.] X, p. 266.*

Petit, Victor Jean Baptiste *(b. 1817)*
 [Ber.] X, p. 265.*

Petrak, Alois *(b. 1811)*
 [Ap.] p. 330.
 Entries: 12.*

Petrignani, Girolamo
See **Pedrignani**

Petrini, Giuseppe Antonio *(1677–1757/58)*
 [B.] XXI, pp. 320–321.
 Entries: 1. Pre-metric. Inscriptions. Described.

Pettenkofen, August Xaver Karl, Ritter von *(1822–1889)*
 Weixlgärtner, Arpad. *August Pettenkofen.* Vienna (Austria): Gerlach und Wiedling, 1916.
 Entries: 162+. Millimeters. Inscriptions. Described. Located.

Petter, Joris *(fl. c.1640)*
 [W.] II, p. 324.
 Entries: 2.*

Petzsch, Robert *(1827–1895)*
 [Ap.] p. 331.
 Entries: 4.*

Peulot, Julien Antoine *(b. 1827)*
[Ber.] X, p. 266.*

Peyre, Jules *(fl. c.1740)*
[Ber.] X, p. 266.*

Peyron, Jean François Pierre *(1744–1814)*
[Baud.] I, pp. 287–296.
Entries: 10. Millimeters. Inscriptions. States. Described.

[Ber.] X, pp. 266–267.*

Peytavin, Jean Baptiste *(1768–1855)*
[Ber.] X, p. 267.*

Pfeiffer, J. B. *(19th cent.)*
[Dus.] p. 185.
Entries: 1+ (lithographs only, to 1821).

Pflugfelder, Friedrich August
(1809–after 1856)
[Ap.] p. 331.
Entries: 4.*

Pfnor, Rudolf *(1824–1909)*
[Ber.] X, pp. 267–268.*

Pforr, Franz *(1788–1812)*
[Dus.] p. 185.
Entries: 2 (lithographs only, to 1821).
Millimeters. Inscriptions. Located.

Phelippeaux, Antoine *(1767–after 1830)*
[Ber.] X, p. 268.*

Phélippes-Beaulieu, Emmanuel
(1829–1874)
Musée des Beaux-Arts, Nantes. *E. Phélippes-Beaulieux, H. W. Deville, R. Pinard; catalogue de l'oeuvre complet de chaque graveur.* Nantes (France), 1955.
Entries: 117. Millimeters. States. Illustrated (selection).

Phelps, James *(1808–1827)*
[Ap.] p. 331.
Entries: 4.*

Philip, T. *(19th cent.)*
[Siltzer] p. 362.
Entries: unnumbered, p. 362. Inscriptions.

Philipon, Albert *(19th cent.)*
[Ber.] X, pp. 269–270.*

Philipon, Charles *(1802–1862)*
[Ber.] X, pp. 268–269.*

Philippe, David *(fl. c.1664)*
[W.] II, p. 325.
Entries: 1.*

Philippe, Pieter *(c.1635–after 1701)*
[W.] II, p. 326.
Entries: 14.*

Philippsen, ——— *(19th cent.)*
[Dus.] p. 186.
Entries: 2 (lithographs only, to 1821).
Millimeters. Inscriptions. Located.

Philips, Caspar Jacobsz *(1732–1789)*
[W.] II, p. 326.
Entries: 9+.*

Phillery, Anton
See **Liefrinck,** W.

Phillips, Charles *(b. 1737)*
[Sm.] III, pp. 995–998.
Entries: 8 (portraits only). Inches. Inscriptions. States. Described.

[Ru.] p. 238.
Additional information to [Sm.].

Phillips, Charles *(fl. c.1842)*
[St.] p. 420.*

Phillips, Walter J. *(b. 1884)*
Scott, Duncan Campbell. *Walter J. Phillips.* Toronto (Canada): Ryerson Press, 1947.
Entries: 63 wood engravings, 139 color woodcuts, (to 1945). Inches.

Phillisdorf, Filipp von *(1769–1845)*
[Dus.] p. 185.
Entries: 1 (lithographs only, to 1821).
Millimeters. Inscriptions. Located.

Pian, Giovanni Maria de *(1764–1800)*
[AN.] pp. 658–675.
Entries: unnumbered, pp. 664–675.
Millimeters. Inscriptions. Described.

[AN. 1968] p. 176.
Entries: unnumbered, p. 176 (additional to [AN.]). Millimeters (selection). Inscriptions (selection).

Piaud, Antoine Alphée *(fl. 1837–1866)*
[Ber.] X, p. 270.*

Piazzetta, Giovanni Battista *(1682–1754)*
[Vesme] p. 369.
Entries: 1. Millimeters. Inscriptions.
Described.

Pibaraud, ———— *(fl. c.1840)*
[Ber.] X, p. 270.*

Pic de Léopol, Andreas *(1789–after 1860)*
[Ber.] X, pp. 270–271.*

Picart, Bernard *(1673–1733)*
Picart, Bernard. "Catalogue des pièces qui composent l'oeuvre de Bernard Picart, dessinateur et graveur." In *Impostures innocentes ou receuil d'estampes d'après divers peintres* . . . Amsterdam: La Veuve de Bernard Picart, 1734. (EPBN)
Entries: unnumbered, 8 pp.

"L'Oeuvre de Bernard Picart." Unpublished ms., 18th century. (EA)
Entries: unnumbered, 34 pp., prints by and after.

Picart, Bernard. "Catalogue des pièces qui composent l'oeuvre de Bernard Picart dessinateur et graveur." Unpublished ms., 18th century. (EA)

Entries: unnumbered, 12 pp. Arranged chronologically.

Picart, Bernard. "L'Oeuvre de Bernard Picart, dessinateur et graveur." Unpublished ms., 18th century. (EA)
Entries: 1459. Arranged by subject.

[W.] II, pp. 326–328.
Entries: 68+.*

Duportal, J. "Bernard Picart." In [Dim.] I, pp. 365–398.
Entries: 1743 prints by and after.

Picasso, Pablo *(1881–1973)*
Geiser, Bernhard. *Picasso, peintre-graveur; catalogue illustré de l'oeuvre gravé et lithographié 1899–1931.* Bern: Published by the author, 1933. 500 copies. (MB)
Entries: 257 (to 1931). Millimeters. Inscriptions. States. Described. Illustrated. Located (selection).

Pouterman, J. E. "Books illustrated by Pablo Picasso, together with a handlist." *Signature* 14 (May 1940): 10–21.
Bibliography of books with illustrations by (to 1940)

Mourlot, Fernand. *Picasso lithographe.* 4 vols. Monte Carlo (Monaco): André Sauret, 1949–1964.
Entries: 383 (to 1963). Millimeters. States. Described. Illustrated. All states are illustrated.

Bolliger, Hans. *L'Oeuvre gravé de Picasso.* Lausanne (Switzerland): Clairefontaine, 1955.
Bibliography of books with illustrations by (to 1954)

Matarasso, H. *Bibliographie des livres illustrés par Pablo Picasso.* Nice (France): Galerie H. Matarasso, 1956.
Bibliography of books with illustrations by (to 1957).

Horodisch, Abraham. *Pablo Picasso als Buchkunstler; mit einer Bibliographie und 50 Abbildungen.* Frankfurt am Main

(West Germany): Gesellschaft der Bibliophilen, 1957.
Bibliography of books with illustrations by (to 1956).

Horodisch, Abraham. *Picasso as a book artist.* Cleveland (Ohio): World Publishing Company, 1962.
Bibliography of books with illustrations by (to 1961).

Foster, Joseph K. *The posters of Picasso.* New York: Grosset and Dunlap, 1964.
Entries: 48 (to 1964; complete?). Illustrated.

Geiser, Bernhard, and Scheidegger, Alfred. *Picasso peintre-graveur, II: catalogue raisonné de l'oeuvre gravé et des monotypes 1932–1934.* Bern: Kornfeld und Klipstein, 1968. 2000 copies.
Entries: 315 (additional to Geiser 1933; to 1934). Millimeters. Inscriptions. States. Described. Illustrated.

Czwiklitzer, Christophe. *290 Affiches de Pablo Picasso.* Paris, Published by the author, Art-C.C., 1968.
Entries: 53 prints by (posters only, to 1966), 237 posters reproducing works by (to 1968). Millimeters. Described. Illustrated.

Mourlot, Fernand. *Picasso lithographe.* Monte Carlo (Monaco): Editions Sauret, 1970. (Not seen). English ed. *Picasso lithographs.* Boston (Mass.): Boston Book and Art Publisher, 1970.
Entries: 434 (lithographs only, to 1969). Inches. Millimeters. Described. Illustrated.

Bloch, Georges. *Pablo Picasso; catalogue de l'oeuvre gravé et lithographié 1904–1967.* Bern: Kornfeld und Klipstein, 1968. *Pablo Picasso, tome II; catalogue de l'oeuvre gravé 1966–1969.* Bern: Kornfeld und Klipstein, 1971.
Entries: 1854 (all published and some unpublished prints, except monotypes; to 1969). Millimeters. Il-

lustrated. Text in French, English and German. A third volume (1972) deals with multiple ceramic editions.

Piccini, Antonio *(fl. c.1878)*
[Ber.] X, p. 271.*

Piccioni, Matteo *(c.1615–1671)*
[B.] XXI, pp. 158–164.
Entries: 23 prints by, 2 prints not seen by [B.]. Pre-metric. Inscriptions. Described.

Pichard, Émile Pierre *(fl. 1848–1859)*
[Ber.] X, pp. 271–272.*

Pichon, [Pierre] Auguste *(1805–1900)*
[Ber.] X, p. 272.*

Pickaerdt, Pieter *(1668/69–c.1732)*
[W.] II, p. 328.
Entries: 12.*

Pickenoy, Elias Nicolas
See **Elias**

Picot, (François) Édouard *(1786–1868)*
[Ber.] X, p. 272.*

Picot, Victor Marie *(1744–1802)*
[Sm.] III, pp. 998–999.
Entries: 1 (portraits only). Inches. Inscriptions. States. Described. Located (selection).

Picou, Henri Jean *(1784–1865)*
[Ber.] X, p. 273.*

Picou, Robert *(1593–1671)*
[RD.] VI, pp. 154–158; XI, pp. 288–289.
Entries: 7. Millimeters. Inscriptions. States. Described.

Picquenot, Michel *(b. 1747)*
[Ber.] X, p. 272.*

Picquet, Jean *(fl. 1620–1650)*
[CdB.] pp. 27–29.

Picquet, Jean (*continued*)

Entries: 8+. Paper fold measure
(selection). Inscriptions (selection).
Described (selection).

Picquot, Henri (*fl. c.1640*)
[RD.] VI, pp. 240–242; XI, p. 289.
Entries: 3. Millimeters. Inscriptions.
States. Described.

Picquot, Thomas (*fl. c.1636*)
[RD.] VI, pp. 233–239.
Entries: 14. Pre-metric. Inscriptions.
Described.

Pidoux, [Henri Joseph] Auguste
(*1809–1870*)
[Ber.] X, pp. 273–274.*

Pieck, Antoon (*b. 1895*)
Hallema, Anne. "Anton Pieck;
catalogus en beschryving van zyn
prenten en schilderyen." *Nederland* 81,
no. 2 (1929): 1049–1072, 1125–1145, 1277–
1297. Separately published. The Hague:
Kunsthandel "de Poort," 1930.
Entries: 185+ (to 1929). Millimeters. Il-
lustrated (selection).

Piehl, Berta Svensson (*20th cent.*)
Stribokken, ———. "*Fru Berta Svensson
Piehl.*" [N. ExT.] 1 (1946–1947): 29–32.
Entries: unnumbered, pp. 30–31,
(bookplates only, to 1945). Described.
Illustrated (selection).

Piera, P. (*d. 1784*)
[W.] II, p. 329.
Entries: 1 print after.*

Pierdon, François (*1821–1904*)
[Ber.] X, pp. 274–275.*

Pierre, Jean Baptiste Marie (*1713–1789*)
[Baud.] I, pp. 37–58.
Entries: 40. Millimeters. Inscriptions.
States. Described.

Pierron, Jean Antoine (*fl. 1780–1812*)
[Ap.] p. 332.
Entries: 4.*

[Ber.] X, p. 275.*

[L. D.] pp. 69–70.
Entries: 2. Millimeters. Inscriptions.
States. Described. Illustrated (selec-
tion). Incomplete catalogue.*

Pierson, Christoffel (*1631–1714*)
[W.] II, pp. 329–330.
Entries: 3 prints after.*

Pietersz, Dirck (*c.1558–1602*)
[W.] II, p. 320.
Entries: 1 print after.*

Pietersz, Gerrit
See **Sweelinck,** Gerrit Pietersz

Pietri, Pietro Antonio de (*1663–1716*)
[B.] XXI, pp. 289–292.
Entries: 4 prints by, 2 prints not seen
by [B.]. Pre-metric. Inscriptions. De-
scribed.

[Wess.] III, p. 52.
Additional information to [B.].

Pietro di Milano
See **Milan,** Pierre

Piette, Ludovic (*1826–1877*)
[Ber.] X, p. 275.*

Pigal, Edmé Jean (*1798–1872*)
[Ber.] X, pp. 276–278.*

Pigeot, François (*b. 1775*)
[Ap.] p. 332.
Entries: 3.*

[Ber.] X, pp. 278–279.*

Pigeot, [Claude] Hilaire (*fl. 1853–1869*)
[Ber.] X, p. 279.*

Pigeot, L'Aîné, ——— *(fl. c.1837)*
[Ber.] X, p. 279.*

Piggott, Robert *(1795–1887)*
[St.] pp. 420–421.*

[F.] p. 215.*

Piguet, Rodolphe *(1840–1915)*
[Ber.] X, pp. 280–281.
Entries: 27. Paper fold measure (selection). Described (selection).

Piles, Roger de *(1635–1709)*
[RD.] II, pp. 96–97.
Entries: 1. Pre-metric. Inscriptions. States. Described.

Pilgrim, Hubertus von *(20th cent.)*
Städtisches Kunsthaus, Bielefeld. [Wulf Herzogenrath, compiler]. *Hubertus von Pilgrim; Graphik und Plastik.* Bielefeld (West Germany), 1966.
Entries: 60 single prints, 3 sets of prints, (to 1966). Millimeters. Illustrated (selection).

Piliński, Adam *(1810–1887)*
Pilinski, Stanislas ["Un Bibliophile"]. *Adam Pilinski et ses travaux; gravures, dessins, lithographies.* Paris: Labitte, Ém. Paul et Cie, 1890.
Entries: unnumbered, pp. 9–34. Inscriptions (selection). Described (selection).

Pillement, Jean *(1728–1808)*
Pillement, Georges. *Jean Pillement.* Paris: Jacques Haumont, 1945.
Entries: unnumbered, pp. 87–95, prints after.

Pillement, Victor *(1767–1814)*
[Ap.] p. 332.
Entries: 4.*

[Ber.] XI, pp. 5–6.*

Pilliard, Jacques *(1814–1898)*
[Ber.] XI, p. 6.*

Pilotell, Georges *(1844–1918)*
[Ber.] XI, pp. 6–7.*

Piloty, Ferdinand I *(1786–1844)*
[Dus.] pp. 186–187.
Entries: 16+ (lithographs only, to 1821). Millimeters. Inscriptions (selection). Located (selection).

Pils, Isidore Alexandre Augustin *(1813–1875)*
[Ber.] XI, p. 7.*

Pilsen, Frans *(1700–1784)*
[W.] II, p. 330.
Entries: 13.*

Pinard, René *(1883–1938)*
Musée des Beaux-Arts, Nantes. *E. Phélippes-Beaulieux, H. W. Deville, R. Pinard; catalogue de l'oeuvre complet de chaque graveur.* Nantes (France), 1955.
Entries: 87. Millimeters. States. Illustrated (selection).

Pinçon, Adolphe *(1847–1884)*
[Ber.] XI, p. 7.*

Pinelli, Bartolomeo *(1781–1835)*
Amici dei Musei, Rome [Giovanni Incisa della Rochetta, compiler]. *Bartolomeo Pinelli.* Rome, 1956.
Entries: 482 (works in all media, including prints). Inscriptions. Described (selection). Illustrated (selection).

Pingot, Henri Auguste *(fl. 1848–1870)*
[Ber.] XI, p. 7.*

Pingret, Édouard Henri Théophile *(1788–1875)*
[Ber.] XI, pp. 7–8.*

Pino, Marco dal *(c.1525–1587/88)*
[B.] XII: *See* **Chiaroscuro Woodcuts**

Pinque, ———— *(19th cent.)*
[Ber.] XI, p. 8.*

Pinson, Nicolas *(b. 1640)*
[RD.] V, pp. 315–316; XI, pp. 289–290.
Entries: 3. Millimeters (selection). In-
scriptions. Described (selection).

Pinwell, George John *(1842–1875)*
Williamson, George C. *George J. Pinwell
and his works.* London: George Bell and
Sons, 1900.
Entries: unnumbered, pp. 125–141.
Wood engravings after. Arranged by
books and periodicals in which they
appeared; location in periodicals
given; no other description. Ms. notes
(MBMu); additional entries. Ms. note
(MBMu): "very badly collected,
numerous omissions (nearly 100!)."

Piola, Domenico I *(1627–1703)*
[B.] XXI, pp. 149–152.
Entries: 5. Pre-metric. Inscriptions.
Described.

Pioline, ———— *(fl. c.1825)*
[Ber.] XI, p. 8.*

Piot, P. F. J. *(fl. c.1857)*
[Ber.] XI, p. 9.*

Piotti-Pirola, Caterina *(b. 1800)*
[Ap.] p. 333.
Entries: 10.*

Pipard, Charles *(b. 1832)*
[Ber.] XI, p. 9.*

Piranesi, Francesco *(1758–1810)*
*Oeuvres des chevaliers Jean Baptiste et Fran-
çois Piranesi qu'on vend séparément dans la
calcographie des auteurs.* Rome: Im-
primerie Pilucchi Cracas, 1792. (EBM)
Entries: unnumbered, pp. 3–29. In-
cludes prints by both Giovanni Bat-
tista and Francesco Piranesi.

Piranesi, Giovanni Battista *(1720–1778)*
See also **Piranesi,** Francesco

Focillon, Henri. *Giovanni-Battista Pira-
nesi; essai de catalogue raisonné de son
oeuvre.* Paris: Librairie Renouard, Henri
Laurens, 1918. 2d ed. 1928.
Entries: 991. Millimeters. Inscriptions.
Described. Located (selection).

Muñoz, Antonio: *G. B. Piranesi.* Rome:
Bestetti e Tumminelli, 1920. 250 copies.
(EFBN)
Entries: 20+. Illustrated (selection).

Hind, Arthur M. *Giovanni Battista Pira-
nesi; a critical study with a list of his pub-
lished works and detailed catalogues of the
prisons and the views of Rome.* London:
Cotswold Gallery; New York: E. Weyhe,
1922. 500 copies. (MB). Reprint. London:
Holland Press, 1967.
Entries: 153 (*Carceri* and *Vedute di Roma*
only). Inches. Inscriptions. States.
Described. Illustrated (selection). Lo-
cated. Also, bibliography of all Pira-
nesi's published works.

Focillon, Henri. *Giovanni Battista Pira-
nesi; a cura di Maurizio Calvesi e Augusta
Monferini, traduzione di Giuseppe Gug-
lielmi.* Bologna: Alfa, 1967.
Entries: 991. Millimeters. Inscriptions.
Described. Illustrated (selection). Re-
print of Focillon 1918, with additional
notes and bibliography by Augusta
Monferini; abundant illustrations.

Robison, Andrew. "Giovanni Battista
Piranesi; prolegomena to the Princeton
collections." *Princeton University Library
Chronicle* 31, no. 3 (1970): 165–203.
Additional information to Hind and
Focillon.

Piringer, Benedikt *(1780–1826)*
[Ber.] XI, p. 9.*

Pirodon, Eugène Louis *(b. 1824)*
[Ber.] XI, pp. 9–11.*

Pisan, Hélidore Joseph *(1822–1890)*
[Ber.] XI, pp. 11–12.*

Pisante, Francesco *(d. 1889)*
[Ap.] p. 333.
 Entries: 1.*

Piscator, Nicolas Joannis
See **Visscher,** Claes J.

Pisis, Filippo de *(b. 1896)*
Malabotta, Manlio. Catalogue. In *De Pisis; le litografie,* by Giuseppe Marchiori. Verona (Italy): Le Edizoni del Galeone, 1969. 780 copies. (DLC)
 Entries: 56 (to 1969). Millimeters (selection). Described. Illustrated. Dimensions are given for all prints not reproduced actual size.

Malabotta, Manlio. *L'Opera grafica di Filippo De Pisis.* Milan: Edizioni di Communità, 1969.
 Entries: 56 (to 1969). Millimeters. States. Described. Illustrated.

Comune di Verona. [Manlio Malabotta, compiler]. *Mostra dell' opera pittorica e grafica di Filippo de Pisis.* Verona (Italy): Arnoldo Mondatori editore, 1969.
 Entries: 58. Millimeters.

Pissarro, Camille Jacob *(1831–1903)*
[Ber.] XI, pp. 12–14.
 Entries: 74. Paper fold measure.

[Del.] XVII.
 Entries: 194. Millimeters. Inscriptions. States. Described. Illustrated. Located (selection). Appendix with 1 doubtful print.

Cailac, Jean. "The prints of Camille Pissarro; a supplement to the catalogue by Loys Delteil." [*PCQ.*] 19 (1932): 74–86.
 Entries: 2 (additional to [Del.]). Millimeters. Described. Additional information to [Del.].

Pissarro, Lucien *(b. 1863)*
Fern, Alan Maxwell. "The wood-engravings of Lucien Pissarro with a catalogue raisonnée." Dissertation, University of Chicago, 1960. (Microfilm, DLC)
 Entries: 384. Millimeters. Inscriptions. States. Described. Illustrated. Based on a ms. catalogue formerly owned by Orovida Pissarro.

Pissarro, Orovida Camille *(b. 1893)*
Nicholson, C. A. "The etchings of Orovida." [*PCQ.*] 13 (1926): 176–202.
 Entries: 60 (to 1925). Inches. States. Illustrated (selection).

"Supplementary list of etchings and aquatints by Orovida." [*PCQ.*] 27 (1940): 98–105.
 Entries: 24 (additional to Nicholson, to 1939). Inches. States. Illustrated (selection).

Pistolesi, Stefano *(fl. c.1830)*
[Ap.] p. 333.
 Entries: 1.*

Pitau, Nicolas *(1632–1671)*
[W.] II, p. 331.
 Entries: 55.*

Pitschalkin, Andreas *(19th cent.)*
[Ap.] p. 334.
 Entries: 2.*

Pitteri, Marco Alvise *(1702–1786)*
Ravà, Aldo. *Marco Pitteri incisore veneziano.* Florence: Istituto di Edizioni Artistiche, Fratelli Alinari, 1922.
 Entries: 444. Paper fold measure (selection). Inscriptions (selection). Illustrated (selection).

Pittoni, Giovanni Battista *(1520–1583)*
[P.] VI, pp. 169–170.
 Entries: 7+. Paper fold measure. Inscriptions (selection).

Pizzi, Luigi *(1759–1821)*
[Ap.] p. 334.
Entries: 3.*

Place, Francis *(1647–1728)*
[Sm.] III, pp. 999–1004, and "additions and corrections" section.
Entries: 14 (portraits only). Inches. Inscriptions. States. Described. Illustrated (selection). Located (selection).

Hake, Henry M. "Some contemporary records relating to Francis Place, engraver and draughtsman, with a catalogue of his engraved work." *The Walpole Society Annual Volume* 10 (1921–1922): 39–69.
Entries: 116 etchings, 23 mezzotints. Inches. Millimeters. Inscriptions. States. Illustrated (selection).

[Ru.] pp. 239, 495.
Entries: 1 (portraits only, additional to [Sm.]). Inches. Described. Additional information to [Sm.].

Plaes
See **Plas**

Planas, Eusebio *(1833–1897)*
[Ber.] XI, p. 14.*

Planat, Émile
See **Marcelin**

Planer, [Christian Julius] Gustav *(1818–1873)*
[Ap.] pp. 334–335.
Entries: 15.*

Plas, David van der *(1647–1704)*
[W.] II, pp. 331–332.
Entries: 1+ prints by, 9 after.*

Plas, Pieter van der *(c.1647–1708)*
[W.] II, p. 332.
Entries: 3+.*

Plassard, Vincent *(fl. c.1650)*
[RD.] I, p. 197.
Entries: 1. Pre-metric. Inscriptions. Described.

[Wess.] IV, p. 62.
Additional information to [RD.].

Platier, J. *(fl. c.1840)*
[Ber.] XI, pp. 14–15.*

Platt, Charles Adams *(b. 1861)*
Rice, R. A. *A catalogue of the etched work of Charles A. Platt.* New York: De Vinne Press, 1889. 100 copies. (MBMu)
Entries: 109 (original prints only, to 1889). Inches. Inscriptions. States. Described.

[Ber.] XI, pp. 15–16.*

Grolier Club, New York. *Exhibition of the etched work of Charles A. Platt.* New York, 1925.
Entries: 120. Inches. Inscriptions. States. Described (nos. 110–120 only; refers to Rice for other prints). Ms. addition (NN); 2 additional entries.

Sherman, Frederic Fairchild. "The etchings of Charles A. Platt." *Art in America* 22 (1933–1934): 110.
Entries: 7 (additional to Rice). Inches.

Platt, H. *(fl. c.1832)*
[F.] p. 215.*

Plattel, Henri Daniel *(1803–1859)*
[Ber.] XI, p. 17.*

Platte-Montagne
See **Plattenberg**

Plattenberg, Matthieu van *(c.1608–1660)*
[RD.] V, pp. 108–127; XI, p. 207.
Entries: 29. Millimeters. Inscriptions. States. Described. Appendix with 5 doubtful prints.

[W.] II, pp. 332–333.
Entries: unnumbered, p. 333.*

Plattenberg, Nicolas *(1631–1706)*
[RD.] V, pp. 300–314; XI, pp. 207–209.
Entries: 33. Millimeters. Inscriptions.
States. Described.

Platzer, Leopold *(fl. c.1821)*
[Dus.] p. 187.
Entries: 1 (lithographs only, to 1821).
Millimeters. Inscriptions. Located.

Plée, François *(fl. 1827–1835)*
[Ber.] XI, p. 17.*

Plée, Pierre
See **Pelée**

Pleginck, Martin *(16th cent.)*
[B.] IX, pp. 590–594.
Entries: 23. Pre-metric. Inscriptions.
Described.

[Heller] p. 103.
Entries: 1 (additional to [B.]). Pre-
metric. Inscriptions. Described.

[P.] IV, pp. 244–246.
Entries: 30+ (additional to [B.]).
Pre-metric (selection). Paper fold
measure (selection). Inscriptions
(selection). Described (selection). Lo-
cated (selection). Additional informa-
tion to [B.].

[A.] IV, pp. 24–35.
Entries: 59. Pre-metric. Inscriptions.
Described. Appendix with 7 doubtful
and rejected prints.

Plimer, Andrew *(1763–1837)*
Williamson, George C. *Andrew and
Nathaniel Plimer, miniature painters, their
lives and their works.* London: George Bell
and Sons, 1903. 110 copies. (MH)
Entries: 9 prints after. Inscriptions.

Plocher, Jacob J. *(d. 1820)*
[St.] pp. 421–422.*

[F.] p. 216.*

Płoński, Michal *(1778–1812)*
[Ber.] XI, p. 17.*

Ploos van Amstel, [Jacob] Cornelis
(1726–1798)
"Het prentwerk van C. Ploos van
Amstel." *Nieuwe Nederlandsche Jaar-
boeken,* 1768, II, pp. 737–743, 1117–1120;
Nieuwe Nederlandsche Jaarboeken, 1771; II,
pp. 1022–1024.
Entries: 14 (to 1768). Described. The
1771 supplement lists one additional
print and mentions four others which
are not listed.

*Berigten wegens een prentwerk volgens de
nieuwe uitvinding van den heere Cornelis
Ploos van Amstel J. Cz., zo als dezelve, van
tyd tot tyd geplaatst zyn in de Vaderlandsche
Letteroefeningen.* Amsterdam, c.1772.
Not seen.

Alten, F. von. "Cornelis Ploos van
Amstel, Kunstliebhaber und Kup-
ferstecher." [*N. Arch.*] 10 (1864): 1–74.
Separately published. Leipzig: Rudolph
Weigel, 1864.
Entries: 144 prints by, 6 after. Pre-
metric. Inscriptions. Described.

[W.] II, pp. 333–335.
Entries: 112+ prints by, 3 after.*

Huffel, N. G. van. *Cornelis Ploos van
Amstel et ses élèves, essai d'une icono-
graphie; catalogue à prix marqués.* Amster-
dam: R. W. P. de Vries, 1915.
Entries: 177. Millimeters. Inscriptions
(selection). Sale catalogue of a collec-
tion of prints produced by or for Ploos
van Amstel.

Huffel, N. G. van. *Cornelis Ploos van
Amstel Jacob Corneliszoon, en zijn*

Ploos van Amstel, [Jacob] Cornelis (*continued*)

medewerkers en tijdgenooten. Utrecht, 1921.
Entries: 190 prints by Ploos van Amstel and his circle, reproducing old master drawings. Millimeters. Medium of drawing noted. Also, list of free copies and independent prints, unnumbered, pp. 66–71.

Plott, John *(d. 1803)*
[Sm.] III, p. 1004.
Entries: 1 (portraits only).

Plowman, George Taylor *(b. 1869)*
Downes, William Howe. "George T. Plowman's etchings." [*P. Conn.*] 2 (1921–1922): 26–49.
Entries: 102 (to 1921). Inches. States. Illustrated (selection). Different states of the same print are separately numbered.

Plüddemann, Hermann Freihold *(1809–1868)*
[A. 1800] IV, pp. 228–237.
Entries: 6. Millimeters. Inscriptions. States. Described.

Plumier, Pierre Denis *(1688–1721)*
[W.] II, p. 335.
Entries: 1.*

Pò, Pietro del *(1610–1692)*
[B.] XX, pp. 245–257.
Entries: 32 prints by, 5 prints not seen by [B.]. Pre-metric. Inscriptions. States. Described.

Pò, Teresa del *(d. 1716)*
[B.] XX, pp. 258–264.
Entries: 16 prints by, 6 prints not seen by [B.]. Pre-metric. Inscriptions. Described.

Pocci, Franz Graf von *(1807–1876)*
Holland, H. "Franz Graf Pocci als Dich-

ter und Künstler." *Oberbayerisches Archiv für vaterländische Geschichte* 36 (1877): 281–331.
Entries: 521 prints by and photographs of drawings by. Millimeters. Inscriptions. Described (selection).

Dreyer, Aloys. *Franz Pocci, der Dichter, Künstler und Kinderfreund.* Munich: Georg Müller, 1907.
Entries: unnumbered, pp. 202–209. Includes some prints not in H. Holland.

Pocci, Franz. *Das Werk des Künstlers Franz Pocci; ein Verzeichnis seiner Schriften, Kompositionen und graphischen Arbeiten.* Einzelschriften zur Bücher- und Handschriftenkunde, 5. Munich: Horst Stobbe, 1926.
Entries: 724+ (prints by and after, and bibliography of books by or illustrated by). Millimeters (selection). Paper fold measure (selection). Inscriptions (selection). Described (selection).

Podestà, [Giovanni] Andrea *(d. before 1674)*
[B.] XX, pp. 168–173.
Entries: 8. Pre-metric. Inscriptions. Described.

[Heller] p. 103.
Additional information to [B.].

Podestat, E. de *(fl. c.1850)*
[Ber.] XI, pp. 17–18.*

Podiani, ——— *(19th cent.)*
[Ap.] p. 335.
Entries: 1.*

Poel, Albert *(17th cent.)*
[W.] II, p. 335.
Entries: 4.*

Poel, Egbert Lievensz van der *(1621–1664)*
[W.] II, p. 336.
Entries: 2 prints after.*

Poelenburg, Cornelis van *(c.1586–1667)*
[W.] II, pp. 336–338.
　　Entries: 4 prints by, 48+ after.*

Poelenburg, Simon *(b. 1591)*
[W.] II, p. 338.
　　Entries: 2+.*

Pöppelmann, Matthäus Daniel *(1662–1736)*
Heckmann, Hermann. *M. D. Pöppelmann als Zeichner.* Dresden: V. E. B. Verlag der Kunst, 1954.
　　Entries: unnumbered, pp. 106–112, prints after. Millimeters. Inscriptions. Illustrated. Located.

Pötzenhammer, J. *(19th cent.)*
[Dus.] pp. 187–188.
　　Entries: 12+ (lithographs only, to 1821). Millimeters (selection). Inscriptions (selection). Located (selection).

Poilly, François I de *(1622–1693)*
Hecquet, F.. *Catalogue de l'oeuvre de F. de Poilly, graveur ordinaire du roi; avec un extrait de sa vie, où l'on a joint un catalogue des estampes gravées par Jan Wissscher et autres graveurs, d'après les tableaux de Wauvermans.* Paris: Duchesne, 1752. Reprint. Abbéville (France): P. Briez, 1865.
　　Entries: 226. Pre-metric. Inscriptions. Described.

Poilpot, Théophile II *(1848–1915)*
[Ber.] XI, p. 18.*

Point, Armand *(1861–1932)*
[Ber.] XI, p. 18.*

Pointel du Portail, —— *(fl. 1820–1845)*
[Ber.] XI, p. 18.*

Poiré, Emmanuel
See **Caran d'Ache**

Pojalostine, J. *(19th cent.)*
[Ap.] p. 336.
　　Entries: 1.*

Pol, John de *(20th cent.)*
University Art Gallery, State University of New York at Binghamton [Gil Wiliams, compiler]. *John de Pol, a retrospective.* Binghamton (N.Y.), 1969.
　　Entries: 47. Also, list of books and commercial prints, pp. 16–31.

Pola, Hendrik *(1676–1748)*
[W.] II, p. 339.
　　Entries: 2 prints by, 2 after.*

Polke, Sigmar *(b. 1941)*
Block, René, and Vogel, Karl. *Graphik des Kapitalistischen Realismus: . . . Werkverzeichnisse bis 1971.* Berlin: Edition René Block, 1971.
　　Entries: 6 (to 1971). Millimeters. Inscriptions. Described. Illustrated.

Poll, Piet van der *(19th cent.)*
[H. L.] p. 779.
　　Entries: 1. Millimeters. Described.

Pollaiuolo, Antonio *(1433–1498)*
[B.] XIII, pp. 201–204.
　　Entries: 3. Pre-metric. Inscriptions. States. Described.

[P.] V, pp. 49–50.
　　Entries: 1 (additional to [B.]). Premetric. Inscriptions. States. Described. Located (selection). Copies mentioned. Additional information to [B.].

Borenius, Tancred. *Four early Italian engravers.* London: Medici Society, 1923.
　　Entries: 1 print by, 2 after. Millimeters. Inscriptions. States. Described. Illustrated. Located. Copies mentioned.

[Hind] I, pp. 189–196.
　　Entries: 6 prints by and after. Millimeters. Inscriptions. States. Described. Illustrated. Located. Copies mentioned. Watermarks described.

Pollard, James *(1797–1859)*
[Siltzer] pp. 194–224, 362.

Pollard, James (*continued*)

Entries: unnumbered, pp. 213–224, 362, prints by and after. Inches (selection). Inscriptions. States. Illustrated (selection).

Selway, N. C. *The Regency road; the coaching prints of James Pollard.* London: Faber and Faber, 1957.
Entries: 66 prints by and after (coaching scenes only). Inches. Inscriptions. Described. Illustrated.

Selway, N. C. *James Pollard 1792–1867, painter of the age of coaching.* Leigh-on-Sea (England): F. Lewis, 1965.
Entries: unnumbered, pp. 26–61. Inches. Catalogue of 345 paintings by, interspersed with unnumbered list of prints by and after.

Pollard, Robert *(1755–1838)*
See also **Jukes,** Francis, and R. **Pollard**

[Sm.] III, p. 1005.
Entries: 3 (portraits only). Inches. Inscriptions. Described.

[Siltzer] pp. 194–213; 362–363.
Entries: unnumbered, pp. 212–213, 362–363, prints by and after. Inches (selection). Inscriptions. States.

Pollet, A. *(fl. c.1840)*
[Ber.] XI, p. 18.*

Pollet, Victor Florence *(1811–1882)*
[Ap.] p. 336.
Entries: 3.*

[Ber.] XI, pp. 19–21.*

Pomedelli, Giovanni Maria
(1478/79–after 1537)
[B.] XV, pp. 494–495.
Entries: 2. Pre-metric. Inscriptions. Described.

[P.] VI, pp. 147–148.

Entries: 3 (additional to [B.]). Pre-metric. Inscriptions. Described.

[Wess.] III, p. 52.
Entries: 2 (additional to [B.]). Millimeters. Inscriptions. Described. Located.

[Hind] V, pp. 225–226.
Entries: 6. Millimeters. Inscriptions. Described. Illustrated. Located.

Pommer, [Josef] Georg *(b. 1815)*
[Ap.] p. 336.
Entries: 2.*

Pompadour, Jeanne Antoinette d'Etioles, marquise de *(1721–1764)*
La Fizelière, Albert de. "L'Art et les femmes en France; Madame de Pompadour." [*GBA.*] 1st ser. 3 (1859, no. 3): 129–152.
Entries: 70. Inscriptions. Described (selection).

Leturq, J. F. *Notice sur Jacques Guay, graveur sur pierres fines du roi Louis XV . . . et notes sur les oeuvres de gravure en taille-douce et en pierres fines de la marquise de Pompadour.* Paris: J. Bauer, 1873.
Entries: 70. Inscriptions. Described.

Véron, Eugène. "Catalogue des estampes de la marquise de Pompadour." *L'Art* 1 (1875, no. 1): 259–260, 297–300.
Entries: 71.

"Suite d'estampes gravées par Madame la Marquise de Pompadour d'après les pierres gravées de La Guay, Graveur du Roy." Unpublished ms. (PJRo)
Entries: 63. Described. Ms. note: "sent me by Godefroy Mayer, June 10, 1909. H. C. Levis."

Ponce, Nicolas *(1746–1831)*
[Ber.] XI, p. 21.*

[L. D.] pp. 70–73.

Entries: 8. Millimeters. Inscriptions. States. Described. Illustrated (selection). Incomplete catalogue.*

Poncet, Jean Baptiste *(1827–1901)*
[Ber.] XI, pp. 21–22.*

Pond, Arthur *(c.1705–1758)*
Hake, Henry M. "Pond's and Knapton's imitations of drawings."[PCQ.] 9 (1922): 324–349.
Entries: 95. Inches. Inscriptions. States.

Ponheimer, Kilian *(1757–1828)*
[Dus.] p. 188.
Entries: 1 (lithographs only, to 1821). Millimeters. Inscriptions. Located.

Ponthus-Cinier, Antoine *(1812–1885)*
[Ber.] XI, p. 22.*

Pontius, Paulus *(1603–1658)*
[Dut.] V, pp. 269–270.*

[W.] II, pp. 340–343.
Entries: 132+.*

Pool, Juriaen II *(1665?–1745)*
[W.] II, p. 343.
Entries: 3 prints by, 2 after.*

Pool, Matthys *(1670–c.1732)*
[W.] II, pp. 343–344.
Entries: 44+.*

Poorten, Hendrik Jozef Franciscus van der *(1789–1874)*
[H. L.] pp. 781–802.
Entries: 32 etchings, 2 stone engravings, 12 lithographs. Millimeters. Inscriptions. States. Described.

Poortenaar, Jan C. *(b. 1886)*
Vries Jr., R. W. P. de. *Jan Poortenaar en zijn werk.* Naarden (Netherlands): Uitgave in den Toren, n.d.
Bibliography of portfolios of prints by.

Poorter, Willem de *(fl. 1630–1648)*
[W.] II, p. 344.
Entries: 2 prints after.*

Poortermans, J. C. *(1786–1870)*
Jeffreys, M. K. "The elusive lithographer J. C. Poortermans." *Quarterly Bulletin of the South African Library* 5 (1950): 1–10. (NN)
Entries: unnumbered pp. 7–10 (complete?). Described (selection).

Popelin, Claudius Marcel *(1825–1892)*
[Ber.] XI, p. 22.*

Popels, Jan *(fl. 1633–1664)*
[W.] II, p. 345.
Entries: 3+.*

Popp, Heinrich *(1637–1682)*
[A.] V, pp. 225–229.
Entries: 3. Pre-metric. Inscriptions. States. Described.

Poppe, Martin *(fl. c.1567)*
[A.] III, pp. 330–331.
Entries: 1. Pre-metric. Inscriptions. Described.

Porcellis, Jan I *(c.1584–1632)*
[W.] II, pp. 345–346.
Entries: 1+ prints by, 2+ after.*

Pordenone [Giovanni Antonio de Sachis] *(c.1484–1539)*
[B.] XII: *See* **Chiaroscuro Woodcuts**

Porporati, Carlo Antonio *(1741–1816)*
[Ap.] pp. 336–338.
Entries: 14.*

[Vesme] pp. 518–538.
Entries: 31 prints by, 1 doubtful print, 7 prints made under the direction of. Millimeters. Inscriptions. States. Described.

[L. D.] pp. 73–74.

Porporati, Carlo Antonio (*continued*)

Entries: 2. Millimeters. Inscriptions. States. Described. Incomplete catalogue.*

Porreau, Jules (*fl. 1845–1866*)
[Ber.] XI, pp. 22–23.*

Porret, Henri Désiré (*1800–1867*)
[Ber.] XI, pp. 24–31.*

Rolants, Edmond. *Un graveur romantique lillois; Henri Porret 1800–1867.* Extract from *Le Bulletin des séances de la Société des sciences, de l'agriculture et des arts de Lille.* Lille (France): Librairie Émile Raoust, 1930. 100 copies. (NN)
Bibliography of books with illustrations by.

Porretti, Alessandro (*b. 1838*)
[Ap.] p. 338.
Entries: 6.*

Porta, Giuseppe
See **Salviati,** Giuseppe

Portaels, Jan Frans (*1818–1895*)
[H. L.] pp. 780–781.
Entries: 4. Millimeters. Inscriptions. Described.

Portalis, Roger, baron (*b. 1841*)
[Ber.] XI, p. 31.*

Porter, J. (*19th cent.*)
[Siltzer] p. 363.
Entries: unnumbered, p. 363. Inscriptions.

Porter, J. T. (*fl. c.1815*)
[St.] p. 422.*

Portier, [Louis] Adolphe [called "Portier de Beaulieu"] (*1820–1889*)
[Ap.] p. 338.
Entries: 1.*

[Ber.] XI, pp. 31–32.*

Porto, Giovanni Battista del
See **Monogram IB** with the bird [Nagler, *Mon.*] III, no. 1944

Posselwhite, James (*1798–1884*)
[Ap.] pp. 338–339.
Entries: 12.*

[Ber.] XI, pp. 32–33.*

Post, Frans Jansz (*c.1612–1680*)
Larsen, Erik. *Frans Post, interprète du Brésil.* Amsterdam: Colibris editora, 1962. Entries: unnumbered, pp. 268–272, prints after (Brazilian subjects only).

[W.] II, pp. 346–347.
Entries: 1+.*

Post, Karl Borromäus (*1834–1877*)
[Ap.] p. 339.
Entries: 10.*

Post, Pieter Jansz (*1608–1669*)
[W.] II, p. 347.
Entries: 3+ prints after.*

Pot, Hendrik Gerritsz (*c.1585–1657*)
[W.] II, pp. 348–349.
Entries: 3 prints after.*

Potel, —— (*fl. c.1840*)
[Ber.] XI, p. 33.*

Potémont, Adolphe Martial (*1828–1883*)
[Ber.] XI, pp. 33–36.*

Potenzano, Francesco (*d. 1599*)
[B.] XVII, pp. 19–24.
Entries: 3. Pre-metric. Inscriptions. Described.

Poterlet, Henri (*19th cent.*)
[Ber.] XI, p. 37.*

Poterlet, Hippolyte (*1804–1835*)
[Ber.] XI, p. 37.*

Poterlet, Marie Victor (*b. 1811*)
[Ber.] XI, p. 37.*

Pothey, ——— *(d. 1877)*
[Ber.] XI, p. 37.*

Pothoven, Hendrik *(1725–1795)*
[W.] II, p. 349.
Entries: 2 prints by, 5 after.*

Potier, [Antoine] Julien *(1796–1865)*
[Ber.] XI, pp. 37–38.*

Potrelle, Jean Louis *(1788–after 1824)*
[Ber.] XI, pp. 38–39.*

[Ap.] pp. 339–340.
Entries: 7.*

Pott, John *(18th cent.?)*
[Sm.] III, pp. 1005–1006.
Entries: 1 (portraits only). Inches. Inscriptions. Described.

[Ru.] p. 239.
Additional information to [Sm.].

Potter, Paulus *(1625–1654)*
[B.] I, pp. 39–72.
Entries: 18 prints by, 8 rejected prints. Pre-metric. Inscriptions. States. Described. Copies mentioned.

[Weigel] pp. 4–8.
Entries: 2 (additional to [B.]). Pre-metric. Inscriptions. Described.

[Heller] pp. 103–104.
Additional information to [B.].

Westrheene, T. van. *Paulus Potter; sa vie et ses oeuvres.* The Hague: Martinus Nijhoff, 1867.
Entries: 31. Also, list of 88 prints after (titles and engravers' names only). Millimeters. Inscriptions. States. Described.

[Dut.] V, pp. 270–281.
Entries: 20. Millimeters. Inscriptions. States. Described. Appendix with 8 rejected prints.

[W.] II, pp. 349–354.
Entries: 22+ prints by, 48 after.*

Allhusen, E. L. "The etchings of Paul Potter." [PCQ.] 26 (1939): 208–223, 335–347.
Entries: 20. Millimeters. Inscriptions. States. Described. Illustrated. Copies mentioned.

Potter, Pieter Symonsz *(c.1597–1652)*
[W.] II, pp. 354–355.
Entries: 10 prints after.*

Pottey, Jan *(17th cent.)*
[W.] II, p. 355.
Entries: 1.*

Pottin, [Louis Aimé] Henri *(1820–1864)*
[Ber.] XI, p. 39.*

Pougny, Jean
See **Puni,** Ivan

Pound, D. J. *(19th cent.)*
[Ap.] p. 340.
Entries: 2.*

Poupard, James *(fl. 1772–1814)*
[St.] pp. 422–423.*

[F.] p. 216.*

Pourbus, Frans I *(1545–1581)*
[W.] II, pp. 356–357.
Entries: 6 prints after.*

Pourbus, Frans II *(1569–1622)*
[W.] II, pp. 357–359; III, p. 133.
Entries: 12 prints after.*

Pourbus, Pieter Jansz *(c.1510–1584)*
[W.] II, pp. 359–361.
Entries: unnumbered, p. 361, prints after.

Pourvoyeur, Jean François *(fl. 1831–1845)*
[Ber.] XI, p. 39.*

Poussin, Gaspard
See **Dughet**

Poussin, Nicolas *(1594–1665)*

Andresen, A. "Die chalcographischen Nachbildungen der Gemälde und Zeichnungen des Nicolas Poussin." [*N. Arch.*] 9 (1863): 237–362. Separately published. *Nicolaus Poussin, Verzeichniss der nach seinen Gemälden gefertigten gleichzeitigen und späteren Kupferstiche.* Leipzig: Rudolph Weigel, 1863.
 Entries: 468 prints after. Pre-metric. Inscriptions. States. Described. Ms. notes (EBM); additional entries and other information.

[RD.] VI, pp. 202–203.
 Entries: 1. Millimeters. Inscriptions. Described.

Denio, Elisabeth Harriet. *Nicolas Poussin.* Leipzig: Karl W. Hiersemann, 1898.
 Entries: unnumbered, pp. 135–144, prints after.

Wildenstein, Georges. "Les graveurs de Poussin au XVIIe siècle." [*GBA.*] 6th ser. 46 (1955): 77–371. Separately published. Paris: Les Beaux-Arts et Presses Universitaires de France, 1957. 500 copies. (NNMM)
 Entries: 239 prints after, 13 prints perhaps after (to 1700). Inscriptions. States. Described. Illustrated. Copies mentioned. Bibliography for each entry. Concordance with Andresen. Appendix reprinting the earliest catalogue of prints after Poussin [Le Comte].

Bertin-Mourot, Thérèse. Notes. In [*GBA.*] 6th ser. 51 (1958): 366.
 Additional information to Wildenstein.

Damiron, Suzanne. "Un Inventaire manuscrit de l'oeuvre gravé de Poussin." In *Nicolas Poussin, ouvrage publié sous la direction de André Chastel.* vol. II, pp. 11–26. Paris: Centre National de la Recherche Scientifique, 1960.

Inventory of an 18th-century collection of prints after Poussin.

Andresen, A. "Catalogue des graveurs de Poussin par Andresen . . . traduction française abrégée, avec reproductions." [*GBA.*] 6th ser. 60 (1962): 139–202.
 Entries: 468. Illustrated (selection). Abridged translation of Andresen.

Davies, Martin, and Blunt, Anthony. "Some corrections and additions to M. Wildenstein's 'graveurs de Poussin au XVIIe siècle.' "[*GBA.*] 6th ser. 60 (1962): 205–222.
 Additional information to Wildenstein.

Pouwelsz, Claes *(17th cent.)*

[Wess.] II, p. 248.
 Additional information to [Andresen, *Handbuch*].

[W.] II, p. 313.
 Entries: 1.*

Powle, George *(fl. c.1770)*

[Sm.] III, p. 1006.
 Entries: 1 (portraits only). Inches. Inscriptions. States. Described.

[Ru.] p. 240.
 Entries: 1 (portraits only, additional to [Sm.]). Inches. Inscriptions. Described.

Poyet, ——— *(fl. c.1890)*
[Ber.] XI, p. 40.*

Poynot, Gabrielle *(fl. c.1885)*
[Ber.] XI, p. 40.*

Pozier, Clément Anatole *(1847–1879)*
[Ber.] XI, p. 40.*

Pozzati, Rudy *(b. 1925)*
Cleveland Museum of Art [Leona E. Prasse and Louise Richards, compilers].

Work of Rudy Pozzati; catalogue of an exhibition incorporating a check list of prints. Cleveland (Ohio), 1955. 3000 copies.
Entries: 53 (to 1955). Inches. Illustrated (selection). Located (selection).

Geske, Norman A. *Rudy Pozzati; American printmaker.* Lawrence: University Press of Kansas, 1971.
Entries: 195 (to 1968). Inches. Inscriptions. States. Described (selection). Illustrated (selection). Located (selection).

Pozzi, Francesco *(1750–c.1805)*
[Ap.] p. 340.
Entries: 1.*

Pozzoserrato
See **Toeput,** Lodewyk

Pradier, Charles Simon *(1783–1847)*
[Ap.] pp. 340–341.
Entries: 15.*

[Ber.] XI, pp. 40–43.
Entries: 30. Paper fold measure.

Pradier, James *(1790–1852)*
[Ber.] XI, p. 43.*

Praendel, Bruno *(19th cent.)*
[Dus.] p. 188.
Entries: 1 (lithographs only, to 1821).

Praet, Stephan de *(fl. c.1645)*
[W.] II, pp. 361–362.
Entries: 4.*

Pralon, Antoine *(fl. 1865–1882)*
[Ber.] XI, p. 43.*

Prasch, Wenzel Ignaz *(d. 1761)*
[A.] V, pp. 352–353.
Entries: 1. Pre-metric. Inscriptions. Described.

Prat, Jacques *(fl. 1836–1841)*
[Ber.] XI, p. 43.*

Pratt, H. L. *(19th cent.)*
[Siltzer] p. 332.
Entries: unnumbered, p. 332, prints after. Inscriptions.

Preciozi, ——— *(19th cent.)*
[Ber.] XI, p. 43.*

Predhomme, ——— *(fl. c.1840)*
[Ber.] XI, p. 44.*

Preisel, Christoph *(b. 1818)*
[Ap.] p. 341.
Entries: 8.*

Preissig, Vojtěch *(1873–1944)*
Rytíř, Václav. *Vojtěch Preissig; popisný seznam jeho ex libris.* Prague: Václav Rytíř, 1927.
Entries: 33 (bookplates only, to 1927). Millimeters. Inscriptions. States. Described. Illustrated (selection).

Preissler, Georg Martin *(1700–1754)*
Leitschuh, Franz Friedrich. *Die Familie Preisler und Markus Tuscher; ein Beitrag zur Geschichte der Kunst im 17. und 18. Jahrhundert.* Beiträge zur Kunstgeschichte, Neue Folge, 3. Leipzig: Verlag von E. A. Seemann, 1886.
Entries: 61. Inscriptions (selection). States (selection). Described (selection).

Preissler, Johann Georg *(1757–1831)*
[Ap.] p. 342.
Entries: 5.*

Preissler, Valentin Daniel *(1717–1765)*
Leitschuh, Franz Friedrich. *Die Familie Preisler und Marcus Tuscher; ein Beitrag zur Geschichte der Kunst im 17. und 18. Jahrhundert.* Beiträge zur Kunstges-

Preissler, Valentin Daniel (*continued*)

chichte, Neue Folge, 3. Leipzig: Verlag von E. A. Seemann, 1886.
> Entries: 61. Inscriptions (selection). States (selection). Described (selection).

Preller, Friedrich I *(1804–1878)*
Ruland, C. *Die Radierungen Friedrich Prellers.* Weimar (Germany): Hermann Böhlaus Nachfolger, 1904.
> Entries: 27. Millimeters. Inscriptions. States. Described.

Prestel, Johann Gottlieb *(1739–1808)*
[Hüsgen] pp. 410–426.
> Entries: 49+ (including prints by Maria Katharina Prestel). Paper fold measure.

[B.] IX, pp. 576–577.
> Entries: 1. Pre-metric. Inscriptions. Described.

[P.] IV, p. 298.
> Additional information to [B.].

Prestel, [Maria] Katharina *(1747–1794)*
[Hüsgen] pp. 410–426.
> Entries: 49+ (including prints by Johann Gottlieb Prestel). Paper fold measure.

Preston, Margaret *(b. 1883)*
Smith, Sydney Ure. *Margaret Preston's monotypes.* Sydney (Australia): A Ure Smith Publication, [194?]. (NN)
> Entries: unnumbered, pp. 65–67. Illustrated (selection). Located.

Preston, Thomas *(d. 1785)*
[Sm]. III, pp. 1006–1007, and "additions and corrections" section.
> Entries: 3 (portraits only). Inches. Inscriptions. States. Described. Located (selection).

[Ru.] p. 240.
> Additional information to [Sm.].

Preusse, Richard *(b. 1888)*
Fogedgaard, Helmer. "Richard Preusse, 75 årig tysk exlibris kunstner."[*N. ExT.*] 15 (1963): 97–100, 103, 107, 112.
> Entries: 90 (bookplates only, to 1963). Illustrated (selection).

Prevedari, Bernardo *(fl. c.1481)*
[Hind] V, pp. 101–102.
> Entries: 1. Millimeters. Inscriptions. Described. Illustrated. Located.

Prévost, Alexandre Celeste Gabriel *(fl. 1850–1886)*
[Ber.] XI, p. 47.*

Prévost, Jacques *(fl. 1530–1580)*
[B.] XV, pp. 496–497.
> Entries: 4. Pre-metric. Inscriptions. Described.

[RD.] VIII, pp. 1–9.
> Entries: 19. Millimeters. Inscriptions (selection). Described.

[P.] VI, pp. 127–129.
> Entries: 20 (additional to [B.]). Pre-metric. Inscriptions. Described. Additional information to [B.].

[Herbet] IV, pp. 340–341.
> Entries: 3. Millimeters (selection). Inscriptions (selection). Described (selection).

Bourdin, E. "L'Oeuvre de Jacques Prévost, peintre, sculpteur et graveur franc-comtois au XVIe siècle." *Mémoires de la Société d'émulation du Doubs,* 8th ser. 2 (1907): 77–162.
> Entries: 19. Millimeters. Inscriptions. Described. Based on [RD.].

Prévost, Nicolas *(fl. 1636–1641)*
[RD.] III, p. 38; XI, pp. 290–293.
> Entries: 15. Pre-metric. Inscriptions. Described.

Prévost, Zachée *(1797–1861)*
[Ap.] p. 342.

Entries: 5.*

[Ber.] XI, pp. 44–47.*

Prey, J. Z. *(1744/45–1823)*
[W.] II, p. 362.
 Entries: 1 print after.*

Priaz, João Vicente *(d. 1840)*
Soares, Ernesto. *Francisco Bartolozzi e os seus discipulos em Portugal.* Estudos-Nacionais sob a égide do Instituto de Coimbra, 3). Gaia (Portugal): Edições Apolino, 1930.
 Entries: 10+. Millimeters. Inscriptions. Described. Located.

Priem, Eva *(20th cent.)*
Nyholm, Paul. "Eva Priem." [*N. ExT.*] 3 (1949–1950): 79–80.
 Entries: 20 (bookplates only, to 1950). Illustrated (selection).

Priem, Werner von *(fl. c.1659)*
[Merlo] p. 686.*

Prignet, Edmond *(fl. c.1875)*
[Ber.] XI, p. 48.*

Prillieux, Édouard Ernest *(fl. 1849–1877)*
[Ber.] XI, p. 48.*

Primaticcio, Francesco *(1504–1570)*
[B.] XVI, pp. 305–306.
 Entries: 1. Pre-metric. Described.

Dimier, L. *Le Primatice; peintre, sculpteur et architecte des rois de France.* Paris: Ernest Leroux, 1900.
 Entries: 162 prints after. Millimeters. Inscriptions. Described.

[Herbet] IV, pp. 341–344.
 Entries: 1.

[Zerner] p. XLII.
 Entries: 1. Millimeters. Described. Illustrated.

Prins, Johannes Huibert *(1757–1806)*
[H. L.] pp. 802–803.
 Entries: 1. Millimeters. Inscriptions. Described. Incomplete; 13 other prints are mentioned (titles only).

[W.] II, p. 362.
Entries: 10.*

Prinzhofer, August *(1817–1885)*
Rittershausen, Gottfried. *August Prinzhofer; ein osterreichischer Porträt-lithograph.* Vienna (Austria): Walter Krieg, 1962.
 Entries: 329. Paper fold measure (selection). Inscriptions. Described. Illustrated (selection). Located.

Prisse D'Avesnes, ——— *(fl. c.1847)*
[Ber.] XI, p. 48.*

Procaccini, Camillo *(1551?–1629)*
[B.] XVIII, pp. 18–22.
 Entries: 5 prints by, 1 doubtful print. Pre-metric. Inscriptions. States. Described.

Prött, Paul *(20th cent.)*
"Paul Prött." [*Kh.*] 13 (1921): 356–358.
 Entries: 73 (to 1921?). Millimeters. Illustrated (selection).

Progel, Joseph Bonaventura *(d. 1849)*
[Dus.] pp. 188–189.
 Entries: 8 (lithographs only, to 1821). Millimeters. Inscriptions. Described (selection). Located.

Proger, Gilich Kilian *(fl. 1531–1540)*
[B.] IX, pp. 33–37.
 Entries: 9. Pre-metric. Inscriptions. Described. Copies mentioned.

[Heller] p. 104.
 Additional information to [B.].

[P.] IV, pp. 137–138.
 Entries: 8 (additional to [B.]). Pre-metric. Inscriptions. Described. Located.

Proia, Pasquale *(19th cent.)*
 [Ap.] p. 343.
 Entries: 2.*

Pronck, Cornelis *(1691–1759)*
 [W.] II, p. 363.
 Entries: 4 prints after.*

Proost, Johannes *(1882–1947)*
 Museum Boymans, Rotterdam. *Etsen Johannes Proost, 27 Februari 1882–26 Maart 1942.* Rotterdam (Netherlands), 1947.
 Entries: 62. Millimeters. Inscriptions. Described. Illustrated (selection).

Prosch, P. *(19th cent.)*
 [Dus.] p. 189.
 Entries: 1 (lithographs only, to 1821). Paper fold measure. Inscriptions. Described.

Prostele, Joseph *(fl. c.1816)*
 [Dus.] p. 189.
 Entries: 1+ (lithographs only, to 1821).

Prot, —— *(fl. c.1800)*
 [Ber.] XI, p. 48.*

Protais, [Paul] Alexandre *(1826–1890)*
 [Ber.] XI, p. 48.*

Protzen, Otto *(1868–1925)*
 Catalogue in [*Bb.*] (1909): 2389ff. Not seen.

 Roeper, Adalbert. "Otto Protzen und sein Werk." [*Kh.*] 8 (1916): 145–149.
 Entries: 115 (to 1914). Millimeters. States. Described. Illustrated (selection).

Prout, Samuel *(1783–1852)*
 [Ber.] XI, pp. 48–49.*

Providoni, Francesco *(d. c.1697)*
 [B.] XIX, pp. 196–197.
 Entries: 1. Pre-metric. Inscriptions. Described.

Provost, A. *(fl. 1834–1855)*
 [Ber.] XI, p. 50.*

Pruche, Clément *(fl. 1831–1870)*
 [Ber.] XI, pp. 50–52.*

Prucker, Nicolaus
 See **Brucker**

Prud'homme, Hippolyte *(1793–1853)*
 [Ap.] p. 343.
 Entries: 5.*

 [Ber.] XI, p. 52.*

Prud'homme, John Francis Eugene *(1800–1892)*
 [St.] pp. 423–433.*

 [F.] pp. 217–218.*

Prud'hon, Jean *(b. 1778)*
 [Ber.] XI, pp. 53–54.*

Prud'hon, Pierre Paul *(1758–1823)*
 Villot, Fréderic. "Essai d'un catalogue raisonné des gravures et des lithographies exécutées par P. P. Prudhon ou d'après ses compositions par différents artistes." [*Cab. am. ant.*] 3 (1844): 481–509.
 Entries: 123 prints by and after. Inscriptions. States. Described.

 Goncourt, Edmond de. *Catalogue raisonné de l'oeuvre peint, dessiné et gravé de P. P. Prud'hon.* Paris: Rapilly, 1876.
 Entries: 196 prints by and after. Millimeters. Inscriptions. States. Described (selection).

 [Gon.] II, pp. 385–458.
 Entries: unnumbered, p. 451. Inscriptions. States. Described. Also, prints after, unnumbered, pp. 451–458. Described (selection).

 Air, Paul d'. "Prud'hon." [*Bull. des B. A.*] 1 (1883–1884): 8–12, 104–106, 151–160.

Entries: 467 prints by and after. Paper fold measure (selection). Described (selection).

[Ber.] XI, p. 53.
Entries: 5. Paper fold measure.

Guiffrey, Jean. L'Oeuvre de Pierre-Paul Prud'hon." *Archives de l'art français,* n.s. 13 (1924): 1–546.
Catalogue of works in all media. Prints after are mentioned where extant.

Dacier, Émile. "Prud'hon et l'art du livre." *Portique* 2 (1945): 68–82.
Bibliography of books with illustrations by.

Prüssen, Eduard *(b. 1930)*
Visel, Kurt. *Eduard Prüssen, Buchillustrationen und Donkey-Press Drucke.* Bergisch-Gladbach (West Germany): Forum, Cologne: Grafische Werkstatt, Druckerei Gebrüder Kopp, 1970. (ENGM)
Bibliography of books with illustrations by.

Prunaire, [Alphonse] Alfred *(fl. 1867–1900)*
[Ber.] XI, p. 54.*

Puccini, Biagio *(1675–1721)*
[B.] XXI, pp. 333–335.
Entries: 2 prints by, 1 print not seen by [B.]. Pre-metric. Inscriptions. Described.

Pudlich, Robert *(1905–1962)*
Doede, Werner. *Robert Pudlich.* Recklinghausen (West Germany): Aurel Bongers, 1968.
Entries: 26+ (sets of prints only). Millimeters.

Pürkinger, Joseph *(19th cent.)*
[Dus.] p. 189.

Entries: 2 (lithographs only, to 1821). Millimeters (selection). Inscriptions. Located (selection).

Puettmann, Émile *(b. 1921)*
Schwencke, Johan. "Overzichten VII." *Boekcier,* 2d ser. 1 (1946): 33–36.
Entries: unnumbered, p. 36 (bookplates and commercial prints only, to 1946). Millimeters. Described (selection). Illustrated (selection).

Puni, Ivan *(1894–1956)*
Gindertael, R. V. *Pougny, avec une biographie, une bibliographie et une documentation complète sur le peintre et son oeuvre.* Geneva: Pierre Cailler, 1957.
Entries: unnumbered, p. 45.

Berninger, Herman, and Cartier, Jean-Albert. *Pougny; Jean Pougny (Iwan Puni) 1892–1956; catalogue de l'oeuvre I.* Tübingen (West Germany): Ernst Wasmuth, 1972.
Entries: 17 (to 1922). Millimeters. Inscriptions. Described. Illustrated.

Punt, Jan [Johannes] *(1711–1779)*
[W.] II, pp. 364–365.
Entries: 21+.*

Purcell, Richard *(d. 1766)*
[Sm.] III, pp. 1008–1030, and "additions and corrections" section.
Entries: 97 (portraits only). Inches. Inscriptions. States. Described. Illustrated (selection). Located (selection).

[Ru.] pp. 240–246, 495–496.
Entries: 9 (portraits only, additional to [Sm.]). Inches. Inscriptions. States. Described. Additional information to [Sm.].

Purnickl, Richard *(1770–1838)*
[Dus.] pp. 189–190.
Entries: 1 (lithographs only, to 1821). Inscriptions. States. Located.

Purrman, Hans *(b. 1880)*
Paul Cassirer, Berlin. *Sonder-Ausstellung Hans Purrmann. 1918.* Berlin: Paul Cassirer, 1918.
Entries: 22 (to 1918; complete?). Millimeters.

Pfälzische Landesgewerbeanstalt, Kaiserslautern [Wilhelm Weber, compiler]. *Hans Purrmann, das graphische Werk.* Kaiserslautern (West Germany), 1963.
Entries: 107. Millimeters. Inscriptions. States. Described. Illustrated. Located.

Pursell, Henry D. *(fl. 1775–1785)*
[F.] p. 219.*

Puschner, —— *(fl. c.1815)*
[Dus.] p. 190.
Entries: 1 (lithographs only, to 1821). Paper fold measure. Described.

Puttaert, Émile *(d. 1901)*
[H. L.] p. 803.
Entries: 2. Millimeters. Inscriptions. States. Described.

Putter, A. de *(fl. 1719–1733)*
[W.] II, p. 365.
Entries: 1.*

Puvis de Chavannes, Pierre *(1824–1898)*
[Ber.] XI, p. 54.*

Puyplat, Jules Jacques *(fl. 1877–1930)*
[Ber.] XI, p. 54.*

Pyall, H. C. *(fl. c.1833)*
[Siltzer] p. 363.
Entries: unnumbered, p. 363. Inscriptions.

Pye, John II *(1782–1874)*
[Ap.] p. 343.
Entries: 5.*

Pyle, Howard *(1853–1911)*
Morse, Willard S., and Brincklé, Gertrude. *Howard Pyle, a record of his illustrations and writings.* Wilmington (Del.): Wilmington Society of the Fine Arts, 1921. Reprint. Detroit (Mich.): Singing Tree Press, 1969.
Bibliography of books with illustrations by.

Pylman, Hermann *(fl. c.1740?)*
[W.] II, p. 365.
Entries: 1.*

Pynacker, Adam *(1622–1673)*
[Dut.] V, pp. 281–282.
Entries: 1. Millimeters. Inscriptions. Described. Illustrated.

[W.] II, p. 366.
Entries: 2 prints by, 5 after.*

Pynas, Jan Symonsz *(1583/84–1631)*
[W.] II, pp. 366–367.
Entries: 7 prints after.*

Pyne, William Henry *(1769–1843)*
[Siltzer] p. 332.
Entries: unnumbered, p. 332, prints after. Inscriptions.

Q

Quad von Kinkelbach, Matthias *(1557–after 1609)*
See also **Monogram Q** [Nagler, *Mon.*] IV, no. 3452

[Merlo] pp. 687–700.*

Quaglio, Angelo I *(1778–1815)*
[Dus.] pp. 190–191.
Entries: 7 (lithographs only, to 1821). Millimeters. Inscriptions. Described (selection). Located.

Quaglio, Domenico II *(1786–1837)*
[Dus.] pp. 191–195.
Entries: 23+ (lithographs only, to 1821). Millimeters. Inscriptions. Located (selection).

Quaglio, Giovanni [Johann] Maria II *(1772–1813)*
[Dus.] p. 196.
Entries: 3+ (lithographs only, to 1821). Millimeters (selection). Paper fold measure (selection). Inscriptions. Located (selection).

Quaglio, Lorenzo II *(1793–1869)*
[Dus.] pp. 196–198.
Entries: 18+ (lithographs only, to 1821). Millimeters (selection). Inscriptions. Located (selection).

Quaglio, Simon *(1795–1878)*
[Dus.] p. 199.
Entries: 5+ (lithographs only, to 1821). Millimeters (selection). Inscriptions (selection). Located (selection).

Quarante, Lucien *(1859–1902)*
[Ber.] XI, p. 54.*

Quartley, John *(fl. 1835–1867)*
[Ber.] XI, p. 55.*

Quast, Pieter Jansz *(1606–1647)*
[W.] II, pp. 368–369.
Entries: 17+.*

Queborn, Crispyn van den *(1604–1652)*
[W.] II, pp. 369–370.
Entries: 49+.*

Quellinus, Erasmus *(1607–1678)*
[Dut.] V, p. 282.
Entries: 1. Inscriptions. Described.

[W.] II, pp. 370–372.
Entries: 10 prints by, 53 after.*

Quellinus, Hubertus [Huybrecht] *(1619?–1687)*
[W.] II, p. 372.
Entries: 8+ prints by, 1 after.*

Quellinus, Jan Erasmus *(1634–1715)*
[W.] II, pp. 372–373.
Entries: 2+ prints after.*

Quenedey, Edmé *(1756–1830)*
Hennequin, René. *Avant les photographies; les portraits au physionotrace gravés de 1788 à 1830; catalogue nominatif, biographique et critique illustré des deux premières séries de ces portraits.* Troyes (France): J. L. Paton, Imprimeur de la Société Académique de l'Aube, 1932.

Quenedey, Edmé (*continued*)

Entries: 1300 (drawings by and prints by and after, to 1796). Described. Illustrated (selection). Addenda to catalogue, pp. 307–338.

Quertenmont, Andreas Bernardus de *(1750–1835)*
[H. L.] pp. 804–807.
Entries: 11. Millimeters. Inscriptions. States. Described.

Quesnel, Basile *(b. 1813)*
[Ber.] XI, p. 55.*

Quesnel, Désiré Mathieu *(fl. c.1870)*
[Ber.] XI, p. 55.*

Questiers, Catharina *(1631–1669)*
[W.] II, p. 373.
Entries: 2+.*

Quéverdo, Louis Marie Yves *(b. 1788)*
[Ber.] XI, p. 55.*

Queyroy, [Mathurin Louis] Armand *(b. 1830)*
[Ber.] XI, pp. 56–57.*

Quillard, [Pierre] Antoine *(1701–1733)*
Messelet, Jean. "Quillard." In [Dim.] II pp. 341–346.
Entries: 7+. Millimeters (selection).

Quillenbois[Ch. M. De Sarcus] *(fl. c.1840)*
[Ber.] XI, p. 57.*

Quinkhard, Julius *(1736–1776)*
[W.] II, p. 374.
Entries: 4.*

Quiter, Edo Heyndricksz *(d. 1694)*
[W.] II, p. 374.
Entries: 2.*

Quiter, Herman Hendrick I de *(1628–1708)*
[Merlo] pp. 700–703.*

[W.] II, p. 374.
Entries: 17+.*

R

Raab, Doris *(b. 1851)*
[Ap.] p. 344.
Entries: 4.*

Raab, Johann Leonhard *(1825–1899)*
[Ap.] pp. 344–345.
Entries: 25.*

Rabasse, Jean *(fl. c.1650)*
[RD.] VII, pp. 165–168; XI, p. 294.
Entries: 3. Millimeters. Inscriptions. States. Described.

Rabel, Jean *(c.1545–1603)*
[RD.] VIII, pp. 118–139; XI, pp. 294–295.
Entries: 79. Millimeters. Inscriptions. States. Described.

Raben, Servatius
See **Raeven**

Raber, Johann Georg *(1764–c.1830)*
[Ap.] p. 345.
Entries: 3.*

Rabouille, Edmond Achille *(1851–1880)*
[Ber.] XI, p. 57.*

Radcliffe, C. *(fl. 1805–1820)*
[St.] p. 434.*

[F.] p. 219.*

Raddon, William *(fl. 1817–1862)*
[Ap.] pp. 345–346.
Entries: 9.*

Rademaker, Abraham *(1675–1735)*
[W.] II, p. 375.
Entries: 7+.*

Radmannsdorf, Albert Riemensberg,
Edler von *(1802–1860)*
[Dus.] p. 199.
Entries: 1 (lithographs only, to 1821).
Millimeters. Inscriptions. Located.

Rados, Luigi *(1773–1840)*
[Ap.] p. 346.
Entries: 12.*

Raeburn, Henry *(1756–1823)*
Caw, J. L. Catalogue. In *Sir Henry Raeburn,* by Walter Armstrong. London:
William Heinemann, 1901.
Catalogue of paintings; prints after are mentioned where extant.

Raeven, Servatius *(16th cent.)*
[W.] II, p. 377.
Entries: 2.*

Raffaëlli, Jean François *(1850–1924)*
[Ber.] XI, pp. 57–60.
Entries: 14 (to 1890?). Paper fold measure.

Alexandre, Arsène. *Jean François Raffaelli, peintre, graveur et sculpteur.* Paris:
P. Floury, 1909.
Entries: unnumbered, pp. 227–230 (to 1909?). Illustrated (selection).

[Del.] XVI.

Entries: 183. Millimeters. Inscriptions (selection). States. Described (selection). Illustrated. Located (selection).

Raffaellino da Reggio *(c.1550–1578)*
[B.] XII: *See* **Chiaroscuro Woodcuts**

Raffet, [Denis] Auguste Marie *(1804–1860)*
Giacomelli, Hector. *Raffet, son oeuvre lithographique et ses eaux-fortes, suivi de la bibliographie complète des ouvrages illustrés de vignettes d'après ses dessins.* Paris:
Bureaux de la Gazette des Beaux-Arts,
1862.
Entries: 11 etchings by, 782 lithographs by, 69 prints after. Millimeters. Inscriptions. States. Described.
Also, bibliography of books with illustrations by.

"Raffet, son oeuvre lithographique et ses eaux-fortes par H. Giacomelli; notes, additions, rectifications par Auguste Raffet, fils." Unpublished ms. (EPBN)
Additional information to Giacomelli.

[Ber.] XI, pp. 61–149. Separately published. Henri Beraldi. *Raffet.* Paris: Imp.
Drager et Lesieur, n.d. (NN)
Entries: 12 etchings, 1995 other prints, by and after. Based on Giacomelli.

Raffort, Étienne *(1802–1895)*
[Ber.] XI, p. 150.*

Raggio, Tommaso *(b. 1804)*
[Ap.] p. 346.
Entries: 4.*

Ragueneau, Abraham *(1623–after 1681)*
[W.] II, p. 376.
Entries: 2 prints after.*

Rahl, Carl *(1812–1865)*
[Ap.] p. 349.
Entries: 2.*

Rahl, Carl Heinrich *(1779–1843)*
[Ap.] p. 347.
Entries: 35.*

Rahn, Hans Rudolph *(1805–1835)*
[Ap.] p. 349.
 Entries: 7.*

Rahoult, Diodore *(1819–1874)*
[Ber.] XI, p. 150.*

Raimbach, Abraham *(1776–1843)*
[Ap.] p. 350.
 Entries: 12.*

[Ber.] XI, pp. 150–151.*

Raimondi, Carlo *(1809–1883)*
[Ap.] p. 351.
 Entries: 4.*

Raimondi, Marcantonio *(c.1480–1527/34)*
Barnard, John. "A catalogue of the prints engraved by Marco Antonio Raimondi after the designs of Rafaello D'Urbino and others." Unpublished ms., 1750–1781 (London, Christopher Mendez).
 Entries: 285+. Inches. Inscriptions. Described. Copies mentioned.

[B.] XIV, pp. v–xxxii; 3–416.
 Entries: 652 (includes work of Agostino Veneziano, Marco Dente da Ravenna, and anonymous prints). Pre-metric. Inscriptions. States. Described. Copies mentioned.

Armano, Gianantonio. *Catalogo di una insigne collezione di stampe delle rinomatissime e rare incisioni del celebre Marcantonio Raimondi.* Florence: Francesco Cardinali, 1830. (EFU)
 Entries: unnumbered, pp. 1–165. Inscriptions. Described. Catalogue of Armano's own collection.

Nagler, Georg Kaspar. *Leben und Werke des Marco-Antonio Raimondi aus Bologna.* Extract from [Nagler] XIII, pp. 434–507. n.p., 1842.
 Entries: 395. Pre-metric. Inscriptions. States. Described. Copies mentioned.

[Heller] pp. 104–105.
 Additional information to [B.].

[Evans] p. 8.
 Entries: 1 (additional to [B.]). Millimeters. Inscriptions. Described.

[P.] VI, pp. 3–49.
 Entries: 308 (new numbering, revision of [B.]). Pre-metric. Inscriptions (selection). States. Described (selection). Only entries additional to [B.] are fully catalogued.

Lippmann, Friedrich. "Ein Holzschnitt von Marcantonio Raimondi." [*JprK.*] 1 (1880): 270–276.
 Entries: 1 (additional to [B.]). Millimeters. Described. Illustrated.

[Wess.] III, pp. 52–53.
 Entries: 2 (additional to [B.]). Millimeters. Described. Located. Additional information to [B.].

Delaborde, Henri. *Marc-Antoine Raimondi; étude historique et critique suivie d'un catalogue raisonné.* Paris: Librairie de l'Art, 1887.
 Entries: 310 prints by, 49 doubtful prints, 39 rejected prints. Millimeters. Inscriptions. States. Described. Illustrated (selection). Copies mentioned.

Kristeller, Paul. "Ein unbeschriebener Kupferstich von Marcantonio." [*Rep. Kw.*] 31 (1908): 63–65.
 Entries: 1 (additional to Delaborde). Millimeters. Described. Located.

Grünwald, M. "Bisher noch unbekannte Zustände des Blattes 'Faun und Nymphe' von Marc Anton Raimondi (B 325)." [*MGvK.*] 1921, p. 60.
 Additional information to Delaborde.

[Dis. 1927]
 Additional information to [B.].

Davidson, Bernice. "Marcantonio Raimondi; the engravings of his Roman

period." Dissertation, Harvard University, 1954. Unpublished ms. (MH)
Entries: unnumbered, pp. 124–219 (prints by), 220–229 (rejected prints). (Prints from Roman period only). Millimeters. Illustrated. Discussion of style, chronology, attribution of compositions. Refers to [B.] and Delaborde for description of subjects.

Raimondi, Marcantonio, school of
[B.] XV, pp. 3–58.
Entries: 68 (additional to anonymous prints listed under Marcantonio). Pre-metric. Inscriptions. States. Described.

[Wess.] III, p. 53.
Additional information to [B.]

[P.] VI, pp. 74–94.
Entries: 163 (new numbering, revision of [B.]). Pre-metric. Inscriptions (selection). States. Described (selection). Only entries added to [B.] are fully catalogued.

Rainaldi, Carlo *(1611–1691)*
[B.] XX, pp. 230–231.
Entries: 2. Pre-metric. Inscriptions. Described.

Rainaldi, Francesco *(1770–1805)*
[Ap.] p. 351.
Entries: 8.*

Rainer, Arnulf *(b. 1929)*
Breicha, Otto. *Arnulf Rainer; Überdeckungen, mit einem Werkkatalog sämtlicher Radierungen, Lithographien und Siebdrucke 1950–1971.* Oesterreichische Graphiker der Gegenwart, 7. Vienna (Austria): Edition Tusch, 1972. 1200 copies.
Entries: 168 etchings, 85 lithographs, 14 silkscreens, (to 1971). Millimeters. Inscriptions. States. Described. Illustrated.

Rajon, Paul Adolphe *(1842–1888)*
[Ber.] XI, pp. 151–167.
Entries: 184. Paper fold measure.

Ralph, W. *(fl. c.1794)*
[St.] p. 434.*

[F.] pp. 219–220.*

Rambaldi, Carlo Antonio *(1680–1717)*
[B.] XIX, pp. 454–455.
Entries: 1. Pre-metric. Inscriptions. Described.

Ramberg, Johann Heinrich *(1763–1840)*
Hoffmeister, Jacob Christoph Carl. *Johann Heinrich Ramberg in seinen Werken.* Hannover (Germany): Carl Meyer, 1877.
Entries: 337 drawings by and prints by and after. Paper fold measure. Inscriptions. Described.

Forster-Hahn, Franziska. "Johann Heinrich Ramberg als Karikaturist und Satiriker." *Hannoversche Geschichtsblätter,* n.s. 17 (1963): 7–235. Separately published. n.p., 1963.
Entries: 164 prints and drawings by. Millimeters. Inscriptions. Described. Illustrated (selection). Located.

Rambert, Charles *(fl. 1848–1863)*
[Ber.] XI, pp. 167–169.*

Ramboux, Johann Anton *(1790–1866)*
[Merlo] pp. 704–708.*

[Dus.] p. 199.
Entries: 2 (lithographs only, to 1821). Paper fold measure (selection). Inscriptions (selection).

Ramelet, Charles *(1805–1851)*
[Ber.] XI, pp. 169–170.*

Rampoldi, Carlo *(1775–after 1822)*
[Ap.] p. 352.
Entries: 10.*

Ramus, Edmond Joseph *(1822–1890)*
[Ber.] XI, p. 170.*

Randel, F. *(fl. c.1846)*
[Ap.] p. 352.
Entries: 1.*

Randon, Gilbert *(1814–1884)*
[Ber.] XI, pp. 171–173.*

Raneke, Jan *(20th cent.)*
Hedman, Dolf. "Jan Raneke, en svenske heraldiker." [*N. ExT.*] 11 (1959): 120–123.
Entries: 39 (bookplates only, to 1959).
Illustrated (selection).

Ranft, [Albert] Richard *(b. 1862)*
Galerie des Artistes Modernes, Paris.
L'Oeuvre gravée de Richard Ranft . . . préface de Gustave Kahn; exposition . . . 1910.
Paris, n.d. (EPBN)
Entries: 136 prints by and after (complete?).

Ransonnette, Charles Nicolas *(1793–1877)*
[Ber.] XI, p. 173.*

Ransonnette, [Pierre] Nicolas *(1745–1810)*
[Ber.] XI, p. 173.*

Ransson, Peter *(fl. c.1614)*
[Merlo] p. 708.*

Ranvier, [Joseph] Victor *(1832–1896)*
[Ber.] XI, p. 173.*

Raoux, Jean *(1677–1734)*
Bataille, Georges. "Raoux." In [Dim.] II, pp. 267–282.
Entries: 19 prints after lost works.

Raphael [Raffaello Sanzio] *(1483–1520)*
Heinecken, Karl Heinrich von. *Nachrichten von Künstlern und Kunst-Sachen.*
Vol. II, pp. 315–524. Leipzig: Johann Paul Kraus, 1769.

Entries: 512+ prints after. Pre-metric (selection). Inscriptions (selection). Described (selection).

[B.] XII: *See* **Chiaroscuro Woodcuts**

[P.] VI: *See* **Chiaroscuro Woodcuts**

Lepel, Wilhelm Heinrich Ferdinand Karl, Graf von [Tauriscus Euboeus].
Catalogue des estampes gravées d'après Raphael. Frankfurt am Main (Germany): Librairie de Hermann, 1819.
Entries: unnumbered, pp. 33–300, prints after. Pre-metric (selection). Inscriptions. Described.

Quatremère de Quincy, ———. *Istoria della vita e delle opere di Raffaello Sanzio da Urbino.* Milan: Francesco Sonzogno, 1829.
Catalogue of paintings; prints after are mentioned where extant.

Passavant, Johann David. *Rafael von Urbino und sein Vater Giovanni Santi.* 3 vols.
Leipzig: F. A. Brockhaus, 1839, 1858.
Entries: 876 works in all media, with prints after mentioned where extant; 122 additional prints after. Pre-metric (selection). Paper fold measure (selection). Described. 3rd volume contains additional information and a number of additional prints.

Passavant, Johann David. *Raphael d'Urbin et son père Giovanni Santi; édition française refaite, corrigée et considerablement augmentée par l'auteur.* Paris: Veuve Jules Renouard, 1860.
Entries: 934 works in all media, with prints after mentioned where extant; 118 additional prints after. Pre-metric. Described. Extensively revised edition of Passavant 1839; numbering changed.

Rapine, Maximilien *(1840–1905)*
[Ber.] XI, p. 174.*

Rapp, [Gottlob] Heinrich von *(1761–1832)*
[Dus.] pp. 199–201.
　　Entries: 6+ (lithographs only, to 1821).
　　Millimeters. Inscriptions. Located
　　(selection).

Rasch, U. *(fl. c.1819)*
[Dus.] p. 201.
　　Entries: 2 (lithographs only, to 1821).
　　Millimeters. Inscriptions. Described
　　(selection). Located.

Rasières, Théodor *(b. 1602)*
[W.] II, p. 465.
　　Entries: 1 print after.*

Rasmus, Friedrich *(20th cent.)*
Rödel, Klaus. *Friedrich Rasmus exlibris.*
Frederikshavn (Denmark): Klaus Rödel,
1968. 80 copies. (DLC)
　　Entries: 136 (bookplates only, to 1967).
　　Millimeters. Described. Illustrated
　　(selection).

Rass, ——— *(fl. c.1830)*
[Ber.] XI, p. 174.*

Rassenfosse, Armand *(b. 1862)*
Ombiaux, Maurice des. *Quatre artistes
liégeois; A. Rassenfosse, Fr. Maréchal, A.
Donnay, Ém. Berchmans.* Brussels: G. van
Oest et Cie, 1907.
　　Entries: 284 single prints, 24 illus-
　　trated books, 66 commercial prints (to
　　1907). Millimeters. Illustrated (selec-
　　tion).

Rouir, Eugène S. "Catalogue de
l'oeuvre gravé d'Armand Rassenfosse."
2 vols. Unpublished ms. (photostat,
EBr)
　　Entries: 1430. Millimeters. Inscrip-
　　tions. States. Described.

Ratti, Giovanni Agostino *(1699–1775)*
[Vesme] pp. 458–463.

Entries: 22. Millimeters. Inscriptions.
States. Described. Appendix with 1 re-
jected print.

Rauch, Ernst *(b. 1797)*
[Ap.] pp. 352–353.
　　Entries: 4.*

Raunheim, Hermann *(1817–1895)*
[Ber.] XI, pp. 174–175.*

Rausch, [Bernhard] Peter von *(1793–1865)*
[Dus.] pp. 201–202.
　　Entries: 5+ (lithographs only, to 1821).
　　Millimeters (selection). Inscriptions.
　　Located.

Rauschenberg, Robert *(b. 1925)*
Minneapolis Institute of Arts [Edward
A. Foster, compiler]. *Robert Rauschen-
berg; prints 1948/1970.* Minneapolis
(Minn.), 1970.
　　Entries: 155 (to 1970). Inches. States.
　　Described. Illustrated.

Rauscher, [Johann Albrecht] Friedrich
(1754–1808)
[Dus.] p. 202.
　　Entries: 2 (lithographs only, to 1821).
　　Millimeters (selection). Paper fold
　　measure (selection). Inscriptions. Lo-
　　cated.

Rauscher, Karl *(b. 1841)*
[Ap.] p. 353.
　　Entries: 4.*

Rauschmayr, Joseph Peter Paul
(1758–1815)
[Dus.] p. 202.
　　Entries: 2 (lithographs only, to 1821).

Ravano, Francesco *(fl. c.1850)*
[Ap.] p. 353.
　　Entries: 4.*

Ravesteyn, Jan Anthonisz van *(c.1570–1657)*
[W.] II, pp. 379–381.
 Entries: 12 prints after.*

Rawdon, Ralph *(fl. c.1815)*
[Allen] p. 146.*

[St.] pp. 434–436.*

[F.] pp. 220–221.*

Rawdon, Clarke and Co. *(19th cent.)*
[St.] p. 436.*

[F.] p. 221.*

Rawdon, Wright and Co. *(19th cent.)*
[F.] pp. 221–222.*

Rawlins, Thomas *(c.1620–1670)*
[Hind, *Engl.*] III, pp. 273–276.
 Entries: 9. Inches. Inscriptions.
 States. Described. Illustrated (selection). Located.

Rayo, Omar *(b. 1928)*
Oniciu, A. P. *Omar Rayo; prints 1960–1970 grabados.* Bogota (Colombia): Instituto Colombiano de Cultura [1971?].
 Entries: 434 (to 1970). Inches. Millimeters. Illustrated.

Read, David Charles *(1790–1851)*
Read, D. C. *A catalogue of etchings, after his own designs, by D. C. Read.* Salisbury (England): W. B. Brodie and Co., 1832. (EBM)
 Entries: 87 (to 1831). Inches. Catalogue of prints available in 1832? Appendix lists 22 additional "worn and destroyed plates."

Read, Raphael W. "Descriptive catalogue of the etchings, landscapes and portraits, of the late David Charles Read of Salisbury." Unpublished ms., 1874. (EBM)
 Entries: 237. Inches. Inscriptions. Described.

Read, Richard *(c.1745–c.1800)*
[Sm.] III, pp. 1030–1031.
 Entries: 2 (portraits only). Inches. Inscriptions. States. Described.

[Ru.] p. 246.
 Entries: 1 (portraits only, additional to [Sm.]). Inches. Inscriptions. States. Described. Additional information to [Sm.].

Réal, Ferdinand Ulysse *(19th cent.)*
[Ber.] XI, p. 175.*

Reatino
See **Gherardi,** Antonio

Rebel, Jules *(fl. 1840–1851)*
[Ber.] XI, p. 175.*

Rebell, Joseph *(1787–1828)*
Lischke, Hertha. "Joseph Rebell, 1787–1828, Leben und Werk." Dissertation, University of Innsbruck, 1956. Unpublished ms. (carbon copy, EWA)
 Entries: unnumbered, pp. 152–154 (complete?). Inscriptions. Described. Located.

Redig, Laurent Herman *(1822–1861)*
[H. L.] pp. 807–809.
 Entries: 3. Millimeters. Inscriptions. States. Described.

Redlich, Henryk *(1838–1884)*
[Ap.] p. 353.
 Entries: 3.*

[Ber.] XI, p. 175.*

Redon, Odilon [Bertrand] *(1840–1916)*
[Ber.] XI, pp. 176–177.*

Destrée, Jules. *L'Oeuvre lithographique de Odilon Redon.* Brussels: E. Deman, 1891. 75 copies. (NN)
 Entries: 93 (lithographs only, to 1891). Millimeters. Described.

Artz and De Bois. *Odilon Redon; oeuvre graphique complet.* 2 vols. The Hague:

Artz et De Bois, 1913. Simultaneous edition: The Hague: Kunsthandel G. J. Nieuwenhuizen Segaar, 1913.
Entries: 192 prints by and after (prints after are 9 drawings reproduced by the Evely process). Illustrated.

Mellerio, André. *Odilon Redon.* Paris: Société pour l'Étude de la Gravure Française, 1913. Reprint. New York: Da Capo Press, 1968.
Entries: 206 prints by and after (prints after are 9 drawings reproduced by the Evely process). Millimeters. States. Described. Illustrated. Ms. notes (EA); additional states, 1 additional entry. 1968 edition includes 4 additional entries based on Mellerio 1923.

Mellerio, André. *Odilon Redon, peintre, dessinateur et graveur.* Paris: Henri Floury, 1923.
Entries: 210. Millimeters. States. Described (selection). Illustrated (selection).

The graphic works of Odilon Redon; 209 lithographs, etchings and engravings, with an introduction by Alfred Werner. New York: Dover Publications, 1969.
Entries: 209 prints by and after (prints after are drawings reproduced by the Evely process). Millimeters. Illustrated.

Redouté, Pierre Joseph *(1759–1840)*
[Ber.] XI, pp. 177–178.*

Léger, Charles. *Redouté et son temps.* n.p., Éditions de la Galerie Charpentier, 1945. 980 copies. (EPBN)
Entries: unnumbered, pp. 125–146, prints after (color prints only). Illustrated (selection).

Reed, Abner *(1771–1866)*
[St.] pp. 437–439.*

[F.] pp. 222–223.*

Reesbroeck, Jacob van *(1620–1704)*
[W.] II, p. 382.
Entries: 1.*

Reeth, Pierre Jean Baptiste van *(1822–1866)*
[H. L.] pp. 809–812.
Entries: 11+. Millimeters. Inscriptions (selection). Described (selection).

Reeve, R. G. *(fl. 1811–1837)*
[Siltzer] pp. 363–364.
Entries: unnumbered, pp. 363–364. Inscriptions.

Reeve, Thomas *(fl. c.1820)*
[Siltzer] p. 365.
Entries: unnumbered, p. 365. Inscriptions.

Reeve and Hunt *(19th cent.)*
[Siltzer] p. 364.
Entries: unnumbered, p. 364. Inscriptions.

Régamey, Félix Élie *(1844–1907)*
[Ber.] XI, pp. 179–180.*

Régamey, Frédéric *(1849–1925)*
[Ber.] XI, pp. 180–181.*

Régamey, Guillaume Louis Pierre *(1814–1878)*
[Ber.] XI, p. 178.*

Regemorter, Ignatius Josephus van *(1785–1873)*
[H. L.] pp. 812–813.
Entries: 5. Millimeters. Inscriptions. States. Described.

Regnault, Jean Baptiste, baron *(1754–1829)*
[Ber.] XI, p. 181.*

[Baud.] I, pp. 302–304; errata, pp. III–IV.
Entries: 3. Millimeters. Inscriptions. Described.

Regnault, Thomas Casimir *(1823–c.1872)*
[Ber.] XI, pp. 181–184.*

Régnier, Claude *(fl. 1840–1866)*
[Ber.] XI, pp. 184–185.*

Régnier, Isidore Désiré *(19th cent.)*
[Ber.] XI, p. 184.*

Regteren Altena, Mia van *(b. 1914)*
Schwencke, Johan. "Overzichten VIII."
Boekcier, 2d ser. 1 (1946): 41–44.
 Entries: 59 (bookplates only, to 1946).
 Millimeters. Described. Illustrated
 (selection).

Rehberg, Friedrich *(1758–1835)*
[A. 1800] II, pp. 61–88.
 Entries: 72+. Pre-metric. Inscriptions.
 States. Described.

Andresen, Andreas. "Andresens
Nachträge zu seinen 'Deutschen Maler-
radierern.' " [*MGvK.*] 1907: 41.
 Entries: 2 (additional to[A. 1800]). Mil-
 limeters. Inscriptions. Described.

[Dus.] pp. 202–204.
 Entries: 15 (lithographs only, to 1821).
 Millimeters (selection). Inscriptions.
 States. Located (selection).

Rehlen, Wilhelm *(c.1795–1831)*
[Dus.] p. 204.
 Entries: 4+. Millimeters (selection).
 Inscriptions (selection).

Reich, —— *(19th cent.)*
[Dus.] p. 204.
 Entries: 1 (lithographs only, to 1821).
 Millimeters. Inscriptions. Located.

Reich, Jacques *(1852–1923)*
Reich, Jacques. *Etched portraits of famous
Americans and of poets, authors and musi-
cians by Jacques Reich.* New Dorp, Staten
Island (N.Y.): Jacques Reich, n.d.
 Entries: 30. Inches. Inscriptions. De-
 scribed (selection). Ms. addition
 (NN); 78+ additional entries.

Reich, Wilhelm *(fl. 1575–1600)*
[Merlo] pp. 716–718.*

Reiche, F. *(fl. 1795–1800)*
[St.] p. 439.*

[F.] p. 223.*

Reiche, Ludwig von *(1775–1854)*
[Dus.] pp. 204–206.
 Entries: 7+ (lithographs only, to 1821).
 Millimeters (selection). Inscriptions
 (selection). Located (selection).

Reichl, Alois von *(19th cent.)*
[Dus.] pp. 206–207.
 Entries: 12 (lithographs only, to 1821).
 Millimeters (selection). Inscriptions
 (selection). Located (selection).

Reid, Susan Esther *(18th cent.?)*
[Sm.] III, p. 1031.
 Entries: 1 (portraits only). Inches. In-
 scriptions. Described. Located.

Reignier, Jean *(19th cent.)*
[Ber.] XI, p. 185.*

Reimer, Carel Frederik *(d. 1796)*
[W.] II, p. 383.
 Entries: 1.*

Reinagle, Philip *(1749–1833)*
[Sm.] III, pp. 1031–1032.
 Entries: 1 (portraits only). Inches. In-
 scriptions. Described.

[Siltzer] pp. 225–236.
 Entries: unnumbered, pp. 235–236,
 prints after. Inches (selection). In-
 scriptions.

[Ru.] p. 247.
 Additional information to [Sm.].

Reinaud, Marius *(1795–1868)*
[Ber.] XI, p. 185.*

Reindel, Albert Christoph *(1784–1853)*
Andresen, A. "Albert Christoph Reindel, Katalog seiner Kupferstiche." [*N. Arch.*] 12 (1866): 161–188. Separately published: Leipzig: Rudolph Weigel, 1867.
Entries: 82. Pre-metric. Inscriptions. States. Described.

[Ap.] pp. 354–355.
Entries: 14.*

Reinhart, Hermann [Erminio] *(b. 1811)*
[A. 1800] I, pp. 353–354.
Entries: 2. Pre-metric. Inscriptions. States. Described.

Andresen, Andreas. "Andresens Nachträge zu seinen 'Deutschen Maler-radierern.' " [*MGvK.*] 1907, p. 41.
Additional information to [A. 1800].

Reinhart, Johann Christian *(1761–1847)*
[A. 1800] I, pp. 177–352.
Entries: 175. Pre-metric. Inscriptions. States. Described.

Andresen, Andreas. "Andresens Nachträge zu seinen 'Deutschen Maler-radierern.' " [*MGvK.*] 1907, p. 41.
Additional information to [A. 1800].

Reisach, M. *(fl. c.1821)*
[Dus.] p. 207.
Entries: 1 (lithographs only, to 1821).

Reiser, Joseph *(fl. c.1819)*
[Dus.] p. 207.
Entries: 1 (lithographs only, to 1821).
Millimeters. Inscriptions. Located.

Reiter, Bartholomäus *(d. 1622)*
[A.] IV, pp. 299–312.
Entries: 20. Pre-metric. Inscriptions. States. Described.

Rektoržik, Franz Xaver *(1793–1851)*
[A. 1800] IV, pp. 98–136.
Entries: 83. Millimeters. Inscriptions. Described.

Rem, Gaspar *(c.1542–1615/17)*
[W.] II, p. 454.
Entries: 1 print after.*

Rembrandt [Rembrandt Harmensz van Rijn] *(1606–1669)*
Röver, Valerius. "Memorie van het werk van Rembrandt van Rhijn bestaande in 456 prenten door hem zelfs geëtst met alle de veranderingen, zonder eenige bijprinten van andere (na zijn tekeningen of schilderijen gemaakt) in meer als 30 jaaren bij een vergadert, en kosten mij f. 450." Unpublished ms., c.1731 (Amsterdam, Universiteits-Bibliotheek).
See below, Gelder 1938.

Gersaint, Edmé François. *Catalogue raisonné de toutes les pièces qui forment l'oeuvre de Rembrandt, composé par feu m. Gersaint, et mis au jour avec les augmentations nécessaires, par les sieurs Helle et Glomy . . .* Paris: Chez Hochereau l'ainé, 1751.
Entries: 342 prints by, 27 doubtful and rejected prints, 50 prints after. Pre-metric. Inscriptions. States. Described.

Gersaint, Edmé François. *A catalogue and description of the etchings of Rembrandt van Rhyn . . . written originally by the late M. Gersaint, and published by Mess. Helle and Glomy.* London: T. Jefferys, 1752.
Entries: 342 prints by, 27 doubtful and rejected prints, 50 prints after. Inches. Inscriptions. States. Described.

Baalen, Pieter Gerard van. *Catalogus van de weêrgalooze en eenigste volkoome verzameling der printkunst van Rembrandt, met alle haar veranderingen . . . Vergaderd zedert den jaare 1728 . . . door Amade'de Burgy. Welke . . . verkogt zal worden ten zynen huize . . . den 2 Juni 1755, door Pieter Gerard van Balen.* (EBr)

Rembrandt [Rembrandt Harmensz van Rijn] (*continued*)

Entries: 655. Sale catalogue of an outstanding collection of Rembrandt prints.

Yver, Pierre. *Supplement au catalogue raisonné de MM Gersaint, Helle et Glomy de toutes les pièces qui forment l'oeuvre de Rembrandt.* Amsterdam: P. Yver, 1756.
Additional information to Gersaint.

"Catalogus van alle de stukken die het werk van Rembrandt uitmaken, gevolgt naer Gersaint." Unpublished ms. [18th cent.?]. (ERB)

[Daulby] pp. 1–259, 335–339.
Entries: 382 prints by, 48 doubtful and rejected prints. Inches. Inscriptions. States. Described. Also, list of prints after, not consecutively numbered, pp. 263–295. Inches.

[B. *Remb.*] I; II, pp. 94–172.
Entries: 375 prints by, 87 "in the manner of," 88 after. Pre-metric. Inscriptions. States. Described.

Claussin, J., chevalier de. *Catalogue de toutes les estampes qui forment l'oeuvre de Rembrandt et des principales pièces de ses élèves, composé par les sieurs Gersaint, Helle, Glomy et P. Yver; nouvelle édition corrigée et considérablement augmentée.* Paris: Firmin Didot, 1824.
Entries: 365. Pre-metric. Inscriptions. States. Described.

Claussin, J., chevalier de. *Supplement au catalogue de Rembrandt, suivi d'une description des estampes de ses élèves, augmentées de pièces et d'épreuves inédites; on y a joint une description des morceaux qui lui ont été faussement attribués et de ceux des meilleurs graveurs d'après ses tableaux ou dessins,* pp. 1–39. Paris: Firmin Didot, 1828.
Entries: 70 doubtful prints, 25 prints from school of Rembrandt, 129 prints

after. Pre-metric. Inscriptions. States. Described.

[Wilson, Thomas]. *A descriptive catalogue of the prints of Rembrandt by an amateur.* London: J. F. Setchel, Colnaghi and Co. [etc.], 1836.
Entries: 369. Inches. Inscriptions. States. Described.

Brou, Charles de. "L'Oeuvre gravé de Rembrandt; états non décrits (Collection d'Arenberg)." [*RUA.*] 9 (1859): 57–65.
Additional information to [B. *Remb.*] and Claussin.

Blanc, Charles. *L'Oeuvre complet de Rembrandt décrit et commenté . . . catalogue raisonné de toutes les eauxfortes du maître et de ses peintures.* 2 vols. Paris: Gide, 1859, 1861.
Entries: 353. Millimeters. Inscriptions. States. Described. Illustrated (selection). A selection from the catalogue, illustrated with photographs, was published in 1853: *L'Oeuvre de Rembrandt, reproduit par la photographie.* Paris: Gide et J. Baudry, 1853.

Linck, J. F. "Zusammenstellung von Nachträgen und Zusätzen zu Bartsch; catalogue raisonné de l'oeuvre de Rembrandt." [*N. Arch.*] 6 (1860): 31–80.
Additional information to [B. *Remb.*].

Blanc, Charles. *L'Oeuvre de Rembrandt . . . Catalogue raisonné de toutes les estampes du maître et de ses peintures.* Paris: A. Lévy, 1873.
Entries: 353. Millimeters. Inscriptions. States. Described. Illustrated (selection).

Amand-Durand, ———. *Oeuvre de Rembrandt, reproduit et publié.* 4 vols. Paris: Amand-Durand, 1876. (NN)
Entries: 352. Illustrated (reproduced actual size). [B. *Remb.*], Claussin, Wilson, and Blanc numbers are given.

Middleton, Charles Henry. *A descriptive catalogue of the etched work of Rembrandt van Rhyn.* London: John Murray, 1878.
Entries: 329 prints by, 30 rejected prints. Inches. Millimeters. Inscriptions. States. Described. Located.

[Wess.] II, pp. 249–250.
Additional information to [B. *Remb.*] and Blanc.

Blanc, Charles. *L'Oeuvre de Rembrandt, décrit et commenté . . . ouvrage comprenant la reproduction de toutes les estampes du maître.* Paris: A. Quantin, 1880. 500 copies. (NN)
Entries: 353. Millimeters. Inscriptions. States. Described. Illustrated (actual size).

Dutuit, Eugène. *L'Oeuvre complet de Rembrandt.* 2 vols. Paris: A. Lévy, 1883. 500 copies. (EWA)
Entries: 363. Millimeters. Inscriptions. States. Described. Illustrated. Located. Copies mentioned.

[Dut.] V, pp. 283–583, 594b; VI, pp. i–xx.
Entries: 363 prints by, 6 doubtful and 2 rejected prints. Millimeters. Inscriptions. States. Described. Located (selection). Survey of major public and private collections of Rembrandt etchings. Concordance with [B. *Remb.*], Claussin, Wilson, Blanc and Middleton.

Rovinski, Dmitri. *L'Oeuvre gravé de Rembrandt, reproduction des planches originales dans tous leurs états successifs; 1000 phototypies sans retouches, avec un catalogue raisonné.* 4 vols. St. Petersburg: Imprimerie de l'Academie Impériale des Sciences, 1890.
Entries: 395 (includes doubtful and rejected prints). Millimeters. Inscriptions. States. Described. Illustrated (every state). Located (selection). Uses [B. *Remb.*] numbering, with additions from later catalogues.

Seidlitz, Woldemar von. *Kritisches Verzeichnis der Radierungen Rembrandts.* Leipzig: E. A. Seemann, 1895. 2d ed. *Die Radierungen Rembrandts, mit einem kritischen Verzeichnis und Abbildungen sämtlicher Radierungen.* 1922.
Entries: 397 (399 in second edition; includes doubtful and rejected prints). Millimeters (second edition only). Inscriptions. States. Described. Illustrated (second edition only). Uses [B. *Remb.*] numbering, with additions from later catalogues. Chronological table of authentic prints; list of doubtful and rejected prints.

Seidlitz, Woldemar von. "Nachträge zu Rembrandts Radierungen." [*Rep. Kw.*] 22 (1899): 208–219. Supplement. "Neuer Nachträge zu Rembrandts Radierungen." [*Rep. Kw.*] 30 (1907): 231–250, 367–372.
Additional information to Seidlitz 1895.

Dodgson, Campbell. *A complete catalogue of Rembrandt's etchings.* n.p., 1905.
Entries: 260 prints by, 14 doubtful prints, 97 rejected prints. States. Descriptions of states based on Seidlitz.

Hind, Arthur M. "Notizen zu Rembrandt's Radierungen." [*Rep. Kw.*] 28 (1905): 150–155.
Additional information to Rovinski and Seidlitz. Uses [B. *Remb.*] numbering.

Singer, Hans W. *Rembrandt; des Meisters Radierungen in 402 Abbildungen.* Klassiker der Kunst. Stuttgart: Deutsche Verlags-Anstalt, 1906. 2d ed.: *Rembrandt, des Meisters Radierungen in 408 Abbildungen,* 1910.
Entries: 139 prints by, doubtful and rejected prints unnumbered. ([B. *Remb.*] numbers are given); 158 prints are accepted in 1910 edition. Illustrated. Preface defends the drastic re-

Rembrandt [Rembrandt Harmensz van Rijn] (*continued*)

duction of the number of prints attributable to Rembrandt.

Springer, Jaro, and Singer, Hans W. *Rembrandts sämtliche Radierungen in getreuen Nachbildungen herausgegeben.* 2 vols. Munich: Holbein Verlag, n.d. 500 copies. (CLCM)
Entries: 312 (not all accepted as by Rembrandt). States. Illustrated. Descriptions of states based on Seidlitz. Most prints are reproduced actual size.

Six, J. "Gersaints lijst van Rembrandts prenten." [*Oud-Holl.*] 27 (1909): 65–110.
Discussion of Gersaint's catalogue, with reference to the true extent of Rembrandt's etched work.

[W.] II, pp. 383–454.
Entries: 375 prints by, including doubtful and rejected prints (follows numbering of [B. *Remb.*]); prints after, unnumbered, pp. 435–453.*

Hind, Arthur. *Rembrandt's etchings, an essay and a catalogue, with some notes on the drawings.* London: Methuen and Co., Ltd, 1912.
Entries: 303 prints by, 86 rejected prints. Millimeters. Inscriptions. States. Described. Illustrated. Located.

Graul, Richard. *Rembrandt, I Teil, die Radierungen.* Meister der Graphik, 8. Leipzig: Klinkhardt und Biermann, 1920.
Entries: 292. Millimeters. Inscriptions. States. Described (selection). Illustrated. Located. Different states of the same print are separately numbered. Extensive review of earlier catalogues in introduction. Concordance of [B. *Remb.*] with Hind 1912, [Dut.], Middleton, Blanc 1859, Wilson 1836.

Hind, Arthur M. *A catalogue of Rembrandt's etchings; chronologically arranged and completely illustrated.* 2 vols. London: Methuen and Co. Ltd, 1923. Reprint. 2 vols. in 1. New York: Da Capo Press, 1967.
Entries: 303 prints by, 86 rejected prints. Millimeters. Inscriptions. States. Described. Illustrated. Located. Revised edition of Hind 1912.

Charrington, John. *A catalogue of the mezzotints after, or said to be after, Rembrandt.* Cambridge: Cambridge University Press, 1923.
Entries: 190 prints after (mezzotints only). Millimeters. Inscriptions. States. Described. Located.

Coppier, André Charles. *Les eaux-fortes authentiques de Rembrandt.* Paris: Firmin-Didot et Cie, 1929.
Entries: unnumbered, pp. 99–108. Millimeters. Inscriptions. States. Illustrated. Chronologically arranged. 140 of the prints in [B. *Remb.*] are rejected.

Catalogus van de versameling etsen van Rembrandt in het bezit van I. de Bruijn en J. G. de Bruijn-van der Leeuw. The Hague: Martinus Nijhoff, 1932.
Entries: 376 (uses [B. *Remb.*] numbering). Located. Catalogue of a virtually complete collection of Rembrandt's prints. Provenance given for each impression. Anthology of quotations from the chief writers on Rembrandt is given for each print.

Gelder, J. G. van, and Gelder-Schrijver, N. F. van. "De 'Memorie' van Rembrandt's prenten in het bezit van Valerius Röver." [*Oud-Holl.*] 55 (1938): 1–16.
Entries: unnumbered, pp. 10–16. Publication and discussion of a catalogue by Valerius Röver, about 1731, of the Rembrandt etchings owned by him. Described as the earliest oeuvre-catalogue of Rembrandt's prints.

Münz, Ludwig. *A critical catalogue of Rembrandt's etchings and the etchings of his school formerly attributed to the master.* 2 vols. London: Phaidon Press, 1952.
Entries: 279 prints by, 116 doubtful and rejected prints. Millimeters. Inscriptions. States. Described. Illustrated. Located.

Biörklund, George *Rembrandt's etchings, true and false; concordance table.* n.p., 1953. (EBM)
Table showing opinions of previous cataloguers on authenticity of each of Rembrandt's etchings. Reprinted in Biörklund 1955.

Biörklund, George, and Barnard, Osbert H. *Rembrandt's etchings, true and false, a summary catalogue in a distinctive chronological order.* Stockholm: George Biörklund, 1955. 300 copies. 2d ed., 1968. 600 copies. (MH)
Entries: not consecutively numbered, chronologically arranged, Hind, [B. *Remb.*] and Blanc numbering cited. Millimeters. States. Described. Illustrated. Located. Description of states based on Hind, with revisions. Concordance with [B. *Remb.*] and Seidlitz. Appendix with a short review of earlier catalogues. Table showing the opinion of various catalogues as to the authenticity of each print catalogued by [B. *Remb.*] and Seidlitz. Copies mentioned. Additional information in 1968 edition: revisions of dating and states, including late posthumous states; list of copies enlarged; review of earlier catalogues extended to include Nowell-Usticke; concordance with Hind; essay on papers and watermarks.

Boon, Karel G. *Rembrandt; Das graphische Werk.* Vienna: Anton Schroll Verlag, 1963. (other editions in Dutch, English and French)
Entries: 287. Illustrated. Located. Chronologically arranged. Prints reproduced actual size.

Nowell-Usticke, G. W. *Rembrandt's etchings; states and values.* Narberth (Pa): Livingston Publishing Co., 1967.
Entries: 379. (uses [B. *Remb.*] numbering). Inscriptions. States. Described. Illustrated. Located. New and eccentric description of states and estimation of rarity and value. Attempt to classify late (19th and 20th cent.) states of Rembrandt prints. Discussion of defects and repairs in old etchings.

[H. *Neth*] XVII–XVIII. (Catalogue compiled by Christopher White and Karel G. Boon).
Entries: 399 (includes doubtful and rejected prints). Millimeters. Inscriptions. States. Described. Illustrated. Located. Copies mentioned. Reproduction of many variant states, including some not previously reproduced. Concordance with Hind, Münz, and Biörklund. Discussion of papers used for particular impressions.

Remius, Johannes *(fl. c.1600)*
[W.] II, p. 454.
Entries: 1.*

Rémond, [Jean] Charles [Joseph] *(1795–1875)*
[Ber.] XI, p. 186.*

Rems, Gaspar
See **Rem**

Renard, Jules [called "Draner"] *(b. 1833)*
[Ber.] VI, pp. 51–57.*

Renard de Saint-André, Simon *(c.1613–1677)*
[RD.] IV, pp. 17–18.

Renard de Saint-André, Simon *(continued)*

> Entries: 1. Paper fold measure. Inscriptions. Described.

Renesse, Constantijn Daniel à *(1626–1680)*
[Wess.] II, p. 250.
> Entries: 4. Millimeters. Inscriptions. Described.

[Dut.] VI, p. 1.
> Entries: 1. Millimeters. States. Described.

[Rov.] pp. 75–76.
> Entries: 11. Millimeters (selection). Inscriptions (selection). States. Described. Illustrated (selection). Located (selection).

[W.] II, pp. 454–455.
> Entries: 18.*

[ThB.] XXVIII, pp. 160–161.
> Entries: 10 (additional to [W.]). Millimeters (selection). Inscriptions (selection). Described (selection). Additional information to [W.].

Reni, Guido *(1575–1642)*
[B. *Reni*] pp. 7–49.
> Entries: 54 prints by, 30 prints in the manner of. Pre-metric. Inscriptions. States. Described.

[B.] XII, *See* **Chiaroscuro Woodcuts**

[B.] XVIII, p. 277–313.
> Entries: 60 prints by, 8 rejected prints, 35 doubtful prints and prints by anonymous followers. Pre-metric. Inscriptions. States. Described. Copies mentioned.

[P.] VI: *See* **Chiaroscuro Woodcuts**

[Wess.] III, p. 53.
> Additional information to [B.].

Rennenkampf, ——— *(fl. c.1808)*
[Dus.] p. 208.

> Entries: 1 (lithographs only, to 1821). Millimeters. Inscriptions. Located.

Renoir, [Pierre] Auguste *(1841–1919)*
[Del.] XVII.
> Entries: 55. Millimeters. Inscriptions. States. Described. Illustrated. Located (selection).

> Roger-Marx, Claude. *Les lithographies de Renoir.* Monte-Carlo (Monaco): André Sauret, 1951.
> Entries: 31 (lithographs only). Millimeters. Described. Illustrated.

Renouard, [Charles] Paul *(1845–1924)*
[Ber.] XI, pp. 186–189.*

Renouf, Émile *(1845–1894)*
[Ber.] XI, p. 189.*

Renoux, Charles Caïus *(1795–1846)*
[Ber.] XI, pp. 189–190.*

Rensch, [Johann] Friedrich Jakob *(1792–1856)*
[Dus.] p. 208.
> Entries: 2 (lithographs only, to 1821). Millimeters (selection). Paper fold measure (selection). Inscriptions (selection). Located (selection).

Rentinck, Arnout *(1712–1774)*
[W.] II, pp. 455–456.
> Entries: 4.*

Resch, Wolfgang *(fl. 1515–1537)*
[B.] VII, p. 473.
> Entries: 1. Pre-metric. Inscriptions. Described.

[P.] III, pp. 252–253.
> Entries: 4 (revision of [B.]). Pre-metric. Inscriptions. Described. Copies mentioned. Additional information to [B.].

Restout, Jean II *(1692–1768)*
Messelet, Jean. "Jean Restout (1692–1768)." *Archives de l'art français,* n.s. 19 (1935–1937): 99–188.
 Entries: 1 print by, 3+ after. Millimeters (selection). Paper fold measure (selection).

Restout, Jean Bernard *(1732–1797)*
[Baud.] I, pp. 152–156.
 Entries: 5. Millimeters. Inscriptions. Described.

Retberg, Ralf Leopold von *(1812–1885)*
"Copieen Dürer'scher Holzschnitte von R. v. Retberg." [*N. Arch.*] 10 (1864): 283–286; [*N. Arch.*] 11 (1865): 64–68, 265; [*N. Arch.*] 14 (1868): 126.
 Entries: 31 (prints after Dürer woodcuts only). Described.

Rethel, Alfred *(1816–1859)*
[Ber.] XI, p. 190.*

Zoege van Manteuffel, Kurt. *Alfred Rethel; sechzehn Bildtafeln nach seinen Radierungen und Holzschnitten, mit einführendem Text und kritischem Verzeichnis der Bilddrucke Rethels.* Hamburg: Hanseatischer Kunstverlag, 1926.
 Entries: 25 prints by, 93 after. Millimeters. Inscriptions. States. Described. Illustrated (selection). Located (selection).

Retzsch, [Friedrich Auguste] Moritz *(1779–1857)*
Hirschberg, Leopold. *Moritz Retzsch, chronologisches Verzeichniss seiner graphischen Werke.* Berlin: Heinrich Tiedemann, 1925.
 Entries: 478 prints after, 7 doubtful prints. Millimeters. Inscriptions. Described. Located.

Reumert, Emmerik *(20th cent.)*
Fougt, Knud. "Emmerik Reumert." [*N. ExT.*] 4 (1951–1952): 23–25.

Entries: 20 (bookplates only, to 1951). Described (selection). Illustrated (selection).

Reuter, Bartholomäus
See **Reiter**

Reuter, Wilhelm *(1768–1834)*
[Dus.] pp. 208–219.
 Entries: 155 (lithographs only, to 1821). Millimeters. Inscriptions. States. Described (selection). Located (selection).

Reutern, Gerhardt Wilhelm von *(1794–1865)*
[A. 1800] III, pp. 222–229.
 Entries: 11. Pre-metric. Inscriptions. Described.

Réveil, [Étienne] Achille *(1800–1851)*
[Ber.] XI, p. 190.*

Revel, Alfred *(d. 1865)*
[Ap.] p. 355.
 Entries: 5.*

[Ber.] XI, p. 191.*

Reverdino, Cesare
See **Reverdy,** Georges

Reverdy, Georges *(fl. 1531–1564)*
[B.] XV, pp. 465–491.
 Entries: 39 prints by, 10 doubtful prints. Pre-metric. Inscriptions. Described.

[Evans] p. 21.
 Entries: 2 (additional to [B.]). Millimeters. Inscriptions. Described.

[P.] VI, pp. 107–117.
 Entries: 52 prints by (new numbering, revision of [B.]), 2 doubtful prints (additional to [B.]). Pre-metric. Inscriptions. States. Described.

Reverdy, Georges (*continued*)

[Wess.] III, pp. 53–54.
Entries: 2 (additional to [B.] and [P.]).
Millimeters. Described. Located. Additional information to [B.] and [P.]).

Baudi di Vesme, Alessandro. "Reverdino incisore cinquecentista." *Maso Finiguerra* 2 (1937): 187–205; *Maso Finiguerra* 3 (1938): 122–155.
Entries: 93. Millimeters. Inscriptions. Described. Illustrated (selection). Located.

Revere, Paul *(1735–1818)*
[Allen] pp. 146–149.*

[St.] pp. 439–446.*

[F.] pp. 223–224.*

Brigham, Clarence S. *Paul Revere's engravings.* Worcester (Mass.): American Antiquarian Society, 1954. 2d ed. New York: Atheneum, 1969.
Entries: 142. Inches. Inscriptions. States. Described. Illustrated. Located (selection). Second edition reproduces more of the prints in color.

Reville, Jean Baptiste *(1767–1825)*
[Ber.] XI, p. 191.*

Rey, Étienne *(1789–1867)*
[Ber.] XI, p. 191.*

Reyher, Robert *(1838–1877)*
[Ap.] pp. 355–356.
Entries: 17.*

Reynier, ——— *(19th cent.)*
[Ber.] XI, p. 191.*

Reynolds, Frederick *(b. 1882)*
Nelson, W. H. de B. "Frederick Reynolds; an American master of mezzotint." [*P. Conn.*] 1 (1921): 2–23.
Entries: 40 (to 1920). Inches. Illustrated (selection).

Reynolds, Joshua *(1723–1792)*
Richardson, William. *A catalogue of portraits, etc. engraved from pictures painted by Sir Joshua Reynolds, Knt.* London: William Richardson, 1794. (NN)
Entries: unnumbered, pp. 1–24, prints after. Described (selection).

"Prints after Sir Joshua Reynolds." In *A selection of curious articles from the "Gentleman's Magazine."* Vol. IV, pp. 603–633. London: Longman, Hurst, Rees, Orme and Brown, 1809–1811.
Entries, unnumbered, pp. 603–633.

Wheatley, Edmund. *A descriptive catalogue of all the prints with the engravers names and dates, which have been engraved from original portraits and pictures by Sir Joshua Reynolds, P.R.A.* London: E. Wheatley, 1825. (NN)
Entries: unnumbered, pp. 1–58.

Cotton, William. *A catalogue of the portraits painted by Sir Joshua Reynolds, Knt., P.R.A.* London: Longman Brown, Green, Longmans and Roberts, 1857.
Catalogue of paintings; prints after are mentioned where extant. Portraits only.

Hamilton, Edward. *A catalogue raisonné of the engraved works of Sir Joshua Reynolds, P.R.A.; from 1755 to 1820.* London: P. and D. Colnaghi and Co., 1874.
Not seen.

Hamilton, Edward. *A catalogue raisonné of the engraved works of Sir Joshua Reynolds, P.R.A. from 1755 to 1822 . . . new edition, enlarged.* London: P & D Colnaghi and Co., 1884. Reprint. Scripta artis monographia, 15. Amsterdam: G.W. Hissink and Co., 1970.
Entries: unnumbered, pp. 1–160. Inches. Inscriptions. States. Described.

Armstrong, Walter. *Sir Joshua Reynolds, first president of the Royal Academy.* London: William Heinemann, 1900.

Catalogue of paintings; prints after are mentioned where extant.

Complete list of engravings after Sir J. Reynolds, by S. W. Reynolds, engraved about 1830. London: Leggatt Bros., 1911. Entries: unnumbered, 6 pp., prints after (by S. W. Reynolds only).

Reynolds, Nicholas *(fl. c.1577)*
[Hind, *Engl.*] I, p. 99.
Entries: 1. Paper fold measure. Inscriptions. Located.

Reynolds, Samuel William I *(1773–1835)*
[Ber.] XI, pp. 192–194.*

Whitman, Alfred. *Samuel William Reynolds.* London: George Bell and Sons, 1903. 500 copies. (MBMu) Entries: 468. Inches. Inscriptions. States. Described. Ms. notes (ECol); additional states.

Complete list of engravings after Sir J. Reynolds, by S. W. Reynolds, engraved about 1830. London: Leggatt Bros., 1911. Entries: unnumbered, 6 pp., (prints after Sir Joshua Reynolds only).

[Siltzer] p. 365.
Entries: unnumbered, p. 365. Inscriptions.

Reynolds, Samuel William II *(1794–1872)*
Whitman, Alfred. *Samuel William Reynolds.* London: George Bell and Sons, 1903. 500 copies. (MBMu) Entries: 92. Inches. Inscriptions. States. Described. Ms. notes (ECol); additional states.

Reysschoot, Petrus Johannes [called "de Engelschman"] *(1702–1772)*
[W.] II, p. 457.
Entries: 5 prints by, 1 after.*

Reyter, Bartholomäus
See **Reiter**

Rhomberg, Joseph Anton *(1786–1855)*
[Dus.] pp. 219–221.
Entries: 28+ (lithographs only, to 1821). Millimeters. Inscriptions. States. Described (selection). Located (selection).

Riballier, Henri *(fl. 1864–1880)*
[Ber.] XI, p. 194.*

Ribault, Auguste Louis François *(fl. 1831–1865)*
[Ber.] XI, p. 195.*

Ribault, Jean François *(1767–1820)*
[Ap.] p. 356.
Entries: 6.*

[Ber.] XI, pp. 194–195.*

Ribera, Jusepe de *(c.1590–1652)*
[B.] XX, pp. 77–88.
Entries: 18 prints by, 1 doubtful print. Pre-metric. Inscriptions. States. Described.

[Heller] p. 105.
Additional information to [B.].

[Wess.] III, p. 54.
Additional information to [B.]

Ribot, [Augustin] Théodule *(1823–1891)*
[Ber.] XI, pp. 195–196.*

Ricci, Bartolomeo *(b. 1752)*
[AN.] pp. 654–656.
Entries: unnumbered, pp. 655–656. Millimeters. Inscriptions. Described.

[AN. 1968] p. 175.
Entries: unnumbered, p. 175. (additional to [AN.]). Millimeters. Inscriptions.

Ricci, Crescenzio *(b. 1729)*
[AN.] pp. 607–608.
Entries: unnumbered, p. 608. Millimeters. Inscriptions. Described.

Ricci, Filippo *(b. 1727)*
[AN.] pp. 603–606.
　Entries: unnumbered, pp. 605–606.
　Millimeters. Inscriptions. Described
　(selection).

[AN. 1968] pp. 173–174.
　Entries: unnumbered, pp. 173–174
　(additional to [AN.]). Millimeters.
　(selection). Inscriptions.

Ricci, Marco *(1676–1729)*
[B.] XXI, pp. 312–319.
　Entries: 20. Pre-metric. Inscriptions.
　Described.

[Wess.] III, p. 54.
　Additional information to [B.]

[AN.] pp. 474–481.
　Entries: 20. Millimeters. Inscriptions.
　Described.

Pilo, Giuseppe Maria. "Otto nuove ac-
queforti ed altre aggiunte grafiche a
Marco Ricci." *Arte Veneta* 15 (1961): 165–
174.
　Entries: 8 (additional to [AN.]). Mil-
　limeters. Illustrated. Located.

Palazzo Sturm, Bassano del Grappa
[Giuseppe Maria Pilo, compiler]. *Marco
Ricci; catalogo della mostra.* Venice: Ediz-
ioni Alfieri, 1963.
　Entries: 41 (33 prints, some in more
　than one state). Millimeters. Inscrip-
　tions. States (selection). Described. Il-
　lustrated. Located.

Ricciani, Antonio *(1775–1836)*
[Ap.] pp. 357–358.
　Entries: 14.*

Riccio Brusasorci, Giambattista
See **Monogram GR VERONE** [Nagler,
Mon.] III, no. 304

Ricciolini, Niccolò *(b. 1687)*
[Vesme] p. 374.
　Entries: 2. Millimeters. Inscriptions.
　Described.

Richard, Stephen *(19th cent.)*
[Ap.] p. 358.
　Entries: 1.*

Richards, B. *(fl. c.1766)*
[Sm.] III, pp. 1032–1033, and "additions
and corrections" section.
　Entries: 2 (portraits only). Inches. In-
　scriptions. States. Described. Located
　(selection).

[Ru.] p. 247.
　Entries: 1 (portraits only, additional to
　[Sm.]). Inches. Inscriptions. De-
　scribed. Additional information to
　[Sm.].

Richmond, George *(1809–1896)*
Dodgson, Campbell. "The engravings
of George Richmond and Welby Sher-
man."[PCQ.] 17 (1930): 352–362. "Quar-
terly notes."; [PCQ.] 18 (1931): 199.
　Entries: 3. Inches. Inscriptions.
　States. Described. Illustrated (selec-
　tion). Located.

Richomme, [Joseph] Théodore *(1785–1849)*
[Ap.] pp. 358–360.
　Entries: 21.*

[Ber.] XI, pp. 196–198.*

Richter, [Adrian] Ludwig *(1803–1884)*
Hoff, Johann Friedrich. *Adrian Ludwig
Richter, Maler und Radierer; des Meisters
eigenhändige Radirungen sowie die nach
ihm erschienenen Holzschnitte,
Radirungen, Stiche, Lithographien,
Lichtdrucke und Photographien.* Dresden:
Verlag von J. Heinrich Richter, 1877.
　Entries: 3334 prints by and after. Mil-
　limeters. Inscriptions (selection).
　States. Described (selection).

Singer, Hans W. *Kritische Verzeichnis der
Radierungen von Adrian Ludwig Richter.*
Dresden: Alwin Huhle, 1913.
　Entries: 212 (etchings only). Millime-
　ters. Inscriptions. States. Described.
　Illustrated (selection).

Budde, Karl. *Nachtrag zu Prof. Dr. Hans W. Singers Kritischem Verzeichnis der Radierungen von Adrian Ludwig Richter.* Leipzig: Georg Wigand, 1913.
Entries: 25 (additional to Singer). Millimeters. Inscriptions. States. Described. Additional information to Singer.

Hoff, Johann Friedrich, and Budde, Karl. *Adrian Ludwig Richter, Maler und Radierer, Verzeichnis seines gesamten graphischen Werkes von Joh. Friedr. Hoff. Zweite Auflage von Grund aus neu gearbeitet . . . herausgegeben von Karl Budde.* Freiburg i Br. (Germany): G. Ragoczy's Universitatäts-Buchhandlung, 1922.
Entries: 3588 prints by and after. Millimeters. Inscriptions. States. Described.

Das Ludwig Richter Album, sämtliche Holzschnitte. Munich: Rogner und Bernhard, 1968.
Entries: unnumbered (woodcuts only). Millimeters. Illustrated. Reproduction of all woodcuts listed in Hoff which could be identified.

Richter, Christian I *(d. 1667)*
[A.] V, pp. 59–68.
Entries: 12. Pre-metric. Inscriptions. Described.

Richter, Christoph *(17th cent.)*
[A.] V, pp. 52–58.
Entries: 17. Pre-metric (selection). Paper fold measure (selection). Inscriptions. Described. Christoph Richter is perhaps identical with Christian Richter.

Richter, Gerhard *(b. 1932)*
Museum Folkwang, Essen. *Gerhard Richter, Graphik 1965–1970.* Essen (West Germany), 1970.
Entries: 26+ (to 1970). Millimeters. Illustrated.

Block, René, and Vogel, Karl. *Graphik des Kapitalistischen Realismus: . . . Werkverzeichnisse bis 1971.* Berlin: Edition René Block, 1971.
Entries: 28 (to 1971). Millimeters. Inscriptions. Described. Illustrated.

Richter, Hans Theo *(20th cent.)*
Balzer, Wolfgang. *Hans Theo Richter.* Dresden: VEB Verlag der Kunst, 1956.
Entries: 109 (lithographs only, 1948 to 1956). Millimeters. Described. Illustrated (selection).

Deutsche Akademie der Künste, Berlin [Werner Schmidt, compiler]. *Hans Theo Richter.* Berlin, 1962.
Entries: 318 (lithographs only, to 1962?). Millimeters. Described. Illustrated (selection).

Richter, J. *(19th cent.)*
[Ap.] p. 360.
Entries: 2.*

Richter, Wilhelm I *(1626–1702)*
[A.] V, pp. 69–70.
Entries: 2. Paper fold measure. Described.

Ridinger, Johann Elias *(1698–1767)*
Thienemann, Georg August Wilhelm. *Leben und Wirken des unvergleichlichen Thiermalers und Kupferstechers Johann Elias Ridinger, mit dem ausführlichen Verzeichniss seiner Kupferstiche, Schwarzkunstblätter . . .* Leipzig: Rudolph Weigel, 1856. Reprint. Amsterdam: N. Israel, 1962.
Entries: 1313 prints by and after. Pre-metric. Inscriptions. States. Described. Ms. notes (EWA); additional information.

Thienemann, Georg August Wilhelm. ''Nachträge, Zusätze und Berichtigungen zu Leben und Wirken des . . . Johann Elias Ridinger . . . von Georg Aug. Wilh. Thienemann.'' [N.

Ridinger, Johann Elias (*continued*)

Arch.] 5 (1859): 140–161. Separately published. Leipzig: J. B. Hirschfeld, n.d. Additional information to Thienemann 1856.

Thienemann, Georg August Wilhelm. "Zweiter Nachtrag zu; Leben und Wirken Johann Elias Ridingers." [*N. Arch.*] 7–8 (1861–1862): 255–262. Separately published. Leipzig: J. B. Hirschfeld, n.d.
 Entries: 4 (additional to Thienemann 1856). Pre-metric. Inscriptions. States. Described.

Stillfried, Heinrich, Graf. *Dritter Nachtrag zu Georg Aug. Wilh. Thienemann's Leben und Wirken des unvergleichlichen Thiermalers und Kupferstechers Johann Elias Ridinger.* Leipzig: Johann Ambrosius Barth, 1876.
 Entries: 91 (additional to Thienemann 1856, 1859, and 1861–1862). Millimeters. Inscriptions. Described.

Schwarz, Ignaz. *Katalog einer Ridinger-Sammlung.* 2 vols. Vienna: Published by the author, 1910. 202 copies. (MH)
 Entries: 1569 prints by and after. Millimeters. Inscriptions. Described. Illustrated (selection). Located. Prints catalogued by Thienemann are less fully catalogued here than previously undescribed prints.

Ridolfi, Carlo *(1594–1658)*
[Vesme] pp. 16–17.
 Entries: 2. Millimeters. Inscriptions. States. Described. Appendix with 1 doubtful print.

Riedel, [Johann Friedrich Ludwig Heinrich] August *(1799–1883)*
[Dus.] p. 221.
 Entries: 2 (lithographs only, to 1821). Millimeters. Inscriptions. Located.

Rieder, Georg *(d. 1575)*
[A.] II, pp. 215–216.

Entries: 1. Pre-metric. Inscriptions. Described.

Riepenhausen, Franz *(1786–1831)* and Johann *(1788–1860)*
[A. 1800] III, pp. 86–122.
 Entries: 17+. Pre-metric. Inscriptions. States. Described. Also, list of 10 prints after (not fully catalogued).

Riester, Martin *(1819–1883)*
[Ber.] XI, pp. 198–199.*

Riffaut, Adolphe Pierre *(1821–1859)*
[Ber.] XI, pp. 200–201.*

Rigaud, Hyacinthe *(1659–1743)*
Hulst, Henri d'. "Catalogue de l'oeuvre gravé du Sieur Hyacinthe Rigaud." In *Memoires inédits sur la vie et les ouvrages des membres de l'académie royale de peinture et sculpture,* by L. Dussieux. Vol. II, pp. 169–200. Paris: Charavay Frères, 1887.
 Entries: unnumbered, pp. 169–200, prints after. Described.

Soulange-Bodin, H. *Rigaud et ses graveurs.* Paris: Émile Paul, 1914.
 Entries: unnumbered, pp. 13–49, prints after. Millimeters. Located.

Rigaud, Jacques *(c.1681–after 1753)*
Ginoux, Charles. "Jacques Rigaud, dessinateur et graveur marseillais, improprement prénommé Jean ou Jean-Baptiste par quelques écrivains (1681–1754)." [*Réunion Soc. B. A. dép.*] 22d session, 1898, pp. 726–740.
 Entries: 141. Based on [Lebl.].

Rijck, Pieter Cornelisz van *(1568–1628?)*
[W.] II, p. 528.
 Entries: 2 prints after.*

Rijckelijckhuisen, A. Hendrik James *(19th cent.)*
[H. L.] pp. 915–935.

Entries: 66. Millimeters. Inscriptions. States. Described.

Riley, E. *(19th cent.)*
[F.] p. 224.*

Rillaer, Jan van *(d. 1568)*
[B.] VII, p. 545.
Entries: 1. Pre-metric. Inscriptions. Described.

[P.] III, pp. 11–12.
Entries: 4 (additional to [B.]), Pre-metric. Inscriptions. Described. Located.

[W.] II, pp. 458–459.
Entries: 5.*

Kuhn, Alfred. "Jan van Rillaer, der Stadtmaler von Löwen." [*ZbK.*] 26 (1915): 81–89.
Entries: 3 (complete?). Millimeters. Described. Illustrated. Located. 3 other prints, not seen by Kuhn, are mentioned.

[H. *Neth.*] XIII, pp. 105–110.
Entries: 10. Illustrated.*

Ring, Ludger tom *(1496–1547)*
See **Monogram LO** [Nagler, *Mon.*] IV, no. 1231

Rios, Ricardo de los *(1846–1929)*
[Ber.] IX, pp. 191–194.
Entries: 52+.

Riou, Édouard *(1833–1900)*
[Ber.] XI, p. 201.*

Rioult, Louis Édouard *(1790–1855)*
[Ber.] XI, p. 201.*

Ripanda, Jacopo *(fl. 1490–1530)*
See **Monogram IB** with the bird [Nagler, *Mon.*] III, no. 1944

Risse, Eduard *(1808–1875)*
[Merlo] pp. 726–727.*

Rist, Gottfried *(c.1789–1824)*
[Ap.] p. 360.
Entries: 6.*

Ritmeister, E. *(fl. c.1851)*
[H. L.] p. 814.
Entries: 1. Millimeters. Inscriptions. Described.

Ritter, Heinrich Wilhelm *(d. 1856)*
[Ap.] p. 361.
Entries: 6.*

Ritter, Johann Paul Josef *(1779–1813)*
[Merlo] pp. 727–728.*

Ritter, Lorenz *(1832–1921)*
Roeper, Adalbert. "Zum 75. Geburtstage Lorenz Ritters." [*Bb.*] 74, no. 276 (27 November 1907): 12820–12823. Separately bound copy. (NN)
Entries: 68 (to 1900). States.

Rivalz, Antoine *(1667–1735)*
[RD.] I, p. 271–276; XI, p. 295–297.
Entries: 9. Pre-metric. Inscriptions. Described.

Vienne, Henri. *L'Oeuvre gravé d'Antoine Rivalz, 1667–1735.* Extract from *La Revue de Toulouse,* November 1886. Toulouse (France): Bonnal et Gibrac, 1866. (EPBN)
Entries: 21. Millimeters. Inscriptions. Described.

Rivera, Giovanni *(c.1776–1861)*
[Ap.] pp. 361–362.
Entries: 8.*

Rivière, Henri *(b. 1864)*
[Ber.] XI, p. 201.*

Toudouze, Georges. *Henri Rivière, peintre et imagier.* Paris: Henri Floury, 1907. 1100 copies. (MH)
Entries: unnumbered, pp. 159–165 (to 1907). Millimeters. Illustrated (selection).

Rivoalen, Émile *(19th cent.)*
[Ber.] XI, p. 201.*

Rivoulon, Antoine *(1810–1864)*
[Ber.] XI, p. 202.*

Rixdorfer Drucke *(20th cent.)*
Ohff, Heinz, and Ohff, Christiane.
Werkstatt Rixdorfer Drucke, Oeuvre-Verzeichnis. Hamburg: Merlin Verlag,
[1970?].
 Entries: unnumbered, pp. 173–187,
 books and prints published by (to
 1970). Millimeters. Described. Illustrated.

Rixon, Edward *(17th cent.)*
[Sm.] III, pp. 1033–1034.
 Entries: 5 (portraits only). Inches. Inscriptions. States. Described. Located
 (selection).

Robaut, Alfred *(1830–1909)*
[Ber.] XI, pp. 202–203.
 Entries: 229.

Robaut, Félix Fleury *(1799–1880)*
[Ber.] XI, p. 202.*

Robbe, Louis *(1806–1887)*
[H. L.] pp. 814–815.
 Entries: 5. Millimeters. Inscriptions.
 States. Described.

Robert, [Anne Philippe] Édouard
(1801–1857)
[Ber.] XI, p. 204.*

Robert, Aurèle *(1805–1871)*
[Ber.] XI, pp. 205–206.*

Robert, Edmond des *(20th cent.)*
Olivier, E. *Edmond des Robert; ses ex-libris
héraldiques.* Nancy (France): Éditions de
l'A[ssociation] F[rançaise des] C[ollectionneurs d'] E[x-] L[ibris], 1950.
 Entries: 77 (bookplates only, to 1949).
 Illustrated. (selection).

Robert, Hubert *(1733–1808)*
[Baud.] I, pp. 171–184.
 Entries: 18. Millimeters. Inscriptions.
 States. Described.

Robert, Jean *(fl. 1746–1782)*
Singer, Hans W. "Der Vierfarbendruck
in der Gefolgschaft Jacob Christoffel Le
Blons." *Monatsheft für Kunstwissenschaft*
11 (1918): 52–54.
 Entries: 35. Millimeters. Inscriptions.
 States. Described. Illustrated (selection). Located.

Robert, Jean François *(1778–1832)*
[Ber.] XI, p. 204.*

Robert, Jules *(b. 1843)*
[Ber.] XI,pp. 206–207.*

Robert, (Louis) Léopold *(1794–1835)*
[Ber.] XI, pp. 204–205.*

Robert, Paul Ponce Antoine [called
"Robert de Séri"] *(1686–1733)*
[RD.] I, pp. 277–285; XI,pp. 297–298.
 Entries: 16. Pre-metric. Inscriptions.
 States. Described.

Robert-Fleury, Joseph Nicolas *(1797–1890)*
[Ber.] VI, p. 137.*

Roberts, David *(1796–1864)*
Ballantine, James.*The life of David
Roberts, R.A.* Edinburgh (Scotland):
Adam and Charles Black, 1866.
 Entries: 9 (etchings by, published in
 the book; complete?). Illustrated.
 Large paper copy, extra-illustrated
 (CSmH); 212 portraits, views and autograph letters inserted.

Roberts, J. *(19th cent.)*
[Siltzer] p. 365.
 Entries: unnumbered, p. 365. Inscriptions.

Roberts, John *(1768–1803)*
[St.] pp. 446–447.*

[F.] p. 224.*

Robetta, Cristoforo di Michele
(1462–after 1522)
[B.] XIII, pp. 392–407.
Entries: 26. Pre-metric. Inscriptions.
States. Described.

[Evans] pp. 5–6.
Entries: 7 (additional to [B.]). Millimeters. Inscriptions. Described.

[P.] V, pp. 56–61.
Entries: 10 (additional to [B.]). Premetric. States. Described. Located.
Additional information to [B.].

[Hind] I, pp. 197–209; V, p. 308.
Entries: 44. Millimeters. Inscriptions.
States. Described. Illustrated. Located.

Robida, Albert *(1848–1926)*
[Ber.] XI, pp. 207–213.*

Robida, Frédéric. "Un artiste protée; Albert Robida (1848–1926)." *Le Vieux papier,* fasc. 227 (1968): 209–224.
Entries: unnumbered, pp. 218–222. (single prints, sets of prints, and bibliography of books with illustrations by). Paper fold measure.

Robillard, Hippolyte *(fl. 1831–1855)*
[Ber.] XI, p. 213.*

Robins, William *(fl. 1730–1740)*
[Sm.] III, pp. 1034–1037.
Entries: 12 (portraits only). Inches. Inscriptions. Described. Illustrated (selection). Located (selection).

[Ru.] p. 247.
Additional information to [Sm.].

Robins, William Palmer *(b. 1882)*
P. and D. Colnaghi and Obach. *A catalogue of the etchings, drypoints and aquatints of William P. Robins, A.R.E., with an introduction by John Cournos.* London: P. and D. Colnaghi and Obach, 1917. (NN)
Entries: unnumbered, pp. 6–29, (to 1916, complete?). Inches. Illustrated.

Robinson, Boardman *(1876–1952)*
Christ-Janer, Albert. *Boardman Robinson.* Chicago: University of Chicago Press, 1946.
Entries: unnumbered, pp. 81–101 (prints and drawings). Inches. Inscriptions. Described.

Robinson, John *(fl. 1780–1810)*
[Sm.] III, p. 1037.
Entries: 1 (portraits only). Inches. Inscriptions. Described. Located.

[Ru.] p. 247.
Additional information to [Sm.]

Robinson, John Charles *(1824–1913)*
Hind, Arthur Mayger. "Sir John Charles Robinsons Radierungen." [GK.] 29 (1906): 49–52. Catalogue: "Verzeichnis der Radierungen von Sir John Charles Robinson," [MGvK.] 1906, p. 54.
Entries: 29 (to 1902). Inscriptions. States. Illustrated (selection).

Hind, Arthur Mayger. Catalogue, accompanying "Sir J. C. Robinson's etchings" by E. L. Allhusen. [PCQ.] 8 (1921): 299–312.
Entries: 30. Inches. Inscriptions. States. Illustrated (selection). Revised and enlarged from Hind 1906.

Robinson, John Henry *(1796–1871)*
[Ap.] p. 362.
Entries: 14.*

Robinson, Lewis *(19th cent.)*
Dalphin, George R., and McCorison, Marcus. "Lewis Robinson—entrepreneur." *Vermont History* 30 (October 1962): 297–313.

Robinson, Lewis (*continued*)

Entries: unnumbered, pp. 311–313.
Inches. Inscriptions. States.

Robinson, R. (*fl. 1688–1696*)
[Sm.] III, p. 1037.
Entries: 1 (portraits only). Inches. Inscriptions. Described. Located.

Robinson, R. (*d. c.1690*)
[Sm.] III, pp. 1037–1039.
Entries: 8 (portraits only). Inches. Inscriptions. States. Described. Illustrated (selection). Located (selection).

Robinson, William S. (*b. 1861*)
[F.] p. 225.*

Robusti, Jacopo
See **Tintoretto,** Jacopo

Rocca, Carlo della
See **Dellarocca**

Roche, Pierre (*1855–1922*)
Massignon, Louis, and Girard, Mme.
Pierre. *Pierre Roche; estampes modelées et églomisations; aquarelles estampées tirées sur plâtre, gypsographies encrées et tirées sur plâtre, gypsotypies tirées sur cuivre ou sur acier . . . catalogue de ces oeuvres.*
Paris: V. Canale, 1935.
Entries: unnumbered, pp. 19–53. Millimeters. Illustrated (selection).

Rochebrune, Jean Bechon de (*17th cent.*)
[RD.] III, p. 227–228; XI, pp. 8–9.
Entries: 3. Pre-metric. Inscriptions. Described.

[M.] III, p. 262.
Entries: 3. Paper fold measure. Inscriptions. States. Described.

Rochebrune, Octave Guillaume de
(*1824–1900*)
[Ber.] XI, pp. 214–225.*

Clouzot, Henri. *Catalogue déscriptif et raisonné de l'oeuvre de O. de Rochebrune (1824–1900).* Fontenay-le Comte, Chateau de Terre-Neuve, Paris: Rapilly, 1901.
Entries: 492. Millimeters. Inscriptions. States. Also, bibliography of books containing the prints.

Rochusseen, A. (*19th cent.*)
[H. L.] p. 817.
Entries: 2. Millimeters. Inscriptions. Described.

Rochussen, Charles (*1824–1894*)
[H. L.] p. 816.
Entries: 3 (etchings only). Millimeters. Inscriptions. Described.

[Ber.] XI, p. 225.*

Franken, D., and Obreen, F.D.O. *L'Oeuvre de Charles Rochussen; essai d'un catalogue raisonné de ses tableaux, dessins, lithographies, eaux-fortes.* n.p., Nijgh et van Ditmar, 1894.
Entries: 1238 (works in various media, including prints by and after). Millimeters. Described. Ms. addition (ERB); additional entries, unnumbered, 47 pp., prints after.

Roddelstet, Peter
See **Gottlandt,** Peter

Rode, [Christian] Bernhard (*1725–1797*)
[Rode, Bernhard?]. *Radierte Blätter nach eigenen historischen Gemählden und Zeichnungen von Bernhard Rode in Berlin.*
[Berlin?]: L. P. Wegener, 1783.(EBKk)
Entries: 148. Paper fold measure. Described (selection). 3 appendices [n.d.] (EBKk); 85 additional entries.

Roden, William Thomas (*1817–1892*)
[Ap.] p. 363.
Entries: 1.*

Rodin, [François] Auguste [René]
(1840–1917)
[Ber.] XI, p. 225.*

 Marx, Roger. *Les pointes sèches de Rodin.*
 Paris: Gazette des Beaux-Arts, 1902.
 Entries: 12 (drypoints only). States.
 Described (selection). Illustrated
 (selection).

 [Del.] VI.
 Entries: 17. Millimeters. Inscriptions.
 States. Described. Illustrated. Lo-
 cated (selection). Appendix with list
 of 7 facsimiles of prints by Rodin.

Rodingh, Pieter *(fl. c.1685)*
[W.] II, p. 461.
 Entries: 2.*

Rodriguez, Gaston L. S. *(fl. c.1885)*
[Ber.] XI, p. 225.*

Röder, Karl von *(19th cent.)*
[Dus.] p. 221.
 Entries: 2 (lithographs only, to 1821).
 Millimeters. Inscriptions. Located.

Röhling, M. *(19th cent.)*
[Dus.] pp. 221–222.
 Entries: 1 (lithographs only, to 1821).
 Millimeters. Inscriptions. Described.
 Located.

Roehn, Adolphe Eugène Gabriel
(1780–1867)
[Ber.] XI, p. 226.
 Entries: 22.

Röhnlein [**Röhnlin**], Philipp *(d. 1598)*
[A.] II, pp. 220–223.
 Entries: 3. Pre-metric. Inscriptions.
 Described.

Roelofs, Willem *(1822–1897)*
[H. L.] pp. 817–819.
 Entries: 6 etchings, 1 lithograph. Mil-
 limeters (selection). Inscriptions.

 States. Described. Dimensions are
 given for etchings only.

Römer, Hermann *(1838–1883)*
[Ap.] p. 363.
 Entries: 3.*

Roemhild, ——— *(19th cent.)*
[Ber.] XI, p. 226.*

Rösel, Christoph *(fl. c.1750)*
[Merlo] p. 730.*

Rössing, Karl *(b. 1897)*
 Ehmke, F. H. *Karl Rössing; das Illus-*
 trationswerk. Munich: C. H. Beck'sche
 Verlagsbuchhandlung, 1963.
 Bibliography of books with illustra-
 tions by (to 1955).

Roestraeten, Pieter Gerritsz van
(c.1630–1700)
[W.] II, p. 462.
 Entries: 1 print after.*

Roffiaen, [Jean] François [Xavier]
(1820–1898)
[H. L.] p. 820.
 Entries: 1. Millimeters. Inscriptions.
 States. Described.

Rogalski, Walter R. *(b. 1923)*
 Cleveland Museum of Art [Leona E.
 Prasse and Louise S. Richards, com-
 pilers]. *Prints and drawings by Walter R.*
 Rogalski. Cleveland (Ohio), 1954.
 Entries: 31 engravings, 5 woodcuts,
 (to 1954). Inches. Illustrated (selec-
 tion).

Rogel, Hans *(1532–1592)*
[A.] IV, pp. 80–88.
 Entries: 9+. Pre-metric. Inscriptions.
 Described. Appendix with one doubt-
 ful print.

Roger, Barthélemy Joseph Fulcran
(1767–1841)
[Roger, Barthélemy?]. "Description de
l'oeuvre de Barthélemy Joseph Fulcran
Roger, graveur en taille douce." Un-
published ms. (EPBN)
Entries: 282 engravings by, 5 litho-
graphs by, 7 prints done in collabora-
tion with other artists, (to 1828). In-
scriptions. Described (selection).
Catalogue of a collection of Roger's
work presented by him to the Bib-
liothèque Nationale: 18 prints lacking
from his total oeuvre.

[Ber.] XI, pp. 227–231.*

Rogers, William *(fl. c.1589–1604)*
[Hind, *Engl.*] I, pp. 258–280.
Entries: 29+. Inches. Inscriptions.
States. Described. Illustrated (selec-
tion). Located.

Roghman, Geertruydt *(17th cent.)*
[Dut.] VI, pp. 18–21.
Entries: 21. Millimeters. Inscriptions.
Described.

[W.] II, p. 463.
Entries: 22+.*

Roghman, Hendrick Lambertsz
(b. 1600/01)
[W.] II, pp. 463–464.
Entries: 12.*

Roghman, Magdalena *(fl. 1640–1652)*
[W.] II, p. 464.
Entries: 1.*

Roghman, Roeland *(c.1620–1686)*
[B.] IV, pp. 15–43.
Entries: 33 prints by, 14 rejected
prints, 6 doubtful prints, 1 print after.
Pre-metric. Inscriptions. States. De-
scribed.

[Weigel] pp. 147–150.

Entries: 1 (additional to [B.]). Pre-
metric.

[Heller] pp. 105–106.
Additional information to [B.].

[Dut.] VI, pp. 4–21.
Entries: 40 prints from [B.] and
[Weigel]; 24 from other sources, prints
by and after. Millimeters. Inscrip-
tions. States. Described.

[W.] II, pp. 464–465.
Entries: 51+ prints by, 8 after.*

Rogier, Camille *(fl. 1835–1847)*
[Ber.] XI, pp. 231–232.*

Rogiers, Salomon *(b. c.1592)*
[W.] II, p. 465.
Entries: 2.*

Rogiers, Theodor
See **Rasières**

Rohlfs, Christian *(1849–1938)*
Vogt, Paul. *Christian Rohlfs, oeuvre-
katalog der Druckgraphik.* n.p., 1950.
Entries: 185. Millimeters. Inscriptions.
Illustrated.

Vogt, Paul. *Christian Rohlfs; das
graphische Werk.* Recklinghausen (West
Germany): Verlag Aurel Bongers, 1960.
Entries: 185. Millimeters. Inscriptions.
Illustrated.

Rohr, Wilhelm *(1848–1907)*
Roeper, Adalbert. "Wilhelm Rohr."
[*Bb.*] 74 (1907): 3300–3302, 5021–5024.
Entries: 152. Millimeters. States.

Rohrscheidt,——— von *(19th cent.)*
[Dus.] p. 222.
Entries: 1. Millimeters. Inscriptions.

Rohse, Otto *(20th cent.)*
Vogel, Carl. *Otto Rohse; Werkverzeichnis
der Holzstiche, 1951–1971.* Hamburg: Otto
Rohse, 1971.

Entries: 346 woodcuts, 50 commercial prints, (to 1971). Millimeters. States. Illustrated.

Roissy, ——— *(fl. c.1830)*
[Ber.] XI, p. 232.*

Rokers, Hendrik
See **Rokesz**

Rokes
See **Sorgh,** Hendrik

Rokesz, Hendrik *(17th cent.)*
[W.] II, p. 465.
Entries: 10.*

Roland Holst, Richard Nicolaas
(1868–1938)
Schwencke, Johan. "Overzichten III."
Boekcier 9 (1940): 13.
Entries: unnumbered, p. 13.
(bookplates only, to 1925). Illustrated (selection).

Polak, Bettina. *Het fin-de-siècle in de nederlandse schilderkunst.* The Hague: Martinus Nijhoff, 1955.
Entries: 14 (works in various media, including prints, 1892 to 1895). Millimeters. Inscriptions. Described. Illustrated (selection).

Roli, Giuseppe Maria *(1645–1727)*
[B.] XIX, pp. 317–321.
Entries: 6 prints by, 1 doubtful print. Pre-metric. Inscriptions. Described.

[Heller] p. 106.
Additional information to [B.].

Rolin-Jacquemins, ——— *(19th cent.)*
[H. L.] pp. 821–822.
Entries: 8. Millimeters. Inscriptions. Described.

Rollet, [Louis] René [Lucien] *(1809–1862)*
[Ber.] XI, pp. 232–233.*

Rollinson, Charles *(fl. c.1808)*
[F.] p. 225.*

Rollinson, William *(1762–1842)*
[Allen] pp. 149–150.*

[St.] pp. 447–451.*

[F.] pp. 225–230.*

Rolls, Charles *(fl. 1838–1851)*
[Ap.] p. 363.
Entries: 5.*

Rolls, H. *(19th cent.)*
[Ap.] p. 363.
Entries: 2.*

Rolls, J. *(19th cent.)*
[Ap.] p. 364.
Entries: 1.*

Romagnesi, Joseph Antoine *(c.1782–1852)*
[Ber.] XI, p. 233.*

Romagnesi, [Pierre] Narcisse *(b. 1796)*
[Ber.] XI, p. 233.*

Roman [Romans], Jacob Pietersz
(1640–1716)
[W.] II, pp. 465–466.
Entries: 1 print after.*

Romanet, Antoine Louis
(1742/43–after 1810)
[Ap.] pp. 364–365.
Entries: 27.*

[Ber.] XI, pp. 233–234.*

[L. D.] pp. 74–75.
Entries: 4. Millimeters. Inscriptions. States. Described. Illustrated (selection). Incomplete catalogue.*

Romans, Bernard *(c.1720–1784)*
[St.] pp. 451–452.*

[F.] p. 230.*

Rombouts, Theodor *(1597–1637)*
[vdK.] pp. 43–46.
 Entries: 2. Millimeters. Inscriptions.
 Described.

[W.] II, p. 467.
 Entries: 2 prints by, 12 after.*

Romeyn, Willem *(c.1624–1694?)*
[W.] II, pp. 467–468.
 Entries: 8 prints after.*

Romilly, Amélie *(fl. c.1823)*
[Ber.] XI, p. 234.*

Romney, George *(1734–1802)*
Horne, Henry Percy. *An illustrated catalogue of engraved portraits and fancy subjects painted by Thomas Gainsborough, R.A., published between 1760 and 1820, and by George Romney, published between 1770 and 1830, with the variations of the state of the plates.* London: Eyre and Spottiswoode, 1891.
 Entries: 145 prints after. Inches. Inscriptions. States. Illustrated (selection). Ms. addition (EBM); additional entries.

Maxwell, Herbert and Horne, H. P. *George Romney.* The makers of British art. London: Walter Scott Publishing Co. Ltd.; New York: Charles Scribner's Sons, 1902.
 Entries: unnumbered, pp. 195–222. Inches. Inscriptions (selection). States. Also, catalogue of paintings; prints after are mentioned where extant. Catalogue of prints is by H. P. Horne, catalogue of paintings by Maxwell.

Gower, Ronald Sutherland. *George Romney.* London: Duckworth and Co., 1904.
 Catalogue of paintings; prints after are mentioned where extant. Based on Maxwell.

Ward, Humphrey, and Roberts, W.
Romney, a biographical and critical essay with a catalogue raisonné of his works. 2 vols. London: Thos. Agnew and Sons, 1904.
 Catalogue of paintings; prints after are mentioned where extant.

Romney, John *(c.1786–1863)*
[Ap.] p. 365.
 Entries: 2.*

Roode, Theodorus de *(1736–1791)*
[W.] II, p. 468.
 Entries: 4.*

Roos, Johann Heinrich *(1631–1685)*
[Hüsgen] pp. 239–255.
 Entries: unnumbered, pp. 249–255. prints by and after. Pre-metric. Inscriptions.

[B.] I, pp. 131–158 and addenda.
 Entries: 39. Pre-metric. Inscriptions. States. Described. Copies mentioned.

[Weigel] pp. 17–21.
 Entries: 5 (additional to [B.]). Pre-metric. Inscriptions. Described (selection).

[Heller] p. 107.
 Additional information to [B.].

[W.] II, pp. 469–470.
 Entries: 43+.*

Roos, Johann Melchior *(1659–1731)*
[B.] IV, pp. 397–399.
 Entries: 1. Pre-metric. Inscriptions. Described.

Roos, Theodor [Dietrich] *(1638–1698?)*
[B.] IV, pp. 297–301.
 Entries: 6. Pre-metric. Inscriptions. Described..

[Weigel] p. 201.
 Entries: 1 (additional to [B.]). Paper fold measure. Inscriptions. Described.

Roosenboom, Nicolaas Johannes *(b. 1805)*
[H. L.] p. 820.
 Entries: 1. Millimeters. Described.

Roosing, Hendrik *(fl. 1780–1799)*
[W.] II, p. 470.
 Entries: 4.*

Rops, Félicien *(1833–1898)*
[H. L.] pp. 823–911.
 Entries: 141 (etchings only). Millimeters. Inscriptions. States. Described.

Ramiro, Érastène. *L'Oeuvre lithographié de Félicien Rops.* Paris: Librairie L. Conquet, 1891. 200 copies. (MBMu)
 Entries: 184 (lithographs only). Inscriptions. Described.

[Ber.] XI, pp. 234–261.*

Ramiro, Erastène. *Catalogue descriptif et analytique de l'oeuvre gravé de Félicien Rops.* Paris: Librairie Conquet, 1887. 550 copies. 2d ed. Brussels: Edmond Deman, 1893. 200 copies. (MBMu)
 Entries: unnumbered, 419 pp. (etchings only, to 1887? Second edition contains an appendix numbering the entries: 1-502). Millimeters. Inscriptions. States. Described. Extra-illustrated copy, assembled by Georges de Récy. (EPBN)

Ramiro, Érastène. *Supplément au catalogue de l'oeuvre gravé de Félicien Rops.* Paris: Floury, 1895. 570 copies. (MBMu)
 Entries: 276 (etchings only, additional to Ramiro 1893). Millimeters. Inscriptions. States. Described.

Deman, Edmond et al. *Félicien Rops et son oeuvre.* Brussels: Edmond Deman, 1897. 366 copies. (PJRo)
 Entries: 732 etchings, 195 lithographs. Millimeters. Based on Ramiro.

Mascha, Ottokar. *Félicien Rops und sein Werk, Katalog seiner Gemälde, Originalzeichnungen, Lithographien, Radierungen, Vernis-mous, Kaltnadelblätter, Heliogravu-ren, usw. und Reproductionen.* Munich: Albert Langen, 1910. 500 copies. (MH)
 Entries: 1038 prints by and after. Millimeters. Inscriptions. States. Described. Located. Table of watermarks and collectors' marks.

Exteens, Maurice. *L'Oeuvre gravé et lithographié de Félicien Rops.* 4 vols. and appendix. Paris: Editions Pellet, 1928. 500 copies. (NN)
 Entries: 807 prints by, 386 after. Millimeters. Inscriptions. States. Described. Illustrated.

Mauquoy-Hendrickx, Marie. " 'L'Experte en dentelles' de Félicien Rops." *Le livre et l'estampe,* no. 38 (1964): 125–144.
 Additional information to Exteens.

Roqueplan, Camille Joseph Étienne [called "Rocoplan"] *(1800–1855)*
[Ber.] XI, pp. 261–264.
 Entries: 63. Paper fold measure (selection).

Hèdiard, Germain. "Les maîtres de la lithographie; Camille Roqueplan." *L'Artiste,* n.s. 6 (1893, no. 2): 246–254, 341–356. Separately published. Le Mans (France): Edmond Monnoyer, [1894?].
 Entries: 73. Millimeters. Inscriptions. States. Described.

Roques, Joseph *(1754–1847)*
[Ber.] XI, p. 264.*

Rordorf, Alexander *(b. 1820)*
[Ap.] p. 365.
 Entries: 9.*

Rosa, Francesco *(d. 1687)*
[B.] XXI, pp. 120–122.
 Entries: 3. Pre-metric. Inscriptions. States. Described.

Rosa, Salvator *(1615–1673)*
[B.] XX, pp. 267–292.
 Entries: 86. Pre-metric. Inscriptions. Described.

Rosa, Salvator (*continued*)

[Heller] pp. 107–108.
Additional information to [B.].

Meyer, C. "Nachtrag zum Verzeichniss der Radirungen Salvator Rosa's." [*Zahn's*] *Jahrbücher für Kunstwissenschaft* 3 (1870): 220–223.
Entries: 24 (additional to [B.]). Pre-metric. Inscriptions. States. Described.

Rosa, Theodor [Dietrich]
See **Roos**

Rosaspina, Francesco (*1762–1841*)
Bolognini Amorini, Antonio. *Memorie della vita e delle opere di Francesco Rosaspina incisor bolognese.* Bologna: Tipi governativi alla Volpe, 1842. (EFKI)
Entries: unnumbered, pp. 19–21.

[Ap.] pp. 366–367.
Entries: 26.*

[Ber.] XI, pp. 264–265.*

Rosaspina, Giuseppe (*1765–1832*)
[Ap.] pp. 367–368.
Entries: 8.*

Rosati, Ferrante (*fl. c.1649*)
[B.] XXI, pp. 153–157.
Entries: 6. Pre-metric. Inscriptions. Described.

Rose, Alphonse Antoine (*fl. c.1850*)
[Ber.] XI, p. 265.*

Rose, Johann Heinrich
See **Roos**

Rose, Johann Melchior
See **Roos**

Rosello, —— (*19th cent.*)
[Ap.] p. 368.
Entries: 1.*

[Ber.] XI, p. 266.*

Rosenberg, Christian (*19th cent.*)
[Siltzer] p. 365.
Entries: unnumbered, p. 365, prints by and after. Inscriptions.

Rosenberg, F. (*fl. c.1827*)
[Siltzer] p. 365.
Entries: unnumbered, p. 365. Inscriptions.

Rosenberg, Louis Conrad (*b. 1890*)
Crafton Collection. Louis C. Rosenberg, with an appreciation by Kenneth Reid. American etchers, 10. New York: Crafton Collection, 1930.
Entries: 72 (published plates only, to 1929). Inches. States. Illustrated (selection).

Rosenberg, Ole (*20th cent.*)
Riis, Kaj Welsch. "Ole Rosenberg, en dansk exlibristegner." [*N. ExT.*] 20 (1968): 28–30.
Entries: 38 (bookplates only, to 1968). Illustrated (selection).

Rosenthal, Albert (*b. 1863*)
[List of portraits, no title]. Philadelphia, 1898. 100 copies, large paper. (NN)
Entries: unnumbered, pp. 2–8. (prints by Max and Albert Rosenthal).

Rosenthal, Albert. *List of portraits; lithographs—etchings—mezzotints by Max Rosenthal and Albert Rosenthal.* Philadelphia: Privately printed, 1923.
Entries: unnumbered, pp. 9–31 (prints by Max and Albert Rosenthal). Inches (selection). Ms. notes (NN); additional entries.

Rosenthal, Leon. "Albert Rosenthal, painter, etcher, lithographer." [*P. Conn.*] 9 (1929): 96–130. Separately published. *Albert Rosenthal, painter-lithographer, etcher.* Philadelphia: Privately printed, 1929.
Entries: unnumbered, pp. 106–130 (unpaged in separate publication).

Rosenthal, Max *(1833–1918)*
[List of portraits, no title]. Philadelphia, 1898. 100 copies, large paper. (NN)
 Entries: unnumbered, pp. 2–8 (prints by Max and Albert Rosenthal).

Rosenthal, Albert. "Max Rosenthal."[*P. Conn.*] 2 (1921–1922): 2–25.
 Entries: 47 (mezzotints only). Inches. States. Described. Illustrated (selection).

Rosenthal, Albert. *List of portraits; lithographs–etchings–mezzotints by Max Rosenthal and Albert Rosenthal.* Philadelphia: Privately printed, 1923.
 Entries: unnumbered, pp. 9–31 (prints by Max and Albert Rosenthal). Inches (selection). Ms. notes (NN); additional entries.

Rosenthaler, Kasper *(d. 1542)*
[P.] III, pp. 129–132.
 Entries: 58+. Pre-metric (selection), paper fold measure (selection). Inscriptions. Described (selection).

Rosex, Nicoletto
See **Nicoletto da Modena**

Roslin, Alexander *(1718–1893)*
Lundberg, Gunnar W. *Roslin, liv och verk; avec un résumé en français et le catalogue des oeuvres.* 3 vols. n.p., Allhems Forlag, n.d.
 Catalogue of paintings; prints after are mentioned where extant.

Rosotte, Édouard *(b. 1827)*
[Ber.] XI, p. 265.*

Rospatt, Johann Josef *(1771–1843)*
[Merlo] pp. 734–735.*

Rossem, Ru van *(20th cent.)*
Baas, Dirk P. *Ru van Rossem, een modern grafisch kunstenaar.* n.p., De Getijden Pers, 1955. 325 copies. (DLC)

 Entries: 126 independent prints, 35 bookplates and commercial prints, 15 monotypes, 20 books with illustrations by.

Rossena, G. *(19th cent.)*
[Ap.] p. 368.
 Entries: 1.*

Rossi, Antonio *(18th cent.)*
Indice delle stampe intagliate in rame a bulino, e in acqua forte esistenti nella già Stamparia de i de Rossi ora nella calcografia della rev. cam. apost. a Pie' di Marmo. Rome, 1754. (NN)
 Entries: unnumbered, pp. 3–115 (list of prints published by, available in 1754).

Rossi, Francesco de
See **Salviati**

Rossi, Girolamo I *(fl. 1632–1664)*
[B.] XIX, pp. 234–237.
 Entries: 6. Pre-metric. Inscriptions. Described.

[Heller] p. 108.
 Additional information to [B.].

Rossi, Giuseppe *(b. 1842)*
[Ap.] p. 368.
 Entries: 2.*

Rosso Fiorentino [Giovanni Battista di Jacopo di Guasparre] *(1494–1540)*
[B.] XII: *See* **Chiaroscuro Woodcuts**

Kusenberg, Kurt. *Le Rosso.* Paris: Albin Michel, 1931. 1670 copies. (MH)
 Entries: unnumbered, pp. 159–168, prints after; pp. 169–170, rejected prints. Millimeters. Described. (selection).

Rossum, Gerard van *(1699/1700–1772)*
[W.] II, p. 471.
 Entries: 1 print after.*

Rossum, Jan van *(fl. 1654–1673)*
[W.] II, pp. 471–472.
 Entries: 1 print after.*

Rot, Dieter *(b. 1930)*
Mayer, Hansjorg, Rot, Dieter and
Sohm, H. *Dieter Rot, gesammelte Werke
Band 20; Dieter Rot collected works volume
20; Bücher und Grafik (1. Teil) aus den
Jahren 1947 bis 1971; Books and Graphics
(part 1) from 1947 until 1971.* Stuttgart:
Hansjörg Meyer, 1972.
 Entries: 53 books, 223 prints (to 1971).
 Millimeters. Described. Illustrated.

Rota, Martino *(c.1520–1583)*
[B.] XVI, pp. 245–285.
 Entries: 114. Pre-metric. Inscriptions.
 States. Described. Copies mentioned.

[Heller] pp. 108–109.
 Entries: 2 (additional to [B.]. Pre-
 metric. Inscriptions. Described. Addi-
 tional information to [B.].

[P.] VI, pp. 184–188.
 Entries: 23 (additional to [B.]. Pre-
 metric (selection). Inscriptions.
 States. Described. Additional infor-
 mation to [B.].

[Wess.] III, pp. 54–55.
 Additional information to [B.] and
 [P.].

Rotari, Pietro Antonio Conte *(1707–1762)*
[Vesme] pp. 466–473.
 Entries: 30 (includes 3 prints not seen
 by [Vesme]). Millimeters. Inscrip-
 tions. States. Described. Appendix
 with 1 rejected print.

Roth, Ernest David *(b. 1879)*
Crafton Collection. *Ernest D. Roth, N.A.,
with an introduction by Elizabeth Whitmore.*
American etchers, 1. New York: Crafton
Collection, 1929.
 Entries: 105 (published prints only, to
 1929). Inches. Illustrated (selection).

Roth, George Andries *(1809–1887)*
[H. L.] p. 913.
 Entries: 2. Millimeters. Inscriptions.
 Described.

Roth, Karl *(19th cent.)*
[Dus.] p. 222.
 Entries: 3+ (lithographs only, to 1821).

Roth, William *(fl. 1768–1777)*
[Sm.] III, pp. 1039–1040.
 Entries: 3 (portraits only). Inches. In-
 scriptions. States. Described.

[Ru.] p. 247.
 Addtional information to [Sm.].

Rothbletz, Johann Georg *(fl. c.1719)*
Hämmerle, Albert. "Johann Georg
Rothbletz." [*Schw. M.*] 1925, p. 132.
 Entries: 3. Millimeters. Inscriptions.
 Described. Illustrated (selection). Lo-
 cated.

Rothenstein, William *(1872–1945)*
Rothenstein, John. *The portrait drawings
of William Rothenstein.* London: Chap-
man and Hall, 1926.
 Entries: 135 (portrait lithographs only,
 to 1926?). Inches. Inscriptions. De-
 scribed. Illustrated (selection).

Rotnberger, Aswerus *(fl. c.1598)*
[A.] IV, pp. 22–23.
 Entries: 1. Pre-metric. Inscriptions.
 Described.

Rottermond, Peeter *(fl. c.1632)*
[Dut.] VI, pp. 1–4.
 Entries: 11. Millimeters. Inscriptions.
 States. Described.

[Rov.] pp. 76–78.
 Entries: 9 prints by, 6 doubtful and
 rejected prints. Millimeters (selec-
 tion). Inscriptions (selection). States.
 Described. Illustrated (selection). Lo-
 cated (selection).

[W.] II, p. 472.
Entries: 14.*

Rottiers, Bernard Eugène Antoine
(1771–1858)
[H. L.] pp. 911–913.
Entries: 6. Millimeters. Inscriptions.
Described.

Rouargue, Adolphe *(b. 1810)*
[Ber.] XI, pp. 266–267.*

Rouargue, Émile *(c.1795–1865)*
[Ap.] p. 368.
Entries: 3.*

[Ber.] XI, p. 266.*

Rouault, Georges *(b. 1871)*
Museum of Modern Art, New York
[Monroe Wheeler, compiler]. *The prints
of Georges Rouault.* New York, 1938.
Entries: 22+ (to 1933). Illustrated
(selection).

Kornfeld and Klipstein. *Auktion 120:
Georges Rouault, Graphik und illustrierte
Bücher, Sammlung B.v.S.; Auktion in
Bern, Donnerstag den 9. Juli 1966.*
Entries: 172. Millimeters. Inscriptions.
States (selection). Described. Illus-
trated. Sale of a complete (?) collection
of prints by, including multiple states
of some. Numbering refers to sale
lots, not to prints.

Roubaud, Benjamin
See **Benjamin**

Rouck, W. de *(fl. c.1656)*
[W.] II, p. 472.
Entries: 1 print after.*

Rougeron, Jules James *(1841–1880)*
[Ber.] XI, p. 267.*

Rouget, François *(b. before 1825)*
[Ber.] XI, pp. 267–268.*

Rouget, Georges *(1784–1869)*
[Ber.] XI, p. 268.*

Rousseau, Jacques *(1630–1693)*
[RD.] IV, pp. 190–198; XI, pp. 298–299.
Entries: 20. Pre-metric. Inscriptions.
States. Described.

Rousseau, Léon *(fl. 1875–1892)*
[Ber.] XI, p. 270.*

Rousseau, [Pierre Étienne] Théodore
(1812–1867)
[Ber.] XI, pp. 268–270.
Entries: 4 (etchings only). Millimeters.

[Del.] I.
Entries: 6. Millimeters (selection). In-
scriptions. States. Described (selec-
tion). Illustrated.

Rousseaux, [Alfred] Émile *(1831–1874)*
[Ap.] pp. 368–369.
Entries: 4.*

Delignières, Émile. "Émile Rousseaux,
graveur d'Abbéville." [*Mém. Abbéville*]
1873–1876, pp. 373–404. Separately pub-
lished. *Émile Rousseaux; biographie et cata-
logue de son oeuvre.* Abbéville (France): C.
Paillart, 1877.
Entries: unnumbered, pp. 388–402
(pp. 18–32 in separate publication).
Millimeters. Described. Located.

[Ber.] XI, pp. 270–272.
Entries: 13. Paper fold measure.

Rousseaux, Franz *(c.1717–1804)*
[Merlo] p. 738.*

Rousseaux, [Franz] Jakob *(1757–1826)*
[Merlo] p. 739.*

Roussel, Ker-Xavier *(1867–1944)*
Kunsthalle Bremen [Christian von
Heusinger, compiler]. *Ker-Xavier Roussel
1867–1944. Gemälde, Handzeichnungen,*

Roussel, Ker-Xavier (*continued*)

Druckgraphik. Bremen (West Germany), 1965.
Entries: 110. Millimeters. Inscriptions. States. Described. Illustrated. Based on the collection of Jacques Salomon.

Salomon, Jacques. Catalogue. In *Introduction à l'oeuvre gravé de K. X. Roussel . . . suivie d'un essai de catalogue,* by Alain. 2 vols. Paris: Mercure de France, 1968. 500 copies. (MH)
Entries: 119. Millimeters. Described. Illustrated. Based on Bremen catalogue, revised and expanded.

Roussel, Nicasius *(fl. c.1684)*
[W.] II, p. 472.
Entries: 1+.*

Roussel, Paul Marie *(1804–1877)*
[Ber.] XI, p. 272.*

Roussel, Théodore *(1847–1926)*
"Catalogue of original etchings in dry point and aquaforte invented, engraved and printed by Theodore Roussel." Unpublished ms., 1932. (EBM)
Entries: 105 monochrome prints, 15 color prints. Refers to another catalogue, by Agnes Mackay; "not yet published in 1932." (Not seen).

Roux, [Nicolas] Hubert *(fl. 1831–1847)*
[Ber.] XI, p. 273.*

Roux, Jakob Wilhelm Christian *(1775–1831)*
[Dus.] p. 222.
Entries: 3 (lithographs only, to 1821). Millimeters. Inscriptions. Located.

Roux, Paul *(d. 1918)*
[Ber.] XI, p. 273.*

Rowlandson, Thomas *(1756–1827)*
Grego, Joseph. *Rowlandson the caricaturist; a selection from his works with* anecdotal descriptions of his famous caricatures. 2 vols. London: Chatto and Windus, 1880. Reprint. New York: Collector's Editions, 1970.
Entries: unnumbered, Vol. I, pp. 96–378, Vol. II, pp. 1–386, prints by and after, complete? Inscriptions. Described (selection). Illustrated (selection). Ms. notes (NNMM); additional information.

Grolier Club, New York. *A catalogue of books illustrated by Thomas Rowlandson.* New York, 1916. Large paper edition. (PJRo)
Bibliography of books with illustrations by. Exhibition catalogue; large paper edition includes books not in the exhibition as well as those exhibited.

[Siltzer] pp. 237–238.
Entries: unnumbered, pp. 237–238, prints by and after. Inches (selection). Inscriptions.

Roy, ——— de *(19th cent.)*
[Ber.] XI, p. 273.*

Roy, Frans de *(fl. c.1758)*
[W.] II, pp. 472–473.
Entries: 11.*

Roy, Jean Baptiste de *(1759–1839)*
[H. L.] pp. 188–191.
Entries: 13. Millimeters. Inscriptions. States. Described.

Roy, José *(fl. c.1886)*
[Ber.] XI, pp. 273–274.*

Roybet, Ferdinand *(1840–1920)*
[Ber.] XI, p. 274.
Entries: 8. Paper fold measure (selection).

Royer, Jan *(18th cent.)*
[W.] II, p. 474.
Entries: 1 print after.*

Roze, Jules *(fl. c.1840)*
[Ber.] XI, p. 274.*

Rozendaal, W. J. *(20th cent.)*
Jacob-Marisstichting and Gemeentemuseum Den Haag. *W. J. Rozendaal; overzichtstentoonstelling.* The Hague, 1959.
 Entries: 235 woodcuts and wood engravings, 81 other prints, (to 1952). Millimeters. Illustrated (selection).

Rozier, Jules Charles *(1821–1882)*
[Ber.] XI, p. 274.*

Rubens, Pieter Pauwels *(1577–1640)*
Hecquet, R. *Catalogue des estampes gravées d'après Rubens, auquel on a joint l'oeuvre de Jordaens et celle de Visscher.* Paris: Briasson, 1751.
 Entries: 556+ prints after. Pre-metric. Inscriptions. Described (selection).

Basan, Pierre François. "Catalogue des estampes gravées d'après P. P. Rubens." In *Dictionnaire des graveurs anciens et modernes depuis l'origine de la gravure.* vol. 3. Paris: De Lormel, Saillant etc., 1767.
 Entries: 704+ prints after. Pre-metric. Inscriptions. Described (selection).

Michel, J. F. M. *Histoire de la vie de P. P. Rubens, Chevalier, et Seigneur de Steen, illustrée d'anecdotes . . . et par la démonstration des estampes existantes et relatives à ses ouvrages.* Brussels: Ae de Bel, 1771. (EA)
 Entries: 24+ prints after (additional to Hecquet and Basan). Pre-metric. Inscriptions (selection). Described.

Del-Marmol, ———. *Catalogue de la plus précieuse collection d'estampes de P. P. Rubens et d'A. van Dyck qui ait jamais existée . . . le tout recueilli . . . par Messire Del-Marmol.* n.p., 1794. (EPBN)
 Entries: 1273+ prints after (different impressions of the same print are separately numbered).

t'Sas, ———. "Estampes de l'oeuvre de P. P. Rubens dont les catalogues d'Hecquet et de Basan ne font pas mention, ou dont les Iiers épreuves, ou avec changement, leurs ont été inconnues." Unpublished ms. (EBr)
 Entries: 611 prints after (additional to Hecquet and Basan, or with additional information to Hecquet and Basan). Pre-metric. Inscriptions. States. Described (selection).

Hasselt, A. van. *Histoire de P. P. Rubens.* Brussels: Imprimerie de la Société des beaux-arts, 1840.
 Catalogue of paintings; prints after are mentioned where extant.

Voorhelm Schneevoogt, C. G. *Catalogue des estampes gravées d'après P. P. Rubens, avec l'indication des collections où se trouvent les tableaux et les gravures.* Haarlem (Netherlands): Les Héritiers Loosjes, 1873.
 Entries: 1841+ prints after. Pre-metric. Inscriptions. States. Located (selection). Ms. notes (EA); additional states.

[Dut.] VI, pp. 21–274.
 Entries: 704+ prints after (uses Basan's categories and numbering; adds about 50 prints, unnumbered, scattered through catalogue according to subject category). Millimeters. Inscriptions. States. Described.

[W.] II, pp. 474–515.
 Entries: prints after, unnumbered, pp. 506–515.*

Hind, Arthur M. "Rubens as etcher."
[PCQ.] 10 (1923): 61–80.
 Entries: 1 print by, 14 rejected prints. Inches. Inscriptions. States. Illustrated (selection). Located.

van den Wijngaert, Frans. *Inventaris der Rubeniaansche prentkunst.* Antwerp (Belgium): De Sikkel; The Hague: Martinus Nijhoff, 1940.

Rubens, Pieter Pauwels (*continued*)

Entries: 779 prints after (prints done in 17th cent. only). Engravers are identified, paintings and drawings for the prints are identified. References to [B.], Voorhelm Schneevogt, [Dut.] and other works on Rubens. Attempt to distinguish which prints were done under Rubens' supervision.

Rucholle, Gilles [Aegidius] (*fl. 1645–1662*)
[W.] II, p. 516.
Entries: 5.*

Rucholle, Petrus (*1618–1647*)
[W.] II, p. 516.
Entries: 8.*

Rud, Torlief (*1884–1926*)
Schyberg, Thorn Bjørn. "Torlief Rud." [*N. ExT.*] 7 (1955): 65–68.
Entries: 11 (bookplates only). Illustrated (selection).

Rudder, Louis Henri de (*1807–1881*)
[Ber.] XI, pp. 275–276.*

Rude, François (*1784–1855*)
[Ber.] XI, p. 276.*

[Del.] VI.
Entries: 1. Millimeters. Inscriptions. Illustrated.

Rudeaux, Edmond Adolphe (*b. 1840*)
[Ber.] XI, pp. 274–275.*

Rudge, B. (*19th cent.*)
[Siltzer] p. 365.
Entries: unnumbered, p. 365, prints by and after. Inscriptions.

Ruel, Johann Baptist de (*c.1634–1685*)
[W.] II, p. 517.
Entries: 2 prints after.*

Ruelles, Jean François de (*fl. c.1680*)
[Merlo] p. 741.*

Ruelles, P. F. des (*18th cent.*)
[Merlo] p. 741.*

Ruet, Louis (*b. 1861*)
[Ber.] XI, pp. 276–277.*

Rueter, Georg (*b. 1875*)
"Overzichten I." *Boekcier* 8 (1939): 41–42.
Entries: unnumbered, p. 42, (bookplates only, to 1934). Illustrated (selection).

Rueter, Pam G. (*20th cent.*)
Rueter, Pam G. "Het spiegelbeeld." In *Gedenkboek 1947 van de nederlandsche exlibris kring,* pp. 61–70.
Entries: 206 (bookplates only, to 1947). Illustrated (selection).

Asselbergs, C . J. Catalogue. In *Het Spiegelbeeld,* by Pam G. Rueter. Breda (Netherlands): J. van Poll Suykerbuyk, de Eeenhorn-Pers, 1948.
Entries: 206 (bookplates only, to 1947). Illustrated (selection).

Behrens, Charles G. *Dienend dichter in zwart en wit; over de exlibris van Pam G. Rueter.* Holland: Stichting de Getijden Pers, 1957.
Entries: 328 (bookplates only, to 1956). Described (selection). Illustrated (selection).

Koolwijk, Th. F. van et al. *Pam G. Rueter.* Zutphen (Netherlands): De Walburg Pers, 1966. 300 copies. (DLC)
Entries: 446 (bookplates only, to 1966). Described (selection). Illustrated (selection).

Rugendas, Georg Philipp (*1666–1742*)
Börner, J. A. "Materialien zu einem Cataloge der radierten und der vorzüglichsten geschabten Blätter des Georg Philipp Rugendas in Augsburg." [*N. Arch.*] 12 (1866): 101–120.
Entries: 36 etchings, 12 mezzotints (mezzotint catalogue is incomplete).

Pre-metric. Inscriptions. States. Described.

Stillfried, Heinrich Graf. *Leben und Kunstleistungen des Malers und Kupferstechers Georg Philipp Rugendas und seiner Nachkommen.* Berlin: Carl Heymann, 1879.
Entries: 663 prints by and after. Millimeters. Inscriptions. Described. Includes prints by Rugendas' descendants.

Rugendas, J. G. *(fl. c.1800)*
[Dus.] p. 222.
Entries: 1+ (lithographs only, to 1821).

Rugendas, Johann Lorenz II *(1775–1826)*
[Dus.] p. 223.
Entries: 1 (lithographs only, to 1821). Millimeters. Inscriptions. Located.

Rugendas, [Johann] Moritz *(1802–1858)*
[Dus.] p. 223.
Entries: 3 (lithographs only, to 1821). Millimeters. Inscriptions. Located.

Hämmerle, Albert. "Die Lithographie in Augsburg." [*Schw. M.*] 1927, pp. 184–196.
Entries: 2 (lithographs only, to 1821). Millimeters. Inscriptions. Described. Illustrated (selection). Located.

[Ber.] XI, p. 277.*

Ruhierre, Edme Jean *(b. 1789)*

[Ap.] p. 369.
Entries: 7.*

[Ber.] XI, p. 278.*

Ruhierre, François Théodore *(1808–1884)*
[Ber.] XI, p. 278.*

Ruhl, Johann Christian *(1764–1842)*
[Dus.] p. 223.
Entries: 1 (lithographs only, to 1821). Millimeters. Inscriptions. Located.

Ruijscher, Jan [Johannes]
(c.1625–after 1675)
[vdK.] pp. 20–21.
Entries: 1. Millimeters. Inscriptions. Described. Illustrated. 1 additional print, not seen by [vdK.], is described.

[Wess.] II, p. 250.
Entries: 1 (additional to [vdK.] Millimeters. Inscriptions. Described.

[W.] II, p. 517.
Entries: 3.*

[ThB.] XXVIII, p. 244.
Entries: 7. Inscriptions (selection). Located.

Ruina, Gaspare *(16th cent.)*
[P.] VI, p. 222, no. 1.
Entries: 1. Pre-metric. Inscriptions. Described.

Ruisdael, Jacob Isaacksz *(1628/29–1682)*
[B.] I, pp. 309–319.
Entries: 7. Pre-metric. Inscriptions. Described.

[Weigel] pp. 39–42.
Entries: 3 (additional to [B.]). Pre-metric. Inscriptions. Described.

[Heller] p. 109.
Additional information to [B.].

[Dut.] VI, pp. 275–284.
Entries: 13. Millimeters. Inscriptions. States. Described.

Amand-Durand, ———, and Duplessis, Georges. *Eaux-fortes de J. Ruysdael reproduites et publiées par Amand-Durand.*
Paris: Amand-Durand, Goupil, 1878.
Entries: 12. Inscriptions. States. Described. Illustrated. Prints are reproduced actual size.

[W.] II, pp. 517–522.
Entries: 12 prints by, 6 after.*

Ruisdael, Salomon *(c.1600–1670)*
[W.] II, pp. 523–524.
Entries: 2 prints after.*

Rullmann, Ludwig *(1765–1822)*
[Ber.] XI, pp. 278–279.*

Rummel, [Johann] Paul *(1774–1832)*
[Dus.] pp. 223–224.
 Entries: 11+ (lithographs only, to
 1821). Millimeters (selection). Inscriptions (selection). Located (selection).

Rumohr, Carl Friedrich Freiherr von
(1785–1843)
 Hirschfeld, Peter. "Rumohr und Nerly;
 Bemerkungen zu einer Porträt-
 zeichnung und Verzeichnis von
 Rumohrs Radierungen." [JprK.] 52
 (1931): 258–266.
 Entries: 24 prints by, 4 doubtful
 prints. Millimeters. Inscriptions. Described. Illustrated (selection).

Rumpf, Paul August *(fl. c.1700)*
[W.] II, p. 524.
 Entries: 1 print after.*

Rumphius, P. A.
See **Rumpf**

Runge, Holger *(20th cent.)*
 Grinten, Hans van der. *Holger Runge,
 Radierungen; Gesamtverzeichnis 1949–
 1968.* Kranenburg/Niederrhein (West
 Germany): Haus van der Grinten, 1968.
 600 copies. (EBKk)
 Entries: 366 (to 1968). Millimeters. Illustrated (selection).

Ruotte, Louis Charles *(1754–c.1806)*
[Ber.] XI, p. 279.*

Ruppe, Christian Friedrich *(18th cent.)*
[W.] II, p. 524.
 Entries: 1.*

Ruprecht, Prinz von der Pfalz *(1619–1682)*
[A.] V, pp. 91–104.
 Entries: 15. Pre-metric. Inscriptions.
 States. Described. Appendix with 4
 doubtful and rejected prints.

[W.] III, pp. 138–139.
 Entries: 19.*

Ruscha, Edward *(b. 1937)*
 Minneapolis Institute of Arts [Edward
 A. Foster, compiler]. *Edward Ruscha
 (Ed-Werd Rew-shay), young artist; a book
 accompanying the exhibition of prints, drawings and books of Edward Ruscha.* Minneapolis (Minn.), 1972.
 Entries: 64 prints, 15 books (to 1972).
 Inches. Illustrated (selection).

Ruscheweyh, Ferdinand *(1785–1846)*
[Ap.] pp. 369–370.
 Entries: 24.*

Rusek, Ladislav *(20th cent.)*
 Rödel, Klaus. *Ladislav Rusek, en tjekkisk
 exlibriskunstner.* Frederikshavn (Denmark): Privately printed, 1968. 100
 copies. (DLC)
 Entries: 250 (bookplates only, to 1968).
 Millimeters. Described. Illustrated
 (selection). Catalogue is in German.

Rushbury, Henry *(b. 1889)*
 Schwabe, Randolph. "The etchings of
 Henry Rushbury." [PCQ.] 10 (1923):
 403–443.
 Entries: 45 (to 1923). Inches. Millimeters. Inscriptions. States. Described.
 Illustrated (selection).

Rushton, Peter
See **Maverick** family

Russholle, Petrus
See **Rucholle**

Ruthart, Carl Borromäus Andreas
(c.1630–after 1703)
[W.] II, p. 525.
 Entries: 5 prints by, 2 after.*

Rutishauser, P. Theodor *(20th cent.)*
 Hodel, P. Urban, and Rodel, Klaus. *P.
 Theodor Rutishauser, en svejtsisk exlibris-*

kunstner. Frederikshavn (Denmark): Privately printed, 1968. 60 copies. (DLC)
Entries: 24 (bookplates only, to 1968). Described. Illustrated (selection). Catalogue is in German.

Rutlinger, Johannes [Jan] *(fl. 1588–1609)*
[Hind, *Engl.*] I, pp. 236–238.
Entries: 2. Inches. Inscriptions. Described. Illustrated (selection). Located.

Rutz, Caspar *(fl. 1567–1582)*
[W.] II, p. 525.
Entries: 4.*

Ruwohlt, Hans Martin *(20th cent.)*
Museum für Kunst und Gewerbe, Hamburg [Heinz Spielmann, compiler]. *Hans Martin Ruwoldt; Bildwerk, Zeichnungen, die Radierungen und Lithographien.* Hamburg, 1969.
Entries: 73 etchings, 1 woodcut, 45 lithographs (to 1954). Millimeters. Inscriptions. Described. Located.

Ruys, Simon *(fl. 1679–1688)*
[W.] II, p. 526.
Entries: 1 print after.*

Ruysch, Rachel *(1664–1750)*
[W.] II, pp. 526–527.
Entries: 1 print after.*

Ruyter, Nicaise de *(b. 1646?)*
[W.] II, p. 527.
Entries: 2.*

Ruyters, Jean Michel *(b. 1813)*
[H. L.] p. 914.
Entries: 2. Millimeters. Inscriptions. States. Described.

Ryck, Pieter Cornelisz van
See **Rijck**

Ryck, Willem de *(1635–1699)*
[W.] I, p. 399, III, pp. 75–76.
Entries: 3 prints by, 2 after.*

Ryckaert, David III *(1612–1661)*
[W.] II, pp. 528–529.
Entries: 3+ prints by, 2+ after.*

Rycken, Henrik *(fl. c.1585)*
[W.] II, p. 529.
Entries: 1.*

Ryckmans, Nicolaes *(fl. c.1616)*
[W.] II, p. 530.
Entries: 11+.*

Rydeng, Leif *(20th cent.)*
Rindholt, Svend Georg. *Leif Rydeng exlibris med fugle.* Copenhagen: Privately printed, 1961. 200 copies. (DLC)
Entries: 58 (bookplates only, to 1960). Described. Illustrated (selection).

Ryland, William Wynne *(1732–1783)*
Bleackley, Ruth. "A list of William Wynne Ryland's engravings." [*Conn.*] 12 (1905): 110–111.
Entries: 65 prints, 7 illustrated books.

Singer, Hans W. "William Wynne Ryland's engravings." [*Conn.*] 13 (1905): 13–18.
Additional information to Bleackly. Responding letter by Bleackly, p. 208.

[Ru.] p. 247.
Entries: 1 (portraits only). Inches. Inscriptions. Described.

Ryley, Thomas *(fl. c.1750)*
[Sm.] III, pp. 1040–1044, and "additions and corrections" section.
Entries: 13 (portraits only). Inches. Inscriptions. States. Described.

[Ru.] p. 248.
Entries: 1 (portraits only, additional to [Sm.]). Inches. Inscriptions. Described. Additional information to [Sm.].

Rymsdyck, Andreas van *(d. 1786)*
[W.] II, p. 531.
Entries: 2.*

Rymsdyck, Jan [John] van *(fl. 1760–1770)*
 [Sm.] III, p. 1044.
 Entries: 1 (portraits only). Inches. Inscriptions. States. Described.

 [W.] II, p. 531.
 Entries: 3+.*

Rynbout, Joannes Everardus *(b. 1839)*
 [H. L.] p. 935.
 Entries: 2. Millimeters. Inscriptions. Described.

Ryne, Jan van *(c.1712–c.1760)*
 [W.] II, p. 531.
 Entries: 6.*

Ryott, W. *(18th cent.)*
 [Sm.] III, pp. 1044–1045.
 Entries: 1 (portraits only). Inches. Inscriptions. Described.

Rysbraeck, Pieter *(1655–1729)*
 [B.] V, pp. 493–498.
 Entries: 6. Pre-metric. Inscriptions. Described.

 [Weigel] p. 345.
 Additional information to [B.].

 [W.] II, p. 532.
 Entries: 1+ prints by, 1 after.*

Rysbraeck, Pieter Andreas *(1690–1748)*
 [W.] II, p. 532.
 Entries: 1+ prints after.*

Rysbroeck, Jacob van
 See **Reesbroeck**

Rysselberghe, Theo van *(1862–1926)*
 Museé des beaux-arts, Ghent [Paul Eeckhout, compiler]. *Retrospective Théo van Rysselberghe.* Ghent (Belgium), 1962.
 Entries: 38 (complete?). Millimeters. Inscriptions. Illustrated (selection).

Ryssen, Geraert van *(17th cent.)*
 [W.] II, p. 533.
 Entries: 2+.*

Ryswyck, Theodor van *(1811–1849)*
 [H. L.] pp. 935–936.
 Entries: 1. Millimeters. Inscriptions. States. Described.

Ryther, Augustine *(fl. 1579–1592)*
 [Hind, *Engl.*] I, pp. 138–149.
 Entries: 7+. Inches. Inscriptions. Described. Illustrated (selection). Located.

S

S ——, Ernst *(19th cent.)*
 [Dus.] p. 124.
 Entries: 5 (lithographs only, to 1821). Millimeters (selection). Inscriptions. Located (selection).

S ——, Hartmann *(19th cent.)*
 [Dus.] p. 124.
 Entries: 2+ (lithographs only, to 1821). Millimeters (selection). Inscriptions. Described (selection). Located (selection).

Saagmolen, Martinus *(c.1620–1669)*
 [W.] II, p. 534.
 Entries: 1.*.

Saint-Aubin, Augustin de *(1736–1807)*
Bocher, Emmanuel. *Augustin de Saint-Aubin. Les gravures françaises du XVIIIe siècle, 5.* Paris: Damascène Morgand et Charles Fatout, 1879. 475 copies. (MH)
 Entries: 1330 prints by and after. Millimeters. Inscriptions. States. Described.

[Ap.] p. 371.
 Entries: 4.*

[Gon.] I, pp. 363–476.
 Entries: unnumbered, pp. 465–472, prints by and after. Based on Bocher.

[Ber.] XI, p. 282.*

[L. D.] pp. 75–77.
 Entries: 6. Millimeters. Inscriptions. States. Described. Illustrated (selection). Incomplete catalogue.*

Saint-Aubin, Charles Germain de *(1721–1786)*
[Baud.] I, pp. 84–97; errata, p. I.
 Entries: 27. Millimeters. Inscriptions. States. Described.

[Gon.] I, pp. 363–476.
 Entries: unnumbered, pp. 473–476, prints after.

Saint-Aubin, Gabriel Jacques de *(1724–1780)*
[Baud.] I, pp. 98–127; errata, pp. I–II.
 Entries: 44. Millimeters. Inscriptions. States. Described.

[Gon.] I, pp. 363–476.
 Entries: unnumbered, pp. 419–459, prints by and after. Described (selection). Based on [Baud.] for prints by.

Dacier, Émile. *L'Oeuvre gravé de Gabriel de Saint-Aubin; notice biographique et catalogue raisonné.* Paris: Société pour l'Étude de la Gravure Française, 1914. 500 copies. (MH)
 Entries: 52 prints by, 10 after. Millimeters. Inscriptions. States. De-

scribed. Illustrated (selection). Appendix with 4 prints not seen by Dacier.

Dacier, Émile. *Gabriel de Saint-Aubin, peintre, dessinateur et graveur.* 2 vols. Paris: G. van Oest, 1929–1931.
 Entries: 1131 (works in all media, including prints by and after). Millimeters. Inscriptions. States. Described. Located (selection).

Saint-Aubyn, Catherine *(1760–1836)*
[M.] II, p. 383.
 Entries: 4. Paper fold measure. Inscriptions.

Saint-Aulaire, Félix Achille *(b. 1801)*
[Ber.] XI, pp. 282–283.*

Saint-Eve, Jean Marie *(1810–1856)*
[Ap.] p. 372.
 Entries: 6.*

[Ber.] XI, pp. 283–285.*

Saint-Evre, Gillot *(1791–1858)*
[Ber.] XI, p. 285.
 Entries: 10. Paper fold measure.

Saint-Igny, Jean de *(c.1600–after 1649)*
[RD.] VIII, pp. 173–192; XI, pp. 299–300.
 Entries: 52. Millimeters. Inscriptions. States. Described.

Hédou, J. *Jean de Saint-Igny, peintre, sculpteur et graveur rouennais.* Rouen (France): E. Augé, 1887. (EPBN)
 Entries: unnumbered, pp. 46–53, prints by and after. Millimeters (selection). Inscriptions (selection). Described (selection). Refers to [RD.] for fuller descriptions; supplements certain incomplete entries in [RD.].

Saint-Marcel, Edme Charles Cabin *(1819–1890)*
Delteil, Loys. "Notes sur les peintres-graveurs français du XIXe siècle;

Saint-Marcel, Edme Charles Cabin (*continued*)

Saint-Marcel." *La Curiosité universelle* 4, no. 206 (December 1890): 1–4.
Entries: 22. Millimeters. Inscriptions. States. Described.

[Ber.] XII, pp. 5–6.
Entries: 21. Paper fold measure.

Saint-Martin, Paul de *(b. 1817)*
[Ber.] XII, p. 6.*

Saint-Mémin, Charles Balthazar Julien Fevret de *(1770–1852)*
Dexter, Elias. "The Saint-Mémin collection of portraits." *The Crayon* 7 (1860): 238–242.
Entries: 761. Prospectus for Dexter 1862.

Dexter, Elias. *The St. Mémin collection of portraits, consisting of seven hundred and sixty medallion portraits, principally of distinguished Americans, photographed by J. Gurney and Son, of New York, from proof impressions . . .* New York: Elias Dexter, 1862. (NN)
Entries: 760. Illustrated.

[St.] p. 453.*

Norfleet, Fillmore. *Saint-Mémin in Virginia; portraits and biographies.* Richmond (Va.): Dietz Press, 1942.
List of Virginians whose portraits were drawn or engraved by Saint-Mémin. Illustrated (selection). Includes some prints not in Dexter.

Saint-Non, [Jean Baptiste Claude] Richard *(1727–1791)*
Guimbaud, Louis. *Saint-Non et Fragonard, d'après des documents inédits.* La gravure et ses maîtres. Paris: Le Goupy, 1928.
Entries: 92+. Millimeters. Inscriptions. States.

Cayeux, Jean de. "Introduction au catalogue critique des griffonis de

Saint-Non." *Bulletin de la Société de l'histoire de l'art français,* 1963, pp. 297–384. Paris: F. de Nobele, 1964. Separately published. Paris: Librarie Armand Colin, 1964. (NN)
Entries: 299. Millimeters. Inscriptions. Described (selection). Discussion of editions, watermarks, etc.

Saint-Raymond, E. de *(19th cent.)*
[Ber.] XII, pp. 6–7.*

Salandri, Vincenzo *(d. 1838)*
[Ap.] p. 372.
Entries: 3.*

Salathé, Friedrich *(1793–1853)*
[Ber.] XII, p. 7.*

Saldörffer, Conrad *(fl. 1563–1583)*
[B.] IX, p. 558.
Entries: 2. Pre-metric. Inscriptions. Described.

[Heller] pp. 110–111.
Entries: 2 (additional to [B.]). Pre-metric. Inscriptions. Described.

[P.] IV, pp. 209–211.
Entries: 11+ (additional to [B.]). Pre-metric (selection), paper fold measure (selection). Inscriptions. Described. Located (selection).

[A.] II, pp. 10–24.
Entries: 20+. Pre-metric. Inscriptions. Described. Appendix with 2 doubtful prints.

Saldörffer, David *(16th cent.)*
See **Monogram DS** [Nagler, *Mon.*] II, no. 1353

Salimbeni, Ventura [called "Bevilacqua"] *(1567/68–1613)*
[B.] XVII, pp. 189–194.
Entries: 7. Pre-metric. Inscriptions. States. Described.

Sallaert, Anthonis *(c.1590–1657/58)*
[W.] II, p. 552.
 Entries: 8+ prints by, 5 after.*

Sallberg, Harald *(1895–1963)*
Bergquist, Eric. "Professor Harald
Sallberg (1895–1963)." [*N. ExT.*] 15
(1963): 117–119, 128.
 Entries: unnumbered, pp. 118–119, 128
 (bookplates only). Illustrated (selec-
 tion).

Sallieth, Matheus de *(1749–1791)*
[W.] II, pp. 552–553.
 Entries: 9+.*

Salm, B. Nikolas *(1810–1883)*
[Merlo] pp. 749–750.*

Salmon, Émile Frédéric *(1840–1918)*
[Ber.] XII, p. 9.*

Salmon, Louis Adolphe *(1806–1895)*
[Ap.] p. 373.
 Entries: 4.*

[Ber.] XII, pp. 7–8.*

Salmon, Théodore Frédéric *(b. 1811)*
[Ber.] XII, pp. 8–9.*

Salneuve, ——— *(19th cent.)*
[Ber.] XII, p. 9.*

Salto, Axel Johann *(b. 1889)*
Salto, Axel, and la Cour, Paul. *Salto's
Traesnit.* Copenhagen: Fischers Forlag,
1940. 550 copies. (DLC)
 Bibliography of books and albums
 with illustrations by, or written or
 published by.

Salvador Carmona, Juan Antonio
(1740–1805)
Rodriguez-Moñino, A., and Lord, Ei-
leen A. *Juan Antonio Salvador Carmona
grabador del siglo XVIII (1740–1805)
noticias biográfricas y catálogo de sus obras.*

Madrid: Blass, S.A. Tipográfica, 1954.
150 copies. (DLC)
 Entries: 194. Millimeters. Inscriptions.
 Located. Bibliography for each entry.

Salvador Carmona, Manuel *(1734–1820)*
[Ap.] pp. 86–87.
 Entries: 15.*

Rodriguez-Moñino, A., and Lord, Ei-
leen A. *Juan Antonio Salvador Carmona,
grabador del siglo XVIII (1740–1805)
noticias biográficas y catálogo de sus obras.*
Madrid: Blass, S. A. Tipográfica, 1954.
150 copies. (DLC)
 Entries: 194. Millimeters. Inscriptions.
 Located.

Salvadori, Aldo *(b. 1905)*
Daniele, Silvano. "Aldo Salvadori,
catalogo completo dell'opera incisa
1951–1971." [*QCS.*] 12 (May–June 1972):
15–31.
 Entries: 63 (to 1971). Millimeters. De-
 scribed. Illustrated (selection).

Salvi, Emilo *(19th cent.)*
[Ap.] p. 373.
 Entries: 1.*

Salviati, Francesco [or Cecchino]
(1510–1563)
 [P.] VI: *See* **Chiaroscuro Woodcuts**

Salviati, Giuseppe *(c.1520–c.1575)*
 [B.] XII: *See* **Chiaroscuro Woodcuts**

 [P.] VI: *See* **Chiaroscuro Woodcuts**

Salway, N. *(fl. c.1760)*
[Rus.] pp. 248–249.
 Entries: 2 (portraits only). Inches. In-
 scriptions. Described.

Samokhvalov, Aleksandr Nikolaevich
(20th cent.)
Barsheva, Irina, and Sazonova, K. *Alek-
sandr Nikolaevich Samokhvalov.* Lenin-
grad: Khudozhnik RSFSR, 1963.

Samokhvalov, Aleksandr Nikolaevich (*continued*)

> Entries: unnumbered, pp. 53–56 (prints and drawings, to 1959). Millimeters. Illustrated (selection).

Sanctis, Filippo de (*b. 1843*)
[Ap.] p. 115.
> Entries: 1.*

Sande, Jan van de (*fl. c.1645*)
[W.] II, p. 553.
> Entries: 2.*

Sandermayr, Simon Thaddäus
See **Sondermayr**

Sanders, Gerard (*c.1702–1767*)
[W.] II, p. 554.
> Entries: 2 prints after.*

Sanders Alexander van Brugsal (*fl. c.1520*)
See **Monogram S** [Nagler, *Mon.*] IV, nos. 3862, 4088

Sandhaas, Josef (*1747?–1828*)
[Dus.] p. 224.
> Entries: 1 (lithographs only, to 1821). Paper fold measure.

Sandi, Antonio (*1733–1817*)
[AN.] pp. 616–627.
> Entries: unnumbered, pp. 618–627. Millimeters. Inscriptions. Described (selection).

[AN. 1968] p. 174.
> Entries: unnumbered, p. 174 (additional to [AN.]). Millimeters (selection).

Sandoz, —— (*fl. 1847–1850*)
[Ber.] XII, p. 9.*

Sandrart, Jakob von (*1630–1708*)
[Hüsgen] pp. 208–210.
> Entries: 21 (portraits omitted). Paper fold measure.

Sandrart, Joachim von I (*1606–1688*)
[Hüsgen] pp. 200–208, 456.
> Entries: 14 prints after.

[A.] V, pp. 127–136.
> Entries: 3. Pre-metric. Inscriptions. States. Described. Appendix with rejected prints, unnumbered.

[W.] II, pp. 555–558.
> Entries: 3 prints by, 16+ after.*

Sandrart, Johann von (*d. after 1679*)
[W.] II, pp. 554–555.
> Entries: 1 print by, 1 after.*

Sands, John (*fl. 1826–1828*)
[F.] pp. 230–231.*

Sandys, [Anthony] Frederick [Augustus] (*1832–1904*)
> Gray, J. M. "Frederick Sandys and the wood-cut designers of thirty years ago." *The Hobby Horse* 3 (1888): 147–157.
> Entries: unnumbered, p. 157. Illustrated (selection). Periodicals in which the prints appeared are given.

Sandzén, [Sven] Birger (*1871–1954*)
> Smalley, Carl J. "The prints of Birger Sandzén." Supplement to: "Sandzén's lithographs of the Smoky Valley," by Minna Powell. [*P. Conn.*] 3 (1923): 214–236.
> Entries: unnumbered, pp. 227–232 (to 1922). Inches. Illustrated (selection).

> Greenough, Charles Pelham, III. *The graphic work of Birger Sandzen.* Lindsborg (Kans.): Birger Sandzen Memorial Foundation, 1952. Reprint. 1957.
> Entries: 207 lithographs, 94 woodcuts, 27 drypoints. Inches. Illustrated (selection).

Sanford, Isaac (*fl. 1783–1822*)
[St.] pp. 453–454.*

[F.] p. 231.*

Sang, F. J. *(19th cent.)*
[Ber.] XII, p. 9.*

Sangiorgi, Emilio *(19th cent.)*
[Ap.] p. 373.
Entries: 5.*

San Giovanni, Giovanni da
See **Mannozzi,** Giovanni

Sangster, Samuel *(c.1804–1872)*
[Ap.] p. 373.
Entries: 4.*

Sanktjohanser, Georg *(fl. c.1812)*
[Dus.] p. 224.
Entries: 1 (lithographs only, to 1821).

San Martino, Marco *(17th cent.)*
[B.] XXI, pp. 217–231.
Entries: 33. Pre-metric. Inscriptions.
Described.

Sansò, Juvenal *(20th cent.)*
Print Club of Cleveland [Leona E.
Prasse and Louise S. Richards, com-
pilers]. *Sansò; catalogue of an exhibition of
work by Juvenal Sansò incorporating a com-
plete checklist of his prints.* Cleveland
(Ohio), 1964.
Entries: 57 (to 1963). Millimeters.

Sansom, F. *(fl. 1788–1790)*
[W.] II, p. 558.
Entries: 2.*

Sanson, Johann *(16th cent.)*
See **Monogram IS** [Nagler, *Mon.*] IV, no.
403

Sant'Agostino, Maria di *(16th cent.)*
[B.] XII: *See* **Chiaroscuro Woodcuts**

Santi, Domenico [called "Mengazzino"]
(1621–1694)
[B.] XIX, pp. 218–221.

Entries: 4. Pre-metric. Inscriptions.
Described.

Santis, Orazio de [called "Aquilano"]
(fl. 1568–1584)
[B.] XVII, pp. 5–14.
Entries: 17. Pre-metric. Inscriptions.
States. Described.

Santvoort, Abraham Dircks *(d. 1669)*
[Wess.] II, p. 252.
Entries: 1. Millimeters. Inscriptions.
Described.

[W.] II, p. 559.
Entries: 10+.*

Santvoort, Dirck Dircksz [van]
(1610/11–1680)
[W.] II, p. 559.
Entries: 3 prints after.*

Santvoort, Pieter Dircksz [van]
(after 1603–1635)
[W.] II, p. 560.
Entries: 1 print after.*

Sanuto, Giulio *(fl. 1540–1580)*
[B.] XV, pp. 499–501.
Entries: 5. Pre-metric. Inscriptions.
Described.

[P.] VI, pp. 104–107.
Entries: 6 prints by (additional to [B.]),
6 prints not seen by [P.]. Pre-metric.
Inscriptions. Described. Additional
information to [B.].

Sarazin de Belmont, Louise Joséphine
(1790–1870)
[Ber.] XII, p. 10.*

Sarcus, Charles Marie de
See **Quillenbois**

Sardou, Victorien *(19th cent.)*
[Ber.] XII, p. 10.*

Sargent, Alfred *(b. 1828)*
[Ber.] XII, p. 10.*

Sargent, John Singer *(1856–1925)*
Dodgson, Campbell. "Catalogue of the
lithographs of J. S. Sargent, R.A." Sup-
plement to "The lithographs of Sar-
gent," by Albert Belleroche. [*PCQ.*] 13
(1926): 31–45.
 Entries: 6. Inches. Inscriptions.
 States. Illustrated.

Sargent, Louis *(fl. 1863–1869)*
[Ber.] XII, p. 10.*

Sarrabat, Isaac *(b. 1667)*
[RD.] III, pp. 296–310; XI, pp. 300–302.
 Entries: 34. Pre-metric. Inscriptions.
 States. Described.

Sarragon, Joannes *(fl. 1621–1644)*
[W.] II, p. 560.
 Entries: 3.*

Sarto, Andrea del *(1486–1530)*
[B.] XII: *See* **Chiaroscuro Woodcuts**

 Shearman, John. *Andrea del Sarto.* Ox-
 ford: Clarendon Press, 1965.
 Catalogue of paintings; prints after
 are mentioned where extant.

Sartor, [Joh.] Conrad *(fl. 1715–1731)*
[Merlo] p. 751.*

Sartor, Johann Jakob *(fl. 1706–1737)*
[Merlo] pp. 751–753.*

Sartorius, Francis *(1734–1804)*
[Siltzer] pp. 239–242.
 Entries: unnumbered, p. 242, prints
 after. Inches (selection). Inscriptions.

Sartorius, John Nost *(1759–c.1828)*
[Siltzer] pp. 239–244.
 Entries: unnumbered, pp. 242–244,
 prints after. Inches (selection). In-
 scriptions.

Satrapitanus
See **Vogtherr,** Heinrich I

Sattler, Josef *(1867–1931)*
Knorr, Theodor: "Josef Sattler, sein
Leben und seine Kunst." *Elsass-
Lothringisches Jahrbuch* 11 (1932): 279–308.
 Entries: 212+ (bookplates only). Also,
 bibliography of books illustrated by.

Sauerweid, Alexander Ivanovich
See **Zauerveyd"**

Saulx, Jean de
See **Desaulx**

Saunders, J. *(18th cent.)*
[Sm.] III, pp. 1046–1049, and "additions
and corrections" section.
 Entries: 9 (portraits only). Inches. In-
 scriptions. States. Described. Located
 (selection).

[Ru.] pp. 249–250.
 Additional information to [Sm.].

Sauvage, Napoléon *(fl. c.1847)*
[Ber.] XII, p. 11.*

Sauvage, Sylvain *(b. 1888)*
Valotaire, Marcel. *Sylvain Sauvage.* Les
artistes du livre, 8. Paris: Henry Babou,
1929. 750 copies. (NN)
 Bibliography of books with illustra-
 tions by (to 1929).

 Bersier, Jean E. "Sylvain Sauvage."
 Portique 8 (1951): 13–28.
 Bibliography of books with illustra-
 tions by (to 1950).

Sauvageot, Claude *(1832–1885)*
[Ber.] XII, p. 11.*

Sauvan, Philippe *(1698?–1789)*
[RD.] VIII, pp. 302–308; XI, pp. 302–304.
 Entries: 10. Millimeters. Inscriptions.
 States. Described.

Sauvé, [Jean Jacques] Théodore
(1792–1869)
 [Ber.] XII, pp. 11–12.*

Saux, Sophie de
 See **Browne,** Henriette

Savage, Edward *(1761–1817)*
 Hart, Charles H. "Edward Savage,
 painter and engraver." Massachusetts
 Historical Society, *Proceedings,* 2d ser. 19
 (1905): 1–19.
 Entries: 18. Inches. Inscriptions. De-
 scribed.

 Hart, Charles Henry. *Edward Savage,
 painter and engraver, and his unfinished
 copper-plate of "The Congress Voting Inde-
 pendence . . ." with a chronological
 catalogue of his engraved work.* Boston
 (Mass.), 1905.
 Entries: 18. Inches. Inscriptions.
 States. Described (selection).

 [St.] pp. 454–458.*

 [F.] p. 231.*

 [Ru.] p. 250.
 Entries: 2 (portraits only). Inches. In-
 scriptions. Described.

Savart, Pierre *(b. 1737)*
 Faucheux, L. E. "Catalogue raisonné de
 l'oeuvre de Pierre Savart." [*RUA.*] 19
 (1864): 321–343.
 Entries: unnumbered, pp. 322–343.
 Millimeters. Inscriptions. States. De-
 scribed.

 Faucheux, L. E. *Catalogue raisonné de
 toutes les estampes qui forment les oeuvres
 gravés d'Étienne Ficquet, Pierre Savart, J. B.
 de Grateloup et J. P. S. de Grateloup.* Paris:
 Veuve Jules Renouard; Brussels: A. Mer-
 tens et Fils, 1864. 100 copies. (NJP)
 Entries: 34. Millimeters. Inscriptions.
 States. Described.

 Andrews, William Loring. *A trio of
 eighteenth century engravers of portraits in*

miniature; Ficquet, Savart, Grateloup. New
York: William Loring Andrews, 1899.
 Entries: unnumbered, pp. 117–118.

Savery
 See also **Xavery**

Savery, Jacob I *(d. 1602)*
 [W.] II, p. 561.
 Entries: 3+ prints by, 6 after.*

 [Burch.] pp. 143–144.
 Entries: 8. Millimeters. Inscriptions.
 States. Described. Located.

Savery, Jacob III *(1617–1666)*
 [W.] II, pp. 561–562.
 Entries: 1+.

Savery, Jan *(1597–1654)*
 [W.] II, p. 562.
 Entries: 9+.*

Savery, Roelant *(1576?–1639)*
 [A.] IV, pp. 346–350.
 Entries: 4. Pre-metric. Inscriptions.
 States. Described.

 [W.] II, pp. 562–564.
 Entries: 4 prints by, 8+ after.*

 Erasmus, Kurt. *Roelant Savery, sein Leben
 und seine Werke.* Dissertation, University
 of Halle-Wittenberg. Halle a. S. (Ger-
 many), 1908.
 Entries: 2 prints by; prints after un-
 numbered, pp. 182–200. Millimeters.
 Inscriptions. Described.

Savery, Salomon *(1594–after 1665)*
 [W.] II, p. 564.
 Entries: 36+.*

 [Hind, *Engl.*] III, pp. 220–221.
 Entries: 4+ (prints done in England
 only). Inches. Inscriptions. De-
 scribed. Illustrated (selection). Lo-
 cated.

Savigny, Frédéric de, baron *(fl. c.1869)*
[Ber.] XII, p. 12.*

Savoy, Carel van *(c.1621–1665)*
[W.] II, p. 564.
 Entries: 1 print after.*

Savoyen, Carel van
See **Savoy**

Say, William *(1768–1834)*
[Siltzer] p. 365.
 Entries: unnumbered, p. 365. Inscriptions.

Sayer, Robert *(fl. 1750–1780)*
[Siltzer] p. 333.
 Entries: unnumbered, p. 333, prints after. Inches. Inscriptions.

Sayler, J. *(16th cent.)*
[W.] II, p. 565.
 Entries: 2+.*

Scacki, Francisco *(fl. c.1815)*
[St.] pp. 458–459.*

Scaddon, R. *(18th cent.)*
[Sm.] III, p. 1049.
 Entries: 1 (portraits only). Inches. Inscriptions. Described.

Scalberge [**Scalle Berge**], Frédéric
(fl. 1623–1636)
[W.] II, p. 565.
 Entries: 2+.*

Scalberge [**Scalle Berge**], Pierre
(c.1592–1640)
[RD.] III, pp. 1–15; XI, pp. 304–306.
 Entries: 55. Pre-metric. Inscriptions. States. Described.

Scaminossi, Raffaello
See **Schiaminossi**

Scaramuccia, Luigi Pellegrini *(1616–1680)*
[B.] XIX, pp. 190–193.
 Entries: 4. Pre-metric. Inscriptions. States. Described.

Scarsella, Ippolito [called "Scarsellino"]
(1551–1620)
[B.] XVII, pp. 25–26.
 Entries: 1. Pre-metric. Inscriptions. Described.

Scarselli, Girolamo *(fl. c.1670)*
[B.] XIX, pp. 249–254.
 Entries: 6. Pre-metric. Inscriptions. States. Described. Copies mentioned.

Scarsellino
See **Scarsella,** Ippolito

Scatter, Francis *(fl. c.1577)*
[Hind, *Engl.*] I, p. 99.
 Entries: 1+. Paper fold measure. Inscriptions. Located.

Scavezzi, Prosper
See **Bresciano,** Prospero

Scawen, ———— *(fl. c.1770)*
[Sm.] III, p. 1050.
 Entries: 1 (portraits only). Inches. Inscriptions. Described.

Schaak, Jeremias van *(fl. c.1695)*
[W.] II, p. 565.
 Entries: 3.*

Schaak, Willem *(fl. c.1700)*
[W.] II, p. 565.
 Entries: 4+.*

Schaal, Louis Jacques Nicolas
(1800–after 1859)
[Ber.] XII, p. 12.*

Schad, Aquilin *(b. 1815)*
[Ap.] p. 374.
 Entries: 2.*

Schadow, [Johann] Gottfried *(1764–1850)*
Friedländer, Julius. *Gottfried Schadow; Aufsätze und Briefe nebst einem Verzeichniss seiner Werke.* Düsseldorf: Julius Buddeus, 1864. Reprint. Stuttgart: Ebner und Seubert, 1890.
Entries: 53 etchings, 21 lithographs, 10 zincographs. Pre-metric (selection). Paper fold measure (selection). Inscriptions. Described.

[Dus.] pp. 224–225.
Entries: 4 (lithographs only, to 1821). Millimeters (selection). Inscriptions (selection). Located.

Mackowsky, Hans. *Schadows Graphik.* Forschungen zur deutschen Kunstgeschichte, 9. n.p., Deutscher Verein für Kunstwissenschaft, 1936.
Entries: 134 prints by, 17 after, 5 rejected prints. Millimeters. Inscriptions. States. Described. Illustrated.

Schaeck, Willem
See **Schaak**

Schädler, Johann Georg
See **Schedler**

Schaefels, Hendrik Frans *(1827–1904)*
[H. L.] pp. 937–951.
Entries: 44. Millimeters. Inscriptions. States. Described.

Schaefels, Lucas Victor *(1824–1885)*
[H. L.] p. 951.
Entries: 1. Millimeters. Inscriptions. States. Described.

Schäffer, Eugen Eduard *(1802–1871)*
[Ap.] pp. 374–376.
Entries: 26.*

Schaeffer von Leonhartshoff, Johann Evangelist
See **Scheffer von Leonhartshoff**

Schaep, Hendrik Adolf *(1826–1870)*
[H. L.] pp. 951–952.
Entries: 3. Millimeters. Inscriptions. States. Described.

Schaep, M. *(17th cent.)*
[W.] II, p. 566.
Entries: 2+.*

Schaepkens, Alexander *(1815–1899)*
[H. L.] pp. 986–994.
Entries: 31. Millimeters. Inscriptions. States. Described.

Schaepkens, [Jean Ant.] Arnaud *(1816–1904)*
[H. L.] pp. 962–986.
Entries: 85. Millimeters. Inscriptions. States. Described.

Schaepkens, Theodor *(1810–1883)*
[H. L.] pp. 953–962.
Entries: 36. Millimeters. Inscriptions. States. Described.

XXII eaux-fortes, avec souvenir biographique de Theodore Schaepkens 1810–1884. Brussels: Imprimerie veuve Monnom, 1887. (EA)
Entries: 35 etchings, 19 lithographs. Illustrated (selection). 22 etchings are printed in the book.

Schäufelein, Hans Leonhard *(1480/85–1538/40)*
See also **Monogram HS** [Nagler, *Mon.*] III, no. 1463

[B.] VII, pp. 244–273.
Entries: 132+. Pre-metric. Inscriptions (selection). States. Described (selection).

[Heller] pp. 111–112.
Entries: 6 (additional to [B.]). Pre-metric. Inscriptions. Described.

[P.] III, pp. 227–239.

Schäufelein, Hans Leonhard *(continued)*

Entries: 42+ (additional to [B.]). Pre-metric. Inscriptions (selection). Described (selection). Located (selection). Additional information to [B.].

Dodgson, Campbell. "Zum Holzschnittwerk Schäufeleins." [*MGvK.*] 1905, pp. 2–10.
Entries: 107 (additional to previous catalogues). Millimeters. Inscriptions. Described. Located.

[Ge.] nos. 1029–1117.
Entries: 99 (single-sheet woodcuts only). Described. Illustrated. Located.

Zimmermann, Hildegarde. "Hans Schäufeleins Holzschnitt-Folgen für Hans Schönsperger." [*Schw. M.*] 1930, pp. 138–149.
Entries: 87 (woodcuts produced for Hans Schönsperger only). Millimeters. Described. Illustrated (selection). Located.

Oldenbourg, M. Consuelo. *Die Buchholzschnitte des Hans Schäuffelein; ein bibliographisches Verzeichnis ihrer Verwendung.* 2 vols. Studien zur deutschen Kunstgeschichte, 341. Baden-Baden: Verlag Heitz GmbH, 1964.
Entries: 854 (woodcut book illustrations only). Millimeters. Inscriptions. States. Described (selection). Illustrated (selection). Reference to reproductions in other works is given for all prints not reproduced here. Also, bibliography of books in which the woodcuts appeared.

Schagen, Gerrit Lucasz van *(1642–after 1690)*
[W.] II, p. 566.
Entries: 6+.*

Schalcken, Godfried *(1643–1706)*
[Wess.] II, p. 252.

Entries: 5. Millimeters (selection). Paper fold measure (selection). States.

[Dut.] VI, p. 301.*

[W.] II, pp. 567–569.
Entries: 8 prints by, 41 after.

Schall, [Jean] Frédéric *(1752–1825)*
Girodie, André. *Un peintre de fêtes galantes; Jean Frédéric Schall (Strasbourg 1752–Paris 1825).* Strasbourg: Compagnie Alsacienne des Arts Photomécaniques A. et F. Kahn, 1927.
Entries: 173 prints after. Illustrated (selection).

Schall, Joseph Friedrich August *(1785–1867)*
[Dus.] p. 225.
Entries: 1 (lithographs only, to 1821). Paper fold measure.

Schallberge
See **Scalberge**

Schampheleer, Edmond de *(1824–1899)*
[H. L.] pp. 995–996.
Entries: 3. Millimeters. Inscriptions. States. Described.

Schanker, Louis *(b. 1903)*
Brooklyn Museum [Una E. Johnson, compiler]. *Abstractions, the woodblock color prints of Louis Schanker.* New York, 1943.
Entries: 45 (to 1942). Inches.

Schanne, ——— *(19th cent.)*
[Ber.] XII, p. 13.*

Schaper, Friedrich *(b. 1869)*
[Sch.] p. 125ff.
Not seen.

Scharffenberg, Georg *(fl. 1565–1590)*
[B.] IX, pp. 439–441.

Entries: 9+. Pre-metric. Inscriptions (selection). Described (selection).

[P.] IV, pp. 66–67.
Entries: 2 (additional to [B.]). Inscriptions. Described (selection).

Scharnagel, Franz Sebastian *(1791–1837)*
[Dus.] pp. 225–226.
Entries: 9+ (lithographs only, to 1821). Millimeters. Inscriptions.

Schattenhofer, Amalia von *(1763–c.1840)*
[M.] II, pp. 499–500.
Entries: 14. Paper fold measure.

Schatzberger, Michael *(fl. c.1820)*
[Dus.] p. 227.
Entries: 1 (lithographs only, to 1821). Paper fold measure.

Schauffele, Hans Leonhard
See **Schäufelein**

Schaumburg, Jules *(19th cent.)*
[H. L.] pp. 996–997.
Entries: 2. Millimeters. Inscriptions. States. Described.

Schawberg, Johann Heinrich *(1717–1760)*
[Merlo] p. 758.*

Schawberg, Peter Joseph *(d. after 1722)*
[Merlo] p. 758.*

Schedler, Johann Georg *(1777–1866)*
[Dus.] p. 227.
Entries: 1 (lithographs only, to 1821). Millimeters. Inscriptions. Located.

Schedoni, Bartolomeo
See **Schidone**

Scheffer, Ary *(1795–1858)*
[Ber.] XII, pp. 13–16.
Entries: 17+. Paper fold measure.

Scheffer, Eugen Eduard
See **Schäffer**

Scheffer, Jean Gabriel *(1797–1876)*
[Ber.] XII, p. 17.*

Scheffer von Leonhartshoff, Johann Evangelist *(1795–1822)*
[A. 1800] III, pp. 80–85.
Entries: 6. Pre-metric. Inscriptions. States. Described.

Schwarz, Heinrich. "Nachträge zu Andresens 'Deutschen Maler-radierern.' " [MGvK.] 1924, pp. 41–51.
Entries: 2 (additional to [A. 1800]). Millimeters. Inscriptions. Described. Located.

Schwarz, Heinrich. "Neue Nachträge zu Andresens 'Deutschen Maler-radierern.' " [GK.] n.s. 1 (1936): 152–159.
Additional information to [A. 1800].

Schei, Pieter *(fl. c.1678)*
[W.] II, p. 570.
Entries: 1 print after.*

Scheidt, Carl von *(19th cent.)*
[Dus.] p. 227.
Entries: 4+ (lithographs only, to 1821). Millimeters (selection). Inscriptions. Located.

Scheifelin, Hans Leonhard
See **Schäufelein**

Scheinhütte, Michael Hubert Aloys Joseph *(1796–1836)*
[Merlo] p. 759.*

Scheits, Matthias *(1625/30–c.1700)*
[W.] II, pp. 570–571.
Entries: 14+ prints by, 4 after.*

Schelfhout, Lodewijk *(b. 1881)*
Huebner, Friedrich M. *Lodewijk Schelfhout.* Junge Kunst, 28. Leipzig: Klink-

Schelfhout, Lodewijk (*continued*)

hardt und Biermann, 1921. Dutch ed. *Lodowijk Schelfhout. Nieuwe kunst,* 1. Amsterdam: Van Munsters Uitgevers-Maatschappij, 1921.
Entries: 85 (to 1920).

"Catalogue des pointes-sèches de Lodewijk Schelfhout." Unpublished ms., 1951. (EA)
Entries: 224. Millimeters. States. Located. All prints are in the collection of the Rijksprentenkabinet, Amsterdam.

Schelk, H. *(fl. c.1844)*
[H. L.] p. 997.
Entries: 1. Millimeters. Inscriptions. States. Described.

Schellemans, Frans
See **Schillemans**

Schellenberg, Johann Ulrich *(1709–1795)*
Quensel, Paul. *Johann Ulrich Schellenberg, 1709–1795, ein Pionier der Darstellung schweizerischer Alpenlandschaften.* Bern: Verlag Paul Haupt, 1953.
Entries: 59 prints by, 48 after. Millimeters. Inscriptions. States. Described (selection). Illustrated (selection).

Schellinks, Willem *(1627?–1678)*
de Vries, A. D. "Willem Schellinks; schilder, teekenaar, etser, dichter." [*Oud-Holl.*] 1 (1883): 150–163.
Entries: 4. Millimeters. Inscriptions. States. Described.

[W.] II, p. 572.
Entries: 4 prints by, 4 after.*

Schenau, Johann Eleazar *(1737–1806)*
[A.] V, pp. 359–372.
Entries: 33. Pre-metric. Inscriptions. States. Described.

[Wess.] I, p. 151.
Additional information to [A.].

Schenck or **Schenckel**
See **Schenk** or **Schenkel**

Schencker, Nicolas *(c.1760–1848)*
[Ap.] p. 376.
Entries: 3.*

Schendel, Gillis [Aegidius] van
See **Scheyndel**

Schenk, Friedrich *(b. 1811)*
[Dus.] p. 227.
Entries: 1 (lithographs only, to 1821). Millimeters. Inscriptions. Located.

Schenk, Jan *(fl. 1731–1746)*
[W.] II, p. 573.
Entries: 4.*

Schenk, Leonard *(fl. 1715–1746)*
[W.] II, pp. 573–574.
Entries: 5+.*

Schenk, Pieter *(1660–1718/19)*
[W.] II, pp. 574–577.
Entries: 320+.*

Schenk, Pieter II *(fl. c.1774?)*
[W.] II, p. 577.
Entries: 3.*

Schenkel, Lampert *(16th cent.)*
[W.] II, p. 577.
Entries: 1 print after.*

Schennis, [Hans] Friedrich [Emanuel] *(1852–1918)*
[Ber.] XII, p. 17.*

Scheppere, Louis Benoît Ferdinand de *(1748–1811)*
[H. L.] p. 998.
Entries: 2. Millimeters. Inscriptions. Described.

Scherm, Lorenz *(fl. c.1700)*
[W.] II, p. 577.
Entries: 7+.*

Scheuffelein, Hans Leonhard
See **Schäufelein**

Scheuflein, Hans Leonhard
See **Schäufelein**

Scheuritzel, Anton *(b. 1874)*
Scheuritzel, Gerhard. *Das graphische
Werk des Maler-Radierers Anton Scheurit-
zel; ein beschreibendes und chronologisch
geordnet Verzeichnis mit 81 Abbildungen.*
Berlin: August Scherl GmbH, 1920.
 Entries: 137 (to 1920?). Millimeters.
 States (selection). Described (selec-
 tion). Illustrated (selection). All unil-
 lustrated prints are described. Ap-
 pendix listing commercial prints, pp.
 46–48.

Scheurleer, H. *(fl. 1750–1760)*
[W.] II, p. 577.
 Entries: 2+.*

Scheutz, Matthias
See **Scheits**

Scheyffelin, Hans Leonhard
See **Schäufelein**

Scheyndel, Gillis [Aegidius] van
(fl. 1622–1654)
[W.] II, pp. 572–573.
 Entries: 24+.*

Schiaminossi, Raffaello *(c.1529–1622?)*
[B.] XVII, pp. 211–245.
 Entries: 137. Pre-metric. Inscriptions.
 States. Described (selection).

Schiavoni, Natale *(1777–1858)*
[Ap.] p. 377.
 Entries: 10.*

Schick, Pieter *(fl. 1662–1666)*
[W.] II, pp. 577–578.
 Entries: 2 prints after.*

Schidone, Bartolomeo *(c.1570–1615)*
[B.] XVIII, pp. 206–207.
 Entries: 1. Pre-metric. Inscriptions.
 Described.

Schieffer, Peter *(c.1811–1869)*
[Merlo] p. 760.*

Schiele, Egon *(1890–1918)*
Gutekunst und Klipstein, Bern
[Eberhard W. Kornfeld, Hans Bolliger
and Otto Benesch, compilers]. *Ausstel-
lung Egon Schiele.* Lagerkatalog no. 57.
Bern, 1956.
 Entries: 11. Millimeters. Inscriptions.
 States. Described. Illustrated.

Schwarz, Heinrich. "Die graphischen
Werke von Egon Schiele." *Philobiblon* 5
(1961): 50–68. Separately published.
Hamburg: Dr. Ernst Hauswedell und
Co., 1961. "Nachtrag." *Philobiblon* 6
(1962): 154.
 Entries: 11. Millimeters. Inscriptions.
 States. Described. Illustrated. Lo-
 cated.

Kallir, Otto. *Egon Schiele, the graphic
work.* New York: Crown Publishers,
1970.
 Entries: 17. Millimeters. Inches. In-
 scriptions. States. Described. Illus-
 trated.

Schiesl, Ferdinand *(1775–c.1820)*
[Dus.] pp. 227–228.
 Entries: 6+ (lithographs only, to 1821).
 Millimeters (selection). Inscriptions.
 Located (selection).

Schiesser, Hans *(fl. c.1550)*
[Ge.] no. 1118.
 Entries: 1 (single-sheet woodcuts
 only). Described. Illustrated. Located.

Schiestl, Rudolf *(1878–1931)*
Kielmann, Wilhelm. *Rudolf Schiestl.* Dis-
sertation, Friedrich-Alexanders-

Schiestl, Rudolf *(continued)*

Universität in Erlangen. Lohr am Main (Germany): J. Grote, 1935.
Entries: unnumbered, pp. 20–37, 44–59. Millimeters. Inscriptions. Described.

Reiser, Karl August, and Böllhof-Becker, Hanna L. *Rudolf Schiestl, das graphische Werk.* Bielefeld (West Germany): Bentrup Druck, 1970.
Entries: 108. Millimeters. Inscriptions. Illustrated. Appendix with 7 prints mentioned in Kielmann, but not seen by Reiser and Böllhof-Becker.

Schijnvoet, Jacobus *(fl. 1704–1733)*
[W.] II, p. 596.
Entries: 3+.*

Schillemans, Frans *(b. 1575)*
[W.] II, p. 578.
Entries: 8+.*

[W.] II, p. 620 (as Sichelmans).
Entries: 1.*

Schindehutte, Ali *(20th cent.)*
Ohff, Heinz, and Ohff, Christiane. *Ali Schindehutte; frühe Zeichnungen, Tafelbilder, Illustrationen, Holzschnitte, Lithographien, Radierungen. Einzelkatalog zum Oeuvre-Verzeichnis der Werkstatt Rixdorfer Drucke.* Hamburg: Merlin, 1970.
Entries: unnumbered, 21 pp. (to 1970). Millimeters. Illustrated.

Schindler, Carl *(1821–1842)*
Haberditzl, Franz Martin, and Schwarz, Heinrich. *Carl Schindler; sein Leben und sein Werk.* Vienna: Österreichischen Staatsdruckerei, 1930.
Entries: 27 prints by, 31 after. Millimeters. Inscriptions. Described (selection). Illustrated (selection). Located.

Schinkel, Karl Friedrich *(1781–1841)*
[Dus.] pp. 228–229.
Entries: 8 (lithographs only, to 1821). Millimeters (selection). Paper fold measure (selection). Inscriptions. States. Located (selection).

Schinnerer, Adolf Ferdinand *(b. 1876)*
Gorm, Ludwig. *Adolf Schinnerer, sein graphisches Werk.* Munich: Graphik-Verlag München, 1915.
Entries: 408 (to 1915). Millimeters. States. Described.

Schirmer, Johann Wilhelm *(1807–1863)*
[A. 1800] II, pp. 303–344.
Entries: 32. Pre-metric. Inscriptions.

Schirnböck, Ferdinand *(1859–1930)*
Franke, Rupert. "Ferdinand Schirnböck, 1859–1930, ein Meister des Wertzeichenstiches." *Österreichisches Jahrbuch für Exlibris und Gebrauchsgraphik* 47 (1966–1967): 23–26, 57–58.
Entries: unnumbered, pp. 57–58. Described.

Schjaerven, Henry *(20th cent.)*
Heier, R. Nysted. "Henry Schjaerven." [*N. ExT.*] 2 (1947–1948): 52–53, 61–64.
Entries: 148 (bookplates only, to 1948). Illustrated (selection).

Schleich, Adrian *(1812–1894)*
[Ap.] p. 378.
Entries: 8.*

Schleich, Carl II *(1788–1840)* and **Seitz,** Johann Baptist *(1786–1850)*
[Dus.] pp. 229–230.
Entries: 3 (lithographs only, to 1821). Millimeters (selection). Inscriptions. States. Located (selection).

Schleicher, Franz *(fl. 1820–1840)*
[Dus.] pp. 230–231.

Entries: 14 (lithographs only, to 1821). Millimeters. Inscriptions. States. Located.

Schlemmer, Oskar *(b. 1888)*
Hildebrandt, Hans. *Oskar Schlemmer.* Munich: Prestel Verlag, 1951.
Entries: unnumbered, p. 152 (prints issued in portfolios only).

Schlemmer, Tut. *Oskar Schlemmer; Zeichnungen und Graphik, Oeuvre-katalog; Einleitung Will Grohmann.* Stuttgart: Verlag Gerd Hatje, 1965.
Entries: 26 monotypes, 1 etching, 20 lithographs, 5 linocuts. Millimeters. Inscriptions. Described. Illustrated.

Schlerth, F. A. von *(fl. c.1818)*
[Dus.] p. 231.
Entries: 1 (lithographs only, to 1821). Paper fold measure. Inscriptions.

Schlesinger, [Wilhelm] Heinrich *(1814–1893)*
[Ber.] XII, p. 17.*

Schley, Jakob van der *(1715–1779)*
[W.] II, p. 579.
Entries: 11+.*

Schlösser, Carl Bernhard *(1832–after 1914)*
[Ber.] XII, p. 18.*

Schlotter, Eberhard *(b. 1921)*
Verlag Eduard Roether. *Eberhard Schlotter, Werkverzeichnis der Radierungen von 1936–1968.* Darmstadt (West Germany): Verlag Eduard Roether, 1971. (EBKk)
Entries: 940. Millimeters. Illustrated.

Schlotterbeck, Christian Jakob *(1757–1811)*
[Ap.] p. 378.
Entries: 15.*

Schlotthauer, Joseph *(1789–1869)*
[Dus.] p. 231.

Entries: 2 (lithographs only, to 1821). Millimeters. Inscriptions. Located.

Schlumpp, Hans *(d. 1514)*
See **Monogram HS** [Nagler, *Mon.*] III, no. 1463

Schmid, Simon *(1760–1840)*
[Dus.] p. 232.
Entries: 3 (lithographs only, to 1821). Millimeters. Inscriptions. Located.

Schmidt, F. F. *(fl. 1817–1819)*
[Dus.] p. 231.
Entries: 1 (lithographs only, to 1821). Millimeters. Inscriptions. Located.

Schmidt, Ferdinand *(19th cent.)*
[Ap.] p. 379.
Entries: 1.*

Schmidt, Georg Friedrich *(1712–1775)*
[Crayen, Aug. Guillaume]. *Catalogue raisonné de l'oeuvre de feu George Frédéric Schmidt, graveur du roi de Prusse.* London, 1789. 2d ed. Paris, 1809.
Entries: 186. Pre-metric. Inscriptions. States. Described. Ms. translation by Thomas Dodd. (EBM)

Jacoby, Ludwig David. *Schmidts Werke, oder; beschreibendes Verzeichniss sämtlicher Kupferstiche und Radirungen . . . nach der französischen Ausgabe frei bearbeitet, mit verschiedenen Vermehrungen und Verbesserungen versehen.* Berlin: Jacoby's Kunsthandlung, 1815. (MH)
Entries: 186. Paper fold measure. Inscriptions. States. Described. Copies mentioned.

[Wess.] I, pp. 151–155.
Additional information to Jacoby.

Apell, A. *Das Werk von Georg Friedrich Schmidt, Zeichner, Kupferstecher und Radierer.* Dresden: G. A. Claus, 1887.

Schmidt, Georg Friedrich (*continued*)

Entries: 223+. Paper fold measure. Inscriptions. States. Described.

Wessely, J. E. *Georg Friedrich Schmidt; Verzeichniss seiner Stiche und Radirungen.* Kritische Verzeichnisse von Werken hervorragender Kupferstecher, 1. Hamburg: Haendke und Lehmkuhl, 1887. Entries: 299. Millimeters. Inscriptions. States. Described. Ms. notes (EA); additional information.

Schmidt, Heinrich Friedrich Thomas (*b. 1780*)
[Ap.] p. 379.
Entries: 5.*

Schmidt, Izaak (*1740–1818*)
[W.] II, p. 579.
Entries: 4+ prints by, 1 after.*

Schmidt, Johan Faber
See **Faber**

Schmidt, Leopold (*b. 1824*)
[Ap.] p. 379.
Entries: 2.*

Schmidt, Martin Johann [called "Kremser-Schmidt"] (*1718–1801*)
Garzarolli-Thurnlackh, Karl. *Das graphische Werk Martin Johann Schmidts (Kremser Schmidt) 1718–1801.* Zurich: Amalthea Verlag, 1925.
Entries: 30 prints by; prints after unnumbered, pp. 115–134. Millimeters. Inscriptions. States. Described. Illustrated (selection).

Schmidt, Matthias (*1749–1823*)
[Dus.] p. 232.
Entries: 1 (lithographs only, to 1821). Millimeters. Inscriptions. Located.

Schmidt, Michael (*d. 1825*)
[Dus.] p. 232.

Entries: 1+ (lithographs only, to 1821). Inscriptions.

Schmidt, Th. (*fl. c.1819*)
[Dus.] p. 232.
Entries: 1 (lithographs only, to 1821). Millimeters. Inscriptions.

Schmidt-Hild, Wilhelm (*b. 1880*)
Gutschmidt, H. "W. Schmidt-Hild." [*Kh.*] 15 (1923): 85, 93–94.
Entries: 109 (to 1923). Millimeters.

Schmidt-Rottluff, Karl (*b. 1884*)
Schapire, Rosa. *Karl Schmidt-Rottluffs graphisches Werk bis 1923.* Berlin: Euphorion Verlag, 1924. 400 copies. Reprint. Hamburg: Hauswedell, 1965. (DLC)
Entries: 300 woodcuts, 105 lithographs, 70 etchings, 78 commercial prints. Millimeters. Described.

Rathenau, Ernest. *Karl Schmidt-Ruttluff; das graphische Werk seit 1923.* New York: Ernest Rathenau, 1964. 600 copies. (MB)
Entries: 85 (additional to Schapire). Millimeters. Illustrated.

Schmied, François Louis (*b. 1873*)
Schmied, F. L. *Catalogue des livres de F. L. Schmied exposés en mars 1927 chez Arnold Seligman Rey and Co. . . . suivi du catalogue générale des livres de F. L. Schmied imprimés et sous presses au 28 février 1927.* Paris: F. L. Schmied, 1927. 300 copies. (NN)
Bibliography of books with illustrations by (to 1927).

Schmischke, Kurt (*20th cent.*)
Meinz, Manfred. "Kurt Schmischke." *Illustration 63* 4 (1967): 14–16.
Bibliography of books with illustrations by.

Schmit, Jean Philippe (*b. 1790*)
[Ber.] XII, p. 18.*

Schmitz, Johann *(fl. c.1846)*
[Merlo] p. 767.*

Schmitz, Johann Jacob *(1724–1810)*
[Merlo] p. 767.*

Schmuttermayer, Hanns *(fl. 1484–1489)*
[Lehrs] VIII, pp. 276–278.
 Entries: 1. Millimeters. Inscriptions.
 Described. Located. Locations of all
 known impressions are given. Copies
 mentioned. Watermarks described.
 Bibliography for each entry.

Schmutzer, Ferdinand *(1870–1928)*
Roeper, Adalbert. "Ferdinand
Schmutzer." [*Kh.*] 1 (1909): 38–43.
 Entries: 98 (to 1909). Millimeters. De-
 scribed (selection).

Weixlgärtner, Arpad. *Das radierte Werk
von Ferdinand Schmutzer 1896–1921.*
Vienna: Fritz Mandel, 1922.
 Entries: 239 (to 1921). Millimeters. In-
 scriptions. States. Described. Illus-
 trated (selection). Located. All unil-
 lustrated prints are described.

Weixlgärtner, Arpad. "Von Ferdinand
Schmutzers letzten Arbeiten." [*GK.*] 52
(1929): 69–96. "Dem Andenken Fer-
dinand Schmutzers." [*MGvK.*] 1930,
pp. 25–26.
 Entries: 45 (additional to Weixlgärtner
 1922). Millimeters. Inscriptions.
 States. Described. Illustrated (selec-
 tion).

Schmutzer, Jakob Matthias *(1733–1811)*
[Ap.] pp. 379–381.
 Entries: 29.*

Trost, Alois. "Jakob Schmutzers
Neujahrsblätter von Wiener
Bruderschaften," [*MGvK.*] 1913, pp.
54–56.
 Entries: 10 (New Year's cards only).
 Millimeters. Inscriptions. Described.

Schnaider, [Louis] Amable
See **Schneider**

Schneider, [Louis] Amable *(1824–1884)*
[Ber.] XII, pp. 18–19.*

Schnell, Ludwig *(b. 1809)*
[Ap.] p. 381.
 Entries: 3.*

Schnetz, [Jean] Victor *(1787–1870)*
[Ber.] XII, p. 19.*

Schnorr von Carolsfeld, Ludwig
Ferdinand *(1788–1853)*
 [A. 1800] V, pp. 311–323.
 Entries: 38. Millimeters. Inscriptions.
 Described. Appendix with 5 addi-
 tional prints not seen by [A.] (not fully
 catalogued).

[Ber.] XII, p. 19.*

Schwarz, Heinrich. "Nachträge zu
Andresens 'Deutschen Maler-
radierern.' " [*MGvK.*] 1924, pp. 41–51.
 Entries: 52 (additional to [A. 1800]).
 Millimeters. Inscriptions. Described.
 Located.

Schwarz, Heinrich. "Neue Nachträge
zu Andresens 'Deutschen Maler-
radierern.' " [*GK.*] n.s. 1 (1936): 152–159.
 Additional information to [A. 1800].

Schödler, Johann Georg
See **Schedler**

Schoel, Hendrik van *(d. 1622)*
[W.] II, p. 580.
 Entries: 15+.*

Schön, Barthel
See **Monogram BS** [Nagler, *Mon.*] I, no.
2079.

Schön, Erhard *(after 1491–1542)*
[B.] VII, pp. 475–481.

Schön, Erhard (*continued*)

Entries: 34+. Pre-metric. Inscriptions (selection). Described (selection).

[P.] III, pp. 243–244.
Entries: 3+ (additional to [B.]). Pre-metric. Inscriptions (selection). Described (selection). Copies mentioned. Additional information to [B.].

Röttinger, Heinrich. *Erhard Schön und Niklas Stör, der Pseudo-Schön.* Studien zur deutschen Kunstgeschichte, 229. Strasbourg: J. H. Ed. Heitz, 1925.
Entries: 315+. Millimeters. Inscriptions. States. Described. Illustrated (selection). Located.

[Ge.] nos. 1119–1315.
Entries: 97 (single-sheet woodcuts only). Described. Illustrated. Located.

Schönberg, Rudolf (*b. 1914*)
Lebeer, Louis. *Rodolphe Schönberg peintre-graveur; étude critique et catalogue de l'oeuvre gravé.* Rotterdam (Netherlands): Ad. Donker, 1949.
Entries: 211. Millimeters. Inscriptions. States. Described. Illustrated (selection).

Schöncke, Leopold (*19th cent.*)
[Dus.] pp. 232–233.
Entries: 6 (lithographs only, to 1821). Millimeters (selection). Inscriptions. Located (selection).

Schöner, Georg Friedrich Adolph (*1774–1841*)
[Dus.] p. 233.
Entries: 1 (lithographs only, to 1821). Millimeters. Inscriptions. Located.

Schönfeld, [Johann] Heinrich (*1609–1682/83*)
[A.] V, pp. 71–79.
Entries: 12. Pre-metric. Inscriptions. Described.

Krapf, Ludwig Herbert. *Johann Heinrich Schönfeldts Radierungen und die nach ihm gestochenen Blätter.* Dissertation, University of Munich. Munich: Hansadruckerei, 1938.
Entries: 18 prints by, 7 prints by not seen by Krapf, 79 prints after. Millimeters. Inscriptions. States. Described.

Voss, Hermann. *Johann Heinrich Schönfeld; ein schwäbischer Maler des 17. Jahrhunderts.* Biberach an der Riss (West Germany): Biberacher Verlagsdruckerei, 1964.
Entries: 18+. Millimeters. Inscriptions. Described (selection). Based on Krapf.

Schöning, Franz (*fl. c.1819*)
[Dus.] p. 233.
Entries: 1 (lithographs only, to 1821). Millimeters. Inscriptions. Located.

Schönleber, Hans Otto (*1889–1930*)
Ammann, Edith. *Das graphische Werk von Hans Otto Schönleber.* Schriften der Staatlichen Kunsthalle Karlsruhe, 6. Karlsruhe (West Germany): 1961.
Entries: 87 etchings and engravings, 40 woodcuts. Millimeters. Inscriptions. States. Described.

Hoentzsch, Alfred. "Erinnerung an Hans Otto Schönleber." *Illustration 63* 8 (1971): 90–95.
Bibliography of portfolios of prints by.

Schoenmakers, Johannes Pietersz (*1755–1842*)
[W.] II, p. 580.
Entries: 2.*

Schöpf, Johann Adam (*1702–1772*)
[Merlo] pp. 770–772.*

Schöpf, Lorenz (*1793–1871*)
[Dus.] pp. 223–235.

Entries: 27+ (lithographs only, to 1821). Millimeters (selection). Inscriptions. Located (selection).

Schöpfer, Franziska *(1763–1836)*
[Dus.] pp. 235–236.
Entries: 3 (lithographs only, to 1821). Millimeters. Inscriptions. Located.

Schoevaerdts, Mathys *(fl. 1690–1694)*
[Wess.] II, p. 252.
Entries: 3 (additional to [Andresen, *Handbuch*]). Millimeters. Inscriptions. Described.

[W.] II, pp. 580–581.
Entries: 4 prints by, 2 after.*

Schol, Hendrik van
See **Schoel**

Scholij, J. C. *(fl. c.1676)*
[Merlo] p. 772.*

Scholten, Henrik Jacobus *(1824–1907)*
[H. L.] pp. 998–999.
Entries: 1. Millimeters. Inscriptions. Described.

Scholtz, Robert Friedrich Karl *(b. 1877)*
Robert F. K. Scholtz; Original-Radierungen, Lithographien. Berlin: Amsler und Ruthardt, 1911.
Entries: 142 (to 1911). Millimeters. Inscriptions.

Schommer, François *(b. 1850)*
[Ber.] XII, p. 19.*

Schongauer, Barthel
See **Monogram BS** [Nagler, *Mon.*] I, no. 2079

Schongauer, Hans I *(fl. 1485–1514)*
See **Monogram HS** [Nagler, *Mon.*] III, no. 1463

Schongauer, Ludwig *(before 1440–1494)*
[P.] II, pp. 115–118.

Entries: 6. Pre-metric. Inscriptions. Described. Located

[Lehrs] VI, pp. 55–63.
Entries: 4. Millimeters. Inscriptions. Described. Illustrated (selection). Located. Locations of all known impressions are given. Copies mentioned. Watermarks described. Bibliography for each entry.

Schongauer, Martin *(c.1430–1491)*
[B.] VI, pp. 103–184.
Entries: 116 prints by, 42 rejected prints. Pre-metric. Inscriptions. States. Described. Copies mentioned.

[Evans] p. 42.
Entries: 1 (additional to [B.]. Millimeters. Described.

[P.] II, pp. 103–115.
Entries: 22 prints by followers, 3 rejected prints (additional to [B.]), 1 doubtful print (additional to [B.]). Pre-metric. Inscriptions. Described. Located. Copies mentioned. Additional information to [B.].

Wurzbach, Alfred von. *Martin Schongauer; eine kritische Untersuchung seines Lebens und seiner Werke, nebst einem chronologischen Verzeichnisse seiner Kupferstiche.* Vienna: Manz'sche K. K. Hofverlags- und Universitäts-Buchhandlung, 1880.
Entries: 104 engravings by, 12 doubtful prints. Millimeters. Inscriptions. Described. Copies mentioned.

Amand-Durand, ———, and Duplessis, Georges. *Oeuvre de Martin Schongauer reproduit et publié par Amand-Durand.* Paris: Amand-Durand, Goupil, 1881.
Entries: 117. Inscriptions. States. Described. Illustrated. Prints are reproduced actual size.

[Wess.] I, p. 155.
Additional information to [B.] and [P.].

Schongauer, Martin (*continued*)

[W.] III, pp. 139–148.
 Entries: 116 prints by, 3 after.*

Lehrs, Max. *Martin Schongauer; Nachbildungen seiner Kupferstiche.* Graphische Gesellschaft: V. ausserordentliche Veröffentlichung. Berlin: Bruno Cassirer, 1914.
 Entries: 115. States. Illustrated. Located. Prints are reproduced actual size.

[Lehrs] V, pp. 1–410.
 Entries: 115. Millimeters. Inscriptions. States. Described. Illustrated (selection). Located. Appendix with 1 doubtful print. Also, list of 26 prints with Schongauer's monogram falsely added to them. Locations of all known impressions are given. Copies mentioned. Watermarks described. Bibliography for each entry.

Shestack, Alan. *The complete engravings of Martin Schongauer.* New York: Dover Publications, 1969.
 Entries: 116. Millimeters. States (selection). Illustrated.

Minott, Charles Ilsley. *Martin Schongauer.* New York: Collectors Editions, 1971.
 Entries: 115. Described. Illustrated.

Schoofs, Rudolf (*20th cent.*)
 Kunsthalle Bremen. *Rudolf Schoofs; Gravuren 1959–1965; nach dem Verzeichnis des Kunstlers gedruckt.* Bremen (West Germany), 1965.
 Entries: 80+. Millimeters.

Schoonebeeck, Adriaan (*1657/58–1705*)
 [W.] II, p. 582.
 Entries: 17+.*

Schoonjans, Anthoni (*c.1655–1726*)
 [W.] II, pp. 582–583.
 Entries: 6 prints after.*

Schoor, Jacobus van (*fl. c.1633*)
 [W.] II, p. 583.
 Entries: 3.*

Schooten, Franciscus van (*d. 1646*)
 [W.] II, p. 584.
 Entries: 3.*

Schooten, Joris van (*1587–1651*)
 [W.] II, p. 584.
 Entries: 2 prints after.*

Schorquens, Juan (*fl. 1618–1630*)
 [W.] II, p. 583.
 Entries: 7.*

Schotel, Andreas (*b. 1896*)
 Museum Boymans, Rotterdam [J. C. Ebbinge Wubben, compiler]. *Andreas Schotel.* Rotterdam (Netherlands), 1956.
 Entries: 76. Millimeters. Illustrated (selection).

Schoten, Franciscus van
 See **Schooten**

Schouman, Aert (*1710–1792*)
 [H. L.] p. 999.
 Entries: 2. Millimeters. Inscriptions. Described.

[W.] II, p. 585.
 Entries: 21 prints by, 2 after.*

Schoute [Schouten], Gilbert [Gysbert] (*fl. 1707–1722*)
 [W.] II, p. 586.
 Entries: 5+.*

Schoute, Jan (*18th cent.*)
 [W.] II, p. 586.
 Entries: 1.*

Schouten, H. M. (*fl. c.1815*)
 [H. L.] pp. 999–1000.
 Entries: 2. Millimeters. Inscriptions. Described.

Schouwenbergh, Johann Heinrich
See **Schawberg**

Schrag, Karl *(b. 1912)*
School of Art, Syracuse University. *Karl Schrag; a catalogue raisonné of the graphic works 1939–1970; commentary by Una E. Johnson.* Syracuse (N.Y.), 1971.
 Entries: 175 (to 1970). Inches. Illustrated. (One early suite of book illustrations is not illustrated.)

Schramm, Johann Michael *(1772–1835)*
[Dus.] p. 236.
 Entries: 10 (lithographs only, to 1821). Millimeters (selection). Inscriptions (selection). Located (selection).

Schreiber, C. *(fl. c.1820)*
[Dus.] p. 237.
 Entries: 1 (lithographs only, to 1821). Millimeters. Inscriptions. Located.

Schreiber, Johannes *(1755–1827)*
[Dus.] p. 237.
 Entries: 2 (lithographs only, to 1821). Millimeters. Inscriptions. Located.

Schreiner, Johann Georg *(1801–1859)*
[Merlo] pp. 776–777.*

Schrettinger, [Martin] Willibald *(1772–1851)*
[Dus.] p. 237.
 Entries: 1 (lithographs only, to 1821). Millimeters. Inscriptions. Located.

Schröder, Franz Adam *(1809–1875)*
[Ap.] pp. 381–382.
 Entries: 6.*

Schroeder, Friedrich *(1768–1839)*
[Ber.] XII, p. 19.*

Schröder, Hubert *(b. 1867)*
Finberg, Alexander J. *Original etchings and aquatints of Hubert Schroder.* London: L. H. Lefèvre and Son, n.d.

 Entries: 45. Inches. Illustrated (selection).

Schröder, Karl *(1760–1844)*
Vasel, A. "Hofkupferstecher Karl Schröder; beschreibendes Verzeichnis seiner graphischen Arbeiten." *Braunschweigisches Magazin,* nos. 12–14 (1900), pp. 89–95, 99–103, 107–111.
 Entries: 151. Millimeters. Inscriptions. States. Described.

Schroeter, C. *(fl. c.1817)*
[Dus.] p. 237.
 Entries: 1 (lithographs only, to 1821). Paper fold measure.

Schubert, Franz August *(1806–1893)*
[A. 1800] II, pp. 262–277.
 Entries: 33 etchings. Pre-metric. Inscriptions. States. Described. Also, list of 5+ woodcuts (titles only).

Schubert, Joseph *(1816–1885)*
[Ber.] XII, p. 20.*

Schütz, Carl *(1745–1800)*
Schwarz, Ignaz. *Wiener Strassenbilder im Zeitalter des Rococo; die Wiener Ansichten von Schütz, Ziegler, Janscha 1779–1798.*
Vienna: Gilhofer und Ranschberg, 1914.
 Entries: 57 (views of Vienna only). Millimeters. Inscriptions. States. Described. Illustrated. Prints by Schütz, Laurenz Janscha (1749–1812) and Johann Ziegler (c.1750–c.1812).

Schuler, Charles August *(1804–1859)*
[Ap.] pp. 382–383.
 Entries: 4.*

 [Ber.] XII, p. 20.*

Schuler, Édouard *(1806–1882)*
[Ap.] pp. 384–385.
 Entries: 23.*

Schultheiss, Albrecht Fürchtegott
(1823–1909)
[Ap.] pp. 385–386.
Entries: 18.*

Schulthess, Jörg *(20th cent.)*
Galerie Raeber, Lucerne [Jörg Schulthess, compiler]. *Jörg Schulthess: das gesamte Werk bis Juni 1970.* Lucerne (Switzerland), 1970.
Entries: 153 (to 1970). Millimeters. Described. Illustrated.

Schulthess, Jörg. *Jörg Schulthess, das gesamte Werk; ein Verzeichnis seiner Grafik, Zeichnungen, Aquarelle und Olbilder.* 2 vols. Basel: Patis-Verlag, 1971–1972.
Entries: 96 (additional to 1970 catalogue, to 1971). Millimeters. Described. Illustrated.

Schultz, ——— *(19th cent.)*
[Ber.] XII, p. 20.*

Schultz, Hermann *(1807–1869)*
[Ap.] p. 382.
Entries: 7.*

Schultz, J. A. *(d. c.1865)*
[H. L.] pp. 1000–1002.
Entries: 8. Millimeters. Inscriptions. States. Described.

Schultz, Johannes Christoffel *(1749–1812)*
[W.] II, p. 587.
Entries: 2.*

Schultz, Johann Karl *(1801–1873)*
[A. 1800] II, pp. 141–156.
Entries: 60 (to 1878). Pre-metric. Inscriptions. States. Described. Also, list of 6 prints after (not fully catalogued).

Schultze van Houten, C. G. *(19th cent.)*
[H. L.] p. 1002.
Entries: 1. Millimeters. Described.

Schulz, Louis *(c.1843–after 1871)*
[Ber.] XII, p. 21.*

Schulze, Christian Gottfried *(1749–1819)*
[Ap.] pp. 386–387.
Entries: 17.*

[Ber.] II, p. 20.*

Schumacher, Carl Georg Christian
(1797–1869)
[A. 1800] II, pp. 121–130.
Entries: 9. Pre-metric. Inscriptions. States. Described.

Schumann, Carl Fr. H. *(19th cent.)*
[Dus.] p. 237.
Entries: 2 (lithographs only, to 1821). Millimeters. Inscriptions. Located.

Schumer, Johann *(fl. c.1678)*
[W.] II, p. 587.
Entries: 5.*

Schuppen, Jacob van *(1670–1751)*
[W.] II, pp. 587–588.
Entries: 10 prints after.*

Bataille, Marie Louise. "Van Schuppen." In [Dim.] I, pp. 283–293.
Entries: 8 prints after lost works.

Schuppen, Peter Ludwig van *(1627–1702)*
[W.] II, pp. 588–590.
Entries: 140.*

Schurman, Anna Maria van *(1607–1678)*
[Merlo] pp. 780–791.*

[W.] II, pp. 590–591.
Entries: 7.*

Schut, A. *(fl. 1713–1733)*
[W.] II, p. 591.
Entries: 4.*

Schut, Cornelis I *(1597–1655)*
[W.] II, pp. 591–594.
Entries: 44+ prints by, 29 after.*

Schut, Pieter Hendricksz
(1618/19–after 1660)
[W.] II, p. 594.
Entries: 7+.*

Schwan, Balthasar *(d. 1624)*
[Merlo] pp. 791–792.*

Schwartz, C. *(fl. c.1814)*
[St.] p. 459.*

Schwarz, Christoph *(c.1545–1592)*
Geissler, Heinrich. *Christoph Schwarz ca.*
1548–1592. Dissertation, University of
Freiburg. Freiburg im Breisgau (West
Germany), 1960.
Entries: 56+ prints after. Millimeters.
Inscriptions. Appendix with 11 prints
after works falsely attributed to
Schwarz.

Schwarzenbach, Jacob *(1763–1805)*
[W.] II, p. 595.
Entries: 2.*

Schwarzenberg, Pauline Charlotte Iris,
princess *(1774–1810)*
Wirth, Zdeněk. *Czech landscapes from the*
etchings of Paulina, Princess Schwarzen-
berg, from the years 1804–1806. Prague:
Vladimír Žikes, 1939. 100 copies. (MH)
Czech and German editions (not seen).
Entries: 37. Illustrated.

Schwegman, Hendrik *(1761–1816)*
[W.] II, p. 595.
Entries: 5+.*

Schweickardt, Heinrich Wilhelm
(1746–1797)
[W.] II, pp. 595–596.
Entries: 2+.*

Schweighofer, Franz *(1797–1861)*
[Dus.] p. 237.
Entries: 1 (lithographs only, to 1821).
Paper fold measure. Inscriptions.

Schwerdgeburth, Carl August *(1785–1878)*
[Ap.] p. 388.
Entries: 25.*

Schwimbeck, Fritz *(b. 1889)*
Duve-Preetz, Helmuth. "Der Radierer
Fritz Schwimbeck." [Kh.] 11 (1919): 125–
129.
Entries: 19+ (to 1919). Millimeters
(selection). States.

Schwind, Moritz von *(1804–1871)*
Wurzbach, Constantin von. "Moriz von
Schwind." *Biographisches Lexikon des*
Kaiserthums Oesterreich, vol. 33, pp.
129–191. Vienna, 1877.
Entries: 19+ prints by, 125+ after.
Paper fold measure. Described.

Weigmann, Otto. *Schwind; des Meisters*
Werke in 1265 Abbildungen. Klassiker der
Kunst. Stuttgart: Deutsche Verlags-
Anstalt, 1906.
Entries: 1265 (works in all media, in-
cluding prints). Millimeters (selec-
tion). Illustrated.

Schyl, Jules *(b. 1893)*
Bergquist, Eric. "Jules Schyl målare och
grafiker." [N. ExT.] 21 (1969): 91–92.
Entries: 7 (bookplates only). Illus-
trated (selection).

Schynvoot, Jacobus
See **Schijnvoet**

Sciaminossi, Raffaello
See **Schiaminossi**

Sckell, Carl August *(1793–1840)*
[Dus.] p. 237.
Entries: 2 (lithographs only, to 1821).
Millimeters. Inscriptions. Located.

Scolari, Giuseppe *(16th cent.)*
[B.] XII: *See* **Chiaroscuro Woodcuts**

Scolari, Giuseppe (*continued*)

Baseggio, Giambattista. *Intorno tre celebri intagliatori in legno vicentini memoria*. Bassano (Italy): Tipografia Baseggio, 1844. (EFKI). First ed. [1839?] (Not seen). Entries: 6. Pre-metric. Inscriptions. Described.

[P.] VI: *See* **Chiaroscuro Woodcuts**

Scoles, John *(fl. 1793–1844)*
[St.] pp. 459–471.*

[F.] pp. 232–238.*

Score, William *(fl. 1778–1815)*
[Sm.] III, p. 1050.
Entries: 1 (portraits only). Inches. Inscriptions. Described. Located.

[Ru.] p. 250.
Additional information to [Sm.].

Scorel, Jan van *(1495–1562)*
Steinbart, Kurt. "Unveröffentlichte Zeichnungen und Holzschnitte des Jan van Scorel." [*Oud-Holl.*] 49 (1932): 281–288.
Entries: 3 (woodcuts only). Millimeters. Described. Illustrated (selection). Located.

Scot, Robert *(fl. c.1783)*
[St.] pp. 471–474.*

[F.] pp. 238–240.*

Scott, B. F. *(fl. 1790–1792)*
[Sm.] III, pp. 1050–1051.
Entries: 1 (portraits only). Inches. Inscriptions. Described.

[Ru.] p. 251.
Additional information to [Sm.].

Scott, James *(1774–1827)*
[Siltzer] p. 365.
Entries: unnumbered, p. 365. Inscriptions.

Scott, John *(1774–1828)*
[Ap.] pp. 388–389.
Entries: 9.*

[Siltzer] pp. 365–366.
Entries: unnumbered, pp. 365–366. Inscriptions.

Scotto, Francesco *(1756–1826)*
[Ap.] p. 389.
Entries: 1.*

Scotto, Girolamo *(c.1787–1878)*
[Ap.] pp. 389–390.
Entries: 8.*

Scriven, ——— *(fl. c.1830)*
[Ber.] XII, p. 21.*

Scultori, Adamo *(c.1530–1585)*
[B.] XV, pp. 375; 417–431.
Entries: 129 prints by, 3 rejected prints. Pre-metric. Inscriptions. Described.

[P.] VI, pp. 140–141.
Entries: 2 (additional to [B.]). Premetric. Inscriptions. Described. Additional information to [B.].

[Wess.] III, p. 48.
Additional information to [B.].

Scultori, Diana *(c.1535–after 1587)*
[B.] XV, pp. 375–376; 432–452.
Entries: 46. Pre-metric. Inscriptions. States. Described. Copies mentioned.

[Evans] p. 20.
Entries: 3 (additional to [B.]). Millimeters. Inscriptions. Described.

[P.] VI, pp. 141–145.
Entries: 13 (additional to [B.]). Premetric. Inscriptions. Described. Additional information to [B.].

[Wess.] III, p. 48.
Entries: 2 (additional to [B.]). Millimeters. Inscriptions. Described. Located. Additional information to [B.].

Scultori, Giovanni Battista *(1503–1575)*
[B.] XV, pp. 373–374; 377–383.
 Entries: 20. Pre-metric. Inscriptions.
 Described. Copies mentioned.

[Evans] p. 20.
 Entries: 1 (additional to [B.]). Mil-
 limeters. Inscriptions. Described.

[P.] VI, pp. 136–137.
 Entries: 1 (additional to [B.]). Pre-
 metric. Inscriptions. Described.

Searle, Ronald *(b. 1920)*
Galerie Wolfgang Gurlitt, Munich. *Ron-
ald Searle; die gesamte Druckgraphik,
1966–1971.* Munich, 1971. (MH)
 Entries: 84 (to 1971). Millimeters. De-
 scribed. Illustrated.

Sears, M. U. *(b. c.1800)*
[Ber.] XII, p. 21.*

Sebron, Hippolyte Victor Valentin
(1801–1879)
[Ber.] XII, p. 21.*

Secher, Alexander *(b. 1913)*
F[ougt], K[und]. "Fortegnelse over
Alex. Sechers Exlibris." [*N. ExT.*] 1
(1946–1947): 56–57.
 Entries: 25 (bookplates only, to 1947).
 Illustrated (selection).

Alex. Sechers Exlibris. Copenhagen:
Christian Benthien, 1947. 175 copies.
(DLC)
 Entries: 35 (bookplates only, to 1947).
 Illustrated (selection).

Sedláček, Vojtěch *(b. 1892)*
Sýkorova, Libuse. *Grafické dílo Vojtěcha
Sedlácka.* Prague: Příloha sborníku
grafického uměří Hollar, [1960].
 Entries: 495 (to 1960). Millimeters.

Sedlmayr, Joseph Anton *(b. 1797)*
[Dus.] p. 238.
 Entries: 1 (lithographs only, to 1821).

Seehaus, Paul Adolf *(1891–1919)*
Rave, Paul Ortwin. "Paul Adolf
Seehaus." *Wallraf-Richartz Jahrbuch* 2
(1925): 181–212.
 Entries: 42. Millimeters. Inscriptions.
 Illustrated (selection).

Seeländer, Nikolaus *(c.1690–1744)*
[W.] II, p. 611.
 Entries: 1.*

Seele, Johann Baptist *(1774–1814)*
[Dus.] p. 238.
 Entries: 1 (lithographs only, to 1821).
 Millimeters. Inscriptions. Located.

Segato, Girolamo *(1792–1836)*
[AN.] pp. 675–678.
 Entries: unnumbered, pp. 676–678.
 Millimeters. Inscriptions. Described.

Ségé, Alexandre *(1818–1885)*
[Ber.] XII, pp. 21–22.*

Seghers, Cornelius Johann Adrianus
(1814–1875)
[H. L.] pp. 1003–1011.
 Entries: 30 etchings, 1 lithograph. Mil-
 limeters. Inscriptions. States. De-
 scribed.

Seghers, Gerard *(1591–1651)*
[vdK.] pp. 216–219.
 Entries: 3. Millimeters. Inscriptions.
 States. Described. Illustrated (selec-
 tion).

[W.] II, pp. 614–615.
 Entries: 3 prints by, 26 after.*

Seghers, Hercules *(1589/90–after 1635)*
Springer, Jaro. *Die Radierungen des Her-
kules Seghers.* 3 vols. Graphische
Gesellschaft, 13, 14, 16. Berlin: B. Cas-
sirer, 1910–1912.
 Entries: 62 prints by, 4 prints known
 only from reworked states, 3 rejected
 prints. Millimeters. Inscriptions.

Seghers, Hercules (*continued*)

States. Described. Illustrated. Located (every known impression).

Collins, Leo C. *Hercules Seghers.* Chicago: University of Chicago Press, 1953.
Entries: unnumbered, pp. 131–134 (chronological list of works in all media, including prints). Illustrated.

Séguin, Gérard *(1805–1875)*
[Ber.] XII, p. 22.*

Seidel, Andreas *(19th cent.)*
[Dus.] pp. 238–239.
Entries: 10+ (lithographs only, to 1821). Millimeters (selection). Inscriptions.

Seidel, Gustav *(1819–1901)*
[Ap.] p. 390.
Entries: 10.*

Seifert, [Carl] Friedrich *(1838–1920)*
[Ap.] p. 391.
Entries: 4.*

Seigneurgens, Ernest *(d. 1904/05)*
[Ber.] XII, p. 22.*

Seiler, ———— *(fl. c.1810)*
[Dus.] pp. 239–240.
Entries: 6 (lithographs only, to 1821). Millimeters. Inscriptions. Located.

Seinsheim, August, Graf von *(1789–1869)*
[A. 1800] III, pp. 333–344.
Entries: 14. Pre-metric. Inscriptions. Described.

[Dus.] p. 240.
Entries: 8+ (lithographs only, to 1821). Millimeters (selection). Inscriptions. Located (selection).

Seitz, Johann Baptist *(1786–1850)*
See also **Schleich,** Carl II

[Dus.] pp. 240–241.
Entries: 2 (lithographs only, to 1821).

Selb, Joseph Anton *(1784–1832)*
[Dus.] pp. 241–242.
Entries: 42 (lithographs only, to 1821). Millimeters (selection). Inscriptions (selection). Located (selection).

Selen, Johannes van *(fl. c.1590)*
[W.] II, p. 617.
Entries: 1.*

Sellier, François Noël *(b. 1737)*
[Ber.] XII, p. 22.*

Sellier, Henry *(fl. c.1848)*
[Ber.] XII, p. 22.*

Semmler, August *(1825–1893)*
[Ap.] pp. 391–392.
Entries: 14.*

Sénave, Jacques Albert *(1758–1829)*
[W.] II, p. 617.
Entries: 1 print after.*

Senefelder, [Johann Nepomuk Franz] Alois *(1771–1834)*
[Ber.] XII, pp. 23–26.*

[Dus.] pp. 242–252.
Entries: 49+ (lithographs only, to 1821). Millimeters. Inscriptions. Located (selection).

Senefelder, Clemens *(1788–1833)*
[Dus.] pp. 252–255.
Entries: 15+ (lithographs only, to 1821). Millimeters (selection). Inscriptions (selection). Located (selection).

Senefelder, Georg *(1778–1827)*
[Dus.] p. 255.
Entries: 2 (lithographs only, to 1821). Millimeters. Located.

Sesto, Cesare da *(continued)*

da Sesto." [*GBA.*] 1st ser. 18 (1865): 546–552.
> Entries: 5. Millimeters. Inscriptions. Described. Illustrated (selection).

Sestri, II
See **Travi,** Antonio

Sette, Jules *(fl. 1836-1846)*
[Ber.] XII, p. 28.*

Seupel, Johann Adam *(1662–1717)*
Hieber, Hermann. *Johann Adam Seupel; ein deutscher Bildnisstecher im Zeitalter des Barocks.* Dissertation, Heidelberg University. Strasbourg: J. H. Ed. Heitz, 1907.
> Entries: 53 (portraits only). Millimeters.

Severati, Filippo *(19th cent.)*
[Ap.] p. 392.
> Entries: 2.*

Séverin, Antoine *(19th cent.)*
[H. L.] pp. 1014–1016.
> Entries: 9. Millimeters. Inscriptions. Described.

Severin, Mark *(b. 1906)*
Schwencke, Johan. "Mark Severin." *Boekcier,* 2d ser. 3 (1948): 1–9.
> Entries: 119 (bookplates only, to 1947). Millimeters (selection). Described (selection). Illustrated (selection).

Sevrette, Jules Adrien *(fl. 1868–1882)*
[Ber.] XII, p. 28.*

Seward, Coy Avon *(b. 1884)*
Murdock, Marsh M. "The lithographs of C. A. Steward" and "List of prints by C. A. Seward." [*P. Conn.*] 5 (1925): 195–207.
> Entries: unnumbered, pp. 200, 205 (to 1925). Inches. Illustrated (selection).

Sewerin, Aage *(20th cent.)*
Fogedgaard, Helmer. "Aage Sewerin." [*N. ExT.*] 7 (1955): 76–79.
> Entries: 27 (bookplates only, to 1951). Described (selection). Illustrated (selection).

Seymour, James *(1702–1752)*
[Siltzer] pp. 245–248.
> Entries: unnumbered, pp. 247–248, prints after. Inches (selection). Inscriptions.

Seymour, Joseph H. *(fl. 1791–1822)*
[St.] p. 474.*

[F.] pp. 240–245.*

Seymour, Samuel *(fl. 1797–1882)*
[St.] pp. 475–478.*

[F.] pp. 245–246.*

Sezenius, Valentin *(fl. 1619–1624)*
Dodgson, Campbell. "Valentin Sezenius." [*PCQ.*] 10 (1923): 81–93.
> Entries: 15. Millimeters. Inscriptions. Described. Illustrated (selection).

Shahn, Ben *(1898–1969)*
Philadelphia Museum of Art [Kneeland McNulty, compiler]. *The collected prints of Ben Shahn.* Philadelphia, 1967.
> Entries: 63 single prints and 2 book illustrations by and after; 1 monotype; authorized and unauthorized reproductions; to 1967. Inches. Inscriptions. States. Described. Illustrated.

Prescott, Kenneth W. *The complete graphic works of Ben Shahn.* New York: Quadrangle/New York Times Book Co., 1973.
> Entries: 333 prints by and after. Inches. Inscriptions. States. Described. Illustrated. Located.

Shallus, Francis *(c.1774–1821)*
[St.] pp. 478–479.*

[F.] pp. 246–248.*

Holt, Mary E. "A checklist of the work of Francis Shallus, Philadelphia engraver." *Winterthur Portfolio* 4 (1968): 143–158.
>Entries: unnumbered, pp. 153–158. Inches. Inscriptions. Illustrated (selection).

Shannon, Charles Hazelwood *(1863/65–1937)*
>Ricketts, Charles. *A catalogue of Mr. Shannon's lithographs.* London: E. J. van Wisselingh, 1902. (MBMu)
>>Entries: 54 (lithographs only, to 1902). Inches. Inscriptions. States. Described. Additions bound in (NN); Walker (Derry) 1914, and an ms. list of 21 prints additional to Walker (Derry) 1914.

>Walker, Rainsforth A. [Derry, George]. "The lithographs of Charles Hazelwood Shannon." [*PCQ.*] 4 (1914): 392–420. Separately published. *The lithographs of Charles Shannon with a catalogue of lithographs issued between the years 1904 and 1918.* London : R. A. Walker, 1920. 100 copies. (MBMu)
>>Entries: 29 (lithographs only, additional to Ricketts; to 1909). Inches. Inscriptions. Described. Illustrated (selection). 1920 edition has 34 entries (to 1918). Not illustrated.

Sharles, —— *(fl. c.1848)*
>[Ber.] XII, p. 28.*

Sharp, Christopher *(d. 1797)*
>[Sm.] III, p. 1051, and "additions and corrections" section.
>>Entries: 4 (portraits only). Inches. Described.

>[Ru.] p. 251.
>>Entries: 1 (portraits only, additional to [Sm.]). Inches. Described.

Sharp, William *(1749–1824)*
>"Biographical memoir of the late Mr. Sharp." Catalogue: "List of the engravings of the late William Sharp, with critiques on some of the principal." *The European Magazine and London Review,* September 1824, pp. 191–199, and October 1824, pp. 357–367. (PJRo)
>>Entries: unnumbered, pp. 357–367. Described (selection).

>Baker, William Spohn. *William Sharp, engraver, with a descriptive catalogue of his works.* Philadelphia: Gebbie and Barrie, 1875.
>>Entries: 231. Inches. Inscriptions. States. Described (selection). Ms. notes (NN); additional states.

>[Ap.] pp. 393–396.
>>Entries: 46.*

>[Sm.] III, p. 1051.
>>Entries: 1 (portraits only). Inches. Described.

Sharp, William *(fl. 1840–1854)*
>[Carey] pp. 371–373.
>>Entries: 24 (lithographs only). Inches. Inscriptions. Described (selection). Located.

Sharpe, C. W. *(fl. c.1850)*
>[Ap.] p. 396.
>>Entries: 3.*

Sharples, James *(1751/52–1811)*
>[Sm.] III, p. 1052, and "additions and corrections" section.
>>Entries: 1 (portraits only). Inches. Inscriptions. Described.

Shayer, William J. *(b. 1811)*
>[Siltzer] pp. 248–249.
>>Entries: unnumbered, pp. 248–249, prints after. Inches (selection). Inscriptions.

Shenton, Henry Chawnes *(1803–1866)*
[Ap.] p. 397.
Entries: 3.*

Shepperson, Claude Allin *(1867–1921)*
Hardie, Martin. "The etchings and lithographs of Claude Shepperson, A.R.A., A.R.E." [*PCQ.*] 10 (1923): 444–471.
Entries: 29 etchings, 21 lithographs. Inches. Millimeters. States. Described. Illustrated (selection).

Sherborn, Charles William *(1831–1912)*
Sherborn, Charles Davies. *A sketch of the life and work of Charles William Sherborn, painter-etcher.* London: Ellis, 1912. 525 copies. (MH)
Entries: unnumbered, pp. 17–35, 41–44, 47–100 (to 1912). Inches. Inscriptions. States. Described. Ms. addition (NN); additional states, 2 additional entries.

Sherman, Welby *(fl. c.1827)*
Dodgson, Campbell. "The engravings of George Richmond and Welby Sherman," [*PCQ.*] 17 (1930): 352–362. "Quarterly notes." [*PCQ.*] 18 (1931): 198–200.
Entries: 4. Inches. Inscriptions. States. Illustrated (selection). Located.

Sherwin, William *(c.1645–1711?)*
[Sm.] III, pp. 1052–1060, and "additions and corrections" section; IV, "additions and corrections" section.
Entries: 20 (portraits only). Inches. Inscriptions. States. Illustrated (selection). Located (selection).

[Ru.] pp. 251–252.
Entries: 3 (portraits only, additional to [Sm.]). Inches. Inscriptions. Described. Additional information to [Sm.].

Shevchenko, Taras *(1814–1861)*
Kasijan, Vasil'. *Oforti Tarasa Shevchenka.* Kiev (USSR): Mistetstvo, 1964.
Entries: unnumbered, pp. 141–157. Millimeters. Inscriptions. States. Illustrated (selection). Located.

Shishkin, Ivan Ivanovich *(1831–1898)*
Pal''chikov, A. E. *Perechen' pechatnykh'' listov'' I. I. Shishkina.* St. Petersburg: A. S. Suvorina, 1885.
Entries: 51 etchings, 31 lithographs, 18 zincographs, 15 experimental zincographs (to 1884). Millimeters. Inscriptions. States. Described. Illustrated (selection).

Shoote, John
See **Shute**

Short, Frank *(b. 1857)*
Strange, Edward F. *The etched and engraved work of Frank Short.* London: George Allen and Sons, 1908. 220 copies. (MBMu)
Entries: 285 etchings, 11 lithographs (to 1907?). Inches. Inscriptions. States. Described.

Hardie, Martin. *The Liber Studiorum mezzotints of Sir Frank Short, R.A., P.R.E., after J. M. W. Turner, R.A.* London: Print Collectors' Club, 1938.
Entries: 47 (mezzotints expanding Turner's *Liber Studiorum* only). Inches. Inscriptions. States. Described. Illustrated.

Hardie, Martin. *The etched and engraved work of Sir Frank Short, II; the mezzotints and aquatints of Sir Frank Short, R.A., P.P.R.E. other than those for the Liber Studiorum.* London: Print Collectors' Club, 1939. 400 copies. (MBMu)
Entries: 122 (mezzotints and aquatints; additional to Hardie 1938). Inches. Millimeters. Inscriptions.

States. Described. Illustrated (selection).

Hardie, Martin. *The etched and engraved work of Sir Frank Short, III; etchings, drypoints, lithographs by Sir Frank Short, R.A., P.P.R.E.* London: Print Collectors' Club, 1940. 400 copies.
Entries: 230 (etchings, drypoints and lithographs; additional to Hardie 1938 and 1939). Inches. Millimeters. Inscriptions. States. Described. Illustrated (selection).

Shute, John *(d. 1563)*
[Hind, *Engl.*] I, p. 59.
Entries: 1+. Inches. Inscriptions. Described. Illustrated (selection). Located.

Sibelius, Gerard *(d. 1785)*
[W.] II, p. 619.
Entries: 3.*

Sibilla, Gijsbert *(c.1598–after 1652)*
[W.] II, pp. 619–620.
Entries: 1 print after.*

Sibmacher, Johann [Hans] *(d. 1611)*
[B.] IX, pp. 595–596.
Entries: 23. Pre-metric. Inscriptions. Described (selection).

[Heller] pp. 112–114.
Entries: 5 (additional to [B.]). Pre-metric. Inscriptions. Described.

Andresen, A. "Johann Sibmacher." [*N. Arch.*] 9 (1863): 19–34.
Entries: 74. Pre-metric. Inscriptions. States. Described.

[P.] IV, pp. 212–217.
Entries: 38+ prints by (additional to [B.]), 1 doubtful print. Pre-metric (selection), paper fold measure (selection). Inscriptions (selection). Described (selection). Located (selection).

[A.] II, pp. 281–420.
Entries: 143+. Pre-metric. Inscriptions. States. Described. Appendix with 8 doubtful and rejected prints.

Sicard, B. *(fl. c.1830)*
[Ber.] XII, p. 28.*

Sichelmans, Frans
See Schillemans

Sichem, Christoffel I van
[P.] III, pp. 470–471.
Bibliography of books with illustrations by.

Sichem, Christoffel II van *(c.1581–1658)*
[W.] II, p. 620.
Entries: 22+.*

Sichem, Karel van *(d. after 1604?)*
[W.] II, p. 620.
Entries: 20.*

Sichling, Lazarus Gottlieb *(1812–1863)*
[Ap.] pp. 397–398.
Entries: 28.*

Sickeleer, Pieter van
See Sikkelaer

Sickert, Walter Richard *(b. 1860)*
Wright, Harold J. L. Ms. catalogue. (ECol)
Early draft of the ms. catalogue. (EBM)

Wright, Harold J. L. "Sickert catalogue (plates of which titles are known) arranged in alphabetical order and catalogue of plates with unknown titles, and lithographs." Unpublished ms. (EBM)
Entries: unnumbered, unpaginated (about 200 prints). Inches. Millimeters. Inscriptions. States. Described. Located (selection). Also, lists of

Sickert, Walter Richard (*continued*)

prints by Sickert at the British Museum, the Victoria and Albert Museum, and the Islington Central Library.

Sickinger, Gregorius (*1558–1631*)
[A.] IV, pp. 44–46.
Entries: 1. Pre-metric. Inscriptions. Described.

Sidler, Joseph (*fl. 1813–1820*)
[Dus.] p. 257.
Entries: 6+ (lithographs only, to 1821). Millimeters (selection). Inscriptions (selection). Located (selection).

Siebelist, Arthur (*b. 1870*)
[Sch.] p. 140 ff.
Not seen.

Siebmacher, Johann [Hans]
See **Sibmacher**

Sieck, Rudolf (*b. 1877*)
Williger, Herbert. "Rudolf Sieck." [*Kh.*] 14 (1922): 81–82.
Entries: 62 (to 1921). Millimeters. Illustrated (selection).

Siedentopf, Johann Christian (*19th cent.*)
[Ap.] p. 398.
Entries: 2.*

Sieg, Carl (*1784–1845*)
[Dus.] p. 257.
Entries: 1 (lithographs only, to 1821). Millimeters. Inscriptions. Located.

Siegen, Ludwig von (*1609–1680?*)
[A.] V, pp. 80–87.
Entries: 9. Pre-metric. Inscriptions. States. Described.

[Wess.] I, p. 156.
Additional information to [A.].

Seidel, Paul. "Ludwig von Siegen; der Erfinder des Schabkunstverfahrens." [*JprK.*] 10 (1889): 34–49.
Entries: 7. Inscriptions. States. Described (selection). Illustrated (selection). Located.

[Merlo] pp. 798–801.
Entries: 11. Pre-metric (selection). Inscriptions (selection). Described (selection). Illustrated (selection).

[W.] III, pp. 148–149.
Entries: 11.*

Sieurac, François Juste Joseph (*1781–c.1832*)
[Ber.] XII, p. 28.*

Sigmund, ——— (*19th cent.*)
[Dus.] p. 257.
Entries: 1 (lithographs only, to 1821).

Signac, Paul (*1863–1935*)
Wick, Peter A. "Paul Signac exhibition." *Bulletin of the Museum of Fine Arts, Boston* 52 (1954): 64–73.
Entries: 21. Inches. States. Illustrated (selection). Located.

Sigrist, [Johann] Wilhelm (*b. 1797*)
[Dus.] p. 257.
Entries: 1 (lithographs only, to 1821). Located.

Siim, Aune (*20th cent.*)
Üürike, Madis. "Aune Siim Konstnärliga exlibris från Malmö." [*N. ExT.*] 17 (1965): 101–105.
Entries: 45 (bookplates only, to 1965). Illustrated (selection).

Sikkelaer, Pieter van (*fl. 1674–1675*)
[W.] II, p. 621.
Entries: 3.*

Sikkinger, Gregorius
See **Sickinger**

Silbermann, Henri Rodolphe Gustave
(1801–after 1855)
 [Ber.] XII, pp. 28–29.*

Sillemans, Experiens *(c.1611–1653)*
 [W.] II, p. 621.
 Entries: 2.*

Silo, Adam *(1674–before 1757)*
 [W.] II, p. 621.
 Entries: 9+.*

Silva, Domingos José da *(1783–after 1843)*
 Soares, Ernesto. *Francisco Bartolozzi e os seus discipulos em Portugal.* Estudos-Nacionais sob a égide do Instituto de Coimbra, 3 Gaia (Portugal): Ediçoes Apolino, 1930.
 Entries: 19+. Millimeters. Inscriptions. Described. Located.

Silvani, Gaetano *(1798–1879)*
 [Ap.] p. 398.
 Entries: 2.*

Silvestre, Israël *(1621–1691)*
 Faucheux, L. E. "Notice sur la vie d'Israel Silvestre." [*Mém. lorraine*] 1st ser. 6 (1856) following p. 224; [*Mém. lorraine*] 1st ser. 7 (1857) following p. 327; [*Mém. lorraine*] 1st ser. 8 (1858) following p. 248. Separately published. *Catalogue raisonné de toutes les estampes qui forment l'oeuvre d'Israel Silvestre.* Paris: Veuve Jules Renouard, 1857. 150 copies. (MBMu). Reprint. Paris: F. de Nobele, 1969.
 Entries: 373+ prints by, 1 rejected print. Millimeters. Inscriptions. States. Described.

 Baré, F. "Israël Silvestre et sa famille." [*Bull. des B. A.*] 3 (1885–1886): 145–234.
 Entries: 1008 prints by and after. Millimeters. Inscriptions. States. Described (selection).

 [W.] III, pp. 149–150.
 Entries: 5.*

Silvestre, Louis I *(1669–1740)*
 Baré, F. "Israël Silvestre et sa famille." [*Bull. des B. A.*] 3 (1885–1886): 149–150.
 Entries: 9+ prints after. Millimeters.

Silvestre, Louis II *(1675–1760)*
 Baré, F. "Israël Silvestre et sa famille." [*Bull. des B. A.*] 3 (1885–1886): 151–154.
 Catalogue of paintings; prints after are mentioned where extant.

Silvestre, Nicholas Charles de *(1699–1767)*
 Silvestre, E. de. *Renseignments sur quelques peintres et graveurs des XVIIe et XVIIIe siècles; Israël Silvestre et ses descendants.* Paris: Veuve Bouchard-Huzard, 1869. (EBM)
 Entries: unnumbered, pp. 96–100. Millimeters. Inscriptions. States.

 Baré, F. "Israël Silvestre et sa famille." [*Bull. des B. A.*] 3 (1885–1886): 155–156.
 Entries: 10. Millimeters. Inscriptions. Described (selection).

Silvestre, Suzanne *(1694–before 1738)*
 Silvestre, E. de. *Renseignments sur quelques peintres et graveurs des XVIIe et XVIIIe siècles; Israel Silvestre et ses descendants.* Paris: Veuve Bouchard-Huzard, 1869. (EBM)
 Entries: unnumbered, pp. 103–107. Millimeters. Inscriptions. States.

 Baré, F. "Israël Silvestre et sa famille." [*Bull. des B. A.*] 3 (1885–1886): 156–158.
 Entries: 23. Millimeters. Inscriptions. States.

Silvestri, Ester *(19th cent.)*
 [Ap.] p. 398.
 Entries: 1.*

Siméon, Fernand *(1884–1928)*
 Benoist, Luc. *Siméon.* Les artistes du livre, 15. Paris: Henry Babou, 1930. 750 copies. (NN)

Siméon, Fernand (*continued*)

Bibliography of books with illustrations by (to 1929).

Simitière, Pierre Eugène du (*c.1736–1784*)
Donnell, Edna. "Portraits of eminent Americans after drawings by Du Simitière." *Antiques* 24 (1933): 17–21.
Entries: 49 prints after. Inches. Inscriptions. States. Illustrated (selection). Located.

Simmler, Friedrich Karl Joseph (*1801–1872*)
[A. 1800] II, pp. 131–140.
Entries: 16 (to 1878?). Pre-metric. Inscriptions. Described.

Andresen, Andreas. "Andresens Nachträge zu seinen 'Deutschen Malerradierern.' " [*MGvK.*] 1907, p. 42.
Entries: 1 (additional to [A. 1800]). Pre-metric. Inscriptions. Described.

Simmons, Will [William Francis Bernard] (*b. 1884*)
Rihani, Ameen. "Will Simmons and his animals." [*P. Conn.*] 2 (1921–1922): 94–113.
Entries: 42 (to 1921?). Inches. Illustrated (selection).

Simmons, William Henry (*1811–1882*)
[Siltzer] p. 366.
Entries: unnumbered, p. 366. Inscriptions.

Simon, ——— (*fl. c.1850*)
[Ber.] XII, pp. 29–30.*

Simon, Jean [John] (*c.1675–1751*)
[Sm.] III, pp. 1060–1130, and "additions and corrections" section.
Entries: 179+ (portraits only). Inches. Inscriptions. States. Described. Illustrated (selection). Located (selection).

[Ru.] pp. 252–263, 496.

Entries: 3 (portraits only, additional to [Sm.]). Inches. Inscriptions. States. Described. Additional information to [Sm.].

Šimon, T. František (*1877–1942*)
Rytíř, Václav. *T. F. Šimon exlibris: popisný seznam 1910–1932.* Prague: Karel Somer, 1932. 285 copies? (DLC)
Entries: 50 (bookplates only, to 1932). Millimeters. Inscriptions. Described.

Novak, Arthur. *Kronika grafického díla T. F. Šimona.* Prague: Sdruženi Českých Umělců Graficů Hollar, 1937. (NN)
Entries: 626 (to 1937). Millimeters. Illustrated (selection).

Simone Ardizzone da Reggio (*fl. c.1475*)
[Hind] V, p. 59.
Discussion of the problems involved in attributing work to Ardizzone.

Simonet, Adrien Jacques (*b. 1791*)
[Ber.] XII, pp. 30–31.*

Simonet, Jean Baptiste (*1742–after 1813*)
[Ber.] XII, p. 30.

[L. D.] pp. 78–80.
Entries: 6. Millimeters. Inscriptions. States. Described. Illustrated (selection). Incomplete catalogue.*

Simonne, T. (*fl. c.1815*)
[St.] p. 479.*

Simons, [Elizabeth] Marie (*1750–1834?*)
[W.] II, p. 623.
Entries: 4+.*

Simpson, Joseph (*b. 1879*)
Granville Fell, H. "The etched work of Joseph Simpson." [*PCQ.*] 19 (1932): 212–233.
Entries: 74 (to 1931). Inches. States. Illustrated (selection).

Simpson, T. *(fl. 1790–1814)*
[Siltzer] p. 366.
 Entries: unnumbered, p. 366. Inscriptions.

Simpson, William *(fl. 1635–1646)*
[Hind, *Engl.*] III, pp. 264–265.
 Entries: 2+. Inches. Inscriptions. Described. Illustrated. Located.

Sims, Charles *(1873–1928)*
Dodgson, Campbell. "The engraved work of Charles Sims, R.A." [*PCQ.*] 18 (1931): 374–387.
 Entries: 15. Inches. Inscriptions. States. Described. Illustrated (selection). Located (selection).

Simson, I. *(18th cent.)*
[Sm.] III, p. 1130.
 Entries: 1 (portraits only). Inches. Inscriptions. Described.

Sinet, André *(b. 1867)*
[Ber.] XII, p. 31.*

Singier, Gustave *(b. 1909)*
Städtisches Museum Braunschweig, Brunswick. *Gustave Singier, das graphische Werk.* Brunswick (West Germany), 1958.
 Entries: 25 (to 1958). Millimeters. Described. Illustrated. Also, list of 4 new, unpublished prints (titles only).

Singry, Jean Baptiste *(1782–1824)*
[Ber.] XII, p. 31.*

Sioertsma, Anthonie Heeres *(1626/27–1652)*
[W.] II, p. 623.
 Entries: 4.*

Sipmann, Gerhard *(1790–1866)*
[Dus.] pp. 257–258.
 Entries: 10 (lithographs only, to 1821). Millimeters. Described. Located.

Sirani, Elizabetta *(1638–1665)*
[B. *Reni*] pp. 82–88.
 Entries: 6. Pre-metric. Inscriptions. States. Described.

[B.] XIX, pp. 151–159.
 Entries: 10. Pre-metric. Inscriptions. States. Described. Copies mentioned.

[Wess.] III, p. 55.
 Entries: 2 (additional to [B.]). Millimeters. Inscriptions. Described.

Sirani, Giovanni Andrea *(1610–1670)*
[B. *Reni*] pp. 74–81.
 Entries: 11. Pre-metric. Inscriptions. States. Described.

[B.] XIX, pp. 147–150.
 Entries: 2. Pre-metric. Inscriptions. States. Described.

Sironi, Mario *(b. 1885)*
Pica, Agnoldomenico. *Mario Sironi, painter.* Milan: Edizioni del milione, 1955.
 Entries: 5 posters (complete?).

Sirouy, Achille Louis Joseph *(1834–1904)*
[Ber.] XII, pp. 31–34.*

Sisco, Louis Hercule *(1778–1861)*
[Ber.] XII, p. 35.*

Sisley, Alfred *(1839–1899)*
[Ber.] XII, p. 35.*

[Del.] XVII.
 Entries: 6. Millimeters. Inscriptions (selection). States. Described (selection). Illustrated. Located (selection).

Sisson, Richard *(d. 1767)*
[Sm.] III, p. 1131.
 Entries: 1 (portraits only). Inches. Inscriptions. Described.

Sittel, Constant *(fl. c.1849)*
[Ber.] XII, p. 35.*

Sivalli, Luigi *(1811–1887)*
[Ap.] p. 399.
Entries: 3.*

Six, Nicolaas *(1694/95–1731)*
[W.] II, p. 624.
Entries: 2.*

Sixdeniers, Alexandre Vincent *(1793–1846)*
[Ap.] p. 399.
Entries: 3.*

[Ber.] XII, pp. 35–38.*

Skarløv, Arne *(20th cent.)*
Andersson, Egart. "Arne Skarløv."
[*N. ExT.*] 7 (1955): 84–86.
Entries: 9 (bookplates only, to 1954).
Illustrated (selection).

Skelton, Joseph *(c.1785–after 1850)*
[Ber.] XII, p. 37.*

Skelton, William *(1763–1848)*
[Ap.] p. 399.
Entries: 7.*

Skinner, Jacob *(d. 1754)*
Booth, W. H. "Bookplates." Ms. (DLC)
Not seen.

Sköld, Otte *(b. 1894)*
Moderna Museet, Stockholm. *Otte Sköld.* Moderna Museets utstallningskatalog, 3. Stockholm, 1959.
Entries: 35 (complete?). Millimeters.
Located (selection).

Slabbaert, Karel *(c.1619–1654)*
[vdK.] pp. 51–53.
Entries: 2. Millimeters. Inscriptions.
Described.

[W.] II, p. 624.
Entries: 2.*

Slevogt, Max *(1868–1932)*
Cassirer, Bruno. *Max Slevogt; ein Verzeichnis der von ihm illustrierten Bücher,*

Mappenwerke und Graphiken erschienen im Verlag Bruno Cassirer. Leipzig, 1924.
Bibliography of books with illustrations by (published by Cassirer, to 1925).

Rümann, Arthur. *Verzeichnis der Graphik von Max Slevogt in Büchern und Mappenwerken.* Hamburg: Gesellschaft der Bücherfreunde zu Hamburg, 1936.
300 copies. (NN)
Bibliography of books with illustrations by, and sets of prints by.

Goering, Max. "Zur Graphik Max Slevogts; ergänzende Bemerkungen zu Rümanns Verzeichnis." [*GK.*] n.s. 3 (1938): 31–36.
Additional entries to Rümann bibliography.

Sievers, Johannes, and Waldmann, Emil. *Max Slevogt, das druckgraphische Werk; Radierungen, Lithographion, Holzschnitte; erster Teil 1890–1914.* Heidelberg (West Germany): Impuls Verlag Heinz Moos, 1962.
Entries: 816 (to 1914). Millimeters. Inscriptions. States. Illustrated.

Slingeland, Pieter Cornelisz van *(1640–1691)*
[Wess.] II, p. 252.
Entries: 1. Millimeters. Inscriptions.
Described.

[W.] II, p. 625.
Entries: 1 print by, 5 after.*

Sloan, [James] Blanding *(b. 1886)*
Sloan, Blanding. *Etchings and block prints of Blanding Sloan 1913–1926.* San Francisco (Calif.): Johnck, Kibbee and Co., 1926.
Entries: 138 etchings, 41 relief prints, (to 1926). Inches. Described (selection). Illustrated (selection).

Sloan, John *(1871–1951)*
Gallatin, A. E. "John Sloan; his graphic work." In *Certain contemporaries; a set of*

notes in art criticism. pp. 23–31. New York: John Lane, 1916.

> Entries: 93 etchings, 6 lithographs (1902 to 1915). Inches. Prints before 1902 are briefly summarized.

Rueppel, Merrill Clement. "The graphic art of Arthur Bowen Davies and John Sloan." Dissertation, University of Wisconsin, 1955.

> Entries: 236 prints by, 7+ early and unpublished prints by. Inches. Located (selection). Also, bibliography of books with illustrations by.

Zigrosser, Carl. "John Sloan memorial, his complete graphic work." *The Philadelphia Museum Bulletin* 51, no. 248 (Winter 1956): 19–31.

> Entries: 285. Inches. Illustrated (selection).

Morse, Peter. *John Sloan's prints: a catalogue raisonné of the etchings, lithographs, and posters.* New Haven (Conn): Yale University Press, 1969.

> Entries: 313. Millimeters. Inches. States. Described. Illustrated. Located. Also, selected list of posters (photo-mechanical reproductions) after.

Slodtz, René Michel [called "Michel-Ange"] *(1705–1764)*

> [Baud.] II, pp. 111–112.
>> Entries: 1. Millimeters. Inscriptions. Described.

Sluyter, Dirk Jurriaan *(1811–1886)*

> [H. L.] pp. 1016–1017.
>> Entries: 2. Millimeters. Inscriptions. Described.

> [Ap.] p. 400.
>> Entries: 4.*

> [W.] II, p. 627.
>> Entries: 8.*

Sluyter, Hendrik Dirk Jurriaansz *(1839–1931)*

> [Ap.] p. 400.
>> Entries: 6.*

Smart and **Hunt** *(19th cent.)*

> [Siltzer] p. 366.
>> Entries: unnumbered, p. 366. Inscriptions.

Smees, Jan *(d. 1729)*

> [B.] IV, pp. 379–383.
>> Entries: 5. Pre-metric. Inscriptions. Described.

> [Weigel] p. 223.
>> Additional information to [B.].

> [W.] II, p. 627.
>> Entries: 1+.*

Smeeton, Burn *(fl. 1840–1860)*

> [Ber.] XII, p. 39.*

Smet, Gustave de *(b. 1877)*

> Hecke, P. G. van, and Langui, Émile. *Gustave de Smet, sa vie et son oeuvre.* Brussels: Aux Éditions Lumière, 1945. Flemish ed. Langui, Émile. *Gust de Smet, de mensch en zijn werk.* Brussels: A. Manteau, 1945.
>> Entries: 819 (823 in Flemish edition) (catalogue of works in all media, including prints). Millimeters. Located.

Smidts, Hendrick *(fl. c.1676)*

> [W.] II, p. 629.
>> Entries: 1+.*

Smillie, James *(1807–1885)*

> Ms. catalogue. (NN)
> Entries: 479.

Smillie, James David *(1833–1909)*

> Ms. catalogue. (NN)
>> Entries: Not consecutively numbered, 8 pp.

Smirke, Robert *(1752–1845)* and **Emes,** John *(d. before 1810)*
 [Siltzer] p. 333.
 Entries: unnumbered, p. 333, prints after. Inches. Inscriptions.

Smit, A. *(fl. 1767–1792)*
 [W.] II, p. 628.
 Entries: 2+.*

Smit, Jan *(fl. 1721–1748)*
 [W.] II, p. 629.
 Entries: 3.*

Smith, C. N. *(19th cent.)*
 [Siltzer] p. 366.
 Entries: unnumbered, p. 366. Inscriptions.

Smith, Charles Loraine *(1751–1835)*
 [Siltzer] pp. 250–256.
 Entries: unnumbered, pp. 255–256, prints after. Inches (selection). Inscriptions.

Smith, Edward *(19th cent.)*
 [Ap.] p. 400.
 Entries: 5.*

Smith, George Girdler *(1795–1859)*
 [St.] pp. 480–482.*

 [F.] pp. 248–249.*

Smith, J. *(18th cent.)*
 [Sm.] III, p. 1241.
 Entries: 1 (portraits only). Inches. Inscriptions. Described.

Smith, J. H. *(19th cent.)*
 [Siltzer] p. 366.
 Entries: unnumbered, p. 366. Inscriptions.

Smith, Johan *(17th cent.)*
 [W.] II, p. 629.
 Entries: 1 print after.*

Smith, John *(1652?–1742)*
 "Portraits in mezzotinto by Mr. John Smith." Unpublished ms., early 19th cent. (EBM)
 Entries: unnumbered, 19 pp. (portraits only).

Wessely, Josef Eduard. *John Smith; Verzeichniss seiner Schabkunstblätter.* Kritische Verzeichnisse von Werken hervorragender Kupferstecher, 3. Hamburg: Haendke und Lehmkuhl, 1887.
 Entries: 485. Millimeters. Inscriptions. States. Described. Appendix with doubtful and rejected prints and prints not seen by Wessely, unnumbered, p. 148.

[Sm.] III, pp. 1131–1241, and "additions and corrections" section; IV, "additions and corrections" section.
 Entries: 287 (portraits only). Inches. Inscriptions. States. Described. Illustrated (selection). Located (selection).

[Ru.] pp. 263–279, 496.
 Entries: 5 (portraits only, additional to [Sm.]). Inches (selection). Inscriptions. States. Described. Additional information to [Sm.].

Smith, John Orrin *(1799–1843)*
 [Ber.] XII, p. 39.*

Smith, John Raphael *(1752–1812)*
 [Sm.] III, pp. 1241–1321, and "additions and corrections" section; IV, "additions and corrections" section.
 Entries: 208 (portraits only). Inches. Inscriptions. States. Described. Illustrated (selection). Located (selection).

Frankau, Julia. *An eighteenth-century artist and engraver, John Raphael Smith; his life and works.* London: Macmillan and Co., Ltd., 1902.
 Entries: 382. Inches. Inscriptions. States. Described. Illustrated (selection).

[Ru.] pp. 279–311, 496–497.
Entries: 5 (portraits only, additional to [Sm.]). Inches. Inscriptions. States. Described. Located (selection). Additional information to [Sm.].

Smith, John Rubens *(1775–1849)*
[St.] pp. 482–486.*

[F.] pp. 249–252.*

Smith, Leslie Victor *(20th cent.)*
Colgate, William. *The bookplates of Leslie Victor Smith.* Weston, Ontario (Canada): Old Rectory Press, 1947. 200 copies. (DLC)
Entries: 100 (bookplates only, to 1946). Inscriptions. Illustrated (selection).

Smith, R. K. *(fl. c.1824)*
[St.] p. 486.*

Smith, Samuel *(c.1745–c.1808)*
[Ap.] p. 401.
Entries: 4.*

Smith, Sidney Lawton *(1845–after 1906)*
[Smith, Sidney L.]. "A check-list of bookplates by Sidney L. Smith." In *The First Year Book, 1915.* pp. 13–25. Kansas City (Mo.): American Bookplate Society, 1915. 210 copies. (PJRo)
Entries: 142 (bookplates only, to 1915). Illustrated (selection).

Teall, Gardner. *Bookplates by Sidney L. Smith.* Kansas City (Mo): Alfred Fowler, 1921.
Entries: 167 (bookplates only, to 1920). Illustrated (selection).

Charles E. Goodspeed and Co. *Sidney Lawton Smith; designer, etcher, engraver, with extracts from his diary and a check-list of his bookplates.* Boston (Mass.): C. E. Goodspeed and Co., 1931. 200 copies. (MH)

Entries: 231 (bookplates only). Inscriptions. States. Described. Illustrated (selection). Ms. addition (NN); 205 additional entries (prints other than bookplates).

Smith, T. *(fl. c.1772)*
[Sm.] III, p. 1321.
Entries: 1 (portraits only). Inches. Inscriptions. Described.

Smith, T. *(19th cent.)*
[Siltzer] p. 333.
Entries: unnumbered, p. 333, prints after. Inches. Inscriptions.

Smith, Thomas [called "Smith of Derby"] *(d. 1767)*
[Siltzer] p. 256.
Entries: unnumbered, p. 256, prints after. Inches (selection). Inscriptions. Described (selection).

Smith, W. R. *(19th cent.)*
[Ap.] p. 401.
Entries: 3.*

Smith, William *(fl. 1774–1802)*
[Sm.] III, pp. 1321–1322, and "additions and corrections" section.
Entries: 6 (portraits only). Inches. Inscriptions. States. Described. Illustrated (selection). Located (selection).

[Ru.] p. 311.
Additional information to [Sm.].

Smith, William D. *(fl. 1829–1850)*
[St.] pp. 486–490.*

[F.] pp. 252–253.*

Smither, James *(1741–after 1800)*
[Allen] pp. 150–151.*

[St.] pp. 490–493.*

Cattle, Frederick, and Marshall, Frank E. "Book-Plates by J. Smither." *The Biblio* 1 (1913): 22–27.

Smither, James *(continued)*

Entries: 12 (bookplates only). Inscriptions. States. Described. Illustrated (selection).

[F.] pp. 253–255.*

Smits, Eugeen *(1826–1912)*
[H. L.] pp. 1017–1024.
Entries: 22. Millimeters. Inscriptions. States. Described.

Smits, Jakob *(1855–1928)*
Lebeer, Louis. *Jakob Smits etsen.* Brussels: Uitgeverij Nébé, 1935. 200 copies. (EBr). French edition. 50 copies. (Not seen).
Entries: 89. Millimeters. Inscriptions. States. Described. Illustrated.

Smits, Louis *(19th cent.)*
[H. L.] p. 1017.
Entries: 1. Millimeters. Described.

Smyth, Emily R. *(fl. 1850–1874)*
[Siltzer] p. 333.
Entries: unnumbered, p. 333, prints after. Inscriptions.

Snayers, Peeter *(1592–after 1666)*
[W.] II, pp. 630–631.
Entries: 5 prints after.*

Snellinck, Jan *(c.1549–1638)*
[W.] II, pp. 632–633.
Entries: 4+ prints after.*

Snoek, Jeremias *(fl. 1792–1795)*
[W.] II, p. 633.
Entries: 2.*

Snow, J. W. *(19th cent.)*
[Siltzer] p. 333.
Entries: unnumbered, p. 333, prints after. Inches (selection). Inscriptions.

Snyder, H. W. *(1829–1910)*
[St.] pp. 493–494.*

Snyders, Frans *(1579–1657)*
[W.] II, pp. 633–635.
Entries: 4 prints by, 19 after.*

Snyders, Michiel *(c.1588–c.1630)*
[W.] II, p. 635.
Entries: 4.*

Snyers, Hendrik *(fl. c.1642)*
[W.] II, p. 635.
Entries: 12.*

Snyers, Peeter *(1681–1752)*
[W.] II, pp. 635–636.
Entries: 3.*

Société des Aquafortistes *(19th cent.)*
Bailly-Herzberg, Janine. *L'Eau-forte de peintre au dix-neuvième siècle, la Société des Aquafortistes 1862–1867.* Paris: Léonce Laget, 1972.
Entries: 300 prints published by. Millimeters. Described. Illustrated.

Söckler, ——— *(17th cent.)*
[Merlo] p. 806.*

Söntgens, Johann Jakob *(fl. 1668–1701)*
[Merlo] pp. 806–808.*

Sørensen, Øivind *(20th cent.)*
Borchgrevink, Ludvig. "Øivind Sørensen." [N. ExT.] 2 (1947–1948): 78–82.
Entries: 72 (bookplates only, to 1948). Illustrated (selection).

Sörensen, J. L. *(fl. c.1855)*
[H. L.] p. 1025.
Entries: 2. Millimeters. Inscriptions. Described.

Soest, Gerard *(c.1600–1681)*
[W.] II, p. 636.
Entries: 4 prints after.*

Soinard, François Louis *(fl. 1824–1837)*
[Ber.] XII, p. 39.*

Sokolov, I. A. *(20th cent.)*
Gosudarstvennyj muzej izjashchnykh iskusstv, Moscow. *Graviury I. A. Sokolova, katalog vystavki.* Moscow, 1929. (EA)
 Entries: 95 (to 1928). Millimeters.

Solana, José Gutiérrez *(1886–1945)*
Casariego, Rafael. *José Gutiérrez Solana, aquafuertes y litografias, obra completa.* Madrid: R. Diaz-Casariego, 1963. 1000 copies. (DLC)
 Entries: 28 etchings, 7 lithographs (to 1963?). Millimeters. Inscriptions. Described. Illustrated.

Sole, Giovan Gioseffo dal *(1654–1719)*
[B.] XIX, pp. 328–331.
 Entries: 3 prints by, 2+ prints not seen by [B.]. Pre-metric. Inscriptions. Described.

Sole, Giovanni Battista del *(d. 1719)*
[B.] XXI, pp. 123–125.
 Entries: 2. Pre-metric. Inscriptions. Described.

[Heller] pp. 114–115.
 Additional information to [B.].

Solier, ——— *(19th cent.)*
[Ber.] XII, pp. 39–40.*

Soliman-Lieutaud, ——— *(c.1810–1880)*
[Ber.] XII, p. 40.*

Solimena, Francesco [called "l'Abate Ciccio'] *(1657–1747)*
Bologna, Ferdinando. *Francesco Solimena.* Naples: L'Arte Tipografica, 1958.
 Entries: unnumbered, pp. 282–284, prints after. Books where prints appeared are identified.

Solis, Nikolaus *(c.1542–1584)*
[B.] IX, p. 231.
 Entries: 3. Pre-metric. Inscriptions.

[P.] IV, pp. 124–128.
 Entries: 38 etchings, 22 woodcuts. Pre-metric (selection). Paper fold measure (selection). Inscriptions. Described (selection).

[A.] II, pp. 83–100.
 Entries: 46 etchings, 1 doubtful etching, 26 woodcuts. Pre-metric. Inscriptions. Described.

Solis, Virgilius *(1514–1562)*
[B.] IX, pp. 242–323.
 Entries: 558 etchings and engravings, 10+ woodcuts. Pre-metric. Inscriptions. States. Described. Copies mentioned.

[Heller] pp. 115–117.
 Entries: 6 (additional to [B.]). Pre-metric. Inscriptions. Described.

[Evans] pp. 26–27.
 Entries: 1 (additional to [B.]). Millimeters. Inscriptions. Described.

[P.] IV, pp. 115–124.
 Entries: 68 etchings and engravings (additional to [B.]). Pre-metric. Inscriptions. Described. Copies mentioned.

Andresen, A. "Die Holzschnittwerke des Virgil Solis, Maler, Kupferstecher und Formschneider." [N. Arch.] 10 (1864): 316–363.
 Entries: 23+ (woodcuts only). Pre-metric. Inscriptions. States. Described (selection).

Ubisch, E. von. *Virgil Solis und seiner biblischen Illustrationen für den Holzschnitt.* Leipzig: Ramm und Seemann, 1889.
 Bibliography of books with illustrations by (biblical woodcuts only).

[Ge.] nos. 1316–1331.
 Entries: 26 (single-sheet woodcuts only). Described. Illustrated. Located.

Solms, Marie Studolmine de *(1833–1902)*
[Ber.] XII, p. 41.*

Solon, Marc Louis Emanuel *(1835–1913)*
[Ber.] XII, p. 41.*

Somer, Jan van *(1645–after 1699)*
Wessely, J. E. "Jan van Somer, Verzeichniss seiner Schabkunstblätter."
[*N. Arch.*] 15 (1869): 105–146.
Entries: 131 (mezzotints only). Premetric. Inscriptions. States. Described.

[Wess.] II, pp. 252–254.
Entries: 17 (additional to Wessely in [*N. Arch.*]). Millimeters. Inscriptions. Described. Additional information to Wessely in [*N. Arch.*].

[W.] II, pp. 637–638.
Entries: 131.*

Somer, Mathias van *(fl. 1649–1675)*
[Merlo] pp. 810–811.*

Somer, Paul I van *(c.1576–1621)*
[W.] II, pp. 638–639.
Entries: 3 prints after.*

Somer, Paul II van *(c.1649–c.1694)*
Wessely, J. E. "Paul van Somer, Verzeichniss seiner Kupferstiche und Schabkunstblätter." [*N. Arch.*] 16 (1870): 39–87.
Entries: 189 etchings, 31 mezzotints. Pre-metric. Inscriptions. States. Described.

[Wess.] II, pp. 254–255.
Entries: 4+ (additional to Wessely in [*N. Arch.*]). Millimeters (selection). Inscriptions (selection). Described (selection).

[Sm.] III, pp. 1415–1421, and "additions and corrections" section.
Entries: 17 (portraits only). Inches. Inscriptions. States. Described. Illustrated (selection). Located (selection).

[Ru.] pp. 335–337.

Entries: 3 (portraits only, additional to [Sm.]). Inches. Inscriptions. Described. Additional information to [Sm.].

Someren
See **Somer**

Somm, Henry
See **Sommier,** François Clément

Sommerard, Edmond du *(1817–1885)*
[Ber.] XII, pp. 45–46.*

Sommier, François Clément [called "Henry Somm"] *(1844–1907)*
[Ber.] XII, pp. 41–45.
Entries: 65+.

Sompel, Pieter van *(c.1600–after 1643)*
[W.] II, p. 639.
Entries: 16.*

Son, Joris [Georg] van *(1623–1667)*
[W.] II, p. 639.
Entries: 1 print after.*

Sondermayr, Simon Thaddäus *(fl. 1725–1750)*
[Merlo] p. 811.*

Sonne, [Carl] Eduard *(1804–1878)*
[Ap.] p. 401.
Entries: 3.*

Sonnenleiter, Johannes *(1825–1907)*
[Ap.] pp. 401–402.
Entries: 8.*

Roeper, A. "Johannes Sonnenleiter." [*Bb.*] 74, no. 253 (29 October 1907): 11314–11317. Separately bound copy. (NN)
Entries: 49. Millimeters. States.

Soper, Eileen Alice *(b. 1905)*
Macfall, Haldane. *Some thoughts on the art of Eileen Soper.* London: H. C. Dickins, n.d.

Entries: 22 (to 19??). Inches. Illustrated (selection).

Preston, Hayter. *Childhood days, an essay . . . suggested by the etchings of Miss Eileen Soper.* n.p., n.d.
Entries: 18 (to 19??). Inches. Illustrated (selection).

Soper, George *(b. 1870)*
Finberg, Alexander J. *Etchings and drypoints by George Soper.* London: H. C. Dickins, 1921.
Entries: 26 (to 1921).

Sorch, Hendrik
See **Sorgh**

Soreau, Jan [?] *(fl. 1620–1638)*
[W.] II, p. 641.
Entries: 1+.*

Sorel, Victor *(fl. 1837–c.1847)*
[Ber.] XII, p. 46.*

Sorge, Peter *(20th cent.)*
Sorge, Peter. *Peter Sorge, Werk-Verzeichnis der Graphik von 1963–1970.* Berlin: Galerie Poll, [1970?].
Entries: 73 (to 1970). Millimeters. Illustrated (selection).

Sorgh, Hendrik Martensz *(c.1611–1670)*
[W.] II, pp. 641–642.
Entries: 8 prints after.*

Soriau, Jan
See **Soreau**

Sorin, François *(1655–1736)*
[CdB.] pp. 81–86.
Entries: 9+. Paper fold measure (selection).

Sorrieu, Frédéric *(b. 1807)*
[Ber.] XII, pp. 46–47.*

Soster, Bartolomeo *(c.1803)*
[Ap.] p. 402.
Entries: 3.*

Sotain, Noël Eugène *(b. 1816)*
[Ber.] XII, p. 47.*

Sotomajor
See **Esquivel Sotomajor**

Soudain, Alexandre Marie *(b. 1833)*
[Ber.] XII, pp. 47–48.*

Soukens, Jan *(fl. 1678–1725)*
[W.] II, p. 642.
Entries: 1.*

Soulange Teissier, Louis Emanuel *(1814–1898)*
[Ber.] XII, pp. 48–50.*

Soulié, Léon *(1807–1862)*
[Ber.] XII, pp. 50–52.*

Soumy, Joseph Paul Marius *(1831–1863)*
[Ap.] pp. 402–403.
Entries: 2.*

[Ber.] XII, pp. 52–53.*

Auquier, Philippe, and Astier, Jean-Baptiste. *La vie et l'oeuvre de Joseph Soumy, graveur et peintre.* Marseille (France): Librairie P. Ruat, 1910. 250 copies. (EPAA)
Entries: unnumbered, pp. 76, 77, 80. Illustrated (selection). Located.

Sourches, Louis François du Bouchet, marquis de *(fl. 1645–1683)*
[RD.] II, pp. 22–31; XI, pp. 306–307.
Entries: 33. Pre-metric. Inscriptions. States. Described.

Souter, Adrian *(d. 1645)*
[W.] II, p. 642.
Entries: 1 print after.*

Soutman, Pieter Claesz *(d. 1657)*
[Dut.] VI, pp. 301–302.*

[W.] II, pp. 642–644.
Entries: 27+ prints by, 6+ after.*

Sovák, Pravoslav *(20th cent.)*
Overbeck-Gesellschaft, Lübeck. *Sovák; Radierungen, gravures, etchings.*
Lucerne and Frankfurt am Main: Verlag C. J. Bucher, 1971.
Entries: 194 (to 1971). Millimeters. Illustrated.

Soye, Philippe de *(fl. 1543–1578)*
[W.] II, p. 644.
Entries: 14.*

[Bierens de Haan, J. C. J.?]. Unpublished ms. catalogue. (ERB)
Entries: 18. Inscriptions.

Soyer, Raphael *(b. 1899)*
Cole, Sylvan, Jr. *Raphael Soyer; fifty years of print-making.* New York: Da Capo Press, 1967.
Entries: 126. Inches. Described. Illustrated.

Spaan, Jan *(fl. 1766–1768)*
[W.] II, p. 644.
Entries: 1.*

Spacal, Lojze *(b. 1907)*
Montenero, Giulio. Catalogue. In *Luigi Spacal, opera grafica 1936–1967,* by Rodolfo Pallucchini et al. Milan: Edizioni di Vanni Scheiwiller, 1968. 1000 copies.
Entries: 40 (to 1967). Described. Illustrated.

Spaendonck, Cornelis van *(1756–1840)*
[Ber.] XII, p. 177.*

Spaendonck, Gerardus *(1746–1822)*
[W.] II, p. 644.
Entries: 1 print after.*

Spafard, Octavia Maverick
See **Maverick** family

Spagnuoli, Francesco *(fl. 1834–1847)*
[Ap.] p. 403.
Entries: 1.*

Spalding, G. B. *(19th cent.)*
[Siltzer] p. 333.
Entries: unnumbered, p. 333, prints after. Inches (selection). Inscriptions.

Sparrow, Thomas *(fl. 1765–1780)*
[Allen] pp. 151–152.*

[St.] pp. 494–495.*

[F.] p. 255.*

Speccard, Hans [Jan]
See **Speeckaert**

Speckel or **Speckle**
See **Speklin**

Specklin, Daniel *(1536–1589)*
[B.] IX, p. 589.
Entries: 1. Pre-metric. Inscriptions. Described.

[P.] III, pp. 350–352.
Entries: 6+ (revision of [B.]). Pre-metric (selection). Paper fold measure (selection). Inscriptions (selection). States. Described (selection). Additional information to [B.].

Specklin, Veit Rudolf *(d. 1550)*
[P.] III, p. 350.
Entries: 1+. Pre-metric. Inscriptions (selection). Described (selection).

Speckter, Johann Michael *(1764–1845)*
[Dus.] pp. 258–259.
Entries: 2 (lithographs only, to 1821). Millimeters. Inscriptions. Located.

Speckter, Otto *(1807–1871)*
Hobrecker, Karl. Catalogue. In *Otto Speckter,* by Fritz H. Ehmcke. Berlin: Furche-Verlag, 1920.
Bibliography of books with illustrations by.

Speeckaert, Hans [Jan] *(d. 1577)*
[W.] II, p. 645.
Entries: 11 prints after.*

Speeth, Peter *(1772–1831)*
[Dus.] p. 259.
Entries: 1 (lithographs only, to 1821).

Spenceley, J. Winfred *(b. 1865)*
Chaignon La Rose, Pierre de. *A descriptive checklist of the etched and engraved book-plates by J. Winfred Spencely.* Boston (Mass.): Troutsdale Press, 1905. 250 copies. (DLC)
Entries: 135 (bookplates only, to 1904). Inches. Inscriptions. Described.

[Drake, James F.] *Check list; J. Winfred Spencely bookplates.* New York: Association Book Club of New York, 1909. 125 copies. (DLC)
Entries: 209 (bookplates only).

Andreini, Joseph M. *J. Winfred Spenceley, his etchings and engravings in the form of book plates.* New York: Privately printed, 1910. 100 copies. (DLC)
Entries: 213 (bookplates only). Inches. Inscriptions. States. Described. Ms. addition (NN); 30 additional entries (prints other than bookplates).

Spicer, Henry *(1743–1804)*
[Sm.] III, pp. 1322–1323.
Entries: 2 (portraits only). Inches. Inscriptions. States. Described.

[Ru.] pp. 311–312.
Entries: 2 (portraits only, additional to [Sm.]). Inches. Inscriptions (selection). Described. Additional information to [Sm.].

Spiegel, Ludwig von *(19th cent.)*
[Dus.] p. 259.
Entries: 1 (lithographs only, to 1821). Millimeters. Inscriptions. Located.

Spielberg
See **Spilberg**

Spierinck
See **Spirinx**

Spiess, Amalie *(1793–1830)*
Andresen, A. "Beschreibung der von J. A. Boerner hinterlassenen radierten Blätter; Anhang." [*N. Arch.*] 9 (1863): 8–19.
Entries: 3. Pre-metric. Inscriptions. States. Described.

Spiess, August Friedrich *(1806–1855)*
[Ap.] p. 403.
Entries: 5.*

Spilberg, Gabriel *(fl. 1590–1620)*
[W.] II, p. 645.
Entries: 2+ prints after.*

Spilberg, Johannes II *(1619–1690)*
[W.] II, p. 646.
Entries: 6 prints after.*

Spilliaert, Léon *(b. 1881)*
Edebau, Frank. "Leon Spilliaert." *West-Vlaanderen* 4 (1955): 105–107.
Entries: unnumbered, p. 107.

Spilman, Henricus [Hendrik] *(1721–1784)*
[W.] II, p. 646.
Entries: 27+.*

Spilsbury, John *(1730?–1795)*
[Sm.] III, pp. 1323–1335, and "additions and corrections" section.
Entries: 44 (portraits only). Inches. Inscriptions. States. Described. Illustrated (selection). Located (selection).

Spilsbury, John (*continued*)

[Ru.] pp. 312–316.
Entries: 6 (portraits only, additional to
[Sm.]). Inches. Inscriptions. States.
Described. Additional information to
[Sm.].

Spirinx, Laurent (*1645–after 1687*)
Rondot, Natalis. "Les Spirinx, graveurs
d'estampes à Lyon au XVIIe siècle."
Revue du Lyonnais, 5th ser. 15 (1893):
73–87, 160–174. Separately published.
Lyons: Imprimerie Mougin-Rusand,
1893.
Entries: unnumbered, pp. 173–174.
Millimeters. Inscriptions.

Spirinx, Louis (*1596–1669*)
Rondot, Natalis. "Les Spirinx, graveurs
d'estampes à Lyon au XVIIe siècle."
Revue du Lyonnais, 5th ser. 15 (1893):
73–87, 160–174. Separately published.
Lyons: Imprimerie Mougin-Rusand,
1893.
Entries: 79 (83 in the separate publica-
tion). Millimeters (selection). Inscrip-
tions. Described (selection). Located
(selection).

[W.] II, p. 647.
Entries: 12+.*

Spirinx, Nicolas (*fl. 1606–1643*)
Rondot, Natalis. "Les Spirinx, graveurs
d'estampes à Lyon au XVIIe siècle."
Revue du Lyonnais, 5th ser. 15 (1893):
73–87, 160–174. Separately published.
Lyons: Imprimerie Mougin-Rusand,
1893.
Entries: unnumbered, pp. 82–83.
Millimeters. Inscriptions.

Spitzer, Peter (*fl. 1533–1578*)
[Ge.] nos. 1332–1336.
Entries: 5 (single-sheet woodcuts
only). Described. Illustrated. Located.

Spol, A. (*fl. c.1834*)
[H. L.] pp. 1025–1026.
Entries: 1. Millimeters. Inscriptions.
Described.

Spooner, Charles (*c.1720–1767*)
[Sm.] III, pp. 1336–1347, and "additions
and corrections" section.
Entries: 46 (portraits only). Inches. In-
scriptions. States. Described. Illus-
trated (selection).

[Ru.] pp. 316–320.
Entries: 8 (portraits only, additional to
[Sm.]). Inches. Inscriptions. De-
scribed. Additional information to
[Sm.].

Sporer, Eugen (*b. 1920*)
Eugen Sporer; Holzschnitte. Preface by
Hans Adolf Halbey. Munich: Prestel
Verlag, 1964.
Bibliography of books with illustra-
tions by (to 1963).

Sporer, Wolf
See **Monogram WS** [Nagler, *Mon.*] V, no.
1899

Spranger, Bartholomaeus (*1546–1611*)
[W.] II, pp. 648–650.
Entries: 6 prints by, prints after un-
numbered, p. 650.*

Niederstein, Albrecht. *Das graphische
Werk des Bartholomäus Spranger.* Disserta-
tion, University of Rostock. Berlin: Wal-
ter de Gruyter and Co., 1931. (NN)
Entries: 3. Millimeters. Inscriptions.
Described. Located. Also, 100 prints
after (prints of Spranger's own time
only). Located.

Oberhuber, Konrad. "Die stilistische
Entwicklung im Werk Bartholomäus
Sprangers." Dissertation, University of
Vienna, 1958. Unpublished ms. (photo-
stat, EUD).

Stadler, Toni [Anton] von (*continued*)

"Die Lithographien Toni von Stadlers."
[*MGvK.*] 1915, pp. 34–36.
 Entries: 32 (to 1915?). Millimeters. De-
 scribed. Located.

Stäbli, —— (*19th cent.*)
[Dus.] p. 259.
 Entries: 1 (lithographs only, to 1821).
 Millimeters. Inscriptions. Located.

Stäbli, Diethelm Rudolf (*1812–1868*)
[Ap.] p. 404.
 Entries: 5.*

Staeger, Ferdinand (*b. 1880*)
Muschler, Reinhold Konrad. *Ferdinand
Staeger, eine Monographie.* Leipzig: Max
Koch, 1925.
 Entries: 283 (to 1924). Millimeters. In-
 scriptions. States. Described. Illus-
 trated (selection).

Staël, Nicolas de (*1914–1955*)
Galerie Messine, Paris. *Nicolas de Staël,
lithographies et gravures.* Paris, 1965. 165
copies. (NN)
 Entries: 23 (complete?). Millimeters.
 Illustrated.

Stage, Mads (*20th cent.*)
Køhler, Johnny. "Mads Stage og hans
exlibris." [*N. ExT.*] 17 (1965): 67–69.
 Entries: 21 (bookplates only, to 1965?).
 Illustrated (selection).

Stalbemt, Adriaen van (*1580–1662*)
[vdK.] pp. 181–186, 232.
 Entries: 6. Millimeters. Inscriptions.
 States. Described. Illustrated (selec-
 tion).

[W.] II, p. 652.
 Entries: 6 prints by, 1 after.*

Stalburch, Jan van (*fl. 1555–1562*)
[B.] IX, pp. 476–478.

Entries: 2. Pre-metric. Inscriptions.
Described.

[P.] III, pp. 106–107.
 Entries: 8 (additional to [B.]). Pre-
 metric. Inscriptions. Described. Lo-
 cated.

[Wess.] II, p. 255.
 Entries: 1 (additional to [B.]). Milli-
 meters. Inscriptions. Described.

[W.] II, p. 652.
 Entries: 11+.*

Stalker, E. (*fl. 1801–1823*)
[F.] p. 256.*

Stang, Rudolf (*1831–1927*)
[Ap.] p. 404.
 Entries: 7.*

Starckman, P. (*18th cent.*)
[W.] II, p. 653.
 Entries: 1.*

Stauffer-Bern, Karl (*1857–1891*)
Lehrs, Max. *Karl Stauffer-Bern (1857–
1891) ein Verzeichnis seiner Radierungen
und Stiche.* Dresden: E. Arnold, 1907.
 Entries: 37. Millimeters. Inscriptions.
 States. Described. Located.

Staveren, Jan Adriaensz van
(*c.1625–after 1668*)
[W.] II, p. 654.
 Entries: 2 prints after.*

Staverenus, Petrus (*fl. 1634–1654*)
[W.] II, p. 654.
 Entries: 1.*

Stee, P. (*fl. c.1778*)
[Sm.] III, p. 1347.
 Entries: 1 (portraits only). Inches. In-
 scriptions. Described.

[Ru.] p. 320.
 Additional information to [Sm.].

Steel, James W. *(1799–1879)*
[St.] pp. 495–502.*

[F.] pp. 256–258.*

Steelink, Willem I *(1826–1913)*
[Ap.] p. 404.
Entries: 2.*

Steen, Franciscus van der *(c.1625–1672)*
[W.] II, pp. 654–655.
Entries: 51+.*

Steen, Jan *(1626–1679)*
Westrheene, T. van. *Jan Steen, étude sur l'art en Hollande.* The Hague: Martinus Nijhoff, 1856.
Entries: 4. Millimeters. Inscriptions. Described. Also, list of 57+ prints after. Paper fold measure (selection).

[W.] II, pp. 655–658.
Entries: 4 prints by, 51+ after.*

Steenwyck, Hendrik II van *(c.1580–c.1649)*
[W.] II, pp. 660–661.
Entries: 6 prints after.*

Steffeck, Carl Constantin Heinrich *(1818–1890)*
[A. 1800] V, pp. 104–116.
Entries: 6 etchings, 18 lithographs. Millimeters. Inscriptions. States. Described. Also, p. 111, list of prints after (not fully catalogued).

Steffelaar, Cornelis *(1797–1861)*
[H. L.] pp. 1028–1036.
Entries: 38. Millimeters. Inscriptions. Described.

Steffen, L. *(fl. c.1830)*
[Dus.] p. 259.
Entries: 1 (lithographs only, to 1821). Paper fold measure.

Stege[r], Erwin vom *(fl. 1456–1475)*
[W.] III, pp. 150–167.
Entries: 314+.*

Steidner
See **Steudner**

Steifensand, Xaver *(1809–1876)*
[Ap.] pp. 404–405.
Entries: 21.*

Stein, Franciscus van der
See **Steen**

Steinber, Manasse *(d. 1627)*
[A.] III, pp. 339–340.
Entries: 1. Pre-metric. Inscriptions. Described.

Steiner-Prag, Hugo *(1880–1945)*
Frenzel, H. K., and Osborn, Max. *Hugo Steiner-Prag.* Berlin: Phönix Illustrationsdruck und Verlag, 1928.
Bibliography of books with illustrations by (to 1927). Ms. notes (MH); 4 additional entries.

Hadamowsky, Franz, and Mayerhöfer, Josef. *Hugo Steiner-Prag; 12 Dezember 1880–10 September 1945.* Biblos-Schriften, 10. Vienna: Gesellschaft der Freunde der Österreichischen Nationalbibliothek, 1955.
Bibliography of books with illustrations by.

Steinhammer, Friedrich Christoph *(17th cent.)*
[A.] IV, pp. 289–290.
Entries: 1. Pre-metric. Inscriptions. Described.

Steinhardt, Jakob *(b. 1887)*
Kolb, Leon. *The woodcuts of Jakob Steinhardt; chronologically arranged and fully reproduced.* San Francisco (Calif): Genuart Co., 1959.
Entries: 446 (woodcuts only, to 1959). Millimeters. Illustrated.

Steinheil, Louis Charles August *(1814–1885)*
[Ber.] XII, p. 56.*

Steinla, [Franz Anton Erich] Moritz
(1791–1858)
 [Ap.] pp. 406–409.
 Entries: 42.*

Steinlen, Théophile Alexandre *(1859–1923)*
 [Ber.] XII, pp. 56–59.*

 Crauzat, A. de. *Steinlen, peintre-graveur et lithographe.* n.p. Société de propagation des livres d'art, 1902. Reprint. 1913. Entries: 745. Millimeters. Inscriptions. States. Described (selection). Located (selection). All prints not illustrated are described.

Steinmüller, Joseph *(1795–1841)*
 [Ap.] pp. 409–410.
 Entries: 13.*

Stella, Jacques *(1596–1657)*
 [RD.] VII, pp. 158–162; XI, pp. 307–308. Entries: 6. Millimeters. Inscriptions. States. Described.

 [P.] VI: *See* **Chiaroscuro Woodcuts**

Stengel, Stephan, Freiherr von *(1750–1822)*
 [Dus.] p. 259.
 Entries: 1 (lithographs only, to 1821). Millimeters. Located.

Stengelin, Alphonse *(b. 1852)*
 Zilcken, Ph. *Catalogue déscriptif des eaux-fortes et lithographies de Alphonse Stengelin.* The Hague: Mouton et Cie, 1910. Entries: 14 etchings, 61 lithographs (to 1910?). Millimeters. Inscriptions. Described. Illustrated (selection).

Stephani, Pieter
See **Stevens**

Sterl, Robert Hermann *(1867–1932)*
 Becker, Heinrich. *Robert Sterl als Zeichner . . . Einleitung und beschreibendes Verzeichnis des graphischen Werks.* Bielefeld (West Germany): Bielefelder Kunstverein, 1952.

Entries: 105 lithographs, 8 etchings. Millimeters. Inscriptions. States. Described. Illustrated (selection).

Sternberg, Harry *(b. 1904)*
 University Gallery, University of Minnesota, Minneapolis. *The prints of Harry Sternberg.* Minneapolis (Minn.), 1957. Entries: 202 (to 1956). Inches.

Steuber, Manasse
See **Steinber**

Steudner, Daniel *(fl. 1672–1692)*
 Hämmerle, Albert. "Die Familie der Steudner." [*Schw. M.*] 1926, pp. 97–114. Entries: 58. Millimeters. Inscriptions. Described. Illustrated (selection). Located.

Steudner, Johann Philipp *(1652–1732)*
 Hämmerle, Albert. "Die Familie der Steudner." [*Schw. M.*] 1926, pp. 97–114. Entries: 11. Millimeters. Inscriptions. Described. Illustrated (selection). Located.

Steudner, Marc Christophe I *(c.1660–1704)*
 Hämmerle, Albert. "Die Familie der Steudner." [*Schw. M.*] 1926, pp. 97–114. Entries: 13. Millimeters (selection). Paper fold measure (selection). Inscriptions. States. Described. Illustrated (selection). Located (selection).

Steuffercher, Jean *(fl. c.1860)*
 [Ber.] XII, p. 60.*

Stevens, Alfred *(1823–1906)*
 [Ber.] XII, p. 60.*

Stevens, [Édouard] Joseph *(1819–1892)*
 [H. L.] p. 1036.
 Entries: 1. Millimeters. Inscriptions. Described.

Stevens, Pieter I *(b. c.1540)*
 [W.] II, pp. 662–663.
 Entries: 1 print by, 9 after.*

Stevens, Pieter II *(fl. c.1689)*
 [W.] II, p. 663.
 Entries: 6.*

Stevenson, F. G. *(fl. c.1910)*
 List of the mezzotint engravings printed in colours by F. G. Stevenson. New York: Max Williams, [1913?].
 Entries: 37 (to 1913). Inches.

Stewart, James S. *(1791–1863)*
 [Ap.] pp. 410–411.
 Entries: 8.*

Stewart, Robert *(fl. 1777–1783)*
 [Sm.] III, pp. 1347–1350, and "additions and corrections" section.
 Entries: 13 (portraits only). Inches. Inscriptions. Described.
 [Ru.] pp. 320–321.
 Entries: 5 (portraits only, additional to [Sm.]). Inches. Inscriptions. Described. Additional information to [Sm.].

Steynberk, Manasse
 See **Steinber**

Stich, G. C. *(17th cent.)*
 [Merlo] pp. 854–856.*

Stiller, Günther *(b. 1927)*
 Wendland, Henning. "Das Betreten der Welt geschieht auf eigene Gefahr!" *Philobiblon* 12 (1968): 32–56.
 Bibliography of books with illustrations by.

Stimmer, Abel *(1542–after 1606)*
 [B.] IX, p. 559.
 Entries: 1. Pre-metric. Inscriptions. Described.

 [P.] III, pp. 461–463.
 Entries: 6. Pre-metric. Inscriptions. Described. Located (selection). Additional information to [B.].
 [A.] I, pp. 62–70.
 Entries: 9. Pre-metric. Inscriptions. States. Described.

Stimmer, Christoph
 See **Monogram CS** [Nagler, *Mon.*] II, no. 669

Stimmer, Hans Christoffel *(1549–1578)*
 [P.] III, pp. 459–461.
 Entries: 3. Pre-metric (selection). Paper fold measure (selection). Inscriptions. Described.

Stimmer, Tobias *(1539–1584)*
 [B.] IX, pp. 330–350.
 Entries: 66+. Pre-metric. Inscriptions (selection). Described (selection).
 [P.] III, pp. 453–458.
 Entries: 28+ (additional to [B.]). Pre-metric (selection). Paper fold measure (selection). Inscriptions. Described. Additional information to [B.].
 [A.] III, pp. 7–217.
 Entries: 166+. Pre-metric. Inscriptions. States. Described. Appendix with doubtful and rejected prints: 2 etchings, 8 woodcuts.
 [Wess.] I, p. 156.
 Entries: 4 (additional to [B.] and [P.]). Millimeters (selection). Inscriptions (selection). Described.

 Stolberg, A. *Tobias Stimmer; sein Leben und seine Werke.* Studien zur deutschen Kunstgeschichte, 31. Strasbourg: J. H. Ed. Heitz (Heitz und Mundel), 1901.
 Additional information to [A.].

Stipulkowsky *(fl. c.1840)*
 [Ber.] XII, p. 60.*

737

Stobbaerts, Jan *(1836–1914)*
[H. L.] pp. 1037–1041.
 Entries: 15. Millimeters. Inscriptions.
 States. Described.

Stock, Andries Jacobsz *(c.1580?–after 1648)*
[W.] II, pp. 663–664.
 Entries: 20.*

Stock, H. *(fl. c.1635)*
[Hind, *Engl.*] II, p. 303.
 Entries: 1. Inches. Inscriptions. States.
 Described. Illustrated. Located.

Stock, Henry J. *(fl. c.1900)*
Guthrie, James. *Bookplates by Henry J.*
Stock, R.I. Kansas City (Mo.): Alfred
Fowler, 1920. 250 copies. (DLC)
 Entries: 12 (bookplates only, to 1919).
 Illustrated (selection).

Stock, Ignatius van der *(fl. c.1660)*
[vdK.] pp. 70–74.
 Entries: 9. Millimeters. Inscriptions.
 States. Described. Appendix with 1
 doubtful print.

[Dut.] VI, pp. 307–311.
 Entries: 9. Millimeters. Inscriptions.
 States. Described.

[W.] II, p. 664.
 Entries: 10.*

Stocks, Lumb *(1812–1892)*
[Ap.] p. 411.
 Entries: 4.*

Stocquart, Ildephonse *(1819–1889)*
[H. L.] pp. 1042–1044.
 Entries: 12. Millimeters. Inscriptions.
 States. Described.

Stöber, Franz Xaver *(1795–1858)*
[Ap.] pp. 411–412.
 Entries: 15.*

Stöber, Joseph *(1768–1852)*
[Ap.] p. 412.
 Entries: 1.*

Stör, Lorenz *(16th–17th cent.)*
[A.] III, pp. 285–288.
 Entries: 1+. Pre-metric. Inscriptions.
 States. Described (selection).

Stör, Niclas *(d. 1562/63)*
Röttinger, Heinrich. *Erhard Schön und*
Niklas Stör, der Pseudo-Schön. Studien
zur deutschen Kunstgeschichte, 229.
Strasbourg: J. H. Ed. Heitz, 1925.
 Entries: 59. Millimeters. Inscriptions.
 States. Described. Illustrated (selec-
 tion). Located.

[Ge.] nos. 1351–1403.
 Entries: 53 (single-sheet woodcuts
 only). Described. Illustrated. Located.

Stössel, Oskar *(b. 1879)*
Binder, Bruno. "Der Radierer Oskar
Stössel." [GK.] 45 (1922): 99–105.
Catalogue: "Verzeichnis der
Radierungen Oskar Stössels." [*MGvK.*]
1922, pp. 80–83.
 Entries: 61 (etchings only, to 1921).
 Millimeters. Inscriptions. States. De-
 scribed. Illustrated (selection). Lo-
 cated (selection).

Binder, Bruno. "Der Malerradierer
Oskar Stössel und sein graphisches
Werk." [*Kh.*] 17 (1925): 432–434.
 Entries: unnumbered, pp. 432–434.
 Millimeters (selection).

Stözel, Christian Ernst *(1792–1837)*
[Ap.] pp. 412–413.
 Entries: 7.*

Stözel, Christian Friedrich *(1751–1816)*
[Ap.] p. 413.
 Entries: 10.*

Stoff, Dirck
See **Stoop**

Stojanović, Bratislav *(20th cent.)*
 Stojanović, Bratislav. *Linorezi 1936–1946.*
 Belgrade (Yugoslavia): Beogradski
 Grafički Zavod, n.d.
 Entries: 130. Described. Illustrated.

Stolker, Jan *(1724–1785)*
 [W.] II, p. 665.
 Entries: 25.*

Stolker, P. *(18th cent.)*
 [W.] II, p. 665.
 Entries: 1 print after.*

Stolz, Franz *(d. after 1845)*
 [Dus.] p. 259.
 Entries: 1. Inscriptions.

Stone, H. and J. *(fl. c.1826)*
 [F.] p. 259.*

Stone, Henry *(fl. c.1826)*
 [St.] p. 502.*

 Wright, Edith A., and McDevitt,
 Josephine A. "Henry Stone, lithog-
 rapher." *Antiques* 34 (July 1938): 16–19.
 Entries: unnumbered, p. 19. Illus-
 trated (selection). Located.

Stone, William J. *(fl. c.1822)*
 [St.] pp. 502–503.*

 [F.] pp. 258–259.*

Stoop, Dirck *(c.1618–after 1681?)*
 [B.] IV, pp. 91–101.
 Entries: 19. Pre-metric. Inscriptions.
 States. Described.

 [Weigel] pp. 157–167.
 Entries: 35 (additional to [B.]). Pre-
 metric. Inscriptions. Described (selec-
 tion).

 [Wess.] II, pp. 255–256.
 Additional information to [B.] and
 [Weigel].

 [Dut.] VI, pp. 311–331, 675.
 Entries: 55. Millimeters. Inscriptions.
 States. Described. Appendix with 7
 doubtful prints.

 [W.] II, p. 666.
 Entries: 57+.*

Stop [Louis Pierre Gabriel Bernard
Morel-Retz] *(1825–1899)*
 [Ber.] XII, pp. 60–61.*

Stopendael [**Stoopendaal**], Daniel
(d. before 1740)
 [W.] II, p. 667.
 Entries: 6+.*

Stopendael [**Stoopendael**], Bastiaen
(1636/37–before 1707)
 [W.] II, p. 667.
 Entries: 9+.*

Storck, Abraham *(c.1635–c.1710)*
 [B.] IV, pp. 387–393.
 Entries: 6. Pre-metric. Inscriptions.
 Described.

 [Weigel] pp. 223–224.
 Additional information to [B.].

 [W.] II, p. 667.
 Entries: 6 prints by, 2 after.*

Storm van 's-Gravesande, Carel Nicolaas
[Charles] *(1841–1924)*
 [H. L.] pp. 383–413.
 Entries: 82 (to 1877?). Millimeters. In-
 scriptions. States. Described.

 Frederick Keppel and Co. *Catalogue of the
 complete etched work of C. Storm van
 's-Gravesande of Brussels.* New York:
 Frederick Keppel and Co., 1884.
 Entries: 188 (etchings and drypoints
 only, to 1884?).

 Rice, R. A. *Catalogue of etchings and dry-
 points by Charles Storm van 's-Gravesande.*

Storm van 's-Gravesande, Carel Nicolaas (*continued*)

Boston (Mass.): A. Mudge and Son, 1887.
> Entries: 240 (etchings and drypoints only, to 1887?).

[Ber.] VII, pp. 223–228.*

Frederick Keppel and Co. *Catalogue of an exhibition of drawings and water colors by Storm van 's-Gravesande together with his etchings executed since 1884.* New York: Frederick Keppel and Co., 1889.
> Entries: 94 (etchings and drypoints only, additional to Keppel and Co. 1884; to 1889?).

Storm van 's Gravesande, Charles. "Catalogue des eaux-fortes et lithographies de Ch. Storm van 's-Gravesande." Ms. copy of the artist's own catalogue 1903, with additions supplied by the artist, to 1919. (NN)
> Entries: 523 etchings and drypoints, 94 lithographs, 26 monotypes (to 1919). Titles only, with occasional notes by the artist.

Storm van 's-Gravesande, Charles. Ms. catalogue. (EA)
> Entries: 523 etchings and drypoints, 97 lithographs, 30 monotypes. Illustrated with a few small sketches.

Storz, Martin (*b. 1816*)
> [Ap.] p. 414.
> Entries: 4.*

Stoss, Veit I (*c.1450–1533*)
> [B.] VI, pp. 66–68.
> Entries: 3. Pre-metric. Inscriptions. Described.

> [Evans] p. 38.
> Entries: 1 (additional to [B.]). Millimeters. Described.

> [P.] II, pp. 152–154.
> Entries: 9 (additional to [B.]). Pre-metric. Inscriptions. Described. Located.

Baumeister, Engelbert. *Veit-Stoss; Nachbildungen seiner Kupferstiche.* Graphische Gesellschaft, 17. Berlin: Bruno Cassirer, 1913.
> Entries: 10. Millimeters. Inscriptions. States. Described. Illustrated. Located. Watermarks described.

[Lehrs] VIII, pp. 243–270.
> Entries: 10. Millimeters. Inscriptions. States. Described. Illustrated (selection). Located. Locations of all known impressions are given. Copies mentioned. Watermarks described. Bibliography for each entry.

Sawicka, Stanislawa. *Ryciny Wita Stwosza.* Warsaw: Wydawnictwo "sztuka," 1957.
> Entries: 10. Millimeters. States. Described. Illustrated. Locations of all known impressions are given.

Stout, Jas. D. (*fl. c.1819*)
> [F.] p. 259.*

Stoutenburgh, Emily Maverick
> *See* **Maverick** family

Strack, [Anton] Wilhelm (*1758–1829*)
> [Dus.] p. 259.
> Entries: 1 (lithographs only, to 1821). Paper fold measure.

Strada, Vespasiano (*c.1582–1622*)
> [B.] XVII, pp. 302–312.
> Entries: 21. Pre-metric. Inscriptions. States. Described.

Stradanus, Johannes
> *See* **Straet,** Jan van der

Straet, Jan van der (*1523–1605*)
> [W.] II, pp. 668–669.
> Entries: 4 prints by, prints after unnumbered, p. 669.*

Stramayr, Hans
> *See* **Strohmayer**

Strang, William *(1859–1921)*
[Ber.] XII, p.61.*

William Strang; catalogue of his etched work. Introduction by Lawrence Binyon. Glasgow (Scotland): James Maclehouse and Sons, 1906. 2d ed., expanded, 1912.
　　Entries: 471 (etchings and engravings only, to 1904). Inches. Illustrated. Second edition has 545 entries, to 1912.

Strang, David. *William Strang; supplement to the "Catalogue of his etched work 1882–1912."* Glasgow (Scotland): Maclehouse, Jackson and Co., 1923. 300 copies. (DLC)
　　Entries: 202 (etchings and engravings only; additional to 1912 catalogue). Inches. Illustrated (except last 23 prints).

Dodgson, Campbell. "The lithographs of William Strang." [PCQ.] 29, no. 3 (1948): 42–56.
　　Entries: 24 lithographs, 2 experimental prints. Inches. Inscriptions. Described. Illustrated (selection). Information about publication of the prints.

Strang, David. *William Strang; catalogue of his etchings and engravings.* Glasgow (Scotland): University of Glasgow, 1962. (MBMu)
　　Entries: 751 (etchings and engravings only). Subjects of the prints are not described, but states are carefully distinguished.

Strange, Robert *(1721–1792)*
Le Blanc, ———. *Catalogue de l'oeuvre de Robert Strange, graveur.* Le graveur en taille douce, 2. Leipzig: Rudolphe Weigel, 1848.
　　Entries: 62. Millimeters. Inscriptions. States. Described.

Dennistoun, James. *Memoirs of Sir Robert Strange, Knt., engraver . . . and of his*

brother-in-law Andrew Lumisden. 2 vols. London: Longman, Brown, Green, and Longmans, 1855.
　　Entries: 97 (list of titles in Appendix I, with page references to where they are discussed in the text).

L———, S. "La vie et les ouvrages de Robert Strange. [RUA.] 20 (1865): 203–210.
　　Entries: unnumbered, pp. 206–208.

[Ap.] pp. 414–419.
　　Entries: 50.*

[Sm.] III, p. 1350.
　　Entries: 1 (portraits only). Inches. Inscriptions. Described.

Strange, William *(18th cent.)*
[Sm.] III, pp. 1350–1351.
　　Entries: 1 (portraits only). Inches. Inscriptions. Described.

Straten, Henri van *(1892–1944)*
Provinciaal Begijnhof, Hasselt (Provincie Limburg, Culturele Dienst). *Het grafisch werk van Henri van Straten, bevattend houtsneden, suites, blokboeken, boekillustraties en lithografieën.* Hasselt (Belgium), 1968.
　　Entries: 137 woodcuts (single prints only), 242 lithographs. Millimeters. Illustrated (woodcuts only). Also, bibliography of sets of prints and books with illustrations by; list of 242 lithographs.

Dewanckel, Gilberte. *Henri van Straten, graveur sur bois.* Thesis, Catholic University of Louvain. Louvain (Belgium), 1972. (EBr)
　　Entries: 420+ (woodcuts only). Millimeters. Inscriptions. Described. Located. Also, bibliography of books with illustrations by.

Strauch, Georg *(1613–1675)*
[A.] V, pp. 140–162.

Strauch, Georg (*continued*)

Entries: 33. Pre-metric. Inscriptions. States. Described.

Strauch, Lorenz *(1554–1630?)*
[B.] IX, pp. 599–600.
Entries: 1. Pre-metric. Inscriptions. Described.

[Heller] pp. 117–120.
Entries: 10 (additional to [B.]). Pre-metric. Inscriptions. States. Described.

[P.] IV, pp. 217–221.
Entries: 22 (additional to [B.]). Pre-metric (selection). Paper fold measure (selection). Inscriptions. States. Described. Located (selection). Additional information to [B.].

[A.] I, pp. 47–61.
Entries: 23. Pre-metric. Inscriptions. States. Described.

Strauch, Stephan *(1645–1677)*
[A.] V, pp. 247–254.
Entries: p. Pre-metric. Inscriptions. States. Described.

Straucher [Maria] Anna *(b. 1805)*
[Dus.] pp. 259–260.
Entries: 2 (lithographs only, to 1821).

Stretti, Viktor *(1878–1957)*
Karásek, Jaroslav G. *Viktor Stretti, popisný seznam grafického díla.* Edice katalogy o díle, 2. Prague: Státní nakladatelství krásné literatury, hudby a umění, 1956. (DLC)
Entries: 223 (to 1955). Millimeters. Inscriptions. Described. Illustrated (selection).

Strickland, William *(1787–1854)*
[St.] pp. 503–508.*

[F.] pp. 260–261.*

Stridbeck, Johann I *(1641–1716)* and Johann II *(1665–1714)*
Biller, J. H. *Leben und Werk der Kupferstecher Johann Stridbeck Vater und Sohn.* Munich, 1966.
Entries: unnumbered, pp. 43–51 (prints by and published by). Inscriptions.

Strij, Abraham I van *(1753–1826)*
[W.] II, p. 671.
Entries: 2.*

Stringa, Francesco *(1635–1709)*
[B.] XIX, pp. 313–316.
Entries: 3. Pre-metric. Inscriptions. Described.

Strixner, [Johann] Nepomuk *(1782–1855)*
[Dus.] pp. 260–268.
Entries: 29+ (lithographs only, to 1821). Millimeters (selection). Inscriptions. Located (selection).

Strohmayer, Hans *(fl. 1583–1610)*
[B.] IX, pp. 582–584.
Entries: 4. Pre-metric. Inscriptions. Described.

[P.] IV, p. 241.
Entries: 3 (additional to [B.]). Pre-metric. Inscriptions. Described. Located (selection).

Stroobant, François *(1819–1916)*
[H. L.] pp. 1044–1045.
Entries: 3. Millimeters. Inscriptions. Described.

Struck, Hermann *(1876–1944)*
Fortlage, Arnold, and Schwarz, Karl. *Das graphische Werk von Hermann Struck.* Berlin: Paul Cassirer, 1911.
Entries: 246 etchings, 18 bookplates, 17 lithographs (to 1911). Millimeters. Inscriptions. States. Described. Illustrated (selection). Ms. addition (NN);

6 additional etchings, 4 additional bookplates.

Strumff, Johann Heinrich *(fl. c.1748)*
[W.] II, p. 671.
Entries: 1 print after.*

Strutt, Joseph *(1749–1802)*
[Sm.] III, pp. 1351–1352.
Entries: 1 (portraits only). Inches. Inscriptions. Described.

[Ru.] p. 321.
Additional information to [Sm.].

Stubbs, George *(1724–1806)*
[Siltzer] pp. 257–273.
Entries: unnumbered, pp. 269–273, prints by and after. Inches (selection). Inscriptions. States.

Taylor, Basil. *The prints of George Stubbs.* London: Paul Mellon Foundation for British Art, 1969.
Entries: 19 prints by, 2 doubtful prints (single prints only). Millimeters. Inches. Inscriptions. States. Described. Illustrated. Located. Bibliography of books with illustrations by.

Stubbs, J. *(19th cent.)*
[Ap.] p. 419.
Entries: 1.*

Stuber, Wolfgang
See **Monogram WS** [Nagler, *Mon.*] V, no. 1899

Stuerhelt, F. *(d. 1652)*
[W.] II, p. 672.
Entries: 12+.*

Stuhlmann, Heinrich *(1803–1886)*
[A. 1800] III, pp. 60–69.
Entries: 26. Pre-metric. Inscriptions. Described.

Stuntz, Johann Baptist *(1753–1836)*
[Dus.] pp. 268–270.
Entries: 12+ (lithographs only, to 1821). Millimeters (selection). Inscriptions. States. Located (selection).

Stuosz, Veit I
See **Stoss**

Stuppi, G. *(19th cent.)*
[Ap.] p. 419.
Entries: 1.*

Sturdevant, S. *(fl. c.1822)*
[F.] p. 261.*

Sturhold, F.
See **Stuerhelt**

Sturk, Abraham
See **Storck**

Stuyvaert, Victor *(b. 1897)*
Roose, Alexis C. *Victor Stuyvaert.* Bruges (Belgium): Editions A. C. Stainforth, 1951. (NN). Dutch ed. Amsterdam and Antwerp (Belgium): Wereld-Bibliotheck, Vereeniging der Ex-Libris Kring [1951?]. (MH)
Entries: unnumbered, pp. 57–62 (bookplates only, to 1951?). Also, bibliography of books with illustrations by.

Stuyvenburgh, Bartholomaeus *(fl. c.1667)*
[W.] II, p. 672.
Entries: 1 print after.*

Suavius, Lambert *(1515/20?–after 1568)*
[P.] III, pp. 109–115.
Entries: 55. Pre-metric (selection). Paper fold measure (selection). Inscriptions (selection). States. Described (selection).

Renier, J. S. *Catalogue de l'oeuvre de Lambert Suavius, graveur liégeois.* Extract from

Suavius, Lambert (*continued*)

Bulletin archéologique liégeois 13 (1877): 245–326. Liège (Belgium): H. Vaillant-Carmanne, 1878.
Entries: 121. Millimeters. Inscriptions. Described. Located. Ms. notes by J. C. J. Bierens de Haan (ERB); additional states.

[W.] II, pp. 673–674.
Entries: 55+.*

Vecqueray, Albert. "Les gravures de Lambert Suavius du Cabinet des estampes de la Bibliothèque de l'université de Liège." *Chronique archéologique du pays de Liège* 39 (1948): 25–32.
Entries: 2 (additional to Renier). Millimeters. Inscriptions (selection). States. Described (selection). Illustrated (selection). Located. Additional information to Renier.

Subercaze, Léon (*fl. c.1848*)
[Ber.] XII, p. 61.*

Subleyras, Pierre (*1699–1749*)
[RD.] II, pp. 255–259; XI, pp. 308–309.
Entries: 4. Pre-metric. Inscriptions. Described.

Arnaud, Odette. "Subleyras." In [Dim.] II, pp. 49–92.
Entries: 9 prints by, 1 after a lost work. Millimeters (selection). Paper fold measure (selection). Inscriptions (selection). States.

Suchtris, Friedrich
See **Sustris**

Suchuduller, Samuel (*fl. c.1609*)
[A.] IV, pp. 234–236.
Entries: 7. Pre-metric. Inscriptions. Described.

Sudre, [Jean] Pierre (*1783–1866*)
[Ber.] XII, pp. 62–64.*

Sürlin, Jörg II
See **Syrlin**

Suerz, Michiel
See **Sweerts**

Suess von Kulmbach, Hans
See **Kulmbach**

Sugai, Kumi (*b. 1919*)
Kumi Sugai. Hannover (West Germany): Kestner-Gesellschaft, 1963.
Entries: 45 (to 1963). Millimeters.

Suhrlandt, Rudolph Friedrich Carl (*1781–1862*)
[Dus.] p. 270.
Entries: 1 (lithographs only, to 1821). Millimeters. Inscriptions. Located.

Sulpis, Émile Jean (*b. 1856*)
[Ber.] XII, p. 65.*

Sulpis, Jean Joseph (*1826–1911*)
[Ber.] XII, pp. 64–65.*

Summer, Andreas (*fl. 1567–1569*)
[B.] IX, pp. 515–516.
Entries: 4. Pre-metric. Inscriptions. Described.

[Heller] p. 132.
Additional information to [B.].

[P.] IV, pp. 191–192.
Entries: 2 (additional to [B.]). Pre-metric. Inscriptions. Described.

[A.] II, pp. 25–31.
Entries: 10. Pre-metric. Inscriptions. Described.

Summerfield, John (*d. 1817*)
[Ap.] p. 419.
Entries: 2.*

Summers, Carol (*b. 1925*)
Associated American Artists, New York. *Carol Summers.* New York, 1962.

Entries: 108 (to 1972). Inches. Illustrated (selection).

Sundström, Harriet *(b. 1872)*
Bergquist, Eric. "Harriet Sundström, 1872–1961, en svensk grafiker och exlibris-konstnär." [*N. ExT.*] 13 (1961): 116–120.
Entries: unnumbered, pp. 116–119 (bookplates only). Described (selection). Illustrated (selection).

Suppini, P. *(19th cent.)*
[Ap.] p. 420.
Entries: 1.*

Surbek, Victor *(b. 1885)*
Kunstmuseum, Bern [F. Schmalenbach, compiler]. *Victor Surbeck; das druckgraphische Werk 1905–1946, neuere Zeichnungen, Aquarelle und Tuschblätter.* Bern, 1947.
Entries: 334 (to 1946). Millimeters. States. Described (selection).

Kunstmuseum, Bern. *Victor Surbek; Das druckgraphische Werk 1947–1964.* Bern, 1964.
Entries: 241 (additional to Kunstmuseum, Bern 1947). Millimeters. States. Described. Located.

Susemihl, Johann Conrad *(b. 1767)*
[Dus.] pp. 270–271.
Entries: 5+ (lithographs only, to 1821). Millimeters (selection). Inscriptions. Located (selection).

Susenbeth, Johann *(fl. c.1816)*
[Dus.] p. 271.
Entries: 3 (lithographs only, to 1821). Millimeters. Inscriptions. Located.

Susterman, Justus
See **Suttermans**

Sustris, Friedrich *(c.1540–1599)*
[A.] IV, pp. 343–344.

Entries: 1. Pre-metric. Inscriptions. Described.

[W.] II, pp. 676–677.
Entries: 1 print by, 11+ after.*

[ThB.] XXXII, pp. 306–314.
Entries: unnumbered, pp. 312–313, prints by and after.

Suter, Wilhelm *(1806–1882)*
[Ap.] p. 420.
Entries: 3.*

Sutherland, Graham *(b. 1903)*
Walker, R. A. "A chronological list of the etchings and drypoints of Graham Sutherland and Paul Drury." Supplement to Ogg, David. "The etchings of Graham Sutherland and Paul Drury." [*PCQ.*] 16 (1929): 75–100.
Entries: 29 (to 1928). Inches. States. Illustrated (selection).

Man, Felix H. *Graham Sutherland; das graphische Werk 1922–1970.* Munich: Verlag Galerie Wolfgang Ketterer, 1970. 700 copies. (NN)
Entries: 102 (to 1970). Millimeters. Inscriptions. States. Described. Illustrated. Text in English, French and German.

Sutherland, Thomas *(b. c.1785)*
[Ber.] XII, p.65.*

[Siltzer] pp. 366–367.
Entries: unnumbered, pp. 366–367. Inscriptions.

Sutter, [Jean] David *(1811–1880)*
[Ber.] XII, p. 65.*

Suttermans, Justus *(1597–1681)*
[W.] II, pp. 675–676.
Entries: 10+ prints after.*

Suyderhoef, Jonas *(c.1613–1686)*
"Portraitten door Jonas Suiderhoef gesneden met de Prÿsen en de Prenten

Suyderhoef, Jonas (*continued*)

tusschenbeide van onderen." Unpublished ms., 18th cent. (ERB)
> Entries: unnumbered, 52 pp. (portraits only). Lists sale prices from 1746 to 1753.

Wussin, Johann. "Jonas Suyderhoef, Verzeichniss seiner Kupferstiche." [*N. Arch.*] 7 (1861): 1–85. Separately published. Leipzig: Rudolph Weigel, 1861. French ed. (translated by Henri Hymans). "Le catalogue de l'oeuvre de Jonas Suyderhoef." [*RUA.*] 16 (1862): 5–21, 143–175, 215–241. Separately published. *Jonas Suyderhoef; son oeuvre gravé, classé et décrit, traduit de l'allemand, annoté et augmenté.* Brussels: Labroue et Mertens, 1862.
> Entries: 130. Pre-metric. Inscriptions. States. Described. Ms. notes by J. C. J. Bierens de Haan (ERB); additional states, 1 additional entry. Ms. notes (EA); additional states.

[Wess.] II, p. 256.
> Entries: 1 (additional to Wussin). Millimeters. Inscriptions. Described. Additional information to Wussin.

[Dut.] VI, pp. 369–418.
> Entries: 131. Millimeters. Inscriptions. States. Described. Appendix with 3 doubtful prints.

[W.] II, pp. 677–679.
> Entries: 130.*

Suythof, Cornelis (*b. c.1646*)
[W.] II, pp. 679–680.
> Entries: 1 print after.*

Švabinský, Max (*b. 1873*)
Palkovský, Napsal B. *Max Švabinský; Popisný seznam grafického díla 1897–1923.* Prague: Vydalo-sdruženi českých umělků graficů Hollar, 1923. 300 copies. (NN)

Entries: 205 (to 1923). Millimeters. Inscriptions. States. Described. Illustrated (selection).

Matějček, Zpracoval A. *Max Švabinsky; popisý seznam grafického díla 1923–1933.* Prague: Vydalo-sdruženi českých umělků graficů Hollar, 1933. 300 copies. (NN)
> Entries: 151 (additional to Palkovský, to 1933). Millimeters. Inscriptions. States. Described. Illustrated (selection).

[Third volume of catalogue; not seen. Prague, 1943?].
> Entries: 100 (additional to previous catalogues, to 1942?).

Loris, Jan. *Max Švabinsky; Popisný seznam grafického díla 1942–1952.* Prague: Vydalo Sdruženi českých umělků graficů Hollar, 1953. (EWA)
> Entries: 158 (additional to previous catalogues; to 1952). Millimeters. Inscriptions. Described. Illustrated (selection). Also, list of prints in earlier catalogues; titles and dimensions only.

Svanberg, Max Walter (*b. 1912*)
Holten, Ragnar von. Catalogue. In *Max Walter Svanberg, grafik/graphique.* Malmö (Sweden): Lilla antikvariatet, 1967. (NN)
> Entries: 48 (to 1967). Millimeters. Described. Illustrated. Text in Swedish and French.

Svolinský, Karel (*b. 1896*)
Thiele, Vladimir. *Karel Svolinsky a kniha.* Soupisy a katalogy Památníku národního pisemnictví, sv. 1. Prague: Památník národního písemnictwí, 1967. (DLC)
> Bibliography of books with illustrations by; list of other graphic work (bookplates, etc.). To 1967.

Swan, W. (*17th cent.*)
[W.] II, p. 680.
> Entries: 2.*

Sweerts, Michiel (*continued*)

[Wess.] II, p. 258.
 Entries: 1 (additional to [B.] and
 [Weigel]). Millimeters. Inscriptions.
 Described. Additional information to
 [B.] and [Weigel].

[W.] II, pp. 684–685.
 Entries: 19+ prints by, 3 after.*

Sweinen, Evert van (*fl. 1686–1710*)
[W.] II, p. 685.
 Entries: 4.*

Swelinck, Jan Gerritsz (*b. c.1601*)
[W.] II, p. 685.
 Entries: 10+.*

Swidde, Willem (*1660/61–1697*)
[W.] II, pp. 685–686.
 Entries: 8+.*

Swinderen, B. van (*fl. c.1695*)
[W.] II, p. 686.
 Entries: 1.*

Switzer, Christopher (*fl. 1593–1611*)
[Hind, *Engl.*] I, pp. 228–230.
 Entries: 3. Inches. Inscriptions. De-
 scribed. Illustrated (selection). Lo-
 cated.

Swynen, T. van (*fl. c.1698*)
[W.] II, p. 686.
 Entries: 1.*

Syl, B. van (*18th cent.*)
[W.] II, p. 686.
 Entries: 1.*

Syl, Gerard Pietersz van
 See **Zyl[I]**

Syl[e]velt, Anthony van
 See **Zylvelt**

Sylvius, Antonius (*fl. c.1525? See* [ThB.]
XXXII, p. 361)
 [Merlo] pp. 801–806.*

[W.] II, p. 622.
 Entries: 11+.*

Sympson, J. (*fl. c.1730*)
[Siltzer] pp. 367.
 Entries: unnumbered, p. 367. Inscrip-
 tions.

Sympson, Joseph II (*d. 1736*)
[Sm.] III, pp. 1352–1354.
 Entries: 4 (portraits only). Inches. In-
 scriptions. Described.

[Ru.] p. 322.
 Additional information to [Sm.]

Sypen, J. B. [Léon?] van der (*1817–1881*)
[H. L.] p. 1055.
 Entries: 1. Millimeters. Inscriptions.
 Described.

Syrlin, Jörg II (*b. c.1455*)
[Lehrs] VIII, pp. 271–275.
 Entries: 1. Millimeters. Inscriptions.
 Described. Illustrated. Located. Loca-
 tions of all known impressions are
 given. Copies mentioned. Water-
 marks described. Bibliography for
 each entry.

Szerdahelyi, Leonhard
 See **Zertahelli**

Szretter, Antoni Lech (*b. c.1830*)
[Ber.] XII, p. 68.*

T

Taiée, [Jean] Alfred *(b. 1820)*
[Ber.] XII, pp. 68–69.*

Tailland, Édouard *(b. 1819)*
[Ber.] XII, p. 69.*

Talin [Henri Meilhac] *(b. 1832)*
[Ber.] XII, p. 70.*

Talleur, John *(20th cent.)*
University of Kansas Museum of Art,
Lawrence. *John Talleur; recent work.* Law-
rence (Kans.), 1966.
Entries: 106 (to 1966). Inches. Illus-
trated (selection).

Tamagnon, Emeric de *(fl. 1859–1864)*
[Ber.] XII, p. 70.*

Tamarind Lithography Workshop, Inc.
Tamarind Lithography Workshop, Inc.
Tamarind Impressions: Documentation.
1960– (periodical).
Entries: in progress; list of all prints
published by; 3000+. Inches. Inscrip-
tions. States. Described (technical in-
formation on papers and printing, no
description of image).

Tamiwier, Charles *(fl. c.1855)*
[Ber.] XII, pp. 70–71.*

Tanguy, Eugène *(1830–1899)*
[Ber.] XII, p. 71.*

Tanjé, Pieter *(1706–1761)*
[W.] II, pp. 688–689.
Entries: 100+.*

Tanner, Benjamin *(1775–1848)*
[St.] pp. 508–517.*

[F.] pp. 261–266.*

Tanner, Vallance, Kearny and Co.
(fl. 1817–1819)
[F.] pp. 266–267.*

Tanttu, Erkki *(b. 1907)*
Puokka, Jaakko. *Erkki Tantun Exlibrista.*
Tuli (Finland): Kustannusosakeyhtiö,
1948. 800 copies. (NN)
Entries: unnumbered, p. 127 (book-
plates only, to 1948?). Illustrated
(selection).

Tàpies Puig, Antonio *(b. 1923)*
Kunstmuseum, St. Gallen [Dieter
Jähnig, compiler]. *Antoni Tàpies; das
gesamte graphische Werk.* St. Gallen
(Switzerland), 1967.
Entries: 47+ (to 1967?). Millimeters.
Illustrated (selection).

Tappert, Georg *(1880–1957)*
Galerie Nierendorf, Berlin [Florian
Karsh, compiler]. *Georg Tappert; das
nachgelassene graphische Werk.* Berlin,
1963. (EBKk)
Entries: 97 woodcuts, 91 etchings, 39
lithographs, 16 monotypes. Millime-
ters.

Altonaer Museum, Hamburg [Dorothy
von Hülsen, compiler]. *Graphik von
Georg Tappert, 1880–1957.* Hamburg,
1971.
Entries: 186 (incomplete, but contains
entries additional to Galerie Nieren-

Tappert, Georg (*continued*)

dorf, Berlin catalogue). Millimeters. Illustrated (selection).

Tarasevych, Oleksander Antonii
(1672–1720)
Sichyns'kyi, Volodymyr. *Oleksander Antonii Tarasevych 1672–1720.* Ukrainske Graverstvo, la gravure ukraïnien. Prague, 1934. (MH)
Entries: 109. Millimeters. Inscriptions. Illustrated (selection). Located.

Taraval, Jean Gustave *(1765–1784)*
[Baud.] II, pp. 317–318.
Entries: 1. Millimeters. Inscriptions. Described.

Tardieu, [Pierre] Alexandre *(1756–1844)*
Galichon, Émile. "Artistes contemporains; Pierre Alexandre Tardieu."
[*GBA.*] 1st ser. 14 (1863, no. 1): 215–222, 384.
Entries: 90. Millimeters.

[Ap.] pp. 420–421.
Entries: 25.*

[Ber.] XII, pp. 71–74.*

Tardieu, Ambroise *(1788–1841)*
[Ber.] XII, pp. 74–75.*

Tardieu, Jacques Nicolas *(1716–1791)*
[Merlo] pp. 873–874.*

Tassaert, Jean Joseph François *(1765–1835)*
[Ber.] XII, pp. 75–76.*

Tassaert, [Nicolas François] Octave
(1800–1874)
Prost, Bernard. *Octave Tassaert; notice sur sa vie et catalogue de son oeuvre.* Artistes modernes. Paris: L. Baschet, 1886. (EPBN)

Entries: 321 prints by and after. Inscriptions (selection). Illustrated (selection).

[Ber.] XII, pp. 76–82.*

Tassaert, Paul *(d. 1855)*
[Ber.] XII, p. 76.*

Tassaert, Philippe Joseph *(1732–1803)*
[Sm.] III, pp. 1353–1356.
Entries: 4+ (portraits only). Inches. Inscriptions. States. Described.

[W.] II, pp. 689–690.
Entries: 12.*

[Ru.] p. 322.
Additional information to [Sm.].

Tattegrain, Francis *(1852–1915)*
[Ber.] XII, p. 82.
Entries: 16. Paper fold measure (selection).

Patoux, Abel. *Francis Tattegrain, notice biographique.* Saint-Quentin (France): Imprimerie Générale, 1902. 100 copies. (EPBN)
Entries: 19. Illustrated (selection).

Tattersall, George *(fl. 1840–1850)*
[Siltzer] p. 333.
Entries: unnumbered, p. 333, prints after. Inscriptions.

Taulier, Johannes *(d. after 1642)*
[W.] II, p. 690.
Entries: 1.*

Taurel, André Benoît Barreau *(1794–1859)*
[Ap.] pp. 421–422.
Entries: 5.*

[Ber.] XII, pp. 82–83.*

Taurel, Charles Édouard *(1824–1892)*
[H. L.] pp. 1045–1046.
Entries: 2. Millimeters. Inscriptions. Described.

[Ap.] p. 422.
Entries: 4.*

[Ber.] XII, pp. 83–84.*

Tavenraat, Johannes *(1809–1881)*
[H. L.] p. 1048.
Entries: 1. Millimeters. Inscriptions.
Described.

Taverne, Pierre Gustave *(b. 1861)*
[Ber.] XII, p. 84.*

Tavernier, Ernest Louis *(fl. 1861–1877)*
[Ber.] XII, p. 86.*

Tavernier, Joseph *(d. 1859)*
[H. L.] pp. 1046–1047.
Entries: 1. Millimeters. Inscriptions.
Described.

Tavernier, Melchior *(1564?–1641)*
[W.] II, p. 690.
Entries: 11+.*

Tavernier, Pierre Joseph *(b. 1787)*
[Ap.] p. 422.
Entries: 6.*

[Ber.] XII, pp. 84–85.*

Taylor, Isaac I *(1730–1807)*
Hammelman, H. A. "Eighteenth century English illustrators; Isaac Taylor the elder." *The Book Collector* I (1952): 14–27. Bibliography of books with illustrations by.

Taylor, Isaac *(1740–1818)*
[Ap.] p. 423.
Entries: 3.*

Taylor, Isidor Justin Séverin, baron *(1789–1879)*
[Ber.] XII, pp. 86–102.*

Taylor, John *(1739–1838)*
[Sm.] III, pp. 1356–1357.

Entries: 2 (portraits only). Inches. Inscriptions. States. Described.

[Ru.] p. 322.
Additional information to [Sm.].

Taylor, Samuel *(fl. c.1736)*
[Sm.] III, pp. 1357–1359.
Entries: 5 (portraits only). Inches. Inscriptions. States. Described. Located (selection).

[Ru.] p. 322.
Entries: 2 (portraits only, additional to [Sm.]). Inches (selection). Inscriptions (selection). Described (selection).

Taylor, W. James *(19th cent.)*
[Ap.] p. 423.
Entries: 1.*

Taylor, William Deane *(1794–1857)*
[Ap.] p. 423.
Entries: 3.*

Teckinger, Hieronymus
See **Deckinger**

Tedeschi, Giovanni *(d. 1725)*
[B.] XXI, pp. 297–298.
Entries: 1. Pre-metric. Inscriptions.
Described.

Teerlink, Abraham [Alexander] *(1776–1857)*
[W.] II, p. 691.
Entries: 1 print after.*

Teichel, Albert *(1822–1873)*
[Ap.] pp. 423–424.
Entries: 22.*

Teissier, Jean George *(1750–1821)*
[W.] II, p. 691.
Entries: 1 print after.*

Tellier, ——— *(fl. 1830–1840)*
[Ber.] XII, p. 102.*

Telman von Wesel *(fl. 1490–1510)*
See also **Monogram TW** [Nagler, *Mon.*]
V, no. 909

[B.] VI, p. 311.
Entries: 1. Pre-metric. Inscriptions.
Described.

[P.] II, pp. 203–205.
Entries: 7+ (additional to [B.]). Pre-
metric. Inscriptions. Described. Lo-
cated. Additional information to [B.].

Tempest, Pierce *(d. 1717)*
[Sm.] III, pp. 1359–1362, and "additions
and corrections" section; IV, "additions
and corrections" section.
Entries: 16 (portraits only). Inches. In-
scriptions. States. Described. Illus-
trated (selection). Located (selection).

[Ru.] pp. 323, 498.
Entries: 2 (portraits only, additional to
[Sm.]). Inches. Inscriptions. De-
scribed. Additional information to
[Sm.].

Tempesta, Antonio *(1555–1630)*
[B.] XVII, pp. 125–188.
Entries: 1461. Pre-metric. Inscriptions
(selection). States. Described (selec-
tion).

Tempinszky, István *(20th cent.)*
Semsey, Dr. Andreoe, and Rödel,
Klaus. *István Tempinszky, en ungarsk kob-
berstikker og hans exlibris.* Frederikshavn
(Denmark): Exlibristen, 1969. 55 copies.
(DLC).
Entries: 100 (to 1969). Millimeters. Il-
lustrated (selection).

Teniers, David I *(1582–1649)*
Houssaye, Arsène. "David Teniers."
[*Cab. am. ant.*] 2 (1843): 481–515.
Entries: 15. Millimeters. Inscriptions.
Described.

[W.] II, pp. 692–693.
Entries: 6+ prints after.*

Teniers, David II *(1610–1690)*
Houssaye, Arsène. "David Teniers."
[*Cab. am. ant.*] 2 (1843): 481–515.
Entries: 1.

[Dut.] VI, pp. 419–431.
Entries: 56 (1 print is accepted by
[Dut.]; all others are considered
doubtful or rejected). Millimeters. In-
scriptions. States. Described.

[W.] II, pp. 693–698.
Entries: 34+.*

Terborch, Gerard II *(1617–1681)*
[W.] II, pp. 698–702.
Entries: 45+ prints after.*

Gudlaugsson, Sturla J. *Geraert ter Borch.*
2 vols. The Hague: Martinus Nijhoff,
1959–1960.
Catalogue of paintings; prints after
are mentioned where extant.

Terbrugghen, Hendrik *(d. 1629)*
[W.] II, p. 703.
Entries: 4 prints after.*

Nicolson, Benedict. *Hendrick Terbrug-
ghen.* London: Lund Humphries, 1958.
Catalogue of paintings: prints after
are mentioned where extant.

Terry, ——— *(19th cent.)*
[Ber.] XII, p. 103.*

Terry, Garnet *(fl. 1779–1796)* **and Batley,**
——— *(fl. c.1770)*
[Sm.] III, p. 1362.
Entries: 1 (portraits only). Inches. In-
scriptions. Described.

[Ru.] p. 323.
Additional information to [Sm.].

Terry, William D. *(fl. c.1836)*
[Allen] p. 152.*

Terwesten, Augustin I *(1649–1711)*
[Wess.] II, pp. 258–259.

Entries: 4 (additional to [Andresen, *Handbuch*]). Millimeters. Inscriptions. States. Described.

[W.] II, p. 704.
 Entries: 10.*

Terwesten, Elias *(1651–1724/29)*
[W.] II, p. 704.
 Entries: 2.*

Terwoort, Leonard *(fl. c.1575)*
[Hind, *Engl.*] I, p. 98.
 Entries: 2 (prints done in England only). Inches. Inscriptions. Described. Located.

Terzio, Francesco *(1523?–1591)*
[A.] II, pp. 224–238.
 Entries: 2 etchings, 1 set of 150 woodcuts. Pre-metric. Inscriptions. States. Described.

Teschner, Richard *(b. 1879)*
Christian M. Nebahay, Vienna. *Liste 86; der künstlerische Nachlass von Richard Teschner (Karlsbad 1884–Wien 1948) mit einem Versuch zur Aufstellung eines Oeuvre Kataloges seiner Graphik.* Vienna: Christian M. Nebahay, 1964.
 Entries: 190. Millimeters. Described (selection). Different impressions of the same print are separately numbered.

Tessier, Jean George
 See **Teissier**

Tessier, Pierre Léon *(fl. 1856–1881)*
[Ber.] XII, p. 103.*

Testa, Angelo *(b. 1775)*
[Ap.] pp. 424–425.
 Entries: 9.*

Testa, Pietro *(1611–1650)*
[B.] XX, pp. 213–229.

Entries: 39 prints by, 1 rejected print. Pre-metric. Inscriptions. States. Described. Copies mentioned.

Testard, François Martin *(fl. 1808–1815)*
[Ber.] XII, p. 103.*

Testard, Jacques Alphonse *(b. 1810)*
[Ber.] XII, pp. 103–104.*

Testas, Willem de Famars *(1834–1896)*
[H. L.] p. 1047.
 Entries: 2. Millimeters. Inscriptions. States. Described.

Testelin, Henri *(1616–1695)*
[RD.] III, pp. 103–107; XI, p. 309.
 Entries: 6. Pre-metric. Inscriptions. Described.

Testelin, Louis *(1615–1655)*
[RD.] III, pp. 100–102.
 Entries: 1. Pre-metric. Inscriptions. States. Described.

Testi, Davide *(d. 1882)*
[Ap.] p. 225.
 Entries: 3.*

Tetar van Elven, Pierre Henri Théodore *(1831–1908)*
[H. L.] p. 216.
 Entries: 1. Millimeters. Inscriptions. Described.

Tetrode, Willem Danielsz van *(16th cent.)*
[W.] II, pp. 705–706.
 Entries: 4 prints after.*

Teufel, Johann
 See **Lucius,** Jakob I

Teunissen, Cornelis
 See **Antoniszoon**

Tevini, Alessandro *(b. 1783)*
[Dus.] p. 271.

Tevini, Alessandro *(continued)*

Entries: 4 (lithographs only, to 1821). Millimeters (selection). Inscriptions (selection). Located (selection).

Texier, [André Louis] Victor *(1777–1864)*
[Ber.] XII, pp. 105–107.*

Teyler, Johan *(1648–after 1698/99)*
[W.] II, p. 706.
Entries: 3.*

Teylingen, Jan van *(d. 1654)*
[W.] II, p. 706.
Entries: 1 print after.*

Teyman, Caspar *(17th cent.)*
[Merlo] p. 875.*

Teyssonnières, Mathilde *(fl. c.1881)*
[Ber.] XII, p. 110.*

Teyssonnières, Pierre *(b. 1834)*
[Ber.] XII, pp. 107–110.*

Thackara, James *(1767–1848)*
[Allen] p. 152.*

[St.] pp. 517–518.*

[F.] pp. 267–268.*

Thackara and Vallance *(fl. 1790–1792)*
[St.] pp. 518–519.*

[F.] p. 269.*

Thaeter, Julius Caesar *(1804–1870)*
[Ap.] pp. 425–428.
Entries: 45.*

Jacoby, Annemarie. *J. C. Thaeter, ein Beitrag zum Reproduktionsstich des 19. Jahrhunderts.* Dissertation, University of Halle-Wittenberg. Halle (Germany): Carl Nieft, 1937. (NN)
Entries: 114. Millimeters. Inscriptions. States. Located.

Thelott, Karl Franz Joseph [Ernst?] *(1793–1830)*
[Dus.] pp. 271–272.
Entries: 2 (lithographs only, to 1821). Millimeters (selection). Paper fold measure (selection). Inscriptions (selection).

Thénot, Jean Pierre *(1803–1857)*
[Ber.] XII, pp. 110–111.*

Théodore, A. *(17th cent.)*
[B.] V, pp. 325–350.
See **Millet,** Jean François I [called "Francisque"]

[RD.] I, pp. 247–268; XI, p. 310.
Entries: 28. Pre-metric. Inscriptions. States. Described. Concordance with [B.].

Thérond, Émile *(b. 1821)*
[Ber.] XII, p. 111.*

Théry de Gricourt, Arnold Joseph [Adrien?] *(c.1627–1694)*
Preux, A. "Anciens artistes et amateurs douaisiens, 4e article; les Théry de Gricourt." *Souvenirs de la Flandre wallonne* 6 (1866): 69–80. Separately published. *Notice sur la famille douairienne Théry de Gricourt et sur ceux de ses membres qui ont cultivé les beaux-arts.* Douai (France): Lucien Crepin, 1866. 27 copies. (EPBN)
Entries: 27 (complete?). Inscriptions. Described. Located.

Thévenin, Charles *(1764–1838)*
[Baud.] II, pp. 313–314.
Entries: 1. Millimeters. Inscriptions. States. Described.

Thévenin, Jean Charles *(1819–1869)*
[Ap.] pp. 428–429.
Entries: 9.*

[Ber.] XII, pp. 111–112.*

Theymann, Caspar
See **Teyman,** Caspar

Theyssens, S. *(17th cent.)*
[Merlo] pp. 876–877.
Entries: unnumbered, pp. 876–877.
Paper fold measure (selection). In-
scriptions (selection). Described
(selection).

Thibault, Charles Eugène *(b. 1835)*
[Ap.] p. 429.
Entries: 1.*

[Ber.] XII, p. 112.*

Thibault, Louis Gustave *(fl. 1836–1842)*
[Ber.] XII, p. 112.*

Thibaut, Willem Willemsz
(c.1525–1597/99)
[W.] II, p. 707.
Entries: 1+.*

Thiebaud, Wayne *(b. 1920)*
Wayne Thiebaud; graphics 1964–1971.
New York: Parasol Press Ltd., 1971.
Entries: 54. Inches. Described. Illus-
trated.

Thiel, J. van *(fl. c.1690)*
[W.] II, p. 707.
Entries: 1.*

Thielley, Claude *(b. 1811)*
[Ber.] XII, p. 112.*

Thielt, Guillaume du
See **Tielt**

Thiem, Veit *(fl. 1565–1570)*
[A.] III, pp. 332–333.
Entries: 1. Pre-metric. Inscriptions.
Described.

Thiemann, Carl Theodor *(b. 1881)*
Thiemann-Stoedtner, Ottilie.
Kunstsammlungen der Stadt Dachau; Kata-

log nr. 1; Carl Thiemann (1881–1966).
Dachau (West Germany): Hans Zauner
jun., 1970.
Entries: 28 etchings, 6 lithographs, 130
monochrome woodcuts, 285 color
woodcuts. Millimeters. Illustrated.
Located.

Thieme, Ekkehard *(20th cent.)*
Kunsthalle Bremen [Ekkehard Thieme,
compiler]. *Ekkehard Thieme; Radierungen,
Holzdrucke von 1958 bis 1963.* Bremen
(West Germany), 1963.
Entries: 133 etchings, 17 woodcuts (to
1963). Millimeters. States.

Thienen, Cornelius van
See **Tienen**

Thiénon, [Anne] Claude *(1772–1846)*
[Ber.] XII, p. 113.*

Thienon, Louis Désiré *(b. 1812)*
[Ber.] XII, p. 113.*

Thiepers, Herman
See **Tipper**

Thier, Bernhard Heinrich [Barend
Hendrik] *(1751–1814)*
[W.] II, p. 708.
Entries: 7+.

Thierriat, Augustin Alexandre *(1789–1870)*
[Ber.] XII, pp. 113–114.*

Thierry, Étienne Jules *(b. 1787)*
[Ber.] XII, p. 114.*

Thierry, Joseph François Désiré
(1812–1866)
[Ber.] XII, p. 114.*

Thiéry, Claude Émile *(1828–1895)*
Bouland, Dr. L. "Claude-Émile Thiéry,
artiste lorrain, et les ex-libris executés
par lui." [*Arch. Ex.-lib.*] 11 (1904): 173–

Thiéry, Claude Émile (*continued*)

188. Separately published. Macon
(France), 1905.
　　Entries: unnumbered, pp. 175–188
　　(bookplates only). Millimeters. In-
　　scriptions. Described. Illustrated
　　(selection).

Thiéry de Gricourt, Arnold Joseph
[Adrien?]
　See **Théry de Gricourt**

Thill, Johann Carl von (*1624–1676*)
[A.] V, pp. 105–122.
　　Entries: 26. Pre-metric. Inscriptions.
　　States. Described.

Thiollet, François (*1782–1859*)
[Ber.] XII, p. 115.*

Thiriat, Henri (*fl. 1874–1882*)
[Ber.] XII, p. 115.*

Thirion, Charles Victor (*1833–1878*)
[Ber.] XII, p. 115.*

Thiry, Leonard (*d. c.1550*)
　See **Monogram LD** [Nagler, *Mon.*] IV,
　no. 1018

Tholen, Willem Bastiaan (*1860–1931*)
Plasschaert, Alb. "Etsen door W. B. Tho-
len." In *Studies en gegevens over schilder-
kunst.* Zeist (Netherlands): Meindert
Boogaerdt jun., 1908. (EA)
　　Entries: unnumbered, pp. 25–53 (to
　　1907). Millimeters. Inscriptions.
　　States. Described.

Bois, J. H. de. "W. B. Tholen's prent-
kunst, met een oeuvre-catalogus van het
grafisch werk." *J. H. de Bois' Bulletin,*
1941 A, pp. 1–4.
　　Entries: 72. Millimeters. Inscriptions.
　　Described.

Knuttel, Ir. G., Jr. *Het grafisch oeuvre van
W. B. Tholen.* The Hague: V/H Mouton
en Co., 1950.
　　Entries: 86. Millimeters. Inscriptions.
　　Described. Illustrated (selection).

Thoma, Hans (*1839–1924*)
Roeper, Adalbert. "Hans Thoma." [*Bb.*]
76 (1909): 11412–11415, 11484–11489.
　　Entries: 106 prints by, prints after un-
　　numbered, pp. 11414–11489 (to 1900?).
　　Millimeters. States.

Roeper, Adalbert. [*Kh.*] 3 (1911): 80.
　　Not seen.

Beringer, Josef A. *Hans Thoma, Griffel-
kunst.* Frankfurt am Main: F. A. C. Pre-
stel, 1916.
　　Entries: 1001 prints by and after.
　　Millimeters. Inscriptions. States. De-
　　scribed (only prints by are fully de-
　　scribed).

Tannenbaum, Herbert. *Hans Thomas
graphische Kunst.* Arnolds graphische
Bücher erste Folge, 2. Dresden: Ernst
Arnold, 1920.
　　Entries: 112 illustrations, with num-
　　bers from Beringer 1916.

Beringer, J. A. *Hans Thoma; Radierungen;
vollständiges Verzeichnis der radierten Plat-
ten und ihrer Zustände.* Munich: F.
Bruckmann A.-G., 1923.
　　Entries: 294 (etchings only). Millime-
　　ters. Inscriptions. States. Described.
　　Illustrated. Appendix with list of etch-
　　ings after.

B[eringer], J. A. *Hans Thoma zum
Gedächtnis; Ausstellung seines graphischen
Werkes.* n.p., [1924?]. (NN)
　　Entries: 595 (complete?).

Ammann, Edith. "Berichtigungen und
Ergänzungen zu J. A. Beringer; Hans
Thoma. Radierungen." *Oberrheinische
Kunst. Jahrbuch der Oberrheinischen Mu-
seen* 9 (1940): 196–213.

Extensive additional information to Beringer 1923. Illustrated (selection).

Böhm, Heinrich M. *Hans Thoma; sein Exlibris-Werk.* Berlin: Maximilian-Druck und Verlag, 1958.
Entries: 54 prints by and after (bookplates only). Described. Illustrated (selection).

Thomas, Antoine Jean-Baptiste *(1791–1834)*
[Ber.] XII, pp. 116–117.*

Thomas, Félix *(1815–1875)*
Girardot, ———, baron de. *Félix Thomas, grand prix de Rome; architecte, peintre, graveur, sculpteur.* Nantes (France): Veuve C. Mellinet, 1875. (EPBN)
Entries: unnumbered, pp. 22–23. States.

Thomas [van Ypern], Johannes *(1617–1678)*
[W.] II, pp. 709–710.
Entries: 22 prints by, 4 after.*

Thomas, N. *(c.1750–c.1812)*
[Ber.] XII, p. 115.*

[L. D.] p. 80.
Entries: 1. Illustrated. Incomplete catalogue.*

Thomas, Napoléon *(fl. 1831–1837)*
[Ber.] XII, pp. 117–118.*

Thomassen, F. J. *(fl. c.1849)*
[Merlo] p. 877.*

Thomassin, Philippe *(1561/62–1622)*
[CdB.] pp. 11–23.
Entries: 93+. Paper fold measure (selection).

Bruwaert, Edmond. "Recherches sur la vie et l'oeuvre du graveur troyen Philippe Thomassin." *Mémoires de la Société académique d'agriculture, des sciences, arts et belles-lettres du départment de l'Aube* 3d ser. 13 (1876): 35–167. Separately published. Troyes (France): Dufour Bouquot, 1876.
Entries: 382 prints by and published by. Millimeters. Inscriptions. States. Described. Appendix with prints not seen by Bruwaert.

Bruwaert, Edmond. "La vie et les oeuvres de Philippe Thomassin, graveur troyen 1562–1622." *Mémoires de la Société académique d'agriculture, des sciences, arts et belles-lettres du département de l'Aube* 3d ser. 51 (1914); 129–236. Separately published. Troyes (France): P. Nouel et J.-L. Paton, 1914; Paris: Société pour l'Étude de la Gravure Français, 1915. 500 copies. (MH)
Entries: 436 prints by and published by. Millimeters. Inscriptions. States. Located (selection). Prints arranged chronologically; cross references to Bruwaert 1876.

[Dis. 1927, 1929.]
Additional information to previous catalogues.

Thompson, Charles *(1791–1843)*
[Ber.] XII, pp. 118–121.*

Thompson, J. *(fl. c.1767)*
[Sm.] III, pp. 1363–1364.
Entries: 2 (portraits only). Inches. Inscriptions. States. Described.

Thompson, Jane *(fl. c.1800)*
[Sm.] III, pp. 1362–1363, and "additions and corrections" section.
Entries: 2 (portraits only). Inches. Inscriptions. Described.

[Ru.] p. 323.
Additional information to [Sm.].

Thompson, John *(1785–1866)*
[Ber.] XII, p. 118.*

Thomsen, Carl Christian Frederik Jakob *(1847–1912)*
Christiansen, Peter. *Carl Thomsen som il-lustrator.* Copenhagen: Gyldendalske Boghandel, Nordisk Forlag, 1939.
Bibliography of books with illustrations by.

Thomson, Clifton *(19th cent.)*
[Siltzer] p. 333.
Entries: unnumbered, p. 333, prints after. Inches (selection). Inscriptions.

Thomson, James *(1789–1850)*
[Ber.] XII, p. 121.*

Thon, Sixt Armin *(1817–1901)*
[A. 1800] IV, pp. 62–79.
Entries: 21. Millimeters. Inscriptions. States. Described. Also, list of 9 prints after (not fully catalogued).

Thopas, Johan *(c.1630–c.1700)*
[W.] II, p. 710.
Entries: 2 prints after.*

Thoren, [Karl Kasimir] Otto *(1828–1889)*
[H. L.] pp. 1048–1049.
Entries: 2. Millimeters. Inscriptions. Described.

Thorer, Bartholomäus
See **Monogram BT** [Nagler, *Mon.*] I, no. 2088

Thornley, [Georges] William *(b. 1857)*
[Ber.] XII, pp. 121–122.*

Thorn Prikker, Jan *(1868–1932)*
Polak, Bettina. *Het fin-de-siècle in de nederlandse schilderkunst.* The Hague: Martinus Nijhoff, 1955.
Entries: 54 (works in all media, including prints, 1889–1903). Millimeters.

Inscriptions. Described. Illustrated (selection).

Cladders, Johannes. Catalogue. In *Johan Thorn Prikker, Glasfenster, Wandbilder, Ornamente 1891–1932,* by Paul Wember. Krefeld (West Germany): Scherpe Verlag, 1966.
Entries: 6 (posters only). Millimeters. Inscriptions. Described. Illustrated (selection).

Thornton, William *(1759–1828)*
[St.] p. 519.*

Thouvenin, Jean [or Th.?] *(1765–after 1828)*
[Ap.] pp. 429–430.
Entries: 12.*

[Ber.] XII, p. 122.*

Thoven, Otto van
See **Thoren,** [Karl Kasimir] Otto

Throop, J. V. N. *(fl. c.1835)*
[St.] pp. 519–520.*

[F.] p. 270.*

Throop, O. H. *(fl. c.1825)*
[St.] p. 520.*

[F.] pp. 269–270.*

Thürmer, Joseph *(1789–1833)*
[Dus.] p. 272.
Entries: 9 (lithographs only, to 1821). Millimeters. Inscriptions. Located.

Thulden, Theodor van *(1606–1669)*
[W.] II, pp. 710–711.
Entries: 7+ prints by, 5+ after.*

Thurneysen, Joh. Jakob I *(1636–1711)* and Joh. Jakob II *(1668–1730)*
Rondot, Natalis. *Les Thurneysen, graveurs d'estampes lyonnais au XVIIe siècle.* Extract from *Revue du Lyonnais,*

1899. Lyons: Librairie Bernoux et Cumin, 1899.
Entries: 518 prints by and published by. Millimeters. Inscriptions. Described.

Thwenhusen, Helmich von
See **Twenhusen**

Thym, Veit
See **Thiem**

Thys, Pieter *(1624–1677)*
[W.] II, pp. 711–712.
Entries: 3 prints after.*

Tiarini, Alessandro *(1577–1668)*
[Vesme] p. 5.
Entries: 1. Millimeters. Inscriptions. Described.

Tibaldi, Domenico [Dominicus Tebaldus de Peregrinis] *(1541–1583)*
[B.] XVIII, pp. 10–17.
Entries: 9. Pre-metric. Inscriptions. States. Described.

[Wess.] III, p. 51.
Entries: 1 (additional to [B.]). Millimeters. Inscriptions. Described. Located. Additional information to [B.].

Tiberghien, Pierre Joseph Jacques *(1755–1810)*
Justice, Jean. *Le graveur P. J. J. Tiberghien; sa vie – son oeuvre.* Brussels: Imprimerie Polleunis et Ceuterick, 1905. (NN)
Entries: 69 (engraved medals by Tiberghien, from which impressions were taken). Inscriptions. Described.

Tichý, František *(b. 1896)*
Dvořák, František. *František Tichý, grafiké dílo.* Prague, 1961. (DLC)
Entries: 299 (to 1958). Millimeters. Inscriptions. States. Described. Illustrated.

Tiebout, Cornelius *(c.1777?–c.1830)*
[St.] pp. 520–533.*

[F.] pp. 271–284.*

Tieck, Ludwig [Carl Louis] *(1789–1823)*
[Dus.] pp. 272–273.
Entries: 2 (lithographs only, to 1821). Millimeters. Inscriptions. States. Located.

Tielemans, Seger *(17th cent.)*
[W.] II, p. 707.
Entries: 2.*

Tielmann, Cornelius *(fl. c.1617)*
[Merlo] p. 877.
Entries: 1. Paper fold measure. Inscriptions. Described.

Tielt, Guillaume *(fl. 1610–1630)*
Vandenpeereboom, Alphonse. *Guillaume du Tielt, graveur, notes sur sa vie et sur ses oeuvres.* Ypres (Belgium): Simon Lafonteyn, 1882. (EBr)
Entries: 45. Millimeters. Inscriptions. Described. Illustrated (selection).

[W.] II, p. 713.
Entries: 2.*

Tielt, Pierre du *(c.1610–1669)*
Vandenpeereboom, Alphonse. *Guillaume du Tielt, graveur, notes sur sa vie et sur ses oeuvres.* Ypres (Belgium): Simon Lafonteyn, 1882. (EBr)
Entries: 3. Millimeters. Inscriptions. Described. Illustrated (selection).

Tienen, Cornelius van *(d. 1678?)*
[W.] II, p. 713.
Entries: 5+.*

Tiepolo, Giovanni Battista *(1696–1770)*
Chennevières, Henry de. *Les Tiepolo.* Les artistes célèbres. Paris: Librairie de l'Art, 1897.

Tiepolo, Giovanni Battista (*continued*)

Entries: 6. Paper fold measure (selection).

[Vesme] pp. 376–395.
Entries: 34. Millimeters. Inscriptions. States. Described. Appendix with 23 doubtful and rejected prints.

Sack, Eduard. *Giambattista und Domenico Tiepolo, ihr Leben und ihre Werke, ein Beitrag zur Kunstgeschichte des achtzehnten Jahrhunderts.* Hamburg: H. v. Clarmanns Kunstverlag, 1910.
Entries: 38 prints by, 113 after. Millimeters. Inscriptions. States. Described. Illustrated (selection).

Hind, Arthur M. "The etchings of Giovanni Battista Tiepolo." [*PCQ.*] 8 (1921): 37–60.
Entries: 38. Inches. Inscriptions. Reference for an illustration of each print is given. Follows numbering of [Vesme].

Metcalfe, Louis R. "The etchings of Giovanni Battista Tiepolo (1696–1770)." [*P. Conn.*] 1 (1921): 344–379.
Entries: 34. Illustrated (selection). Based on [Vesme] with additions.

Vitali, Lamberto. "Nuove stampe di G. B. Tiepolo (un problema di grafica tiepolesca). " *Bolletino d'Arte* 7 (1927/ 1928): 60–74.
Entries: 73 (additional to Sack). Millimeters. Inscriptions. States. Described. Illustrated (selection). Attribution to Tiepolo of the staffage figures in a group of etchings by Giuliano Giampiccoli.

Calabi, Augusto. "Note su G. B. Tiepolo incisore." [*GK.*] n.s. 4 (1939): 7–20.
Description of a volume of prints after paintings and views of Venice: *Il gran teatro di Venezia* [1717?]. Drawings from some paintings were made by Tiepolo for the prints.

Loggia del Lionello, Udine [Aldo Rizzi, compiler]. *Le acqueforti dei Tiepoli.* Milan: Electa Editrice, 1970.
Entries: 37. Millimeters. Inscriptions. Described. Illustrated. Bibliography for each entry.

Rizzi, Aldo. *L'Opera grafica dei Tiepolo; le acqueforti.* Venice: Electa Editrice, 1971. English ed. *The etchings of the Tiepolos.* London: Phaidon, 1971.
Entries: 38 prints by, 27 collaborative, doubtful and rejected prints and prints not seen by Rizzi. Millimeters. Inscriptions. States. Described. Illustrated. Bibliography for each entry. Related drawings are illustrated. Concordance to [Vesme].

"Nuove catalogazioni e rettifiche." [*QCS.*] 9 (November-December 1971): 36–37.
Additional information to [Vesme] and Rizzi (first state of [Vesme] 104, Rizzi 109).

Tiepolo, Giovanni Domenico (*1727–1804*)
Chennevières, Henry de. *Les Tiepolo.* Les artistes célèbres. Paris: Librairie de l'Art, 1897.
Entries: 101. Paper fold measure (selection).

[Vesme] pp. 396–439.
Entries: 177. Millimeters. Inscriptions. States. Described.

Sack, Eduard. *Giambattista und Domenico Tiepolo, ihr Leben und ihre Werke, ein Beitrag zur Kunstgeschichte des achtzehnten Jahrhunderts.* Hamburg: H. v. Clarmanns Kunstverlag, 1910.
Entries: 182. Millimeters. Inscriptions. States. Described.

Loggia del Lionello, Udine [Aldo Rizzi, compiler]. *Le acqueforti dei Tiepoli.* Milan: Electa Editrice, 1970.

Entries: 170. Millimeters. Inscriptions. Described. Illustrated (selection). Bibliography for each entry.

Rizzi, Aldo. *L'Opera grafica dei Tiepolo: le acqueforti.* Venice: Electa Editrice, [1971?]. English ed. *The etchings of the Tiepolos.* London: Phaidon, 1971.
Entries: 183. Millimeters. Inscriptions. States. Described. Illustrated. Bibliography for each entry. Related drawings are illustrated. Concordance to [Vesme].

Tiepolo, Lorenzo Baldissera
(1736–before 1776)
Chennevières, Henry de. *Les Tiepolo.* Les artistes célèbres. Paris: Librairie de l'Art, 1897.
Entries: 11. Paper fold measure (selection).

[Vesme] pp. 440–444.
Entries: 9. Millimeters. Inscriptions. States. Described. Located (selection).

Sack, Eduard. *Giambattista und Domenico Tiepolo, ihr Leben und ihre Werke, ein Beitrag zur Kunstgeschichte des achtzehnten Jahrhunderts.* Hamburg: H. v. Clarmanns Kunstverlag, 1910.
Entries: 9. Millimeters Inscriptions. States. Described.

Loggia del Lionello, Udine [Aldo Rizzi, compiler]. *Le acqueforti dei Tiepoli.* Milan: Electa Editrice, 1970.
Entries: 9. Millimeters. Inscriptions. Described. Illustrated. Bibliography for each entry.

Rizzi, Aldo. *L'Opera grafica dei Tiepolo; le acqueforti.* Venice: Electa Editrice, [1971?]. English ed. *The etchings of the Tiepolos.* London: Phaidon, 1971.
Entries: 10. Bibliography for each entry. Related drawings are illustrated. Concordance to [Vesme.]

Til, N. van *(fl. c.1686)*
[W.] II, p. 713.
Entries: 1.*

Tilborgh, Gillis van *(c.1625–c.1678)*
[W.] II, pp. 713–714.
Entries: 7 prints after.*

Till, Johann Carl von
See **Thill**

Tillemans, Peter *(1684–1734)*
[W.] II, p. 714.
Entries: 2 prints by, 4+ after.*

[Siltzer] pp. 273–274.
Entries: unnumbered, pp. 273–274, prints by and after. Inches (selection). Inscriptions. Illustrated (selection).

Tiller, Robert *(fl. 1818–1825)* and Robert, Jr. *(fl. 1828–1836)*
[St.] pp. 533–535.*

[F.] pp. 284–285.*

Timms, ——— *(fl. c.1843)*
[Ber.] XII, p. 122.*

Tinayre, [Jean] Julien *(1859–1923)*
[Ber.] XII, p. 123.*

Tinney, John *(d. 1761)*
[Sm.] III, pp. 1364–1366.
Entries: 7 (portraits only). Inches. Inscriptions. Described.

[Ru.] p. 324.
Entries: 1 (portraits only, additional to [Sm.]). Inscriptions. Additional information to [Sm.].

Tinthoin, Jules Louis *(1822–1859)*
[Ber.] XII, p. 123.*

Tinti, Lorenzo *(1626/34–1672)*
[B.] XIX, pp. 240–246.
Entries: 9 prints by, 2 prints not seen by [B.]. Pre-metric. Inscriptions. Described.

Tintoretto, Jacopo *(1518–1594)*
 [B.] XVI, pp. 104–105.
 Entries: 1. Pre-metric. Inscriptions.
 Described.

 [P.] VI: *See* **Chiaroscuro Woodcuts**

Tipper, Herman *(17th cent.)*
 [W.] II, p. 714.
 Entries: 1.*

Tirpene, Jean Louis *(b. 1801)*
 [Ber.] XII, pp. 123–124.*

Tischbein, [Johann Heinrich] Wilhelm
(1751–1829)
 [A. 1800] II, pp. 1–60.
 Entries: 147. Pre-metric. Inscriptions.
 States. Described.

 Andresen, Andreas. "Andresens
 Nachträge zu seinen 'Deutschen Maler-
 radierern.' " [*MGvK.*] 1907, p. 41.
 Additional information to [A. 1800].

Tisdale, Elkanah *(c.1771–after 1834)*
 [St.] pp. 535–539.*

 [F.] pp. 285–286.*

Tissandier, Albert Charles *(1839–1906)*
 [Ber.] XII, p. 125.*

Tissot, ———— *(19th cent.)*
 [Dus.] p. 273.
 Entries: 1 (lithographs only, to 1821).

Tissot, James [Jacques Joseph] *(1836–1902)*
 Yriarte, Charles. *J.-J. Tissot, eaux-fortes,
 manière noire, pointes sèches.* Paris: Imp.
 réunies, C., 1886.
 Entries: 90 (to 1886, complete?).
 Millimeters. Inches. States. Illus-
 trated (selection). Different states of
 the same print are separately num-
 bered.

 [Ber.] XII, pp. 125–134.
 Entries: 74 (to 1892?). Paper fold mea-
 sure. Described.

Titian [Tiziano Vecellio] *(1477–1576)*
 *Catalogo delle incisioni in legno ed in rame
 tratte dalle opere di Tiziano ed esistente nella
 collezione delle stampe di G. B. Cadorin in
 Venezia.* n.p., n.d. (EBM)
 Entries: 490 prints after. Ms. additions
 (EBM); numbering of entries, index of
 engravers.

 [B.] XII: *See* **Chiaroscuro Woodcuts**

 [B.] XVI, pp. 95–101.
 Entries: 8. Pre-metric. Inscriptions.
 States. Described.

 Hume, A. *Notices of the life and works of
 Titian.* London: John Rodwell, 1829.
 (EBM)
 Entries: unnumbered, pp. 1–94 (in
 appendix). Inscriptions. Described.

 Segelken, H. "Über die holzschnittliche
 Behandlung der Zeichnung Tizians 'der
 Triumph Christi.' " [*N. Arch.*] 5 (1859):
 198–227.
 Entries: 1+ (editions of the *Triumph of
 Faith* only). States.

 [P.] VI: *See* **Chiaroscuro Woodcuts**

 Tietze, Hans, and Tietze-Conrat, Erika.
 "Tizian Graphik." [*GK.*] n.s. 3 (1938):
 8–17, 52–71.
 Entries: 63 prints by and after. Milli-
 meters. Inscriptions. Described.

 Tietze, Hans, and Tietze-Conrat, Erica.
 "Titian's woodcuts." [*PCQ.*] 25 (1938):
 332–360, 464–477.
 Entries: 15 (woodcuts designed by Ti-
 tian only). Millimeters. Inscriptions.
 Illustrated (selection).

 Mauroner, Fabio. *Le incisione di Tiziano.*
 Venice: Le Tre Venezie, 1941. 2d ed.,
 rev. Padua: Le Tre Venezie, 1943.
 Entries: 31 woodcuts (27 in 1943 edi-
 tion); 53 prints after (40 in 1943 edi-
 tion). Millimeters. Inscriptions.
 States. Described. Illustrated (selec-
 tion). Located (selection).

Wethey, Harold E. *The paintings of Titian, complete edition.* 2 vols. London: Phaidon, 1969, 1971.
Catalogue of paintings; prints after are mentioned where extant.

Tittle, Walter Ernest *(b. 1883)*
Fowler, Alfred. *A check-list of prints by Walter Tittle.* Alexandria (Va.): Print Collectors' Club, 1950. (Mimeographed checklist, CSfAc)
Entries: 271 etchings, 13 lithographs (to 1950). Inches.

Tocqué, Louis *(1696–1772)*
Doria, Arnauld. *Louis Tocqué, biographie et catalogue critiques.* Paris: Les Beaux-arts, Édition d'Études et de Documents, 1929.
Catalogue of paintings; prints after are mentioned where extant.

Todd, A. *(fl. c.1812)*
[St.] p. 539.*

Töpffer, Rodolphe *(1799–1846)*
[Ber.] XII, pp. 134–136.*

Toeput, Lodewyk [called "Pozzoserrato"] *(c.1550–1603/05)*
[W.] II, p. 715.
Entries: 5 prints after.*

Toerring-Seefeld, Clemens Maria Anton, Reichsgraf von *(1758–1837)*
[Dus.] p. 273.
Entries: 3 (lithographs only, to 1821). Millimeters. Inscriptions. States. Located.

Tognola, Luigi *(fl. 1837–1842)*
[Ap.] p. 430.
Entries: 1.*

Tol, Dominicus van *(c.1635–1676)*
[W.] II, p. 715.
Entries: 2 prints after.*

Toller, Melchiorre *(1800–1846)*
[An]. pp. 680–683.
Entries: unnumbered, pp. 681–683. Millimeters. Inscriptions. Described.

[AN. 1968] p. 176.
Entries: unnumbered, p. 176 (additional to [AN.]). Millimeters (selection). Inscriptions.

Tomba, Giulio *(1780–1841)*
[Ap.] p. 430.
Entries: 6.*

Tompson, Richard *(d. 1693?)*
[Sm.] III, pp. 1366–1381, and "additions and corrections" section; IV, "additions and corrections" section.
Entries: 52 (portraits only). Inches. Inscriptions. States. Described. Illustrated (selection). Located (selection).

[Ru.] pp. 324–328, 498.
Entries: 1 (portraits only, additional to [Sm.]). Inches. Inscriptions. Described. Additional information to [Sm.].

Toorenburgh, Gerrit *(c.1737–1785)*
[W.] II, p. 716.
Entries: 1 print after.*

Toorenvliet, Abraham I *(d. 1692)*
[W.] II, p. 716.
Entries: 1 print after.*

Toorenvliet, Jacob *(1635/36–1719)*
[vdK.] pp. 22–24, 226.
Entries: 7. Millimeters. Inscriptions. Described.

[W.] II, pp. 716–717.
Entries: 7 prints by, 22 after.*

Toorn, Dirk van den *(1778–1811)*
[W.] II, p. 717.
Entries: 1+.*

Toorop, Charley *(b. 1891)*
Hammacher, A. M. *Charley Toorop.*
Rotterdam (Netherlands): W. L. en J.
Brusse, 1952.
Entries: 10. Millimeters. Inscriptions.
Located.

Toorop, Jan *(1858–1928)*
Polak, Bettina. *Het fin-de-siècle in de
nederlandse schilderkunst.* The Hague:
Martinus Nijhoff, 1955.
Entries: 134 (works in all media; 1886
to 1903 only). Millimeters. Inscriptions. Described. Illustrated (selection).

Rijksprentenkabinet/Rijksmuseum Amsterdam [J. Verbeek, compiler]. [*De
Grafiek van*] *Jan Toorop 1858–1928.* Amsterdam, 1969.
Entries: 84 (complete?). Millimeters.
Inscriptions. States. Described. Illustrated. Located.

Torelli, Giacomo *(1604–1678)*
Bjurström, Per. *Giacomo Torelli and
Baroque stage design.* Stockholm: Kungl.
Boktryckeriet P. A. Norstedt och Söner,
1961.
Entries: 58 prints after (stage designs
only). Millimeters. Inscriptions (selection). Illustrated (selection).

Torgersen, Otto *(20th cent.)*
Iversen, Ragnvald. "Otto Torgersen."
[*N. ExT.*] 5 (1953): 72–75.
Entries: unnumbered, p. 75 (bookplates only, to 1950). Illustrated (selection).

Toro, B.
See **Turreau,** [Jean] Bernard [Honoré]

Torrey, Charles Cutler *(d. 1827)*
[St.] p. 539.*

[F.] p. 286.*

Torri, Flaminio *(1621–1661)*
[B.] XIX, pp. 213–217.
Entries: 7. Pre-metric. Inscriptions.
Described.

Tortebat, François *(c.1621–1690)*
[RD.] III, pp. 214–223; XI, p. 310.
Entries: 25. Pre-metric. Inscriptions.
Described.

Tortorel, Jacques
See **Perrissin,** Jean

Toschi, Paolo *(1788–1854)*
[Ap.] pp. 430–433.
Entries: 29+.*

[Ber.] XII, pp. 136–138.*

Tosetti, Filippo *(b. c.1780)*
[Ap.] p. 433.
Entries: 4.*

Touchemolin, Aegidius *(fl. c.1800)*
[Dus.] pp. 273–274.
Entries: 7 (lithographs only, to 1821).
Millimeters (selection). Paper fold
measure (selection). Inscriptions. Located.

Touchet, Jacques *(20th cent.)*
Babou, Henry. *Jacques Touchet.* Les artistes du livre, 23. Paris: Henry Babou,
1932. 700 copies. (NNMM)
Bibliography of books with illustrations by.

Toudouze, Édouard *(1848–1907)*
[Ber.] XII, p. 140.*

Toudouze, Gabriel *(1811–1854)*
[Ber.] XII, p. 139.*

Toullion, Tony *(fl. 1848–1880)*
[Ber.] XII, p. 140.*

Toulouse-Lautrec, Henri [Raymond] de *(1864–1901)*
[Del.] X–XI.
Entries: 368. Millimeters. Inscriptions (selection). States. Described. Illustrated. Located (selection).

M. Knoedler and Co. *Toulouse-Lautrec, 1864–1901, his lithographic work.* New York: M. Knoedler and Co., 1950.
Additional information to [Del.].

Adhémar, Jean. *Toulouse-Lautrec; lithographies, pointes-sèches, oeuvre complet.* Paris: Arts et Metiers Graphiques, 1965. English ed. *Toulouse-Lautrec; his complete lithographs and drypoints.* New York: Harry N. Abrams, Inc. 1965. (German and Italian editions as well).
Entries: 370. Millimeters. Inches. Described. Illustrated. One state of each print is illustrated and identified; other states are not described. Concordance with [Del.] published as supplement to *Nouvelles de l'Estampe*, 1966, no. 1.

Dortu, M. G. *Toulouse-Lautrec et son oeuvre.* 6 vols. New York: Collectors' Editions, 1971.
Entries: 6 (monotypes only). Millimeters. Inches. Inscriptions. Described. Illustrated. Located.

Tourfaut, Léon Alexandre *(d. 1883)*
[Ber.] XII, p. 140.*

Tournachon, Félix
See **Nadar**

Tournières, Robert *(1667–1752)*
Bataille, Marie-Louise. "Tournières." In [Dim.] I, pp. 227–243.
Entries: 17 prints after lost works, 2 illustrations after.

Tourny, Joseph Gabriel *(1817–1880)*
[Ber.] XII, p. 141.*

Toussaint, [Charles] Henri *(1849–1911)*
[Ber.] XII, pp. 141–142.*

Toussyn, Johann *(1608–1631)*
[Merlo] pp. 879–888.
Entries: 8 prints by, 31 after. Paper fold measure (selection). Inscriptions (selection). Described (selection).

Town, Charles *(1763–1840)*
[Siltzer] p. 333.
Entries: unnumbered, p. 333, prints after. Inches (selection). Inscriptions.

Townley, Charles *(1746–after 1800)*
[Sm.] III, pp. 1381–1393, and "additions and corrections" section; IV, "additions and corrections" section.
Entries: 35 (portraits only). Inches. Inscriptions. States. Described. Illustrated (selection). Located (selection).

[Siltzer] p. 367.
Entries: unnumbered, p. 367. Inscriptions.

[Ru.] pp. 328–330.
Entries: 2 (portraits only, additional to [Sm.]). Inches. Inscriptions. Described. Additional information to [Sm.].

Townsend, J. *(19th cent.)*
[Siltzer] p. 333.
Entries: unnumbered, p. 333, prints after. Inscriptions.

Townsend, Maria Ann Maverick
See **Maverick** family

Trachez [Trachy], Jacques André Joseph *(1742–1820)*
[H. L.] pp. 1049–1050.
Entries: 3. Millimeters. Inscriptions. Described.

[W.] II, p. 719.
Entries: 3.*

Trackert, [Gg.] Friedrich [Ludw.]
(1806–1858)
[Dus.] p. 274.
 Entries: 4 (lithographs only, to 1821).
 Paper fold measure.

Traixegnie, Gilles *(fl. c.1661)*
[W.] II, pp. 719–720.
 Entries: 1.*

Tramontin, Virgilio *(b. 1908)*
Trentin, Giorgio. *Le incisioni di Virgilio Tramontin.* Udine (Italy): Doretti, 1970.
 Entries: unnumbered, 16 pp. (to 1970). Millimeters. Illustrated (selection).

Trasmondi, Pietro *(b. c.1799)*
[Ap.] p. 434.
 Entries: 4.*

Traut, Wolf *(c.1478–1520)*
[Ge.] nos. 1404–1420.
 Entries: 17 (single-sheet woodcuts only). Described. Illustrated. Located.

Travalloni, Luigi *(1814–1884)*
[Ap.] p. 434.
 Entries: 3.*

Traversier, Hyacinthe *(fl. 1840–1860)*
[Ber.] XII, p. 142.*

Travi, Antonio [called "Il Sestri"]
(1608–1665)
[Vesme] pp. 336–337.
 Entries: 2. Millimeters. Inscriptions. States. Described. Located (selection).

Traviès, Édouard *(b. 1809)*
[Ber.] XII, pp. 153–154.*

Traviès, [Charles] Joseph *(1804–1859)*
[Ber.] XII, pp. 142–153.*

Ferment, Claude. "Charles Joseph Traviès; catalogue de son oeuvre lithographié et gravé." Thesis, École du Louvre. Unpublished ms. (EPBN)

Entries: 826. Inscriptions. States. Described (selection).

Trayer, J. Ange *(19th cent.)*
[Ber.] XII, p. 154.*

Tregean, G. S. *(19th cent.)*
[Siltzer] p. 333.
 Entries: unnumbered, p. 333, prints after. Inches. Inscriptions.

Trémolières [**Tremollière**], Pierre Charles
(1703–1739)
[Baud.] II, pp. 21–29.
 Entries: 10. Millimeters. Inscriptions. States. Described.

Messelet, Jean. "Trémollières." In [Dim.] I, pp. 267–281.
 Entries: 4 prints by, 3 prints after lost works, and 3+ book illustrations after. Millimeters. Inscriptions.

Trenchard, Edward [E. C.] *(d. 1824)*
[St.] p. 539.*

[F.] p. 286.*

Trenchard, James *(fl. 1777–1793)*
[Allen] pp. 152–155.*

[St.] pp. 540–544.*

[F.] pp. 286–287.*

Treu, Martin
See **Monogram MT** [Nagler *Mon.*] IV, no. 2180

Trevisani, Angelo *(1669–after 1753?)*
[Vesme] p. 362.
 Entries: 1. Millimeters. Inscriptions. Described.

Triadó Mayol, José *(b. 1870)*
Miquel y Planas, Ramon. *Primer Llibre d'exlibris d'En Triadó.* Barcelona: Joseph Borrás, 1906. 300 copies. (DLC)
 Entries: 25 (bookplates only, to 1902). Illustrated.

Trichon, Auguste *(b. 1814)*
[Ber.] XII, p. 154.*

Trichot-Garnerie, François *(fl. c.1838)*
[Ber.] XII, pp. 154–155.*

Trière, Philippe *(1756–c.1815)*
[L. D.] pp. 80–81.
Entries: 3. Millimeters. Inscriptions. States. Described. Illustrated (selection). Incomplete catalogue.*

Trimolet, Alphonse Louis Pierre
(fl. c.1867)
[Ber.] XII, p. 162.
Entries: 31. Paper fold measure.

Trimolet, Louis Joseph *(1812–1843)*
[Ber.] XII, pp. 155–161.
Entries: 45 (original etchings only). Paper fold measure. Described (selection). Also, survey of lithographs, reproductive etchings and prints after.

Triva, Antonio Domenico *(1625/26–1699)*
[B.] XIX, pp. 230–233.
Entries: 4 prints by, 2+ prints not seen by [B.]. Pre-metric. Inscriptions. Described.

Trobriand, A. de *(fl. c.1830)*
[Ber.] XII, p. 163.*

Troger, Paul *(1698–1762)*
Aschenbrenner, Wanda, and Schweighofer, Gregor. *Paul Troger, Leben und Werk.* Salzburg (Austria): Verlag St. Peter, 1965.
Entries: 32 prints by and after. Millimeters. Inscriptions. Described. Illustrated. Bibliography for each entry.

Tromp, Outgert *(d. 1690)*
[Sm.] III, pp. 1393–1394.
Entries: 1 (portraits only). Inches. Inscriptions. Described.

[W.] III, p. 171.
Entries: 1.*

Tronchon, ——— *(19th cent.)*
[Ber.] XII, p. 163.*

Troost, ——— *(19th cent.)*
[H. L.] p. 1050.
Entries: 1. Millimeters. Inscriptions. States. Described.

Troost, Cornelis *(1697–1750)*
Ver Huell, A. *Cornelis Troost en zijn Werken.* Arnhem (Netherlands): P. Gouda Quint, 1873.
Entries: unnumbered, pp. 46–75, prints by and after (complete?) Millimeters (selection). Paper fold measure (selection). Inscriptions (selection). Described. Located. Based on Ver Huell's own collection. Ms. notes (EA); additional states, 1 additional entry.

[W.] II, pp. 720–721.
Entries: 8 prints by, 47+ after.*

Troost, Sara *(1731–1803)*
[W.] II, pp. 721–722.
Entries: 1 print by, 2 after.*

Troostwyk, Wouter Joannes van
(1782–1810)
[vdK.] pp. 187–197.
Entries: 30. Millimeters. Inscriptions. States. Described.

[Dut.] VII, pp. 431–438.
Entries: 30. Millimeters. Inscriptions. Described.

Trossin, Robert *(1820–1896)*
[Ap.] pp. 434–436.
Entries: 18.*

Trotter, Thomas *(c.1750–1803)*
[Sm.] III, "additions and corrections" section.
Entries: 1 (portraits only). Inches. Described.

Trouilleux, Joseph Jean Jacques
(fl. 1860–1880)
[Ber.] XII, p. 163.*

Troy, François de *(1645–1730)*
[RD.] VII, pp. 337–338; XI, p. 311.
Entries: 3. Millimeters. Inscriptions.
Described.

Troy, Jean de *(1645/46–1691)*
Renouvier, Jules. "Jean Troy, directeur
de l'académie de peinture, sculpture et
gravure de Montpellier." *Archives de l'art
français* 7 (1855–1856): 81–93.
Entries: unnumbered, pp. 89–93. In-
scriptions (selection). Described.

Troy, Jean François de *(1679–1752)*
[RD.] VIII, pp. 299–301; XI, pp. 311–312.
Entries: 2. Millimeters. Inscriptions.
Described.

Brière, Gaston: "Detroy." In [Dim.] II,
pp. 1–48.
Entries: 1 print by, 29 after lost works,
2+ illustrations after.

Troyen, Jan van *(b. c.1610)*
[W.] II, p. 722; III, p. 171.
Entries: 9.*

Troyen, Rombout van *(c.1605–1650)*
[W.] II, p. 722.
Entries: 1 print after.*

Truchot, Jean *(d. 1823)*
[Ber.] XII, p. 163.*

Sandblad, Nils Gösta. *Anders Trulson;
en studie i sekelskiftets svenska måleri.*
Lund (Sweden): C. W. K. Gleerups För-
lag, 1944. (DLC)
Entries: 26. Millimeters. Inscriptions.
Described. Located (selection).

Tschaggeny, Charles Philogène
(1815–1894)
[H. L.] p. 1051.

Entries: 2 (etchings only). Millimeters.
Inscriptions. Described. Also, 2 litho-
graphs (titles only).

Tschaggeny, Edmond Jean Baptiste
(1818–1873)
[H. L.] p. 1051.
Entries: 1. Millimeters. Described.

Tscharner, [Antoine] Théodore
(1826–1906)
[H. L.] p. 1052.
Entries: 4 Millimeters. Inscriptions.
Described.

Tschemessoff, Evgraf Petrovich
See **Chemessov**

Tucker, William E. *(d. 1857)*
[St.] pp. 544–548.*

[F.] pp. 287–289.*

Tudot, [Louis] Edmond *(1805–1861)*
[Ber.] XII, pp. 163–164.*

Tuer, Herbert *(d. before 1680)*
[W.] II, p. 723.
Entries: 2 prints after.*

Tulden, Theodor van
See **Thulden**

Tully, Christopher *(fl. c.1775)*
[St.] p. 548.*

Tummerman[n], Abraham *(fl. c.1660)*
[W.] II, p. 723.
Entries: 2.*

Turken, Henricus *(1791–before 1856)*
[H. L.] p. 1053.
Entries: 1. Millimeters. Described.

Turkowitz, ——— *(19th cent.)*
[Dus.] p. 274.

Entries: 3 (lithographs only, to 1821).
Millimeters (selection). Paper fold
measure (selection). Inscriptions.

Turnbull, Andrew Watson *(20th cent.)*
"List of etchings by A. Watson Turn-
bull." Unpublished ms. (EBM)
 Entries: unnumbered, 26 pp. Index to
a catalogue or to a collection of prints.
Publishers' names and dates of publi-
cation are given.

Turner, Charles *(1773–1857)*
[Ber.] XII, p. 164.*

Whitman, Alfred. *Nineteenth century
mezzotinters; Charles Turner.* n.p.,
George Bell and Sons, 1907.
 Entries: 921. Inches. Inscriptions.
States. Described. Illustrated (selec-
tion). Located. Ms. notes (ECol); addi-
tional states.

[Siltzer] pp. 367–368.
 Entries: unnumbered, pp. 367–368.
Inscriptions.

Turner, F. C. *(c.1795–c.1846)*
[Siltzer] pp. 275–277.
 Entries: unnumbered, pp. 275–277,
prints after. Inches (selection). In-
scriptions.

Turner, G. A. *(fl. c.1840)*
[Siltzer] p. 368.
 Entries: unnumbered, p. 368. Inscrip-
tions.

Turner, James *(d. 1759)*
[Allen] pp. 155–157.*

[St.] pp. 548–550.*

[F.] p. 289.*

Turner, Joseph Mallord William
(1775–1851)
Burlington Fine Arts Club, London. *Ex-
hibition illustrative of Turner's Liber
Studiorum.* London, 1872.

Entries: 91 prints by and after (*Liber
Studiorum* and related prints only). In-
scriptions. States. Located.

Rawlinson, W. G. *Turner's Liber
Studiorum; a description and a catalogue.*
London: Macmillan and Co., 1878.
 Entries: 91 prints by and after (*Liber
Studiorum* only.). Inscriptions. States.
Described. Also, list of 9 drawings in-
tended for the *Liber Studiorum* but
not engraved.

Grolier Club, New York. *Catalogue of an
exhibition of the Liber Studiorum of J. M. W.
Turner at the rooms of the Grolier Club at
no. 64 Madison Avenue.* New York, 1888.
 Entries: 100 prints by and after (*Liber
Studiorum* only).

Brooke, Stopford. *The Liber Studiorum of
J. M. W. Turner, R.A., reproduced in fac-
simile by the autotype process from examples
of the best states in possession of the Rev.
Stopford Brooke, M.A.; each plate accom-
panied with a critical notice by him.* 2 vols.
London: Henry Sotheran and Co., 1899.
 Entries: 71 prints by and after (*Liber
Studiorum* only). Described. Illus-
trated.

Armstrong, Walter. *Turner.* London:
Thos. Agnew and Sons, 1902.
 Catalogue of paintings and watercol-
ors; prints after are mentioned where
extant.

Rawlinson, W. G. *Turner's Liber
Studiorum; a description and a catalogue,
second edition, revised throughout.* Lon-
don: Macmillan and Co., 1906.
 Entries: 99 prints by and after (*Liber
Studiorum* only). Inscriptions. States.
Described. Ms. notes (Williams Col-
lege Library, Williamstown, Mass.);
annotations by Bullard.

Rawlinson, W. G. *The engraved work of J.
M. W. Turner.* 2 vols. London: Mac-
millan and Co., 1908, 1913.

Turner, Joseph Mallord William
(*continued*)

Entries: 867 prints after (prints other than *Liber Studiorum*). Inches. Inscriptions. States. Described. Located. Preparatory drawings are located.

Bullard, Francis. *A catalogue of the engraved plates for Picturesque views in England and Wales, with notes and commentaries.* Boston (Mass.): Privately printed, 1910.
Entries: unnumbered, pp. 23–82, prints after (*Picturesque views in England and Wales* only). States. Cites numbering of Rawlinson 1908; includes states unknown to Rawlinson.

Liber Studiorum miniature edition. New York: Frederick A. Stokes, 1911.
Entries: 101 prints by and after (*Liber Studiorum* only). Illustrated.

Bradley, William Aspinwall. *A catalogue of the collection of prints from the Liber Studiorum of Joseph Mallord William Turner formed by the late Francis Bullard of Boston, Massachusetts and bequeathed by him to the Museum of Fine Arts in Boston.* Boston (Mass.): Privately printed, 1916. (MH)
Entries: 91 prints by and after (*Liber Studiorum* only). States. Described. Illustrated. Description of states is based on the Bullard collection.

Finberg, Alexander J. *The history of Turner's Liber Studiorum with a new catalogue raisonné.* London: Ernest Benn Ltd., 1924. 650 copies. (MB)
Entries: 91 prints by and after (*Liber Studiorum* only). Inches. Inscriptions. States. Described. Illustrated. Located. Copies mentioned. Extensive ms. notes (ECol) by Harold J. L. Wright; additional states and other information.

[Siltzer] p. 334.

Entries: unnumbered, p. 334, prints after. Inches. Inscriptions.

Finberg, A. J. *An introduction to Turner's Southern Coast, with a catalogue of the engravings in which all the known working proofs are arranged and described for the first time.* London: Cotswold Gallery, 1929. 200 copies. (MH)
Entries: 40 prints after (*Southern Coast* only). Inches. Inscriptions. States. Described. Located. Numbering based on Rawlinson 1908, 1913. Thorough description of working proofs, with transcription of Turner's marginal notes.

Turpin de Crissé, Lancelot Théodore, comte de *(1782–1859)*
[Ber.] XII, p. 165.*

Turreau, [Jean] Bernard Honoré [called "Toro"] *(1672–1731)*
Lagrange, Léon. "Catalogue de l'oeuvre sculpté, peint, dessiné et gravé de Bernard Toro." [*GBA.*] 2d ser. 1 (1869): 289–296.
Entries: 36+. Inscriptions. Described (selection).

Brun, Robert. "Toro." In [Dim.] I, pp. 351–364.
Entries: 5 illustrations, 145 other prints.

Tushingham, Sidney *(b. 1884)*
James Connell and Sons Ltd. *Etchings and drypoints by S. Tushingham.* Notes by P. G. Konody. London: James Connell and Sons Ltd., 1921. (MB)
Entries: 39 (to 1921?). Inches. Illustrations.

James Connell and Sons Ltd. *Etchings and Dry-Points by S. Tushingham.* Introduction by Malcolm C. Salaman. London: James Connell and Sons Ltd., 1929. (DLC)

Entries: 99 (to 1928). Inches. Illustrated (prints subsequent to 1921 catalogue only).

Tuttle, [Henry] Emerson *(1890–1946)*
T———, I. H. *Emerson Tuttle; fifty prints with . . . a complete catalogue from 1921 to 1946.* New Haven (Conn.): Yale University Press, 1948.
Entries: 177. Inches. States. Described. Illustrated. Located (selection).

Twachtman, John Henry *(1853–1902)*
Ryerson, Margery Austen. "John H. Twachtman's etchings." *Art in America* 8 (1920): 92–96.
Entries: 26. Inches. States. Illustrated (selection).

Cincinnati Art Museum [Mary W. Baskett, compiler]. *A retrospective exhibition; John Henry Twachtman.* Cincinnati (Ohio), 1966.
Entries: 24 (complete?). Inches. Inscriptions. States. Illustrated (selection). Located.

Twenger, Johann *(1543–1603)*
[A.] II, pp. 50–53.
Entries: 2. Pre-metric. Inscriptions. Described.

Twenhusen, Helmich II van *(c.1590–after 1660)*
[W.] III, p. 170.
Entries: 2 prints after.*

Tychyna, Anatol' Mikalaevich *(b. 1897)*
Gerasimovich, Piotr. *Anatol Mikalaevich Tychyna.* Minsk (USSR): Redaktsyja Vyjawlenchaj praduktsyi, 1961. (DLC)
Entries: unnumbered, pp. 62–67 (to 1960; complete?). Millimeters. Illustrated (selection).

Tyler, Valton *(20th cent.)*
Valley House Gallery, Dallas [Rebecca Reynolds, compiler]. *The first fifty prints; Valton Tyler.* Dallas (Tex.): Southern Methodist University Press, 1972.
Entries: 50 (to 1972?). Inches. Described. Illustrated.

Tys[sen], Pieter
See **Thys**

U

Ubbelohde, Otto *(1867–1922)*
Graepler, C. *Katalog sämtlicher Radierungen von Otto Ubbelohde und andere Beiträge zur Ubbelohde-Forschung.* Marburg (West Germany): Marburger Universitätsmuseum für Kunst und Kulturgeschichte, 1967.
Entries: 169. Millimeters. Inscriptions. Described. Illustrated. Located. Also, list of 171 bookplates after (titles only).

Uberti, Lucantonio degli *(fl. c.1520)*
[Hind] I, pp. 211–214; V, pp. 308–309.
Entries: 7. Millimeters. Inscriptions. Described. Illustrated. Located. 26 rejected prints are listed in the preface to the catalogue.

Udemans, H. *(fl. c.1660)*
[W.] II, p. 725.
Entries: 1.*

Uden, Lucas van *(1595–1672/73)*
[B.] V, pp. 13–56.
Entries: 59. Pre-metric. Inscriptions. States. Described. Copies mentioned.

[Weigel] pp. 228–233.
Entries: 2 (additional to [B.]). Pre-metric. Inscriptions. States. Described.

[Wess.] II, p. 259.
Entries: 1 (additional to [B.] and [Weigel]). Paper fold measure. Inscriptions. Additional information to [B.] and [Weigel].

[Dut.] VI, pp. 438–450.
Entries: 62. Millimeters. Inscriptions. States. Described.

[W.] II, pp. 725–726.
Entries: 60+ prints by, 3 after.*

Ufer, [William] Oswald *(1828–1883)*
[Ap.] pp. 436–437.
Entries: 10.*

Uffenbach, Philipp *(1566–1636)*
[B.] IX, pp. 577–578.
Entries: 3. Pre-metric. Inscriptions. Described.

[P.] IV, pp. 238–240.
Entries: 6 engravings and etchings (additional to [B.]), 1 woodcut. Paper fold measure (selection). Pre-metric. Inscriptions. Described (selection).

[A.] IV, pp. 313–324.
Entries: 11 etchings, 1 woodcut. Pre-metric. Inscriptions. States. Described.

Malss, G. "Berichtigung zu Andresen." [*Rep. Kw.*] 1 (1876): 410–411.
Entries: 1 (additional to [A.]).

Ugolini, Antonio *(fl. c.1700)*
[B.] XX, pp. 297–298.
Entries: 1. Pre-metric. Inscriptions. Described.

Ugonia, Giuseppe *(1881–1944)*
Bianchi, Lidia, and Isola, Maria Catelli. *Giuseppe Ugonia.* Faenza (Italy): Litografie Artistiche Faentine, 1970. (DLC)
Entries: 35. Millimeters. Illustrated (selection). Located.

Uil, Jan
See **Uyl**

Uitenbroeck, Moysesz van
See **Uyttenbroeck**

Ulerick, Pieter
See **Vlerick**

Ulft, Jacob van der *(1627–1689)*
[W.] II, p. 727.
Entries: 2 prints by, 8 after.*

Ulmer, Johann Conrad *(1783–1820)*
[Ap.] p. 438.
Entries: 13.*

[Ber.] XII, p. 165.*

Umbach, Jonas *(c.1624–1693)*
"Etchings by Jonas Umbach." Unpublished ms., 19th cent. (EBM)
Entries: unnumbered, pp. 1–88. States.

Umbach, [Friedrich] Julius *(1815–1877)*
[Ap.] p. 438.
Entries: 4.*

Umpfenbach, Johann Daniel *(1786–1836)*
[Dus.] p. 274.
Entries: 1 (lithographs only, to 1821). Millimeters. Inscriptions. Located.

Underwood, Thomas *(c.1795–1849)*
[F.] p. 289.*

Unger, [Christian] Wilhelm [Jacob] *(1775–1855)*
[Dus.] p. 277.

Entries: 9+ (lithographs only, to 1821).
Millimeters (selection). Inscriptions
(selection). Located (selection).

Unger, William *(1837–1932)*
[Ap.] p. 438.
 Entries: 1.*

[Ber.] XII, p. 166.*

Roeper, Adalbert. "Zum siebzigsten
Geburtstag William Ungers." [*Bb.*] 74
(1907): 8828–8834, 8886–8891. Separately
bound copy. (NN)
 Entries: unnumbered, pp. 8830–8832,
8886–8891. Millimeters. States.

Dorotheum, Vienna. *Katalog der
Sammlung William Unger; Ausstellung
vom 9.-14. November 1908. K.K.
Dorotheum in Wien.* Vienna: Adolf
Holzhausen, 1908.
 Entries: 811. Millimeters.

Unold, Max *(b. 1885)*
Höck, Wilhelm. "Max Unold als Illus-
trator." *Illustration 63,* 2, no. 3 (1965):
unpaginated.
 Bibliography of books with illustra-
tions by.

Unwin, Francis Sydney *(1885?–1925)*
Schwabe, Randolph. "Francis Sydney
Unwin, etcher and lithographer."
[*PCQ.*] 21 (1934): 59–91.
 Entries: 83. Inches. Inscriptions.
States. Described. Illustrated (selec-
tion). Located (selection).

Upitis, Peteris *(20th cent.)*
Rödel, Klaus. *Peteris Upitis Exlibris.*
Frederikshavn (Denmark): Privately
printed, 1968. 50 copies. (DLC)
 Entries: 124 (bookplates only, to 1968).
Millimeters. Illustrated (selection).

Upton, Richard *(20th cent.)*
Syracuse University, School of Art.
*Richard Upton; a retrospective exhibition
1962–1970.* Syracuse (N.Y.), 1970.

Entries: 117 (to 1970). Inches. Illus-
trated (selection).

Urrabieta y Vierge, Daniel *(1851–1904)*
[Ber.] XII, pp. 234–239.*

Clement-Janin, ———. *Daniel Vierge.*
Paris: Jules Meynial, Libraire, 1929. 300
copies. (CSfAc)
 Bibliography of books with illustra-
tions by.

Urruty, Alphonse *(fl. c.1835)*
[Ber.] XII, pp. 166–167.*

Urteil, Andreas *(1933–1968)*
Breicha, Otto. *Andreas Urteil; Mono-
graphie mit Werkverzeichnis der Plastiken,
zeichnungen, Aquarelle und der Druck-
graphik.* Vienna: Verlag Jugend und
Volk, 1970.
 Entries: 5. Millimeters. Described. Il-
lustrated.

Utewael, Joachim Antonisz
See **Wtewael**

Utkin, Nikolaj Ivanovich *(1780–1868)*
[Ap.] p. 439.
 Entries: 11.*

Rovinskij, Dmitrij A. *Nikolaj Ivanovich"
Utkin ego žizn' i proizvedenia.* St. Peters-
burg: V" Tipografii imperatorskoj Aka-
demii Pauk", 1884. (DLC)
 Entries: 230. Millimeters. Inscriptions
Described.

Uyl, Jan [Johannes] Jansz [van] den
(1595/96–1639/40)
[B.] IV, pp. 185–188.
 Entries: 3. Pre-metric. Inscriptions.
States. Described.

[Weigel] pp. 181–182.
 Additional information to [B.].

[Dut.] VI, p. 560.

Uyl, Jan [Johannes] Jansz [van] den (*continued*)

Entries: 3. Millimeters. Inscriptions. States. Described.

[W.] II, p. 729.
Entries: 3.*

Uylenburgh, Rombout [van]
(*d. before 1628*)
[W.] II, p. 729.
Entries: 1 print after.*

Uytewael, Joachim Antonisz
See **Wtewael**

Uyttenbroeck, Moysesz van (*c.1590–1648*)
[B.] V, pp. 81–119.
Entries: 58. Pre-metric. Inscriptions. States. Described. Copies mentioned.

[Weigel] pp. 236–246.
Entries: 9 (additional to [B.]). Pre-metric. Inscriptions. States. Described.

[Wess.] II, pp. 259–260.
Additional information to [B.] and [Weigel].

[W.] II, pp. 729–730.
Entries: 62+ prints by, 2+ after.*

V

Vaart, Jan van der (*1647–1721*)
[Sm.] III, pp. 1403–1407; IV, "additions and corrections" section.
Entries: 9 (portraits only). Inches. Inscriptions. States. Described. Illustrated (selection). Located (selection).

[W.] II, p. 732.
Entries: 12.*

[Ru.] pp. 333–334.
Entries: 1 (portraits only, additional to [Sm.]). Inches. Described. Additional information to [Sm.].

Vadder, Lodewyk de (*1605–1655*)
[B.] V, pp. 59–71.
Entries: 11. Pre-metric. Inscriptions. States. Described.

[Weigel] p. 233.
Additional information to [B.].

[W.] II, p. 732.
Entries: 11+ prints by, 3+ after.*

Vaenius
See **Veen**

Vafflard, Pierre Antoine Augustin
(*b. 1777*)
[Ber.] XII, pp. 167–168.*

Vagliani or **Vaiani,** Alessandro
See **Vajani**

Vaiani, Anna Maria (*fl. c.1630*)
[B.] XX, pp. 126–128.
Entries: 5. Pre-metric. Inscriptions. Described.

Vaiani, Sebastiano (*fl. c.1627*)
[B.] XX, pp. 174–175.
Entries: 1. Pre-metric. Inscriptions. Described.

Vaillant, André [Andries] (*1655–1693*)
[W.] II, p. 733.
Entries: 10.*

Vaillant, Bernard *(1632–1698)*
[W.] II, p. 733.
 Entries: 13+.*

Vaillant, Jacques [Jacob] *(c.1625–1691)*
[W.] II, p. 733.
 Entries: 2.*

Vaillant, Jean [Jan] *(b. 1627)*
[A.] V, pp. 189–192.
 Entries: 6. Pre-metric. Inscriptions.
 Described.

[W.] II, p. 733.
 Entries: 1+.*

Vaillant, Wallerand [Wallerant]
(1623–1677)
 Wessely, J. E. *Wallerant Vaillant;*
 Verzeichniss seiner Kupferstiche und Schab-
 kunstblätter. Vienna: Wilhelm Brau-
 müller, 1865.
 Entries: 7 etchings, 206 mezzotints, 5
 rejected prints. Pre-metric. Inscrip-
 tions. States. Described. Ms. notes.
 (EA)

 Wessely, J. E. "Zusätze und Ver-
 besserungen zum Werke über Wallerant
 Vaillant." [*N. Arch.*] 11 (1865): 207–223.
 Additional information to Wessely
 1865.

 Themaat, Verloren van. "Le catalogue
 de M. Wessely sur l'oeuvre de Wallerant
 Vaillant annoté et amplifié." [*RUA.*] 21
 (1865): 362–370. Separately published.
 Utrecht: Kemink et fils, 1865.
 Entries: 7 (additional to Wessely 1865).
 Pre-metric. Inscriptions. States. De-
 scribed. Additional information to
 Wessely 1865.

 Wessely, J. E. *Wallerant Vaillant;*
 Verzeichniss seiner Kupferstiche und Schab-
 kunstblätter; zweite mit zusätzen und Ver-
 besserungen versehene Auflage. Vienna:
 Wilhelm Braumüller, 1881.
 Entries: 7 etchings, 238 mezzotints.
 Millimeters. Inscriptions. States. De-

scribed. Ms. notes by J. C. J. Bierens
de Haan (ERB); additional states.

[W.] II, pp. 733–736.
 Entries: 211 prints by, 6 after.*

Vandalle, Maurice: "Portraits de famille
gravés en manière noire par W. Vail-
lant." *Revue belge d'archéologie et d'histoire
de l'art* 13 (1943): 167–172.
 Entries: 1 (additional to Wessely and
 Verloren van Themaat). Millimeters.
 Described. Located. Additional in-
 formation to Wessely and Verloren
 van Themaat.

Vajani
See also **Vaiani**

Vajani, Alessandro *(b. c.1570)*
[B.] XX, pp. 123–125.
 Entries: 1. Pre-metric. Inscriptions.
 Described. Appendix with 1 print by
 Sebastiano Vajani after Alessandro
 Vajani.

Vajani, Sebastiano *(fl. 1627–1628)*
See **Vajani,** Alessandro

Valadon, Marie Clémentine [called "Su-
zanne"] *(1867–1938)*
 Pétridès, Paul. *L'Oeuvre complet de Su-
 zanne Valadon.* Paris: Compagnie Fran-
 çaise des Arts Graphiques, 1971.
 Entries: 31. Millimeters. Inscriptions.
 States (selection). Described. Illus-
 trated. Different states of the same
 print are separately numbered.

Valck, Aelbert Symonsz de *(d. 1657)*
[W.] II, p. 736.
 Entries: 1 print after.*

Valck, Gerard *(1651/52–1726)*
[Sm.] III, pp. 1394–1396; IV, "additions
and corrections" section.
 Entries: 10 (portraits only). Inches. In-
 scriptions. States. Described. Located
 (selection).

Valck, Gerard (*continued*)

[W.] II, pp. 736–737.
Entries: 62+.*

[Ru.] pp. 330–332.
Entries: 3 (portraits only, additional to [Sm.]). Inches. Inscriptions. Described. Additional information to [Sm.].

Valck, Pieter (*fl. 1575–1584*)
[W.] II, p. 737.
Entries: 3+.*

Valckenborch, Lucas (*before 1535–1597*)
[W.] II, pp. 739–740.
Entries: 2 prints after.*

Wied, Alexander. "Lucas van Valckenborch." [*WrJ.*] n.s. 31 (1971): 119–231.
Entries: 3 prints after. Millimeters. Inscriptions. Illustrated (selection).

Valckenborch, Martin I (*1535–1612*)
[W.] II, p. 740.
Entries: 2+ prints after.*

Valckenborch, Martin III (*1583–1635*)
[W.] II, p. 740.
Entries: 1 print after.*

Valckenburg, Dirk [Theodor]
See **Valkenburg**

Valckert, Werner van den
(*c.1585–after 1627*)
[Wess.] II, p. 260.
Entries: 1 (additional to [Nagler] XIX, p. 307, and [Nagler, *Mon.*] V, no. 1971). Millimeters. Inscriptions. Described.

[W.] II, pp. 737–738.
Entries: 15 prints by, 1 after.*

[Burch.] pp. 138–142.
Entries: 17. Millimeters. Inscriptions. States. Described (selection). Located.

Valdahon, Jules César Hilaire Leboeuf, marquis de (*1770–1847*)
[Ber.] XII, p. 168.*

Valdenuit, ——— (*fl. c.1797*)
[F.] p. 290.*

Valdor, Jean I and Jean II
See **Waldor,** Jean I and Jean II

Valens, Carel van
See **Falens**

Valentin de Boullogne (*1594–1632*)
[RD.] VII, pp. 163–164; XI, p. 312.
Entries: 1. Millimeters. Inscriptions. States. Described.

Valentin, Henry (*1820–1855*)
[Ber.] XII, p. 168.*

Valentin, Henry Augustin
(*1822–after 1882*)
[Ber.] XII, p. 169.*

Valentin, Moïse
See **Valentin de Boullogne**

Valentine, Edward Virginius (*1838–1930*)
[St.] p. 550.*

Valentinis, Sebastiano de (*d. c.1560*)
[B.] XVI, pp. 240–242.
Entries: 2. Pre-metric. Inscriptions. Described.

[P.] VI, p. 183–184.
Additional information to [B.].

Valério, Théodore (*1819–1879*)
[Ber.] XII, pp. 169–171.*

Valesio, Giovanni [Giovan Luigi]
(*c.1583–c.1650*)
[B.] XVIII, pp. 211–248.
Entries: 111 prints by, 16 prints not seen by [B.]. Pre-metric. Inscriptions. States. Described.

Valk, H. de *(fl. 1693–1717)*
[W.] II, p. 737.
 Entries: 1 print after.*

Valkenburg, Dirk [Theodor] *(1675–1721)*
[W.] II, p. 739.
 Entries: 3 prints after.*

Vallance, John *(1770?–1823)*
[Allen] pp. 157–158.*

[St.] pp. 550–551.*

[F.] p. 289.*

Vallée, Alexandre *(1558–after 1618)*
[RD.] VIII, pp. 140–169; XI, pp. 312–316.
 Entries: 142. Millimeters. Inscriptions.
 States. Described.

Vallet, Édouard *(1876–1929)*
Graber, Hans. *Edouard Vallet, vollstän-
diges Verzeichnis seiner Radierungen mit
Abbildung sämtlicher Blätter.* Basel: Benno
Schwabe und Co., 1917.
 Entries: 87 (to 1917). Millimeters. In-
 scriptions. States. Illustrated.

Graber, Hans. *Édouard Vallet 1876–1929.*
Zürcher Kunstgesellschaft Neu-
jahrsblatt, 1930. Zurich: Verlag der
Zürcher Kunstgesellschaft, 1930. (ICB)
 Entries: 26 (additional to Graber 1917).
 Millimeters. Inscriptions. States. De-
 scribed. Illustrated.

Vallet, Pierre *(c.1575–after 1657)*
[RD.] VI, pp. 101–142.
 Entries: 250. Pre-metric. Inscriptions.
 States. Described.

Valli, Antonio *(19th cent.)*
[Ap.] p. 440.
 Entries: 5.*

Vallot, Philippe Joseph *(1796–1840)*
[Ap.] p. 440.
 Entries: 7.*

[Ber.] XII, pp. 171–172.*

Vallotton, Félix *(1865–1925)*
[Ber.] XII, p. 172.*

Meier-Graefe, Julius. *Félix Valloton,
Biographie.* Berlin: J. A. Stargardt ; Paris:
Edmond Sagot, 1898.
 Entries: 98 (to 1897). Millimeters. Illus-
 trated (selection). Text in French and
 German.

Godefroy, Louis. *L'Oeuvre gravé de Félix
Vallotton (1865–1925).* Paris: Published by
the author; Lausanne (Switzerland):
Paul Vallotton, 1932.
 Entries: 223. Millimeters. States. De-
 scribed. Illustrated. Located. Also, list
 of 15 etchings after works by other art-
 ists (not illustrated).

Vallotton, Maxime, and Goerg, Charles.
*Félix Vallotton, catalogue raisonné de
l'oeuvre gravé et lithographié; catalogue
raisonné of the printed graphic work.*
Geneva: Les Editions de Bonvent, 1972.
 Entries: 249. Inches. Millimeters. In-
 scriptions. States. Described. Illus-
 trated.

Vallou de Villeneuve, Julien *(1795–1866)*
[Ber.] XII, pp. 172–174.*

Valmon, Léonie *(19th cent.)*
[Ber.] XII, p. 174.*

Valmont, Auguste de *(fl. 1815–1845)*
[Ber.] XII, p. 174.*

Vanderbank, John *(c.1694–1739)*
[M.] II, p. 668.
 Entries: 30+ prints after. Paper fold
 measure.

Hammelmann, H. A. "Eighteenth cen-
tury English illustrators; John Vander-
bank 1694–1739." *The Book Collector* 17
(1968): 285–299.
 Bibliography of books with illustra-
 tions by.

Vandervaart, John
 See **Vaart,** Jan van der

Vanlembrouck, ——— *(fl. c.1884)*
 [Ber.] XII, p. 175.*

Vanni, Francesco *(1563–1610)*
 [B.] XII: *See* **Chiaroscuro Woodcuts**

 [B.] XVII, pp. 195–198.
 Entries: 3 prints by, 1 doubtful print, 1
 rejected print. Pre-metric. Inscrip-
 tions. Described.

Vanni, Giovanni Battista *(1599–1660)*
 [B.] XX, pp. 113–118.
 Entries: 17. Pre-metric. Inscriptions.
 Described.

Vanpaemel, Jules *(b. 1896)*
 Vanpaemel-Le Roy, Marguerite. *Cata-
 logue raisonné de l'oeuvre gravé de Jules
 Vanpaemel.* Brussels: André de Rache,
 1970.
 Entries: 285. Millimeters. Inscrip-
 tions. States. Described. Illustrated
 (selection).

Váradi, Albert *(b. 1896)*
 Delteil, ———. "Albert Varadi, graveur
 transylvain." *Byblis* 3 (1924): 49–52 and
 2 pp., unpaginated, following p. 80.
 Entries: unnumbered, 2 pp. (to 1924).
 Millimeters.

Varcollier, Atala *(fl. 1827–1835)*
 [Ber.] XII, p. 177.*

Varin family *(active 18th–19th cent.)*
 Jadart, H. "L'Oeuvre des Varin,
 graveurs champenois, et la ville de
 Reims au XVIIe et au XIXe siècle." [*Ré-
 union Soc. B. A. dép.*] 27th session, 1903,
 pp. 523–547.
 Entries: 22+. Millimeters (selection).
 Paper fold measure (selection). In-
 scriptions. Described (selection).

Varin, [Pierre] Adolphe *(1821–1897)*
 See also **Varin** family

 [Ber.] XII, pp. 179–181.*

Varin, [Pierre] Amédée *(1818–1883)*
 See also **Varin** family

 [Ap.] pp. 440–441.
 Entries: 11.*

 [Ber.] XII, pp. 177–179.*

Varin, Charles Nicolas *(1741–1812)*
 See also **Varin** family

 [L. D.] p. 81.
 Entries: 1. Millimeters. Inscriptions.
 States. Described. Incomplete cata-
 logue.*

Varin, Eugène *(1831–1911)*
 See also **Varin** family

 [Ber.] XII, pp. 181–183.*

Varotari, Dario II *(fl. c.1660)*
 [B.] XXI, pp. 167–168.
 Entries: 2. Pre-metric. Inscriptions.
 Described.

Vasarely, Victor *(b. 1908)*
 Kestner-Gesellschaft, Hannover. *Vas-
 arely.* Hannover (West Germany), 1963.
 Entries: unnumbered, pp. 72–74 (to
 1963). Millimeters.

 Stedelijk Museum, Amsterdam [Luna
 Martinet, compiler]. *Victor Vasarely;
 serigrafieën.* Stedelijk Museum Amster-
 dam, Prentenkabinet catalogus no. 406.
 Amsterdam, 1967.
 Entries: 128 (silkscreen prints only, to
 1966). Millimeters. Illustrated.

Vaucanu, Émile *(fl. c.1889)*
 [Ber.] XII, p. 183.*

Vaughan, Robert *(fl. 1622–1678)*
 [Hind, *Engl.*] III, pp. 48–91.

Entries: 116+. Inches. Inscriptions. States. Described. Illustrated (selection). Located.

Vaughan, William *(fl. c.1664)*
[Hind, *Engl.*] III, pp. 92–94.
Entries: 6+. Inches. Inscriptions. Described. Located.

Vauthier, Jules Antoine *(1774–1832)*
[Ber.] XII, p. 183.*

Vauzelle, Jean Lubin *(b. 1776)*
[Ber.] XII, p. 184.*

Vavassore, Florio *(fl. c.1530)*
[P.] V, pp. 88–89.
Entries: 1. Inscriptions. Described.

Vazquez, Bartolomé *(1749–1802)* and José *(1768–1804)*
[Ap.] p. 441.
Entries: 4.*

Veber, Jean *(1864–1928)*
Veber, Pierre, and Lacroix, Louis. *L'Oeuvre lithographié de Jean Veber.* Paris: Henri Floury, 1931. 500 copies. (MH)
Entries: 219. Millimeters. Inscriptions. States. Described. Illustrated (selection).

Vecchio, Beniamino del *(fl. 1800–1850)*
[Ap.] p. 111.
Entries: 4.*

Vecello, Cesare *(c.1521–1601)*
[P.] VI: *See* **Chiaroscuro Woodcuts**

Vecellio, Tiziano
See **Titian**

Veen, Gijsbert [Gysbrecht] van *(1562–1628)*
[W.] II, p. 742.
Entries: 26+.*

Veen, Otto [Otho, Octavius] van *(1556–1629)*
[W.] II, pp. 742–744.
Entries: 34+ prints after.*

Veenhuysen, Jan *(fl. 1656–1685)*
Bergau, R. "Zu den Werken des Jan Veenhuysen." [*N. Arch.*] 14 (1868): 270.
Entries: 1 (additional to [Kramm]).
Pre-metric. Inscriptions. Described.

[W.] II, p. 745.
Entries: 6+.*

Vehm, Zacharias
See **Wehme**

Veiel, Marx Theodosius *(1787–1856)*
[Dus.] p. 277.
Entries: 5 (lithographs only, to 1821). Millimeters (selection). Inscriptions (selection). Located (selection).

Veillat, Just *(fl. c.1840)*
[Ber.] XII, p. 184.*

Veith, [Johann] Philipp *(1768–1837)*
[Ap.] p. 441.
Entries: 4.*

Velaert, Dirk Jacobsz
See **Vellert**

Velázquez, Diego Rodríguez de Silva y *(1599–1660)*
Stirling-Maxwell, Sir William. *Essay towards a catalogue of prints engraved from the works of Diego Rodríguez de Silva y Velasquez and Bartolomé Estéban Murillo.* London: Privately printed for Sir W.S.M., 1873. 100 copies. (NN)
Entries: unnumbered, pp. 1–45, prints after. Inches. Described (selection). Ms. addition (EBM); index of engravers.

Curtis, Charles B. *Velasquez and Murillo; a descriptive and historical catalogue.* London: Sampson Low, Marston, Searle

Velázquez, Diego Rodríguez de Silva y (*continued*)

and Rivington; New York: J. W. Bouton, 1883.
Catalogue of paintings; prints after are mentioned where extant.

Loga, Valerian von: "Hat Velasquez radiert?" [*JprK.*] 29 (1908): 165–168.
Entries: 1. Described. Illustrated. Located. Attempt to attribute an etching to Velasquez.

Velde, ——— van de (*fl. c.1813*)
[Dus.] p. 278.
Entries: 1 (lithographs only, to 1821).

Velde, Adriaen van de (*1636–1672*)
[B.] I, pp. 211–228.
Entries: 21. Pre-metric. Inscriptions. Described. Copies mentioned.

[Weigel] pp. 26–30.
Entries: 4 (additional to [B.]). Pre-metric. Inscriptions. Described.

[Wess.] II, p. 260.
Additional information to [B.] and [Weigel].

[Dut.] VI, pp. 450–461.
Entries: 26. Millimeters. Inscriptions. States. Described. Illustrated (selection).

[W.] II, pp. 748–750.
Entries: 26+ prints by, 42 after.*

Velde, Bram van (*b. c.1910*)
Bram van Velde. Turin: Edizioni d'Arte Fratelli Pozzo, n.d. 1500 copies. (ERB)
Entries: 10 (to 1959; complete?). Illustrated. Also, catalogue of paintings and gouaches, to 1960: prints after are mentioned where extant.

Worpsweder Kunsthalle [Hans Herman Rief, compiler]. *Das graphische Werk Bram van Velde.* Worpswede (West Germany), 1969. 1000 copies. (MH)

Entries: 52 (to 1969). Millimeters. Described. Illustrated.

Velde, Esaias I van de (*c.1591–1630*)
[W.] II, pp. 751–752.
Entries: 11+ prints by, 4 after.*

[Burch.] pp. 151–170.
Entries: 38+ prints by, 10 copies and prints after. Millimeters. Inscriptions. States. Described. Located.

Velde, Henry van de (*1863–1957*)
Hammacher, A. M. *Le monde de Henry van de Velde.* Antwerp (Belgium): Edition fonds Mercator; Paris: Librairie Hachette, 1967. Flemish ed. *De wereld van Henry van de Velde;* (not seen).
Entries: 3. Millimeters. Inscriptions. Illustrated (selection). Located.

Velde, Jan II van de (*c.1593–1641*)
Franken, D., and van der Kellen, J. Ph. *L'Oeuvre de Jan van de Velde.* Amsterdam: Frederik Muller et Cie; Paris: Rapilly, 1883. Reprint. Amsterdam: G. W. Hissink en Co., 1968.
Entries: 488 prints by, 39 doubtful prints, 5 prints after. Millimeters. Inscriptions. States. Described. Ms. notes (ERB); additional states, 1 additional entry. Ms. note (EA); mentions additional prints. 1968 reprint includes Laschitzer (see below).

Laschitzer, Simon. "Litteraturbericht: L'Oeuvre de Jan van de Velde décrit par D. Franken Dz. et J. Ph. van der Kellen." [*Rep. Kw.*] 7 (1884): 120–125.
Additional information to Franken and van der Kellen.

[W.] II, pp. 752–754.
Entries: 488 prints by, 3 after.*

Velde, Jan IV [Johan] van de (*d. 1686*)
[W.] II, p. 754.
Entries: 3.*

Velde, Justus van de *(fl. 1686–1695)*
[W.] II, p. 754.
 Entries: 1 print after.*

Velde, Willem I van de *(1611–1693)*
[W.] II, pp. 755–756.
 Entries: 1 print after.*

Velde, Willem II van de *(1633–1707)*
[W.] II, pp. 756–757.
 Entries: 13 prints after.*

Velden, Georg van de *(fl. c.1597)*
[W.] II, p. 752.
 Entries: 3.*

Veldener, Johan *(d. after 1501)*
[W.] II, p. 757.
 Entries: 3.*

Vellert, Dirk Jacobsz. *(fl. 1511–1544)*
[B.] VIII, pp. 26–34.
 Entries: 19. Pre-metric. Inscriptions.
 Described. Copies mentioned.

[P.] III, pp. 23–24.
 Entries: 1 (additional to [B.]). Inscrip-
 tions. Described. Located.

[Dut.] VI, pp. 302–306.
 Entries: 19 etchings and engravings, 1
 woodcut. Millimeters. Inscriptions.
 Described. Also, list of 5 prints from
 [Heinecken] (titles only).

[W.] II, pp. 746–748.
 Entries: 30+ prints by, 1 after.*

Popham, A. E. "The engravings and
woodcuts of Dirick Vellert." [PCQ.] 12
(1925): 343–368.
 Entries: 21 prints by, 1 doubtful print.
 Millimeters. Inscriptions. States. De-
 scribed (selection). Illustrated (selec-
 tion). Located. All prints not illus-
 trated are described.

Velsen, J. E. *(fl. c.1631)*
[W.] II, p. 758.
 Entries: 1 print after.*

Velt, ——— van *(19th cent.)*
[H. L.] p. 1056.
 Entries: 2. Millimeters. Inscriptions.
 Described.

Velten, ——— *(19th cent.)*
[Dus.] p. 278.
 Entries: 1+ (lithographs only, to 1821).

Vendramini, Francesco *(1780–1856)*
[Ap.] p. 442.
 Entries: 6.*

Vendramini, Giovanni [John] *(1769–1839)*
[Ap.] p. 442.
 Entries: 8.*

Veneziano, Agostino [Agostino dei Musi]
(c.1490–after 1536)
 [B.] XIV: *See* **Raimondi,** Marcantonio

[Evans] p. 18.
 Entries: 2 (additional to [B.]). Millime-
 ters. Inscriptions. Described.

[P.] VI, pp. 49–66.
 Entries: 188 (new numbering, revision
 of [B.]). Pre-metric. Inscriptions
 (selection). States. Described (selec-
 tion). Only entries additional to [B.]
 are fully catalogued.

[Wess.] III, p. 51.
 Entries: 1 (additional to [B.]). Millime-
 ters. Inscriptions. Described. Lo-
 cated. Additional information to [B.].

[Dis. 1927].
 Additional information to [B.].

[Dis. 1929].
 Additional information to [B.].

Venius
See **Veen**

Venne, Adriaen Pietersz van de
(1589–1662)
 Franken, S. *Adriaen van de Venne.* Am-
 sterdam: C. M. van Gogh; Paris: Rapilly,
 1878.

Venne, Adriaen Pietersz van de (*continued*)

Entries: 59 prints after, 16 books with illustrations by. Millimeters (selection). Inscriptions (selection). Described (selection). Ms. notes by J. C. J. Bierens de Haan (ERB); additional states.

[W.] II, pp. 758–760.
Entries: 19 prints after.*

Vennekamp, Johannes (*20th cent.*)
Ohff, Heinz, and Ohff, Christiane. *Johannes Vennekamp; Reklame für mich.* Einzelkatalog zum Oeuvreverzeichnis "7 Jahre Werkstatt Rixdorfer Drucke Berlin." Hamburg: Merlin Verlag, 1970. (EBKk)
Entries: unnumbered, 31 pp. (to 1970). Millimeters (selection). Illustrated.

Venninger, Nannette (*fl. c.1818*)
[Dus.] p. 278.
Entries: 1 (lithographs only, to 1821). Millimeters. Inscriptions. Located.

Verbeeck [**Verbeecq**], Pieter Cornelisz (*c.1610–before 1654*)
[Rov.] pp. 79–81.
Entries: 10. Millimeters (selection). Inscriptions (selection). Described (selection). Illustrated. Located.

[W.] II, pp. 761–762.
Entries: 9.*

Gerson, Horst: "Leven en werken van den paardenschilder Pieter Verbeeck, echtgenoot van Elizabeth van Beresteyn." In *Genealogie van het geslacht van Beresteyn*, by E. A. van Beresteyn and W. F. del Campo Hartman, pp. 179–220. The Hague, 1941–1954. (ERB)
Entries: 15. Millimeters. Inscriptions. States. Described. Illustrated. Located.

Verboeckhoven, Eugène Joseph (*1799–1881*)
[H. L.] pp. 1056–1070.
Entries: 53 (etchings only, a few lithographs are mentioned). Millimeters. Inscriptions. States. Described.

Verboom, Adriaen Hendriksz (*c.1628–c.1670*)
[B.] IV, pp. 73–76.
Entries: 2. Pre-metric. Inscriptions. States. Described.

[Weigel] pp. 156–157.
Additional information to [B.].

[Heller] p. 122.
Additional information to [B.].

[Wess.] II, p. 260.
Additional information to [B.].

[Dut.] IV, pp. 461–463.
Entries: 4. Millimeters. Inscriptions. States. Described.

[W.] II, pp. 762–763.
Entries: 4 prints by, 2+ after.*

Verburcht, Augustyn Jorisz (*c.1525–1552*)
[W.] II, p. 764.
Entries: 1.*

Vercruys, Theodor
See **Verkruys**

Verdeil, Pierre (*b. 1812*)
[Ber.] XII, pp. 184–185.*

Verdier, François (*1651–1730*)
[RD.] VIII, pp. 280–284.
Entries: 5. Millimeters. Inscriptions. States. Described.

Verelst, Herman (*c.1641/42–c.1690*)
[W.] II, p. 766.
Entries: 3 prints after.*

Verelst, Johannes *(fl. 1691–1719)*
[W.] II, p. 766.
Entries: 1+ prints after.*

Verger, Peter C. *(fl. 1796–1806)*
[St.] p. 551.*

Vergnes, Camille *(fl. c.1881)*
[Ber.] XII, p. 185.*

Verhaecht, Tobias van *(1561–1631)*
[W.] II, pp. 767–768.
Entries: 4 prints after.*

Verhoeven-Ball, Adrien Joseph
(1824–1882)
[H. L.] pp. 1070–1074.
Entries: 15. Millimeters. Inscriptions.
States. Described.

Verhulst, Charles Pierre *(1774–1820)*
[W.] II, p. 770.
Entries: 1 print after.*

Verhulst, Rombout *(1624–1698)*
[W.] II, p. 771.
Entries: 1 print after.*

Verico, Antonio *(b. c.1775)*
[Ap.] p. 443.
Entries: 6.*

Verkolje, Jan I *(1650–1693)*
Wessely, J. E. "Jan Verkolje, Ver-
zeichniss seiner Schabkunstblätter," [N.
Arch.] 14 (1868): 81–98.
Entries: 49 prints by, 7 doubtful and
rejected prints. Pre-metric. Inscrip-
tions. States. Described.

[Sm.] III, pp. 1422–1423, and "additions
and corrections" section.
Entries: 5 (portraits only). Inches. In-
scriptions. States. Described. Illus-
trated (selection).

[W.] II, pp. 771–772.
Entries: 49+ prints by, 2 after.*

[Ru.] p. 338.
Additional information to [Sm.].

Verkolje, Jan II *(fl. c.1707)*
[W.] II, p. 772.
Entries: 4.*

Verkolje, Nicolaas *(1673–1746)*
Wessely, J. E. "Nicolas Verkolje, Ver-
zeichniss seiner Schabkunstblätter." [N.
Arch.] 14 (1868): 99–115; (see also p. 271).
Entries: 38 prints by, 6 doubtful and
rejected prints. Pre-metric. Inscrip-
tions. States. Described.

[W.] II, pp. 772–773.
Entries: 37 prints by, 4+ after.*

Verkruys, Theodor *(d. 1739)*
[W.] II, pp. 773–774.
Entries: 8.*

Verlat, Charles *(1824–1890)*
[H. L.] pp. 1074–1077.
Entries: 8. Millimeters. Inscriptions.
States. Described.

Verly, François *(1760–1822)*
[W.] II, p. 774.
Entries: 1.*

Vermeulen, Cornelis *(c.1644–c.1708/09)*
[W.] II, pp. 777–778.
Entries: 75+.*

Vermeyen, Jan Cornelisz *(c.1500–1559)*
[P.] III, pp. 103–105.
Entries: 11 prints by, 3 prints not seen
by [P.]. Pre-metric. Inscriptions. De-
scribed. Located (selection).

[W.] II, pp. 778–780.
Entries: 15.*

Popham, A. E. "Catalogue of the etch-
ings of Jan Cornelisz Vermeyen."
[Oud-Holl.] 44 (1927): 174–182.

Vermeyen, Jan Cornelisz (*continued*)

Entries: 27 prints by, 3 doubtful prints. Millimeters. Inscriptions. Described. Illustrated (selection). Located.

Vermont, Nicolae (*1886–1932*)
Pavel, Amelia, and Ionescu, Radu. *Nicolae Vermont.* Bucharest (Romania): Editura Academiei Republicii Populare Romîne, 1958. (EPBN)
Entries: 65. Millimeters. Illustrated (selection).

Vermorcken, Édouard (*fl. 1840–1895*)
[W.] II, p. 780.
Entries: 1.*

Verneilh, Jules de (*fl. c.1867*)
[Ber.] XII, p. 186.*

Vernet, Carle [Antoine Charles Horace] (*1758–1836*)
[Ber.] XII, pp. 186–210.
Entries: 891 prints by and after. Paper fold measure.

Colin, Paul. *Collection de Rosen; catalogue analytique de l'oeuvre de Carle Vernet.* Brussels: Editions de la Galerie Giroux, 1923.
Entries: 230+ prints by and after. Millimeters. Illustrated (selection). Sale catalogue of an extensive collection, with an appendix listing 38+ prints not included (titles only). Incomplete listing of states.

Dayot, Armand. *Carle Vernet, étude sur l'artiste suivie d'un catalogue de l'oeuvre gravé et lithographié.* Paris: Le Goupy, 1925.
Entries: 242 prints by and after. Millimeters (selection). Paper fold measure (selection). Inscriptions. States. Illustrated (selection).

Vernet, Fanny Catherine Françoise Moreau (*b. c.1770*)
[Ber.] XII, p. 210.*

Vernet, [Émile Jean] Horace (*1789–1863*)
Bruzard, L. M. *Catalogue de l'oeuvre lithographique de Mr. J. E. Horace Vernet.* Paris: J. Gratiot, 1826. 30 copies. (NN)
Entries: 204 (to 1826). Pre-metric. Millimeters. Inscriptions. Described. Ms. notes and addition (EPBN) by Bruzard and by Joseph de La Combe. Ms. addition (NN); 30+ additional entries. Also, an autograph letter from Bruzard.

[Ber.] XII, pp. 210–223.
Entries: 227. Paper fold measure (selection). Also, selection of prints after.

Vernet, [Claude] Joseph (*1714–1789*)
[Baud.] I, pp. 59–64.
Entries: 5. Millimeters. Inscriptions. Described.

Vernier, Charles (*1831–1877*)
[Ber.] XII, p. 224.*

Vernier, Émile Louis (*1829–1887*)
[Ber.] XII, pp. 225–227.*

Vernon, Thomas (*1825–1872*)
[Ap.] p. 443.
Entries: 4.*

Verrocchio, Andrea del (*1436–1488*)
[P.] V, pp. 52–54.
Entries: 3. Pre-metric. Described. Located.

Verschuring, Hendrik (*1627–1690*)
[B.] I, pp. 123–128.
Entries: 4. Pre-metric. Inscriptions. Described.

[Weigel] p. 17.
Additional information to [B.].

[Wess.] II, p. 261.
Entries: 1 (additional to [B.] and [Weigel]). Millimeters. Described. Located.

[Dut.] VI, pp. 463–465.
Entries: 7. Millimeters. Inscriptions. States. Described.

[W.] II, pp. 781–782.
Entries: 7 prints by, 5+ after.*

Verschuring, Willem *(1657–1715)*
[W.] II, p. 782.
Entries: 2.*

Verspronck, Jan Cornelisz *(1597–1662)*
[W.] II, p. 783.
Entries: 1+ prints after.*

Verspuy, Gysbert Jan *(1823–1862)*
[H. L.] pp. 1077–1083.
Entries: 23. Millimeters. Inscriptions. States. Described.

Verster, Floris *(1861–1927)*
Scheron, W. *Floris Verster, 9 Juni 1861–21 Januari 1927; volledige geïllustreerde catalogus van zijn schilderijen, waskrijt- en waterverfteekeningen, en grafisch werk.* Utrecht: W. Scheron, 1928, 150 copies. (EBM)
Entries: 20. Millimeters. Illustrated.

Verstralen, Hendrik Jansz *(fl. 1588–1635)*
[W.] II, p. 784.
Entries: 2.*

Vertès, Marcel *(b. 1895)*
Hesse, Raymond. "Marcel Vertès." [*AMG.*] 2 (1928–1929): 709–718.
Bibliography of books with illustrations by (to 1927).

Salmon, André. *Marcel Vertès.* Les artistes du livre, 17. Paris: Henry Babou, 1930. 750 copies. (NN)
Bibliography of books with illustrations by (to 1930).

Vokaer, Michel. *Bibliographie de Marcel Vertès.* Brussels: Émile Relecom, 1967. 483 copies. (NN)
Bibliography of books, albums, etc. with illustrations by.

Vertommen, Willem Joseph *(b. 1815)*
[H. L.] pp. 1083–1093.
Entries: 32. Millimeters. Inscriptions. States. Described.

Vertue, George *(1684–1756)*
"Catalogue of portraits by Vertue." Unpublished ms., 19th cent. (EBM)
Entries: unnumbered, 42 pp. (portraits only). Described (selection).

[Sm.] III, pp. 1423–1424, and "additions and corrections" section.
Entries: 1 (mezzotint portraits only). Inches. Inscriptions. Described.

[Ru.] p. 338.
Additional information to [Sm.].

Verveer, Adriaen [Ary] Huybertsz *(d. 1680)*
[W.] II, pp. 784–785.
Entries: 1 print after.*

Vervoort, Michiel Frans van der
See **Voort**

Verwée, Alfred Jacques *(1838–1895)*
[H. L.] p. 1093.
Entries: 2. Millimeters. Inscriptions. States. Described.

Verwer, Abraham, *(d. 1650)*
[W.] II, p. 785.
Entries: 1 print after.*

Verwilt, François *(c.1620–1691)*
[W.] II, pp. 785–786.
Entries: 1 print after.*

Verzwyvel, Michael Karel Antoon
(1819–1868)
[Ap.] p. 443.
Entries: 1.*

Vespré, Victor
See **Vispré**

Veth, Jan Pieter *(1864–1925)*
Huizinga, J. *Leven en werk van Jan Veth.*
Haarlem (Netherlands): H. D. Tjeenk
Willink en Zoon, 1927.
Entries: 965 paintings and prints. Located (selection).

Veyrassat, Jules Jacques *(1828–1893)*
[Ber.] XII, pp. 227–228.
Entries: 63. Paper fold measure (selection).

Vèze, [Jean] Charles Chrysostome
Pacharman, baron de *(1788–1855)*
[Ber.] XII, p. 229.*

Vianden, Heinrich [Henry] *(b. 1814)*
[H. L.] pp. 1094–1098.
Entries: 15. Millimeters. Inscriptions.
States. Described.

Vianen, Adam van *(c.1593–1627)*
[W.] II, p. 786.
Entries: 1+ prints after.*

Vianen, Berthold van *(fl. c.1606)*
[W.] II, p. 787.
Entries: 1 print after.*

Vianen, Jan van *(c.1660–after 1726)*
[W.] II, p. 787.
Entries: 16+.*

Viani, Domenico Maria *(1668–1711)*
[B.] XII: *See* **Chiaroscuro Woodcuts**

[B.] XIX, pp. 432–434.
Entries: 1 print by, 1 print not seen by
[B.]. Pre-metric. Inscriptions. Described.

Viani, Giovanni Maria *(1636–1700)*
[B.] XIX, pp. 308–312.
Entries: 4 prints by, 5 prints not seen
by [B.]. Pre-metric. Inscriptions. Described.

Vibert, Jehan Georges *(1840–1902)*
[Ber.] XII, p. 230.*

Vibert, Remy
See **Vuibert**

Vibert, Victor *(1799–1860)*
[Ap.] p. 443.
Entries: 3.*

[Ber.] XII, p. 229.*

Vicentino, Andrea
See **Michieli**

Vicentino, Niccolò [Giuseppe Nicola
Rossigliani] *(16th cent.)*
[B.] XII: *See* **Chiaroscuro Woodcuts**

Baseggio, Giambattista. *Intorno tre
celebri intagliatori in legno vicentini memoria.* Bassano (Italy): Topografia Baseggio, 1844. (EFKI)
Entries: 7. Pre-metric. Inscriptions.
Described.

[P.] VI: *See* **Chiaroscuro Woodcuts**

Vico, Enea *(1523–1567)*
[B.] XV, pp. 275–370.
Entries: 494 prints by, 2+ rejected
prints. Pre-metric. Inscriptions.
States. Described. Copies mentioned.

[Evans] pp. 19–20.
Entries: 5 (additional to [B.]). Millimeters. Inscriptions. Described.

[P.] VI, pp. 121–124.
Entries: 9 (additional to [B.]). Premetric. Inscriptions. States. Described. Additional information to
[B.].

[Wess.] III, p. 55.
Additional information to [B.].

[Dis. 1927].
Additional information to [B.].

Victor, —— *(fl. 1830–1840)*
[Ber.] XII, p. 230.*

Victoria, Queen of England *(1819–1901)*
Scott-Elliot, A. H. "The etchings by
Queen Victoria and Prince Albert."
Bulletin of the New York Public Library 65
(1961): 139–153.
Entries: 62 etchings by, 2 doubtful
etchings, 3 lithographs. Millimeters.
Inscriptions. Described. Located
(selection).

Victors, Jan [Johan] *(1620–1676)*
[W.] II, pp. 788–789.
Entries: 8 prints after.*

Vidal, Géraud *(1742–1801)*
[L. D.] pp. 81–83.
Entries: 5. Millimeters. Inscriptions.
States. Described. Incomplete cata-
logue.*

Vidal, [Marie Louis] Pierre *(1848–1929)*
[Ber.] XII, pp. 231–233.*

Viel, Pierre *(1755–1810)*
[Ap.] p. 444.
Entries: 6.*

Viel-Castel, Horace, comte de *(1798–1864)*
[Ber.] XII, p. 233.*

Vien, Joseph Marie *(1716–1809)*
[Baud.] I, pp. 65–81; errata, p. i.
Entries: 40. Millimeters. Inscriptions.
States. Described.

Vierge, Daniel
See **Urrabieta y Vierge,** Daniel

Viette, P. A. *(fl. c.1850)*
[H. L.] pp. 1099–1103.
Entries: 20. Millimeters. Inscriptions.
States. Described.

Vigne, Édouard de *(1808–1866)*
[H. L.] pp. 1107–1108.
Entries: 4. Millimeters. Inscriptions.
States. Described.

Vigneron, Pierre Roch *(1789–1872)*
[Ber.] XII, pp. 239–241.*

Vignocchi, Michele *(fl. 1837–1842)*
[Ap.] p. 444.
Entries: 1.*

Vignon, Claude *(1593–1670)*
[RD.] VII, pp. 148–157; XI, pp. 316–318.
Entries: 31. Millimeters. Inscriptions.
States. Described.

Vignon, [Henri François] Jules de
(1815–1885)
[Ber.] XII, p. 241.*

Viguier, Constant *(b. 1799)*
[Ber.] XII, p. 241.*

Viktor, Knud *(20th cent.)*
Andersson, Egart. "Knud Viktor, en
dansk grafiker." [*N. ExT.*] 9 (1957): 119–
121, 126, 128.
Entries: 8 (bookplates only, to 1957).
Illustrated (selection).

Villa, Georges *(b. 1883)*
Villa, Nicole. "Georges Villa, carica-
turiste et illustrateur." [*Vieux P.*] 61
(1960): 321–336, 353–368.
Entries: 329 prints by and after. Milli-
meters (selection). Described (selec-
tion). Also, bibliography of books
with illustrations by.

Villemin, Charles *(fl. 1835–1849)*
[Ber.] XII, p. 242.*

Villeneuve, Jules Louis Frédéric *(1796–1842)*
[Ber.] XII, pp. 242–243.*

Villequin, Étienne *(1619–1688)*
[RD.] VIII, p. 259.
 Entries: 1. Described.

Villeret, François Étienne *(c.1800–1866)*
[Ber.] XII, p. 243.*

Villerey, Antoine Claude François *(1754–1828)*
[Ber.] XII, p. 244.*

Villevieille, Léon *(1826–1863)*
[Ber.] XII, p. 244.*

Villiez, ——— *(18th cent.)*
Beaupré, J. N. "Notice sur quelques graveurs nancéiens du XVIIIe siècle et sur leurs ouvrages." [*Mém. lorraine*] 2d ser. 9 (1867): 240–248. Separately published. n.p., n.d.
 Entries: 12. Millimeters. Inscriptions. Described.

Villon, Jacques [Gaston Duchamp] *(1875–1963)*
Auberty, Jacqueline, and Pérussaux, Charles. *Jacques Villon, catalogue de son oeuvre gravé.* Paris: Paul Prouté et ses Fils, 1950. 150 copies. (MB)
 Entries: 551. Millimeters. States. Illustrated.

Rouir, E. "Une lithographie non décrite de Jacques Villon." *Le livre et l'estampe,* no. 39–40 (1964): 276–277.
 Entries: 1 (additional to Auberty and Pérussaux). Described. Illustrated.

Lucien Goldschmidt, Inc., New York. *Jacques Villon; a collection of graphic work 1896–1913 in rare or unique impressions.* New York, 1970.
 Additional information (including additional entries) to Auberty and Pérussaux.

Villot, Frédéric *(1809–1875)*
[Ber.] XII, pp. 244–245.*

Vilsteren, Joannes van *(fl. 1723/4–1750)*
[W.] II, p. 790.
 Entries: 12.*

Vimont, Alexandre *(1822–1905)*
[Ber.] XII, p. 245.*

Vincent, François André *(1746–1816)*
[Baud.] I, pp. 297–299.
 Entries: 2. Millimeters. Inscriptions. Described.

Vincent, William *(fl. c.1690)*
[Sm.] III, pp. 1424–1427, and "additions and corrections" section.
 Entries: 16 (portraits only). Inches. Inscriptions. States. Described. Located (selection).

[Ru.] p. 338.
 Additional information to [Sm.].

Vinci, Leonardo da *(1452–1519)*
[P.] V, pp. 179–184.
 Entries: 10 doubtful prints. Pre-metric. Inscriptions. States. Described. Located.

Blum, André: "Léonard de Vinci graveur." [*GBA.*] 6th ser. 8 (1932): 89–104.
 Entries: 5 prints by, 3 after, 3 prints from studio, 2 rejected prints. Millimeters. States. Described. Illustrated (selection). Located.

[Hind] V, pp. 83–95.
 Entries: 24 prints after, or closely related to. Millimeters. Inscriptions. States. Described. Illustrated. Located.

Vincidor, Tommaso di Andrea *(d. c.1536)*
See also **Master of the DIE**

[W.] III, p. 173.
 Entries: 1 print after.*

Vinck, Abraham *(c.1580–before 1621)*
[W.] II, p. 790.
Entries: 2 prints after.*

Vinck, Baron de *(b. 1808)*
[H. L.] pp. 1104–1105.
Entries: 5. Millimeters. Inscriptions.
Described.

Vinckeboons, David I *(1576–1629)*
[W.] II, pp. 790–792.
Entries: 7 prints by, 39+ after.*

Vingles, Juan de *(fl. c.1550)*
Thomas, Sir Henry. *Juan de Vingles ilus-*
trador de libros españoles en el siglo XVI.
Valencia (Spain): Editorial Castalia,
1949. 400 copies. (DLC)
Entries: 108. Millimeters. Illustrated
(selection). Books where the prints
appear are identified.

Vinkeles, Reinier *(1741–1816)*
[W.] II, p. 793.
Entries: 47.*

Vinne, Isaac *(1665–1740)*
[W.] II, p. 794.
Entries: 2+.*

Vinne, Jan I, *(1663–1721)*
[W.] II, pp. 793–794.
Entries: 4+.*

Vinne, Jan III van der *(1734–1805)*
[W.] II, p. 793.
Entries: 2.*

Vinne, Laurens II *(1712–1742)*
[W.] II, p. 794.
Entries: 1 print after.*

Vinson, Ludovicus
See **Finsonius**

Vintraut, Frédéric *(19th cent.)*
[Ber.] XII, p. 245.*

Violet, Pierre Noël *(1749–1819)*
Bruel, François L. "Catalogue de
l'oeuvre peint, dessiné et gravé de Pierre
Noël Violet (1749–1819)." *Archives de l'art*
français, n.s. 1 (1907): 367–408.
Entries: 26 prints by and after. Milli-
meters. Inscriptions. States. De-
scribed. Located.

Viollet-le-Duc, Eugène Emanuel
(1814–1879)
[Ber.] XII, pp. 245–248.*

Vion, Henri Félix *(c.1854–1891)*
[Ber.] XII, pp. 248–249.*

Virbent, Gaston *(fl. c.1830–1878)*
[Ber.] XII, p. 249.*

Vischer
See also **Visscher**

Vischer, Georg *(fl. 1625–1637)*
[A.] V, pp. 123–126.
Entries: 2. Pre-metric. Inscriptions.
Described.

Vischer, Hans [Johannes] *(c.1489–1550)*
Röttinger, Heinrich. *Dürers Doppel-*
gänger. Studien zur deutschen
Kunstgeschichte, 235. Strasbourg: J. H.
Ed. Heitz, 1926.
Entries: unnumbered, pp. 284–286
(works in various media, including
prints). Illustrated (selection).

[Ge.] nos. 786–807.
Entries: 22 (single-sheet woodcuts
only). Described. Illustrated. Located.

Vischer, Hermann II *(c.1486–1517)*
See **Master of the Woodcuts for the**
Comedies of HROSVITHA

Vischer, Peter I *(c.1460–1529)*
Röttinger, Heinrich. *Dürers Doppel-*
gänger. Studien zur deutschen

Vischer, Peter I *(continued)*

Kunstgeschichte, 235. Strasbourg: J. H. Ed. Heitz, 1926.
Entries: unnumbered, pp. 280–284 (works in various media, including prints). Illustrated (selection).

Vischer, Peter II *(1487–1528)*
Röttinger, Heinrich. *Dürers Doppel-gänger.* Studien zur deutschen Kunstgeschichte, 235. Strasbourg: J. H. Ed. Heitz, 1926.
Entries: unnumbered, p. 286 (works in various media, including prints). Illustrated (selection).

[Ge.] no. 808.
Entries: 1 (single-sheet woodcuts only). Described. Illustrated. Located.

Viset, Jean *(fl. c.1536)*
Arnauldet, Thomas. "Noel Garnier et Jean Viset." *Archives de l'art français,* 2d ser. 1 (1861): 357–369.
Entries: 25 prints by and after. Milli-meters. Inscriptions. Described.

Vispré, Victor *(fl. 1762–1789)*
[Sm.] III, p. 1428.
Entries: 3 (portraits only). Inches. In-scriptions. States. Described.

[Ru.] p. 338.
Additional information to [Sm.].

Visscher, Claes Jansz [Nicolas Joannis] *(c.1550–c.1612)*
[W.] II, pp. 795–796.
Entries: 28+.*

Simon, Maria. "Claes Jansz. Visscher." Dissertation, Freiburg University, 1958. Mimeographed. (ERKD)
Entries: 306. Millimeters. Inscrip-tions. States. Located (selection).

Visscher, Cornelis *(c.1520–1586)*
[W.] II, p. 796.
Entries: 2 prints after.*

Visscher, Cornelis *(c.1619–1662)*
Hecquet, R. *Catalogue des estampes gravées d'après Rubens, auquel on a joint l'oeuvre de Jordaens et celle de Visscher.* Paris: Briasson, 1751.
Entries: 52 subject prints, 99 portraits. Pre-metric. Inscriptions. Described (selection).

Basan, F. *Dictionnaire des graveurs anciens et modernes . . . suivi des catalogues des oeuvres de Jacques Jordans, et de Corneille Visscher.* 2 vols. Paris: De Lormel [etc.], 1767. Catalogue is separately paginated at end of vol. 2.
Entries: 92 prints by, 6 rejected prints. Pre-metric. Inscriptions (selection). Described (selection). Based on Hec-quet, with additional information.

"Portraitten gesneden door Cornelis Visser met de prijzen en zijn prenten van onder." Unpublished ms., 18th cent.? (ERB)
Entries: unnumbered, 45 pp. Prices from period 1745–1755 are given.

Smith, ———. "Corneille Visscher, 1629–1658," [*Cab. am. ant.*] 4 (1845–1846): 339–368.
Entries: 183. Millimeters. Inscriptions. States. Described.

Smith, William. *A catalogue of the works of Cornelius Visscher.* Extract from the *Fine Arts Quarterly Review.* Bungay (En-gland): John Childs and Son, 1864. (NN)
Entries: 198. Inches. Inscriptions. States. Described.

Wussin, Johann. *Cornel Visscher, Ver-zeichniss seiner Kupferstiche.* Leipzig: Ru-dolph Weigel, 1865.
Entries: 188 prints by, 16 doubtful and rejected prints. Inches. Millimeters. Inscriptions. States. Described.

[Wess.] II, p. 261.
Additional information to Wussin.

[Dut.] VI, pp. 465–528.

Entries: 198. Millimeters. Inscriptions. States. Described.

[W.] II, pp. 796–799.
Entries: 185 prints by, 11+ after.*

Visscher, Jan [Johannes] de
(c.1636–after 1692)
Wessely, J. E. "Jan de Visscher; Verzeichniss seiner Kupferstiche." [*N. Arch.*] 11 (1865): 113–191. Separately published. *Jan und Lambert Visscher; Verzeichniss ihrer Kupferstiche.* Leipzig: Rudolph Weigel, 1866.
Entries: 157 prints by, 20 doubtful and rejected prints. Pre-metric. Inscriptions. States. Described.

[Wess.] II, p. 261.
Additional information to Wessely in [*N. Arch.*].

[Dut.] VI, pp. 529–532.*

[W.] II, pp. 799–800.
Entries: 157+.*

Visscher, Lambert *(1633–after 1690)*
Wessely, J. E. "Lambert Visscher; Verzeichnis seiner Kupferstiche." [*N. Arch.*] 11 (1865): 192–206. Separately published. *Jan und Lambert Visscher; Verzeichniss ihrer Kupferstiche.* Leipzig: Rudolph Weigel, 1866.
Entries: 31. Pre-metric. Inscriptions. States. Described.

[Wess.] II, p. 261.
Additional information to Wessely in [*N. Arch.*].

[Dut.] VI, p. 532.*

[W.] II, pp. 800–801.
Entries: 31.*

Visscher, Nicolas *(1618–1709)*
[W.] II, p. 801.
Entries: 4.*

Vissec, Astruc de *(fl. c.1760)*
[M.] II, p. 358.
Entries: 7. Millimeters.

Visselet, M. *(17th cent.)*
[RD.] III, pp. 21–31; XI, pp. 318–319.
Entries: 46. Pre-metric. Inscriptions. Described.

Vita, Luciano de *(b. 1929)*
Emiliani, Andrea. *Le acqueforti di Luciano de Vita.* Bologna: Edizioni Alfa, 1964. 287 copies. (NNMo)
Entries: 119 (to 1964). Millimeters. Described. Illustrated.

Vitali, Pietro Marco *(c.1755–c.1810)*
[Ap.] p. 444.
Entries: 11.*

Vitringa, Wigerus *(1657–1721)*
[W.] II, p. 801.
Entries: 1 print after.*

Vivant-Denon, Dominique, baron
See **Denon**

Vivarès, François *(1709–1780)*
Vivarez, Henry. *Pro Domo mea; un artiste graveur au XVIIIe siècle, François Vivarès.* Lille (France): Imprimerie Lefebvre-Ducrocq, 1904.
Entries: 102. Inscriptions (selection). Described (selection). Located (selection).

Vivarès, Thomas *(b. c.1735)*
Vivarez, Henry. *Pro Domo mea; un artiste graveur au XVIIIe siècle, François Vivarès.* Lille (France): Imprimerie Lefebvre-Ducrocq, 1904.
Entries: 10. Inscriptions (section). Described (selection). Located (selection).

Viviani, Antonio *(1797–1854)*
[Ap.] pp. 445–446.
Entries: 13.*

Viviani, Giuseppe *(b. 1899)*
Santini, Pier Carlo. *L'Opera grafica di Viviani.* Ivrea (Italy): Centro Culturale Canavesano, 1958.
Entries: 103 (to 1957). Millimeters. Illustrated (selection).

Chiara, Piero. *Giuseppe Viviani, opera grafica.* Padua: Bino Rebellato, 1960.
Entries: 98 (monochrome etchings only). Millimeters. Inscriptions. States. Described. Illustrated. Different states of the same print are separately numbered.

Opera Bevilacqua la Masa, Venice [Giorgio Trentin, compiler]. *Incisioni e litografie di Giuseppe Viviani, mostra antologica.* Venice, 1964. 700 copies. (DLC)
Entries: 95 etchings, 60 lithographs (to 1964). Millimeters. States. Illustrated (selection).

Vizentini, Augustin *(1780–1836)*
[Ber.] XII, p. 249.*

Vlaanderen, André *(b. 1881)*
Stainforth, A. G. *CLX Ex-librissen van André Vlaanderen.* Antwerp (Belgium): Boekuil en Karveel uitgaven, 1946. 800 copies. (DLC)
Entries: 160 (bookplates only, to 1945). Millimeters. Inscriptions. Described. Illustrated.

Vlaminck, Maurice de *(1876–1958)*
Kunstmuseum, Bern. *Vlaminck.* Bern, 1961.
Entries: 106 prints by, 3 posters. Millimeters. Located. Also, bibliography of books with illustrations by. Catalogue and bibliography are based on the catalogue in preparation by Dr. Sigmund Pollag, Zurich.

Vlerick, Pieter *(1539–1581)*
[W.] II, pp. 726–727.
Entries: 1.*

Vleughels, Nicolas *(1668–1737)*
[RD.] VIII, pp. 285–287.
Entries: 1. Millimeters. Inscriptions. Described.

[W.] II, p. 802.
Entries: 1.*

Bataille, Marie Louise. "Vleughels," in [Dim.] I, pp. 245–260.
Entries: 1 print by; 83 prints after lost works, and book illustrations. Millimeters (print by only).

Vlieger, Simon de *(c.1600–1653)*
[B.] I, pp. 21–36.
Entries: 20. Pre-metric. Inscriptions. Described.

[Weigel] pp. 3–4.
Additional information to [B.].

[Wess.] II, p. 262.
Additional information to [B.] and [Weigel].

[Dut.] VI, pp. 532–540.
Entries: 20. Millimeters. Inscriptions. States. Described.

[W.] II, pp. 803–804.
Entries: 21+ prints by, 7+ after.*

Vliet, Hendrik Cornelisz van [der] *(1611/12–1675)*
[W.] II, p. 804.
Entries: 7 prints after.*

Vliet, Jan Hendriksz *(fl. c.1670)*
[W.] II, p. 805.
Entries: 1+ prints after.*

Vliet, Jan Joris van *(b. c.1610)*
[Daulby] pp. 323–331.
Entries: 35. Inches. Inscriptions. Described.

[B. *Remb.*] II, pp. 61–93.
Entries: 92. Pre-metric. Inscriptions. States. Described.

Linck, J. F. "Bemerkungen und Zusätze zu dem Verzeichnisse von Bartsch über die Radirungen des Jan Georg van Vliet." [N. Arch.] 5 (1859): 285–294.
Entries: 4 prints by (additional to [B. Remb.]), 2 doubtful prints. Pre-metric. Inscriptions. States. Described.

[Wess.] II, p. 262.
Entries: 1 (additional to [B. Remb.] and Linck in [N. Arch.]). Millimeters. Inscriptions. Described. Additional information to [B. Remb.] and Linck in [N. Arch.].

[Dut.] VI, pp. 540–557.
Entries: 92. Millimeters. Inscriptions. States. Described. Appendix with 3 additional prints, not fully catalogued.

[Rov.] pp. 41–56.
Entries: 99 prints by, 35 doubtful prints. Millimeters. Inscriptions. States. Described. Illustrated. Located.

[W.] II, pp. 805–806.
Entries: 95+.*

Vliet, Willem Willemsz van [der] (c.1584–1642)
[W.] II, pp. 806–807.
Entries: 2 prints after.*

Vlindt, Paul
See Flindt

Vockerot, Vitus Jeremias (b. 1771)
[Dus.] p. 278.
Entries: 1 (lithographs only, to 1821). Millimeters. Inscriptions. Located.

Völlinger, Joseph (1790–1846)
[Dus.] p. 278.
Entries: 1 (lithographs only, to 1821). Paper fold measure.

Voerst, Robert van (1597–1635/36)
[W.] II, p. 807.
Entries: 23+.*

[Hind, Engl.] III, pp. 202–211.
Entries: 27. Inches. Inscriptions. States. Described. Illustrated (selection). Located.

Voet, Alexander I (1613–1689/90)
[W.] II, pp. 807–808.
Entries: 31.*

Voet, [Jakob] Ferdinand (1639–1700?)
[W.] II, p. 808.
Entries: 9 prints after.*

Vogel, ⸺ (19th cent.)
[Dus.] p. 278.
Entries: 1 (lithographs only, to 1821).

Vogel, Hermann (1856–1918)
[Ber.] XII, p. 249.*

Vogel, Johann Friedrich (1828–1895)
[Ap.] p. 446.
Entries: 4.*

Vogel, Louise (fl. c.1830)
[Ap.] p. 446.
Entries: 2.*

Vogel, [Georg] Ludwig (1788–1879)
[A. 1800] II, pp. 250–261.
Entries: 2. Pre-metric (selection). Inscriptions (selection). States. Described (selection). Also, list of 16 prints after (not fully catalogued).

Vogel von Vogelstein, Carl Christian (1788–1868)
[A. 1800] II, pp. 101–120
Entries: 5. Pre-metric. Inscriptions. Described. Also, list of 43 prints after (not fully catalogued).

Vogelaer, Pieter *(1641–c.1720)*
[W.] II, p. 809.
 Entries: 1.*

Vogeler, Heinrich Joh. *(1872–1942)*
Roeper, Adalbert. ''Das graphische
Werk Heinrich Vogelers.'' Supplement
to ''Heinrich Vogeler,'' by Karl Schaefer.
[*Kh.*] 8 (1916): 231–234, and Beilage 11
(November 1916). Separately published.
*Heinrich Vogeler; 48 Abbildungen seiner
Original-Radierungen.* Lübeck (Ger-
many): L. Möller, 1916.
 Entries: 53 (to 1916). Millimeters.
 States. Described. Illustrated (selec-
 tion).

Vogt, [Pierre] Charles *(fl. 1833–1882)*
[Ber.] XII, pp. 250–251.*

Vogt, Nikolaus *(1756–1836)*
[Dus.] pp. 278–279.
 Entries: 7+ prints by and after (litho-
 graphs only, to 1821). Millimeters
 (selection). Inscriptions.

Vogtherr, Heinrich I *(1490–1556)*
[P.] III, pp. 292–293.
 Entries: 3. Pre-metric. Inscriptions.
 Described. Located. Listed by [P.] as
 Monogram HS [Nagler, *Mon.*] III, no.
 1449.

[P.] III, pp. 344–348.
 Entries: 8+ (prints by Heinrich Vogt-
 herr I and II). Pre-metric (selection).
 Paper fold measure (selection). De-
 scribed (selection). Located (selec-
 tion). Copies mentioned.

[Ge.] nos. 1016–1020 (as **Satrapitanus**).
 Entries: 5 (single-sheet woodcuts
 only). Described. Illustrated. Located.

[Ge.] nos. 1421–1460.
 Entries: 40 (single-sheet woodcuts
 only). Described. Illustrated. Located.

Vogtherr, Heinrich II *(1513–1568)*
[P.] III, pp. 344–348.
 Entries: 8+ (prints by Heinrich Vogt-
 herr I and II). Pre-metric (selection).
 Paper fold measure (selection). In-
 scriptions (selection). Described
 (selection). Located (selection).
 Copies mentioned.

[Ge.] nos. 1461–1480.
 Entries: 20 (single-sheet woodcuts
 only). Described. Illustrated. Located.

Voigt, Moritz *(fl. 1840–1881)*
[Ap.] p. 446.
 Entries: 4.*

Vois, Ary [Arie] de *(c.1632–1680)*
[W.] II, pp. 809–810.
 Entries: 7 prints after.*

Voisin, Henri *(b. 1861)*
[Ber.] XII, p. 251.*

Volkert, August *(b. 1818)*
[Ap.] p. 447.
 Entries: 4.*

Volkmer, Tobias *(1586–1659)*
[A.] IV, pp. 239–241.
 Entries: 2+. Pre-metric. Inscriptions.
 Described.

Vollard, Ambroise *(1867–1939)*
Le Portique, Paris. *Catalogue complet des
editions Ambroise Vollard, exposition.*
Paris, 1931. (ICB)
 Bibliography of books published by,
 to 1930.

Johnson, Una. *Ambroise Vollard editeur
1867–1939, an appreciation and a catalogue.*
New York: Wittenborn and Co., 1944.
 Entries: 203+ prints and bronze sculp-
 tures published by. Millimeters. In-
 scriptions. Illustrated (selection). Lo-
 cated (selection). Bigliography for
 each entry.

Vollenhoven, Herman van
(fl. 1611–1627)
 [W.] II, p. 810.
 Entries: 1 print after.*

Vollmer, Adolf Friedrich *(1806–1875)*
 [A. 1800] III, pp. 24–41.
 Entries: 29. Pre-metric. Inscriptions.
 States. Described. Also, list of 2 prints
 after (not fully catalogued).

Vollon, Antoine *(1833–1900)*
 [Ber.] XII, p. 252.*

Volmar, Joseph Simon *(1796–1865)*
 [Ber.] XII, p. 252.*

Volpato, Giovanni *(1733–1803)*
 [Ap.] pp. 447–450.
 Entries: 54.*

Voltz, Karl Friedrich *(b. 1826)*
 [Ap.] p. 450.
 Entries: 3.*

Volz, Wilhelm *(1855–1901)*
 Ammann, Edith. *Das graphische Werk von
 Wilhelm Volz.* Schriften der Staatlichen
 Kunsthalle Karlsruhe, 4. Karlsruhe
 (Germany): Staatliche Kunsthalle
 Karlsruhe, 1944.
 Entries: 12 etchings, 5 lithographs, 9
 commercial and occasional prints.
 Book illustrations by and after, un-
 numbered, pp. 15–21. Millimeters. In-
 scriptions. States. Described.

Vondřous, Jan C. *(b. 1884)*
 Podzemská, Jiřina. *J. C. Vondrouš; soupis
 grafického díla.* Prague: Hollar, 1963.
 (DLC)
 Entries: 405. Millimeters.

Voogd, Hendrik *(1766–1839)*
 [W.] II, p. 811.
 Entries: 1+.*

Voorde, Peter van [de] *(fl. c.1671)*
 [W.] III, p. 173.
 Entries: 2.*

Voorhout, Johannes I *(1647–before 1723)*
 [W.] II, pp. 811–812.
 Entries: 1 print after.*

Voorst, Robert van
 See **Voerst**

Voort [**Voorde**], Cornelis van der
(c.1576–1624)
 [W.] II, pp. 812–813.
 Entries: 1 print after.*

Voort, Michiel Frans van der *(1714–1777)*
 [W.] II, p. 813.
 Entries: 1.*

Vordemberge-Gildewart, Friedrich
(b. 1899)
 Jaffé, Hans L. C. *Vordemberge-Gildewart;
 Mensch und Werk.* Cologne: Verlag M.
 Du Mont Schauberg, 1971.
 Entries: unnumbered, p. 115 (to 1970).
 Millimeters. Illustrated (selection).

Vorsterman, Johannes *(1643?–1699?)*
 [W.] II, pp. 813–814.
 Entries: 1 print by, 1 after.*

Vorsterman, Lucas [I] Emil *(1595–1675)*
 [Dut.] VI, pp. 557–559.*

 Hymans, Henri. *Lucas Vorsterman; cata-
 logue raisonné de son oeuvre.* Brussels:
 Bruylant Christophe et Cie, 1893. 756
 copies. (MH)
 Entries: 225 prints by, 12 doubtful and
 15 rejected prints. Millimeters. In-
 scriptions. States. Described. Copies
 mentioned.

 [W.] II, pp. 814–818.
 Entries: 225+.*

 [Hind, *Engl.*] III, pp. 195–201.

Vorsterman, Lucas [I] Emil (*continued*)

Entries: 15 (prints done in England only). Inches. Inscriptions. States. Described. Illustrated (selection). Located.

Vorsterman, Lucas II (*b. 1624*)
[W.] II, p. 818.
Entries: 24+.*

Vorsterman, O. (*fl. c.1632*)
[W.] II, p. 818.
Entries: 1 print after.*

Vos, Anth. de (*17th cent.*)
[W.] II, p. 818.
Entries: 1 print after.*

Vos, Cornelis de (*1584?–1651*)
[W.] II, pp. 818–819.
Entries: 6 prints after.*

Vos, Jan [Johannes] II de (*1615–after 1683*)
[W.] II, p. 820.
Entries: 3 prints after.*

Vos, Paul de (*c.1596–1678*)
[W.] II, p. 822.
Entries: 3 prints after.*

Vos, Simon de (*1603–1676*)
[W.] II, pp. 822–823.
Entries: 1 print after.*

Voss, Hans D. (*b. 1907*)
Schwencke, Johan. "Overzichten IX." *Boekcier*, 2d ser. 2 (1947): 2–4.
Entries: 42 (bookplates only, to 1946). Described. Illustrated (selection).

Schwencke, Johan. *Grafisch werk van H. D. Voss.* De gouden Hommel, 2. Zaandijk (Netherlands): de Getijden Pers, 1951. 220 copies. (MH)
Entries: 78 (bookplates only, to 1951). Described. Illustrated (selection).

Kunsthalle, Bremen [Hans D. Voss, compiler]. *Hans D. Voss; Serigraphien; Werkverzeichnis von 1956 bis 1962.* Bremen (West Germany), 1962.
Entries: 20 (to 1962). Millimeters. States.

Oldenburger Kunstverein [Ilona Voss, compiler]. *Hans D. Voss, Serigrafien, Mappenwerke; Werkverzeichnis von 1956 bis 1968.* Oldenburg (West Germany), 1968.
Entries: 43 (to 1968). Millimeters. Illustrated (selection).

Kunsthalle, Bremen [Jürgen Schultze, Annemarie Winther and Ilona Voss, compilers]. *Hans D. Voss, das druckgraphische Werk 1956–1972.* Bremen (West Germany), 1972.
Entries: 55 (to 1972). Millimeters. Illustrated (selection).

Voss, V. (*19th cent.*)
[Dus.] p. 279.
Entries: 3 (lithographs only, to 1821).

Vostell, Wolf (*20th cent.*)
Block, René, and Vogel, Karl. *Graphik des kapitalitischen Realismus: . . . Werkverzeichnisse bis 1971.* Berlin: Edition René Block, 1971.
Entries: 51+ (to 1971). Millimeters. Inscriptions. Described. Illustrated.

Vouet, Ferdinand
See **Voet**

Vouet, Simon (*1590–1649*)
[RD.] V, pp. 71–72.
Entries: 1. Millimeters. Inscriptions. Described.

Vouillemont, Sébastien (*b. c.1610*)
[RD.] IX, pp. 184–236; XI, p. 319.
Entries: 144. Millimeters. Inscriptions. States. Described.

Vuillard, [Jean] Édouard (*continued*)

Entries: 52 (lithographs only). Paper fold measure. Inscriptions. Described. Illustrated (selection).

Roger-Marx, Claude. *L'Oeuvre gravé de Vuillard.* Monte Carlo (Monaco): André Sauret, 1948.

Entries: 67 (lithographs only). Millimeters. States. Described. Illustrated.

Vuillefroy, Félix Dominique de (*b. 1841*)
[Ber.] XII, p. 252.*

Vuyl, Jan
See **Uyl**

W

Wachsmann, Anton (*c.1765–c.1836*)
[Ap.] p. 450.
 Entries: 4.*

Wachsmuth, Ferdinand (*1802–1869*)
[Ber.] XII, p. 253.*

Wacquez, Adolphe André (*b. 1814*)
[Ber.] XII, p. 253.*

Wächter
See **Wechter**

Wael, Cornelis de (*1592–1667*)
[Dut.] VI, pp. 563–564.
 Entries: 4. Described.

[W.] II, pp. 836–837.
 Entries: 47+ prints by, 4+ after.*

Wael, Jan [Hans] de (*1558–1633*)
[B.] V, pp. 3–10.
 Entries: 14. Pre-metric. Inscriptions. Described.

[Weigel] p. 227.
 Additional information to [B.].

[Dut.] VI, pp. 561–564.
 Entries: 14. Millimeters. Inscriptions. Described.

Wael, Jan Baptist de (*b. 1632*)
[Dut.] VI, p. 564.
 Entries: 3. Millimeters. Inscriptions. States. Described.

[W.] II, p. 837.
 Entries: 4+ prints by, 1 after.*

Waels, Gottfried
See **Wals**

Waerden, D. (*b. c.1594*)
[W.] II, p. 838.
 Entries: 2+ prints after.*

Waes, Aert van (*c.1620–after 1664*)
[vdK.] pp. 54–57.
 Entries: 10. Millimeters. Inscriptions. Described. Appendix with 3 doubtful and rejected prints.

[W.] II, p. 838.
 Entries: 11 prints by, 1 after.*

Waesberge, Isaac van (*fl. 1632–1639*)
[W.] II, p. 838.
 Entries: 3.*

Wagenaar, P. (*18th cent.*)
[W.] II, p. 839.
 Entries: 2 prints after.*

Wagenbauer, Max Josef *(1774–1829)*
[Dus.] pp. 279–283.
Entries: 59+ (lithographs only, to 1821). Millimeters (selection). Inscriptions (selection). Located (selection).

Wagenknecht, Hans *(d. 1530)*
[B.] VI, pp. 415–416.
Entries: 1. Pre-metric. Inscriptions. Described.

[P.] III, p. 288.
Additional information to [B.].

Wagenmann, Adolf *(b. 1839)*
[Ap.] p. 451.
Entries: 4.*

Wagner, Carl Ernst Ludwig Friedrich *(1796–1867)*
[A. 1800] II, pp. 166–197.
Entries: 47. Pre-metric. Inscriptions. States. Described.

Wagner, Friedrich *(1803–1876)*
[Ap.] pp. 451–452.
Entries: 20.*

Wagner, [Johann] Martin von *(1777–1858)*
[A. 1800] I, pp. 37–43.
Entries: 1. Pre-metric. Inscriptions. Described. Appendix mentions a set of prints not seen by [A.].

Wagner, Michel *(15th cent.)*
[Lehrs] VIII, pp. 279–281.
Entries: 3. Millimeters. Inscriptions. Described. Illustrated. Located. Locations of all known impressions are given. Copies mentioned. Watermarks described. Bibliography for each entry.

Wagner, Otto *(1803–1861)*
[Dus.] pp. 283–284.
Entries: 2+ (lithographs only, to 1821). Millimeters. Inscriptions. Located.

Wagner, Peter *(b. c.1795)*
[Dus.] p. 284.
Entries: 2+ (lithographs only, to 1821).

Wagner, William *(fl. 1820–1835)*
[St.] p. 552.*

[F.] p. 290.*

Wagner, Xaver *(b. c.1785)*
[Dus.] p. 284.
Entries: 7 (lithographs only, to 1821). Millimeters (selection). Inscriptions (selection). Located (selection).

Wagstaff, Charles Edward *(1808–after 1845)*
[Siltzer] p. 368.
Entries: unnumbered, p. 368. Inscriptions.

Wailly, Charles de *(1729–1798)*
[Baud.] II, pp. 181–188.
Entries: 14. Millimeters. Inscriptions. States. Described.

Wakkerdak, Pieter Anthony *(1729–1774)*
[W.] II, p. 839.
Entries: 11.*

Walch, Hans Joachim *(b. 1927)*
Wendland, Henning. "Illustrationen von Hans Joachim Walch, Leipzig." *Illustration 63,* 4 (1967): 68–70.
Bibliography of books with illustrations by.

Walde, Hermann *(1827–1883)*
[Ap.] p. 453.
Entries: 17.*

Waldherr, Johann *(1779–1842)*
[Dus.] p. 285.
Entries: 1 (lithographs only, to 1821).

Waldor, Jean [Johannes] I *(c.1580–c.1640)* and Jean [Johannes] II *(1616–1670)*
Renier, J. S. *Les Waldor, graveurs liégeois.* Extract from *Bulletin de l'Institut archéol-*

Waldor, Jean [Johannes] I (*continued*)

ogique liégois 6 (1863): 321–335, 439–480.
Liège (Belgium): Imprimerie de L.
Grandmont-Donders, Libraire, 1865.
 Entries: 20 prints by Jean I, 92 prints
 by Jean II. Millimeters. Inscriptions.
 Described.

[W.] II, p. 738.
 Entries: 23 prints by, 1 after.*

Waldorp, Jan Gerard (*1740–1808*)
[W.] II, p. 839.
 Entries: 4.*

Waldschmidt, Arno (*20th cent.*)
Ohff, Heinz, and Ohff, Christiane. *Arno
Waldschmidt; Gepräge und Bilder;
Einzelkatalog zum Oeuvreverzeichnis 7
Jahre Werkstatt Rixdorfer Drucke Berlin.*
Hamburg: Merlin Verlag, 1970.
 Entries: unnumbered, 10 pp., (to
 1970). Millimeters. Illustrated.

Wale, Peter de (*d. 1570*)
[W.] II, p. 839.
 Entries: 1.*

Wale, Samuel (*d. 1786*)
Hammelmann, H. A. "Eighteenth cen-
tury English illustrators: Samuel Wale,
R.A." *The Book Collector* 1 (1952): 150–165.
 Bibliography of books with illustra-
 tions by.

Wales, George C. (*20th cent.*)
Holman, Louis A. *George C. Wales, etcher
of the sea.* Boston (Mass): Charles E.
Goodspeed and Co., 1922.
 Entries: 63 (to 1922). Inches. Illus-
 trated (selection).

Walker, ———. "Etchings of ships by
Geroge C. Wales." [*P. Conn.*] 3 (1923):
2–22.
 Entries: 63 (to 1922). Inches. Illus-
 trated (selection).

Wales, George C. *Etchings and litho-
graphs of American ships by George C.
Wales; a catalogue with historical and tech-
nical notes.* Boston: Charles E. Good-
speed, 1927. 500 copies. (MB)
 Entries: 81 etchings, 17 lithographs (to
 1927). Inches. States. Described. Illus-
 trated.

Walker, Anthony (*1726–1765*)
Hammelmann, H. A. "Eighteenth cen-
tury English illustrators; Anthony
Walker." *The Book Collector* 3 (1954):
87–102.
 Bibliography of books with illustra-
 tions by.

Walker, George (*fl. 1803–1816*)
[Siltzer] p. 334.
 Entries: unnumbered, p. 334, prints
 after. Inscriptions.

Walker, J. F. (*19th cent.*)
[Siltzer] p. 334.
 Entries: unnumbered, p. 334, prints
 after. Inscriptions.

Walker, James (*1748–c.1808*)
[Sm.] IV, pp. 1429–1439, and "additions
and corrections" section.
 Entries: 27 (portraits only). Inches. In-
 scriptions. States. Described. Located
 (selection).

[Ru.] pp. 339–343.
 Entries: 5 (portraits only, additional to
 [Sm.]). Inches. Inscriptions. De-
 scribed. Additional information to
 [Sm.].

Walker, William (*1791–1867*)
[Ap.] p. 454.
 Entries: 4.*

Wall, Willem Rutgaart van der (*1756–1813*)
[W.] II, p. 840.
 Entries: 1 print after.*

Wallace, William Henry *(1838–1929)*
Wallace, Margaret L. "William Henry Wallace; a sketch of his life and a list of his etchings." Unpublished ms., 1930. (Photostat, NN)
 Entries: 63. Inches.

Walle, ——— (fl. c.1825)
[Ber.] XII, p. 253.*

Wallet, ——— *(fl. c.1890)*
[Ber.] XII, p. 253.*

Walraven, Izaak *(1686–1765)*
[W.] II, p. 840.
 Entries: 1+.*

Wals, Gottfried [Goffredo] *(17th cent.)*
[A.] V, pp. 137–139.
 Entries: 1. Pre-metric. Inscriptions. Described.

Walter, Henry *(1786–1849)*
[Siltzer] p. 334.
 Entries: unnumbered, p. 334, prints after. Inches. Inscriptions.

Walther, Johann Philipp *(1798–1868)*
[Ap.] p. 454.
 Entries: 8.*

Waltner, Charles Albert *(1846–1925)*
[Ber.] XII, pp. 254–269.
 Entries: 135. Paper fold measure.

Beraldi, Henri. "Les graveurs du XXe siècle; Waltner." *Revue de l'art ancien et moderne* 17 (1905): 101–104, 180.
 Entries: 6 (original prints only, to 1905). Millimeters. Described (selection). Illustrated (selection).

Waltner, Charles Jules *(b. 1820)*
[Ber.] XII, p. 254.*

Walton, Henry *(fl. 1829–1857)*
[Carey] pp. 388–391.

Entries: 19 prints by (lithographs only), 3 after (various techniques). Inches. Inscriptions. Described. Illustrated (selection). Located.

Wandelaar, Jan [Joannes] *(1690–1759)*
[W.] II, pp. 840–841.
 Entries: 9+.*

Wandereisen, Hans *(d. 1548?)*
See also **Monogram HW** [Nagler, *Mon.*] III, no. 1645

 [B.] VII, pp. 470–471.
 Entries: 3. Pre-metric. Inscriptions. Described.

 [P.] IV, p. 308.
 Entries: 18+ (additional to [B.]). Pre-metric (selection). Inscriptions. Described. Located.

Wappers, [Egidius Karel] Gustaaf, Baron *(1803–1874)*
 [H. L.] p. 1109.
 Entries: 1 (etchings only). Millimeters. Described.

Ward, George Raphael *(1797–1879)*
 [Siltzer] p. 368.
 Entries: unnumbered, p. 368. Inscriptions.

Ward, James *(1769–1859)*
 [Sm.] IV, pp. 1439–1453, and "additions and corrections" section.
 Entries: 44 (portraits only). Inches. Inscriptions. States. Described. Located (selection).

 Frankau, Julia. *William Ward, A.R.A., James Ward, R.A.; their lives and works.* London: Macmillan and Co., Limited, 1904.
 Entries: 83. Inches. Inscriptions. States. Described. Located (selection).

Ward, James (*continued*)

Grundy, C. Reginald. *James Ward, R.A. his life and works, with a catalogue of his engravings and pictures.* "Connoisseur" special number. London: Otto Limited, 1909.
Entries: 114. Inches. Inscriptions (selection). States. Described (selection). Illustrated (selection). Also, list of 124 prints after. Inches.

[Siltzer] pp. 278–285.
Entries: unnumbered, pp. 284–285, prints by and after. Inches. Inscriptions. States. Illustrated (selection).

[Ru.] pp. 343–353.
Entries: 3 (portraits only, additional to [Sm.]). Inches. Inscriptions. States. Described. Additional information to [Sm.].

Ward, Lynd (*b. 1905*)
Haas, Irvin. "A bibliography of the work of Lynd Ward." *Prints* 7 (1936–1937): 84–92.
Bibliography of books with illustrations by.

Ward, William (*1766–1826*)
[Sm.] IV, pp. 1453–1487, and "additions and corrections" and "later additions and corrections" sections.
Entries: 111+ (portraits only). Inches. Inscriptions. States. Described. Illustrated (selection). Located (selection).

Frankau, Julia. *William Ward, A.R.A., James Ward, R.A.; their lives and works.* London: Macmillan and Co., Limited, 1904.
Entries: 339. Inches. Inscriptions. States. Described. Located (selection).

[Siltzer] pp. 368–369.
Entries: unnumbered, pp. 368–369. Inscriptions.

[Ru.] pp. 353–377.
Entries: 36 (portraits only, additional to [Sm.]). Inches. Inscriptions (selection). States. Described. Additional information to [Sm.].

Warf, L. van der (*fl. 1748–1754*)
[W.] II, p. 841.
Entries: 1 print after.*

Warhol, Andy (*b. 1930*)
Crone, Rainer. *Andy Warhol.* Stuttgart (West Germany): Gerd Hatje, 1970.
Entries: 50+. Inches. Millimeters. Described. Illustrated.

Warnberger, Simon (*1769–1847*)
[Dus.] pp. 285–287.
Entries: 28 (lithographs only, to 1821). Millimeters. Inscriptions. Located.

Warner, G. J. (*fl. c.1796*)
[St.] p. 552.*

Warnersen, Pieter (*fl. c.1540–1560*)
[W.] II, p. 841.
Entries: 8.*

Warnicke, John G. (*d. 1818*)
[St.] p. 553.*

[F.] p. 290.*

Waroquier, Henry de (*b. 1881*)
Auberty, J. *Henry de Waroquier; catalogue de son oeuvre gravé.* Paris: Paul Prouté et ses Fils, 1951. 200 copies. (MH)
Entries: 222. Millimeters. States. Illustrated.

Warren, Alfred William (*19th cent.*)
[Ap.] p. 454.
Entries: 3.*

Wart, Derk Anthoni van de (*1767–1824*)
[W.] II, p. 841.
Entries: 3+.*

Washburn, Cadwallader *(1866–1955)*
Frederick Keppel and Co. *Etchings and dry-points of Mexico and Maine by Cadwallader Washburn.* New York: Frederick Keppel and Co., 1911.
 Entries: 97 (to 1911, complete?).

Wasinger, ——— *(19th cent.)*
[Dus.] p. 287.
 Entries: 2 (lithographs only, to 1821). Millimeters. Inscriptions.

Watelet, Louis Étienne *(1780–1866)*
[Ber.] XII, pp. 269–270.*

Waterloo, Anthonie *(c.1610–1690)*
Bartsch, Adam. *Anton Waterlo's Kupferstiche ausführlich beschrieben.* Vienna: A. Blumauer, 1795.
 Entries: 136. Pre-metric. Inscriptions. States. Described.

[B.] II, pp. 3–154.
 Entries: 136 prints by, 1 doubtful print. Pre-metric. Inscriptions. States. Described.

[Wiegel] pp. 70–77.
 Entries: 1 (additional to [B.]). Pre-metric. Inscriptions. Described.

[Heller] pp. 122–125.
 Additional information to [B.].

[Wess.] II, pp. 262–265.
 Entries: 2 (additional to [B.] and [Weigel]). Millimeters. Inscriptions. Described. Located. Additional information to [B.] and [Weigel].

[Dut.] VI, pp. 564–620.
 Entries: 139 (137–139 are doubtful prints). Millimeters. Inscriptions. States. Described.

Wessely, Josef Eduard. *Antonj Waterloo; Verzeichniss seiner radirten Blätter.* Kritische Verzeichnisse von Werken hervorragender Kupferstecher, 7. Hamburg: Haendke und Lehmkuhl, 1891.

 Entries: 136 prints by, 3 doubtful and rejected prints. Millimeters. Inscriptions. States. Described.

C. G. Boerner, Leipzig. *Sammlung Paul Davidsohn, Kupferstiche alter Meister dritter Teil Rembrandt-Z; Versteigerung . . . den 26.-29. April 1921.* pp. 141–146. Leipzig, 1921.
 Additional information to earlier catalogues.

Waterloos, J. *(fl. c.1680)*
[W.] II, p. 845.
 Entries: 4.*

Watson, Charles John *(1846–1927)*
Watson, Charles J. *Catalogue of the etched and engraved work of Charles J. Watson, R.E.* Hammersmith (England): Printed for private circulation for Mrs. C. J. Watson by E. Walker Ltd., 1931. (NN)
 Entries: 204. Inches. Inscriptions. Described. Illustrated.

Watson, James *(c.1740–1790)*
[Sm.] IV, pp. 1487–1548, and "additions and corrections" section.
 Entries: 170 (portraits only). Inches. Inscriptions. States. Described. Illustrated (selection). Located (selection).

Goodwin, Gordon. *British mezzotinters; Thomas Watson, James Watson, Elizabeth Judkins.* London: A. H. Bullen, 1904. 520 copies. (MH). Second edition: 1914.
 Entries: 200. Inches. Inscriptions. States. Described. Located.

[Siltzer] p. 369.
 Entries: unnumbered, p. 369. Inscriptions.

[Ru.] pp. 377–396.
 Entries: 7 (portraits only, additional to [Sm.]). Inches (selection). Inscriptions (selection). Described. Additional information to [Sm.].

Watson, Thomas *(1748–1781)*
[Sm.] IV, pp. 1549–1567, and "additions and corrections" and "later additions and corrections" sections.
Entries: 47 (portraits only). Inches. Inscriptions. States. Described. Illustrated (selection). Located (selection).

Goodwin, Gordon. *British mezzotinters; Thomas Watson, James Watson, Elizabeth Judkins.* London: A. H. Bullen, 1904. 520 copies. Second edition: 1914.
Entries: 74. Inches. Inscriptions. States. Described. Located.

[Ru.] pp. 396–403, 498.
Entries: 1 (portraits only, additional to [Sm.]). Inches. Described. Additional information to [Sm.].

Watt, James Henri *(1799–1867)*
[Ap.] p. 455.
Entries: 8.*

Watt, W. H. *(fl. c.1847)*
[Ap.] p. 456.
Entries: 4.*

Watteau, Antoine *(1684–1721)*
See also **Caylus**

[RD.] II, pp. 181–187; XI, pp. 323–324.
Entries: 8. Pre-metric. Inscriptions. States. Described.

Goncourt, Edmond de. *Catalogue raisonné de l'oeuvre peint, dessiné d'Antoine Watteau.* Paris: Rapilly, 1875.
Entries: 795 prints by and after. Millimeters. Inscriptions. States.

[Gon.] I, pp. 1–60.
Entries: unnumbered, pp. 55–60, prints by and after. Based on Goncourt 1875.

Dacier, Émile, and Vuaflart, Albert. *Jean de Jullienne et les graveurs de Watteau au XVIIIe siècle.* 4 vols. Paris: Société pour l'Étude de la Gravure Française, 1921–1929.

Entries: 316 prints after, 29 doubtful and rejected prints. Millimeters. Inscriptions. States. Described. Illustrated. Catalogue of the *Oeuvre gravé de Watteau* assembled by Jullienne; the *Figures de different caractères* are not catalogued.

Réau, Louis. "Watteau." in [Dim.] I, 1–59.
Entries: 10 (refers to Dacier and Vuaflart). Also, catalogue of paintings; prints after are mentioned where extant.

Wattier, Édouard *(1793–1871)*
[Ber.] XII, p. 270.*

Wattier, [Charles] Émile *(1800–1868)*
[Ber.] XII, pp. 270–274.
Entries: 14 (etchings only). Millimeters. Described. Also, brief survey of lithographs by and prints after.

Watts, John *(fl. 1766–1778)*
[Sm.] IV, pp. 1567–1570, and "additions and corrections" section.
Entries: 6 (portraits only). Inches. Inscriptions. States. Described. Illustrated (selection). Located (selection).

[Ru.] p. 403.
Additional information to [Sm.].

Waumans, Coenrad *(b. 1619)*
[W.] II, p. 845.
Entries: 43+.*

Wauters, Charles Augustin *(1811–1869)*
[H. L.] pp. 1109–1110.
Entries: 3. Millimeters. Inscriptions. States. Described.

Wautier, Charles *(fl. 1652–1660)*
[W.] II, p. 901.
Entries: 2 prints after.*

Wautier, Michaelina
See **Woutiers**

Wayers, ——— *(19th cent.)*
[H. L.] p. 1108.
Entries: 1. Millimeters. Inscriptions.
States. Described.

Wayne, June C. *(b. 1918)*
Basket, Mary W. *The art of June Wayne.*
New York: Harry N. Abrams; Berlin:
Gebr. Mann, 1969.
Entries: 167 (to 1968). Inches. States.
Described (selection). Illustrated
(selection).

Weaver, Thomas *(1774–1843)*
[Siltzer] p. 334.
Entries: unnumbered, p. 334, prints
after. Inches. Inscriptions. States.

Weaver, William *(19th cent.)*
[Siltzer] p. 334.
Entries: unnumbered, p. 334, prints
after. Inches. Inscriptions.

Webb, W. *(fl. 1819–1828)*
[Siltzer] p. 334.
Entries: unnumbered, p. 334, prints
after. Inches. Inscriptions.

Weber, Antoine Jean *(1797–1875)*
[Ber.] XII, p. 274.*

Weber, Friedrich *(1813–1882)*
[Ap.] pp. 456–457.
Entries: 23.*

[Ber.] XII, p. 275.*

Weber, J. *(fl. c.1720)*
[Merlo] p. 917.*

Weber, Joh. Friedr. *(fl. 1805–1816)*
[Dus.] pp. 287–288.
Entries: 8 (lithographs only, to 1821).
Millimeters (selection). Inscriptions
(selection). Located (selection).

Weber, Joseph *(c.1803–after 1881)*
[Merlo] pp. 917–918.*

Weber, Max *(b. 1881)*
Downtown Gallery, New York [Holger
Cahill, compiler]. *Max Weber.* New York,
1930.
Entries: 38 (lithographs only, to 1930).
Inches.

Weber, Otto *(1832–1888)*
[Ber.] XII, p. 275.*

Weber, [Franz] Thomas *(1761–1828)*
Hämmerle, Albert: "Die Lithographie in
Augsburg." [*Schw. M.*] 1927: 184–196.
Entries: 6 (lithographs only, to 1821).
Millimeters. Inscriptions. Described.
Illustrated (selection). Located.

Wechter, Georg I *(c.1526–1586)* and Georg
II *(c.1560–before 1630)*
[B.] IX, pp. 164–166.
Entries: 4 engravings, 1+ woodcuts.
Pre-metric. Inscriptions. Described.

[P.] IV, pp. 207–208.
Entries: 4+ (additional to [B.]). Pre-
metric. Inscriptions. Described. Lo-
cated.

[A.] V, pp. 1–10.
Entries: 11+. Pre-metric. Inscriptions.
States. Described.

[ThB.] XXXIV, pp. 230–231.
Additional information to [B.], [P.],
and [A.].

Wechter, Hans I *(c.1550–after 1606)*
[A.] IV, pp. 331–340.
Entries: 8. Pre-metric. Inscriptions.
Described.

[ThB.] XXXIV, pp. 231–232.
Additional information to [A.].

Wechtlin, Hans *(1480/85–after 1526)*
See also **Monogram EFGW** [Nagler,
Mon.] II, no. 1581

[B.] VII, pp. 449–452.
Entries: 10. Pre-metric. Inscriptions.
Described.

Wechtlin, Hans (*continued*)

[P.] III, pp. 327–335.
Entries: 52 (additional to [B.]). Pre-metric. Inscriptions. States. Described. Located (selection). Copies mentioned. Additional information to [B.].

Rottinger, Heinrich. "Hans Wechtlin." [*WrJ.*] 27 (1907/09): 1–54.
Entries: unnumbered, pp. 50–51. Illustrated (selection).

[Ge.] nos. 1481–1498.
Entries: 19 (single-sheet woodcuts only). Described. Illustrated. Located.

Wedgwood, John Taylor (*c.1783–1856*)
[Ber.] XII, p. 275.*

Weenix family
[Dut.] VI, pp. 621–623.
Entries: 7. Millimeters. Inscriptions. States. Described.

Weenix, Jan (*1640–1719*)
See also **Weenix** family

[W.] II, pp. 847–848.
Entries: 1 print after.*

Weenix, Jan Baptist [Giovanni Battista] (*1621–1663*)
See also **Weenix** family

[B.] I, pp. 391–394.
Entries: 2. Pre-metric. Inscriptions. Described. Copies mentioned.

[Weigel] pp. 65–67.
Entries: 5 (additional to [B.]). Pre-metric. Inscriptions. Described.

[W.] II, pp. 846–847.
Entries: 7 prints by, 9+ after.*

Weerden, Jacques van
See **Werden**

Weerdt, Adriaan de (*c.1510?–c.1590*)
[Merlo] pp. 919–920.*
Prints after.

[W.] II, pp. 848–849.
Entries: 3 prints by (doubtful), 16+ after.*

Weert, Jakob de (*b. 1569*)
[W.] II, p. 849.
Entries: 12+.*

Wegelin, Adolf (*1810–1881*)
[Merlo] p. 923.*

Wegener, Heinrich (*19th cent.*)
[Ap.] p. 457.
Entries: 1+.*

Wehme, Zacharias (*c.1558–1606*)
See **Monogram ZW** [Nagler, *Mon.*] V, no. 2126

Wehrbrun [**Wehr von Wehrbrun**], Emanuel von (*d. 1662*)
[Merlo] pp. 923–929.
Entries: unnumbered, pp. 924–929. Paper fold measure (selection). Inscriptions (selection). Described (selection).

Weicher, Hans
See **Weiner**

Weidemann, Carl Friedr. (*1770–1843*)
[Dus.] p. 288.
Entries: 1 (lithographs only, to 1821). Millimeters. Inscriptions. Located.

Weidenaar, Reynold Henry (*b. 1915*)
Fowler, Alfred. *A check-list of prints by Reynold Weidenaar, A.N.A.* Alexandria (Va.): Print Collectors' Club, 1949. (Mimeographed, CSfAc)
Entries: 106 (to 1949). Inches.

Weiditz, Christoph II (*before 1517–before 1572*)
[B.] IX, pp. 164–166.

Entries: 4 engravings, 1+ woodcuts. Pre-metric. Inscriptions. Described. Engravings are probably by Georg Wechter.

Weiditz, Hans II *(before 1500–after 1536)*
See **Master of PETRARCH**

Weigel, Hans I *(d. before 1578)*
See also **Monogram HW** [Nagler, *Mon.*] III, no. 1645

[P.] IV, pp. 309–311.
Entries: 11+. Paper fold measure (selection). Pre-metric (selection). Inscriptions. Described.

[A.] IV, pp. 93–128.
Entries: 20+ (prints by Hans Weigel I and Martin Weigel). Pre-metric. Inscriptions. Described.

Weigel, Martin *(fl. 1553–1568)*
[A.] IV, pp. 93–128.
Entries: 20+ (prints by Hans Weigel I and Martin Weigel). Pre-metric. Inscriptions. Described.

Weiland, Carl F. *(b. c.1782)*
[Dus.] p. 288.
Entries: 1 (lithographs only, to 1821). Paper fold measure.

Weinbrenner, [Johann Jakob] Friedrich *(1766–1826)*
[Dus.] pp. 288–289.
Entries: 2+ (lithographs only, to 1821). Millimeters. Located.

Weiner, Hans *(c.1575–after 1619)*
[A.] II, pp. 210–214.
Entries: 3. Pre-metric. Inscriptions. Described.

Weinher, Peter *(d. 1583)*
[B.] IX, pp. 551–557.
Entries: 12. Pre-metric. Inscriptions. Described.

[P.] IV, pp. 235–238.
Entries: 11 prints by (additional to [B.]), 1 doubtful print. Pre-metric. Inscriptions. Described.

[A.] IV, pp. 47–62.
Entries: 25. Pre-metric. Inscriptions. Described.

Weinher, Peter II *(fl. c.1590?)*
[A.] IV, pp. 63–64.
Entries: 1. Pre-metric. Inscriptions. Described. See [ThB.] XXXV, p. 296.

Weinreis, Johann *(1759–1826)*
[Merlo] pp. 929–930.
Entries: 6. Pre-metric (selection). Paper fold measure (selection). Inscriptions (selection).

Weir, Julian Alden *(1852–1919)*
[Ber.] XII, p. 276.*

Ryerson, Margery Austen. "J. Alden Weir's etchings." *Art in America* 8 (1920): 243–248.
Entries: 105. Inches. States.

Metropolitan Museum of Art, New York [Agnes Zimmermann, compiler]. *An essay towards a catalogue raisonné of the etchings, dry-points, and lithographs of Julian Alden Weir.* New York, 1923.
Entries: 123. Inches. Inscriptions. States. Described. Located.

University of Nebraska Art Galleries, Lincoln [Jon Nelson, compiler]. *The etchings of J. Alden Weir.* Lincoln (Neb.), 1967.
Entries: 128. Inches. Inscriptions. States. Described (selection). Illustrated (selection). Located. Only prints which are not listed in Metropolitan Museum of Art [Zimmermann] are described.

Weirotter, Franz Edmund *(1730–1771)*
Dodd, Thomas. Unpublished ms. catalogue. Early 19th cent. (EBM)

Weirotter, Franz Edmund (*continued*)

Entries: unnumbered, pp. 1–80. Inches. Described.

Weise, Gotthelf Wilhelm (*1751–1810*)
[Ap.] p. 458.
Entries: 15.*

Weishaupt, Franz (*19th cent.*)
[Dus.] p. 289.
Entries: 3 (lithographs only, to 1821). Millimeters (selection). Inscriptions. Located (selection).

Weiss, Bonaventura (*b. 1812*)
[Merlo] p. 930.*

Weiss, David (*1775–1846*)
[Ap.] p. 458.
Entries: 1.*

Weiss, Josef (*b. 1894*)
Bredt, E. W. "Josef Weiss." [GK.] 44 (1921): 73–86. Catalogue: "Josef Weis' graphisches Werk, 1914 bis 1921." [MGvK.] 1921, pp. 47–49.
Entries: 190 (to 1921). Millimeters.

Weiss, Joseph Anton (*1787–1878*)
[Dus.] p. 289.
Entries: 3 (lithographs only, to 1821). Millimeters. Inscriptions. Located.

Weissenbruch, Jan [Johannes] (*1822–1880*)
[H. L.] pp. 1119–1123.
Entries: 18. Millimeters. Inscriptions. States. Described.

Weitsch, Friedrich Georg (*1758–1828*)
[Dus.] p. 289.
Entries: 1 (lithographs only, to 1821). Millimeters. Inscriptions. Located.

Welbronner, Nicolaus
See **Wilborn**

Welle, David van (*1772–1848*)
[W.] II, p. 850.
Entries: 2 prints after.*

Welle, H. van (*18th cent.*)
[W.] II, p. 850.
Entries: 1 print after.*

Welle, Hieronymus (*fl. c.1568*)
[W.] II, p. 850.
Entries: 1.*

Wellenstein, Walter (*b. 1898*)
Pfefferkorn, Rudolf. "Walter Wellenstein als Illustrator." *Illustration 63*, 9 (1972): 53–56.
Bibliography of books with illustrations by (to 1969).

Wells, J. G. (*fl. c.1780*)
[Siltzer] p. 369.
Entries: unnumbered, p. 369. Inscriptions.

Welsh, E. (*fl. c.1771*)
[Sm.] IV, p. 1570.
Entries: 1 (portraits only). Inches. Inscriptions. States. Described.

Welter, Michael (*1808–1892*)
[Merlo] pp. 930–931.*

Welti, Albert (*1862–1912*)
Zürcher Kunsthaus [W. Wartmann, compiler]. *Albert Welti, 1862–1912; Verzeichnis der Gemälde, Zeichnungen und Kunst in der Gedächtnis-Ausstellung . . . vollständiges Verzeichnis der graphischen Werke des Künstlers nach ihren verschiedenen Platten-Zuständen und Drucken.* Zurich, 1912.
Entries: 170. Millimeters. Inscriptions. States.

Wartmann, W. *Albert Welti, 1862–1912; vollständiges Verzeichnis des graphischen Werkes . . . zweite, durchgesehene Ausgabe*

mit 124 Abbildungen. Zurich: Zürcher Kunst-Gesellschaft, 1913.
Entries: 172. Millimeters. Inscriptions. States. Described (selection). Illustrated (selection). Located. Revised version of 1912 catalogue.

Wenban, Sion Longley *(1848–1897)*
Weigmann, Otto A. *Sion Longley Wenban, 1848–1897; kritisches Verzeichnis seiner Radierungen mit einer biographischen Einführung.* Leipzig: Verlag von Klinkhardt und Biermann, 1913.
Entries: 371. Millimeters. Inscriptions. States. Described. Illustrated (selection).

Wenig, F. W. *(fl. c.1818)*
[Dus.] p. 291.
Entries: 2 (lithographs only, to 1821). Millimeters (selection). Inscriptions (selection). States. Described (selection). Located (selection).

Wenig, J. G. *(fl. c.1630)*
[A.] V, pp. 88–90.
Entries: 4. Pre-metric. Inscriptions. Described.

Wening, Michael *(1645–1718)*
Stetter, Gertrude. *Michael Wening; Leben und Werk des bayrischen Kupferstechers und Topographen.* Munich: Süddeutscher Verlag, 1964.
Entries: unnumbered, pp. 76–77 (works in all media, including prints). Illustrated (selection). Located.

Wenne, Abraham Meindersz van der *(c.1656–1693)*
[W.] II, p. 850.
Entries: 2.*

Wenng, Carl Heinrich *(1787–c.1850)*
[Dus.] pp. 290–291.

Entries: 11+ (lithographs only, to 1821). Millimeters (selection). Inscriptions (selection). Located (selection).

Wentel, Cornelis Hendrik *(1818–1860?)*
[W.] II, p. 850.
Entries: 1.*

Wenzel von Olmütz *(fl. 1481–1497)*
[B.] VI, pp. 317–343.
Entries: 57 prints by, 1 doubtful print. Pre-metric. Inscriptions. States. Described.

[Evans] pp. 40–41.
Entries: 4 (additional to [B.]). Millimeters. Inscriptions. Described.

[P.] II, pp. 132–138.
Entries: 25 Prints by (additional to [B.]), 2 rejected prints. Pre-metric. Inscriptions. Described. Located. Copies mentioned. Additional information to [B.].

[Wess.] I, p. 144.
Entries: 1 (additional to [B.] and [P.]). Millimeters. Inscriptions. Described. Additional information to [B.] and [P.].

Lehrs, Max. *Wenzel von Olmütz.* Dresden: Verlag von Wilhelm Hoffmann, 1889.
Entries: 91. Millimeters. Inscriptions. States. Described. Illustrated (selection). Bibliography for each entry.

[Lehrs] VI, pp. 178–280.
Entries: 91. Millimeters. Inscriptions. States. Described. Illustrated (selection). Located. Locations of all known impressions are given. Copies mentioned. Watermarks described. Bibliography for each entry.

Werd, N. van *(fl. 1668–1682)*
[W.] II, p. 850.
Entries: 1.*

Werden, Jacques van *(17th cent.)*
 [W.] II, p. 850.
 Entries: 6+ prints after.*

Werdlen, ——— van *(18th cent.)*
 [Sm.] III, pp. 1421–1422.
 Entries: 3 (portraits only). Inches. Inscriptions. States. Described. Located (selection).

 [Ru.] p. 337.
 Entries: 1 (portraits only, additional to [Sm.]). Inches. Inscriptions. Described. Additional information to [Sm.].

Werff, Adriaen van der *(1659–1722)*
 [Wess.] II, p. 265.
 Entries: 3.

 [W.] II, pp. 850–852.
 Entries: 3+ prints by, 56 after.*

Werff, Pieter van der *(1665–1722)*
 [W.] II, pp. 852–853.
 Entries: 3 prints after.*

Werkman, Hendrik Nicolaas *(1882–1945)*
 Stedelijk Museum, Amsterdam. *Catalogus h. n. werkman drukker-schilder, groningen.* Amsterdam, 1945.
 Entries: 407. Illustrated (selection).

 Städisches Kunstgalerie Bochum [Jan Martinet, compiler]. *Hendrik Nicolaas Werkman.* Bochum (West Germany), 1961.
 Entries: unnumbered, pp. 2–118. Millimeters. Inscriptions. Illustrated.

 Stedelijk Museum, Amsterdam [Jan Martinet, compiler]. *Hot printing; catalogue of the "druksel" prints and interim catalogues of general printed matter, lithographs, etchings, woodcuts, typewriter compositions and paintings by hendrik nicolaas werkman.* Amsterdam: H. N. Werkman Foundation, 1963.
 Entries: unnumbered: pp. 2–125, "druksel" (stamped monotype)

prints; pp. 155–173, books, pamphlets, etc.; pp. 189–203, prints, typewriter compositions and paintings. Millimeters. Inscriptions. Described (selection). Illustrated (selection). Located. "Druksel" prints are all described and illustrated. Concordance with 1945 catalogue.

Werner, Carl Friedrich Heinrich *(1808–1894)*
 [Dus.] p. 292.
 Entries: 1 (lithographs only, to 1821).

Werner, Friedrich Bernhard *(1690–1778)*
 Bretschneider, Paul. *Der Zeichner, Stecher und Chronist Friedrich Bernhard Werner und seine Arbeiten.* Neustadt/Schlesien (Germany): Privately printed, 1921.
 Entries: 33+ drawings by and prints after. Millimeters (selection). Paper fold measure (selection). Inscriptions (selection). Described (selection). Located.

Werner, Fritz [Alexander Friedrich] *(1827–1908)*
 [A. 1800] V, pp. 89–103.
 Entries: 12 (to 1863). Millimeters. Inscriptions. States. Described. Appendix with 2 collaborative prints partly by Werner.

 [Ap.] p. 458.
 Entries: 3.*

 Roeper, A. "Fritz Werner." [Bb.] 75 (1908): 4861–4863.
 Entries: 17. Millimeters. States. Described.

Wéry, Pierre Nic. *(1770–1827)*
 [Ber.] XII, p. 276.*

West, J. *(19th cent.)*
 [Siltzer] p. 334.
 Entries: unnumbered, p. 334, prints after. Inscriptions.

West, Levon *(b. 1900)*
Torrington, Otto M. *A catalogue of the etchings of Levon West.* New York: William Edwin Rudge, 1930. 810 copies. (MB)
　　Entries: 125 (to 1929). Inches. Inscriptions. States. Described. Illustrated.

Westall, R. *(fl. 1848–1889)*
[Siltzer] p. 334.
　　Entries: unnumbered, p. 334, prints after. Inches. Inscriptions.

Westerbaen, Jan Jansz I *(c.1600–1686)*
[W.] II, p. 854.
　　Entries: 2 prints after.*

Westerhout, Arnold van *(1651–1725)*
[W.] II, pp. 854–855.
　　Entries: 51+.*

Westerhout, Balthasar van *(d. 1728)*
[W.] II, p. 855.
　　Entries: 7.*

Western, J. *(fl. c.1771)*
[Sm.] IV, p. 1570.
　　Entries: 1 (portraits only). Inches. Inscriptions. Described.

Westervelt, Abraham van *(d. 1692)*
[W.] II, p. 855.
　　Entries: 1 print after.*

Weston, Henry W. *(fl. 1796–1802)*
[St.] p. 553.*

[F.] pp. 290–291.*

Wet, Jacob Willemsz I de *(c.1610–1671/72)*
[W.] II, pp. 855–856.
　　Entries: 1 print after.*

Wett, Jakob de *(fl. c.1677)*
[Merlo] pp. 941–942.
　　Entries: 1. Pre-metric. Inscriptions. Described.

Weydtmans, Claes [Nicolaes] Jansz *(c.1570–1642)*
　　[W.] II, p. 877 (as H. Weydmans). Entries: 4.*

　　[W.] II, p. 907 (as N. Weydtmans). Entries: 1+.*

Weygel, Hans and Martin
See **Weigel,** Hans I and Martin

Weyrauch, Heinrich
See **Wirich**

Wheatley, Francis *(1747–1801)*
[Sm.] IV, pp. 1570–1571.
　　Entries: 1 (portraits only). Inches. Inscriptions. States. Described.

Roberts, W. F. *Wheatley, R.A., his life and works, with a catalogue of his engraved pictures.* "Connoisseur" special number. London: Otto Limited, 1910.
　　Entries: unnumbered, pp. 37–51, prints after. Inches (selection). Described (selection). Illustrated (selection).

[Siltzer] p. 334.
　　Entries: unnumbered, p. 334, prints after. Inches. Inscriptions. Described.

Whessell, John *(b. c.1760)*
[Siltzer] p. 369.
　　Entries: unnumbered, p. 369, prints by and after. Inscriptions.

Whistler, James Abbott MacNeil *(1834–1903)*
Thomas, Ralph. *A catalogue of the etchings and drypoints of James Abbott MacNeil Whistler.* London: Privately printed by John Russell Smith, 1874. 50 copies. (NJP)
　　Entries: 86 (etchings and drypoints only, to 1874). Inches. Inscriptions. Described.

Whistler, James Abbott MacNeil (*continued*)

Wedmore, Frederick. *Whistler's etchings; a study and a catalogue.* London: A. W. Thibaudeau, 1886. 140 copies. (NN)
Entries: 214 (etchings and drypoints only, to 1886). Inches. Millimeters. Inscriptions. States. Described.

[Ber.] XII, pp. 276–290.*

Way, Thomas R. *Mr. Whistler's lithographs; the catalogue.* London: George Bell and Sons, 1896. 140 copies. (NN)
Entries: 130 (lithographs only, to 1896). Inches. Inscriptions. Described.

Wedmore, Frederick. *Whistler's etchings; a study and a catalogue.* London: P. and D. Colnaghi and Co., 1899. 135 copies. (MH)
Entries: 268 (etchings and drypoints only, to 1899). Inches. Millimeters. Inscriptions. States. Described.

Kennedy, Edward Guthrie ["An Amateur"]. *Catalogue of etchings by J. McN. Whistler, supplementary to that compiled by F. Wedmore.* New York: H. Wunderlich and Co., 1902. 135 copies. (NN)
Entries: 104 (etchings and drypoints only, additional to Wedmore 1899; to 1902). Inches. Inscriptions. Described. Additional information to Wedmore 1899.

Way, Thomas R. *Mr. Whistler's lithographs.* London: George Bell and Sons, 1905. 250 copies. (MH)
Entries: 160 (lithographs only). Inches. Inscriptions. States. Described. Ms. note (ECol); 1 additional entry.

Mansfield, Howard. *A descriptive catalogue of the etchings and dry-points of James Abbott McNeill Whistler.* Chicago: Caxton Club, 1909. 303 copies. (MH)
Entries: 440 (etchings and drypoints only). Inches. Inscriptions. States. Described. Located (selection).

Kennedy, Edward G. *The etched work of Whistler, illustrated by reproductions in collotype of the different states of the plates.* 6 vols. New York: Grolier Club, 1910. 404 copies. (MBMu)
Entries: 446 (etchings and drypoints only). Inches. Inscriptions. States. Described. Illustrated. Every state is illustrated. Ms. notes by Harold J. L. Wright (ECol); additional states, location of impressions.

Way, T. R. *The lithographs by Whistler illustrated by reproductions in photogravure and lithography, arranged according to the catalogue by Thomas R. Way, with additional subjects not before recorded.* New York: Kennedy and Co., 1914. 400 copies. (MBMu)
Entries: 166 (lithographs only). Inches. Inscriptions. States. Described (selection). Illustrated.

Johson, Una E. "The wood engravings of James McNeill Whistler." [PCQ.] 28 (1941): 274–291.
Entries: 6 (wood engravings only). Inches. Inscriptions. Illustrated. Located. Information on proofs and editions is given in the accompanying text.

White, George (*1684?–1732*)
[Sm.] IV, pp. 1572–1590, and "additions and corrections" section.
Entries: 59 (portraits only). Inches. Inscriptions. States. Described. Illustrated (selection). Located (selection).

[Ru.] pp. 404–407.
Additional information to [Sm.].

White, Robert (*1645–1703*)
[Sm.] IV, pp. 1591–1593.
Entries: 9 (portraits only). Inches. Inscriptions. States. Described. Illustrated (selection). Located (selection).

[Ru.] p. 407.
Additional information to [Sm.].

White, W. J. *(fl. c.1818)*
 [Ap.] p. 458.
 Entries: 1.*

Whitefield, Edwin *(1816–1892)*
 Carey, pp. 402–404.
 Entries: 20+ (lithographs only).
 Inches. Inscriptions. Described. Illus-
 trated (selection). Located.

 Norton, Bettina A. "Edwin Whitefield,
 1816–1892." *Antiques* 102 (1972): 232–243.
 Entries: unnumbered, pp. 241–243,
 prints after. Inches. Inscriptions. Il-
 lustrated (selection).

Whitfield, Edward Richard *(b. 1817)*
 [Ap.] p. 459.
 Entries: 2.*

Whittakers, John I *(fl. c.1619)*
 [Hind, *Engl.*] II, p. 307.
 Entries: 1. Inches. Inscriptions. De-
 scribed. Illustrated. Located.

Whitwell, Charles *(fl. 1593–1606)*
 [Hind, *Engl.*] I, pp. 223–227.
 Entries: 6+. Inches. Inscriptions. De-
 scribed. Located.

Wibaille, Gabriel Émile *(b. 1802)*
 [Ber.] XII, p. 290.*

Wichers-Wierdsma, Roline Maria *(b. 1891)*
 Schwencke, Johan. "Overzichten, V."
 Boekcier 9 (1940): 27–30.
 Entries: unnumbered, pp. 28–30
 (bookplates only, to 1938). Illustrated
 (selection).

Wickey, Harry Herman *(b. 1892)*
 Weyhe Gallery, New York. *Harry Wickey
 and his work.* New York, [1938?]. (CSfAc)
 Entries: 79 (to 1936). Inches.

Widgery, William *(1822–1893)*
 [Siltzer] p. 334.

Entries: unnumbered, p. 334, prints
after. Inscriptions.

Wiegmann, Rudolf *(1804–1865)*
 [A. 1800] II, pp. 157–165.
 Entries: 9. Pre-metric. Inscriptions.
 States. Described.

 Andresen, Andreas. "Andresens
 Nachträge zu seinen 'Deutschen Maler-
 radierern.' " [*MGvK.*] 1907, p. 42.
 Entries: 1 (additional to [A. 1800]).
 Pre-metric. Inscriptions. Described.

Wieringen, Cornelis Claesz van
(1580?–1633)
 [W.] II, pp. 878–879.
 Entries: 3+ prints by, 2+ after.*

Wierix family *(16th cent.)*
 Alvin, J. *Catalogue raisonné de l'oeuvre des
 trois frères Wierix.* Brussels: T.J.I. Arnold,
 1866.
 Entries: 2055. Millimeters. Inscrip-
 tions. States. Described. Ms. notes
 (EBM); additional states, about 90
 additional entries, index of title in-
 scriptions. Ms. notes by J.C.J. Bierens
 de Haan (ERB); additional states, ex-
 tensive notes on portraits, a few addi-
 tional entries. Ms. notes (EA); addi-
 tional states.

 Alvin, Louis. *Catalogue raisonné des por-
 traits gravés par les trois frères Wierix.*
 Brussels: T.J.I. Arnold, 1867. (MH)
 Entries: 225 (portraits only). Millime-
 ters (selection). Inscriptions (selec-
 tion). States. Described (selection).

 Alvin, J. *Catalogue de l'oeuvre des frères
 Wierix, supplément.* Brussels: Fr. J.
 Olivier, 1870. (DLC)
 Additional information to Alvin 1866.
 A few additional entries.

 Alvin, J. "Supplément au catalogue de
 l'oeuvre des frères Wierix." *Le Bibliophile
 belge,* 3d ser. 5 (1869–1870): 45–54. *Biblio-*

Wierix family (*continued*)

phile belge, 3d ser. 7 (1872): 39–56.
Bibliophile belge, 3d ser. 8 (1873): 284–301.
Additional information to Alvin 1866.

Wierix, Anton *(c.1552–1624?)*
See also **Wierix** family

[Wess.] II, p. 266.
Entries: 2 (additional to Alvin 1866).
Millimeters. Inscriptions. States. Described. Additional information to Alvin 1866.

Wierix, Henrick *(fl. c.1536)*
[W.] II, p. 881.
Entries: 1.*

Wierix, Hieronymus [Jerome] *(1553?–1619)*
See also **Wierix** family

[Wess.] II, pp. 266–267.
Entries: 7 (additional to Alvin 1866).
Millimeters. Inscriptions. Described.
Additional information to Alvin 1866.

[Dut.] VI, pp. 625–626.*

Wierix, Jan [Johan] *(c.1549–after 1615)*
See also **Wierix** family

[Wess.] II, p. 267.
Entries: 3 (additional to Alvin 1866).
Millimeters. Inscriptions. Described.
Additional information to Alvin 1866.

[Dut.] VI, pp. 624–625.*

Wiesener, Pierre Félix *(fl. 1841–1850)*
[Ber.] XII, p. 290.*

Wiessner, Conrad *(1796–1865)*
[Dus.] p. 292.
Entries: 1 (lithographs only, to 1821).
Millimeters. Inscriptions. Located.

Wightman, Thomas *(fl. 1802–1820)*
[St.] pp. 553–555.*

[F.] p. 291.*

Wigmana, Gerard *(1673–1741)*
[W.] II, p. 881.
Entries: 2.*

Wiiralt, Eduard *(1898–1954)*
Ljati, X. *Èduard Vijarl 't 1898–1954.* Tallin (USSR): Iskusstvo Èstonskoj S.S.R., 1958. (DLC)
Entries: 772 (works in all media, including prints). Illustrated (selection).

Wijck, Thomas *(c.1616–1677)*
[B.] IV, pp. 139–156.
Entries: 21. Pre-metric. Inscriptions.
Described. Copies mentioned.

[Weigel] pp. 170–176.
Entries: 4 (additional to [B.]). Pre-metric. Inscriptions. States. Described.

[Wess.] II, pp. 267–268.
Additional information to [B.] and [Weigel].

[Dut.] VI, pp. 626–634.
Entries: 25. Millimeters. Inscriptions.
States. Described. Appendix with 1 doubtful print.

[W.] II, pp. 906–907.
Entries: 25+.*

Wijenberg, J *(fl. c.1752)*
[W.] II, p. 907.
Entries: 1 print after.*

Wilborn, Nicolaus *(fl. 1531–1538)*
[B.] VIII, pp. 543–551.
Entries: 18. Pre-metric. Inscriptions.
Described.

[P.] IV, pp. 139–142.
Entries: 16 (additional to [B.]). Pre-metric. Inscriptions. Described. Located (selection). Additional information to [B.].

[Wess.] I, p. 156.
Entries: 2 (additional to [B.] and [P.]).
Millimeters (selection). Described.

Wild, John Caspar *(fl. 1835–1846)*
Snyder, Martin P. "J. C. Wild and his Philadelphia views." [*Pa. Mag.*] 77 (1953): 32–75.
> Entries: unnumbered, pp. 54–75. Inches. Inscriptions. States.

[Carey] p. 417.
> Entries: 8 (lithographs only). Inches. Inscriptions. Described (selection). Illustrated (selection). Located.

Wilde, Franz de *(b. 1683?)*
[W.] II, p. 881.
> Entries: 6.*

Wilde, Samuel de
See **Paul,** J. S.

Wildens, Jan *(1586–1653)*
[W.] II, p. 882.
> Entries: 2 prints after.*

Wilder, Georg Christian *(1797–1855)*
Arnold, Georg. *Das Werk von Georg Christoph Wilder jun., Maler und Kupferstecher in Nürnberg.* Nuremberg: Fr. Korn'schen Buchhandlung, 1871.
> Entries: 324. Pre-metric. Inscriptions. States. Described. Also, list of 65 prints after (titles only).

Wilder, Johann Christoph Jakob *(1783–1838)*
Andresen, A. "Johann Christoph Jacob Wilder." [*N. Arch.*] 9 (1863): 50–96.
> Entries: 137 etchings. Pre-metric. Inscriptions. States. Described. Also, list of 6 lithographs. Paper fold measure.

[Dus.] pp. 292–293.
> Entries: 8 (lithographs only, to 1821). Millimeters. Inscriptions. States. Located.

Wildiers, Joseph *(1832–1866)*
[Ap.] p. 459.
> Entries: 3.*

[W.] II, p. 882.
> Entries: 3.*

Wilge, Anthonis Pietersz van der
See **Willigen**

Wilkie, David *(1785–1841)*
Laing, David. *Etchings by Sir David Wilkie, R.A., limner to H. M. for Scotland, and by Andrew Geddes, A.R.A., with biographical sketches.* Edinburgh (Scotland), 1875. 100 copies.
> Not seen.

Dodgson, Campbell. "The etchings of Sir David Wilkie, R.A." *The Walpole Society Annual* 11 (1922–1923): 73–79.
> Entries: 14. Inches. Millimeters. Inscriptions. States. Described. Illustrated (selection). Located.

Dodgson, Campbell. *The etchings of David Wilkie and Andrew Geddes: a catalogue.* London: Print Collectors' Club, 1936. 425 copies. (MB)
> Entries: 14. Inches. Millimeters. Inscriptions. States. Described. Illustrated. Located. Ms. notes (ECol); additional information.

Willaerts, Adam *(1577–1664)*
[W.] II, pp. 883–884.
> Entries: 5 prints after.*

Willaerts, Isaac *(c.1620–1693)*
[W.] II, p. 884.
> Entries: 1 print after.*

Willard, Asaph *(d. 1880)*
[St.] pp. 555–560.*

[F.] p. 292.*

Willaume, Louis *(b. 1874)*
"Repertoire de la gravure contemporaine; Willaume, eaux-fortes et pointes-seches." *Byblis* 2 (1923), 2 pp., unpaginated, following p. 68.
> Entries: Unnumbered, 2 pp. (to 1923). Millimeters.

Wille, Johann Georg *(1715–1808)*
Le Blanc, Charles. *Catalogue de l'oeuvre de Jean Georges Wille, graveur.* Le graveur en taille douce, 1. Leipzig: R. Weigel, 1847.
Entries: 170. Millimeters. Inscriptions. States. Described. Ms. notes (EBM); additional states.

[Ap.] pp. 459–471.
Entries: 93.*

[L. D.] p. 88.
Entries: 1. Millimeters. Inscriptions. States. Described. Incomplete catalogue.*

Wille, Pierre Alexandre *(1748–1821)*
[Baud.] II, pp. 298–303.
Entries: 6. Millimeters. Inscriptions. Described.

Wille-Nielsen, Muggi *(20th cent.)*
Fogedgaard, Helmer. "Muggi Wille-Nielsen, en ny dansk exlibris-kunstner." [N. ExT.] 9 (1957): 84–87.
Entries: 9 (bookplates only, to 1957). Illustrated (selection).

Fogedgaard, Helmer: "Muggi Wille-Nielsen - II." [N. ExT.] 11 (1959): 70–73.
Entries: 70 (bookplates only, additional to Fogedgaard 1957; to 1958). Illustrated (selection).

Willeboirts, Thomas [called "Bosschaert"] *(1614–1654)*
[Wess.] II, p. 267.
Entries: 1. Millimeters. Inscriptions. Described.

[W.] II, pp. 884–885.
Entries: 1 print by, 8 after.*

Willem V, prins van Oranien *(1748–1806)*
[W.] II, pp. 259, 882–883.
Entries: 2.*

Willemart, Albert Philipp *(fl. c.1671)*
[W.] II, p. 885.
Entries: 1.*

Willemin, Nicolas Xavier *(1763–1839)*
[Ber.] XII, p. 291.*

Willemsens, Sidrach *(b. 1626)*
[W.] II, p. 886.
Entries: 1.*

Willenigh, Michel *(d. 1891)*
[Ber.] XII, p. 291.*

Willermet, ——— *(fl. c.1851)*
[Ber.] XII, p. 291.*

Willette, [Léon] Adolphe *(1857–1926)*
[Ber.] XII, pp. 291–298.*

Williams, Fred *(20th cent.)*
Rudy Komon Gallery, Woollahra [James Mollison, compiler]. *Fred Williams' etchings.* Woollahra (Australia), 1968. (NN)
Entries: 246 (to 1968). Inches. States. Described. Illustrated.

Williams, Henry *(1787–1830)*
[St.] p. 555.*

Williams, J. *(18th cent.)*
[Sm.] IV, pp. 1593–1594.
Entries: 1 (portraits only). Inches. Inscriptions. Described.

[Ru.] p. 407.
Additional information to [Sm.].

Williams, Robert [or Roger] *(fl. 1680–1704)*
[Sm.] IV, pp. 1594–1612, and "additions and corrections" section.
Entries: 60 (portraits only). Inches. Inscriptions. States. Described. Illustrated (selection). Located (selection).

[Ru.] pp. 407–411.
Entries: 2 (portraits only, additional to [Sm.]). Inches. Inscriptions. Described. Additional information to [Sm.].

Willigen, Anthonis Pietersz van der
(1591–c.1640)
[W.] II, p. 886.
 Entries: 1.*

Willmann, Eduard *(1820–1877)*
[Ap.] p. 471.
 Entries: 17.*

[Ber.] XII, pp. 298–299.*

Willmann, Michael Lukas Leopold
(1630–1706)
[W.] III, p. 176.
 Entries: 19 prints by, 1+ after.*

Kloss, Ernst. *Michael Willmann, Leben
und Werke eines deutschen Barockmalers.*
Breslau (Germany): Ostdeutsche Ver-
lagsanstalt, n.d. (NNMM)
 Entries: 11. Millimeters. Inscriptions.
States. Described. Illustrated. Ap-
pendix with 14 doubtful and rejected
prints.

Willmes, Engelbert *(1786–1866)*
[Merlo] pp. 965–966.
 Entries: 11. Paper fold measure (selec-
tion). Inscriptions (selection). De-
scribed.

Willmore, James Tibbitts *(1800–1863)*
[Ap.] pp. 471–472.
 Entries: 8.*

Willumsen, Jens Ferdinand *(b. 1863)*
Schultz, Sigurd. *J. F. Willumsen, grafiske
arbejder; litografier, traesnit, raderinger.*
Copenhagen: Bianco Lunos Bogtrykkeri
A-S, 1943. 900 copies. (NN)
 Entries: 138. Millimeters. Inscriptions.
States. Illustrated (selection).

Schultz, Sigurd. *Willumsens grafik, ny
fortegnelse.* Copenhagen: Rasmus Nav-
ers Forlag, 1961. (DLC)
 Entries: 226. Millimeters. Inscrip-
tions. States. Described. Illustrated
(selection).

Schultz, Sigurd. *Willumsens grafik, tillaeg
til ny fortegnelse.* Copenhagen: Rasmus
Navers Forlag, 1967. (DLC)
 Additional information to Schultz
1961.

Wilm, Hubert *(b. 1887)*
Wilm, Anni. "Verzeichnis der Origi-
nalradierungen und Original-
steinzeichnungen von Hubert Wilm."
Supplement to "Hubert Wilm," by
Richard Braungart. [*Kh.*] 10 (1918): 148–
154, 166–171.
 Entries: 280 (to 1918). Millimeters. De-
scribed. Illustrated (selection).

Wilm, Anni. Catalogue. In *Das graph-
ische Werk von Hubert Wilm; beschreibendes
Verzeichnis seiner Radierungen und Stein-
zeichnungen, Geleitwort von Professor Dr.
E. W. Bredt.* Lübeck (Germany): Ludwig
Möller, 1919. 200 copies. (NN)
 Entries: 280 (to 1918). Millimeters. De-
scribed. Illustrated (selection).

Wilson, Benjamin *(1721–1788)*
[Sm.] IV, p. 1613, and "additions and
corrections" section.
 Entries: 2 (portraits only). Inches. In-
scriptions. Described. Illustrated
(selection).

[Ru.] pp. 411–412.
 Entries: 1 (portraits only, additional to
[Sm.]). Inscriptions. Described. Addi-
tional information to [Sm.].

Wilson, Edward A. *(b. 1886)*
Cheever, Lawrence Oakley. *Edward A.
Wilson, book illustrator; a biographical
sketch, together with a check-list of his work.*
Muscatine (Iowa): Prairie Press, 1941.
 Bibliography of books with illustra-
tions by (to 1941).

Wilson, James *(c.1735–after 1786)*
[Sm.] IV, pp. 1614–1618, and "additions
and corrections" section.

Wilson, James (*continued*)

Entries: 24 (portraits only). Inches. Inscriptions. States. Described.

[Ru.] pp. 412–413.
Entries: 2 (portraits only, additional to [Sm.]). Inches. Inscriptions. States. Described. Additional information to [Sm.].

Wilson, James (*fl. c.1813*)
[St.] p. 560.*

Wilson, Sydney Ernest (*b. 1869*)
Roberts, W. *Engravings in mezzotint by Sidney Ernest Wilson.* London: Vicars Brothers, n.d. (NJP)
Entries: 20. Described. Illustrated.

Bland, Harry McNeill. "Sydney E. Wilson, an English master of mezzotint." [*P. Conn.*] 1 (1921): 185–205.
Entries: 32 (to 1921?). Illustrated (selection).

Wilson, William (*18th cent.*)
[Sm.] IV, pp. 1618–1619.
Entries: 2 (portraits only). Inches. Inscriptions. States. Described.

Wilt, Thomas van der (*1659–1733*)
[W.] II, p. 887.
Entries: 3.*

Windesheim, Hans von
See **Monogram HW** [Nagler. *Mon.*] III, no. 1691

Windschiegl, ——— (*fl. c.1821*)
[Dus.] p. 293.
Entries: 4 (lithographs only, to 1821). Millimeters. Inscriptions. Located.

Wingendorp, G. (*fl. c.1654*)
[W.] II, p. 887.
Entries: 1.*

Winghen, Jodocus (*1544–1603*)
[W.] II, pp. 887–888.
Entries: 32+ prints after.*

Winhart, Dietrich (*fl. c.1558*)
[P.] IV, p. 314.
Entries: 2. Pre-metric. Inscriptions. Described.

Winkel, Pieter van (*fl. 1738–1754*)
[W.] II, pp. 888–889.
Entries: 1.*

Winkler, John W. (*b. 1890*)
Winkler, J. W. "List of the etchings of J. W. Winkler." Supplement to "The etchings of J. W. Winkler," by Louis Godefroy. [*P. Conn.*] 4 (1924): 168–191.
Entries: 104 (to 1923). Millimeters. Illustrated (selection). Photostat with ms. addition (NN); 4 additional entries.

Winkles, Henry (*19th cent.*)
[Ap.] p. 472.
Entries: 5.*

Winner, Gerd (*20th cent.*)
Städtisches Museum Braunschweig. *Gerd Winner, Graphik.* Brunswick (West Germany), 1966.
Entries: 80 (to 1965). Millimeters. Inscriptions. Illustrated (selection).

Winter, Fritz (*b. 1905*)
Frankfurter Kunstkabinet, Frankfurt am Main [Karlheinz Gabler, compiler]. *Das graphische Werk von Fritz Winter.* Frankfurt am Main, 1968.
Entries: 74 (to 1968). Millimeters. Described. Illustrated.

Winter [**Wintter**], Heinrich E. von (*1788–1825*)
[Dus.] pp. 293–295.
Entries: 42+ (lithographs only, to 1821). Millimeters (selection). Inscriptions. Located (selection).

Winter, Hendrik *(d. 1671/77)*
[W.] II, p. 889.
Entries: 4.*

Winter [**Wintter**], Joseph Georg
(1751–1789)
Andresen, A. "Der Münchener Jagd-
maler und Kupferstecher Joseph Georg
Wintter." [*N. Arch.*] 14 (1868): 188–220.
Entries: 139 prints by, 1 rejected print.
Pre-metric. Inscriptions. Described.

Winter [**Wintter**], Raphael *(1784–1852)*
[Dus.] pp. 295–299.
Entries: 42+ (lithographs only, to
1821). Millimeters. Inscriptions. Lo-
cated.

Winterhalter, Franz Xavier *(1805–1873)*
[Ber.] XII, pp. 299–300.*

Wirich, Heinrich *(d. 1600)*
[Merlo] p. 968.*

Wiricx, Antonie, Hieronymus or Johan
See **Wierix**

Wiring[s], Heinrich
See **Wirich**

Wismes, Jean Bapt. Héracle Olivier
Bloquel de Croix, baron de *(1814–1887)*
[Ber.] XII, p. 301.*

Wisselingh, Johannes Pieter van
(1812–1899)
[H. L.] pp. 1112–1119.
Entries: 24. Millimeters. Inscriptions.
States. Described.

Wit, Isaac Jansz de *(1744–1809)*
[W.] II, pp. 891–892.
Entries: 12+.*

Wit, Jacob de *(1695–1754)*
[Rov.] p. 66.
Entries: 2. Millimeters. Inscriptions.
Described. Illustrated. Located.

[W.] II, pp. 890–891.
Entries: 7+ prints by, 5+ after.*

Witdoeck, Jan [Hans] *(b. c.1615)*
[W.] II, p. 892.
Entries: 22+.*

Withouck, Heyndrik *(16th cent.)*
[W.] II, p. 892.
Entries: 7+ prints after.*

Witsen, Nicolaes Cornelisz *(1641–1717)*
[W.] II, p. 893.
Entries: 3+.*

Witsen, Willem *(1860–1923)*
Witsen, Willem. "Annotated list of the
etchings of Willem Witsen." Unpub-
lished ms. (NN)
Entries: 29 (mostly unpublished
prints, to 1915).

E. J. van Wisselingh en Co. *Het etswerk
van Willem Witsen, uitgegeven door E. J.
van Wisselingh en Co.* Amsterdam: E. J.
van Wisselingh en Co., [after 1923]. En-
glish ed. *The etched work of Willem Witsen,
published by E. J. van Wisselingh and Co.*
Amsterdam: E. J. van Wisselingh en
Co., [after 1923].
Entries: 104 (published etchings only).
Millimeters. Inches. Illustrated. Prints
are numbered (not consecutively)
401–504.

Stedelijk Museum, Amsterdam [K. G.
Boon, compiler]. *Witsen en zijn vrienden-
kring.* Amsterdam: J. M. Meulenhoff,
1947. (NNMM)
Entries: 214. Millimeters. Inscriptions
(selection). Described. Appendix with
3 unfinished etchings.

Witt, P. de *(17th cent.)*
[Rov.] pp. 81–82.
Entries: 5 doubtful prints. Illustrated.

Witte, Adrien Lambert Jean de *(1850–1935)*
[Ber.] XII, pp. 301–302.*

Witte, Adrien Lambert Jean de (*continued*)

Delchevalerie, Charles. *Adrien de Witte, peintre, dessinateur et graveur, catalogue de son oeuvre.* Liège (Belgium): Imprimerie Bénard, 1927. 410 copies. (EBr)
Entries: 188 (to 1902).

Witte, Emanuel de (*c.1617–1692*)
[W.] II, p. 894.
Entries: 4 prints after.*

Manke, Ilse. *Emanuel de Witte, 1617–1692.* Amsterdam: Menno Hertzberger en Co., 1963.
Catalogue of paintings; prints after are mentioned where extant.

Witte, Franz Karl (*19th cent.*)
[Merlo] p. 967.
Entries: unnumbered, p. 967, prints by and after. Paper fold measure (selection). Inscriptions (selection). Described (selection).

Witte, Peter de
See **Candid**

Witthöft, [Joh.] Wilhelm Friedr. (*1816–1874*)
[Ap.] p. 472.
Entries: 4.*

Wittich, Ludwig Wilhelm (*d. 1832*)
[Dus.] p. 299.
Entries: 1 (lithographs only, to 1821). Millimeters. Inscriptions. Located.

Wittkamp, Johann Bernard (*1820–1885*)
[H. L.] pp. 1110–1111.
Entries: 4. Millimeters. Inscriptions. States. Described.

Wittmer, Johann Michael II (*1802–1880*)
[A. 1800] II, pp. 288–302.
Entries: 2. Pre-metric. Inscriptions. States. Described.

Wlonden, P. C. (*fl. c.1814*)
[H. L.] p. 1119.
Entries: 2. Millimeters. Inscriptions. Described.

Woeiriot, Pierre II (*1532–after 1596*)
[RD.] VII, pp. 43–140; XI, pp. 324–352.
Entries: 414. Millimeters. Inscriptions. States. Described.

[P.] VI, pp. 268–271.
Entries: 5 (additional to [RD.]). Pre-metric. Inscriptions. Described. Additional information to [RD.].

Jacquot, Albert. "Pierre Woeiriot. Les Wiriot-Woeiriot, orfevres-graveurs lorrains." [*Réunion Soc. B. A. dép.*] 15th session, 1891, pp. 184–232. Separately published. Paris, 1892.
Entries: 440. Inscriptions (selection). Described (selection). Based on [RD.] with additions.

Woensam von Worms, Anton (*d. before 1541*)
See also **Monogram AW** [Nagler *Mon.*] I, no. 1485

[B.] VII, pp. 488–491.
Entries: 11+. Pre-metric. Inscriptions. Described.

[Heller] pp. 125–126.
Entries: 2 (additional to [B.]). Pre-metric. Inscriptions. Described.

[Evans] p. 44.
Entries: 2 (additional to [B.]). Millimeters. Inscriptions. Described.

[P.] IV, pp. 149–153.
Entries: 12 (additional to [Merlo] 1st ed., 1850). Pre-metric. Inscriptions. Described. Located (selection.)

Merlo, J. J. "Anton Woensam von Worms, Maler und Xylograph zu Köln, sein Leben und seine Werke." [*N. Arch.*] 10 (1864): 129–274. Separately published. Leipzig: Rudolph Weigel, 1864.

Entries: 549. Pre-metric. Inscriptions. Described. Also, bibliography of books with illustrations by.

Merlo, Johann Jakob. *Anton Woensam von Worms, Maler und Xylograph zu Köln, sein Leben und seine Werke. Nachträge.* Leipzig: Johann Ambrosius Barth, 1884.
Entries: 137 (additional to Merlo 1864). Pre-metric. Inscriptions. Described. Additional information to Merlo 1864. Additional entries to bibliography of books with illustrations by.

[Merlo] pp. 971–1101.
Entries: 549+. Pre-metric (selection). Paper fold measure (selection). Inscriptions. Described. Also, bibliography of books with illustrations by.

[Ge.] nos. 1551–1571.
Entries: 21 (single-sheet woodcuts only). Described. Illustrated. Located.

Wörle, Hans Conrad *(d. 1632)*
[P.] IV, p. 154.
Entries: 1. Pre-metric. Inscriptions. Described. Located.

[A.] IV, pp. 89–92.
Entries: 4. Pre-metric. Inscriptions. Described.

Wörnle, Wilhelm *(1849–1916)*
Roeper, Adalbert. "Wilhelm Woernle." [Bb.] 76 (1909): 960–966.
Entries: 141 (to 1905). Millimeters. States.

Roeper, Adalbert: "Wilhelm Woernle und sein graphisches Werk." [Kh.] 8 (1916): 99–104.
Entries: 141 (to 1905). Millimeters. States.

Wohlers, Julius *(b. 1867)*
[Sch.] p. 144ff.
Not seen.

Woiceske, R. W. *(20th cent.)*
Kleemann Galleries, New York. *Catalogue of etchings, dry-points, aquatints by R. W. Woiceske.* New York, [1938?].
Entries: 64 (to 1937). Inches. Illustrated (selection).

Woiserie, J. I. Bouquet
See **Bouquet de Woiserie,** J. I.

Wolf, Gustav *(20th cent.)*
Eugen Diedrich Verlag. *Sendschreiben an die Freunde der Graphik über das Werk von Gustav Wolf.* Jena (Germany): Eugen Diederich, 1922. (NN)
Entries: 5 (to 1922). Millimeters. Described. Illustrated (selection).

Wolf, Henry *(1852–1916)*
Smith, Ralph Clifton. "Henry Wolf," [P. Conn.] 5 (1925): 209–225.
Entries: unnumbered, pp. 222–225.

Smith, Ralph Clifton. *The life and works of Henry Wolf.* Champlain (N.Y.): Winfred Porter Truesdell, 1927.
Entries: 789. Inches. Place of publication given.

Wolf [**Wolff**], [Ulrich] Ludwig Friedrich *(1776–1832)*
[Dus.] pp. 299–300.
Entries: 5 (lithographs only, to 1821). Millimeters (selection). Paper fold measure (selection). Inscriptions (selection). Located (selection).

Wolf, Sebastian *(19th cent.)*
[Dus.] p. 300.
Entries: 2 (lithographs only, to 1821). Inscriptions. Located.

Wolff, Cor de *(b. 1889)*
Schwencke, Johan. "Overzichten X." *Boekcier,* 2d ser. 2 (1947): 13–19.
Entries: 46 bookplates, 64 commercial prints (to 1947). Millimeters. Described. Illustrated (selection).

Wolff, Gustav Heinrich *(1886–1934)*
Holthusen, Agnes. *Gustav H. Wolff; das plastische und graphische Werke.* Hamburg: Dr. Ernst Hauswedell und Co., 1964.
Entries: 130. Millimeters. Inscriptions. Described. Illustrated.

Wolff, Heinrich *(1875–1940)*
Wolff, Heinrich. Ms. catalogue. (EBM)
Entries: 79. List of impressions for sale; different states of the same print are separately numbered.

Wolffgang, J. G. *(fl. c.1688)*
[Merlo] p. 969.*

Wolfsfeld, Erich *(b. 1884)*
Verlag Neue Kunsthandlung. *Verzeichnis der in unserem Verlag erschienenen Arbeiten von Erich Wolfsfeld.* Berlin: Verlag Neue Kunsthandlung, n.d. (CSfAc)
Entries: 22 (prints published by Neue Kunsthandlung only). Millimeters. Illustrated.

Wolfsheimer, Isaak *(fl. 1817–1831)*
[Dus.] p. 300.
Entries: 3 (lithographs only, to 1821). Millimeters. Inscriptions. Located.

Wolgemut, Michel [Michael] *(1434–1519)*
Stadler, Franz J. *Michael Wolgemut und der nürnberger Holzschnitt im letzten Drittel des XV. Jahrhunderts.* Studien zur deutschen Kunstgeschichte, 161. Strasbourg: J. H. Ed. Heitz, 1913.
Entries: unnumbered, pp. 1–86 (prints by Wolgemut and Pleydenwurff). Millimeters (selection). Described (selection).

Betz, Gerhard. "Der Nürnberger Maler Michael Wolgemut (1434–1519) und seiner Werkstatt." Dissertation, Freiburg University, 1955. Unpublished ms. (Photocopy, ENGM)

Entries: unnumbered, pp. 90–109. Described (selection). Survey of prints from Wolgemut's shop, with review of the literature and discussion of attributions.

Wols [Alfred Otto Wolfgang Schulze] *(1913–1951)*
Grohmann, Will. "Das graphische Werk von Wols." *Quadrum* 6 (1959): 95–118. Separately published. Cologne: Galerie der Spiegel, 1959.
Entries: 52. Millimeters. Illustrated.

Wolstenholme, Dean I *(1757–1837)* and Dean II *(1798–1882)*
[Siltzer] pp. 286–313, 369–370.
Entries: unnumbered, pp. 309–313, prints by and after. Inches (selection). Inscriptions. States. Illustrated (selection).

Wolters, E. F. *(fl. c.1815)*
[Dus.] p. 300.
Entries: 1 (lithographs only, to 1821). Paper fold measure.

Wood, Franklin T. *(b. 1887)*
Thomas, T. H. "List of the etchings of Franklin T. Wood." Supplement to "The etchings of Franklin T. Wood," by T. H. Thomas. [*P. Conn.*] 5 (1925): 228–245.
Entries: 84. Inches. Illustrated (selection).

Wood, J. *(fl. c.1826)*
[F.] p. 293.*

Wood, Joseph *(1778–c.1832)*
Groce, George C. "The first catalogue of the work of Joseph Wood." Supplement to "Joseph Wood; a brief account of his life and the first catalogue of his work," by George C. Groce and J. T. Chase Willet. *The Art Quarterly* 3 (Spring 1950): 148–161, 393–400.

Entries: 4. Inches. Inscriptions. Also, catalogue of paintings; prints after are mentioned where extant.

Woodman, Richard *(1784–1859)*
[Siltzer] p. 370.
>Entries: unnumbered, p. 370. Inscriptions.

Woodruff, William *(fl. 1817–1824)*
[St.] pp. 560–562.*

[F.] pp. 293–294.*

Woodward, Thomas *(1801–1852)*
[Siltzer] pp. 314–315.
>Entries: unnumbered, p. 315, prints after. Inches. Inscriptions. Described (selection).

Woollett, William *(1735–1785)*
Fagan, Louis. *A catalogue raisonné of the engraved works of William Woollett.* London: Fine Art Society, 1885.
>Entries: 123 prints by, 12 after. Inches. Inscriptions. States. Described. Located.

[Siltzer] p. 370.
>Entries: unnumbered, p. 370. Inscriptions.

Wootton, John *(c.1686–1765)*
[Siltzer] pp. 316–317.
>Entries: unnumbered, p. 317, prints after. Inches (selection). Inscriptions.

Worlidge, Thomas *(1700–1766)*
Worlidge, ———. *A catalogue of Mr. Worlidge's prints, and of his collection of antique gems.* [London?], n.d. (EBM)
>Entries: 310.

Worm, Nicolaas van der *(1757–1828)*
[W.] II, p. 899.
>Entries: 1+.*

Worms, Anton Woensam von
See **Woensam von Worms**

Worms, Jules *(1832–1914?)*
[Ber.] XII, p. 302.*

Worrell, Abraham Bruiningh van *(fl. 1809–1849)*
[Siltzer] p. 334.
>Entries: unnumbered, p. 334, prints after. Inscriptions.

Worthington, William Henry *(b. c.1790)*
[Ap.] p. 473.
>Entries: 4.*

Wostry, Carlo *(b. 1865)*
Mencarini, Giuseppe. L'Opera grafica di Carlo Wostry." *Gutenberg Jahrbuch* 36 (1961): 242–248.
>Entries: 89. Millimeters. Inscriptions. Described (selection). Illustrated (selection).

Woudt, Jan Cornelisz. van 't. [called "Woudanus"] *(c.1570–1615)*
[W.] II, p. 899.
>Entries: 8+ prints after.*

Woumans, Conrad
See **Waumans**

Wouters, Augustus Jacobus Bernardus *(1829–1867)*
[H. L.] p. 1112.
>Entries: 2. Millimeters. Inscriptions. States. Described.

Wouters, Charles Augustin
See **Wauters**

Wouters, Frans *(1612–1659)*
[vdK.] pp. 40–42.
>Entries: 4. Millimeters. Inscriptions. Described.

[W.] II, pp. 899–900.
>Entries: 4.*

Wouters, Gomar *(c.1649–1680/96)*
[W.] II, p. 900.
 Entries: unnumbered, p. 900.*

Wouters, Rik *(1882–1916)*
Avermaete, Roger. *Rik Wouters.* Brussels: Les Editions l'Arcade, 1962.
 Entries: 56. Millimeters. Illustrated (1 print only).

Woutiers, Charles
See **Wautier**

Woutiers, Michaelina *(fl. 1643–1646)*
[W.] II, p. 901.
 Entries: 1 print after.*

Wouwerman, Philips *(1619–1668)*
Hecquet, R. *Catalogue de l'oeuvre de F. de Poilly, graveur ordinaire du roi; avec un extrait de sa vie, où l'on a joint un catalogue des estampes gravées par Jan Wissscher et autres graveurs, d'après les tableaux de Wauvermans.* Paris: Duchesne, 1752. Reprint. Abbéville (France): P. Briez, 1865.
 Entries: 112 prints after. Pre-metric. Inscriptions.

[B.] I, pp. 397–400.
 Entries: 1. Pre-metric. Inscriptions. Described. Copies mentioned.

[Weigel] pp. 68–69.
 Entries: 1 (additional to [B.]). Pre-metric. Inscriptions. Described.

[Dut.] VI, pp. 635–636.
 Entries: 3 doubtful prints. Millimeters. Inscriptions. States. Described.

Woty-Wimmer, Hubert *(b. 1901)*
"Exlibris-Liste von Hubert Woty-Wimmer. Gelegenheitsgraphik von H. Woty-Wimmer." 2 single printed sheets. (EWA)
 Entries: 144 bookplates, 153 commercial prints (to 1949).

Wright, Benjamin *(b. 1575/76)*
[Hind, *Engl.*] I, pp. 212–220.

Entries: 11+. Inches. Inscriptions. Described. Illustrated (selection). Located.

Wright, Charles Cushing *(1796–1857)*
[St.] pp. 562–563.*

[F.] p. 294.*

Wright, J. H. *(19th cent.)*
[Siltzer] p. 370.
 Entries: unnumbered, p. 370. Inscriptions.

Wright, John *(c.1745–1820)*
[Sm.] IV, pp. 1619–1621, and "additions and corrections" section.
 Entries: 7 (portraits only). Inches. Inscriptions. Described.

[Ru.] pp. 413–414.
 Entries: 1 (portraits only, additional to [Sm.]). Inches. Inscriptions. Described. Additional information to [Sm.].

Wright, John Buckland *(b. 1897)*
Reid, Anthony. *A check list of the book illustrations of John Buckland Wright.* Pinner (England): Private Libraries Association, 1968. (DLC)
 Bibliography of books with illustrations by.

Wright, John Michael *(c.1623–1700)*
[Hind, *Engl.*] III, p. 332.
 Entries: 1. Inches. Inscriptions. Described. Illustrated. Located.

Wright, Joseph [called "Wright of Derby"] *(1734–1797)*
Bemrose, William. *The life and works of Joseph Wright, A.R.A., commonly called "Wright of Derby."* London: Bemrose and Sons, 1885.
 Entries: 46 prints after. List is not perfectly complete; several other prints are mentioned at the end.

Nicolson, Benedict. *Joseph Wright of Derby; painter of light.* London: Routledge and Kegan Paul; New York: Pantheon Books, 1968.
> Catalogue of paintings; prints after are mentioned where extant.

Wright, Joseph *(1756–1793)*
[St.] p. 563.*

Wright, Thomas *(1792–1849)*
[Ap.] p. 473.
> Entries: 4.*

Writs, Willem *(fl. 1760–1786)*
[W.] II, p. 904.
> Entries: 3+.*

Wtewael, Joachim Antonisz *(c.1566–1638)*
[W.] II, pp. 730–731.
> Entries: 3 prints after.*

Wtewael, Paulus *(fl. 1570–1599)*
[Wess.] II, p. 259.
> Entries: 4 (additional to [Nagler] XIX, p. 283). Millimeters (selection). Paper fold measure (selection). Inscriptions. States. Described.

[W.] II, p. 728; III, p. 171.
> Entries: 11+.*

Wthouck, Heyndrick
See **Withouck**

Wttenbrouck
See **Uyttenbroeck**

Wuchters, Abraham *(c.1610–1682)*
[W.] II, p. 905.
> Entries: 4.*

Wünsch, Anton *(1800–1833)*
[Merlo] pp. 1102–1103.
> Entries: unnumbered, pp. 1102–1103. Paper fold measure (selection).

Würtenburger, Ernst *(1868–1934)*
Würtenburger, Franzepp. *Das graphische Werk von Ernst Würtenberger.* Schriften der Staatlichen Kunsthalle Karlsruhe, 1. Karlsruhe (Germany): Staatliche Kunsthalle, 1938.
> Entries: 211. Millimeters. Inscriptions. States. Described.

Wüsten, Johannes *(1896–1943)*
Städtische Kunstsammlung, Görlitz [Ernst-Heinz Lemper, compiler]. *Johannes Wüsten, 1896–1943; Gedächtnisausstellung.* Görlitz (East Germany), 1966.
> Entries: 75. Millimeters. Illustrated (selection).

Wulf[f]hagen, Franz *(1624–1670)*
[W.] II, p. 905.
> Entries: 2.*

Wunderlich, Paul *(b. 1927)*
Brusberg, Dieter. *Paul Wunderlich; Werk-Verzeichnis der Lithographien von 1949–1965.* Hannover (West Germany): Verlag der Galerie Dieter Brusberg, 1966.
> Entries: 211 (to 1965). Millimeters. Described. Illustrated. Appendix with 4 additional prints, separately numbered.

Brusberg, Dieter. *Paul Wunderlich; Nachtrag 1966 zum Werkverzeichnis der Lithographien.* Hannover (West Germany): Verlag der Galerie Dieter Brusberg [1966?].
> Entries: 26 (additional to Brusberg 1965). Millimeters. Described. Illustrated.

Brusberg, Dieter. *Paul Wunderlich; Werkverzeichnis der Lithografien von 1949–1971.* Berlin: Propyläen Verlag, 1971.
> Entries: 343 (to 1971). Millimeters. States. Described. Illustrated.

Wyck
See also **Wijck**

Wyck, Jan [John] *(c.1640–1700)*
[W.] II, p. 906.
 Entries: 1 print by, 8 after.*

Wyckersloot, Jan van *(fl. 1643–1683)*
[W.] II, p. 907.
 Entries: 3 prints after.*

Wydtmans, N.
See **Weydtmans,** Claes [Nicolaes] Jansz

Wyld, William *(1806–1889)*
[Ber.] XII, pp. 302–303.*

Wyngaerde, Frans van den *(1614–1679)*
[W.] II, p. 909.
 Entries: 25+.*

Wynter, Hendrik
See **Winter**

Wyon, Everhard *(fl. 1721–1767)*
[Merlo] pp. 1104–1106.
 Entries: unnumbered, pp. 1105–1106.
 Paper fold measure (selection). In-
 scriptions (selection). Described
 (selection).

Wyon, Maria Elisabeth *(fl. 1738–1756)*
[Merlo] p. 1106.

Entries: unnumbered, p. 1106. Paper
fold measure. Inscriptions. Described
(selection).

Wyon, Peter *(fl. 1727–1765)*
[Merlo] pp. 1106–1107.
 Entries: unnumbered, p. 1107. Paper
 fold measure (selection). Inscriptions
 (selection). Described (selection).

Wyspianski, Stanisław *(1869–1907)*
Muzeum Narodowe w Krakowie
[Helena Blumówna et al., compilers].
*Stanisław Wyspiański, 1869–1907; Tom I;
biografia – plastyka.* Cracow (Poland),
1958.
 Entries: 6 (complete?). Millimeters.
 Inscriptions. Located.

Wyss, Urban *(d. before 1561)*
[P.] III, pp. 450–451.
 Entries: 3+. Inscriptions (selection).
 Described (selection).

Wyssenbach, Rudolf *(fl. 1545–1560)*
[B.] IX, pp. 168–169.
 Entries: 10. Inscriptions. Described.

[P.] III, pp. 448–450.
 Entries: 9 (additional to [B.]). Inscrip-
 tions. Described. Additional informa-
 tion to [B.].

X

Xavery
See also **Savery**

Xavery, Gerard Jozeph *(fl. c.1741)*
[W.] II, p. 561.

Entries: 4+ prints by, 1 after.*

Xavery, Jacob IV *(b. 1736)*
[W.] II, p. 562.
 Entries: 2 prints after.*

Y

Yale, Leroy Milton *(1841–1906)*
Yale, Leroy Milton. "List of etchings by Leroy Milton Yale." Unpublished ms., 1906. (NN)
Entries: 238 (to 1905). Inches. Inscriptions.

Yate, George *(17th cent.)*
[Hind, *Engl.*] II, pp. 243–244.
Entries: 5. Inches. Inscriptions. States. Described. Illustrated (selection). Located.

Yeager, Joseph *(fl. 1816–1845)*
[St.] pp. 563–566.*

[F.] pp. 294–296.*

Weiss, Harry B. "Joseph Yeager: early American engraver, publisher of children's books, railroad president." *Bulletin of the New York Public Library* 36 (1932): 611–616. Separately published. New York: The Public Library, 1932.
Bibliography of books published by, including books illustrated by. Text gives additions to [St.] and [F.].

Yeatherd, John *(18th cent.)*
[Sm.] IV, pp. 1621–1622, and "additions and corrections" section.
Entries: 3 (portraits only). Inches. Inscriptions. States. Described.

[Ru.] p. 414.
Entries: 1 (portraits only, additional to [Sm.]). Inches. Inscriptions. Described. Additional information to [Sm.].

Yon, Edmond Charles *(1836–1897)*
[Ber.] XII, pp. 303–304.*

Young, James Harvey *(b. 1830)*
[F.] pp. 296–297.*

Young, John *(1755–1825)*
[Sm.] IV, pp. 1622–1646, and "additions and corrections" section.
Entries: 82 (portraits only). Inches. Inscriptions. States. Described. Located (selection).

[Siltzer] p. 370.
Entries: unnumbered, p. 370. Inscriptions.

[Ru.] pp. 415–425.
Entries: 8 (portraits only, additional to [Sm.]). Inches. Inscriptions (selection). Described. Located (selection). Additional information to [Sm.].

Young, Mahonri *(1877–1957)*
C. W. Kraushaar Art Galleries, New York. *Catalogue; complete collection of etchings by Mahonri Young.* New York, 1935.
Entries: 91 (to 1934).

Yran, Knut *(20th cent.)*
Høgdahl, Hugo: "Knut Yran." [*N. ExT.*] 3 (1949–1950): 13–18.
Entries: 132 (bookplates only, to 1948). Illustrated (selection).

Schyberg, Thor Bjørn. "Knut Yrans exlibris." [*N. ExT.*] 17 (1965): 69.
Entries: 13 (bookplates only, additional to Høgdahl). Illustrated (selection).

Yudovin, Solomon Borisovich *(20th cent.)*
Ioffe, I, and Gollerbakha, E. *S. Yudovin graviury na dereve.* Leningrad: Tipografija Akademii Khydozestv, 1928.
Entries: 100 (to 1928). Illustrated (selection).

Brodskij, V. A., and Zhemtsova, A. M. *Solomon Borisovich Yudovin.* Leningrad: "Khudoshchnik RSFSR," 1962.
Entries: unnumbered, pp. 69–77. Millimeters. Illustrated (selection).

Yunkers, Adja *(b. 1900)*
Brooklyn Museum [Una E. Johnson and Jo Miller, compilers]. *Adja Yunkers; prints 1927–1967.* Brooklyn (N.Y.): Brooklyn Museum; Bradford (England) and London: Lund Humphries, 1969.
Entries: 123. Inches. Illustrated (selection).

Yves, ——— *(fl. c.1855)*
[Ber.] XII, p. 304.*

Z

Zaagmolen, Martinus
See **Saagmolen**

Zaal, J. *(fl. c.1670)*
[W.] II, p. 534.
Entries: 1.*

Zacharie, Ernest Philippe *(1849–1915)*
[Ber.] XII pp. 304–305.*

Zadkine, Ossip *(1890–1967)*
Czwiklitzer, Christophe. *Ossip Zadkine, le sculpteur-graveur de 1919 à 1967; première partie, eaux-fortes; deuxième partie, lithographies.* Paris: Published by the author, 1967. 375 copies. (CSfAc)
Entries: 183. Millimeters. Inscriptions. Described. Illustrated.

Zaen, Egidius de
See **Saen**

Zaisinger, Matthäus
See **Zasinger**

Zambaldi, Antonio *(1753–1847)*
[AN.] pp. 656–658.
Entries: unnumbered, pp. 657–658. Millimeters. Inscriptions. Described.

[AN. 1968] p. 176.
Additional information to [AN.].

Zan, Bernhard *(fl. c.1580)*
[A.] III, pp. 256–262.
Entries: 52. Pre-metric. Inscriptions. Described.

Zande, Jan van de
See **Sande**

Zanetti, Antonio Maria *(1680–1757)*
[B.] XII, pp. 160–192.
Entries: 75. Pre-metric. Inscriptions. States. Described.

[P.] VI, pp. 246–247.
Entries: 5 (additional to [B.]). Pre-metric. Inscriptions. Described. Additional information to [B.].

Lorenzetti, Giulio. *Un dilettante incisore veneziano del XVIII secolo; Anton Maria Zanetti di Girolamo.* Extract from *Miscellanea di storia Veneta,* 3d ser. 12. Venice: Carlo Ferrari, 1917. (EBKk)
Entries: 84 woodcuts, 2 rejected woodcuts, 35 engravings, 5 doubtful engravings, 16 engravings after drawings owned by Zanetti. Millimeters. Inscriptions. Described.

Zangrius, Jan Baptist *(fl. c.1600)*
[W.] II, p. 558.
Entries: 1+.*

Zani, Giovanni Batt. *(d. c.1660)*
[B.] XIX, pp. 238–239.
Entries: 1. Pre-metric. Inscriptions. Described.

Zantvoort
See **Santvoort**

Zao Wou-Ki *(b. 1921)*
Jacometti, Nesto. *Catalogue raisonné de l'oeuvre gravée et lithographiée de Zao Wou-Ki, 1949–1954.* Bern: Gutekunst et Klipstein, 1955.
Entries: 65 (to 1954). Millimeters. Described. Illustrated.

Zapouraph
See **Curel,** Chevalier de

Zasinger, Matthäus *(b. c.1477)*
[B.] VI, pp. 371–381.
Entries: 21. Pre-metric. Inscriptions. Described. Appendix with 12 doubtful prints.

[Evans] p. 41.
Entries: 1 (additional to [B.]). Millimeters. Inscriptions. Described.

[P.] II, pp. 169–172.
Entries: 1 print by (additional to [B.]), 4 doubtful prints. Pre-metric. Inscrip-

tions. Described. Located. Copies mentioned.

[Lehrs] VIII, pp. 330–378.
Entries: 22. Millimeters. Inscriptions. Described. Illustrated (selection). Located. Locations of all known impressions are given. Copies mentioned. Watermarks described. Bibliography for each entry.

Lenz, Angelika. *Der Meister MZ; ein Münchner.* Dissertation, Universität München. Munich: Giessen Chemoprint, 1972. (EMSGS)
Additional information to [Lehrs].

Zauerveyd", Oleksander Ivanovich *(1783–1844)*
[Ber.] XII, p. 10.*

Zech, Daniel *(d. 1657)*
Hämmerle, Albert. "Die Punzenstiche des Goldschmiedes Daniel Zech in Augsburg." [*Schw. M.*] 1926, pp. 117–122.
Entries: 24. Millimeters. Inscriptions. Described. Illustrated. Located.

Zeeman, Reinier Nooms *(c.1623–before 1667)*
[B.] V, pp. 123–146.
Entries: 154. Pre-metric. Inscriptions. States. Described.

[Weigel] pp. 247–269.
Entries: 23 (additional to [B.]). Pre-metric. Inscriptions. Described (selection).

[Wess.] II, p. 268.
Entries: 1 (additional to [B.] and [Weigel]). Millimeters. Inscriptions. Described. Additional information to [B.] and [Weigel].

[Dut.] VI, pp. 636–663.
Entries: 179. Millimeters. Inscriptions. States. Described.

Zeeman, Reinier Nooms (*continued*)

[W.] II, pp. 611–613.
Entries: 166+.*

Zehender, Gabriel (*fl. 1527–1535*)
See **Monogram GZ**[Nagler, *Mon.*] III, no. 493

Zeigler, ——— (*19th cent.*)
[Siltzer] p. 334.
Entries: unnumbered, p. 334, prints after. Inches. Inscriptions.

Zeising, Walter (*1876–1933*)
Boettger, Franz (introduction by H. W. Singer). *Walter Zeising; Verzeichnis seiner Radierungen, Lithographien, Holzschnitte und Kupferstiche.* Dresden: Verlag Emil Richter, 1919.
Entries: 118 (to 1919). Millimeters. Described (selection). Illustrated (selection).

Singer, Hans W. "Walter Zeising." [*Kh.*] 15 (1923): 27–30.
Entries: unnumbered, pp. 28–30 (to 1922). Millimeters.

Zeissig, Johann Eleazar
See **Schenau**

Zeissinger, Matthäus
See **Zasinger**

Zeitblom, Bartholome (*1455/60–1518/22*)
Harzen, E. "Ueber Bartholomäus Zeitblom, Maler von Ulm, als Kupferstecher." [*N. Arch.*] 6 (1860): 1–30, 97–123.
Entries: 158 engravings, 12 rejected engravings, 5 woodcuts. Pre-metric. Inscriptions. Described. Also, bibliography of books with illustrations by.

Zeller, Adam (*fl. 1500–1523*)
[B.] IX, p. 580.

Entries: 1. Pre-metric. Inscriptions. Described.

Zenoi [**Zenoni**], Domenico (*fl. 1560–1580*)
[Evans] p. 21.
Entries: 1. Millimeters. Inscriptions. Described.

Zertahelli, Leonhard (*fl. 1809–1852*)
[Dus.] pp. 300–301.
Entries: 6+ (lithographs only, to 1821). Millimeters (selection). Inscriptions (selection). Located (selection).

Zerzavy, Jean
See **Zrzavý**

Ziarnko, Jan (*fl. 1596–1629*)
Potocki, Antoni. *Katalog dzieł Jana Ziarnki, malarza i rytownika polskiego z XVI i XVII w.* Cracow (Poland): Nakładem muzeum narodowego, odbito w drukarni "czasu" skład główny w muzeum narodowen w Krakowie R, 1911.
Entries: 90. Millimeters (selection). Paper fold measure (selection). Inscriptions.

Sawicka, St. M. "Jan Ziarnko, peintre-graveur polonais et son activité à Paris au premier quart du XVIIe siècle." *La France et la Pologne dans leurs relations artistiques* 1 (1938): 103–257. (EPBN)
Entries: 45+ prints by and after. Millimeters. Inscriptions (selection). States. Described (selection). Illustrated (selection). Located.

Ziegler, ——— (*fl. c.1812*)
[Dus.] p. 301.
Entries: 1 (lithographs only, to 1821). Paper fold measure.

Ziegler, Johann
See **Schütz,** Karl

Ziegler, Jules (*1804–1856*)
[Ber.] XII, p. 305.*

Ziegler, Walter *(1859–1932)*
Roeper, Adalbert. *Walter Ziegler und sein Werk, zum fünfzigsten Geburtstage des Künstlers, 23 März 1909.* [*Bb.*] 76 (23 March 1909): 3562–3564. (Separately bound copy, NN)
Entries: 59 (to 1907). Millimeters. States. Also, unnumbered list of bookplates and book illustrations.

Zieler, Mogens Holger *(b. 1905)*
Bärenholdt, H. C. "Mogens Zielers exlibris." [*N. ExT.*] 2 (1947–1948): 54–55.
Entries: 25 (bookplates only, to 1948). Illustrated (selection).

Zierholdt, ―――― *(19th cent.)*
[Dus.] p. 301.
Entries: 1 (lithographs only, to 1821). Millimeters. Inscriptions. Located.

Zignani, Marco *(c.1802–1830)*
[Ap.] pp. 473–474.
Entries: 5.*

Zilcken, [Charles Louis] Philippe *(1857–1930)*
Zilcken, P. H. "Zilcken; manuscript catalogue of etchings." Autograph ms., 1889–? (NN)
Entries: 422. Millimeters (entries 1–235 only).

Pit, A. *Catalogue déscriptif des eaux-fortes originales de Ph. Zilcken, mentionnant deux cent et une pièces.* Paris: Mouton et Cie., Imprimeurs, 1890.
Entries: 201+. Millimeters. Inscriptions. States. Described. Ms. addition (EA); list by Zilcken, "catalogue définitif, 1889," 162 titles.

[Ber.] XII, p. 306.*

Grolier Club, New York. *Catalogue of etchings by Ph. Zilcken of the Hague, Holland.* New York: Grolier Club, 1892.
Entries: 217. Based on Pitt 1890, with 16 additional entries.

Pit, A., Bourcard, G., and Smit, G. *Catalogue déscriptif des eaux-fortes de Ph. Zilcken mentionnant 633 pièces.* Amsterdam: R.W.P. de Vries, 1918.
Entries: 633+ (to 1918?). Millimeters. Described. Ms. notes (NN); additional information regarding states.

Zimmermann, Clemens von *(1788–1869)*
[A. 1800] III, pp. 145–167.
Entries: 12+. Pre-metric. Inscriptions. States. Described. Also, list of prints after, unnumbered, p. 161 (not fully catalogued).

[Dus.] pp. 301–302.
Entries: 5+ (lithographs only, to 1821). Millimeters (selection). Paper fold measure (selection). Located (selection).

Zimmermann, Friedrich Wilhelm *(1826–1887)*
[Ap.] p. 474.
Entries: 11.*

Zimmermann, Mac *(b. 1912)*
Mac Zimmerman grafik-oeuvre. Munich: Heinz Moos, 1970. (DLC)
Entries: 86 (to 1970). Millimeters. Illustrated.

Zinck, Mathis
See **Zündt**

Zitek, Johann *(1826–1895)*
[Ap.] p. 475.
Entries: 2.*

Zix, Benjamin *(1772–1811)*
[Dus.] p. 302.
Entries: 1 (lithographs only, to 1821). Millimeters. Inscriptions. Located.

Zoan Andrea *(fl. 1475–1505)*
[B.] XIII, pp. 293–310.
Entries: 33. Pre-metric. Inscriptions. Described. Copies mentioned.

Zoan Andrea (*continued*)

[Evans] pp. 11, 14, 30.
Entries: 7 (additional to [B.]). Millimeters. Inscriptions. Described.

[P.] V, pp. 79–88.
Entries: 25 (engravings, additional to [B.]), 3 (doubtful prints), 5+ wood or metal cuts. Pre-metric. Inscriptions. Described. Located. Copies mentioned. Additional information to [B.].

[M.] I, pp. 698–706.
Entries: 35 prints by, 12 doubtful and rejected prints. Paper fold measure. Inscriptions. States. Described.

[Wess.] III, p. 43.
Entries: 4 (additional to [B.]). Millimeters. Inscriptions. Described. Located.

[Hind] V, pp. 61–71.
Entries: 37. Millimeters. Inscriptions. States. Described. Illustrated. Located.

Zoffany, John [Johann] Joseph (*1735–1810*)
Manners, Lady Victoria, and Williamson, Dr. C. G. *John Zoffany, R.A.; his life and works 1735–1810.* London: John Lane, The Bodley Head, 1920. 500 copies. (MH)
Entries: unnumbered, pp. 259–264, prints after. Inches. States. Described.

[Siltzer] p. 335.
Entries: unnumbered, p. 335, prints after. Inches. Inscriptions. States.

Zompin, Gaetano Gherardo (*1700–1778*)
Battistella, Oreste: *Della vita e delle opere di Gaetano Gherardo Zompini, pittore e incisore nervesano del secolo XVIII.* Bologna: Presso Nicola Zanichelli, 1930.

Entries: 190 (drawings, prints by and prints after). Millimeters (selection). Inscriptions. Described (prints after only). Illustrated (selection).

Zonta, Luca Antonio de
See **Giunta**

Zoppellari, Carlo (*b. c.1833*)
[Ap.] p. 475.
Entries: 2.*

Zorg, Jan Pietersz (*c.1641–1726*)
[W.] II, p. 642.
Entries: 1 print after.*

Zorn, Anders Leonard (*1860–1920*)
[Ber.] XII, pp. 307–308.
Entries: 37 (to 1892).

Schubert-Soldern, Fortunat von. *Das radierte Werk des Anders Zorn.* Dresden: Ernst Arnold, 1905.
Entries: 155 (to 1904). Millimeters. Inscriptions. States. Described. Illustrated (selection). Located (selection).

[Del.] IV.
Entries: 217. Millimeters. Inscriptions (selection). States. Described (selection). Illustrated. Located (selection).

Asplund, Karl. *Zorns graphische Werk.* 2 vols. Stockholm: A.-B. H. Bukowskis Konsthandel, 1920. (NN). English ed. *Zorns engraved work, descriptive catalogue.* 2 vols. Stockholm: A.-B. H. Buckowskis Konsthandel, 1920, 1921. 325 copies. (NN)
Entries: 288. Millimeters. Inscriptions. States. Described. Illustrated. Located.

Zoust, Gerard
See **Soest**

Zrzavý, Jan (*b. 1890*)
Dolléans, Édouard. "Jean Zerzavy." [*AMG.*] 3 (1929–1930): 800–803.

Bibliography of books with illustrations by (to 1929?).

Zuccari [**Zuccaro**], Federico *(1540?–1609)*
[P.] VI: *See* **Chiaroscuro Woodcuts**

Zündt, Mathis *(1498?–1572)*
[B.] IX, pp. 527–529 (as **Monogram MZ**).
Entries: 5. Pre-metric. Inscriptions. Described.

[B.] IX, pp. 530–532.
Entries: 3. Pre-metric. Inscriptions. Described.

[Heller] pp. 126–131.
Entries: 11 (additional to [B.]). Pre-metric. Inscriptions. Described. Additional information to [B.].

[P.] IV, pp. 194–200.
Entries: 33+ prints by, 10 doubtful prints. Pre-metric (selection). Paper fold measure (selection). Inscriptions. States. Described. Located (selection). Additional information to [B.].

[A.] I, pp. 1–46.
Entries: 78 prints by, 4 doubtful prints. Pre-metric. Inscriptions. States. Described.

Zuliani, Felice *(d. 1834)*
[Ap.] p. 476.
Entries: 11.*

Zunta, Luca Antonio de
See **Giunta**

Zustris
See **Sustris**

Zuze, Zigurds *(20th cent.)*
Kreituse, I. *Zigurds Zuze, Grafika katalogs 1965.* Latvian S.S.R.: Latvijas Makslinieku savienība, 1965. (EOBKk)
Entries: 182 prints, 38 bookplates. Millimeters. Illustrated (selection).

Zwart, Wilhelmus H.P.J. de *(1862–1931)*
Bois, J. H. de. *De etsen van Willem de Zwart; introducties, aanteeken over kunst.* Bussum (Netherlands): J.-A. Sleeswyck, 1911.
Entries: 104 (to 1911?). Millimeters. Described. Ms. addition (NN); 3 additional entries.

Zwiers, Wim *(20th cent.)*
Zwiers, Wim, and de Jong, Mar. *Grafiek miniatuur.* [Rotterdam (Netherlands), 1949?]. (EL)
Entries: 84 (to 1949). Millimeters. Described. Illustrated (selection).

Zwiers, Wim. Catalogue. In *Wim Zwiers, le graveur néerlandais,* by Gianni Mantero. Grafiek miniatuur, 5. Rotterdam (Netherlands), 1956. 50 copies. (EL)
Entries: 146 (to 1955). Millimeters. Described.

Zwiers, Wim. Catalogue. In *Een essay,* by Anne Buffinga. Grafiek miniatuur, 7. Rotterdam (Netherlands), 1958. 60 copies. (EL)
Entries: 175 (to 1957). Millimeters. Described.

Zwiers, Wim. Catalogue. In *Een essay; exlibris en gelegenheidsgrafiek van Wim Zwiers,* by Anne Buffinga. De Gouden Hommel, 11. Nijmegen (Netherlands): Stichting de getijden Pers, 1961. 250 copies. (EH)
Entries: 209 (to 1960). Millimeters. Inscriptions (selection). Described. Illustrated (selection).

Zwinger, Gustav Philipp *(1779–1819)*
[A. 1800] IV, pp. 292–299.
Entries: 13. Millimeters. Inscriptions. States. Described.

[Dus.] pp. 302–303.
Entries: 4 (lithographs only, to 1821). Millimeters. Inscriptions. States. Described (selection). Located.

Zwinger, Jean Bapt. Ignace *(b. 1787)*
 [Ber.] XII, p. 309.*

Zyl[1], Gerard Pietersz van *(c.1607–1665)*
 [W.] II, pp. 686–687.
 Entries: 16 prints after.*

Zylvelt, Anthony van *(c.1643–after 1695)*
 [W.] II, p. 687.
 Entries: 10+.*

Zyndler or **Zynndt,** Mathis
 See **Zündt**